PRAISE FOR VIETNAM

"Monumental. . . . Hastings sees the Vietnam War in much the same way as that of an anguished villager. In his telling, it was a conflict without good guys. . . . Through vivid accounts of battle and suffering, Hastings shows that the American war machine devastated the society it intended to save. . . . He deserves enormous credit for helping us, half a century after the peak of the fighting, to see beyond old arguments about which side was right. What is visible when the blinders come off is indeed no pretty sight."

-New York Times Book Review

"A masterful account of the war . . . Hastings's narrative, along with Ken Burns's masterful series on PBS, offers a well-balanced account of a war that ended more than four decades ago. The author weaves anecdotal and first-person accounts from both sides into the overall history to produce a compelling account that veterans of the war, those who felt its impact at home, and readers born decades after the fighting ended will find hard to put down."

—Associated Press

"We've seen a shelf-load of histories, analyses, memoirs, and novels on Vietnam. But what Hastings does in *Vietnam* is pull all these genres together in a highly readable and vivid narrative that, I think, will become the standard on the war for many years to come."

—NPR.org

"Hastings shows that there is perspective enough—plus bibliography not available to his predecessors—to achieve a balance between traditional narratives of doomed Western hubris and revisionists who believe that America could have prevailed and South Vietnam survived. Hastings's observations—despite the familiarity of the material—are fresh because the author is an equal opportunity judge. None is spared: hawks, doves, communists, politicians, soldiers, antiwar activists—all fall under Hastings's scrutiny. And this is no screed of the sort the history of these events has too often generated; his criticisms are fair. Hastings fluently weaves together the experiences of ordinary people and those of decision makers at the highest levels. . . . Complexity and controversy are bound to this subject, and while *Vietnam* unfolds as a standard chronological narrative, what impresses most are the clarity of the author's assessments and the facility of his presentation."

—CIA, "Studies in Intelligence"

"Vietnam is a product of Hastings's prodigious research and his aptitude for pungent judgments. It is an unsparing look, by a warm friend of America, at the mountain of mendacities, political and military. . . . Almost every page contains riveting facts . . . as successful as printed words can be in achieving his aim of answering the question 'What was the war like?"

—Houston Chronicle

"A gripping, well-researched look at a divisive American war." —New York Post

"In his comprehensive, brilliant, and heartbreaking account, Hastings views the thirty years of war against French colonialism and American interference as one long tragedy for the people of Vietnam. Individual acts of courage and nobility are recounted here among mind-numbing acts of savagery, but there are few heroes. Hastings even portrays many anti-war protesters in the US as cynical, infantile, or simply wanting to avoid death in a distant land. This isn't an easy read, but it is an essential one to comprehend the totality of the wars in that long-besieged country." —Jay Freeman, *Booklist* (starred review)

"The prolific, prizewinning military historian turns his attention to the Vietnam War. Hastings lets no one off the hook. The author brings his usual brilliant descriptive skills to the action, mixing individual anecdotes with big-picture considerations. A definitive history, gripping from start to finish, but relentlessly disturbing."

—Kirkus Reviews (starred review)

"Exceptionally thorough. . . . [Hastings's] greatest service is to demystify the Vietnam War and to place this conflict squarely into a broader history of other wars of the twentieth century. Who better to accomplish this task than Hastings, who in previous works has helped us understand the First World War's Battle of the Argonne Forest, the Normandy invasion of the Second World War, and the Battle of Chosin Reservoir in Korea."

—Financial Times (London)

"A work of considerable quality, marked by a possibly unique combination of military expertise, historical grasp, and journalistic skill in unearthing hitherto undiscovered human stories of the war, as well as judiciously selecting from among others already known. It helps, too, not to be an American, because that lends a certain useful distance. . . . It is a very sad story and one that Hastings tells very well."

—The Guardian (London)

"Magnificent. . . . One by one, the sacred canons of right and left are obliterated. The war is laid bare, with all its uncomfortable truths exposed."

—The Times (London)

"[A] masterpiece. . . . Manages with great skill to combine the accumulation of strategic and political disaster with the real experience of those fighting on the ground."

—Antony Beevor, *The Spectator* (London)

"A masterful performance."

—Sunday Times (London)

"Award-winning journalist Hastings, who previously covered the Vietnam War, now revisits the conflict from start to finish, laying out what happened both in the United States and Vietnam and interspersing throughout personal reminiscences of its participants. Hastings also maintains that the American press played a role in rousing disaffection with the war but, in his judgment, the most egregious error of American leaders was hiding the facts of the war from the people. . . . [Vietnam] may become one of the standard accounts of the war."

—Library Journal (starred review)

"In this wonderfully impressionistic book, Hastings tells a familiar story eloquently. He skillfully uses a series of vignettes from all sides of the conflict to capture the nature of the Vietnam War. . . . Hastings's great gift is his ability to synthesize large amounts of material into a compelling narrative. . . . Marvelously readable."

—Irish Times

"A comprehensive and compelling narrative that illuminates political and military tactics and strategies—and the daily realities of a war that killed two million people."

—Pittsburgh Post-Gazette

"This is a comprehensive, spellbinding, surprisingly intimate, and altogether magnificent historical narrative."

—Tim O'Brien, author of Pulitzer Prize finalist The Things They Carried

"Brilliant. Vietnam appears just in time to help explain the tragedy of that war not only to many who lived through it, but also to new generations of readers who inherited its legacy. Vietnam still matters. Hastings reveals human tragedies that highlight the importance of clear thinking about complex problems, integrity in national security decision making, and a sensitivity to the limits of agency and control in war."

—H. R. McMaster, author of Dereliction of Duty: Lyndon Johnson, Robert McNamara, the Joint Chiefs of Staff, and the Lies that Led to Vietnam

"Max Hastings's meticulously researched, superbly written account will now become the standard by which all other histories of the Vietnam War are judged. He leaves no stone unturned in examining three decades of conflict from the vantage points of all combatants at all levels—from offices in Washington, Hanoi, and Saigon and conference tables in Geneva and Paris, to treacherous trips down the Ho Chi Minh Trail, savage firefights in jungles and rice paddies, and terror-inducing air attacks. The result is a work both eminently readable and definitive."

—Mark Clodfelter, author of *The Limits of Air Power:*The American Bombing of North Vietnam

"A characteristically brilliant, monumental work by Max Hastings that masterfully presents the political, cultural, military, and social factors that produced the most divisive and disastrous conflict in American history. Hastings synthesizes innumerable sources, including many from North Vietnam, that, in an unflinching, clear-eyed manner capture the brutality of both sides in this war, as well as the heroism and the ineptitude, the public confidence and the inner doubts that resulted in the tragedy that was Vietnam—a war that Hastings implies neither side deserved to win."

—General David Petraeus (US Army, Ret.), chairman, KKR Global Institute and former commander of coalition forces in Iraq and Afghanistan, commander of US Central Command, and director of the CIA

"This balanced and insightful book is a pleasure to read. It destroys the fantasy that one side or the other held the moral high ground or a monopoly on devastating folly."

—Karl Marlantes, author of What It Is Like to Go to War and Matterhorn: A Novel of the Vietnam War

"The bible for anyone who wants to try to understand the war."

-General Walter E. Boomer

"This book is a tour de force, a deft, engrossing, and admirably fair-minded chronicle of the three-decades-long struggle for Vietnam. It's narrative history at its very finest."

—Fredrik Logevall, Pulitzer Prize-winning author of Embers of War: The Fall of an Empire and the Making of America's Vietnam

Also by Max Hastings

REPORTAGE

America, 1968: The Fire This Time Barricades in Belfast: The Fight for Civil Rights in Northern Ireland The Battle for the Falklands (with Simon Jenkins)

BIOGRAPHY

Montrose: The King's Champion Yoni: Hero of Entebbe

AUTOBIOGRAPHY

Did You Really Shoot the Television?

Going to the Wars

Editor

HISTORY

Bomber Command
The Battle of Britain (with Len Deighton)
Das Reich
Overlord: D-Day and the Battle for Normandy
Victory in Europe
The Korean War
Warriors: Portraits from the Battlefield
Armageddon: The Battle for Germany, 1944–1945
Retribution: The Battle for Japan, 1944–1945
Winston's War: Churchill, 1944–1945
Inferno: The World at War, 1939–1945

COUNTRYSIDE WRITING

Catastrophe 1914: Europe Goes to War

Outside Days Scattered Shots Country Fair

ANTHOLOGY (EDITED)

The Oxford Book of Military Anecdotes

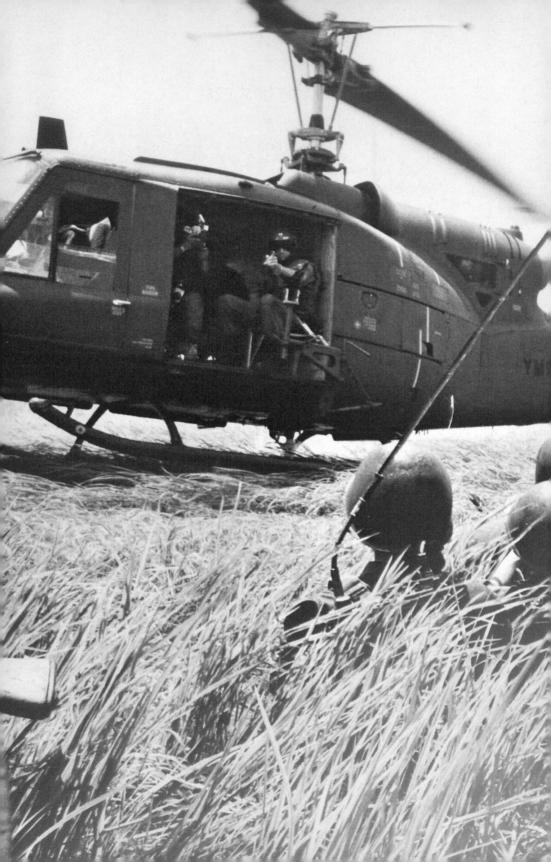

METNAM

An Epic Tragedy, 1945-1975

MAX HASTINGS

HARPER

PERENNIAL

NEW YORK . LONDON . TORONTO . SYDNEY . NEW DELHI . AUCKLAND

HARPER PERENNIAL

A hardcover edition of this book was published in 2018 by HarperCollins Publishers.

VIETNAM. Copyright © 2018 by Max Hastings. All rights reserved. Printed in the United States of America. No part of this book may be used or reproduced in any manner whatsoever without written permission except in the case of brief quotations embodied in critical articles and reviews. For information, address HarperCollins Publishers, 195 Broadway, New York, NY 10007.

HarperCollins books may be purchased for educational, business, or sales promotional use. For information, please email the Special Markets Department at SPsales@harper collins.com.

FIRST HARPER PERENNIAL EDITION PUBLISHED 2019.

Designed by William Ruoto

Library of Congress Cataloging-in-Publication Data has been applied for.

ISBN 978-0-06-240567-8 (pbk.)

19 20 21 22 23 DIX/LSC 10 9 8 7 6 5 4 3 2 1

For my dear friend Rick Atkinson, who chronicles the triumphs and tragedies of American armies with an elegance, penetration, and human sympathy that his fellow historians strive to match.

Asia will have a long-deferred revenge on her arrogant younger sister.

—DEAN INGE, 1928

Every military fact is also a social and political one.

-ANTONIO GRAMSCI

This film contains mature content, strong language and graphic violence: Viewer discretion advised.

—CONTENT WARNING INTRODUCING THE 2017 PBS BURNS-NOVICK SERIES *THE VIETNAM WAR*

CONTENTS

List	of Maps	XV
Intro	oduction	xvii
Note	e on Styles Adopted in the Text	XXV
Glos	ssary of Common Acronyms and Military Terms	xxvii
1	BEAUTY AND MANY BEASTS	1
	1. Clinging to an Empire	1
	2. The Vietminh March	10
2	THE "DIRTY WAR"	21
	1. Steamroller Types	21
	2. Washington Picks Up the Tab	32
	3. Peasants	36
3	THE FORTRESS THAT NEVER WAS	45
	1. Waiting for Giap	45
	2. Disaster Beckons	55
4	BLOODY FOOTPRINTS	66
	1. Quit or Bomb?	66
	2. "A Triumph of the Will"	73
	3. Geneva	82

CONTENTS

5	THE TWIN TYRANNIES	95
	1. "A Regime of Terror"	95
	2. "The Only Boy We Got"	104
	3. Boom Time	110
	4. A Recall to Arms	116
6	SOME OF THE WAY WITH JFK	127
	1. "They're Going to Lose Their Country If "	127
	2. McNamara's Monarchy	141
	3. Le Duan Raises His Stake	148
7	1963: COFFINS FOR TWO PRESIDENTS	155
	1. Small Battle, Big Story: Ap Bac	155
	2. The Buddhists Revolt	166
	3. Killing Time	170
8	THE MAZE	185
	1. "Enough War for Everybody"	185
	2. Dodging Decisions	197
9	INTO THE GULF	213
	1. Lies	213
	2. Hawks Ascendant	222
10	"WE ARE PUZZLED ABOUT HOW TO PROCEED"	234
	1. Down the Trail	234
	2. Committal	241
11	THE ESCALATOR	256
	1. "Bottom of the Barrel"	256
	2. New People New War	268

	CONTENTS	· xi
12	"TRYING TO GRAB SMOKE"	288
	1. Warriors and Water-Skiers	288
	2. Unfriendly Fire	295
	3. Traps and Trail Dust	302
13	GRAFT AND PEPPERMINT OIL	312
	1. Stealing	312
	2. Ruling	315
	3. Gurus	321
14	ROLLING THUNDER	328
	1. Stone Age, Missile Age	328
	2. "Up North"	340
15	TAKING THE PAIN	358
	1. Best of Times, Worst of Times	358
	2. Friends	364
16	"WAIST DEEP IN THE BIG MUDDY"	379
	1. Peaceniks	379
	2. Warniks	386
	3. Fieldcraft	392
	4. Guns	406
17	OUR GUYS, THEIR GUYS: THE VIETNAMESE WAR	413
	1. Song Qua Ngay—"Let's Just Get Through the Day"	413
	2. Fighters	418
	3. Saigon Soldiers	429
18	TET	434
	1. Prelude	434
	2. Fugue	444
	3. A Symbolic Humiliation	455

CONTENTS

19	THE GIANT REELS	461
	1. Fighting Back	461
	2. Surrender of a President	480
20	CONTINUOUS REPLAYS	488
	1. Dying	488
	2. Talking	510
21	NIXON'S INHERITANCE	516
	1. A Crumbling Army	516
	2. Aussies and Kiwis	533
	3. Gods	544
	4. Vietnamization	550
22	LOSING BY INSTALLMENTS	556
	1. The Fishhook and the Parrot's Beak	556
	2. Counterterror	564
	3. Lam Son 719	572
23	COLLATERAL DAMAGE	585
	1. Mary Ann	585
	2. The "Goat"	593
	3. "Let's Go Home"	597
24	THE BIGGEST BATTLE	601
	1. Le Duan Forces the Pace	601
	2. The Storm Breaks	606
	3. An Empty Victory	633
25	BIG UGLY FAT FELLERS	639
	1. "It Will Absolutely, Totally, Wipe Out McGovern"	639
	2. "We'll Bomb the Bejeezus out of Them"	649

	CONTENTS	· xiii
26	A KISS BEFORE DYING	664
	1. The Prisoner	664
	2. "Peace"	668
	3. War of the Flags	675
27	THE LAST ACT	689
	1. Invasion	689
	2. "Ah, My Country, My Poor Country"	708
28	AFTERWARD	726
	1. Vengeance	726
	2. The Audit of War	739
Ackı	nowledgments	753
Note	es	757
Sele	ect Bibliography	811
Inde	V .	827

MAPS

1.	French Indochina	. xvi
2.	Dienbienphu, 13 March–7 May 1954	. 57
3.	Partitioned Vietnam	. 89
4.	South Vietnam	. 98
5.	The Ho Chi Minh Trail	237
6.	The Tet Offensive, 1968	446
7.	Hue	477
8.	The Battle of Daido, 30 April–2 May 1968	501
9.	Operation Linebacker, 1972	632
10.	January 1973: Rival Areas of Control	673
11.	The 1975 North Vietnamese Offensive: Main Thrusts	698

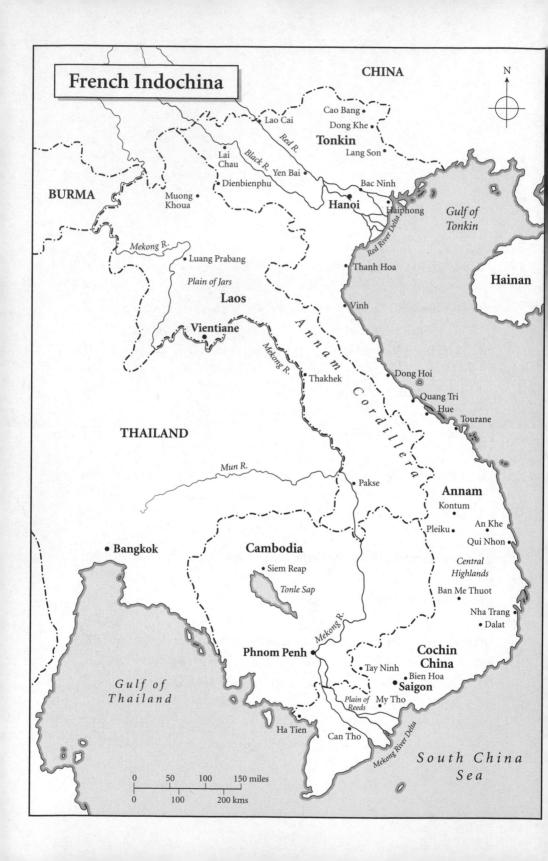

INTRODUCTION

The struggle for Vietnam—a poor Southeast Asian country the size of California, comprising mountains, jungles, and paddies that enchant twenty-first-century tourists but were uncongenial to twentieth-century Western warriors—lasted three decades and cost between two and three million lives. In the eyes of the world, and even those of the communists' Chinese and Soviet armorers, for the first twenty years, it was a marginal affair. During its last phase, however, the war seized the imagination, roused the dismay and indeed revulsion of hundreds of millions of Western people, while destroying one US president and contributing to the downfall of a second. In the wave of youthful protest against authority that swept many countries in the Sixties, rejection of old sexual morality and an enthusiasm for the joys of marijuana and LSD became conflated with lunges against capitalism and imperialism, of which Vietnam appeared an exceptionally ugly manifestation. Moreover, many older Americans who lacked sympathy for any of those causes came to oppose the war because it was revealed as a fount of systematic deceits by their own government, and also seemed doomed to fail.

The 1975 fall of Saigon was a humiliation for the planet's most powerful nation: peasant revolutionaries had prevailed over American will, wealth, and hardware. The silhouetted stairway up which, on the evening of April 29, fugitives ascended to a helicopter as if toward Calvary, secured a place among the symbolic images of that era. Vietnam exercised greater cultural influence upon its times than has any other conflict since 1945.

The merits of rival causes are never absolute. Even in the Second World War, the Western allied struggle against fascism was compromised by its reliance upon the tyranny of Stalin to pay most of the blood price for

destroying the tyranny of Hitler. Only simpletons of the political Right and Left dare to suggest that in Vietnam either side possessed a monopoly of virtue. The authors of all the authoritative works about the conflict are American or French. More than a few of the former write as if it was their own nation's story. Yet this was predominantly an Asian tragedy, upon which a US nightmare was overlaid: around forty Vietnamese perished for every American. Although my narrative is chronological, I have not attempted to chronicle or even mention every action, but instead to capture the spirit of Vietnam's experience through three decades. As in all my books, while relating the political and strategic tale, I also try to answer the question "What was the war *like*?"—for Northern sappers, Mekong Delta peasants, Huey pilots from Peoria, grunts from Sioux Falls, air defense advisers from Leningrad, Chinese railway workers, and bar girls in Saigon.

I was born in 1945. As a youthful correspondent, I lived for almost two years in America, later repeatedly visited Indochina. My understanding was so meager, my perceptions so callow, that in the text that follows I shall not allude to personal experiences, instead summarizing them here. In 1967–68 I traveled widely in the United States, first on a journalistic study fellowship and then as a reporter during the presidential election campaign. I had brief encounters with many of the major players, including Robert Kennedy, Richard Nixon, Eugene McCarthy, Barry Goldwater, Hubert Humphrey, Ronald Reagan . . . and Harrison Salisbury, Norman Mailer, Allen Ginsberg, Joan Baez.

In January 1968, I was among a group of foreign journalists who visited the White House. Seated in the Cabinet Room, we were harangued for forty minutes by President Lyndon Johnson about his commitment to Vietnam, weeks before he stunned the American people by announcing that he would not run for reelection. That morning his personality seemed no less formidable for being close to the caricature. "Some of you like blondes, some of you like redheads, and some of you maybe don't like women at all," he declared in that deadweight drawl, gesticulating constantly to emphasize his points and making broad pencil strokes on a notepad before him. "I'm here to tell you what kind I like. I'm prepared to

meet Ho Chi Minh any time in a nice hotel with nice food and we can sit down and talk to settle this thing."

After making his pitch, this big man left the room abruptly, without taking questions, merely loosing a Parthian shaft at antiwar columnist Walter Lippmann. We had risen and were gathering our notes, when suddenly the president put his head around the door again. "Now, before y'all go," he said almost coyly, "I want to ask: do any of you feel any different from anything you had read or heard about me before you came?" We were stunned into inarticulacy by this glimpse of Johnson's awesome vulnerability.

In 1970, I presented a series of reports for BBC TV's 24 Hours program from Cambodia and Vietnam, then returned in the following year to do more of the same, interviewing President Nguyen Van Thieu and also visiting Laos. Among other themes of those films, I accompanied men of the US 23rd Division on a sweep in the Hiep Duc valley, flew in a Vietnamese Skyraider on a strafing mission, and reported on the battle for Firebase 6 in the Central Highlands. Later that year, in Beijing's Great Hall of the People, I shook the hand of Zhou Enlai. In 1973 and 1974, I traveled again in Vietnam, and in 1975 reported the final campaigns, including the shambles of Danang just before its fall and later from the situation around Saigon.

I intended to remain among the handful of correspondents covering the North Vietnamese takeover. On the afternoon of the final day, however, I lost my nerve, forced a path through the mob of terrified Vietnamese around the US Embassy, and scrambled over its wall with some assistance from the Marine defenders. A few hours later, I was evacuated in a Jolly Green Giant to the USS *Midway*. The above episodes* yielded immature journalism, but today lend personal coloring to my descriptions below of the sweat-soaked, dust-clinging, bomb-happy "boondocks," as Vietnamese, French, and American fighters knew them. In later years, I met Robert McNamara, Henry Kissinger, and other giants of the Vietnam era. Arthur Schlesinger became a friend.

^{*} Described, along with other experiences of conflict, in the author's 2000 memoir *Going to the Wars*.

All wars are different, and yet the same. A myth has grown up, in the US at least, that Vietnam inflicted unique horrors on its participants, attested in countless veterans' anguished gropings into poetry. Yet anyone who lived through Rome's Carthaginian struggles, the Thirty Years' War in Europe, Napoléon's campaign in Russia, or the 1916 Somme battles would mock the notion that Indochina offered qualitatively worse experiences. The violence that men inflicted with spears and swords and unleashed on innocents in the path of armies was as ghastly in the second century as in the twentieth. An attacker set afire by burning oil poured from the walls of a medieval city suffered as terribly as one who fell victim to napalm. Looting, rape, black markets, and casual violence toward civilians and prisoners are inseparable from all conflicts. The 1939-45 cities of Europe hosted as many girls for sale as later did Saigon—recall London's "Piccadilly commandos." In times gone by, however, little was said to folks back home about such sordid manifestations. Film footage authorized for public screening excluded images that were deemed demoralizing because explicit.

In the new revelatory mood of the Sixties, however, suddenly the world witnessed nightly on prime-time TV the excesses and uglinesses perpetrated by US and South Vietnamese forces. Among images that inflicted special injury upon American purposes were those of Saigon's police chief shooting a Vietcong prisoner during the 1968 Tet offensive and of a screaming child running naked in her agony after falling victim to a 1972 napalm strike. Hanoi released no comparable snapshots of cadres executing indigenous opponents by burying them alive or of Vietcong being mowed down in unsuccessful assaults. It broadcast only heroic narratives, together with heartrending footage of devastation inflicted by capitalist air power. The visual contrast between the war making of a superpower, deploying diabolical technology symbolized by the B-52 bomber, and that of peasants clad in coolie hats or pith helmets, relying for mobility upon sandals and bicycles, conferred a towering propaganda advantage on the communists. In the eyes of many young Western people, Ho Chi Minh's "freedom fighters" became imbued with a romantic glow. It seems quite mistaken to suggest, as did some hawks fifty years ago, that the media lost the war for the United States, but TV and press coverage made it impossible for Westerners either to ignore the human cost or to deny the military blunderings.

Hours before I myself, aged twenty-four, flew to Saigon for the first time, I sought advice from Nicholas Tomalin, a British *Sunday Times* reporter. He gave me the address of the Indian bookshop on Tu Do Street that offered the best rate for changing dollars on the black market. Then he said, "Just remember—they lie, they lie, they lie." He meant the US command, of course, and he was right. Like many other Western writers then and since, however, Nick ignored the important point that Hanoi did the same. This fact does not render acceptable the deceits perpetrated by MACV (Military Assistance Command Vietnam) and JUSPAO (the Joint US Public Affairs Office), but it provides a context often absent from judgments upon the so-called credibility gap.

Moreover, although American and South Vietnamese spokesmen peddled fantasies, MACV seldom barred reporters from getting out there and seeing for ourselves. In a fashion unmatched in any conflict before or since, free passage was accorded on fixed-wing aircraft and helicopters to journalists and photographers, many fiercely hostile to their carrier's cause. Relative American openness, contrasted with the communist commitment to secrecy, in my view constitutes a claim upon a fragment of moral high ground. The egregious error committed by US statesmen and commanders was not that of lying to the world but rather that of lying to themselves.

In modern Vietnam, collectivist economic policies have been largely discarded; yet the legitimacy of its autocratic government derives solely from its victory in 1975. Thus, no stain is permitted to besmirch that narrative: few survivors feel able to speak freely about what took place. This opacity has been amazingly successful in defining the terms in which Western as well as Asian writers address the war. While it is unlikely that US archives still conceal important secrets, many must be locked in Hanoi's files. Liberal America has adopted an almost masochistic attitude, which has distorted the historiography as surely as do jingoistic works by conservative revisionists. I recently asked one of the most celebrated cor-

respondents of the war era, "If peace demonstrations had been permitted in Hanoi, how many people would have shown up?" He replied unhesitatingly: "None. The North was one hundred percent behind the struggle."

This seems heroically naïve. Most normal human beings crave escape from an experience that is inflicting grief and hardship on themselves and loved ones. Many of those in the West who opposed the war made a well-founded assessment that the US was doing something unlikely to succeed, employing grievously haphazard violence. Some then went a step further, adopting a view that if their own nation had embraced a bad cause, the other side's must be a good one. Yet the Hanoi politburo and National Liberation Front caused the South Vietnamese people merely to exchange oppression by warlords and landlords in favor of even harsher subjection to disciples of Stalin. Democracy allows voters to remove governments with which they are dissatisfied. Once Communist rule has been established, however, no further open ballot is indulged, nor has one been under Hanoi's auspices since 1954.

In conducting its war effort, the Northern politburo enjoyed significant advantages. Its principals were content to pay an awesome price in human life, secure from media or electoral embarrassments. They could suffer repeated failures on the battlefield without risking absolute defeat, because the US had set its face against invading the North. By contrast, when the South lost once, its fate was irreversible. There are significant parallels between the Vietnamese communists' struggle and the Soviet Union's 1941–45 war effort: Stalin yoked patriotism, ideology, and compulsion in just the fashion emulated by Ho Chi Minh and Le Duan a generation later. Beyond peradventure, the communists proved more effective warriors than the soldiers of Saigon, but it seems prudent to hesitate before anointing them the good guys in this saga.

Much of the narrative below depicts cruelties and follies, yet within the big canvas many individuals, Vietnamese and American, of all ages and both sexes, military and civilian, behaved decently. I have sought to tell stories of such people, because it is mistaken to allow virtuous endeavor to vanish into the cauldron of bomb blasts, brutalities, and betrayals from which most accounts of the war are served up. I decided not to conduct

primary political research: US archives have been trawled by scholars for decades; exhaustive accounts exist of the Western participants' decision making, notable among them those of Fredrik Logevall. Ken Hughes's 2015 rendition and analysis of the White House tapes establish an almost incontrovertible record about the thinking and decision making of Nixon and Kissinger that ended in the January 1973 Paris Accords, which supersedes much of the self-serving narrative presented in the participants' memoirs. However, I have spent many hours studying testimony in the US Army Military Heritage and Education Center at Carlisle, Pennsylvania, and the US Marine Corps Archive at Quantico, Virginia. I have also accessed online material from Texas Tech University's Vietnam War Study Center at Lubbock, Texas, and conducted almost a hundred interviews with survivors of all ages and both sexes, American and Vietnamese. Thanks to the indispensable aid of Merle Pribbenow, I have read many thousands of pages of translated Vietnamese memoirs, histories, and contemporary documents.

Any historian publishing a 2018 study of the war should acknowledge a debt to the recent Ken Burns–Lynn Novick TV documentary series, which around the world has reawakened consciousness about this epochal struggle. I hope that my own work conveys something of the enormity of the experience that the Vietnamese people endured over three generations, from the consequences of which they remain unliberated to this day.

Max Hastings Chilton Foliat, Berkshire, and Datai Langkawi, Malaysia January 2018

NOTE ON STYLES ADOPTED IN THE TEXT

Viet Nam is represented thus by its own people: in the interests of accessibility, however, I sustain the Western custom of using Vietnam, just as I render Ha Noi, Sai Gon, Dien Bien Phu, Da Nang, and Viet Cong as single words.

The Vietnamese language makes extensive use of tone marks. I omit these in my text, but in the bibliography and index all proper names are appropriately accented.

Vietnamese names are commonly triple-barreled, with the family name coming first, and I have adhered to this convention. Many Westerners are bewildered by the profusion of Vietnamese named Nguyen, but this is an accident beyond my undoing.

Wherever possible without forfeiting coherence, I omit province names to avoid crowding the narrative with geographical detail.

Translations often yield stilted prose. When quoting from foreign-language documents and memoirs in all my books, I respect Dryden's admonition that a translator "should not lackey behind his author, but mount up beside him." Thus, I seek to convey Vietnamese and French conversations in colloquial English.

African American is a modern term; in the Vietnam era, the word black was used, and thus I retain it here. I cite an American's race only where this seems relevant.

Ranks attributed are those held at the time of episodes described.

North and South Vietnam are capitalized thus when referenced as separate states but lowercased as *north* and *south* when the country was unified, before 1954 and after 1975.

All the combatants measured distances metrically. I nonetheless adopt feet, yards, and miles, even in direct quotations.

The colloquial phrase for joining South Vietnam's communist guerrillas was *ra bung*, which meant "going out into the marshes," rather as some French World War II resistants called themselves *maquisards*, because they sought refuge in the *maquis*, the wilderness. *Vietcong* and its abbreviation *VC* were South Vietnamese slang terms but are too familiar not to retain here.

In thematic sections—notably about the experience of combat—personal experiences from different periods of the war are sometimes merged where this does not distort their significance and validity.

Timings of military operations are given by twenty-four-hour clock but others in accordance with twelve-hour civilian practice.

No attempt seems plausible to set a value upon the South Vietnamese piaster against the US dollar, since chronic inflation and unrealistic official exchange rates render comparisons valid only for short periods of the wartime era.

GLOSSARY OF COMMON ACRONYMS AND MILITARY TERMS

AFN: US Armed Forces Network radio stations

AK-47: Soviet-designed Kalashnikov assault rifle; a Chinese variant was issued in quantity to Vietnamese communist forces beginning in 1965

APC: armored personnel carrier, most often in Vietnam the tracked M-113

ARVN: Army of the Republic of [South] Viet Nam, always pronounced as "Arvin"

bangalore torpedoes: explosive charges packed in sections of metal or bamboo tubing, for breaching wire entanglements

battalion: military unit, comprising four hundred to a thousand men, normally organized into three or four companies and a headquarters

boonie-rat: slang term for US infantry soldier

brigade: military headquarters, controlling up to five thousand men

cadre: core organizing or controlling group or a functionary in such a group

CAP: combat air patrol

cherry: green infantryman

chieu hoi: "welcome return," name of Saigon's program to process and rehabilitate defectors from the VC or NVA, often used to categorize the many thousands who joined it—"he's a chieu hoi"

CIA: Central Intelligence Agency

Claymore: M18 directional antipersonnel mine, which sprays a hundred steel balls at human height through a kill range of hundreds of feet across a 40-degree arc, triggered by remote control as an ambush weapon

company: military unit, a captain's command, consisting of 100 to 180 men in three or four platoons

CORDS: Civilian Operations and Revolutionary [later changed to Rural] Development Support

corps: military headquarters directing two or three divisions, commanded by a lieutenant general

COSVN: Central Office for South Vietnam or Trung Uong Cuc Mien Nam—communist headquarters, usually located near the Cambodian border

CP: command post

division: military formation comprising eight to fifteen thousand men, organized in two or three brigades, commanded by a US major general or sometimes a Vietnamese colonel

DMZ: the Demilitarized Zone, created near the 17th parallel by the 1954 Geneva Accords, separating the new North and South Vietnams

dust-off: slang for a medevac helicopter

DZ: drop zone for paratroops

ECM: electronic countermeasures deployed by aircraft against ground defenses

FAC: forward air controller

flak: slang term for antiaircraft fire

F0: forward observer, accompanying infantry to direct artillery or mortar fire

FOB: forward operating base

FSB: fire support base

GCMA: Groupement de Commandos Mixtes Aéroportés—French special forces

grunt: slang term for US infantry soldier

hooch: slang term for soldiers' quarters, alternatively a bunker or hut

ICC: International Control Commission, established under the 1954 Geneva Accords with Indian, Polish, and Canadian membership to monitor implementation; it persisted, albeit little heeded, until the 1973 Paris Accords, after which it was supplanted by the ICCS, International Commission for Control and Supervision, which had a wider member-

ship, to address an alleged eighteen thousand cease-fire violations, but proved equally ineffectual

JCS: US Joint Chiefs of Staff

Kit Carson scouts: NVA or VC defectors serving with US units

LAW: light antitank weapon, a shoulder-fired 66mm rocket, used by US and South Vietnamese forces

LRRP: long-range reconnaissance patrol

LZ: landing zone for a helicopter assault; a "hot" LZ was one defended by the enemy

M14: US Army 7.62mm semiautomatic infantry rifle, standard until 1966–68, when progressively withdrawn

M16: US 5.56mm rifle, a much lighter automatic weapon than the M14 that it replaced, whose 1966–68 versions proved prone to jam in action

MACV: US Military Assistance Command Vietnam, US headquarters in Saigon; pronounced "Mac-V"

MEDCAP: Medical Civic Action Program—deployment of military medical teams to provide care to the civilian population

Montagnards: French term for Vietnamese hill tribes, often abbreviated by Americans to Yards; they were almost universally anticommunist and often were recruited by special forces as irregulars

NLF: National Liberation Front, supposedly a political coalition but in reality an entirely communist-run movement, established in 1960, to promote and direct Southern resistance to the Saigon government

NSC: US National Security Council

NVA: North Vietnamese Army, a contemporary American usage adopted in preference to the more common modern PAVN, People's Army of Vietnam

platoon: element of thirty to forty men, normally four to each company, customarily commanded by a lieutenant, seconded by a sergeant

PRC-10: the standard US infantry voice radio set, weighing 23.5 pounds including battery, later replaced by the PRC-25. A company commander might be accompanied by up to three RTOs—radiotelephone operators—each carrying a set tuned to different nets

PRG: Provisional Revolutionary Government, the government-in-waiting

created by the communists in June 1969 to supersede the NLF; initially at COSVN, from February 1973 it was located at South Vietnam's "provisional capital" at Loc Ninh, north of Saigon

recoilless rifle: a relatively portable Soviet-designed 82mm light gun, which could penetrate armor at a range of five hundred yards or propel an explosive bomb up to four thousand yards, mounted either on a tripod or a two-wheeled carriage; extensively used by the VC and NVA

regiment: military unit normally composed of three battalions, commanded by a full colonel

RF, PF: Regional Forces, Popular Forces—militias recruited by Saigon for local defense, lightly armed and commanded by province chiefs, totaling 525,000 men, sometimes known as Ruff-Puffs

RoE: Rules of Engagement whereby US forces were permitted to attack communist forces and installations; entirely different in South Vietnam, North Vietnam, Laos, and Cambodia and varied during the course of the war

RPG: rocket-propelled grenade launcher, a superbly effective communist shoulder-fired weapon, delivering a rocket with a range of 150 yards that could penetrate seven inches of armor

R&R: rest and recuperation—a weeklong out-of-country leave granted to all US personnel at least once during a Vietnam tour, usually in Hawaii, Hong Kong, or Australia

SAC: USAF Strategic Air Command, of which the B-52 bomber force was the principal component

SAM: Soviet-built surface-to-air missile, most commonly the SA-2, deployed in North Vietnam from 1965

sappers: VC and NVA elite spearhead units, specially trained in the use of explosives

SF: Special Forces

short: a term used by US soldiers ("I'm short") to mean being close to one's DEROS, date of estimated return from overseas service, and thus exceptionally reluctant to die

slick: troop transport helicopter, most often a Huey

SOP: standard operating procedure

squad: eight to ten men commanded by an NCO, subdivided into fireteams; normally four in each infantry platoon

USIA: United States Information Agency

Vietcong or VC: derives from term Cong San Viet Nam, meaning Vietnamese communist, progressively adopted from the late 1950s

Vietminh: common usage for the Viet Nam Doc Lap Dong Minh Hoi, Vietnamese communist front organization founded in 1941

BEAUTY AND MANY BEASTS

1. CLINGING TO AN EMPIRE

Let us start this long tale, tragic even among the myriad tragedies of wars, not with a Frenchman or an American, but with a Vietnamese. Doan Phuong Hai was born in 1944 in a village on Route 6 only eighteen miles from Hanoi, yet wholly rustic. Among Hai's earliest memories was that of wire, barbed wire, the rusty strands that encircled the French army post on a hillock near the marketplace, and the manner in which they sang when the wind blew through them. Behind the wire and beneath France's fluttering tricolor flag lived a Vietnamese trumpeter named Vien, whom the little boy loved. Vien gave him empty butter tins and metal bottle caps, from which he built and cherished a toy car. Hai would sit among a little cluster of admiring children listening to Vien's tales of his many battles, peering at the scar from a leg wound he had received at Limestone Mountain where he blew the call for a charge in which Foreign Legionnaires claimed to have killed a hundred communists. The boys stroked the sergeant's stripes and hoarded empty cartridge cases that he occasionally gave to them.

Sometimes Vien would sing in a deep, sad voice, perhaps about his mother, who had died in the previous year. Then, as a special treat, he led his small followers down to the riverbank and played in succession the bugle calls of the army, "some that made our hearts thrill to the notes, others so sad that they made one want to cry." Then came a day in 1951

when Hai's family moved to Hanoi, taking all their possessions aboard the aged district bus. Vien was commanding a picket by the roadside, and gave him parting gifts of two pieces of chewing gum and a gentle tug on the ear. As the bus pulled away, the boy saw him waving through a cloud of red dust behind, as houses, paddy fields, bamboo groves, *da* trees at the end of the village disappeared from his own life forever. Hai embarked upon a succession of journeys, exiles, a few joys and many misfortunes, such as were the shared experience of the Vietnamese people for half a century. Though he himself became a soldier, never again would warriors be imbued in his eyes with the glow of romance conferred upon them by Sgt. Vien and his bugle.

Vietnam endured a thousand years of rule by the Chinese before their expulsion in 938; they returned several times, and were finally driven out only in 1426. Thereafter the country enjoyed independence, though by no means stability or good governance. Rival dynasties controlled the north and south until 1802, when Emperor Gia Long imposed unity, ruling from the city of Hue. During the late-nineteenth-century scramble for empires, France fixed its attentions on Indochina and by force of arms established a progressive dominance, initially in the south, Cochinchina. In May 1883, when the National Assembly in Paris voted five million francs for an expedition to consolidate the region as a "protectorate," the conservative politician Jules Delafosse proclaimed, "Let us, gentlemen, call things by their name. It is not a protectorate that you want, but a possession." So it was, of course. The French committed twenty thousand troops to securing Tonkin—northern Vietnam. Achieving this after a year's hard fighting, they imposed a ruthless governance. While they abolished the old custom of condemning adulteresses to be trampled to death by elephants, the penalty of beheading, formerly imposed only upon thieves, was extended to all who challenged French hegemony. Opium consumption soared after the colonial power opened a Saigon refinery.

Vietnam comprises 126,000 square miles, a few more than Italy, most of which are either mountains shrouded in exotic vegetation or flatlands of extraordinary seasonal wetness and fertility. Almost every

visitor who escaped the penance of exertion in the clinging heat was awed by its beauty and penned lyrical descriptions, celebrating views of "paddy fields in which water buffalo grazed, almost every one with a white egret perched on its back picking at insects; of vegetation so bright and green that it hurt the eyes; of waits at ferries beside broad rivers the color of café crème; of gaudy pagodas and wooden homes on stilts, surrounded by dogs and ducks; of the steaming atmosphere, the ripe smells and water everywhere, giving a sense of fecundity, of nature spawning, ripening and on heat."

Westerners rejoiced in the sublimity of Vietnamese weaving skills, manifested in thatch, basketwork, and conical coolie hats. They peered curiously at the exotic dead creatures purveyed in street stalls, the profusion of fortune-tellers, dice-throwers, spices. Jungle butterflies grew as big as bats. There was a glorious water culture: sampans glided up rivers and canals where carts could not creak; fishing was fun, as well as a prolific source of food. Visitors described cockfights and gambling halls; glittering ceremonies in the imperial palace at Hue where the French indulged a puppet emperor who held banquets surmounted by roast peacock, said to taste like tough veal. The coastal region around the old capital was regarded with considerable suspicion by inhabitants of the Mekong Delta who said, "The mountains are not high nor the rivers very deep, but the men are deceitful and the women over-sexed." A Westerner who loved the Vietnamese wrote that they spoke in cadences that made them "sound to me like charming ducks: their monosyllabic language comes out in a series of sweet quacks."

Among fifty ethnic groups, the wildest tribes shared the wildest regions of Annam with tigers, panthers, elephants, bears, boars, and a few Asian rhinos. Two great deltas, those of the Red River in the north and the Mekong in the south, yielded prodigious agricultural produce. A boom in the rice export trade prompted a French land-grab at the expense of native peoples, matching those conducted by Americans in their own West and by British colonists across swathes of Africa. The peoples of Indochina were taxed to fund their own subjection, and by the 1930s, 70 percent of peasants were reduced to tenantry or smallholding. French planters—a few

hundred families who accumulated colonial Indochina's great fortunes—adopted in the twentieth century an uncompromising attitude toward the Vietnamese, in the words of a British visitor "identical with that of any of the old slave-owning aristocracies. It is one of utter contempt; without which effective exploitation would probably be impossible."

French plantocrats, rubber magnates, and coal-mine owners were indulged in institutionalized cruelty toward their workforces by the colonial administration, which also imposed an artificially high exchange rate for the franc against the local piaster that further enriched the Paris exchequer. The invaders were successful in imbuing many Vietnamese with their language, education, and culture. A schoolboy recalled being taught in class that his forebears were Gauls. He learned better only when his father, an NCO in the French army, told him sternly and proudly, "Your ancestors were Vietnamese." An Australian surgeon wrote of a consciousness, even among relatively humble people, "of their long unbroken history and ancient civilization."

Their circumstances were slightly better than those of the Congolese ruled by Belgium, somewhat worse than those of Indians under the British. There was a contradiction about the lives of upper- and middle-class Vietnamese. Compulsorily immersed in a European culture and language, they nonetheless saw little of French people outside working hours. Nguyen Duong, born in 1943, grew up with a passion for Tintin and French spy stories. Yet like all Asians to whom a physical blow is the worst of insults, at his school he recoiled from French teachers' habitual slapping of dunces. He never knew his parents to entertain a *colon* family nor to dine out with such people. Norman Lewis described Saigon as "a French town in a hot country. It is as sensible to call it the Paris of the Far East as it would be to call Kingston, Jamaica, the Oxford of the West Indies. Its inspiration has been purely commercial and it is therefore without folly, fervour or much ostentation. . . . Twenty thousand Europeans keep as much as possible to themselves in a few tamarind-shaded streets."

Colonial life seemed to most of its beneficiaries infinitely comfortable and agreeable—for a time. Those who lingered too long, however, risked worse diseases than malaria or dysentery: the crippling lassitude of the

East, compounded by opium and access to many servants. Old French hands—les anciens d'Indo—spoke of le mal jaune. Mastery did not spare them from the disdain of Indochina's upper-crust native inhabitants. It was a Vietnamese tradition to blacken teeth with enamel, which caused them to regard white fangs with disdain. An emperor demanded, on receiving a European ambassador, "Who is this man with the teeth of a dog?" Norman Lewis wrote, "They are too civilized to spit at the sight of a white man, but they are utterly indifferent. . . . Even the rickshaw coolie, given—to be on the safe side—double his normal fee, takes the money in grim silence and immediately looks away. It is most uncomfortable to feel oneself an object of universal detestation, a mere foreign-devil."

Few Vietnamese regarded French rule with equanimity, and local revolts were commonplace. In 1927 the Mekong Delta village of Vinh Kim spawned a remarkable band of teenage performers called the United Women's Troupe, which staged anticolonialist shows and plays. The 1930s witnessed rural demonstrations, crop burnings, and insurgencies. A relentless debt squeeze caused some peasants to be imprisoned for non-payment of taxes, others to be so harrowed by loan sharks that by 1943 almost half of Vietnam's land was in the hands of less than 3 percent of its farmers. The colonial authority was confident that repression was the best medicine. As a Vietnamese sûreté officer taunted an arrested revolutionary, "How can a grasshopper kick an automobile?"

Guerrilla and bandit groups nonetheless persisted in the country's many wildernesses—les grands vides. On the terrible prison island of Poulo Condore, cells were seldom empty. There was little pretense of due process for Vietnamese consigned there, and the place became the "revolutionary university." Many of those who later played prominent roles in the independence struggle served time there. Indeed, the man who became their leader, one of the most famous revolutionaries of the twentieth century, was among the few who did not.

Ho Chi Minh was born Nguyen Sinh Cung in a central Vietnamese village in 1890. His father had risen from being a mere concubine's son to mandarin status, but then abandoned the court to become an itinerant teacher. Ho, like Vo Nguyen Giap, Pham Van Dong, and Ngo Dinh

Diem, later attended Hue's influential Quoc Hoc high school, founded in 1896, from which he was expelled in 1908 for revolutionary activity. He cast off family ties, and after a brief period teaching in a village school, in 1911 became a stoker and galley boy aboard a French freighter. For three years he roamed the world, then spent a year in the United States, which fascinated him, before taking a job as an assistant pastry chef in London's Carlton Hotel. He became increasingly politically active and met nationalists of many hues—Irish, Chinese, Indian. He spoke English and French fluently, together with several Chinese dialects and later Russian.

In 1919 he drafted an appeal that was delivered to US president Woodrow Wilson at the Versailles peace conference, soliciting his support for Vietnamese independence when "all subject peoples are filled with hope by the prospect that an era of right and justice is opening to them . . . in the struggle of civilization against barbarism." He attended the 1920 French socialist congress, at which he delivered a speech that later became famous: "It is impossible for me in just a few minutes to rehearse to you all the atrocities committed in Indochina by the bandits of capitalism. There are more prisons than schools. . . . Freedom of the press and opinion does not exist for us. . . . We don't have the right to emigrate or travel abroad. . . . They do their best to intoxicate us with opium and brutalize us with alcohol. They . . . massacre many thousands . . . to defend interests that are not [Vietnamese]." Ho became a prolific pamphleteer and contributor to left-wing journals, often quoting from Lenin.

In 1924 he traveled to Moscow, meeting Russia's new leaders and spending some months at the so-called University of Oriental Workers before moving on to Canton, where he became an interpreter for the Soviet adviser to Chiang Kai-shek. Three years later, after Chiang turned on the communists, Ho fled back to Europe. A French acquaintance described a conversation on a bridge over the Seine, during which the Vietnamese said reflectively, "I always thought I would become a scholar or writer, but I've become a professional revolutionary. I travel through many countries, but I see nothing. I'm on strict orders, and my itinerary is carefully prescribed, and you cannot deviate from the route, can you?"

"Orders" from whom? There are many mysteries concerning Ho's life.

He never married, and his emotional needs appear to have been fulfilled by commitment to political struggle. Who funded his global travels? Was he a paid servant of Moscow, or did he merely receive ad hoc financial assistance from political fellow travelers? It is unsurprising that he became a communist, because the world's capitalists were implacably hostile to his purposes. He was less remarkable for his own writing and thinking, which were unoriginal, than for an extraordinary ability to inspire in others faith, loyalty, and indeed love. A Vietnamese student wrote of a first meeting with Ho some years later in Paris: "He exuded an air of frailty, a sickly pallor. But this only emphasized the imperturbable dignity that enveloped him as though it was a garment. He conveyed a sense of inner strength and generosity of spirit that impacted upon me with the force of a blow."

In 1928, Ho appeared in Bangkok, a rendezvous for exiled Indochinese nationalists. The following year, he moved to Hong Kong, where he presided over a meeting of leaders of rival Vietnamese factions, held in a soccer stadium during a match, to evade police attention. He persuaded his compatriots to unite under the banner of the Indochinese Communist Party, which in 1931 was formally recognized by the Moscow Comintern. During the years that followed, a series of revolts took place in Vietnam. The French responded with bombings of suspected insurgent villages and guillotinings of identified leaders. Though Ho was not directly linked to the risings, he was now a wanted man, pursued through the European powers' colonies. After a series of adventures, he escaped into China by persuading a Hong Kong hospital employee to have him declared dead. Thereafter he commuted between China and Russia, suffering chronic privations and recurrent sicknesses. A French communist agent who met him during his odyssey described Ho as "taut and quivering, with only one thought in his head: his country."

Early in 1941, after an absence of three decades, he secretly returned to Vietnam, traveling on foot and by sampan and assuming the pseudonym by which he would become known to history—Ho Chi Minh, or "Bringer of Light." He took up quarters in a cave in the hills of the north, where he met young men who embraced this fifty-year-old as "Uncle Ho," among

them such later heroes of the revolution as Pham Van Dong and Nguyen Vo Giap. Giap at first introduced Ho to the little guerrilla group by saying, "Comrades, this is an old man, a native of this area, a farmer who loves the revolution." But they quickly realized that this was no local, and certainly no farmer. Ho drew maps of Hanoi for those who had never seen it, and advised them to dig latrines. A veteran recalled, "We thought to ourselves, 'Who is this old man? Of all the things he could tell us, he gives advice about how to take a shit!'" Nonetheless Ho was readily accepted as leader of the group, and indeed of the new movement, which they called the Vietnam Independence League, shortened to Vietminh. Its leaders did not disguise their own ideological commitment, but only much later did they explicitly avow communism as their only permitted creed.

Nazi mastery of Western Europe drastically eroded France's authority in its colonies and intensified peasant suffering. In Indochina the French requisitioned to meet their own needs such basic commodities as matches, cloth, and lamp oil. In the Mekong Delta, there was a brief 1940 communist-led rising in which several French officials were killed, army posts seized. Rice granaries were occupied and their contents distributed; bridges were broken down by insurgents waving hammer-and-sickle flags. The so-called Nam Ky insurrection lasted just ten days, and only a small minority of local people participated, yet it emphasized the rage latent in the countryside.

From the summer of 1940 onward, Tokyo exploited its regional dominance to deploy troops in Indochina, first to sever the Western supply route to China, later progressively to establish an occupation, which provoked President Franklin Roosevelt to impose his momentous July 1941 oil embargo. Although the French retained nominal authority, the Japanese thereafter exercised the real power. They craved commodities to supply their domestic industries and insisted that the Vietnamese should curtail rice-growing in favor of cotton and jute. This, together with enforced export of foodstuffs, created increasing hunger among the inhabitants of the richest rice-producing area in Southeast Asia.

In 1944, a drought followed by floods unleashed a vast human tragedy. At least a million Vietnamese, one in ten people of Tonkin, perished in a

famine as disastrous as the contemporaneous East Bengal disaster in British India. There were credible reports of cannibalism, yet no Frenchman is known to have starved. The famine remained in the memory of many northern Vietnamese as the most dreadful experience of their lives, not excluding subsequent wars. One peasant's earliest memories of life in a village near Hanoi were of his mother scolding the children if they wasted food: "You wouldn't do that if you remembered 1945."

Another peasant described deserted hamlets and desperate people: "Skinny bodies in rags roamed every country road and city street. Then corpses began to appear along roadsides and in pagoda yards, church grounds, market-places, city parks, bus and railway stations. Groups of hungry men and women with babies in their arms and other children at their sides invaded every accessible field and garden to search for anything they thought edible: green bananas, cores and bulbs of banana trees, bamboo shoots. The people of my own village had to defend their land by force." Oxcarts carried away corpses, to be interred in mass graves. One day his three-year-old sister was eating a rice cake outside their house when an emaciated young man "who looked like a ghost in ragged clothes" sprang forward, snatched the morsel from her hand and darted away.

In some areas, charity food kitchens were established to provide gruel for the starving, and long queues gathered before them. Van Ky, a Tonkin teenager who became a famous Vietminh balladeer, said later, "When you opened the front door in the morning, you might see a corpse lying there. If you saw a big flock of crows, that meant a body underneath." It is unsurprising that such experience bred revolutionaries, including Ky himself. He was born in 1928 into a peasant family but grew up in the unusually literate household of an uncle, from whom he learned Lafontaine's fables and performed little plays based on them. He read such books as Victor Hugo's *Les Misérables*. By the age of fifteen, Ky was distributing leaflets for the communists. He became chief of his local secret militia, serving until it was decided that he had artistic talents more useful to the revolution than his military ones. Communist propagandists exploited music to great effect, resetting traditional folk songs to fit their own message, delivered by traveling troupes. Ky later wrote a ballad entitled "*Hy Vong*"—

"Hope"—which became one of the favorite tunes of the Resistance. His experience demonstrated a notable aspect of the independence struggle: that a respect for French culture was no barrier to a determination to see France quit Vietnam.

2. THE VIETMINH MARCH

The last phase of the world war had momentous regional consequences. In March 1945 the Japanese staged a coup, deposing the French puppet regime and assuming full mastery over Vietnam. Colonialism was sustainable only as long as it appeared to subject peoples as the inevitable order, a perception changed forever in Southeast Asia. Vietnamese recoiled from the new rulers' brutalities but were impressed by the spectacle of fellow Asians wielding authority: some called the Japanese oai—"awe-inspiring." In July the Office of Strategic Services—US sponsor of guerrilla war dispatched to Indochina a team of paramilitary agents led by Maj. Archimedes Patti, who pitched camp with Ho Chi Minh. Those callow young men, like so many of their kind both American and British in occupied countries around the world, were grateful to find friends in a hostile environment: they fell in love with the romance of their circumstances, and with their hosts. A twenty-two-year-old guerrilla told one of the OSS men with jocular humor that he should not show himself outside their camp at Tan Trao, "because if the Japanese catch you, they will eat you like a pig!" When he chortled to Giap about this sally, however, he was reprimanded: "We are revolutionaries, and the members of this team are our allies, so we must talk to them in a cultured and civilized way."

Washington's Indochina policy making was fumbling and erratic. The allied warlords were preoccupied with completing the defeat of Germany and Japan. From Yugoslavia to Burma, however, and from Greece to Vietnam, local nationalists focused their ambitions almost exclusively upon securing political control once Axis forces were gone. Colonial subjects saw no merit in securing liberation from fascist suzerainty only to bend once more beneath the yoke of their former masters, whether French, British, or Dutch. The OSS team with Ho became fascinated by his personality

and allowed themselves to suppose that the arms with which they supplied him were being used to harry the Japanese. In truth, the Vietminh staged a few small showpiece actions against the occupiers but focused upon building their organization and husbanding weapons to fight the French. Ho's appointed military chief was Giap. This former teacher and avid student of history had no military training whatsoever when, on December 22, 1944, he formed the so-called Vietnamese Liberation Army Propaganda Unit, just thirty-four strong, three of them women. On May 15, 1945, this body was absorbed into an embryo "Liberation Army."

Modern Hanoi histories record with glee the manner in which communist cadres exploited Western arms and training to pursue their own purposes. In 1943, following the Allied occupation of French Madagascar, the British secret warfare organization, Special Operations Executive, recruited seven Vietnamese prisoners whom its officers found languishing in a Vichy prison. These men assured the liberators of their eagerness to return home to fight, without mentioning that they numbered the French among the fascist foes. A later Vietminh account asserted: "The seven intelligence men appeared to be Allied agents, but their hearts and minds belonged to communism." After the usual training in the black arts, they were parachuted back into Vietnam, fearing rejection by the Party for having accepted service with SOE. Instead they received a warm welcome and were promptly ordered to signal Calcutta for more arms, wirelesses, and medical supplies.

The suddenness with which the war ended in August 1945 enabled Ho to seize the initiative, to fill a power vacuum that yawned widest in the north. His emissaries persuaded Bao Dai, Vietnam's whimsical and indolent young puppet emperor, to write to the Paris government, asserting that the only way to safeguard France's position was "by frank and open recognition of the independence of Vietnam." Gen. Charles de Gaulle, interim master in Paris, declined to respond to this missive but was obliged grudgingly to notice that, before abdicating on August 25, Bao Dai had invited Ho to form a government. The Vietminh leader marched his followers into Hanoi, Tonkin's capital, and on September 2, 1945, proclaimed before a vast and ecstatic crowd in the city's Ba Dinh Square the

I2 · VIETNAM

establishment of a Vietnamese state. He declared: "The French have fled, the Japanese have capitulated, Emperor Bao Dai has abdicated, our people have broken the fetters which for over a century have tied us down."

The news was broadcast throughout the country, and a schoolboy who lived south of Hue later recalled, "Our teachers were so happy. They told us we must go out and celebrate independence. They said that when we are old men . . . we must remember this as a day of celebration." Ho in his speech quoted from the US Declaration of Independence and secured a propaganda coup when the OSS group allowed itself to be photographed saluting the Vietminh flag-raising ceremony. By chance, at that moment a flight of USAAF P-38 fighters roared overhead: in the eyes of thousands of beholders, the US thus laid its blessing upon the new government.

In truth, of course, a cluster of idealistic young State Department and OSS men merely exploited Washington's lack of a policy to make their own weather. Patti, upon whose considerable vanity Ho played like a lutenist, described the Vietminh leader as "a gentle soul," and another American said, "We felt that he was first a nationalist, second a communist." The major admitted long afterward, "I perhaps was somewhat naïve with respect to the intent and purpose in using the words [of the 1776 Declaration]. . . . But I felt very strongly that the Vietnamese had a legitimate gripe or claim, to really govern themselves. After all what was [the Second World] War all about?"

Charismatic leadership is a determinant in most revolutionary struggles—consider India's Gandhi and Nehru, Kenya's Kenyatta, Cuba's Castro. Ho Chi Minh established a legitimacy that proved impregnable even when the shortcomings and indeed barbarities of his regime became apparent, because in 1945 he seized sole ownership of Vietnam's independence movement. Sixteen-year-old Nguyen Cao Ky wrote later that in those days in Hanoi, "the one name on my lips, as well as those of nearly everyone of my generation, was Ho Chi Minh." Many households began to display his portrait: in the words of another young Vietnamese, "We were hungry for a hero to worship." The French had made no attempt to foster an indigenous political class with any sympathy for the aspirations of its own people: rich and educated Vietnamese existed in a world en-

tirely alien from that of the peasantry. While Ho and his intimates knew that few would endorse an avowed communist prospectus, he was able to unite a great swathe of his people behind expulsion of the French. In the years that followed, he achieved a mystic stature unrivaled by any fellow countryman.

During the early years of the independence struggle, in "liberated zones," land was compulsorily transferred from landlord to peasant ownership. Ho and his associates did not reveal that they viewed redistribution as a mere transit stop, pending collectivization. Political cadres painted a glowing picture of Russia as an earthly paradise, which Vietnam should aspire to emulate. Ho himself exuded an aura of dignity and wisdom that impressed all those who met him, and he proved to be a brilliant political manipulator. Beneath a veneer of benignity, he possessed the quality indispensable to all revolutionaries: absolute ruthlessness about the human cost of the courses he deemed appropriate for his people. It seems a fair test of any political movement to inquire not whether it is capitalist, communist, or fascist, but whether it is fundamentally humane. A remark of Giap's answered this question for the Vietminh: "Every minute, hundreds of thousands of people die upon this earth. The life or death of a hundred, a thousand, tens of thousands of human beings, even our compatriots, means little"

Ho Chi Minh's conduct reflected the same conviction, though he was too astute a politician ever to be recorded by Westerners as expressing it. There has been much debate about whether he was a "real" communist or merely a nationalist driven by political necessity to embrace Lenin's creed. Evidence seems overwhelming in favor of the former view. He was never the Titoist some of his Western apologists suggested; he repeatedly condemned Yugoslavia's 1948 severance from the Soviet bloc. He avowed an unflagging admiration for Stalin, though the Russian leader never reciprocated either by trusting the Vietminh leader or by providing substantial aid to him.

It seems narrowly possible that Vietnam's subjection to communism could have been averted if France in 1945 had announced its intention to quit the country and embarked upon a crash transition process, to identify I4 · VIETNAM

credible indigenous leaders and prepare them to govern, as did the British before quitting Malaya. Instead, however, the French chose to draft a long suicide note, declaring their ironclad opposition to independence. The colonialists' intransigence conceded to Ho Chi Minh the moral high ground in the struggle that now began to unfold.

De Gaulle bore chief responsibility for this blunder. In March 1945 he overrode the views of Pierre Messmer, his liaison officer in the Far East, who argued the necessity of parleying with the Vietminh. Instead, the haughty general committed the restoration of French authority to the intractable colonialist Adm. Georges Thierry d'Argenlieu, who became high commissioner in Saigon. In some parts of the world, Africa notable among them, a dearth of credible nationalist movements enabled European empires to cling to their power and privileges for another generation. In Vietnam, however, as elsewhere in Asia, foreign hegemony became unsustainable once local leaders found voices that could not be silenced, together with audiences to heed them. This was the reality that France spent the ensuing decade attempting to deny.

On September 12, 1945, less than a month after the Vietminh appropriated authority in Hanoi, British and Indian troops landed in Saigon. They freed the embittered French colonialists from their prisons and dismissed the Vietminh aspirants to power amid messy and bloody skirmishing, in which some Japanese were deployed alongside the allies. The British commander, Maj. Gen. Douglas Gracey, asserted, "The question of the government of Indochina is exclusively French." One of his officers described a first encounter with the Vietminh: "They came to see me and said 'welcome' and that sort of thing. It was an unpleasant situation and I promptly kicked them out. They were obviously communists." Gracey is sometimes criticized for using his troops to suppress Ho's people. Yet he was merely a relatively junior soldier, no Caesar nor even Mountbatten, mandated to emulate many of his peers around the world in those days: use bayonets to restore the prewar order.

At Washington's behest, 150,000 Chinese troops, Chiang Kai-shek's men, descended upon northern Vietnam to assume a share of the allied occupation role. The Vietnamese dubbed them *tau phu*—the "swollen

Chinese"—because they all seemed to have bulging feet, perhaps from beriberi. The newcomers behaved more like locusts than warriors, stripping the countryside of everything edible or portable. They interfered little with Ho's energetic extension of his political authority and obligingly sold weapons to the Vietminh. Early in October 1945, the first French troops appeared in Saigon, but more than a year elapsed before they reasserted control in the north—a delay priceless for the communists and fatal to the imperialists.

At the age of sixteen, student Pham Phu Bang was an enthusiastic revolutionary who saw the Vietminh exclusively as an independence movement: "I knew nothing about communism." When the Japanese swept over the country, at first he found it thrilling to see fellow Asians humiliate the French colonial power—"like two great water buffaloes locking horns." After Japan's collapse, Bang started his own revolutionary career, stealing weapons from careless Chinese soldiers, writing posters and banners proclaiming UP WITH HO CHI MINH and LONG LIVE FREE VIETNAM. One day he joined a train taking rice north to famine-stricken areas, which became trapped at a bridge wrecked by allied bombing. Its Vietminh escort enlisted local villagers to hump sacks across the river but soon found the train besieged by a throng of starving people. Young Bang was accosted by a skeletal figure who had been given a can of rice for himself but pleaded desperately for one more for his child. "We argued a lot among ourselves about who was to blame for these terrible things—the Japanese who ruled; the French who took as much food as they wanted to feed themselves; or the Americans who had bombed the railways. We decided it was all three. We asked each other: why did our small, fragile country have so many enemies?"

In the course of 1945–46, the Vietminh took over the noncommunist Vanguard Youth movement and suppressed other opposition groups in the north. Many of the rival leaders were jailed, and in the countryside some thousands of alleged "enemies of the people" were liquidated. The Vietminh hustled to announce its own triumph in a January 4, 1946, national election, as assuredly rigged as was every other ballot in Indochina through the decades that followed. For a brief season while the Chinese army and

allied representatives were conspicuous in the north, a semblance of free speech was tolerated. By mid-June, however, most of Chiang's men were gone, and purges resumed.

Ho's people moved swiftly and effectively to secure control of rural areas, especially in remote regions toward the Chinese border. In the Mekong Delta, by contrast, early in 1946 the French reasserted themselves, so that insurgent structures had to evolve secretly, alongside the colonial administration. Among Vietminh returnees from imprisonment was Le Duan, who two decades later would become ruler of his country. As the French expelled the Vietminh from urban areas, he was among those who established himself in the Delta countryside, where guerrillas began to fight. And the colonial power fought back.

France's adoption of this doomed course derived in significant measure from its humiliation in the Second World War. A similar disaster was averted in India, probably only because British voters at their 1945 election displayed the wisdom to endorse a socialist government, which made the historic decision to quit the subcontinent and Burma. By contrast, in Paris in the summer of 1945, a black delegate from Guyana, Gaston Monnerville, asserted that "without the Empire, France today would be no more than a liberated country. . . . Thanks to her Empire, France is a victorious country." Successive revolving-door governments of the Fourth Republic proved feeble in everything save a willingness to deploy force in France's overseas possessions, with a ruthlessness seldom matched by the Soviets. Following a 1945 Muslim revolt in Algeria in which a hundred Europeans were killed, an estimated twenty-five thousand people were slaughtered by French troops. After a March 1947 rebellion in Madagascar, where thirty-seven thousand colons lorded it over 4.2 million black subjects, the army killed ninety thousand people. Only in the enervating climate of a world that had exhausted its stock of moral outrage could the creation of such mountains of corpses by a European power have passed with so little remark. Algeria and Madagascar provide important context for the matching bloodshed that descended upon Indochina.

More puzzling than France's rashness and inhumanity was US willingness to support them. Without military aid, Paris's colonial policy would have collapsed overnight. Fredrik Logevall observes that there would have been no contradiction about an American decision to assist France's domestic revival while withholding backing for its imperial follies. Washington's contrary call was made partly because, even before the Cold War became icy, policy makers recoiled from acquiescence in communist acquisition of new territorial booty. While American liberal intellectuals detested colonialism, in an era when much of their own country was still racially segregated, the spectacle of white men lording it over "lesser races" did not seem as odious as it would soon become. In the late 1940s, French policy was less closely linked to US anticommunism than it later became, but the interests of the Vietnamese people—or for that matter of their Malagasy, Algerian, and suchlike brethren—ranked low in the priorities of President Harry Truman.

Some Vietnamese at first regarded the return of the French as an acceptable temporary expedient, to rid themselves of the Chinese plundering the north. Ho Chi Minh received token recognition as master of Tonkin, while Bao Dai's nominal rule over the country was acknowledged. In July 1946, when Ho visited Paris for talks about the constitutional future, he was greeted with the honors of a head of state. This, however, was mere window dressing. In the talks at Fontainebleau that followed, the Paris government made it plain that he had been summoned only to receive the instructions of his masters, not to negotiate a reassignment of power. De Gaulle said, "United with the overseas territories which France opened to civilization, she is a great nation. Without these territories she would be in danger of no longer being one."

The head of the French delegation told a Vietminh representative contemptuously, "We only need an ordinary police operation for eight days to get all of you out." For some weeks, Ho lingered in frustration. Truong Nhu Tang, almost three decades later a Southern revolutionary minister, was among a group of Vietnamese students who met their hero in Paris. They were entranced when the aspiring national leader instructed them to call him Uncle Ho rather than Mister President. He asked their opinions about Vietnam's future and devoted an afternoon to conversation with them. "It is hard to think of another world leader who under

similar circumstances might have done the same." When Ho found that the north, center, and south of the country were all represented in the student group, he said: "Voila! The youth of our great family. . . . You must remember, though the rivers run dry and the mountains crumble, the nation will always be one." His remarks profoundly impressed his young compatriots, because they evoked "the language of slogan and poetry that Vietnamese leaders had always used to rally the people. . . . From that afternoon I was Ho Chi Minh's fervent partisan. I had been won by his simplicity, charm, familiarity. His . . . burning patriotism offered me a role-model for my own life."

Ho returned to Tonkin knowing that no peaceful settlement was attainable. The French behaved with unswerving duplicity: as fast as more troops, planes, and warships became available, they tightened their grip in the south, then reached out for the north. That summer of 1946, their foremost soldier, Philippe Leclerc, directed military operations. He branded Ho an enemy of France and unwisely declared the conflict as good as won. The general treated with contempt Giap, Ho's former intelligence chief who was then presumptive Vietminh "minister of defense." Giap's broad, infectious grin deluded some Westerners into believing that he was a more genial and pliable figure than his leader. In truth, Giap's vanity matched his ruthlessness: the Frenchman's casual insults fueled his loathing for the colonialists.

Leclerc belatedly changed his mind about Indochina, becoming convinced that it could not be held in the face of a nationalist hostility shared by communists and noncommunists alike. Yet shortly afterward, he was killed in an air crash in Africa, and Georges Thierry d'Argenlieu thereafter dominated his country's policy making. The high commissioner was a figure of Jesuitical inflexibility, who persuaded the Paris government that the Vietminh could be crushed: "It is from now on impossible for us to deal with Ho Chi Minh. . . . We shall find other people with whom we can negotiate." The French dallied with promoting the young ex-emperor Bao Dai. Yet in Vietnam, as in many oppressed nations around the world, a tide was running strongly for the Left. No other Vietnamese remotely matched the grip upon popular imagination secured by Ho.

In November 1946, following the breakdown of negotiations, the French launched a brutal naval and air bombardment of the Vietminh's alleged strongholds in and around the port of Haiphong. Several thousand people perished, and only the city's European quarter escaped devastation. On December 19, d'Argenlieu issued an ultimatum calling on the Vietminh to quit, to which they responded by staging an armed insurrection in Hanoi, sustained for sixty days. When at last they were expelled amid widespread destruction, the French deluded themselves that they had regained control of Tonkin.

Foreign observers were skeptical, however. A correspondent of *The Times* of London wrote in December, "Any colonial power which puts itself in the position of meeting terrorism with terrorism might as well wash its hands of the whole business. We are about to see the French army reconquer the greater part of Indochina only to make it impossible for any French merchant or planter to live there outside a barbed-wire perimeter." Ho and Giap, preparing for a long campaign, needed bases beyond range of France's airfields and heavy guns. Thus, their main army, some thirty thousand strong, abandoned towns and cities and marched away to Viet Bac, the remote northwestern region.

The Vietminh leaders, who became cave or hut dwellers, never deluded themselves that they could achieve absolute military victory. Instead, they sought merely to make French rule prohibitively costly. To this end, covert local groups waged guerrilla war while regular forces launched set-piece operations where conditions appeared favorable. They relied chiefly on captured weapons but also began to manufacture their own, assisted by some three thousand Japanese deserters. With boundless ingenuity, they scavenged French cartridge cases for reloading and made mines from captured shells and mortar bombs. At the outset, they exercised overt or secret control of around ten million people, most of whom paid taxes to them and performed labor or military service. Though the Vietminh denounced opium trafficking as a manifestation of colonial exploitation, Ho boosted the movement's revenues by the same means.

Families are almost sacred hubs of Vietnamese society, yet in those days many became riven. Ten-year-old Tran Hoi's father was a Hanoi

small-businessman who continued to acquiesce in French rule. He said, "If we have to choose between colonial domination and communism, I will take colonialism, because it means access to Western civilization." There was a bitter row when Hoi's uncle, a doctor, announced his own determination to join Ho Chi Minh. The clan's divisions, like those of many others, remained unhealed through decades of strife that now began to unfold.

THE "DIRTY WAR"

1. STEAMROLLER TYPES

In the early months of 1947, Charles Trenet crooned irresistibly, reminding the world of the glory of the French language: "La Mer, qu'on voit danser lu long des golfes claires," words rendered banal in English—"The sea, that we see dancing the length of the bright bays." Christian Dior seized the imagination of fashionable womankind with his New Look, unfolding swathes of fabric beneath a tight waist and bodice, putting to flight years of austerity. French culture, style, and beauty, both natural and man-made, were once more ascendant. From Paris the writer Nancy Mitford tirelessly mocked her English compatriots for their inability to match her hosts' cuisine, wit, sophistication.

And yet these same clever, conceited, morbidly insecure people chose to immerse themselves in a brutal colonial war eight thousand miles from home, which eventually cost their own side more than ninety thousand dead, and the Vietnamese people far more. Most of the inhabitants of metropolitan France regarded the struggle to preserve their overseas empire—la sale guerre, "the dirty war"—with indifference, if not outright cynicism. De Gaulle, now in political exile, displayed belated doubts, which soon became certainty, that France had no vital interest in Indochina and could not prevail there. Yet a vocal minority cared passionately and promoted a fabulously expensive military commitment.

George Orwell observed that the quickest way to end a war is to lose

it, whereas it was France's misfortune to take almost a decade to achieve this. The struggle for Indochina took different forms, according to the regions of the country. In the north, large forces maneuvered and fought against communist formations that eventually mustered sixty thousand men, supported by a revolving cast of peasant porters. A Vietminh document declared the dry season between October and April "most propitious for fighting," while the rainiest months from May to October, when movement became difficult, were for rest, training, redeployment, and planning. Meanwhile, in towns and cities, the French strove to combat terror attacks—bombs thrown into crowded cafés, shootings of officials. Such incidents became part of a new normality: at a mayoral reception in Haiphong, guests were momentarily alarmed by a nearby explosion and gunshots, but cocktails and conversation resumed when it was learned that a Vietminh had merely been shot dead after tossing a grenade at a police station. In one unusually successful and cruel attack, guerrillas burst in upon a dinner party held at a French home at Cap St. Jacques, near the mouth of the Saigon River. With grenades and old British Sten guns, they killed eight officers, two women, six children, and four Vietnamese servants.

Throughout the countryside, a network of almost a thousand forts and miradors—watchtowers skirted with mines, concertina wire, logs, sandbags, corrugated iron, and trenches prickling with sharpened bamboo stakes—was created to protect villages and roads. These had indifferent success in containing the Vietminh, who lifted the mines for their own use, and could usually overrun a local post if they set their minds to it. French small craft fought fierce battles on the Black River against guerrillas firing from the shore.

Meanwhile high in the mountains and deep in the jungle, French special forces of the GCMA—Groupement de Commandos Mixtes Aéroportés—led tribesmen who hated the communists for their own reasons. Since insertion and extraction were dependent upon airstrips, some GCMA men went native because they had no choice; more than a few never returned to civilization. This became the last conflict in which paratroops made repeated operational jumps, some as often as once a week.

For most French units, however, this was a road-dominated war, in which helicopters played only a marginal role: even in the struggle's last days, the colonial power owned just twenty-three. Infantry conducted an interminable succession of sweeps across the countryside, with such lyrical code names as Citron, Mandarine, Mercure, Artois, Mouette, and Nice I & II. These killed some Vietminh, but only in return for a terrific expenditure of effort and intensification of peasant grievances.

Giap had attended no war college but read voraciously. He became obsessed with Napoléon, Clausewitz, and the guerrilla tactics of Mao. His forces achieved one of their first high-profile successes on January 27, 1947, ambushing a convoy carrying Vietnamese politicians in French service on an inspection tour of the north. Fourteen vehicles were destroyed, the education minister and a French engineer killed. The attack impressed the authorities by its boldness and efficiency, and more of the same followed. Highway 5 from Hanoi to Haiphong became known as "the road of blood." A village on the north-south Highway 1 was so notorious an ambush site that the French bulldozed it.

The two sides competed in ruthlessness. The Vietminh executed village chiefs who declined to bow to their will, often by live burial before peasant audiences, after subjecting them to tortures of medieval ingenuity. When the Vietminh killed one Vietnamese soldier captured in French service, a guerrilla borrowed a pair of pliers from a nearby house, with which he removed the man's gold fillings. A child witness wrote, "I had seen many corpses beheaded, dismembered, eviscerated, even scalped, yet nothing more disgusting than the sight of that guerrilla holding the two gold teeth, his face beaming." Vietnamese adapted readily to conducting covert lives in parallel with their overt ones, because their society had a long tradition of secret associations.

The French employed every extravagance of firepower on the battlefield and allowed their troops almost absolute license behind it. The writer Norman Lewis described his first flight to Saigon. His neighbor in the Air France plane was a Foreign Legion colonel, who peered at the Mekong Delta below with the jaundiced eye of familiarity. As they passed a cluster of huts at two thousand feet, Lewis's innocent gaze fixed upon what might

have been a wisp of incense curling upward. Then he grasped that it was, instead, a billowing pall of smoke. When moving specks also became visible, his neighbor the Legionnaire observed sagely "une operation." Lewis wrote: "Somehow, as he spoke, he seemed linked psychically to what was going on below. Authority flowed back into the travel-weary figure. With the accession of this priestly essence he dominated the rest of the passengers. Beneath our eyes violence was being done, but we were as detached from it almost as from history. . . . One could understand what an aid to untroubled killing the bombing plane must be."

French brutality was driven partly by the habit of racial domination, partly by consciousness that even if many peasants were not active foes, they knew where the enemy was; in which culvert or on what path his snares awaited the unwary. The colonialists and their allies of the Cao Dai and Hoa Hao—southern religious sects with formidable private armies—are reckoned to have killed five civilians for every one of their own people who perished. The November 1948 massacre of some three hundred Vietnamese women and children at My Trach, in the southernmost province of what would become North Vietnam, is scarcely acknowledged in modern France, yet seems evidentially beyond doubt. Meanwhile "the Hoa-Hao liked to tie Viet-Minh sympathisers together with rope and throw them into the rivers to drown in bundles," in the words of Bernard Fall, "floating down the river like so many trains of junks, at the mercy of the currents and tides."

An American, Bob Miller of United Press, was aboard a French armored barge patrolling a canal late one night when its searchlight fixed upon three sampans breaching the curfew. Two that ignored an order to halt were riddled with machine-gun fire. The third contained two elderly peasants and their son, with a cargo of rice. The sacks were duly tipped overboard, whereupon the boy sought to escape by leaping into the water. A soldier tossed a grenade in his wake, killing him. A courteous young French officer explained to Miller "that it was only by making people understand that breaches of the regulations would be punished with extreme severity that [the French] could hope to keep the upper hand." Upper hand? Even in the relatively quiet years 1947–48, a single Foreign Legion

battalion suffered two hundred casualties from mines, skirmishes, and ambushes.

The Legion has become part of a heroic legend of Indochina. Yet other French soldiers derided them as *genre rouleau compresseur*—"steamroller types." Among Vietnamese civilians their units—which included some former members of Hitler's SS and Wehrmacht—achieved an appalling reputation for rape and pillage. Duong Van Mai, of a traditional mandarin family, described how Legionnaires entered her home, slit suitcases with their bayonets, and removed whatever property took their fancy. As her family trekked through the northern war zone, French soldiers stripped them of cash and gold, deemed legitimate warriors' perquisites. Black colonial troops were less discriminating, seizing even villagers' poor stocks of salt and *nuoc mam*—fish sauce. As in Europe in World War II, Moroccans were the most unwelcome visitors that a district could suffer. Meanwhile the Vietminh might be notoriously cruel but were also famously honest.

The Austrian-born French writer and adventurer Bernard Fall's books on his nation's Indochina war are often cited as classics: they offer vivid anecdotage, some of it believable, and shrewd analysis of the difficulties of conducting counterinsurgency. Yet they embrace an essentially heroic vision of the French army, while remaining mute about the many atrocities its soldiers committed, of which Fall, as a contemporary witness, must have been aware. Vietnamese in French service showed little more sensitivity: American Howard Simpson watched exuberant parachutists tearing down a Saigon street in a jeep which crushed and scattered a row of bamboo panniers, filled with red peppers laid out to dry in the sun. After the vehicle passed, two old women set to work painstakingly to collect the debris and salvage what they could of their ravaged wares. Here was a minuscule event amid a vast tragedy, yet Simpson asked himself, how could it fail to influence the hearts and minds of its victims, those two elderly street sellers?

Early in 1948 a halfhearted attempt was made to establish an anticommunist political front under the patronage of Bao Dai, who returned from exile shortly afterward, aged thirty-four. Yet the emperor, indolent and spoiled, was soon preoccupied with currency racketeering in partnership

with French politicians. Bereft of both moral and political authority, his interests were girls, hunting, and yachts. Thus France resolved to settle its difficulties by military means, and eventually deployed in Indochina sixty-two infantry battalions, including thirteen North African, three paratroop, and six Foreign Legion. In addition, several hundred thousand militiamen, of doubtful utility, guarded villages and roads.

Until the last stage of the war, the French never lacked for local volunteers, who needed the money. Some Vietnamese soldiers distinguished themselves in France's service—brave, proficient, loyal to their salt. Many more, however, proved reluctant to fight with anything like the necessary determination. Moreover, French commanders never resolved a chronic dilemma: how to concentrate superior strength against Giap's regular formations in the north, while protecting a thousand prospective targets elsewhere. Neither the French and their allies nor the communists had strength enough to dominate the whole country. In Christopher Goscha's words, "Instead they all administered competing, archipelago-like states, whose sovereignties and control over people and territories could expand and shrink as armies moved in and out and the balance of power shifted." It seems to some historians strange that the French, who had so recently suffered a cruel occupation of their own homeland, should decline to recognize that atrocities alienate. Yet some Frenchmen derived a different message from their experience: that Nazi harshness had worked, until mid-1944 cowing an overwhelming majority of their countrymen.

In October 1949 the struggle intensified dramatically. China, Vietnam's giant northern neighbor, acquired a communist government led by Mao Zedong, who set aside his nation's historic animosity to back the Vietminh. Suddenly, Ho and Giap gained access to safe havens and American weapons captured from Chiang Kai-shek's defeated Nationalists. Vietminh training schools were established behind Mao's frontier. Hundreds of Chinese military advisers attached themselves to Giap's troops. In the northwest of Vietnam, the French began to suffer calamitous attrition. They were striving to hold the country with forces largely confined to the roads, against an enemy of the jungle and mountains. One ambush on Route 4, which twisted through mountain defiles just below the Chinese

border, cost a column of a hundred vehicles half that number, and most of the occupants were butchered. The French were obliged to relinquish swathes of territory.

One of the most extraordinary human stories of that period concerns Le Duan, who would later succeed Ho Chi Minh. Born in 1907 in central Vietnam, he was a committed communist revolutionary a decade before Ho returned from exile, serving two long terms of imprisonment. He now acted as secretary of COSVN, the Vietminh's southern directorate. Whereas other leaders had their own huts, bodyguards, and cooks, the grimly austere Le Duan chose to sleep in a sampan moored deep in the Mekong Delta, from which he worked with two aides. Among their couriers was a pretty, French-educated girl named Nguyen Thuy Nga. She was in love with another revolutionary, but the province Party committee had terminated the relationship because the man had a wife and family elsewhere.

One day in 1950, Le Duan asked Nga to join him for breakfast. She was somewhat in awe of the ferocious energy and commitment that had earned him the nickname "two hundred candlepower." Tall, lean, gaunt, his clothes were in rags. Chain-smoking incessantly, he seemed to have no thought for anything save the revolution, and was twice Nga's age. Before long, however, he announced that he had chosen her as his bride. She remonstrated that he, like her previous lover, already had a wife and children in the north. Le Duan shrugged and said that he had been victim of an arranged marriage, and had known nothing of his "wife" for twenty years. Their wedding was held at COSVN jungle headquarters with Le Duan's close comrade Le Duc Tho acting as matchmaker. The couple's new life was scarcely domesticated: there was no trousseau, for the bride owned only a single pair of trousers. When they shifted camp, taking what little they owned in sampans, often Nga had to leap into the water alongside the men and push the boat over shallow places. They were always hungry, and seldom found more than a few jungle roots and vegetables with which to flavor the meager rice ration.

Through 1951–52, Nga worked devotedly as Le Duan's political secretary, and gave birth to a daughter named Vu Anh. Her husband seemed to

love her, and once astonished her by a gesture of shameless frivolity when she approached COSVN through a patch of elephant grass. Glimpsing her, he ran forward, seized her by both hands and swung her joyfully around himself. Here was an almost unique glimpse of human frailty in the life of this icily focused man who would play a role in Vietnam's wars second only to that of Ho.

From 1951 onward, the Vietminh emphasized ever more strongly the centrality of ideology, which in earlier years Ho had downplayed. The Chinese supplied not merely military tutelage but also political advice about how to establish a communist society, for which a key imperative was suppression of dissent: in the first two years of Mao Zedong's rule, he killed an estimated two million of his own people. Now, in many Vietminh-controlled areas, radios were banned, to deny peasants access to information except that dispensed by the Party. Most intellectuals and middle-class adherents of the movement became outcasts.

Because the most fiercely contested battlefields lay in the north, that region's people suffered dreadfully at the hands of both sides. Nguyen Cong Luan grew up in a small village near Hanoi, which reluctantly accepted French suzerainty. In consequence his father was seized by the Vietminh and was subjected to torture and eventually met death in one of their punishment camps. Yet colonial troops frequently detained his son, and on several occasions the boy feared for his life. France's definition of its own role in Indochina as a *mission civilisatrice* was mocked by the reality. Luan wrote, "Our submission to the French military authority did not protect us from being looted, raped, tortured, or killed. Every private, whether he was a Frenchman, an African, or a Vietnamese, could do almost anything he wanted to a Vietnamese civilian without fear of being tried in a court or punished by his superiors. . . . A sergeant . . . had the power of a viceroy in the Middle Ages. . . . People addressed him as 'Ngai,' a word equivalent to 'Your Excellency,' only used in connection with gods and mandarins."

The colonists' conspicuously privileged existence enabled the Vietminh to exploit their own austerity as a propaganda gift. Lt. Gen. Sir Gerald Templer, Britain's security overlord during Malaya's insurgency, observed with dry wit, "You can see today how the communists work. They seldom go to the races. They don't often go to dinner or cocktail parties. And they don't play golf." Because French draftees were not obliged to serve in Vietnam, most of their army's rank and file were mercenaries—North Africans, West Africans, or Vietnamese. Half the Legion's men were Germans. A licensed indiscipline prevailed among off-duty troops, with widespread alcoholism. The scent of burning caramel revealed the proclivity of old hands for opium smoking as surely as did their yellow complexions and an oily smudge on the left forefinger. When Gen. Jean de Lattre de Tassigny assumed proconsular powers in December 1950, he began to create an explicitly Vietnamese conscript army. Vietnamization would become a dirty word by 1971, but the French made it so twenty years earlier with their term for de Lattre's policy—jaunissment, "yellowing" the war, or at least its corpses. No one held the new Vietnamese force in much esteem, partly because a fifty-thousand-piaster bribe procured escape from service.

Giap now deployed in northern Vietnam six ten-thousand-man divisions, well armed with light weapons, though short of food, clothing, and equipment. In the early years, the Vietminh had no waterproof clothing or weather protection. Only in 1952 were there issues of flimsy coverings, which seemed miraculous to those simple peasants. In the words of a communist soldier, "We marveled that mankind had produced a piece of paper that rain ran off."

The French continued to have their successes: gunboats in the Red River Delta choked rice shipments to communist forces farther north. On May 25, 1950, after the enemy bombarded a French camp at Dong Khe, a few miles inside Vietnam's border with China, parachute-landed reinforcements drove the attackers scuttling away into the jungle. Nonetheless, colonial garrisons in the mountainous far north, holding positions linked by ribbons of road strung along narrow valleys, remained vulnerable, especially when Giap's regular units acquired mortars and artillery. The French had been rash enough to extend delicate tendrils—relatively small forces—into ant heaps crawling with Vietminh. While the colonial power had far more soldiers countrywide, in the northwest Giap could sometimes outnumber his foes.

Early on September 16, five Vietminh battalions, supported by artillery, once more attacked the French base at Dong Khe. The communists had spent weeks preparing and planning, a hallmark of all their important operations. Early in the battle, Giap's headquarters was alarmed by reports that one regiment had lost its way, failing to reach the start line, and that initial casualties were heavy. But Ho Chi Minh, who had walked many miles to witness the assault, urged calm and perseverance. After fifty-two hours of fierce fighting, the attackers prevailed; Dong Khe fell at 1000 on the 18th. An officer and thirty-two Foreign Legionnaires escaped just before the end, emerging from the jungle to rejoin French forces after a terrible weeklong march.

Giap now embarked upon a banquet at his enemy's expense in the mountainous Chinese border region. The French resigned themselves to abandoning another camp at Cao Bang, twenty miles north of Dong Khe. On October 3, its foulmouthed but popular commander, Lt. Col. Pierre Charton, led forth a truck column bearing 2,600 mainly Moroccan soldiers and 500 civilians, including the personnel of the town brothel, together with a tail of artillery and heavy equipment. Charton had ignored orders to abandon such baggage: he determined to retreat with dignity and honor, a gesture of stubbornness that cost hundreds of lives. In defiles nine miles south of Cao Bang, his straggling caravan was checked by a succession of blown bridges and ambushes. Within twenty-four hours, the retreat stalled, amid teeming enemy forces firing from dense vegetation on higher ground.

Charton's predicament represented only half of a horror story, however. A second force, designated Task Force Bayard and composed of 3,500 mainly Moroccan troops stiffened by a crack paratroop battalion, was dispatched north to meet the Cao Bang column and support its passage to safety. Bayard left That Khe on September 30, commanded by Col. Marcel Le Page. As the force approached Dong Khe, it too was halted by Vietminh, raking and pounding the column with machine-gun and mortar fire. Higher headquarters ordered Le Page to adopt desperate measures: burn his vehicles, abandon his guns, take to the jungle, and march his men around the Vietminh to meet Charton. The experience that fol-

lowed was dreadful indeed. In accordance with his almost deranged instructions, Le Page led his men away from the French lines, ever deeper into a wilderness, to link hands with another doomed force.

Marchers soon began to fall out and vanish, never to be seen again: a man wounded was a man fated to die. Each climb and descent was agony for heavily laden infantry, drenched by rain that also denied them air support. The Vietminh were weary, too, after days of strife and pursuit, but they enjoyed the peerless thrill of winning: they knew the French were in desperate straits. Giap issued an exultant October 6 order of the day: "The enemy is hungrier and colder than you!" Charton and Le Page met next day, their columns alike shrunken by losses and lacking water, food, and ammunition. Then the Vietminh struck again—fifteen battalions pouring fire into their exhausted enemies. The Moroccans broke in panic. Their commanders ordered dispersal into small parties, what became almost literally a "sauve qui peut!" Charton was wounded and taken prisoner; most of the other fugitives were killed piecemeal. Just 600 men eventually reached French positions farther south; some 4,800 were listed as dead or missing, while materiel losses were immense-450 trucks, 8,000 rifles, 950 automatic weapons, and 100 mortars. Giap celebrated by getting drunk with his Chinese advisers, for what he later claimed was the first time in his life.

On October 18, the French abandoned another northern camp, at Lang Son, where huge stocks of munitions fell into communist hands. The cost of these battles was high for the Vietminh—an estimated nine thousand casualties. But whereas the world quickly discovered the scale of the French disaster, now as in the future the communists suppressed all tidings that might tarnish their triumphs, demoralize their supporters. Not all the fighting went one way: during the early months of 1951 Giap failed in a succession of large-scale assaults. In January when the Vietminh attacked a base thirty miles northwest of Hanoi, French air power and especially napalm inflicted crushing losses—six thousand dead, eight thousand wounded. The lesson for the communist commander was that he must still expect to be beaten when he committed large forces within reach of French air and firepower.

A Western general who suffered such a succession of defeats as did Giap in the spring of 1951, creating such hecatombs of his own men's corpses, would have faced a political and media storm and almost certainly been sacked. The Vietminh politburo, however, faced no public scrutiny. Ho Chi Minh, the only arbiter who mattered, kept faith in his general. Giap, like Marshal Zhukov in World War II, was never held to account for the shocking "butchers' bills" his victories imposed. This gave him an important edge over an enemy whose people were reading daily, in newspapers back home in France, about the anguish of their army in Indochina.

2. WASHINGTON PICKS UP THE TAB

Perhaps the most famous lines in Graham Greene's novel *The Quiet American*, set in Saigon during the late French era, are delivered by his protagonist, the cynical British journalist Thomas Fowler, who says of the title character, Alden Pyle, "I never knew a man who had better motives for all the trouble he caused . . . impregnably armored by his good intentions and his ignorance." The most historically important trend in the war was that as the French reeled before its soaring cost, they turned to the Americans to pay the bills. Which, from 1950 onward, they did. Far away in Washington, policy makers became ever more alarmed by the notion that Southeast Asia might follow China, submerged beneath a communist inundation. Moreover, the US sought leverage to reconcile a bitterly reluctant France to the rearmament of Germany. Dollars, not francs, soon paid for almost every bomb and bullet expended on the Vietnam battlefield.

American largesse was prompted by communist threats to the stability and democratic institutions of many nations, notably including Greece, Italy, France, and Turkey. George Kennan, head of the State Department's policy planning staff and author of the famous 1946 Long Telegram from Moscow, characterized Soviet assertiveness as a "fluid stream" that sought to fill "every nook and cranny available to it in the basin of world power." Stalin and later Mao supported revolutionary movements wherever these

seemed sustainable. On March 12, 1947, America's president proclaimed before Congress what became known as the Truman doctrine: "At the present moment in world history nearly every nation must choose between alternative ways of life. The choice is too often not a free one. . . . I believe that it must be the policy of the US to support free peoples who are resisting attempted subjugation by armed minorities or by outside pressures."

Yet while the international communist threat was real and the Western commitment to resist it deserves historic admiration, it caused the United States and its allies to commit some grievous injustices. For almost two generations, Washington acquiesced in the fascist tyranny of Spain's Gen. Francisco Franco and also sustained Central and South American dictatorships whose only merits were their protestations of anticommunism. In southern Africa, the British and Americans indulged white minority rule for decades after its indefensibility had become apparent. And in Indochina the French persuaded the West's Croesus-state that the cause of colonialism was also that of anticommunism. After Mao Zedong's forces swept China, conservative Americans appalled by the "loss" of their favorite Asian nation demanded stern measures to ensure that such an outcome was not repeated elsewhere. Henry Luce, proprietor of Time-Life and a passionate supporter of the Chinese Nationalists, threw the weight of his empire behind the anticommunist cause in Vietnam, for which it remained an advocate through two decades.

The Sino-Soviet treaty of February 1950 seemed to create a real threat of a Red Asia. The American conservative Michael Lind has written in his revisionist study of Vietnam, "On the evening of February 14, 1950, in a banquet hall in the Kremlin, three men whose plans would subject Indochina to a half century of warfare, tyranny and economic stagnation, and inspire political turmoil in the United States and Europe, stood side by side: Stalin, Mao Zedong, and Ho Chi Minh. . . . There was an international communist conspiracy, and Ho Chi Minh was a charter member of it." Kim Il Sung's June invasion of South Korea galvanized a frightened West. US and allied forces hastened to the Korean peninsula, where they fought a three-year war, latterly against the Chinese. The Korean

experience goes far to explain why the Americans threw their support behind French colonialism in Indochina, without diminishing the rashness of the policy.

At the State Department, Dean Acheson and his assistant secretary Dean Rusk were haunted by memories of the disasters that had followed the democracies' 1930s appeasement of fascist dictators. The Democratic administration faced mounting congressional pressure to show steel toward the "Moscow-Beijing axis." Senator William Fulbright observed later that it was essential to judge contemporary US policies against the background of indisputable Soviet expansionism: "Here we were in this deadly confrontation with the Russians, and we thought it our duty to thwart them everywhere." The McCarthyite witch hunt for left-wing sympathizers in the US government caused the Foreign Service officers who knew most about Asia to be winnowed out of the State Department, leaving behind an awesome ignorance, especially about Vietnam.

Even so, not everyone in Foggy Bottom wanted to see America embrace colonialist France. State's Raymond Fosdick early in 1950 urged presciently against repeating America's China blunder, of becoming "allied with reaction." Despite residual Parisian delusions, Fosdick wrote, Indochina would soon become independent. "Why, therefore, do we tie ourselves to the tail of their battered kite?" The French were losing their war not primarily because they lacked guns and ammunition but because they would offer nothing that any reasonable Vietnamese might want.

In the following year, a young congressman from Massachusetts visited Saigon and wrote in his trip diary, "We are more and more becoming colonialists in the minds of the people. Because everyone believes that we control the U.N. [and] because our wealth is supposedly inexhaustible, we will be damned if we don't do what the new nations want." Here was wisdom from John F. Kennedy, but Americans were in no mood to heed it. George Kennan in old age bemoaned the manner in which his advocacy of containing the Soviets and later the Chinese was misinterpreted in Washington to justify employing to this end almost exclusively military tools, whereas political, cultural, economic, and diplomatic ones were often more appropriate.

During 1950's Korean winter panic, when outright defeat for UN forces seemed possible, Washington signed off on a massive Indochina aid increase. Thereafter, as France's will to fight weakened, that of the US stiffened: the colonial army became increasingly an American proxy. Truman and Acheson, far from pressing Paris to negotiate with the Vietminh, urged it to do no such thing. Here was Washington's first big blunder in Indochina, from which US policy making never recovered. Its military aid contribution ballooned to \$150 million, delivered almost without strings—the proud French refused to confide in their paymasters about operational plans. By early 1951, they were receiving more than 7,200 tons of military equipment a month. The imperial power waged its war wearing American helmets, using many American weapons, driving American jeeps and trucks, and flying mostly American planes. Under such circumstances, it is scarcely surprising that when American soldiers a decade later arrived in Vietnam, they seemed to its people children of their earlier oppressors.

By September 1951, it had become apparent to objective observers that the French had no realistic prospect of holding Indochina. Nevertheless, after their warlord Gen. Jean de Lattre de Tassigny staged a brilliantly theatrical personal mission to the US, within four months Washington shipped to his forces 130,000 tons of equipment, including fifty-three million rounds of ammunition, eight thousand trucks and jeeps, 650 fighting vehicles, two hundred aircraft, fourteen thousand automatic weapons, and 3,500 radios. This was de Lattre's last important contribution before his abrupt departure from Indochina and death from cancer.

By the end of 1953, the new Eisenhower Republican administration was paying 80 percent of the cost of the war, a billion dollars a year. The British, still important allies and increasingly expert at retreats from empire, deplored this: they believed that no quantity of guns and bullets could avert looming French expulsion from Indochina. The government of Winston Churchill was alarmed by what it considered an ill-directed US obsession. Selwyn Lloyd, a Foreign Office minister, wrote in August 1953, "There is now in the United States an emotional feeling about Communist China and to a lesser extent Russia which borders on hysteria."

The Vietminh were, of course, branded as instruments of the satanic forces in play.

3. PEASANTS

A small minority of Vietnamese who were sufficiently educated to think beyond their own villages witnessed the brutalities of the Vietminh and welcomed the promise of foreign succor. A schoolboy in the north wrote that "from the books I read, I believed that the Americans might be at least better than the French. . . . I was sure that like any other country the US must have some interest when it helped its allies, but . . . the Americans seemed to be generous in assisting poor countries." However, it is easy to understand why many Vietnamese adopted a contrary view and supported a revolutionary movement that promised the removal of an oppressive colonial regime, together with an assault on a landowning class, French and indigenous, that had exploited the peasantry for generations.

Such was the poverty of rural Vietnam that a man with a primary school certificate was respected as an "intellectual." Some couples owned only a single pair of trousers, which husband and wife took turns to wear. Much of the peasants' daily labor involved paddling water uphill to irrigate the paddies, often by moonlight because the days became so hot, in good times singing as they worked. The rice had to be fertilized once, weeded three or four times, and cut twice. The spring crop accounted for three-quarters of the harvest, because it profited from higher rainfall. Poor villagers might supplement their income by trekking into the wilderness to gather firewood for sale. Some migrated to towns to work. Those burdened by the worst indebtedness hired themselves out as field laborers.

Family and village were the dominant social institutions. Beside nearly every hut stood its wooden altar, containing offerings of fruit and sweets; the richer the family, the grander its altar. Few parents felt embarrassed by establishing a hierarchy of affection for their many children, rooted in a judgment about which were the ablest and most hardworking. A father's word was law, though mothers arguably wielded the real power. There was a popular saying: "Without a father you could still enjoy rice and fish, but

without a mother you might expect to eat only fallen leaves." Beyond family, peasants said, "The king rules—subject to village regulations." Most Catholic communities had a bell tower, Buddhist ones a temple and magnolia trees. There might also be a meeting hall called the *dinh*, and maybe a carpenter's and a tailor's shop.

Villages were subdivided into hamlets in which much of life and labor was shared: at new year people worked together to make rice cakes that were cooked overnight, then threaded on fine strands of bamboo. They gathered to wish parents long life, health, and wealth. The Vietnamese, like most Asians, believed that each year conferred upon the old an additional accession of wisdom. After a pig had been slaughtered, children might beg for its bladder as a plaything. They played hide-and-seek, shot "jute guns" made from bamboo pipes like Western peashooters, or competed at another game, "hitting stick." At festivals they might taste jam, sweets, peanuts, birds' eggs, and squashes coated in sugar. For the most part, however, they knew only rice and vegetables—and were thankful to get them.

Some Vietnamese later idealized the simplicity of peasant life before war descended. One said, "Everybody knew each other and never closed doors." She waxed lyrical about "the beauty of togetherness," shared tasks and pleasures. Yet such nostalgia was rare among the vastly greater number who recalled only hardship, persecution, and near starvation. Nguyen Thanh Binh was born east of Hanoi in 1948, daughter of a poor peasant who cultivated four hundred square yards of rice. Her parents and their six children occupied a thatched hut in a hamlet of some thirty families, none of which owned a radio set or bicycle. Few inhabitants could read: when an occasional newspaper reached them, people gathered under a tree while a literate villager with a good voice perched on a branch to read aloud to them interesting items.

Such people grew up without photographs of parents or children, because none owned a camera. Pajamas, *ba ba* dress, brown in the north and black in the south, was the clothing of peasants and only incidentally became the uniform of guerrillas. Infant mortality rates were appalling, partly because it was customary to sever umbilical cords with fragments

of broken glass. Villages frequently had to be abandoned because of flood or famine. Binh had no memories of childhood happiness: life was merely an unremitting struggle for existence in which children gathered snails to supplement the family diet. At twenty she became a lifelong member of the Communist Party, regarding Ho Chi Minh with quasi-religious fervor as "the indispensable, incomparable leader."

Although Ho's armed supporters in the southwest never matched the spectacular military successes achieved by Giap's formations in the north, his movement won widespread support on the single issue of land redistribution. Even prosperous tenant farmers craved ownership: many were hopelessly in thrall to creditors who appropriated up to half their production. Debtors could become body slaves, enlisted to rock a landlord's hammock. They eagerly supported the secret land redistribution plan of the Vietminh, one of whose cadres told Norman Lewis in 1950, "Our enemies are slowly converting us to communism. If it is only by becoming communists that we shall achieve our liberty, then we shall become communists."

A historian has described Giap's soldiers as "simple men whose world view was formed entirely by their own and their families' immediate experience . . . colored by oppression and hardship over generations." The foremost strengths of Vietminh fighters were discipline, patience, ingenuity, a genius for fieldcraft and especially camouflage, and tolerance of hardship and sacrifice. Above all there was motivation: they yearned to share the fruits of a political, economic, and social revolution. Itinerant communist cadres launched political education programs and composed folk songs to help villagers learn their alphabets. There was a "learn through play" program for children. Virtuous as that may sound, it was reinforced by compulsion: cadres caused villagers to display banners decorated with flowers, proclaiming LONG LIVE THE FIGHTERS AGAINST IL-LITERACY. In some places nonreaders were wantonly humiliated, forced to crawl through mud to go to market. As ever when communist doctrine was imposed, victims were reminded that this was cruelty with a purpose, for the ultimate good of the people.

As for more drastic penalties, even an official Party history admitted later that "not a few innocent people were killed." Simple country folk

serving the Vietminh assumed that any man who affected blue trousers and a white shirt with a tailor's label must be a French spy. Whereas the Mafia employed the euphemism of sending an enemy to "sleep with the fishes," in the equally watery words of Vietnam's communists, he was dispatched "to search for shrimps." Killings were conducted with maximum brutality and publicity: Vietminh death squads favored burying victims alive or eviscerating them in front of assembled neighbors. "Better that a possible innocent dies than that a guilty man escapes," ran a Party catchphrase. In the "liberated zones," the Vietminh established notorious punishment camps. When Nguyen Cong Luan's father died in one of them, a cigarette lighter was the only possession his jailers grudgingly returned to the widow.

In 1947, the Vietminh conducted an ideological "cleansing" campaign, in which a large though never quantified number of "class enemies" were murdered. Any landlord or government officeholder lived under threat of a death sentence that extended to his family. The Catholic religion bore the taint of foreign ownership, and thus its adherents were vulnerable. Local denunciation sessions—dau to—held in the courtyard of a pagoda or landlord's house, inspired the dread their organizers intended. Farmers or peasants, often impelled by grudges, rehearsed landlords' alleged crimes before people's courts run by Vietminh cadres. If death sentences were pronounced, a victim might there and then be shot, stoned to death, hanged, or face a crueler death. At My Thanh in the Mekong Delta, a Cao Dai functionary, about to be buried alive, pleaded for a merciful bullet. His killers observed contemptuously that ammunition was being conserved for "the pirates"—the French.

As a peasant child, Nguyen Thanh Binh remembered landowners hiding from their accusers by immersing themselves in the nearby pond and covering their heads with reeds, while others adopted crude disguises. Some failed, and she stood among her fellow villagers watching their trials. Even as a loyal Party cadre, she later admitted that "a lot of those people were wrongly accused." In the north, a "people's court" was often staged as a theatrical event, held at night in an area the size of a soccer pitch, ringed by bamboo torches. A presidium of seven judges, poor peasants,

40 .

was attended by a Land Reform cadre and sometimes also Chinese advisers. Behind the stage hung portraits of Ho, Mao, and Stalin, together with painted slogans such as DOWN WITH THE TREACHEROUS REACTIONARY LANDLORDS.

As for summary executions, one peasant retained an indelible child-hood memory of the Vietminh visiting his northern village in 1952, seizing two unarmed soldiers in French service who had called to wish friends a happy new year, and beheading them behind his family's house. This twelve-year-old said later, "I can still hear the sound of their necks being cut through." Then the guerrillas left, and French troops arrived. They accused neighbors of responsibility for the men's deaths—and burned every surrounding house. In 1953, the Vietminh sentenced the child to spend two weeks in reeducation camp, conducting self-criticism: "Everything that I did wrong, or my parents or grandparents did wrong, had to be written down. Everybody had to think hard what to write." When Stalin died, all prisoners were obliged to assume black mourning bands. Soon after, a French offensive forced the guerrillas to flee, liberating the boy. He and his family briefly returned to their house, then fled to Hanoi.

The struggle's seesaw fortunes imposed continual strain. A poor peasant in the Mekong Delta expressed his delight during a period of Vietminh reverses, when their economic blockade was lifted and he was for a time free to sell his produce: "The people were very happy . . . I myself said many times, 'I hope that just one side will control us—no matter which one. Living under the control of both is too much." Le Thi Anh, a daughter of landowning parents, joined the Vietminh because she sought the expulsion of the French, married a fellow fighter, gave birth to a son, and shared the hardships of life as a guerrilla in the Mekong Delta. In 1952, however, she quit: "I saw too many frightening things. The communists were grabbing all the power and killing off the nationalists." She attributed her own survival merely to the fact that she was too young to pose a threat.

In the "liberated zones" of the north, rather as some British people in old age became nostalgic for the legendary "blitz spirit" of 1940, Vietminh later looked back on wartime as a halcyon era. As guitarist Van Ky, who became a guerrilla strolling minstrel, enthused, "The spirit was

marvelous! We imagined that we were all part of one big family." Volunteer canteens were formed, known as "soldiers' mothers' restaurants," at which local women provided free food for fighters. Ky and his trio walked hundreds of miles to perform: "There was something very interesting and wonderful about this. Even though we were in a war zone where the fighting was very fierce, every night we would organize a show, and draw big crowds. The songs I sang weren't very good, and we did not harmonize well, but we would tell stories, recite poetry." Often the lights around the stage had to be masked to escape French attention. Ky performed as far south as Hue, where he slept on the bank of the Perfume River, ate food brought out from the city, smoked Philip Morris cigarettes, and briefly fell in love with a girl in one of his audiences.

Ky persuaded his English-speaking fellow performer Hai Chau to read aloud to them from Reader's Digest, to help them learn English phrases in preparation for life after the war. Some of these were unexpected, such as, "I have a surprise for you in my pocket." Periodically on their travels, they would be abruptly awakened by a voice shouting "Tay can!"-"French sweep!" As the enemy approached, Vietminh fighters would say wearily, "The buffalo are out." Hai Chau wrote a song with that title, which soldiers loved, satirizing the occupiers. Ky was one among many revolutionaries who discovered romance in their shared experience. It offered Vietnamese what the French had for a century denied them: self-respect. Moreover the passage of each month, then of each year, increased the belief of millions of Vietnamese that the best reason to support the communists was that they were destined to win. A little peasant girl sat up far into the night with her mother and sisters in their hut near Hue, making Vietminh flags, "red with the yellow star, because we knew that the people would want them to celebrate . . . victory."

Yet it seems mistaken uncritically to accept Van Ky's picture of the war years as a romantic idyll. The privations and sacrifices were terrible. Tensions increased between the revolutionary movement's peasant supporters and its bourgeois ones. Nguyen Duc Huy, born in 1931 the son of a poor farmer, was sent to study at the new Vietminh military academy in China, where he found the atmosphere poisoned by class struggles and relentless

self-criticism sessions. A cadet who had been decorated for bravery in battle killed himself under ideological interrogation. Huy was variously accused of running a French spy network and a Nationalist assassination team, then imprisoned for seven months in an underground cell. He wrote in his memoirs, "The injustice of it all is impossible to describe." What seems extraordinary is that after such experiences, he served as a company commander against the French, then led a battalion against the Americans, without losing faith in the Party.

Throughout Nguyen Thi Ngoc Toan's early years with the Vietminh, she was harassed about her background in a wealthy dynasty. Her father was a member of the royal family who had served in the emperor's cabinet. With Giap's army, at first she was merely described dismissively as "bo doi nhoc"—"a kid soldier." Later, however, despite her passion for the cause, comrades said scornfully, "This girl went to a French school—why have they sent her here? How can a mandarin's daughter live with the Resistance?" Toan said later, "They made things hard for me. I was very unhappy." Nonetheless she remained loyal to the Vietminh, but the enthusiasm for the guerrillas of another bourgeois, sixteen-year-old Nguyen Cao Ky, waned: "For them the Resistance movement was not merely about expelling foreigners. It was about turning the tables, becoming rulers, revenge." Ky eventually took an army commission with the French, becoming a pilot.

Despite heavy losses in clashes around Hanoi, the Vietminh continued to expand their northern "liberated zones." By 1952 they were estimated to control a quarter of the south's population, three-quarters of the people of central Vietnam, and over half in the north. The French wasted immense resources on fortifications. The so-called "de Lattre line," created to protect the Red River Delta, poured fifty-one million cubic yards of concrete into 2,200 pillboxes, each one of which was allotted a number prefaced by "PK"—poste kilométrique. This suited the Vietminh strategy of grignotage—gnawing away at French strength; they progressively eliminated such isolated positions, always in darkness. The first that defenders knew of their nemesis was the explosion of a pole charge in the barbed wire, followed by cries of "Tien-len!"—"Forward!" from attack-

ing communist infantry. By dawn, the Vietminh would be gone, leaving only corpses, often mutilated, and blackened patches where mortars or rockets had exploded on earth or concrete. And in Hanoi or Haiphong, one French staff officer would mutter to another, "Did you hear what happened to PK141 last night?"

The war created many larger-than-life French leaders, such as the huge, red-bearded Col. Paul Vanuxem, a fifty-year-old intellectual warrior qualified to hold tenure as a professor of philosophy. Maj. Marcel Bigeard had gone into World War II as a sergeant and parachuted into France in 1944. Col. Christian de Castries was a cavalryman and a dandy, never without his silk scarf, who cherished his reputation as a ladies' man. There were famous women, too—the likes of Valérie André, a doctor who was also a helicopter pilot, and the highly decorated airborne nurse Paule Dupont d'Isigny.

In the autumn of 1952, Giap concentrated three divisions on the east bank of the Red River, tasked with seizing Nghia Lo, a strategically important ridge. Thanks to night marches and brilliant use of daylight concealment, each man looking to the backpack camouflage of the soldier in front of him, they deployed unnoticed by the French. Then, in a series of assaults that began on October 17, they overran a chain of posts. Marcel Bigeard's para battalion covered the retreat of the surviving detachments toward the Black River, in a series of actions that became a nightmare legend. They were obliged to abandon their wounded, and local people later reported finding Bigeard's trail adorned with the severed heads of those left behind, set on stakes by the Vietminh. The major and those of his men who survived were greeted as heroes when at last they reached the French lines, but the Nghia Lo battles had been a significant disaster.

In April 1953, the communists opened a new front in Laos, to disperse French strength. By June, Chinese deliveries of supplies and munitions had risen from 250 tons in the same period the previous year to 2,000 tons a month, together with Molotova trucks and bulldozers. Meanwhile, French forces were running short of officers and NCOs, many of the North African troops were scarcely trained, and nobody retained much confidence in the spirit of 110,000 locally recruited soldiers. Gen. John "Iron Mike"

O'Daniel, senior US Army officer in the Pacific, visited Saigon in the summer of 1953, soon after Gen. Henri Navarre became commander in chief. With characteristic bombast, the American urged the French to stir their stumps—adopt a more aggressive military posture. The Korean experience had shown that when lightly armed Chinese troops caught Americans in the open, they sometimes prevailed. But where circumstances were contrived in which US forces held prepared positions covered by air power and artillery, they became almost invincible. Why couldn't the French exploit the same realities? Navarre agreed. He cast about for a battlefield on which French strength and Vietminh weakness could be laid bare before the world. He chose Dienbienphu.

THE FORTRESS THAT NEVER WAS

1. WAITING FOR GIAP

So many "fatal decisions" were made in Indochina that it would be invidious to single out any for primacy, but that which was made in November 1953 removed any lingering doubt about who was to become the victor, who the vanquished. Dienbienphu was a relatively small battle, engaging on the colonialist side barely a division. Yet it assumed decisive moral significance, because it was launched as a French initiative, with the explicit purpose of bringing the Vietminh to battle, and was then lost by epic bungling. Navarre's bosses in Paris were in those days almost as confused as was the general himself, being unwilling either to give up the struggle or to continue it. France's committee of national defense concluded at a November meeting that the strategic objective was "to oblige the enemy to recognise the impossibility of achieving a decisive military outcome." This could be achieved only by delivering punitive blows on some or all of Giap's six regular formations, deployed in the north. Yet Adm. Georges Cabanier was thereupon dispatched to Saigon bearing instructions for Navarre to attempt nothing ambitious: everything important should henceforward be left to the politicians.

On November 2, however, the general had determined to reoccupy in strength an old camp at Dienbienphu, 175 miles west of Hanoi and close to the border with Laos. The decision was made without much intelligence about the enemy's whereabouts or intentions. Giap was always

better informed than his French counterpart, partly through well-placed communists in Paris, whose first loyalty was to the Party rather than to the *tricolore*. Nonetheless, Navarre said afterward, "We were absolutely convinced of our superiority in defensive fortified positions." His deputy responsible for Tonkin, Maj. Gen. René Cogny, was a big, self-important forty-nine-year-old who had endured Gestapo captivity in World War II. Cogny favored concentration upon defense of the Red River Delta but acquiesced in Navarre's new plan.

By creating a powerful air-land base so far west, they reasoned that its garrison could sally forth to interdict Vietminh movements and give the enemy a bloody nose if he dared to attack the camp. Occupying the cluster of hamlets known as Dienbienphu would deny Giap access to a big rice- and opium-growing area. Though its airstrip lay far from Hanoi, Cogny could call upon sixty-nine C-47 Dakotas to meet the garrison's eighty-ton daily supply requirement. Most of the perils to French forces were deemed to lie in the initial drop onto a "hot" DZ, where a Vietminh battalion was known to be encamped.

Navarre, a fifty-five-year-old veteran of World War I, thought the risks acceptable. He was a chilly, personally fearless, and strikingly handsome officer, with little experience of senior command but a formidable presence and indeed conceit. He had arrived in Indochina the previous May with the sort of mandate that became grimly familiar among his American successors: to create conditions for an exit negotiation from strength. In Washington John Foster Dulles, the dour, unyielding, messianic sixty-five-year-old lawyer who served as Eisenhower's secretary of state, cited the precedent of Korea, where United Nations forces had fought fiercely to the end—only six months earlier—to empower the UN delegation parleying at Panmunjom. Whatever Navarre's subordinates said afterward, there is no convincing evidence that any supposed the downside risks of Dienbienphu to be more than tactical headaches, certainly not that they might precipitate a disaster.

The first two battalions of French and Vietnamese paratroopers jumped at 1035 on Friday, November 20, just before Navarre met Cabanier, his

visitor from Paris. The general almost certainly knew the nature of the directive the admiral bore—not to stick his neck out—and had deliberately preempted it. Unfortunately, the French initiative perfectly conformed to the hopes of Ho Chi Minh, Giap, and chief ideologist Truong Chinh. At an October meeting in a simple bamboo house deep in the mountains, they had agreed that contesting the Red River Delta merely enabled the French to apply forces and firepower close to their own bases. The Vietminh objective must be to tempt them instead to disperse, then strike where their troops ventured farthest. With a characteristic gesture and figure of speech, Ho raised his clenched fist and likened it to French strength in the east, then said, "But if you spread your hand, it becomes easy to break the fingers, one by one." Navarre, by extending a finger westward to Dienbienphu, fulfilled Ho's appointed role for him.

The opening gambit was played when French and Vietnamese *paras* began to leap from C-47s over their designated objective, as dispatchers gave the repeated "Go! Go! Go!" that propelled them from the dim fuselages and engine roar into brief sunlit coolness six hundred feet above the steamy landing zone. Foremost among the tough, unyielding French officers swaying beneath their canopies was Col. Pierre Langlais, a forty-four-year-old Breton of boundless courage but limited intellect and notoriously vile temper. They landed into the firefight they had expected. A medical officer, making his first combat drop, took a bullet in the head before he hit the ground. By nightfall the attackers had forced the Vietminh to withdraw with substantial losses and had secured a perimeter, at the cost of fifteen of Langlais's men dead and thirty-four wounded. He himself was cursing even more freely than usual, because he smashed his ankle in the drop, as many parachutists do, and had to be evacuated to spend a month in plaster.

Next day, US-built C-119 Flying Boxcars droned overhead, dropping heavy equipment and vehicles; nothing could yet land on the strip, cratered by the Vietminh. By the time the struggle at Dienbienphu finally ended, the French had used there almost sixty thousand parachutes, so that white and colored blotches came to dominate aerial photographs

48 .

like plague spots. Once bulldozers had rendered the airstrip serviceable, a stream of reinforcements arrived, enlarging the garrison toward its eventual peak of twelve thousand men.

The camp's appointed commander was Col. Christian de Castries, a fifty-one-year-old military aristocrat who boasted a marshal, an admiral, and nine generals in his family tree. A famous off-duty equestrian, he had won many medals and suffered grievous wounds from a mine in Indochina, but he was afterward accused of cowardice by his critics, who claimed that at Dienbienphu he lurked in his bunker. Castries's record makes such a charge implausible. On the moral side, however, the verdict is less assured. He lacked any gift for inspirational leadership. As his predicament became ever more burdensome, he lapsed into gloomy fatalism. He cannot justly be blamed for the outcome—Navarre and Cogny were the battle's architects—but he made many tactical errors, both of commission and omission.

The word *fortress* was repeatedly used to describe Dienbienphu, yet it was never anything of the sort. Rather it was a chain of low hills amid a plain overlooked by densely wooded mountains, and now it was entrenched with shocking casualness. Scarcely any of the defensive positions created in the months before the Vietminh assault were adequately fortified: many of the garrison's men were courageous enough but regarded digging with disdain. Their commanders took for granted a 24/7 air link with Hanoi.

Meanwhile far away in the hills, Giap learned of the deployment: the French press, of which his staff were assiduous readers, reported Navarre's intention to stand and fight. The Vietminh general's decision directly to challenge the enemy commander in chief—to commit large forces to attack the camp—was founded upon a shift in the military balance, at first unknown at French headquarters in Hanoi. The Chinese had supplied the Vietminh with American-built 105mm M2A1 howitzers captured from the defeated Nationalists, together with 120mm mortars and 37mm anti-aircraft guns. These provided Giap's artillerymen with much-enhanced hitting power and, above all, range—a 105mm shell could reach targets from gun pits almost seven miles away.

The most important and indeed historic call Giap made, in which his Chinese advisers played an unproven but possibly influential role, was logistical: to convince himself and the politburo that his men could drag these weapons, each of which weighed over two tons, five hundred miles over some of the most intractable terrain in Asia, and sustain for months supplies for a four-division siege force. To achieve this, on December 6 a general mobilization was decreed throughout the "liberated zone" to muster a rotating host of peasant porters, each of whom served at least a month before stumbling home exhausted, emaciated, and racked by disease. To motivate these men and women, new emphasis was placed on the imminence of land reform, their prize for victory. Alongside the familiar army slogan "Everything for the front, everything for victory!" there now appeared a new one: "The land to the peasants!"

Giap shifted his advanced headquarters three hundred miles to a cluster of bombproof caves and man-made tunnels nine miles from the French camp, where he laid out his map table on January 5, 1954. His staff began to publish a bulletin for the troops. Among its news reports and exhortations were lurid cartoons. One such depicted France as a grossly ugly woman who has given birth to Dienbienphu, and lies beset by tiny black-clad figures who are severing the umbilical cord of the air link—as indeed they would do, just a few weeks later.

Communist logisticians and engineers labored on their supply route, some stretches capable of accommodating Soviet Molotova trucks, which operated in relays, off-loaded and reloaded by gangs of porters. Rice was rafted partway from China down the Black River. Giap demanded a battlefield stockpile of a thousand tons of ammunition; each 105mm shell weighed forty-four pounds. Vietminh infantry began moving toward Dienbienphu, where on arrival they were presented with spades and ropes. Along the length of the trail, close attention was paid to camouflage. In jungle, treetops were lashed together to form a tunnel, while bridges were created, invisible just beneath river surfaces. In open country, gangs followed trucks, brushing away telltale tracks. When French aircraft caught them anyway, the only succor for the wounded was provided by medical students equipped with rags and peasant palliatives.

As for the guns, Vietminh officer Tran Do described a routine repeated through weeks: "Each night when freezing fog descended into the valleys, groups of men mustered. . . . The track was so narrow, soon an ankle-deep bog, that the slightest deviation of the wheels would have caused a gun to plunge far into a ravine. By sheer sweat and tears we hauled them into position one by one, with men playing the part of trucks. . . . We existed on rice either almost raw or overcooked, because the kitchens had to be smokeless by day and sparkless by night. On ascents, hundreds of men dragged the guns on long ropes, with a winch on the crest to prevent them from slipping. The descents were much tougher, the guns so much heavier, the tracks twisting and turning. Gun crews steered and chocked their pieces, while infantry manned the ropes and winches. It became the work of a whole torchlit night to move a gun five hundred or a thousand yards." Vietminh propaganda made a posthumous hero of a man who threw himself beneath a wheel to check a slipping gun's escape into a chasm.

French intelligence, striving to monitor this fevered activity in the northwest, estimated that Giap could muster just twenty thousand porters, who could feed only a matching number of soldiers. In reality, however, the communists mobilized sixty thousand. Strengthened bicycles became a critical link in the supply chain, each bearing a load of 120 pounds, rising in emergencies to 200. Communist leaders inspired not only their fighters, but also the porters, to levels of physical effort and sacrifice that few Frenchmen or mercenaries proved capable of matching. A prisoner was deeply impressed when ten Vietminh raised their hands in response to a cadre's call for volunteers to dispose of delayed-action French bombs.

The campaign developed in slow motion, with a lapse of more than a hundred days between the initial parachute landing on November 20 and Giap's first assault in March. From the outset, French attempts to advance beyond their perimeter were punished: in December two *para* battalions that probed toward a village nine miles distant were mauled by the besiegers and forced to retire. Navarre gave new orders to Castries: he must simply hold the camp at any cost. Once the French had landed four 155mm guns, as well as 105mm howitzers and 120mm mortars, they

felt confident about outgunning the Vietminh. Yet it proved frustratingly difficult to pinpoint targets: the poor quality of local maps impeded air and artillery observers, so the enemy's heavy weapons were seldom visible.

Through December the French high command received a steady trickle of intelligence that disturbed Navarre and Cogny, though not nearly as much as it should have. They now knew that four Vietminh divisions were moving in the northern mountains, but remained uncertain of their destination; enemy diversionary actions in the Central Highlands and Red River Delta fed vacillation in Hanoi. Throughout the war hitherto, Vietminh assaults that met strong French resistance had been aborted, so the generals believed that Giap's army would respond to a costly repulse at Dienbienphu by folding its tents. A correspondent of *Le Monde* who visited the camp told his readers that the prevailing spirit was "On va leur montrer!"—"We'll show them!"

As the year-end approached, Navarre became aware that the Vietminh were deploying howitzers. On December 31, he reported to Paris that the camp might become indefensible. Yet through the first weeks of 1954, boredom was the garrison's principal enemy. Col. Langlais returned from the hospital with a heavily strapped ankle and rode about on a little pony. Patrols suffered a steady stream of casualties. Many men yearned for the Vietminh to attack, so that they might be hurled back into their mountain fastnesses, freeing the defenders to adjourn to the fleshpots of Hanoi. Yet some also were apprehensive. Lt. Col. Jules Gaucher wrote to his wife on January 11, "Time passes slowly and nothing interesting happens. They tell us of hard times coming, that will shake us out of our routine. Rumour has it that we are destined for sacrifice."

During the weeks that followed, the garrison launched several sorties against the enemy's artillery, all of which failed. Attempts to interdict Giap's supply routes from the air were also unsuccessful, partly because of the limitations of French B-26 Invader crews. Langlais once found his positions undergoing an apparent Chinese air attack but then discovered that they had been hit by an errant Frenchman. This was unsurprising, as many bombloads were released from twelve thousand feet. Far away from Dienbienphu, the Vietminh staged night commando attacks designed

both to sap French air strength and to distract Navarre's attention. Twenty aircraft, most of them precious C-47s, were destroyed in raids on airfields around Hanoi and Haiphong.

From December onward, Navarre and his colleagues had ample intelligence, shared with their superiors in Paris, to show that they faced the prospect of a full-blooded disaster. Yet they persevered because a lethal cocktail of pride, fatalism, stupidity, and moral weakness prevented them from acknowledging their blunder. If the garrison of Dienbienphu had been evacuated, nobody outside Vietnam would ever have heard of the place. There would have been merely a local withdrawal of a kind that had become familiar. Navarre bears principal responsibility, but France's entire political and military leadership deserves to share. It was the country's misfortune to be governed and commanded by men burdened with the humiliations of the previous decade and thus constrained in every decision by a yearning to restore national honor, revive *la patrie*'s glory. In a spirit of defiance, they perpetrated one of the least inevitable military fiascos of the twentieth century.

During the last week of January, the defenders were placed on high alert: intelligence reported that the Vietminh would launch their big assault within hours. Intelligence was right: that was the plan, but then Giap changed it. The foundation stones of the Vietminh commander's recent successes had been meticulous preparations. To the frustration of his subordinates, Giap now decided that conditions at Dienbienphu were insufficiently propitious. His men were there, sure enough, but not the massive stockpile of artillery and mortar ammunition that he wanted. He postponed the scheduled assault.

His new, revised timetable meant that the impending battle must continue into the wet season, which in that region would be very wet indeed. Giap calculated that his own men, deployed on the hills, would suffer less than the garrison on the plain. In Paris a senior officer agreed, observing gloomily that by April, at the camp command post Castries would be paddling in a foot of water: "We believed we could destroy three of the best Vietminh divisions. Instead the enemy has tied down an important portion of our forces, and it is he who maneuvers around us." There

was further discussion of evacuation, but such a course would have meant abandonment of huge stocks of materiel and almost certain extinction of the rear guard. Instead, Navarre reinforced.

For a further seven weeks, which seemed interminable to besiegers and besieged alike, the rival forces gazed at each other across the scrub and hills. Planes came and went. There were skirmishes beyond the perimeter, and a stream of distinguished visitors—military and political grandees, the novelist Graham Greene, the US Army's Mike O'Daniel—all of whom departed unscathed. Meanwhile air attacks on the Vietminh supply line made little impact. Aircrew were inexperienced, and they dubbed their battered old planes les pièges—"the death traps." Many of the 650 French airmen who died in Indochina were victims of human error or mechanical failure rather than enemy action. The Vietminh learned that though raids were noisy, they inflicted surprisingly few casualties. A young man who survived a strike on his village wrote that "bombing and shelling scared people more than it really hurt them. . . . Repeated bombardments can make people less afraid." Moreover, around Dienbienphu aircraft faced increasingly fierce ground fire from Soviet-made 37mm guns. In December, fifty-three planes were hit more or less seriously. Thereafter, as the weather suffered its usual seasonal deterioration, pilots reliant on World War II navigation technology faced ever greater hazards, which caused a steady stream of losses.

From Navarre's viewpoint, more alarming even than the battlefield story was news from Europe, which overnight lofted the stakes at Dienbienphu: there was to be a Big Power summit conference, a negotiation. Soldiers sensed in the air a stench wretchedly familiar to Frenchmen, that of looming betrayal. Unwilling as they were to acknowledge that their own efforts to shoot and shell a path to victory in Indochina were failing, they professed now to see themselves about to fall victim to the machinations of politicians whom they despised.

In the US and Europe, dismay had been growing about the Indochina War. During the early years of the wartime Manhattan Project, which created the first atomic bombs, British prime minister Winston Churchill displayed naïveté and even insouciance about its implications. A decade

later, however, even despite increasing senility, the old statesman was far more sensitive to the perils of unleashing nuclear weapons than were many Americans, including President Dwight Eisenhower. Churchill and his foreign secretary, Anthony Eden, understood that the newly created H-bomb was not just another toy of war, that even to threaten its use in fulfillment of foreign policy objectives was a supremely grave proposition.

As the US administration pondered options, prominent among these was that of bombarding China to punish Mao Zedong for backing the Vietminh. Such a prospect appalled Britain. Although only a few Americans—some wearing uniforms that bore generals' stars—spoke explicitly of nuking the Chinese, once such a conflict started, there was no knowing where it would end. The British cherished a belief in diplomacy that the Eisenhower administration, increasingly contemptuous of its ally's perceived temerity, did not share. American conservatives denounced as appeasement Britain's willingness to engage diplomatically with China and the USSR.

The French exit process from Indochina was precipitated by a tense, difficult January 1954 foreign ministers' meeting in Berlin. Vyacheslav Molotov, for the Russians, urged the convening of a conference at which communist China, hitherto excluded from international gatherings at American insistence, would be represented. This would address outstanding issues in Asia, notably Korea and Indochina. US secretary of state John Foster Dulles balked. The notion of attending a conference with the communist usurpers of China was anathema. Yet Eden strongly endorsed the idea, with the backing of Churchill. For France, Georges Bidault concurred: the tottering government of which he was foreign minister was desperate to open a dialogue with Beijing about its support for the Vietminh. Dulles then grudgingly acquiesced. On February 18, the foreign ministers announced that a conference would begin in Geneva on April 26, to which all interested parties would be invited, chaired jointly by Britain and Russia.

Both armies in Indochina were now impelled by a new urgency, to achieve the strongest possible battlefield position in advance of negotiations. Navarre and his subordinates abandoned the seesawing predictions they had made since December, and expressed vacuous hopes of victory. Emboldened by the soldiers' confidence, the Paris government dismissed out of hand a proposal from India's leader Jawaharlal Nehru for an immediate Indochina cease-fire. It is unlikely that the Vietminh would have accepted such a truce, but there it was: the French rejected a chance—the last conceivable chance—to retrieve their stakes from the table at Dienbienphu.

2. DISASTER BECKONS

Far from Paris, amid the red earthworks, scurrying jeeps, and sporadic shellfire of that wilderness outpost in western Tonkin, the French discerned another unexpected development in the enemy camp. Conventional wisdom demanded that artillery should be deployed on reverse inclines, beyond immediate reach of the enemy. Yet Giap, making new rules, sited his howitzers on forward slopes, where their barrels looked down on Castries's positions, with sufficient reach to claw most. Lodged in tunnels until dragged forward to fire, the guns remained almost invulnerable to French counterbombardment. The plain of Dienbienphu lies 1,000 feet above sea level; the loftiest French positions rose 600 feet higher. Yet less than three miles away, the communists held a hill line with an average elevation of 3,600 feet. Giap's artillery would soon be able to ravage every French movement.

Castries's guns and mortars stood in open pits, hideously exposed. A few dismantled eighteen-ton Chaffee tanks were flown into the camp and reassembled, providing mobile firepower. But French officers began to understand that they faced an ordeal by bombardment such as few of their men had ever experienced. Increasingly lively communist shelling meant that few men on outlying positions could avail themselves of the joys of the camp's two field brothels. By mid-February, though no serious Vietminh attack had taken place, 10 percent of the garrison had already become casualties. Diminished availability of C-47s caused worsening shortfalls in deliveries of supplies and munitions.

On March 11, Vietminh artillery began to pound planes parked

beside Dienbienphu's runway. From the 13th, every takeoff and landing came under fire; airspace became unsafe below seven thousand feet. On the 12th, René Cogny paid what proved to be his last visit: his plane departed amid a flurry of incoming shells, which the garrulous general was fortunate to survive. For weeks Giap's troops had been digging, digging, digging on a scale such as no army had matched since the Western Front in World War I. One of them wrote, "The shovel became our most important weapon." They created around the perimeter a network of tunnels and trenches that provided shelter and covered approaches. The French positions focused upon nine hills, to each one of which was allotted the beautiful name of a woman. Isabelle and Béatrice were deemed the strongest, though a newly arrived *para* officer noted with dismay the vulnerability of their trenches and emplacements: the garrison might have fared better had its men spent the previous weeks digging as energetically as the besiegers.

On the morning of March 13, Giap's 312th Division was read a message from Ho Chi Minh; then all joined in singing the Vietminh anthem. That afternoon, its soldiers mustered to attack Béatrice, the northeastern French position, less than two miles from the airstrip. At 1705, as the defenders saw the Vietminh beginning to move, they were about to order defensive mortar and artillery fire when Giap preempted them. A storm of shells and heavy mortar bombs descended not only on Béatrice, but on widely dispersed targets throughout the camp, especially gun positions and headquarters. The bombardment was extraordinarily accurate, perhaps assisted by Chinese advisers among the Vietminh gunners, who had enjoyed weeks of leisure in which to calibrate ranges and scrutinize Castries's strongpoints. Vietminh patrols had reconnoitered with courage and infinite patience, crawling for hours in darkness among the French wire and trenches. In particular, they pinpointed the wireless antennae that marked command centers.

Pierre Langlais's group survived only by a miracle. The colonel himself was standing naked beneath a pierced-fuel-drum shower when the barrage began, and he ran unclad into his bunker seconds before a shell exploded on its roof. He and his officers were left stunned in a chaos of

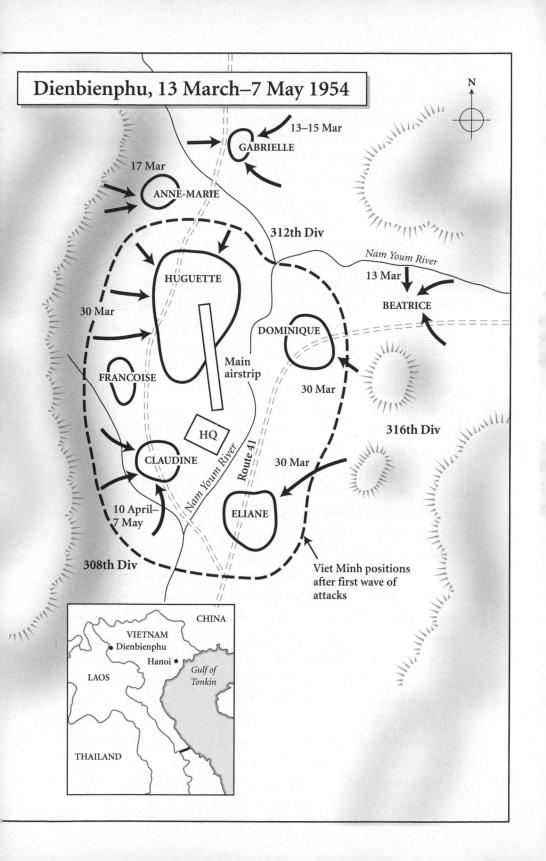

fallen timbers, debris, earth, and wrecked equipment, but a second shell failed to explode. Elsewhere, a red-and-yellow fireball marked the eruption of the camp's fuel and napalm dump. All but one of Castries's spotter aircraft were wrecked.

As the light faded on March 13, defending commanders found themselves crippled. Many phone lines had been cut, and radios were working poorly in the usual evening atmospheric mush. The 450-strong Foreign Legion battalion holding Béatrice was understrength and short of officers. Commanders expected an attack, but not before nightfall. The Vietminh had excavated trenches within fifty yards of Béatrice's perimeter, and from these their infantry stormed forward amid a cacophony of cries and bugle calls, followed by detonations as bangalore torpedoes exploded beneath the defenders' wire. Artillery dealt the deadliest blows: at 1830 a shell devastated Béatrice's command post. As darkness deepened, the occupants of each bunker on the hill were obliged to fight isolated battles beneath the glow of flares. Some Legionnaires imposed heavy losses upon the attackers before succumbing. Within an hour, however, and exploiting a ruthless disregard for their own casualties, the Vietminh occupied positions deep inside the defenses.

One French company commander continued to radio for gun support even as his trenches were overrun: "Right 100 . . . 100 nearer . . . 50 nearer . . . Fire on me! Les Viets are on top of us!" Then there was only a hiss of static, as the voice fell silent. Col. Gaucher, who had gloomily predicted to his wife that he and his comrades were "destined for sacrifice," was mortally wounded. Langlais was ordered to take over but lacked phone and radio links. Soon after midnight, the Vietminh secured control of Béatrice, having killed over a hundred defenders and captured twice as many, most of them wounded. Just a hundred men led by a sergeant major made good their escape. When sunrise came at 0618 on the 14th, a strange silence overhung the battlefield, under a drizzle that turned to heavy rain. The camp's medical staff emerged blinking and exhausted from their stifling bunker, having handled ten abdominal and ten chest cases, two cranials, fifteen fractures, and fourteen amputations. Debris lay everywhere: blackened and burned-out vehicles, smashed aircraft and

equipment. A belated and futile air attack was launched against the Vietminh gun positions.

Then a wounded officer prisoner, Lt. Frédéric Turpin, staggered across from Béatrice to Dominique, bearing from the Vietminh the offer of a truce to evacuate casualties, which Cogny's headquarters authorized. This was a shrewd psychological move by Giap, since it passed to the garrison responsibility for eight badly wounded men and acknowledged his army as local victors. Turpin was fortunate enough to secure air evacuation to Hanoi. As for the men who remained, Pierre Rocolle wrote, "A stupor fell upon all those not engaged in urgent tasks. Officers and men could not stop asking themselves: 'How could a Legion unit have been so swiftly overcome?'" Cogny's response was to reinforce the garrison with yet another battalion of paratroopers.

Giap prepared to repeat his success against Gabrielle, farther north, defended by the 7th Algerian Tirailleurs, who are supper in anticipation of a busy night. Sure enough, at 1800 on the 14th, just before sunset, men of the Vietminh's 308th Division hurled themselves forward. A bitter struggle continued into darkness, lit by flares dropped from an orbiting Dakota. For some hours the defenders clung on, with French artillery harrowing the Vietminh infantry. At 0330 on the 15th, however, renewed communist fire fell on the hill, scoring a hit on the command post that killed or wounded most of its occupants. The French hoped to counterattack at daybreak, and defending officers were heartened by news of tanks and paras concentrating in readiness. The Algerians had had enough, however. At 0700 on the 15th, the first Vietminh soldiers appeared on the crest of Gabrielle. The Tirailleurs, including one company that had not been engaged, scrambled out of their trenches and ran pell-mell down the hill. The communists took possession and found the battalion's concussed colonel among 350 prisoners and 80 dead. The newly arrived Vietnamese battalion was committed to counterattack across open ground, but in the face of shellfire its men faltered, and the assault was abandoned as Tirailleur fugitives trickled into the camp's shrunken perimeter.

French leaders reeled under this second blow within twenty-hours, and they chose to attribute blame for Gabrielle's loss to its officers. Navarre

observed in a letter to Marshal Alphonse Juin in Paris that the collapse of morale had been "most conspicuous in the command elements, which had previously displayed high confidence (too much of it, indeed) and tended to veer from one extreme to the other." The general dispatched two volunteer colonels to Dienbienphu to replace those who had fallen. With the air force conspicuously failing to interdict Giap's supply routes, Navarre instead proposed a ludicrous scheme to seed rainclouds over the jungle, inundating the communists.

In the camp, several of Castries's headquarters officers suffered nervous collapses. The chief of staff sat motionless in his bunker, refusing to remove his helmet. Castries himself exercised command but not leadership: he offered his men no ringing oratory nor comradely cheer, instead apparently resigning himself to the administration of a descent toward disaster. Communist howitzers turned their attentions upon French artillery, and the gunners suffered terribly: one-third of 155mm crews and more than 50 percent of Castries's 120mm mortarmen became casualties. By the third day of battle, half the garrison's stock of 27,000 shells was already expended. The French had lost their forward observation positions, so that their remaining guns were forced to fire almost blind, dependent for targets on air photographs of Giap's lines processed in Hanoi, then parachuted into the camp.

Castries's artillery commander, the jolly, roly-poly Col. Charles Piroth, had rashly promised that he could suppress any guns the communists deployed. Now he suffered a lacerating verbal assault from Langlais about the failure of his batteries during the first two nights' fighting. The colonel retired to his bunker, sobbing despairingly, "I am completely dishonored." In truth, it was his superiors who merited disgrace, for choosing to fight a battle in such a place, pitting twelve thousand French and colonial troops against five times their number of Vietminh, led by a commander of brilliance. Piroth nonetheless clutched a grenade to his body, then jerked forth the pin. Castries sought to conceal the colonel's suicide, but the news quickly leaked and was published in *Le Monde*. On the night of March 14, several shells fell on the main dressing station, killing fourteen men in the triage room and nine postoperative cases, as well as destroying the X-ray

facility. Thereafter the wounded suffered terribly. Before the end, doctors and surgeons treated 2,665 men, performed 934 operations, and watched 319 patients die. The camp's airstrip continued to be raked by fire, which destroyed ten aircraft stranded by bad weather.

The next two days, March 15-16, passed almost without incident. Vietminh propaganda loudspeakers broadcast surrender appeals to the defenders in French, Vietnamese, Arabic, and German. These were not without effect: Cogny had included in Dienbienphu's garrison, against Castries's strongly expressed wishes, one Vietnamese and two Thai battalions that were known to be unreliable. French officers had always feared that peace negotiations would precipitate a catastrophic unraveling of their local forces, and so it proved. Following the announcement of the looming Geneva Conference, many Vietnamese in French service saw who was winning the struggle for Indochina and that it was not the colonial power. During the night of March 15, the first trickle of what swelled into a river of desertions took place from the Thai battalion manning position Anne-Marie, a mile and a half southwest of Gabrielle: one strongpoint was entirely abandoned. Shortly afterward, Vietminh bombardment precipitated a wholesale flight. A French forward observer radioed laconically, "The Thais are off." Anne-Marie 1 and 2 fell into Giap's hands almost bloodlessly, and he promptly repositioned there his own mortars and recoilless rifles.

Garrison morale was now crumbling in such a fashion that Giap's formations could probably have overrun the entire camp—as his subordinate officers chafed to do. Castries wrote later of the chasm between the spirit of the defenders and that of the enemy as being "between the men of a national army fighting for independence . . . and a mercenary force honoring a contract." Giap, however, refused to be hurried. Dogged, methodical preparation had served him well. Moreover, his formations had bled heavily for their early successes: around a quarter of the infantry attacking Béatrice are thought to have fallen, and one of the battalions assaulting Gabrielle lost 240 dead. Six half-trained Vietminh medics struggled to tend 700 wounded.

Amid cascades of shell and mortar fragments, the besiegers paid dearly

for their lack of steel helmets and for early "human wave" attacks. They labored all night, every night, to deepen trenches and extend saps: timber props were carried miles from the nearest forest to the battlefield. A wholesale call-up of reinforcements, many of them untrained teenagers, was undertaken throughout communist-controlled northern Vietnam: the martyrdom that took place at Dienbienphu was by no means exclusively a French one.

Giap each day studied graphs of supply deliveries—"the moving red line." One morning he demanded of his logistics chief why not a single ton of rice had been delivered the previous night and was told there had been torrential rain. The general responded, "Whether it rains or hails, we cannot allow our soldiers to fight on empty stomachs!" This was cynical verbiage: he knew full well that many of his men were starving. They received scarcely any meat or vegetables, and by mid-March were eating "rice so rotten that we did not know how to cook it," in the words of a man of the 312th Division. They were deprived of cigarettes, reduced to foraging for edible wild roots and plants.

Yet Giap chose to persist with his assault in the manner he had started it, painstakingly ensuring the success of each successive thrust, denying to the French any revival of hope. His 37mm flak guns inflicted a crippling toll on aircraft, so that scarcely one returned from the camp unscathed. Through the days and weeks that followed the fall of three of Castries's nine hills, Vietminh artillery harried the airstrip. The landing of each of the diminishing procession of medevac flights precipitated a panic-stricken surge of would-be passengers, wounded and otherwise. Photojournalist Jean Péraud filed a dispatch describing the scene, which he likened to 1945 Germany: "Cries. Tears. Stampede of wounded toward the door. Never seen anything like it since concentration camp." On the 17th, the Vietminh made another skillfully judged "humanitarian gesture," presenting the garrison with eighty-six wounded prisoners. These, of course, merely increased the burden on the camp's overburdened medical facilities: among the doctors' embarrassments was disposal of a mound of amputated limbs.

French medevac crews earned no plaudits. On March 23, an H-19 he-

licopter landed against orders on a notoriously exposed site. As it was being loaded with wounded, its crew wandered away, thus escaping the destruction by shellfire of their machine and its helpless occupants, including a general's son, Alain Gambiez. A French writer observed bitterly, "Certainement, the helicopter crews had not been chosen from the best elements of the Air Force," and Castries deplored their lack of guts. Soon, hard things were also being said about the fixed-wing aircrew, who were exhausted and demoralized. American mercenary pilots of the CIA's airline, CAT (Civil Air Transport) flew a growing number of resupply missions, displaying more skill and steel than their French counterparts. Especially hair-raising were napalm sorties: as one C-119 roared down the runway toward take-off, its pilot raised the undercarriage prematurely, causing the plane to career on its belly along the tarmac in a cascade of sparks, amid four tons of "hell-jelly" and 1,500 gallons of aviation fuel. By some freak of fortune, the crew survived.

As for the garrison of Dienbienphu, most of the French units remained staunch, but contempt for their colonial brethren rose by the day. Not only had the Vietnamese *paras* failed to regain Gabrielle on the 15th, but their French officers "had given a deplorable example," in the words of Pierre Rocolle. An Algerian battalion abandoned its positions and drifted away into the scrub and villages beyond the perimeter, where some hundreds of "the rats of Nam Youm," as they became known, lingered for the rest of the battle, living off pillaged supplies. North African gunners and engineers remained impressively steady, but suffered fifty casualties a day, even when no big attack was taking place.

It was not Castries who became the soul of the defense, but instead Langlais, who, in the words of an admiring fellow Legionnaire, "sang the 'Marseillaise' for fifty-six days. He never weakened." The colonel, however, was no more a thinking soldier, nor indeed a tactician, than are most career heroes. Castries confided to Navarre, "He has the weaknesses of his virtues." On the 16th Langlais was joined by Maj. Marcel Bigeard, a new arrival though an old comrade, who became another legend of the siege. The son of an impecunious Toul railway worker, after one bloody action, Bigeard had recommended every *para* in his unit for a Croix de Guerre.

This man of iron was always known by his radio callsign, Bruno. Yet both Langlais and Bruno were better suited to enduring a crucifixion than inspiring a resurrection.

A couple of successful sorties gave a modest boost to the garrison's morale, but Castries was obliged to weigh the gains of such actions, and even of routine patrolling, against the lives they cost. The plight of the wounded worsened: a certain Sgt. Leroy suffered shrapnel wounds on Isabelle on March 16 and was at the hospital recovering when it was shelled, wounding him again. He was driven back to Isabelle in time to encounter a new bombardment, which killed the driver of his truck. After rescue from the wreckage, he somehow survived a stomach operation, then spent the ensuing three nights in a drainage ditch before being flown to Hanoi on March 25.

Between the 13th and the 27th, 324 casualties were evacuated, but on the 28th Vietminh artillery wrecked a Dakota on the airstrip. Giap's guns now ranged at will, and Maj. Bigeard led twelve hundred *paras* in a desperate sortie against them. In that day's fighting, the Vietminh were reckoned to have lost 350 men killed, together with many flak mountings destroyed. But the French suffered 110 casualties—a company written off, for no decisive result—and Castries had fewer lives to play with. The airstrip's utility was at an end: the "air bridge," on which the whole Dienbienphu plan had been founded, was rent asunder. Soldiers began to lift pierced steel plank from the runway to roof trenches and bunkers: planes would not again need them.

Thereafter, the sufferings of the wounded became terrible indeed. Supplies ran short of *vinogel*, wine concentrate, the stimulant that had been the lifeblood of generations of French soldiers. On March 29, the miseries of both sides were intensified by torrential rain, which persisted through the remaining weeks of the battle: men fought and died in a sea of mud. Now that the garrison was dependent upon parachute-dropped supplies, the inadequacy of air support was laid bare. Flak forced transports to abandon low-level daylight operations and resort instead to high-altitude night drops, which caused an increasing volume of materiel to descend into Giap's hands. The Vietminh commander observed dryly that "enemy

parachutages constituted a not negligible source of supplies, which literally fell out of the sky!"

The most famous French defense of the twentieth century was that of Verdun in 1916, where Gen. Philippe Pétain's forces were sustained by a single tenuous supply road that passed into history as the "voie sacrée." On March 22, Col. Castries observed in a personal letter to Gen. Cogny that Dienbienphu was becoming an Indochinese Verdun, with one critical deficiency: there was no voie sacrée.

BLOODY FOOTPRINTS

1. QUIT OR BOMB?

Giap committed three-quarters of his regular troops at Dienbienphu. Even as the battle was being fought, however, Vietminh regional guerrillas sustained pressure elsewhere, to disperse French strength. There were firefights in the Red River Delta and farther south in Annam: between February and mid-May, fifty-nine fortified posts were overrun. Much of the Mekong Delta fell into communist hands as French troops quit the region for deployment farther north. Navarre and Cogny struggled to defend positions throughout Vietnam and deep into Laos. While they faced looming disaster at Dienbienphu, French authority tottered all over Indochina. Only one power on earth was deemed to possess the means to avert its collapse: the United States.

For almost two months in the spring of 1954, President Eisenhower and his foremost policy makers promoted a military intervention that they were willing, and in some cases eager, to undertake. As would often be the case in Washington's deliberations through the ensuing twenty years, they were unconcerned with the interests or wishes of the Vietnamese people. They merely perceived looming in Asia a new communist triumph that would raise the prestige of China while lowering that of the West. Such an outcome would have dismayed the Republican domestic constituency, already rendered fractious and dangerous by McCarthyite fever.

Debate about options was infused with a new urgency by the arrival

in Washington of French chief of staff Gen. Paul Ély on March 20, a week after Giap launched his first assault at Dienbienphu. Ély delivered a blunt warning: without US succor, the camp would fall. The Americans immediately agreed to provide small change—another score of Invader bombers and eight hundred parachutes. Ély, however, was looking for much more, and quickly found an enthusiastic interlocutor. Adm. Arthur Radford, chairman of the Joint Chiefs of Staff, was a hawk's hawk. He immediately proposed that sixty Philippines-based B-29 Superfortresses should bombard Giap's besieging army. A Pentagon study group went further, suggesting that three tactical nuclear weapons, "properly employed," could at a stroke eliminate the communist threat. Radford embraced this, too, as a viable option. The State Department, however, urged against even whispering the word *nuclear*, saying that if the scheme was mooted to the French, it would surely leak, with tumultuous consequences.

Gen. Matthew Ridgway, US Army chief of staff and foremost hero of the Korean struggle, persistently, staunchly, and presciently opposed any intervention as the wrong war in the wrong place. President Eisenhower, however, saw things differently. He favored committing American power, subject to two caveats, which proved important and indeed decisive: both congressional and allied support needed to be mobilized. America must rally friends, notably the British. Secretary of State Dulles shared with Radford and Vice President Richard Nixon an enthusiasm for Operation Vulture—the B-29 proposal. Even as Castries's men fought throughout the weeks that followed, in Washington, London, and Paris, discussions and indeed fierce arguments took place, as the Americans strove to assemble a quorum for a major new strategic commitment.

On March 30 at Dienbienphu, successive assaults by five Vietminh regiments overran objectives on and around Eliane 1, held by Algerians whose officers were almost unknown to them. Among colonial troops, leadership was all. If men knew and trusted their officers, they would probably fight. If leaders failed or fell, however, soldiers quit. The Vietminh opened a bombardment at their usual hour of 1700 and launched infantry an hour later. Heavy rain had flooded trenches and made air support impossible.

Meanwhile farther north, Dominique was also beset: Langlais could only watch grimly through his field glasses as the position was hacked and harrowed. There were soon four separate infantry battles, in all of which the French were hard-pressed. The Algerian defenders of Eliane 1 began to take flight, prompting a paratroop officer to shoot down several, in an effort to stem the panic. It was all for nothing, and a gaping hole opened in the perimeter. After almost four hours of heavy action, the position collapsed. Similar scenes took place on Dominique 2: some Algerians ran toward the attackers with their hands in the air. By 2200 that position, too, was overrun.

A few brave men fought to the last, among them an eighteen-year-old Eurasian sergeant named Chalamont, who manned a machine gun until encircled and cut down. Dominique 3 just held, thanks to the efforts of a twenty-seven-year-old officer named Paul Brunbrouck, a veteran of an epic December 1952 defense of Na San, another besieged French base. Now, he repeatedly rallied defenders and kept their 105mm guns in action, finally giving the dramatic order to fire over open sights: "Débouchez à zéro!" Langlais radioed Brunbrouck to abandon his pieces. The young gunner responded, "Never!" Early on the 31st, he and his indomitable Senegalese gunners retreated with three howitzers that remained serviceable, having fired 1,800 rounds. Brunbrouck was awarded the Knight's Cross of the Legion of Honor. Two weeks later, he died of wounds after another equally heroic action.

Eliane 1 fell quickly, along with a position proudly named Champs-Élysées. Morning found both sides exhausted. One attacking Vietminh regiment was so depleted that it had to be withdrawn from Giap's line. The French lost a substantial part of their artillery and exhausted half their ammunition stockpile, five hundred tons. Navarre arrived in Hanoi from Saigon to learn of these new misfortunes—and to discover that Cogny had been absent from his headquarters throughout the night, probably with a woman. This precipitated a cussing match between the two generals, whose predicament was now unenviable. The US Army's Mike O'Daniel advanced a preposterous suggestion, that the French should dispatch an armored force westward from Hanoi to relieve the camp. This

ignored both the wild country intervening and the Vietminh's record of savaging French road columns. President Eisenhower nonetheless later expressed surprise that the O'Daniel scheme was not attempted.

Navarre and Cogny embraced additional futile gestures: that morning of the 31st, another *para* battalion jumped into the camp. Even now that it was plain the garrison was doomed, among such forlorn hopes was a procession of volunteers—Capt. Alain Bizard, for instance, abandoned a pampered existence as aide to the army chief of staff in Paris to join Castries's garrison. It seems fair to speculate that young career soldiers sought to atone for the shame of their nation's collapse in 1940, to show that a new generation of Frenchmen possessed a willingness for sacrifice such as some of their fathers had lacked.

Late on the 31st, French counterattacks briefly regained Dominique 2 and Eliane 1, only to see them fall to renewed Vietminh assaults. Enemy night attacks were repulsed on April 1 and 2, but on the morning of the 2nd, Huguette 2 was abandoned by the French, who now tardily labored to strengthen the defenses of their remaining hills. The defenders' faith in the Foreign Legion received a blow on April 3, when twelve of its men, survivors from Béatrice who had had enough, abandoned strongpoints to surrender. Like all deserters who fell into Giap's hands, they were promptly set to work digging and carrying for his army. By April 7, the garrison's surgeons were struggling to care for 590 casualties. The Legion and *para* battalions mustered fewer than three hundred men apiece. Giap ignored a French request for a truce to allow aircraft to evacuate the wounded—and why should he have done otherwise?

The debate in Washington about a possible US commitment—not to rescue the French, but to humble the communists—became much more important to history than was the fate of Dienbienphu. From late March onward, Dulles conducted a media blitz designed to rouse the American people. The secretary of state characterized the enemy as cat's-paws of the Chinese. The US government, he said, would not stand idly by while Reds triumphed, though he remained studiously vague about what action might follow. Front-page stories prepared readers for intervention. *U.S. News & World Report* said, "Blunt notice is given to communists that [the]

US does not intend to let Indochina be gobbled up." Most of the world still supposed that, at Dienbienphu, superior firepower would ultimately prevail: the British *Spectator* observed on March 19 that "the French ought to be able to win this battle, and if they do win, it may for the first time be possible to see light at the end of the Indochinese tunnel." The magazine editorialized again on April 9: "In spite of the terrible unpopularity of the war, the siege of Colonel de Castries and his 11,000 men has reminded France that she can still fight and still be the admiration of the world." Such remarks reflected both wishful thinking and extravagant Francophilia, but they emphasize that nothing about the battle seemed inevitable until its outcome.

On April 3, the US secretary of state presided over a meeting of congressional leaders, including the Southern Democrats Lyndon Johnson of Texas, Richard Russell of Georgia, and Earle Clements of Kentucky, as well as the Republicans Eugene Millikin of Colorado and William Knowland of California. Radford briefed them on the dire predicament of Dienbienphu. Dulles said that the president wanted a joint resolution of Congress endorsing the deployment of American air and naval power. Radford said that if Indochina was lost, "it was only a question of time until all of Southeast Asia falls, along with Indonesia." Under skeptical questioning from the politicians, the admiral was obliged to admit that he was alone among the Chiefs in favoring military action. One of the visitors demanded, why so? Because I know more about Asia than my colleagues, responded Radford, who, though not the sharpest knife in the box, never lacked self-assurance.

Then they addressed the key issue of unilateral versus multilateral action. Lyndon Johnson said, "We want no more Koreas with the US providing 90% of the manpower." The domestic lesson of the 1950–53 war that wrecked Harry Truman's presidency was that, though Americans were willing to pay other people to die combatting Reds in faraway Asian countries, they resisted seeing their own boys sacrificed. Dulles was asked explicitly: would the British associate themselves with a US operation in Vietnam? He admitted this was doubtful. The meeting's outcome, unwelcome to the secretary of state and the president, was that they could secure

their congressional resolution only if other nations signed up, too. At the White House on the following evening, April 4, Eisenhower said it had become evident that the British attitude would be decisive. Late that night, the French formally requested US air power for Dienbienphu. Navarre helpfully suggested that planes thus employed could be unmarked or wear French roundels, which emphasized his diminishing grasp upon reality.

On the evening of April 5, Winston Churchill received an impassioned personal letter from Eisenhower, evoking the familiar specters of Hitler, Hirohito, and Mussolini—"May it not be that our nations have learned something from that lesson?"—in support of a request for British participation in an Indochina intervention. The following day, Eisenhower told the National Security Council that the struggle was still "eminently winnable." At an April 7 press conference, the president for the first time publicly articulated what became notorious as the domino theory. If Indochina was lost, he said, the rest of Southeast Asia would "go over very quickly." The French had already voiced their own variation—the "tenpin theory," as in bowling.

The carriers *Boxer* and *Essex* were dispatched to the Tonkin Gulf, to be on hand if Eisenhower acceded to France's pleas. Yet there were still plenty of doubters. On Capitol Hill the young Democratic senator from Massachusetts urged that it was time to tell the American people the truth: no US intervention could achieve anything useful, said John F. Kennedy, unless France conceded full independence to her colonies: "To pour money, materiel and men into the jungles of Indochina" would be most unlikely to deliver victory against a guerrilla enemy which was everywhere, yet nowhere, and "has the sympathy and covert support of the people." Eisenhower nonetheless remained game to fight—if others would do likewise. Impatiently, testily, he awaited the outcome of deliberations in London.

At Dienbienphu, yet more reinforcements were committed. A dramatic decision was taken to dispatch volunteers without parachute training. It is hard to imagine a more terrifying introduction to airborne warfare than a night jump into a tight perimeter encircled by the enemy. As planes approached the drop zone, men were told there was time for only six to

exit on each pass. Tracer streamed up from communist flak guns, and one soldier in ten declined to jump; refusals are infectious amid the roar of engines, shouts of dispatchers, blind uncertainty below. Nonetheless, most of the battalion sprang courageously into the darkness, and landed in the French lines with surprisingly few losses. By a monumental act of bureaucratic meanness, survivors were subsequently denied paratroopers' badges, on the grounds that they had not completed the prescribed course.

It was now April 1, an appropriate date for another of Navarre's black-comic gestures: an orgy of promotions for officers of the garrison, including the advancement of Castries to brigadier general rank. While Giap's besiegers continued to dig furiously, advancing trenches and tunnels toward their next objectives, on the morning of April 10 the newly made Col. Marcel Bigeard directed a counterattack on Eliane 1. The men advanced singing, spearheaded by a flamethrower carrier escorted by two submachine gunners, into a storm of communist fire. At 1130, after bitter fighting, they reached the hillcrest—then were stuck, having suffered sixty casualties. At dawn on April 18, the hundred-strong garrison of Huguette 6, which was now thought indefensible, leaped from their trenches and ran for their lives, leaping over Vietminh foxholes toward the French lines. Sixty made it.

Throughout the Anglo-American crisis meetings that took place in April 1954, Dulles was obliged to mask his disdain for Britain as a nation and for her leaders in particular. This sentiment was mutual. Churchill characterized the secretary of state as "a dull, unimaginative, uncomprehending man." In London on April 11–12, the visitor again rehearsed familiar arguments about the need to fight together against totalitarian threats. Anthony Eden was unfailingly courteous, unflaggingly skeptical. It was, of course, a large irony that he should in 1954 reject comparisons with the 1930s to justify Western military action, when two years later as prime minister, he would deploy the same analogy to justify Britain's disastrous invasion of Egypt. As it was, the two men parted with cold civility. The American visitor fared no better in Paris, where foreign minister Georges Bidault declined to agree that France should grant absolute independence

to Indochina, an American precondition for intervention. Yet Washington hawks remained keen to act. On April 16, Vice President Richard Nixon told newspaper editors, "The US must go to Geneva and take a positive stand for united action by the free world." Far away in Indochina, the French heard of his words and nursed flickering candles of hope.

2. "A TRIUMPH OF THE WILL"

Between April 14 and 22, the garrison of Dienbienphu lost 270 men. Fragging by the disgruntled was not an American invention: one night a soldier tossed a grenade into a bunker full of NCOs and was summarily executed for his pains. By April 14, Castries mustered 3,500 effective infantrymen; 2,000 deserters lurked around the fringes of the camp, each night slinking out to compete in a scramble for parachute-landed rations. At the outset, the French perimeter enclosed 1,200 acres; this had now shrunk by half. The battlefield resembled a fragment of the 1917 Western Front: a barren, mud-churned wasteland littered with debris, broken weapons, and spent munitions, scarred and blackened by bombardment. Few men on either side ventured to expose themselves in daylight. French airmanship remained lamentable. On April 13, Castries reported to Cogny three bomber attacks on his own troops, together with the *parachutage* of eight hundred shells into enemy hands. This message ended with a terse, acidulous "No Comment."

The Vietminh displayed marvelous energy and ingenuity in sapping trenches and tunnels into the French positions, together with much courage in their infantry attacks. Yet to the end, the defenders inflicted far more casualties than they suffered. In 2018 Hanoi has still not credibly enumerated its Dienbienphu losses, surely a reflection of their immensity. Prisoners who fell into French hands testified to the dejection prevailing in many Vietminh battalions, among which malaria was endemic. The communist commander's difficulties were sufficiently serious to cause him to abandon human wave attacks in favor of more measured tactics and to stage a succession of propaganda and self-criticism meetings. Political officers sought to inspire their overwhelmingly peasant soldiers and porters by

promising that land reform—confiscation of landlords' holdings—would be imposed in the "liberated zone" within weeks of this battle being won. The most powerful stimulus for these simple men, however, was surely the knowledge that their sacrifices, unlike those of the garrison, were not in vain. They were winning.

On the night of April 22–23, Giap's men overran Huguette 1 after bursting forth from tunnels dug into its perimeter. Its senior officer was last seen fighting to the death in the midst of a throng of Vietminh. Castries demanded a counterattack, because without Huguette 1 there was little space left for supply drops. *Paras* were due to start such an operation at 1400 on April 23, but an hour beforehand it became plain they would not be ready. Chaos ensued: it was impossible to cancel a scheduled air strike by four Invaders and a dozen fighters, which went in at 1345, when most of the available artillery ammunition was also fired off. The Vietminh on Huguette suffered severely but then enjoyed a forty-five-minute lull during which reinforcements were rushed forward.

By the time two French companies leaped from their positions, they met intense fire, exhausted momentum on open ground halfway to their objective, and by 1530 were pinned down and suffering heavy casualties. An hour later, survivors withdrew, having lost seventy-six men killed or badly wounded. One of the latter, a Lt. Garin, whose legs were mangled, blew out his own brains to forestall an attempt to rescue him. The communists now held half the airfield, and Castries's dressing station wrestled with 401 serious cases and 676 less severe ones. An officer told casualties for whom no shelter was available, "Those who can't stand or sit had better lie in their trenches."

As the Geneva Conference drew near, once more Dulles flew to Europe, this time accompanied by Adm. Radford, to renew their pleas to the government of Winston Churchill and to consult with the French. It was becoming clear to the world that without US action Dienbienphu's fate was sealed, and the *Spectator* reflected some conservatives' enthusiasm for intervention, "if Ho Chi Minh and the Chinese have to be persuaded by military means that peace is desirable." On April 22, Dulles and foreign

minister Bidault met again in Paris to seek a common policy front for Geneva; Ély and Navarre meanwhile pressed for more US aircraft. When the British joined the talks, Bidault became emotional, perhaps influenced by a copious intake of alcohol. He later claimed that Dulles had asked him privately whether he thought nuclear weapons would be effective at Dienbienphu; it seems at least possible this issue was informally raised.

Both Eisenhower and his secretary of state were weary of the Europeans: of the French, because they wanted aid without strings; of the British, because they refused to acknowledge the merits of joining the Indochina fight before the French packed their bags. Britain was also considered pitifully nervous about the Chinese threat to its Hong Kong colony. The old prime minister and his foreign secretary, Anthony Eden, nonetheless stuck to their chosen course. They rejected Eisenhower's domino theory and declined to support any new military action in advance of Geneva, which Eden was to co-chair with Soviet foreign minister Molotov. As for Churchill, when Radford unleashed his personal powers of persuasion on Britain's leader at an April 26 dinner at Chequers, the prime minister told the American, "The loss of the fortress must be faced." After Britain had been unable to save India for herself, he added, it was implausible that she could save Indochina for France.

Dulles cabled home on April 29: "UK attitude is one of increasing weakness. Britain seems to feel that we are disposed to accept present risks of a Chinese war and this, coupled also with their fear that we would start using atomic weapons, has badly frightened them." The British contribution was their most influential and benign in the course of all Vietnam's wars. Had Churchill given a different answer, while it remains unlikely that Eisenhower would have unleashed nuclear weapons, the Western allies would probably have committed forces to support a fundamentally hopeless French position. Eisenhower's cables to Dulles make plain that, while he declined to deploy US might unilaterally, he was not merely willing but keen to do so, if he could secure the political cover Britain could provide, backed by a token commitment of RAF bombers.

Since 1940, the British had engaged in many displays of diplomatic gymnastics to avoid a falling-out with the United States. They were most

uncomfortable about now disagreeing with Washington on a matter to which the administration attached such importance. Yet it is hard to doubt that London's caution was well founded. Churchill is often and justly said to have been a shadow of his old self during his 1952–55 premiership. On this issue, however, he displayed admirable clarity and stubbornness. The British feared that the real objective of any US action would be to punish China. The administration's indignation about Chinese military aid to the Vietminh seemed bizarre, when the US was already providing vastly more weapons and equipment to its own French client. In British eyes, the Korean conflict had represented an intolerably protracted mud-wrestling match with the communists. A plunge into Indochina could precipitate something worse—conceivably, a big war. Churchill told the Americans that he declined to collude in misleading Congress by backing Western military action that could not save Dienbienphu but might have untold implications for peace.

Radford was furious, and so was Eisenhower, who wished to see the communists "take a good smacking in Indochina." It is plausible that resentment about what Washington branded as British pusillanimity contributed two years later to the president's renunciation of Eden in the Suez debacle. Yet no Western action in the spring of 1954 could have saved Dienbienphu, short of unleashing insanely disproportionate conventional or even nuclear firepower. The later American commitment to Vietnam was seen by much of the world as implicitly colonialist; such action in 1954 would have been explicitly so. Almost entirely absent from the Washington debate was an understanding that Indochina's future would be principally determined by political, social, and cultural forces. Instead discussion focused solely upon what weight of firepower should be deployed. It was taken for granted in 1954, as it would be a decade later, that if the US decided to deploy its might against rubber-sandaled peasants, Giap's army would suffer defeat, even obliteration.

The Americans reasoned that if the French are losing, this was because they were . . . well, French. Bernard Fall recoiled in disgust from a US official who dismissed France's presence in Indochina: "The whole damn country is degenerate, admit it. And the French are scared of the Germans,

and the whole damn French Army is in Indochina just to make money and they have no fight left in them anyway." Since no US military commitment was made in the spring of 1954, events in the remote northwest of Vietnam ran their course. A cartoon in *Le Figaro* was captioned "The Final Redoubt." It depicted government ministers in Paris using their last bullets to kill themselves. If most French people had become resigned to the fall of Dienbienphu, among the elite this was thought to signify the end of France as a great power.

Navarre and Cogny clung to hopes, either that worsening monsoon weather might render Giap's assaults logistically unsustainable or that a cease-fire in place might be imposed by the powers meeting in Geneva. The two generals urged Paris that further reinforcements would improve the garrison's chances, adding, "As well as military honor, there is at least hope of a favorable outcome that justifies additional sacrifices." This was absurd, of course. Aircrew, few of whom made any pretense of exerting themselves, were pushing supplies out of their planes from ten thousand feet, so that almost half fell into Giap's hands. Much of the bombing was conducted blind, through cloud. On April 28, one wing, Groupe Franche Comté, reported the claims of its commanding officer, his adjutant, and eight pilots to be medically unfit to fly. Their colonel said defiantly, "My refusal to send them [over Dienbienphu] in daylight, at low altitude, to certain death, is a matter between me and my conscience. The sacrifice would be futile." Castries complained bitterly to Hanoi about aircrew who flinched, while his own soldiers were passing the stations of the cross: "There cannot be a double standard."

Among the American mercenaries who performed more creditably than did the French over Dienbienphu was the huge, bearded figure of CAT pilot James McGovern—"Earthquake McGoon" to his buddies. On the last of countless missions to the camp, his C-119 was hit as he approached the drop zone with a load of ammunition. He turned away with one engine out, rejecting a bailout. He had once performed an epic hike after coming down in China, and declined now "to do all that walking again." This time around, his efforts to nurse the plane to safety failed. McGovern crashed into the ground with a spectacular explosion.

With reckless disregard for security, on April 24 Le Monde revealed the launch of Operation Condor, a "forlorn hope" jungle march by three thousand men who set out from Laos to relieve Dienbienphu. It quickly became plain that Condor had no chance of success in impossible terrain against Vietminh opposition, though rumors of such relief kept alive among a few optimists a vestige of hope. Most of the garrison, by contrast, were now resigned to death or capture. There was a distinction only between a minority who faced their doom with stoic courage and those who succumbed to rage or despair. Men holding positions near the center of the shrunken perimeter continued to receive rations to eat and wine in which to drown their sorrows. Others, in outlying bunkers, sometimes passed days without resupply, and spoke later of subsisting on stale bread and tomato sauce. In the hospital, Dr. Paul Grauwin reassured men who recoiled from the maggots in their wounds, saying that the creatures fed only on decayed tissue. On April 26, Algerians panicked during a struggle on Isabelle, then mutinied. Their colonel wished to shoot the ringleaders, but Castries overruled him. On April 30, the Legion solemnly celebrated the anniversary of its 1863 fight to the death at Camerone in Mexico, now drenched by rainstorms that intensified the miseries of the exhausted, filthy, half-starved garrison.

On the following night, May 1, Giap's infantry assaulted Eliane 1, which they overran after ninety minutes of close-quarter fighting. Meanwhile on Dominique 3, Thai and Algerian defenders put up a tough fight before succumbing. In the Eliane 2 battle, Castries lost 331 men killed or missing and 168 wounded and now fielded not much above two thousand infantry against Giap's fourteen thousand. The Vietminh showed off new weapons: Soviet Katyusha multiple rocket launchers, formidable in their screeching moral impact. As the relationship between Navarre and Cogny became ever more sulfurous, the commander in chief threatened his subordinate with a court of inquiry, charged with leaking defeatist gossip.

The shades closed in upon Dienbienphu, where the stench of excrement, unburied corpses, and decaying humanity was becoming intolerable. A trickle of reinforcements, volunteers to embrace catastrophe, continued to parachute into the camp for the sole purpose of enabling the French delegation in Geneva to dispute the inevitability of defeat. Walking wounded were invited to rejoin their units: more than a few defenders manned trenches while wearing mud-caked bandages. Langlais and Bigeard discussed a scheme whereby dispersed columns might break out through the jungle: they concluded, inevitably, that any sortie was doomed.

Then came another Vietminh attack. On the morning of May 4, the garrison's wireless operators heard a grim succession of voice messages from a lieutenant who had assumed leadership of the Moroccan unit on Huguette 4 after his company commander was hit: "There are only ten of us left around the CP. We are waiting for reinforcements. . . . Where are the reinforcements? . . . Les Viets attaquent. . . . I hear them. . . . They are coming toward me down the trench. . . . They are here. . . . Aaah!" On the evening of the 5th, Cogny sent the hapless Castries an imperious signal demanding "a prolonged resistance on the spot which now remains your glorious mission."

During the ensuing twenty-four hours, the garrison received a further air-dropped reinforcement of 383 men, of whom 155 were Vietnamese. On the morning of May 6, intelligence warned Castries to expect a big attack that night. Capt. Yves Hervouet demanded that Dr. Grauwin cut the casts off his broken arms, so that he could once more man his tank. At 2130, a Vietminh mine exploded beneath Eliane 2, which was then overrun in a brisk action fought in torrential rain; Capt. Jean Pouget led an unsuccessful counterattack. Savage melees also took place on Eliane 4 and Eliane 10, which caused Langlais and Bigeard to radio aircraft overhead, canceling a reinforcement jump. The perimeter was now so tight that parachutists were likely to land in the arms of the Vietminh. The last message from the officer commanding Eliane 4, lost soon after 2100, urged against shelling the fallen position, because every trench was crowded with French casualties. Meanwhile around the dressing station, in addition to the wounded and dead, clusters of men lingered slumbering through the long hours because, lacking weapons or a military function, they could do nothing else.

At 1700 on May 7, Castries radioed to Cogny's headquarters, saying, "We have done all that we can. At 1730, I shall send out emissaries." Cogny himself came up on the circuit, seeking to prevent a formal capitulation: "You must not raise the white flag. You should let the fighting die out of its own accord." Castries professed to assent: "Bien, mon général." His commander said, "Allez, au revoir mon vieux." Then, from the dank, sultry bunker, Castries passed orders to destroy as many weapons as his survivors could before the formal surrender. Capt. Pouget wrote, "Under the harsh, naked electric light, he looked ten years older than he had done in March." Dienbienphu's commander, seldom visible to his men, had shown none of the qualities that might have made him a hero, but it would be quite mistaken to hold him responsible for the fall of the encampment, ordained from the moment that its garrison was deployed so far beyond sustainable support. The Vietminh had staked many more chips than the French could match, and now they swept the board.

The battle petered out slowly. A ground operator aborted an incoming fighter-bomber strike, radioing callsign César 5, "We're blowing up everything-goodbye to our families . . . Adieu César." One position, Isabelle, held out for some hours more; its 1,200 men attempted a sortie that ended with two companies cut to pieces in a chaotic night fight. A Moroccan gunner named Mohammed ben Salah is thought to have been the last man to die, manning a 105mm howitzer hours after Castries quit. The Vietminh found themselves with 5,500 prisoners, of whom all but a thousand were wounded. The French command had formally recorded 1,161 deserters, who now joined the ranks of the POWs: in all, sixteen battalions of French and colonial troops were wiped off Navarre's order of battle. The Vietminh cadre and musical bard Van Ky said wonderingly, "This was an unbelievable victory, something beyond the bounds of our imaginations. No one could figure out how we could have defeated such a powerful force." Col. Tran Trong Trung justly asserted that the victory was above all "a triumph of the will."

More of Castries's men perished in captivity than had died in action. Once in a communist POW camp—and some never got that far—a commissar addressed the French officer prisoners in characteristic fashion:

"You are here for an indeterminate period, to be reeducated by work. You will live the same life as those whom you have oppressed; you will suffer like them, come to understand them. We shall guide you in your search for truth." Some 3,900 members of the garrison were eventually returned to their own people, 43 percent of those captured. Sixty Thais and 19 Europeans escaped from the battlefield and hacked through a hundred miles of jungle to safety. Castries's first question to the naval officer who received him on his release late in 1954 was, "Is it true they want to shoot me?"

Only one in ten of 14,324 Vietnamese troops taken prisoner in French uniform during the course of the war returned alive. In defense of the Vietminh, their own people lacked medical support and existed on the edge of starvation. It is nonetheless plain that Giap and his comrades were indifferent to the survival or extinction of compatriots who had chosen the losing side. How could it be otherwise, when they had sacrificed an estimated 25,000 of their own followers to secure victory at Dienbienphu? Nguyen Thi Ngoc Toan, the mandarin's daughter who had become a fervent revolutionary, served as a twenty-one-year-old medic in Giap's army. In the wake of its triumph, she was married to Cao Van Khanh, deputy commander of the 308th Division, at a ceremony held in Castries's command bunker.

On paper, the battle need not have been the decisive event of the war, because the French still possessed powerful forces. Giap's army had exhausted itself and was incapable of translating this local triumph into a successful general offensive. Yet France's government and people could stand no more. Pierre Rocolle has written, "Dienbienphu became an imperious invitation to stop the shooting, because the will to pursue the struggle no longer existed." France's American quartermasters had provided sufficient military aid to fight a war yet not enough to win it.

It is usually mistaken to assume that the outcome of any historical drama was preordained, but there is an absolute lack of suspense about a narrative of France's Indochina experience between 1945 and 1954. Colonial rule there had become unsustainable due to the strength of nationalist resistance and the weakness of noncommunist political elements—the

mythical "third force" that many Americans yearned to identify. Doug Ramsey, a US Foreign Service officer who would become a significant figure in Vietnam a decade later, said, "I wonder that we could have taken ourselves in, that many years in a row. It went back to Roosevelt making accommodations with the colonial powers. Think of the inanities of John Foster Dulles."

There has been speculation about how much Giap's success was owed to his Chinese advisers. Mao's men obviously provided technical instruction. For the most part, however, subsequent history shows that the North Vietnamese—as we might now begin to describe them, though many communist leaders came from the south and center of the country-needed and accepted remarkably little guidance from others. A decade's experience of war had made Giap and his comrades proficient, even inspired soldiers, fortified by the indifference to casualties common to all communist armies: foreign admirers later dubbed the North Vietnamese Prussians of the Orient. Hanoi's histories pay effusive tribute to the personal role of Ho Chi Minh. Such claims are rooted in the demands of an authoritarian state's official legend. Yet thus far, at least, they are valid: Giap could not have accomplished what he did nor survived so many bloody setbacks as commander in chief without the support of Ho in good times and bad. The general himself was hugely respected, but his egotism made him little loved. In his subsequent writings about the battle and Vietnam's wars, he tells a story of Giap, Giap, With scarcely a nod to the contributions of his subordinates. Nonetheless, his victory at Dienbienphu stands as one of the military classics of the twentieth century.

3. GENEVA

News of the capitulation was broadcast in Paris at 4:45 p.m. on May 7 and acknowledged in Geneva somewhat later, just hours before the assembled foreign ministers began to debate the political future of Vietnam. Georges Bidault, making the announcement, paid implausible tribute to France's "civilizing" role in Vietnam, speaking of "this conflict that was forced upon us." What was extraordinary about subsequent events at the confer-

ence tables—Dulles refused to sit at a common board with the Chinese—was that French humiliation yielded no triumph for the Vietminh. After expending torrents of blood to strengthen their negotiating position, they were eventually obliged to go home with half a loaf. How so?

The Geneva story began with the arrival of the first delegations, on April 24, 1954. Representatives of the world's media thronged around the two-hundred-strong Chinese group, led by the urbane, handsome, supremely sophisticated Zhou Enlai, fifty-six-year-old scion of a scholarly family. Zhou bore to his grave the respect of the international community despite serving as Mao Zedong's instrument through decades of mass murder. The Russians arrived bearing a large consignment of caviar with which to enrich their hospitality at the multilateral feasts they intended to hold, but none eventually took place. John Foster Dulles sustained his usual standard of diplomatic courtesy, turning his back on Zhou when the Chinese extended a hand. The British were far more nervous about the US secretary of state than about the communists: they feared that Dulles's rancor might provoke him to sabotage the proceedings. The obvious dominance of China and Russia reinforced the American conviction that Ho Chi Minh was their pawn: at Geneva the delegations of Zhou and Molotov were seen everywhere, that of the Vietminh only in conference sessions.

As the disparate national groups dispersed to their various hotels and mansions, Dulles led the only party stubbornly eager to sustain the Indochina War. He expressed disgust that he had been invited to attend a diplomatic sellout to the communists, comparable with that at Yalta in 1945. The veteran liberal columnist Walter Lippmann observed, "The American position at Geneva is an impossible one, so long as the leading Republican senators have no terms of peace except unconditional surrender of the enemy and no terms for entering the war except as a collective action in which nobody is now willing to engage."

Yet the obduracy of the US secretary of state played a critical role in producing a settlement far less favorable to the communists than their victory at Dienbienphu made likely. In 1972, President Richard Nixon would fail in an attempt to convince the North Vietnamese that he was

reckless enough to commit any military excess—the "madman theory." Yet in 1954, common to all the communist delegations at Geneva was morbid dread of an American troop commitment in Asia. The Chinese and Russians had enjoyed the Korean War even less than did the Western powers. They read newspapers and were acutely conscious of the conservative forces in play within the US. They knew that the Eisenhower administration needed scant further provocation to commit American firepower—and just conceivably, nuclear weapons. Moreover, though the Vietminh were often hailed as possessing an infinite capacity for sacrifice, by May 1954 the leadership knew that its followers were weary. Vietnam's "liberated zones" groaned under the stresses of fighting a war while simultaneously implementing a social revolution.

The word partition seems to have crossed Russian lips before anyone else's. The Vietminh dominated the north while remaining weak in the south. Korea's division at the 38th parallel, insouciantly mandated by Dean Rusk in 1945, set a precedent. On May 3, before the formal Vietnam sessions opened in Geneva, Bao Dai's pantomime government threatened to boycott the conference without a French guarantee that partition was not on the agenda. That same day, Dulles returned to Washington to sulk, leaving deputy secretary Walter Bedell Smith, Eisenhower's wartime chief of staff, to lead the American team. Everybody heaved a sigh of relief, because "Beadle" was rational, and Dulles was not. A flurry of private bilateral conversations followed, involving all the delegations, before formal proceedings began on May 8, beneath the shadow of Dienbienphu's fall.

For the first week, the Chinese remained almost mute: the only two foreign ministers who displayed impatience were Eden and Molotov. On May 10, Pham Van Dong made an opening statement, proclaiming the Vietminh's commitment to full independence for all three states of Indochina. He promised that those Vietnamese who had fought against Ho Chi Minh would be "free from repression." Then, to the amazement of the Westerners, he expressed willingness to consider partition. It seems almost certain that the Vietminh had been heavily pressured by the Chinese and Russians to initiate such a proposal.

Once the communist camp had put it on the table, this outcome became overwhelmingly likely, though much horse trading was bound to follow, about where a line should be drawn between a new North and South Vietnam. The French initially favored a "leopard-skin" distribution of territory, identifying regions that should be conceded to the communists with the special objective of excluding Hanoi and Haiphong. On May 12, Bao Dai's delegation reasserted its rejection of any divide. Yet bilateral staff conversations about ways and means began between French and Vietminh representatives, encouraged by the British.

In the United States, Dulles made plain his own alienation, and conservative media whipped up a frenzy. *Time* said that Britain's leaders "look alarmingly like appeasers." Bedell Smith told a press conference that partition was unacceptable, and in private became increasingly irked by Eden's apparent eagerness to indulge communist aspirations. In secret bilateral talks, Washington sought to stiffen Paris's resistance, but the French responded that only immediate US military action could dissuade them from cutting a deal. Once again, Eisenhower and Dulles explored the possibilities of forging a coalition for military action even without the British. However, Australia and New Zealand declined to participate, which snuffed out that final flurry of American enthusiasm for belligerence. The *Spectator* described the early talks at Geneva as "an appalling mess," and none of the participants disagreed.

To comprehend the events of the next few weeks, it should be recognized that capitulation at Dienbienphu did not check the fighting and dying elsewhere throughout Vietnam: the French continued to suffer punishment even as the flow of desertions from their locally recruited forces became a flood. On June 4, Navarre was relieved of command, making way for Paul Ély to become proconsul. Two new military disasters took place. In the first, Groupe Mobile 100, while conducting a withdrawal from An Khe in the Central Highlands, fell victim to a devastating succession of ambushes commencing on June 24. About half of GM100's personnel were killed and four-fifths of its vehicles destroyed; one of France's finest regiments, First Korea, was wiped out. On July 12, Groupe Mobile 42, preparing for a potential withdrawal from Pleiku, suffered a similar

fate. Meanwhile Giap was known to be preparing a big new offensive in the Red River Delta. A Chinese rail link to the northern border of the "liberated zone" was now delivering to the Vietminh four thousand tons of munitions and equipment a month.

Protraction of the Great Power negotiations, even as the killing went on, attracted the dismay and impatience of a global audience. At London's Café de Paris, Noël Coward introduced Marlene Dietrich by declaiming a superbly witty verse in praise of female allure through the ages. Laughter reached its climax in response to his lines about Cleopatra: "The Serpent of Nile / Could achieve with a smile / Far quicker results than Geneva." Yet suddenly, there was hope: in the midst of France's continuing battle-field reverses, in Washington awareness dawned that there could be worse outcomes than partition. Absent US intervention, all Vietnam might be overrun by the communists. Bedell Smith accepted the need to take a deal. Meanwhile in Geneva, on June 15 the communist camp held a secret strategy session: Zhou pressed the Vietminh to become more realistic, notably by abandoning their big lie that they had no forces in Laos and Cambodia. Molotov seconded his Chinese counterpart.

Three days later, there was another dramatic development: Joseph Laniel quit as France's leader, to be replaced by Pierre Mendès-France. The new prime minister immediately announced that he, too, would resign unless he could achieve an Indochina cease-fire within thirty days. He thus imposed a deadline on the Geneva talks, and Zhou told Eden and others that he was keen to see this met. On June 23 in Bern, he held private talks with Mendès-France, at which the two men got on well. Zhou made no bones about his prime objective: to keep US forces out of Indochina. To achieve this, they agreed that there must be a partition.

The anticommunist Vietnamese representatives, led by their own new prime minister Ngo Dinh Diem, whimsically chosen by Bao Dai, remained implacably hostile. Yet only one dissenter mattered: would Washington impose a veto? Churchill wrote to Eisenhower, "I think Mendès-France has made up his mind to clear out on the best terms available. If that is so, I think he is right." On June 24, Dulles told congressional leaders that the US would adopt a new policy: to defend southern Vietnam, Laos, and Cambodia from

communist takeovers, to "hold this area and fight subversion with all the strength we have." His statement implicitly acknowledged loss of the north.

Meanwhile, Chinese and Vietminh leaders reviewed their position in advance of the crucial next round in Geneva. At a July 3–5 meeting in the southern Chinese city of Liuzhou, Premier Zhou Enlai recalled the reversal of the communist invasion of South Korea in the summer of 1950. Zhou told Ho Chi Minh and his delegation, "The key to the Korea issue lay in US intervention. . . . It was completely beyond our expectation that [MacArthur's] reinforcements would arrive so quickly. . . . If there had not been US intervention, the Korean People's Army would have been able to drive Syngman Rhee's [forces] into the ocean." Here was an expression of fears that mirrored those of the Americans: the Chinese were apprehensive that if the Vietminh overplayed their hand, as had North Korea's Kim Il Sung, a geostrategic disaster could unfold.

In 1954 Mao Zedong's civil war triumph, together with the perceived humiliation of the US and its Nationalist clients, was only five years in the past. Some American conservatives still cherished hopes, however fanciful, of reversing the "loss of China." Four years earlier, the Chinese had entered the Korean War because they felt unable to tolerate MacArthur's victorious army on their Yalu River border. At the time of Geneva, Mao felt far less secure than his regime's subsequent longevity might suggest. Zhou Enlai's priority was Chinese security. This seemed best advanced by appeasing American sensitivities: he could live with a noncommunist South Vietnam if this would calm Dulles and Eisenhower.

Thus the Liuzhou conference took its course. If the Indochina War continued inconclusively—as well it might, with the French still deploying some 470,000 troops against 310,000 Vietminh—and wider East-West tensions worsened, Washington might yet lash out. Everything gained in a decade of struggle might be forfeit. Giap acknowledged that without a political settlement it could take two to five years to achieve absolute military victory, a view shared by his Chinese advisers. The French were then proposing a far northern partition at the 18th parallel, just south of Vinh. The initial Vietminh offer was for a boundary at the 13th parallel, in the midst of the Central Highlands of Annam. The Chinese suggested

a compromise at the sixteenth, from which Ho Chi Minh appears not to have demurred. When Zhou reported to Mao on 7 July, the chairman accepted the need for concessions and a swift settlement. The Russians agreed, for similar geopolitical reasons.

Dulles petulantly declined to attend the first meetings of the final session of the Geneva Conference on July 10. He regarded the deal under discussion as representing a surrender comparably odious and craven with those of the 1930s to the fascists: it would likely prove a mere way station toward a communist takeover of all Vietnam. This, after the US had expended \$2.5 billion on funding the anticommunist war effort, more than France itself had received in economic aid since 1945. Meanwhile Mendès-France had not troubled to inform Bao Dai about the progress of negotiations. In Saigon the newly installed prime minister, Ngo Dinh Diem, still resisted partition, even when the US ambassador urged him to accept that half a country was preferable to none. Diem instructed his foreign minister in Geneva to pursue the fantasy of keeping Hanoi and Haiphong under Saigon's rule; here was a foretaste of his later rejections of unwelcome realities. He insisted upon placing on record his government's view, that partition ignored "the unanimous desire of the Vietnamese people for national unity."

On July 16, deputy secretary of state Bedell Smith arrived in Geneva to lend a reluctant American presence. Under instructions, however, he took no part in the horse trading now conducted, through a tense round of bilateral and ad hoc meetings. Two days later, the foreign ministers agreed that the proposed cease-fire would be supervised by an international control commission composed of Indians, Canadians, and Poles. On July 20, a partition was agreed between the French and the Vietminh close to the 17th parallel, which gave the new South Vietnam a short, defensible border with the North. This partition "would be provisional and should not in any way be interpreted as constituting a political or territorial boundary." All Vietnamese were granted a three-hundred-day grace period in which to decide under which regime they would henceforth live, with guaranteed freedom of movement northward or southward. General

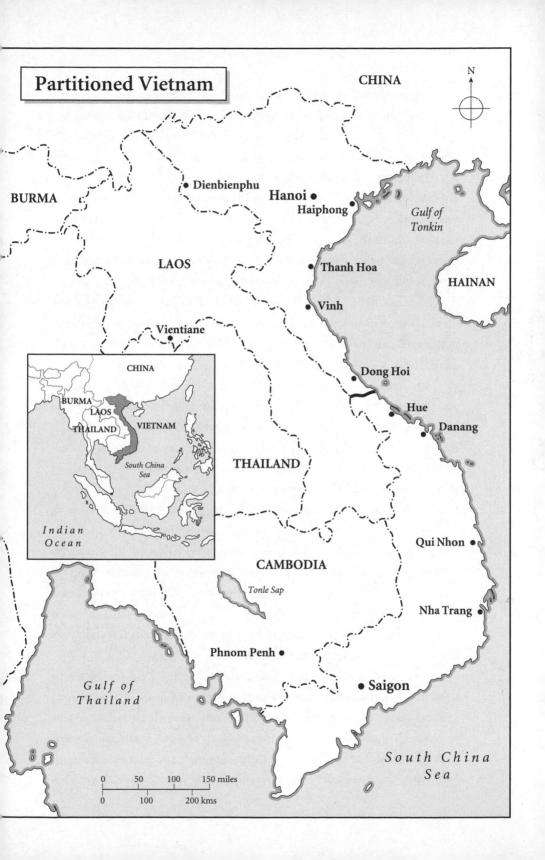

elections would be held within two years. Both Vietnams would join Laos and Cambodia as avowed neutral states. The French would go home.

Early on the morning of July 21, 1954, the Final Declaration was endorsed by the French, British, Chinese, and Russians, but conspicuously not by the Americans, who merely "took note" of it, nor by either Vietnamese delegation. Dulles issued a statement emphasizing his nation's special interest in the fate of the newborn twins: he warned that any violation of the deal's terms would be "a matter of grave concern and seriously threaten international peace and security." Everyone involved save the Americans gave credit to Anthony Eden for his performance as co-chairman, through many weeks when the talks seemed doomed to fail. An eyewitness wrote of his "almost inhuman good humor and patience": this was the finest hour of the career as a statesman of the brilliant, unstable, absurdly handsome British foreign secretary.

The Geneva Accords, as they became known, merely settled terms of truce between the departing French colonialists and the communists, who were to assume governance of the North. Therein lay the basis for the later insistence of both Washington and Saigon that refusal to conduct national elections within the specified two years was no breach of anything to which either had consented. Many people around the world quickly understood that though the outcome of Geneva was distasteful, nothing more palatable was on offer. The *Spectator* editorialized on July 23, "This is a bad peace. It is almost certainly the best peace that could, in the circumstances, be obtained." The magazine went on to speculate that the communist bloc had curbed its demands because of fears roused by Washington's saber rattling. "It would seem to follow that the United States, with its wild, ugly and undisciplined grimaces, has nevertheless indirectly contributed to the conclusion of peace."

Eisenhower and Dulles thereafter invested the new semi-nation with a legitimacy and importance rooted in the need to calm their constituency at home and to restore the administration's self-esteem after failing to save the North. South Vietnam, said the secretary of state, might yet prosper "free of the taint of French colonialism," through the instrumentality of Ngo Dinh Diem, a figure whom Washington embraced with an enthusi-

asm that was somewhat startling, given how little the Americans knew of him. The British saw matters differently: they had consistently refused to associate themselves with engagement in Indochina because they saw no vital interest at stake there. They believed the West had its hands full confronting the Soviets in Europe. Meanwhile the Russians and Chinese were reflexively willing to provide some assistance to North Vietnam, now a fellow socialist state. They would be gratified if the Americans failed in an attempt to make South Vietnam a capitalist showcase, but they had no appetite for making Indochina a scene of high noon between East and West.

The Vietminh went home from Geneva convinced that Zhou Enlai had double-crossed them, yet Ho Chi Minh accepted that hegemony over all Vietnam must be deferred for a season. When North-South elections took place, he could be confident that unification would follow. For the present, he and his comrades addressed themselves with ruthless single-mindedness to building the socialist state of which they had dreamed for so long, into which the South would soon be subsumed. Although the Vietminh had displayed a tenacious appetite for armed struggle, by 1954 its leaders must have been grateful at last to sleep on beds under roofs with their families, eat half-decent food, and live and work without fear of bombs and shells.

No Westerner regarded Geneva as a success story, instead it was seen merely as an exercise in damage limitation, as is most Big Power diplomacy: its achievement was to extricate an exhausted colonial power from an unwinnable war. Yet what was extraordinary about the Accords was that the new Saigon government got so much, the triumphant Vietminh so little. This was because the Russians and Chinese were far less interested in the fate of Indochina, and explicitly of Vietnam, than Washington's Cold Warriors supposed. Mao Zedong had no wish to see a too mighty communist Vietnam on his doorstep and appears to have been eager to draw Laos and Cambodia into his own sphere of influence rather than that of Ho Chi Minh.

A general cease-fire took effect on July 27, pending the temporary partition of Vietnam. After years living at COSVN's secret headquarters in

the Mekong Delta, COSVN secretary Le Duan emerged to start his travels across the South on a hand-pumped railway trolley. In the North the communists assumed control. On October 9, the French army left Hanoi, marking the occasion with a series of defiant, vainglorious military ceremonies that caused an American spectator to think of Don Quixote. Amid a great roll of drums, boomph of brass, and clash of cymbals, Gen. René Cogny, ringmaster of Dienbienphu, saluted the flags of regiments that had fought—paras, Legionnaires, Marines, Senegalese, North Africans—passing by along with armored columns that chewed up the soft tarmac of Hanoi's streets. France's departure was characterized not by nobility and generosity, but instead by a spiteful scorched-earth policy: the colonials removed or destroyed everything that might be of value to the victors.

Ten-year-old Doan Phuong Hai thought the trumpets of the French quitting Hanoi "so sad that they seemed to be sobbing." Their flag was lowered for the last time over the citadel on a cold, blustery, wet afternoon. Two NCOs folded the sodden *tricolore*, then presented it to the presiding general, who in turn passed it to the garrison commander. Rain masked the tears of many officers and men as the band played the "Marseillaise." Then the garrison boarded its trucks and drove away toward the coast. It was just seventy-five years since the colonial power had assumed governance of the city.

The departing French were first replaced by representatives of the International Control Commission, "Indian Army officers with swagger sticks and bristling Guards mustaches, pale-faced Poles in their odd triangular caps, and beer-drinking Canadians speaking their own puzzling brand of French." They, in turn, were followed by the victors, the first elements of Giap's army. In Howard Simpson's words, "They came forward in two files, one on each side of the street, small men in drab uniforms wearing leaf-woven, cloth-covered helmets fitted with camouflage nets. Loaded down with weapons and equipment, the *Bo Doi* [infantry] of the 308th Division were entering an environment totally unfamiliar. Their approach was heralded by the soft shuffle of hundreds of feet in

cheap tennis shoes: the Vietminh entry into Hanoi thus proved one of the most silent victory marches in the history of the world." Peasant soldiers gawked in wonder at the grand buildings and broad avenues, booty of their struggle. They were watched by crowds who displayed an enthusiasm that was not entirely spontaneous: cadres had for days toured the city, persuading its hesitant citizens that it would be in their interests to cheer the victors.

Among the handful of Americans present was big, clunky Maj. Lucien Conein—"Black Luigi," "Lou-Lou," or "Three-Finger Lou"—an American born in France who had returned to his birthplace in 1939 to share the French defeat, then served with the OSS in Europe and southern China. As leader of Col. Edward Lansdale's US military advisory group in North Vietnam, he was now charged with organizing stay-behind teams. Conein was a caricature of a semisecret warrior—hard-drinking, tough, outspoken, often outrageous. He once expressed his exasperation with a stalled automobile engine by emptying a .45 pistol into it. Now, in the midst of the throng of Vietninh shuffling by, he suddenly punched the air and shouted in Vietnamese, "Long live Ho Chi Minh!" This won him a cheer from surrounding communists, who failed to perceive that he was mocking them—as he would continue to do through the years that followed.

Before the end came for the French, Norman Lewis mused uncertainly about "whether it had all been worth it—the brief shotgun marriage with the West, now to be so relentlessly broken off. Had there been, after all, some mysterious historical necessity for all the bloodshed, the years of scorn, the servitude, the contempt? Would the free Nations of Indo-China, in their coming renascence, have gained in the long run from the enforced rupture with the old, unchanging way of life, now to be replaced, one presumed, by a materialist philosophy and the all-eclipsing ideal of the raised standard of living?"

An elderly peasant who lived beside Highway 1 said, "The happiest day in my whole life was when I saw two truckloads of French soldiers leaving Hue for the last time. They drove by my house, and looked so sad." France left behind the graves of ninety-three thousand of its soldiers

who had died since 1945 in the futile struggle to cling to Indochina. Those men had no Kipling to weave for them shrouds of romance. A decade later in Saigon, however, a legend was spun that the fallen of Groupe Mobile 100 had been buried beside Route 19 in the Central Highlands where they perished, standing upright in the stiffness of death, facing toward France.

THE TWIN TYRANNIES

1. "A REGIME OF TERROR"

Northern and southern Vietnam have always been as different as are their regional counterparts in Britain, the United States, Italy, and many other nations, even employing slightly different obscenities: the common expletive "fuck mother" translates as du me in Saigon, dit me in Hanoi. In the years that followed the Geneva Accords, both fell into the hands of oppressive authoritarian regimes. That of Ho Chi Minh, however, profited from some notable political advantages. While the North was devastated by the war and subjected to destitution rapidly worsened by communist economic policies, it became far more efficiently disciplined. Ho had spent less of his own life in Vietnam than had Ngo Dinh Diem. As victor in the independence struggle, however, he commanded immense prestige, and deployed his charisma and charm to formidable effect on the international stage. Moreover, by exercising iron control over information and access, North Vietnam veiled from foreign eyes its uprisings, purges, and killings. In the South, by contrast, the follies and cruelties of the Diem regime took place in plain view. Many peasants found Vietnamese landlordism no more acceptable than the French variety but learned nothing of the worse plight of their Northern brethren. Only much later would Southerners come to look back on "the six years"—the period between 1954 and 1960—as a lost idyll, because relatively few of their countrymen killed each other.

Following the July 25, 1954, cease-fire, a vast exodus from the North took place, as a million people who feared the new rulers—businessmen, servants of the French, landlords, anticommunists, and above all Catholics—fled the country by land, sea, and air. It was a time of turmoil, sunderings, fears, and farewells. Vietminh cadres stopped buses carrying fugitives to the port of Haiphong down Route 1, urging and sometimes compelling passengers to remain. Nguyen Duong's modestly prosperous family, small-businesspeople, suffered a disaster: in the throng at an air-field outside Hanoi, his mother briefly set down the bag containing all their portable wealth in jewelry and gold. Within seconds it vanished, never to be seen again: they started a new life in Saigon almost penniless.

Even as the Northern government-in-waiting issued a Dienbienphu commemoration mug, pathetic scenes took place in Hanoi as its more prosperous citizens stacked possessions in the streets outside their homes for disposal at fire-sale prices. Some families split. Nguyen Thi Chinh's father, Cuu, head of a once-rich landlord family, told the sixteen-year-old girl and her nineteen-year-old brother, Lan, that they would go south; one daughter had already left, after marrying a French doctor. The night before they flew, he gave each teenager a belt containing a little money, some food, and other essentials. Very early next morning, however, Chinh was shaken awake by Lan, who whispered to her, "Come outside." On the road, they found a friend of her brother's holding two bicycles. Her brother said, "We're going to join the revolution. Father would understand, but he wouldn't give permission." Chinh was appalled. She pleaded, begged, screamed, and dragged at the bikes' handlebars, all in vain. Lan and his friend pedaled away.

Distraught, she wakened her father. He decided that she must leave as planned, while he stayed behind to search for Lan. A few hours later she found herself among a pushing, shouting, desperate mob at the airport, boarding a cargo plane. Her father at their parting gave her a gold bracelet. On arrival in Saigon she was consigned to a refugee camp, where through the weeks that followed she sobbed relentlessly. At last she encountered a kindly family friend, who said, "Come and stay with us"; two years later,

she married his son. She would hear no more of her brother for almost forty years.

Tran Hoi, serving as an apprentice with the French Air Force, had no hesitation about moving to Saigon with his squadron. His mother, however, determined that she must stay behind to sell their house and the family bus company. Hoi flew south aboard a C-47. "I cried all the way—Vietnamese never abandon their relations." He would have sobbed louder, had he known that he would have no further contact with his kin until 1998. He embarked on a life in the South that was always tinged with sorrow, because on holidays and feast days he could never again make the pilgrimage to a family home.

By bus, train, car, and on foot, families trekked to Haiphong to board ships, mostly provided by the Americans. It was later claimed that US agents staged a propaganda campaign to frighten Northerners into flight. That there was propaganda is beyond dispute, including atrocity stories fabricated by the American conservative "hero" Dr. Tom Dooley, author of a mendacious best-selling memoir *Deliver Us from Evil*. Equally well attested, however, are the tragedies that befell many of those who remained, accepting the false assurances of Ho Chi Minh that they had nothing to fear.

Landlord's son Nguyen Hai Dinh was eighteen when his only sister joined the flight southward. He himself remained. "Why? Because I was very stupid. . . . We had thought the French were colonial oppressors until the communists took over; then we started to think of the French as our friends." All those possessed of property or education became marked for exclusion, even death, under the new order. Dinh found that his class background made him ineligible for college or any responsible job. His new ideology teacher said, "In the past this country was feudal: now it belongs to the peasants and workers. You have no country." His father was stripped of citizenship rights for five years as an "antisocial element" and had to scratch a living as a cook for Party cadres. Dinh came to hate everything about his own society, above all the impossibility of saying what he thought. He dated a student named Phuong, but through the five years

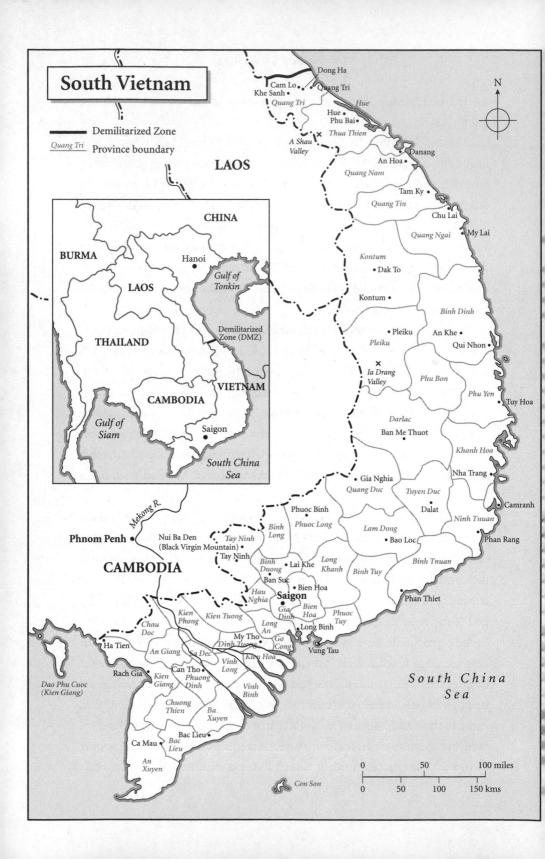

of their dalliance, he never dared to discuss any political subject: "Every-body was watching everybody else. Anyone could be an informer." He was deemed eligible only for manual labor.

In some tribal areas armed resistance persisted, using weapons provided by France's special forces before the cease-fire. Bernard Fall claimed that several French officers serving with the tribes could not be retrieved from remote districts and were abandoned until they were gradually rounded up or killed. He describes a Frenchman radioing desperately as late as the summer of 1956: "You sons-of-bitches, help us! Help us! Parachute us at least some ammunition so that we can die fighting instead of being slaughtered like animals." Fall asserts that nothing was done: "There was no 'U-2' affair, no fuss: France did not claim the men, and the communists were content to settle the matters by themselves." The Hanoi weekly *People's Army* reported in September 1957 that in the two years following the cease-fire, their forces in the mountains east of the Red River had killed 183 and captured 300 "enemy soldiers," while forcing the surrender of 4,336 tribesmen. Probably not more than a handful of these were Frenchmen, but the report confirms the persistence of resistance.

Meanwhile the new government set about implementing collectivization. The Party daily *Nhan Dan* (The People) called on cadres to "banish selfish and pacifist doctrine" and "resolutely lead the peasantry to crush the whole landlord class." The Indian representative on the ICC reported that those who supposed that the regime was composed of mere nationalists and socialists were naïve. Hanoi's leadership, he said, bore an "indisputably communist character." Northern media poured forth strident anti-American propaganda. Pierre Asselin, noting that all totalitarian governments require enemies, has written that "demonization of the United States . . . created a 'useful adversary' that facilitated gaining and maintaining public support . . . for advancing the Vietnamese revolution."

The draconian land reform program introduced between 1954 and 1956 pleased some peasants who saw their old landlords dispossessed, but it imposed so many hardships that despite the benefits generated by the cessation of armed strife, many Vietnamese found themselves continuing to face chronic hunger, and later near-starvation. Duong Van Mai, daugh-

IOO · VIETNAM

ter of a former colonial official, observed, "The state had removed an incentive for hard work by paying peasants according to their needs, not according to their labor." When collectivization was later superimposed, "shortages became a way of life."

Adults were accorded rations of twenty-eight pounds of rice a month, plus ten ounces each of meat and sugar and a pint of fish sauce. They received four yards of cloth a year and two sets of underwear. Yet even in the darkest days, Party leaders and their families fared much better. The Northern elite enjoyed nothing like the riches that soon accrued to their Southern counterparts, but they never went hungry. In 1955, only deliveries of Burmese rice averted a famine as grave as that of a decade earlier. Hanoi's principal sources of cash were \$200 million provided by China and another \$100 million from Russia. These sums were not gifts, however, but payments for commodities shipped abroad and desperately missed at home.

Credible statistics have never been published about the cruelties and executions perpetrated by North Vietnam's rulers in the early years of revolution. Significant admissions were made in an October 29, 1956, speech by Giap, by then deputy prime minister: "We indiscriminately viewed all landowners as enemies, which led us to think there were enemies everywhere. . . . In suppressing enemies we adopted strong measures . . . and used unauthorized methods [a communist euphemism for torture] to force confessions. . . . The outcome was that many innocent people were denounced as reactionaries, arrested, punished, imprisoned." Estimates of executions range up to fifteen thousand. While Ho Chi Minh is alleged to have wrung his hands about the excesses, he never deployed his huge prestige to prevent them.

Not only were large portions of landlords' holdings confiscated, but in many cases the new regime demanded that they repay to their tenants money collected over years in "excessive" rents. Assets and draft animals were seized at will, so that Duong Van Mai's elderly uncle found himself attempting to till his residual patch of paddy with a plough strapped to his own shoulder. Space in another uncle's big house was "reallocated": revisiting forty years later, she found it occupied by forty people. Northerner

Doan Phuong Hai's grandmother seemed to age before his eyes as she suffered indictment as a landlord, followed by interrogation, denunciation, and property confiscation. The old woman refused her son's offer to take her to Hanoi for medical treatment, merely coughing and wheezing to a premature grave.

The entire landlord class suffered institutionalized humiliation, designed to boost the self-regard of the peasantry as much as to abase owners of property. Even an ardent communist such as Dr. Nguyen Thi Ngoc Toan admitted later, "Many things happened that I thought didn't make sense." For years she herself was denied promotion, despite her devotion to the Party: "everything required the right family background." By this she meant that those of peasant origins were favored over people like her, from educated and relatively privileged backgrounds. Dissent, diversity, and freedom of information were abolished. North Vietnam adopted the Stalinist approach to truth, which became whatever the politburo decreed that it should be.

Truong Nhu Tang, later a secret cadre, acknowledged that many of the executed "enemies of [the] people . . . so-called landlords . . . had simply been poor peasants who happened to own slightly larger plots than their neighbors, all the holdings being minuscule to begin with." He also notes that the Party has never expressed remorse for its 1956 campaign to suppress "intellectuals." Even those who escaped imprisonment were condemned to house arrest, incommunicado. In November 1956, there were violent rebellions, which two army divisions were deployed to suppress. One such episode took place in Nghe An Province, which a later communist history attributed to three "reactionary Catholic priests," named as fathers Can, Don, and Cat, who barricaded villages, seized weapons, captured cadres, and organized demonstrations against land reform.

A communist narrative acknowledges, "We were obliged to use military forces. . . . All leaders and their key lackeys were arrested." In addition to hundreds who died in hot blood, up to two thousand executions followed, and many more prison sentences. Between 1956 and 1959, there were further disturbances in Lai Chau Province. Hanoi professed to blame these on agitation by Chinese Nationalist agents, but the revolts created

IO2 · VIETNAM

"many difficult political situations . . . creating fear and worry among the population about socialism and diminishing the people's confidence in the Party and Government."

Lan, whose sister Nguyen Thi Chinh had fled south in 1954, was frustrated in his attempt to join the Vietminh, who instead imprisoned him for six years. Thereafter, denied a ration card, he was reduced to selling his blood to hospitals and became a street porter. Their father's fate was worse: even when released from imprisonment he was unable to secure a ration card or access to employment and eventually succumbed to beggary. One night, cold and starving, he knocked at the door of an old friend and novelist named Ngoc Giao. Giao's wife, on opening the door, took one look at the visitor and implored him to go away: her husband was himself in bad odor with the regime. But Giao came down from the roof, where he had been hiding in expectation that the night visitor was a policeman. He insisted on admitting Cuu, feeding him and allowing him a shower. They talked all night, until the writer said regretfully, "I'm afraid you can't stay here." Before Cuu left, he said to Giao: "If you ever hear anything of my daughter, please tell her how much I love her." Then he vanished into the street. Giao and his wife thereafter provided the only assistance they dared, placing a bag of rice in the back alley early each morning. This was collected for a fortnight or so, then one night was left untaken. Cuu vanished from their lives and from that of Vietnam, dying at a time and place unknown. Chinh secured this glimpse of her father's latter days only long after the war ended.

In Western intelligence parlance, North Vietnam became a "denied area." Yet thanks to the prestige of its leader, a figure of unimpeachable anti-imperialist credentials, embodiment of a triumphant revolutionary struggle, his country stood well in the world. Its status as a closed society invited shrugs from most Westerners, who felt that this was merely the communist norm. A Northern intellectual suggested later that Ho's career should be seen in three distinguishable phases—first, as a simple patriot; then, as a communist; finally, as an apparent nationalist who was in reality pursuing the interests of the Communist International. In the view of

a compatriot, Ho profited greatly from his cosmopolitan experience and ideological ties with China and the USSR, whereas his nationalist rivals knew little of the world outside Indochina. He conducted an extraordinarily skillful balancing act between the two great communist powers, especially after their own relationship turned glacial in the late 1950s.

Hanoi's politburo was stunned by Nikita Khrushchev's February 1956 speech to the Twentieth Congress of the Soviet Communist Party, denouncing the Stalinist cult of personality even as Vietnam's leader was being promoted as a near deity. Most of Ho's senior comrades were Stalinists, who had mourned their hero's 1953 death "with tears streaming down our cheeks" in the words of a Party functionary. Now they were disgusted by Moscow's renunciation of a military showdown with the West in favor of a mere economic and ideological contest. The 1956 Hungarian uprising confirmed North Vietnam's leadership in its view that any indulgence of dissent risked unleashing challenges to its authority.

A Canadian diplomat reported from Hanoi: "There is little point in speaking of the possibilities of an economic collapse of North Vietnam, since there is no economic structure." At independence, among a population of thirteen million people, there were only thirty qualified engineers and a handful of factories. The country's rulers were too preoccupied with their domestic predicament to have any stomach for aggressive action in the South. Eighty thousand troops were demobilized and dispatched to swell the rural labor force. Both China and the Soviet Union made it plain that they opposed any armed provocation that might alarm the Americans.

Evidence remains meager about Hanoi's 1954–57 Party power struggles. It seems nonetheless plain that Ho Chi Minh and Giap wanted no new war: they believed they could secure a unified communist Vietnam without fighting for it. Their oft-rehearsed commitment to achieving this peacefully was—at that stage—sincere. Other rising men, however, thought differently. As they watched the evolution of Diem's government in Saigon, they saw scant hope of securing their just inheritance of a unified Vietnam other than through armed struggle.

IO4 · VIETNAM

2. "THE ONLY BOY WE GOT"

The 1954 exodus from North Vietnam was accompanied by a lesser one from the South. Communist troops marched away, often after emotional send-offs from the communities in which they had been based. In 1954-55, a total of 173,900 Vietminh fighters and 86,000 of their dependents "regrouped" to the North. One veteran revolutionary paid a farewell visit to the Mekong Delta before reluctantly obeying the order to join the migration. She told comrades who were staying behind, "See you in two years"-meaning when the country was reunited after the communists' assured election victory. It became a familiar gesture for Vietminh veterans to hold up two fingers, signifying the time lapse before inevitable fulfillment of their dream. COSVN secretary Le Duan's wife, Nga, was pregnant with their second child when her husband dispatched her to the North on a Polish ship, along with the family of his close comrade Le Duc Tho. He himself stayed. To the end of his days, Le Duan argued that Ho Chi Minh's two historic mistakes were to acquiesce, first in the 1945 return of the French, then in the 1954 partition. He and other hard-liners believed that a unified, communist Vietnam would be achieved only by fighting for it. His parting words to Nga were, "Tell Ho it will be twenty years before we see each other again."

In violation of the Geneva Accords, Hanoi ordered ten thousand Vietminh to remain undercover in the South, insurance against a resumption of the armed struggle. Most of the guerrillas who marched North were bewildered and indeed enraged by partition, and they became no less so after crossing the new Demilitarized Zone—the DMZ. They experienced hardships greater than they had known in the relatively well-fed South, and many were also gnawed by family separations. Le Duan's wife found herself living with two small children in a room above a Hanoi garage, writing a column called Vietnamese Women for the Party newspaper, knowing nothing of the fate of her husband at COSVN. Some of the Southerners defied Northern authority, and almost all harbored a single ambition—to return whence they had come. Some cadres' children were meanwhile dispatched to further their education in Russia or China.

The new South Vietnam and its government enjoyed considerable advantages. The Mekong Delta was the most productive rice-growing area in Southeast Asia. The countryside was relatively unscarred. While the Vietminh had commanded widespread support there as independence fighters, there was much less enthusiasm for communism. Moreover, the Americans were eager that the country should become a showcase for what they called the free world. A South Vietnamese Army officer later reflected, "We took our lives for granted. We were not rich, but we were comfortable and had some freedoms. We were soft, as South Vietnamese have always been soft, because they live on rich land. Northerners are tough, because they come from a tough, poor place." An exile from the North, who rose high in the Saigon civil service, wrote that "for many of us . . . the years 1956-60 were among the best of our lives—we were full of expectation and promise." Peasant girl Phung Thi Le Ly, born in 1949, recalled her rustic childhood as "a paradise, full of tropical birds and buffalo; dogs and chickens and pigs that we called our pets; rushing rivers to swim in; and wide fields where we could run and laugh."

Ho Chi Minh had secured mastery of the North after an ordeal by fire. Ngo Dinh Diem, by contrast, was merely the arbitrary nominee of playboy head of state Bao Dai, accorded grudging nods first by the French, then by the Americans. He had some of the qualities that make great leaders: courage, honesty, fluency, and passionate commitment to his country. Unfortunately he was also a Catholic religious zealot imbued with messianic faith in his own rightness, blindly devoted to a greedy and unscrupulous family, nostalgic for a nonexistent past, and insensitive to the needs and aspirations of his people.

Life under Diem seemed to most Vietnamese a mere continuation of colonialism. The big Americans who pervaded his life—and death—emphasized his own physical slightness. Born in 1901, for a time he favored a career in the priesthood like that of his brother Ngo Dinh Thuc, whom he persuaded the Vatican to make archbishop of Hue. Instead, Diem entered the civil service and by twenty-five was a provincial governor. In 1933 the French caused Bao Dai to make him minister of the interior, a role in which he lasted only three months, because the colonial

power would not invest any Vietnamese with real authority such as he demanded. It was then that he made a remark later hailed as prophetic: "The communists will defeat us, not by virtue of their strength, but because of our weakness." For a time during World War II, he was held prisoner by the Vietminh, who also murdered one of his brothers and a nephew. Diem met Ho Chi Minh, who sought his cooperation, only to be rebuffed. "You are a criminal who has burned and destroyed the country," Diem claimed that he told Ho. "My brother and his son are only two of the hundreds you have killed." The communists later lamented Ho's folly in freeing him.

After a Vietminh assassination attempt, in 1950 Diem left Vietnam. He spent his first two years of exile as an inmate of Maryknoll Seminary in Lakewood, New Jersey, often performing the humblest domestic chores but also gaining introductions to such influential fellow Catholics as Cardinal Francis Spellman, Supreme Court justice William O. Douglas, together with Senators Mike Mansfield and John F. Kennedy, whom he impressed with the fervor of his hatred for both colonialism and communism. In 1953 he moved to a Benedictine monastery in Belgium, where he made important French connections and somehow also won the trust of Bao Dai, in exile outside Cannes. Diem's astute younger brother Nhu, later notorious as his gray eminence, played an important role in steering him toward power.

Diem's appointment as prime minister, followed by a low-key return to Saigon on June 26, 1954, neither corrupted his asceticism nor diminished his wildly exaggerated self-belief. Religious faith and moral conceit convinced him that he ruled by a divine right as assured as that professed by King Charles I three centuries earlier on the throne of England. Diem viewed South Vietnam's security entirely as a military problem. His response to it was the 1955 introduction of conscription. He showed no interest in either cultivation of new friends or reconciliation with old foes. He pronounced decisions and demanded fulfillment of them, himself working sixteen hours a day. Obsessed with detail, he might lecture a visiting ambassador or foreign journalist for four hours without a comfort break; he sometimes signed exit visas personally. Whereas Ho Chi Minh was a notably witty conversationalist, Diem was devoid of humor,

especially about himself. As for money—national income for his new country—on August 12, 1954, the US National Security Council decided that the domino theory was valid, that it was thus essential to restore the prestige of the West in Indochina, grievously injured by French defeat. A week later, Eisenhower approved NSC 5429/2, which caused the US to become South Vietnam's paymaster.

The gravest handicap burdening the Saigon regime was that scarcely any of its standard-bearers and officials had participated in the independence struggle; many, indeed, were former servants of the French. Diem broke an early promise to grant amnesty to Vietminh activists, whom he began to imprison. In Paris, Prime Minister Edgar Faure asserted that the little zealot was "not only incapable but mad," and the US government was increasingly inclined to agree. Yet who else was there? Not until 1961 did Vice President Lyndon Johnson deliver his memorable apologia for Diem: "Shit, man, he's the only boy we got out there." But from 1954 onward, though Americans doubted the prime minister's survivability, within the tiny circle of Saigon's educated elite, they could identify no more plausible noncommunist candidate to rule.

Among early American players in South Vietnam was Air Force Col. Edward Lansdale, forty-eight-year-old head of the Military Mission, a covert operations group that launched ineffectual sabotage sorties into the North, which cost the liberties or lives of virtually all the locals ill-starred enough to be recruited for them. In the course of the ensuing two decades, Washington impresarios would introduce onto the Vietnamese stage a succession of actors auditioning for the role of Lawrence of Indochina, of whom Lansdale may be deemed the first. A former advertising executive of notable persuasive charm, he established a relationship with Diem that seemed likely to give Washington leverage. The colonel had made his reputation advising Philippines president Ramon Magsaysay on suppression of the Huk guerrillas and was now mandated by Dulles to repeat this achievement. He enjoyed a mixed press among his fellow countrymen in Saigon. Some regarded him as an unguided missile, but one colleague said later, "What I respected was that with both Americans and Vietnamese, he was a good listener and shrewd calculator. He displayed a very good

understanding of what was possible, and what was not." Lansdale repeatedly warned Diem that he must win hearts and minds.

The colonel's intrigues were more controversial. He is alleged to have been responsible for thwarting an October 1954 generals' coup. He paid the leaders of the Cao Dai and Hoa Hao sects several million dollars of CIA money to stick with Diem. He sought also to cut a deal with Bay Vien, boss of Saigon's mighty armed mafia, the Binh Xuyen. Its empire of brothels and opium dens centered upon the Dai The Gioi—Great World Casino—located behind high walls in Cholon and composed of fifty tin-roofed wooden buildings housing two hundred tables. Vien was protected by a green-bereted private army forty thousand strong—and by the French.

In those days, the dispossessed colonial rulers were competing for influence with the Americans, the new kids on the block, a situation that produced some black-comic clashes. Lansdale liked to tell a story of how the US Embassy secretaries were alarmed by the discovery of grenades in the vestibule of their quarters, which the CIA identified as a gesture of menace by its Gallic rivals. That evening the Military Mission's roughgames specialist, Lou Conein, marched into L'Amiral, Saigon's most popular French rendezvous, produced a grenade from which he extracted the pin, and brandished it while he addressed the clientele in their own language: "I know how distressed you all are that the American community, and especially our secretaries, should feel threatened. If anything unpleasant or unworthy should take place, we would have common cause for regret." He then replaced the pin in the grenade and strode out, justly confident that the mission staff would be exposed to no further French frights.

When Lansdale failed in his attempt to buy off Bay Vien, however, the Americans became alarmed that French support might enable the gangster to prevail over the prime minister. British observers were equally pessimistic. A Foreign Office review concluded, "M. Diem has many of the qualities required by a national revolutionary leader dedicated to saving his country—courage, integrity, persistence, faith and an implacable hostility to communism." Unfortunately, added the British diplomat, he

was also "incapable of compromise" and had "little administrative capacity." When Gen. Joseph "Lightning Joe" Collins, a bustling, short-fused 1944–45 corps commander under Eisenhower, visited Vietnam as the president's personal envoy, he returned home to report that the US was backing a loser. Collins said later, "I liked Diem, but I became convinced he did not have the strength of character to manage this bizarre collection of characters." At 6:10 p.m. on April 27, 1955, Dulles sent a cable from Washington to Saigon, authorizing the prime minister's removal, much as he might have ordered the sacking of an unsatisfactory parlor maid.

Yet Diem confounded the skeptics. That very evening and probably by coincidence, though it is possible that Lansdale played a role, a Saigon street battle erupted between the South Vietnamese Army and the Binh Xuyen. Six hours after Dulles demanded that Diem be put down, he hastily rescinded his cable; the issue remained in abeyance through a miniature civil war in which five hundred Vietnamese died. At the end of May, the government's forces emerged victorious: Bay Vien fled into exile, becoming a permanent guest of his French sponsors. The Americans decided that Diem had more about him than previously thought and clasped him in a mawkishly warm embrace. Senator Hubert Humphrey, a prime mover in the influential lobby group American Friends of Vietnam, declared that the South's leader was "honest, wholesome, and honorable." Henry Luce wrote in *Life*, "Every son, daughter or even distant admirer of the American Revolution should be overjoyed [by the defeat of the Binh Xuyen] and learn to shout 'Hurray for Ngo Dinh Diem!'"

In October 1956, Diem, unwilling to hold elections that the communists would almost certainly win, instead staged a referendum that deposed Bao Dai and installed himself as South Vietnam's president and head of state. Lansdale claimed credit for a characteristic stunt—printing Diem's ballots in red, a lucky color in Vietnamese eyes, and those of Bao Dai in green, a color of misfortune. Diem secured a mandate with a preposterous 98.2 percent of the vote, a majority that even a Soviet candidate might have thought excessive. In Washington Dulles said, "[South] Vietnam is now a free nation. It is not a puppet." Yet Diem's state depended for its existence upon dump-truck loads of dollars. There was no

IIO · VIETNAM

viable North Vietnamese economy, nor was there much of a Southern one. Instead, there was a massive trade deficit and a flood of imports funded by the Americans. Vietnamese began to quote a cynical old French saying: "Turn Catholic and have rice to eat." Nguyen Van Thieu, later president, was among those who heeded this advice, converting from Buddhism in 1958. Aid soared from just \$1 million in 1954 to \$322 million a year later, and continued to rise thereafter—more cash per capita than Washington provided to any other nation in the world except Korea and Laos. Paul Kattenberg of the State Department made the imaginative proposal that the US should offer North Vietnam a bribe of \$500 million to "repair war damage"—in truth, to leave the South alone. Such a payment, urged Kattenberg, offered a cheaper alternative to funding Diem.

Nobody in Washington was interested, however. Cash poured into Saigon's coffers to be spent at the almost absolute discretion of the president's generals and officials, a formula for waste and corruption. Securing a government import permit opened the tap to a fortune. Some of the urban middle class prospered mightily from the inflow of cash and commodities. Many of the new rich were former Northern exiles who made good—or perhaps made bad—in the South capital. Under the capitalist system, it seemed that only peasants needed to commit to honest toil. Saigon experienced a surge of bubble prosperity.

3. BOOM TIME

In the late 1950s, the Southern capital still possessed a colonial elegance tinged with oriental decadence that delighted Westerners. New arrivals were moved to ecstasies by glimpsing Vietnamese girls in *ao dai* gowns or, better still, out of them. Literate foreigners recalled a Graham Greene line: "To take an Annamite to bed with you is like taking a bird: they twitter and sing on your pillow." Most Westerners' sexual couplings were conducted with professionals, while middle-class Vietnamese sustained notably innocent social lives, in which few went beyond handholding in advance of their arranged marriages. Nguyen Cao Ky, who later became well known for the range of his wives and lovers, asserted that when he

traveled to France as a twenty-one-year-old pilot trainee, like almost all his contemporaries, he was a virgin.

Respectable Vietnamese called girls who associated with "round eyes" me My, "American mother," a term only marginally less contemptuous than branding them as hookers, and families exercised rigorous social discipline over their offspring of both sexes. Truong Nhu Tang's father directed his six sons toward appointed careers as doctor, pharmacist, banker, engineer, engineer, engineer. Tang indeed pursued pharmacological studies until he decided that instead he wished to be a revolutionary. "Each Sunday we would gather at my grandfather's house to listen as he taught us the precepts of Confucian ethics. He would remind us of our duty to live virtuous lives of personal rectitude and filial piety. And he would talk about the cardinal ethical principles: nhon, nghia, le, tri, tin-benevolence, duty, propriety, conscience, and fidelity. . . . For boys especially, he would tell us, there are two unshakable necessities: protection of family honor and loyalty to the country. We would sing together the morality verses that we all knew by heart: 'Cong cha nhu nui Thai Son'-'Your father's sacrifice in raising you climbs as high as Thai Son Mountain / Your mother's love and care are ever-flowing streams."

The young Hanoi exile Nguyen Thi Chinh's life took a new twist one day in 1956, when this beautiful young woman met Joseph Mankiewicz, who was in Saigon to shoot the movie of *The Quiet American*. He asked her to test for the role of Phuong, the Vietnamese girl who is the lover first of Fowler, a British journalist, then of the CIA man Alden Pyle. Chinh was thrilled: her new husband, an army officer, was training in the US. In his absence, propriety obliged her instead to seek consent from her mother-in-law, who rejected with horror the notion of an actress in the family. Only in the following year did Chinh's movie career get started, when she took a role in a Vietnamese movie that secured the approval of her husband's family—as a Buddhist nun.

Thereafter, she found herself starring in successive films, twenty-two in all, with such titles as *A Yank in Viet-Nam* and *Operation C.I.A.* She filmed all over Southeast Asia and became a famous and indeed worshipped woman in her own country. For all her success, however, the trag-

II2 · VIETNAM

edy of her family's split and absolute ignorance of the fate of those in the North never faded from her consciousness. "War is my enemy," she said. "Without it, what a wonderful life I could have had." As for Mankiewicz's film, Col. Lansdale, who was wrongly supposed to be the original of Greene's antihero, attended a gala screening in Washington and praised the movie to the sky. Nobody else did, however. Audie Murphy played the quiet American as a wholesome good guy, and the author deplored the sanitization of his cynical novel.

Though much American money was stolen or wasted, some of the huge aid infusion, together with a respite from war, brought happy times to the Mekong Delta in the later 1950s. A peasant said, "I regarded this period as something from a fairy tale; I was carefree and enjoyed my youth." Communist Party membership declined dramatically. There was rice in the fields, fruit in the orchards, pigs snuffling around the yards, fish in village ponds. Wooden houses increasingly replaced huts. Some peasants acquired a little furniture; many bought bicycles and radios; children attended schools. The first motorized sampans and water pumps began to modernize agriculture.

Yet those at the bottom of the heap failed to benefit. There was an absence of generosity about the Southern political system, mirroring that in the North, though at first less tinged with blood. Landowners returned to claim their rights in villages from which they had been expelled by the Vietminh and even tried to collect back rent. Diem became progressively more authoritarian: Tran Kim Tuyen, chief of his secret police, the innocuously named SEPES (pronounced say-pay, the Service des Études Politique, Économique, et Sociales), stood less than five feet tall and weighed only a hundred pounds but was notorious as one of the most ruthless killers in Asia. The president never wavered in rejecting any obligation to conduct elections. On this, he could make a fair case: his government had never been party to the Geneva Accords; no matching poll held in the North would be free or fair.

Moreover, Americans and some Europeans viewed South Vietnam in the context of other US client nations. Regimes survived and prospered that were notably more unpleasant than Diem's. The brutality and corruption of South Korean dictator Syngman Rhee had proved to be no impediment to his continuing rule. President Ramon Magsaysay of the Philippines employed ruthless methods to triumph over the Huks. The communist threat to Greece had finally been crushed with shocking savageries by both sides. Few of Latin America's dictators ran their countries with any pretense of honesty, justice, or humanity, yet they continued to enjoy Washington's favor.

Thus, in the late 1950s, Americans saw no reason to suppose that the incompetence, corruption, and repression of Diem's regime need undo him, so long as they continued to pay the bills. He survived unscathed a February 1957 communist assassination attempt. Col. Lansdale boomed the little president to his bosses, and some were impressed, for there were few Western correspondents in Saigon to gainsay Washington's claims of progress. When Diem paid a May 1957 visit to the United States, he received a personal welcome from President Eisenhower, and a quarter of a million New Yorkers turned out for his ticker-tape parade. The *New York Times* described him euphorically as "an Asian liberator, a man of tenacity of purpose"; the *Boston Globe* dubbed him "Vietnam's Man of Steel." *Life* magazine published an article headed "The Tough Miracle Man of Vietnam: Diem, America's Newly Arrived Visitor, Has Roused His Country and Routed the Reds." It would have been hard to crowd more fantasies into a sentence.

Back in Saigon, American advisers persuaded Diem that he should show himself more often before his people, and when he did so, they orchestrated enthusiastic crowds. Diem's monomania was fueled by these tours, which he believed to reflect genuine adulation. He sought to make a virtue of stubbornness, once musing to journalist Marguerite Higgins, that even if the US controlled the Saigon government "like a puppet on a string, . . . how will it be different from the French?" The USIA's Ev Bumgardner said that Diem regarded the Americans as "great big children—well-intentioned, powerful, with a lot of technical know-how, but not very sophisticated in dealing with him or his race."

Diem was indeed his own man, as the South Vietnamese leaders who succeeded him were not. Unfortunately, however, the advice he rejected

II4 · VIETNAM

was that which might have secured his survival and even success: to curb the excesses of his own family, renounce favoritism toward Catholics, select subordinates for competence rather than loyalty, check corruption, abandon the persecution of critics, and impose radical land reform.

Saigon people liked to think of themselves as nguoi Viet—true Vietnamese—while they looked down on Northerners, Bac Ky. Yet Catholic Northern exiles were conspicuous in their dominance of Diem's court circle and his Can Lao political party. Duong Van Mai, who had herself fled from Hanoi, wrote later, "The Diem regime increasingly took on the look of a carpetbagger government." The most disastrous influence on the president was his brother Ngo Dinh Nhu, the clever, sinuous, brutal security supremo, whose "dragon lady" wife, Madame Nhu, might have been chosen by central casting to play the Wicked Witch of the East. The North Vietnamese politburo employed plenty of executioners and torturers, but the names and faces of such people were unknown outside their own prisons. The Nhus, by contrast, became globally notorious, doing untold harm to the image of the Saigon government.

Likewise, Diem's generals affected heavy, brassbound military caps worn above sunglasses, a combination that had become a worldwide hall-mark of the servants of tyrants. Some top men went further, affecting tuxedos—Western formal garb—at banquets. Any South Vietnamese peasant who saw photographs of his leaders thus attired beheld a chasm between "them" and "us." A Vietnamese UPI reporter watching Diem arrive at the National Assembly in Saigon observed to a colleague, "The people in Hanoi may be absolute bastards, but they would never be so stupid as to appear before the people in a Mercedes-Benz." Here was a glaring contrast with Ho Chi Minh, who rejected the former Hanoi governor-general's palace as a personal residence in favor of a gardener's cottage on its grounds. An American reporter said, "The people upon whom we were relying to build a nation had no relationship with their own people."

As late as 1960, about 75 percent of all the South's farmland was owned by 15 percent of the population, almost all absentees because terror made them so. The communists urged peasants not to pay their rents, because defiance made them supporters of the revolution: if landlords and their

government protectors regained control of a village, debts would have to be repaid. There was widespread resentment of Saigon's reintroduction of the old colonial system of forced labor, whereby people were obliged to give five days' free service a year to government projects. When the CIA's William Colby pressed Diem for a radical redistribution of farmland, the president replied, "You don't understand. I cannot eliminate my middle class." Government-appointed village officials became petty tyrants with absolute power to decree the guilt or innocence of those beneath their sway, even to pass death sentences. The nurse running the local dispensary took bribes; so did the policeman counting families for taxes and the village council members arbitrating disputes. Fearful villagers felt obliged to invite their oppressors to become guests at weddings and funerals and to offer them choice cuts of the cats and dogs killed for food. Not all officials were bad, but the general run were incompetent, brutal, or corrupt, sometimes all three.

Thus when assassinations became widespread in 1960-61, many villagers applauded, because the terrorists were skillful in targeting the most unpopular officials. Diem also introduced "agrovilles," fortified hamlets into which peasants were compulsorily relocated. The objective was to isolate them from the communists, but the consequence was to alienate them, for most resented displacement. How brutal was Diem? The communists advanced a claim, to which they still adhere, that between 1954 and 1959 he killed 68,000 real or supposed enemies and arrested 466,000. These figures seem fantastically exaggerated, just as Southerners inflate numbers killed during the North's land redistribution. What can be stated with confidence is that the Saigon government rashly promoted the interests of Catholics and persecuted former Vietminh. Whereas the Northern communists created a highly efficient police state, its workings veiled from the world, Diem and his family built a ramshackle one, its cruelties conspicuous. This achieved some success in inspiring fear but almost none in securing respect.

The regime's failure was not inevitable. Had the president governed in a moderately enlightened fashion, the communist revival could have been averted. Fredrik Logevall has written that, granted the indifference

of both China and the Soviet Union to nonfulfillment of the terms of the Geneva Accords, "It is not impossible to imagine a scenario in which Diem's South Vietnam survives, South Korea—style. . . . Diem was the only major non-communist political figure to emerge in Vietnam from 1945 to 1975." But he became an architect of countless follies: in the three years after 1957, the Saigon regime presided over construction of 500,000 square yards of high-rental apartment and villa space and 56,000 square yards of dance halls but just 100,000 square yards of school classrooms and 5,300 square yards of hospital floor space.

The regime's domestic excesses and shortcomings, rather than its failure to hold reunification elections, provided communists with the tinder to rekindle the war in the South. Both among his own people and on the world stage, Ho Chi Minh was a towering victor in the contest for legitimacy as the voice of the Vietnamese people. Ten-year-old Truong Mealy's communist teacher in the Mekong Delta asked, "Do you know why Ngo Dinh Diem came to Vietnam? He was sent by the U.S. Now his whole family has power and all the poor people must work to feed them. Who should run Vietnam—Diem or Ho Chi Minh?" Five years later, Truong Mealy was a courier for the Vietcong, as the South's resurgent communist guerrilla movement will hereafter be called.

4. A RECALL TO ARMS

The last French soldiers left Saigon on April 28, 1956. To the dismay of Hanoi, the principal Western signatory to the Geneva Accords thus washed its hands of Indochina, specifically of any responsibility to promote elections. The revival of warfare in the South thereafter was not, at the outset, prompted by a policy decision in Hanoi but resulted instead from spontaneous anger among local opponents of the Diem regime. A peasant told American researcher James Trullinger that he and his village attributed the communists' temporary dormancy to cunning—a calculation that if Hanoi waited until Southerners had experienced a few years of Diem, they would be ripe for revolution. Southern fighters began to

launch attacks on government troops and installations without authorization from any higher authority.

The first communist call to arms was an impassioned December 1956 missive to the Northern politburo from Le Duan, still presiding over COSVN in the Mekong Delta. He described the persecution of comrades, the snuffing out of Party cells, the tightening military grip of Saigon, especially in the Central Highlands. In response, Hanoi reluctantly agreed that Southern fighters should be authorized to shoot in self-defense. It also endorsed some assassinations of "reactionary traitors" and terror bombings of "Diem institutions." A small contingent of intelligence officers and elite sappers—what Westerners would call commandos—was dispatched southward. Thereafter, in the course of 1957, Southern communists claimed that 452 South Vietnamese government appointees, mostly village chiefs, were killed, kidnapped, or suborned. Terrorism resumed: seventeen people died in an attack on a bar in Chau Doc on July 17; thirteen were wounded in a Saigon café on October 10; thirteen American servicemen were injured by three other bombings in the capital.

The next important development was the recall of Le Duan to the North. In the summer of 1957 when he reached Hanoi with a comrade, for a time the two were held in a guesthouse under guard. This was a precaution presumably rooted in the power struggle then taking place, precipitated by the ongoing economic crisis. The new arrivals nonetheless sneaked out in the evenings to amuse themselves, finding standing room at the Hong Ha Theatre and suchlike, until guards deflated their bicycle tires to keep the visitors at home. Le Duan is alleged to have complained savagely that the politburo sought only a quiet life: "They have abandoned us."

The longer he spent in Hanoi, the better he understood how little support for a new war would be forthcoming from either Moscow or Beijing. Yet fierce energy enabled him, during the months that followed, to shoulder past Northern rivals and become a major influence upon the politburo, supported by his close ally Le Duc Tho, whom a senior cadre characterized as "taciturn and chilly," and who later became Henry

II8 · VIETNAM

Kissinger's interlocutor at the 1972–73 Paris peace talks. Le Duan's record, as a veteran who had suffered more for the revolution than almost any other comrade, conferred immense prestige. He famously said, "You can't get anywhere reasoning with the imperialist gang; you have to take a hammer and bash their heads." North Vietnam's Party secretary had been sacked for his role in the shambles of land collectivization. Giap seemed the natural candidate to succeed him. Instead, however, in December 1957 it was Le Duan who got the job.

He was born Le Van Nhuan fifty years earlier in northern South Vietnam, a carpenter's son who became a committed revolutionary long before Ho returned from exile. His force of personality was indisputable, but a coarseness of tone and language grated on more fastidious colleagues. Lacking social graces, he despised weakness, either ideological or human, which from an early stage he identified in Giap and probably also—though he would never have dared to say as much—in the aging Ho Chi Minh. His personal life remained an enigma until long after his death. Only in the twenty-first century did his second wife, former Vietminh courier Nguyen Thuy Nga, reveal her tragic story.

At Tet 1956—the Vietnamese New Year—while Le Duan was still in the South, Nga traveled outside Hanoi to visit his father, bearing gifts of honey, ginseng roots, and a few yards of Ha Dong silk. She found at his house her husband's first wife, who collapsed in sobs on being confronted with Nga's existence. A few months later, Party officials descended on Nga: a senior cadre, they said, could have only one wife, and in Le Duan's case, it could not be her. As the mother of his two children she was stunned, but said she could agree to nothing until her husband himself came to Hanoi—as he did, soon afterward. He offered Nga no sympathy, merely impregnating her for a third time before handing her over to the Party's Central Women's Association, under whose auspices she was dispatched to China to "study."

In her exile, Le Duan began to write Nga letters, sometimes passionate, including one which said, "I love you, I love you so much. Don't let a few outward actions or a few unfortunate happenings give rise to any misunderstanding. My darling, love triumphs over all obstacles. If you

love me, then you can solve all of your problems and difficulties." They saw each other occasionally when he visited Beijing on state business, and once she met Ho Chi Minh. Le Duan took custody of their three children, and Nga sobbed desperately when she learned that they were thereafter to be reared by his other wife. After some years, she was granted permission to visit Vietnam briefly and see the children. She spent three days with Le Duan, who seemed "uncomfortable and unhappy," as well he might be. In 1964 she was dispatched to the Mekong Delta to work as a propaganda cadre and did not see her children again until 1975. Here was a glimpse through a dark window of the man and the Party to which he devoted his life.

Radicalism in Hanoi was prompted by the rising conviction that peaceful reunification would not come. This precipitated the Party's November 1958 Resolution 14, advancing the Northern revolution another dramatic step with agricultural collectivization. The following month, a large number of detainees in South Vietnam, including communists, died of food poisoning in a Diem detention camp. Early in the following year, the politburo received emotional plaints and pleas from Southern villages, such as this one obviously drafted by local cadres: "Uncle Ho! The Americans and Diem have been wicked too much already—we ask your permission to cut off their heads." Weeks of debate followed, at the end of which the Party Central Committee promulgated Resolution 15, an important step toward escalation. It authorized more aggressive action, in the familiar language of Party exhortations: "Only the triumph of the revolution can assuage the plight of the poor and wretched people of the South, [and] confound the evil policies of the American imperialists and their puppets who divide the nation and provoke war."

Resolution 15 opened the way for "volunteers"—as the Chinese had earlier dubbed their troops who fought in Korea—to set forth for the war zone. During the months that followed, some 4,600 political cadres, technicians, and engineers headed into Diem's territory, most of them Southern natives, former "regroupers." Authorization was given to open "Strategic Route 559," a secret path to the battlefield that ran through neutral Laos and evolved into the Ho Chi Minh Trail. Three-year military

I2O · VIETNAM

conscription had already been reintroduced. One of those who approved Resolution 15 said later that "only [in 1959] did we finally acknowledge that there would be no general elections, that Diem was massacring our people. There were signs that the US would continue to strengthen its presence [and therefore that] the only path to the unification of our country must lie through violence."

It was significant that Hanoi was slow to inform the Russians about Resolution 15, because Le Duan and his comrades knew how unwelcome it would be. Moreover, only on May 7, 1959, was word of the new mandate passed to COSVN, communist headquarters in the South. North Vietnam's leaders remained morbidly fearful of provoking the Americans, perhaps even causing them to strike at their own land. The ideological divide between Russia and China was deepening apace and this was reflected by rival factions in Hanoi. Ho Chi Minh and Giap leaned toward Moscow; Le Duan led those who inclined toward Beijing.

At the time of Mao Zedong's catastrophic industrialization program, the Great Leap Forward, which cost the lives of at least fifty-five million of his own people, Le Duan may have been responsible for Hanoi's inopportune expression of national ambition: "The China of today is the Vietnam of tomorrow." Meanwhile he and his comrades still struggled to suppress domestic dissent. Catholics staged demonstrations at which they demanded a right to migrate South. Chants of "down with communism" prompted troops to open fire, inflicting casualties. Economic woes obliged Hanoi to slash defense spending, from 27 percent of the national budget in 1955 to 19.2 percent in 1958, and 16 percent in 1960. Factories languished, and falling agricultural production prompted a cut in the rice ration. The Czech ambassador reported home that much Soviet bloc aid was being wasted. In June 1959 the British consul in Hanoi reported that "the standard of living is sinking into ever shabbier and drabber uniformity. Even the poor are poorer. . . . No member of the Western community has ever met a Vietnamese who was in favor of the regime, except the members of the regime itself."

In a mirror reflection of Diem's advancement of loyalists at the expense of honest men, Hanoi promoted war veterans and ideological purists rather than its brightest and best. A French diplomatic observer reported that nine-tenths of the North's population was "ready for an uprising if it had the means." Yet Le Duc Tho, as head of Party organization, chose this moment to demand fresh purges of "undesirables," meaning former landlords and "rich" peasants. In its preoccupation with ideological rectitude, the North Vietnamese politburo behaved more like Bolsheviks of forty years earlier than mid-twentieth-century socialists. A new Party statute, denouncing dissenters, was enforced by the Ministry of Public Security, whose chief, Tran Quoc Hoan, became known to his critics as the Beria of Vietnam, a nod to Stalin's most notorious enforcer.

Meanwhile in the South, during the months following promulgation of Resolution 15, revolutionaries continued to kill government officials and launched a new round of attacks on the South Vietnamese Army, hereafter known by the acronym conferred by its US trainers: the ARVN (Army of the Republic of Vietnam). A young Vietnamese told an American interviewer, "I hated the soldiers . . . because they were very haughty. The villagers were already very poor, and yet the soldiers commanded them to build roads and bridges. . . . The soldiers carried weapons to protect [Diem] and his regime." Symbols of American nation-building became favored targets. For instance, in the spring of 1959 near the Cambodian border, black-clad attackers blew up two John Deere tractors.

Many young country people, trapped in a relentless cycle of agricultural toil under the petty tyranny of local officials, discovered a romance in revolution. An eighteen-year-old told how an old man who had fought against the French exhorted the teenager to take up arms in his turn. "I got excited when he told me about Vietnamese heroes. He told me that Diem had asked the Americans to . . . help in their plot to put South Vietnam under their rule. He urged me . . . to perform the duty of a young patriot in fighting for the independence of the country to bring back happiness and prosperity." During the weeks of military training that followed, fifteen peasants in his group deserted, demoralized and homesick. He, however, stuck it out: "I only saw the glory and didn't think of the hardships."

In the course of 1959, Vietcong attacks grew steadily in intensity. On the evening of July 8, American advisers with the Southern 7th Infantry I22 · VIETNAM

Division near Bien Hoa were watching the opening credits roll at a screening of *The Tattered Dress*, starring Jeanne Crain, when six VC launched a gun and grenade attack in which thirty-eight-year-old Maj. Dail Ruis and MSG Chester Ovnand, forty-four, were killed. These were the first Americans to die at communist hands in what became known as the Second Indochina War. The tempo of guerrilla attacks increased nationwide: in early morning darkness one day in December, a VC platoon stopped a bus on Highway 4 in the Delta. They ejected the passengers, clambered in with their weapons and forced the driver to take them to a government fortified post. They arrived at dawn, to find the gates opened to allow soldiers to visit the market. When the attackers stormed in, a policeman and several defenders were quickly shot down; the rest of the garrison surrendered. The guerrillas collected weapons and wrecked the post before disappearing into the jungle with the village chief, whom they killed.

The VC objective was to show an ability to strike at will. A cadre proclaimed exultantly, "The Tiger has awakened!" Villagers found themselves obliged to make ever more perilous calculations about the local balance of power, in which a misjudgment cost, at best, all that they owned; at worst, their lives. Almost all paid secret taxes to the communists, whose imaginative propaganda much exaggerated their reach and power. Cadres cited proverbs beloved of Vietnamese, such as "Better the head of a rat than the tail of an elephant" and "No matter how hard you try to shed your horns, you will always remain a water buffalo." They staged rallies that sometimes mustered a thousand peasants, under varying degrees of compulsion, accompanied by a cacophony of gongs, megaphones, and "wooden fish"—the clackers of temple bells. Government flags were torn down and tree trunks plastered with posters and slogans. Reports were spread about the VC's supposedly mystical powers: their magic rice cookers, inflatable boats carried in knapsacks, "sky horses," and guns that could kill fifty men with one shot. Credulous peasants embraced such fairy tales. Guerrillas sometimes paraded through villages in daylight, merely to show that they could.

Some of the many murder victims of 1960 were tried and dispatched with machetes in front of village crowds, just as in the Vietminh era. One

woman was hacked to death because she had two sons in the ARVN. A man being buried alive shrieked repeatedly, "I'm going to die! I'm going to die!" before his cries faded beneath a rising mound of earth. Another was killed merely because he drank with the local policeman. For every peasant who backed the communists out of belief, two did so from fear. Yet real support also existed, partly because the revolution offered the poor a sense of belonging to something bigger than themselves: it conferred pride on humble folk. Prudence was a factor, too—a growing belief that the communists represented the future, Diem the past.

By the beginning of 1960, it was claimed that VC armed propaganda units had killed 1,700 government officials, village chiefs, teachers, and hospital workers, and to have seized another 2,000. Uprisings took place in the Central Highlands. Diem's troops fought back, recapturing lost ground. Under the terms of a draconian new treason law, thousands of dissidents and members of religious minorities were rounded up, along with communist suspects. The guillotine was reintroduced as the preferred tool of government executioners.

Many Vietcong were frustrated by the refusal of COSVN—and ultimately, of Hanoi—to authorize escalation to full-scale open warfare. Local cadres made renewed appeals for weapons to resist Saigon's "cruel terrorism." Without the stimulus of action, many men found intolerable the boredom and privations of a covert existence. A fighter with a unit based in the Mekong Delta spoke later of the awesome, sinister silence of the wilderness, broken only by its wild creatures: "Because of the jungle vastness, the polluted waters and malaria, it was sad all the time." A company commander exploded before senior officers, pounding his chest and saying, "I'd rather die than live like this! Let's start the armed struggle!"

At last, in September 1960, COSVN gave the order that its supporters had waited so long to receive: there were to be coordinated uprisings against government forces. Thereafter, the revolution's territories expanded with remarkable speed. One-third of South Vietnam's population, an estimated six million people, were soon estimated to be living under open or secret communist control. Cadres embarked upon energetic land redistribution. Guerrilla activity increased steeply, especially in the Delta,

where insurgents exploited local people's intimate knowledge of river and tide conditions. Ambushes were set on bends of streams and canals; underwater mines were buoyed with driftwood and wired to electrical detonators ashore. While North Vietnam was now a fiercely disciplined, regulated society, in response to terrorism the South became an oppressively militarized one. Nine-tenths of US aid was spent not on economic or agricultural development, but instead on arms to sustain the regime. The American advisory group focused on creating a conventional army, capable of resisting an invasion from the North such as South Korea had faced. Meanwhile, in one province of six hundred thousand inhabitants there were six hundred police, nine Civil Guard companies, and twenty-four militia platoons manning thirty fortified posts and guarding 115 villages. Yet still the communist tide rose.

In 1960 Cold War tensions increased throughout the world. In April the South Korean dictatorship of Syngman Rhee collapsed, prompting exultation in Hanoi, with hopes that this was the precursor of a similar fate awaiting Diem. A week later, the Russian shoot-down of an American U-2 reconnaissance aircraft blew apart East-West détente. The Sino-Soviet split was ever more visibly reflected in North Vietnam's politics, with Ho Chi Minh making a vain attempt to mediate. Le Duan, Le Duc Tho, and their pro-Chinese faction achieved dominance in the politiburo. For Hanoi, the political imperative to support the Vietcong's armed struggle had become irresistible. The only issue was how much aid should be provided, how quickly: Le Duan faced the prospect of supporting the war that he wanted almost entirely from his own country's resources.

Meanwhile in Saigon, on April 26, 1960, eighteen prominent anticommunist South Vietnamese met at a well-known hotel, after which they issued the Caravelle Manifesto, signed by "a group of patriots," calling on the government to change course. Later that year, US ambassador Elbridge Durbrow submitted a memo to Diem that itemized reforms Washington considered essential: publication of government decisions and budgets, scrutiny of all branches by elected representatives, liberalization of press laws and improved relations with the foreign media, radio "fireside chats" with the peasantry, and more generous credit for farmers. These were all sensible, perhaps indispensable measures for a functioning democracy, but they were wholly unacceptable to Diem. Just as he ignored the Caravelle Manifesto, so he received this shopping list as a manifestation of American condescension. He might also have responded to Durbrow by asking how much of his liberal wish list was fulfilled by the Northern politburo.

The US remained overwhelmingly preoccupied with the armed struggle. Washington responded to the Vietcong upsurge by dispatching several hundred additional military advisers, raising the total number from 342 to 692, in breach of the limit on such personnel set by the Geneva Accords. Their commanders, notably including Gen. Sam Williams of the Military Aid and Assistance Group, viewed the guerrillas solely as a security problem, to be addressed from the business end of a gun.

At the end of 1960, the communists formally rebranded the Southern resistance movement as the National Liberation Front (NLF). It is important to note that, though all its leaders were communists, it sought to project itself as a nationalist coalition. Here, incoming US president John F. Kennedy would be told, was a political force that constituted an unacceptable threat to freedom and democracy in Southeast Asia. The avowed objectives of the NLF were to bring social unity to the South, overthrow Diem, evict the Americans, impose land redistribution, and unify the country by negotiation. This prospectus admitted nothing of Le Duan's unswerving intention to create a Stalinist society.

In the years that followed the Geneva Accords, it was the misfortune of both Vietnams to fall into the hands of cruel and incompetent governments. Had Southern peasants known the plight of their Northern brethren, they might have thought less harshly of their own: at least few of Diem's people went hungry. His American sponsors entirely misjudged the attitudes of Moscow and Beijing, supposing their leaderships guilty of fomenting the rising insurgency. Instead, until 1959 resistance to the Saigon regime was spontaneous and locally generated. For some time thereafter, it received only North Vietnamese rather than foreign support.

Le Duan was the principal personality driving renewal of the unification struggle: it is hard to exaggerate his personal role in what followed.

As for his politburo comrades, it seems legitimate to speculate that some favored war in the South as a means of escaping acknowledgment of the failure of their policies at home and instilling a new sense of purpose in Ho Chi Minh's threadbare people. It was their good fortune that the "imperialist" foe, indispensable to such a regime as their own, had harnessed its fortunes to Ngo Dinh Diem, a dead donkey if ever there was one. The war that now gained momentum was one that neither side deserved to win.

SOME OF THE WAY WITH JFK

1. "THEY'RE GOING TO LOSE THEIR COUNTRY IF . . . "

When Dwight D. Eisenhower briefed his successor, John F. Kennedy, about the issues that he would confront on assuming the presidency, it was not Vietnam, of which he said nothing, but neighboring Laos that evoked stridency from the old warhorse. Eisenhower said he had been warned by the State Department that Laos was "a nation of homosexuals," which bemused Kennedy. This was the first domino, asserted the outgoing president, key to Southeast Asia, loss of which could threaten neighboring Thailand. Here would come a test of the new commander in chief's resolve, a rite of passage. Such a view seems fanciful in the eyes of posterity but appeared real at the time. Laos, once known as "the land of a million elephants," made headlines around the world as a collision point between communist and anticommunist forces. In 1960 the *New York Times* devoted three times more space to this tiny country, a wilderness with few and very poor inhabitants, than it did to Vietnam.

The Lao people, or the multiplicity of ethnic groups that they comprise, have perplexed the outside world by appearing to giggle their way through the past century of political upheavals, famines, civil wars, and foreign-fostered tragedies. They love parties and priapic jokes, especially at the spring rocket festival when everybody makes their own fireworks, some enormous, and launches them at mortal risk to life and property. In the late 1950s, the Americans began to throw money at Laos, to which

France ceded independence in October 1953, and which had since become an alleged focus of Chinese and North Vietnamese meddling. A visiting *Wall Street Journal* reporter described the leadership as "ecstatically drowning in American aid," big cars and iceboxes while the rest of the country subsisted on an average annual income of \$150. The CIA began to take an interest, not least because its officers, such as Texan Bill Lair, who became famous there, fell in love with this new frontier. Lair's colleague Robert Amory said later that many of the Agency's men embraced Laos as "a great place to have a war." Outside Vientiane, the frontier-town capital, you could do pretty much what you liked come to that, fight pretty much whomever you chose, and grow what narcotics you fancied—without bothering anybody who would make a fuss.

The Lao government, if a rackety clutch of local potentates and generals could be so dignified, sustained a precarious rule until in 1960 a civil war erupted between rival factions and was fought out on the streets of Vientiane. On slender grounds, the Americans persuaded themselves that a communist takeover loomed. What was indisputable was that Reds were roaming the country, both indigenous Pathet Lao, who intermittently claimed a share in coalitions, and some North Vietnamese troops. Bill Lair achieved what was deemed a notable coup by making a deal with local Hmong chieftain Vang Pao. In return for cash and arms, this warlord launched a guerrilla campaign against the communists. The initial US investment in him and his kind swelled from \$5 million to \$11 million in 1962, then to \$500 million by the end of the decade, with Vang Pao claiming leadership of twenty thousand fighters and considerable battlefield success, as well as a fortune acquired through drug trafficking. Some seven hundred CIA personnel were deployed, most engaged in secret paramilitary activities, shifting food and weapons to the tribesmen and their families, leapfrogging hither and thither betwixt mountains in jeans and Pilatus Porter STOL aircraft, occasionally joining a battle themselves.

The tinpot country achieved a bizarre prominence on the agendas of both East and West. Mao Zedong asked Le Duan, "How big is Laos?" The Vietnamese answered, almost eighty thousand square miles, with a population of two million. "My God," said Mao, "they have so much land

and so few people. Yunnan is about the same size but has forty million. If we could send fifteen or twenty million over there to live, wouldn't that be a good idea?" The Poles and Indians on the ICC found it politic to avert their eyes from landings by Soviet transport aircraft at Hanoi's Gia Lam Air Base, delivering war materiel destined for Laos. The British Conservative government was pressed by Washington to support the American countercommitment, and at a March 1961 summit with Kennedy, Prime Minister Harold Macmillan reluctantly promised some military gesture if the Vientiane government collapsed. When Pathet Lao troops moved near the western border of Laos the following year, in response a squadron of RAF Hunters was deployed in neighboring Thailand. It was the usual story: the British were desperate to avoid a new commitment but obsequiously eager to comply with American wishes.

As a West Point cadet, Mike Eiland found himself participating in exercises in a fictional country called Soal—Laos spelled backward—and in Washington the Joint Chiefs favored committing ground troops. In May 1961, however, President Kennedy declared that he preferred to reinforce covert operations, for which he nursed a romantic enthusiasm. Better still would be for all the foreign powers to stop messing around on Laos's Plain of Jars. The erratic Prince Norodom Sihanouk, ruler of neighboring Cambodia, proposed an international conference, bastard offspring of 1954, to "neutralize" Laos. With varied degrees of reluctance, all the interested parties signed up. After more than a year of negotiations in which Averell Harriman was a prime mover, in July 1962 new Geneva Accords were signed by the United States, Russia, China, and both Vietnams, for the neutralization of Laos.

Hanoi's leadership treated this arrangement with contempt, as a mere fig leaf thrust over its military operations by Moscow, requiring no more respect than Saigon had given to the 1954 settlement. North Vietnamese troops continued to move freely through Laos, though their presence was always denied. CIA cynics dubbed the Ho Chi Minh Trail the "Averell Harriman Memorial Highway," because the veteran diplomat had secured no safeguards against the communists' systematic violations of the Accords. For the purposes of this story, which is Vietnam's, all that matters

I3O · VIETNAM

is that Prince Souvanna Phouma thereafter ruled in Vientiane, ever more deeply in thrall to the US. Elsewhere throughout his wild and woolly country, a desultory and unacknowledged war raged in which several hundred thousand people fell victim to the insistence of Hanoi upon using Laos as an estuarial network of protected supply routes into Cambodia and South Vietnam and to the desire of the Americans to stop them from doing so without too conspicuously flouting neutralization.

Almost from inauguration day, MIT economist Professor Walt Rostow, a World War II bomb-target analyst now translated into Kennedy's deputy special assistant for national security and within a few months director of policy planning at the State Department, urged the administration to shift focus from Laos to Vietnam. The president himself soon agreed that the latter looked like a better place to face down the communists and that in the face of intensifying guerrilla activity, more must be done to shore up Diem. Security in the Mekong Delta had become so precarious that medical supplies could be distributed to civilian hospitals only by the CIA's planes and helicopters, among abandoned villages and untilled rice fields. In May 1961 Vice President Lyndon Johnson visited Vietnam, pledged America's continuing backing, and dubbed Diem "the Winston Churchill of Asia." David Halberstam wrote later of this trip, "He had given our word. It not only committed the Kennedy Administration more deeply, . . . attached Washington a little more firmly to the tar baby of Saigon, escalated the rhetoric, but it committed the person of Lyndon Johnson. To him, a man's word was important."

In October Ed Lansdale wrote to World War II airborne commander Gen. Maxwell Taylor—Kennedy's personal military adviser until he was appointed chairman of the Joint Chiefs in the following year—saying, "The Vietnamese are an able and energetic people. They don't seem to be themselves today. They are going to lose their country if some spark doesn't make them catch fire to go to work to win this war. The spark could well be to place the right Americans into the right areas of the Vietnamese government to provide operational guidance. . . . Such work will require Americans of talent and compassion."

Lansdale thus recommended that the answer to the problems of the

Vietnamese was to send them more Americans, and over the thirty-four-month span of the Kennedy presidency, that is what was done. In May 1961, four hundred Green Berets were dispatched, followed a few months later by forty US Army helicopters, along with four hundred personnel to fly and maintain them, together with a steadily increasing corps of advisers, soon serving alongside the ARVN down to battalion level, and by mid-1962 totaling eight thousand. The February 8, 1962, creation of MACV—Military Assistance Command Vietnam—was correctly interpreted by Hanoi as signifying Kennedy's intention to raise his stake. By November 1963, there would be sixteen thousand Americans on the ground: soldiers, sailors, airmen, technicians, electronic eavesdroppers, agriculturalists, academic social analysts, and flamboyant special forces cowboys—spooks and geeks of every hue.

US aid was running at \$400 million a year, with military equipment and vehicles being shipped in unprecedented quantities. In April 1962, the Diem government embarked on a "strategic-hamlets" program, a refinement of the earlier agrovilles, designed to separate peasants from guerrillas by relocation behind barbed wire—at the cost of displacement from the burial plots that meant so much to every family. A RAND Corporation report questioned the policy's acceptability, but at the Pentagon Marine Maj. Gen. Victor "Brute" Krulak pounded the table and asserted that his country would "force the peasants to do what's necessary to make the program succeed." The hamlets had significant tactical success, making life tougher for the Vietcong, but the social and political cost was high. Old Indochina hand Howard Simpson watched as a "sullen, bedraggled group of peasants" was herded from their huts for resettlement. An old man with sores on his scalp protested vehemently in rapid French to a TV crew filming the scene: "It isn't just! They are making us move. We don't want to move. Tell them. It is not just!" As security men hustled the old peasant away, he wailed disconsolately: "The Americans don't understand. Tell the Americans we don't want to leave!"

At a July 23, 1962, strategy conference in Honolulu, Gen. Paul Harkins told an audience of politicians and brass headed by Defense Secretary Robert McNamara, "During April, 434 ground operations were

mounted . . . increased to 441 in May. Over 1,000 air sorties were flown in June. . . . PRES DIEM has indicated that he plans his troops will get out into the field more often and stay out longer. . . . There is no doubt that we are on the winning side." Asked about timing, Harkins said that he thought victory over the NLF could be attained by the end of 1963. McNamara entered a cautionary note, saying, "We must expect the worst and make our plans accordingly," which the defense secretary interpreted as scheduling Vietcong defeat for year-end 1965.

In those Kennedy years, many of the characters who would play roles throughout the American war, some prominent and others less so, gathered around the stage and set about learning their lines. In 1961 Duong Van Mai traveled from Saigon to Washington to study. She was fascinated by the US but troubled by segregation, in Southern states feeling usure whether she was expected to use a White or Colored bathroom. Then she met David Elliott, who would become her husband and the other half of a remarkable partnership that committed most of two lifetimes to studying the Vietnamese people. A Bostonian, he had attended Yale before serving with the US Army's radio interception unit at Tan Son Nhut. He then spent a year with MACV intelligence before joining RAND, for which he embarked on a protracted research program in the Delta. Why Vietnam? Elliott said, "This was where it was happening, the most intense front in the Cold War. I was offered a front seat to see history being made."

Idealists and sensation seekers alike plunged into the heady mudge created on Saigon's streets by diesel fumes, spices, obsessive vehicle horn abuse, and breathless heat. Some of those strolling up Tu Do and gawking at the sights—or more likely, at the girls—were bright young men eager to set the world to rights, who came to care passionately about the Vietnamese. Frank Scotton, born in 1938, grew up in Massachusetts, "where the revolutionary war against oppressive foreign occupiers is part of the culture"; his father had been killed at the Bulge in 1944. "I thought that I would perform some sort of service. In the past we had been good tinkerers abroad, getting in there and fixing things. We had the folk belief that we would always win, even after Korea sandpapered that ideal a lit-

tle." Throughout Scotton's long stint in Vietnam, he remained powerfully conscious of his own heritage, his family's record of physical courage: "I didn't want them to feel that I wasn't measuring up."

He joined the US Information Agency rather than the Foreign Service, "because I'm a natural field man." In Washington, he met three young Vietnamese lieutenants, who asked if he spoke their language. No, he said, but he had been told that French would do. They looked uncomfortable. One said, "That is the colonial language." When the American reached Vietnam in 1962, he quickly became aware of the handicap imposed on almost all his countrymen by the inability to converse. "They couldn't even pronounce place-names. I also became very conscious of the weight of history against which we were contending. Within a few weeks, I was a sufficiently wise guy to recognize that Diem was not 'the Winston Churchill of Asia."

Scotton became an impassioned student of the country, traveling fearlessly and indeed recklessly through paddies and jungle, supervising a survey for the US ambassador about sentiment in remote hamlets. One of a small band of Americans who became committed to the cause, he said, "I was always looking for other people who felt the same way. There was a divide between those who really cared, and those who did not." Young Saigonese who met him soon began to say that Scotton was ky qua—strange or eccentric—and plenty of Americans would have agreed; embassy people called him the "maverick mongrel." Vietnam cost him a marriage: his wife, Katherine, did her utmost to make a life at their house in Qui Nhon, even organizing English classes. After some months, however, she went home, they divorced, and thereafter he formed a series of passionate local relationships.

Doug Ramsey also arrived in 1962 fresh from language school and was posted to spend his first months circulating USIA material from an office in Dalat. "I found it ironic to be distributing a paper entitled 'Free World' in the interests of the Diem dictatorship." Local people were wary of expressing opinions about anything to a foreigner unless or until they knew him well, but Ramsey quickly decided that Diem was not a credible or sustainable leader, and developed an enthusiasm for some elusive political

"third force." "I got interested in what Frank Scotton was doing—trying to build from the bottom." He came increasingly to believe that a decade or two of communist domination was preferable to "the imbecility of our policies" and an interminable war. Dominance of a given area by either side "in many places extended to no more than the lethal range of an AK-47 or an M14." Ramsey professed to be less dismayed by communist terror than by "indiscriminate artillery and air strikes by the US and Saigon regime." Down in the Mekong Delta, he caught an early glimpse of the limitations of government forces, when the mere rumor of an impending attack caused the local ARVN unit to take flight.

Bob Destatte was one of sixteen children in a Catholic family of poor but fiercely industrious Ohio factory workers. He abandoned a college teaching course in favor of the army: "I wanted to see something outside my small town." He volunteered for the Army Security Agency because a military friend told him this would ensure overseas postings, and he became a Morse code interceptor. In 1961 he was sent to Saigon. On the plane flying in, he expected something, he said, "like those people in Terry and the Pirates-sneaky folk hiding in the shadows." But from the moment that from the back of a truck he glimpsed his first two girls in ao dais, he thought differently—so differently, indeed, that within months, at the age of twenty-two, he was married to Nguyet Thi Anh. He met her when a young Vietnamese boy who worked with their unit, in those days based in two vans at Tan Son Nhut Air Base, invited him to a family dinner. He liked the mother from their first meeting, and the boy's sister Anh taught him to use chopsticks. "I guess it was love at first sight." They were joined in a civil ceremony, but in collusion with his officers, the marriage was not made official until just before he rotated back to the US in 1963, because local weddings triggered instant repatriations. Unlike many such partnerships, that of the Destattes lasted.

Bob Kelly, a psychological-warfare adviser working with the South Vietnamese in Quang Ngai Province, organized pro-government rallies, of which the first was not an unqualified success. Local people were herded like cattle to attend, then left sitting without water under a hot sun. The

occasion's highlight was to be a C-47 flying low overhead, broadcasting government propaganda. The plane arrived early, and from a thousand feet its raucous tones drowned out the local province chief's speech on the ground. Then the airborne broadcaster demanded in Vietnamese, "Mr. Province Chief, have you finished yet?" This infuriated and humiliated local officials, whose temper was not improved when the plane began to drop leaflets in bundles that failed to burst in the air, so they landed like bombs. It never occurred to the Americans involved, some laughing and others almost tearful amid the shambles, that it was wildly inappropriate for them to be seen orchestrating a Vietnamese political rally.

William Colby, born in 1920, spent part of his childhood in China, then attended Princeton. In 1944–45 he served some months with the OSS in occupied France and Norway, which he found an intensely romantic experience, then spent a few boring years working for "Wild Bill" Donovan's law firm. Better times started in 1950 when he joined the CIA, "a band of brothers." He did an apprenticeship in Sweden and Italy, then in 1959 was posted to Saigon. He traveled widely throughout the country and decided that containment of the communists was the only realistic objective. He dissented when Max Taylor and Walt Rostow recommended a dramatic increase in US advisory strength, saying that Vietnam "really wasn't a military problem." In July 1960, Colby became CIA head of station; he presided over a series of doomed efforts to infiltrate paramilitary groups into the North and to launch counterterror operations against the Vietcong. Like many Americans, he grasped a few strands of the Vietnam tangle, but never enough to promote coherent policies.

Al Gray, born in 1928 the son of a New Jersey railroad conductor, became a career Marine and found boot camp easy: "We were tough guys." He became an NCO, then in 1952 was commissioned and saw a little service as a forward observer at the back end of the Korean War. Thereafter he got into signals intelligence and special operations, monitoring North Korea, Russia, and the Thai-Burma border. In 1960 Capt. Gray was sent to Saigon, liked the South Vietnamese, and admired Diem: "I thought he was on the right track." As a semi-spook he traveled in civilian clothes,

often as a passenger on Air America. He spent the next ten years working on an interface between the Marines and the intelligence community: "I felt what we were doing was some day going to save lives."

Though Frank Scotton was a civilian, he indulged a passion for roaming the countryside, often alone but always armed, in search of action as well as knowledge. This practice led him into situations unexpected for an information agency staffer. One morning during his early wanderings in the Central Highlands, he saw a man with a slung weapon approaching him. "I would have been relieved had he not seen me and simply passed by. But he pulled his rifle forward and raised it while still looking as surprised as I felt myself. I was the quicker for having my carbine chambered and off safety. We were so close that I could not miss. Aiming is as simple as pointing your finger, extension of intention. If something must be done, make sure it is done. I fired several times. I felt no guilt afterwards, but some deep remorse that two strangers would meet by a hillside and one lose his life."

On another occasion, Scotton was moving across country with a young tribesman guiding him. As the light faded at evening, they saw two armed men strolling carelessly toward them. The American's companion sprang forward and dispatched the rearmost guerrilla with a knife thrust in the back. As the other turned to raise his rifle, Scotton shot him several times. The Montagnard dragged the corpse of his own victim to a trail intersection and sat him upright, apparently gazing back whence he had come. Scotton asked his companion, who spoke some French, why he did this. The man shrugged. "C'est la guerre psychologique!"

Throughout the Kennedy years, there was an ongoing debate in Washington about whether the US should go much further than its advisory and support commitment—start deploying major combat units. Gen. Maxwell Taylor was among those who, before recanting when he learned a little, favored an increased troop commitment. He said that South Vietnam "is not an excessively difficult or unpleasant place to operate. . . . North Vietnam is extremely vulnerable to conventional bombing. . . . There is

no case for fearing a mass onslaught of communist manpower into South Vietnam and its neighboring states, particularly if our air power is allowed a free hand." As a military man, Taylor viewed the conflict as a military problem. He recommended dispatching at least eight thousand logistical personnel.

Secretary of State Dean Rusk and Defense Secretary Robert Mc-Namara dissented: neither thought that a small commitment would achieve enough to justify the political cost. The Pentagon calculated that to see off South Vietnam's communists 205,000 American troops would be required. Some of the young diplomats who had accompanied Taylor on his visit to Vietnam not merely opposed the general's recommendation for troops, but thought the Diem regime unsustainable. Memories of the World War II experience hung heavy over strategy making. Its foremost lesson seemed to be that overwhelming might was irresistible. Greg Daddis has written, "The one common failing of most military officers and senior civilian officials . . . was their faith that military power, broadly defined, could achieve political objectives in post-colonial states." Possession of armed might can be corrupting: it feeds an itch among those exercising political authority to put them to practical use. Successive Washington administrations have been seduced by the readiness with which they can order a deployment and see their instructions promptly executed. It is much easier to commit armed forces, especially air power, in pursuit of an objective than to grapple the complexities of social and cultural engagement with an alien people.

In 1961 and indeed thereafter, there was an insensitivity among policy makers about the impact that a Western military presence makes. Many harsh things may justly be said about what communist fighters did to Vietnam, but their footprint on the ground was light as a feather by comparison with that made by the boots of the US military. The very presence of affluent Westerners, armed or unarmed, uniformed or otherwise, could not fail to exercise a polluting influence on a predominantly rural and impoverished Asian society. Like other senior Americans posted to Saigon, the CIA's Bill Colby adopted a domestic style befitting an imperial

proconsul, occupying a villa with a domestic staff of six. Army enlisted men took it for granted that Vietnamese would clean their boots and police their huts.

By contrast, one of the perceived virtues of the enemy was that they had so little save their guns. Again and again, peasants were heard to say that, whatever else was wrong with the communists, they were not getting rich. Western wealth and technology did not generate envy among poor Vietnamese; it merely emphasized a remoteness, an alienation from their enormous foreign visitors, that no amount of MEDCAP visits, inoculations, food aid, tractors, outboard motors, and "miracle" rice could assuage. Material aid never secured the gratitude its donors hoped for. Children visiting the Saigon Zoo often likened the apes to Americans, because both had such long, hairy arms. Some older Vietnamese were uncomfortable with black soldiers, who awakened memories of France's exceptionally brutal colonial units. Local cynics, as well as communist propagandists, asserted that Washington shipped to Indochina only commodities discarded by Americans, such as hated bulgur wheat.

A West Point adviser could scarcely fail to regard with disdain a fortyseven-year-old battalion commander with blackened teeth, alongside whom he was assigned to serve without any common language. An ARVN officer wrote, "No superior anticipated or taught the young [American] captain to adapt to our situation and cultural environment. He would make ridiculous intrigues to control his Vietnamese counterparts and take control of the battalion, as if it was his toy." After a year, before he went home, the American told his counterpart that he was now starting to understand the war and regretted his earlier crassness. But then he boarded his plane, another adviser came, and the cycle restarted. "That is the history of advisors. American people have goodwill, but they are impatient." A Vietnamese officer trainee cited the sort of cultural clash an American might precipitate: at Dalat Military Academy, a US Army captain tapped on a cadet's helmet with his briefing stick, to awaken him from a doze. This gesture almost provoked a riot prompted by the shared fury it aroused among the Vietnamese, for whom even a token blow signaled colonial contempt. That confrontation was eventually defused by the school commandant, Col. Nguyen Van Thieu, later Vietnam's president.

Chuck Allen's special forces A-team, out at Khe Sanh in the winter of 1962, referred to their Vietnamese counterparts as LLDB—lousy little dirty bastards. "It could be hard to get [them] out on an operation. They didn't want to leave the camp. Sometimes we had to bribe them with extra food or clothing." Patrolling Americans were exasperated by "accidental" discharges of weapons or willfully tall plumes of smoke from cooking fires to warn away the VC. "It takes a while to learn that the American way isn't always the right way. . . . In Vietnam, the poor bastards had been at war for fifteen years. And here we come, full of piss and vinegar, wanting to win in six months." That A-team nonetheless felt good about its own little corner of the action, singing a song that a host of Americans would reprise before it was all over: "We were winning where we were."

Yet the vast majority of the three million Americans who eventually served in the country departed without holding any more meaningful interaction with its inhabitants than a haggle about the price of sex. It was inevitable that US forces should require access to ersatz American facilities when serving in a faraway country: so do all foreign armies in such circumstances. Even the correspondents of many nations who reported the war took for granted their privilege of receiving sanctuary in American messes to write dispatches that were often savagely critical of American failings. But the manner in which most of Kennedy's crusaders lived apart from the Vietnamese, except when orchestrating violence, was a formula for alienation.

Robert Kennedy, as attorney general present at the creation of much Indochina policy making, said that "a military answer is the failure of counter-insurgency. . . . Any effort that disregards the base of social reform, and becomes preoccupied with gadgets and techniques and force, is doomed to failure and should not be supported." Lyndon Johnson reported after his 1961 trip to Vietnam on the importance of "responsible political institutions. . . . There must be a simultaneous, vigorous and integrated attack on the economic, social and other ills of the Vietnam-

I40 · VIETNAM

ese people. The leadership and initiative in this attack must rest with the Vietnamese leaders." Roger Hilsman of the State Department opined that insurgency "isn't a war, it's a political struggle with military aspects." Such good sense should have led the policy makers to a harsh conclusion: unless a political foundation existed, the military commitment was futile. The Vietnamese were unimpressed by programs and systems; they judged everything by personalities, and most recoiled from the Ngo family nexus—its cruelty, incompetence, and militant Catholicism. Even Americans were embarrassed by the fact that, while democracy was the mantra constantly cited as providing a moral basis for promoting resistance to communism, Washington set its face against any outcome determined by ballot.

Yet some influential people continued to argue that the regime's short-comings did not matter. The CIA's Colby cared nothing that Diem was running a dictatorship, only that it should sort of work. He wrote later, "The task in South Vietnam required strong leadership, and Diem's messianic dedication seemed more appropriate than did the confusion and indecision that could come from overly precise application of the American doctrine of the separation of powers." Colby formed an amicable working relationship with Ngo Dinh Nhu—indeed, Agency colleagues were bemused by his enthusiasm for this sinister figure. When the case for replacing Diem became an Agency talking point, Colby bizarrely suggested that brother Nhu might fill the bill.

The April 17, 1961, Bay of Pigs invasion by Cuban exiles backed by the CIA took place less than four months into the Kennedy presidency and overshadowed all its subsequent policy making. So too did the communists' erection of the Berlin Wall in August and Khrushchev's taunt that Vietnam was a Soviet laboratory for wars of national liberation. Nobody then knew that the West would win the Cold War. No American heard Khrushchev tell Anatoly Dobrynin, who in 1962 became the Soviet ambassador to Washington, that he must never forget that an armed showdown with the US was unthinkable and thus his foremost priority was to work to prevent it: "Don't ask for trouble." The world lived in a climate of nuclear fear, and the communists posed a historic challenge. In such circumstances, it was hard for national leaders and their advisers to think

and act proportionately and wisely. Today it is easy to forget that the other side blundered as often as and even more brutally than did the Western powers—for instance in Hungary, Cuba, Berlin, and Poland.

Kennedy and his fellow crusaders saw themselves engaged in a life-and-death global competition with the communists. The president said of insurgencies such as that mounted by the NLF: "No one can call these wars of liberation. . . . These are free nations." This was half true—more true than some American liberals recognized then or since—but also half false, because however ugly the ruling regime in North Vietnam was, the one in the South was almost equally oppressive, mitigated only by the fact that Diem's people did not go hungry.

2. McNAMARA'S MONARCHY

An extraordinary aspect of the decision making in Washington between 1961 and 1975 was that Vietnamese were seldom, if ever, allowed to intrude upon it. Successive administrations ignored any claims by the people who inhabited the battlefields to a voice in determining their own fate: business was done in a cocoon of Americanness. Frederick "Fritz" Nolting, 1961-63 ambassador in Saigon, once cautioned Defense Secretary Robert McNamara that it was "difficult, if not impossible," to put a Ford engine into a Vietnamese oxcart. The secretary professed to agree—but went ahead with doing that anyway. There is a great line in David Halberstam's The Best and the Brightest, about Vice President Lyndon Johnson's awed reaction after seeing McNamara, Rusk, Bundy, Schlesinger, Rostow, and the rest of the Kennedy Round Table gathered for the first time. He rushed off to tell his friend and mentor Sam Rayburn, Speaker of the House, about this brilliant group, only to be deflated by the droll response: "Well, Lyndon, you may be right and they may be every bit as intelligent as you say, but I'd feel a whole lot better if just one of them had run for sheriff once." Or knew some Vietnamese.

When McNamara visited Vietnam with Max Taylor, a Vietnamese eyewitness wrote that most of the secretary's questions were directed to the American advisers present, rather than to those doing the fighting: I42 · VIETNAM

"Some [US officers] looked like naughty . . . students in front of an austere principal. . . . In one exchange that greatly embarrassed a Vietnamese intelligence officer and his American counterpart, McNamara asked how many of our secret agents were working in the enemy's ranks." The answer was none, which remained the case until late in the war. The CIA did not contrive a wiring diagram of the communist leadership until 1969.

As well as military advisers in the field, the administration received plenty of advice from gurus back at home. The Cold War spawned a proliferation of think tanks, committed to provide both technological studies and intellectual underpinning for strategy, above all nuclear deterrence. The Defense Advanced Research Projects Agency, familiarly known as DARPA and created in 1958 following the shock of the Soviet Sputnik launch, conceived a range of counterinsurgency techniques, almost all of which proved fanciful, and also begat the chemical defoliation program that deployed Agent Orange. The Santa Monica—based RAND Corporation, a nonprofit body, received large funding from the Air Force. It employed smart people but showed a predisposition to ride with policies already espoused by those who paid its bills.

McNamara was an unsurprising enthusiast for its work, much of which reflected the systems analysis he favored. When the British academic Professor Michael Howard visited Santa Monica, he was impressed by the brainpower on site but wrote later of his unease that RAND "seemed like a monastery inhabited by clever theologians, who were quite remote from the real affairs of the world. . . . The Randsmen seemed to be falling into the error of assuming that everything connected with war could be quantified." Howard was especially dismayed to hear them earnestly debating how quickly the city of Los Angeles could get humming again after a nuclear war.

With the coming of Jack Kennedy, RAND's chiefs realized that counterinsurgency was becoming big business, and in 1961 they dispatched their first emissary to Saigon. During the years that followed, the corporation played a significant advisory role. Almost nobody among its eggheads questioned the rationale for US engagement; fired by missionary zeal, they simply sought to figure out how their country could best win this thing.

Analyst Alex George said, "There were no pacifists at RAND." In the early 1960s, most of their research was done in Santa Monica, because few staffers wanted to relocate to Saigon.

In justice to the Kennedy administration, in those days a significant number of Southeast Asian leaders, notably including Singapore's Lee Kuan Yew, shared or professed to share its belief that the defeat of Vietnam's communists was critical to regional stability. So did some key allies. The British government regarded the US position in Indochina as precarious, but foreign secretary Lord Home noted, "I hope the Americans can hold on." Whatever Britain's reservations about the commitment had been, now that Western prestige was staked, winning seemed to matter. Malaysia's prime minister Tunku Abdul Rahman told Sir Robert Thompson, who had played an important role in orchestrating the defeat of Malaysia's communist insurgency, "You must go to Vietnam and help hold my front line."

Some Americans derived encouragement from Britain's successes in suppressing nationalist guerrillas, though British officers were coy about acknowledging the ruthless means used. They behaved less brutally in their colonial wars than did the French, but their methods in Malaya, Kenya, Cyprus, and Aden were not for sensitive stomachs. RAF aircraft sprayed chemical herbicides and later defoliants onto crops in guerrilla-dominated areas. In 1952 British communist newspaper the *Daily Worker* published a photograph of a Royal Marine brandishing the heads of two Malayan terrorists, about which public distress did not abate when it was officially explained that these souvenirs had been recovered for identification purposes. There was plenty of bombing of villages. And somehow the British had contrived to prevail.

The London government was uneasily and sometimes guiltily conscious of its status as co-chair of the original Geneva Accords and thus was dismayed by the rising number of advisers dispatched to Vietnam in breach of the terms. In 1961, the British ambassador suggested that the US might get away with upping the number by a hundred, only to be peremptorily informed that eight thousand were coming. Prime Minister Harold Macmillan, loyal as ever, agreed to make no fuss and expressed relief that

I44 · VIETNAM

there were no plans to commit American combat troops. His people nonetheless urged the State Department to be discreet about the buildup, and thus had to swallow a new snub in December, when Washington said that it had decided not to be bound by some clauses of Geneva.

The British continued to vacillate about how far they themselves were willing to engage alongside the Americans. They retained a proprietorial view of Southeast Asia, believed they understood counterinsurgency, and devoutly wished for the communists' defeat. They opposed a 1962 proposal for a conference to neutralize Vietnam, like Laos, because Diem's position seemed so weak. Harry Hohler, British envoy in Saigon, wrote hawkishly in January that "any solution of the Vietnam problem that does not crush and eradicate the Viet Cong will simply hand South Vietnam over to the Communists," an outcome that he considered would be "disastrous to British interests and investment in Southeast Asia and seriously damaging to the prospects of the Free World containing the Communist threat."

Nonetheless, the British were underwhelmed by the Americans' management of South Vietnam's affairs and bewildered by the strife between the CIA, State Department, US Army, and successive ambassadors. The Americans, meanwhile, resented meddling on their patch. Ed Lansdale, especially, was impatient of advice from a bunch of ex-colonialist losers. He, like the Pentagon, was dismissive of a proposal favored by the State Department, to invite the British Army to commit some training personnel. Instead Ambassador Nolting told his UK counterpart that President Diem would merely appreciate some advice from Robert Thompson on police and organizational issues. At that time, with a Tory government in power at Westminster and Kennedy in the White House, if the Americans had requested military trainers, they would probably have got them, which might have proved the thin end of an embarrassingly thick wedge. As it was, the war effort merely acquired Thompson. His experience, together with the advice of a small British mission, had one significant effect: the CIA acknowledged the importance for intelligence gathering of a police Special Branch, which they persuaded the Vietnamese to replicate. Otherwise, while Thompson was sometimes granted audiences in Washington and Saigon, he exercised little influence on big issues.

That winter of 1962, there was a brief surge of optimism among Americans, that the regime was doing better. The Australians agreed to open a jungle warfare school. Prominent pundit Denis Warner explained the rationale to his fellow countrymen thus: "Why is Australia getting involved in the Vietnam war? Partly because we think a Communist victory there would threaten the rest of Southeast Asia and jeopardise our security and partly because of the need to convince the Americans that we are more than paper tigers. . . . It's a sort of life insurance cover." The premiums got steeper: in 1969 the number of Australians serving in Vietnam peaked at 7,672, where five hundred died.

While Washington strategy advisers came and went, one arbiter remained a constant for seven years. The man who would play a role in the making of America's Vietnam tragedy second only to that of Lyndon Johnson was among the more unlikely knights at the court of Camelot. Robert McNamara was forty-four when in 1961 he first entered his huge Pentagon office, 3E 880. He never seemed to have been young and feckless: administration sophisticates whispered in mockery that he practiced the twist at home in front of a mirror, lest he embarrass himself when making a dancing debut at the White House. This former star of Harvard Business School and wunderkind boss of Ford Motors had risen from a humble Californian background by brainpower and unremitting, humorless toil. McNamara's character recalls a line about a hypernumerate British statesman: "He uses figures as if they were adjectives." When this former Eagle Scout took his loved ones hiking on weekends, he was alleged to slide-rule what his children and tiny wife Margy should carry in their rucksacks. He accepted the defense job because he was irresistibly attracted by the opportunity to exercise power. Outside the family, he was a cold man who could scarcely be called a moral one: in 1961 he endorsed the fiction of the strategic "missile gap" that he knew did not exist, and made shamelessly baseless attacks on his predecessor, Thomas Gates.

McNamara's office became a dynamo room: for programming a missile buildup, expanding the army in response to the Berlin crisis, promoting new weapons systems, and so on. During the October 1962 Cuban drama, it was McNamara who conceived the US Navy blockade. He

146 · VIETNAM

seemed devoid of self-doubt and believed that a good decision should also be a fast one. His obsession with control caused him to deplore loose talk: he waged war on military leakers, and sought himself to preside as the sole public voice of America's armed forces.

McNamara told the Senate in September 1961, "There is no true historical parallel to the drive of Soviet Communist imperialism to colonize the world. . . . [No dictator] has ever been so well organized, possessed so many instruments of destruction." He was unafraid of telling outright lies in the cause of countering the Soviet menace, a habit that would eventually destroy his reputation. Testifying to Congress, he reeled off data that was hailed as evidence of his extraordinary powers of recall. Gen. Fred Weyand, however, observed that many of the secretary's "facts" were simply wrong. Although a committed Cold Warrior, in the first year of the administration, he opposed a penny-ante commitment in Vietnam, saying, "We would be almost certain to get increasingly mired down in an inconclusive struggle." Alternatively, if the US made a big troop commitment "the struggle may be prolonged and Hanoi and [Beijing] may intervene overtly. . . . Success will depend on factors many of which are not within our control—notably the conduct of Diem himself."

But then McNamara changed his mind. In May 1962, he paid his first visit to Vietnam. Paul Harkins, the fantasist who commanded MACV, hosted the trip. The general was given an advance list of the defense secretary's questions, so that he had time to frame plausible answers, founded on statistics such as McNamara loved, though largely invented. Harkins asserted that American aid was empowering the Diem regime to defeat the communist insurgency, though even as the secretary was being briefed at Binh Duong, an ARVN convoy was attacked nearby, five men killed. While he toured the northerly base at Danang, the Vietcong blew up a troop train ten miles away, killing twenty-seven people and wounding thirty. McNamara told young UPI reporter Neil Sheehan that "every quantitative measurement we have shows that we're winning." He did not perceive that the "quantitative measurements" were being pulled out of the air by Harkins, of whom Sheehan wrote later, "He willed himself to believe what he wished to believe and to reject what he wished to reject."

McNamara's admirers respected his aloofness as reflecting impartiality and incorruptibility: he was even touted as a possible 1964 running mate for Kennedy. Hanson Baldwin, the respected military commentator, wrote a piece in the *Saturday Evening Post* headed "The McNamara Monarchy," describing the new defense bureaucracy. But the secretary's enemies, many of them uniformed, deplored his hubris. He developed an ill-founded belief that he understood the military. James Reston later wrote shrewdly in the *New York Times*, "He has the sincerity of an Old Testament prophet, but something is missing; some element of personal doubt, some respect for human weakness, some knowledge of history." Between 1961 and 1967, McNamara nonetheless wielded greater influence on Vietnam policy than any of his fellow countrymen save successive presidents.

The main thing those Americans who really knew about Vietnam knew was how little they knew. Military adviser Gordon Sullivan had volunteered, terrified that the war would be over before he could get to it. The twenty-five-year-old lieutenant from Massachusetts landed in-country after a six-week Vietnamese language course that taught him a few staple phrases. He found Saigon "idyllic, just a sleepy town on the river: no bomb screens, Filipino band music blaring across Tu Do. It wasn't easy to be an adviser in those days: I had a radio, but there was nothing on the other end of it"-from beginning to end of the war, US advisers were chiefly valued by the Vietnamese for their power to magic artillery and air support through a handset. Sullivan's incoming group was warned: "Remember that you guys aren't even supposed to be here." He landed at a two-bit airstrip near the Cambodian border, which boasted a wrecked H-21 beside the runway and a sign by the control tower announcing that it stood two feet above the water level in the dry season, two feet below in the wet. The officer who drove a jeep up to collect him greeted him with "Hi, Sullivan. Do you like eeny-weenies and cocktail onions? Our team chief gets a fresh shipment every two weeks."

In the months that followed, the lieutenant and an NCO drove all over the Delta with a huge crate of medicines, which they dispensed in 148 · VIETNAM

the villages, between inspecting strategic hamlets. Looking back on the craziness of their wanderings in a region already teeming with Vietcong, Sullivan reflected, "It was an adventure. . . . There was no logical reason why we survived." He "tried to reach out to the Vietnamese," but they seemed to function on a different voltage. Another adviser, Lt. Col. John Paul Vann, told Frank Scotton soon after the latter's arrival in-country, "Hell, I don't even know what is going on across the river at night." Special Branch officer Capt. Phan Tan Nguu said of his relationship with CIA counterparts, "I only told the Americans what I thought they needed to know."

An important 1962 Pentagon war game, SIGMA I, estimated that half a million US troops would be needed to defeat the communists. A subsequent SIGMA II examined an air war option and concluded that no amount of bombing would deflect Hanoi. The conflicting evidence and projections put before the policy makers caused the various factions in Washington to box the compass with rival proposals, repeatedly changing their minds. Throughout the Kennedy era, Pentagon brass favored bombing the North but opposed the commitment of ground troops.

3. LE DUAN RAISES HIS STAKE

In the course of 1961–62, the North Vietnamese government tilted away from Russia toward closer links with China, yet still neither power encouraged Hanoi to escalate. The communists felt enmeshed in a sufficiency of turmoil elsewhere—Cuba, Berlin, Albania, the Congo. The North's domestic difficulties persisted: its population was increasing by half a million a year, yet grain production per head had fallen. China was taking a substantial proportion of the country's rice output and three-quarters of its coal in return for a drip feed of cash. There was a massive migration of hungry peasants toward the cities but little for them to do when they got there; raw-material shortages caused factories to languish.

From May 1961 North Vietnam's allowance of meat, which included cat and dog, fell to barely four ounces a week per person. That summer, hunger protesters set fire to rice stocks, amid clashes with troops, and in August burned down a bicycle factory. Λ bomb exploded in the city of Dong Anh. There was a local army mutiny, and on two occasions Hmong tribesmen attacked army convoys. South Vietnam and its US advisers encouraged such acts and ran a program of risibly unsuccessful commando stabs into the North. However, the dissent among Ho Chi Minh's people was overwhelmingly spontaneous, driven by hunger and met with repression, which worked. By October 1961, a French diplomat reported that people had been reduced to "passive resignation." Duong Van Mai said of the Northerners, "People were incredibly uninformed. It was as if they were sitting at the bottom of a well, seeing only a patch of sky. The communists had so many mechanisms of control."

Le Duan now dominated Hanoi's policy making, as he would continue to do for the next quarter century, though the world did not know this. In the Hollywood epic El Cid, the corpse of the eponymous Spanish medieval hero is strapped into the saddle to lead his army to one final victory. Something of the same was true of Ho Chi Minh. He was haunted by fears that Vietnam would become a new Korea, a devastated battlefield on which Americans and Chinese contested mastery. As his health declined and younger men grasped the initiative, he abdicated mastery and even influence on war making, but he remained an indispensable figurehead, commanding respect throughout much of the world. Ho and Prime Minister Pham Van Dong remained the public faces of North Vietnam's leadership, while Le Duan was almost invisible. The Moscow-leaning Giap became the object of animosity from comrades who deplored his bloated personal staff and lust for celebrity. One called him "a show-off and braggart." The armed forces' former chief logistician at Dienbienphu hated his old commander and often complained about him to Ho. Another senior general and cabinet minister, who was also a brother of Le Duc Tho, likened the veteran to an old barrel, growling, "The emptier a barrel, the louder it booms."

Le Duan displayed skill and patience in conducting relations with the Soviets and Chinese. He liked to quote a Vietnamese version of the English proverb "When in Rome . . .": "Visiting a pagoda, you must wear the robes of a Buddhist monk, and when you walk with a ghost, you must wear

ISO · VIETNAM

paper clothes." He and his clique considered the Russians untrustworthy and weak, not least because they had blinked first in the Cuban missile crisis. Among those hard men, the Spartan ethic—a willingness to suffer in pursuit of a high purpose—reigned supreme. Le Duan deplored the need to travel repeatedly to Beijing as a suppliant, and to endure its snubs. One of his acolytes claimed that on a 1961 visit Zhou Enlai asked him, "Why are you people conducting armed struggle in South Vietnam? . . . If the war expands into the North, I am telling you now that China will not send troops to help you fight the Americans. . . . You will be on your own, and have to take the consequences."

Le Duan sometimes referred to Mao as "that bastard," and when China's chairman once fantasized aloud before a Hanoi delegation about sending his People's Liberation Army to liberate the South, he awakened every visceral Vietnamese fear of their neighbor's imperialistic inclinations. While Le Duan leaned toward China, he forswore direct criticism of the Soviet Union, because Hanoi needed its more sophisticated weapons and industrial plant. He often made cynical remarks about the parsimony of Chinese aid, professing to believe that Beijing regarded the Vietnamese revolution as "a bargaining chip in negotiations between China and the US."

In 1961–62 the North Vietnamese saw risks in pushing a new US president too hard: though they increased their commitment in the South, they remained anxious to avoid provoking the Americans to dispatch combat troops. They agonized about whether to enter negotiations and urged their Southern comrades through COSVN to focus on the political struggle. In one of Le Duan's "letters to the South," dated February 7, 1961, he acknowledged that "we are weaker than the enemy." It was important, he said, to emphasize the autonomy of the National Liberation Front and not allow it to be branded as Hanoi's tool. It was a contradiction of this period that while North Vietnam gave its Southern comrades far less support than they wanted, on the international stage its leaders' rhetoric became ever more bellicose. Le Duan was bent upon establishing his credentials as a standard-bearer for worldwide revolution. His stridency antagonized India, to name but one country, which no longer viewed North Vietnam

as a fellow crusader against imperialist oppression, but instead as a menace to regional stability.

In 1962, Hanoi at last authorized large numbers of "returnees"— Vietminh who had gone North in 1954—to head South, where Communist Party membership was once more resurgent. Everywhere the NLF held sway, its cadres labored to change the habits of centuries. Education programs challenged Vietnamese fatalism—and the subordination of women. When couples married, the village Party secretary often supplanted the old matchmaker. In primary schools, children were invited to address such problems in arithmetic as: "There were fifty soldiers in a government post. We attacked it and killed twenty of them. How many were left?" An occasional nervous voice dared to inquire when the NLF or the Communist Party would provide insecticide, loans, pumps, tractors, and animal breeding advice such as the Saigon regime offered. Cadres assured peasants that all these good things would descend from the North as soon as the revolution triumphed.

Until 1963 the Vietcong's main sources of arms were captures from government forces. At the end of 1961, there were reckoned to be only twenty-three thousand serviceable weapons in guerrilla hands. Assassinations required little firepower, however. Between 1957 and 1960, a credible estimate has suggested, 1,700 Saigon village and provincial officials were murdered. Another 1,300 were killed in 1961. Beyond the usual eliminations of village chiefs and suchlike, there were high-profile victims, such as a Southern colonel—Saigon's senior liaison officer with the ICC—snatched and tortured to death. Such killings peaked at 2,000 in 1963, then fell to 500 the next year because the communists had liquidated most of their accessible local foes. Surviving officials and landlords took care not to place themselves in harm's way, meaning that-much to the detriment of Saigon's authority—they physically distanced themselves from the peasantry, taking refuge in towns and cities. The NLF appropriated the lands of those who fled, presenting them to friends of the revolution, who thus found themselves with a tangible stake in its success.

Throughout the war, American soldiers veered between contempt for the "dinks" and "gooks" as a primitive enemy and an exaggerated belief in IS2 · VIETNAM

their superhuman skills and powers of endurance. Grunts recalled the old Wild West story about a cavalryman who rode a horse a hundred miles in pursuit of an Apache and then, when it collapsed, shifted his saddle to another animal and kept chasing; meanwhile the Apache doubled back, revived the foundered mount, rode it a further hundred miles, then ate it. In reality, the Vietcong's performance was uneven and sometimes outright clumsy, its units as vulnerable to human frailties as any army in the world. Nam Kinh, a local commander in the Delta respected as a tactician but also notoriously harsh, was shot in the back by one of his own men whom he had forbidden to marry an attractive local widow. Thanh Hai—"Blue Ocean"—a landlord's son aged around thirty, was one of the most popular VC commanders, both for his military skill and his human weaknesses. Hai was repeatedly demoted for drinking and womanizing, the latter exemplified by his climbing under the mosquito net of a young conscript's wife.

One fighter spoke for many when he complained about interminable indoctrination sessions: "Talking to me about political matters is like playing a guitar to a water buffalo." Some liked propaganda fairy tales, however. A unit in Long An Province was led by a woman named Kim Loan, whose husband had been killed by government troops. She became a local folk heroine, imbued with supposedly mystical powers. On one occasion she killed a policeman who tried to arrest her while shopping. On another she fled through the back door of a beauty parlor, and when soldiers scoured a nearby hamlet for her, she climbed a tree, changed into a bird, and flew. Frank Scotton challenged the old man who told him that story, saying, "You can't really believe that?" The Vietnamese smiled and responded that while he couldn't know for sure, "She got away, didn't she?"

Savagery remained the communists' principal weapon. The Vietcong once entered a village in Lai Cay, denounced twenty inhabitants of both sexes as government spies, beheaded them, and threw the bodies in the street, each with a scrap of paper attached listing their alleged crimes. Elsewhere a hamlet chief was tied to a stake and disemboweled in front of the assembled villagers; his pregnant wife was eviscerated, their children beheaded. Such atrocities were artistically crafted to persuade peasants

that the price of resistance to the revolution was much worse than mere death.

Brutality was not confined to one side, of course. Doug Ramsey conducted a survey among students in Long An Province and found that between a quarter and half had lost relations to the activities of Saigon's security forces. In the course of 1962–63, government troops killed 150 inhabitants of a single village in the Mekong Delta. Of these, an estimated 60 were associated with the NLF, but the rest were not. Among thousands of political prisoners held in appalling conditions in South Vietnam's jails and camps, some in a wing of the Saigon Zoo, there were many innocents. Of legal processes, there were none.

Though urban areas remained firmly under government control, in the countryside the guerrilla struggle seesawed, with control of villages and provinces frequently changing hands. Saigon acquired an arsenal of new weapons and equipment, and sometimes used these effectively. In late August 1962, guided by a defector, Southern troops overran an NLF training base at My Phuoc Tay, killing 150 cadres and trainees; surviving recruits fled back to their villages. American helicopters dramatically increased ARVN tactical mobility, so that they ranged into rural areas where the communists had for years held unchallenged sway. But capability and will were not the same thing: many South Vietnamese units declined to patrol where they might be ambushed and flinched from pressing firefights. In 1963 the Vietcong began to receive arms shipped in quantity from North Vietnam, often landed from the sea, especially in the Mekong Delta (including some recoilless rifles and mortars).

In cities, cadres labored to prepare the masses for a popular uprising. Children were often used to toss grenades into cafés and markets. Government intelligence remained poor, and communist activists were skilled in concealing their identities. As a VC courier, ten-year-old Truong Mealy was sometimes sent into a town to meet a code-named figure in a restaurant, clutching half a banknote to identify himself to a contact bearing the other half. If he or others of his kind were caught, their knowledge was confined to the first name of their Party teacher. Only senior NLF cadres knew the names of province chiefs.

154 · VIETNAM

The tempo of the war was rising. After two years in which the impetus of the armed struggle had come chiefly from Southern hostility to the Saigon government, Hanoi's influence and resources were becoming ever more conspicuous. Northern leaders scented rotting flesh, a stench of terminal decay, drifting upcountry from Saigon's presidential palace. They had become impatient to expedite funerary arrangements for the Diem regime. So, too, were important people in Washington.

1963: COFFINS FOR TWO PRESIDENTS

1. SMALL BATTLE, BIG STORY: AP BAC

Alongside the swarms of American advisers, diplomats, fliers, special forces, electronic eavesdroppers, and spooks setting up shop in Vietnam, ever more journalists came—men and a few women who would exercise at least as much influence on the story as the warriors and politicos. The swelling press corps reflected an awareness among their employers that the investment being made by the United States deserved more attention at the sharp end than it had hitherto received. Saigon bureaus got not quite the A-team, such as then went to Washington, Paris, Moscow, or London, but A-team wannabes. Most were young, green, pretty bright, and fiercely ambitious, and they fell in love with the romance of Saigon: men like David Halberstam of the *New York Times*, Malcolm Browne and Peter Arnett of the Associated Press, François Sully of *Newsweek*, and Neil Sheehan of United Press International, who shared desk space with Halberstam and became his close friend.

Sheehan was in Japan, finishing his draft hitch with the US Army, when he persuaded UPI's Tokyo bureau to let him earn ten dollars a throw pulling night shifts. Then the news agency's Saigon correspondent quit, and Sheehan got the job. He was a Massachusetts farm boy born in 1936, strikingly handsome, who won a scholarship to Harvard before becoming a precocious alcoholic. After 1961 he never touched a drink, but he arrived in Vietnam the following year still a little high on faith in the United

156 · VIETNAM

States, born out of his elevation to the Ivy League, which would be sorely tested during the years that followed. "Saigon was a very nice place that hadn't then been mucked up by Americans," he said. "For the first six months I was not at all afraid. I thought it was thrilling, skiing over rice paddies in a helicopter. I was a child of the Cold War. We all felt the same way. Americans could do no wrong. We went there to stop these evil communists trying to take over the world. We had very little grip on reality. We felt this country deserved support."

A cluster of the young correspondents, who swiftly acquired beautiful Vietnamese girlfriends, lived as a rat pack, dining together at L'Amiral, La Souris Blanche, or Bistro Brodard, where they had a special table bearing a sign réservé pour la presse; they shared cyclos or tiny blue-and-cream Renault taxis to briefings, helos to battle. Plenty of unattributable information was available from advisers, diplomats, and the ubiquitous Lou Conein: in Sheehan's laconic phrase, "Lou liked to talk." Ivan Slavich Jr., a soldier who commanded the first Huey helicopter unit, would sometimes call and say, "Come out for breakfast," which was a coded tip that an operation was on. However, "most Vietnamese wouldn't speak to you—they didn't want to get into trouble."

The US Army sucked up much of the precarious electricity supply, so that when air conditioners went down, the reporters sweated profusely onto their shirts, typewriter keys, and stories. They made small fortunes from submitting expenses at the official currency exchange rate while changing dollars on the black market, though Sheehan stayed clean because he was fearful of expulsion. Halberstam later urged him to title his Vietnam book The Last Frontier, "because it was the last place to have fun, to fool around with somebody else's country." Though the correspondents loved the place, most adopted an increasingly earnest view of their mission, having identified a chasm between the relentless optimism of the US military, especially its 1962–64 commander, Gen. Paul Harkins, and the realities as they observed them.

From an early stage, MACV propagated willful falsehoods and suppressed inconvenient truths, such as the fact that US aircrew were flying combat missions in VNAF cockpits, belatedly revealed when the *India*- napolis News published letters home from Air Force Capt. Edwin "Jerry" Shank, which made nonsense of official denials. Shank wrote, "What gets me the most is that they won't tell you people what we do over here. . . . We—me and my buddies—do everything. The Vietnamese 'students' we have on board are airmen basics. . . . They're stupid, ignorant sacrificial lambs, and I have no use for them. In fact I have been tempted to whip them within an inch of their life." The use of napalm was unacknowledged until photos of its flame sheets appeared in the press. Peter Arnett later revealed the use of CS tear gas, which was seized upon by hostile propagandists to mean poison gas, in the face of deafening MACV and Pentagon silence.

Halberstam, then twenty-eight, started out as a true believer, but by the fall of 1962, he had grown skeptical, writing in the New York Times, "This is a war fought in the presence of a largely uncommitted or unfriendly peasantry, by a government that has yet to demonstrate much appeal to large elements of its own people. The enemy is lean and hungry, experienced in this type of warfare, patient in his campaign, endlessly self-critical, and above all, an enemy who has shown that he is willing to pay the price." When in December Halberstam informed his office about reporting restrictions imposed by Nhu and his creatures, the Times forwarded the protest to the State Department, which shrugged, saying that Americans in Vietnam were guests of a sovereign state. This much was true: when the regime persistently dismissed advice and imprecations from the US Embassy, MACV, and the CIA, it scarcely acted out of character by refusing to indulge hostile—and, in Diem's eyes, considerably depraved—liberal journalists. Come to that, Jack Kennedy once telephoned the *Times*'s publisher to lean on him to shift its correspondent.

As for the American military's pronouncements, *Time*'s Lee Griggs composed a song about its chief, to the tune of the hymn "Jesus Loves Me":

We are winning, this I know.
General Harkins tells me so.
In the mountains, things are rough,
In the Delta, mighty tough,

158 .

But the V.C. will soon go. General Harkins tells me so.

Homer Bigart wrote in a June 1962 valedictory dispatch for the *New York Times* that unless Diem mended his ways, either US combat troops would have to be committed or the Saigon government replaced by a military junta. *Newsweek*'s François Sully was the daddy of them all, a Frenchman born in 1927 who had been around Saigon since 1945. He was by no means universally beloved by colleagues and was suspected by some of being a communist, but his connections on both sides were impressive. In one of Sully's last dispatches before being expelled by Diem, he cited Bernard Fall's view that the politics were far more important than the tactics, yet the US Army was training the Southerners to resist a Koreanstyle invasion. Marine helicopters, he said, could not provide the Vietnamese with an ideology worth dying for. The piece was accompanied by a photo of Diem's female militia captioned, "The enemy has more drive and enthusiasm."

Neil Sheehan said of the 1962–63 Saigon press corps, "We were a pretty serious bunch of guys: we found ourselves in conflict—very serious conflict—with the [US] command. You got pretty angry with the generals' lying." Sheehan marveled at the courage of some reporters, the cowardice of others: "One New York paper's reporter wouldn't leave Saigon—he bribed operators for carbons of other correspondents' dispatches." Then there were the adventurers, most of whom arrived somewhat later. "A British freelancer carried an M16 and killed people. Sean Flynn exulted about what a glorious thing street fighting was." In Sheehan's first weeks, he himself toted a pistol in the field, "then I realized this was crazy." He also stopped carrying a camera, because he decided that if you kept peering through a viewfinder, you didn't see what was happening around you—and what might kill you.

Sheehan's generation of reporters enjoyed a notable advantage over most of their successors in the twenty-first-century war-corresponding business: having themselves served in uniform, they were familiar with weapons and military ways. Nonetheless, they recoiled from the racism they observed in

many American soldiers, exemplified by a special forces colonel who said, "You don't need to know the gook's language 'cos he's gonna be dead. We're gonna kill the bastards." Several of the correspondents' group, Halberstam and Sheehan foremost among them, made national reputations in Vietnam, though some Americans, not all of them uniformed, went to their graves believing that the reporters betrayed their country while winning plaudits from media counterparts around the world.

The news story that unfolded on January 2, 1963, started out as a firefight between Diem's soldiers and the Vietcong but turned into a far more significant struggle between the US high command and the Saigon press corps, believers against unbelievers. The killing part was unleashed by Lt. Col. John Paul Vann, since mid-1962 senior adviser to the ARVN 7th Division in the Mekong Delta. Vann, a wire-thin stick of ferocious energy and aggression, was weary of inconclusive encounters with the enemy. After US airborne electronic interceptors pinpointed transmissions from the Vietcong regional 514th Battalion in Ap Bac—North Hamlet fourteen miles northwest of My Tho, the colonel was thrilled when Harkins's headquarters ordered him to orchestrate a massive concentration of force to trap and destroy it: two local Civil Guard battalions; an infantry unit heli-lifted by ten American H-21 "flying bananas," or "angle worms," as the Vietcong knew them; VNAF Skyraider ground-attack aircraft; five Bell UH-1 Iroquois (aka Huey) gunships; a company of M-113 tracked APCs; and a battalion of paratroopers.

American intelligence was significantly mistaken about enemy strength in Ap Bac, estimated at 120 guerrillas. In addition to a reinforced company of the 514th VC Battalion, there was also present an overstrength company of the main force 261st, on its way to an operation elsewhere. This was considered an elite unit. Women said that, if you had to marry a soldier, it was best to choose one from the 261st. Its men were thoroughly experienced, having an average of more than two years' service, senior cadres as much as five years. The total number of full-time Vietcong guerrilla fighters in the South had more than doubled since the previous year, to fifty thousand, the overwhelming majority in the Mekong Delta.

Although they relied heavily on captured arms, an increasing volume came by sea. Disguised fishing trawlers from the North delivered 112 tons of arms and ammunition in 1962, and this total would rise steeply to 4,289 tons in 1963–64, far more than moved down the Ho Chi Minh Trail.

The 261st Battalion was largely composed of "returnees" from exile in the North. It was led by Hai Hoang, whose real name was Nguyen Van Dieu, a popular commander considerate toward his men. Second in command was Tu Khue, tall, gaunt, bald, and stern. A company commander, Bay Den, had an unusually smart social background in Saigon: his sister once arrived to see him, poled to the 261st's camp in a rented sampan. She was appalled to find her brother digging a trench, and begged him to give it all up and come home. Den shook his head. He was committed, he said, and indeed he stayed until killed in action.

The Vietcong around Ap Bac on January 2 mustered 320 fighters, who had been tipped off that an attack by Saigon forces was coming. What John Vann did not know—though he would have welcomed the prospect—was that communist province chiefs had ordered Dieu and his comrades not to pull back as usual when the ARVN struck, but instead to stand and fight. Thus, foxholes and bunkers had been dug along the tree line fronting the hamlet. The defenders were well armed and ammunitioned, mostly with captured American weapons: .30 caliber machine guns, Browning automatic rifles, M1 carbines, and .45 caliber Thompson submachine guns. Most of the 1,200 peasants in the adjoining hamlets of Ap Bac and Tan Thoi fled into the nearby swamps on hearing that a battle was imminent, but some thirty stayed to carry ammunition and casualties. The board was set for Vann's game to be played.

Who were the human checkers on his side that morning? From beginning to end of the war, South Vietnam's soldiers took most of its strain, grief, and losses. Nothing did more to alienate peasants from the Saigon government than the draft, which stole workers from the paddy fields and made many newly minted soldiers oppressors of country people in a region that was not their own, to which they owed nothing. There were ghastly tales of ARVN callousness, some possibly true—of two riflemen, for instance, wagering a pack of cigarettes on who could hit a child riding a

water buffalo. In the war's early years, 1955–59, only men between twenty and twenty-two were conscripted, for twelve months. This was then increased to two years and in 1964 to three. Once inducted, many South Vietnamese never escaped from green fatigues except in a wheelchair or body bag. A common factor between the US and the two Vietnams was that in all three societies, children of privilege were excused from military service. In the South, their families paid a bribe, while in the North, the offspring of senior cadres were dispatched to higher education abroad. Though the Southern Army consumed 15 percent of the nation's GDP, its soldiers were paid a pittance. Most were posted to fighting units after five or six weeks of perfunctory training, assured that they could learn on the job. An officer spoke for most of his comrades when he said, "The communists seemed to know why they were fighting, and we did not. Our political training emphasized Diem's personality but not much else."

John Vann's plan for the morning of January 2, 1963 might have won a staff college commendation if all its human elements had acted as programmed. Instead of performing a balletic pincer movement, however, they descended on the battlefield as randomly as toys kicked out of a box. Early morning fog delayed the infantry airlift, so Civil Guard troops advancing on foot were the first to bump into the Vietcong, soon after 0700. When their leaders were shot down, they hugged the earth during a long, desultory exchange of fire. The government province chief, who was personally directing them, refused to order his second battalion forward. Soon after 1000, against Vann's orders, H-21s carrying an infantry company clattered down onto the paddy within easy shot of the "Victor Charlies." Vietcong recruits were told not to fear helicopters, that they were soft targets made of cardboard pasted to metal frames. That morning at Ap Bac, this must have seemed true: communist fire quickly downed two of the old H-21s and mortally injured a third. A Huey that tried to rescue their American crews was shot full of holes before toppling alongside the other wrecks.

The hapless infantry were going nowhere, stuck on open ground swept by enemy fire. Almost every helicopter in the sky above the battlefield was taking hits, and neither air strikes nor misdirected artillery fire made much impact on the defenders of Ap Bac. From a circling L-19 spotter plane, Vann watched in raging frustration as his operation floundered in mud, blood, and chaos. Ly Tong Ba, a captain commanding a company of armored personnel carriers, refused to advance to rescue the stranded infantry and aircrew because Vann's histrionics over the radio roused his pride against succumbing to hectoring. "I've got a problem Topper Six," Capt. Jim Scanlon, the adviser with Ba, radioed Vann ruefully, "My counterpart won't move."

"Goddamn it, doesn't he understand this is an emergency?"

"He says, 'I don't take orders from Americans.'"

Vann bellowed into the handset: "Ba! If you don't get your vehicles across the canal I shall tell General Le Van Ty to sling you in jail!" The Vietnamese belatedly ordered his company forward, which spent the ensuing two hours struggling to cross dikes and canals. The captain forever afterward argued that neither Vann nor Scanlon recognized the difficulties of overcoming the water obstacles. When the machine gunners finally engaged, several were shot off their exposed steel hulls by Vietcong, whose positions were so skillfully camouflaged in the banana and coconut groves that few attackers glimpsed an enemy all day. When one crew tried to use their flamethrower, they found that the fuel had been mixed wrongly, so that the jet drooped to a trickle. Around 1430 the armored CRABs began to pull back, and two more helicopters were forced down by enemy fire.

Vann's L-19 made repeated deck-level passes as he strove in vain to identify Vietcong positions and energize the stalled ground movements. At 1805 a mass parachute drop from seven USAF C-123s yielded a crowning disaster: the troops landed half a mile off their intended DZ, within easy range of Vietcong in Tan Thoi, whose fire plowed into them, killing nineteen paras and wounding thirty-three, including two Americans. When darkness fell, the communists still held almost all the ground they had occupied at first light, and they experienced no difficulty in slipping away to the sanctuary of the nearby Plain of Reeds.

The guerrillas did not have the day's fight all their own way, losing 18 men killed and 35 wounded, most to artillery and air strikes. On Saigon's side, however, 3 Americans had been killed and 5 wounded, along with

63 Vietnamese dead and 109 wounded. Back in May's Landing, New Jersey, a seven-year-old boy cried out in excitement as he watched a TV clip of a helicopter door gunner in action, "Look, there's my daddy." Just six hours later, a telegram arrived to report the death of his father, crew chief William Deal, in a Huey outside Ap Bac.

The media experience of next day, January 3, however, exercised a greater influence on the history of the war than did the battle itself. Paul Harkins, MACV's supremo, descended on IV Corps headquarters to cheerlead a renewed assault on Ap Bac. He told David Halberstam and Peter Arnett, "We've got [the Vietcong] in a trap, and we're going to spring it in half an hour." However, the journalists knew that the enemy were long gone and thus that the South Vietnamese "assault" was a pantomime. Harkins's remark suggests that the general was either a fool or a willful deceiver—probably the former, because he never looked further into any situation than he wished to see.

A few miles away, matters got worse. Neil Sheehan and Nick Turner of Reuters reached the previous day's battlefield to find the Southern soldiers unwilling to handle their own and the Americans' dead; the disgusted journalists themselves loaded the corpses aboard helicopters. Then, as they talked to US Brig. Gen. Robert York, an Alabaman World War II veteran, artillery support for the new "assault" started to thump in around them, blasting up geysers of mud. York said to Sheehan, "Jesus Christ, run for your life, boy." They bolted across the rice paddy, before throwing themselves to the ground, Sheehan convinced that he was about to die. When the shelling stopped, they were covered with filth. York remained almost pristine, however, having adopted a pushup posture in the dirt. He shrugged. "I didn't want to get my cigarettes wet." Sheehan said ruefully, "Never mess with a man who's so calm under fire." Fifty rounds had landed in the vicinity, killing four ARVN soldiers and wounding twelve. The enraged infantry battalion commander drew his pistol and shot in the head the young lieutenant acting as forward observer for the artillery.

The defeat at Ap Bac was less militarily significant than, for instance, a 1960 action at Tua Hai in Tay Ninh Province, in which the communists also beat a much larger government force. The difference was that at Tua

164 · VIETNAM

Hai there had been no foreign witnesses, while now the sharpest American correspondents in Vietnam were in the bleachers. Sheehan wrote later, "We knew this was the biggest story we had ever encountered." The dispatches by him and Halberstam quoted anonymously an American adviser who condemned the Southern showing on January 2 as "a miserable damn performance," at a moment when Harkins was still insisting that Ap Bac was a victory. Few people, including the general, doubted that the dismissive words came from John Vann, and he demanded the colonel's head.

MACV finally decided that it would be more prudent to allow this galvanic but famously indiscreet officer to complete his tour in March as scheduled. Vann's influence on the war would thereafter wax and wane until its dramatic termination almost a decade later, but in 1963 he played a critical role in providing authoritative briefings to Sheehan, Halberstam, and others about the bungling and pusillanimity that characterized Southern operations, and the deceits practiced to conceal these. The colonel warned Maj. Gen. Bruce Palmer that Harkins was allowing himself to be duped by Saigon's officers, who routinely assaulted objectives they knew to be untenanted by the enemy. It was nonetheless the Harkins version that Maxwell Taylor and Robert McNamara chose to believe. Frances FitzGerald later wrote in her influential history Fire in the Lake, "The United States had . . . made the Saigon government into a military machine whose sole raison d'être was to fight the Communists. The only difficulty was that the machine did not work." The ARVN was not an army "but a collection of individuals who happened to be carrying weapons." This was an overstatement, but it contained a core of truth.

The Ap Bac affair prompted extensive media comment. Arthur Krock wrote in his syndicated column on January 9, "No amount of US military assistance can preserve independence for a people who are unwilling to die for it." Richard Hughes, a Hong Kong-based Australian veteran who wrote for London's *Sunday Times*, said that he saw clear parallels with US follies in China after World War II. The best the Americans were promising, he said, was a ten-year war to preserve a "reactionary, isolated,

unpopular" regime. The only way out, he suggested, was for the Saigon government to admit communists to a coalition.

Within Vietnam, word spread swiftly about the fiasco. A Vietnamese officer wrote that Ap Bac "greatly hurt ARVN morale." Ly Tong Ba, who rose to become a general, later denounced Neil Sheehan, who only wrote "articles filled with malicious arguments and inaccuracies." He also argued that his own adviser on the ground at Ap Bac, Jim Scanlon, was as "terrified" of Vann as of the Vietcong, which prompted him also to paint a false picture of events. The press coverage was seized upon by MACV officers, and by others who deplored "negative" reporting, as highlighting the difficulties of fighting a war observed by journalists who recognized no obligation to favor "our side"—the United States and its South Vietnamese client—as had been the patriotic duty of every correspondent in World War II, when the press was additionally constrained by censorship.

It remains as difficult now as it was then to see virtue in Gen. Harkins's attempts to deny the real state of affairs. The maxim obtains for all those who hold positions of authority, in war as in peace: Lie to others if you must, but never to yourselves. MACV's chief could make a case for talking nonsense to Halberstam and Arnett, but he was peddling the same fairy tales in top-secret cables to Washington. Nonetheless, a valid criticism persists of the media's coverage throughout the war: the critics got bang to rights the shortcomings of the Diem regime and its successors but gave nothing like the same attention to the blunders and horrors perpetrated by the communists. Halberstam, Sheehan, and the rest conscientiously and sometimes brilliantly fulfilled their duty to tell what they saw and heard; Saigon's apologists, exemplified by Time magazine, destroyed their own credibility by denying unpalatable realities. The South was only half of the rightful story, however. Much of the media showed itself ignorant of or blind to the tyranny prevailing in the North, which was inflicting worse hardships on its own people.

An Australian surgeon, who served as a civilian volunteer down at Vung Tau, later wrote, "It seems fair to say what is usually left unsaid, that if the economic aid to South Vietnam had not been prevented by the 166 ·

activities of the Vietcong, the people of the country which today is wartorn and unhappy would have been well-fed, in better health and better-educated." Frances FitzGerald concluded her powerful 1972 account of America in Indochina with an expression of yearning for North Vietnamese victory, for a moment when "individualism and its attendant corruption give way to the discipline of the revolutionary community." American officials, she wrote, might attribute this to the triumph of brainwashing by "hard-core Communists." Not so, she asserted: "It will simply mean that the moment has arrived for the narrow flame of revolution to cleanse the lake of Vietnamese society." Here was a view of the war that seems as delusional at one end of the political spectrum as was that of Gen. Harkins and his kind at the other.

VIETNAM

2. THE BUDDHISTS REVOLT

Throughout the spring of 1963, the credibility of the Diem government drained away, as surely as Vietcong morale and strength rose, impelled by a surge of excitement after the victory at Ap Bac. In the 261st Battalion, its history records, "there was much singing." COSVN broadcast a new slogan: "Emulate Bac!" The battle provided an important boost to the "forward" faction in Hanoi, which argued ever more insistently that the season for caution had passed; that in the South, the prize lay ripe for the taking. Michael Burleigh has written of US policy making, "Seldom has an imperial power put its prestige behind a more suicidal group of puppets than the Ngo Dinh clan." Even as the security situation deteriorated, in May the Saigon regime adopted an initiative that set its wagon careering downhill toward the final wreck. Vietnam's Buddhist priesthood had always resented the favoritism shown by the Ngos toward their fellow Catholics. On May 8, 1963, when worshippers assembled in Hue for the 2,527th birthday of the Buddha, a Catholic army officer sought to enforce an old decree banning them from displaying their flag. Several thousand Buddhists gathered outside the local radio station to hear a broadcast by prominent bonze Thich Tri Quang. The station director suddenly canceled the transmission, saying that it had not been approved

by the censors. He also telephoned the army, which dispatched to the scene a troop of armored cars. When the Buddhists ignored an order to disperse, the soldiers opened fire. A woman and eight children died in the ensuing melee.

This gratuitous murderous folly prompted weeks of antigovernment demonstrations in many cities, Buddhists being joined by thousands of students. It was subsequently claimed that the protests were orchestrated by the communists. Plainly they suited the NLF and Hanoi, and cadres may have encouraged the bonzes. Beyond doubt, however, what took place represented a surge of spontaneous anger against the regime, which refused to apologize for the deaths in Hue or to punish those responsible. Diem sat on his hands, ignoring warnings from Washington, while his brother Nhu embarked on a program of repression.

Frank Scotton said, "Most of the bonzes were victims of their own wishful thinking about the possibility of representative government, but the Buddhist crisis was not just about politics. For Diem to have made a grand gesture of reconciliation, he would have had to go up against his own younger brother, and he couldn't bring himself to do that." Reporter Marguerite Higgins described Quang, foremost among the rebellious monks. Far from being a passive, meditative figure, she said, "Deep, burning eyes started out from a gigantic forehead. He had an air of massive intelligence, total self-possession and brooding suspicion." A Southern officer wrote, "The [Buddhist] crisis was like a great fire, uncontrollable and raging quickly. It had a strong negative effect on the morale of officers and enlisted men. . . . I knew that it was impossible to maintain Diem's government. My only hope was that power would fall into the hands of a new, competent and loyal leadership."

When Duong Van Mai returned to Saigon from Washington that autumn, she found that her family and especially her mother had become bitterly hostile to the government because of its assault on the faith to which an overwhelming majority of Vietnamese professed adherence. On June 10, David Halberstam wrote, "The conflict between the South Vietnamese Government and Buddhist priests is sorely troubling American officials here, . . . [who] are deeply embarrassed . . . and frustrated in the

168 .

face of persistent questioning by individual Vietnamese, who ask, 'Why does your Government allow this to go on?'" Americans were perceived as literally calling the shots.

Next day, Western media organizations were alerted to attend a protest in Saigon. Few took heed, however, because its nature was unspecified. On the morning of the 11th at a busy intersection, an elderly Buddhist monk named Thich Quang Duc disembarked from a car in orange robes, adopted the lotus position on the street, then sat motionless surrounded by a large crowd while another bonze poured ten gallons of gasoline over him, taking care to saturate every part of the man, even returning to get a spot he'd missed. Duc himself struck a match and flicked it into the puddle around him, then without a gasp or a twitch allowed flames to consume and shrivel him. Throughout the process, another bonze proclaimed through a megaphone, "A Buddhist priest burns himself to death! A Buddhist priest becomes a martyr!" At this and other such ghastly human sacrifices, it was noticed that signs, placards, and denunciations were in English; the intended audience was not Vietnamese.

The only Western journalist who had troubled to turn up, Malcolm Browne of AP, wrote later, "I could have prevented that immolation by rushing at him and kicking the gasoline away. . . . As a human being I wanted to. As a reporter I couldn't. . . . I would have propelled myself directly into Vietnamese politics. My role as a reporter would have been destroyed along with my credibility." Yet Browne assuredly altered the face of South Vietnamese politics by photographing the scene, just as the Buddhists had intended when they alerted him. His devastating images were "pigeoned" to Manila, then wired around the world. Madame Nhu fueled outrage with her televised description of the event as a "barbecue." She shrugged. "Let them burn, and we shall clap our hands." Browne said that he never forgot the overpowering scent of joss sticks mingling with that of burning flesh. The perpetrators, well satisfied with the attention secured by their grisly gesture, displayed Duc's heart in a glass case.

Americans responded with stunned incomprehension. Lt. Gordon Sullivan, an adviser with a Ranger group who chanced to be in Saigon, said, "The whole thing changed. This was something new. We didn't know

people did stuff like that." The Washington Post editorialized on June 20, 1963: "Of course the communists will exploit Buddhist grievances. And why not? It is Mr. Diem's regime itself that is gratuitously serving communist purposes by policies that are morally repugnant and politically suicidal." US ambassador Fritz Nolting still maintained that this was the least bad Saigon government the US would get, and the CIA's Bill Colby agreed. However, Kennedy's national security adviser, McGeorge "Mac" Bundy, and the State Department's Roger Hilsman took a bleaker view. So did Henry Cabot Lodge, who arrived in Saigon in mid-August to replace Nolting, whose "appeasement" of Diem was deemed discredited.

The new envoy was sixty-one, a Republican grandee from Massachusetts with long experience of diplomacy and the Senate, who had run as vice presidential candidate on Nixon's ticket in 1960. Arthur Schlesinger wrote, "The president has a habit of designating 'liberals' to do 'conservative' things, and vice versa." Lodge's appointment was a classic example of this: he was a big figure, bound to seek to play a big role more proconsular than ambassadorial. If he subsequently misplayed or overplayed his hand, blame rightfully lay with those who appointed him.

On August 21, after Diem imposed martial law in response to the continuing storm of protests, Nhu's forces assaulted Saigon's principal Buddhist sanctuary, the Xa Loi Temple. They arrested four hundred monks and nuns, including Vietnam's eighty-nine-year-old patriarch. Henry Luce's *Time* suppressed condemnatory dispatches from its own correspondents; Colby shared his friend Nhu's contempt for the Buddhists, as did Harkins. Yet despite the imposition of rigorous press censorship and a stream of mendacious government statements, most Americans, including Ambassador Lodge, recognized that the president's brother was rampaging out of control.

The nationwide security situation continued to deteriorate. The NLF, impatient to see the back of the regime, intensified its campaign of terror, while Southern army morale grew shakier by the day. Because David Halberstam's grim reports were so widely read, MACV and Washington worked ever harder to trash them. Secretary of State Dean Rusk personally contradicted an August 1963 dispatch that described the communists

I70 · VIETNAM

gaining ground in the Mekong Delta. Harkins itemized details that he asserted were untrue. In September the general cabled Maxwell Taylor at the White House: "From most of the reports and articles I read, one would say Vietnam and our programs here are falling apart at the seams. Well, I just thoroughly disagree."

Nevertheless, the record shows that the young Turks, Halberstam and Sheehan prominent among them, were far more correct in their assessments, both military and political, than was MACV. There were more and more such episodes like one in September, when in broad daylight the Vietcong overran a government post in the Delta almost without loss, because the provincial VC had infiltrated two of its own men into the garrison. They killed six defenders, seized six prisoners and thirty-five rifles, and blew up bunkers and watchtowers before withdrawing. That autumn, according to Frank Scotton, "It was apparent that many cultured city-dwellers"—attentistes, as those folk were known who waited upon events rather than precipitating them—"anticipated a change of government." Diem's time was almost up. It remained only to be seen whether the communists, the Buddhists, or his own generals would pull the plug. And what Washington decided to do about it all.

3. KILLING TIME

The countdown to the murder of President Ngo Dinh Diem started on August 23, 1963, when a top-secret cable to the State Department from Lodge demanded to know whether Washington would support a coup. A positive reply was drafted and sent to Saigon over a weekend when Kennedy, Rusk, and McNamara were out of town. Its authors were Averell Harriman, Roger Hilsman, and Michael Forrestal. If Diem refused to make reforms and sack his brother Nhu, they wrote in the name of the US government, "we are prepared to accept the obvious implication that we can no longer support Diem. You may tell appropriate military commanders we will give them direct support in any interim period of breakdown. . . . Ambassador . . . should urgently examine all possible al-

ternative leadership and make detailed plans as to how we might bring about Diem's replacement if this should become necessary."

On Monday morning, when Kennedy returned to the White House, he was disturbed by the insouciance with which this momentous directive—for such the cable was—had been dispatched, by middle-ranking officials. He consulted with McNamara and Taylor, who equivocated, saying they would prefer that Diem stayed, albeit without Nhu. If the generals decided otherwise, however, the US should support an interim military government. Kennedy finally decided not to rescind the weekend telegram: it would be left to Lodge to determine policy. The ambassador later claimed to have been "thunderstruck." His entirely reasonable interpretation of the Washington cable was that he was now mandated to precipitate Diem's fall.

On September 2, the US president, answering a question about Vietnam in a CBS interview with Walter Cronkite, said that the Saigon regime needed to gain more support but that "with changes in policy and perhaps in personnel I think [the government] can win. If it doesn't make those changes, I would think the chances of winning would not be very good." Kennedy appealed for more help—practical help—from America's allies. "It doesn't do us any good to say, 'Well, why don't we all just go home and leave the world to those who are our enemies." He added that "the only people who can win are the people of Vietnam." Some historians have interpreted such words as indicating Kennedy's acknowledgment that Americans could not achieve what Vietnamese would not do for themselves and that he was pointing toward an exit. This seems fanciful: he had his own presidential reelection race to win, which might conceivably be lost in Southeast Asia, just as Korea doomed Harry Truman in 1952.

Events now accelerated. The North Vietnamese were probing for any means of separating Diem from the Americans. To this end, Hanoi embarked on a roundabout dalliance with Saigon, via Polish and French intermediaries, which soon became known to the Kennedy administration. The most ignoble aspect of Washington's mounting interest in a coup was the impetus provided by fears that Diem or his brother Nhu might be

172 .

contemplating a deal. Bernard Fall, who commanded a readership among decision makers because he was known to have good contacts on both sides, reported that, in the event of a meaningful North-South dialogue, Ho Chi Minh would accept a delay to reunification—a "decent interval," to use a phrase that Fall did not employ, which would become the focus of many future Indochina peace efforts. In truth, the exchanges had little chance of an outcome: Le Duan was interested only in achieving a communist Vietnam, while the Ngos labored under the delusion that they held good cards—an imminent prospect of military victory and their own indispensability to the Americans. The mere fact of contacts between the two sides nonetheless set alarm bells ringing in Washington. The Saigon regime's willingness to parley reflected increasing animosity toward its paymasters.

President Kennedy's friend Charles Bartlett claimed later that the Saigon regime's flirtation with the North was the principal reason for the decision to dispense with Diem. He quoted the president as saying, "Charlie, I can't let Vietnam go to the Communists and then go and ask [American voters] to re-elect me. Somehow we've got to hold that territory." Nonetheless, Kennedy allegedly added, "But we've got no future there. [The South Vietnamese] hate us. They want us out of there. At one point they'll kick our asses out of there." This reported conversation seems credible. Kennedy's private attitude was colored by the bad faith shown by the communists about implementing his administration's Laos neutralization pact: there seemed likewise no prospect of Hanoi being an honest partner in any coalition settlement for Vietnam.

American alarm increased when France's president Charles de Gaulle took a hand. This lofty, profoundly anti–Anglo Saxon nationalist repeatedly urged that the US should disengage, allowing Vietnam to be neutralized. Washington believed that de Gaulle's remarks reflected jealousy about France's displacement from a region that had once been its property. Fredrik Logevall has written, "American planners would spend much time discussing the French leader's actions and ideas, but only in terms of how best to counter them. The substance of his argument was not closely

examined, then or later, partly because it was anathema to American officials, and partly because they were convinced he had ulterior motives."

Walter Lippmann warned in his column on September 3, "If there is no settlement such as General de Gaulle proposes, then a protracted and indecisive war of attrition is all that is left." The veteran commentator, who in those years wrote more about Indochina than any other single issue, believed that the best to which the US could aspire was a Titoist outcome, whereby a unified Vietnam became communist, but not a tool of China or the Soviets. Lippmann implicitly argued that Ho Chi Minh could not be defeated on the battlefield and that the best alternative might be to woo him with dollars. This was implausible: there seems no more reason to believe that Le Duan, a Robespierrian "sea-green incorruptible," could have been bribed into running a moderate, humane government had he been granted suzerainty over a unified Vietnam in 1963 than he did after 1975. But that does not diminish the validity of Lippmann's thesis that the Americans could not prevail by force of arms.

On September 13 the NSC's Chester Cooper wrote from Saigon to his old CIA colleague John McCone, saying that he thought a diplomatic rapprochement between the Diem regime and Hanoi, involving expulsion of the Americans, was in the cards. Here were gall and wormwood, which made the administration even less inclined to discourage Lodge from inciting Saigon's generals to intervene. The ambassador had no hesitation about exploiting the authority delegated to him by the White House to instigate a change of government, though this proved a tortured process. It was hard to urge into action the influential soldiers whom he addressed generals Duong Van Minh, Tran Van Don, Le Van Kim, and Tran Thien Khiem. The CIA's Colby hated Lodge and strongly opposed action against a Vietnamese national leader who was also a devout Catholic. Colby wrote later: "There was an almost total absence of consideration and evaluation of the personalities who might succeed Diem, beyond generalized references to 'the military." The ARVN officers were not unreasonably hesitant about deposing Diem unless and until they were sure their own hand was strong enough, which required unequivocal American backing.

174 · VIETNAM

They knew that they could expect nothing on paper from the embassy but were unwilling to risk their own necks merely on the verbal assurances of Lou Conein, who hereafter acted as covert liaison officer between Lodge and the army chiefs.

A few years after these events, US undercover agents were watching a Marseilles bar involved in the huge transatlantic heroin-smuggling operation that became notorious as "the French Connection." The surveillance team was startled to identify Conein among those present, glad-handing Corsican gangster friends from his OSS days. Frank Scotton nonetheless argued that beneath Conein's posturings as buccaneer or buffoon, the big thug could work effectively to fulfill an allotted task, which in October 1963 meant providing the link between the US government, which acquiesced in Diem's extinction, and the Vietnamese generals who brought this about.

Lodge chafed at the sluggishness of the plotters who, he wrote crossly, had "neither the will nor the organization . . . to accomplish anything." Harkins, having no time for the ambassador, shrugged and told Max Taylor, "You can't hurry the East." George Ball later argued that the notorious August Harriman/Hilsman telegram was less influential in energizing the generals than Kennedy's TV appearance two weeks later, warning that the US would withdraw aid unless Saigon changed its ways. Many South Vietnamese, both in uniform and out of it, sensed backing for Diem ebbing away. Army Lt. Nguyen Cong Luan was a passionate anticommunist who also hated the government. "My comrades and I believed that it was necessary to bring new leaders to power so that South Vietnam could deal effectively with the communists and become a place of full freedom and democracy like the United States." They had been much excited when South Korea's dictator Syngman Rhee was forced out of power in 1960. "We believed that if our side [in Vietnam] showed enough resolution and strength for a coup attempt, the Americans would have to support us."

President Kennedy now confused the issue by dispatching McNamara and Taylor on a ten-day "fact-finding mission" to Vietnam, which began on September 25. They returned to fantasize about "great progress" on the battlefield, while deploring Diem's intransigence. They had probed in vain

for tidings about the supposedly imminent coup. When Gen. Duong Van "Big" Minh, leader of the army plotters, said nothing significant to Taylor during an energetic tennis game at Saigon's Cercle Sportif, the American decided that the plan must have been aborted. He and McNamara nonetheless concluded that military victory remained attainable, if only the Saigon government could be sorted out—which required removal of the Ngos.

The White House cabled Lodge on October 2, emphasizing that deniability was all. "No initiative should now be taken to give any covert encouragement to a coup. There should, however, be an urgent effort . . . to identify and build contacts with possible alternative leadership as and when this appears." Three days later, Lodge messaged the president that the coup seemed likely to happen after all. Conein and Minh met for some frank exchanges, conducted in French, at an old colonial bungalow in the Saigon garrison compound. The Vietnamese said that his only nonnegotiable demand was an assurance that US aid would continue. He warned Conein that time was of the essence, because his own was merely one of several rival conspiracies. That day another Buddhist monk burned himself to death.

Conein's report caused Lodge to recommend to Washington that he need merely give Minh an assurance that the US "will not attempt to thwart" regime change. Kennedy assented, though warning that the Americans must not be actively engaged in the operational process of a coup. The mood in Saigon was now febrile, with rumors everywhere of an impending threat to Diem. These alarmed the Vietnamese generals, who once more drew back from the brink. Lodge felt obliged to sack CIA station chief John Richardson, who shared Paul Harkins's skepticism about dumping Diem.

Then Nhu intensified his campaign of political repression, and publicly heaped obloquy on the Americans for alleged meddling. After the war, senior communists observed that this would have been an ideal moment to provoke an uprising: South Vietnam had become unstable and vulnerable; almost everyone hated the Ngos. COSVN, however, merely sustained its guerrilla campaign, while in Saigon the generals bargained

for support from key army units. Lou Conein sought to keep the plotters on course through soothing conversations with Gen. Don at their mutual dentist's office, which became a safe house for meetings.

On October 26, National Day, Diem visited the hill resort of Dalat. In the prevalent jittery mood, his plane was preceded by an identical but empty decoy C-47, and the welcoming honor guard's rifles were inspected to ensure that they were unloaded. The president had scheduled a meeting with the US ambassador, and Frank Scotton was tasked to inquire of a Vietnamese contact privy to the coup planning whether Lodge could enter the presidential guesthouse without getting caught in a storm of bullets. The USIA man got the necessary nod: the generals were not yet ready. The visit, and Diem's meeting with the ambassador, took place without incident.

In Washington, divisions persisted. Vice President Lyndon Johnson had little influence but persistently opposed eviction of the Ngos. As a visceral anticommunist, he saw the challenge as being simply to contrive the military defeat of the Vietcong. Never a man for nuances, he liked to pretend to jest that "foreigners are not like the folks I am used to," though this indeed emphasized an important truth about himself. On October 29, Kennedy convened the NSC to discuss a cable from Harkins expressing the general's desire to stick with the Ngos: "Rightly or wrongly, we have backed Diem for eight long hard years. To me it seems incongruous to get him down, kick him around and get rid of him." This message shook Robert Kennedy, who decided that a coup now looked risky.

National Security Adviser McGeorge Bundy dispatched another cable to Lodge, reflecting the president's new doubts. Yet the ambassador had become determined to see the plot through: he never conveyed Washington's equivocations either to the Vietnamese generals, or to Lou Conein. On November 1, the old OSS man arrived by appointment at army head-quarters in uniform, carrying a .357 revolver and \$40,000 in cash, which he deemed the appropriate fashion accessories for an afternoon's work overthrowing a government. He left his wife and children in their villa guarded by Green Berets and radioed from his jeep an agreed signal to his superiors that the operation was starting: "Nine, nine, nine,

Rebel troops launched an assault on Diem's palace, where the president and his brother took refuge in the cellar. In Saigon, the plotters seized and shot several Ngo loyalist officers. At four thirty p.m., Diem telephoned Lodge to seek his support but received only the offer of safe conduct out of the country.

The plotters phoned the president, urging him to quit in exchange for his life. Instead he contacted intimates, trawling for support, which was not forthcoming. At eight o'clock that evening, Diem and Nhu attempted a desperate gambit, slipping out of the palace and driving to Cholon through deserted streets, defying a curfew imposed by the army plotters. The two took refuge in a house prepared by Nhu for just such an emergency, with its own communications system. They were in Cholon when rebel troops shelled and finally stormed the palace, overcoming guards who died in defense of an absent Diem. Only after hours of fighting was the wrecked building secured, then looted of everything from Madame Nhu's negligees to the president's impressive collection of American comics.

At six a.m. on November 3, an audibly exhausted Diem telephoned Big Minh and offered to negotiate terms for his resignation. The generals rejected the proposal, likewise a suggestion that he should be allowed to leave the country with the public honors due to the head of state. Minutes later, Diem called again. He and his brother had decided to surrender unconditionally and were to be found at Saint Francis Xavier, a Catholic church in Cholon. The generals, uncertain what they should do with their superfluous president, turned to Lou Conein. He said it would take twenty-four hours to produce an American plane to fly Diem out, and they would need to find a country willing to grant him asylum.

The generals delegated a veteran secret policeman to fetch Diem and Nhu from Cholon in an M-113 APC. In the party was also Capt. Nguyen Van Nhung, Minh's personal bodyguard, to whom the general is alleged to have given a discreet signal—two raised fingers—to indicate that the captives should be killed. Nhung had already executed two Diem loyalists the previous night. At the church, the Ngos shook hands with their escort, who ushered them into the carrier with an assurance that its armor offered protection against "extremists." On the way back into Saigon, the little

178 · VIETNAM

convoy halted at a railroad crossing, where an officer emptied a submachine gun into the passengers. The carrier, awash with blood, then continued to Minh's office at garrison headquarters, where his man announced tersely, "Mission accomplie." The general told Conein that Diem had committed suicide, then asked, "Would you like to see him?" Absolutely not, said the American. There was a "one-in-a-million chance" that the world would swallow the coup plotters' story, and he declined to be embarrassed by confronting the truth.

A British Council lecturer was called upon to identify the bodies of Diem and Nhu at Saint Paul Hospital, because he was married to the late president's niece. Diem appeared to have been hit just once in the neck, Nhu repeatedly in the back. Lodge summoned the generals to the US Embassy, where he described the coup as "a remarkable performance in all respects," then sent a buoyant cable to Washington: "The prospects now are for a shorter war." There were public celebrations in Saigon and other cities, and the deposed dictator's image was exultantly torn from the walls of public buildings. Hundreds of political prisoners, some showing marks of torture, were set free. An incongruous memory lingered in the minds of many Saigonese: a ban on dancing, imposed by Madame Nhu in the alleged interests of public morality, was rescinded. Thousands danced, figuratively, on the Ngos' graves.

Neil Sheehan and some of his press corps colleagues detected an illusory gleam of hope: "If you stuck with Diem, you were going to lose the war. We thought, if they got a decent military regime, they had a chance." Gen. Duong Van Minh assumed leadership of the junta that took over the government of South Vietnam. In London *The Times* reported on November 5, "Saigon was acting as if a great weight was lifted. Streets were crowded as they have never been crowded. . . . Thousands of Buddhists flocked to Xa Loi pagoda for almost jubilant prayer services." A special correspondent added, "The pro-American leanings of several of the Junta . . . should incline them toward democracy."

John F. Kennedy was attending a meeting with Max Taylor when news was brought of Diem's death. The soldier recorded how the president "rushed from the room with a look of shock and dismay." Subsequent arguments about responsibility seem spurious. The administration had authorized Lodge to open the seacocks, allowing the regime to founder. Recriminations, about whether Washington should have ensured the availability of lifeboats for survivors, are beside the point. The South Vietnamese generals would not have dared to remove Diem had they not been assured that this represented Washington's will. Nobody convincingly warned them not to kill him.

It is sometimes argued that Diem's regime could have reformed and survived; that the president was South Vietnam's last nationalist and independent head of state. VNAF fighter pilot Tran Hoi said, "I thought the Americans quite wrong to depose him. He was a true patriot." Some thoughtful South Vietnamese respected Diem's efforts, however ill judged, to pursue his own policies rather than merely to execute American ones. Another air force officer, Nguyen Van Uc, said, "Diem knew that if [American combat troops] came in, the communists would always be able to say they were fighting a campaign against imperialist domination." A naval officer agreed: "After Diem's death, there was no more real politics in South Vietnam."

The record shows that the regime was rotten to the core and commanded negligible popular support. Yet the manner of the president's killing, resembling that of a Roman emperor by his Praetorian Guard, dealt a crippling and probably irretrievable blow to America's moral standing in Southeast Asia. The US Chiefs of Staff were appalled, calling it "the Asian Bay of Pigs." Frank Scotton said, "Killing Diem was a catastrophic mistake." He told those of his bosses who claimed to see the prospect of a fresh start, "Some of these generals are quite likable guys, but do any of them have the smallest administrative or political leadership skills? Now that the first bloody coup is accepted, anyone with more than two tanks will believe they have license for a change of government."

David Elliott had arrived in Vietnam "confident that we were doing the right thing. But I soon came to believe that instead of supporting the coup we should have faced the fact that there was no common purpose between ourselves and our ally. We should have walked away." An Australian working later in Vietnam wrote, "What Americans have not learnt is that 180 .

they cannot impose 'democracy' on the South. For [the United States] to support any government is to doom it to failure." An Ed Lansdale protégé, CIA officer Rufus Phillips said of Diem's killing, "I wanted to sit down and cry. . . . That was a stupid decision and, God, we paid, they paid, everybody paid." Former Saigon ambassador "Fritz" Nolting resigned from the State Department in protest.

On November 22, 1963, forty-six-year-old President John F. Kennedy was assassinated in Dallas. Even as the world mourned, the knot of Americans privy to the secrets of what had taken place in Saigon less than three weeks earlier reflected upon the harsh symmetry. Kennedy was succeeded by his vice president, a man of notable political gifts, most of which would later be forgotten as Lyndon Johnson bore to his grave the terrible incubus of Vietnam. In those first days, few people outside America knew anything about its new leader. In London *The Times* observed with obvious skepticism, "On the world stage he is almost unknown." Arthur Schlesinger wrote dismissively, "He knows little and yet seems disinclined to add to his knowledge as, for instance, by talking to foreign visitors."

Torrents of ink have been expended on speculation about the course John F. Kennedy might have pursued in Vietnam, absent the Texas bullets. The CIA's William Colby thought he would have recognized the need for a credible political strategy as a precondition for any US troop commitment. White House aide Kenny O'Donnell later claimed to have heard the president say that the ideal outcome would be for a Saigon regime to ask the Americans to leave. The monarch of Camelot might have persisted in a limited commitment without dispatching half a million troops. Robert McNamara asserted that Kennedy would have got out, once the 1964 election was won. However, the defense secretary's biographer notes that he expressed this belief only long afterward.

The evidence seems overwhelming that the president's thinking was dominated by the requirements of his forthcoming reelection campaign. In the previous spring, he had told Senator Mike Mansfield that he favored quitting Vietnam but could not be seen to do so before polling day. On November 22 at the Dallas Trade Mart, Kennedy was scheduled to say, "We in this country in this generation are the watchmen on the walls

of freedom. . . . Our assistance to . . . nations can be painful, risky, and costly, as is true in Southeast Asia today. But we do not weary of the task." John Kenneth Galbraith recalled, "I heard [Kennedy] say many times . . . 'There are just so many concessions that one can make to the Communists in one year and survive politically.'"

Breathless modern admiration often obscures the fact that in mid-November 1963, Kennedy's global standing was low. In London *The Times* editorialized on the 12th, ten days before Dallas, about a "sense of paralysis" pervading the US government, of "'general disappointment' about its performance," reflected in failures of policy on several continents. "For some reason, the American administration is becoming increasingly powerless to influence events at home or abroad." It seems implausible that Kennedy would have dared to act in a fashion that made him seem weak in advance of November 1964. Following reelection, he might have displayed the moral courage, which Lyndon Johnson lacked, to cut America's losses—but he probably would not have.

Kennedy's Vietnam policy suffered from the same fundamental flaw as that of every other president between 1945 and 1975: it was rooted in the demands of US domestic politics rather than in a realistic assessment of the interests or wishes of the Vietnamese people. Kennedy was a sufficiently intelligent and sensitive man—consider his earlier skepticism about Indochina—to recognize the unlikelihood of American military success there. However, in the climate of the Cold War, which was then very cold, the political cost of staying in South Vietnam appeared to the Kennedy White House lower than that of being seen to quit, fail, lose, or give in to the communists. Neither the president nor Robert McNamara grasped the depth of the potential downside of Vietnam for their own country.

By the end of 1963, the Saigon government had no physical presence in some parts of the Mekong Delta, designated by the communists the 20/7 Zone, after the date of the 1954 Geneva Accords, and such "liberated areas" expanded rapidly in the confusion following the death of Diem. Southern troops' morale slumped, and even supposedly elite formations showed little appetite for engaging the enemy. The strategic-hamlets

program collapsed. With astonishing suddenness, in large areas of the country, the NLF found themselves in the driver's seat. Americans enjoyed a black joke about an alleged conversation between Lodge and Big Minh, in which the ambassador urged the general to promote reassurance among the Vietnamese just as Lyndon Johnson did with his televised address after Kennedy's assassination. Minh said, "Fine. Give us TV."

The fall of Diem prompted a crisis meeting of Hanoi's central committee, which began on November 22. Ho Chi Minh offered to moderate, but the hawks rebuffed this suggestion. There is an unconfirmed claim that he stormed out, in dismay or disgust. Such a gesture would have been uncharacteristic, though a month later he is alleged to have told the Soviet ambassador that he was retiring from politics. What is certain is that the meeting marked the end of Ho's significant influence upon events—though not of his status as the personification of his country in the eyes of the world—and confirmed Le Duan as foremost power in Hanoi, with Le Duc Tho his most influential subordinate. Le Duan enjoyed an immense advantage over his foes, both in his own country and in the US: he was the only important player whose objective was clear and unwavering—to create a unified, Stalinist Vietnam. It is worthy of notice, that less than thirty years before the collapse of the Soviet empire, he displayed no glimmer of understanding of the epochal failure of its economic model.

Relations with Beijing—now more Stalinist than Stalin's Soviet successors—had become much closer. On August 2, the Chinese had signed an agreement promising direct military support for North Vietnam in the event of a US invasion. Whether Mao would have honored this is highly debatable, but in the autumn of 1963, the pact greatly strengthened the hand of Le Duan and his activist comrades in the politburo. China's president, Liu Shaoqi, visiting Hanoi, offered more active encouragement for the Southern liberation struggle than had any recent Beijing leader. Chinese weapons began to arrive in quantity and to flow southward, while 7,850 troops from the North made the epic trek to Battlefield B, as Hanoi designated the South. November's Party Central Committee meeting ended with an unequivocal commitment to a new proactive, aggressive, explicitly military campaign.

Le Duan and his colleagues thought the new Saigon regime would quickly implode and that the Americans were unlikely to dispatch ground troops in support of a lost cause. Anxiety to fill the power vacuum in the South caused them to decide upon an urgent escalation, expressed in Resolution 9, formulated in December 1963 and enshrined in two documents, of which one was published on January 20, 1964, the other remaining secret. The resolution was titled "Strive to Struggle, Rush Forward to Win New Victories in the South." Meanwhile at home, the hard-liners launched a new purge of "rightist deviationists," some of them heroes of the Vietminh era: thousands of officials, journalists, and intellectuals were dispatched for reeducation.

Resolution 9 was a historic commitment to wage an armed struggle to the bitter end. While Moscow and Beijing were troubled by its possible consequences, and for some months Soviet aid was near zero and the Russians had no ambassador in Hanoi, both became reluctantly convinced that they must be seen to support the cause of revolution and liberation with ever more generous arms supplies. Hanoi roused its supporters: "The time has come for North Vietnam to increase its assistance to the South. . . . The enemy . . . is using his armed forces to kill and plunder the people. . . . The only way to smash them is through armed struggle, which hereafter becomes decisive." Though the Mekong Delta witnessed the most immediate increase in guerrilla activity, the epicenter of the struggle would progressively shift toward the Central Highlands and the area northwest of Saigon. The communists' ambitious new objective was to engage, maul, and break the spirit of the South Vietnamese Army.

Some historians believe that in 1962–63, important opportunities were missed to make a peace deal. This may be true, insofar as the North Vietnamese, and Le Duan himself, for a season considered negotiating an American exit, followed by neutralization. It is wildly unlikely, however, that President Diem would have accepted a deal that involved sharing power with the NLF. Moreover, had a bargain been struck, this would have provided only the briefest pause before Vietnam became a unified communist state, because neither Hanoi nor COSVN would have renounced violence in exchange for anything less.

Hindsight may suggest that such an outcome, such a surrender, would have been preferable to the decade of murderous strife that instead ensued. Most South Vietnamese, and especially the Buddhist leadership, would have chosen peace on any terms. It was their American sponsors who rejected such an outcome, arguing that to sentence the people of South Vietnam to share the dismal economic, social, and political fate of their Northern brethren would be a historic betrayal.

The communists and the United States rightfully share responsibility for the horrors that befell Vietnam after the death of John F. Kennedy, because both preferred to unleash increasingly indiscriminate violence rather than yield to the will of their foes. American field artillery officer Doug Johnson said, "The first major turning point in the war was the assassination of Diem. From that day, we had lost the moral high ground. Everyone knew that we were complicit. Who was going to trust us? Serving in Vietnam, I thought, *I will do the best I can, and I wish these people well, without much hope that this will end in a good way.*"

THE MAZE

1. "ENOUGH WAR FOR EVERYBODY"

A general soothed the impatience of Lt. Don Snider on his passage to Vietnam, saying, "Son, there's going to be enough war for everybody." Snider, born in 1940, hailed from an Ohio cattle farming family. He had loved West Point, "because it represented the kind of values I had been raised with," and in 1964 he found himself training and advising Vietnamese special forces. All the Americans who served in those early days went by choice, finding thrills and also frustrations. Snider made operational parachute descents near the junction of the Vietnamese, Laotian, and Cambodian borders. "When I jumped out of the plane at night, I couldn't have told you what country we were over." They landed atop triple-canopy jungle, then roped themselves to the ground. He loved some of his American comrades, especially a formidable NCO named Sgt. Zahky. "What an opportunity it was, to go to war with somebody like that!" he said wonderingly. After days and nights of probing the enemy's territory, the hard part was to make the rendezvous with extraction helicopters.

Snider never bonded effectively with his men, most of them Nungs—ethnic Chinese. "In three tours I never really got to know them, to work out whom to trust. They were mercenaries. They said, 'If you pay me, I'll fight.' Eventually, however, the pay wasn't enough." Snider completed seven deep recon missions before transferring to the Delta to train and lead local defense forces on the Cambodian border. They ran into some bad

ambushes while searching for Lt. Nick Rowe, a Texan special forces man held by the Vietcong for five years. Snider came out of one clash humping a wounded interpreter on his back, with bullet holes in their radio. "There was no will among the Vietnamese people I was with. I thought, If this is the way we are going to fight this war, it is not going to be a successful proposition." By tour's end, "I didn't want any more to do with special forces or with the Vietnamese. I wasn't disillusioned with war. Experience had just taught me that what I was doing wasn't worth it."

Snider came to believe that the only advisers who accomplished worthwhile things were those who, unlike himself, forged relationships with local people. Frank Scotton, soon after arriving in-country, rode in a jeep with a sergeant who waved and smiled extravagantly at every civilian they passed. Scotton asked, "Why the big show?" The driver replied, "If I get captured, I want the Vietnamese to remember me as a big, dumb, friendly American." Helicopter door gunner Erik Dietrich loved his ARVN comrades, among whom he ferried many wounded back from battlefields, though sometimes not. "They died quietly, sometimes even with what I took to be an apology for the inconvenience and mess they were causing." Dietrich nonetheless admitted embarrassment when a little paratrooper whom he'd befriended tried to hold hands. "His last letter wandered about the country for a time before finding me: 'A month missing you. I couldn't help remembering of our working days. I never forget . . . I wish you a good luck on your way of duty. And when we see each other again, I shall give you a good narration." Dietrich reflected sadly later, "The 'narration' never got told. Nguyen Chanh Su, Vo Van Co, Bong Ng-Huu. What became of you all? Pham Gia Cau, you dear brave man who fought at Dienbienphu and walked south at the partition, to whose capabilities I unhesitatingly entrusted my life, you are ever in my prayers. . . ."

Some Americans, however, were driven almost to despair. On March 1, 1964, Foreign Service officer Doug Ramsey wrote home to his parents, "The fabric of this government is rotten to the core, and from top to bottom. You pull a lever and find that there is no cable attached to it; and if you manage to get hold of a cable, there's nothing on the far end of that, either. . . . Unless we are willing to promote real revolutionary change, I'm

afraid I must agree with those who say we have no business being here. If we cannot offer the people of Vietnam anything better than a protracted struggle, . . . if we merely continue to . . . bolster a feudal regime that is doomed anyway, . . . we cannot expect real support."

Ramsey later became assistant to John Vann, out of the Army and serving as regional pacification chief in the Delta. He described the colonel, starting with "the small, determined, reverse-slanting eyes, somewhat reminiscent of the movie star Lloyd Bridges, which transfixed you like blue-gray laser beams. His voice was slightly harsh, with a southern Virginia accent. He was fairly short, with blond hair thinning in front, and at forty-one, he was beginning to develop a slight paunch." Ramsey respected Vann's "animal physical vitality" which persisted through sixteen hours of every twenty-four, and the man's competitiveness. "He wanted to know everything about everything and everybody. With his prodigious memory and eye for detail, he could have been an immensely successful administrator . . . save that he cherished a passion for action. He described himself as a Virginia redneck at heart, and maybe he was. His loyalty to friends and loathing for foes were absolutes. He was also a fabulous networker, cultivating ruthlessly and usually successfully the acquaintanceship of anyone who might fit his purposes." Superbly athletic, he could perform a somersault from a standing start and was a showy volleyball player.

Lt. Gen. Fred Weyand said, "He was one guy I would have trusted with my life." Ramsey described Vann as fanatically self-disciplined about everything but sex: "John's idea of relaxation was to have two sisters on the same night, but I had no right to complain, because he offered to cut me in." He believed that for all Vann's manic womanizing, this muddled man retained a deep love for Mary Jane, the former wife whom he had betrayed so often. Army captain and adviser Gordon Sullivan admired Vann's grasp of Vietnamese realities, as opposed to games the people played to please Americans. "He'd say, 'I'm not interested in the dog and pony show.' A lot of the opposition to him came from jealousy."

Such thoughtful men as Doug Ramsey were alternately exasperated by failures of US policy and revolted by communist savagery. The latter's 188 .

atrocities took place daily: "shooting into school yards in the hope of getting three ARVN soldiers amid fifty children, or killing dozens of civilians in restaurants or on the streets to chalk up two Americans; mortaring towns willy-nilly to terrorize; assassinating unarmed teachers and murdering disarmed POWs; killing female friends of GVN officers, as well as the officers themselves." Ramsey urged that a successful pacification program must work through small local advisory groups, unashamedly modeled on communist cells.

He and Frank Scotton once arrived in a hamlet unannounced, and entered its chief's courtyard, and found a cluster of black-pajama-clad men, obviously NLF, conferring within. They scowled at the newcomers, but made no hostile move as both Americans were armed. The hamlet chief assured both groups that if everybody stuck to his own business, nothing unpleasant need happen. The communists eventually recognized the comedy of the situation and posed for photos. Nonetheless, when the Americans drove away, they were relieved there had been no High Noon. And sobered to witness the freedom with which the enemy transacted business in broad daylight within an hour's drive southwest of Saigon.

For all its difficulties and frustrations, Ramsey, like Scotton and Vann, loved the life. While rejecting Lawrence of Indochina comparisons, he liked to see himself as Spartacus, "though look what happened to him." He wrote, "At worst, being in Nam provided one with opportunities to pander to and magnify childhood macho self-images: the heroic swash-buckler, rifle in one hand and candy for the kids in the other, by day doing his thing for God, country, democracy and free enterprise, in an environment providing enough danger to keep the blood running fast, the stories flowing and building, the promotions coming through—and by night being able to sample all that Saigon had to offer. In the words of Tom Lehrer's 1953 'Old Dope Peddler,' in Vietnam, while doing good you could also do very well indeed." More than Lehrer's satirical ballad, however, Ramsey became increasingly obsessed with the music of Benjamin Britten's War Requiem.

The CIA's Frank Snepp came to Vietnam later but was cast in the same mold. He was the son of a fiercely establishment ex-Marine colonel and subsequent judge, with whom he had a troubled relationship. The most loving bond of his childhood in North Carolina was with his black nanny. His best claims to employment by the CIA on leaving Columbia's School of International Affairs, he wrote, were "Aryan blood, a country-club mentality, and an immense capacity for dissembling." He might have added, good looks that enabled him to sleep with an astonishing range of girls, some of them employed by the Agency. His critics called him priapic, though he would have preferred the word *romantic*. Two weeks into Snepp's first tour as an intelligence officer, the Pilatus Porter in which he was crossing the Mekong Delta took rounds in the wings from communist small arms, and the twenty-six-year-old exulted, murmuring to himself, "I love it! My God, I love it." He said later, "It was simply great. I fell in love with Vietnam and the Vietnamese. . . . I believed that if the CIA generated the right intelligence and got it to the right people, we could really make a difference for the better."

Harry Williams started working as a wireless eavesdropper in April 1964 and embraced the assignment eagerly: "This was a good war, a wonderful war. We were cowboys. I loved the work, and felt I was making a real contribution. I felt assured of the rightness of our cause, and that we would win." He left his pregnant wife, Peggy, at home in the US, and rented a Saigon apartment. Because he could speak their language, to his Vietnamese neighbors he was "the Frenchman." He traveled extensively around the country chatting to local people, in those days before wandering became prohibitively perilous. One day up near Danang, a village elder asked him in puzzlement, "Why did they kill Kennedy?" Williams found that many Vietnamese grasped the notion that the president had been seeking to help them, and vaguely suspected that his death might have been linked to this. The American decided that the default political stance of most local people was indifference to both sides: "The average Joe on the street really couldn't care less, except to stay alive."

The longer sensitive Americans stuck around, the more they lamented the change coming over Saigon. The tall plane trees on Tu Do were felled, and traffic doubled. Old hand Howard Simpson said, "The sleepy colonial capital had become a crowded, dirty wartime metropolis." Adviser Col.

Sid Berry wrote, "Saigon has greatly changed. . . . It has grown crowded, vulgar, glossy, commercial, grasping, greedy, dirty, tinny. Too many Americans. Far too many Americans. Who drive up prices, attract the cheap and gaudy and tasteless."

The tempo of the war rose steadily. Williams often dined at the Brasserie, a little restaurant behind the Rex Cinema run by a French-Vietnamese woman named Hélène. One night in August when he entered, she greeted him by saying seriously, "You should eat somewhere else." Sure enough, an hour later the place was bombed. That summer, Williams was assigned to a team monitoring North Vietnamese infiltration on the Ho Chi Minh Trail. They established a base at Khe Sanh, close to the western end of the DMZ, less than three miles from the border with Laos, where a special forces A-team was already ensconced. The key personnel were civilians from Syracuse University Research Corporation, a body created by the Office of Naval Intelligence. Their technology was dubbed POSSUM, Portable Signal Unscramble Monitoring System.

The plan was to plant sensors on nearby Hill 1701. On May 28 an H-34 airlifted Marine Capt. Al Gray and three Vietnamese to clear the summit with defoliants. Gray was an austere, dedicated warrior who relished the drollery that his ARVN sergeant had once commanded a Vietminh machine-gun company: "He was a great warrior." On the mountain, matters went sour: within hours of their arrival, rain and mist descended—and stayed down for thirty days, preventing the team's extraction. They subsisted for a while on starvation rations, then decided they must walk out. The descent went without incident save the usual leeches and big animals, until they emerged from the jungle to confront a man bathing: VC. They shot him, then bolted toward Khe Sanh. For the last six miles, Gray carried a wounded man, earning himself a Bronze Star. The electronic monitoring eventually got started.

Many of that first crop of Americans were earnest men who feared God as well as honoring the flag. Sid Berry wrote to his wife, Anne, "A good rest this weekend. Needed it. Now back to the fray. 101 sit-ups, 40 push-ups, 30 waistbands, two chapters of Romans, a shave, shower and now a letter to thee." Even some of those who spent fewer hours with their

Bibles than did the good colonel were less preoccupied with bar girls than legend suggests. A newly arrived special forces NCO looked in awe at the filth coating Frank Scotton and his team after days in the hills and said, "Gee, after your experiences I bet you guys go wild with the ladies when you get into town." Scotton disabused him: their first priorities were always the same—a bath and decent sleep in a clean bed.

A few Vietnamese managed to enjoy the war, including Nguyen Van Uc, who clocked six thousand hours as a helicopter pilot. "I loved flying," he said, "and got huge satisfaction from doing the job when it went right." Most of his countrymen, however, took a bleaker view. One morning in August 1964, Lt. Phan Nhat Nam of Saigon's 7th Airborne approached a bunker entrance in an apparently deserted village. "Anyone down there?" shouted one of his men, then turned to Nam. "Lieutenant, let me toss a grenade in." Nam, twenty-one years old and experiencing his first operation, told the soldier instead to fire a burst from his Thompson.

This prompted an old man slowly to emerge, sobbing, carrying an old woman with a hideous head wound. He laid her on the ground before bowing solemnly in all four directions. Nam felt shocked by the spectacle, together with that of two dead teenage Vietcong in a nearby ditch, the first enemy corpses he had seen. This was a Catholic community, and in its church he found five more bodies—those of a husband and wife clutching three children to their breasts, all killed by blast, as had been a young girl he found nearby, her purple blouse flapping in the breeze. Nam wrote, "I felt stunned and found it hard to breathe, in a daze from my anger and sense of boundless grief."

Next day, as his battalion swept through an almost abandoned village amid occasional bursts of enemy fire, he found a young woman sitting silent on the brick floor of a wrecked house, holding a wicker basket. "Her eyes looked straight ahead in a blank, stupefied stare." She stood up as the soldiers entered and Hieu, the radio operator, slipped past her into the ruined kitchen to search for food. Nam asked why the girl lingered in the midst of a battlefield. When he gestured toward her with his pistol, "she remained silent, her stunned eyes emitting a flash of terror. Suddenly, as if performing a gymnastic exercise, she thrust out the basket toward

me. It contained two sets of clothing, blouses and pants, a head-scarf and a small paper package tightly secured with a rubber band. When I opened it, I saw two gold-strand necklaces and a pair of earrings. Hieu muttered behind my back, 'This bitch is crazy. She's got so scared she's insane.' Then he caught the glint of the necklaces. 'Gold! It must be more than one *tael*! Keep it, lieutenant.' He motioned the girl away. She turned and began to walk, moving like a corpse."

Nam described how he called her back and held out the basket. Her hands trembled so violently with terror that she was unable to take it, and instead began to unbutton her blouse, sobbing the while. The young man was profoundly embarrassed: she had interpreted his rejection of her most valuable property as a sign that he sought her body instead. "What kind of life had she experienced, that in her terror she would unbutton her blouse and offer herself to a soldier who could be her younger brother, while tears ran down her terrified face?" Nam persuaded the girl to follow his platoon to the nearby river, crowded with sampans filled with fugitives from the fighting. People were calling out to learn the fate of their homes and families. Among them a voice screamed, "Lai! It's you, Lai!" This was an old woman who recognized Lt. Nam's traumatized follower. The girl stopped, "as if she was trying to summon up a memory from a past life." Then she cried, "Mother! Mother! Our house has burned down! Our house is gone." Nam described her walking away toward the water "like a person in a trance."

This narrative deserves notice on several counts. First, though some South Vietnamese units acquired a dreadful reputation for pillage and rape, there were also men like Nam, imbued with deep feelings both for his country and its humbler inhabitants. Many Americans persuaded themselves that "Asians don't feel about death the way we do." This was not so. Sid Berry was moved by the fortitude of those with whom he fought: "The Vietnamese wounded don't cry or moan or complain. They suffer silently and patiently. I've never seen anything like it. It tears your heartstrings to see them—and to watch them silently die."

A British reporter walked along a dike near Can Tho among a file of soldiers, one of whom chattered about his home in Nha Trang and

urged the visitor to come and see him there. The Vietnamese pointed covetously to the foreigner's suede boots: "Shoes you, number one." Their owner said that he could have them after the operation: "Oh, no. You very big. Small me." In the midst of a sudden rainstorm, a solitary mortar bomb burst among them, throwing the Englishman to the ground. To his surprise, no more "incoming" followed. "My hands shook and my heart thumped, and I heard a strange human sound quite close to me; half-sob, half-gasp. A helmet lay on the ground like an abandoned seashell and near it lay my new friend from Nha Trang. He was clasping his stomach with one hand, and pushing at the ground with the other. . . . His eyes were screwed up, and rain poured down his face, and I suddenly was aware of a terrible smell. I opened his sodden shirt, and saw that below his breastbone was nothing but a dark, shining mess—ripped clothing stained with rain, blood, bile and whatever comes out of bellies torn open by metal splinters. His eyes flickered open and he frowned. 'Hurt me,' he said faintly." And soon after, he died.

Many higher commanders became regional warlords. A 1966 American report claimed that only one senior officer had been wounded in action since 1954. Frank Scotton described how Vietnamese love to play co tuong, the Chinese war game Capture the General, resembling its old European counterpart L'Attaque. There are realistic pieces with realistic limitations—for instance, infantry cannot cross a river back. And the generals at the heart of the game cannot leave their tents, which was true of most of their Saigon counterparts.

District chiefs were allocated rice for their soldiers, of which they would appropriate a generous portion before issuing the balance to those for whom it was intended. Police chiefs made fortunes by selling licenses for every form of commercial activity—running restaurants, fishing, logging. "In the extended family culture you would probably have been considered sinful not to take advantage of the opportunity to help your family," said Edward Brady, who spent years as an adviser. A general would solemnly assert that he never sold a commission, and indeed did not—instead his wife and mistresses did the business on his behalf. "[The officers] divorced themselves from that reality. The Vietnamese are great at that. They have

this mental ability to dissociate themselves and claim innocence." Nguyen Cao Ky wrote sourly, "Most senior Vietnamese officers were concerned only with pleasing their [American] advisor."

Then there was the other side. Prompted by the deepening Sino-Soviet split, Mao Zedong changed his tune, suddenly seeing virtue in an intensified Vietnamese struggle. He offered Le Duan a big new injection of aid and a conference of Asian communists without the Soviets. Politburo members began to call the Chinese "comrades"; the Russians, only "friends." So bitter became the ideological strife that forty Vietnamese working or studying in Russia—many of them close to Giap—requested asylum. Foreigners noted that Russian works were withdrawn from sale at Hanoi's only foreign-language bookshop. Le Duan nonetheless turned down Mao's conference scheme: he had no desire to precipitate an absolute rift with the Bear, who could offer more sophisticated weapons than the Dragon. He and Le Duc Tho led a delegation to Moscow to reassure the Russians that they would not breach the Soviets' global policy of peaceful coexistence.

At a March 1964 conference in Hanoi, Ho Chi Minh made a remarkable personal plea for moderation, emphasizing the leadership's decision to send no NVA regular formations South. Nonetheless, an increasing number of cadres, advisers, and specialists made the journey down the Trail, suffering hardships that owed little to American interference, almost everything to the terrain: shortages of food and medical supplies but none of weather, bugs, and malaria. The Vietcong campaign received from the North fifteen tons of munitions per day by land and sea, to service a force estimated at around 170,000, including 30,000 deployed in main-force units. Among both Northern hard-liners and the Southerners at COSVN, bitterness persisted about the perceived pusillanimity of Ho's faction, when the Vietcong were fighting for their lives.

However, North Vietnamese war making, driven by Le Duan and Le Duc Tho, was becoming infused with a new urgency, a determination not to wait twenty years for unification. Within weeks of the spring 1964 promulgation of Hanoi's Resolution 9, in the South there was a 40 percent rise in Vietcong-triggered local incidents and a 75 percent rise in

bigger attacks. The guerrillas introduced their own conscription system, intensifying peasant miseries in areas they controlled. In one Delta village, three hundred young men found themselves forced to take up arms for the revolution, whereas a mere eighty served with Saigon's forces. A VC draftee's aged father abused the cadres, saying, "You always criticize the imperialists, but you are even worse. I want my son back."

David Elliott has written, "Brute force and subterfuge were the main methods of dragging reluctant recruits into a service which the rural youth had come to dread as an almost certain death sentence." Meanwhile NLF taxes were higher than Saigon's, forcing the average peasant to surrender at least 20 percent of his income. One, who lived in a nominally government-controlled village, said that in 1964 he paid 125 Vietnamese piasters to the government and 900 to the NLF, out of an income of 17,000 from selling mangoes. In the following year, disaster struck; his income fell to 3,000 piasters, but the communists were implacable in extracting from him all but 200.

The best of the Vietcong's main-force units were now deployed in the Central Highlands and the so-called Iron Triangle, 125 square miles of dense country, fifteen miles north of Saigon. Most of their operations were carried out in company strength, because it was hard to concentrate larger units. Esprit de corps was highest among the sappers—demolition platoons—who in exchange for playing the most skilled and dangerous role on the battlefield, were subject to more relaxed discipline away from it. When the guerrillas sought soft targets, they attacked civilian vehicles, especially buses, often with fatal consequences for passengers. Village and local VC units were instructed to establish "anti-American annihilation perimeters," to protect the revolution's areas of control.

Some government RF and PF—Regional Forces and Popular Forces—militiamen sold their weapons for cash, and the Vietcong established a price list: 2,000 piasters for an M1 carbine; 8,000 for a Browning automatic rifle; 8 piasters per round of ammunition, and 20,000 for the surrender of an entire post. The commander of one such place did even better, emerging in darkness with a lantern over his head to collect 30,000

piasters from the local guerrillas, who then rushed through the gate he had opened, prompting the flight of the little garrison, leaving behind five dead and two wounded.

Unless Vietcong units bivouacked in remote and secure sanctuaries like the Plain of Reeds, most shifted camp every seventy-two hours, marching eighteen miles a day in the dry season, fifteen in the wet. They were at their most vulnerable when they moved, especially when traversing roads. One of Van Ky's old Vietminh ballads was entitled "Crossing the Highway." Wet feet left telltale tracks, so the guerrillas carried waterproof cloth to unroll ahead of their passage at sensitive points. Village chiefs were expected to maintain hidden reserves of rice for units that bivouacked with them, and also to supply porters. These were often women who served in relays, each carrying three rifles, a single shell, or 250 small-arms rounds. Some girls enjoyed porterage, because it introduced them to young men. By contrast, the task they all hated, guerrillas and conscripted laborers alike, was digging trenches and bunkers. This, at least, they had in common with their ARVN and American foes. The VC lost a steady stream of defectors, but the government's treatment of these chieu hois was often unimaginative. When a guerrilla leader who had commanded a successful attack on a government post changed sides, he found himself translated into a South Vietnamese private.

The airborne defoliation program, which became more intensive in 1964, caused the VC real difficulties by destroying natural cover; moreover, while government forces suffered plenty of defeats, they also had their successes. One day in the Delta, the Vietcong's fabled 514th Battalion suffered a notable reverse in a clash with ARVN in the hamlet of Ap Bac, where John Vann's ambitious plan had miscarried so disastrously. Following the communists' 1964 defeat, they repeated the folly perpetrated by Gen. Harkins a year earlier—lying about what had taken place. Cadres spread word that they had killed a hundred government troops for the loss of only twelve of their own men. Local people, however, had not merely seen the nearby road strewn with VC dead, but also numbered some of their own sons among them. Grieving parents went to desperate lengths to discover where bodies lay, so that they might dig them up and

rebury loved ones in family plots. A cadre wrote in the unit log, "As a result of this battle the 514th Battalion went into a serious decline." On another occasion three communist units concentrated for an attack on an airfield, suffered a murderous repulse—and also tried to lie to the people about what had happened.

This credibility gap cost the local NLF a temporary decline in peasant support. It did not last, however, for the usual reason: government fire-power blasted away every wisp of goodwill. Civilians suffered far more grievously from careless air strikes and shelling than did Vietcong fighters, who were surprised by how few casualties they received, if dug in. A peasant told a RAND interviewer, "The Americans strafe and destroy too much. They only kill the people, and not many VC." Cadres told peasants, "[The government] will kill you even if you do not fight against them, therefore you might as well fight before you die." Too many Vietnamese agreed. While the communists suffered their share of defeats in 1964, the overarching theme was that they gained ground and popular support, while the forces of the Saigon government lost them.

2. DODGING DECISIONS

President Lyndon Johnson said long afterward about Vietnam, "I knew from the start that I was bound to be crucified either way I moved. If I left the woman I really loved—the Great Society—in order to get involved with that bitch of a war on the other side of the world, then I would lose everything at home. . . . But if I left that war and let the Communists take over South Vietnam, then I would be seen as a coward and my nation would be seen as an appeaser and we would both find it impossible to accomplish anything for anybody anywhere on the entire globe."

Every president inherits a stable from his predecessor—starts out riding someone else's horses. The war was the least biddable of Johnson's. Creation of the Camelot legend began within a microsecond after the bullets struck John F. Kennedy. The first assurance that his successor gave to Congress and the American people was that he would sustain the legacy, and it is impossible to see how he could have promised anything else.

198 .

Johnson took pride in being the rough-hewn Texas ranch owner, mocked for his homely maxims ("Don't spit in the soup; we've all gotta eat"), for his supposed taste for okra with black-eyed peas, and for being photographed holding up a beagle by its ears, but he was nagged by his own lack of refinement alongside the Kennedys and their courtiers. Johnson said much later, in a fit of self-pity about his alleged abandonment by JFK's men, that in 1964 he had "kept on the eleven cowhands"—the Kennedy cabinet.

Setting aside the elephant of Vietnam, the former vice president was a much more effective politician than the wartime commander of PT-109. Every human being needs to get comfortable with himself, however. Such togetherness was achieved by Jack Kennedy, but it eluded Lyndon Johnson, going far to explain the latter's tragedy. America's top military men were wary of him, not least because of sorties into windbaggery about his own record in World War II. He once told a reporter that he had been known as Raider, an implausible claim since his combat experience consisted of flying as a passenger on a single 1942 B-26 mission in New Guinea, which secured the visiting Texas congressman one of the more tarnished Silver Stars awarded by Gen. Douglas MacArthur.

No legacy imperative obliged the new president to bomb North Vietnam, nor to dispatch half a million troops to the South. It was unthinkable, however, that in his first year of office—a reelection campaign year—he should tell the Americans already in Indochina to pack up and come home. Nothing that came later was inevitable, but everything derived from the fact that sixteen thousand men were in-country because John F. Kennedy had put them there. Just before David Nes took off to become deputy US mission chief in Saigon, his commander in chief told him: "Lyndon Johnson is not going down as the president who lost Vietnam. Don't you forget that."

At the end of November 1963, MACV launched a new initiative to strengthen government control in the Mekong Delta. This involved wide-spread shelling of rural areas, and the declaration of "free-fire zones," wherein anything that moved was assumed hostile. Villages were aban-

doned, and their inhabitants took up residence in shantytowns along Highway 4. Some peasants adopted white clothes instead of their traditional black, because American pilots assumed that the latter was dress code for guerrillas. The new aggressive policy was effective in lowering Vietcong morale and eroding popular support. It did nothing, however, to promote loyalty to the Saigon government, as distinct from temporarily outbidding the communists in the auction of peasant terror.

Then the generals started something new. Big Minh had been running the country for less than three months, but some of his fellow officers already had lost confidence in him. So, too, had the Americans. McNamara visited Saigon in December and was appalled by the chaos. The US mission believed that Minh, like Nhu before him, had become dangerously interested in talking to Hanoi. The general was also a skeptic about the strategic-hamlets program and the merits of bombing. On January 28, 1964, thirty-seven-year-old Gen. Nguyen Khanh traveled down to Saigon from his headquarters at Hue on a scheduled Air Vietnam flight, wearing civilian clothes, supposedly to visit the dentist. In the early hours of the 30th, he donned uniform and drove to ARVN headquarters with an aide. Khanh expected to rendezvous there with paratroopers and a close colleague, Gen. Tran Thien Khiem, to stage a coup to depose the Minh junta. Instead, he found the building in darkness. He telephoned to ask Khiem why nothing was happening. "Oh, I must have forgotten to set my alarm clock," said this indolent plotter, "but don't worry, we have the situation in hand."

The coup indeed proceeded smoothly. At daybreak the new leader of South Vietnam broadcast to the nation, saying that he was assuming power because Gen. Minh and his colleagues were messing up the war. Not a shot was fired. The inevitable Lou Conein had flagged the plot to his superiors, who decided to acquiesce because they accepted Khanh's claim that Minh had become eager to neutralize Indochina, a concept wholly unacceptable in Washington. McNamara and Lodge thought the newcomer "the ablest of the generals." The most notable achievement of his first days in power was the liquidation of Maj. Nguyen Van Nhung,

killer of Diem and Nhu. This professional executioner was himself professionally executed, being ordered to kneel in the garden of a Saigon villa, then presented with a single bullet in the back of the head.

South Vietnam and its army were reduced to confusion and demoralization under a military "strongman" who quickly appeared weak. British ambassador Gordon Etherington-Smith thought that the US should have prevented the coup: the readiness with which Washington turned down its thumb on Big Minh suggested that the governance of South Vietnam was now at the disposal of any senior officer with a few regiments. Etherington-Smith wrote to London extolling Khanh's "bounce and fluency" but lamenting, "It seems increasingly probable that the very qualities which make Khanh attractive to American soldiers render him unpleasant to a very great many Vietnamese."

Khanh quickly began to agitate for an invasion of North Vietnam, on the grounds that it was unacceptable for the war's death and destruction to be confined to the South. He was not alone in cherishing this fantasy: some Saigon soldiers and politicians ever afterward argued that they could have won the war, had the Americans allowed them to strike into the North. Bui Diem, Saigon's former Washington ambassador, argues that the Southern cause was doomed from the moment the US ruled out this option: the communists could be sure of eventual victory if they merely did not quit. Such enthusiasts were thus far correct, that Hanoi enjoyed an important advantage, because it need make scant provision to meet a major ground attack, while its own soldiers roamed freely in Laos, Cambodia, and soon South Vietnam. But the US government displayed wisdom by forswearing any such overreach as MacArthur had perpetrated by racing to North Korea's border with China in November 1950. Moreover the Saigon generals deluded themselves in supposing that the ARVN could unaided have mounted a successful invasion: in such an eventuality, they would assuredly have been repulsed.

Khanh's adventurism nonetheless compounded the discomfort already prevailing in Washington. Decision makers began to see that the general's fluency and affability were his principal virtues. He was a less intelligent man than the displaced Minh, with a meager understanding of his own people. Even those Americans who assumed that South Vietnam must be ruled by generals now strove to identify some new ones who were clever, effective, honest—and biddable. This last requirement was the hardest to fulfill, because the only way for any Vietnamese leader to secure popular respect was to distance himself from the US. Twenty-year-old embryo officer Doan Phuong Hai was bewildered, dismayed, and rendered increasingly cynical by the four changes of command at Dalat Military Academy following successive Saigon coups during his time there: "We young cadets began to see that our seniors, rather than being imbued with the spirit of military brotherhood, turned on each other in pursuit of personal gain, power, fame."

In those early months after the change of US president, almost every military option was on the table in Washington, at Lodge's embassy, and at MACV. A key question was: who is our enemy? Was the rightful target for American might the communist guerrilla force fighting in South Vietnam? Or instead North Vietnam, which was seen—half rightly, half wrongly—as the struggle's fountainhead? America's Joint Chiefs of Staff, now chaired by Maxwell Taylor, tended to favor the latter view. Among them were two "weak," or at least cautious, men—the Army's Gen. Earle Wheeler and the Navy's Adm. David Macdonald—and two "strong" ones who cherished a clear vision. These latter were the Air Force's Gen. Curtis LeMay, ringmaster for the 1945 B-29 firebombing campaign against Japan, which killed far more people than the atomic bombs, and Gen. Wallace Greene of the Marine Corps.

Both favored deploying either overwhelming force or none at all. LeMay was an intemperate, obsessive advocate of strategic air power, arguing every case he espoused "with an abrasive voice that could sometimes whine like a turbine engine," in the words of a colleague. For instance, he fiercely resisted soldiers' demands to be allowed to operate their own helicopter gunships, one day removing the cigar customarily clamped to his lips to bellow at the army chief of staff a challenge to fight a duel: "You fly one of these damned Hueys and I'll fly an F-105, and we'll see who

202 .

survives. I'll shoot you down and scatter your peashooter all over the goddam ground!" McNamara decided this particular dispute in favor of the Army, a call that only enhanced LeMay's disdain for the defense secretary.

Greene's quiet, professorial manner earned him the nickname Schoolboy. He was intolerant of the instinctive caution of politicians, and even more so of the virtues of limited war, favoring "prompt, positive, dramatic and consistent action . . . pursued with the full concerted power of U.S. resources." Like LeMay, he believed that North Vietnam could quickly be brought to heel by devastation of its installations and infrastructure. Greene told Lyndon Johnson on March 4, 1964, that air strikes might well precipitate another Korea-type conflict, with a risk of escalation into global war. "However, the bitter fact was that we were going to have to take a stand somewhere and the decision which he was going to have to make, as President, was—whether or not [Vietnam] was where this stand should be made." Maxwell Taylor, who remained chairman until July, when Wheeler replaced him, changed his mind so often that he could later claim to have advocated at least five different policies, according to taste and date. The general came increasingly to believe that, since defeating the Vietcong in the South was so intractable a task, the US should instead focus on punishing the North. He thus became an exponent of bombing.

The Chiefs' impact on policy making was limited, partly because successive chairmen conveyed to the White House anodyne expressions of JCS views and partly because the president spent far more time with his civilian advisers, among whom McNamara carried most weight. A more unexpected influence was lawyer and soon-to-become Supreme Court justice Abe Fortas, who knew nothing about Vietnam but was the president's most intimate counselor, communing with him almost daily. Those who have sought to blame the Chiefs of Staff for America's 1964–65 policy choices seem mistaken, because all decisions for war or peace are ultimately political. Even after the Korean experience, most of America's senior officers displayed an imperfect understanding of the merits of limiting conflict. Had the brass been permitted to dictate the course of events, they might well have mandated an even more disastrous escalation than that which took place.

The most remarkable aspect of the Washington debate was that it was almost entirely fixed upon identifying the appropriate level of force to apply, rather than considering the case for extraction by political means. It was a weakness of Dean Rusk, that though responsible for America's diplomats, he never had much faith in diplomacy. Lyndon Johnson seldom engaged with foreign leaders, far less allowed himself to be influenced by their opinions. Throughout the first year of his administration, its principals showed themselves morbidly fearful of France's influence, believing that President Charles de Gaulle's enthusiasm for Vietnam's neutralization reflected a spiteful desire to see the US humiliated.

Great states have an unsurprising predilection for fighting the kind of conflict that suits their means, rather than the one they have got. In World War II, the Western allies were spared from most of the embarrassments of being two naval powers confronting a land power, because the Red Army did the heavy lifting to destroy Hitler's Wehrmacht. In Vietnam, Washington policy makers assumed that US technology and firepower could substitute for the acknowledged absence of a viable political and social structure. Lt. Gen. Andrew Goodpaster once warned Robert McNamara, "Sir, you are trying to program the enemy and that is one thing we must never try to do." An American prisoner told his communist interrogators that he thought his compatriots' presence in their country was prompted 10 percent by concern for the Vietnamese, the rest by a determination to check Mao Zedong. In that case, demanded his puzzled captors, "Why do you not go and fight him in China? We do not like the Chinese either."

In the spring of 1964, Walt Rostow, director of policy planning at the State Department, reprised LeMay's enthusiasm for the application of overwhelming air power. No credible studies were carried out about the costs and consequences; it was merely assumed that the North Vietnamese would find the experience of being bombed sufficiently damaging and dispiriting to mend their ways. Some senior officers favored going further, dispatching ground forces into Laos to cut the Ho Chi Minh Trail, or into North Vietnam. The phrase "going North," which recurred repeatedly in meetings and memoranda during the 1964 debate, embraced the bombing option, covert operations, and full-scale invasion. In April Curtis LeMay

204 .

asked the C-in-C Pacific what would be needed to win the war. Adm. Harry Felt responded that the US "would have to go North some time." From the spring of 1964 onward, McNamara was conspicuously gloomy about Vietnam. Instead of causing him to advocate withdrawal, however, pessimism moved him slowly and reluctantly toward favoring escalation, eventually with perfervid zeal. In April a reporter sallied that Senator Wayne Morse was calling Vietnam "McNamara's war." The defense secretary riposted defiantly, "I don't mind its being called McNamara's war. In fact I'm proud to be associated with it." Bobby Kennedy observed that this remark did not seem very smart politics.

Conservative journalists, such as William F. Buckley, Marguerite Higgins, Rowland Evans, and Robert Novak, insistently urged fighting to a victorious finish. Joseph Alsop taunted Johnson for an alleged lack of guts, unleashing the dreaded charge of appeasement. Yet while the president would certainly have received slings and arrows from such people had he pulled back, there were now also plenty of media folk who understood the mess the United States had gotten itself into. Johnson's personal standing was sufficiently high that he would have been believed if he had told the American people that they were backing losers in Vietnam. He would have received influential backing for such an admission from the likes of Walter Lippmann, *New Republic*, and the *New York Times*, which predicted disaster if the nation committed combat troops.

Inside government, from May 1964 Undersecretary of State George Ball displayed prescient pessimism. He rejected the view that the US had vital interests at stake and said he could not see why attacking North Vietnam should boost the Southern government. He argued that the war was unwinnable, whatever level of force the administration committed. Gloomy about the Khan regime's sustainability, the intelligence community was of the same opinion. At the US Embassy, after two months in Saigon, on February 17, David Nes put on record to Lodge his belief that de Gaulle was right, that the US should either get out or reconcile itself to a major escalation. Willard Matthias, an analyst with the CIA's Board of National Estimates, described the Vietcong as "under the direction of

the Hanoi government but dependent largely on their own resources." He, too, urged a settlement.

Pentagon aide John McNaughton, though a passionate admirer of McNamara who followed his boss up the escalator, in the spring of 1964 experienced a stab of doubt and self-knowledge when he told his friend Michael Forrestal, "You always think we can turn this thing off. But I wonder. I think it gets harder every day, each day we lose a little control, each decision that we make wrong, or don't make at all, makes the next decision a little harder, because if we haven't stopped it today, then the reasons for not stopping it will still exist tomorrow, and we'll be in even deeper." McNaughton was in no doubt about the selfishness of US purposes in Indochina, enumerating these a few months later: "70% to avoid a humiliating defeat (to our reputation as a guarantor), 20% to keep South Vietnam (and the adjacent territory) from Chinese hands, 10% to permit the people of South Vietnam to enjoy a better, freer way of life."

Scarcely anybody in Washington privately doubted that the Saigon government was rotten, that the war was languishing. Until November 3, however, and Lyndon Johnson's confirmation by the American people as their electoral choice of president, bad news was inadmissible: they must merely hang in there. In March McNamara visited Vietnam with Max Taylor and delivered a ringing endorsement of Gen. Khanh, the new capo. Brig. Gen. William DePuy wrote home from Saigon, "Soon all the people in Washington will be in Vietnam and there won't be any room for Vietnamese. That perhaps is one way to win the war."

In the ARVN General Staff building, Rufus Phillips passed a Vietnamese major whose desk was piled high with books. The visitor asked what he was doing. "I'm helping to write the constitution." Beside the officer lay books on the American and French constitutions and all previous Vietnamese versions, such as those were. Gen. Khanh had assigned him this task, he said. A draft was passed to the US Embassy, which conferred its seal of approval. Khanh informed his fellow generals, some of them dissenting, that this was what the Americans wanted; thus it was duly implemented. Then the new constitution provoked Buddhist and student

protests. Max Taylor scolded Khanh for doing things all wrong. The Vietnamese was understandably indignant: had he not done exactly what his mentors demanded?

Rufus Phillips fumed about the mind-set this episode reflected. "We had carefully, painfully for nearly ten years tried to build up this very fragile new nation. Then we destroyed any kind of stability. And every time a general would run a coup during the 'revolving door' period, all the previous guys were kicked out. We were getting people in power who just didn't know the score at all. And the bigger our involvement became out there to compensate for the chaos, the more we displaced the Vietnamese leadership. We decided that we were going to win the war and then give the country back to the Vietnamese. That was the *coup de grace* to Vietnamese nationalism. . . . And this became the basic issue that the communists played on."

The defense secretary submitted to the president a report that, characteristically, McNamara had drafted before visiting Saigon, articulating his perception of US purposes: "We seek an independent non-Communist South Vietnam. Unless we can achieve this objective...almost all of Southeast Asia will probably fall under Communist dominance." This became the basis for the NSC's National Security Action Memorandum (NSAM) 288, emphasizing America's commitment. Thereafter the administration proceeded on the assumption that its goals could be fulfilled by the application of military power, heedless of the attitudes of the Vietnamese people. The only virtue it deemed indispensable in a local ruler worthy of Washington's endorsement was that he should forswear any parley with Hanoi.

Behind closed doors, McNamara readily admitted that the situation in Vietnam was "a hell of a mess" and that another Saigon coup could take place at any time. However, both he and the president rejected absolutist counsel, both from those who favored abandoning South Vietnam and from those who sought a dramatic raise in the stakes. Johnson professed skepticism about whether bombing the North would achieve much. In the early election campaigning months of 1964, both men emphasized their commitment to the regime but were unwilling to go beyond small, incre-

mental steps in managing the war, such as would not attract unwelcome notice from voters. When Soviet ambassador Anatoly Dobrynin had his first meeting with the president on April 17, to his surprise, Vietnam was scarcely mentioned.

The following month, a flare-up of fighting in Laos caused France, India, Cambodia, and the USSR to call for a reconvening of the 1962 Geneva Conference. The Americans rejected the proposal, lest neutralization of Vietnam should also become an issue. Yet if they wanted out, such a forum might have opened a door. McNamara's man Daniel Ellsberg, later famous as leaker of the Pentagon Papers, identified 1964 as "the last time in which a loyal bureaucrat could conceive of it being appropriate for the US just to cut its losses." By the beginning of the following year, America had suffered so many failures and humiliations, both military and political, that a withdrawal would inevitably be viewed by the world as a defeat such as no administration could readily countenance. In the early summer of 1964, however, matters were not yet that bad.

The defense secretary's prevarication—as the Joint Chiefs viewed it exasperated especially LeMay and Greene, who were convinced that mere persistence with existing policies would not suffice to turn a tide that, all parties agreed, was running strongly for the communists. They were also impatient with Taylor, their chairman, who they felt was unwilling to tell the president and McNamara harsh truths they didn't wish to hear. Through the spring, the mood among the brass grew sourer. Johnson's military aide Maj. Gen. Chester Clifton wrote on March 27, "I sense a potentially difficult—and even dangerous—situation. . . . The Chiefs are badly split." Greene wrote contemptuously on May 18, "We see both Mc-Namara and Taylor deliberately fishing for courses of action." The election seemed too far off to keep losing the war meanwhile, a view shared by such commentators as Hanson Baldwin, influential military editor of the New York Times, who now favored bombing the North. Greene not merely despised the defense secretary, but also believed that the Chiefs were being prevented from fulfilling their proper role as military advisers to the nation's commander in chief. However, both he and LeMay at the time, and some historians afterward, displayed naïveté in failing to recognize

that in all countries at all times, frustration with political leaders is the default posture of professional warriors, who are themselves almost invariably blessed with less wisdom than they suppose.

On May 17, the lean little World War II veteran and aspiring military intellectual Brig. Gen. William DePuy wrote to his wife, Marj, from Saigon, "I haven't made up my mind whether we are gaining or losing ground. It is grave indeed. Whether the 'will' exists I do not know." He added a week later, "It is awfully difficult to tell how all this turmoil will come out. Without a miracle it will drag us further down." By the end of that month, in Washington matters had moved on thus far, that Mc-Namara discussed with the Chiefs the option of committing US ground troops, and also commissioned a study of bombing targets in North Vietnam, which produced a list of ninety-four. It was acknowledged that one or both of these courses would be adopted, unless Hanoi backed off: reconnaissance flights indicated increased usage of the Ho Chi Minh Trail. There was a recognition that some legislative underpinning would become necessary if it was decided either to bomb or to send troops—what the acting attorney general Nicholas Katzenbach called the "functional equivalent of a declaration of war." Late in May, State's William Bundy produced a resolution empowering the president to commit US forces, but his draft was merely docketed: no need just yet to face the Senate's awkward squad, headed by Mike Mansfield and Wayne Morse.

In the presidential election campaign now engrossing the nation, far more rhetoric was addressed to Johnson's promised Great Society than to Vietnam. "Kennedy had demanded sacrifice; Johnson promised happiness," wrote Theodore White, chronicler of presidential contests, in 1965. "Even the quaking globe seemed to settle down during spring and summer to permit Johnson to conduct his foreign affairs from what may be called an at-ease position. Vietnam was the only crisis, slowly worsening from week to week—but the president arranged temporarily to sterilize that politically."

The White House nonetheless decided that new blood was needed in Saigon: both the ambassador and MACV's commander in chief were replaced. Lodge had run out of ideas, and was scarcely on speaking terms with Harkins. The names of Robert Kennedy, McGeorge Bundy, and Robert McNamara were mooted as possible successors before the choice fell upon Max Taylor, the soldier most personally trusted by the president. Taylor was sent in July not to do diplomacy but to run a smarter war. If the general had not been addicted to office, position, and power, at sixtytwo he would surely have declined to occupy such a bed of nails. It is hard to imagine how he could have supposed that assuming proconsular responsibility at such a time in such a place would enhance his reputation. Nonetheless, accept the embassy Taylor did, confirming the view of skeptics among his World War II comrades, who considered that the general's vanity and penchant for backstairs politicking notably exceeded his talents and judgment. Taylor's place as chairman of the JCS was taken by Gen. Earle Wheeler, a bureaucrat and military power broker with little field experience, whom Gen. Harold Johnson succeeded as army chief. With Taylor in Saigon, it was never likely that Wheeler would have a dominant voice in Vietnam strategy making, but the new chairman's weakness of character soon became apparent.

Gen. William Westmoreland, who on June 20, 1964, took over MACV, said, "I inherited this political chaos. . . . It was almost like trying to push spaghetti." Harkins was permitted to retire with honor, though his failure had been egregious and his misjudgments apparent. His successor was junior to Taylor, while directly answerable to the Navy's C-in-C Pacific. Before Westmoreland was appointed, questions were asked about whether he was sufficiently big, bright, or tough for the job. It is alleged by some that the Chiefs instead wanted Harold Johnson, Creighton Abrams, or Bruce Palmer in command; that Taylor was characteristically deceitful when he informed the president and McNamara that "Westy" was the ICS choice.

Westmoreland has often since been derided as "the most impressive regimental commander the US Army ever produced," and it is hard to make a plausible case that in Vietnam he showed himself one of history's great captains. One of his staff, a Marine, wrote home: "He has a good grasp of the whole picture, a quick ear for the trouble spots but he lets his imagination run away with him. Some of his projects are crazy." It seems

2IO · VIETNAM

nonetheless unlikely that Sherman, Patton, or even Ridgway would have done better. Soldiers observe wryly that the unique selling point of their profession is that they kill people. It is too much to ask of most, that they should resolve political and social challenges beyond their intellect, experience, conditioning, and resources.

Westmoreland said later, "Very much ringing in my ears and the ears of all officers at that time was Mr. Kennedy's very emotional and stirring inaugural address: 'We'll bear any burden and meet any hardships, support any friend, oppose any foe, to ensure the survival and success of liberty.' . . . We felt pretty good about going to Vietnam to fight for such an idealistic principle." If such an assertion sounds trite to a cynical twenty-first-century listener, it seems mistaken to question the sincerity of the general's fervor when he took up his post in 1964. Like almost all military professionals, he was imbued to excess with the spirit of "can do."

The price of such an attitude, however, was that on Westmoreland's watch realism was banished as surely as it had been under Harkins. Old Indochina hand Howard Simpson was reassigned to the US Saigon Embassy at this time. In transit he attended a Honolulu strategy summit at which the cast was headed by McNamara, Rusk, Taylor, Westmoreland, and CIA director John McCone. Simpson noted with dismay that no one present had real knowledge of Vietnam, and his spirits sank further as he followed the ebb and flow of discussion: "I soon learned that the lessons of recent history were not on the agenda. The French had lost. We were going to win. . . . I could have shut my eyes and imagined myself sitting through a briefing at the French high command in 1953."

Simpson did not dare speak out himself, but he listened in disbelief as plans and projects were explained that he knew no Vietnamese would implement. Worse, indeed, Saigon's soldiers and officials would adopt their familiar tactic of agreeing to everything while intending to do nothing. "The Vietnamese were being cast as the little men who weren't there. To all intents and purposes they appeared to have become outsiders in the struggle for their country." This was profoundly true, profoundly important. The Americans, so proud of their own anticolonialist heritage and mind-set, were bent upon conducting a war in exactly the style of colo-

nialist governments through the ages. Frank Scotton defined the average American's attitude to the Vietnamese as "callous disregard. Americans of all grades joked about Vietnamese technology being defined by picking up one thing with two sticks or carrying two things with one stick. . . . We were allies who understood very little of each other."

In South Vietnam, force quite often sufficed to inflict tactical defeats on the communists. Yet such sensitive Americans as Scotton, Simpson, Vann, and Ramsey understood that battlefield successes could contribute astonishingly little. Perhaps the foremost irony of the war, especially for those who perished, was that fighting was the least important part of it, as against the social and cultural contest between Hanoi and Saigon. By delegating the central role in the American mission to Max Taylor, the administration mandated an electrician to address a lethal gas leak, though Taylor himself used a different figure of speech: "My task was that of the Dutch boy with the leaking dike, sticking in his thumb to plug the thing up." William DePuy wrote to his family as Westmoreland took over, "We can't win, but we can perhaps keep from losing."

That summer, as throughout the war, days of relative tranquility in Saigon promoted spasms of optimism in Washington that big decisions might be deferred. Westmoreland, with Lodge's support, told the Honolulu strategy conference that "the situation had bottomed out, was leveling off, and would start slowly uphill. . . . There would be no collapse in SVN unless there was some unusual violent occurrence such as a coup or assassination." McNamara and the CIA's McCone urged a bleaker view, but Westmoreland and the outgoing ambassador stuck to their guns.

The general excelled at the part of his role that demanded managerial skill. One officer described his staff as "the crème de la crème." Dick Stilwell, the chief of staff, and punchy, pint-size DePuy as operations officer were workaholics like their boss. The administration of a fast-expanding US presence was conducted with notable efficiency, albeit at brutal cost to the social and natural environment. The fighting part, however, went less well. On July 28, DePuy wrote home, "There is a great collection of brass in this area. Frankly the poor little Vietnamese are overwhelmed and bewildered, and I am not sure they are not slightly frightened by it

2I2 · VIETNAM

all... visibly weary of the war and apparently unwilling to contemplate another ten years of grinding, tedious but bloody pacification. I am sure they would like to have us attack North Vietnam for them." DePuy added in August, "It's hard to see how we can win if the leaders of the country don't think they can win."

In Washington, the mood became slowly, secretly, but relentlessly more hawkish. McGeorge Bundy, Dean Rusk, and John McCone favored committing ground troops after the election, though Rusk at the Honolulu meeting stressed "the unpreparedness of the US public to absorb increased military action." McNamara remained wary of sending an army but now favored bombing the North. Intelligence produced a new thesis: precisely because Hanoi owned so little industry and infrastructure, it would be especially sensitive about seeing these obliterated. Assistant Secretary John McNaughton, a long, lanky, fluent young lawyer, proposed an orientally subtle bombing strategy based on raising the level of pain one cut of a thousand at a time: "We should strike to hurt but not to destroy."

When the Chiefs met at the White House on July 31, Wallace Greene restated his conviction that the US must carry the war to North Vietnam to have any hope of achieving a tolerable outcome in the South. Present policy, said the stiff Marine, was a "violation of a fundamental military principle, i.e., letting the enemy dictate the ground on which battle would be joined." The president said bizarrely that in many ways South Vietnam's problem was much like America's: "recovering from the assassination"—of Diem as of Kennedy. Although he told the brass there would be no political hesitation about doing anything militarily urgent, nobody present believed him. Everything, absolutely everything, would be subordinated to achieving victory in the presidential election, now less than a hundred days away.

INTO THE GULF

1. LIES

It will always be a matter of dispute whether Lyndon Johnson sought an opportunity to showcase his virility before the American people voted in November 1964, or whether crisis was thrust upon him. In August, two weeks before the Democratic Convention, the struggle in Southeast Asia took a new turn. Since January the Americans had been running into North Vietnam covert missions with the umbrella designation OPLAN34-A. These were designed to destabilize Hanoi with dropped agents and commando raids. Whatever alternative judgments are possible on the wider war, OPLAN34-A sacrificed the lives or liberties of some hundreds of Vietnamese to no purpose whatever. Since 1961, communist intelligence had been playing "radio games" with American paramilitary operations chiefs, using "turned" operators from captured agent groups. This, combined with double-agent penetration in the South, ensured that each capture paved the way for the next. In 1963 eighty groups entered the North by parachute or small boat. The CIA's Gilbert Layton said, "In my shop . . . you assumed [the South Vietnamese] were penetrated. . . . When I started recruiting these people, somebody said, aren't you afraid there might be some Vietcong in there that you're hiring? I said, we figure on about ten percent but then we outnumber them nine to one."

Bill Colby recognized failure when he saw it: "The message sent to me was that the thing wouldn't work. So, stop doing it." In the winter of 1963, he said as much to Robert McNamara, who made no response. The defense secretary persuaded himself that covert ops could help to sustain pressure on Hanoi, if placed under MACV control and backed by military muscle. He argued this to Lyndon Johnson in December, and soon afterward the OPLAN34-A series was launched. Almost two hundred South Vietnamese were trained to parachute, paddle, or swim into the North. Their briefings were imperfect, however: agents tasked to head for towns were urged to seek out Catholic priests, who would assuredly be anticommunist. So indeed the clergy were, but in consequence churches were under close surveillance. Some parachutists were detected because they wore shoes, rather than the universal sandals. One was captured in American blue jeans—promptly appropriated by the soldier who seized him. Many surrendered the moment their feet touched the ground.

The North Vietnamese staged occasional show trials of Saigon agents, while firing squads executed intruders who resisted capture. Most of the OPLAN34-A personnel were indefinitely imprisoned, the last survivors being released only in 1995. Col. Clyde Russell, who ran the Studies and Observation Group, or SOG, overseeing the missions, told a later JCS inquiry, "We did commit most of these people without very high expectations. . . . We never had a successful operation." Yet the raids continued because some soldiers and officials, McNamara foremost among them, fancied that they represented a low-cost, low-visibility means of keeping heat on the enemy.

The South Vietnamese crews of the high-speed patrol boats that conducted the amphibious raids relished being an elite—as well as the cash bounties the US paid them. Most missions, launched out of Danang, lasted only a few hours of darkness. Craft operated in pairs, an average of once a week, their officers briefed by Americans using aerial photos. Swift and Nasty boats landed SEAL teams, Vietnamese Nung, to fire on shore installations. There were occasional clashes with North Vietnamese craft, some of which they engaged with their own 40mm guns. None of the Northern incursions was truthfully recorded; they appeared in logs under the cryptic heading "US liaison." The Vietnamese found it thrilling

to drive their 55-knot boats, which no communist craft could catch, and, in the words of an officer, "It was great to be taking the war to the North, instead of just passively defending our own territory."

The communists had grown accustomed to repelling the raiders, so that coastal defenses maintained a high state of alert. On July 28, after an attack on the island of Hon Gio, Chinese-built Swatow-class patrol boats pursued the attackers for forty-five miles. Two days later, commandos were repulsed during an attempt to storm a radar station on Hon Me Island; they merely sprayed the facility with automatic weapons fire. The defenders were thus wide awake three days later, when the destroyer *Maddox*, conducting a DESOTO (DeHaven Special Operations off Tsingtao) electronic eavesdropping mission within a few miles of these same islands, entered waters claimed by North Vietnam, though beyond the limit recognized by the US. One of *Maddox*'s appointed tasks was to gather intelligence for MACV, including "determining DRV [Democratic Republic of Vietnam] coastal patrol activity . . . [and] to stimulate and record North Vietnamese reactions in support of the U.S. Sigint effort."

On August 1, interceptors warned USN Capt. John Herrick, the mission commander at sea, of North Vietnamese transmissions indicating that their naval commanders had DECIDED TO FIGHT THE ENEMY TONIGHT, which persuaded *Maddox* to retire into less contentious waters. The communists then ordered P-4 torpedo boats and sixty-seven-ton Swatows to concentrate off Hon Me Island the next day, the 2nd, which the Americans interpreted as meaning that they intended to engage the US destroyer. The NSA sent urgent warnings to that effect to MACV and assorted naval commands—though not to the warship itself—early on August 2: The Indicated sensitivity on part of DRV as well as Their Indicated Preparation to Counter, possible the DRV REACTION TO DESOTO PATROL MIGHT BE MORE SEVERE THAN WOULD OTHERWISE BE ANTICIPATED. This was followed by a "Critic"—critical message—from the sigint unit at Phu Bai at 1144G,* reporting a Swatow boat's acknowledg-

^{*} Tonkin Gulf local time.

ment of attack orders. Despite all this, the destroyer was allowed to resume its inshore DESOTO mission. Around noon on the 2nd, *Maddox* caught sight of five communist craft off Hon Me, yet held its own course.

The command duty officer in Hanoi that afternoon was Sr. Col. Tran Quy Hai, a deputy chief of the General Staff. Colleagues later asserted that, when telephoned by naval headquarters to report the presence of *Maddox* and seek instructions, he said, "What? They're asking how we should respond? When an enemy ship violates our territorial waters we have to attack it! What the hell are they waiting for?" The deputy director of combat operations called the naval command duty officer, who ordered three boats of Torpedo Group 135, supported by two patrol vessels, to engage *Maddox*.

At Saigon's Tan Son Nhut Air Base, Harry Williams, duty officer at the NSA interception station, received a Navy sigint warning from San Miguel, Philippines, that an attack on US warships was imminent. There was also evidence of confusion within the North Vietnamese command chain: decrypts included a recall order issued to the P-4 boats, which failed to prevent the brief clash that followed. At 1400G Maddox spotted the North Vietnamese boats, turned east and increased speed to twentyfive knots. Forty minutes later Herrick signaled shore command that he would use his guns in self-defense as seemed necessary. Four F-8 Crusader aircraft, flying combat air patrol above the carrier Ticonderoga, were vectored to support the destroyer. At 1505G, and absolutely contrary to the administration's later claims that the communists fired first, Maddox's 5-inch guns loosed three warning rounds, then began to shoot in earnest at the boats, which were making forty knots, bouncing across the swell toward the destroyer. The American shells missed, as did torpedoes fired by the attackers, but at 1520G the Crusaders arrived, dived on the P-4s, and hit them hard with cannon fire: all three were badly mauled; four crewmen were killed and six wounded. Maddox ended the action with a single bullet hole in its upperworks; one Crusader suffered damage but landed safely back at Danang.

On August 3, North Vietnam's chief of the General Staff, Van Tien Dung, flew to the coast. The boats had not yet returned, having taken refuge beside an offshore island to repair their damage. The general professed to congratulate the navy, yet on the helicopter flight back to the capital, Dung told an accompanying officer that he thought the attack had been a mistake, "at a time when we are trying to limit the conflict." He thought the command duty officers had exceeded their authority.

Washington's initial reaction to the clash was muted, but on the president's instructions a stern warning was dispatched to Hanoi that any further "unprovoked" attacks on American warships would have "grave consequences." On August 2, McNamara was escorting Jackie Kennedy to Mass when he was summoned back to the Pentagon. Next day he presided over a meeting with the Joint Chiefs at which they discussed a gloomy new general sitrep from Saigon. The secretary said, "We are losing. . . . We can't afford to take this and we won't." There were reports of a Chinese air division moving into North Vietnam. The CIA's John McCone warned of possible Chinese air attacks on Saigon; the Russians might also take a hand, perhaps with fighter aircraft without avowal, as they had done in Korea. A second carrier, Constellation, was sent to support Ticonderoga off the Northern coast. Another destroyer, Turner Joy, was dispatched to join Maddox. Capt. Herrick, at sea, was in no doubt that matters had gotten serious, signaling, DRV HAS CAST DOWN THE GAUNTLET AND NOW CONSID-ERS ITSELF AT WAR WITH US. He urged providing heavier warship support for the DESOTO mission—which was ordered to close the coast once more on August 3.

That same night of the 3rd, South Vietnamese commandos staged another OPLAN34-A raid, during which four boats fired on shore installations at Vinh Son, and one was chased by the communists. This activity took place many miles from Hon Me Island, where the North Vietnamese were still struggling to salvage their three craft damaged that afternoon. The Phu Bai interceptors, however, misinterpreted enemy radio traffic, believing that it presaged another looming attack on US warships: at 1656G, Phu Bai thus issued a new Critic warning. The next day, the 3rd, one Swatow boat indeed tracked the American vessels by radar, but from a safe distance. Though there were tense hours at sea, not a shot was fired near *Maddox* or *Turner Joy*.

Nobody in Washington suggested pulling back the DESOTO mission. Next morning, the 4th, the two destroyers resumed inshore eavesdropping. At 1840G Phu Bai issued a new warning: POSS DRV NAVAL OPERATIONS PLANNED AGAINST DESOTO PATROL TONIGHT. Less than two hours later, in worsening weather, Maddox reported two "skunks" (surface radar contacts) and three "bogies" (air radar contacts), range a hundred miles. Herrick speculated later that the latter might have been false "terrain returns" from China's Hainan Island. At 2045G Herrick reported losing the surface skunks, but at 2108G picked up another. Navy Skyhawks overhead reported spotting the destroyers' white wakes in the darkness, but no sign of any hostile craft. At 2134G every alarm bell rang aboard Maddox, following a new radar contact at 9,800 yards, apparently closing at forty knots; Turner Joy's operator also reported activity. Then the sonar team spotted something underwater, which Maddox's Combat Information Center—though not the sonar operators—identified as an incoming torpedo. At 2140G Herrick reported that his ships were firing on "attackers" but said the destroyers were finding it hard to sustain a radar lock on them. This was unsurprising, because they were figments of American imagination.

Reports from *Maddox*—"am under continuous torpedo attack"—passed to the Pentagon that night, still early morning in Washington, reflected errors by technical personnel afloat, and excitable reactions by their superiors. Adm. Ulysses Grant Sharp in Hawaii briefly endorsed the false reports as "renewed hostile action." The North Vietnamese combat operations log, published years later and almost certainly authentic, shows that they deployed no ships near the Americans. Nonetheless, the destroyers responded to the new radar contacts by taking wild evasive action. *Maddox* could not identify a target for its guns, but *Turner Joy* expended over three hundred rounds of 5-inch ammunition, and recorded two dozen incoming torpedoes: all this, though flare-dropping aircraft glimpsed no sign of any enemy. At 2335G the "action" was finally broken off, with Herrick reporting two enemy boats sunk and another damaged. Yet some of his subordinates remained skeptical that any clash had taken place. It soon became clear that the "incoming torpedo" effects were caused by drastic

rudder movements as the destroyers maneuvered. Within an hour Herrick was signaling entire action leaves many doubts, and soon afterward NEVER POSITIVELY IDENTIFIED A BOAT AS SUCH.

However, in Washington, following the Critic warning from Phu Bai, McNamara had warned the president of an imminent North Vietnamese attack. Three hours after the "battle" ended, Johnson authorized a retaliatory strike against North Vietnamese bases. Five hours before the planes took off, Adm. Sharp warned the Pentagon that "a review of the action makes many reported contacts and torpedoes fired appear doubtful." But then sigint produced an NSA intercept in which the North Vietnamese claimed to have "shot down two planes in the battle area . . . we had sacrificed two ships and all the rest are okay. . . . The enemy ship could also have been damaged." This message related, in reality, to the events of the 2nd, about which the communists themselves were still confused. McNamara, however, seized on it as confirming the new August 4 attack. Along with specious "eyewitness reports" from the destroyers, the defense secretary felt confident that he knew enough to allow the president to launch his air strikes.

At six p.m. on the 4th, a Pentagon spokesman announced to the world "a second deliberate attack." Dean Rusk told aides at the State Department to dust off William Bundy's May draft of a congressional resolution. Johnson stormed to McNamara: "I not only want those torpedo boats that attacked the Maddox destroyed, I want everything in the harbor destroyed.... I want to give them a real dose." The defense secretary did nothing to restrain the president's fury, to correct his misapprehensions, even though evidence was available to do so. McNamara's use of sigint was highly selective. Both then and in subsequent evidence before Congress, the defense secretary chose first to ignore, later to suppress, a mass of data showing that the North Vietnamese were preoccupied with rescuing their damaged boats and were explicitly ordered not to tangle with the Americans again. The fundamentals are plain clarification of what history knows as the Tonkin Gulf incident: Maddox was "coat-trailing" on a mission explicitly linked to OPLAN34-A. Given the repeated coastal commando raids taking place, it was unsurprising that North Vietnamese fingers were

tight on triggers. The decision to commit their boats against the US warship was taken by a gung-ho communist officer whose decision was none-theless regretted—and soon known in Washington to be regretted—by many of those in high places, albeit not by Le Duan and Le Duc Tho. No "second attack" took place.

McNamara, however, was impatient for action. The president, at a critical moment in the election campaign, was anxious not to concede any opening for Republicans to charge him with weakness. He won plaudits for his prompt and tough response to an assault on the American flag. Thereafter, it was almost inevitable that the administration would lie and lie again to conceal the multiple blunders and deceits already perpetrated and to justify air strikes on North Vietnam. The president delayed his August 4 national TV address until 11:36 p.m. Eastern Time, when Adm. Sharp told him that *Ticonderoga*'s and *Constellation*'s planes were airborne. "Aggression by terror against peaceful villages of South Vietnam," Johnson told his people, "has now been joined by open aggression on the high seas. . . . Repeated acts of violence against the armed forces of the United States must be met not only with alert defense but with positive reply. . . . We know, although others appear to forget, the risks of spreading conflict. We seek no wider war."

The Joint Chiefs' order to the Navy began: "By 0700 local conduct a one-time maximum effort... with objective of maximum assurance of high level of target destruction." Sixty-four sorties were flown, which destroyed some North Vietnamese boats for the loss of two US aircraft. One of the pilots, Lt. Everett Alvarez, said that "it was sort of like a dream" suddenly to find himself committed to a combat mission after years of make-believe. His dance with unreality turned into a nightmare: he spent the ensuing eight years in a North Vietnamese prison.

The president's response to the Tonkin Gulf incident reflected an anger of state, a frustration that a tinpot Asian communist half country should dare to defy the United States of America. The details didn't much matter to him. Already on the morning of August 4, Johnson indicated his intention to exploit the "second attack" conjectured by sigint to secure a resolution from Congress supporting escalation. He would have been dis-

mayed if, later that day, anticlimactic facts had pricked the bubble of his carefully crafted indignation. It nonetheless reflects poorly upon his advisers, and above all on McNamara, that they failed to correct the earlier misinformation, or to calm the commander in chief. They allowed him to elevate into a major drama a brush at sea that could easily and should rightfully have been dismissed as trivial.

The only plausible explanation is that the defense secretary had himself become impatient for aggressive action. America's leaders chose to exploit a skirmish provoked by their own inshore gamesmanship so as to rationalize a demonstration of will and power. Earlier that summer, Washington had sent a message to Hanoi by way of Canada's ICC delegate, warning Pham Van Dong of "the greatest devastation" if North Vietnamese meddling in the South persisted. After the Tonkin Gulf incident, at American bidding, the Canadian repeated his earlier warning that there were lots more bombs where the August 5 ones had come from. In response, Dong became "very angry" and said, "The more USA spreads war, the greater will be its ultimate defeat."

Following the Tonkin Gulf clash, McNamara told an important lie before the Senate: "Our Navy played absolutely no part in, was not associated with, was not aware of any South Vietnamese actions [in the same operational area as Maddox], if there were any." The so-called Tonkin Gulf Resolution, closely following Bill Bundy's draft, was now laid before Congress. It empowered the administration "to take all necessary measures to repel any armed attack against the forces of the United States and to prevent further aggression." Senator Richard Russell spoke for most of his colleagues when he said, "Our national honor is at stake. We cannot and we will not shrink from defending it." Senator Eugene McCarthy, who later played Brutus to Johnson's presidency, said, "The proposition was: 'Is it alright for American boats to fire back if they're fired upon?' It's pretty hard to vote against that." Democrats Ernest Gruening and Wayne Morse cast the only dissenting votes against the August 7 passage of the resolution, which thereafter provided the authority for America's war making in Southeast Asia.

2. HAWKS ASCENDANT

At 1330G on August 5, North Vietnam's Party military committee met in the headquarters of the General Staff, known as Dragon Court because stone dragons flanked the nine steps leading to its entrance. They had just begun to review the events of August 2 when they heard of the American air attacks on the coast. This was followed, in turn, by news that two planes had been shot down and a pilot captured, prompting such a display of glee that the meeting was suspended, as also were immediate recriminations about the Tonkin Gulf clash. Those first raids prompted demonstrations in the streets of Hanoi that were—in the words of a British diplomatic witness-"as near to spontaneous as such things ever are in communist countries." The bombing did more for North Vietnamese unity than any propaganda exhortation. A teenager, who watched from his village as aircraft struck nearby oil tanks, at first experienced mere shock and bewilderment. Then, "I began to see that the lives of young people like me would soon reach a turning point, when we would have to fight for the independence and freedom of our people." Far from cowing the boy, the bombs convinced him that his people were victims of unprovoked terror. He later became an air defense officer.

Max Taylor once observed that Americans knew little about the communist leadership, and less about its intentions. The British consulate in Hanoi, which was chiefly its Secret Intelligence Service (SIS) station, reported with notable prescience after this first round of bombing that North Vietnam's leaders "will not be intimidated. Nor will they be deflected. Roads will be rebuilt, bridges replaced by simpler bamboo structures, and supply dumps resupplied . . . [air attack would] only strengthen their resolution." The politburo was indeed much less dismayed by the bombing than by private expressions of anger from Moscow and Beijing about the attack on *Maddox*. Ho Chi Minh emerged from semi-retirement, chairing a session at which he demanded sternly, "Who gave the order?" Giap demanded disciplinary action against those responsible, notably Sr. Col. Tran Quy Hai. Hai said that, before unleashing the boats, he had consulted a member of the politburo. He refused to identify the responsible

comrade, but they all assumed that he meant Le Duan. Though Hai was formally reprimanded, Chief of Staff Dung shrugged and dismissed talk of regrets or recriminations: "Even if we don't attack them, they will attack us. That is their nature as imperialists." A distinguished NVA officer who defected in 1990 confirmed that the August 2 attack was authorized by Le Duan, who had mocked Giap's anxiety to avert a showdown with the Americans, saying, "He's as timid as a rabbit."

Since the US had fabricated the August 4 clash to justify bombing the North, Hanoi saw no merit in further military restraint on its own side. This was where Washington paid the heaviest price for these first air strikes. By translating the threat of bombing into reality, it played a card that was most potent while retained in the hand. Following a September 25–29 Party Central Committee meeting, Nguyen Chi Thanh was appointed chief of COSVN, and a warning order was issued for the first regular North Vietnamese Army formation to prepare to march South. Elements of the 325th Division set forth in November, after a delay imposed partly by the need to square Moscow and Beijing, partly by equipment shortages.

China, which on October 16 raised East-West tensions by testing a nuclear weapon, dramatically increased its deliveries of arms. The NVA began to receive AK-47 assault rifles, 7.62mm machine guns, 82mm mortars, rocket-propelled grenade launchers, and recoilless rifles. For the North's home defense, Beijing supplied thirty-four MiG-17 fighters, for which Vietnamese pilots had been training in China for two years: their Chinese adviser remained with the unit through its early combat sorties. In Hanoi, flak guns were deployed on rooftops, and half the civilian population was set to digging trenches.

On the evening of October 5, in Beijing, Mao Zedong and Zhou Enlaid discussed the war with a Hanoi delegation. Mao said he was confident that Johnson had no desire to invade North Vietnam, but he opposed wantonly provoking the Americans. Pham Van Dong concurred, telling the Chinese leaders, "We should try to restrict the conflict to the sphere of 'special war' and to defeat the enemy within [this] context." He added, however, "If the US dares to [commit troops], we shall fight, and we shall

win." They discussed possible negotiations through the United Nations, which Secretary General U Thant had proposed. Though Mao changed his mind a few months later, that evening he said, "It is no bad thing to negotiate. You have already established a [good] bargaining position. It is another matter whether the negotiations succeed." Le Duan had traveled to Beijing immediately after the Tonkin Gulf incident, to inform Mao of his intention to send a regular division South. Now, the Chinese leader urged the North Vietnamese to consider carefully the timing of this deployment, before the formation marched.

As for Lyndon Johnson, in the months following the August drama, it remained his preferred option to hold down the temperature in Southeast Asia until polling day. There was no further bombing of the North; the president used the hotline to soothe Moscow. The Tonkin Gulf clash and subsequent resolution came to loom large in history only much later, when the administration's deceits were revealed. Soon after the event, journalisthistorian Theodore White could write respectfully in The Making of the President 1964, "The deft response of American planes to the jabbing of North Vietnam's torpedo boats . . . had been carried off with the nicest balance between boldness and precision." The country was vastly more interested in and impressed by the July 2 passage of the Civil Rights Act, of the Mass Transit Act four days later, and of the Civilian Pay Act and Anti-Poverty Act—the first wave of Great Society legislation. Johnson took justified pride in his forty-five major proposals that passed the second session of the Eighty-Eighth Congress, yielding a far higher batting average than Kennedy had achieved.

Vietnam proved a marginal election issue. Turmoil in Saigon had come to be accepted as the city's default condition. Yet as Gen. Nguyen Khanh assumed ever more authoritarian powers, these were challenged on the streets by Buddhists and student demonstrators. Khanh made matters worse by promising that he would discuss their demands with Max Taylor, an admission of his own vassal status. On August 25, the general supposedly agreed to share power with two other familiar military figures, Tran Thien Khiem and Duong Van Minh. Then troops fired on a protest, killing six people. The capital descended into new chaos, while the Vietcong continued to cre-

ate mayhem in the countryside. Through the autumn, there was a constant stream of bad news about both terrorism and political protests.

The Americans convinced themselves that the Buddhist demonstrators were tools of the communists. Veteran British correspondent Gavin Young took a more nuanced view. He saw the Buddhists as "convinced that communism was barbaric and malign, just as they considered the Americanization of their country degrading. Strangely enough . . . they merely desired the means to wage a more successful war against the communists. For they believed that the American-sponsored generals who ruled the country were hopelessly corrupt and incompetent. . . . They [themselves] were pure Vietnamese nationalists, proud of their history and their culture. They feared and mistrusted foreign influences of any kind." The Buddhists were certainly naïve—but no more than were the generals who presided in Saigon.

An ARVN officer, Lt. Phan Nhat Nam, described his unit's experience of a Saigon street demonstration: "A yellow-robed monk held in his hand a small flag which he raised high, spreading his arms in a V, like a boxer climbing into the ring and greeting the audience. Most of the young male demonstrators were wearing Japanese sandals and tight trousers with their shirt-tails hanging out. There were a few young girls hugging book-bags, like they were going to school. The two most active and animated, however, were older women wearing black trousers and flowered blouses. They carried staves, and one would scream curses for a while; run over to a water fountain and take a long drink; then run back and resume screaming."

The soldiers stood back while riot police charged the demonstrators, firing tear gas until the street stood empty, littered with abandoned wooden clogs, bookbags, coolie hats, and sandals. Under the blazing sun, troops lined a wired barricade across the street. Then, wrote Lt. Nam, "One guy, with a sharp rat face, pointed at me and screamed, 'You mother-fucker! How much are the Americans paying you? When you die there is no hell hot enough to punish you for your crimes.' . . . A rock flew out of the crowd and hit Cpl. Long in the chest. He shouted in pain, then smashed his rifle butt into the face of a kid cavorting in front of him. I tossed a CS gas grenade, and my bottled-up rage exploded. I swung my

own rifle-butt, prompting a scream of pain. I heard bones cracking under the impact of the stock. My platoon burst forth, surging into the crowd in a wild fit of anger and hatred." When his men pulled back, gratefully dragging off their gas masks, Nam felt a stab of wretchedness, that the high military calling he thought he had embraced was reduced to a sordid street squabble. This was how many South Vietnamese people felt: bewildered and trapped between rival malign forces. An American adviser asked a province chief, "If you were twenty years old, had no family responsibilities and no record of support for the Saigon government, which side would you be on?" The man sat mute, leaving his visitor in no doubt of the answer.

At a September 9 White House meeting, Max Taylor said, "Eventually we must go North because we cannot afford to lose this war." Johnson responded that there must be a stable Saigon government before anything big was attempted elsewhere—which meant further delaying strategic decisions, a course deplored by JCS members. Marine Gen. Greene denounced as "a gigantic gamble" the president's refusal to make any big commitment before the election. He instead urged that the administration should give Khanh 100 percent support, declare martial law, suppress all riots and demonstrations, authorize the ARVN to attack the Ho Chi Minh Trail in Laos and Cambodia with American air support—and assault North Vietnam "for the purposes of either forcing the North Vietnam[ese] to cease support of the Viet Cong or establishing a base for bargaining and withdrawal of US forces." In September MACV estimated that sixty-six thousand Vietcong had been killed in the previous three years—but admitted even to those who swallowed this statistic that half of South Vietnam's population was now paying communist taxes.

USIA chief Ev Bumgardner told Frank Scotton that Nguyen Khanh's brief stint as regime leader was drawing to a close: "Americans are all over him, like flies, and his sun is setting." Bumgardner advised Scotton to meet IV Corps commander Gen. Nguyen Van Thieu, who was the up-and-coming man. Scotton expressed surprise: surely Thieu was just a lightweight. Bumgardner laughed. "Maybe he is, but that might allow for

floating to the top. None of the others feel threatened by him, and when they do, it just might be too late." Sure enough, when the military rulers shuffled their deck yet again, for the first time the thirty-four-year-old Air Vice Marshal Nguyen Cao Ky, together with Thieu, emerged as important players on a so-called Armed Forces Council. On October 20, a civilian government was announced, led by Tran Van Huong; nobody expected this to survive long, however, and it did not.

Meanwhile the Vietcong battered relentlessly at everything appertaining to the Americans and the government. Compared with what came later, ARVN losses were relatively low—fewer than six thousand killed in 1963 and not many more in the succeeding year. But Washington hawks were dismayed by a spectacular October 31 attack on the B-57 flight line at Bien Hoa, in which eight Americans were killed, and by Washington's refusal to respond with another air strike on the North. On November 1, Earle Wheeler formally reported to McNamara the JCS view that the US should either make a major military commitment or withdraw.

Next day the defense secretary described the situation as "damn serious . . . critical." Yet still he felt that strikes against the North, as recommended by the chiefs, "will not bring any major change in the attitude of the 'Viet Cong' in South Vietnam." He reaffirmed his concern that the Chinese might come in, and said that the president wanted to move, "but he wants to be goddamned sure of himself before he does so." Most Americans who went to the polls next day believed that by endorsing Lyndon Johnson rather than Barry Goldwater, they were voting to escape an escalation of the Vietnam War. The Democratic candidate was royally cheered when he told crowds that he would not send "American boys to fight a war Asian boys should fight for themselves."

On November 3, the election was finally over. Johnson got his landslide victory, the largest plurality in American history. This huge mandate offered what was probably the last, best chance to order a withdrawal from Vietnam. Yet for weeks, within the administration it had been assumed that domestic political success would be followed by escalation. Only an effective North Vietnamese capitulation could have prevented a troop

commitment. It was taken for granted by McGeorge Bundy, Robert McNamara, and the rest that if the enemy remained unyielding, he must be addressed with appropriately increased force.

Johnson's determination to assist the people of South Vietnam in spite of themselves was strengthened by the rise in his Louis Harris poll ratings after the August air strikes. Americans responded positively to a perceived display of strength, purpose, decision. The president managed Congress with his accustomed skill. While its key arbiters of foreign policy—senators William Fulbright, Mike Mansfield, and Richard Russell—were privately skeptical about the administration's Vietnam policy, Johnson persuaded them to keep their doubts to themselves until the big decisions were history. It was an extraordinary aspect of the war, that the American people and their legislature acquiesced with little remark in a vast military commitment to a faraway country, heedless of the fact that the rest of the world, including Britain, France, Japan, Canada—almost every developed democracy except Australia—thought US policy foolhardy in the extreme.

George Ball, Rusk's undersecretary, became in 1964-65 the most eloquent in-house opponent of escalation. He expressed his views in a sixty-seven-page memorandum of October 5, 1964, which was read by the president only five months later. This was because McNamara, its initial recipient, regarded the paper with repugnance, in Ball's words "like a poisonous snake, . . . next to treason." The undersecretary argued that withdrawal, far from weakening US prestige, would enhance it, since all her allies opposed the war. Instead of relentlessly debating military options, he urged, the same energy should be deployed to find a political exit. He found it grotesque that when "what we had charitably referred to as the government in Saigon was falling apart, yet we had to bomb the North as a form of political therapy." He cited the 1962 SIGMA II Pentagon war game, which highlighted the unlikelihood that the North would buckle under air attack, and later dismissed bombing as "a painkilling exercise that saved my colleagues from having to face the hard decision to withdraw." Ball hereafter became the administration's licensed dissenter, granted respectful hearings even from the president himself—while changing nothing.

Why was there so little argument? Americans have never been much impressed by the views of foreigners or East Coast intellectuals about their affairs. In 1964-65 the conservatism of Middle America was still manifested in its willingness to trust the national leadership, to believe what its presidents said, even across a party divide. Patriotism helped to stifle debate when American boys were already dying. Though the New York Times and Washington Post had become critical of the commitment, relatively few people got their news from the liberal press. Meanwhile, the foremost reason for public passivity was surely that no gunfire was being heard, no shells or bombs were falling on their own continent. There was an urgency, even desperation, in the attitude of Vietnamese to their own predicament, because they paid a daily blood price. Americans did not. Nothing concentrates the mind—not always rationally but certainly powerfully-so much as the spectacle of death and destruction in one's own streets and fields. The Johnson administration, by contrast, could make its decisions confident that, whatever the consequences for Southeast Asia, no material damage would befall the continental United States. In 1964-65, the highest stakes appeared to be relatively small sums of money, together with the egos of the president and those around him, which they so deftly enfolded in the flag that personal reputations seemed, in that season, inseparable from the nation's global prestige. If the rubble on the streets of Saigon, the tears of peasants in the paddies of the Mekong Delta, had lain instead on Pennsylvania Avenue or fallen on North Carolina tobacco fields, Americans might already have been demonstrating as vigorously as were Vietnam's Buddhists. The course of events after Lyndon Johnson's election triumph might have been very different.

The president chose to deny himself choices, determining that the only acceptable outcome was a military victory for which South Vietnamese will was conspicuously lacking. On November 21, William Bundy submitted a memorandum proposing alternative degrees of escalation. Ten days later, Johnson authorized Operation Barrel Roll—secret bombing of

the Ho Chi Minh Trail inside neutral Laos. This was deemed politically safe, because it was far from prying Western eyes, and indeed it did not leak until Christmas. The president explicitly asked Taylor in Saigon if he wanted US ground troops, and may have been disappointed that the ambassador continued to oppose a deployment.

By December 1, 1964, though the world supposed the big decisions about Vietnam to lie in the future, the only serious argument within the administration was about whether to launch a major air campaign against the North, to send ground troops, or to do both. The president was convinced that to fight to the end, almost heedless of cost, was the courageous course, the honorable course, the only course worthy of *Time*'s Man of the Year. David Halberstam described Johnson as "the elemental man, a man of endless, restless ambition, a politician the likes of which we shall not see again in this country . . . of stunning force, drive and intelligence, and of equally stunning insecurity."

From December onward, the Vietcong launched a series of devastating attacks close to Saigon, and almost a thousand lesser acts of terrorism within a fortnight. At a meeting of the US Chiefs of Staff attended by Westmoreland, an exasperated general demanded, "Why is it that the North Vietnamese appear to be so well-disciplined and the South Vietnamese appear to be an undisciplined rabble?" MACV's boss said the NLF had a very strong leadership. What was to be done about the generals' relentless dogfighting? Westmoreland thought that "the Vietnamese-at least in Saigon-are coming more and more to feel that they can count on the [US Army] to worry about the commies, while they put their own efforts into jockeying for political power." The army's deputy chief of staff said contemptuously after the meeting broke up, "If we add up everything Westy has said so far, it amounts to one, MACV is doing a fine job; two, he is not optimistic, but on the other hand he is not pessimistic; three, he has little to recommend; and four, he is a smug young politician but not as smart as he thinks."

Early in December the president instructed the State Department to start hustling among America's allies for co-participants in the war, and he did not mean just "a chaplain and a nurse." When William Bundy met the Australian and New Zealand ambassadors, the latter avowed his government's caution. On the 7th, during meetings with Britain's new Labor prime minister, Johnson sought Harold Wilson's backing, urging that "a few soldiers in British uniforms . . . would have a great psychological effect and political significance." Here was a familiar theme in the Anglo-American relationship: US armed forces were well capable of pursuing whatever objectives they chose without aid from soldiers bearing the union flag, but London could provide valuable political cover. McNamara once said that he would pay a billion dollars for a British brigade, and he seldom joked. In Washington, Wilson temporarily deflected Johnson by saying that the Queen's soldiers had their hands full in Asia, addressing Indonesian aggression toward Borneo and Malaysia. He was not told of American plans for escalation, because it was plain that his government wanted no part in it. Dean Rusk told a British journalist with considerable bitterness, "When the Russians invade Sussex, don't expect us to come and help you."

On December 20, amid continuing Buddhist demonstrations, a new coup took place in Saigon—a shake-up of the Armed Forces Council now led by Khanh, Thieu, and Ky. This prompted a shouting match between an enraged Maxwell Taylor and the generals. They were summoned to the embassy to hear a harangue about the damage their reckless politicking was doing to the war effort. Taylor started by demanding, "Do all of you understand English?" Then he went on to say, "Now you have made a real mess. We cannot carry you forever if you do things like this." Taylor's insults disgusted the Vietnamese. Ky wrote later, "We Young Turks were well aware that the military was the only institution capable of leading the country. Our challenge was to do so in the face of continuing US pressure to bring in civilian leadership."

Following successive coups, rumors of CIA conspiracies, some of them true, became a staple of Saigon conversation. A junior officer wrote, "In all my years serving the ARVN, the events in late 1964 brought me the deepest despair." The martial tunes played over Saigon radio during coup attempts became the stuff of jokes. When a soldier begged for a few hours' grace to visit home, his platoon commander asked how he would

know when he was needed for duty again. He responded cheerfully, "No problem, Lieutenant." When he heard the radio playing "coup music," he would know that it was time to report. Even some passionately anticommunist South Vietnamese had come to regard Saigon as the hub of everything they hated about the squalor and cynicism of their own society. A month in the capital, an Airborne officer wrote, "was enough to destroy one's soul, to see how we were betrayed by a duplicitous rear area built on the blood and tears of soldiers. . . . I dream of a great flood that will wipe away the . . . filth that our capital has smeared upon the tragic face of our native land."

During December coordinated Vietcong assaults culminated in a Christmas Eve attack on the Brink Hotel in Saigon in which two Americans died and fifty-eight were injured. The Brinks explosion took place as Ambassador Taylor was delivering Bob Hope to another hotel a few blocks away, following the star's arrival for his annual Christmas show. "This is the warmest reception I've ever received," cracked Hope, but senior Americans were enraged. Taylor urged a reprisal air attack on the North, as did McGeorge Bundy. The president demurred, but a few days later there was a new shock when the communists attacked a village southeast of Saigon where a thousand North Vietnamese Catholics had been resettled a decade earlier. On December 28, two VC regiments mauled ARVN troops, then shot down four American helicopters. In an ambush on the 31st, they inflicted 60 percent casualties on a Vietnamese Marine battalion, killing most of its officers. Within a matter of days, the South Vietnamese had lost three hundred dead.

At New Year 1965, Lyndon Johnson was still professing to vacillate about the way forward. In Saigon political chaos had become the norm. There were some twenty-six thousand Americans in Vietnam, most of them advisers. If more were to reinforce these, Johnson favored sending special forces, Rangers and suchlike. What the hawks saw with a clarity that eluded some doves was that pursuit of any political option—neutralization, a new Geneva conference, bilateral negotiations with Hanoi—meant acquiescing in a course that could only end with a unified

communist Vietnam. No political or military force in the South possessed the will—means were less important—long to resist the iron men who ruled the North. And since such an outcome was gall and wormwood to Robert McNamara, McGeorge Bundy, and above all the president, a dramatic expansion of America's war in Vietnam had become inevitable.

"WE ARE PUZZLED ABOUT HOW TO PROCEED"

1. DOWN THE TRAIL

Vietnam's communist leadership, supposing victory at hand, entered 1965 in a mood of fierce excitement. Le Duan wrote to COSVN chief Nguyen Chi Thanh, "This is the moment to seize our opportunity." Hanoi's Party secretary now envisaged popular uprisings in the South's towns and cities. Northern officer Col. Nguyen Huu An wrote exuberantly of "a high tide of mass insurrection sweeping through the rural lowlands and mountains." An had commanded the Vietminh regiment that stormed Eliane 2 at Dienbienphu in 1954. Ten years later, this hoary veteran assumed command of the 325th Division, earmarked to become the first NVA formation to march South. He was suffering from bleeding hemorrhoids, that humiliating and painful complaint which often afflicts soldiers, and told Dragon Court, "Give me a week so that I can get them treated." In the event, he was granted longer grace: the deployment was postponed until November "because of the requirements of our struggle on the diplomatic front."

An was briefed that rice for his men was stockpiled in dumps along the Ho Chi Minh Trail. An army logistics officer added encouragingly, "It's been stored a long time and has worms, but is still edible." The general spent the next two months in his division's thatched bamboo headquarters at Dong Hoi, laboring in intense heat to scrape together enough equipment to outfit his troops. Each man was issued a "frog" pack, hammock,

two khaki uniforms, and a little Saigon currency. There were no sweaters, however, and in the face of night chills "the shortage of [warm clothing] adversely affected the health and morale of the troops during our long march"—meaning that they shivered as well as almost starved on their harrowing progress to the battlefield.

Early in November, An led a hundred-strong advance party south. At first, they found that the rotting rice stockpiled at way stations stank, "but didn't taste too bad." The trek was an epic, however, as it would remain for every North Vietnamese until much later in the war, when trucks took some of the strain. One day they waded a wide river, then followed a path along its bank toward the base of "One Thousand and One Mountain," the first high ridge they traversed from east to west. Pioneers had cut steps and positioned supports, but An complained that "the ropes and branches one had to grab were worn slippery by many previous hands. . . . I could feel the weight of every fly that landed on my pack." In places, the track was so narrow that it could accommodate only climbers in single file. When Bao Ninh, a college lecturer's son, later endured his own agony on the Trail, he felt envious of his peasant comrades' strength, notably greater than his own, and was grateful when they sometimes relieved him of part of the contents of his pack.

As An and his party advanced, rations shrank. Each man started out on two daily milk-cans of spoiled rice, but this was reduced to one can, mixed with stinking mildewed manioc, accompanied by a token shake of salt. They began to dream of meat, of boiled spinach and fish sauce, of lemonade. The cooks shook their heads in despair when they tried to wash the old rice in stream water and watched it turn to powder, leaving behind only worms. Eventually the men were served a gruel thickened with wild vegetables scavenged in the jungle. An felt bitter that Hanoi could have allowed such privations to fall upon his formation even before it started to fight. "Looking at the pale, haggard faces of my officers and men, I became so upset that I sat down and wrote a letter . . . so that the high command could learn from our experience." At long last they reached a way station just short of South Vietnam's Central Highlands, commanded by a colonel who had attended the same Russian language course as An.

His host produced a supper of fish cooked in a sour soup, which caused An to enthuse, "I have since attended many banquets, but none so good!"

It was December when they reached Kontum Province. An and his staff marched to the local front headquarters, where they found plentiful food, and had time to rest while they awaited his division's main body. There were three cans of good rice a day, bamboo shoots and potatoes gathered from the jungle, and occasional fish caught by soldiers. Orders arrived from Hanoi: two of the 325th's regiments were to move farther south while An remained in the Highlands with the third, as deputy front commander. He directed a series of local attacks to "blood" his men, before launching their first major operation, against a district capital. The plan exploited familiar communist tactics: they encircled and bombarded the objective, having laid an ambush for an ARVN relief force approaching from Tan Canh. After a brutal night exchange of fire lasting several hours, there was still no sign of movement from Tan Canh, so An ordered his sappers forward anyway. "[Their commander] answered the field telephone in a nervous and hurried voice. 'Sir! company commander Luong, executive officer Mo, and all the other officers of 9th company are dead!" An responded: Shut up and attack. It was essential that the sappers should move to relieve pressure on other elements of the regiment, being heavily shelled. Dawn found his men triumphant, having overrun the first Southern district headquarters to fall into communist hands.

Through three days and nights that followed, hungry and impatient, they waited in ambush for the expected ARVN relief force. At last the South Vietnamese obliged Hanoi's colonel by driving headlong up the road—and receiving a pounding. Next, the 325th overran a series of strategic hamlets without firing a shot, and briefly occupied Dak To. An celebrated by holding a feast, of which the centerpiece was a tiger, shot by two young soldiers to whom the beast had given the fright of their lives. "It was delicious," wrote the colonel, whose memoirs reflect a preoccupation with his stomach. As Saigon began to take serious notice of the NVA presence, they fell back into the jungle. Their foremost prizes from those early battles were two 105mm howitzers, which they dismantled and carried over the border into Cambodian sanctuaries.

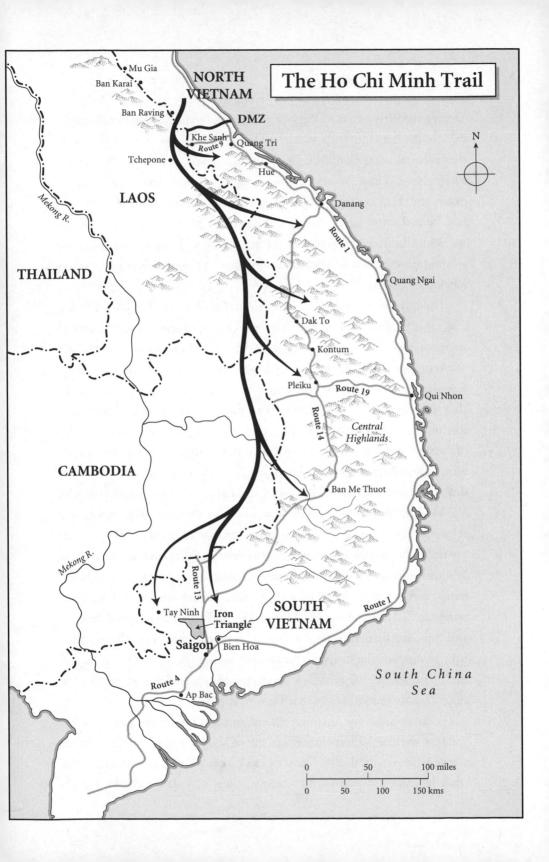

* * *

During the early weeks of 1965, the Vietcong intensified attacks throughout South Vietnam. For a time, Le Duan pinned hopes on the prospects of a political coup planned by a communist sleeper agent, Southern Col. Pham Ngoc Thao. When a senior Northern cadre who had marched down the Trail reached COSVN headquarters, exuberant staffers told him he had better hurry, "because if we didn't get our men down quickly we would be too late"—the Saigon regime would have collapsed. New communist currency was printed and shipped to South Vietnam in boxes labeled '65 goods.

Though the Pham Ngoc Thao coup failed, forcing the colonel to flee and to suffer assassination in mysterious circumstances, there was a surge in terrorism. In the Central Highlands, for instance, two anti-malaria workers spraying DDT were seized and tried before a "people's court." Convicted of "spying for the Americans and the puppet government," they were executed with machetes. Two nurses working on a cholera inoculation program, one of them pregnant, were captured and found guilty of "acting in the name of the American imperialists and as a propaganda tool." The woman's life was spared, but her male colleague was hacked to death before her eyes. Soldiers' and militiamen's families suffered. The VC kidnapped the wife and child of a notably energetic Regional Forces sergeant. When he rejected their proposal that he should change sides, guerrillas cut the child's throat. In this war without mercy, torture and arbitrary killings were commonplaces. A Southern officer wrote, "The situation was too complicated for even a Vietnamese to understand, let alone foreigners." After peasant girl Phung Thi Le Ly had been raped, beaten, and exploited by both sides, becoming an outcast from her village with a baby to support, she scraped a pittance by selling goods, including herself, to Americans. She wrote sadly long afterward, addressing a foreign readership, "You do not know how hard it is to survive."

Traditional family discipline was strained to the limits, and often beyond. A woman NLF member was the only daughter of an ailing father whose wife was dead. She found it hard to fulfill her filial duty to him while laboring as a communist cadre: "It was very dangerous for my life

and virginity." At night, when at last they were alone in their hut, he pleaded with her: "You're my girl. Because you have left this house and abandoned domestic chores, [most] of our land is barely cultivated and weeds have grown up everywhere. Where can we get food to eat? Many people can work for the revolution without pay, but I can find no one like you. . . . You should at least take pity and cook for me. . . . If you are killed by a bomb or shell I shall have to bury you. [Yet] according to the divine law of our ancestors, children should rightfully bury their parents."

As the war grew bloodier, the NLF found that the promise of land redistribution became a less potent propaganda weapon, because peasants were preoccupied with the mere daily battle for survival. Throughout most of the Vietnamese countryside, 95 percent of the time neither government troops nor guerrillas were visible. In the words of David Elliott, however, "It was the 5 percent that was the problem." It is hard to exaggerate the stultifying dreariness and the relentless toil of peasant life, which go far to explain why some young people chose either to become guerrillas or to migrate to the cities. When a friend of Phung Thi Le Ly returned to their village from a stint as a bar girl, full of stories of makeup, beehive hairdos, and flushing toilets, Le Ly said, "Saigon . . . sounded like heaven." A sixteen-year-old poor peasant girl from My Tho who visited the capital to stay with her brother, a policeman, was thrilled to find that she could earn 25,000 piasters a month washing dishes. To be sure, she worked until nine p.m. every night, but "I thought it was fun." Everybody had shoes or sandals, instead of going barefoot. An averagely successful prostitute made much more than 25,000 piasters, as many girls discovered, at the price of ostracism if they later returned to their villages.

In 1964 the RAND Corporation had launched what became one of its most important projects, the Vietcong Motivation and Morale study. The Army was not much interested, and delegated as its representative a mere lieutenant, David Morrell, who became passionately committed. He said later, "The remarkable phenomenon we were probing was why did [the enemy] keep slugging it out so incredibly? . . . What was this cause, and why did they eschew the goodies we were trying to give . . . and just go and breathe under the reeds, live in the tunnels at Cu Chi?"

Morrell was astonished that the US was undertaking this important survey without informing or consulting the South Vietnamese general staff. When the young RANDsmen's Vietnamese researchers quizzed local people, they were appalled by the tales they heard from prisoners and defectors, detailing mistreatment and torture. In December 1964, the field team presented its initial findings to Westmoreland, arguing that the Vietcong must be regarded as a far more committed foe than his staff acknowledged. The general demanded, "Do they believe in God?" The interviewers were not sure about that. They were sure, however, about the torture, which made Ambassador Taylor look uncomfortable when they highlighted it during a briefing that he attended.

The military men were unimpressed by the RAND report, which implied that the enemy was in a considerably better strategic place than were the rulers of South Vietnam. They remained baffled by the unwillingness of Vietnamese peasants to recognize that their material interests absolutely demanded partnership with the US. In January 1965, the Morale report was presented in Washington. RAND's Harry Rowen told the assistant defense secretary, John McNaughton, "John, I think we're signed up with the wrong side—the side that's going to lose this war." Daniel Ellsberg, McNaughton's assistant, was impressed by RAND's depiction of the enemy, who now controlled half of Vietnam's countryside and a quarter of its population as "selfless, cohesive, dedicated soldiers who saw themselves as patriots, particularly within the context of a corrupt South Vietnam and a disintegrating army." McNaughton responded to Rowen's depiction of the communists by saying, "They sound like monks." Yet he did not convey this exchange to McNamara, his boss, because he knew that the real argument was done and dusted. The administration had already made its commitment: to secure military victory in Vietnam.

Senior NLF cadre Truong Nhu Tang expressed the bewilderment felt by himself and his kind: "The unrestrained irresponsibility and incompetence of the [Saigon] generals had led to apathy and disgust among people at every level. South Vietnam was a society without leadership and without direction—and these essentials the Americans could not provide. They could not impose order on chaos. And without a government that could claim at least some tatters of legitimacy and effectiveness, how could the United States dare commit its troops and its all-important prestige?"

2. COMMITTAL

In January 1965, Maj. Gen. William DePuy wrote home to his son from Westmoreland's headquarters: "You ask me who is in power in Saigon. The fact is, no one is in power, and this explains much of the trouble we are having." Ambassador Taylor sent a similarly gloomy assessment, saying that the US must either bomb the North or commit American troops: he himself strongly favored the former option but still resisted the latter. On the 21st in Washington, the president invited key members of Congress to hear from his defense secretary a euphorically optimistic and almost entirely unrealistic account of the war. McNamara said that covert operations against North Vietnam were going well, as was bombing of the communists' Laos infiltration routes. The Southern army was increasing in effectiveness. When McNamara said that only 254 Americans had thus far died, he failed to mention that half that total fell in the previous year. Johnson said nothing about his private determination to renew bombing and asserted that he saw no need for US troops. Once again, he played the patriot card, calling for bipartisan support: "There are no Democrats or Republicans on Vietnam."

Less than a week later, however, on January 27, after another wave of Buddhist demonstrations in Saigon and the pillage of the American library in Hue, the Armed Forces Council dismissed the Huong government and reinstated Khanh. Taylor cabled that the general appeared to be in league with the Buddhist Institute, which held "a position of dominant power and influence. . . . The most sinister aspect is . . . that the Buddhist victory may be an important step toward the formation of a government which will eventually lead the country into negotiations with Hanoi and the National Liberation Front." In other words, the South Vietnamese might be preparing to abandon a war Americans were determined that they should persevere with.

That day McGeorge Bundy submitted to the president a memorandum asserting that the communists "see the enormous power of the United States withheld and they get little sense of firm and active US policy. They feel that we are unwilling to take serious risks." Robert McNamara chose to associate himself with Bundy's memo, signaling the transformation of the defense secretary into an explicit proponent of escalation. These two powerful men were weary of cautious, half-assed strategy making. So was the president. He responded, "We will move strongly. Khanh is our boy." He ordered Bundy to proceed to Saigon to formulate recommendations. Given the national security adviser's status as chief hawk, there was little doubt what the nature of these would be.

He found Saigon in a fever of street demonstrations and rumors, most of the latter about a looming coup by nationalists who would expel the Americans. Gen. Khanh at first refused to meet the presidential emissary, apparently because he was fearful of upsetting the Buddhists. News of this snub caused a spasm of Johnsonian rage against the Vietnamese leader whom he had endorsed only days earlier. The Americans began to search frantically, farcically, for a replacement, to be installed in yet another coup.

Their alarm was not diminished by the presence in Hanoi of Soviet premier Alexei Kosygin. Washington had no inkling that, privately, this distinguished guest was urging Le Duan against escalation. Moscow felt obliged to provide him with antiaircraft systems, both guns and missiles, as the price of preserving the Soviet Union's status as acknowledged leader of the world socialist camp. Yet just as the Chinese had no intention of sending ground troops to fight in South Vietnam, so the Russians were desperate to avoid further entanglement. The White House, State Department, and CIA alike failed to understand that, despite stentorian liberationist rhetoric from both Moscow and Beijing, North Vietnam was not a guided weapon in the hands of either.

Meanwhile Bundy's visit to the South exploded into a lethal firework display, almost certainly without authorization or encouragement from Hanoi. On the night of February 7, the Vietcong staged a showpiece attack on US base Camp Holloway at Pleiku in the Central Highlands. Eight Americans were killed and 108 wounded; five helicopters were destroyed,

and a dozen more damaged. This feat, achieved by a single sapper company, was followed three days later by another destructive attack. Bundy, in Saigon, viewed the Pleiku raid almost as a personal affront. He cabled the White House that a drastic response was necessary, saying that "the best available way of increasing our chance of success is the development and execution of a policy of *sustained reprisal* against North Vietnam." In Washington the National Security Council approved renewed bombing, oddly enough with the support of George Ball; Senator Mike Mansfield raised the only dissenting voice. A few hours later, 132 US and 22 South Vietnamese aircraft attacked North Vietnam.

At the Pentagon, McNamara asked for a study of new contingencies, including a possible requirement to hit target systems inside China. "What faces us is how are we going to respond to a massive Chinese and North Vietnamese ground effort." He proposed using napalm for flak suppression, a notion quashed on political grounds by Dean Rusk. Earle Wheeler said in jocular fashion, "The secretary of defense is sounding like General LeMay. All he needs is a cigar." The South Vietnamese government was not consulted. Hanoi suffered an uncharacteristic spasm of panic, that the US might invade the North.

Columnists Arthur Krock and James Reston were alike skeptical of administration claims that the new air attacks represented a spontaneous reprisal for Pleiku. They noted that three carriers instead of the usual one had been pre-positioned in the Tonkin Gulf, plainly poised to launch strikes as soon as a plausible pretext emerged. Reston wrote in the *New York Times*, "The time has come to call a spade a bloody shovel. This country is in an undeclared and unexplained war. . . . Our masters have a lot of long and fancy names for it, like escalation and retaliation, but it is a war just the same."

Bundy in Saigon saw a feeble local government struggling against a surge of anti-Americanism. He told the White House, "The situation in Vietnam is deteriorating, and without new action defeat appears inevitable.... The energy and persistence of the Vietcong are astonishing.... There is still time to turn it around, but not much. The stakes... are extremely high.... Any negotiated US withdrawal today

would mean surrender on the installment plan." In the first six months of 1965, the ARVN lost to death, wounds, and desertions the equivalent of fifteen battalions.

McNamara was now exerting relentless pressure on the president, making plain his own desire to dispatch troops in quantity; a figure of 175,000 was mentioned. His biographer has written of his "deep personal instinct for activism." A few months later, he avowed to British foreign secretary Patrick Gordon Walker that he saw no alternative to escalation, because it was impossible to admit to the American people that the war was unwinnable. Yet domestic considerations made it seem prudent to dispatch troops in doses modest enough for voters to swallow without taking fright. The Chiefs of Staff later asserted that they never had a chance properly to argue to the president that a piecemeal commitment was doomed, that the US needed to go for broke. Yet it remains hard to accept that even a full-blooded commitment from the outset, accompanied by a call-up of the reserves, would have secured victory.

McGeorge Bundy deserves credit at least for urging the president that the American people should be warned to expect a long war. Johnson, however, refused to accede, and delegated Dean Rusk to persuade William Fulbright to prevent a Senate debate. H. R. McMaster has written, "Vietnam was not forced on the US by a tidal wave of Cold War ideology. It slunk in on cat's feet. . . . Johnson and McNamara succeeded in creating the illusion that the decisions to attack North Vietnam were alternatives to war rather than war itself." It was ironic, as well as morally and politically deplorable, that the administration was able to escalate by stealth, because the president's best chance of escaping from the morass into which he was headed would have been to bow to powerful voices on Capitol Hill who, had the options been honestly set before them, would have been happy to tell the American people that Vietnam was not worth a big war.

William Bundy came to believe that Johnson made a fundamental error by failing to take the case for war to Congress, writing, "Of course the debate would have been divisive, but if the doves had prevailed, the door to a political solution would have been opened much sooner." Bundy observed that Johnson's actions in 1964–65 were no more dishonest than

those of Franklin Roosevelt in 1941 during America's dalliance with entry into World War II—which is true. Bundy added ruefully, however, "The trouble was that this turned out badly, and therefore looks much worse in history."

On February 11, 1965, British prime minister Harold Wilson telephoned the president to protest against escalation and to seek an invitation to Washington to discuss it. Johnson rebuffed him, saying, "I won't tell you how to run Malaysia, and you don't tell us how to run Vietnam." Wilson explained that he was under immense domestic pressure for Britain to distance itself from US action. Johnson remained immovable, and indeed subjected his caller to a considerable tongue-lashing. He was disgusted by the negative attitude to his war displayed by both the British and the French. His own resolve was stiffened by a meeting with former president Eisenhower, who urged adoption of whatever military measures seemed necessary to avert defeat.

Yet there remained in Washington plenty of prudent doomsters. An NSC staffer, James Thomson, wrote, "We have slipped into a gross overcommitment of national prestige and resources on political, military and geographic terrain that should long ago have persuaded us to avoid such a commitment." The CIA's almost unfailingly pessimistic assessments, both of South Vietnam and of the unlikelihood of a successful air campaign, exasperated the president, who in April 1965 forced John McCone's resignation as director. The Agency's record of analysis was far from perfect, but proved consistently better than that of most other bodies, especially MACV. On February 17, Vice President Hubert Humphrey sent Johnson a brilliant memorandum, urging against an escalation that most of the American people would not understand. He argued that, following the election victory, 1965 was the ideal year for the administration to exploit its sky-high standing to cut America's losses in Southeast Asia. The president's response was to exclude Humphrey from the Vietnam loop.

On February 18, there was a new coup in Saigon, after which the deposed general, Nguyen Khanh, departed into exile. Dr. Phan Huy Quat became nominal leader, but real power rested in the hands of the military leaders, among whom Nguyen Cao Ky and Nguyen Van Thieu now loomed

largest. In June their dominance would become explicit. Four days later, Westmoreland asked for Marines to protect the ever expanding US base facilities at Danang. His call came as no surprise to Washington, and the administration was braced to accede. Max Taylor wrote later, "It was curious how hard it had been to get authorization for the initiation of the air campaign against the North and how relatively easy to get the Marines ashore."

A 1,200-man brigade landing team was earmarked for the Danang mission, though the president dallied with sending instead the 173rd Airborne Brigade, on the curious grounds that the American people would deem a commitment of paratroopers less momentous than an amphibious landing. Already in February there was an expectation of going further—sending much larger numbers of troops to shield all the US bases: an estimate of forty-four battalions or a hundred thousand men was put forward. Gen. Wallace Greene thought a force of this size would be necessary "to guarantee 100 percent protection."

Throughout February 1965, the designated assault force for Danang steamed circular courses in the South China Sea, while in Washington the president deliberated. Ensign Jim Koltes, aboard USS Henrico with the 3/9th Marines, was deeply impressed by their quality, the finest warriors America owned. "These weren't draftees or guys who had signed up because they couldn't get a job: I met officers who had been with me at Notre Dame. Their discipline was terrific, and there was wonderful camaraderie. Everybody believed in the cause." The wait under warning orders persisted through thirty-two apparently interminable days and nights. In darkness, they gazed from the ship's rail at flares and gunflashes plainly visible in the hills above Danang. "Nobody had any idea what to expect when they went ashore, because almost none of them had done anything like this before. We wondered: would it be like D-Day in Normandy?" It was not, of course. On March 8, 1965, when Ensign Koltes led elements of a flotilla of landing craft across the few miles of sea to the beach, not a shot was fired.

Marine Phil Caputo's company commander held an orders group before his unit left their assault ships, saying, "Okay, listen up. When you brief your people, make it clear that our mission is defensive only. I don't want anyone going in there thinking he's going to play John Wayne. We're to provide security and that's all. We're not going in to fight, but to free the ARVNs to fight. It's their war." Lt. Caputo, like Gen. Westmoreland, saw himself fulfilling the vision of JFK: "If he was the King of Camelot, then we were his knights and Vietnam our crusade. There was nothing we could not do because we were Americans, and for the same reason, whatever we did was right." Their communist foes were "the new barbarians who menaced the far-flung interests of the new Rome."

A significant aspect of the Marines' landing, before a throng of photographers, excited children, and pretty girls distributing garlands of flowers, was that nobody in Washington, the US Embassy, or MACV saw fit to inform the South Vietnamese government that they were coming. Moreover, in Max Taylor's phrase, once the camel's snout was in the tent—the first troops ashore—there was no getting it out again, though the president had yet to articulate a credible game plan. Walter Lippmann wrote, "It used to be a war of the South Vietnamese assisted by the Americans. It is now becoming an American war very inefficiently assisted by the South Vietnamese."

Col. Sid Berry wrote of an ARVN operation he witnessed in the Delta: "Good air strikes. Good artillery support. Good helicopter landings and armored personnel carrier actions. Good troop movements on the ground." Yet the end of that story was depressingly familiar: "We didn't get any big Vietcong units. Killed six, captured four, and got some documents. But the big numbers of VC we hoped for just weren't there. Maybe next time." Another adviser quickly noticed that out with the Southern troops, "We never seemed to bump into anybody. . . . There was pretty much a gentleman's agreement that if they left the VC alone, the VC would do the same to them."

Paul Warnke, who later became an assistant secretary for defense, thought that the whole story might have turned out better if Washington had imposed an honest-to-God occupation, rather than merely sought to hand-hold a grossly incompetent local government. "What we were trying to do was to impose a particular type of rule on a resistant country. And that required occupation, just as we occupied Japan [in 1945]." Warnke

missed the obvious point, that such a policy would have required treating the South Vietnamese as a conquered people, rather than as citizens of a supposedly sovereign state. But he articulated a dilemma that would recur in twenty-first-century Iraq and Afghanistan.

Many middle-class families in Saigon, like that of Duong Van Mai, had become so despairing of their society's predicament that only lack of means prevented them from seeking exile. Some such people were at first delighted when the US troop commitment was announced. Mai's father, a former mayor of Haiphong, said, "We're incredibly lucky. We're such a small and weak country, and yet the Americans have decided to save us with their money and their own lives." If such a view was confined to relatively privileged people, it deserves notice that, for a season at least, some felt a surge of hope.

The process that began on March 8, 1965, nonetheless proved less a commitment than a committal to the earth—of US strategy, hundreds of thousands of corpses, and eventually of the Johnson presidency. Almost every modern Anglo-Saxon leader who sets a course toward a foreign policy catastrophe either compares himself to Winston Churchill or his chosen enemy to Adolf Hitler. On April 13, Lyndon Johnson told visiting diplomats that Vietnam posed a challenge comparable to that faced by Churchill in 1940. He was contemptuously contradicted by President de Gaulle, who predicted that the war would last ten years and "completely dishonor" the United States. Those in Washington who accused the French leader of a disdain for American culture and resentment of American power were right, but that did not annul the validity of his warnings. Frank Scotton wrote that when the US began to seek to run parallel but separate Vietnamese and American campaigns, "the only player who seemed to understand the one-war concept, with everything having political impact and purpose, was the Viet Nam Communist Party."

From March 1965 onward, the process wherein US troops supplanted the ARVN at the forefront of the struggle evolved astonishingly swiftly. The procession of coups had drained the heart out of South Vietnam's soldiers even more than of the US Embassy. Desertions soared, reaching eleven thousand in April alone; units became increasingly reluctant to get

into fights. A junior officer said, "When I first joined the army in 1962, I did so because I was patriotic. I loved my new country and hated the communists. Over time, however . . . so many leadership changes in Saigon and dependence on the Americans made it impossible for me to talk about 'the nation.'"

Max Taylor had always believed that it would be disastrous if Americans assumed the burden of doing the fighting, but now he bowed to the administration's decision and withdrew his objections—for a while, anyway. For an assessment of future US troop requirements, the president dispatched to Saigon the head of the army, Harold Johnson, a survivor of the 1942 Bataan death march. The general must frequently have winced in the presence of Lyndon Johnson, because he deplored profanity and once sternly rebuked a subordinate: "I would appreciate it if you never again took the Lord's name in vain in my presence." Now, the commander in chief gave the army chief his marching orders. As they descended together in a White House elevator, he jabbed his visitor in the chest with a forefinger and said, "You get things bubbling, general." Within the Pentagon, Harold Johnson was already on record as believing that it would take five years and half a million men to achieve an outcome. He returned from Saigon with a proposal to dispatch one division, and the Chiefs upped this recommendation to three. The president said at a March 10 meeting at Camp David, "Come hell or high water, we are going to stay there." On his notes was written: "To give in = another Munich."

He temporarily delayed a response to the Pentagon troop proposals, but on April 1 approved the dispatch of two more Marine battalions and twenty thousand support personnel. Three weeks later he authorized deployments that by June would put forty thousand Americans into the theater. Taylor urged that these men should be confined to defense of coastal enclaves. Westmoreland protested, however, that this would be intolerably inglorious, and the president agreed. Once troops began to move from the West Coast to Asia, the White House faced a barrage of proposals for escalation. Westmoreland wanted more men, and yet more men. Adm. Sharp, as C-in-C Pacific, argued that Marines were especially well suited to counterinsurgency. On April 6 the president approved Rolling

Thunder II, an Air Force program for sustained though target-restricted bombing of North Vietnam. In the days that followed, the first antiwar protesters appeared outside the White House.

Still the military situation continued to deteriorate. On May 9, Doug Ramsey wrote in his diary from Hau Nghia Province, "Report that at least one platoon of 33rd Ranger Battalion was nearly wiped out at bivouac positions at about 0245. VC also blew bridge. . . . Total friendly [military] KIA [Killed in Action] 41, with 36 WIA [Wounded in Action] and 50 missing. VC attack reportedly accompanied by procession of villagers carrying knives and spears, torches. Number of civilian and VC combatants each said close to 500. According to province chief, troops of 33rd were again caught asleep."

Saigon's army was crumbling before the Americans' eyes. On May 18, Ramsey described how RF militia and Rangers had conducted a comradely half-hour battle with each other, apparently provoked by a row over cards, in which a Ranger was killed by tommy-gun fire. He wrote to his parents, "Military discipline, never very good, has been atrocious during the past two months. Every few days someone shoots up the town and no one does anything about it. [The ARVN] are almost universally detested for their misbehavior and aggressiveness toward unarmed civilians. . . . The pacification effort is rendered meaningless by the inability of [Saigon] forces to provide security. . . . The American government, furthermore, is almost as bad as the Vietnamese in covering up, or lying outright about, the situation." Hanoi also deceived its own people, but did so more successfully, because it exercised ironclad control of its society's information streams.

The communists scarcely needed to employ spies when Saigon newspapers recklessly flagged troop movements. On June 9, as Airborne soldiers rode trucks toward an airfield, they read on the morning's front pages that their unit was to be committed to a heliborne assault against an identified objective. An officer wrote, "We cursed to each other, saying, 'Those mothers! We have not yet received our orders or the battle plan, but the papers are publishing sketches of the Landing Zone!' Some brass

hat in starched fatigues obviously wanted to make himself seem important to some journalists."

Lt. Doan Phuong Hai led the point platoon onto the battlefield, some forty miles north of Saigon. They set down among the usual corpses and wrecked buildings, an ox dead in the shafts of a cart loaded with Vietcong bodies, ownerless dogs barking, abandoned bicycles, and a derelict truck. More ominously, they passed a cluster of wrecked helicopters, downed earlier when they landed in the midst of a communist concentration. The Airborne's first task was to collect the corpses of both friend and foe, already decayed and stinking. Lt. Hai sniffed repeatedly at a bottle of heavily scented *nhi thien duong*—skin care oil—but this did not suffice to suppress his horror as he gazed on the ants hastening busily in and out of the ears, noses, and eyes of the dead. By evening, when he opened a ration tin, "the pork covered with a layer of grease so closely resembled the rotting flesh of the bodies I had seen that afternoon that I threw up."

Next afternoon, June 12, while the platoon was approaching a rubber plantation, a ferocious firefight erupted. Beneath a storm of incoming mortar bombs, Hai requested air and artillery support—but was turned down. The plantation compound was crowded with civilians, he was told. "I shouted into my radio, 'What motherfucking civilians?! They're VC!' All I could see were men wearing yellow-green khaki uniforms and pith helmets running all around the rubber-processing plant and housing compounds." His platoon was ordered to make a frontal attack across the flat ground of an intervening airstrip. To his astonishment, most reached the cluster of houses alive. But then torrential rain descended, and he awaited an inevitable counterattack.

Enemy troops swarmed forward. Once again the Airborne begged for air and artillery support, and once again were refused. Much later, as firing belatedly subsided, Hai learned that his company commander was dead, along with an elderly second lieutenant who had somehow survived twenty years of war until his luck ran out that day. "I prayed that his next life would be less wearisome." Another of the day's casualties proved to be a captain who had been among the garrison of hill Béatrice at Dienbienphu.

How could any man expect to survive indefinitely while fighting through his country's interminable conflicts?

Hai wrote despondently, "Our battalion had virtually disintegrated. All four company commanders were dead. Suddenly I saw stars in front of my eyes. My arm flew upward and my AR-15 dropped from my grasp. I collapsed next to a machine-gun, which was still spraying fire at the enemy." When he regained consciousness, darkness was falling, rain dripped from the rubber trees, and a dead enemy soldier lay across his stomach. His face and right arm were acutely painful. One AK-47 round had cut through his cheekbone and nose, while two more had passed through his right arm. He was soaked in blood from the VC corpse, which he was somehow able to push aside. Then he crawled to the base of a rubber tree, and lay listening to enemy troops searching the battlefield, cursing considerably about their own losses. One of them kicked Hai, then stripped him of his watch, webbing, and transistor radio. The thick skein of blood on his torso convinced the scavenger that the body was that of a dead man. The communist moved away, arguing with companions about the disposal of Hai's property. As silence descended and the rain intensified, Hai was just capable of crawling to the body of his radioman, Cpl. Tam, from whom he borrowed a poncho for which Tam had no further use.

"The two of us lay there, one dead and one still alive, our bodies curled up next to each other. I looked at Tam sadly, thinking of our good and bad times together. I thought about my parents, who would be eating dinner at this time, and wondering about me. My mother would have run over to the family altar and lit an incense stick for me." As Hai lay nursing his pain among so many dead men, the bombs and cannon fire that might have saved them a few hours earlier raked the area, lit up by flares. He eventually staggered to join a small group of stragglers, mostly wounded like himself. For two days, they dragged themselves across the devastated landscape until they reached a friendly base, where doctors found his wounds unsurprisingly infected. He proved to be almost the only surviving officer of his battalion, which had lost over two hundred dead and around three times as many wounded.

The Airborne division was among the most effective combat forma-

tions Saigon had, yet here was one of its units chewed to pieces by the Vietcong. This was a story repeated again and again in 1965, so that Westmoreland reported to the White House, "The South Vietnamese armed forces cannot stand up to this pressure without substantial US combat support." MACV had developed a grand strategic plan: use American troops first to defend their own facilities, then to reinforce the Central Highlands, then to pursue the enemy in "search-and-destroy" missions, all while conducting pacification activities and sustaining the bombing of North Vietnam. DePuy, Westmoreland's operations officer, was convinced that the Vietcong could not resist overwhelming firepower. David Halberstam characterized him as "tiny but cocky and imperious." Neil Sheehan wrote with repugnance that he believed in "more bombs, more shells, more napalm . . . till the other side cracks and gives up."

Westmoreland urged that his own forces must relegate the South Vietnamese to local security duties, the garrisoning of towns and cities. MACV's commander proposed that the 1st Cavalry Division should be deployed in Thailand, to operate from the west against the Ho Chi Minh Trail in Laos. DePuy said it was crazy that the Americans were expected to respect neutralities when the enemy refused to do so. The president demanded of Westmoreland, what do you need? The general responded: 180,000 men immediately (thirty-four US battalions and ten from South Korea, with appropriate support) and a further 100,000 to follow in 1966. While this request was under consideration, the Navy launched Operation Market Time, a protracted inshore commitment, designed to interdict shipments of arms from North Vietnam by sea into the South.

Between air raids and troop deployments, the president extended occasional olive branches. In an April speech at Johns Hopkins University, he suggested that if the North Vietnamese abandoned the war, he would mail them a billion-dollar check for a Mekong dam—a massive bribe to leave the South alone. After he spoke, he leaned over to his aide Bill Moyers and patted the younger man's knee complacently. "Old Ho can't turn that down," he said, then repeated, "Old Ho can't turn that down." Hanoi of course did so, baffling Johnson.

On May 13, the president ordered a five-day bombing halt while a

254 · VIETNAM

new peace offer was passed North via Moscow. Pham Van Dong declined even to read the message. It is interesting to speculate whether, if the billion-dollar carrot had been advanced with more diplomatic subtlety, it might have changed anything. Had Ho Chi Minh's half-starved people been consulted, informed that all this could be theirs in exchange for postponing reunification, who is to say how they might have responded? They couldn't eat national pride. But this was capitalist money, imperialist money, tainted money, proffered like swill to swine, before a society whose inhabitants were permitted no choices. It was unthinkable that Hanoi would take it.

In Washington, it was still assumed that the Russians could halt the war at any moment their new leaders Leonid Brezhnev and Alexei Kosygin chose to pick up the telephone to Hanoi. Dean Rusk told Ambassador Anatoly Dobrynin, "We are puzzled as to how to proceed, assuming both of us really want peace." The Soviets were alarmed by escalation, apprehensive that the Americans might even deploy tactical nuclear weapons in Vietnam. Yet Dobrynin could offer Rusk no comfort: Moscow declined to assume the thankless role of intermediary, when both combatants were bent upon achieving military dominance before negotiating.

A bitterly indignant Lyndon Johnson told Senator Fulbright that it was Hanoi's rejection of his peace proposal—North Vietnamese withdrawal from the South in exchange for a cessation of bombing—that made it necessary for the US to make more war. Yet the world recognized that the administration was vacillating. On May 17, 1965, *The Times* in London reported that "bombing has failed as an instrument of diplomacy. . . . With the US in its present fix, on the lower rungs of an escalation ladder which it does not want to climb further, there would appear to be small reason for Hanoi to help it to the ground." If this was by no means an accurate appraisal of where the White House had got to, the paper correctly grasped that it was in a muddle. On June 7, Westmoreland bluntly informed Washington that South Vietnam faced military defeat unless forty-four US maneuver battalions were committed. "I see no course of action open to us except to reinforce."

From the State Department, George Ball penned a new memoran-

dum, warning against sending more men: "Before we commit an endless flow of forces to South Viet-Nam we must have more evidence . . . that our troops will not bog down in the jungles and rice paddies, while we slowly blow the country to pieces." But the Joint Chiefs supported the general's assessment, and his request. The president told a congressional group, "Westy wants help—and I'm gonna give it." Attorney General Nicholas Katzenbach reported to the White House that "as a matter of law, further Congressional approval at this time is not necessary," for an increased commitment. On June 16, McNamara announced reinforcements that would raise the troop level to seventy thousand.

Two days later, giant USAF B-52s began to attack alleged communist troop concentrations in South Vietnam. In the eight years that followed, the bombers carried out 126,615 so-called Arc Light sorties, dropping four million tons of bombs. Aircrew considered them milk runs. Pilot Doug Cooper shrugged. "The job had all the excitement of being a long-haul truck driver without being able to stop for coffee." A navigator said he felt that he and his crew just bombed an endless succession of map coordinates "that seemed to do nothing except put holes in the jungle floor." From mid-1968 onward, ordnance was released not on the judgment of bombardiers but instead that of Skyspot radar operators on the ground. The B-52s operating over South Vietnam and later Cambodia and Laos faced no threat from enemy action, merely a slight risk of accidents. Most of these elderly monsters suffered from corrosion: one had its bombs fall off the wing racks onto the runway during takeoff, because of wiring corroded by rain and sea salt. In eight years, just twelve Arc Light planes were lost to such mishaps. The B-52 crews suffered very little to destroy very much.

THE ESCALATOR

1. "BOTTOM OF THE BARREL"

A new military junta had assumed power in Saigon. It was headed by Nguyen Cao Ky as premier, with Nguyen Van Thieu as head of state. A despairing William Bundy described the pair as "absolutely the bottom of the barrel." Ky, in a later account of the generals' meeting that preceded his appointment, described himself challenging the others: "Anyone want to be prime minister?" Only after a silence did he say that he himself would try it. He shrugged. "I am not a good politician, not a good diplomat. The only thing I can do well is to fly airplanes." That spasm of modesty, however, was avowed only after years in exile, following defeat.

Lyndon Johnson professed to be unmoved by the latest political upset, saying, "We will move strongly—stable government or no stable government." The new prime minister was just thirty-four, a 1954 fugitive from the North who had trained as a pilot in France, then flown thousands of hours both in transports and combat aircraft, participating in agent-dropping missions over North Vietnam. Ky was a slick dandy with a pencil-thin mustache; he affected a custom-made black flight suit and an impressive procession of wives and girlfriends. He was publicly affable, fluent, enthusiastic about all things American but the taste of Coca-Cola—and as remote as a Martian from the Vietnamese people. In June 1965, he was confident that he had secured the real power in Saigon, relegating

the less flamboyant Thieu to a merely ceremonial role, though time would show otherwise.

Chester Cooper described the first appearance of the new prime minister and head of state at a July US Embassy dinner for Robert McNamara: "Ky made a spectacular entrance. He walked in breezily, wearing a tight, white dinner jacket, tapered formal trousers, pointed patent leather shoes, and brilliant red socks. A Hollywood central casting bureau would have grabbed him for a role as a sax player in a second-rate Manila night club." The defense secretary seemed bemused by the encounter, later describing Ky contemptuously as "'executive agent' for a directorate of generals." Another American studying Ky muttered to Cooper, "At least no one could confuse him with Uncle Ho!" President Thieu, more conservatively dressed in a business suit, seemed content to allow Ky to occupy the limelight the airman craved.

It was on July 16, during this same McNamara visit, that the defense sccretary received a cable advising that the president had privately determined to go ahead with the forty-four-battalion commitment West-moreland sought. This dramatic surge was accompanied by the usual interservice squabbles and jealousies: Adm. Sharp warned Gen. Greene that "General Westmoreland and Ambassador Taylor . . . will do everything they can to prevent the Marine Corps from getting credit for their accomplishments in South Vietnam."

Greene, in consequence of the war, presided over a dramatic expansion of his service, but was nonetheless astonished when McNamara informed the Joint Chiefs about the reinforcements, because an agreed strategic plan was still lacking. The Army's Gen. Harold Johnson recognized that the decision to escalate without a public acknowledgment of its significance was extraordinary, and left him "tongue-tied." Years later he said, "What should my role have been? I'm a dumb soldier under civilian control. . . . I could resign and what am I? I'm a disgruntled general for 48 hours and then I'm out of sight. Right?" This was, of course, a limp-wristed explanation of his pusillanimity. On July 14, Earle Wheeler told McNamara, "There appears to be no reason we cannot win if such is our will—and if

that will is manifest in strategy and tactical operations." Wheeler meant, of course, if the gloves were taken off, curbs lifted from the generation of violence, as the president—haunted by fears that hitting the North too hard would trigger a Chinese intervention, such as took place in Korea—refused to do.

Maxwell Taylor, who had obviously lost faith, was recalled from the Saigon Embassy to which, for a season, Henry Cabot Lodge returned. McNamara identified to Lodge three alternative courses: quit, and accept humiliation; deliver more of the same, and preside over a progressive deterioration; or escalate, with "a good chance of achieving an acceptable outcome within a reasonable time." Lodge endorsed the third option, knowing that this was already ordained. The defense secretary now favored the mining of Haiphong Harbor, far heavier bombing of the North's infrastructure, and mobilization of Army Reserves to enable a massive deployment of troops. Johnson decisively rejected this last measure: a call-up would do what he had set his face against: proclaim to the American people that they were in a big war.

George Ball had submitted a new memorandum: "Politically SV is a lost cause. The country is bled white from twenty years of war and the people are sick of it. The Viet Cong—as is shown by the RAND Corporation Motivation and Morale Study—are deeply committed. Hanoi has a government and a purpose and a discipline. . . . The 'government' in Saigon is a travesty. . . . South Vietnam is a country with an army and no government." Ball asserted that Gen. Matthew Ridgway's arguments against a 1954 intervention remained equally valid a decade later. Yet McGeorge Bundy absolutely rejected the assertion that America was assuming the same unworthy role as the old colonial power, himself writing that "the US in 1965 is responding to the call of a people under Communist assault." Yet where was the evidence of such a call, from any popular faction within South Vietnam?

On July 21, Ball was among the participants at a White House summit, supposedly to discuss all options. Yet those present knew that they had been summoned to confirm commitments already stone-set in the

only place that mattered: the mind of Lyndon Johnson. The diffidence and humility displayed in the first weeks of his presidency had long since vanished. Special Counsel Harry McPherson wrote him a private note, warning that his personality was so overpowering that the public, if it considered his advisers at all, "thinks of docile calves hustling around at the will of a singular bull." Yet it remained important to Johnson to ensure that the herd was with him before he embarked upon what would prove the most momentous ride of his presidency. On July 21, one of the "docile calves," Carl Rowan, head of USIA, expressed fears about the debility of the Saigon regime: "Unless we put the screws on the Ky government, 175,000 men will do us no good." Henry Cabot Lodge riposted, "I don't think we ought to take this government seriously. There is simply no one who can do anything. We have to do what we think we ought to do regardless. . . . As we move ahead on a new phase, we have the right and the duty to do certain things with or without the government's approval."

These were awesomely arrogant words, reflecting a mind-set at the heart of the catastrophe that befell policy making. Ky claimed once to have told the Americans, "What Vietnam needs is a man like Ho Chi Minh for the North Vietnamese, a true leader for the South Vietnamese, not an American man. But that they never understand." Christopher Thorne, author of a classic study of the World War II experience of the Western allies in Asia, observed that a generation later in Indochina, the US followed the same wrong path it had earlier taken in China, "relying on assumptions that were based to a considerable extent on a projection of American values, experiences, and self-image, this being coupled with a failure to appreciate the nature of the very different civilization and political culture . . . on the far side of the Pacific."

At the July 21 meeting, George Ball reasserted his conviction that American soldiers would not prevail in an Asian jungle war. Earle Wheeler probably felt that he owed it to his boys to refute this slight, staunchly assuring the president that Westmoreland's proposed "search-and-destroy" strategy would see off the VC. Ball then declared that he would be much less troubled if there was a realistic prospect of victory within a year, but

"You know, dear, I've a nasty feeling that very soon we're going to have to know the difference between Vietnam and Vietcong." 5.iii.65

"What the Americans don't seem to realise is that, however high you escalate, there's always a ticket-collector at the end." 30.vii.65

World opinion was almost uniformly skeptical about the US commitment, as reflected in cartoons which appeared on the front page of the *London Daily Express* by Osbert Lancaster, respectively in the spring and summer of 1965.

that if the struggle persisted longer, as he feared it would, both domestic and international opinion would become problematic. Lodge threw at the undersecretary a familiar but embarrassingly cheap jibe: a comparison with the British and French leaders who rolled over before Hitler at Munich in 1938.

The president himself challenged Ball: "But George, wouldn't all these countries say that Uncle Sam was a paper tiger, wouldn't we lose credibility breaking the word of three presidents, if we did as you have proposed? It would seem to be an irresponsible blow."

Ball: "No sir. The worse blow would be that the mightiest power on earth is unable to defeat a handful of guerrillas."

President: "But I believe the Vietnamese are trying to fight."

Ball: "Thieu...the other day...said the communists would win [an] election."

President: "I don't believe that. Does anyone believe that?" [All expressed views contrary to Ball.]

The undersecretary then threw down his hand on the table, saying, "Mr. President . . . if the decision is to go ahead, I am committed . . . I have had my day in court." Though Ball had displayed wisdom and courage in speaking truth to power, his appetite for office proved too great to allow him to make the principled sacrifice of a resignation. One of his favorite sayings was "Nothing pinks like propinquity," by which he meant that there was no substitute for the elixir of intimacy with power. The president, with his brilliant instinct for men's vulnerabilities, indulged Ball because he was confident he would not break ranks. Johnson said later of his vice president, "I've got Hubert's balls right there in my pocket, and that's where they're going to stay." The same was true of the undersecretary of state.

Next day, Johnson met the Joint Chiefs, who urged going for broke both with bombing and troop numbers. The Marines' Wallace Greene said, "Five years, plus 500,000 troops. I think the American people would back you." Johnson said, echoing McNamara weeks earlier, "The least desirable alternative is getting out. The second least is doing what we are doing. The best alternative is to get in and get the job done." None doubted that the war would be long, the cost immense. Quite unlike, for instance, the 2002 decision to invade Iraq, in 1965 every hazard was anticipated. In the midst of Johnson's discussion with the Chiefs, he suddenly broke off and mused aloud, "But remember, they are going to write stories about this like they did in the Bay of Pigs. Stories about me and my advisors."

The president asked all the right skeptical questions: he merely declined to heed the answers. His refusal to call up the reserves, to avert a huge domestic debate, is sometimes cited as an important mistake. Some insiders thought McNamara would resign when Johnson rejected his recommendation to adopt this course. Instead, the defense secretary took the snub on the chin. While refusal to mobilize certainly contributed to the precipitous decline in the US Army's performance at the end of the decade, and especially to the collapse of its NCO corps, it seems quite mistaken to regard this as a major cause of US defeat. The entire strategy was founded on false premises, both about the domino theory and the nature of Asian communism. Many of the decision makers remained

262 .

haunted by the "loss" of China. The historian Michael Howard identifies parallels with delusions that beset Europe's leaders in 1914: "The mixture of apprehension, national arrogance, misperception and misguided military expertise . . . like the German and Austrian statesmen of the earlier era, American statesmen saw how a minor and local shift in the balance of power might produce a major and sinister transformation of the whole world order. [They believed that] Hanoi could do as much damage as Belgrade threatened in 1912–14 (or, for that matter, Egypt in 1956); so she had to be checked and chastised before matters got totally out of hand. Further, there was in the US . . . an enormous self-confidence and pride not unlike that of the Germans before 1914; a consciousness of national greatness seeking an outlet, a searching for an appropriate challenge to their powers, a refusal to believe that any problem was beyond their capacity to solve. Statesmen who might themselves have doubts were conscious of a great groundswell of public opinion bearing them on."

Experience in two world wars cured most European politicians of a belief in the serviceability of conflict as a mere instrument of policy. For Washington's 1965 decision makers, however, when no nuclear threat overhung a battlefield, the mere notion of engaging in combat held few terrors. Failing to define objectives, Lyndon Johnson merely mandated his generals to "kill more Vietcong." Adm. David McDonald, 1963–65 chief of naval operations, wrote a decade later, "Maybe we military men were all weak. Maybe we should have stood up and pounded the table. . . . I was part of it and I'm sort of ashamed of myself too. At times I wonder, 'Why did I go along with this kind of stuff?'"

At a private Camp David meeting in July, the president's veteran political adviser Clark Clifford warned Johnson, "This could be a quagmire. . . . I can't see anything but catastrophe for my country." McGeorge Bundy, hitherto an unyielding hawk, recoiled from McNamara's proposals for a massive ground commitment. On July 23, Bundy warned that "our troops are completely untested in the kind of warfare projected. . . . This program is rash to the point of folly," then saying that McNamara "omits examination of the upper limit of US liability." Senators Mike Mansfield and Richard Russell also advised the president against sending more

troops. Outgoing ambassador Max Taylor yet again changed his mind and was now opposing reinforcements. All were swept aside: the cost of pulling back was deemed greater than that of plunging deeper.

At a news conference on July 28, Johnson announced the dispatch of fresh troops that would increase total American numbers to 175,000. Bizarrely, he presented this as a decision not to go to war. Dean Rusk said, "We never made any effort to create a war psychology. . . . We felt that in a nuclear world it is just too dangerous for an entire people to get too angry and we deliberately played this down. We tried to do in cold blood perhaps what can only be done in hot blood." It is striking to contrast Johnson's essay in low-key war making, designed to preserve the American people's peace of mind, with the strident appeals to patriotism, socialism, sacrifice, and national unity that dominated the lives of every North Vietnamese for the next decade.

Conservative columnist Joseph Alsop wrote in the Washington Post on July 29: "There is a genuine element of pathos (and pray God, the pathos does not turn into tragedy) in the spectacle of this extraordinary man in the White House wrestling with the Vietnamese problem, which is so distasteful to him, and all the while visibly longing to go back to the domestic miracle-working he so much enjoys." Once the first ground forces were committed, American lives and prestige staked on a vast scale, politicians, warriors, and citizens alike faced enormous pressure to "get on the team," to stifle dissent, support this commitment made in the name of the American people, though without their understanding or consent. Even George Ball urged Walter Lippmann and other skeptics to mute their criticism, on the grounds that antiwar agitation encouraged Hanoi. William Small, boss of CBS's news division, found himself confronted at a Washington cocktail party by Dean Rusk, who poked him in the chest and said fiercely, "All American journalists want to win Pulitzer prizes for their reporting, but some day they're going to ask what side are you on; and I don't know how you fellas will answer."

The president resented critics even more bitterly. Having enjoyed a honeymoon with the press through his first year of office, there had since been a big falling-out: Johnson persuaded himself that those who failed to

264 .

accept him at his own valuation were on the payroll of Bobby Kennedy. When Senator Frank Church became a vocal critic of Vietnam policy, Johnson observed sourly, "Next time ol' Frank wants a dam over there in Idaho, he can go ask Walter Lippmann for it!"

Military operations generate their own momentum. In April 1965 Johnson had committed US Marines and the 82nd Airborne Division to prevent a communist takeover of the Dominican Republic. In a climate of crisis, the impulse to "support our boys" enabled the president to secure in short order from Congress a \$700 million appropriation, for operations in the Caribbean . . . and Vietnam.

From November 22, 1963, onward, did Lyndon Johnson ever really vacillate about escalation or merely pretend to do so, for instance in anguished telephone conversations with Richard Russell and others? There is a good argument that, for all the hours he devoted to debate with military and civilian advisers, it was never plausible that he would adopt a course that might cause his fellow countrymen to accuse him of weakness, of acquiescing in defeat. Moreover, Korea had set an important precedent, fostering a belief that a military outcome short of victory could nonetheless produce an acceptable compromise peace.

Who deserves the blame? H. R. McMaster has written, "The Chiefs . . . failed to confront the President with their objections to McNamara's approach to the war. Instead they attempted to work within that strategy in order to remove over time the limitations to further action. They did not recommend the total force they believed would ultimately be required in Vietnam." Lt. Gen. Bruce Palmer was another military man who indicted the JCS for failure to tell the nation's leader that his incremental escalation was almost certainly doomed. "They could not bring themselves to make such a negative statement or to appear to be disloyal." Yet uniformed leaders face an oft-repeated dilemma: it is their duty to fulfill the purposes of their political masters, and they also need to justify the vastly expensive existence of the armed forces. If US troops were incapable of defeating a ragtag guerrilla force, then wherein lay their utility? For all Westmoreland's limitations, he should not rightfully receive blame for the decision to commit a vast American army, merely because he asked for one. To

paraphrase Tennyson, his not to reason why, his but to send men to do and die. Johnson and McNamara made the vital decisions. Adm. Sharp, C-in-C Pacific, complained that all meetings attended by the defense secretary ended up reaching the conclusion that he wanted: McNamara conducted his office far more in the manner of a field commander than a political manager.

As for Lyndon Johnson, not for nothing does the president of the United States bear the title commander in chief. What was the choice before him in 1964-65? Some modern critics of the decision to escalate decline to acknowledge that to concede victory to the communists was to condemn the Vietnamese people to an ice-age future under Le Duan's collectivist tyranny, such as eventually became their lot after 1975. Frances FitzGerald wrote, "There was no 'other side' in this war. . . . We were not only on the wrong side, we created the wrong side. . . . It was not the Vietnamese that began the violence, it was ourselves by going in there. . . . In Vietnam what we were doing was trying to stop a local government from coming to power." This ignores the profoundly undemocratic, inhumane character of the North Vietnamese regime. Much wiser seems the view of Senator Eugene McCarthy, who said long afterward, "The moral issue as I saw it finally got down to the question of was there any proportion between the destruction and what possible good would come out of it? . . . You started with the judgment . . . about people in South Vietnam wanting to have a free society. But the price of getting it was the destruction practically of a total community. You make a pragmatic judgment . . . you don't pursue it to all-out destruction."

While today the failure of collectivization is apparent in every society where it has been tried, in the twentieth century it was probably historically inescapable that impoverished rural societies, China and Vietnam notable among them, should attempt implementation of the theories of Marx and Lenin and so discover for themselves their unworkability. The human cost was appalling—but so was that of the American attempt to prevent such an experiment by force of arms. Doug Ramsey suggested that communism offered the Vietnamese, with their strongly structured relationships between the individual and the family, and the family and

266 .

society, a more plausible vision than did Western liberal individualism. In 1965 many could scarcely be blamed for judging that peace at any price was preferable to a continuation of their murderous struggle. The fatal error of the United States was to make an almost unlimited commitment to South Vietnam, where its real strategic interest was minuscule, when North Vietnam—the enemy—was content to stake all and faced no requirement to secure or renew popular consent. Moreover, the 1964–65 American takeover of the South, which *is* what took place, legitimized Vietnamese communism.

The basis for a historical indictment of Lyndon Johnson's decision is that he made his choices with a view to his own interests and those of his country, rather than those of the Vietnamese people. He showed himself blind to proportionality, as defined by Eugene McCarthy; he failed to heed wise and insistent counselors who argued that his war making would almost certainly fail; and finally, he deceived the American people. Daniel Ellsberg, assistant to John McNaughton at the Pentagon in 1965-66, said bitterly later, after his own conversion, "Everything we did was secret from the public, all the lies, the illegal actions that were being prepared, the aggressive actions against North Vietnam." On July 27, 1965, Senator Mike Mansfield reported to the president on a meeting he had held that afternoon with William Fulbright, Richard Russell, and other senior members of the Foreign Relations Committee. "There was a general sense of reassurance that your objective was not to get in deeply, and that you intended to do only what was necessary in the military line until January, while [UN ambassador Arthur] Goldberg and Rusk were concentrating on attempting to get us out."

Dean Rusk acknowledged the almost surreptitious shipment of forces: "We didn't want to present Moscow and Hanoi with a dramatic new situation." Thus, in terms of numbers of troops moving toward Vietnam, "one week wasn't much different from the last." The administration was careful to eschew the drama of parades, regiments marching through city streets to the dock- or planeside. Robert McNamara was getting ready to send more soldiers. Like many apparently masterful men, the defense secretary was susceptible to dictation from an even stronger one, such as

Lyndon Johnson. If the president called and invited him over as he cooked burgers for the family at Sunday lunchtime, McNamara would douse the barbecue and climb into his car, though the summons was merely whimsical and social.

Posterity has chained the two men to the war in tandem, yet they had little in common. The fastidious McNamara hated the vulgarity of Johnson's language and behavior. He was nonetheless in awe of the president's power and strength of will. Meanwhile his boss valued McNamara's intelligence, ruthlessness, and above all loyalty. Some months earlier, when it was already plain that the war was turning bad, friends urged the defense secretary to quit office. He responded that he must stay and "see the Vietnam thing through." In truth, he could not bring himself to walk away. It was an unpleasant contradiction, that he understood better than most the probably irredeemable weakness of the South Vietnamese regime, yet he became increasingly vicious in his attitude to critics, such as George Ball. Here was a decision maker who prided himself on his rationality, but from mid-1965 he became an obsessive, some of whose decisions verged upon madness. No man paid a higher reputational price for engagement with the war than did the defense secretary.

Senator Mike Mansfield wrote presciently to the president on July 27, 1965: "The main perplexity . . . is that, even if you win, totally, you still do not come out well. What have you achieved?" Among his colleagues on the Senate Foreign Relations Committee, he said, "there was full agreement that . . . we are deeply enmeshed in a place where we ought not to be; that the situation is rapidly going out of control; and that every effort should be made to extricate ourselves." Lyndon Johnson could never say that he was not warned about the likely consequences of the course upon which he was now embarked.

As for the enemy, a senior NLF cadre wrote that the prospect of all-out US engagement "filled us with sick anticipation of a prolonged and vastly more brutal war. It was not a question of any lack of determination or confidence in our ultimate victory. . . . But if the Americans were to intervene in strength, the scale of violence would increase exponentially."

2. NEW PEOPLE, NEW WAR

And hereafter legions of Americans landed in Vietnam. Medic David Rogers had to buy his own one-way ticket to Oakland for embarkation: "It was almost like they were sneaking you out of the country." The girl at the airline counter asked, "No round trip?" Flying was so strange and new to Robert Daniels, a black kid from a poor street on Chicago's South Side, that on the plane crossing the Pacific, he remembered "I was scared to death. I thought we'd never get there." After a seventeen-hour flight, the zonked arrivals were told, "Okay, everybody, form up on the hardstand," then herded into buses, which took them to a white clapboard building. Their money was changed into MPCs—military payment certificates—and they were assigned bunks in a transient barracks.

When Sergeant Jimmie Spencer got there in December 1965, "It looked to me as if the United States had taken over the country." Spencer was born in Mobile, Alabama, in 1944, to an unmarried mother "back before it was popular." He volunteered initially for three years, then after discharge found that he missed the service and signed up again. He first served in Vietnam with a special forces unit, acutely conscious of veteran NCOs around him who had done Korea and World War II, striving to measure up to them. Every new arrival was given the same advice about how to treat Vietnamese: "You grab 'em by the balls and the hearts and minds will follow." Spencer said, "I was in my element. Everybody was a volunteer. I was very proud of my service. We were doing what people had done in World War II—going to the aid of people who needed it."

Capt. Gordon Sullivan said, "In 1965 we decided that we had come to win this war, and we wanted the Vietnamese to stand aside while we did it. . . . Americans had a very low opinion of the Vietnamese people." Capt. Henry Gole characterized himself and his special forces comrades as saying to their allies, "Step aside. The first team is here to clean up this mess." Some of these young men knew as little about alien regions of their own country as they did about the one to which they were now translated. A lance corporal from the East Coast demanded of a corpsman from Oregon, "Are there still wild Indians out where you come from?" Capt. Joseph

Fitzgerald noticed that "some soldiers thought it cute to walk around Saigon rodded up like Wyatt Earp, with a pistol in an open holster." Pfc Reg Edwards's first shock had nothing to do with death and devastation, but instead with finding that even tiny children smoked cigarettes, which seemed to him horrible. "The first Vietnamese words I learned were *Thuoc la co hai cho suc khoe*, 'Cigarettes are bad for your health.'" In the boondocks, many men were afraid of snakes and disconcerted by gibbons shrieking in the trees. They loathed the ubiquitous leeches.

Infantry were issued a machete, entrenching tool, Claymore mine with wire and "hellbox" firing device, poncho and poncho liner, helmet with liner and cover, bug repellent, olive drab towel, web belt, ammo pouches, radio batteries, and an M14 semiautomatic rifle. NCOs told their men, "At one hundred yards you aim at the crotch and hit the chest cavity. At three hundred yards you aim at the head and hit the chest cavity." They were told that French rubber planters were communist sympathizers who paid VC taxes. Down in the Delta, Sgt. Mike Sutton traded captured weapons for everything his adviser team needed, up to and including 40-horsepower Johnson outboards, in what they called the green market. The new American facility in My Tho was christened Base Whiskey, until a hand-wringing USIA officer got this changed to the more sonorous Dong Tam, meaning "With One Accord." Vietnamese people received leaflets explaining that the visitors might find certain English phrases pleasing: "I want peace." "Do you miss your wife and children?" "We are civilians." "This route is dangerous." Instead, however, children were likely to say: "Hello . . . No VC . . . Vietnam Number One."

Peasants were bemused by the joshing of GIs—"grunts" in this new war—who tied NLF flags around their own heads and cried out to villagers, "VC Number One!" A Marine jeep collected an officer fresh from home, who gazed wonderingly at pillars of black smoke curling upward on the horizon. "Is that incoming?" he asked. "Hell no, Major," said a Pfc. "They're just burning the shitters." Behind the troops came a stupendous array of equipment, vehicles, and machinery. Beyond helicopters and fixed-wing aircraft, there were jeeps, deuce-and-a-half trucks, steel containers—Conexes—millions of sandbags and millions of miles of wire, hundreds

270 · VIETNAM

of thousands of tons of concrete, a fabulous array of weapons, and a few million condoms, just to get everybody started, plus billions of cigarettes in those days when almost every soldier smoked tobacco, even if he had not graduated to other stuff. In 1966 Americans would complete fiftynine airfields; each month ship into Vietnam six hundred thousand tons of stores; and write checks approaching \$2 billion. Forty-two military construction companies labored halfway around the clock, while civilian contractors such as RMK-BRJ and DMJM brought in thirty-inch pipeline dredgers, thirty-ton dump trucks, four-hundred-ton-per-hour rock crushers, giant winches, bulldozers, and Rome plows that consumed six hundred gallons of diesel a day.

They dug ditches, raised blast walls, and erected plywood huts thirty-two feet by sixteen with galvanized roofs that drummed an ear-splitting tattoo in the rain. Pacific Architects & Engineers, Vinnell Corp., Computer Sciences Corporation, Dynalectron, and many others waxed fat on the cost-plus system, which meant that the more they spent—for instance, on their own employees' housing—the more profit they made. Frank Scotton said, "The Vietnamese knew all about this, and it vitiated the image of Americans as trusted partners."

A CIA officer wrote of a typical contractor, holding forth in Mimi's Bar in Saigon: "Florid, bull-necked, checkered shirt hanging loose over the barrel gut . . . here in all his glory is the American homesteader, the former truck driver or factory foreman, who hangs on year after year bossing Vietnamese road gangs or construction teams. Master to a cringing Vietnamese wife or mistresses, keeper of the American superiority complex." Yet such a man might have riposted to this scornful spook that he was hard because only hard men could do the business in that hard place.

Everything about the war was hard—vehicles, guns, shells, planes, body armor, bullets, C-ration cans, Conexes, the will of the enemy—everything except human flesh and most of the ground underfoot. Soldiers and civilians were carpeting the country with a network of bases, runways, all-weather roads, and PXes—Post Exchange stores. For every American serviceman, a hundred pounds of supplies and equipment was delivered daily, straining to the breaking point the port and airfield facil-

ities of a relatively primitive Asian land. Theft on an industrial scale became endemic. Trucks bouncing breakneck along potholed roads brushed aside peasants and their lumbering water buffalo, while low-flying Hueys blew dust clouds over countless washing lines. Far out in the wilderness, American propaganda paper "turned the forest white," according to a communist officer; by 1968 MACV would be putting out four hundred million leaflets a month. One that was deemed notably effective was addressed to men marching down the Ho Chi Minh Trail: "A North Vietnamese Soldier's Poem to His Mother." Across large tracts of Laos and South Vietnam, aerial defoliation caused forests and indeed all vegetation to vanish.

When army nurse Sharon Bystran left Oakland in July on a ship carrying three thousand troops, she noted that even at that early date, a small group of hostile demonstrators waved banners on the shoreline. As a twenty-three-year-old from Oregon, she was thrilled by the prospect of the adventure: "It's sort of exciting finding out what the unknown is." When they landed at Qui Nhon, however, their first sensation was revulsion from the stench. She joined the staff of the 85th Evacuation Hospital, and in the year that followed gained a decade's worth of nursing experience. But it was tough being a woman in an overpoweringly male environment, because many senior officers saw the nurses as founts of discord. The captain running a mess hall shooed them away. "[He] explained to me that it was better to fight a war without women around. . . . I think it was the sense of wanting to remain loyal to his wife and he didn't like the idea that there were women there, constantly reminding him that women did exist." The nurses learned to shower in groups, allocated thirty seconds of water apiece. "We used to say, 'One in the shower, one on the pot, and one at the sink.' The rule was never to lock the bathroom door except when you were having your period. You were allowed a little more privacy then."

Meanwhile, the warrior newcomers started to fight, to "search and destroy." Phil Caputo wrote, "There was no pattern to these patrols and operations. Without a front, flanks or rear, we fought a formless war against a formless enemy who evaporated like the morning jungle mists, only to

272 .

materialize in some unexpected place. Most of the time, nothing happened; but when something did, it happened instantaneously, and without warning." Westmoreland had summoned his huge reinforcements on the assumption that the Vietcong were escalating their own operations, planning big assaults that would suit the US Army's maneuver battalions. George Ball was skeptical: "We have no basis for assuming that the Viet Cong will fight a war on our terms. . . . We can scarcely expect [General] Giap to accommodate us by adopting our preferred method of combat, regardless of how many troops we send."

Events proved Ball right. Many of the early clashes with the Americans involved only small groups of VC, and the average guerrilla found himself in action just one day in thirty. The communist war effort in the South was sustained on 380 tons of supplies and munitions a day, of which ninetenths were generated locally. Only 34 daily tons had to be shipped from the North, the equivalent of seven two-and-a-half-ton truckloads, albeit rather more bicycle or porter loads. The Joint Chiefs reported in August 1965 that the quantity of supplies Hanoi shipped South "is primarily a function of their own choosing." Newly arrived American infantry found themselves sweeping successive swathes of almost impenetrable wilderness. An NCO said, "If we made contact, the enemy would not stand and fight-most often he would just leave behind the odd sniper tied up in a tree. . . . In the Central Highlands jungle, you were lucky if you could see more than twenty feet. Sometimes the vegetation was so thick it was almost impossible to get resupply." In those early days, they tried to climb mountains wearing twenty-pound flak jackets, which caused a lot of casualties from heat exhaustion.

Though the US Army and Marine Corps waged war somewhat more effectively than did most ARVN formations, their political masters in Washington had been mistaken in supposing that the mere appearance of Americans would open a path to victory. Capt. Andrew Comer was executive officer of 3/3rd Marines during the August 1965 Operation Starlite, an amphibious assault on the Batangan Peninsula near Danang. Although his superiors reported success, he assessed the battle as a shambles. He described how the commander of a tank "fired with its machine-gun on

a boy of about ten years of age at a range of 75 yards." Comer ran to the ditch where the boy had taken refuge, "saw that he was unarmed and unhurt, and sent him on his way." Seeking to remonstrate with the shooter, he could not make himself heard above the roar of the tank's engine.

An amphibious tractor driver succumbed to hysterics under incoming mortar fire. The man repeatedly reversed his vehicle over wounded men, killing five prostrate Americans beneath its tracks. When Comer tried to check the "frantic" driver, "I was totally ignored and was nearly entangled myself." The captain gazed in revulsion at the helmeted head of one of the victims, a man he recognized: this lay at his feet, while the rest of the remains were caught beneath the tractor's tracks. Comer also described his outrage that a named private received a Silver Star: "The truth is that he evacuated himself from the battlefield by climbing aboard a helicopter and riding to Chu Lai. . . . He did nothing that was considered heroic that I recall." The Marine officer wrote in 1991, "I have suppressed my anger over that tank action on Hill 30 for 26 years and feel that I cannot go to the grave without revealing these facts. . . . I desire to have my knowledge of them recorded."

A North Vietnamese General Staff directive issued on June 10, 1965, required all units to submit detailed reports on encounters with US forces, so that tactical lessons could be learned. It decreed, "Keep the enemy constantly in a defensive, reactive posture. Force him to fight on our terms . . . in a constant state of psychological tension to erode his strength. . . . Ambush and annihilate small parties. . . . Conduct independent, isolated sapper attacks." Units were urged to seek opportunities to attack relief and rescue parties, to promote tensions between the "longnoses" and the Saigon regime's troops. The newcomers' key weakness, said Hanoi's military chiefs, was their aversion to casualties: "If we were able to conduct some early actions in which American units suffered annihilation, they would become confused politically as well as militarily."

While most US battalions took casualties, these were nothing like as bad as they would become a year or two later. Between March and August 1965, 1/3rd Marines, for instance, lost 10 percent of strength, over a hundred killed and wounded. But during a battle in the following spring, one

274 .

company lost that many men in a single hour. The newcomers saw themselves as pros, in the words of an officer, "self-confident and proud": they had acquired all the military virtues "at the price of a diminished capacity for compassion." Capt. Walt Boomer said, "I was willing to do anything to get to Vietnam because I thought the war was going to pass me by. I fully bought into this thing that the communists were going to take over the world, and this was the place to stop them. Even then, high school kids were saying, 'This war doesn't make any sense to us,' but I thought they were pretty stupid."

Jimmie Spencer was bemused by the otherworldliness of Vietnamese rural communities. "Some of those folks didn't even know what was on the other side of the mountain to where they lived." Men learned to hate the inhabitants of hamlets close to the scene of ambushes in which their comrades died or were maimed, because these stony-faced people must have known the perpetrators and where they hid out until the early hours of morning, a favorite time for killing Americans. Doug Ramsey wrote in August 1965, deploring "the willful and unilateral burning of whole villages by US Marines in response to a few rounds of sniper fire." Ramsey and John Vann also compiled a report on pacification in Hau Nghia Province, fiercely critical of the Saigon regime: "The present leaders, bureaucrats and province and district officials do not come from, think like, know much about, or respond to the wishes of, the rural majority of the population." The social structure had been transformed by the communist murder program, so that with almost all landlords and relatively prosperous folk dead or fled, only poor peasants were left in villages and hamlets, prey for both sides.

A local chief in Vinh Kim was described by his US adviser as "honest, fair, dynamic and a man whose military competence is obvious. . . . Gradually he has given the peasants the feeling that Vinh Kim is reasonably safe from Viet Cong harassment." In August 1965, Marguerite Higgins, an inveterate optimist, wrote a story about this admirable figure headed "Vietnam Town Regains Prosperity." Yet local people hated Mister D, as he was known, because they held him responsible for the deluges of shells and mortar bombs that fell upon them. He was subsequently

replaced by an officer who became very popular because he stopped the bombardments.

Many Americans found it impossible to regard thatch-and-bamboo huts, their dim interiors boasting only a few pots and beds of woven straw, as the homes of real people deserving of respect. Vietnamese watched with apparent indifference as soldiers or Marines probed their walls and straw piles with bayonets. Phil Caputo wrote, "I smiled stupidly and made a great show of tidying up the mess. See, lady, we're not like the French. We're all-American good-guy GI Joes. You should learn to like us." Caputo was dismayed to discover that not all his Marines, in whom he took such pride, had a store of humanity as impressive as their combat skills: "Some of them were not so decent and good. Many had petty jealousies, hatred and prejudices. And an arrogance tempered their ingrained American idealism." His sergeant observed that in Korea he had seen men sight-in their rifles by firing at farmers. "Before you leave here, sir, you're going to learn that one of the most brutal things in the world is your average ninetcenyear-old American boy."

He was thinking of men like L/Cpl. Marion McGhee, a fire-team leader in the 3/3rd Marines, who on August 12, 1965, walked out of the unit perimeter announcing that he was "going after a VC." Two men sent in pursuit heard a shot and a scream, then met McGhee walking calmly toward them. He said he had just killed a VC and was going back for more. It was later established that he had kicked through the wall of a hut in which a family was sleeping, seized a fourteen-year-old girl and shot her father dead when he tried to intervene. At his subsequent court-martial he offered a defense of insanity—the usual plea in scores of such cases during the years that followed—but was eventually found guilty of unpremeditated murder, for which he served six years' imprisonment. Most Marines, most soldiers, were not like L/Cpl. McGhee, but from the first days of the 1965 commitment, it became plain how hard it would be to convince the people of South Vietnam that escalation would serve their interests.

So much must be said about those who did reckless or wicked things, that it deserves emphasis that there were also fine Americans, some of

276 .

them chronicled in action in the Mekong Delta by David and Mai Elliott. Maj. William Willcox was a Midwesterner "who had an exceptional rapport with the Vietnamese, and represented all his nation's virtues. He could have been a case study for the perfect adviser." When Willcox's time was up, David Elliott pleaded with higher authorities to have his tour extended, but the US Army's routines were inexorable, and the major moved on. Elliott lamented that "he was just getting in the swing of things, just getting to know his way around." Another hero in the Elliotts' eyes was US Navy Lt. (JG) Henry Klein, who appeared in My Tho one day to organize a riverine operation and delighted them by his enthusiasm to learn about local people and ways. "He didn't just look on his assignment as a job to be done by numbers." When they heard a few months later that he had been killed, they mourned. "He was the all-American boy, the flower of American youth who lost his life doing something pointless." Sid Berry was joined for a time by Capt. Peter Dawkins, a fellow West Pointer who became Life magazine's cover pinup for April 8, 1966.

Players from allied nations were also arriving, as Washington called in debts and favors. The South Koreans sent a contingent that grew to two Army divisions and a Marine brigade. They were highly regarded as fighters and eventually lost more than five thousand dead, though their soldiers were also held responsible for several notorious massacres of civilians. The Philippines dispatched a brigade. America had acquired a powerful Australian friend when Paul Hasluck became its government's external affairs minister in 1964. He embraced the domino theory with special fervor, at a time when Australian troops were already confronting Indonesians in Borneo. Hasluck, like his prime minister Robert Menzies, was convinced of Australia's duty to stand foursquare with the Americans in Southeast Asia, as it had done in Korea. Menzies and Hasluck ignored the warnings of influential journalists, such as Denis Warner, who wrote in December 1964 that South Vietnam had become an "uncountry." They towed in their wake the New Zealand government, which was convinced that no good could come out of the war but felt obliged to follow the lead of its much larger neighbor.

On April 28, 1965, an agreement for the dispatch of combat troops

was reached between the Australians and the Saigon government, and a battalion reinforced by a New Zealand contingent was soon on its way and eventually swelled to brigade strength with support elements and special forces. One of these men, nineteen-year-old Lt. Neil Smith, stared wide-eyed around him on arrival, especially at the blacks and Latinos: "In those days, you didn't see many of them in Australia. And we'd never seen so much military kit in our lives—we didn't know so many planes and helicopters existed." Prime Minister Menzies fiercely rebutted critics of the commitment, but the cost to his successors proved high. Before the decade ended, his bold gesture of support for the US became a dominant issue in Australian politics.

Moreover, although Americans henceforward saw themselves as the foremost players in the war, vastly more Vietnamese people continued to die; they were merely much less important than Westmoreland's men in the eyes of Washington, maybe also of the world. Doug Ramsey described the expansion of Saigon's forces: "We were building, instead of an army, an ever-larger façade of one—a steel superstructure of M-113s, Patton tanks, and jet aircraft, resting on societal feet which were not even of hardened clay." Vietnamese experienced intimate cruelties of internecine strife such as no foreigner knew. There was the helicopter pilot who flew into Hue to retrieve an ARVN body bag and discovered from its label that it contained his own brother. Skyraider pilot Tran Hoi said that before he flew on the first South Vietnamese mission against the North, "as I was running up my engine I prayed that if our ancestors could hear us, they should not permit my brother to be among the enemy soldiers beneath my bombs that day."

The wife of Ly Van Quang, a colonel in the Airborne, sustained a correspondence throughout the war with her brother in the North, a famous NVA general, each mailing letters through Paris. One day Quang shouted at his wife in exasperation, "Are you trying to get me shot, keeping these letters going with the enemy?" She was undeterred, however. For her, as for so many Vietnamese, family loyalties transcended all others. When one of her nine sons perished on the battlefield, she was eventually able to secure details of his death through her Hanoi brother.

278 · VIETNAM

One of the CIA's more imaginative programs was the establishment of a Saigon radio station, known as House 7, from which women read over the airwaves extracts from captured letters and diaries written by NVA soldiers on the Ho Chi Minh Trail. The station called itself Mother Vietnam and was designed to demoralize infiltrators by bombarding them with harsh evidence to highlight their impending doom. Like many such operations, however, House 7 had unintended consequences: one woman was so much moved by the tales she read out on the air that she embraced the communist cause. And successive CIA bosses fell in love with the station's beautiful broadcasters, almost unfailingly winding up in relationships with one or other of them.

The clatter of rotor blades had become the struggle's orchestral music, as familiar to every man who fought as the snick of a cocking rifle and hiss of radio static. As Southern soldiers rode Hueys into battle, they exchanged the usual semisuperstitious valedictions, like "Don't you be the one to get your 'third leg' shot off!" The communists deployed automatic weapons increasingly effectively against low-flying aircraft. A Vietnamese pilot said, "Unless you have experienced it, you cannot know the loneliness of flying home from a mission without your wingman." Helicopters were remarkably durable, but luck played a big part in their survival. Nguyen Van Uc flew a CH-34 into a firefight one day and suffered a stream of hits without a man aboard being scratched. When they landed, however, his crew chief pointed upward and said, "We ought to be dead." A heavy machine-gun bullet had cut halfway through a control rod to the rotors. If it had sheared, the chopper would have tumbled out of the sky.

The US intervention rattled many Vietcong cadres, who at New Year 1965 had anticipated imminent victory. In VC-controlled areas, there was a new drive toward austerity and ideological purity; private radios were banned, to deny access to Saigon's propaganda. There was a campaign to boycott American merchandise, which proved notably unsuccessful. The communists always underrated the charms of consumer goods: nylon trousers and shirts were especially prized. When a guerrilla in the Delta was killed wearing these fashion items, his corpse was stripped, the clothes

next seen on his platoon commander. A civilian witness said, "I must say I admire the hard-core VC for their cold hearts!"

For the most part, the Vietcong displayed greater fortitude on the battlefield than did government forces. This made manifestations of Southern courage seem all the more moving, because so little was celebrated. The world never heard of the Ranger lieutenant commanding an encircled position, who called in an air strike on his own red smoke grenade, killing him along with half his platoon, but saving the rest of his company. There were no headlines for a twelve-year-old boy who led to safety the pilot of a US Air Force F-101 that crashed in a VC-controlled area, although helicopters were sent to extract the child's family from their village before communist vengeance struck them. A PF soldier named Nguyen Van Moi of Duc Lang in Chuong Thien Province received two bravery awards which seemed exceptionally well-deserved, because he was seventy years old.

Giong Dinh was a small outpost thirty-five miles south of Saigon, which at 0225 on the morning of October 3, 1965, became the target of attack by a large force of Vietcong. In the initial shoot-out, two of five guards on duty were killed, and two bunkers were destroyed by recoilless rifle fire, which was followed by a mortar barrage. Nguyen Van Thi, the thirty-five-year-old post commander, retreated with fifteen men into the sole surviving bunker and watchtower. He told Man, his wireless operator, to call for artillery fire, but the radio went dead. An hour of tension followed, interrupted by sporadic flashes of fire from both sides across the darkness. Several attackers broke into the compound and seized two men, four women, and four children. They then forced the wives to call on their husbands to surrender or forfeit the hostages' lives. Thi refused, and his men tossed a shower of grenades.

A defender crawled to the ammunition bunker, where after an exchange of fire he was able to grab more grenades and regain Thi's position. The district chief was now monitoring the attack from his headquarters five miles away, and called in artillery toward the beleaguered post. Then Man got the radio working again. His nineteen-year-old wife, crouching

280 · VIETNAM

beside him, adjusted supporting fire within twenty-five yards of their own bunker. By the coming of daylight, the guns had fired 550 rounds. The Vietcong withdrew, leaving behind three of their own dead, two more men wounded, and twelve weapons. At 0930 a Regional Forces relief column reached Giong Dinh, where they found twelve of the garrison and their families dead, ten of these murdered in cold blood by the communists. Here was the sort of action for which Americans would have showered Thi and his comrades with Silver Stars, maybe even a Medal of Honor. The only reward for Vietnamese, however, was a stay of execution, knowing that they must face similar ordeals again and again.

The supposed indispensability of advisers with South Vietnamese troops raised a big question: how was the NLF able to fight its own war without such assistance? The obvious answer was that the communists were better motivated and more skilled. It was one of Hanoi's most astute propaganda strokes, that while its forces relied on foreign arms, Chinese and Russian personnel remained invisible in most areas of the North and entirely absent from the South. By contrast, the Americans failed to perceive the damage done by the presence of their own officers at the elbow of every Vietnamese in authority. South Vietnam's prime minister Nguyen Cao Ky wrote, "Insensitivity to appearances was characteristic of the American approach.... There were hundreds of thousands of Chinese soldiers in North Vietnam, along with a significant Soviet presence, but neither the Chinese nor the Soviets called press conferences and issued statements. They left that to the North Vietnamese." Soon after the fall of Nikita Khrushchev in October 1964, the Russians began to provide technicians to train North Vietnamese air defense personnel—and initially, sometimes to fire missiles—but such largesse did not spare them from their hosts' disdain.

In 1965, both sides bled plentifully. Doug Ramsey recorded an episode in Binh Dinh Province during which massive air strikes and shelling of "suspected military formations" caused 1,100 Vietnamese casualties, among whom examination of bodies showed just 15 to have been armscarrying communists. He fumed at the tendency of US aircrew to assume that a line of black-clad figures on the ground below must be a military

formation, whereas it was more likely to be composed of peasants tilling a field. "If its members fled—a normal human impulse—this often made matters worse, as some pilots were likely to take this as a confirmation of their suspicion." Huey pilot Dan Hickman acknowledged that a running figure was often deemed guilty: "I had one guy shot who turned out to be unarmed. He ran by, looking like he had a pack, so I said, 'Shoot him,' because the enemy were pretty close by. Turned out he was only carrying a sack of fish, but I still think he was foraging for the local VC." The communists learned to exploit fliers' instincts by instructing cadres to stand their ground when overflown, thus persuading pilots that they were probably innocents.

Yet privation and firepower inflicted punishing losses both on North Vietnamese formations sent to the South and on local Vietcong. By May 1965, Le Duan had become notably more cautious about the outlook. In a new letter to COSVN, he recognized that no political deal was imminent: "This is not yet the time for bargaining and negotiations." He admitted that he had underestimated the strength of American will. Among his forces in the South, in the month beginning October 19, the NVA's 32nd Regiment reported the loss of 166 men killed and 199 wounded; the 33rd Regiment, 170 killed and 232 wounded; and the 66th, 208 killed and 146 wounded-and all these figures are probably lower than the reality. In addition, chronic malaria and beriberi rendered half the soldiers in some NVA units in the South unfit for duty. One of their officers wrote later that morale languished and soldiers were prone to sudden descents into tears. It became difficult to enforce sanitary discipline, because men who deemed themselves soon to die could not be troubled to wash. Political officers censoring letters were dismayed to find soldiers convinced that they were doomed-by starvation if not by bombs and bullets. Around the campfire, they sang plaintive little songs:

It is easier to march to the Highlands than to find a way home, The lack of rice and salt numb a man's heart. When we're sick we lack medicine, So wherefore is a purpose in love for each other? 282 · VIETNAM

The crab lies unmoving on the chopping block, Heedless of when the knife will fall.

Vietcong attacks on towns helped to sap confidence in the Saigon government but were always repulsed. A night assault on the district center of Cai Be in the Delta by the VC 261st Battalion targeted the post office, police headquarters, and civil guard barracks, but was met with artillery fire and Skyraider strikes, which inflicted two hundred casualties on the attackers. A civilian eyewitness said that as at dawn he watched survivors withdrawing, "They looked sad and tired, and their ranks were noticeably thin. Most carried the rifles of two or three dead." An attack on a big government post at Phu My likewise failed with the loss of forty-two dead, all from one company of the VC's 514th Battalion.

On May 17, 1965, COSVN issued a directive entitled "Security Operations against the Puppet Police," which called on local cadres to "exploit every opportunity to kill enemy leaders and vicious thugs, intensify our political attacks aimed at spreading fear and confusion among the enemy, and . . . recruit support among police lower ranks." A member of Hanoi's politburo once boasted to the British SIS station chief of having agents in every ministry and village in the South. The spy, Daphne Park, responded feistily, "In that case, why do you find it necessary to hang village headmen?" The Vietnamese replied, "Because we are Leninists and Lenin believed in revolutionary terror."

The communists' Saigon intelligence cell held a target list of some two hundred regime figures. Among its most prominent victims was the chairman of the National Constituent Assembly. Three murder attempts failed, but there came a morning on which four communist agents riding motorcycles overtook his speeding car and fired four shots, one of which took fatal effect. To the glee of Hanoi, the BBC broadcast a report that he had been assassinated by the Saigon regime as an alleged rival for power, which obliged President Thieu to issue a public denial. The same communist cell planted a bomb in the back of a vehicle driven into the National Police headquarters compound, where it exploded, killing or wounding seventeen officers.

As a RAND field researcher, Duong Van Mai was impressed by the implacable will of a senior Vietcong cadre whom she interviewed as a POW. "Seeing the evidence doesn't change your mind," she said. "But it increases your fear, because you see that they might win." She found herself adopting an incoherent but widely held view: "I hated the war and I wanted peace, but a peace that would keep the communists from winning." Frank Scotton's feelings had become equally confused: "I was suddenly struck by the thought that we would win by pouring in enormous resources, hundreds of thousands of troops, but we would win in the wrong way . . . by smothering Vietnam with materiel and scorching the countryside." In the streets of America, and especially Washington, protests against the war had begun to attract thousands of people, not all young prospective draftees. On November 2, 1965, thirty-one-year-old Baltimore Quaker Norman Morrison emulated the suicidal bonzes of Saigon, ritualistically burning himself to death outside McNamara's office window.

The first big battle of the new war took place in the Ia Drang Valley of the Central Highlands, favored by the NVA as an initiation area for troops freshly arrived from the North. Special forces camps, of which there were eventually around a hundred throughout Vietnam, were deemed especially attractive objectives, because almost all were located beyond range of American fire support. US Army chief Harold Johnson expressed "horror" at SF operations that he believed consumed extravagant resources. Their personnel, in his disdainful view, were "fugitives from responsibility who . . . found a haven where their activities were not scrutinized too carefully." Mike Eiland, an SF officer who ran Khmer Krom recon teams into Laos and Cambodia, shared Johnson's skepticism, saying later, "The existential question is 'What good did we do?' and I suspect the answer is 'Not very much.' The information the teams brought back was pretty low-level."

When the communists hit an SF camp, they always inflicted pain, sometimes minor disasters. Following an October 19, 1965, attack on Plei Mei Base, Westmoreland ordered the 1st Cavalry Division to "seek and destroy" the enemy units responsible, in the Ia Drang Valley. This suited NVA commanders, who wished to test the new foe's mettle. Col. Nguyen

284 .

Huu An claimed that MACV's Operation Silver Bayonet "gave us the chance to begin to kill Americans." At a two-hour command meeting on November 13 that he described as historic, he expounded the objective: learning how to fight the newcomer by engaging him in a series of company- and battalion-scale actions. "We would beat the Americans, just as we had defeated the puppets."

On November 14, his men became engaged in a savage, protracted clash following an air assault on their concentrations at LZ X-Ray by Col. Hal Moore's 1/7th Cavalry, supported by B-52 strikes. That morning Col. An set out to trudge a muddy path toward Chu Pong Mountain, accompanied by his thirty-man command group. Just before noon, amid incessant fire and explosions around X-Ray, he was leaning on his walking stick, studying the terrain, when a staff officer grabbed him and hurled him to the ground just before a series of devastating concussions shook the earth, from the bombs of a Stratofortress. An shrugged as he stood up and dusted himself off, saying that when so much ordnance was flying about, the whim of providence alone determined whether a man survived, upright or prone. He told his command group to take up residence in the new craters, and tasked a battalion to attack the Americans just before dawn next day, the 15th. An described what followed: "For about fifteen minutes the enemy was thrown into confusion, then fought back ferociously." The struggle continued all day, then after nightfall flaredropping C-130s circled above; 105mm guns fired thirty-three thousand rounds. When the communists renewed their attacks early next day, one NVA battalion got lost on its march to the start line, and the others found themselves engaged in a desperate struggle. A US general wrote later, "Some of the fiercest fighting in American history took place, almost all of it within the length of a football field."

For the Cavalry, the most deadly phase of the battle came on the 17th. At noon, one of An's battalions was eating its rations when scouts reported enemy troops approaching. The NVA hastily deployed and ambushed the inexperienced 2/7th as its men advanced in extended file through high elephant grass. For the next two hours, little groups of Americans fought confused close-quarter actions, too much entangled with their enemies

to call in artillery or air support. An, likewise, found the situation "tense, complicated and difficult." From his perspective the worst fighting took place between 1400 on the 17th and 2000 on the 18th. At last the Americans were able to summon air strikes and artillery, causing the NVA especially heavy losses among runners and liaison officers—men obliged to keep moving across the battlefield, who often vanished without trace. The 66th Regiment was considered to have distinguished itself, even though its colonel mysteriously disappeared from the unit at the start of the battle and remained missing, allegedly lost, for three days; political officer La Ngoc Chau took command.

An avalanche of shells, bombs, and bullets eventually caused the NVA to break off the action. They afterward asserted that engaging US infantry held no special terrors, but in Col. An's words, "This does not mean that fighting the Americans was easy, as some of our people have claimed. Their firepower was devastating. They had so many aircraft, so many bombs, so much artillery. They were practical people who learned quickly from their experiences, and had game-changing technology. . . . They were clever and ingenious, sometimes capable of completely overturning an unfavorable tactical situation."

Both sides claimed a victory after the Ia Drang battles. The Cavalry estimated that it had killed more than ten communists for every one of its own men lost. Senior Americans suggested that the enemy could not long endure punishment on such a scale. Westmoreland considered that Ia Drang, which effectively ended on November 26, showed what fire and air power could achieve in support of "search-and-destroy." MACV estimated enemy dead at 3,561. On the American side, the 2/7th lost 151 dead, with 305 killed the entire division, and wounded in proportion. However, not only were communist losses overestimated by their enemies, but also North Vietnamese commanders adopted and sustained a ruthless tolerance of casualties. After Ia Drang, their commanders held a triumphalist conference at B3 Front headquarters, presided over by Central Highlands commander Brig. Chu Huy Man. Col. An wrote, "I have seldom attended a battlefield meeting that was so happy and lively. Everybody, friends and strangers alike, shook hands to congratulate each other

on the victory." The communists, like the Americans, wildly overstated their achievement, claiming to have "annihilated"—one of their favorite words—several US battalions.

It is easy to think cynically of Bob Hope's annual Christmas Vietnam shows, or the visits to the war zone by other Hollywood stars, but those who served loved every moment of them. A US adviser team was likewise thrilled when James Garner, Robert Mitchum, and Henry Fonda turned up in the Delta. They were especially grateful that Ann-Margret took it so well when she found two sniggering NCOs peering up through the floorboards of her hooch as she undressed. Col. Sid Berry and his adviser team at My Tho gave a Christmas party outside their headquarters in an old seminary for three hundred family members of the Vietnamese staff, including "some of the cutest, most appealing children I've ever seen. Almost all of us Americans just wandered around amidst that mass of childish humanity soaking up love and happiness and tenderness and joy and compassion." The huge foreign visitors distributed ice cream, cake, and a gift apiece, before the screening of a cartoon movie. With boundless American ingenuity, they created another seasonal touch: a forward air controller zoomed overhead, throwing out a storm of white paper flakes labeled snow. Courtesy of the usaf and G-3 section.

On the January 7, 1966, edition of *Country Music Hour* on AFN Vietnam, Roger Miller sang, "Atta boy, girl, atta way to make me cry." Then came Eddie Arnold, Carl Smith, and Tennessee Ernie Ford. Sid Berry especially liked "Oh I love the girl wearing nothing but a smile and a towel in the picture on the billboard" and "While the curtain in the window waves goodbye." There were now four divisions and a total of almost two hundred thousand American troops in Vietnam, but Robert McNamara reported to the president that these would not suffice. If the North Vietnamese didn't quit, in 1966 he proposed doubling the size of Westmoreland's army, with a likely further increase to six hundred thousand men in 1967. "US killed-in-action can be expected to reach 1000 a month," advised this obsessive statistician.

Even so, displaying a confusion of mind greater than that of Duong

Van Mai, America's executive warlord was already privately warning that the Chinese might come in and that the best the United States could expect was "withdrawal with honor." On January 21, 1966, McNamara told a group that included Arthur Schlesinger and J. K. Galbraith that "he did not regard a military solution as possible. . . . [Johnson] seems deeply oppressed and concerned at the prospect of indefinite escalation." Schlesinger wrote after that conversation, "The military have the bit between their teeth and are convinced that they can 'win' the war." The irony, informed liberals noted, was that even as McNamara lost faith—an awesome turn of events—Dean Rusk gained it. The secretary of state seized the torch from the defense secretary and bore it aloft through 1968. It was becoming plain to McNamara's intimates that almost two years and countless corpses before his belated departure, he was gnawed by uncertainty and indeed pessimism. It is extraordinary that he chose to retain his office, while harboring such misgivings.

At the sharp end, Sgt. Jimmie Spencer said ruefully, "It turned out to be a marathon, not a sprint." Sid Berry wrote home, "I would be nowhere else. . . . I am convinced of the rightness and importance of our being here. I have come to have great respect and affection for the Vietnamese. They do surprisingly well under circumstances more difficult than our country has ever imagined. But a long road lies ahead. I hope that our country and our countrymen have the maturity, stamina, patience, guts, faith to stay in the fight as long as is necessary." The top of the escalator was in distant view. What remained absent, however, was any glimpse of an exit beyond.

"TRYING TO GRAB SMOKE"

1. WARRIORS AND WATER-SKIERS

There was never one Vietnam War, instead fifty different ones, according to where a man fought or—in the case of nine out of ten non-infantrymen—did other stuff. Company commander Andy Finlayson once reprimanded an engineer corporal working on their positions, because his men refused to dig or man foxholes. "We don't do that shit," said the NCO stubbornly. "That's the infantry's job." Artillerymen, excepting FOs (forward observers) were exposed to far less risk than foot soldiers. Capt. Chuck Hood, a thirty-year-old Virginian commanding a battery of heavy guns, found that, while his men had to work hard in the dust, mud, rain, and heat—on maximum charge, the huge 175mms needed barrel changes every three hundred rounds—his biggest problem was assuaging boredom, "trying to come up with something different to keep their attention up and keep them out of the local villages and not drinking all the time."

They were there for just one year, and most infantry officers served only six months with a company before being shifted to staff roles. West-moreland pressed for longer tours, but the White House overruled him. The limit may have been politically necessary, but it was operationally corrosive. There were few really experienced American field soldiers, save a few "lifers." Maybe two-thirds of the men who came home calling themselves veterans—entitled to wear the medal and talk about their PTSD

troubles—had been exposed to no greater risk than a man might incur from ill-judged sex or "bad shit" drugs.

Support, technical, and logistics personnel could serve in some giant base compound without seeing any Vietnamese except laundry women and bar girls, their worst gripe the stink in the huts of JP4 fuel and urinal pipes. Paratrooper Gene Woodley called Cam Ranh Bay "the biggest surprise of my life. There was surfing. There was big cars being driven. There was women with fashionable clothes and men with suits on. I said, 'Hey, what's this? Better than being home." Navy radarman Dwyte Brown agreed: "Cam Ranh Bay was paradise, man. I would say, 'Boy, if I got some money together, I'd stay right here and live.' I was treated like a king." Brown gained forty pounds during his "war service," on a diet of lobster and steak and spent much of his time in the plotting room assembling music tapes for a captain who returned the favor by lending Dwyte his jeep. Outside An Khe, the 1st Cavalry created its own neighborhood R&R center, "Sin City." A man could go to a Class 6 store and get two half gallons of Gilbey's gin for \$1.65 each and, for \$5 or \$10, a girl who had been checked by medical staff.

Black infantryman Richard Ford said of another camp, "I didn't believe Nha Trang was part of Vietnam because they had barracks, hot water, mess halls with three hot meals, and air conditioning. [It] was like a beach, a resort. . . . They be playing football and basketball. They were white. And that's what freaked me out. All these white guys in the rear." Green Berets on Phu Quoc Island water-skied and surfed in a bay off the Mekong Delta. A Western visitor wrote of Vietnamese spectators, "The children thought it was fun to splash in the water and watch the huge blond men sweep by at the end of the rope, but the old people glared and muttered. Even in South Vietnam I have never felt so detested because of my size and color."

It was almost entirely arbitrary, who got to go where. Medic Charlie Shyab arrived in-country with illusions that he would stay with the men with whom he had trained and established a relationship. Like almost every replacement, however, he was sent to face mortal peril among 290 .

strangers. Lt. John Wright emerged from the assignment room at Danang looking ashen and told a friend laconically, "I'm fucked." He was being sent to the 1/9th Marines, dubbed the "walking dead" because of their ghastly casualty record. When corpsman David Rogers finished his infantry field time, he was posted to a hospital in Cu Chi. "The doctors and nurses were all officers, and would eat and flirt together. I'd been in the jungle, and now found myself in this crazy world, just like *M*A*S*H*."

Lt. Judd Kinne rode with the company first sergeant to identify bodies in the divisional mortuary, a refrigerated Quonset hut in which he was discomfited to find staff listening to AFN and cracking jokes. The sergeant inspected the battalion's quota of body bags, present and correct among a great many more. "It looked like a full house," said Kinne, who thought with a shiver, *I'm not going home like that*. Phil Caputo also did morgue time. "If I had been an agent of death as a platoon leader, as a staff officer I was death's bookkeeper." All the dead looked pretty much the same, he reflected, whether in life they had been white, black, or yellow. Their skin turned to tallow, so that they resembled wax dummies, "pupils a washed-out gray, mouths opened wide as if death had caught them in the middle of a scream." Where men's faces had gone absent without leave, they were identified by dental records.

A few of Vietnam's would-be liberators succumbed to funk. Sid Berry deplored the poor spirit of his chaplain, who clung to a weapon and wore his flak jacket day and night: "He has been talking with people about the awfulness of war; and he sees Viet Cong all around us. He asks earnestly if we think the war will be over by Christmas. . . . We cannot afford to have a man of God spread fear. He should be a man of calm faith and certainty." The chaplain was relieved.

Others lived dangerously but exotically. The special forces A-team at Ban Don, near the Cambodian border, used elephants to shift supplies, laying stars and stripes on the animals' backs to deflect American bombs. George Bonville, who was prey to romanticism, gazed out on the Delta waterway beside his quarters one balmy evening and wondered, "Why are men fighting for control of this place? It is an agricultural paradise where anybody with a brain can live, work, and be comfortable. Only evil

people can make war in this place—egad, I thought, I guess I am part of them. But I did not start this disaster. I only hoped to end it." A major about to rotate home warned Bonville not to risk his neck, because the cause was not worth it. The US should have cut bait back in 1964, said this gray-haired skeptic. "Just look out, son. We've already lost too many good young officers here. I got my battlefield commission in Korea—it was different; the Koreans were tough and determined to stop the Reds, and the terrain was favorable to defend. This place is like a sieve, with Laos and Cambodia. Keep your head down. This place is gone."

As for the big picture, participants at an NVA General Staff conference at Dragon Court agreed that the more troops the Americans committed, the greater would become their difficulties. Hanoi's existing strategy was confirmed, whereby Saigon's army and militias remained primary targets, because if they collapsed, Washington's rationale for intervention went with them. Hanoi identified grandiose 1966 objectives: 250,000 to 300,000 ARVN casualties, and 25,000 to 30,000 Americans; destruction of a thousand aircraft and helicopters; occupation of 80 to 90 percent of rural areas. They sought to build communist strength in the South—"Battlefield B"—to 400,000 guerrillas, 90,000 local forces and 200,000 NVA regulars.

Vietnam's war history acknowledges that such objectives were wildly overambitious: "The plan that was approved was simplistic and unrealistic...did not reflect our real capabilities, and took inadequate heed of the [impact of] the enemy's [air] attacks on our supply lines, which created enormous problems." Logistics were "confused and disorganized.... The quality of some units sent to the battlefield was low." Hanoi's chroniclers also admit to having underrated American and even ARVN battlefield capabilities.

The NVA and Vietcong leaderships pursued parallel and sometimes conflicting purposes. There were tensions between Southerners and their Northern brethren, whom some VC derisively dubbed "the spinach eaters," because their meager diet could include pondweed. Le Duan and his politburo supporters were eager for big-unit showdowns. Giap opposed this strategy, because he believed that it enabled Westmoreland to maximize

his own firepower advantages. The 1966 dispatch to the South of fifteen more regiments reflected the growing dominance of Hanoi's hawks and the diminished influence of the victor of Dienbienphu.

The political officer of Long An Province's Vietcong analyzed the January 1966 activities of the US 173rd Airborne Brigade as closely as had the NVA's Col. An those of the 1st Cavalry two months earlier. First experiences of air assaults were terrifying, said the guerrillas: "Helicopters filled the air, swarming like flies, and in moments the field . . . was filled with American troops. As soon as even one shot was fired, they called for air support and artillery to plaster everything. They expended bombs and shells like there was no tomorrow. Our fighters concluded that American troops were slow, but could call upon inexhaustible resources." Tanks and APCs "crawled across the rice fields like crabs . . . right over the people's . . . crops."

Long An VC had planned to launch a big, full-frontal assault on a US battalion during the 1966 fighting season. After studying their enemies, however, they concluded that this was beyond their capabilities. They agreed instead to bide their time, husband their strength, and sustain relatively small-scale guerrilla attacks. The communists thought American soldiers unobservant, because they often failed to spot fighters a few yards away. Their fear of mines and booby traps was evident and must be exploited. Americans also became vulnerable during their regular halts.

Meanwhile in Washington, John McNaughton and Bill Bundy composed for Robert McNamara a shopping list of 1966 objectives that was a mirror image of Hanoi's. The first was to "attrit" (their word) the enemy faster than he could reinforce. They sought a reduction of between 10 and 50 percent in secure communist base areas. They called for an increase of between 30 and 50 percent in secure rail and road accessibility, and extension of government population control to 50 to 60 percent. Critics later deplored the emphasis on statistical measures of progress, characteristic of McNamara and his protégés—yet also of Hanoi's Dragon Court.

In February two new Northern divisions moved into the Quang Tri Province of I Corps. This roused fears among allied commanders that the enemy might cut off the tip of the country, gaining control of everything beyond the spine of hills north of Danang. The US Marine Corps would spend much of the year, and indeed most of the rest of its war, fighting to prevent this. Fierce argument persisted about whether Westmoreland committed too large a proportion of his troops to "search-and-destroy" operations, at the expense of "clear-and-hold"—securing territory. Capt. Chuck Reindenlaugh, an adviser serving at Xuan Loc, east of Saigon, wrote home on January 30, 1966, describing his awe at what the enemy achieved with only small arms, mortars, and courage: "Our weakness is rooted in our inability to garrison every village, hamlet or settlement. . . . They attack where forces are not stationed. . . . Imagine a football game in which one of the teams is conventionally uniformed, observes the NFL rules of play.

"The opposing team, however, wears no uniform and in fact has been deliberately clothed to resemble spectators. This team plays by no rules, refuses to recognize the boundary markers, the ref's whistle, and when hard-pressed at their own goal the team's quarterback will hide the ball under his shirt and calmly run into the spectator boxes and defy you to find him. The inclination of the unenlightened is to holler 'shoot 'em up, burn 'em out, smash the villages harboring the Vietcong.' That is what the VC hope we will do, and it is very difficult to refrain."

Robert "Blowtorch" Komer was the famously dynamic former CIA and NSC man who acquired the unlikely title of president's special assistant for pacification, then in May 1967 became boss of CORDS (the Civil Operations and Revolutionary Development Support program) in Saigon. He was always critical of search-and-destroy, which he considered injurious to winning hearts and minds. What was for sure was that South Vietnamese people comprehended few of the subtleties of Westmoreland's tactics, nor indeed of the "better kind of war" that admirers of his successor claimed that Creighton Abrams later waged. Many Americans were equally bemused. A frustrated Marine lieutenant told a reporter that the fight was "like trying to grab smoke—when you open your fist there's nothing there." There was no good answer to the deployment issue: there never were and never could have been enough American troops to seek out

the enemy while simultaneously protecting South Vietnam's populated areas.

Late on the afternoon of January 17, 1966, the Vietcong claimed an important scalp. Province pacification chief Doug Ramsey was traveling in the cab of a truck delivering civilian aid near Cu Chi, a ride that the daughter of the local Vietnamese province chief insistently warned him not to take. Suddenly Lo, his driver, gave a cry: a hundred yards ahead crouched two armed figures in blue shirts and black trousers; the head of a third man bobbed up from behind an embankment. Ramsey raised his AR-15 carbine. Uncertain who the men were, however, he did not immediately fire. For a few seconds, he thought they had passed unscathed through the VC ambush, for such it was. Then communist bullets began to rip the rice sacks in the back of the truck, and the vehicle stopped: a round had penetrated the driver's leg. Ramsey turned and squeezed off a dozen single shots. Lo said the engine was dead. The American swore: he would have cursed even more fluently had he known that the vehicle was merely stalled. Lo climbed down from the cab and first stood with his hands in the air, then fell on his knees in a supplicatory position. More Vietcong rounds punctured a five-gallon can at Ramsey's feet, shooting a jet of oil onto his forehead which poured down into his eyes.

As he struggled to clear his vision, he heard footsteps immediately behind the truck. He shouted, "Toi dau hang!"—"I surrender!" Leaving his weapon, he stepped down with arms raised. Expecting to die, in his stomach-shrinking fear he muttered to himself unoriginally, "Oh, shit!" But his captors were too thrilled with their catch to do any killing. They were young and happy, especially after appropriating Ramsey's carbine, wristwatch, and billfold. Having secured him to a rope, they allowed his driver to go free and led him off into the bush to begin a captivity that would continue for seven dreadful years, some spent in a bamboo cage. So much for the Lawrence of Indochina fantasies that he, like Vann, Scotton, and later Frank Snepp, loved to cherish.

2. UNFRIENDLY FIRE

In February 1966, when Lyndon Johnson heard that the 1st Cav had launched a search-and-destroy mission dubbed Operation Masher, the president personally intervened to demand a more mellifluous code name. Whitewing, as it became, claimed 1,342 enemy dead. In the course of the year, the Cavalry estimated that it killed an average of ten communists a day, and in 1966 MACV credited every unit in the country with one dead Vietcong per diem. This was not nearly enough, however, to keep pace with the enemy's force buildup. On February 5, Marine staff officer Col. John Chaisson wrote to his wife, Marguerite, back in Maine. "The more I see of this war and these fortified outposts, the more I think of the Indian frontier wars." Chaisson wrote of the "slow, ponderous pattern of redemption of the country from the clutches of VC terror. . . . We can defend our positions forever, but this doesn't get us anywhere." In jungle-clad mountains, a patrol might take a week to cover thirty miles. On March 9 there was another embarrassing debacle at a special forces camp: NVA attacked A Shau, thirty miles southwest of Hue. Many of the camp's 360 irregulars not unreasonably mobbed choppers, inbound to rescue 17 US advisers, who opened fire to hold back their own men. In the chaos, five Americans were killed, and only half the Vietnamese ever returned to duty. Marine Lt. Col. Charles House, who led the rescue squadron, received the Navy Cross—accompanied by a formal reprimand for having given reporters a frank account of the shambles.

In April Westmoreland's operations officer, Maj. Gen. William DePuy took over 1st Division, covering the northwesterly approaches to Saigon from Cambodia. He became the most gung-ho formation commander in the country, conducting parallel reigns of terror against the Vietcong and his own officers. Operations Abilene, Lexington, Birmingham, El Paso, and Amarillo were sweeps of the countryside, supported by unobserved night "harassing fire"—artillery delivering sporadic salvos on tracks likely to be used by the enemy, or areas where he might be deprived of rest. Meanwhile the little general winnowed perceived weaklings among his subordinates. A bleak legend grew of "the midnight Chinook," which

removed unwanted battalion commanders, who were said to have been "DePuyed."

His ruthlessness attracted the unfavorable attention of Gen. Harold Johnson, who told him irritably, "To me, the mark of a real leader is doing the best with what you've got." DePuy wrote back impenitently, saying that one sacked G-2 was "a fat disheveled officer without any soldierly characteristics whatsoever." A discarded G-5 was "a completely inadequate officer; no initiative, imagination or drive. Valueless." He wrote of a superseded battalion commander, "The first time I saw C, I strongly suspected that he was weak. . . . [He] completely lost control over his battalion and suffered a number of unnecessary casualties while inflicting none on the VC." DePuy's energy was not in doubt, but his tenure of command did little to win either American or Vietnamese hearts and minds. Harold Johnson wrote to him: "It's very popular to say, 'Let's send a bullet instead of a boy' . . . [but] I think we overemphasize firepower." DePuy carried on regardless.

Adviser George Bonville felt sapped by the physical demands of his daily life with a Southern unit: "Up at 3.30am, eat a quick breakfast snack, load up trucks to My Tho, board [landing craft] for an amphibious attack at break of dawn somewhere along the Mekong—or load up on Huey helicopters for transport deep into the Plain of Reeds—kill/capture a few VC, then get out. This usually means carefully withdrawing the 6–9 miles out of the operational area through sweltering heat, slogging through the paddies, mucking it through canals in bamboo/nipa palm tree jungles then, if lucky, finally back at Cho Gao late. . . . The monotonous rice with some local scrawny chicken and tasteless canned vegetables killed our appetites. The gums of our teeth began to recede. . . . We also started radio duty at night—2 hours per man—as we realized that we were so tired that we would not hear an attack, with our own artillery banging away."

Vietcong terror was relentless. Bonville described a typical episode in which Miss Anh, a typist at the nearby district headquarters, was seized during the night at her parents' home. Her head was beaten in with a rifle butt and her young brother stabbed to death after she refused to assist an attack on the US advisers' compound. Bonville wrote, "She was maybe

twenty years old, a devout Christian, very pretty and very much a lady. My team used to sit on the porch in the morning and watch her stroll in to work in the long, flowing *ao dai* with a matching umbrella protecting her alabaster skin from the sun. She ignored their stares and you could only guess that maybe she disliked these foreign devils admiring her beauty, or maybe not." Adviser Mike Sutton landed a Huey in a Delta hamlet where they found a limp figure hanging from ropes lashed to a tree—the village chief, disemboweled during the night. His wife had been less artistically murdered, their son castrated. "I thought, *What barbarians!* But then later I saw Americans do some terrible things, too."

Mike Eiland was a Californian from a modest background who secured a nomination to West Point. He married a general's daughter three days after graduation, partly because in those days a wedding ring was the likeliest way for most young men to secure access to regular sex, "though there should be a federal law against cadets getting married for a year after they leave." He spent three years as a bored gunner officer in Germany before quitting this conventional career path to become a warrior. During his training as a Green Beret—"It was a cool hat—his great fear was that the war would be over before he could get into it. At Fort Bragg they read Bernard Fall's *Street Without Joy* and adopted the unofficial motto "*Poussez!*" ("Push!") because everybody was always saying that in a training film they watched about an OSS team in 1944 in occupied France.

On May Day 1966, with the scantiest briefing, he was sent to command a twelve-man A-team at a riverside base in the extreme southwest, a few miles short of the Cambodian border. "They just dropped us into the middle of nowhere." The 5th Special Forces camp, located on the edge of that VC stronghold the Plain of Reeds, had been derelict since being overrun three years earlier. Eiland and his men quartered themselves in villas around an old French sugar mill, wired the compound, and set about recruiting fighters. This process, they discovered, required tortuous negotiations with local chiefs. They formed one company from the Hoa Hao religious sect, another from army deserters and suchlike, and a third through a Khmer Krom leader based at a Saigon temple. "He could deliver

trained men in whatever number you wanted—it was just a question of fixing a price, which could take all day."

Eiland found himself almost drowning in a medley of novel sensations—the greenness of everything, the alien culture, the heat and stench. His unit, some four hundred strong, began conducting four-man patrols, punctuated by firefights that sometimes persisted all night. Because the area was a free-fire zone, whatever civilians they encountered were trucked away in Vietnamese custody, labeled as refugees. Bemused by his orders to do this, the soldier said, "They were not refugees until we made them that way. Mostly we were just abducting them, as part of the policy of denying the area and food to the enemy."

On the night of May 12, when the A-team had been operating for less than a fortnight, local VC attacked the camp in strength, achieving total surprise. In almost impenetrable darkness, the Green Berets conducted a passive defense, firing M14s and M79s from their villas, which lay behind a deep drainage ditch that the attackers made no attempt to cross. "We could hear them shouting to each other, 'Where are the Americans?' and milling around. It became clear the place was collapsing." The night was rent by gunfire, but neither side possessed illuminants, and Eiland had no access to artillery. Few of the Vietnamese put up much of a fight, and the ones who tried were soon dead. Those who lay low fared best—saying, doing, and shooting nothing. At first light, the Americans found the enemy gone, having destroyed all vehicles and sunk landing craft moored on the river. Prostrate figures lay everywhere, mostly those of defenders. Eiland was stunned: "I had never seen bodies before, especially chopped-up ones." Lacking medevac, his corpsman did what he could for the wounded.

Eiland never felt much confidence in the ARVN special forces whom he was supposed to work with, and he had less when it became apparent that hunger was driving his remaining recruits to the brink of mutiny; their Vietnamese captain was stealing most of their rice. The Americans determined to take over the distribution of rations, which caused the captain to lodge a bitter complaint about interference with local custom, and with his own income. Eiland and his sergeant found themselves summarily relieved, "for displaying a lack of cultural sensitivity."

Infantrymen's lives lacked the exotic flourishes available to Green Berets. For Bob Nelson, the best thing about the service was that for the first time in his life as a black American, he met no racial issues. "We looked after each other." A card-carrying Ku Klux Klan member told him that his perception of blacks was transformed after a "brother" dragged him back across a rice paddy when he froze in a firefight. Nelson was the son of a maid and a laborer who died when Bob was six. He spent his later child-hood with grandparents on their little tobacco farm in rigidly segregated South Carolina. He joined the Marine Corps out of high school because he needed a job, and found Parris Island as tough as did most recruits, maybe more so because drill instructors addressed all blacks as "nigger." He never forgot the big sign at their field training center in California: LEARN TO LOOK DEATH IN THE FACE, BECAUSE YOU ARE GOING WHERE MEN ARE GOING TO DIE. A Marine's death, their sergeant told them, was a "good death."

Nelson was not sure about that, but when he joined a battalion at Phu Bai in March 1966, he was pleased to find how easy it was to become buddies with "Fred the Farmer" from Minnesota; he got along fine with men from Wilmington, Pittsburgh, and Chicago. On interminable marches through the bush, they heckled each other to keep going past their exhaustion thresholds: "Come on, man—let's go! Let's go!" A keen basketball player, half-miler, and miler, he exercised fiercely to stay fit, and for the first time in his life felt a real sense of self-worth. "It was a mark of honor to go on and on, never to quit." Yet Nelson found some things hard to get his mind around: he had grown up in a deeply religious household where nobody spoke aloud the word *kill*. In his new environment, by contrast, everybody talked of little else but "wasting Charlie."

They were awed by the impact of their own firepower. Nelson watched air strikes, artillery, and small arms fire devastate a hillside, 20mm gunship rounds "chewing up the ground. We thought, *Man, we're really in control here*. Nobody could walk through all that lead!" Generals felt the same way, yet vast tracts of real estate remained untouched; even in the midst of a barrage, an astonishing proportion of enemy soldiers survived. The rigmarole involved in proving a kill to higher authority could

be grotesque. Reg Edwards delighted his platoon sergeant by shooting a Vietnamese who proved to have a grenade. "Goddam. This is fucking beautiful," the NCO kept repeating. Edwards was then ordered to drag the body back to camp. He said, "His arm fell off. So I had to go back and get his arm. I had to stick it down his pants. It was a long haul. And I started thinkin'. . . . You think about the mist and the smells the rain brings out. All of a sudden I realize this guy is a person, has got a family. All of a sudden it wasn't like I was carrying a gook."

Frank Scotton wrote, "By a peculiar syllogism (people like us don't live like animals; Vietnamese live like animals: therefore, they aren't people), Vietnamese were too often considered subhuman. Only a rare American combatant recognized the sophistication of Vietnamese culture and its relationship to the environment and concluded, 'We were the gooks.'" George Bonville recoiled from the excesses of some Americans, one in his own adviser team: "Old papa-sans were getting killed by ambushes or patrols for just getting up in the dark of night and wandering out of their huts to take a leak. When a child might get very ill and the mother was terribly concerned, she might light a torch and try to carry the child across rice paddies to the clinic. . . . In one case the torch blew out and unknowingly, a US ambush took the family under fire as they were coming out of a contested hamlet. The mother was wounded and the child died. What a hell of a war I was involved in."

Nor were Vietnamese the only victims of friendly fire. Bob Nelson's squad included a Cherokee machine gunner: "Man, he loved his gun—fired it every chance he got." One night on ambush a shadowy figure in front was challenged and failed to provide the password quickly enough. The M60 gunner fired, stopping only when voices in front screamed, "Marines! Marines!" and identified themselves as a returning patrol, whose point man had taken a round in the hip. George Bonville was dismayed when the Southerners to whom he was attached laid down "prepping" fire, even when no target was identifiable. One morning during an assault, "we had mortars landing in the trees forward of us like airbursts, spewing ricochet fragments. Then the .50s opened up, piercing the not so dense

jungle, ripping over our heads and ricocheting off the hard wood of the coconut trees. Spent bullets were plopping around us and a bent, hot, sizzling tracer round splattered in the mud right in front of my nose." German photographer Horst Faas, who was accompanying the operation, lay cursing the prospect of death by friendly fire and urged Bonville to tell the ARVN to stop. "You stupid Americans!" he exclaimed, "getting involved in this shit war!" Not an enemy was encountered on that noisy, violent morning, but the encounter with Faas fed the loathing for the media felt by Bonville and many other soldiers.

"The only thing they told us about the Vietcong was they were gooks," said Reg Edwards. "They were to be killed. Nobody sits around and gives you their historical and cultural background. They're the enemy. Kill, kill, kill." At 1900 on September 23, 1966, a nine-man Marine ambush patrol set out from Hill 22, northwest of Chu Lai. It was nominally led by Sgt. Ronald Vogel, but an aggressive twenty-year-old combat veteran, Pfc John Potter, announced that he was assuming command and the mission would be a "raid." Every man was told to remove his unit insignia and not to refer to each other audibly by name. In a nearby hamlet, they seized a peasant, accused him of being a Vietcong, and began beating him. Four other men dragged his wife out of their hut, pulled her three-year-old child out of her arms, then raped her. The patrol next shot her husband, child, sister-in-law, and sister-in-law's child. Potter tossed a grenade at the bodies "to make it look good." Finally the Marines shot the rape victim and left her for dead.

The story got worse. When the Marines returned to base and their company commander ordered an investigation of this alleged "enemy contact," an officer who went to the scene directed attempts to hide the truth. During this process, a badly wounded child was spotted, whom Potter clubbed to death with a rifle butt. The facts emerged only when the rape victim, who had been left for dead, was found alive by fellow villagers and carried to the Marine base for treatment. She told her story, which a medical officer immediately reported. Potter served twelve years' imprisonment for premeditated murder and rape. The officer responsible for the

302 .

attempted cover-up was sentenced to be dismissed from the Corps, but this verdict was overturned on appeal. Only two other patrol members served significant prison sentences.

Reg Edwards later described with regret his involvement in casual village burnings and killings. Oddly enough, he was most affected by shooting a piglet: "You think it's just gonna fall over and die. Well, no. His little guts be hangin' out. He just be squiggling around and freakin' you out. See, you got to shoot animals in the head. They don't understand that they supposed to fall over and die." Bob Nelson was once ordered to fire an M79 round into a bunker entrance. As the smoke cleared, another man peered in and shouted back, "There's just a bitch and two kids," all dead. Nelson said with deep sadness later, "That's one image that stayed with me, that I could have done without in my memory bank." Emmanuel Holloman from Baltimore was an interpreter who spent his first Vietnam tour distributing compensation among civilians: \$10 or 1,000 piasters for a destroyed house; \$40 for a corpse, or maybe \$60 on a good day. Holloman thought black Americans like himself got on better with local people than did whites, because they had a shared sense of victimhood.

Bob Nelson said, "Sometimes it was serious, then at times it was not serious, then it would turn serious again"—almost always without notice. Mike Sutton was advancing through a Delta hamlet one morning with an adviser team when suddenly a lone VC in black pajamas appeared from behind a tree and shot Sutton's comrade and friend, a young Texan named Dave Hargraves, in the back. Vietnamese soldiers blew away the killer before Sutton could raise his own rifle, but the shock and sorrow were all the greater because they had had no previous contact for days and experienced no further action in those that followed.

3. TRAPS AND TRAIL DUST

There were booby traps, booby traps, booby traps—what the twenty-first century calls IEDs, improvised explosive devices—and how they hated them all! Most were manufactured from scavenged US ordnance. A 60mm mortar round would remove a foot, while an 81mm bomb would

hack off a leg and maybe some fingers and an elbow. A 105mm round would take both legs and often an arm. A 155mm round would vaporize its immediate victim below the waist and almost certainly kill anybody else within twenty yards. Mines were often planted in clusters, so that the first crippled a man and the next wrecked the corpsman who sought to tend to him. Grunts engaged in macabre debates about which limb they would soonest lose; most claimed a preference for keeping knees and what was above them. In one two-month period, a single Marine company lost fifty-seven legs to mines and booby traps. As an officer bleakly observed, that amounted to almost a leg a day.

A man who glimpsed a tripwire ahead could throw a grenade toward the business end in hopes of detonating its attached charge. Buried mines were always tough, however. Even if an engineer stayed alive while digging down to the blasting cap and fuse, it was necessary to crimp both with precision, an inch from the bottom of the cap: carelessness was fatal. Everybody hated having to handle the three-prong primers on "Bouncing Betties." Combat engineer Harold Bryan once worked for an hour on a man from the 1/9th Cavalry who was standing on such a mine but had not—yet—detonated it. The prongs were irremovably trapped in the cleats of one of his jungle boots; the slightest movement would be lethal. Bryan attached a rope to the man's waist, got his team to take the other end from a safe distance of twenty yards, then together snatched and swung him balletically fifteen feet before the explosion came.

That mine-walker lost only the heel of his jungle boot, but few were so lucky, and after such a bang there was a yearning to identify gooks—any accessible Vietnamese—upon whom to wreak vengeance. When a mine detonated in the midst of Bob Nelson's squad, after the casualties were evacuated and the patrol moved on, "innocent people died," in the Marine's words. "We got aggressive." An ARVN general said, "The enemy does not confront you. But he harasses you every night to give the impression that all the people around are hostile. Everyone becomes your enemy. But in reality it is only the same five or six VC who come back every night. And they plant the punji pits, booby traps, land mines. . . . The VC make you nervous to the point that you lose your patience and say, 'I want to be

304 .

finished with this.' And you have fallen into their trap. You kill the wrong people."

Harold Hunt was one of five sons of a black car worker who joined the army the day he left high school in 1961 and seldom regretted it. "Not many of the kids I knew ever went anywhere outside Detroit in the rest of their lives, and I went everywhere." He served a first Vietnam hitch as a helicopter door gunner before returning in December 1965 to lead a squad of the 2/27th Infantry. "It was ugly from the first day," he said. "We had to fight our way into Cu Chi, fight our way to secure almost every yard of ground that the 25th Division became responsible for." One morning in April 1966, Hunt was leading a patrol through high grass toward Outpost Ann-Margret when he was slightly wounded by a burst of incoming fire. After the Americans threw themselves prone and started shooting back, he found himself clutching wire—a tripwire. He was carrying a radio on his back and exchanged hasty words with Willie Somers, their M60 man: "This is either a dud or a pressure-release job—can you see it?" Somers could indeed see, though not reach, an improvised enemy Claymore mine. The firing died down; the VC faded. Hunt carefully rolled over, putting his back to the presumed end of the wire, which he then released. The mine exploded, lacerating his right side—face, body, and legs; only the radio saved his life, taking most of the shrapnel. He spent the next half year in an army hospital whose staff rebuilt his face, repaired his legs, and subjected him to a long course of physical therapy before he was pronounced fit for limited duties.

Vietnam started going equally badly for Bob Nelson on a patrol one June morning when a booby trap exploded beside him, scattering shrapnel that cost him a trip to the field hospital and a week back at base. There followed a succession of firefights, big and small. His Vietnam finally ended on an October day when his scout team heard voices beyond a hedge and the squad leader shouted, "VC!" He emptied his Thompson in their direction and received in return a shower of grenades. One of these exploded beside Nelson, detonating a smoke canister on the front of his webbing. Struggling against blinding, choking fumes, he grabbed at the hot metal to throw it free and found his hand stuck in agony. Screaming

and cursing, he rolled around in the paddy even as a firefight continued around him. When the shooting finally died away, he was medevacked and sent home.

Who set all the booby traps? While American commanders enthused about "zapping Charlie Cong." A communist officer wrote of visiting the Delta "personally to direct the organization of an American-killing zone. . . . Day by day the operations [in this] became richer, more creative and more enthusiastic." The writer claimed that it was often locals, not guerrillas, who laid the traps: "The people did not automatically decide to attack the Americans, nor did anyone push them into it. It was the things done by American troops that decided the people's attitude. [At first] they handed out candy and cookies, distributed T-shirts to the children, repaired and outfitted schools, provided medical examinations and gave out free medicine. Only a short time later, however, these same American units shelled villages; destroyed people's crops . . . shot and killed innocent civilians. Buses loaded with passengers flipped over into canals and streams after being forced off the road by American trucks. Soldiers regularly threatened and beat up the weak and innocent. That is why peasants, on their own initiative, planted mines and booby traps. People's war . . . developed on its own." There is some element of truth in this communist explanation, but VC units stimulated local IED industries by organizing collections of unexploded bombs and shells for conversion into mines in little village factories. Empty sardine tins were also favored receptacles, filled with explosive and fused.

Infantry Capt. Ted Fichtl said that as he gained combat experience, he learned to listen to his streetwise—or rather, paddywise—NCOs. "We could more easily live with green lieutenants than with green sergeants." He discovered the importance of making men dig in whenever and wherever they halted, and enforcing the discipline of sleep: "We were all thoroughly imbued with the macho spirit that we could do it and just catnap here and there. But we found that wasn't the case—your logic gets muddled. Your ability to discern the reality of your circumstances just falls apart very rapidly."

More important still, and often neglected, was making the big effort

necessary not to surrender the hours of darkness to the enemy. Fichtl said, "There is a fundamental fear, I think, in American soldiers about operating at night. . . . I was a victim of that myself. [But] if you don't extend your eyes and ears by way of patrolling and outposting, you become very, very vulnerable." Capt. Dan Campbell, a West Pointer commanding an Airborne company, shared Fichtl's view. He thought his unit did not do nearly enough night patrolling, partly because they were so tired by the time darkness fell. Contrarily, Campbell was astonished by the willingness—even enthusiasm—of some of his men to brave the terrors of exploring enemy tunnels.

A few reveled in the Vietnam experience. Lt. John Harrison's Airborne company included a formidable sergeant named Manfred Fellman, who as a boy in 1945 had won an Iron Cross as a member of the Wehrmacht defending Breslau. Fellman's request to be allowed to wear his medal in Vietnam was vetoed by an officer who said, "Think how a survivor of Auschwitz would feel, if he saw it." Harrison, who admired the German's warrior gifts, said, "Fellman was something, but he was always being busted for drinking problems." Helicopter pilot Capt. Frank Hickey said, "We enjoyed what we did. . . . We always won. . . . To me, we were always successful. We used to say to each other, 'Go get Charlie!'"

Arkansas farm boy Carlos Norman Hathcock II was a superb shot who killed ninety-three communists as confirmed by observers, although he himself claimed the actual toll was between three and four hundred. Much of the time he was a quiet, shy man, though also prone to outbreaks of extreme violence, one of which almost caused him to be busted for getting into a fight with an officer and overstaying leave. In 1965 he won America's most prestigious shooting prize, the Wimbledon Cup, a thousand-yard event, and in March the following year went to the war, first as a military policeman, then as a Marine sniper. "Vietnam was just right for me," he said later. He never willingly took time out or R&R. On discharge he found that he knew how to do nothing else. He reenlisted and returned to the war, where one morning he was traveling in an amphtrac that ran over a mine. He suffered burns over 43 percent of his body, and on returning from the hospital to Quantico, he found himself unable

to shoot straight anymore. He continued to instruct other riflemen but drank heavily and sometimes exploded in bouts of uncontrollable anger.

When Jonathan Polansky, a draftee assigned to the 101st Airborne, reached his new firebase as a skinny kid weighing 112 pounds, he felt a sense of despair. "I was taken to the company commander, a big strong strapping guy with about eight days' growth of beard and blond hair straight back. The platoon sergeant was this big black guy. I was awed by these men with the dirty clothes. I was in my brand-new little green fatigues and my boots were still shiny. I looked about twelve years old with my bald head and helmet that was too big. And they just kind of looked at me and laughed. My heart fell. I can't ever remember feeling so intimidated, so weak, so ineffectual. Nobody wanted a 'cherry.'" After an interminable day climbing a mountain, Polansky went to see his captain and asked to be transferred out of the company, saying, "I can't do it." The officer laughed and told him not to worry: he would make it. Next day the company climbed an even higher mountain. "At the end of the day I felt fantastic. I felt that I would survive. By the third day in-country, I knew I would make it. I didn't know how, but I knew I would."

Among some terrible deeds, virtuous ones deserve emphasis. Shirley Purcell was a veteran nurse summoned to active duty in 1966. Her brother, a Texas redneck, urged her not to go, but she was convinced of her duty and struggled successfully to reduce her weight to meet service requirements. At Bien Hoa, between shifts she spent many hours working in the hospital of an orphanage, among other things teaching Vietnamese nuns in the labor ward the importance of surgical gloves. She formed a deep attachment to a five-year-old girl she called Scamp, for whose sake Purcell later served a second tour in the country. She took a passionate pride in her work: "I really didn't have a political commitment . . . [but] there were American troops there that needed help."

She was thinking, for instance, of an infantryman who had triggered a Bouncing Betty. "This young man had literally been ripped in half—from his knees up and from just below his ribs down. It was like hamburger meat. All of the internal organs were just chopped up, but his legs were perfect laying on the litter, and his arms, hand, upper chest were perfect,

and his mind was still very much alert. He was looking up at us. The sense that went over that entire unit, with that young man lying in the emergency room dying because there was absolutely nothing that we could do for him, was like nothing I've ever experienced. It was total helplessness and hopelessness. The terror and frustration in the doctors' eyes, because with all of this training that they had, and all the knowledge and all that we could give, we still couldn't give this man a chance."

Another soldier came in with half his head blown away: "He was about nineteen, it was an inoperable wound. . . . I remember trying to wrap his head so that his brains would not be lying on the litter. He looked up at me and said, 'Well, how does it look?' I had to tell him, 'It doesn't look good, but you won't be alone.' That was really all we had to offer him—that he would not be alone." Purcell had been a teetotaler all her life, but in the officers' club at Chu Lai she started on screwdrivers, and who could blame her? Later, she could never bring herself to watch M*A*S*H on TV, because her memories imposed a veto upon laughter.

The two Australian battalions based in the southeastern corner of Vietnam, above Vung Tau, at first found themselves struggling to fulfill their mission with relatively meager manpower and the usual vast tracts of wilderness to patrol and sweep. In their first weeks, the enemy proved elusive, but a night mortar attack on their camp in mid-August 1966, which wounded twenty-four men, provoked the battalion commander to dispatch a force to scour the area. In vile weather on the afternoon of August 18, a hundred Australians clashed with a powerful force of VC near the abandoned village of Long Tan and found themselves fighting for their lives. Artillery hit the communists hard, but small-arms ammunition ran dangerously low. Two RAAF helicopters braved rain and low cloud to fly an emergency resupply, and just as the infantry began to fear being overrun, APCs reached them carrying .50 caliber machine guns and a reinforcement company. The communists withdrew, leaving behind 245 dead. The Australians had lost 18 killed. They prevailed, but knew that they had been on the brink of suffering a disaster, partly because their contingent lacked sufficient mass to handle a powerful enemy on territory the communists considered their own. During the months and years that

followed, the Australians and New Zealanders forged a reputation as formidable infantry soldiers.

Alongside search-and-destroy missions, there was an ever more relentless aerial assault on the wildernesses in which the communists sought refuge. Operation Trail Dust, defoliation of infiltration routes, began in 1961. In July 1965, the first vegetation killers were unleashed in the heart of South Vietnam, where chemical clouds drifted onto orchards near Bien Hoa and Lai Thieu, with disastrous consequences for crops of mango, custard apple, jackfruit, and pineapple. Almost overnight, fruit fell; leaves turned brown on thousands of rubber trees. Local people were at first bewildered, unable to comprehend the cause of this apparent natural disaster. When the truth emerged, farmers were not much comforted by assurances that the consequences of Agent Orange would not linger for more than a year. A Southern colonel observed that the popular anger and distress caused by defoliation around inhabited areas "far eclipsed any military gain." He acknowledged nonetheless that defoliants were effective in denying the enemy jungle communication routes, especially in the mangrove swamps along the Saigon River.

The program peaked in 1968-69: in all, almost twenty million gallons of defoliants, over half of them dioxin-contaminated, were sprayed throughout Indochina. This remains one of the most vexed issues in posterity's view of the war: it is impossible to avoid a sense of revulsion about systematic destruction of the natural environment to serve tactical purposes. It is hard to doubt that some Vietnamese, and perhaps Americans too, suffered ill effects from Agent Orange. It seems nonetheless prudent to be cautious about extreme twenty-first-century claims made by Hanoi, and by some American bodies, that hundreds of thousands of people of the war generation suffered lasting harm—birth defects, cancer, and other hideous diseases. Hanoi's official history of the war gives figures of two million civilians affected by Agent Orange. Yet for humans to suffer serious harm they would have needed to face heavy sustained exposure to dioxins on a scale that relatively few did. An ARVN veteran recently noted that he and his comrades constantly handled defoliants, broadcasting them from hand-pump sprayers, without ill effects. He suggests that

Vietnamese farmers' notoriously reckless use of insecticides is as likely to have injured their health as did Agent Orange.

Be that as it may, Australia's Justice Philip Evatt spent two years in the 1980s examining evidence about the effects of Agent Orange on his countrymen who served in Vietnam and produced a report of nine volumes and 2,760 pages, which found the chemical not guilty. One of the scientific advisers to the Royal Commission said with typical Australian bluntness, "Most of the problems that worried the veterans after the Vietnam War weren't due to Agent Orange: they were just due to it being a bloody awful war." Evatt suggested that tobacco, alcohol, and posttraumatic stress were the most convincing and widespread causes of veterans' difficulties. A historian is not obliged to pass a verdict on Agent Orange in the face of rival masses of contradictory evidence. The defoliant was indisputably a loathsome instrument; yet that does not make it necessary to accept the more extreme claims made about its effects on human beings exposed to it.

Almost every week of 1966 witnessed an action such as that which took place one September morning sixty miles north of Saigon. At 0900 the 2/18th Infantry advanced north up Highway 13 between Loc Ninh and the Michelin rubber plantation, where the Vietcong were known to be strongly emplaced. The Americans were riding APCs and supported by tanks. C Company commander, twenty-seven-year-old Ted Fichtl said, "We knew we were going out as bait. . . . But the confidence in our ability to trigger it and get through was very high. . . . We knew the rest of the battalion, brigade, and division was locked and loaded, just waiting for that to occur, and by God it did." They met a storm of fire from ambushes on both sides of the road with small arms, mortars, recoilless rifles. "It was extremely violent; very, very accurate and effective. . . . We lost a lot of tracks and took a lot of casualties right away." Fichtl's dismounted C Company was supported by flamethrowers and heavy machine guns but found itself in deeper trouble than commanders had anticipated. The struggle went on hour after hour; undamaged American vehicles pulled back out of the killing zone.

The battalion commander reached Fichtl on foot, and ordered him to disengage and move to support A Company, which was in desperate straits. The captain felt emotionally exhausted. He protested that he had lost half his own men already, that somebody else should do the job. "The colonel said, 'That's not the issue. The issue is that A Company needs to be reinforced. Move out." Fichtl said, "The colonel got us to do it by sheer force of leadership." The action continued for five hours, across a front of eight hundred yards, with guerrillas and Americans sometimes exchanging fire within twenty yards of each other. Fichtl's executive officer and a platoon commander were among the dead. C Company's spirits rose when they saw the rest of the battalion being air-landed three miles beyond the enemy. "It was great to see helos going in. . . . Instantly you could tell that [the VC's] attention was divided between what was going on directly in front of them and what may have been going on behind."

The Americans were obliged to evacuate casualties on tracks, because medevac helicopters—dust-offs, as they were always known—couldn't land through the intense fire. When at last the battle ended and the enemy withdrew, around 1400, Fichtl found his company reduced to sixty-six effectives, and there was a delay of weeks before all the losses were made good by replacements. He never forgot the shock he received when he heard a divisional staff officer report over the radio an enemy body count three times that which he had been given by the participants. The year 1966 witnessed a hundred battles such as that which the 2/18th fought. In the overwhelming majority, the communists lost more men than the Americans, but they seldom acknowledged a defeat. This was the year in which Westmoreland discovered that the "Charlies" were seldom, if ever, quitters. And merely by staying in the ring, they were being seen to frustrate the will of the most powerful nation on earth.

GRAFT AND PEPPERMINT OIL

1. STEALING

Corruption was endemic throughout South Vietnam. US narcotics agencies despaired of curbing the traffic in heroin, cocaine, and marijuana, because the regime's leaders and clients were engaged up to their necks. In both army and civil life, promotion on merit was almost unachievable. Some officers languished for decades as lieutenants, because they lacked influence or cash. Higher commands were allocated, not by assessing generals' competence, but instead in accordance with their political allegiances. The coming of Americans in bulk boosted graft and fraud. The Commercial Import Program—US economic aid—peaked in 1966 at \$400 million. Some money was used prudently—for instance, to provide thousands of sewing machines for clothing manufacture. Much, however, was merely diverted into the pockets of businessmen, and explicitly of regime supporters, who imported luxury goods that ended up in the street markets of Saigon. Duong Van Mai wrote, "The newly affluent class included many who stole without qualm from the Americans." Old people grumbled that while in the past, Vietnam's hierarchy of merit placed scholars first, peasants second, artisans third, and merchants last, now bar girls seemed to rule in a society in which maids and cyclo and taxi drivers ranked ahead of honest toilers. "For us 'Western culture' meant bars, brothels, black markets and bewildering machines-most of them destructive," recalled peasant Phung Thi Le Ly.

A postwar USAID report concluded: "Corruption . . . was a critical factor in the deterioration of national morale which led ultimately to defeat." A Southern general wrote gloomily about one of President Thieu's reshuffles of ministers and commanders: "These changes did not improve leadership or advance the national cause. They were made in the same old pattern of power intrigue, based not on talent, experience or merit, but instead on personal loyalty and clannish relations." Gen. Cao Van Vien deplored the typical case of a man who had been a good regimental officer but when appointed province chief of Binh Dinh, sold public posts and favors for cash and allowed his wife to run a gambling joint.

The official exchange rate for the Vietnamese piaster was set artificially high, so that import licenses ensured fat profits. Black market currency dealings enriched thousands of people, many of them ethnic Chinese, with access to dollars or US Army scrip. Every commodity—from cement and freezers to vehicles, weapons, and ammunition—was available at a price, and forgery networks flourished. Such scourges are by-products of all conflicts, but the protraction of this one caused them to become institutionalized. According to Prime Minister Nguyen Cao Ky, who sought to project himself as a crusader against corruption, the police officer responsible for enforcing vice law in Cholon paid \$130,000 to secure his post, and showed a profit after two years. Meanwhile the military governor of Saigon deployed soldiers to protect Cholon's big casino, in return for a slice of its take.

According to the US Army judge advocate general, black marketeering and currency violations "[surpassed] the capacity of the law enforcement agencies." The case of three Marine deserters was typical. While hiding out in Danang, they forged orders for their own transit to Saigon, where they joined a ring of forty-seven army deserters engaged in a huge moneyorder racket. On the proceeds, they rented Saigon apartments, sent cash home, and bribed military police to stay away. The ring was eventually broken and those involved jailed, but there were many more uniformed gangsters where they came from. The most baffling aspect of the criminality was not that the Vietnamese were unable to check it, but the degree to which elements of the US government became complicit. A civilian

contractor, Cornelius Hawkridge, was so outraged by what he witnessed in Saigon that he tracked illegal activities and formally reported them to American authorities—who ignored his claims. Hawkridge's lonely little crusade became the subject of a 1971 book, *A Very Private War*, which attracted less attention than it deserved. Civilian contractors, including some of the largest US corporations, were deeply engaged in crime. Investigators reported that the currency black market was dominated by a syndicate in Madras; a Senate subcommittee estimated the traffic's annual value at a quarter of a billion dollars.

Senator Karl Mundt of South Dakota rightly observed that the trade could only be viable with the complicity of US banks that handled the launderers' profits, prominently including Irving Trust and Manufacturers' Hanover. Frank Furci, son of a Florida mobster, served briefly in the US Army in Vietnam, then after his discharge returned with a friend to run rackets in partnership with serving NCOs, whose profits were posted to the International Credit Bank of Geneva. Another important illegal money exchange was the Hong Kong branch of Deak & Company, founded in 1939 by Hungarian immigrant Nicholas Deak, who spent the war years in the OSS. In 1964 Time magazine called him "the James Bond of the world of money." Crooks who funneled cash through Deak knew they were protected from attention by law enforcement agencies, because the firm was used by US corporations as a conduit for bribery of foreign governments. It was revealed by the Washington Post in 1976 that Deak also handled huge black market transactions for the CIA's Saigon station, doubling the spending power of its budget.

However deplorable the conduct of powerful Vietnamese, they could not have robbed their own people without the active or passive complicity of thousands of Americans, some of them relatively exalted. In 1972 the US Army's most senior NCO, Sgt. Maj. William Woolridge, was convicted for his part in a massive fraud involving military clubs and PXs, in which scores of supply sergeants were involved. Young CORDS officer Hal Meinheit was asked to sign receipts for purchased material that the briefest inquiries showed were phony. He was disgusted to discover that the money went into the pocket of a colleague. "I had expected Vietnam-

ese corruption but had not expected a well-paid American adviser to twist the system."

2. RULING

It is mistaken to regard corruption as a mere by-product of the war. It was a plague bacillus that infected the entire US effort. A society in which vice was seen to prosper and virtue received no reward was sorely wounded even before the enemy opened fire. Who could be surprised by the respect accorded to a Vietcong province chief dressed in peasant black calico and sandals cut from old tires, in contrast to his Saigon-appointed counterpart, who rode in a Mercedes and decked his wife in jewels? American apologists shrugged at corruption, observing that every Asian government acted this way. Yet not all were engaged in a death-grapple with communist insurgents.

As South Vietnam's 1965-66 prime minister, Nguyen Cao Ky found that "everything I touched was potentially worth money! A duty assignment closer to home for a major, or far away for someone's romantic rival. A license to import some goods, to build a factory or close one, to start a business. A construction contract. An easy job for a relative. An exemption from the draft or from service in a combat unit. A lenient sentence for a convicted criminal." Ky damned his own reputation in the eyes of the Saigon press corps, and of a global audience beyond, by repeatedly praising the ruler of the Third Reich, as in a 1966 interview with a German correspondent, to whom he said, "I admire Hitler because he pulled your country together when it was in a terrible state in the early thirties. Our situation here in Vietnam is so desperate that we need four or five Hitlers." The Hanoi politburo displayed a mirror enthusiasm for Stalin and Mao Zedong, the twentieth century's other supreme mass murderers, but in the 1960s neither inspired remotely as much revulsion among Western liberals as did Hitler.

The prime minister was further damaged by his handling of the case of a thirty-five-year-old Chinese-Vietnamese merchant named Ta Vinh. The first step in Ky's campaign against corruption was Vinh's conviction

for embezzlement, hoarding, speculation, and attempted bribery. An exemplary death sentence was carried out at dawn on March 14, 1966, in Saigon's Central Market, by a firing squad of ten paratroopers, before a large crowd that included Vinh's wailing wife and seven of his eight children. The riflemen botched the job; an officer's pistol had to finish off the condemned businessman. No one doubted his guilt, but it seemed monstrously unjust to kill Vinh for pursuing practices for which thousands of other rich Vietnamese went unpunished. The communists murdered people even more barbarically but had the prudence not to invite the world's TV cameras. The brutal clumsiness of Ky's intervention caused his standing abroad, never high, to sink further.

In February President Johnson met both Ky and Thieu in Honolulu, where he warned them sternly of the need to address issues that roused popular resentment. For instance, an estimated two million South Vietnamese had become displaced. Johnson told his guests that the refugee issue was "just as hot as a pistol in my country. You don't want me to raise a white flag and surrender, so we have to do something about that." He added that if they read the New York Times and transcripts of the latest Senate Foreign Relations Committee hearings, they would understand the pressure facing the White House to produce evidence of things getting better in Saigon. Max Taylor had just told the committee, chaired by William Fulbright, that the US aspired to achieve sufficient battlefield success to oblige the enemy to accept an independent noncommunist Vietnam. Dean Rusk said, "Toughness is absolutely essential for peace." The great George Kennan, however, won wider plaudits than either witness when he told the committee that there "was more respect to be won in the opinion of the world by a resolute and courageous liquidation of unsound positions."

Few Vietnamese, and certainly not Ky, had much grasp of how the United States worked. The prime minister scarcely read the US press, and wrote later, "If Americans, who came to my country by the million, never came to understand Vietnam, then my people... also failed to understand America.... I had not learned to appreciate the power of American media in shaping public opinion.... I thought that America was Presi-

dent Johnson and his ambassadors, that when we spoke to congressmen, cabinet secretaries, and top generals, we were talking to America. We were 100 percent wrong." He regretted not having expended more attention on winning over the US public, though given his own personality and the nature of his government, it is hard to see how this might have been achieved.

The insularity and naïveté of Saigon's generals now precipitated a new crisis. Even as the Americans lavished unprecedented resources upon winning the war, their Vietnamese clients started playing a road race game of their own, all over the highway. The experience of sitting at a Honolulu conference table opposite the president of the United States persuaded Ky that he should start exerting his own authority. His first gambit was to sack I Corps commander Gen. Nguyen Chanh Thi, who ruled the northern provinces as a personal fiefdom, focused on Hue.

The ancient capital beside the Perfume River was the last important Southern city still distinctively Vietnamese in character: serene and peaceful, scarcely touched by Americanization. Hue's women were alleged to be the country's best cooks. Students sat reading on the Ngo Mon Gate and beside the lotus ponds. Enigmatic graffiti were scrawled on the walls of the citadel: "Liberté, qu'est-ce que c'est?" "Amour?" In the old colonial club with its half-empty swimming pool, dust lay thick on the piano, and on old copies of Le Monde and France Soir. The city also boasted a formidable, indeed dominant, Buddhist presence. Thi persuaded the bonzes that his interests and theirs were aligned. On March 12, demonstrations against the general's sacking erupted, which soon embraced students, spread to Danang and Saigon, and then escalated into workers' strikes. A leaflet issued by the Buddhist Struggle Group proclaimed: "We are oppressed by two forces—the communists and the Americans. We must regain our right of self-determination."

For all Ky's pretensions to rule, he was merely the most visible of a committee of warlords. In the face of the northern turbulence, he panicked. A despairing Ambassador Lodge wrote to Lyndon Johnson: "Most of the things [Ky] says come about a week too late. Also, one always wonders whenever a Vietnamese says something intelligent and true, whether

he is in any way able to do anything about it." Yet the prime minister persuaded the Americans that the Buddhists were promoting communist interests; that the north was close to secession. The II Corps's chief of staff had earlier told MACV that "the army was being systematically subverted by its Buddhist chaplains, who had told units to prepare to lay down their arms because the war was being fought for the good of the US." Lodge lent Ky planes to airlift two battalions of Vietnamese Marines to Danang, a gesture that intensified anti-Americanism. Then Ky weakened, promising elections within three to five months, after which he would resign.

These assurances briefly pacified the Buddhists, reemboldening the prime minister to ship another thousand troops to Danang without telling either President Thieu or the Americans—and to retract his pledge to quit. Ky summoned thirteen leading monks to a meeting at which he told them they were mistaken if they supposed that he would let himself be toppled as readily as Diem. "Before I let you kill me, it will be my pleasure to shoot each of you personally." Demonstrations resumed, almost entirely distracting American attention from operations against the communists, who were bewildered spectators of the civil strife.

The US government took for granted its own right to ordain the governance of South Vietnam. On May 14, Averell Harriman recorded a conversation with McNamara: "I asked him why we shouldn't get the [Saigon] military committee to put someone else in as prime minister." McNamara responded that such action had best be postponed until the Vietnamese had held assembly elections in September. That day Ky's troops landed in Danang, and fourteen dissidents perished in all-day fighting. Then the prime minister dispatched his ruthless police boss, Col. Nguyen Ngoc Loan, who restored government control of the northern cities, killing hundreds of Thi's supporters, some of whom were dragged from sanctuary in Buddhist temples. Eight more monks and nuns conducted public self-immolations, with a new refinement: companions poured peppermint oil on the fires, to mask from the squeamish the odor of roasting flesh.

Loan progressively suppressed the remaining insurgents, jailing several hundred irreconcilables. He crushed the Buddhists, but at a high price for South Vietnam's threadbare international standing. James Reston wrote in the New York Times that the country had become "a tangle of competing individuals, regions, religions, and sects, dominated by a single group of military warlords representing different regions, an army without a country presiding over a people who have been torn apart by war and dominated and exploited . . . for generations." Prime Minister Ky promoted to command of I Corps Hoang Xuan Lam, notoriously incompetent commander of the 2nd Division. Lam kept his post for years despite repeated battlefield debacles, because he possessed the only merit that counted loyalty to the regime. From Washington, Gen. Earle Wheeler warned Westmoreland that Saigon's chaos was feeding antiwar fever. "One cannot expect the American people to suffer indefinitely the continuation of this truly sickening situation. . . . I think I can feel the first gusts of the whirlwind." The US government had "lost irretrievably the support of some of its own citizens. . . . Many people will never again believe that the effort and sacrifices are worthwhile." The Chiefs were now specifying a requirement for half a million troops in Vietnam, and Westmoreland wanted seven hundred thousand.

The Vietcong declared June 1966 Hate America Month. This prompted senior embassy figures in Saigon to stage a folk music evening, to which they invited Pham Duy, a famous composer and singer who had once served with the Vietminh, but had defected in disgust at their cultural repression. The Americans, led by Henry Cabot Lodge and Ed Lansdale, sang the "Whiffenpoof Song" and "Wounded Soldier" and were followed by Pham Duy's 1965 hit "The Rain on the Leaves." The Vietnamese, dressed in his usual peasant black, recited his tone poem "Mother Vietnam," then sang three old Vietminh numbers, "Guerrilla March," "Winter for the Fighting Man," and "Carrying Rice for the Soldiers." Finally, he said how moved he was by the theme song of the Civil Rights Movement, "We Shall Overcome." Duy, whose work remained banned by the communists until 2000, was dismayed soon afterward to find his favorite American ballad adopted by the antiwar movement.

Assembly elections were held in September, with the important constraint that the only candidates permitted to run were those acceptable to Prime Minister Ky. A major surprise thereafter was that Nguyen Van

Thieu exercised increasing authority. It was said that Thieu's wife pushed and prodded the taciturn soldier forward, just as many other ambitious, formidable Vietnamese spouses goaded their husbands. When a presidential election was held in the following year, to implement a new constitution mostly drafted in Washington, Ky agreed to seek only the vice presidential slot, believing that he had cut a private deal to retain the real power. Instead, he found himself marginalized: his rival ruled until South Vietnam's demise. A significant minority who cast protest votes against the military found their own candidate, an unappetizing lawyer, dispatched to jail.

American politicians demanded ever more insistently why the US should support Saigon governments composed of autocratic soldiers, but the CIA responded that there was nobody else. "They are the best-educated, best-disciplined and most talented among the elites." This was unsurprising, since war had been their society's principal activity since 1945. Yet the dominance of Ky and now Thieu made it impossible credibly to project South Vietnam as a democracy. A Southern general long afterward wrote about the mismatch between the US and its Saigon clients: "Americans are active, impatient and rationalistic. Vietnamese are quiescent, patient and sentimental." Democracy was an unfamiliar novelty, observed the soldier, and the uneasy compromises whereby South Vietnamese retained many freedoms, especially that of speech, gave the Saigon regime the worst of all worlds. It was oppressive enough to secure international censure, yet too liberal to control its own people effectively.

In October 1966, Lyndon Johnson became the first serving US president briefly to visit Vietnam, where he urged troops at Cam Ranh Bay to "nail the coonskin to the wall." Robert Komer said, "We're beginning to 'win' the war": trend lines looked good. Robert McNamara sustained a public posture of relentless optimism, though in private he now admitted haunting doubts and fears. The outcome of the 1966–67 political upheavals in Saigon, Hue, Danang, and other cities was that the Thieu-Ky regime achieved a stability that persisted until 1975, at the price of becoming explicitly those creatures despised by Vietnamese of all political hues:

cat's-paws of a foreign power. Relatively few villagers found themselves eligible to vote in the conspicuously corrupt 1967 local elections.

If there was to be no more meaningful politics, there could not be much pride in this state that so many thousands continued to die to sustain. The blessing that South Vietnam's leaders proved conspicuously incapable of conferring upon their fellow countrymen was self-respect. Late in 1967, Thieu moved into Saigon's presidential palace. He was thereafter maddened by Ky landing his helicopter on the roof of the building, immediately above his bedroom, at unsocial hours. He left it to his wife to complain, however, and coexisted precariously with the airman. Neil Sheehan said, "Thieu knew how to play the game. Though he was an outrageous crook, he never made himself a threat to the US. The Americans would tolerate bad Vietnamese leadership as long as it didn't threaten their objectives."

When Duong Van Mai became a researcher for RAND, interviewing Vietcong prisoners, though an unwavering anticommunist, she found herself musing about why the Saigon regime was incapable of motivating its people as the communists did, building belief in a "just cause." She wrote, "Gradually it dawned on me that . . . we were losing because of ourselves, because we had been unable to come up with a system, an ideology, and a leadership that could tap these same qualities in the people, inspire them, and pull them together." The United States attempted to provide generous sustenance for Vietnamese bodies, yet offered little that nourished Southern souls.

3. GURUS

As the struggle intensified, so too did the range of proposals for winning it, most of them fanciful. Among the psychological warfare options considered was May 1966's Operation Shotgun. This demanded a series of amphibious feints against North Vietnam's beaches, to convince Hanoi that a US invasion was imminent. Earle Wheeler demurred: if the threat was believed, he said, world opinion would be appalled, providing

"excellent propaganda material" for the enemy. Contrarily, if everybody was told to expect an invasion which never happened, the US would look pathetic. Gen. Westmoreland's flights of fantasy included a forced urbanization program, shifting peasants into city areas and thus forcibly separating them from the Vietcong, a concept also favored by Bob Komer.

Meanwhile the defense secretary espoused a proposal from a Harvard scientist, Professor Roger Fisher, subsequently endorsed by the JASON division of the Institute for Defense Analyses, for an electronic and explosive barrier, to seal off the DMZ and the Ho Chi Minh Trail from South Vietnam. The "McNamara Line" would have required air-dropping 240 million Gravel mines, 300 "button bomblets" developed by Piccatinny Arsenal, 120,000 Sadeye cluster bombs, and 19,200 acoustic sensors, together with deploying more than a hundred aircraft, at an annual cost of \$800 million. Elements of the plan were implemented—vast numbers of sensors were dropped around the Trail, and bombed when movement was detected. The barrier scheme was abandoned, however, in the face of ridicule shared even at MACV. The project came to be viewed as a spectacular manifestation of the madness that overtook Vietnam war making.

Much extravagant theorizing concerned air bombardment, employed in South Vietnam, Laos, and later Cambodia with an intensity unprecedented in the history of warfare. The NVA's Col. An wrote wearily, "If tree-leaves suddenly withered, if water in a stream turned cloudy, if a path appeared where no path was seen on the photographs taken a day before, the enemy would bomb and shell the location." Among sensitive participants and onlookers, there was dismay—indeed, revulsion—at the impact on civilians of promiscuously broadcast ordnance. On July 1, 1966, for instance, USAF bombs hit a village designated as friendly, killing seven people and wounding fifty-one. On August 9, F-100s wreaked havoc upon a Delta community, killing sixty-three civilians and wounding eightythree. These were only conspicuous examples of daily mishaps. Adviser Sgt. Mike Sutton said sadly, "We killed an awful lot of people who didn't have anything to do with the war." In My Tho, David Elliott agreed: "Vietcong brutality was individualistic, but American devastation was a matter of policy." Correspondent Neil Sheehan asked Westmoreland if he

was troubled by the civilian casualties caused by friendly fire. The general replied, "Yes, Neil, it is a problem, but it does deprive the enemy of population, doesn't it?"

Air chiefs enlisted the backing of a guru who argued, first, that bombing worked, and second—oh so soothing to their own sleep patterns—that civilian victims didn't blame America. RAND researcher Leon Gouré played an influential and frankly sinister role in the evolution of bombing policy. Back in August 1964, following a one-month field trip to Vietnam, he told the USAF that he thought his RAND colleagues' respectful study of the motivation and morale of the Vietcong was defeatist. He promised the airmen a more upbeat view of all the good things that bombs could contribute to the war effort.

Gouré was born in Moscow in 1922, son of a Menshevik revolutionary soon forced to flee to Berlin. He moved to Paris in his teens. A Jew, he was fortunate to escape to America in the nick of time in 1940. After war service, he became an academic, a Cold Warrior with an implacable loathing for communists, and an analyst for RAND. Unlike most of his colleagues, he was happy to move to Saigon, funded by \$100,000 of Air Force money. He assumed responsibility for a new, expanded Vietcong Motivation and Morale study, which he started in December 1964. His work became a case study in the distortion of academic research to serve factional ends and contributed to the killing of many thousands of Vietnamese.

Gouré cataloged the weapons captured in enemy caches—Czech submachine guns, Russian shells, Romanian rocket launchers, East German flamethrowers—and demanded, how could the Vietcong not be part of a worldwide communist offensive? Once established in RAND's big villa at 176 Pasteur Street in Saigon, he took pains to glad-hand every important visitor to the city, and to stifle dissenting colleagues. His message, for which he proselytized tirelessly through more than two years that followed, was that all restraints on the use of air power should be lifted. Noting that the enemy feared planes more than any other US weapons system, he urged that it was thus logical to maximize their use. Bombs could bring uncooperative villages to heel, forcing the inhabitants to leave VC-controlled areas for new locations "where they could be

more effectively screened and administered." Gouré's logic was certainly inhumane, arguably deranged, and his junior colleagues recoiled in disgust and disbelief. RAND's chiefs, however, decided that the corporation secured enhanced standing from their man's access and popularity in Washington.

On one of Gouré's returns to Saigon, he was met at Tan Son Nhut by Susan Morrell, whose husband, David, had been intimately involved with RAND's original morale study. She asked the sage what he hoped to achieve. "I have the answer right here," he said, tapping his briefcase. "When the Air Force is paying the bill, the answer is always bombing." His vanity and ambition were matched by a shameless lack of concern for Vietnam, other than as a theater in which to play out an act in the Cold War. In March 1965, he produced a first interim report, which professed to show that US might was working its magic and that more might could deliver more magic. He concluded that while, a few months earlier, 65 percent of defectors had believed the communists were winning, after a year exposed to American air power, the proportion of enemy optimists had declined to just 20 percent.

He perceived no negative effects upon civilian opinion, and said that enemy troop quality was declining and desertions increasing. He urged intensification of crop destruction to starve out the enemy. Some correspondents, such as Neil Sheehan, dismissed Gouré as a Cold War crooner, serenading hawks with tunes they loved to hum. The RAND man's admirers nonetheless included decision makers: the Pentagon and the White House received him with open arms. Walt Rostow thought he was terrific. McNamara, after one of Gouré's brilliantly fluent briefings, inquired as to the size of his project budget. Told that it was \$100,000, the defense secretary asked, "What can you do with a million?" Something much bigger, responded the RAND man. "You've got it," said McNamara.

Thereafter Gouré galloped from podium to podium, relishing his own celebrity. When a colleague voiced dissent from his methodology and conclusions, this apostle of air power waved him aside, saying, "Oh, I talked

to Bob McNamara yesterday . . . and I said to him these B-52 bombings are really effective . . . and if we can do it with a little more accuracy so we don't bomb quite so many villages, we can destroy their logistics and deny them the support of the people." Through 1966, Gouré's remained an influential voice. His team eventually generated some thirty-five thousand pages of transcribed and translated interviews with prisoners and defectors, though latterly even Westmoreland came to question the optimism of the conclusions derived from them. A review of Gouré's findings by Konrad Kellen, another Jewish émigré working for RAND, concluded that they were fundamentally flawed, rooted in a Cold War mind-set and willful misreading of data.

Leon Gouré cannot be held responsible for the extravagant American use of air power, but he supplied a fig leaf of intellectual respectability for policies the Johnson administration and many generals favored anyway. He provided a vivid vindication of Michael Howard's unease about RAND's isolation from "friction, the contingent, the unforeseeable, all the things that really mattered" in understanding war. An authoritative USAF historian has written that Seventh Air Force's own commander, Lt. Gen. William Momyer, eventually became "appalled by the enormous tonnage of bombs the B-52s were dropping on the South Vietnamese jungle with little evidence of much physical effect on the enemy, however psychologically upsetting." When Harry Rowen became president of RAND in 1967, he insisted on Gouré's displacement, asserting that the man's work was "harmful to the country," as well as to the corporation. This evangelist for air power was first exiled to Danang to study enemy infiltration, later sacked.

Still, it is striking to contrast the enthusiasm with which Gouré's findings were received by most of the military, and the tepid response other Santa Monica researchers encountered when they presented data that cast doubt upon strategy or tactics. For instance, a report arguing that chemical crop destruction did little to hurt the enemy, while causing infinite grief to peasants, was dismissed out of hand. When its author visited MACV in hopes of briefing senior officers, he was sent home unheard.

Bruce Griggs, the general's scientific adviser, said contemptuously, "This is crap," and in Washington the Joint Chiefs agreed.

By December 31, 1966, there were 385,000 Americans in Vietnam, and Robert McNamara announced that many more would be coming. Retired general John Waters published an article in *U.S. News & World Report* that reflected the views and frustrations of many of his serving colleagues. It was headed how the us can win and urged dramatic ground thrusts into Laos and Cambodia. "It should be stated simply, clearly and in a dignified manner that we will not tolerate any interference from the Chinese, Laos and Cambodia. . . . The US must choose the harder right rather than the easier compromise. We must . . . lay the future squarely on the line. . . . In the end it will save men, money and materiel. It will accomplish the U.S. mission with honor, with decision, and win the esteem and respect of the free world."

Maybe so. However, the 1966 cost of the war had been budgeted at \$2 billion, but the final bill came in above \$15 billion and rose the next year to \$17 billion, about 3 percent of US GNP. In President Johnson's January 1967 State of the Union address, he announced a 6 percent personal and corporate income tax surcharge to fund the war. Privately, he was increasingly troubled by fear that Chinese "volunteers," of whom a million had fought in Korea, would soon appear alongside the NVA. He was shocked when the supremely charismatic Senator Robert F. Kennedy announced that he no longer believed the war winnable. Thereafter Johnson became morbidly convinced that Kennedy, a close friend of McNamara, suborned his defense secretary.

After twenty-eight months in Vietnam, Gen. William Westmoreland told a *Life* magazine interviewer, "We're going to out-guerrilla the guerrilla and out-ambush the ambush. And we're going to learn better than he ever did because we're smarter, we have greater mobility and firepower, we have more endurance and more to fight for. . . . And we've got more guts." The US, he said, was now fighting a war of attrition, in which more than six thousand Americans had died in 1966. He was increasingly convinced

that it was time to take whatever steps were necessary to cut the Ho Chi Minh Trail.

In Hanoi, however, Premier Pham Van Dong inquired urbanely of Harrison Salisbury of the *New York Times*, "And how long do you Americans want to fight, Mr. Salisbury? . . . One year? Two years? Three years? Five years? Ten Years? Twenty years? We shall be glad to accommodate you."

ROLLING THUNDER

1. STONE AGE, MISSILE AGE

Air Force chief Curtis LeMay never lived down a sentence in his 1965 memoirs: "My solution . . . would be to tell [the North Vietnamese] frankly that they've got to draw in their horns and stop their aggression, or we're going to bomb them back into the Stone Age." Deep in the South Vietnamese jungle, one of LeMay's readers, Doug Ramsey, hankered to meet the general so he could point out that "it is hard to bomb something back into the stone age which has never left that in the first place." Lyndon Johnson committed US aircraft against the North because he was desperate to break out of the cycle wherein Washington seemed forever to dance to the enemy's tune. McGeorge Bundy wrote to him on June 30, 1965: "It is within our power to give much more drastic warning to Hanoi. . . . If Gen. Eisenhower is right in his belief that it was the prospect of nuclear attack which brought an armistice in Korea, we should at least consider what realistic threat is available to us." Fred Weyand, one of America's smartest officers, and later MACV's chief, supported Lyndon Johnson's "Rolling Thunder II" offensive of North Vietnam: "If we were going to bend their will to ours, [this] was the only thing we had going for us."

For the past century, air power has exercised a potent and often illusory charm for governments seeking to leverage might. It appears less messy, ugly, and politically costly to dispatch planes to deliver ordnance

from virgin skies than to send soldiers to wade through a figurative and sometimes actual mangrove swamp. Most aircrew take for granted the spurious moral absolution conferred upon those who escape eye contact with the people whom they kill.

Skeptics who have studied a little history know the limitations of bombing. It invariably hurts bystanders. It can be effective, indeed decisive, against moving troops and vehicles and against unhardened installations. It often fails, however, against dug-in troops and complex industrial and communications targets. Between 1950 and 1953, the USAF expended enormous effort on severing the supply routes between China and North Korea, but Operation Strangle was never more than a limited success. In 1965 the bomber barons said, "Air power has moved on; technology enables us to land a bomb on a dime," and Lyndon Johnson invited the US Navy and USAF to inflict measured punishment upon the North Vietnamese. Operation Rolling Thunder was intended to unleash American might in a restricted and thus humane fashion, forswearing any intent to enforce regime change.

This exasperated some airmen, LeMay prominent among them, who argued for general devastation, especially for closure of the port of Haiphong. In their eyes, striking softly was anathema, even un-American; they believed that the Allies did it right against Germany and Japan in 1944–45. Yet though US Air Force and Navy chiefs fulminated against 1965–68 political restrictions on bombing, none stipulated that these rendered their forces incapable of delivering a result. They deemed the enemy's society, a thing of bamboo and cotton, so frail that even a moderate dose of air-dropped explosives would destroy both his will and his means. Only much later, when communist resilience had become apparent, did commanders vociferously attribute blame for failure to their political masters. They remained blind to the fact that in a war of choice, the US could sustain the acquiescence of its own people and allies, never mind of its Russian and Chinese foes, only if there was some proportionality between force employed, civilian casualties incurred, and the objective at stake.

In February 1965, the White House ordered bombing as a mere token of US resolve, rather than to fulfill defined military objectives. William

Bundy said later, somewhat nonsensically, "Really, the policy was making itself and, in effect, declaring itself through our actions. And this was what the President wanted." On March 8, Maxwell Taylor cabled Johnson from Saigon, demanding a heavier punch: "I fear to date that Rolling Thunder in [North Vietnamese] eyes has merely been a few isolated thunder claps." A pilot wrote sourly, "It seemed as if we were trying to see how much ordnance we could drop, without disturbing the country's way of life." The CIA's John McCone warned that American scruple was interpreted by Hanoi as weakness. Thereafter more and more explosives were heaped upon an ever wider range of targets, so that by 1968, North Vietnam had been struck by 643,000 tons of bombs.

Yet during the same period 2.2 million tons of bombs fell on the South. America's leaders worried much more about killing civilians in the hostile North than in its supposedly friendly neighbor. "Hell jelly"—napalm—used promiscuously on Saigon's territory, was never authorized on Hanoi's. Arguments about the legitimacy of hitting specified installations and activities became arcane and ill-tempered. In May 1965, a wing commander expressed bewilderment: "What's a military convoy? When a specified number of vehicles covers what length of road is it a convoy? Is a single vehicle traveling by itself an authorized target? . . . How far off a specified route are we authorized to follow a truckable ancillary road?"

Early targets for Rolling Thunder were decided during Lyndon Johnson's Tuesday luncheons with McNamara and Rusk. As they ate, the defense secretary produced a non-gastronomic menu, already endorsed by the secretary of state. The president approved some objectives and rejected others, chiefly influenced by their presumed political sensitivity and proximity to Hanoi, where in 1965–66 he wanted no unpleasantness. He decreed a thirty-mile buffer zone along the Chinese border and around cities, wherein targets were safe from attack unless explicit consent was given. Lt. Gen. Bruce Palmer asserted that "for most of his presidency [Johnson] remained the target officer." The intimacy of those White House discussions allowed the three principals to speak frankly to each other—until late 1967, no military representatives attended—but since decisions were unrecorded, there was quibbling afterward about what had been agreed.

In the early days, bridges accounted for four-fifths of authorized targets, yet Hanoi's massive Paul Doumer Bridge was spared for two years. The best chance of achieving a hit on a narrow span was to drop a stick of bombs at a diagonal to it, but such tactics were deemed too hazardous to civilians, and thus ordnance was instead released in alignment, causing a high proportion of misses.

Fliers shifting at five hundred knots were invited to distinguish civilian from military trucks from a height of three thousand feet. The Hanoi bicycle plant, an important component of North Vietnam's transport system, was kept out of bounds until late in the war. To appease the squeamish, in 1967–68 the State Department sometimes decreed specific bombloads. A staffer observed wearily as he watched Rusk, his chief, dash to a White House meeting, "If you told him of a sure-fire way to defeat the Vietcong and get out of Vietnam, he would groan that he was too busy to worry about it now; he had to discuss next week's bombing targets."

Fighter-bombers were used rather than B-52 Stratofortresses, which flew only 141 Rolling Thunder missions, just north of the DMZ. However, like most of the Navy's planes, the USAF's six hundred F-4 Phantoms and matching force of F-105 Thunderchiefs lacked all-weather capability. During the late spring monsoon months when the cloud base over North Vietnam seldom lifted, half the airmen's designated objectives were unreachable. Moreover an energetic defense exacted a rising toll. In 1965 the Americans lost 171 aircraft over the North; in the following year, 280; in 1967, 326. The communists deployed massive numbers of antiaircraft guns, and successive models of MiG fighters; the Russians supplied ground-controlled radar intercept systems. Within a few months of Khrushchev's fall, in November 1964, his successor Leonid Brezhnev began to dispatch SA-2 missiles to North Vietnam; two years later, there were two hundred launch sites. Col. Jack Broughton, deputy commander of the 355th Tactical Fighter Wing, said enemy territory was "the center of hell with Hanoi as its hub." Finally, while accuracy of aim was fair by contemporary standards, "iron bombs," as distinct from the precision-guided munitions that came only later, were clumsy tools.

Between March 1965 and July of the following year, Washington ex-

tended the rules of engagement to permit US planes to attack ever larger expanses of the North, though city centers remained off-limits. SAM sites under construction were spared: an F-4 squadron commander from the Midway repeatedly overflew a missile launcher that eventually became operational and shot him down. Only when the first Phantom was lost on July 24, 1965, did the president reluctantly authorize strikes on a few sites: three days later fifty-four F-105s bombed two alleged launcher clusters. Prewar tactical doctrine decreed that missiles, not guns or fighters, represented the key threat. Thus the planes approached at five hundred feet, below the missiles' "envelope"—and met a storm of antiaircraft fire. The targets proved to be heavily protected decoys: the ground defenses had prepared an ambush, and downed four "Thuds"—Thunderchiefs; that range of hills became known to aircrew as Thud Ridge, because it was the downfall of so many. Two F-105s collided on the way home, making this the most costly raid of the conflict thus far. Thereafter the Air Force adopted more sophisticated tactics, dispatching "Wild Weasel" aircraft specially armed with Shrike radar-seeking missiles, their warheads laced with phosphorus so that further waves of attackers could aim at the smoke.

Yet between one-third and half of all enemy missile launchers remained immune because of their proximity to population centers. The North Vietnamese placed SAMs in Hanoi's football stadium, knowing that no harm would befall them. Not infrequently their own spent munitions and flak debris fell in civilian areas, where damage and casualties were of course blamed on the Americans. Ships in Haiphong Harbor, some of them Chinese and Russian, fired on passing aircraft with impunity. Although Haiphong's lighthouse was a forbidden target, pilots occasionally shot at it to relieve their feelings.

Throughout the campaign, a fierce and debilitating rivalry about target selection persisted among the Joint Chiefs, the C-in-C Pacific, the Navy, and Seventh Air Force. Mark Clodfelter, authoritative historian of the bombing, has written, "The absence of a single air commander produced chaos." Seventh's chief, Gen. William Momyer, based in Saigon, nurtured a list of some four thousand possibilities, while the Defense Intelligence Agency's rival catalog ran to five thousand. C-in-C Pacific controlled the

B-52s from Honolulu. Momyer was eager to destroy the Red River dikes, wrecking the rice production of the Delta, but the White House would not hear of attacks that might precipitate mass starvation.

The first phase of the air war was among its most costly for the Americans. In March 1965, the Navy lost fifteen to thirty planes per thousand sorties, whereas by autumn and through 1966, this fell to seven, later to four. Of Navy combat losses, 58 percent were attributed to ground fire, compared to 73 percent of the USAF's, and 64 percent of the Marines'. In all, flak accounted for 1,600 of the 2,300 US planes downed. Prewar theoreticians had been correct that guns could not track low-level attackers, but they underrated the potency of saturating "boxes" of sky with fire.

The US air effort intensified in the latter part of 1965, rising from 2,879 sorties in August to 3,553 in September. By the year's end, the Joint Chiefs were realistic enough to acknowledge that the enemy's war-making capability was scarcely impaired. They now fixed on oil as a key objective, though the Defense Intelligence Agency believed that North Vietnam could sustain essential activity using just 32,000 metric tons a year, while having a storage capacity of 179,000 tonnes. The oil-target enthusiasts might also have noticed that Hanoi's trains ran on coal or wood.

Authorization to attack oil was secured by the new national security adviser, Walt Rostow, who in April 1966 replaced an exhausted and dispirited McGeorge Bundy. To colleagues Rostow extolled Johnson's guts and compared him to Lincoln, asserting that "if LBJ only kept up the military momentum, he would be in the clear in another few months." On June 29, Navy planes hit the Haiphong POL (petroleum, oil, and lubricant) complex. A poststrike reconnaissance pilot said, "It looked as if we had wiped out the entire world's supply of oil." By that date, however, the Vietnamese had dispersed their reserves in drums and underground tanks. Later in the summer, Washington allowed B-52s to bomb military targets within the DMZ and some ten miles north into communist territory. Each aircraft could deliver ten times the bombload of a fighter-bomber. The Stratofortresses transformed the area into a cratered moonscape. Enemy supply movements, however, seemed almost undiminished, there and along the Ho Chi Minh Trail in Laos. Weather restricted US bombing in late 1966,

334 .

so that targets around the Red River Delta could have been hit only by using B-52s, with the prospect of increased civilian casualties, an option rejected by the White House. Between December 2 and 5, however, fighter-bombers attacked rail yards, truck depots, and fuel dumps close to Hanoi.

At year's end, the Defense Intelligence Agency calculated that a total of 4,600 North Vietnamese trucks had been destroyed and the same number damaged, together with 4,700 supply boats sunk and 8,700 damaged, and eight hundred railroad cars and sixteen locomotives wrecked. Seventh Air Force had so many target photos that it lacked interpreters to examine them all and make sense of the findings. In April 1967, when attacks on the North's electricity grid began, intelligence calculated how much power plant was being destroyed but offered no plausible estimate of how much remained—which was what mattered.

Almost all the uniformed decision makers favored bombing and mining Haiphong, through which flowed most of Hanoi's military imports. The president, however, flinched from a confrontation with Moscow about the Soviet freighters that off-loaded there. Hanoi's government communications remained inviolate, because key switchboards were located close to the Soviet Embassy. In December 1966, the president advanced through the Poles on the ICC an absurd proposal to restrict bombing within ten miles of Hanoi if the communists would abstain from attacks within ten miles of Saigon. This offer having failed to elicit a response, the US imposed a unilateral ten-mile prohibition on targets around Ho's capital.

By one of the larger in the war's feast of ironies, Rolling Thunder did incomparably more harm to the government of Lyndon Johnson than to that of Le Duan. International and some US domestic opinion recoiled from the mere fact of the bombing and was unimpressed by its moderation. Contrarily, Johnson faced fierce criticism from congressional hawks who wanted him to hit the enemy harder—to go for the jugular. When he sought credit for his humanity by staging a seasonal bombing pause between December 24, 1965, and January 31, 1966, this was greeted by a familiar stony silence from Hanoi, scorn from the airmen, and worldwide indifference. The graduated escalation of air attacks provided the communists with a gentle learning curve, which enabled them progressively to

improve their defenses and to develop countermeasures amid an ongoing drizzle of explosives rather than the monsoon the USAF and USN wished to unleash.

By 1967 the Vietnamese had deployed twenty-five SAM battalions with six launchers each, around a thousand AA guns, and 125 MiG fighters. While there was no large-scale industrial manufacturing in Ho Chi Minh's dominions, war created a more technologically sophisticated local activity than any Vietnamese could earlier have envisaged: air defense. American losses rose as more targets were attacked around Haiphong and Hanoi—Downtown, as American pilots knew the capital. Until late 1966, air operations throughout Southeast Asia cost the US an average of less than one plane per thousand sorties. Over North Vietnam, however, Air Force losses approached twenty-five times that rate. Planes began to bomb from higher altitudes, often releasing ordnance at seven rather than four thousand feet. This cut gunfire losses at the cost of further reducing accuracy. The attackers began to employ antipersonnel cluster bombs, some of them filled with delayed-detonation bomblets, to force defending gun and missile crews to hug their shelters.

Although communist MiGs shot down relatively few US planes, they sometimes forced attackers to jettison bombs and even ECM-electronic countermeasure—pods in order to evade them. At a conference in the Philippines about the MiG problem, Gen. Momyer conferred with Col. Robin Olds, the big, boisterous commander of an F-4 wing. The two men, both World War II fighter aces, devised an ingenious plan, Operation Bolo, which was executed on January 2, 1967. Communist fighters avoided F-4s, tangling only with bomb-laden Thunderchiefs. Thus some F-4s were disguised as F-105s by the addition of radar pods, and headed toward an apparent big bombing raid on the MiG base at Phuc Yen. Early in the afternoon above a thick cloud base, Olds was poised overhead with more than forty fighters. The MiGs were slow to respond, but when they took off, the F-4s' Sparrow and Sidewinder missiles downed at least five enemy aircraft in fifteen minutes, with no loss to themselves. Olds himself achieved the first of four kills. A few days later, a similar ruse was employed: two F-4s entered enemy airspace so close together that ground

radar identified them as a single plane: when MiG-21s engaged the Phantoms, two were shot down.

In March almost three hundred sorties were directed against the Thai Nguyen ironworks, which eventually fell silent. From above the persistent spring overcast, the Air Force conducted night bombing by radar, with indifferent results: ordnance landed an average of a thousand yards from aimpoints, not much of an improvement on World War II accuracy. The Navy meanwhile mounted almost a hundred sorties against Haiphong's power plants, which were forced to suspend generation at the end of May.

The USAF mounted up to two hundred sorties daily when weather permitted: two waves in the morning, two in the afternoon. Though the enemy did not fall for any further stunts like Col. Olds's faux Thunderchiefs, in May 1967 the Americans claimed destruction of twenty-three MiGs for the loss of just three of their own planes in combat; half of North Vietnam's fighter pilot strength was wiped out. On the 19th, the Navy began to employ Walleye TV-guided bombs against Hanoi's power installations, having persuaded the president that these were accurate enough to do minimal civilian damage. This was so, but the North Vietnamese had enough generators to sustain vital electricity supplies. By July eight thousand sorties a month were being flown against the North Vietnamese panhandle, south of the 20th parallel, bringing rail traffic to a standstill. Further north, however, the communists held open the vital lines between China and Hanoi.

Within the president's intimate circle, by early 1967, Walt Rostow and Dean Rusk, together with Johnson intimates Clark Clifford and Abe Fortas, remained committed to the struggle. In May Averell Harriman told the Russian ambassador that Rostow was the most dangerous hawk in the White House. Other members of the administration, however—even those whose faith in the war remained unshaken—now doubted that the military utility of bombing the North justified its high political cost. McNamara had emerged as a born-again skeptic, as were most members of an influential discussion group that met each Thursday afternoon in the office of Undersecretary of State Nicholas Katzenbach. They included Cyrus Vance and William Bundy, sometimes Rusk and the CIA's Richard

Helms, occasionally the defense secretary himself. They called themselves the No Committee, because their existence was denied. They advocated focusing air power on the communists' direct supply routes into South Vietnam.

Some were frankly distressed by the White House's behavior when peace proposals were advanced: through the United Nations; via British premier Harold Wilson, who dallied with the Russians in February 1967; and using French intellectual admirers of Ho Chi Minh and the good offices of Harvard professor Henry Kissinger. Johnson made public noises in support of negotiations with Hanoi, and occasionally advanced grandstand proposals of his own, but his oft-repeated gambit of accompanying these with intensified bombing showed that he was bent upon achieving a military advantage before talking in earnest. Since Hanoi had the same idea, none of 1967's "peace initiatives" had much prospect of success.

The US military resisted the defeatism that privately beset some politicians, especially McNamara. Its leaders were weary of their tiptoe, gradualist approach; they were in this thing now, and wanted a result. At the sharp end, pilots especially resented restrictions on attacking elements of the communist air defenses. Col. Jack Broughton was a West Pointer from New York who since 1945 had flown almost every type of combat aircraft. He served two fighter tours in Korea, then won a string of decorations, headed by the Air Force Cross, flying 102 F-105 missions over North Vietnam. By the summer of 1967, Broughton had become exasperated by the manner in which his chiefs ran the air war. "I was looking for a fight," he wrote in a later memoir.

He found it on June 2, while serving as an acting wing commander. Two of his pilots returned from a mission on which one reported that he might have fired on a Russian ship in Haiphong Harbor, as indeed he had. Next day, Moscow delivered a formal complaint about hits on its merchantman *Turkestan*, which had killed a seaman. Adm. Sharp, C-in-C Pacific, at first assured Washington that the Soviet charge was unfounded. Then the USAF launched an inquiry, in which Broughton intervened: he personally destroyed his pilots' camera-gun film to save them from blame. This cost him a court-martial conviction and a \$40 fine. Though later

overturned by the secretary of the Air Force, the episode effectively ended the tough New Yorker's career. He stayed angry for the rest of his days, a professional warrior cast in a familiar mold: of priceless value when tangling with his country's enemies but incapable of reconciling himself to limited war. Meanwhile, on June 29, 1967, Navy fighters strafed another Soviet ship, causing the administration to impose even more restrictive rules of engagement around Haiphong.

A faction among the military, including Adm. Sharp and Gen. Earle Wheeler, continued to press for intensification of the air war. Senator Richard Russell, for decades a supporter of the president's career, argued that the US should either start fighting to win or quit Vietnam. At the end of August 1967, the Stennis subcommittee of the Senate published a report demanding air escalation, to "take the risks that have to be taken, and apply the force that is necessary to see the job through." The Stennis hearings exposed the depth of the divide that had opened between Mc-Namara and the president, and the JCS. As far back as eighteen months earlier, the defense secretary had told correspondents at a private briefing, "No amount of bombing can end the war." By late 1967, his intimates were puzzled and dismayed that he didn't submit a principled resignation rather than instead await the eviction order that belatedly came in November, when he discovered that he would be moving to the presidency of the World Bank, an appointment fixed by the president without consultation with the nominee.

Meanwhile, the air hawks, led by Rostow, retained the ascendancy: Johnson authorized an ever longer list of targets in North Vietnam. On the morning of August 11, 1967, bombers for the first time broke Hanoi's Paul Doumer Bridge. There were intensive new attacks on the Yen Vien rail yards, but at a significant cost in casualties: five F-4s were lost to AA guns and MiGs, which suddenly reappeared in force, for the first time attacking from the rear. Pilots were always warned to "check six"—to watch for enemy behind at the six o'clock position—but they were so accustomed to seeing MiGs ahead that these unexpected new tactics hurt. Robin Olds, who led an attack in which two F-4 pilots were lost, wrote bitterly later, "I heard them scream. I turned, and all I saw were two burning objects."

The "Kissinger peace initiative" was an autumn 1967 piece of brokerage between Hanoi and Washington, using French intermediaries, which the Harvard academic attempted in a private capacity, though exploiting his influential government connections. Following its collapse, in mid-October Johnson approved the first direct attacks on the Phuc Yen MiG base. American losses nonetheless persisted. During a November 17 raid on an air defense facility outside Hanoi, Maj. Charles Cappelli's F-105 was destroyed by a missile. A comrade remembered ruefully afterward that "Cappy" had breached a powerful taboo among pilots, by saying before he took off that he would handle some paperwork when he got back. His friend said, "It's not done. You don't talk about coming back."

During the last phase of Rolling Thunder, which began in November 1967, American airmen faced the worst weather they had yet encountered. In December, enemy fighters, displaying growing proficiency, forced more than 10 percent of attackers to jettison their bombloads before reaching targets. On the 17th, airmen reported seeing twenty MiGs in the sky simultaneously; two days later, fourteen. On December 2, five Air Force and three Navy planes were shot down, all but three by SAMs. Radar bombing remained chronically inaccurate. In 1968, a hundred thousand sorties were flown against North Vietnam, but after Lyndon Johnson in March decreed an end of all strikes north of the 19th parallel, these took place in a limited area, where the communists were able to concentrate 2,600 AA guns.

The air campaign sometimes seemed cursed. Attempts to interdict river traffic were frustrated when air-dropped magnetic mines detonated too far from passing ships. In March 1968, the swing-wing F-111 Aard-vark entered the war accompanied by high hopes, but technical failures caused a series of crashes, and on its early sorties the aircraft performed poorly. On March 11, the communists mounted a devastatingly successful commando operation. NVA sappers of the 41st Battalion stormed the USAF's mountaintop Station 85 on Pha Thi Mountain in Laos, from which many Rolling Thunder missions were controlled. Twelve of its eighteen American personnel were killed, and the Air Force was obliged to bomb the captured installations to destroy sensitive equipment. For the

remainder of the Johnson presidency, the fliers' principal business was to restrict communist truck traffic southward.

The tentative bombing policy initiated by the White House in February 1965 could have succeeded only against a weak-willed foe, which the Hanoi politburo was not, or against a population that was offered choices, which North Vietnam's people were denied. Most of what went wrong with the 1965–68 campaign reflected the inability of air power to overcome a primitive society that was contradictorily strongly defended, through erratic and unhelpful weather patterns, using imperfect aiming technologies. Lyndon Johnson became merely one among a long procession of national leaders over the past century to discover the limitations of aerial bombardment.

2. "UP NORTH"

When the air campaign began, morale was high among the fliers of the USAF, Navy, and Marine Corps. Only a few flinched, when their wives delivered an ultimatum, "Me or the war: take your pick!" Most young men—and some veterans, knocking forty—having devoted their careers to training for combat, were thrilled to be granted the opportunity to do it for real, to test themselves and their fabulous flying machines at the outer edge of danger, without need for the munificent \$2.16 that a grateful nation awarded them in daily combat pay. After a spell of operations, USAF men headed for Bangkok, while an offshore carrier rotated to the Philippines for rest and maintenance. Ashore in the Cubi Point Officers' Club at Subic Bay, there was frenzied partying: karaoke, food fights, fistfights. Cmdr. John Nichols wrote, "They got knee-walking, commode-hugging drunk the first couple of days, then recuperated with golf, swimming, or deep breathing." And soon sailed back across the South China Sea, toward the enemy.

For targeting purposes, the USAF, Navy, and MACV were apportioned responsibility for different sectors of North Vietnam. The carrier fliers attacked Route Packages 2, 3, 4, and 6B, which extended from the 18th parallel north to China; the Air Force owned RPs 5 and 6A, which

included Hanoi and the northwest railroad; MACV borrowed RP 1 from the USAF. Most of the USAF's tactical aircraft, together with some B-52s, were deployed at bases in Thailand, where by 1966 the US had thirty-four thousand servicemen, more than two-thirds wearing Air Force blue and almost all working for the war, though also contriving to play a little: dispensaries at each of the air bases ministered to a thousand VD sufferers a year. The Bangkok government, uneasy about complicity in bombing, initially insisted that aircraft taking off from Thailand should not attack targets in Saigon's territory and that planes heading North should pretend to have taken off from the South, a fiction abandoned only in 1967.

None of the available Cold War aircraft was well suited to ground attack. The USAF's big F-105 "Thud" could take punishment but lacked maneuverability and demanded intensive maintenance; more than three hundred F-105s were eventually lost. The F-4 Phantom, designed as an interceptor, was magnificent for anything but low-altitude operations over North Vietnam, where thick black smoke from its engines showed off its position to every MiG within miles, and it was vulnerable to ground fire. When operations against North Vietnam began, the USAF owned six hundred F-105s, and about the same number of Phantoms. But while two hundred a year of the latter were still rolling off production lines, the former was no longer manufactured. Thuds were thus sent on the most dangerous missions, partly because their loss took down only one pilot, while F-4s carried crews of two. There was a sour joke that the backseat man was needed to read the rules of engagement over enemy territory.

The Navy's best ground-attack aircraft was the A-4 Skyhawk, much smaller than the Phantom. Designed by Ed Heinemann, it was simple, rugged, and easily maintained—which mattered as combat operations intensified. Many A-4 squadrons maintained 100 percent availability, which was seldom the case with more fickle types, such as the photo-reconnaissance A-5 Vigilante: Skyhawks eventually flew more combat missions than any other Navy warplane. The older F-8 Crusader was strangely configured, with the pilot sitting six feet ahead of the nosewheel. It was a fine interceptor, the last with guns as its main armament, but was handicapped by poor radar and a high accident rate. Robust old prop-driven Douglas

A-1 Skyraiders flew many early missions—they scored two of the Navy's first ten MiG kills—but their sluggishness caused them to be relegated to ECM and rescue cover duties. Pilots said, "Speed is life."

Aircraft over North Vietnam were directed from Station 85 in Laos or from a control center on Monkey Mountain—callsign Motel—located at Danang, midway between Saigon and Hanoi. Udorn Air Force Base in Thailand provided backup. However, none of these sites could see what was happening over the Red River with sufficient precision to guide strikes effectively. Attackers were pretty much on their own, dependent on airborne leaders, a colonel or commander according to service. Weather was an important factor in both operational effectiveness, which declined steeply in the monsoon months, and losses, which rose sharply in the same season. Again and again, pilots endured the terrors of forging far over enemy territory, only to find themselves obliged to divert or abort, jettisoning bombs amid low cloud at the target.

The Navy attacked the North from platforms ploughing hither and thither on "Yankee Station" in the Tonkin Gulf, between 60 and 150 miles offshore. The US owned more aircraft carriers than the rest of the world put together—sixteen strike and ten antisubmarine variants. The 75,000-ton Forrestal class were much safer than the older Essexes: their size sustained stability even in heavy seas. Both carried around seventy aircraft—two fighter squadrons apiece, plus two or three ground-attack units, together with early warning, photo-reconnaissance, and helicopter detachments. In June 1965, Independence arrived, with a complement of aircraft that included A-6A Intruders, variously said to resemble frying pans or tadpoles, and equipped with DIANE (digital integrated attack and navigational equipment), which conferred all-weather capability. In November Kittyhawk brought a second A-6A squadron.

At full stretch, the carriers could make a lot of war: one December day, *Enterprise* handled 165 sorties. In the first full year of the campaign, the Navy mounted 57,000 sorties, losing over a hundred planes and eighty crewmen. The communists wisely abstained from launching their own air attacks on US warships, which would have incurred heavy losses at the hands of the combat air patrols. Aboard each of the giant flattops, five

thousand sailors and technicians sustained the activities of a hundred or more fliers. While on offshore naval escorts and bombardment vessels, men worked a comfortable and almost hazard-free routine, the pressure and peril of flight operations were very great, even before the enemy entered the story. Medical stress measurement showed that pilots found a night deck-landing more alarming than a daylight pass over Hanoi. Russian surveillance trawlers, seeking to make mayhem, regularly crossed the bows of carriers during launches. Chinese MiGs from Hainan Island buzzed outgoing sorties.

Intense activity seldom flagged on flight and hangar decks. Personnel were identified by different jersey colors: yellow for plane directors, blue for elevator operators and handlers, green for catapult and arrester-gear men, brown for plane captains, and red for ordnance crews and firefighters. It was a constant struggle to make space for a full complement of planes: the operations room carried a scale template chart showing the position of all parked aircraft, shifted in accordance with orders phoned to the handlers. Tractor drivers, mostly eighteen or nineteen years old, bore a heavy responsibility. So did duty pilots, obliged to sit for two or three hours in their ejector seats under the fiercely hot sky, ready to roll forward at a moment's notice to the steam-wisping catapults.

Accidents, some of them grievous, were inseparable from carrier operations. In October 1966, after two skylarking crewmen ignited a parachute flare belowdecks, *Oriskany* suffered a fire in which forty-four men died. *Forrestal* mounted 150 sorties in four days without losing an aircraft, then an F-4 on the aft end of the flight deck released a Zuni rocket into the aircraft park, with dire consequences: another Phantom's fuel tank caught fire, and wind fanned the flames. Within minutes ordnance was exploding, and living quarters beneath the conflagration became a death trap. Escorts closed alongside and played their hoses, but secondary fires burned below for another twelve hours. A bomb already licked by flames exploded as a petty officer approached it, killing him and several other men. This did not deter similar acts of courage: a slightly built young lieutenant somehow rolled another bomb over the side. When the conflagration was finally suppressed, 134 men were dead, and twenty-one aircraft

had been destroyed, another forty-three damaged. *Forrestal*'s repairs cost \$72 million.

Carriers customarily launched three strikes a day, with perhaps an hour's interval between. Division staffs assigned targets; operations offices passed orders to wing commanders; air groups and intelligence officers plotted routes. The first fliers were eating breakfast at 0430, then suiting up and being briefed for an 0600 launch. When possible, new pilots were assigned targets close to the coast, so that if hit they had a better chance of ejecting into the sea. Fliers are superstitious, and many stroked rabbits' feet or palmed silver dollars as they waddled to cockpits in G suits and harnesses. Once aboard, ordnance safety pins were extracted, ejection seats armed, canopies locked, and wings extended. Handlers guided out the planes, engines screaming gently: an A-4 weighed a mere twenty thousand pounds with fuel and bombload, but a KA-3 tanker nudged seventy-three thousand. On the catapults, in three seconds they rocketed from standstill to 160 knots. Noise was relentless, and the skill demanded from all involved, fliers and sailors alike, was very great.

A typical strike force might be composed of twenty planes, perhaps sixteen A-4s and four F-8s, supported by two Operation Iron Hand flak-suppression aircraft. Crusader TarCAP escorts took up positions outside the formation, choosing the flank most likely to meet MiGs. An ECM aircraft stayed offshore, likewise a pair of airborne tankers. Two helicopters flew patterns, poised to pick up any flier downed in the sea or within reach on shore. Once airborne, the formation passed over an armada of small craft, most of them fishing junks and sampans: they crossed the coast knowing that the enemy was ready and waiting. In 1944 an average Pacific Navy combat mission had lasted four hours; twenty years later, that was foreshortened to ninety minutes. Nonetheless, flying over North Vietnam was far more perilous than missions over North Korea had been.

As they approached the coast at twenty thousand feet, engine whine muted by helmets and headsets, pilots flicked switches to arm guns, bombs, rockets. They began a slow descent, its rate determined by the distance to the day's target: Skyhawks might be making 350 knots, while the faster Crusaders held back. They heard the high-pitched tone indicating the en-

emy's Fansong radar and warning of SAMs en route. Thereafter radio silence could be broken, but they chatted as little as possible. Pilots were told, "If you're hit, get off strike freq.!" Commanders did not want the operational channel cluttered by desperate men proclaiming their plight. MiGs might start to flirt around formations, so that they would hear the immortal combat radio warning: "Bogies at nine o'clock"—or four o'clock or whatever. The enemy often sought to lure escorts toward SAM batteries; the fighter jocks, however, were briefed to stick close to their charges. Ground-attack pilots tried to dive onto targets with wing tanks already emptied, because nobody wanted to carry external fuel into the dice game with flak. They approached from several angles simultaneously, to divide the enemy's fire.

Once the North Vietnamese identified the targets that the Americans favored, they concentrated guns around bridges, barracks, and suchlike. Older pilots asserted that the fire was worse than they had experienced over Germany. The communists developed frightening expertise at box barrages: "They could fill a five-square-mile column with murderous flak from 3,000 to 20,000 feet," wrote Cmdr. John Nichols. "It was awesome. It was spectacular, it was perilously close to beautiful. The light guns, 23mm and 37mm, burst with white smoke. The 57mm shells exploded in dark gray and the heavy 85mm and 100mm stuff exploded in black clouds. Mix in occasional strings of colored tracer from heavy machineguns arching up to perhaps 5,000 feet, and you can imagine all these vari-colored clouds bursting somewhere in that cone of air every second for several minutes." Commanders urged pilots not to jink, no help in evading a box barrage, but instead to concentrate on hitting the target: luck alone would determine their fate.

MiG-17s first appeared during a fifty-plane raid south of Hanoi on April 3, 1965, and the following day the USAF lost two F-105s. On June 17, Sparrow missiles secured their first two MiG kills. Pilots experimented with tactics. For a time they favored high-speed, low-altitude approaches until at a designated point they switched course and gained height to dive on a target—the "pop-up" method. Its limitations were that it required fliers making five hundred knots to identify several landmarks

and also made aircraft vulnerable to light flak. They carried a formidable array of electronic defensive equipment in pods on wing pylons. The Navy also deployed EA-3B Skywarriors and EF-10B Skyknights as ECM aircraft. Attackers released "chaff" to baffle communist radar, and fired Shrike AGM-45A missiles at the enemy's guidance sets. Both sides played deception games. Sometimes US jammers believed they had identified the enemy's fighter-direction frequency, only to discover that it was playing recordings of pilot chatter, while the MiGs' real business was done on another channel. The defenders also learned to keep tracking radar switched off until the last seconds before a missile launch, to avoid attracting a homing Shrike.

The enemy fighter threat waxed and waned, but was less feared than flak. North Vietnamese pilots were tightly controlled from the ground, instructed even about when to ignite afterburners. The MiG-17 was wonderfully nimble; the MiG-21 was less so, especially at low speeds. They usually attacked only with a clear tactical advantage, especially of altitude; fired their Atoll missiles—equivalent to American Sidewinders—then scooted for home after a single pass. On June 21, 1966, New Yorker Lt. Phil Vampatella was flying one of four Crusaders, covering a shot-down RF-8 pilot until a rescue helo could reach him. Suddenly his plane shuddered: he'd been hit by flak. Hemorrhaging fuel, he broke away to find an airborne tanker. Then over the radio he heard the warning, "Tallyho, MiGs!" The remaining fighters had been set upon by MiG-17s. He turned back to support them, found himself behind a communist plane chasing an American. He called urgently, "Break right!" but it was too late. The Crusader went down.

Vampatella found another MiG-17 closing on his own stern and dived, his plane bucking and yawing at six hundred knots. He pulled out almost at tree height, expecting to have shaken off the enemy. The MiG was still behind him, but had turned away apparently toward home. Given the damage to his own aircraft, Vampatella took the huge risk of going after it. He loosed a Sidewinder, watched the MiG explode, then found a tanker to give him just enough fuel to cover the sixty miles to *Hancock*. Vampatella's display of courage was afterward cited at training schools, but persistence

in combat aboard a damaged aircraft was usually a quick way to earn a "Missing" telegram for the folks at home.

The Navy was for years embarrassed by the fact that its fighters shot down far fewer enemy aircraft than the USAF, in part because many of its Sparrow air-to-air missiles missed. Sidewinders were much more effective; cannon, which only the Navy's F-8s carried, were better still. The wise-acres who had claimed that missiles made guns redundant were proved wrong. The Navy's air-combat performance improved only in the war's last phase, when the tactics and doctrine school at Miramar, California, created its Top Gun course, whose graduates became impressive MiG killers.

By the time strike aircraft pulled out of the target toward the sea, in the words of a pilot, "about three minutes—and one or two eternities—had elapsed." As they approached the shelter of the mother carrier, a landing officer's "talker" sustained a running radio commentary on the deck status: "Foul deck... foul deck. foul deck, gear set, Skyhawk. Foul deck... Clear deck!" It was a close judgment call whether the pilot of a damaged aircraft should attempt a landing or eject over the sea: a crash could not merely kill a flier but also wreak havoc across the flight deck. Undamaged planes set down gratefully, bounced a tad before halting abruptly in front of the arrester wires. Another day's work was done.

Fliers averaged sixteen to twenty-two combat sorties a month, a few made twenty-eight: a handful eventually totaled five hundred. By autumn 1966, the pressure of operations was generating shortages of munitions, especially bombs, and also of equipment and aircrew. A dismaying number of the latter found that a tour of operations ended with a one-way ticket. Jack Broughton wrote of the day an unnoticed SAM took out one of his F-105 squadron: "The first sign of trouble was a large rust-colored ball that enveloped his aircraft [which] appeared intact, but he started a stable descent with his left wing dipped slightly low. His only transmission was, 'I gotta get out. I'll see you guys.' With that, he pulled the handles and we saw a chute and heard the beeper as he headed for Hanoi via nylon."

The USAF's Maj. Fred Cherry was the son of black farmworkers in Virginia; he had reached flight school in 1951 by sheer persistence, after

many rejections, and flew fifty-three missions in Korea. On the morning of October 25, 1965, he was leading an F-105 squadron on his fiftieth mission when, a few minutes short of the target, he heard a fierce thump. He switched off electrics and hydraulics, but the plane filled with smoke. At low level he ejected and prayed, just as the Thud blew up, its instrument panel slashing his face. He was forty miles northeast of Hanoi, just two minutes flying time short of the coast and safety. He landed in a crowd of militia and children. "I thought they might chop me into little pieces with all those farm tools, but they just stood back and giggled." Told to put up his hands, he pointed out that his left shoulder was smashed, his ankle broken up. A crowd followed him, the forty-third American airman to be captured, as he staggered to the road. A soldier said, "You a criminal." He was taken to Hoa Lo prison, the "Hanoi Hilton." Later he was transferred to a jail known to POWs as "the Zoo," where he found himself sharing a cell with a Navy North Carolinian named Porter Halyburton, who at first spurned him because he didn't believe that a black man could be a USAF major and so branded him a French spy. Yet familiarity and shared privation bred between the two men not merely respect but something close to love. After Cherry's wounds became badly infected, "Hally" cared for him devotedly. When their jailers moved the Southerner out of his cell, "I never hated to lose anybody so much in my entire life."

Norm McDaniel, born in 1937, was one of eight children of a black North Carolina sharecropper; he grew up with terrible family tales of their experience during the Depression, when his father picked cotton for a dollar a day. In Norm's childhood, he often went to bed hungry: "If my father got to the whiskey store before the grocery store, we had a problem." His mother, an orphan, had a fanatical belief in education and embraced the mantra "Make the best of whatever you have." It was a notable achievement that in 1959 her son advanced from a mechanical engineering degree at North Carolina's segregated A&T University to become a commissioned navigator in the USAF. He loved Air Force life, and flew for several years with a Stratofortress wing. Only when he and his wife, Jean-Carol, traveled off-base did racial issues beset them: "In Mississippi and even Utah, hotels and restaurants wouldn't have us."

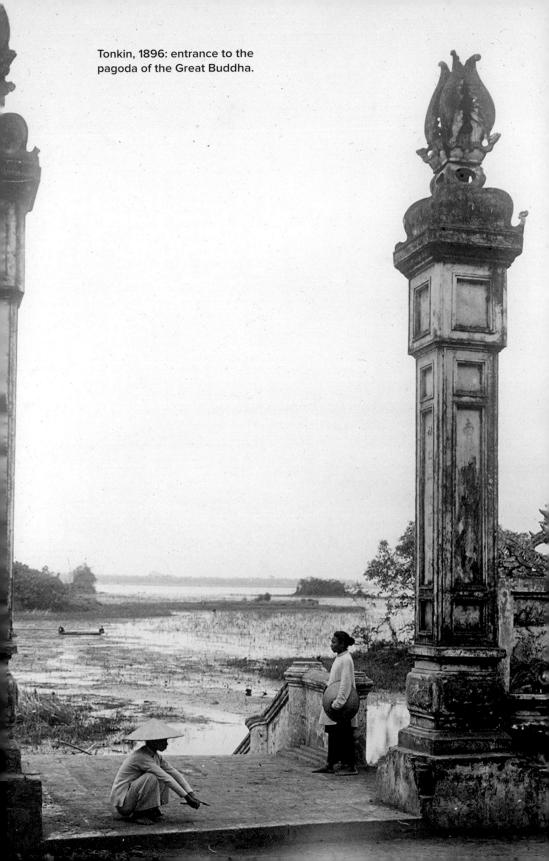

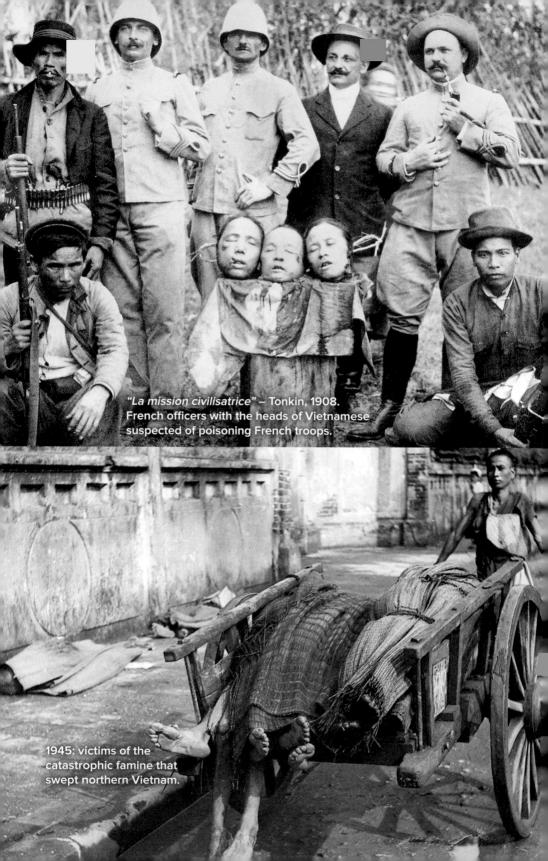

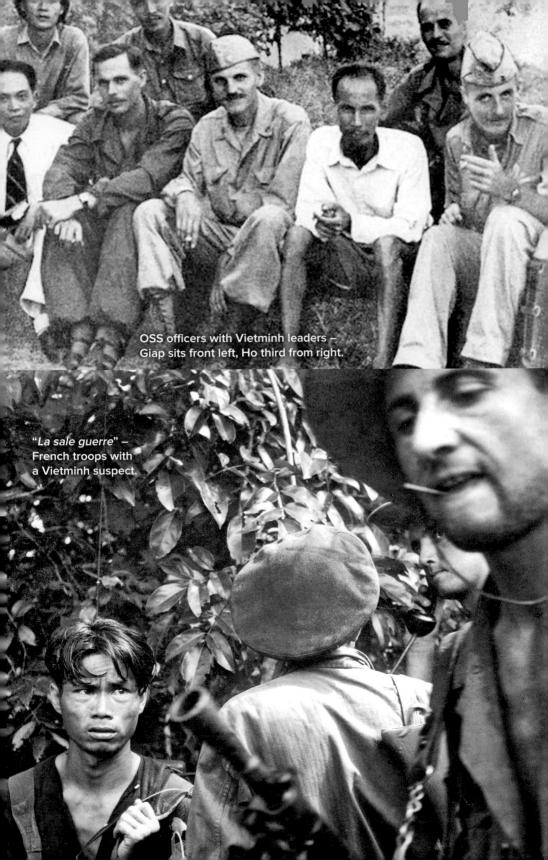

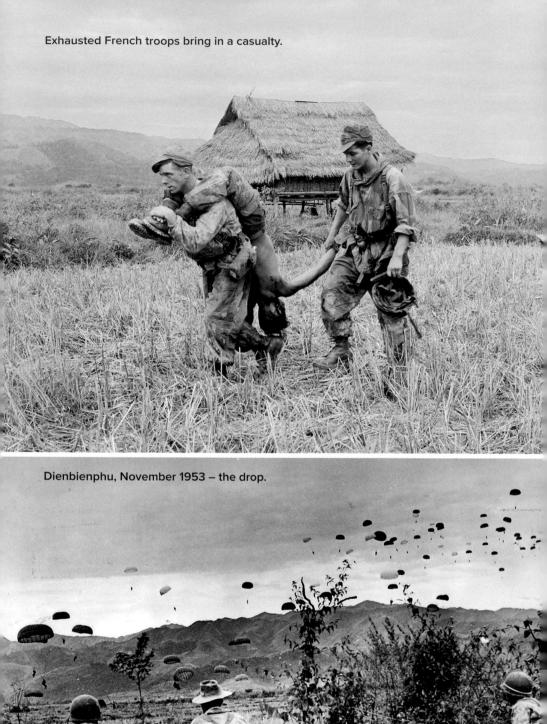

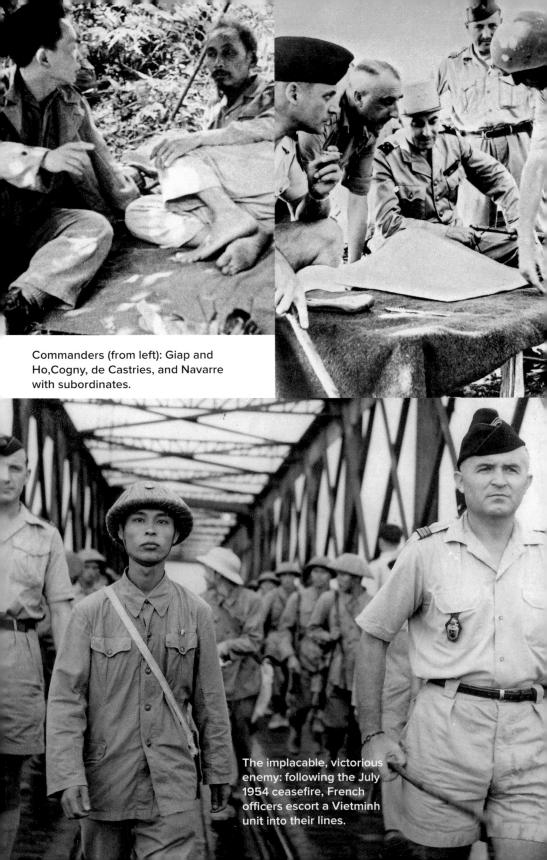

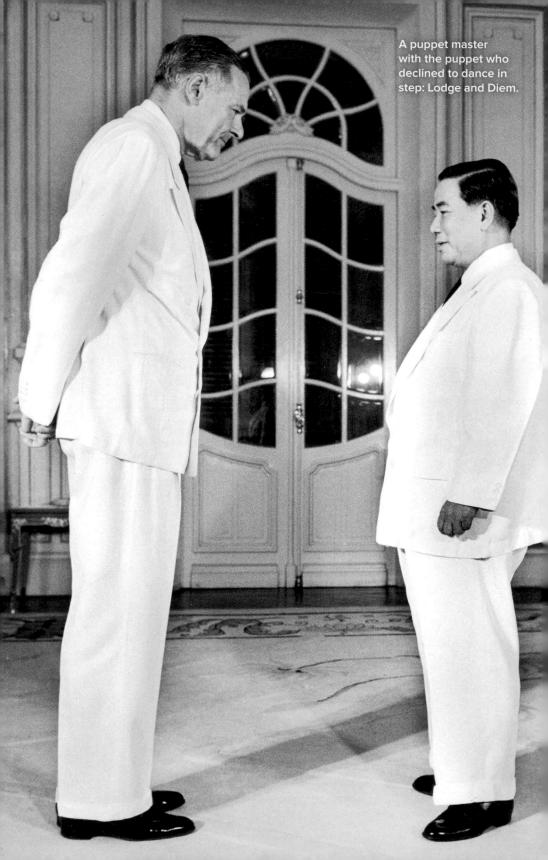

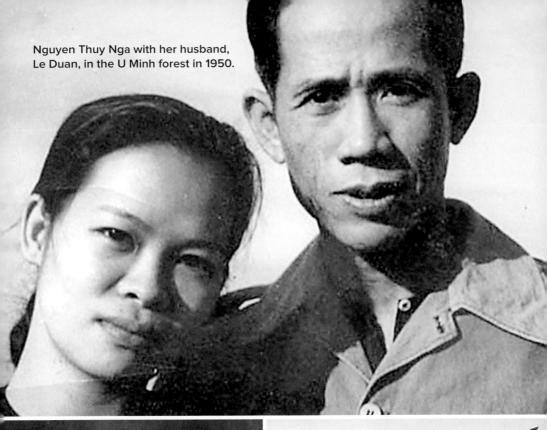

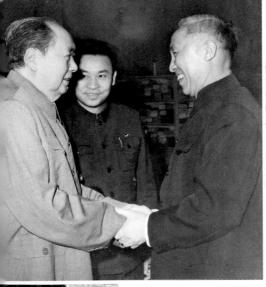

(Clockwise) Mao Zedong shakes the hands of Le Duc Tho; Max Taylor and Paul Harkins in Saigon; Lou Conein, the spook for all seasons.

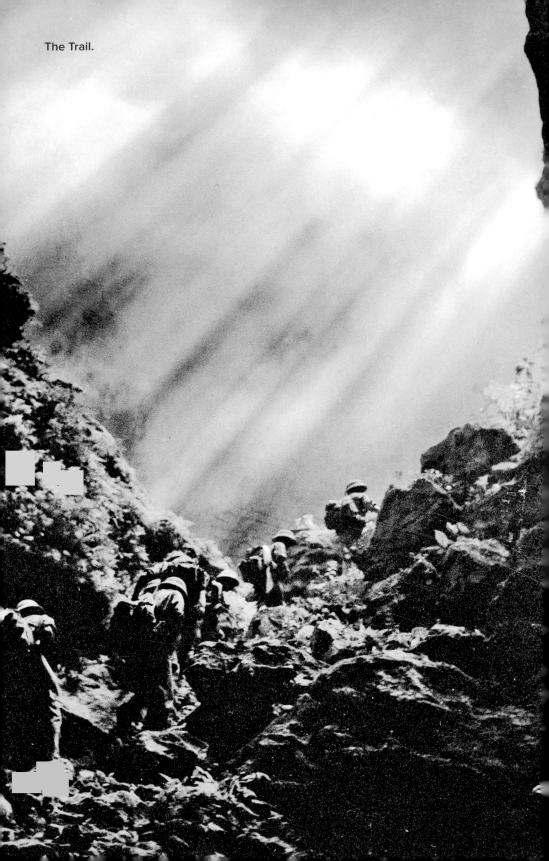

Hueys: a classic image of troop-carrying "slicks."

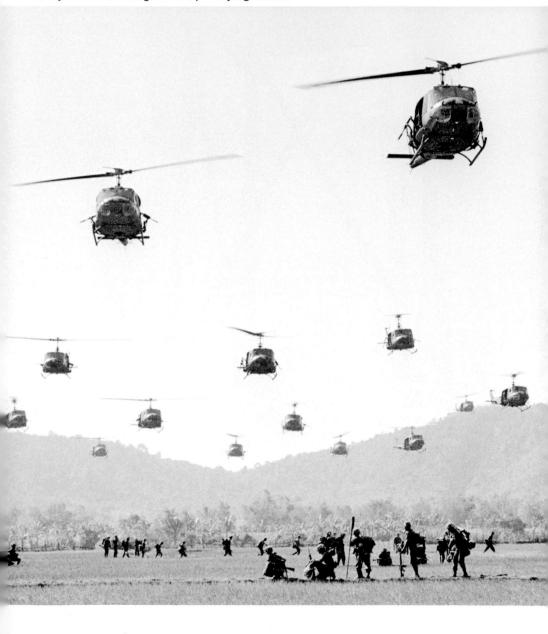

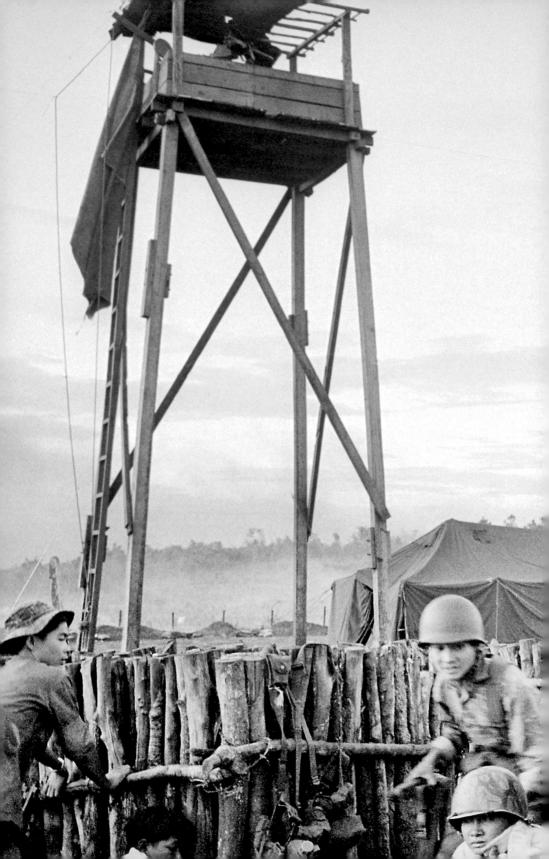

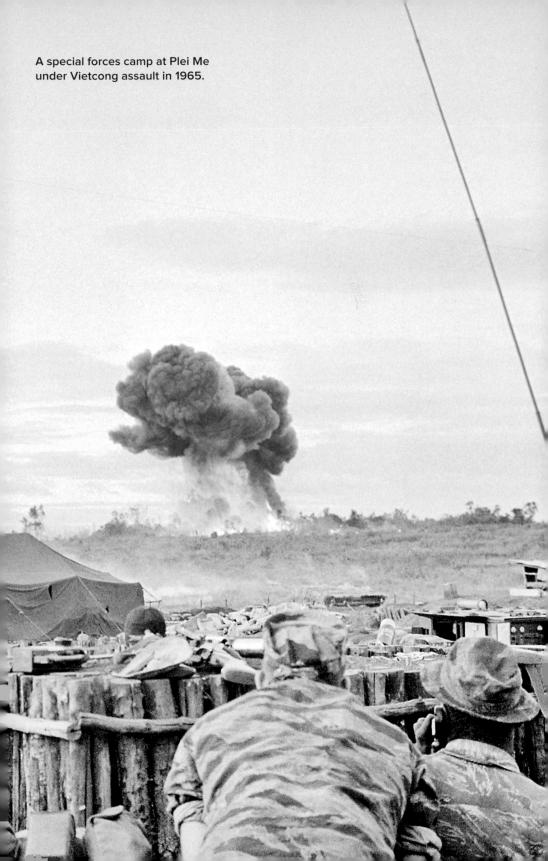

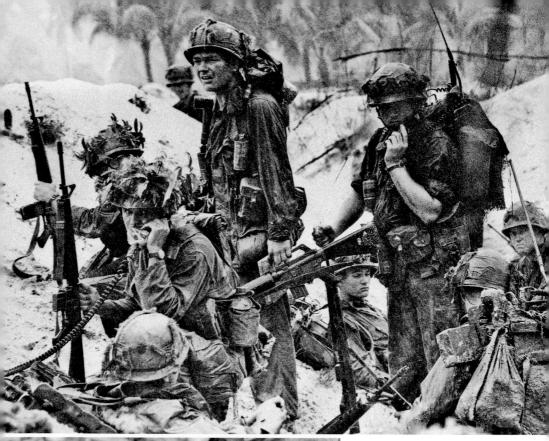

Americans and allies (clockwise from top left): Walt Boomer; Tim O'Brien; A radio-operator's war – 1st Air Cav at An Thi in 1966; Australian private Tom Blackhurst cools off tracker dog Justin; John Paul Vann (second left) with Doug Ramsey (foreground) in 1965.

Below: Mike Eiland at special forces camp Long Thanh with Khmer recruits, 1972.

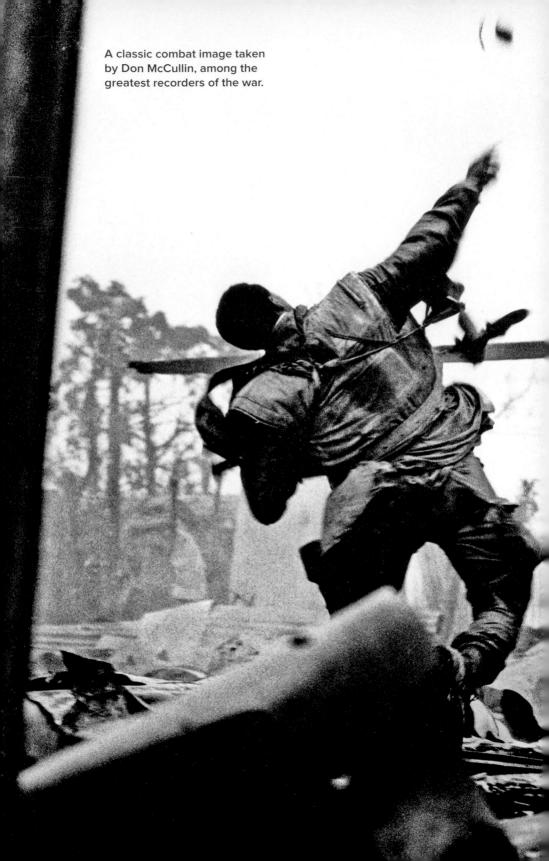

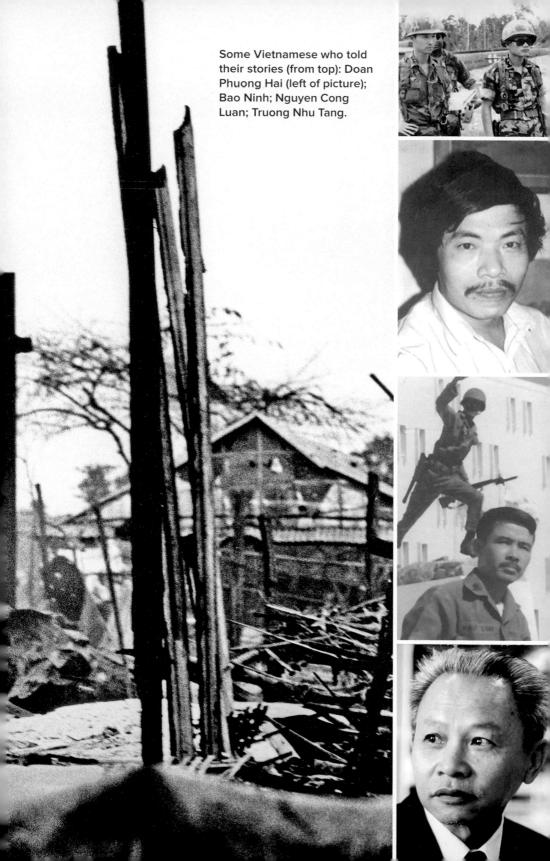

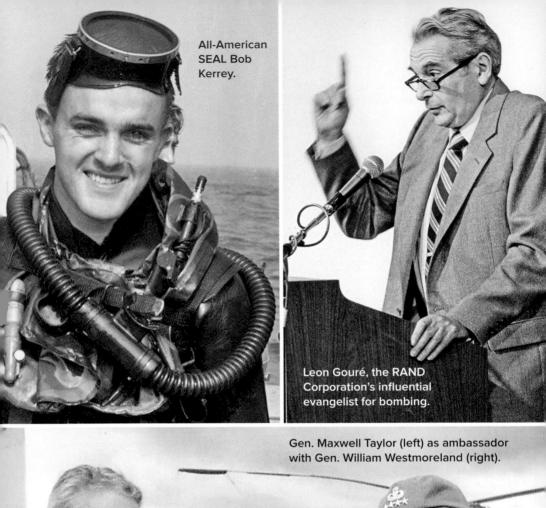

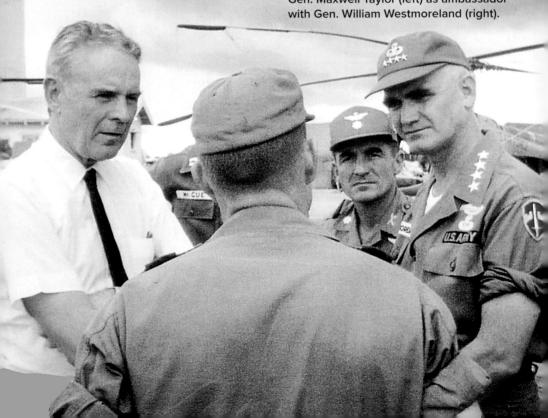

In the autumn of 1965, McDaniel was posted out of B-52s to serve as an electronic warfare officer with an EB-66C squadron flying out of Thailand. "I didn't have any apprehension about going. I just felt like I was doing what I was supposed to." Their aircraft was notoriously underpowered, however, using up the whole runway on takeoff, especially on a hot day. McDaniel said a little prayer every time, "not for me, but for my family." Missions customarily lasted around three hours, of which twenty-five minutes were spent orbiting the target area at twenty-five thousand feet, monitoring and jamming enemy radar transmissions. When a threatening signal was detected, they voiced the strike pilots, "Red alert, enemy aircraft," "missile tracking," or whatever, then later reported "all clear." McDaniel was one of four "Ravens" peering into a battery of scopes in their B-66's EW (electronic warfare) compartment, a windowless cell behind the cockpit.

The campaign became a routine: a pilot was required to complete a hundred trips "Up North," as aircrew referred to enemy territory, before being recycled homeward. Back at their comfortable base, McDaniel read a lot, worked out, played Ping-Pong. In the officers' club, there was a running game of "Dead-Bug!": when a flier shouted the words, they all hit the floor. Last man down paid for maybe sixty drinks, but alcohol was so cheap that such a forfeit did wallets little harm. McDaniel would have enjoyed his tour at Takhli but for missing his family and knowing they were missing him. He said, "I was never much scared. We figured this mess was going on for years. We just thought about clocking up our hundred missions, then going home in eight or nine months." On their twentyninth trip, near Hanoi they suffered a SAM-2 lock-on and had to take violent evasive action. Only after what seemed a stomach-churning eternity did the crew hear the terse, infinitely reassuring words over the intercom: "breaking lock." They figuratively wiped their brows and went home to hot, sticky, comfortable Thailand.

McDaniel thought, *Hey, I've had my big scare*. Two missions later, however, on July 20, 1966, approaching a target near Hanoi, the plane gave a terrific lurch, "like flying right by a big air pocket." The crew asked fast, frightened, explosive questions, to which pilot Bill Means responded

reassuringly, "That was a near miss, but we're still flying." Not for long. Seconds later Means lost control, and the plane began to plunge erratically. When it leveled off, they waited in vain for more news from the pilot. Communications were gone, along with oxygen. Smoke began to fill the EW compartment. The four Ravens were required to eject in sequence, and McDaniel, in the forward left position, was due first. "It was decision time. We had flames and smoke, and I thought, *I'm outta here*." He followed procedure, pulling down his helmet visor, activating the personal oxygen bottle, tucking himself up tight before pulling one lever to jettison the hatch, then a second to blast himself into the sky.

Everything worked perfectly until, as he hung on his parachute, he glimpsed holes appearing in its canopy: people were shooting at him. The moment he hit the ground, he was surrounded by peasants, soldiers, and militia, who stripped him to his shorts and T-shirt. It was eight thirty a.m., and he was thirty miles northwest of Hanoi. At first they tried to push him into a pit, where he was sure they planned to shoot him. Then, instead, he was blindfolded, led to a vehicle, and eventually driven to the Hanoi Hilton, where he arrived at evening.

He was for a time haunted by misgivings that he was the only one of his crew to bail out; that the rest were safely back at Takhli mocking his panic-stricken exit. Soon enough, however, he found that all but one man, who perished soon after capture, were also POWs, as they remained until 1973. Back at home, after the family heard that he was missing, fate unknown, his mother told Jean-Carol, "Mac's alright. I visited him in a dream. He's in a little room lying down. I said, 'Mac, are you alright?' and he said, 'Yes, Mam. You take care of yourself.' "McDaniel's mother's tale proved to be sort of true. Yet many other families with missing loved ones had similar otherworldly visions that went unfulfilled. Only after eighteen months of agonizing suspense did the North Vietnamese belatedly disclose that the navigator was a POW.

In Hanoi, McDaniel fared better than many. "Though the food was garbage, it was quite healthy garbage, and I was used to being hungry from my childhood." Like most of his comrades, he was periodically subjected to cruelties, in some cases amounting to torture. Evidence from

both Vietnamese and Russian sources suggests that the communists gained significant operational data from aircrew interrogations, but the prime objective was to secure ideological dominance, to inflict punishment on the only accessible examples of a hated enemy. Back in the US, the barbarities inflicted on prisoners, which were real enough, roused enduring public outrage. Yet it deserves emphasis that communist captives in the hands of both Americans and South Vietnamese were subjected to equal and worse things, often before being killed. When CIA man Frank Snepp's revelatory Vietnam book Decent Interval became a bestseller in 1977, the author was astonished how few readers seemed troubled by his account of "enhanced interrogations" and torture of captives, the veracity of which has never been challenged. Doug Ramsey also wrote with repugnance about his colleagues' "casual toleration of the abuse of prisoners." Indignation about the cruelties inflicted upon Hanoi's captives could be justified only by an assumption that American capitalists should expect more humane treatment in enemy hands than Vietnamese communists.

Norm McDaniel, in July 1966 the newest guest at the Hanoi Hilton, possessed an equable, relentlessly cheerful temperament, which proved of great service to him through almost seven years that followed. While some prisoners nursed hatred of their North Vietnamese captors, he thought this counterproductive. "I consider myself an eternal optimist. We knew that Vietnam prisoners were an elite compared with the way PoWs in Korea had been treated. You had to reach beyond yourself: I had my faith in God and my family."

A significant minority of pilots were veterans with immense experience. Cmdr. Richard Bengler was forty-two years old. He had flown B-17s and B-25s in World War II, then fighters in Korea. In July 1966, he survived ejection into the sea when his F-8 was shot up by a MiG-17. Four months later, he was able to turn the tables, shooting down the Navy's first MiG-21 with Sidewinders. Back on his carrier, he said exultantly, "I've waited twenty years for something like this. It was a tremendous feeling." Capt. Jack Nolan, from Freeport, Long Island, was already thirty-six when he went to war. He was a lawyer's son and briefly a medical student. "There

was a girl involved. I married her, by golly." His heart was in flying, however. "I was fascinated by airplanes after I took an invitation ride in a Stimson at five years old." In 1952 Nolan joined the USAF, shipped to Korea, and was in mid-Pacific when the armistice was signed. After a decade as an instructor, and rearing five children, late in 1966 he was posted to a Thud wing based, like Norm McDaniel's EB-66s, at Takhli in Thailand. "What did my wife think about it? I never asked her." On the big base, they lived in comfortable cinder-block buildings, two beds to a room. The squadron's twenty pilots flew whichever aircraft they were allocated that day—the planes had no personalized names, no artwork, just green-and-brown camouflage on the upper surfaces, blue undersides. The F-105 was very comfortable to fly, capable of supersonic speeds at low level. On missions against North Vietnam, it usually carried six 750-pound bombs, an ECM radar baffler, and Sidewinders, though Jack Nolan never fired one.

On operational days, they might rise any time between 0230 and 0700 for breakfast and the long, painstaking preparation of equipment. A veteran pilot said one day as he entered the briefing room before another trip down Thud Ridge, "Anyone who is not completely terrified doesn't understand the problem." The same morning in the latrines, Jack Broughton heard a man throwing up, and knew that it was a fellow flier. Broughton wrote of the long wait and taxi to take off on a sun-roasted Thai base crowded with aircraft: "You sweated so badly that sometimes you could hardly see. The flight line was organized confusion as one flight after another hit the starter button and filled the air with the stench and smoke of the black-powder cartridge starter that spun the engine through its initial revolutions. The noise was deafening. . . . I mused, What's it going to be—a SAM day or a MiG day?"

When Jack Nolan was airborne among the usual sixteen ships and two standby reserves, they cruised at 450 knots in flights of four, "at 15,000 feet every damn mission." Before entering enemy airspace, they closed on one of two KC-135 fuel tankers for a ten-minute top-up, then slid apart into tactical formation as they approached the IP—initial point. F-4 flak suppressors aimed to reach targets fifteen to thirty seconds ahead of the bombers, attacking with cannon and Zuni rockets every muzzle flash they

spotted on the ground, until with ammunition expended they pushed the handheld throttle sideways to ignite afterburners. These provided a surge of power, enabling the aircraft to soar away, at the cost of dramatically increased fuel consumption. The Thuds attacked next, slipping into a forty-five-degree dive before bombing from five thousand feet, "then running like hell"—or rather, feeling the force of four to six Gs as they pulled out.

The targets might be bridges, rail yards, or airfields. There was always flak, which cost maybe one lost aircraft a day between their two wings, and the occasional white streak of a SAM, which pilots ignored unless they received aural warning that its track was personal. "I saw one of ours go down, watched the pilot bail out, though he was never heard of again." The best tactic after a SAM launched was to make a very steep turn against its track—the missile should eventually break radar lock and explode. Nolan, like many pilots, viewed his role with dispassion interspersed with spasms of fear: "I didn't think much about what was on the ground. I was just doing a job, trying to stay alive and get promoted to major—which didn't happen." They recognized that a lot of ordnance was falling short, especially the 3,000-pound bombs they threw at bridges. "It was frustrating to see the pontoons lined up on the bank, ready to fill the gap if we broke a span." One day as Nolan's flight dived on a span near the Chinese border, he caught a burst of automatic weapons fire under the right wing that crippled his hydraulics, making it impossible to couple with a tanker to get home. He jettisoned his bombs into the river and nursed the big plane to Danang, escorted by his leader. On approach he cranked down the undercarriage by hand and landed safely. He caught a ride back to Thailand in a C-123, and headed for the bar. Soon afterward, he was transferred to the combat operations staff of Seventh Air Force, analyzing the bombing. "That experience reinforced my feeling that a lot of bombs were falling short, but nobody cared."

Nolan's combat record was relatively humdrum, but other airmen experienced extraordinary dramas. On April 20, 1967, the Navy's famously brave Lt. Cmdr. Mike Estocin led a three-plane flight against Haiphong, where they took out three SAM sites, but his A-4 suffered blast damage. He pulled out, convinced that he could stay airborne, and fired his last

Shrike at a ground target before turning away, bleeding fuel fast. With just five minutes' worth remaining, he plugged onto a KA-3 airborne tanker, which flew back to *Ticonderoga* with his little Skyhawk still attached. Two miles from the flight deck, he uncoupled and made his approach with enough gas for a single pass. The plane burst into flames as he made a perfect landing. Estocin pulled open his canopy as the fire crews sprayed foam, jumped down, tossed his helmet to a handler, and walked away without a backward glance. It was a magnificent display of insouciance, but six days later he was less fortunate. An SA-2 hit his aircraft as he attacked oil storage tanks near Haiphong, and the remains plunged to the ground. Estocin was awarded a posthumous Medal of Honor.

One of the most dramatic, and often heroic, features of the air war was the sustained effort to rescue aircrew whose planes were hit. About one-third of downed aircrew were snatched back into American hands; a smaller proportion was taken prisoner by the communists; the rest perished. In the Navy's sector, offshore rescue crews experienced weeks of boredom, cruising over the sea in heavily armored HH-3E Jolly Green Giant helicopters, listening for an appeal that seldom came; then they were electrified by a summons, a hot flush of danger and drama. There was often a race between "the Angels" and fishermen, who could earn a rich ransom from the communists—the equivalent of \$200—for any American they retrieved from the sea.

On April 27, 1966, an A-6A was hit by flak. Bombardier-navigator Brian Westin saw his wounded pilot, Bill Westerman, turn ashen, his left arm limp, oxygen mask off, the plane in an erratic climb. Westin unbuckled his harness and leaned over to take the stick and guide the plane toward the coast while radioing for help. Westerman roused himself sufficiently to resume control as they steered an erratic course back to *Kittyhawk*, while their squadron CO lingered alongside. They did not dare attempt a landing, instead ejecting into the sea. One in three of all those who took this route drowned before help could reach them. Westin was winched aboard the SH-3 rescue helicopter but saw that his pilot was too weak from loss of blood to slip into a sling. He jumped back into the water to help Westerman to safety. He waved away the Sea King, hasten-

ing the wounded man toward medical aid, which saved his life. Westin was himself rescued by a second helo, just as sharks began circling the blood in the water. He received a Navy Cross.

A reconnaissance aircraft was once downed on the coast, its pilot killed. As the navigator stood forlorn on a beach surrounded by local people, he glimpsed a rescue chopper approaching, homing on his beeper. Unzipping his flight suit, he pulled a pistol, shot the militiaman guarding him, then plunged into the surf and swam toward a successful pickup. On another such occasion, a Seasprite helicopter flew in darkness from a destroyer to pick up two F-4 crewmen hiding in thick cover on North Vietnamese soil. The Seasprite's gunners held off enemy troops and picked up the Americans under intense fire, then landed back on board with only a few gallons of fuel remaining. Another pilot drifted offshore for hours while two helicopter attempts to recover him failed under fierce gunfire that mortally wounded a crewman. Overhead fighters contrived to keep the North Vietnamese away from their man in the water until at last light, a rescue chopper swooped. A triumphant voice called on all Task Force radio frequencies, "We got him out!" A fellow flier wrote, "For the pilots who fought this insane war year after year, this was one victory no one could dispute." In 1967 alone, seven Navy helicopters were shot down while attempting rescues.

The Air Force also achieved some extraordinary feats. As North Vietnamese troops approached a Crusader pilot who had ejected into thick cover southwest of "Dodge City"—Hanoi—a chopper crew lowered a "jungle penetrator," which exhausted its cable ten feet short of the pilot's outstretched hands. Under fire, with one crewman killed, the chopper pilot descended into the canopy, using the rotors to hack a passage through the trees until the man on the ground could grab the sling to be wafted aloft. The helicopter was so damaged that it had to forced-land a few miles on, where a Jolly Green Giant extracted the whole party.

Lt. Dieter Dengler was a German-born Navy Skyraider pilot who crashed in Laos after being hit by ground fire. He was captured and held by the Pathet Lao for four months before making an escape with an Air Force pilot, Duane Martin. They lived for days on fruit, berries, and a

little rice until they reached water, built a raft, and drifted downriver until they came to a deserted village in which they found a little corn. Dengler was suffering from jaundice and malaria. When they reached another village, a man with a machete attacked them, fatally wounding Martin. Dengler stumbled on alone until, twenty-two days after his escape, he could go no farther. As he lay waiting to die, he laid out rocks to form the letters SOS. Miraculously, this was spotted by a passing USAF flier, who directed a helicopter to recover the stricken man. Dengler emerged weighing ninety-eight pounds, having lost sixty.

While the Air Force and Navy clamored against politically imposed constraints, they were obliged to accept the shortcomings of their attacks even upon the targets authorized. For instance, between March 1965 and November 1968, almost seven hundred sorties were launched against the Thanh Hoa rail bridge, eighty miles south of Hanoi. In March 1967, three hits were achieved with Walleye TV-guided glider bombs. Yet the bridge, and the rail link, stayed defiantly open. Hanoi's Paul Doumer Bridge was closed for six months from August 1967, but only after a long succession of failed attacks.

That year, a sharp improvement in enemy missile performance caused American losses to rise. Every sortie was met by a hail of SAMs: eighty were fired on August 21 alone. A Russian general complained that his North Vietnamese allies were firing these vastly expensive toys "as if they were firecrackers." In the month of August, the Navy lost sixteen aircraft. Around Hanoi, almost six hundred AA guns and fifteen SAM sites were deployed. Lt. Gen. Bruce Palmer wrote, "The price of admission for our attacking forces ultimately became very high, almost prohibitive." In 1967 the Navy claimed destruction of thirty SAM sites, 187 flak positions, and 955 bridges—some of the latter number representing repeat strikes—together with large quantities of rail rolling stock. Overall, it was estimated that bombing had inflicted \$300 million worth of damage on North Vietnam—but at a cost of 922 aircraft destroyed, of which the cash value was three times greater. The ground defenses now deployed eight thousand AA guns and two hundred missile launchers. The North's elec-

tricity capacity had been cut by 85 percent, but the country kept going on portable generators. American intelligence about the enemy's industry and infrastructure remained poor. There was little sign that the air offensive was impeding North Vietnam's war effort.

Fliers' morale declined in the face of the losses and perceived lack of achievement. They referred derisively to their planners and commanders as the Tonkin Bay Yacht Club. Aircrew kept flying, bombing, and sometimes dying, but found it ever harder to believe that the results were worth it, though their commanders stubbornly resisted the idea that Vietnam signaled any limitations of air power. The 1984 edition of the USAF's Basic Doctrine Manual persisted doggedly with the assertion that "aerospace forces have the power to penetrate to the heart of an enemy's strength without first defeating defending forces in detail." Such power, claimed the bomber barons, enabled attacking aircraft to assail "a selected series of vital targets," which, if destroyed, would wreck the enemy's capability and will to fight. A 1986 interviewer who asked Curtis LeMay if the Vietnam War could have been won received this response: "In any two-week period you want to mention, through a program of unrestricted bombardment." This was the view that LeMay, like Gen. William Momyer and Adm. Ulysses Grant Sharp, carried to grave. In the eyes of posterity, however, it seems a fantasy. Tactical air attacks in the South, notably including those on the Ho Chi Minh Trail, caused immense difficulties for the communist war effort. However, the political cost of Rolling Thunder to the United States was much greater than the damage inflicted upon North Vietnam. This would almost certainly have remained the case, even if America's air chiefs had been granted the open range for which they clamored.

TAKING THE PAIN

1. BEST OF TIMES, WORST OF TIMES

In January 1966, Poland's deputy foreign minister arrived in Hanoi bearing a message about the Americans' eagerness to negotiate, which was contemptuously dismissed; in June, a Canadian emissary met the same response. A month later, Jean Sainteny, French representative in the March 1946 negotiations with Ho Chi Minh, delivered new proposals. He urged the North Vietnamese to convert a winning hand into a peace agreement, saying that the Americans' only aspiration was to save face. Yet even as the Frenchman was talking to Pham Van Dong, Ho himself entered the room. He told the visitor to go home and report to Washington that his people were wholly unafraid, and would fight to the end "even if we must sacrifice everything." The communists had set their faces against any settlement that protracted the existence of the Saigon regime; they were bent upon victory and nothing less.

Just as the Luftwaffe's 1940 blitz on Britain enabled Winston Churchill to energize the British people to meet it, so US bombing proved a godsend to North Vietnam's leaders, empowering them to rally their citizens against a visible menace from the skies, rather than for the mere political objective of reunification. Old rifles were issued, enabling villagers to fire at enemy planes, which contributed little to air defense, but something to the shooters' morale. Musician Van Ky said, "To our people, [the bombing] was nothing unexpected or strange—we were psychologi-

cally prepared for it. Uncle Ho told us at the start, 'The war may become very prolonged, and our capital Hanoi may be destroyed, but we are not afraid.'" A teenager said that he was urged by his mother to drop out of high school and join the army, in contradiction of the usual parental inhibitions, after a stray bomb landed on a local playground, killing several children, including two of his cousins.

A committed cadre remained for the rest of her days nostalgic for the exhilaration of the days when she was a young Party member under American bombardment. "We had an ideal, an aspiration, something to strive for. We competed fiercely with each other to fulfill every task, and I remember sometimes bursting into tears when others did better than me. Nobody needed to be conscripted—they were just eager to serve. And there was no corruption."

This was less than the whole truth. While North Vietnam's people indeed displayed notable stoicism, it seems absurd to pretend that they embraced enthusiastically their ordeal by fire. A veteran who later became a university literature professor said in 2016, "For years Vietnamese have been told the war story as if it was a romance. Some of us are tired of this approach." A woman high school teacher agreed: "It was a terrible time. There was no happiness—we had so little of absolutely everything. The men knew they all had to join the military, but nobody wanted to go. I remember one of my pupils, called up before he had even finished school, returning just before he went South, and asking to be allowed to sit one more time at his old desk."

Pham Hung, living in an eastern coastal town, had a friend named Huong, very handsome and a fine soccer player, who led a lonely life because his father and most of his family had fled South in 1954. For years after Huong reached military age, he was rejected for service because of his parents' past links with the French. At last, the authorities were so impressed by his enthusiasm for the revolutionary cause that they dispatched him down the Trail. His martial zeal was faked, however: he sought only reunion with his father. He was imprisoned after an attempt to desert, and was last heard of making unsuccessful escape bids. "His story was a real human tragedy," said Hung. A similar sequence of events unfolded when

army recruiters visited a remote village to take its draft quota: one family told their eldest son to hide in the jungle. Officials warned that unless the young man reported within three days, his parents would lose their ration cards. He duly went to the army, but deserted at the first opportunity down South, with the warm encouragement of the family.

As a boy, Hung was bemused by his father's obsessive commitment to his two sons' education: he lashed and goaded them toward securing college places. One day Hung played truant to join a quest for wreckage from a downed US Navy fighter, for which he received the thrashing of his life. Only later did he understand the cause: college kids, like their counterparts in South Vietnam and America, escaped the draft. Hung's father was desperate to keep his boys in education and thus away from the war. Every Vietnamese remembered forever afterward where they were on first seeing American aircraft: Hung, a ten-year-old, was so terrified when he saw a nearby bridge blow up that he ran to hide his prized schoolbag and books, lest they should be destroyed. Afterward, he laughed at himself for this preoccupation with childish possessions rather than with his life. He laughed less a few years later, however, when an army colonel's wife and daughter, evacuated from Hanoi, were billeted in his parents' little house. He fell in love with the daughter, a teenager like himself. One day her mother was walking back from the nearby town when she was killed by a bomb aimed at a bridge.

Hung's family lived in a small Buddhist community, not far from a matching Catholic one. The children of the two towns waged a miniature religious war, hurling pretend grenades at each other, firing fantasy rifles, digging tunnels. It grieved some adults that the children's games should be those of the battlefield, but such is the fashion in every warring society. Huge posters hung in village streets, depicting Lyndon Johnson and later Richard Nixon as grotesques, their protruding tongues runways for bombers. At school every morning, pupils performed mass calisthenics while chanting prescribed slogans. Most Vietnamese received their only news through networks of government street loudspeakers. Propaganda asserted that their Southern counterparts lived in privation, exploited as slaves by the Americans.

Bombers' radar-baffling American chaff was strewn upon fields and homes. Even in rural communities, people spent countless hours in shelters—and learned to delay leaving them for several minutes after an all-clear sounded, to allow time for the last spent rounds and debris to fall out of the sky. Dogs were often named after Johnson, and later his successor: "the name Nixon was used to frighten children, as if he was a monster from a fairy tale." Because most raids took place in daylight, the Vietnamese adjusted to living, working, shopping as creatures of the night. Trains could reach Hanoi from the Chinese border inside the hours of darkness. Truck drivers were taught to familiarize themselves with stretches of road they could cover without benefit of headlights.

Engineers displayed boundless energy and ingenuity in repairing damaged bridges and rail track. About 600,000 laborers, mostly women, were eventually employed on repairing bomb damage. After pilots attacked the Kep rail yard on the vital China line, it reopened to traffic inside twenty hours. Another 145,000 people manned air defense facilities. When so many men were absent performing military service, women bore the lion's share of physical burdens. One peasant child's earliest memory was of hearing his mother rise at three a.m. during the rice planting and harvesting seasons, to fulfill the most strenuous tasks before the sun reached its full height. Yet some days the hapless woman became so exhausted that she drifted into sleep in the midst of the paddy fields.

Familiarity with attack did not breed contempt but did diminish fear. Many Vietnamese city people seized respites conceded by the US government for national holidays to briefly escape into the countryside. A Russian diplomat described the rush homeward through darkness in the last hours before a bombing pause was due to end: "Endless columns of lorries and fuel trucks jammed the narrow, ruined roads, on which bomb craters had been hastily patched up. As midnight approached, the atmosphere close to Hanoi grew tense, in queues of traffic that often stalled. I had to get out of the car and awaken one very young Vietnamese driver who had fallen asleep at the wheel."

Because of rationing, there was a constant search for supplemental

food. In the countryside, this included stewed rat with saffron, grilled rat with lemon leaves, as well as locusts, grasshoppers, beetles, and silkworm larvae. No pet was safe. When an eleven-year-old was told that the family was moving home, he hugged a cherished pooch he had to leave behind. "Some strangers took it away in the morning and I understood that they were going to kill it." Dog was said to taste best if the flesh was beaten and softened before the animal was killed.

Do Thi Thu and her fellow students at Hanoi University were almost as hungry as their compatriots down the Ho Chi Minh Trail. "The boys felt it most," she said. There was little meat and few vegetables; potatoes or corn were sometimes substituted for rice. Even water for washing was in short supply. In the evenings, instead of amusements or movies, there were long meetings of the Youth Union, to discuss how to become a good citizen, which could degenerate into fierce arguments—especially one night when a student put down his watch in the washroom and a bad citizen stole it. There was no smoking, no alcohol, and almost no sexual relationships. "We were good kids. People didn't complain much—we just accepted this was how things were."

As a Hanoi teenager, Pham Phuong felt no animosity toward the Americans. Then the air campaign started, however. With the deluge of bombs came terror: the first explosion prompted her to run and hide under a tree. Thereafter, life-changing countermeasures were adopted. Phuong and her family were among hundreds of thousands evacuated from cities to the countryside, where the people were welcoming but food was always short. Evacuee families were separated, each member taking up quarters in a different house, so that uncomprehending small children ran hither and thither, sobbing in search of their mothers. Huts were lit only by kerosene lanterns, which conferred sooty noses on those who embraced them closely in order to read.

Phuong, a pretty young schoolgirl and then an office bookkeeper, experienced austerity beyond the imagination of most Westerners. She walked two miles to primary school, and later five miles to high school—barefoot, of course. As a teenager, instead of fantasizing about boy-girl romance, she spun secret dreams about smart clothes, especially silk trou-

sers, and above all about more and better food. Her father forbade her to attend the open-air screenings of Chinese and Russian movies, mostly about wars, because tickets were prohibitively expensive. She enjoyed an occasional treat after school, visiting her uncle to listen to programs on his little Chinese-made radio; she did not set eyes on a TV set until after the war ended. And yet Phuong was the daughter of a relatively privileged family, proud of its scholarly tradition; her father read fluently in English, French, and Russian. An expertise in communications secured his continued employment, but when the time came for her to attend college, she was rejected because of her "unsound" class background, as the daughter of an "intellectual."

A single black mark on one's personal record could blight a career. When Nguyen Dinh Kien received his draft notice, his parents secured him a deferment because he was their only surviving son, after his elder brother was killed fighting in Laos. His government file recorded the fact that his father had once been a security guard for the French and asserted that "he has not yet worked hard enough in his personal ideological struggle." Kien wrote later, "These harsh, bitter words caused untold problems throughout my life." His application for Party membership was rejected. Despite a good school record, he was debarred from the most cherished privilege—travel abroad for study. When he volunteered for pilot training, although he passed every test, he was rejected as "unreliable." For years, he was denied an army commission.

After young men donned uniform, for all that loved ones knew of them thereafter, they might have been swallowed by a dragon, as was figuratively the case. Families suffered terribly, awaiting news about the battlefield fate of husbands and children. For five months after NVA soldier Nguyen Hien was killed in 1965, his kin knew nothing. Hien's mother ran out to meet the postman each time he called on their remote village—and received only a headshake. Their first intimation of tragedy was a Tet greeting from his regiment, such as was sent to next of kin of all the dead, with Hien's name misspelled. They received formal notification of his death only three weeks later.

Le Duan and his colleagues achieved extraordinary success in

mobilizing North Vietnam and sustaining its people's will for war. But personal justice, fulfillment, and happiness had no place on their agenda, with or without American bombing.

2. FRIENDS

At the outset of Rolling Thunder, the US Embassy in Moscow opined that direct Russian intervention remained unlikely, so long as North Vietnam's existence as a socialist state was not threatened. While this proved true, bombing goaded both the Soviets and the Chinese to dispatch aid on an unprecedented scale. The first SAM-2 site was established southeast of Hanoi in April 1965. A typical battery comprised four to six launchers deployed at fifty-yard intervals around a radar-and-communications van. Each thirty-five-foot missile resembled a flying telephone pole with stubby winglets—a two-stage rocket soaring to a ceiling of almost sixty thousand feet, pursued by the white trail left by its kerosene and nitric acid fuel. A booster burned for five seconds after launch, then a sustainer took over for a further twenty. Missiles were usually fired in pairs or fours, and the 350-pound warhead was almost invariably lethal if it exploded within a hundred yards of an aircraft. In 1965, a plane fell for every seventeen SAMs launched, but as electronic countermeasures improved, that ratio became thirty-five to one. By 1972, it took an average sixty missiles to achieve a kill.

Several hundred Russian technicians and aircrew members served in North Vietnam as instructors and advisers, and most enjoyed the experience. Col. Yury Kislitsyn, born in Kazakhstan in 1934, was a highly experienced SAM-2 commander when posted east. "I was very keen—it was romantic, you know." Pyotr Zalipsky from Vinnytsia, a twenty-one year-old corporal, was the youngest of a hundred men who endured a seemingly interminable train journey across Russia and China. Every arriving Russian was issued an identity document in the vernacular, stating that he was a Soviet citizen, "providing assistance to the Vietnamese people in their struggle against the American aggressors, who should be given all possible assistance."

Lt. Valery Miroshnichenko was twenty-one when he went to Vietnam, a twenty-hour flight that involved five refueling stops. His superiors made plain that the assignment was a privileged one: to mask their military status, he and his comrades traveled in civilian clothes, selected from a large Moscow wardrobe of East German—tailored suits, "extremely chic for the time." They signed in as "visiting engineers" in a North Vietnamese hotel register. "We kept looking around, laughing, exchanging remarks about how lovely and interesting everything was, when suddenly *Bang! Bang!* There were explosions and cannon fire—two Phantoms hitting an oil storage facility. They made three passes, with antiaircraft guns shooting. We found ourselves pushed into the dirt, spoiling our lovely clean shirts. When the firing stopped and we got back on the bus, there were no more jokes." The journey to their appointed missile site involved a ferry trip, and through every moment of the forty-minute passage, the Russians nursed terrors that US aircraft would catch them in mid-river.

In 1966 Lt. Valery Panov became scnior officer at a Haiphong communications facility, relaying takeoff warnings from the Soviet trawlers that shadowed US carriers. The Russian detachment wore Vietnamese uniforms with no distinguishing marks, and lived discreetly and uncomfortably in the roofless ruins of an old French barracks. They suffered from chronic heat rash, and because of a water shortage did most of their washing in the sea. In the course of the war, only eighteen Russians were killed by US aircraft, but Panov once came close enough to an exploding bomb to spend two days concussed by a masonry fragment that struck his helmet. "It was a special time," he said somberly, "when you could depend only on yourself and the next man." One of Maj. Viktor Malevanyi's officers took shelter in a fresh bomb crater, believing that the same spot is never struck twice. He turned out to be wrong, and was blown to fragments.

Most of the Vietnamese in the thousand-strong regiment trained by Pyotr Zalipsky's unit spoke a little of his language, and some technical personnel had studied in Russia. From July 1965, their battery launched missiles at least every second day, sometimes more often. "There was constant tension." Amid the urgency of the need, training was cut from six

366 .

months to three, and the Russians learned to share the fierce Vietnamese hatred of the Americans. One battalion commander, a Maj. Ilinykh, a popular and emotional character, besought his three controllers before their first launch, "My dear guys, please catch the bastards and destroy them, prove we are Soviet patriots!" Local Vietnamese civilians, who viewed the foreign officer as their would-be savior, greeted every appearance of his KAZ-59 "goat" vehicle with cries of "Ilinykh! Ilinykh!"

When they shifted locations, villagers presented them with pineapples and bananas, and helped to dig trenches—a backbreaking task in the stony ground. Folk legend among the Russians held that shot-down American aircrew were safe if they fell into military hands, but liable to be torn limb from limb if civilians or militia got to them first, as had sometimes been the fate of Allied fliers in wartime Germany. Valery Panov asserted with some relish, "The peasants would kill them with hoes and bury them in the nearest bomb crater." Valery Miroshnichenko said, "We all were bursting to do some shooting at the Yanks, to show them who was boss." Viktor Malevanyi, who had lived through World War II as a child in occupied Ukraine, said, "Vietnamese feeling against the Americans was even more bitter than ours had been toward the Germans."

A radar controller peered at one approaching American formation and puzzled over an appropriate aimpoint for his SAM-2. Amid jamming, said Pyotr Zalipsky, "all we could see on the monitor was a horizontal line, while the vertical one flashed light. The lead aircraft was throwing chaff that baffled our beam. One had to try to figure out which aircraft was the jammer. There were two groups of fifteen aircraft—F-4D and F-105. My instinct was just to fire at the center of the formation. I gave Major Ilinykh the coordinates. He said, 'OK, shall we chance it? Maybe we'll hit something in the midst of that mass of light.'" They fired, and as usual claimed a hit, though often this was no more plausible than a MACV body count.

The eventual ten Vietnamese missile regiments adopted the slogan "Keep moving or die," because harsh experience showed that to remain in any location longer than twenty-four hours was to invite American devastation. They could dismount launchers within an hour, to shift to a

new location perhaps five miles distant. They learned to activate guidance radars only five to seven seconds before a missile launch. "Two bright spots appeared very close to each other on the screen," in the words of Nguyen Kien, sweating amid the stifling heat of the guidance van. "The three operators read off the aircraft's speed, simultaneously shouted, 'Target!' . . . Then battalion gave the order "Launch two missiles, range . . ." There was a flash of light, a white cloud, and a thunderous explosion. The bright streak of the missile could be seen speeding toward the enemy aircraft, and the van rocked slightly. Six seconds later, a second SAM-2 blasted skyward, and thereafter crews heard only the voice of the guidance officer reading off ranges. When the two signals met on the screen, a bright spot blossomed, enveloping the target's return signal. All three guidance operators shouted, "Warhead detonation!" Successes were relatively rare, however. Kien's missile battalion operated for two years before achieving a confirmed kill.

Advantage in the electronic war tilted hither and thither through the course of Rolling Thunder. It is hard to overstate the impact made by awareness of homing Shrikes on the courage and morale of defending missile crews. When North Vietnamese personnel understood that activation of their tracking radar invited obliteration, sometimes within seconds, some became conspicuously reluctant to open fire. They took refuge in claims that they were unable to identify a target, prompting the fury of commanders. One day near Haiphong in 1966, confronted with this excuse for inertia, a senior officer visiting a battery's control van exploded: "Even my old eyes can see the target on your screen! Launch your missiles, damn it! They're attacking the Uong Bi power plant!" In December 1967, the defenders faced a crisis: the Americans began to successfully jam the guidance channel radio link between missile control vans and their associated SAM launchers. The balance tilted back, however, when a POW under interrogation revealed details of the new Walleye TV-guided bomb, together with its intended targets. Two months later, on St. Valentine's Day 1968, an almost intact F-105 fell into communist hands, laying bare the secrets of its jamming pod.

* * *

Russians found the summer heat of Vietnam almost intolerable, even working in shorts and showering every few hours. Sugar melted. Cigarettes were rationed. They seldom received mail, and their radios could pick up no home station. Newspapers appeared in bundles, weeks late. The arrival of a parcel—containing perhaps caviar, salami, brown bread, "short" calendars for soldiers close to the end of their tours, vodka, and Russian champagne—was a big event. Officers also received brandy.

They came from a society that was scarcely affluent yet were shocked by the barefoot poverty of North Vietnam, and by the relentless labors performed by women. Russians were as fascinated as Americans by their beauty, but nonfraternization rules were strictly enforced. Girls from a nearby village dropped by to chat with Pyotr Zalipsky's unit "and maybe allow a few kisses, but if you put your hands where they shouldn't be, or tried to press a girl into a corner, she would punch you—only softly, but that was enough. They were very strong." His friend Ivan fell in love with a stunning half-French girl who worked in the canteen, and they requested permission to marry. Instead, the girl vanished and Ivan was sent smartly home to Russia. When Valery Miroshnichenko saw women shifting rocks under guard and asked who they were, his interpreter said coldly, "They are convicts being punished for having affairs with foreigners."

The ten-year-old son of a radio engineer had been brought up never to speak to strangers, and a young Russian named Selyagin who was posted to work with his father was dismayed when every time "Uncle Se" offered him a sweet, the child screamed his head off: "I was so scared of his height, thick hair and gray eyes." Most Russians, however, were welcomed. One delighted local children with card tricks. In a society bereft of personal cameras, others made themselves popular by photographing family groups and distributing prints. But the Vietnamese monitored every movement of their guests, even to the latrines, and were conspicuously reluctant for these supposed allies to learn their language.

The Russians hated the mosquitoes, "big as B-52s" in the wondering words of one soldier. They were fascinated by the vicissitudes of diet. Their hosts provided them with far more generous rations than their own

people received, together with copious supplies of beer, but meat was always short. Pyotr Zalipsky's unit used grasshoppers as bait to catch giant frogs—"delicious, with sweet white flesh like chicken . . . to this day I prefer frog to seafood." Many Russians learned to enjoy eating snake, which they thought better than the local pork, which had bristles still clinging to it. Ants routinely invaded mess tins, and milk was seldom available. Valery Panov felt fortunate that at Haiphong he could fish in the sea and occasionally use a trawl line to catch wild ducks. Yury Kislitsyn said, "This was a very hungry country: we had a saying that Vietnamese eat anything that crawls except tanks, everything that swims except aircraft carriers, everything that flies except B-52s." One day he fondled his own pet dog Kao-Kee—and the next day ate it, with tolerable satisfaction.

Maj. Pyotr Isaev headed the Soviet aviation adviser group in the late 1960s, when North Vietnam's defense was spearheaded by MiG-21s. He witnessed more than a few fiascos, for instance the Vietnamese wing commander making a wheels-up belly landing in front of a crowd of VIP spectators, because he had forgotten the correct position for the undercarriage lever. The Vietnamese felt understandably humiliated, and the Russian, shrugging, sought to console him: "Anything can happen in the flying business." Isaev was more dismayed by the manner in which ideology pervaded training: a committee decreed which Vietnamese should fulfill a given mission, though half its membership was bereft of flight qualifications. When he sought to change such practices and introduce after-action analysis, he was sternly rebuffed by the regiment's political officer, who said through an interpreter, "Comrade, you have come here to help us in our struggle against the American aggressors. Other matters are absolutely no business of yours."

As relations between China and the Soviet Union became more acrimonious, there were suspensions and outright stoppages of Russian rail shipments through Mao's territory, including coffins. Thereafter Soviet personnel who died had to be buried where they fell, so that Pyotr Zalipsky and his comrades joked with the local girls that they must fulfill Russian custom "and visit our graves with vodka and brown bread." A fierce competition developed between Chinese and Russian technicians

and diplomats, to snatch technology from shot-down US aircraft, with the Vietnamese often deceiving both about wrecks' whereabouts. Soviet diplomat Anatoly Zaitsev recalled a song one of his colleagues composed, about their mad dashes through jungle and paddy, to reach unexploded ordnance or downed planes before the Chinese:

Come for a date with me
At six in the evening after the war.
I'll wait for you in Arbat Square,
I'll be holding a piece of F-105 under my arm.

Local villagers appropriated aluminum, a precious metal for domestic purposes. "By the morning after a crash," said a wondering Russian in the salvage trade, "there would be nothing left of a wreck. The Vietnamese had taken it to make combs and rings." The Soviet Embassy in Hanoi reported bitterly to Moscow in March 1967: "Our military specialists work in a very difficult atmosphere . . . often unnecessarily worsened by Vietnamese comrades . . . [who] on various pretexts conceal crash sites and delay visits. On numerous occasions shot-down aircraft have been examined before the arrival of Soviet specialists by others who turned out to be Chinese . . . and removed everything of value."

In July 1966, the Russians wrote angrily to the North Vietnamese government, suggesting that delays in unloading cargoes at ports reflected a desire to keep Soviet vessels at Haiphong, to deter American attacks. The Soviet Embassy reported to Moscow that far from the Vietnamese being grateful for industrial equipment supplied, much was simply stored. The recipients also complained ungraciously about the poor quality of Russian materiel. In March 1968, they introduced a law to "punish counterrevolutionary activity," which included a ban on Soviet diplomats' travel and barred all unauthorized conversation with local people. A member of the Russian mission appears to have been expelled for contacting the eclipsed Giap faction. The Hanoi politburo, said the embassy angrily, regarded the USSR merely as a "rear area" providing equipment for their war

effort, and despised its eagerness to see peace made with the Americans. An NVA general told the Soviet chargé d'affaires, "Had we been defeated, we would have had no choice but to agree to talks. As it is, we are constantly winning decisive victories. What would talks mean for us? Losing everything, above all friendship with China, which is utterly opposed to negotiations."

On the SAM sites, however, there was a tolerable working relationship between Russian advisers and their Vietnamese pupils. Lt. Valery Miroshnichenko said, "You told them to learn something and they did so, even if they did not understand what they had learned. It wasn't so much that they lived in fear, as that they were driven by discipline, thoroughness, striving for victory. They were constructing a communist society." He and his comrades were fascinated by how much the Vietnamese accomplished on their miserable rations—"a couple of spoonfuls of plain rice . . . Where did their strength come from? They were like ants, fixed solely upon achieving appointed tasks." North Vietnamese commanders grudgingly authorized a small increase in the rations of missile crews, in hopes of improving their visual skills.

In June 1965, in response to a request from Le Duan, China dispatched to Vietnam a contingent of military engineers and logisticians. More than 170,000 troops—mostly pioneers or engineers—followed during the ensuing year, and between 1965 and 1968, a total of 310,011 Chinese served there, together with 346 advisers. Fifty-seven-year-old Col. Guilin Long was a railway specialist who had served through both the Chinese civil war and the Korean conflict. He was summoned to the PLA General Staff building in Beijing one day in April 1965, to be ordered to join a ten-man command group flying immediately to Vietnam. Their role was to direct the repair of rail links damaged by American bombing and thus speed the flow of arms and supplies from China. Long's special responsibility was to be the border crossing at Huu Nghi Quan—Friendship Pass—and the 150-mile Hanoi—Lao Cai sector. Led by a senior general, on arrival in North Vietnam they were greeted by Pham Van Dong and other members

of the politburo. "The situation was extremely serious," Long wrote in his memoirs. "If Vietnam's national rail network deteriorated further, the whole war effort would be at risk."

He was able to exploit his 1950–53 experience in sustaining North Korea's rail system under air assault. He felt his age, however, traveling relentlessly through the worst of the monsoon season. During the heat of the day, when the temperature sometimes touched 97 degrees Fahrenheit, "we grew dizzy and found our clothes bathed in sweat. When it rained, we were coated in mud from head to foot. . . . We did not live well." In June the first of the workforce arrived—five regiments of the PLA's Railway Corps, plus a regiment of antiaircraft artillery. Long assumed the title of engineering director for the No. 1 Detachment of the Chinese People's Volunteer Engineer Corps, though it is unlikely that any of its personnel had been consulted about their posting.

Long established a headquarters in Lang Son Province, his workers encamped around the tracks. The Chinese were dismayed to learn that Saigon radio had carried reports of their arrival. When US reconnaissance aircraft circled the area on July 3, the Vietnamese persuaded them to shift quarters. This didn't spare them from strafing, however, which inflicted significant casualties. Long wrote, "We found ourselves in the same predicament as in Korea twelve years earlier. . . . All our locations were obviously known to the enemy." Vietnamese cadres suggested that the blue cotton suits worn by every Chinese betrayed their nationality.

As the summer advanced, beyond the grief inflicted by American bombing, temperatures sometimes reached 120 degrees, with humidity of 85 percent. The men laboring on the tracks consumed fifteen liters of water a day, yet some nonetheless collapsed. Diseases spread and multiplied from bacteria present in every stream and puddle. China's soldier-laborers fell prey to endemic skin sores and insomnia. Food was short; the Vietnamese provided their allies only with pumpkin and water spinach, accompanied by a few bananas. Long's regiments had to import canned food and dried vegetables from China. Soldiers hated the local centipedes, leeches, and mosquitoes as much as did their American counterparts, a few hundred miles to the south. They found snakes attacking eggs stacked

in the mess kitchens, and slithering into sleeping quarters; one man died from a viper bite. Thousands succumbed to malaria. "Though we of the Railway Corps had suffered all manner of difficulties in the [civil war] and in Korea, we were never before obliged to work in such a hostile environment," wrote Long.

Then the bombers came again, intensifying their misery. A July 9, 1965, raid on the western line damaged both stations and bridges. On August 23, US aircraft hit the northern line and the Chinese working on it. A big September 20 attack on the Thanh Hoa river bridge inflicted twenty hits and serious damage; five more raids followed. The Chinese took pride in the fact that their men contrived swift repairs; the link to China was never severed for long. Farther south, however, important bridges in Bac Giang Province, near Hanoi, were hit repeatedly. A Chinese soldier drove a blazing truck off one span under fire, lest it explode and inflict further damage. More antiaircraft guns were summoned from Beijing; deep trenches and bunkers were dug; camps were dispersed and much reduced in size. Flak gunners claimed spectacular successes, as gunners always do, suggesting that they shot down eleven US aircraft during four October raids and damaged another seventeen. When the Chinese first arrived, they had only two intelligence personnel to monitor American activity. Over the ensuing two years, the air defense network expanded to include thirty-one raid-plotting tables and an elaborate telephone warning system. To improve the soldiers' parlous physical conditions, the threadbare PLA authorized unprecedented indulgences: a spare set of work clothes for every man; plastic sandals in place of canvas shoes, mosquito repellent, snakebite remedies, and medical advisers. The Vietnamese grudgingly allowed their guests to plant their own vegetable patches.

The perils did not abate, however. On the afternoon of August 21, 1966, Guilin Long was driving to inspect a construction site on Highway 1 near Yulong Mountain, when US aircraft struck. Because of the noise of his own vehicle, he was oblivious of peril until he saw soldiers dashing for the shelter of the nearby jungle. He and his aides stopped the car and leaped out into a hail of cannon fire. Blast from an explosion hurled Long into a nearby trench. His chief of operations was killed,

along with their driver; the Vietnamese interpreter was wounded. Long's personal escort suffered a severed artery in his arm which caused him to collapse as he tried to pull his unconscious chief out of the trench. When Long recovered his senses, he found himself drenched in the man's blood. The colonel was later sent home, suffering concussion and spinal damage. He became one among 1,675 Chinese personnel wounded, along with 771 killed, during Rolling Thunder.

So far as is known, no Russian or Chinese aircrew flew in combat against the Americans. Under a September 1966 agreement between Hanoi and Pyongyang, however, North Korea initially committed ten MiG-17 pilots to combat, later increased to twenty, based at Kep Airfield, northeast of Hanoi, and known as Group Z. A total of eighty-seven North Koreans flew for North Vietnam at one time or another between early 1967 and their withdrawal at the end of 1968. They lost fourteen pilots killed, and claimed to have shot down twenty-six US aircraft.

On December 23, 1966, New York Times deputy managing editor Harrison Salisbury arrived in Hanoi on a visit with momentous propaganda consequences. He had been chosen to receive a visa from among a host of media applicants, because he was a declared opponent of US bombing. Salisbury was shown sites in Hanoi where three hundred homes were said to have been destroyed and ten people killed—five miles from the USAF's nearest authorized targets. A Vietnamese-Polish Friendship high school was said to have been destroyed. He was also driven sixty miles to Nam Dinh, which he was told had been hit fifty-two times, killing eighty-nine people and wrecking more than one-tenth of the city's housing. He reported that US aircraft were "dropping an enormous weight of explosives on purely civilian targets." Salisbury encountered difficulties familiar to every visitor granted privileged access to a totalitarian state. He was thrilled by the experience, and empathized with a poor Asian people subjected to bombardment in a doubtful cause by the most powerful nation on earth. However, he gave insufficient weight in his dispatches and subsequent book to his inability to check anything that his hosts told him,

crediting some North Vietnamese assertions that were simply untrue—for instance, that the Americans had been deliberately bombing the Red River dikes and the Nam Dinh textile mill. The US government sought to discredit some of Salisbury's findings by highlighting the fact that he used statistics of casualties that also featured in communist propaganda pamphlets. Salisbury published a photograph purporting to show a destroyed Catholic cathedral, which later investigation revealed to be undamaged. The journalist's vivid and emotive articles, like similar later reports by left-wing Western visitors to North Vietnam, revealed considerable credulousness.

Nonetheless, the US government was unable convincingly to deny important and unwelcome truths, foremost among which was that a substantial proportion of American air-dropped ordnance fell in the wrong places. For instance, during attacks on Nam Dinh's power plant, bombs did land on the adjoining textile mills. Navy fighters shot at guns sited on dikes. Once, aircraft assigned to attack one rail yard bombed another instead, close to Hanoi. One of the foremost USAF chroniclers of the war, Wayne Thompson, acknowledges in his own account, "Even if a pilot correctly identified a target, most of his bombs were apt to miss." By the Air Force's own estimates, only half of the ordnance dropped by F-105s, which customarily carried six 750-pound bombs, landed within five hundred feet of the aiming point. This constituted reasonable accuracy, but left a wide margin for what would come to be called collateral damage. Moreover, jettisoned bombs, fuel tanks, air-to-ground missiles, and the mass of debris from North Vietnamese shells and missiles had to land somewhere. It was beyond dispute that substantial damage had been inflicted on nonmilitary facilities and homes, and that substantial numbers of civilians had been killed.

Salisbury conveyed to the world—for his reports reached a huge audience, making an impact beyond anything the Hanoi politburo might have anticipated—two important messages. First, that American bombing was hurting innocents; second, that a simple people were responding with determination and courage. Lyndon Johnson's clumsy attempts at

humanitarian restraint went for naught, since Salisbury demanded why so many trivial targets in the countryside were being attacked, while Hanoi's power plant and the huge Paul Doumer Bridge remained, at that date, unviolated. Yet nobody got quite what they wanted out of the *New York Times* man's trip. A February 1967 poll showed that, while 85 percent of Americans now acknowledged that civilians were being killed, 67 percent continued to favor bombing. The months that followed witnessed a substantial intensification of the air war.

In the last six months of World War II, under Curtis LeMay's direction, the USAAF dropped 147,000 tons of bombs on Japan, killing 330,000 Japanese. Operation Rolling Thunder II unleashed four times as much ordnance, and eventually killed 52,000 out of eighteen million North Vietnamese. Half of Haiphong's residents fled; Hanoi's population shrank by a third. In 1966 the air campaign cost the United States \$6.60 for every dollar's worth of damage it inflicted, and almost \$10 a year later. The previous spring, when Cmdr. James Stockdale was asked by his pilots, "Why are we fighting?" he responded, "Because it is in the interests of the United States to do so." The longer the bombing continued, however, and the higher losses mounted, the more skeptical became those who did the work. Lt. Eliot Tozer, an A-4 pilot, wrote in his diary, "The frustration comes on all levels. We fly a limited aircraft, drop limited ordnance, on rare targets in a severely limited amount of time. Worst of all, we do all this in a limited highly unpopular war."

Tozer's sensations were shared at the top of the command chain. At the end of a 1967 briefing, a despairing Gen. John McConnell of the USAF held his head in his hands and lamented, "I can't tell you how I feel. . . . I'm so sick of it. I have never been so goddamn frustrated." Rolling Thunder destroyed 65 percent of Hanoi's oil storage, 59 percent of its power plants, 55 percent of major bridges, 9,821 vehicles, and 1,966 railcars. Yet Hanoi was able to leverage the bombing to formidable effect, to induce Moscow and Beijing to provide much-increased aid. By 1968 China was shipping a thousand tons of supplies a day down the northeast railroad. North Vietnam had received a total of almost \$600 million in economic

and \$1 billion in military aid, enormous sums for a small, relatively primitive Asian nation.

The Pentagon's secret 1966 JASON study showed notable perspicuity about the unintended consequences of Rolling Thunder: "Bombing clearly strengthened popular support of the regime by engendering patriotic and nationalistic enthusiasm." The study acknowledged that "those more directly involved in the bombing underwent personal hardships and anxieties. . . . Morale was probably damaged less by the direct bombing than by its indirect effects, such as evacuation of the urban population and the splitting of families." Nonetheless, "a direct, frontal attack on a society tends to strengthen the social fabric of the nation, to increase popular support of the existing government, to improve the determination of both the leadership and the populace to fight back."

RAND analyst Oleg Hoeffding argued in December 1966: "The US campaign may have presented the [Hanoi] regime with a near-ideal mix of intended restraint and accidental gore." Though Hoeffding's tone was flippant, he asserted a truth that remained fundamental: "Hanoi has reaped substantial benefits from its response to what was an exaggerated threat assessment. . . . As to the effects on public morale and the effectiveness of government control, the cautious guess would be that they have redounded to the regime's net benefit. . . . The bombing has produced enough incidental damage and civilian casualties to assist the government in maintaining anti-American militancy, and not enough to be seriously depressing or disaffecting."

Yet the Joint Chiefs remained unwavering in their enthusiasm for more bombing. In an almost Strangelovian memorandum of June 16, 1967, Gen. Earle Wheeler urged intensified attacks on Hanoi and Haiphong, saying: "There is some possibility that it could be decisive. . . . Although no expert on domestic or world opinion, I believe that *more* rather than *less* vigorous action will bring increased support, except from the communists from whom we would only gain increased respect. Finally I do not believe that this would entail serious risk. . . . 123 attack sorties . . . are worth their human cost if they only reduce allied deaths in SVN by one. Stated in another way, the air campaign pays its way in lives if it is responsible

for only 1.6% of the difference between potential and actual infiltration [of the South by the NVA]—in dollars, if it is responsible for 2.1% of the difference in infiltration."

Well before the closure of Rolling Thunder in March 1968, however, its meager results had precipitated an extraordinary political recantation, an apostasy, a conversion: that of Robert McNamara. Before his final departure from office on February 29, at a private luncheon he was moved to assert in emotional terms his distress about the "crushing futility" of bombing. He, like some military chiefs more enlightened than Earle Wheeler, had come to understand that victory by this means, if it was achievable at all, could be won only by imposing devastation on a scale wholly incompatible with the values of the United States.

Lyndon Johnson's desire to display might and resolve in Vietnam was constrained by his own uncertainties: fears for the Great Society program; concern about provoking Soviet or Chinese military intervention; anxiety to sustain allied support for, or at least acquiescence in, American war making; and hopes of protecting both his domestic political base and the global image of the United States. The president declined to acknowledge that it is impossible to bomb an enemy nicely with much prospect of breaking his will. Moreover, so small were the communists' supply requirements that it is unlikely that even the intensified air campaign advocated by the Chiefs would have produced a different outcome. Amid the Sino-Soviet confrontation of the late 1960s, it is hard to imagine a scenario wherein either major communist power would have abandoned its ally, even if America's airmen had reduced North Vietnam to rubble—or, more appositely, to matchwood and straw.

"WAIST DEEP IN THE BIG MUDDY"

1. PEACENIKS

Two parallel Vietnam wars evolved in 1967: the first was, of course, America's intensifying battlefield struggle; the second was the ever fiercer fight against it, back home. CBS TV began broadcasting *The Smothers Brothers Comedy Hour*, which became the surprise hit of the season. Although its satirical sallies were soft stuff by twenty-first-century standards, a row exploded about whether the antiwar folk singer Pete Seeger should be allowed a guest appearance. He finally delivered a rousing rendering of a number in which the punch lines ran "We're waist deep in the big muddy / but the big fool says to push on." The song was supposedly about an army platoon exercising in 1941 Louisiana, but nary a single viewer doubted, or was intended to doubt, that it really addressed Vietnam and the leadership of Lyndon Johnson.

That spring, domestic resistance to America's commitment burst forth to become a mass movement, entwined with, though certainly not confined to the hippie movement, originating in San Francisco's Haight-Ashbury district, and the new baby-boom generation's embrace of drugs and sex. Hairy hippie leader Jerry Rubin said, "There's a war going on between young people and the old people who run this country." A galaxy of stars and celebrities came out against the Vietnam War, headed by most of the Kennedys and their intimates, such as John Kenneth Galbraith and Arthur Schlesinger, but also including Joan Baez and Bob Dylan,

380 .

Norman Mailer and Jane Fonda, pediatrician Dr. Benjamin Spock, British philosopher Bertrand Russell, and many artists, academics, and leftists on both sides of the Atlantic, together with the leaders of the black Civil Rights Movement. Martin Luther King proclaimed in August 1967, "The promises of the Great Society have been shot down on the battlefields of Vietnam."

At veteran diplomat Ellsworth Bunker's April confirmation hearing before succeeding Henry Cabot Lodge, the newly designated US Saigon ambassador reasserted the war aim of a strong, viable, and free South Vietnam. Senator William Fulbright demanded "whether the right of self-determination of fifteen million Vietnamese is worth the damage it is doing to our own country." Month by month, demonstrations grew in scale until by October fifty thousand protesters rallied in Washington, where ten thousand troops were deployed to protect the Pentagon. Senator Edward Kennedy declared, "No great nation can long claim to have won freedom and democracy for another people if . . . destruction of their land and way of life was the hallmark of the effort."

Nuance was a significant casualty of the argument. Supporters of the war saw themselves as patriots as well as foes of communism. The *New York Times* reported the strident words of a Reform rabbi, newly returned from Vietnam, who asserted that those attacking the administration "are helping to prolong the war... doing what the 'hawks' in Hanoi most desire" by portraying the United States as "the aggressor and the Vietcong and North Vietnamese as the innocent victims." Carl McIntire, founder of the Bible Presbyterian Church, declared the struggle "a righteous and holy cause," while evangelist Billy James Hargis argued that Americans were fighting for "freedom . . . security and protection of the United States." The editors of *Christianity Today*, an evangelical weekly, urged more bombing.

Meanwhile at the opposite end of the spectrum, the antiwar movement became increasingly frenzied. Many Americans familiar with Vietnam deplored the manner in which their nation was conducting the fight. They also, however, acknowledged communist brutality and the totalitarian character of the Hanoi regime, and thus recoiled from protesters who made a moral leap beyond chants about the iniquity of their own president—"Hey hey, LBJ / How many kids have you killed today?"—to assert the goodness of the enemy. When Frank Scotton addressed students, he was dismayed to find that they took for granted the legitimacy of the struggle waged in the name of Ho Chi Minh. "When I challenged that, they couldn't see what I was getting at. It was as if I had started talking higher mathematics." The chairman of the JCS was shocked to hear an antiwar protester, confronted with evidence that POWs were being tortured, declare that blame lay with America's fliers, for taking the work.

Henry Kissinger once referred contemptuously to the "inexhaustible masochism of American intellectuals, for whom it was a symbol of faith to be convinced that all the difficulties in [East-West] relations were caused by the stupidity or the intractability of the USA." This was the freakish phase of history at which a significant portion of the youth of the Western democracies professed to admire Mao Zedong, Fidel Castro, Che Guevara, and other revolutionaries, heedless of the oppression their heroes promoted—and in Mao's case, the mass murders over which he presided, incomparably worse than any modern horror for which the US could be held responsible.

The consequences of the rising tide of domestic turbulence were profound, especially on college campuses. Since the war's beginnings, while in the field some soldiers, sailors, and airmen had bungled and many had shown themselves insensitive, their pervasive spirit reflected commitment to an unwelcome but necessary duty. From 1968 onward, however, this changed. As veterans went home, they were replaced by new men, many infected by a cult of dissent, drugs, and disbelief. When a MACV briefer reported that incoming battalions included some men with college educations, Gen. Creighton Abrams thought that sounded good. However one of his officers said sepulchrally, "More capable of writing their congressman."

Robert Holcombe was a black New Yorker who evaded the draft for a year and eventually took the military oath in handcuffs. The son of schoolteachers, he was an avowed rebel, stalwart of sit-ins and teach-ins, who devoured Mao's *Little Red Book* and was expelled from the University

of Tennessee for participating in a riot. He said later, "I had read tons of books including literature from Cuba, China, Hanoi itself. Wars are only fought over property, really. As I saw it, we were after a foothold in a small country in the Orient with rubber plantations, rice, timber and possibly oil. And the people. A cheap source of labor." Yet at the end of his long Dodg'em game with authority, he found himself unwillingly serving the US Army in Vietnam.

Holcombe, though in 1967 he had not yet got near the war, was an extreme example of what was coming. A study of soldiers proceeding to Vietnam in that year showed that one in five were already using marijuana, a proportion that three years later would rise to half. The incountry percentage of known pot smokers grew from one-quarter in 1967 to two-thirds in 1971. As for the antiwar movement, a host of men read with disbelief about the virulence of the protests back in the States, in newspapers from home delivered to paddies or elephant grass. Lt. Andy Finlayson's sergeant recoiled in disgust when their unit picked up Englishlanguage communist leaflets quoting Eugene McCarthy's and Robert Kennedy's denunciations of the war. "Unfortunately I could not give him a good reason for why these American political leaders would say such things," said this career Marine. Some American warriors came later to believe-indeed, forever after to insist-that rather than losing the war in the field, they had been betrayed by moral weakness at home, the "stab in the back."

Texan Capt. John McNamara wrote from Danang, observing that he and most of his kind were "hurt by evidences of civil dissention [in the US]... I saw a VC-mined civilian bus the other day: women, kids, animals splashed all over the place." Yet he acknowledged his own confusion: "We don't do that. The larger question is, did I and my government and by inference Western civilization create the conditions that bred the Asian terrorist?" Yet even the communists were bemused by the excesses of the US antiwar movement. Radical activist Tom Hayden, who later married Jane Fonda, visited Hanoi and became its passionate advocate. One of the few comic moments in Doug Ramsey's jungle captivity took place when Hayden's name was mentioned during an interrogation. The pris-

oner asked his captors their opinion of him. A cadre replied coldly, "We admire his ideology, but despise him as a person. How can you respect a man who betrays his own country?"

It remains debatable how far American domestic opposition to the war was influenced by principle and how far by conscription for military service—the draft—which gave some young men an overriding personal motive to crusade against a conflict that might waste two years of their youth, at worst forfeit their lives. Statistics show that relatively few young Americans fought against their will. Some 25 million of the 27 million draft-age men of the war generation never fired a shot. Of those draftees who went, however, comprising a quarter of all the 2.1 million Americans who served in Vietnam, 17,725 died. A Harris survey found that most Americans considered them "suckers, having to risk their lives in the wrong war, in the wrong place, at the wrong time."

Supporters of the conflict highlighted the fact that only 1 percent of draft-eligible Americans failed to register, and a similarly tiny proportion refused induction. However, this argument ignored the extraordinary range of legal exemptions available to those savvy enough to exploit them. Until 1966, married men escaped, prompting a 10 percent rise in adolescent weddings. Others escaped merely by being in school—the Bill Clinton and Donald Trump option. Yale president Kingman Brewster spoke witheringly of "a cynical avoidance of service, a corruption of the aims of education, a tarnishing of the national spirit."

Draftee Don Graham recalled that his father's generation had defined each other by who did and did not go to fight in World War II: "My dad could never forget that Hubert Humphrey was a 4F who stayed at home. Yet in Vietnam I was meeting almost no one who had been to college. . . . I realized that the winners of our generation would be those who went to law school." Mark Rudd, leader of Students for a Democratic Society, sought a deferment on the grounds that he was a professional revolutionary. He was later declared physically unfit, though the draft board likely considered his adverse impact on the army if forced into fatigues.

The parents of one in four college students incited their sons to avoid the draft. Some got off because they could claim to be of "questionable

moral character," for instance through convictions for cattle rustling, pot smoking, or killing an eagle. Gays were also exempt. National Guardsmen escaped—the route preferred by George W. Bush, along with ten players for the Dallas Cowboys, whose management arranged for them all to be assigned to the same local Guard unit. A Philadelphia footballer who likewise avoided Vietnam said, "If we had been called up, the Eagles would have been left without a backfield." Some smart doctors joined the federal Health Service Corps, becoming—as they mockingly called themselves—"Yellow Berets"; an astonishing nine such men later became Nobel Laureates. Sympathetic or venal medical examiners could get rich kids off, an avenue also exploited by Donald Trump. It was possible to fake a gastrointestinal ulcer by extracting a pint of blood, then drinking this just before taking tests. Certain city draft boards were identified as soft touches for exemptions, such as Seattle, Washington, and Butte, Montana. The Berkeley, California, city council adopted a resolution barring the police from arresting deserters.

Lawrence Baskir and William Strauss, authors of a study of wartime conscription, wrote: "The draftees who fought and died in Vietnam were primarily society's 'losers,' the same men who get left behind in schools, jobs and other forms of social competition." Only 7 percent of those from high- and middle-income families saw combat; of college graduates, 9 percent, as against 14 percent of high school dropouts. In 1965 blacks accounted for a quarter of all enlisted men's combat deaths, which was such an embarrassment to the Defense Department that it contrived thereafter through selective posting to dramatically lower the percentage. Gen. Westmoreland said later that rather than the American people "bearing any burden, . . . the only ones that . . . paid a price and made a sacrifice were those on the battlefield, who were mainly poor men's sons."

Nevertheless, US Army historian Conrad Crane has reexamined the statistics on Vietnam service and makes an impressive case for qualifying this view. He cites a 1992 study showing that while 30 percent of all those killed in action came from the lowest third of the income range, 26 percent were drawn from the highest. Of all combat deaths, 12.5 percent were black and 5 percent Hispanic, loss rates slightly *lower* than those minori-

ties' proportions of draft-age males. The black militants who convinced themselves and much of the world that they were bearing an unjust share of a white man's war overstated their case.

Some adolescents chose to make principled stands against service. The first ritual draft-card burnings took place in 1964. Fifty thousand refuseniks became fugitives, and some adopted exotic expedients. One took to the mountains and spent six years living in a tree house. A Minnesota resister was arrested in Eureka, California, while working as a department store Santa Claus. Some stayed in the US under false identities. Rural New England was dubbed Little Canada, because so many fugitives hung out on its farms and campuses. For exiles, Mexico was sympathetic, but a tough place to hustle a dollar. Some new arrivals in Sweden, up there with Canada as US fugitives' first choices, were obliged to become beggars, because welfare paid only \$15 a week, but then a sympathetic Swedish government doubled this subsidy—to the fury of Congress.

One deserter spent the entire Vietnam period bicycling around Canada, living on handouts. Another argued, "I'm not a draft-dodger-I'm a twentieth-century runaway slave." A young soldier identified only as Bob deserted to Canada while on pre-embarkation leave, whence he wrote to a friend serving in the field: "I am not a pacifist, but in the army I became aware of what that war is—a racist war conducted on behalf of the huge American war machine. . . . You guys are in the best position to let the people of America [k] now just what kind of shit is being carried out in their name." Some dodgers must later have asked themselves whether their long exiles were worth it, because the US judicial system dealt charitably with more than half a million draft violators: only 25,000 were indicted, and 3,250 jailed. Among high-profile resisters, in 1967 Muhammad Ali was sentenced to five years but never served a day. Nonetheless, in this respect blacks generally fared poorly, receiving longer sentences than white violators. Mississippi and Louisiana boards became notorious for using draft law as a weapon against civil rights workers. Only one in seven draftees saw combat. All but 3 percent of these finally came home, 10 percent having suffered a wound needing hospitalization. Many were also burdened by memories they would have been happier without.

It deserves notice that a vast number of young patriots, who had not the smallest desire to serve, went to Vietnam without complaint or fuss, because they believed it to be their duty. Out on a South Dakota farm, Larry Pressler's pa told his boys they should make no attempt to dodge the draft. If they got out of it, he said, somebody poorer than themselves would have to go in their place, "and you will regret it for the rest of your lives." The two Pressler brothers went, fought, and came home. David Rogers, son of a New Jersey research chemist, studied English and history at Hamilton College. Rogers, a thoughtful young man, whose father was a Quaker strongly opposed to the war, then registered as a conscientious objector but could not bring himself to stay home: "There were no good choices. I was from a small town. I felt it wasn't right to let someone else go in my place. I saw a photo of a medic taking care of people and thought, I can do that." He defied his father's anger to serve as an infantry corpsman. Far more young Americans accepted the call than refused it, though the latter received most of the publicity.

One further point about the antiwar movement deserves consideration: Americans will forgive almost anything but failure. The struggle tried beyond endurance the patience of the world's greatest democracy. Many of its citizens turned sour not because their cause appeared morally wrong but instead because it seemed doomed.

2. WARNIKS

In Vietnam, by the spring of 1967, Frank Scotton was among those deeply depressed. "It was obvious we were making a lot of mistakes, basing the conduct of war on creating terrible destruction among the people we had come to protect." On February 21, the perennially adventurous French journalist Bernard Fall was killed when he trod on a mine while accompanying a sweep in the "Street Without Joy" near Danang. He had come to be hailed by skeptics as a seer, for the insistence with which he proclaimed that the US was repeating all the French blunders of the 1950s, only with more firepower. "Free world" forces now numbered 1.3 million South

Vietnamese and Americans, one soldier for every fifteen of the population, with two thousand tactical aircraft supported by SAC's B-52s. While Chicago's O'Hare Airport boasted 690,000 plane movements a year, by 1968 Tan Son Nhut could claim 804,000, Danang 846,000, and Bien Hoa a record-shaking 857,000—and those numbers did not include helicopters.

Scotton formed an enduring conviction that the only credible strategy was to deploy US forces in depth and permanently along a line between Quang Tri and the Mekong, sealing access to South Vietnam. "If we did not do this, we were doomed to a long war, the sort Americans are not good at." It remains highly doubtful that it was feasible thus to close the Ho Chi Minh Trail; moreover, even success would not have cured the debility of the Saigon regime. Scotton's view remains nonetheless widely shared among veterans.

Out on the battlefield, or rather a hundred battlefields on high hills, in flat paddies, and in dense jungle, by American decree the ARVN had become bystanders, while US forces launched a succession of bloody, messy operations to locate, engage, and destroy both NVA formations and Vietcong guerrillas—in 1967–68, still many more of the latter than the former. Westmoreland hounded his commanders to keep their men moving, the enemy off balance. After a battle near the Cambodian border on March 31 to April 1, 1967, in which an attacking VC regiment was harrowed by Lt. Col. Alexander Haig's 1/26th Infantry, MACV's chieftain "royally chewed out" corps commander Bruce Palmer for failing to pursue the retreating foe.

"One of the agonies you'd go through," said Fred Weyand, then commanding the 25th Division, "is that you'd send out a sweep operation . . . maybe take fifteen men killed. Then, after that operation, we'd have to pull out of there . . . and when we went back a month later, we had the same problem all over again." Weyand was highly critical of Westmoreland's belief that the US Army could crush the enemy through attrition: "It just seemed ridiculous." The Americans had nothing like enough infantry to secure anything beyond artillery range from the network of firesupport bases now excavated and fortified throughout the country, mostly

388 .

on red hilltops stripped of vegetation. Foot soldiers surged forth, fought, and moved on, leaving behind discarded C-ration cans and munitions that returning Vietcong found most serviceable.

Officers and men learned to dread the words *body count*, yet in a war with no prospect of raising a flag in the enemy's capital, there seemed no other plausible yardstick of success. Contrary to myth, this was not an original concept: every army in every war judges its progress partly by how many enemies it kills or captures. In Vietnam, however, this became obsessional, so that commanders belabored subordinates who failed to deliver a sufficiency of corpses. Their attitude promoted a carelessness, if nothing worse, about which of the enumerated dead were communist fighters, how many hapless peasants.

Capt. Vince Felletter of the 101st Airborne complained that his superiors were "a little bit sensitive to that body-count crap." Once, his company started digging in and found themselves in an NVA graveyard: "Brigade actually wanted us to dig up all [the bodies], and they reported them as a body count related to a previous contact." The 9th Division in the Delta became especially notorious: at its headquarters, a wall chart measured "efficiency" by "enemy eliminated per company day in the field." Regional and Popular Forces scored 0.30 each, ARVN 0.75, and US troops 1.50. A wall graph eventually showed the 9th's alleged body count rise from 1,998 in the second quarter of 1967 to 2,671 in the same period of 1968, then to 8,138 in second quarter 1969. Abrams later fulminated about "the worship of charts. . . . It finally gets to the point where that's really the whole war, fucking charts, instead of the people and the real things." John Vann heaped contempt on the means by which body-count numbers were secured, telling Frank Scotton of "a shameful 9th Division rampage." The two provinces in which the formation operated averaged five hundred civilian casualties a month, whereas the other twelve provinces of IV Corps together accounted for only four hundred. Vann said of one of the 9th's later commanders, Julian Ewell, that he "could kill his own grandmother if he could put her on his body count." Ewell provided the principal role model for the monstrous Gen. Lemming in Josiah Bunting's novel The

Lionheads, a fictional assault on the US conduct of the war, written by a former career officer of the 9th Division.

Still, it is mistaken to view 1967–68 as a time of American tactical failure: whenever Westmoreland's troops were able to bring the enemy to bay, they inflicted heavy casualties. Captured documents revealed a slump in the morale of many VC and NVA units. One described the communist 2nd Division's propaganda efforts, to counter "dread of protracted war, reluctance [to fight] . . . and to put an end to desertions, defections, surrenders and suicides." Communist commanders were infuriated by reports of their men turning tail during contacts. Robert Komer, as director of pacification, wrote to the president on February 28, 1967: "Wastefully, expensively, but nonetheless indisputably, we are winning the war in the South. Few of our programs—civil or military—are very efficient, but we are grinding the enemy down by sheer weight and mass."

After a mid-1967 battle in which the VC 514th Battalion in the Delta was hit by both heliborne and riverine forces, a communist survivor complained that they had always been indoctrinated that the "longnoses" were poor fighters, instead they now saw "that the Americans fight fiercely . . . much better than the ARVN." The Joint Chiefs wrote to McNamara on October 17: "Current strategy and military actions are resulting in steady progress. . . . The enemy is probably in significantly greater difficulty than current battle statistics and hard intelligence indicate." Among mountains of falsehoods that dominate the documentary landscape of the war, this assessment was not unreasonable.

In Hanoi politburo discussions, "differing opinions were expressed about the scale of victory that might be attained." By the end of 1967, Dragon Court estimated that it had 232,000 fighters in South Vietnam—190 battalions—up from 204,000 men a year earlier. This increase was achieved by committing more regular NVA units, and unflinching acceptance of losses. According to Hanoi's war history, its chiefs viewed this as a time of difficulties and frustrations: "Aside from the American battalions that we had destroyed in the Ia Drang Valley in November 1965, we had not since fought a single battle in which we had been

390 .

able to achieve the objectives we set." Unless they embraced some spectacular initiative, the North Vietnamese saw themselves doomed forever to grind on in a stalemated struggle: their patience was not, as they liked to claim, inexhaustible. Hanoi's July 1967 strategic plan called for "concentration of maximum effort on securing a decisive victory through a general offensive-uprising, no matter what the cost." Here was the genesis of the 1968 Tet offensive, a stroke born partly out of false hopes—but partly also out of a sense of urgency to show their people a result.

Yet the Americans had manifold difficulties of their own. The antiwar movement was gaining traction at home faster than the US Army was advancing in Southeast Asia. Thoughtful policy makers had come to understand that it was a weakness, not a strength, that while North Vietnamese objectives stretched to the horizon, those of the US were very narrow. This restricted the means acceptable to fulfill them, above all by excluding invasion of the North. Earle Wheeler wrote on August 9, 1967, "Our government has repeatedly made it clear that . . . we are not out to destroy the Hanoi regime . . . nor are we out to devastate NV. We simply want NV to cease its direction and support of the Vietcong insurgency in the South and take its forces home."

Moreover, the US never resolved the problems caused by a chaotic allied chain of command. Intelligence was a chronic weakness. When Fred Weyand once chastised Bill Colby for the CIA's inability to predict communist moves, Colby answered, "You know, I'd trade all of our assets in the South to get just one asset in the North." Weyand commented, "I simply was astounded that this country of ours, with all the power that we've got, didn't have that. It tells you something about the power of the communist system that it can keep us in the dark like that. Every family in the North must have had someone killed or wounded, or a person that they knew, and yet that government could maintain control over them, while we couldn't maintain control over the streets in New York."

Trust was low between Americans and South Vietnamese, and indeed within the forces of the Saigon regime, because communist penetration went so deep. Lt. Gen. Bruce Palmer was confused when an ARVN divisional commander insisted on taking him outdoors, away from his own

staff, before speaking seriously. Then the Vietnamese explained that his own intelligence officer was a suspected enemy agent. Palmer was one of many soldiers disgusted by the waning of political support in Washington even as the men of a vast US army fought and died to fulfill its government's declared wishes. The general wrote after McNamara visited in June 1967, "It . . . became perfectly clear that our civilian and military leaders were far apart."

The American buildup ever more grievously polluted Vietnam. A journalist described a characteristic scene in Danang: "On the main street beside the waterfront . . . Alps of ammunition were joined to an Andes chain of crates and containers of tinned food, soft drinks, plastic boots, transistor radios, electricity generators, air-conditioners, heavy artillery pieces, tanks, trucks, baseball bats, candy and pulp magazines. Every company in the United States appeared to have dumped here its surplus goods, soon to become garbage." Barbed wire was heaped in masses beside concrete blocks; old women squatted next to crated ammunition, while children cadged cigarettes from sentries, practicing scraps of English amid excesses of plenty that threatened to bury their society. Moreover, many commanders were increasingly doubtful whether the comforts lavished upon US troops, exemplified by ice cream issues to some units in the field, boosted morale as was intended, or instead corroded the warrior spirit.

Most of the world's media no longer believed what the military said. On September 3, 1967, Richard Harwood of the *Washington Post*, himself a Marine veteran of Iwo Jima, published a dispatch headed "The War Just Doesn't Add Up." He addressed a single example of what he perceived as official deceit. MACV, wrote Harwood, had reported as "much improved" the 1966 combat performance of the South Vietnamese armored regiment based in Saigon. Yet how could this assertion be squared with the fact that its 8th Squadron claimed just 1 enemy dead; 5th Squadron, 12; 10th, 23; and the 9th, 148 enemy, while all these squadrons together had lost only 14 of their own men killed? MACV's firehose output of numbers, to show things getting better, seemed believable only by those who wrote letters to Santa Claus in expectation of an authentic reply.

Yet the spirit of the protesters, the draft dodgers, and Pete Seeger, had

not yet spread to most of the Americans at the sharp end. Marine Walt Boomer enthused, "If ever there was a good time to fight in Vietnam, 1967 was it. There were no drugs, no race problem. Whatever might be happening back in Danang, in the field we didn't know about it." Boomer, son of a North Carolina small businessman and himself a graduate of Duke University, became one of his country's most distinguished warriors. Such an officer thought little about the wider war; he merely rejoiced in fulfilling the role he had trained for, commanding a company whose members he deeply respected as "courageous young men. We operated in a bubble of the Corps. I didn't understand what was happening in the real world."

Capt. Jim Williams, son of a Winona, Minnesota, school superintendent, agreed: "It was a time of real patriotism, a lot of post–World War II sentiment and parades." Williams spent much of 1967 commanding a reconnaissance unit near the border with Laos, amid tribesmen shepherding laden elephants to market. This was before the North Vietnamese laid siege to Khe Sanh, and the area was tranquil enough for him to attend Mass in the local village church, celebrated by an American mission priest. "If you're a *Terry and the Pirates* type," wrote home Texan career officer Capt. John McNamara, "you can get into the hinterland and intrigue and blood-brother yourself to the Montagnards to your heart's content. If you like to maneuver regiments and battalions, you can even get a chance at that. So, as a professional playground, it's excellent." It was the rest of the war that troubled McNamara—how the Vietnamese people felt about it all: "I suppose I'm considerably less optimistic about this thing than I was last time I wrote."

3. FIELDCRAFT

If a soldier wanted to stay safe, his best course was to remain absolutely still, preferably in a hole: every movement made him more vulnerable. Yet it was the duty of infantrymen to move. They spent much of their field time seeking out the enemy in platoon, company, or battalion strength. For fifty thousand Americans fulfilling that role at any one time, exotic Asian nature became the new normal: the brilliant green of rice paddies,

darker green of palm groves, small boys leading out water buffalo, farmers plodding with the patience of centuries behind ox-drawn wooden plows. At dusk grunts watched the buffalo being driven back home, flanks caked with mud from their wallows, pretty much like themselves. And somewhere concealed within all this rustic charm, there was the enemy.

Walt Boomer said, "We were looking for a fight every day, hopefully on our terms. I soon began to realize, *This guy's sitting back and he's watching.* Sometime he's going to see a moment when you get a bit careless, and he's going to whack you. He knew the terrain, and we didn't. I remember a terrible day we had. We were advancing down a very narrow valley of mixed brush, and we got hit pretty hard: they ambushed a platoon, which had three men killed; I lost one guy who had a Navy Cross. We thought, *We've got artillery and air support—if only they stick around, we'll get them.* But they didn't. That operation wasn't part of anything larger, it was just me and the company going through the country and clearing—whatever that meant. How many of them did we kill? I don't know. Headquarters was furious about the [poor] kill ratio."

Men were sorely tried by humping heavy loads through fierce heat in tough terrain, even before the enemy entered the story. Each carried a weapon; at least eight magazines and rounds to fill them; a steel ammo can, used to keep paper and suchlike dry; four fragmentation and two smoke grenades; and four canteens, which were seldom enough—in dry places a man might think it prudent to start out with twenty pounds of water. Some burdened themselves with extra hardware, perhaps a .45 pistol. As for rations, Andy Finlayson took on five-day recce patrols one can of beans and franks, one of spaghetti and meatballs, four of fruit, three small cans of snacks. David Rogers subsisted on peanut butter, jelly, and crackers, fruit and cake. Thus it was no wonder that most foot soldiers lost weight, a lot of weight. Walt Boomer went into Vietnam 180 pounds, came out at 155.

Once they started walking, the bush became ornamented with discarded munitions as sweating newcomers—"cherries"—lightened their burdens. They learned that only cowboys draped their bodies in M60 machine-gun belts, because exposed rounds became filthy rounds, prone

to jam. Jim Williams afterward found that the surest way to discover the nature of a fellow vet's service was to ask whether he wore underwear. If he did, he had missed the bad places: underpants bred crotch fungus, so few men tolerated them. Phil Caputo said, "Everything rotted and corroded quickly over there: bodies, boot leather, canvas, metal, morals."

Capt. Chuck Reindenlaugh wrote to his wife, "No single piece of earth is less suited to waging conventional warfare. . . . Oozing water into which one sinks to the knees; trees and underbrush so thickly entwined that it is impossible to force a man's body through in many places; giant trees whose upper bough structure keeps the ground in perpetual half-light." Poorsighted men marched in dread of losing their glasses in the endless brush, branches, and creepers. British officer Freddy Spencer Chapman entitled a classic memoir of the 1942 Malayan campaign The Jungle is Neutral, and the same was true in Vietnam a generation later: country boys coped best, reared to be unafraid of wilderness-triple-canopy foliage, snakes, screaming gibbons. Many Americans, however, were city-bred. It was hard for them to walk easy through thick cover, in which paths were likely booby-trapped. Where visibility was only a yard or two, each man had to keep his eyes intent on the one in front: the careless strayed and vanished. Walt Boomer's company lost a Marine during a sweep: "We had to stop the whole operation and find him before the North Vietnamese did."

Most Americans moved noisily. "The best way to get killed," wrote Andy Finlayson, "was simply to talk in a normal tone of voice. . . . One usually never saw one's enemy, but a voice was like a bullet magnet." A unit that sought to move fast made as much racket as an elephant herd, snapping branches and bamboo. In heavy and hostile country, a prudent point man might advance only one pace every five or six seconds, ten a minute, three hundred yards an hour. A long-range patrol religiously dedicated to concealment could take a day to cover a mile, the rear man responsible for erasing tracks. Company trudges were punctuated by the hourly chant of radio operators giving posreps—position reports—into their "Prick-Tens"—PRC-10s, later replaced by PRC-25s: "All secure. Situation remains the same." Nearly all US units radioed too much, failing to grasp the diligence of communist monitoring.

Though an officer navigated by map and Lensmatic compass, an enlisted man was designated to count the paces they advanced. The leaderpoint did not "break trail"; he simply advanced with infinite watchfulness, leaving those behind to wield machetes. Every unit had its small quota of eager warriors. In Judd Kinne's platoon, there was S/Sgt. Hayward Riley, famously good at handling men, and Cpl. Thompson Flute, a Native American from Oklahoma not to be trusted near a drink back at base, but magnificent in the field. Walt Boomer always picked for point "the most skilled hunter, with a sixth sense." Reg Edwards became less afraid of going first when he learned from experience that point usually survived the shock of contact; those immediately behind were more likely to get whacked. Space—at least five yards between men—was critical, especially in heavily booby-trapped areas: bunching meant multiplying mutilations and deaths. Action seldom started in the middle of a column, which made that a popular place to be. "Drag" demanded as much bushcraft as point; he was rear man, tasked to catch enemy sneaking up from behind.

Tim O'Brien, among the most vivid chroniclers of the infantryman's experience, wrote: "If you weren't humping, you were waiting. Digging foxholes. Slapping mosquitoes. The sun and the heat and the endless paddies. Even in the deep bush, where you could die any number of ways, the war was nakedly and aggressively boring. . . . You'd be sitting at the top of a high hill, the flat paddies stretching out below, and the day would be calm and hot and utterly vacant, and you'd feel the boredom dripping inside you like a leaky faucet. . . . You'd try to relax. You'd uncurl your fists and let your thoughts go. Well, you'd think, that wasn't so bad. And right then you'd hear gunfire behind you and your nuts would fly up into your throat and you'd be squealing pig squeals."

Some fights started with an air assault onto a "hot" LZ, a landing zone occupied by an enemy who shot back even before infantrymen sprang heavily down from the choppers. Phil Caputo wrote that such an operation "creates emotional pressures far more intense than a conventional ground assault. It is the enclosed space, the noise, the speed, and, above all, the sense of total helplessness. There is a certain excitement to it the first time, but after that, it is one of the more unpleasant experiences

396 .

offered by modern war." It was nail-biting to ride the first bird in, but the second was often the enemy's target of choice. Fred Childs was perched on the edge of a Huey hovering a few feet above an LZ when two men on the opposite side jumped down, causing the helo to lurch sideways and Childs to fall out and hit his head. Concussed, he recalled nothing about the battle that followed.

One day up near Chu Lai, a notably stoical black soldier named Davis took a bullet as he hit the ground, but kept shooting back. When another wounded man, Taylor, merely lay sobbing, Davis mocked him mercilessly, goading him to use his weapon: "You cryin' cause you gettin' ready to die. You dying, and you know you dying. You might as well come on and take some of these gooks with us." Taylor said sulkily, "I'm not gonna die," which caused Davis to prod him again: "Why you sittin' there crying if you not gon' die? You cryin' cause you a big faggot." Then both Davis and Taylor kept shooting until a dust-off came. Twenty-nine-year-old company commander Vince Felletter once lost six men who jumped from a stricken Huey only to have the wreck flip on top of them, rotors flailing, which imposed on survivors the ghastly task of sorting body parts. Next night, battalion HQ flew a hot turkey meal out to them. "Feeling sorry for us, I guess." This gesture went awry: the entire company suffered food poisoning, and at dawn fourteen men were medevacked with temperatures over 103. Felletter said, "That was the worst time in my command."

On foot, scent could kill almost as surely as noise. Both sides cherished their scouts, some of whom had supremely refined senses. An NVA soldier named Nga was dubbed the German shepherd, because, in a comrade's words, "His nose is legendary. Whenever he says he can 'smell' Americans, he always turns out to be right." Some US officers, especially those leading deep penetration patrols, barred smoking, so that men instead chewed tobacco. Scout dogs could be an asset, but were vulnerable to dehydration: more than one handler wound up carrying his canine charge. Australian animal-lovers raised a storm in Canberra when Cassius, one of their contingent's trackers, died of heat exhaustion even after being immersed in ice baths by US Army veterinarians. Landon Thorne's Marines prompted

Vietnamese Kit Carson scouts to kick his platoon's hapless dogs, "so they knew the difference between the good guys and the bad ones." Despite the animals' training, sometimes they barked, betraying their owners.

It is hard to exaggerate the strain of sweeps, in which days of mere discomfort, filth, exertion, and apprehension could end in a train wreck with an enemy ambush. Capt. Julius Johnson said his biggest problem "was keeping my men sharp enough, after a week or two without contact, to maintain their reactions that allowed them to be fired on and get off that second shot." They had their own droll variant on the 23rd Psalm: "Yea, though I walk through this valley of the shadow of darkness and death, I shall not fear for thou art with me. . . . Thy arty and thy B-52s are on call to comfort me."

The chronic wet rusted grenade pins, cans, guns, electrical circuits. The best way to ward off insects was to soak clothing and boots in repellent, but often juice was short. They had no prophylactic for the leeches: men wore steel-spring blousing garters to hold trousers tight, but the crawling horrors got through anyway, their heads boring a quarter inch into a man's skin before the pain started. They could be removed with a burning cigarette only at the evening halt.

Booby traps were most often spotted early in the day, when troops were fresh. Sgt. Mike Sutton was wading thigh-deep through a swamp when among a heap of cut bamboo, he found himself hard up against a tripwire. He never forgot the seconds of cold sweat before he stepped back . . . and lived. The most dangerous time came at late afternoon, when men were filthy, hungry, riddled with bug bites, weary of climbing hills and negotiating swamps. That was when it was wise to exchange point men, to secure a renewal of vigilance. A frenzied shout of "Hit it!" signified, usually too late, that a man had heard the *pop* as a mine triggered; that the squad should dive for the deck. It was almost always the enemy who initiated contacts, with a burst of fire or shower of "Chi-Coms"—grenades—that killed one, two, three Americans before they could respond. Lt. Frank Boccia compared the sort of stuff that followed to "a slugging match in a tar pit while blindfolded." A Marine wrote, "As tired and bored as you get

fighting both fatigue and the heat, all it takes is a shout, or someone moving too fast, and suddenly you have never felt so alert, so alive. Your nose, ears, eyes, working all of a sudden better than ever before. It is a real rush."

The Americans had overwhelming firepower, yet this meant little to grunts confronting an almost invisible enemy in close country. David Rogers said, "We felt pretty evenly matched. B-52s won't solve your problem when you're pinned down; I never felt we had immense superiority. Their RPG was better than our LAW. Their AK-47 was better than our M16." At the heart of every squad was its "pig"—the M60 machine gun, a superb weapon that delivered a terrific weight of fire, at the cost of being heavy to carry—thirty pounds including a belt—and heavier still to feed. Some men carried M79 "Thumper" grenade launchers, which resembled sawed-off shotguns and fired 40mm shells. M79s and 66mm LAW rockets gave handy immediate support. Rogers said that in a firefight "sometimes we'd fire a LAW just for the noise"—the morale boost its heavy bang provided. CS gas grenades were also sometimes used to shift enemy from stubbornly held positions or to test for their presence in a discovered tunnel system.

Soldiers were awed by their own air strikes and 105mm support. "Simply by speaking a few words into a two-way radio, I had performed magical feats of destruction," one officer marveled. Gunners five or six miles away would drop a smoke round to mark their aimpoint, then wait for an FO or company commander to adjust fire. Soldiers forgave officers many failings but never poor map reading, which was how friendly fire got to kill them. FOs directed aircraft on a course across their front, because if they attacked from behind, short munitions would hit Americans. Walt Boomer: "We loved napalm. I don't know how effective it was, but it surely helped your morale." A stupendous volume of air-dropped ordnance was wasted on untenanted wilderness. When Andy Finlayson led a patrol inserted in the jungle by helo to investigate the impact of a B-52 strike, they found the usual devastation, together with evidence that many men had recently crossed the target area. The only blood pools, however, appeared to be from elephant or buffalo.

In a firefight many grunts—if their rifles were working—couldn't resist shooting into the green as if it was the Fourth of July, on full automatic

"rock 'n' roll." FO Bill Hardwick wrote, "Poor fire discipline was endemic. At times it just felt good . . . to rip off a few rounds . . . the sign of an amateur. The enemy usually had excellent fire discipline." This was partly because the Vietcong carried relatively little ammunition, sometimes no more than two magazines, and this limitation could give Americans or South Vietnamese the edge in a sustained exchange. Capt. Joe Tenney complained that many of his own company made no pretense of aiming. "In one case I saw an enemy soldier run through the killing zone of an ambush without ever being hit, though nine men were shooting at him."

Tim O'Brien wrote of "the stiff thump of the bullet, like a fist, the way it knocks the air out of you and makes you cough, how the sound of the gunshot arrived about ten years later, and the dizzy feeling, the smell of yourself, the things you think about and say and do right afterward, the way your eyes focus on a tiny white pebble or blade of grass and how you start thinking, Oh man, that's the last thing I'll ever see, *that* pebble, *that* blade of grass, which makes you want to cry."

The most contentious phrase in every infantryman's lexicon is *pinned down*. It can mean that a squad, platoon, company is trapped in the face of such heavy enemy fire that it would be suicidal to advance. More often, it means that nobody that day is feeling heroic enough to try for a Medal of Honor, that it seems smarter to stay prone and call in arty or an air strike—the logic that made Vietnam so much a radio operator's war. Most firefights were brief; in one that lasted just thirty seconds, fifteen of thirty-five patrolling Marines were killed or wounded. Often a handful of VC used their weapons for a minute or two, then pulled out before artillery could work on them. Vince Felletter said, "They could break off a firefight much easier than we could."

It was tough for junior leaders to exercise control in thick bush, where hand signals could not be seen and shouts were inaudible above a cacophony of exploding grenades, automatic weapons fire, and screams of fear and pain. Some battalion commanders ran their units from overhead Hueys, a practice that seldom impressed their men. Capt. Ken Moorefield's colonel and operations officer could be hovering at a thousand feet, the brigade commander at fifteen hundred, the divisional commander at twenty-five.

"I swear to God, one day I was in a battle where the commander of all US forces was at thirty-five hundred feet. . . . From the point of view of some infantryman who is down there sweating his ass off, facing hot lead at close quarters, it's very difficult to respect or identify with his leadership sitting up in the clouds in starched fatigues."

Company commanders were sometimes maddened by senior officers trying to micromanage firefights. Vince Felletter said, "I got into a little bit of push and shove with my battalion commander when I told him to get the hell off the net till the contact was over. I lost my cool a little bit . . . and that caused some problems." It's striking how many novels and memoirs, Karl Marlantes's *Matterhorn* notable among them, display not merely a lack of respect for higher commanders, but active contempt and even hatred for them.

Anything could happen during a contact. Riflemen in Charlie Shyab's platoon put a few rounds over the heads of skulkers hanging back, men "who just didn't want to do it." Every platoon had some. Shyab found that he had replaced a medic who refused to go into the bush anymore and instead got a job at base. When the company met trouble on Chu Moor Mountain, survivors were shocked to discover that their sergeant, who had seemed a decent guy, "went into shock. He just wasn't there for us." The NCO vanished forever, carrying a wounded man to the rear.

All grunts called their corpsman Doc, knowing that if they were hit, he was as near to a real doctor as they were going to get before providence decided whether they lived or died. David Rogers on reconnaissance missions carried his medical kit in a C-4 explosives bag: salt tablets, dressings, morphine, two cans of albumen, an intravenous drip, and smoke grenades to call in dust-offs. On normal field duty, this was reinforced by an AK-47 magazine vest filled with morphine ampules and other kit. He also carried scissors on a D ring. He said, "Most wounds had a little hole going in and a big one coming out. I really didn't know what to do with one guy, because I couldn't find a clear wound: some shrapnel must have got into him. He was alive when we put him onto the helicopter, dead before he got to Cu Chi." Fred Hillyard, a twenty-six-year-old West Pointer, felt that too often attacks lost momentum because of the priority given to casualty

evacuation, which vanished if a man was dead. He cited "the emotional attraction that one has to a casualty and how that changes once it's a KIA. The light inside of a body is so important that once that light is extinguished, you have a totally different emotional attention. . . . Then it's a logistics burden." Jim Williams said that when men broke off an attack to carry a casualty, "Part of that was just an excuse to get out of the fire, and it was killing us—literally—because once you lose fire superiority the enemy gains it and you're pinned down." He told his own company, "I don't care if it's your mother that goes down, you leave her lying there and you keep going."

A communist officer expressed skepticism about American soldiers for the usual reasons—"They carried too many luxuries, were too heavy, too slow. We could see them coming a long way off." Nonetheless, the NVA's fieldcraft was not always superior. American ambushes could be alerted to an approaching enemy by the same sounds they themselves generated—metal on metal, a clanking canteen, careless chatter. Once during a fire-fight in which Americans became momentarily unnerved, their spirits rose when a man began shouting taunts at the communists. Andy Finlayson again: "Soon all of us were laughing and yelling at the enemy to come and get us. . . . I am not sure whether it was the heavy volume of fire we poured in, or the laughing or the grenades, but whatever it was, the enemy stopped firing and moved away from us."

After a killing fight, men tried to gather to say a brief prayer over fallen comrades, though that indulgence had to be abandoned where casualties mounted. The practice of mutilating enemy dead was widespread. An October 1967 episode brought shame on the media: a CBS cameraman handed a soldier a knife with which to sever the ear of a dead communist for the benefit of TV viewers. Both the cameraman and his reporter fled the country rather than testify at the soldier's subsequent court-martial. It was well known, however, that men took such souvenirs. One day Walt Boomer's battalion medical officer led the captain aside and warned him that his men were collecting ears. Boomer gathered the company around him that night, sat them down, and said, "If you ever do this again, I'll kill you. What would your mothers say?" He believed tough leadership was

the only way to check excesses: "From cutting off ears you can spiral into terrible atrocities. My Lai happened because officers failed." Some men instead contented themselves with leaving an ace of spades on VC corpses.

John McNamara wrote home that he was appalled by the amount of loose talk about the need to employ terrorist tactics against terrorists: "Just a few years ago it was confined to the fringe. If the actual [US military] establishment ever start going that way—good grief. Quite decent people become frustrated. . . . Beware the wrath of the centurions." With the 1st Air Cav, Don Graham felt "really proud" when he saw a colonel relieve in the field a company commander whose men had wantonly burned civilian homes.

Even if religious faith was on short ration—less than one man in five attended regular services, and two-thirds never did—most did plenty of praying. During September 1967's Operation Swift, chaplain Vincent Capodanno comforted a casualty by saying, "Stay calm, Marine. Someone will be here to help soon. God is with us all here today." The man later testified that Capodanno's presence had given him an extraordinary sense of peace. The chaplain was killed soon afterward, awarded a posthumous Medal of Honor, and declared a Servant of God by the Catholic Church. Capodanno's mere presence at the sharp end won the respect of his flock, though this could be overdone. James May described his own unit's man of God seeking to showcase his brotherhood with the soldiers by delivering obscene imprecations, such as, "Please, God, let the bombs fall straight on the little yellow motherfuckers." Another chaplain was photographed carrying a rifle and grenades; yet another liked to take shifts as a helicopter door gunner.

A unit in the field usually halted at late afternoon, where possible on higher ground, commanding a view. Men finished the day coated with red dirt baked in sweat, which it became ecstasy to scrub off with sand in river water, if there was any nearby. Walt Boomer made his men shave. "I wanted them to think with the cunning of animals, but I didn't want them to become animals." Few officers dared to enforce such discipline, however, especially as the war grew older and sicker.

Most evenings began with digging, which everybody hated, though it

often made the difference between living and dying. Good units sank twoman foxholes forty inches deep, cursing the rocks and roots they encountered below the thin surface layer of clay. When rain came, as it so often did, biblical torrents collapsed fighting holes and makeshift poncho roofs, prompting an orgy of obscenities. After they had dug, they cooked, usually on a stove improvised from a C-ration tin punched full of holes fueled with small pieces of C-4 explosive, which hissed and flared to a white-hot flame. There was trading and bitching about who got to eat what. Everybody liked canned fruit and pound cake, while nobody relished ham and lima beans except Walt Boomer. Most men preferred LRRP recon packs to C-rations, but the former were hard for infantry units to get their hands on. Some men made elaborate messes, for instance extracting the potatoes from a meat-and-potatoes can, mashing them with dried cream substitute, while cooking the meat and gravy in a canteen cup. They brewed instant coffee or cocoa, finished with crackers perhaps spread with melted cheese, shakes of tarragon leaves, and onion chips.

After two weeks out, everything tasted the same, and sometimes they thought themselves lucky to get fed at all. If the weather closed in, a "skate"—air resupply day, with mail and maybe beer—was canceled. Most units occasionally found themselves hungry, though never remotely as ravenous as their enemies. The worst peril was exhausted radio batteries, a special risk for deep-penetration patrols. Dead communications cut their air hose to fire support, rescue, maybe even survival. Almost everybody smoked, and cigarettes came in C-ration sundry packs along with candy, razor blades, toothpaste and brushes, writing paper and pencils. Pills played a big role: they sucked salt tablets and purified their water with halazone, which made it taste like iodine and gave them the shits anyway, for which they took two Lomotil tablets four times a day. They swallowed daily malaria tablets—under a corpsman's eye, because some men yearned for fever, to escape the bush. In 1967-68, while drug abuse increased, it was mostly confined to the rear: officers and NCOs still had sufficient clout to keep men clean in the field.

In the evenings, in their hammocks or prone on flattened C-ration cartons after a skate, some men took out battered paperbacks. Andy

Finlayson read voraciously on OPs—observation patrols—far from any firebase. He soaked up history, political science, anthropology, Conrad, Hardy, Hemingway, Updike, and the Japanese classic The Tale of Genji. Comics were more popular, however. Harold Bryan was sometimes reduced to reading the Bible his mother had sent him, "when I couldn't find any Playboys." Those who couldn't read talked. David Rogers: "You'd think about home—'What are they doing now?' I had a friend, a sergeant, who liked to play word games. We'd been through a lot, and were very close." Sooner or later, all talk got around to the universal obsession: DEROS, Date Estimated Return from OverSeas, which each man carried burned into his heart, especially when he was getting "short." The 101st Airborne's signature "boonie-rat song" started: "I landed in this country / One year of life to give / My only friend a weapon / My only prayer to live." Some men in the field carried "short-timers' sticks"—elaborately carved walking canes; others confined themselves to calendars and folk art on which they marked off the days. Nonetheless, it was thought unlucky for a new man to ask old sweats how long they had been there, before they saw fit to tell him.

John Del Vecchio wrote, "For many soldiers Vietnam was depression, despair, a valley of terror. Much of the anxiety came not from the NVA, not from the jungle . . . [it] came from being taken away from wives and friends and family and being totally out of control." Some men wrote letters, others made audiotapes. A few were crass enough to include recordings of the noises in their lives, mortars and dime-nickels-the 105mm guns. The tapes were vivid, sure enough, but frightened the bejeezus out of hapless folks back home. Meanwhile many idle soldiers clowned. Tim O'Brien wrote, "The average age in our platoon was nineteen or twenty, and as a consequence things often took on a curiously playful atmosphere, like a sporting event at some exotic reform school. The competition could be lethal, yet there was a childlike exuberance to it all, lots of pranks and horseplay." Some, whether willfully or through lack of mental equipment, took this spirit into the field, and paid. One boy was "always playing around." One morning he did his playing outside the perimeter, triggered a mine, and lost a leg.

During the hours of darkness, most men's sleep was interrupted by a stint on watch. If out with a patrol, they were tiptoeing in their fear of stepping on something lethal, striving to avoid stumbling over a mangrove root or falling off a paddy dike. Everybody hated night patrols, knowing that their silent movement skills were imperfect, especially in the dry season when every stick and leaf crackled under the feet even of practiced "ghost walkers." In darkness the communists could move freely into hamlets and villages, knowing that it was unlikely they would find Americans or Southern troops. Walt Boomer: "At night we weren't there, and the Vietcong was."

Most often, commanders contented themselves with putting out ambushes, anything from a hundred to a thousand yards out. Sgt. Jerry Ledoux said, "I always stayed awake, and it shocked me because I had guys actually snoring when they were supposed to be on watch. Some people just didn't realize that, hey, this is not a game, this is a life-and-death thing." Capt. Joe Tenney agreed: "Too many men slept on watch, without their officers or NCOs checking up on them." Even if a squad on ambush was awake, when large numbers of enemy appeared it became a judgment call whether to fire or stay mute. Wayne Miller sometimes got so cold, wet, and miserable that he urinated underneath himself, partly for the relief of the hot wetness and partly because it was so dangerous to stand up and do it anywhere else—plenty of men got shot by nervous buddies. In a dozen contacts during Miller's eight months in the field, he never knew whether his shooting hit anybody, but one night he was nannying a Claymore in an ambush when three enemy walked by. He had been instructed to do nothing until somebody fired. Sure enough, the first shots caused the Vietnamese to dash back up the trail, pausing momentarily in front of Miller's hiding place. He touched the hellbox that tripped the Claymore and watched with horrified fascination as these human bodies disintegrated before his eyes.

As a 1967 company commander, Walt Boomer said, "I realized that I only became effective after several months. But as soon as that happened, you were pulled out." In his last weeks, up near the DMZ, "our mission was to find North Vietnamese. It was pretty brutish living. We

were always on the go—once out for forty-five days with no shower. We lived like animals—and didn't accomplish much. The enemy would either find us on their terms, or occasionally we'd find them on ours: the North Vietnamese soldier knew that if he came square on with us he was going to die. We didn't understand that no matter how many we killed, it wasn't going to be enough."

4. GUNS

In close country, the infantryman's personal weapon was what counted, and cost Westmoreland's army a crisis of confidence. The most technologically advanced nation on earth equipped its infantrymen with a gun inferior to that which armed most of Hanoi's soldiers. This assertion demands qualification: on a shooting range, the US rifle was much better. Not in the boondocks, however. The supreme virtue of the communist AK lay in its empowerment of an ill-trained peasant to deliver automatic fire after the immersion of himself and his weapon in sand, mud, or water, despite a paucity of maintenance that would cause most M16s to refuse duty.

The AK-47, numbered for the year of its prototype, was invented by Russian designers led by Sgt. Mikhail Kalashnikov, a Red Army tank veteran wounded in 1941, who was thereafter employed as a small-arms specialist. The gun's inspiration was an intermediate $7.62 \times 39 \, \mathrm{mm}$ cartridge, devised by the Germans for medium range—fifty to two hundred yards. Kalashnikov and his collaborators took this relatively light round and built around it an absurdly simple assault rifle, of which the firing mechanism owed something to the American M1. Its reliability derived from having only eight big, heavy moving parts, assembled so loosely that grit did not trouble them. Chromium-plating of the barrel lining, gas chamber, and piston increased the gun's durability. Its only vices were a tendency to shoot slightly left and a loud *clack* when the change lever was shifted.

The AK-47's inaccuracy was unimportant: it enabled guerrillas to deliver heavy fire, usually semiautomatic or in short bursts. Nearly a hundred million copies have been manufactured since 1947 at factories throughout

the communist world. The Kalashnikov has been the most influential single firearm in history, the revolutionary's weapon of choice from Angola to the Philippines, instantly recognizable by its banana-shaped magazine. In 1963 the Chinese began to supply North Vietnam with their Norinco-56 variant, which became responsible for killing or wounding more American and South Vietnamese soldiers than any other weapon in the theater.

In the Korean era, the US Army viewed the AK with contempt, as a mere submachine gun. The Pentagon rejected a 1953 British proposal to equip NATO with a similar .280 caliber light assault weapon, preferring its own M14 long-range semiautomatic rifle, almost four feet long and weighing twelve pounds. In October 1962, however, Robert McNamara wrote to Army Secretary Cyrus Vance: "I have seen certain evidence . . . which appears to indicate that with the M14 rifle, we are equipping our forces with a weapon definitely inferior in firepower and combat effectiveness to the assault rifle with which the Soviets have equipped their own and their satellite forces worldwide since 1950."

The Army had nothing on its shelves with which to respond to this call for a new American weapon. It turned to Colt's, manufacturers of a small-caliber rifle designated the AR-15 ArmaLite. This was originally created in a workshop in the Hollywood garage of George Sullivan, a Lockheed aero-engineer fascinated by small arms. Sullivan hired Eugene Stoner, an ex-Marine with an ordnance background, to lead a design group. Fairchild Aviation bought their company, which produced several guns that never entered mass production, but roused armed forces interest. Stoner's AR-15 cvolved into a handy 5.56mm weapon weighing 6.35 pounds unloaded, 39 inches long, clad in black plastic. In 1959 Fairchild sold ArmaLite to Colt's, which began to promote the AR-15, manufactured at its Hartford, Connecticut, plant.

First field trials in Vietnam generated enthusiasm, especially for its accuracy and lightness, but there were concerns that the ArmaLite's high-velocity bullet was prone to shatter on impact, creating a dumdum effect and thus possibly breaching international law. Macabre secret experiments were performed at the Army's Aberdeen Proving Grounds in Maryland on live angora goats and severed human heads and limbs imported from

India. These concluded with the good news that the AR-15 did more cranial damage than the AK-47 or M14. In January 1963, Earle Wheeler reported that the new gun was plainly superior to the Kalashnikov. He admitted some doubts about its reliability, but said these could be "readily corrected." In December the Pentagon placed a first big order for 104,000 rifles, now designated M16s, though hesitation persisted about their general issue: the Marines wanted a different model from the same stable, the Stoner 63.

By 1965, the M16 was still under field testing, and earning mixed reports. Lt. Col. Hal Moore gave the gun a rave review after the 1/7th Cavalry used it in the Ia Drang Valley battle, and this persuaded Westmoreland to get behind it. Colt's meanwhile lobbied on Capitol Hill, exploiting media reports that soldiers in the field felt undergunned, fighting against the AK-47 with the old M14. The influential Senator Richard Russell phoned McNamara on December 7, and said laconically, "Buy a hundred thousand rifles today, or I'm releasing the story to the press." Contracts were signed. Colt's had posted a financial loss in 1963, but the M16 launched it into boom times: the new weapon would eventually sell eight million copies.

However, grievous design flaws were becoming apparent just as general issue began. The Army's insistence on a weapon capable of long-range fire, effective at five hundred yards, imposed huge strains on the working parts of a light automatic weapon, especially when its cartridge was filled with so-called ball powder, which causes superenergetic detonation and heavy barrel fouling. *Shooting Times*, the civilian gun enthusiast's bible, experienced repeated malfunctions with a test M16. Its published report assumed that these would be corrected before military issue, but they were not. The gun's historian C. J. Chivers has written, "The army and Colt's had effectively put a prototype into mass production, and were fine-tuning it as it failed in the troops' hands."

Through 1966, soldiers fighting in Vietnam suffered insistent problems with their new weapons, which corroded fast in tropical conditions. After a round was fired, the empty case often jammed in the chamber. It then had to be extracted, maybe under fire, by a soldier pushing a rodif he was fortunate enough to have one—down the barrel. There was a chronic shortage of cleaning kits, which caused many men to rely on phone wire or nylon cord to pull through. Some men wrote home, asking their families to buy and send out cleaning rods. Of 2,000 early M16s tested by armorers, 384 malfunctioned.

The real scandal of the rifle began here. Behind closed doors, the US Army knew it faced a crisis: it was equipping infantrymen with a tool unfit for mortal combat. For months, however, it strove to hide this. "Teething troubles" were blamed on soldiers' sloppy cleaning practices. Col. Richard Hallock of the Army's Advanced Research Development Agency led a campaign to conceal the M16's deficiencies, above all from Congress. He placed a SECRET KEEP CLOSE stamp on an ARDA memorandum about the rifle. An institutional cover-up was launched to ensure that the M16's rollout could continue uninterrupted. In February 1967, Marines began to receive the weapons in Vietnam. When users protested about jams, these were blamed on their own clumsiness. At a Danang press conference, Lt. Gen. Lew Walt insisted that his men were "one hundred percent sold" on the new rifle. MACV warned its information officers to admit nothing about M16 malfunctions.

Angry Marines and soldiers nonetheless began writing home. On March 26, 1967, the Washington *Daily News* broke the story, asserting a growing belief among grunts that the communists' old gun was superior to the Americans' new one. Extraordinary tales began to seep back, of firefights during which scores of men found themselves grappling with jammed weapons. After one action, a Marine was quoted in a US local paper, the *Asbury Park Evening News*, saying, "You know what killed most of us? Our own rifle. . . . Practically every one of our dead was found with his rifle tore down next to him where he had been trying to fix it." This was surely hyperbole, but Congress started taking notice. On May 20, 1967, a representative from New Jersey sent the *Asbury Park* clipping to McNamara, who could not thereafter plead ignorance.

This was the time when Marines were engaged in the so-called Hills battles, in which more than 150 died, some of them carrying guns that would not shoot. In July, the 2/3rd Marines suffered crippling losses amid

4IO · VIETNAM

continuing difficulties with M16s. Capt. Gerry Turley described his own battalion's changeover as "a disaster. . . . We were just told, 'Put the M14s on this pile, and take M16s out of that one.' There was a 75 percent increase in weapon malfunctions. We complained and they just shrugged. 'Clean 'em better.'" When the battalion lost all five of its company commanders in thirty days of intensive action, some officers blamed the high casualties explicitly on the new weapon. Turley said, "Can you imagine the effect on that infantry battalion? The morale factor was absolutely disastrous."

A twenty-three-year-old lieutenant named Michael Chervenak wrote home, detailing how in one firefight forty weapons malfunctioned in the company of which he was executive officer. He dispatched copies to his congressman, to Bobby Kennedy, and to newspapers headed by the Washington Post, which published the letter on October 29. The Marine Corps responded by investigating not the rifle's flaws, but instead the alleged crime of the letter writer, and Chervenak received a formal reprimand. Yet a Colt's representative in Asia, Kanemitsu Ito, wrote to his employer stating that the allegations about its product's shortcomings were justified. He himself had addressed a meeting of Marines, which he likened to encountering "a den of angry, ferocious lions." Ito said that most of the men hated their new rifle, "and had a right to hate it." Colt's responded to the private intelligence and published allegations with a barrage of lies. The company stubbornly refused to admit that there was anything wrong with the rifle. Late in 1967, M16s were dumped from helicopters onto one Marine battalion in the field, without benefit of familiarization training. Walt Boomer said, "That was a nightmare. In one ambush half the rifles malfunctioned. I've always loved the Marine Corps, but I've also held them accountable for stupid things." Likewise, Judd Kinne "always thought the M14 was a better weapon."

Enthusiasm for the rival AK-47 was not universal. A South Vietnamese officer whose men tested the guns reported that most eventually relinquished them, saying that it was hard to change their magazines on the move, they were prone to rust, and they rapidly became less effective when intensively fired. The US Army and Marine Corps learned to live with the M16, and to fight with it; more cleaning equipment was issued. Some of the problems identified in 1966 were solved in two years: a modified version with a new buffer and a chromium-plated bore worked better. Yet the fundamental fact remained that, while the M16 was a much more sophisticated tool than the Kalashnikov, it was not as robust. It is also debatable whether issuing US forces in Vietnam a rifle that could squirt off a magazine in three seconds promoted their best interests. In significant respects, the M16/AK-47 story may be considered a paradigm for the military difficulties that beset US efforts to preserve South Vietnam.

Like many unsophisticated people, William Westmoreland enjoyed the limelight, at least until its glare destroyed his reputation. One day when MACV's chieftain visited the 1st Air Cavalry, Don Graham traveled for a few hours with the great man and his three aides. He asked one, "Sir, what exactly do you do for the general?" He replied, "I carry his cleanly pressed uniforms so he does not look disgusting when he meets the troops." In November 1967, at the behest of Lyndon Johnson, the general paid a high-profile visit home, to lend his weight to assurances that the war was going fine.

Privately, Westmoreland thought nothing of the sort; he was demanding many, many more soldiers. He nonetheless did the job that his commander in chief wanted. The Washington Star used his words in a November 7 report headlined, in a military sense the war is just about won. Bob Considine of the Philadelphia Inquirer echoed the general's song when he wrote, "Stop griping. We're winning this lousy war. It is not, repeat not, a stalemate." On November 21, Westmoreland told the National Press Club, "The enemy has not won a major battle in more than a year. . . . He can fight his large forces only at the edges of his sanctuaries. . . . His guerrilla force is declining at a steady rate. Morale problems are developing." Even James Reston, a longtime skeptic, felt obliged to treat with respect Westmoreland's expressions of confidence. After the National Press Club appearance, loyalists and patriots throughout America rallied behind their

commander in chief and his general. More than that, they grew increasingly strident in denouncing naysayers. At the AFL-CIO union convention on December 2, Secretary of State Dean Rusk actually compared antiwar protesters to Hitler's stormtroopers.

In a different vein, Capt. John McNamara wrote home, "Between the VC/NVA and myself there is an honest and mutually shared respect. . . . We're approaching a situation frighteningly like the French—militarily indomitable [but] politically hopelessly fragmented." Don Graham exchanged letters with his mother, Kay, back home, where she owned the Washington Post. He said afterward, "I was confused then about what we should have done, and I'm confused now. By the time I went home [in July 1968], I thanked God I was out of there, and I would not have recommended to anyone else that they should go. We could be there twenty years without making any difference. The central fact was that we couldn't find the enemy." Graham viewed the war from what might be called a privileged low level, but he was right.

NVA officer Pham Phu Bang was awed by the American assaults in Tay Ninh Province during the February—March 1967 Operation Junction City. "They just kept coming and coming." His men found themselves running out of food, medical supplies, weapons, ammunition. Bang was convinced his last hour had come when his unit was ordered to serve as rear guard in a blasted forest, while the rest of the division pulled out. Hour after hour, they lay over their weapons waiting to fight, and to die. Yet the Americans passed them by. Slowly and almost disbelievingly, Bang and his men understood that they would live to fight another day—indeed, many more days.

Neither the communists' energy nor savagery seemed much diminished by all their foes' sweeps, patrols, and cutely code-named air assaults. In December 1967, having occupied the Montagnard community of Dak Son in the Central Highlands, they killed more than 250 of its 2,000 people before burning the village. And at Dragon Court, North Vietnam's generals were planning much bigger things.

OUR GUYS, THEIR GUYS: THE VIETNAMESE WAR

1. SONG QUA NGAY—"LET'S JUST GET THROUGH THE DAY"

Doug Ramsey, before his capture, often risked joyriding with John Vann in a bright yellow pickup pockmarked with bullet holes, for the simple pleasure of gazing on the Vietnamese countryside. He wrote: "As we passed field after lush field of ripening rice, we would watch the fat kernels of grain turn slowly, then rapidly, from straw color to sunset saffron to burnished copper in the afterglow. We had enjoyed the cool, moving air, the visual and aural panorama and the pungent rural odors as if we had been small city children on the way to camp for the first time. Occasionally, we would stop for a minute or two in some red-tiled or thatch-roofed hamlet, where the people were settling in for the evening as they and their ancestors had done for hundreds of years—while we ourselves tried for a little while to forget lifeless memos and lifeless bodies and rediscover what ordinary sane life and ordinary sane beauty and truth in ordinary sane people were all about.

"I knew, of course, that all of this had to vanish from the landscape someday—probably rather soon, and be replaced by the appurtenances of the eighteenth century, if not the twentieth. I also knew that my wistful, romantic images masked harsh realities of backbreaking, lifelong heavy

manual labor, perpetual semipoverty, progress-thwarting superstition, and short life expectancy suffered by probably 90 percent of the population." Over a decade, the war doubled the country's city dwellers, to 40 percent by 1970.

Life is what you are used to. Young Vietnamese accepted the conflict as their natural environment, along with paddies and palm trees. Nghien Khiem said of his schooldays, "We learned to run when we heard a rocket, and otherwise not to worry much." Yet the struggle determined the life courses of all but the most privileged. Phan Tan Nguu cherished ambitions to exploit his college chemistry major to work in pharmaceuticals. In 1966 in South Vietnam, however, he saw no choice but to join some element of the security forces, and he became a police Special Branch officer. He ever afterward sustained a tinge of regret for that lost career: "I was successful in the service, but policemen carry that stigma. . . . " Everywhere that US military might held sway, local people earned dollars but also paid a toll: on successive nights, truck drivers of a field artillery unit on road runs to Qui Nhon first killed a six-year-old Montagnard girl, then hit an elderly woman outside Kontum. One of the drivers thought it comic to sound his deafening horn behind a bike rider who swerved into the bush, catching a foot in his wheel spokes, with agonizing consequences. A fellow driver said later, with the mortification of maturity, "That's how some Americans behaved"

The rival capitals had assumed mantles of decay, Hanoi's the grimmer. In the later 1960s, the austerity of North Vietnamese life was intensified by an infusion of the spirit of Mao Zedong's Cultural Revolution. Children attended state nurseries; agricultural collectivization was rigorously enforced and private property increasingly frowned upon. Such measures were readily justified to Ho Chi Minh's people by the imperatives of the unification struggle, and the crimes of the American imperialists. The Soviet Union was now explicitly branded as revisionist.

Saigon's condition reflected a preoccupation with the war to the exclusion of almost all else, including street cleaning. In the 1930s, the city's Phu Tho racecourse had been almost as elegant as Paris's Longchamp. By the later 1960s, however, the red-and-yellow grandstands were crumbling,

and dragonflies swarmed in the paddock. There were still occasional Sunday meetings at which featherweight eighty-pound jockeys rode horses that disliked the heat as much as any grunt, though they facilitated manic gambling. Yet it would have been rash to bet on which side in the war even the flashiest spectator supported. Consider Truong Nhu Tang, boss of the Société Sucrière d'Annam, which employed five thousand people. He lived the smart social life, owned a beach house on Cap Saint Jacques, vacationed in Dalat, played tennis and the "four color" card game at the best houses, yet was secretly a top NLF cadre.

He survived a 1965 denunciation, being fortunate enough to be released to return to his big office at the Société after six months in jail. Two years later, however, he was betrayed by Ba Tra, a cadre who defected to the government and was later assassinated by the Vietcong. Tang painted a vivid picture of the Saigon prison to which he was consigned: "The scene that presented itself . . . struck me with a horror and fear so terrible that I felt I had lost my soul. Sprawled out on the floor the whole length of the corridor were people chained together by the ankles. Many of their faces were bloody and swollen; here and there, limbs jutted at unnatural angles. Some writhed in agony. Others just lay, staring blankly. From the tangle of bodies came groans and the sound of weeping. The air was filled with a low, continuous wail. My heart began to race. One side of the passage was lined with doors that apparently led to interrogation rooms. From behind these came curses and spasmodic screams of pain." Tang, a privileged person in the eyes of both sides, with access to big money, escaped lightly. His wife bribed his principal interrogator \$6,000 to spare him from torture. Later she paid another \$5,000 to the president of the tribunal that tried his case—a man who afterward became Thieu's chief security adviser—to secure a sentence of just two years' imprisonment, after which 'Tang joined his NLF comrades in the jungle.

In Southern life, family ties counted for at least as much as ideology. The CIA's long-serving Saigon officer Frank Snepp loved and admired the Vietnamese but rejected Frances FitzGerald's idealized view: "She wasn't writing about the Vietnam I had to deal with. I didn't see them vibrating with anti-colonialist intensity. They seemed intensely pragmatic: South

Vietnam was an endless series of accommodations." President Thieu's psywar chief sheltered in his house a sister-in-law who had run a communist cell in Hue. The army chief of staff protected two of his wife's nephews whose father was a top communist. Tang's daughter Loan was a close friend of Thieu's daughter Tuan-Anh: the president continued to welcome the girl into his home even after Tang was revealed as a traitor and—much to Thieu's credit—eventually sponsored Loan's computer science course in Pennsylvania.

While the country retained peerless natural beauties, much of it was polluted by the war, in a fashion evidenced by its seventy-seven orphanages and two hundred thousand child delinquents. Some farmers, weary of seeing their paddy fields wrecked by the passage of military vehicles, abandoned rice growing, promoting the drift to the cities. A permanent chemical pall hung over Saigon and its adjoining military suburbs of Long Binh and Tan Son Nhut. Almost every street was rutted and potholed by neglect, excesses of climate, and traffic, the last increased from 1967 onward by a tsunami of Honda mopeds. Piles of cement and rubbish were as ubiquitous as security barriers, barbed wire, and belching black truck diesel smoke.

Shantytowns had sprung up alongside the Saigon River and its adjoining canals. Everywhere artisans hammered, sawed, and screwed at outdoor workshops, while each of many of the capital's streets offered its own specialized goods and goodies for sale: kitchen equipment in one, electric fans in another, elsewhere air conditioners, bicycles, clothes, books, cameras, replica military fatigues for children, fish sauce, soups, vegetables, nuts, oranges, frog and eel in garlic, rice alcohol thinly disguised as Scotch or bourbon. There were also girls: in prodigious quantity, of considerable beauty, wearing excessive makeup and expressions that ranged from absolute ruthlessness to profound melancholy. There were still islands of romance in Saigon, but squalor dominated. It was a matter of ideological taste whether Hanoi's uniform socialist drabness was preferred.

The war was happening in the countryside. Villagers often said to Vietcong fighters, "It's easy for you. All you have are your guns and your packs. You can go and live anywhere. But we have our wives, children,

rice, gardens, and we cannot take them with us. It is difficult enough to get the buffalo to follow us. So we must stay here." Many adopted the fatalistic motto *Song qua ngay*—"Let's just get through the day." An important element in the communists' successes was that they worked with the grain of rural society more effectively than did the Saigon regime. They spread rumors that "round eye" inoculation programs were really punishments for supporting the VC and would make children infertile. An American pest control expert insisted on ignoring warnings that farmers made a good thing out of selling rats for the table.

A US initiative to improve soldiers' rations substituted for *nuoc mam*—the fermented fish sauce that all Vietnamese love—soy sauce imported from Korea, which they hated. "Miracle rice" boosted harvests, to farmers' initial delight; soon, more than half of South Vietnam's production derived from these revolutionary strains, which became jocularly known as Honda rice, because the profits enabled growers to buy mopeds. Unfortunately, "miracle" varieties also required heavy inputs of fertilizer and pesticides; when American aid later shrank while oil and fertilizer prices soared, South Vietnamese rice producers were crippled.

Few rural people looked on the government as a force for good, instead viewing it as a remote entity that taxed them and took away their young men. The communists did the same, but were more skillful in presenting their imposts as benign. While ARVN troops plucked at will peasants' fruit and poultry, an American prisoner marveled at the VC's respect for the edible property of others. "Our line of march carried us through a vegetable garden. But because it apparently belonged to a sister unit, none of the guards gave in to the temptation to grab even a handful of cabbage leaves—this despite the fact that most of them hadn't seen fresh vegetables for more than a year." Australian Dr. Norman Wyndham wrote in Vung Tau, "The peasants want nothing more than peace. They have nothing to lose, so they do not fear that any new government can take anything away from them."

Creighton Abrams characterized Saigon's district chiefs as "so incompetent that assassination would be counterproductive." Almost the only rural inhabitants of South Vietnam who thought well of its government

were a small minority who had experienced life in the North, including an old village chief named Ngo Dinh Ho. In 1967, he described to a British journalist his youth under the communists as ten years of "earthly hell." Many of his neighbors on Phu Quoc Island, off the Delta, were likewise fishermen originally from the communist state. "This red earth is very good," said Ho. "If only we could get rid of the Vietcong it would be just like heaven—just like a dream of women. . . . I'm very grateful for the help given by the United States." If there had been more Vietnamese who had shared Ho's life experience, the war might have had a different outcome.

2. FIGHTERS

It was a tough year for communist forces in South Vietnam in 1967. A soldier of the NVA's 3rd "Yellow Star" Division described how its units were harrowed by crippling losses: "Having gone into battle strong and keen, when they returned a whole company might consist of just four to seven men sitting eating around a single tray of rice." After receiving a mauling at the hands of the 1st Air Cavalry, "Our soldiers could not help being frightened and confused." The same soldier asserted that after one battle in the winter of 1967, his own battalion—"ripped to shreds"—was reduced from a strength of 240 men to 38. Yet still it was obliged to fight on.

The dramatically increased US troop presence increased pressure on the Vietcong in the Mekong Delta, where most of the terrain was less suited to guerrilla activity than the hills and jungle farther north; no tunnels could be dug. NLF efforts to maintain their dominance, partly through a resumption of murders of alleged government sympathizers, sometimes smacked of desperation. Naval offshore and riverine patrolling almost shut down the communists' sea supply line from the North, which since 1963 had played a critical role in the campaign.

Henceforward northern South Vietnam and the Central Highlands, more readily accessible from the Ho Chi Minh Trail, would provide the communists' favored big battlefields. The country's wildernesses were so vast that, even despite the sophistication of American surveillance technology, they could sustain permanent base camps. Andy Finlayson described one that his long-range patrol encountered near the Laotian border, concealed by the hundred-foot-high jungle canopy and protected by a bamboo fence, thickets of sharpened punji stakes, and bunkers. "At each end of the fortified village was a guard tower on ten-foot-high stilts. I counted eight well-constructed huts, each large enough to hold a squad of enemy soldiers. There was a large animal pen with pigs in it, a hut used as a kitchen, a raised stage with a roof over it, and a very large two-story building made of finished lumber, bamboo, and thatch with a balcony. The size and sophistication of this camp shocked us."

In one or other such place, shifted periodically between 1966 and 1973, Doug Ramsey and a handful of other American prisoners enjoyed unusual opportunities to study communist fighters. Ramsey wrote, "The best of the VC and NVA... suffered chiefly from the defects of youthful exuberance, the arrogance of the true believer, and sheer ignorance concerning the West." The American discerned the same mix as in all clusters of humanity. "There were truly beautiful people and spaced-out sadomasochists. There were spindly bookworms and big-man-on-campus types; loudmouths and shrinking violets; city sophisticates and raw hay-seeds; intellectual snobs and intelligent people genuinely interested in the pursuit of truth... I felt safer in the hands of the VC than I believed I would have been in the custody of certain American hate groups of the far left. A good case could be made, that we were a more violent people than the Vietnamese."

His captors were wonderfully kind to children, unspeakably barbaric to animals: Western visitors to the Saigon Zoo remarked on the enthusiastic audiences for the feeding of live ducklings to the snakes. Ramsey, like many Americans, noted a distinction between the appetite of North Vietnamese people for indoctrination, to which they had grown accustomed, and the indifference of most Southerners, committed merely to the eviction of foreigners and a better life for the peasantry. POW interrogator Bob Destatte agreed that ideology was much subordinate to hatred of foreign influence: "Even many Party members had joined just because it was the practical thing to do." Most of the guerrillas whom Doug Ramsey

encountered were aged between twenty-five and forty, far more experienced fighters than their American counterparts. They shrugged fatalistically and said, "Thoi ke me no? Bao nhieu thi bao; cu danh giac hoai vay thoi!"—"Hell, what can we do about it? We can talk until we're blue in the face, but we'll just have to keep on fighting." Many yearned for some decisive step—a showdown, no matter how perilous—which goes far to explain their eagerness to participate in the 1968 Tet offensive.

A vivid insight into the mind of an ardent revolutionary is provided by the diary of a young woman doctor in the mountains of Quang Ngai Province. Unlike many other communist narratives, this document was neither censored at the time nor later embellished. Dang Thuy Tram was twenty-four, daughter of a distinguished Hanoi surgeon, when in 1967 she made a ten-week march down the Trail to work at a Vietcong field hospital. The guiding passions in her life were unrequited love for an NVA officer whom she had known since her teens, and hatred for the American "bandits." She wrote of her yearning for Party membership, dismay that her supposed "intellectual" background threatened to thwart this ambition. "Why do they fill the path of a bourgeois with spikes and thorns?" she asked. "No matter how much effort you have shown through your achievements . . . you are still below a person of the laboring class who has only just begun to comprehend Party ideals." She was ecstatic when at last she secured the coveted badge.

Tram often wept over the deaths of VC fighters whom she tended: "One comrade falls today, another tomorrow. Will such agonies ever cease? Heaps of flesh and bones keep piling up into a mountain of hatred rising ever higher in our hearts. . . . When can we drive the whole blood-thirsty mob from our motherland? . . . If some day we find ourselves living amid the fragrant flowers of socialism, we should remember this scene forever, recall the sacrifice of all those who shed blood for the common cause." Although such phrases seem parroted from a lexicon of propaganda clichés, their sentiments nonetheless suffused this young woman's soul. When a comrade poured out to her a declaration of love, she responded sternly: "My heart has banished all private dreams to focus on my duties. . . . Could anything make one more proud than to be part of this

family of revolutionaries?" One of her young comrades named Luc was sufficiently sensitive to natural beauty that he liked to sing in their camp:

O mountain and river, how beautiful, When the moon lights the hills, clouds fly beneath the feet.

But Luc also affected a red scarf with the words PLEDGE RESOLUTELY TO SACRIFICE FOR THE NATION'S SURVIVAL stitched into its fabric, and he was wearing this when he was killed attacking Duc Pho district center.

The fervor of committed revolutionaries like Luc and Tram impressed some Americans. Jack Langguth, a reporter who covered the war for the *New York Times*, wrote in a subsequent book, "North Vietnam's leaders . . . deserved to win. South Vietnam's leaders . . . deserved to lose." This view, quite widely held among correspondents, was influenced by daily encounters with the cruelties and bungles of the Saigon regime and its American mentors, while those of the communists took place out of sight. Citizens of modern liberal democracies, many of whom exercise the privilege of their freedom to care more for the fate of a sports team than about politics, are often impressed by true believers in other cultures. Yet history's least humane movements have also inspired and perverted young men and women to sacrifice all in their name. It is unsurprising that foreigners in Vietnam favorably contrasted the commitment of the communists with the corruption and lethargy of the Saigon regime. Yet this was only half the story.

Hanoi's success in the global propaganda contest was partially rooted in a policy of *omertà*, silence enforced by threat of murder. The oppression of its own people and the failure of its economic policies were curtained by censorship. No images of its war crimes existed. Only card-carrying foreign sympathizers were granted glimpses even of its scenery. French writer Jean Lacouture, a prominent contemporary apologist for Ho Chi Minh, told a Milan newspaper in a hand-wringing interview long afterward, "With regard to Vietnam, my behavior was sometimes more that of a militant than that of a journalist. I dissimulated certain aspects of North Vietnam at war . . . because I believed that the cause . . . was good

and just enough so that I should not expose their errors. I believed it was not opportune to expose the Stalinist nature of the North Vietnamese regime."

Propaganda policy enforced the exclusion from North Vietnam's state broadcasts and publications of all tidings not relevant to the national struggle. Thus, radio announcer "Hanoi Hannah" made no mention of the 1967 Middle East war, the 1968 Russian invasion of Czechoslovakia, or the 1969 American moon landing. Prisoner Doug Ramsey recoiled in disgust from a communist *True War Heroes* comic that extolled the virtues of a female suicide bomber. He hated Radio Hanoi's incessant war songs, "frightening in their obvious sympathy with and preference for violence, their narrowness of view, shrillness, tendency to find only hero figures and villains in Washington and Vietnam alike." He became weary of the marching song of the NLF:

Liberate the South!

We are staunchly resolved to march

To kill the American imperialists,

Smash and scatter their lackeys who sell our country.

Yet Bao Ninh's fine autobiographical novel *The Sorrow of War* helps to dispel the notion that communist soldiers were brainwashed automatons. Ninh—real name Hoang Au Phuong—was born in 1952 and spent four years in the South as an NVA infantryman. His harrowing narrative shows men driven by much the same forces as their American foes: camaraderie, a yearning for survival, dismay about the relentless loss of friends, obsession with a girl left behind. In one passage the writer's alter ego, the young officer Kien, resists with dismay a young comrade's attempted intimacy: "He hated any confidences. . . . Hell, if everyone in the regiment came to him with personal problems after those horrendous firefights, he'd feel like throwing himself over a waterfall."

Kien supports the Northern struggle but curls his lip in cynicism, knowing that its chief burden is borne by country boys permitted no voice in the decisions about their own lives and deaths. He himself, a highly educated young man, privileged by the standards of his society, loved those "friendly, simple peasant fighters whose extraordinary qualities had created an almost invincible fighting force." Pot-smoking grunts had company on the other side: Kien and his men experimented with drying and smoking the flowers and roots of *Rosa canina*, dog rose, which blossomed white in the rainy season, "its perfume filling the air, especially at night . . . fueling erotic, obsessional dreams. When we awoke the perfume had evaporated, but we were left with a feeling of smoldering passion, both painful and ecstatic."

When they smoked shredded flowers and roots mixed with tobacco, "after just a few puffs they felt themselves lifted, quietly floating like a wisp of smoke itself floating on the wind. . . . They could decide what they'd like to dream about, or even blend the dreams, like preparing a wonderful cocktail. With *canina* one smoked to forget the daily hell of the soldier's life, smoked to forget hunger and suffering. Also, to forget death. And totally, but totally, to forget tomorrow." Ninh's novel mocks the weary round of indoctrination: "Politics continuous. Politics in the morning, politics in the afternoon, politics again in the evening. 'We won, the enemy lost. The enemy will surely lose. The North had a . . . bumper harvest. The people will rise up and welcome you. Those who don't just lack awareness.'"

Americans could take for granted their daily rations, as their enemies could not. North Vietnamese officers observed to each other that "rice is the field-marshal of our army." One of them, Pham Phu Bang, described obsessional conversations about food with his close friend Thanh Giang. Month after month and eventually year after year, they also shared jokes—"yes, there were jokes"—and recitals of each man's alleged past love life. When at last Bang was terribly wounded in an air strike near Tay Ninh, it was Giang who dragged him to the rear, cut off his blood-soaked clothing, dressed him in a suit from his own pack. Bang found out only later that these were his friend's intended wedding clothes, which he had cherished pristine. Thanh Giang later became a successful writer, dubbed the Ernest Hemingway of Vietnam.

Col. Nguyen Huu An was an enthusiastic hunter who shot deer when

he found them, and occasionally his men met bigger game. "Once as we marched," he wrote, "word was suddenly passed back from the head of the column, 'We've got elephant meat. Hurry up!'" Every man quickened his pace. When An and his group reached the spot where the elephant had been killed, they discovered that soldiers had detonated a small explosive charge to expose its rump, because the beast's hide was impervious to knife thrusts. "One man was crawling out of its belly carrying big slabs of meat, men were pushing and shoving each other as they ripped flesh from the curved ribs, others were struggling to cut steaks from the rump. The most delicious parts—the trunk and four feet—had already been taken away. In just a few hours, all that was left were hide and bones." That happy place lingered in their memories, written onto NVA maps as Elephant Field.

Yet even hungry Northerners declined to eat everything. Bao Ninh tells of how his comrade "Lofty" Thinh one day shot a big orangutan, and summoned his squad to drag it triumphantly back to their hut. "But, oh God, when it was skinned, the animal looked like a fat woman with ulcerous skin, the eyes, half-white half-gray, still rolling. The entire squad was horrified and ran away screaming, leaving all their kit behind." Instead of eating the beast, they eventually bury it beneath a headstone.

Nor was hunger the NVA's worst privation. Natural hazards created by snakes, centipedes, and other poisonous creatures did not exclusively afflict foreigners, as Americans sometimes supposed. As for the weather, Vietnamese have a mournful little song of which one line runs: "The rain dripping off the banana leaves, drop by drop, tells us autumn has come." It was amazing that either side's fighters could find repose in the jungle during the wet season, their clothing forever soaked through, waterfalls cascading down their faces. "But," in Bang's words, "when you had marched eighteen miles that day, and probably eighteen more the day before, you fell asleep the moment you halted, rain or no rain."

They fell prey to diseases for which their medical officers had few remedies. One day in 1967, a Northern private surrendered to Saigon soldiers. He was suffering from acute malaria, for which he had been treated at a camp in Cambodia by a Northern doctor who chanced to be a relative.

This man told him he should "go *chieu hoi*"—defect—if he wished to survive: continued jungle life would kill him. He was admitted to a US Army field hospital needing massive blood transfusions: these were funded by contributions from twenty generous Americans, out of their own pockets. Restored to health, he joined a government armed propaganda company, exclaiming to a friend, "Long live Thieu, Ky, and the American imperialists!" He said that the only communist he still regarded with enthusiasm was the doctor who had advised him to go *chieu hoi*.

Chronic sickness—malaria and diseases brought on by vitamin deficiencies—afflicted even senior cadres at COSVN. Truong Nhu Tang spent two months of each of his six years in the jungle flat on his back, fighting fever. "Almost all jungle dwellers were marked by a jaundiced and sickly pallor." Hanoi's minister of health traveled South to explore ways of combatting malaria but died of it himself. A host of VC and NVA suffered from the debilitating misery of hemorrhoids.

American grunts felt far from home, but the North's soldiers endured almost absolute remoteness: they knew virtually nothing of what was happening in the world beyond their immediate experience. Traversing the Ho Chi Minh Trail was never less than hazardous, even now that trucks covered some stretches. The NVA's Col. An, recalled to Hanoi, offered a vignette: "Every night, hundreds of trucks and [other] vehicles stretched out in a long line. Once, as we drove, the whole column stopped suddenly and every vehicle turned off its lights. Enemy aircraft roared overhead, and we could see flares in the sky some distance in front. We sat there waiting for hours. I looked anxiously at my watch and saw that it was 0400—dawn coming soon.

"I walked to the head of the column to see what was happening. The night was strangely quiet. It seemed that there was nothing alive in the area and all I could hear was the buzzing of night insects. I pounded on the doors of the cabs of several trucks and asked loudly, 'Anybody home?' but got no answer. I listened carefully for a moment and heard the sound of snoring. Our car pulled out and drove on past the head of the convoy."

Shortly afterward, An was badly injured when a bridge collapsed under his vehicle, so that he eventually reached Hanoi swathed in bandages.

A jovial fellow colonel said, "After all these years in the Central Highlands, you finally get a chance to go home to your wife and those lips you had planned to use to kiss her are swollen up like balloons. What the hell are you going to do now?"

At regular intervals, an army mailman set forth down the Trail carrying perhaps sixty pounds of letters. It became a small miracle when any fraction of these survived bombs and weather to reach the army. "Quite often rain had made letters unreadable," said one soldier, adding that they cherished them anyway. "In good times, we might receive mail twice a year, but less often if things were going badly. When a letter reached a man, it was never his private property: the whole squad gathered, to hear it read aloud."

American and South Vietnamese operations forced communist units to shift camp often and fast. Young Dr. Dang Thuy Tram described her grief when forced to quit her mountain fastness. Intensely romantic, she had grown to love the primitive little hospital: "Perhaps nothing is sadder than the spectacle of an evacuation—the houses abandoned, stripped of furniture, devoid of life. This afternoon as I return to the clinic from the forest, the enemy is not far away—I look at the lovely houses, and my heart fills with hatred. . . . So much sweat has been expended on the laying of each stone and sheaf of straw. If we have to leave this place, when can we enjoy such treatment facilities again?"

Early next day, a long column of fighters, porters, and medical staff set forth, carrying the sick and wounded on stretchers, together with as many medical supplies as they could hump: "We trudge up the hill, sweat pouring down our faces, not daring to pause to rest. We are so exhausted I have to cajole some men to return and bring out the last three stretchers. Kiem, a wounded soldier with a broken leg, is on the last litter. . . . I call one of the students, Ly—a little girl—to help me carry him. He is big—too heavy for the two of us to lift. We . . . can only drag him a short distance." She found two guerrillas to carry Kiem to a hiding place. Next day, she looked back across the mountains and sobbed as she saw thick smoke rising from the ruins of her hospital.

Throughout the war, the US and Saigon regime devoted immense

and vain effort to destroying the NLF's headquarters, customarily located in some cluster of huts just inside or outside Cambodia. After Truong Nhu Tang's release from imprisonment, he described a two-week march through the Mekong Delta to reach COSVN, then sited on the Mimot rubber plantation, straddling the border in the so-called Fishhook area: "The first sign of it was a wooden barrier across the trail and a control point manned by about ten guards," from which other soldiers were summoned on bicycles to lead new arrivals to a guest hut, one among several hidden beneath the jungle canopy. The headquarters building, they found, likewise resembled a simple peasant hut. "Up close you could see the system of tunnels and bunkers that jutted off from it. COSVN was, and always had been, people rather than a place . . . a leadership group that implemented the directives of the North Vietnamese Politburo and co-ordinated the operations of the Party and the NLF."

Urban Party luminaries like himself found it hard to adapt to living "like hunted animals." His only possessions were two pairs of black pajamas, underpants, a mosquito net, and a few square yards of plastic, interchangeable as bivouac roof or raincoat. VC fighters had the same, adding only "elephant's guts"—the long tubes of rolled cotton filled with rice that they carried slung over their shoulders as they marched. Constantly hungry, they grew vegetables and killed wild animals to supplement their meager diet. When they stayed in one place long enough, they also raised chickens and pigs, destined for cooking in Hoang Cam stoves, named for a guerrilla commander who devised a horizontal chimney that diffused smoke. At one time or another, the NLF leaders are elephant, tiger, wild dog, monkey, none of which the softly reared Tang digested with much pleasure. Unlike Col. An, he described elephant disdainfully as "a rubbery substance, tough as old shoes." He thought better of big jungle moths, which they captured fluttering around their lanterns and barbecued over a flame with their wings cut off.

Tang was among many communists—and likewise hapless Vietnamese, Cambodian, and Lao peasants—for whom a dominant war memory was that of enduring B-52 Arc Light strikes. COSVN and main-force NVA units usually received warning of their imminence from the Soviet

428 .

intelligence trawlers off Guam and Okinawa that monitored American takeoffs; North Vietnamese radar picked up formations approaching from Thailand. Thus senior cadres and their staff could grab some rice and a few possessions before fleeing the likely target area on foot or bicycle. Sometimes, however, the bombers and the torment of explosives caught them anyway. Tang wrote, "The concussive whump-whump-whump came closer and closer, moving in a direct line toward our positions. Then, as the cataclysm walked onto us, everyone hugged the earth—some screaming quietly, others struggling to suppress surges of violent trembling. Around us the ground heaved spasmodically, and we were engulfed." Few prayed to Lenin or Uncle Ho, most instead to Buddha.

"From a thousand yards away the sonic roar of the explosion tore ear-drums, leaving many victims permanently deaf, while the shock waves knocked some senseless. A bomb within five hundred yards collapsed the walls of an unreinforced bunker, burying alive those cowering within. . . . The first few times I experienced a B-52 attack, I felt that I had been caught up in the Apocalypse: terror was absolute. One lost control of bodily functions as the mind screamed incomprehensible orders to get out of the bunker." There was once a strike while a Soviet delegation was visiting COSVN: their Russian guests were afterward embarrassed that they had visibly soiled their trousers. Tang wrote, "The visitors could have forgone their shame; their hosts were well-accustomed to the same experience."

Tang and his colleagues sometimes returned to COSVN after an Arc Light strike and found nothing left: "It was as if an enormous scythe had swept through the jungle, shearing like grass the giant teaks and go trees, shredding them into billions of scattered splinters. The hut complex was annihilated; food, clothes, supplies, documents, everything. In some awe-some way they had ceased to exist. . . . The bomb craters were gigantic—thirty feet across and nearly as deep. In the rainy season they filled with water, then did service as duck or fish ponds."

Yet the veteran cadre observed that once he and his comrades grew accustomed to the bombers, shock and terror were replaced by "an abject fatalism. The B-52s somehow put life into perspective. Many of those who

survived an attack found that afterwards they viewed everything from a more serene and philosophical perspective. This lesson lingered, and on more than one future occasion helped me to compose myself for death."

3. SAIGON SOLDIERS

After the war ended, an American general wrote that the great enigma was why "the enemy apparently fought so much better than the South Vietnamese." Doug Ramsey said, "If you compared the average ARVN officer with his VC counterpart—so much more motivated—you knew the South had little chance." The Vietcong asserted mockingly that the only beneficiaries of the Saigon regime were monks, whores, Americans, and generals. Yet some South Vietnamese passionately believed in the cause, fought hard, and liked Americans. Pilot Tran Hoi said, "I was awed by their generosity, and especially that of the US Air Force. Whatever we needed they gave us, even down to toys for our children."

Hoi flew air-cover and ground-attack sorties in a Douglas A-1 Skyraider, a prop-driven workhorse armed with a medley of 2.75-inch rockets and 250-pound bombs, in addition to four 20mm cannon. On sunny days, the cockpit and its metal fittings were painfully hot when he climbed aboard and ran up his engine before takeoff. A delicious coolness prevailed in the air, however. Hoi loved the mere fact of flying, sometimes contourchasing for miles, as low as fifty feet. He claimed to be untroubled by his daily business of strafing, because he was confident that he served the right side. One day, ordered to attack a cluster of huts, he called base to say that he saw no enemy below, only a man walking his dog. The radio crackled back that intelligence was sure the communists had just moved in. The controller urged him on. "Go for it!" Hoi dropped his napalm without a qualm: "I knew how cunning the communists were."

Another day he and his wingman were ordered to attack a big junk moving up the Mekong estuary. They quickly identified the target, which was flying a Saigon flag. Ignore that, said the controller—just a ruse. Hoi rolled, dived, and unleashed a pair of rockets that exploded in the boat's hull. Immediately, black-clad figures emerged and began to leap over the

side. Hoi dived again, firing cannon at the survivors struggling and splashing in the brown water. His wingman, however, made only a dry pass, without touching the gun button. It was his first combat mission, and he exclaimed emotionally, "I can't shoot! It's too cruel!" Hoi rebuked him over the radio as they turned for home, "This is our job. We're not doing it for fun. Unless you change your mind, you'd better ask for reassignment." His young companion never again flinched.

As a VNAF pilot, Tran Hoi was a privileged person. The principal burden of the war, however, was borne by soldiers, most of whom were overwhelmingly preoccupied with survival. Their officers often responded to US advisers' proposals for aggressive action by saying, "No, cannot do. Much danger." Sgt. Mike Sutton found himself on a night operation with an RF group whose men carried squawking live chickens and pots that clanked at every step. When he urged them to leave the kitchenware behind, their officer insisted that they must have rations and means to cook them. "Of course it was really that they wanted to make enough noise to be sure the VC would stay away." Preston Boyd, Sutton's medic, was a Sioux who carried a Swedish K submachine gun and enjoyed using it. After a couple of night clashes in which the RF men simply dropped their weapons and ran away, Boyd told them, "You do that again tonight and I'll shoot you myself."

Yet who could be surprised by their conduct? A theme of Joseph Heller's Catch-22 is that whenever a flier thinks he is close to completing the appointed tour of combat missions, his mad commanding officer increases the quota. South Vietnamese conscripts faced a worse variant: there was no quota; they had to fight on and on, alongside Americans who were excused after a year. The Saigon training machine processed 159,138 new recruits in 1966 and 503,740 four years later. Desertion was endemic, and as in all wars, most of the quitters were those who faced most danger—infantrymen. Recaptured deserters gave as their reasons, in descending order: homesickness, unwillingness to fight, personal antipathy to a superior, and inability to support their family. All ranks were pitifully paid; a private earned half the wages of a civilian laborer, and a

single 105mm shell cost more than a major's monthly pay. Between 1964 and 1972, consumer prices rose ninefold and the cost of rice twelvefold, but army pay only doubled. A lieutenant said, "I never thought about getting married because I never knew when I was going to die, and I didn't want to inflict suffering upon loved ones. For the same reason, no girl who had a choice wanted to marry a soldier."

Rich Vietnamese might dine off crab or meat-noodle soup, fried fish, spiced steak, stewed duck, and rice, followed by lotus fruit stuffed with nuts. Their less privileged compatriots seldom starved, but the skinniest were those who served their country in uniform. Soldiers were hungry even in barracks, because officers stole much of their rice ration. Many enlisted men moonlighted as taxi drivers, teachers, or construction workers. An American adviser discovered that whenever he was absent in the field, his Vietnamese driver rented out their jeep. Officers as well as soldiers said, "How can we fight on empty stomachs? . . . To be able to practice the 'Correct Way'"—to be honest men—"one must first have enough to eat." A US combat ration for one meal contained 3,800 calories, almost twice the daily calorie allocation for an ARVN soldier, even in the unlikely event that he received it.

A general described lieutenants taking home most of the issued rations to feed their families: "I saw infantry school instructors pack a piece of plain bread or a ball of sticky rice in their rucksacks at the start of a long field exercise. That was all they could afford for breakfast and lunch. . . . Many [officers] fell heavily into debt just to keep their families fed." At the top of the tree, there were richer pickings. Some generals sold goods to the enemy: typewriters, cigarettes, Hondas—even Claymore mines and grenades. In the words of an NLF cadre, "More than a few American soldiers were killed with mines bought from their Vietnamese comrades." The communists had no appetite for M16 rifles, sharing the American view that AK-47s were better, but they purchased all the PRC-25 radios they could lay hands on.

As for Saigon soldiers' health, a man was more likely to contract cholera or malaria than to die in battle. Phyllis Breen, one day fitting a cath-

eter to a South Vietnamese soldier, was appalled to see a huge tapeworm emerge. In 1966 the country had only a thousand doctors, seven hundred of whom were conscripted into the armed forces. Even so, many wounded soldiers staggered home rather than endure the ghastly conditions prevailing in military hospitals. Conversely, at the army's paraplegic center at Vung Tau, beds were filled by a semipermanent population of five hundred disabled soldiers, who lingered because they had nowhere else to go. The bereaved faced sorrows beyond even the deaths of loved ones. When Ngo Thi Bong traveled to retrieve the body of her elder son, Van, killed in action with the ARVN, she found that he had been blown apart by a mortar bomb; she herself had to gather his body fragments in a garbage bag. Try as she would, she could not locate his left arm. Thus, according to Buddhist teaching, young Van's spirit would roam restless for eternity, mourning his lost limb.

British journalist Richard West wrote in 1967, "When you listen to briefs given by the Americans, Koreans, or Australians, then listen to the Vietnamese, you are struck by one supreme difference. The outsiders are eager and energetic. The Vietnamese do not care very much any more. Foreigners of every hue have lorded it over them for so long that the Vietnamese are tired of them all." This was unquestionably true—of the Southerners. Yet in the Northern ranks, there were also such committed revolutionaries as Dr. Dang Thuy Tram. She found herself one evening sitting in a desolate hamlet recently destroyed by the Americans. The villagers with whom she bivouacked lacked sufficient fuel to boil their rice. Yet Tram wrote doggedly, "We are not defeated; the enemy has burned this house, but we will build another. It's not hard. A few palm leaves are enough. One needs very little to live at war, when life is solely about fighting and working. We need only a pot of rice with pickled fish, a sheet of plastic to lay out in a bomb shelter, clothes, and salt, ready in a pair of baskets to carry off on our shoulders when the enemy descends."

Dang Thuy Tram seemed to exult in the hardships she endured. Her emotions were heightened, like those of many young people in all wars, by the shared experience of hardship, sacrifice, comradeship, peril. Who could dispute the romance of her predicament? She had also been polit-

ically conditioned from the cradle, so that this credulous young woman questioned nothing about "her" revolution. Still, the most disquieting aspect of Tram's diary, had it been read by Lyndon Johnson or William Westmoreland, was that it would have been hard to imagine any South Vietnamese compiling a record remotely as assured in its conviction.

TET

1. PRELUDE

It became the Chinese New Year never forgotten by any Vietnamese or American who was there. The question "Where were you at Tet?" could refer only to January 30, 1968, and the weeks that followed. Le Duan was personally responsible for launching an offensive in South Vietnam that ended in defeat, with catastrophic losses. The Northern leader anticipated a general uprising in support of the communist cause, yet only a few hundred Southerners answered the call. In an open society, the outcome of such a fiasco would have been the fall of its architect, the ruin of his credibility and reputation. Instead, it precipitated the collapse of Lyndon Johnson's presidency and of the American people's will to win in Vietnam. Tet became a stunning manifestation of an important truth about modern wars: success or failure cannot be judged solely, or even principally, by military criteria. Perception is critical, and the events of February 1968 became a perceptional disaster for American arms. The communists were deemed to have secured a triumph, merely by displaying the power to engulf South Vietnam in destruction and death, even if most of the latter fell upon their own fighters and hapless bystanders.

The Tet story began in the early summer of 1967, with fierce wrangling among members of Hanoi's central military committee. Since the previous year, there had been agreement that a "general insurrection-uprising" should be launched in the South when conditions were right. Le Duan,

Le Duc Tho, and Nguyen Chi Thanh—COSVN's chief—believed this hour had now come; they emerged as vociferous advocates for a decisive throw of the dice. Meanwhile Giap, together with another senior general and the enfeebled Ho Chi Minh, favored sustaining the tempo of the insurgency, while opening negotiations with the Americans. Ho's caution was rooted in fears of heavy losses, weakening the communists' strategic position in the protracted struggle that he was convinced still lay ahead. There were now 492,000 US troops in Vietnam, plus another 61,000 members of allied contingents, 342,000 ARVN, and 284,000 RF and PF militias, the last of which took more than half the war's military casualties. These nearly 1.2 million troops were supported by 2,600 fixed-wing aircraft, 3,000 helicopters, and 3,500 armored vehicles.

The North's big-battle advocates were encouraged by a report from the foreign minister, highlighting the rising clamor of American domestic opposition. He, too, supported a twin-track "talk-fight" strategy, and communist propaganda leaflets featured antiwar cartoons lifted from the US press. Le Duan did not dismiss negotiation; he merely argued that such a process should start only after a spectacular demonstration of communist means and will. A member of the NLF mission in Hanoi told a Russian diplomat, "Talks will begin when the Americans have inflicted a defeat on us or when we have inflicted a defeat on them. Everything will be resolved on the battlefield." Gen. Van Tien Dung, for fifteen years Giap's deputy, was a barely literate soldier of peasant origins who had spent his youth working in a textile mill. Weary of subjection to his high-handed boss, he now defied Giap by embracing Le Duan's Tet project, and thereafter did most of the planning—which was shambolic.

In June the "forward faction" prevailed, with agreement on "Plan 67–68." The military committee's Resolution 13 decreed "an all-out effort . . . to win a decisive victory." Both the Russians and the Chinese cautioned against such action, but an NVA officer said later, "If you wanted victory, guerrilla struggle had to evolve into large-scale conventional war." Le Duan predicted, "Half a million people will take up arms for us." On July 6, COSVN's chief, Thanh, collapsed and died at Hanoi's Military Hospital 108, almost certainly of heart failure following an exuberant

farewell dinner before his return to the South. Giap departed shortly afterward for Hungary, to receive medical treatment for kidney stones, and on September 5 the ailing Ho Chi Minh flew to Beijing for "rest." There is no reason to suppose that these absences were part of a deception plan: they merely emphasized the dominance of Le Duan. By the time Ho came home on December 21, detailed planning for the "Quang Trung" offensive was almost complete.

During the winter of 1967, the Vietcong launched significant attacks, to sharpen their own spearheads and test the enemy in advance of the "big push." On October 29, there was a sustained assault on Loc Ninh, and another soon afterward against Dak To. On the night of November 4, two battalions supported by mortars raided the provincial center of Cai Lay, an action that cost the lives of fifty-six defending soldiers and civilians, and thirty-six communists. Defectors told government interrogators that the communists were recruiting hard in advance of an offensive in which "glory will smile on the NLF." Ba Me, an illiterate fighter in his forties, told a Delta peasant that 1968 was to be a decisive year. Me was a disreputable figure, always in trouble with his chiefs for embezzling funds and forcing himself on village women, for which he escaped retribution only because of his prowess as a warrior. Intelligence officers who heard of his boasting may be forgiven for shrugging and noting that VC windbags made such vainglorious promises every year.

Giap's associates carried to their graves a belief that the general continued to linger in Hungary because of fears for his own freedom if he returned home; the latter months of 1967 saw upheavals in Hanoi that removed from influence some of his principal subordinates. A senior colonel, Giap's personal chief of staff, was detained; the director of military operations and director of intelligence were sacked, along with thirty other significant figures, including Ho Chi Minh's former personal secretary and the deputy minister of defense, who were accused of such crimes as "revisionism" and "plotting against the politburo." Three waves of 1967 purges, in July, October, and December, appear to have had more to do with ideological strife rooted in the Sino-Soviet split than with arguments about Tet, but their outcome was that most of Giap's allies were displaced.

The general himself retained a seat on the politburo, but with much diminished influence.

The same was true of Ho Chi Minh, now seventy-seven. On December 28, there was a special uprising briefing in a building adjoining Ho's cottage. An eyewitness who watched the old man totter home afterward said that he looked both frail and unhappy. Three days later, he returned to Beijing for further medical treatment, absenting himself from the summit meeting before the offensive, held in January thirty miles outside Hanoi, at which Le Duan expounded the plan. Only on the 15th was a final decision made to attack at Tet, contemptuously breaching the NLF's commitment to a seasonal truce. With remarkable carelessness, Dragon Court failed to notice that under the latest revolutionary dispensation there was a twenty-four-hour difference between the onset of the New Year in the North, January 29, and in the South, the 30th. Resultant confusion caused the Tet attacks to forfeit synchronization; some began early, others late.

On January 25, 1968, Giap traveled from Budapest to Beijing to consult with Ho, though what was said remains unknown. The general finally flew home five days later to be briefed by the new director of military operations. He acquiesced in the plan but retained lasting bitterness about his eclipse. New NLF currency was printed and shipped to the South, code-named "'68 goods." Le Duc Tho was dispatched to act as COSVN deputy Party secretary, a post that he retained until May. Two generals were sent to brief Vietcong units.

The principal objective of the "Tet General Offensive-General Insurrection" was to destroy three or four ARVN divisions and with them the credibility of the Saigon regime. The plan, more fantastic than any created by the Pentagon or MACV, called for the "annihilation" of 300,000 "puppet troops" and 150,000 Americans, together with "liberation" of five to eight million people in the South's urban areas. There were to be energetic pre-Tet attacks in the countryside, to lure ARVN and US forces away from cities. Four NVA divisions were assigned to the northern sector, from Khe Sanh in the west to Dong Ha near the coast, tasked to "annihilate" 20,000 to 30,000 enemy troops, including five to seven American

infantry battalions. Some officers insistently mentioned the difficulty of confronting massed firepower. Gen. Tran Van Tra said afterward, "The strategic goals we set . . . were unrealistic: they underestimated the U.S. reaction and capabilities." Yet Le Duan was implacable, and professed indifference to the risk that the attacks would fail to precipitate a popular uprising. The experience would justify itself, he said. "Comrade Fidel Castro's armed forces attacked the cities [of Cuba] three times before they finally triumphed." Even if the insurgents failed to capture South Vietnam's cities, "the entire countryside and mountain jungles belong to us."

William Westmoreland entered 1968 thoroughly aware that the communists intended something big but uncertain about its nature. A MACV cable warned of the enemy exhibiting "a very unusual sense of energy" and apparently planning "a coordinated offensive." Yet the problem was always the same: to distinguish between a familiar flood of revolutionary rhetoric and Hanoi's real intention; the Americans remained ignorant of Giap's marginalization. Yet back in November, the CIA's Joseph Hovey, a veteran of almost three years as an analyst in Saigon, produced a brilliantly prescient assessment. He studied the evidence from POW interrogations, increased enemy supply movements, and the drafting of Northern children as young as fourteen. There were signs of increased communist intelligence interest in the ARVN, highlighted by exposure of a sevenman VC cell that had infiltrated a Regional Forces unit. The Americans knew that there had been big Chinese arms deliveries—this time gifts, rather than purchases—and a new aid agreement with Moscow, signed on September 23.

Hovey pulled together these strands and concluded that the communists would sustain pressure in the border areas to tie down allied forces and to "relieve the pressure on the VC/NVN activities in the populated areas." The real objective however, wrote the CIA man, was to launch "the long-promised 'general uprising.' To accomplish this the VC/NVN have set themselves the task of occupying and holding some urban centers in South Vietnam and of isolating many others . . . [believing that] this will break the 'aggressive will' of the Americans and force them to agree to

withdraw from South Vietnam." Hovey said he accepted that the communists' objectives were unrealistic, but that did not mean they would flinch from an attempt to try to meet them. He suggested that, even if it failed militarily, such an offensive in a US election year could inflict crippling political damage on the allied war effort.

On November 17 the NLF proposed a seven-day Tet truce, which Saigon assumed was intended to provide a breathing space to organize Vietcong logistics before making another big play. In December truck sightings on the northern Ho Chi Minh Trail doubled over the previous month, to six thousand. A cadre later claimed that in December and January the communist "campaign to kill tyrants and spies took out three hundred persons"-officials or supporters of South Vietnam's government. On the 19th, MACV analyst James Meacham wrote, "The word is out that the VC are going to make an all-out terrorist effort against Saigon Americans from now on through Tet. Our ARVN counterparts are really concerned—the first time in living memory that they have been. This is a bad sign, because they know the VC infinitely better than we." South Vietnamese alarm was increased by the capture of a document that revealed detailed Vietcong knowledge not merely of Saigon's intelligence department, but of the interior layout of its headquarters: since the previous August, communist agents, many of them women, had been laboring to garner information about major installations.

On January 1, 1968, Hanoi Radio broadcast a poem by Ho Chi Minh: "This spring far outshines previous springs. / Of triumphs throughout the land come happy tidings. / Forward! Total victory shall be ours." On the 5th, MACV released a document captured in November, which stated, "The time has come for a general offensive, and the opportunity for a general uprising is within reach. . . . Use very strong military attacks in coordination with uprisings by the local population to take over towns and cities." That same day, American troops captured orders for the Tet attack on Pleiku Province. On January 22, Westmoreland warned the White House that the communists might try a show of strength before Tet. Next day the North Koreans seized the crew of the US Navy's electronic surveillance ship *Pueblo* off their own coast, precipitating a crisis

that distracted the attention of the US government. Speculation persists that the communist camp deliberately orchestrated this diversion, which is plausible: Beijing certainly incited Pyongyang to provoke Washington.

An American prisoner being escorted up the Ho Chi Minh Trail encountered NVA units moving down to join the offensive, attired in new green uniforms and tennis shoes rather than the usual tire-rubber sandals: "They appeared fresh, healthy, poised, and confident." One of them, carrying the wheels of a 75mm howitzer, claimed to be a veteran of Dienbienphu; he admitted that he found hills a trifle steeper than they had seemed back in 1954. He nonetheless pointed out with pride that some younger men were carrying burdens of over a hundred pounds, which he said was more than Vietminh porters could have managed in the campaign against the French. The American inquired what the NVA thought of his own countrymen as enemies. The soldier answered that US soldiers seemed keen enough when they started something, but lacked staying power. He thought the Marines impressive but believed that no Americans could match the NVA's motivation and experience. As the prisoner was hustled onward, he was impressed by the absence of hostility toward himself. He reflected that a B-52 strike might change that.

When a contingent of US Marines arrived to reinforce the garrison of the big American firebase close to the Lao border, coffee beans hung heavy on the bushes of a plantation that fringed one side of its perimeter. The newcomers hailed a rifleman walking beside the pierced-plank runway. "Hey, man, what's the name of this place?" The Marine responded, "This is Khe Sanh, and you'll never forget it." The first significant event of 1968 was a communist buildup around that red earth clearing, "raw as a wound in the jungle," garrisoned on the personal orders of Westmoreland against the strong advice of Marine commanders whose territory this was.

Although the war had been going on for a long time, when the NVA's 304th Division moved South in November 1967, bound for a shared destiny with those Americans, few of its officers and men had much combat experience. On the night of January 2, the 9th Regiment's command group attempted an extraordinarily perilous reconnaissance: wearing

TET · 44I

American fatigues, they advanced toward outposts of Khe Sanh sited on the old French lateral Route 9 from Laos to the coast. They chattered noisily, and one comrade sang. Their weapons were slung. Near the Tchepone River, Americans challenged them in English. Receiving no reply, they opened fire, killing an NVA regimental chief of staff and the deputy commander of a sapper battalion. The regimental CO vanished without trace and was later found badly wounded in a clump of bushes, having trodden on a mine.

Farther east, Route 9 witnessed frequent clashes as the communists ambushed American and ARVN convoys or harassed the string of fire-bases along it: Khe Sanh became dependent on air supply. The two NVA divisions dispatched to the area were intended to draw US forces from the east, and especially to reduce their strength around Hue, a key objective of the looming offensive, because it is a symbol of Vietnamese nationhood. Two more Northern divisions were deployed in the Cua Viet–Dong Ha sector near the coast. For the first time in the war, Dragon Court committed some tanks in support of these formations. The plan originally scheduled attacks toward the end of February, and communist commanders were discomfited to be ordered to move a month earlier. They had stockpiled nothing like sufficient ammunition and rice.

The two NVA divisions around Khe Sanh subjected its Marine garrison—eventually six thousand strong—to an intermittent bombardment, rendering the landing strip hazardous. In the course of January and February, harassment of the base became a huge worldwide news story. Westmoreland suggested that Giap intended to make this a new Dienbienphu, a comparison that caught the imagination of the media, though the general added that the communists would assuredly fail to match the Vietminh's triumph. Day after day, the camp was pounded by fire. TV news films showed reporters talking to the camera as they crouched in flak jackets while Marines off-loaded aircraft amid shellbursts. Before, during, and after Tet, B-52s directed by Combat Skyspot radar flew 2,548 sorties and dropped sixty thousand tons of bombs, some within a thousand yards of Marine positions. The base became the scene of repeated dramas, such as that which took place when CWO Henry Wildfang landed a

C-130 crippled by communist fire, its wings ablaze, successfully swerving to avoid parked planes on the strip. Wildfang's feat was rewarded with his fifth Distinguished Flying Cross, and there were many comparable displays of grit.

MACV forged an obsession with Khe Sanh, and Lyndon Johnson famously had a photomural of it installed in the White House. Yet although there were fierce contests around American positions on the surrounding hills—numbered for their elevations 950, 881, 861, and 558—the main perimeter was never seriously attacked. This caused some commentators to conclude that Westmoreland allowed himself to become the victim of a brilliant enemy feint. Although the communists as usual paid a far higher price in lives than did the Americans, James Wirtz argues that at Khe Sanh they were able "to generate enough noise to overwhelm the signals leaked by the preparations for the impending urban offensive." A Southern colonel wrote, "The probability of Khe Sanh becoming a decisive contest objective like Dienbienphu was foremost in the minds of our intelligence analysts. Little attention, if any, was given to the cities as probable objectives. . . . [Our experts] were all convinced, out of prejudice and pride, that the enemy did not possess the capability."

Westmoreland endowed Khe Sanh with an importance that it did not deserve; like Dienbienphu, the place should probably never have been garrisoned. Worse, he allowed the world to see where his gaze was fixed, which made him appear foolish—indeed, helped to destroy his reputation—when the enemy struck elsewhere. Nonetheless, it seems mistaken to imagine that the North Vietnamese deployed two divisions solely as a deception. It is overwhelmingly likely that they would have attempted its capture if American artillery and, above all, air power had not made this impossible. Communist officers later lamented the fact that the two formations had not instead been committed farther east, preferably at Hue.

MACV's men were not the only ones who made comparisons with Dienbienphu. Northern veterans discussed the 1954 battle and observed ruefully that the Americans had not reprised the French mistake of failing to occupy surrounding high ground. US defenses were also far more im-

pressive, air resources almost unlimited. The communists' concentration on the Laos border hurt their strategy even more than Westmoreland's response injured the American cause, but Hanoi's misjudgments did not make headlines, while MACV's did. Westmoreland and his staff, convinced that this was an American war, discounted the notion that the communists might make South Vietnamese forces their principal targets.

Meanwhile Washington bore its own share of responsibility for the poor decision, given the flood of intelligence about enemy activity, not to cancel the Tet truce. The embattled Johnson administration swallowed hints that Hanoi was close to opening negotiations. It thus insisted that the truce should be honored, allowing many ARVN soldiers to go home for leave. Moreover, even though Westmoreland recognized the likelihood of a big communist play, he refused to cancel his own offensive plans and chafed at Washington's refusal to allow drives into Laos and Cambodia. His staff ignored the discovery of caches of brand-new enemy weapons, including a big one near Saigon, together with evidence that VC sappers had been reconnoitering Tan Son Nhut.

Lt. Gen. Fred Weyand, the slow-spoken Californian commanding II Field Force, is often hailed as the only senior officer who prepared for trouble, moving units into Saigon and canceling his own planned operations. It was certainly thanks to Weyand, a former army intelligence officer, that twenty-seven US maneuver battalions were deployed within reach of Saigon when the communists struck. His fears nonetheless focused on that area; he did not anticipate countrywide attacks. Westmoreland and his senior subordinates were justified in asserting after Tet that they had foreseen trouble, but they had shown no grasp of its scale. Moreover, since the previous summer, many units had been on maximum alert at least half the time. They were told nothing special now to suggest a looming cataclysm. US commanders committed the oldest error in the military playbook: they discounted the interpretation of Le Duan's intentions made by Joseph Hovey and his kin, because it failed to conform to MACV logic.

2. FUGUE

The suicide bomber is often supposed to be a twenty-first-century phenomenon. Yet Le Duan's offensive brilliantly achieved his purposes because Vietcong guerrillas reinforced by regular NVA troops proved willing to face almost inevitable death to fulfill their Tet assignments. The communists unleashed some sixty-seven thousand fighters in attacks on 36 of the country's 44 provincial capitals and 64 of its 245 district capitals, while continuing the wilderness battles at Khe Sanh and elsewhere. By demonstrating the power to coordinate operations on such a scale, to motivate so many men and women to pursue objectives that even most North Vietnamese commanders deemed unattainable, they blinded the world to the brutality of a leadership that could unleash such horrors, for which the civilians of South Vietnam paid most of the price.

On the morning of January 27, ARVN troops captured audiotapes prepared by the NLF for broadcast through radio stations they intended to target, announcing the capture of Saigon, Danang, and Hue. The communists thus lost a significant element of surprise, while their attacks proved to be ill-prepared and poorly coordinated because of the priority accorded to secrecy in delaying the issue of orders to their own fighters. On the 28th, some of the South's top cadres were at the "Red Office," a refuge in the midst of a huge swamp adjoining the Plain of Reeds, which they called "the Atlantic Ocean." They were living relatively comfortably, enjoying cigarettes and liquor sent down from Saigon, eating a newly caught fish. Joint VC commanders Vo Van Kiet and Tran Bach Dang were squatting on a mattress, chopsticks in hand, when a motorcycle courier arrived. He handed them a letter marked MOST URGENT AND TOP SECRET, which read, "A7 to A404: D-Day. Start the battle between the first and second days of the Tet Lunar New Year. H-Hour: 1200 midnight. This is the decision of Uncle Huong"—code name of the politburo.

They were astonished and dismayed, because they had expected an H-Hour five days later. Now, instead, they had just three days and nights to reach start lines outside Saigon. Dang, a forty-two-year-old veteran born in the Delta, recalled grimly, "Nobody felt like eating and drinking

any more." They immediately broke camp and set forth, wearing uniforms but carrying civilian clothes, cash, and ID cards forged for them in Saigon by police sympathizers. Some fighters burned their own huts, a symbolic gesture designed to emphasize a commitment to victory or death. Soon a thousand men were following Kiet and Dang in one among dozens of similar columns converging on their urban objectives. "The entire north part of the Plain of Reeds was filled with moving groups of people." Because this was the dry season, the Delta contingent often had to portage boats laden with weapons and ammunition.

Their command group was to rendezvous with local guerrillas outside Saigon. In the fierce heat, they made slow progress, astonished by their good fortune not to be spotted by the aircraft they often heard in the distance. At night the column moved even more slowly, while Dang and Kiet held muttered flashlight consultations over a map. The mood was one of fierce excitement, extending from their leaders to graybeards and raw recruits; most of these men and women were true believers. Before dawn on the 29th, they halted and hid themselves in the huts of a Party district headquarters, where they ate Tet cakes. Then there was a bad time: helicopters and aircraft rocketed and strafed the area. Kiet and Dang, watching Hueys circling so low they could distinguish the door gunners' faces, insisted that no one should fire back. By noon, quiet was restored; the Americans had seen movement and correctly identified enemies but failed to grasp their numbers. For all the sound and fury, the air strikes merely put holes in several sampans.

That night of the 29th to 30th, the first attacks of the offensive were launched, ahead of time because of the confusion about dates. Danang, the coastal town of Nha Trang and other northern centers became scenes of bitter fighting. Southern VC units still marching toward Saigon were bewildered to hear of a government radio announcement at 9:45 a.m. on Tuesday, the 30th, canceling the Tet truce due to the night's attacks. A senior cadre for Long An Province described their bafflement: "No one could understand how this could have happened. Was it possible that all our preparations had only been an elaborate deception? Could there be any possible military advantage to starting the offensive in this fashion?"

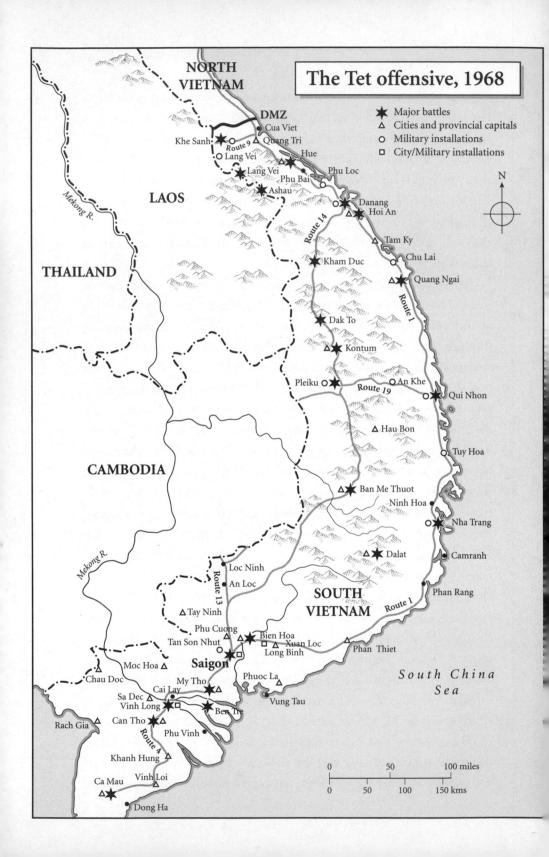

They waited expectantly for radio messages that would answer these questions, yet none was forthcoming. Early that morning, Kiet and Dang arrived unannounced at the rendezvous near Saigon, at the head of their own column. They abruptly informed assembled comrades: "The situation is extremely critical. Saigon must be attacked tonight!"

One cadre moaned in near despair: "Oh my God! Oh my God!" His staff set about using a bare twenty hours to arrange the deployments of ten battalions dispersed across the countryside, with tenuous communications and some officers absent on Tet leave. Rations and ammunition had to be issued, guides allocated. Dang gave them a rousing eve-of-battle speech, concluding by raising a clenched fist and shouting the watchwords "Resolution! Attack! He himself later asserted that three thousand voices shouted back in joyful unison. This was the most inspiring moment of their war, he said, when hopes were sky-high. But another officer was exasperated by Dang's exuberance, which he deemed a poor substitute for realistic planning.

The last day's march was an agony of delays and seething impatience. They waded canals, hastened across rice fields, listened to Saigon radio reports about the fighting farther north, puzzled that passing aircraft still seemed oblivious of them. As darkness fell, local civilians stood outside their homes, watching the files of armed men pad by. Some said, "Why not celebrate the holiday here?" They were given Tet cakes, pickled cabbage, and meat to munch as they advanced to battle.

At 2100 they came upon a bivouacked VC battalion. To Dang's disgust, he found its senior cadre prostrate on a plank, drunk. The man pulled himself to his feet, stood at attention, and saluted, saying, "Sir! I am the deputy commander!" Dang demanded furiously, where were his CO and political officer? "Sir! The battalion commander has gone to get married, and the commissar is a guest at the wedding."

"Haven't you received your orders?"

"Not yet, sir."

The battalion was hastily assigned to attack Saigon's National Police headquarters. Yet by that night, some of the northern attacks had already been crushed. In Nha Trang, 377 Vietcong lay dead and 77 more were

prisoners. Of the government troops defending the city, 88 had perished, along with 32 civilians. Six hundred homes were destroyed, a foretaste of destruction that would soon sweep the country.

Gen. Tran Do, who exercised political command of the Vietcong's Tet operations, said later that the curse of their war effort was too much ideological theorizing and too little hardheaded military planning. A senior officer in the principal northern operation of the offensive recalled years later the dismay among the leadership at the terse order from Hanoi: "Mount a general offensive and uprising to liberate Hue." He said that he was vividly reminded of Lenin's line "One should not play at revolution." To have a chance of success, said this cadre, the local Vietcong would need the support of two Northern regiments, two artillery battalions, supplied with four hundred tons of ammunition. Though the guerrillas were indeed reinforced by some NVA, they mustered nothing like this order of battle when they marched upon Hue.

Vietnam's third-largest city, with a population of 140,000, offered one notable advantage as an objective: it was only an overnight march for guerrillas sent forth from local sanctuaries to reconnoiter. They had dug observation bunkers and stockpiled a thousand tons of rice within easy reach. On the afternoon of January 30, columns began to move toward the city. The communist narrative asserts that a man swept away during a river crossing shouted no appeal for help to avoid distracting his comrades from their mission; cynics will prefer to believe that his mouth was full of water. But then another column was spotted at the Duong Hoa River by ARVN who called down artillery fire that inflicted thirty-two casualties. Some VC units became lost, causing them to arrive late at their start lines.

US military communications were saturated, so that priority messages were slow to reach recipients. That day, January 30, Phu Bai interceptors picked up North Vietnamese signals about the imminent attack on Hue, but by the time these had traveled up the command chain, the American compound in the city was already taking fire, and its four hundred occupants were fighting for their lives. Despite later MACV claims that US commanders were not surprised—citing the alert Fred Weyand had called in his own area at 2037 on the 29th—the behavior of many Americans

does not convey consciousness of imminent crisis. On the night of the 30th, Westmoreland's intelligence chief, Brig. Gen. Phil Davidson, retired to his quarters. A humble soldier named Louis Pumphrey, from Panesville, Ohio, was in his bunk at Di An, near Tay Ninh. A tape-recorder geek, before falling asleep he made a cassette for his family, which included squeaking noises made by Charlie, his spider monkey. "I'm going to bed pretty soon after I've put in the nightly report. They're expecting an attack because of Tet. Nothing's happening. Probably nothing will." Then rockets started thumping into the base.

In the early hours of January 31, Hue's inhabitants were roused by the sights and sounds of columns of Vietcong, accompanied by two NVA battalions in smart new Chinese-made uniforms, wending their way north through the city streets in a thin, damp mist toward the gate of the citadel, built in 1802. The ARVN 1st Division, headquartered in its northeast corner, had been alerted two hours earlier, after a patrol reported the enemy's approach. Air-dropped flares were soon drifting over the city, rival green and red tracer arching across the sky. The attackers nonetheless faced no significant resistance. Frank Scotton's USIA colleague Bob Kelly recorded laconically, "Charlie came into town . . . Unopposed! NVA were escorted in by the local VC. Locals wore white armbands, main force wore red, and NVA wore yellow."

Ngo Thi Bong and her family were asleep at their home, 103 Tran Hung Dao Street, when the communist assault began. They had grown so accustomed to gunfire that they were not especially disturbed until she and her sons came downstairs and glimpsed through their shuttered windows some twenty very young Vietcong. A middle-aged woman who had lost her husband in the French wars, then a son killed with the ARVN in 1966, she said, "I knew we would suffer." In the battle that began desultorily in the early hours of Wednesday, January 31, the communists occupied much of Hue city, the massive citadel, and palaces within its walls. Critically, however, they failed to secure the 1st Division command post in the Mang Ca sector, or the American advisers' compound, a mile southward across the Huong River. Many Southern soldiers fled or sought hiding places, enabling the attackers to seize large stocks of weapons and

ammunition, some of which were issued to hundreds of VC liberated from the city's prisons. Sappers blew up a tank park at nearby Tam Thai, and the NVA established a strong blocking position north of the city.

Twenty-six-year-old Lt. Tran Ngoc Hue heard the shooting in Hue city at his home within the citadel wall. He led his parents, wife, and daughter into the family bunker, such as all prudent South Vietnamese had dug, then set out to bicycle through the darkness in civilian clothes to join his men. Hue commanded the Hac Bao or Black Panthers, the 1st Division's rapid-reaction force, whose elements were scattered around the city. He suddenly found himself moving among a column of NVA, too intent on their own affairs to notice him. Reaching his depleted company on the little airstrip inside the citadel walls, he was immediately radioed to move to 1st Division's headquarters. The company reached the CP just before North Vietnamese troops attacked—and were repulsed. One of Hue's platoon commanders, deployed at the provincial prison south of the river, sent a last message just before it was overrun and he was killed, asking Hue to look after his wife and seven children.

All that day, January 31, fighting ebbed and flowed around the ARVN command post and the American compound, with communist mortar bombs and 122mm rockets incoming, LAWs outgoing. At one stage, communist troops broke into the Southerners' perimeter and were expelled only after the defenders called down artillery on their own bunkers. The South Vietnamese position continued to hold out through the days that followed, though the communists established a headquarters in the throne room of the nearby Palace of Perfect Peace, and cadres toured the city in captured jeeps, detaining people of all ages and both sexes who were deemed tainted by association with the regime or Americans.

One in five men of Maj. Pham Van Dinh's 2/3rd Infantry outside Hue were on Tet leave when the attack came. American adviser Capt. Joe Bolt found himself unable to secure air or fire support. At noon on the 31st, Dinh was ordered to move into the city. He and his 260 men reached the Perfume River at midafternoon, then became locked in a contest for a marketplace, which cost ten dead and many more wounded. Most of Dinh's soldiers were desperately apprehensive, because their own families

TET . 45I

lived in an area now controlled by the communists; he himself learned only much later that his wife and children had escaped as refugees. Early next morning, some of Dinh's men scaled the citadel's massive walls, only to fall to communist fire. During the street fighting that followed, Joe Bolt got through to the American compound, from which he returned with a jeepload of ammunition and rations. He also secured two 106mm recoilless rifles, which proved invaluable for blowing away sniper positions. Every ARVN attempt to push into the citadel failed. The communists and South Vietnamese exchanged abuse over common radio frequencies. Americans who afterward criticized the performance of Saigon's troops in Hue were justified in asserting that they had not been effective, but the casualty figures argue that not all were cowardly.

Outside Ngo Thi Bang's front door lay a wounded, bleeding government soldier whom nobody dared to help. Eventually a communist strolled up to the prostrate figure and put a final bullet into him. Soon afterward, the enemy entered her house. The Vietcong made no threats—simply stated baldly that since they were winning, it would be wise to help them. Through the hours and days that followed, guerrillas slept and ate there, distributed propaganda leaflets and sang Party songs. Some humble local people—rickshaw drivers and the like—carried arms and ammunition for them, but such middle-class families as the Ngos did as little as they dared.

The grim, unsmiling occupiers seemed baffled that these Buddhists, who they knew disliked the Saigon regime, appeared equally unenthusiastic about the rival cause. Later communist narratives admitted that "if we wanted the masses to rise up, it was essential to deploy strong enough military forces to promise victory." In other words, revolutionary fervor did not suffice: the people needed also to be confident that Hanoi's soldiers looked like winners—as still they did not, in the eyes of most citizens of Hue. Terrified refugees thronged churches, university buildings, and soon the hopelessly overcrowded American compound. There, when water ran short, the occupants drank orange soda, which they learned to hate. The running theme of the battle that persisted through February, destroying half the former capital and killing thousands of civilians, was that the

communists fought doggedly to hold the ground they had seized during the first night and day, while American and South Vietnamese forces dispossessed them only with agonizing sluggishness. The first US relief column, dispatched north toward the MACV compound from Task Force X-Ray at Phu Bai, blundered into strong North Vietnamese forces and was mauled. Thereafter a continuing trickle of reinforcements got through to the beleaguered Americans, most of them borne by river transport. Again and again, however, senior officers issued unrealistic orders, such as those to 1st Marines' CO Lt. Col. Ernie Cheatham from his regimental commander on Saturday, February 3: "I want you to attack through the city and clean the NVA out!"

An initial suicidal attempt to charge north across the Truong Tien Bridge into the citadel cost ten dead, fifty-six wounded out of a hundred Marines. They were untrained in street fighting, a specialized art. Until they learned the hard way through the weeks that followed, they suffered constant casualties from snipers and automatic weapons because they exposed themselves carelessly, advanced headlong up thoroughfares where buildings and soon rubble provided plentiful cover for the enemy. At no time did any American above the rank of colonel grasp the realities of the battle: generals instead issued impracticable directives from Camp Evans to the north and Phu Bai to the south.

For the first ten days, cultural scruples inhibited air strikes and artillery from hitting the citadel where the NVA were concentrated. In residential streets south of the river, by contrast, massed 106mm recoilless rifle fire was deployed, followed by tear-gas shells and grenades. Within occupied areas, the communists "killed tyrants and eliminated wrongdoers," to use their own parlance for thousands of murders. Electricity and water failed, and the city's radio station fell silent. By day and night, Hue's inhabitants fell prey to the sights and sounds of war without mercy.

For most of February, Westmoreland gravely underestimated the scale of the enemy commitment in and around Hue, partly because of his obsession with Khe Sanh and partly because of a breakdown of American command-and-control machinery, especially intelligence. Marine

TET · 453

and army commanders convinced themselves that the communists had deployed up there no more than two thousand men, whereas their real strength was five times greater. The Americans thus fed a succession of relatively weak forces into the battle, enabling the communists to engage and mangle them. No small part of the propaganda success of Hanoi's Tet gambit derived from the protraction of the Hue struggle. And no small part of the anguish of US soldiers and Marines stemmed from having to fight on terms that their enemies locally dictated. For many days, the high command fooled itself that Hue represented merely one among the communists' many Tet failures. In reality, it became by far their biggest success. The NVA and VC were able to forge from it a legend comparable with that of the 1942 American defense of Corregidor—doomed, but heroic.

Capt. Charles Krohn, intelligence officer of the 2/12th Cavalry, compared the fate of his own unit, insolicantly dispatched south toward Hue on the fourth day, with that of the Light Brigade in the Crimean War: "We only had to advance two hundred yards or so, but both we and the Light Brigade offered human-wave targets that put the defenders at little risk. . . . There was no satisfactory or compelling reason for a US battalion to assault a fortified North Vietnamese Army force over an open field." Krohn wrote of their February 4 encounter at a hamlet four miles north of Hue: "Some four hundred of us got up to charge. A few never made it past the first step. By the time we got to the other side of the clearing, nine were dead and forty-eight wounded. . . . We killed only eight NVA (at best) and took four prisoners. . . . We reported higher figures to brigade, based on wishful thinking that made us feel better. But privately we knew that the enemy had scarcely been scratched."

Krohn watched the body of a medic named Johnny Lau being loaded aboard a dust-off: "We had spoken earlier before the attack, and he told me he was from Sacramento, California. He said his family was in the grocery business. We broke off our conversation about the best way to prepare beef with ginger when the attack started but promised each other to pick it up later." They never did. The battalion's foxhole strength fell in six weeks

454 .

from five hundred to less than two hundred. Krohn wrote bitterly, "The NVA had better senior leadership than we did." His battered battalion felt lucky to extricate itself, to lick its wounds.

The Tet battles spread progressively down the country, until most of Westmoreland's battalions were engaged. When it all started, Airborne platoon commander John Harrison was leading a patrol near Nha Trang, thinly disguised as a "deer hunt" out of respect for the Tet truce. A sudden radio warning came through: "You are hot. I say again, 'You are hot.' Do you copy?" The platoon turned around fast and returned to FOB Betty, whence they were immediately sent forth again to sweep the area for Vietcong. They didn't have far to look, surprising a group of guerrillas gathering to attack. One man ran straight toward the Americans firing a pistol. Harrison's point man was so surprised by this pathetic, hopeless sally that he did not respond. The lieutenant pumped sixteen rounds into the guerrilla until he fell, dust rather than blood finally spouting out of his wounds.

POW interrogator Bob Destatte was riding in a jeep with two lieutenants on the road south of Tuy Hoa city. The first he knew of Tet was a file of Vietnamese wearing a ragbag of clothing, some clad only in shorts, crossing the road in front of the vehicle. Some of them started shooting, and Destatte thought angrily, *Jesus Christ, if they go on like that, they're going to kill someone!* Then he realized "there were bad guys in town." The three Americans abandoned their vehicle and lay in cover, thoroughly frightened, until some refugees passed, heading out of town. Destatte spoke to one group in Vietnamese, saying, "When you meet government troops, please tell them there are some longnoses in trouble down here." A while later, an RF platoon showed up and asked, "Are you the longnoses looking for help?" The Americans blessed their good fortune in escaping unscathed.

A Navy carrier pilot who had made an emergency landing at Danang was stretched out exhausted on the floor of its operations room when he was shaken awake by a hysterical colonel who demanded, "Is that your aircraft out front? You have to get it out of here. I have no revetment for it. It must get out of here." The pilot responded with obscenities, concluding,

TET . 455

"If you want it moved, move it yourself." The colonel became even more emotional, shouting that he would bulldoze the plane off the parking area. The pilot wrote later, "I realized I was dealing with a madman. He had become unglued." Rather than see his "beautiful fighter" bulldozed, he dragged on his G suit and took off through the darkness, landing two hours later in the Philippines.

At 2100 on January 30, an armed Vietcong was captured in Saigon who revealed that six hours later multiple objectives would be assaulted in and around the city. Half an hour later, another guerrilla was seized carrying two folding-stock AK-47s. It was too late for the defenders to make significant redeployments, but most units were alerted before the attacks began. Many guerrillas, having never set foot in a town, became lost in Saigon's maze of streets: local people handed over to police a teenage peasant fighter whom they encountered seated weeping on a curb, having mislaid his comrades.

Tran Bach Dang, furious in frustration at his battalions' tardiness, found himself and his men almost running the last miles through the darkness toward Saigon. He laid out maps in a suburban village temple even as the first rattle of gunfire became audible in the city center. A battalion commander reported that he had been ordered to attack Nha Be fuel dumps, but he had no idea where these were, and his men were exhausted. Yet when Dang tuned in to Saigon and ARVN broadcast networks and found both silent, he enjoyed a brief spasm of exultation, assuming that the transmitters were already in communist hands. A stream of local residents visited the temple bringing melons, firecrackers, tea, medicine, and Tet cakes. So far, so good.

3. A SYMBOLIC HUMILIATION

At 0130 on January 31, leading elements of a total force of four thousand Vietcong—the NVA stayed out of the capital—thrust at multiple Saigon targets, of which the first was the presidential palace: this was untenanted, because President Nguyen Van Thieu was vacationing in My Tho. The attackers, thirteen men and one woman, were quickly repulsed and

retreated to a nearby apartment building, where they were progressively killed during a fifteen-hour firefight. Other guerrillas seized the national radio station with the aid of a staff sympathizer who provided keys. They held the building for six hours, but their plans to broadcast propaganda appeals were frustrated by severance of the cables to its transmitter. Communist assaults were also launched on the Newport Bridge, on the ethnic Chinese suburb of Cholon, and on outlying bases at Long Binh, Bien Hoa, and Tan Son Nhut. Vice President Nguyen Cao Ky ordered a general civilian curfew, so that anyone seen on the streets of Saigon could be assumed to be an enemy.

So cynical had Vietnamese become that some who heard Hanoi radio broadcasts announcing that the regime was being overthrown thought that Ky must be staging a putsch against Thieu. David and Mai Elliott, overnighting in the RAND compound on Rue Pasteur, were awakened by an immense bang. They switched on lights, earning a bawl from a Marine colonel, "Switch'em off! We're under attack!" The Elliotts, too, assumed a coup—exclusively Vietnamese business—and returned to bed. In reality, the explosion was caused by VC sappers blasting a hole in the outer walls of the nearby US Embassy, precipitating one of the war's most dramatic episodes.

Nineteen commandos of the communist C-10 Battalion approached in a small Peugeot truck and a taxi, having spent the previous days concealed in a local auto repair shop. They spilled out of the vehicles and opened fire on two American military policemen, who responded with notable presence of mind, locking the embassy gate and shooting down the VC platoon leader and his assistant. At 0247 they radioed the code for an attack, "Signal 300!" One American added, "They're coming in, they're coming in! Help me! Help me!" before being killed. As the embassy's ARVN guards fled, the rest of the attackers scrambled through the breach made by their fifteen-pound satchel charge. Once inside the compound, however, the commandos faltered. They fired two rockets at the chancery building, blowing the US national seal off the wall, wounding a Marine, and putting the fear of God into the handful of other occupants, while killing no one. Thereafter, they took cover behind the concrete surrounds

TET · 457

of some large flower beds and for the next few hours merely exchanged desultory fire with a handful of Marines and MPs in surrounding buildings.

Allan Wendt, a thirty-three-year-old economic specialist who was diplomatic duty officer, was awakened by the thunderous explosion. His first reaction was to dive under the bed, his second to ring down to a Marine on the ground floor, who told him the building was under attack. Black farce followed. There were no weapons in the embassy building but those in the hands of three guards, one of whom was quickly wounded. Wendt saw no reason why the attackers should not storm the place: "I thought I was living my last moments." He made the first of several telephone calls to MACV from the sanctuary of the armored cipher room, where he locked himself in. Westmoreland's staff assured him that help would soon be on the way, but pointed out-somewhat in the spirit of corporate recorded messages asserting that "your call is very important to us"—that they were responding to multiple attacks around the Saigon area. Wendt protested, emotionally but entirely accurately, "This place is the very symbol of American power in Vietnam." A MACV officer promised that an armored column was on its way, though it was not. The diplomat also took calls from the State Department's Operations Center and the White House Situation Room, for whose occupants he held up the telephone mouthpiece so they might hear the rattle of gunfire.

The initial Saigon response was even less disciplined than were most of the VC's attacks. The 716th MP Battalion, the only American unit in the city center, was ordered to send help to the embassy. Its officers declined to move until armor and helicopters were available, and resisted joining a firefight in darkness. One shrugged: "The VC are inside the compound. They're not going anyplace." Most of the Americans—Marines and MPs—who progressively eliminated the commandos during the hours that followed, were doing their own thing rather than fulfilling orders. They also killed four South Vietnamese embassy drivers, though one of these was probably assisting the attackers.

The hero of the defense was twenty-year-old Marine Sgt. Ron Harper, the guard who closed and barred the heavy teak doors of the chancery just before the VC addressed themselves to it. During the long shoot-out that

followed, scores of TV and press reporters gathered nearby to describe an irresistible drama unfolding a few hundred yards from their hotels. Brig. Gen. John Chaisson, director of Westmoreland's Combat Operations Center, found himself standing beside the sentry outside his quarters a block away, watching the sights and listening to the sounds: "There is something weird about street fighting. Everything seems to be going in all directions and the big booms are accentuated by bouncing off the buildings."

At first light, Hueys belatedly airlifted a platoon of the 502nd Airborne to the embassy's relief. Capt. Jack Speedy wrote, "The morning was spectacularly beautiful as the sun rose higher in the sky. Mists rose from the Saigon River. Smoke from cooking fires was in evidence in many of the dwellings below. Green, shimmering vegetation emerged from the golden reflection of the rising sun." The streets were deserted as they peered down toward the embassy. Then they began to take fire from invisible enemies—the VC commandos—which wounded a door gunner, who slumped back streaming blood. With astonishing pusillanimity the pilot, rather than land on the embassy roof, swung away toward Long Binh, where as they approached at 0630, part of its ammunition dump exploded—another success for suicidal communist sappers. Steve Howard, an eyewitness, said, "It was like somebody's introduced nuclear weapons into Vietnam."

The paratroopers landed in the midst of conspicuous panic. "This Tet thing was clearly having a widespread effect." While the wounded gunner was taken away, the paratroopers ran to another Huey, flew back to the embassy, and landed on the roof more than six hours after the first attacker had entered the compound. As they jumped down, a Marine guard and an Army communications man seized the opportunity to climb aboard and vanish. The newcomers raced downstairs, meeting a civilian staffer, probably Wendt, "with a look that said we were the greatest people on the face of the earth." Follow-on "slicks" (troop-carrier choppers) dropped more paratroopers. Two wounded attackers taken prisoner were handed over to the South Vietnamese.

Col. George Jacobson was a retired officer who occupied a villa in the compound, and held the post of mission coordinator—civilian adviser to the ambassador. Jacobson had held a Tet firework party in his garden the

TET · 459

previous evening, then spent the ensuing hours lying low and clutching a grenade, his only weapon; living within the compound of the fortified embassy, it would have seemed ridiculous to keep a gun under the pillow. First light brought the colonel a drama worthy of a Hollywood Western: he heard a VC—the last commando at liberty—downstairs, and called softly out of the window to a Marine he glimpsed outside, demanding a weapon. The man tossed up a pistol, which a few moments later, at 0645, Jacobson emptied into the enemy fighter, who charged into the bedroom firing an AK-47.

At 0915 the embassy was declared secure. Tom Speedy said, "The bodies of the Communist dead were not even cold when a Mongolian horde of the press burst into the compound. . . . My most pressing problem became newsmen." A paratrooper told the newcomers that attackers had penetrated the chancery building. These sensational though false tidings were broadcast around the world, making a bad story worse. Somebody observed that the weapons the communists had employed to inflict this stunning blow upon US prestige had cost a tiny fraction of the \$4,000 minimum charge for access to the Pacific satellite by which the story was televised to the world, with an impact greater than that of any bullet.

Gen. William Westmoreland had been alerted to the first attacks at 0300, but did not leave his quarters until driven direct to the embassy just after it was secured. What he then said inflicted lasting injury upon his reputation. First he upset his own soldiers, snapping at Speedy and his unshaven men, who were told to disappear and smarten themselves up, "then he spun away and inflicted himself on some other poor souls. . . . There were enough Westmorelands and his kind to make many of us hate some of our own side." Allan Wendt, the diplomat who had endured a night of terror, was even less impressed. There were no apologies for the six-hour delay before the US Cavalry arrived, figuratively speaking. Instead, after viewing the debris and corpses outside, the general expressed disgust at the unseemly mess. "I suggest you get this place cleaned up," he told the duty officer, "and get these people back to work by noon."

Westmoreland told newsmen that the enemy had suffered a great defeat. Speaking like a preacher shocked that the collection plate has been

460 .

raided, he said, "The enemy, very deceitfully, has taken advantage of the Tet truce to cause maximum consternation." He later suggested that the attack on the capital was "diversionary" to the communists' "main effort" in Quang Tri Province. Peter Braestrup of the Washington Post demanded scornfully, "How could any effort against . . . downtown Saigon, be a diversion?"

THE GIANT REELS

1. FIGHTING BACK

The assault on the US Embassy was only the most conspicuous among hundreds of violent clashes that erupted in the early hours of January 31. Tran Tan was a high school student, living with his parents and their nine other children in a little thatched house on the outskirts of Saigon, when he was shaken awake by his mother. "There's a lot of noise outside that doesn't sound like firecrackers," she said. Tan dressed hastily, while his father, a former soldier for the French, went to investigate. He came back and said, "The VC are everywhere—you'd better get out." Tan took his younger brother on the back of the family Honda and fled by back alleys to an uncle's house; the two boys were the only ones of an age to be of dangerous interest to the communists. Their parents and neighbors took refuge in a nearby school, which became home for the next six months, until they were moved to a refugee camp. During the destruction of most of the area in the Tet fighting, the Trans' little home was incinerated, leaving them destitute.

Down in the Delta, a student invited into his home for tea a cadre who entered the town of Cai Lay with VC guerrillas. The communist said there was no time for that: "For now, let's be happy in welcoming peace. I hope you will contribute to bringing it about." The young man was invited to write down the names and addresses of every government, police, or army man he knew and duly did so, omitting only close friends. Two weeks of

fierce fighting followed, in which the civilian population cowered in their homes. The attackers were eventually repulsed from the main government compound.

In Saigon, VC commander Huynh Cong Than wrote, "Events during the first day of fighting were completely different from what we had expected. The spearhead battalions were unable to make rapid progress because they had only small arms and little ammunition, while enemy forces were numerous and exploited the tangle of streets and alleys to mount fierce resistance. Civilians gave our men a warm welcome, but we were not . . . supporting a popular uprising." Communications broke down between the battalions thrusting into the city and their headquarters outside, which was obliged to rely for information on Saigon radio, soon transmitting again. Thirty-five VC battalions were committed in the region, eleven of them within the city. Poor intelligence frustrated the purpose of an assault on the South Vietnamese armored center by fighters accompanied by drivers trained to use captured heavy weapons: they found the tanks gone, breechblocks removed from 105mm howitzers, making them unusable. A major thrust was launched against the military headquarters at Tan Son Nhut. Vice President Ky, who was inside the base, armed his wife and three older children with rifles and pistols. Lt. Col. Glen Otis became one of the American heroes of the battle for the manner in which he directed his 3/5th Cavalry in a night relief thrust from Cu Chi, hitting the communist attackers in the rear. His own unit was considerably mauled as he flew ahead of them in a Huey, pinpointing ambushes and ordering diversions, but the Cav contributed importantly to blunting the Tan Son Nhut assault.

In a nearby house, teenage student Tran Van De peered cautiously through a slit in the gate and saw a soldier in an unmistakable Vietcong pith helmet shouting down the street: "Come on out, everybody. The revolutionary army is here to liberate you." De and his family stayed put, however, because as good Catholics they had been reared since the cradle to hate and fear communists. Soon afterward, he heard shooting close at hand, and crept back to where his mother and four younger siblings

were huddled apprehensively. He put his finger to his lips, and motioned all of them under the big bed. Terrifying hours followed: bullets zipped through their front door; they heard helicopters firing rockets, one of which set the neighboring house on fire. Eventually the whole family fled to a patch of wilderness a few hundred yards distant and crouched in a ditch for the next three days. Each dawn De returned to check their house, which survived. On the third morning he found himself confronting the raised rifle of a huge American soldier. "I am a student," said De, in English. The man lowered his weapon, but the Vietnamese could see the doubt, the suspicion, lingering in his eyes.

Generals feel most comfortable handling large forces in coherent battles. Fred Weyard prided himself on having ensured resilient communications, which enabled him quickly to feed units of his II Field Force into the struggles around Saigon. The rest of MACV's brass, however, seemed unmanned by the chaos that overtook the country. Liaison between Americans and South Vietnamese was poor. Many local commanders were thrown back on their own initiative. During the first hours in Saigon, American military police took significant casualties because they were understandably ill-prepared to fight as infantry. Sixteen MPs were killed and twenty-one wounded, many of them aboard a blown-up truck. In Cholon heavy fighting persisted for weeks. A handful of Australians fought off a VC attack on their billet in which one enemy rocketeer was killed by a cook, Pvt. "Pop" Clement. He spoke later in terms characteristic of his nation: "I knew when I saw him lift up that drainpipe he wasn't coming round to fix the plumbing." The big picture was of government forces holding most of their ground, and inflicting far higher casualties than they received, while those on the streets saw only bloodshed and mayhem.

Much of the accustomed daily business of the US 3rd Field Hospital in a Saigon suburb was to address civilians' terrible teeth and issue them with the multicolored placebos they loved. Now, suddenly, the facility was plunged into a maelstrom. American surgeons were working on a wounded Vietcong when a male nurse put his head around the door and said, "They've just hit the embassy." Disbelieving voices muttered, "Yeah,

464 .

right." Then the nurse said earnestly, "Forget this case. We have plenty more to go." Medical aid William Drummond said, "The marathon started at that point. . . . We worked continuously for like forty hours."

There were harsh decisions to abandon some bad cases because resources had to be prioritized. Walking wounded were loaded aboard buses and driven to Tan Son Nhut for evacuation to Hawaii. A few staff succumbed. Drummond described the collapse of the head of surgery: "He was overwhelmed. He just seemed like an inadequate person who couldn't deal with it." He himself stepped outside to be confronted by a two-and-a-half-ton truck carrying American corpses, maybe a dozen of them. Junior ranks' quarters were commandeered as a morgue, which at one time was occupied by 600 bodies, Vietnamese and American. The hospital had 150 beds but at its Tet peak held 500 patients. Inside the windowless facility "you were in a tomb": sometimes medics stepped briefly outside, merely to discover whether it was daylight or dark.

Drummond found his job toughest among "expectants"—doomed men. "It was real hard to see somebody that could have been my brother, same age, that was talking to me and we knew was going to die." The hospital's chief nurse and her assistant were motherly women in their fifties. One of them saw a Marine descend from a truck with an elbow bone protruding, everything gone below. The nurse said, "Poor boy, you lost your arm." He responded, "That ain't nothing, honey, they shot me in the balls, too!" The pace slowed only on the third day, when the hospital's sterile supplies were exhausted.

Back home, the American people were stunned, and often misinformed. NBC anchor Chet Huntley told viewers that Vietcong snipers had penetrated the US embassy building and fired down from its rooftop on rescuers in the courtyard. Sarah McClendon said on the DC news program *Capital Tieline*, "The situation is very, very bad, and I think people should realize this." More temperately, Tom Buckley of the *New York Times* expressed awe that "after years of fighting and tens of thousands of casualties, the Viet Cong can still find thousands of men who are ready not only to strike at night and slip away, but also to undertake missions in which

death is the only possible outcome." CBS's Mike Wallace said the attacks "demolish the myth that the allies are in military control of South Vietnam." Senator John Stennis of Mississippi told reporters that even if the attacks cost the enemy heavy casualties, they represented a personal humiliation for Lyndon Johnson. The president was indeed deeply shocked: his faith in the military, and explicitly in Westmoreland, never recovered.

And the battle raged on. In Saigon at 0600 on February 1, VC commander Dang and his staff boarded big sampans flying NLF flags, motored upriver, and docked in the city. Then they walked under intermittent gunfire to the Ba Tang Bridge through streets in which many houses were displaying their flags. Dang was a Vietminh veteran who had known Saigon back in 1945–46. He stopped by the house of a certain Mrs. Chin, where the Party committee had its headquarters in those faraway days. One guerrilla said he found it so wonderful to be in the capital that he took off his sandals, the better to feel its streets.

That afternoon at MACV, Brig. Gen. John Chaisson wrote with reluctant admiration, "This is really a fantastic effort. The enemy has hit nearly every airfield and province capital in the country simultaneously. So far he has caused us considerable damage, not too many casualties, but he has paid a stupendous price. If we can stay on top of this (and we will) I don't think he will have too much left in reserve. He either is going to make it on this one, or he has shortened the war for us."

At the insurgents' field headquarters, spirits were already sagging. Cadres reported that all VC commandos in the city center had been killed. Dang set up a new command post in a pagoda near the Binh Tien Bridge, and dispatched "occupation teams" through the streets, calling on every citizen to join the uprising . . . largely in vain. He heard that a bomb had fallen on the house of his friend Mrs. Chin, killing its occupants. In the nights and days that followed, there was no sleep and an unbroken diet of ill tidings, mostly borne by women couriers who braved the shot-torn streets. Advancing allied forces, committing ever more firepower, were shrinking communist perimeters. Helicopters circled continuously, dropping flares in the hours of darkness. American direction finders pinpointed Dang's radio transmissions, so that shells began to bracket his location. A

steady stream of casualties were carried in, for whom little could be done. The guerrillas subsisted on a diet of duck and duck eggs, sickening of both. Dang pleaded desperately and in vain for reinforcements.

Meanwhile throughout the country, almost every American combat unit found itself engaged somewhere, somehow. Capt. Myron Harrington was a thirty-year-old from Augusta, Georgia, who took over a company of the 1/5th Marines five days before Tet, feeling embarrassed that he had hitherto served eight years without seeing action. "I was very conscious of being green." A few hours after the offensive began, he and his men were dispatched on a sweep south of Hue along the old coastal rail line, where they promptly collided with some NVA and had a messy firefight in an abandoned village. After a night in which their positions were intermittently mortared, at dawn Harrington was ordered to lead two platoons across country to join up with the rest of the battalion eleven miles away. Here was a classic instance of the confusion and fumbling leadership: it was absurd to dispatch a small force on such a hazardous march.

Harrington asked battalion, "What's between thee and me?" Nothing, battalion said. Yet his Delta Company moved only a few hundred yards before meeting enemy fire. They took four hours to disengage and evacuate eight wounded, covered by naval gunfire. Harrington could see NVA gathering in force, amid hand signals and whistle-blowing. "I realized this was getting serious." Only after another thirty-six hours were they able to redeploy, under cover of darkness, reaching the battalion at midnight on February 2.

Lt. John Harrison's Airborne company outside Nha Trang was committed to advance across open paddies toward two houses and a graveyard where they were told that the Vietcong were waiting. Harrison said, "Suddenly a lot of them were behind us, firing rockets and mortars thump-thump." He and three men sought refuge in a hooch, only to find bullets zipping through its walls. They fought all day, the rest of his company pinned down a thousand yards back. "It became a slugfest—who was better than whom. In most contacts if you were going to lose guys, it happened in the first thirty seconds, but this went on and on." His point man was killed on the porch of the adjoining hut. Harrison called in air

strikes so close that a blast blew the roof off his own hooch and set him bleeding through nose and ears. At one stage, six F-4s were stacked overhead, diving in succession.

Yet still the VC kept firing. A child ran out of a hut, grabbed a gun lying on the ground, and darted inside again. The officer told his M60 gunner, "If she does that again, shoot her." Though just before nightfall another company arrived to relieve them, they lost a further three men in the course of extracting a casualty. It had been a rough, tough day. Harrison said, "It was the first time in Vietnam that I could not establish fire superiority. We were shooting massed M60s yet we couldn't make them slow their fire. We scarcely saw the enemy, only glimpses of the flashes from their AKs." The paratroopers retreated just before dusk, then later the lieutenant led a patrol back to the battlefield, to recover their own dead. They got lost on the way home, and had to radio the Airborne perimeter to fire tracer into the air as a guide.

The vivid and sometimes moving memoirs of Vietcong who participated in Tet conspicuously omit the widespread atrocities committed in areas that they occupied. Cadre Nguyen Van Lem is alleged to have captured an ARVN officer and his family, then personally cut the throats of Lt. Col. Nguyen Tuan, his wife, their six children, and his eighty-year-old mother. Shortly afterward, on February 1, Lem fell into the hands of ARVN Rangers. When he was brought before Saigon's police chief, Brig. Nguyen Ngoc Loan simply drew a Smith & Wesson and shot him in the head. Nonetheless, Eddie Adams's photograph of Loan shooting the prisoner, which won the AP man a Pulitzer Prize, inflicted devastating damage on the American and South Vietnamese cause, an outcome regretted by the photographer: "I thought absolutely nothing of it. He shot him, so what? . . . And I just happened to be there this time." Adams lamented that he was unable to get a picture "of that Viet Cong blowing away the [Tuan] family." American historian Ed Moise is convinced that the entire story of Lem murdering the Tuan family was a postwar South Vietnamese propaganda fabrication. The truth will never be known, but Vice President Ky wrote bitterly, "In the click of a shutter, our struggle for independence and self-determination was transformed into an image of a seemingly senseless and brutal execution."

MACV urged the media to consider countless atrocities committed by the other side but could offer no remotely comparable visual images. It was the same story later in the battle, when newspapers published AP photos of a Vietnamese Marine shooting a PoW. A US adviser was quoted as saying, "We usually kill the seriously wounded Viet Cong for two reasons. One is that the hospitals are so full of our own soldiers and civilians that there is no room for the enemy. The second is that when you've seen five-year-old girls with their eyes blindfolded, their arms tied behind their backs, and bullets in their brains, you look for revenge. I saw two little girls that dead yesterday. One hour ago I shot a Viet Cong."

At MACV, Brig. Gen. John Chaisson faced the ordeal of briefing reporters—"that group of buzzards." Army information lagged hours behind events, so that on the morning of February 1 Westmoreland's staff announced that in Hue a VC company had merely attacked a bridge and loading ramp before being driven off. That evening's US Army press release reported only two mortar rounds landing in an ammunition dump at Phu Bai, nine miles to the south, whereas by that time much of Hue city was in communist hands. Scrabbling for good news, spokesmen highlighted the voluntary return from leave of many Vietnamese soldiers, together with the fact that few civilians were rallying to communist appeals. Chaisson himself told reporters on February 3 that clearing Hue was "just a matter of time," a process that should be completed "in the next day or so." In reality, the city's battle had three weeks to run.

The *Christian Science Monitor* that day asserted that the US faced the possibility of military defeat. The *Wall Street Journal* editorialized that something was "awfully wrong. The South Vietnamese government, with all the vast aid of the US, has revealed its inability to provide security for large masses of people in countryside and city." The satirical columnist Art Buchwald wrote, "Little Big Horn, Dakota, June 27, 1876: General George Armstrong Custer said today in an exclusive interview with this correspondent that the battle of Little Big Horn had just turned the corner and he could now see the light at the end of the tunnel."

Some Vietnamese senior officers behaved well, but others succumbed

to funk. Westmoreland told the Pentagon that IV Corps's commander had sought refuge in his mansion behind a screen of tanks, while another senior officer had taken to wearing civilian clothing beneath his uniform. Lt. Gen. Creighton Abrams complained to the ARVN chief of staff that in Hue three battalions of Vietnamese Marines had moved forward less than half a city block in three days. "In this time of great need... if the Marines cannot [rise to the occasion], ... they have forfeited their right to be a part of your armed forces." David Brannigan of NBC claimed that the South Vietnamese troops were doing more looting than fighting. Fred Weyand said later, "Some of them did remarkably well—as well as we would have done—and some were just terrible.... In too many cases, when they felt in danger of being overwhelmed, they fell apart."

By the fifth day of fighting in Saigon, February 4, the VC's regional commander proposed a general withdrawal, a call immediately rejected by the Party secretary. Senior cadres later lambasted some leaders' supposed lack of determination, though such criticism was surely designed to deflect attention from their own responsibility for launching the offensive on the basis of multiple false assumptions. That same February 4, after formally celebrating the thirty-eighth anniversary of the founding of the Vietnamese Communist Party, Dang shifted his command post. He and his staff rode bicycles to a ferry, then withdrew across the Saigon River. As American shelling intensified and their casualties mounted, on February 5 they quit. COSVN ordered units withdrawing from the city's center to keep fighting on its fringes, but a battalion commander blurted despairingly, "The suburbs are a meat-grinder: if we hold on there we shall lose a lot of men." Sluggish trickles of survivors set forth on a long, dejected march back toward the sanctuary of the Plain of Reeds.

John Chaisson wrote home on February 6: "Gen. Westmoreland is bearing up pretty well, but he is taking a drubbing in the press." MACV's chieftain retained his fixation with the northwest. On February 8 he cabled the Pentagon: "Although I feel we can hold Khe Sanh, it is conceivable that we will not be so fortunate. If we lose it, it will be essential that we retake it and that is why I have put the 1st Cav Div in the area. . . . It

is only prudent to plan for the worst contingency." As late as the 10th he messaged Adm. Sharp that he was still convinced that North Vietnam "intends to make Khe Sanh another Dienbienphu."

The media followed the general's lead. In February and March, the base on Route 9 accounted for 38 percent of all Vietnam AP stories from outside the capital, and one-fifth of all war photos published in the *New York Times* and *Washington Post*. TV stations broadcast repeated shots of casualties and damage inside the Marine perimeter—half of CBS's nightly war coverage featured the siege—but could show nothing of the far heavier carnage among the NVA. On February 16, CBS reporter Murray Fromson asserted bleakly, "Here the North Vietnamese decide who lives and who dies . . . and sooner or later they will make the move that will seal the fate of Khe Sanh." Although scores of aircraft took off and landed unscathed, TV focused on three C-123s and one C-130 wrecked on the airstrip. CBS's Walter Cronkite, visiting Vietnam, is alleged to have said that few people doubted that the communists could take Khe Sanh if they really wanted it.

Amid this high tide of crisis, CIA analysts upgraded their estimates of total communist strength in the South from 515,000 to 580,000, though the real number was probably nearer 300,000. Waves of fear at MACV lapped up to the White House. How else to explain the president's remark to Earle Wheeler on February 3? He said that, while he had no wish to drop an atomic bomb at Khe Sanh, the enemy might force that decision upon him. Westmoreland assured the president that this would not be necessary—one of very few direct telephone exchanges between the two men that took place during Tet. But then the general himself said that if the NVA now unleashed a full-scale invasion of the South, the US should be willing to use whatever was needed to stop them, including chemical or nuclear weapons.

On February 5, an aide of William Fulbright received an anonymous call suggesting that the senator should ask why one of America's foremost experts on tactical nuclear weapons, Professor Richard Garwin, had recently visited South Vietnam. This tip-off prompted intense and alarmed speculation. On February 8, Eugene McCarthy, now the anti-

Johnson Democratic aspirant in the 1968 presidential election, asserted that the military had requested access to tactical nuclear weapons. The White House and Pentagon immediately denounced McCarthy's remarks as unfair speculation, which indeed it was. Yet at a news conference, Earle Wheeler refused to rule out the possibility of using nuclear weapons if Khe Sanh was in danger of being overrun; meanwhile Johnson briefly considered invading the North.

The persistence of such fevered discussion was reflected in a February 17 New York Times story about the president headed Johnson Denies Atom Use in Vietnam is considered. Such talk appalled America's allies. British prime minister Harold Wilson said on CBS's Face the Nation that the use of nuclear weapons would be "lunacy... sheer lunacy." In truth, nobody got close to unleashing such a nightmare; most of the generals' obtuse remarks reflected a desire to keep Hanoi guessing, rather than real intent. On February 12, Adm. Sharp sought to foreclose the issue by ordering Westmoreland to abandon nuclear contingency planning. The damage to international confidence was done, however, and proved irrevocable.

The communists deployed sixty thousand men on the northern sector battlefields. Early on February 7, a battalion of the 304th Division, ineffectually supported by armor, launched an assault on a US special forces camp at Lang Vei, five miles west across the mountains from Khe Sanh. The first NVA PT-76 tank was quickly hit and left burning, but infantry breached the perimeter. The Army pressed the Marines at Khe Sanh to dispatch a relief column, a proposal wisely rejected: the NVA was deployed to punish just such a move, and it was a reflection of the panic in high places that soldiers proposed it. At Lang Vei the attackers hit some defenders' bunkers with B40 rockets, poured gasoline into one whose men continued to hold out, lit it, then raised their flag at the cost of 30 percent casualties. Helicopters evacuated American survivors before the impossibly exposed camp was abandoned.

Though the communists crowed about their success, their losses throughout the region were appalling. Disease took a steady toll even before B-52s intruded: one man in five suffered from malaria, more when

the rainy season came. In one failed assault, a regiment lost a quarter of its strength, then another lost one man in five attacking Hill 832. The NVA's 9th Regiment suffered typical tribulations: on the evening of February 6, its men bivouacked along a stream a mile from Route 9. Next morning as the troops resumed their march, aircraft suddenly appeared overhead: six B-52s, unrolling a blanket of devastation. Half the regiment was directly beneath thunderous columns of bombs.

As men scurried among the dead and strove to save the wounded, a second and then third wave of bombers attacked. When the last B-52s faded into the distance, wrecked bodies lay everywhere among stripped trees and bloodred water. The regiment had suffered almost three hundred casualties, 15 percent of its strength, before firing a shot on the battlefield. One company commander had a nervous collapse. The divisional history acknowledges a slump in morale. Back on the Ho Chi Minh Trail, almost two hundred tons of ammunition, transported South by herculean labor, were also destroyed by air strikes.

After the first weeks of Khe Sanh's siege, the green hills around the base were reduced by bombardment to red wastes shrouded in dust and smoke. Each air strike was followed by a frenzy of communist digging, to rescue buried men. One bomb exploded by a command bunker, killing five new arrivals, fresh out of high school. The two sides' snipers waged protracted duels, but most of the communist effort was devoted to pushing trenches ever closer to the American perimeter. The urgency of their excavations was driven by knowledge that only through closely grappling with the defenders might they gain respite from air attacks. By March, some NVA companies were reduced to thirty men. The Americans who held those positions never forgot the experience. Cpl. Orville Fulkerson noted curiously that a tangle of intermingled American and NVA corpses on Hill 881 "jolted like jelly" as they were hit again and again by the small-arms fire of one side or the other. Jeff Anthony, among the defenders of Hill 861, never believed that the North Vietnamese could capture Khe Sanh, because they were hammered in every attack on his own company's positions. Again and again in the darkness, the Marines glimpsed shadowy figures at sixty yards, then forty, then thirty-closer than ever before

in the Vietnam experience of most Americans. Yet guided by overhead illuminants, the defenders mowed down the NVA, emptying magazine after magazine, belt after belt, "though we took a lot of casualties from their mortars." After one clash on the morning of February 25, the NVA tried an old psychological warfare ruse from Dienbienphu, inviting the Americans to remove their own dead under a white flag. The Marines ignored this attempt to secure a priceless propaganda image.

Communist commanders deployed an entertainment troupe to alleviate the boredom, as well as the exhaustion and terror, besetting the besiegers. A playwright named Chu Nghi created a work entitled At the Ta Con Perimeter Wire, which was duly performed. Its morale-boosting effect was somewhat diminished when the author was himself killed in an air attack, which also wounded an actor and actress. Hanoi histories cite fantastic statistics for casualties inflicted on the Americans, including an alleged body count of 3,055 in place of the real 500, and claims of 279 US aircraft destroyed. One squad reported killing forty enemies for each of its own men lost, claiming that "the tall, heavy, slow Americans died in large numbers." Khe Sanh is described as "a glorious victory." No communist soldier privately believed such nonsense, however. The 304th Division's history admits that its units suffered "considerable attrition during this ferocious trial of strength," which caused "problems . . . in the thinking and ideology of the division's cadres and enlisted men." Desertions and self-inflicted wounds soared. Disciplinary action was taken against an extraordinary 399 men, including 186 Party members and 85 cadres, for infractions that included "lack of offensive spirit."

The North Vietnamese Army asserts that 45 percent of all its losses were caused by air strikes, a similar percentage by artillery, less than 10 percent by small arms. By the time the Tet battles ended, the communists in the northern sector faced a sick list of twelve thousand and admitted six thousand killed and another fifteen thousand wounded in action. The siege of Khe Sanh petered out through the spring. Perceived objectively, it was a major defeat for the NVA, which lost at least ten men for every American killed. But Westmoreland and the media between them snatched a psychological defeat from the jaws of victory. MACV was

deemed to have fallen victim to a brilliant communist deception—and to a considerable degree, it had.

In Hue, by the night of February 4–5, the attackers had suffered well over a thousand killed and four thousand wounded, and they faced shortages of ammunition and food. Yet when NVA commanders sought permission to withdraw, it was refused. They were told that airdrops would soon take place, for which they should prepare marker fires, that on February 18, a new wave of nationwide attacks would be launched, and that reinforcements were at hand. A cadre later expressed his bitterness about these lies and the betrayal of his men's trust by the willful propagation of false hopes. Few senior communists dared to acknowledge bad news openly. In the words of the NVA's Col. Nguyen An, "Everyone was afraid to speak for fear of being accused of cowardice or some ideological fault."

Vice President Ky was told that the Americans hesitated to bombard Hue's temples and palace, in which the communists were now concentrated. He responded with his accustomed ruthlessness: "These things were made by men. They can be rebuilt by men. Hit them!" Shells and air strikes pounded the citadel whenever persistent poor weather permitted. Yet the city's recapture proceeded with agonizing slowness, securing only a few hundred yards of rubble a day. Marines became contemptuous of their South Vietnamese allies. An American who clambered onto the hull of an ARVN tank to fire its turret machine gun battered in vain on the hatch for ammunition: the crew had locked themselves down.

From a foxhole north of Hue, Lt. Andy Westin wrote to his wife, Mimi: "My darling, for the first time since I came here, last night, I cried. I wasn't the only one. From the CO on down, our men were crying. . . . Our entire battalion got caught in a gook trap. . . . It was a slaughter! All the brass thought the gooks had moved out, so we just went waltzing into this woodline. . . . I've never seen anything like it and I hope I never do again." As losses mounted, Americans grew increasingly careless about the plight of civilians in the path of their shells, bombs, and bullets. Sorely conscious of their own bleak prospects, they became cruel in their contempt for property; there was much wanton destruction. It cost four days

of dogged fighting, blasting out the enemy with fire from tanks, flame-throwers, and 106mm recoilless rifles, to secure a mile-long strip of the Southern city between the MACV compound and the Phu Can Canal. Meanwhile across the river, ARVN efforts to retake the citadel still made painfully slow progress.

On February 11, Myron Harrington's Marine battalion was dispatched up Highway 1 to Hue. "Nobody knew what was happening." He was given a perfunctory briefing on street-fighting tactics, "about which I didn't have a clue." On the 13th, the battalion's Alpha Company suffered heavily attempting to advance into the citadel. Next day, Harrington's bewildered Delta moved upriver in landing craft and junks, taking incoming fire. That evening Harrington was told casually, "By the way, tomorrow you're going to have to take the Dong Ba Gate," which "put the fear of God into me."

He passed a sleepless night, partly from anxiety and partly from the relentless din of artillery. The morning of February 15 found him leading a hundred men scrambling southward up a ditch inside the citadel wall, grateful for heaps of rubble that gave them cover. "It was suddenly very quiet, like those apparently silent Japanese Pacific beaches in World War II." Then the communists opened up, quickly wounding Harrington's runner: "The fire was so intense it was like being on the 300-yard range at Quantico. I couldn't hear myself think. One platoon commander was lying on a balcony, wounded by an RPG, with his radio knocked out. I sent several runners to his position, who were all hit." Harrington told Sgt. Maury Whitmar to take a squad up onto the wall. "He gave me an incredulous look—then did it."

The Marines started working toward the base of the tower that was their objective, halfway down the western side. A tank rumbled forward, commanded by a young lieutenant named Morris, which started shooting in support: "He was superb." A black Marine ran up to Harrington and said in mock exultation, "I just got my third Purple Heart!" The captain said later, "It was only a nick on his chest, so I made him my runner, and he took ammunition to the guys fighting up on the wall. I still didn't know the names of most of my men, living or dead. I just had to order

them to go toward death. The stench of death was horrible, and it was everywhere. When you were eating your rations, it was like eating death."

There was an especially bizarre moment in the midst of the carnage: a young lieutenant named Joe Allen ran under fire to Harrington, announced himself as a replacement, and blurted out, "Captain, I saw your wife and daughter a week ago." Amid the detonations and bursts of small arms, Harrington recalled, "it took my breath away. I was forced to think outside the battle, and that's a bad idea." It was late afternoon before more men got up onto the high wall of the citadel, led by Cpl. Bob Thoms, a formidable warrior whose fatigues were in rags. By 1630 the area had been secured, at a cost of six killed and forty wounded among the hundred-odd Marines with whom the captain had started the day. At 0400 next morning, the 16th, the NVA counterattacked. There were more fierce exchanges of fire before the tower was again secure. Twenty-four enemy dead were found in its ruins.

Harrington had thirty-nine men left, who were immediately committed to slow, painful, nerve-racking house clearing. "The enemy had had two weeks to prepare positions. We were reaching a point where we were almost ineffective, when you don't care if you live or die. We were mentally wiped out. Nobody had any appreciation of what was going on. Higher headquarters kept asking, why is it taking you so long to knock out a few NVA?" Their commanding officer, Maj. Bob Thompson, incurred the wrath of Creighton Abrams for his unit's slow progress, and was indeed sacked before senior Marines got the order countermanded. Harrington felt overwhelmed when he heard that he himself had been awarded the Navy Cross: "I didn't feel I was worth it." Others did.

At 0630 on February 22, the remaining NVA trapped in the citadel staged a suicidal rush. Some South Vietnamese troops broke and fled, ignoring their lieutenant's threats to shoot them. The Hac Bao, Black Panthers, finally raised their own flag on the Imperial Palace, lowering that of the NLF, at 0500 on the 23rd. As they did so, an almost naked figure emerged from the ornamental lake—a South Vietnamese soldier who had remained concealed for twenty days, creeping out at night to forage; he proved to be the elder brother of Capt. Pham Van Dinh. The

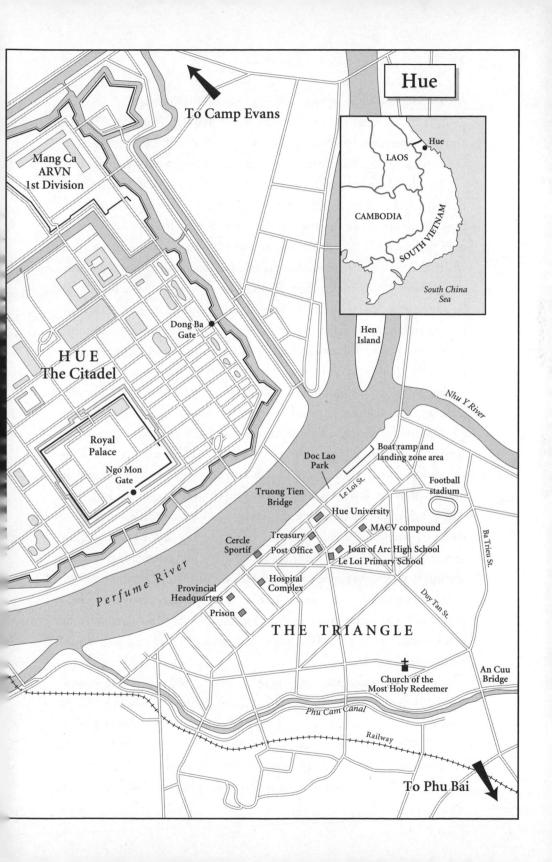

ARVN lost 458 dead in Hue, and more than 1,000 wounded: some, at least, must have put up a respectable fight. The US Army lost 74 dead and 507 wounded, the Marine Corps 142 killed and 857 wounded. An estimated 6,000 civilians died, a substantial proportion by "friendly fire."

The day after the citadel was secured, Bob Kelly of USIA wrote to Frank Scotton, "South of the river every house is shot up. Burned cars, tanks and trees litter the streets. Rocket and 8" [artillery] holes are all over the place. . . . All of the houses and shops around the big market, where the sampans were always parked, are destroyed. Napalm, CS, 8" [shells], and 500-pounder [bombs] are used every day. Those bastards in Saigon have no idea of the magnitude of the problem. . . . What makes me so mad is those fuckin' generals of ours who say, 'we knew it was coming,' as though they let it happen. And now, with a stunning defeat on their hands, are claiming a body count victory." Kelly's anger was increased by having witnessed the ignominious flight of many South Vietnamese officials as well as soldiers.

A journalist described Hue's residential and commercial area as resembling something out of Goya. "Whole streets were laid waste. Rubble choked the sidewalk, there were bomb craters in the tarmac and the blackened shells of burned-out cars. A truck was embedded in a wall. The stench of the dead was overpowering. . . . That day Hue was no more the city I had known and loved than a friend lying in the street, charred and ripped by a bomb, is the human being one had once talked or made love to. Between them the communists and the US high command have killed the flower of Vietnamese cities." A local onlooker pointed to a heap of rubble: "The man who lived there was shot by the Viet Cong. Now his house is destroyed by the Americans. Curious, eh?" Rats and dogs feasted on the corpses.

The communists lost somewhere between 2,500 and 5,000 dead—they have never revealed credible figures—but in the last days of February, their survivors withdrew westward unmolested, a measure of American and ARVN disarray. The battle had been small by 1939–45 standards, but it was the bloodiest single action of the Second Indochina War. On February 26, the first of several mass graves was discovered in Hue: during

the NLF's short rule, its cadres had systematically murdered every government official and supporter, intellectual, bourgeois, and "enemy of the people" whom they could identify, together with their families. Albeit on a lesser scale, similar killings took place elsewhere. A communist attempted to justify the atrocities: "The people so hated those despots that they treated them as they would have done poisonous snakes—which had to be destroyed to prevent them striking again."

Among the victims were fifty-three-year-old Nguyen Tat Thong, the government's director of social services, who had come to celebrate the holiday with family, along with six of his relatives, including two teenage student brothers. Also murdered was a forty-eight-year-old widow named Nguyen Thi Lao, a street cigarette seller, as well as Catholic priests and American civilians. Hundreds were liquidated whose only offense was to appear on a list of supposed government sympathizers. Some 2,810 bodies were eventually found, but the real total of victims was almost certainly higher. Capt. Denis Campbell, an Australian adviser, wrote, "One can understand the hate that lets [the communists] strangle military types with wire and decorate the walls with the bodies, but to bury alive whole families including the children on no stronger pretext than that they refused to take up arms defies the imagination. I have always had a grudging admiration for the VC . . . but that has now gone."

The killings mock the pretensions of Vietnam's communists to represent forces morally superior to the Saigon regime. The media, however, were slow to report the story, partly because MACV announced the discovery of the mass graves only on March 9, by which time its own credibility was in tatters. Westmoreland was privately critical of the Marines, whom he believed had made a mess of the battle for Hue. So they had, but the blame attaching to senior officers, who repeatedly invited their men to attempt tactically impossible tasks, rightfully extended to MACV's chief. For weeks the entire US command misjudged the situation, committing sorely inadequate resources.

In the last days of February and first of March, remaining pockets of communist resistance were cleared from South Vietnam's cities. There were now 636 accredited correspondents in the traumatized country, for

whom Tet had provided a banquet. Some reporters filed dispatches and delivered broadcasts in a tone close to hysteria. Others displayed notable courage and produced some of the most vivid prose of the war. The general tone expressed awe at the communists' achievements and made little of what soldiers saw as the central reality—that the enemy lost. William Hammond's account of the media in the US Army's official history of the war is a model of evenhandedness, yet he wrote, "They yielded far too readily to the pressures of their profession. Competing with one another for every scrap of news, under the compulsion of headlines at home, sacrificing depth and analysis to color, they created news where none existed."

But Hammond also observes, in a devastating passage that almost negates his strictures above, "It is undeniable . . . that press reports were still often more accurate than the public statements of the administration." He may have been thinking of the Tet dispatches of the New York Times's Gene Roberts. For much of February the newsman, only recently arrived, assessed the condition of American arms in Hue better than any higher commander in the northern battle zone. Here was impressive mitigation for media shortcomings, and an indictment of US Army and Marine leadership.

2. SURRENDER OF A PRESIDENT

In the aftermath of Tet, morale slumped among the NVA and Vietcong, who acknowledged a military defeat that cost them around twenty thousand dead. Hanoi's official history concedes that "the battlefield had temporarily turned in favor of the enemy. . . . Our posture and strength were seriously weakened." By the communists' own estimates, exposure to US firepower had cost some guerrilla units 60 to 70 percent of their strength. Long An's VC commander wrote, "There was no time in my whole military career when I felt as confused and ineffective as I did during this period . . . I still cannot fully explain the events." In truth, history shows that citizen uprisings almost invariably fail—consider Warsaw 1944, Budapest 1956, Prague 1968—unless there is a collapse of will by the ruling regime and its forces. An NVA colonel said, "We learned that a general

insurrection was impossible." Some South Vietnamese might have rallied to the insurgents' cause if they had looked like winners, but this was never the case. He described the initial penetrations of the US Embassy and several urban centers as "a tremendous victory." The mistake, he conceded, was to seek thereafter to hold them. "It would have been best to have withdrawn to consolidate our grip on the countryside." Some American officers wholeheartedly concurred, that going head-to-head with large forces of enemy suited MACV far better than fighting guerrillas. A divisional commander said a few months later, "The only thing that saves us is that COSVN is a bunch of militaristic goddam army officers who want to win the war in big battles."

Despondent communist survivors returned to bases where they had left behind personal effects, finding most unclaimed and never destined to be. They understood that the offensive had been deplorably planned. VC leader Tran Do said, "Tet clearly changed the entire nature of the war. . . . It was a 'go for broke' attack. We set inappropriate, unattainable goals. . . . The words 'finish them off' sounded so wonderful. We lapsed into a period of tremendous difficulties in 1969, 1970, 1971. When we were asked what proportion of the population we controlled, we said 'most,' yet in truth we had lost practically all." Do nursed lasting bitterness toward COSVN and Hanoi for the cynicism with which they had exploited the will for sacrifice of their most devoted supporters.

The NVA's Col. An wrote, "Many of our people lost heart. . . . They believed that the enemy was now on top." Vietcong losses increased further, to around fifty thousand dead, during spectacularly unsuccessful second and third "mini-Tets" in May and August 1968. The NLF's armed forces were reduced to their old condition of local guerrilla groups; thereafter the war's burden fell overwhelmingly upon the NVA.

Countrywide, the Americans lost around four thousand dead at Tet, the South Vietnamese military nearer six thousand, but the outcome—a dramatic decline in rural violence—prompted a surge of optimism among the soldiers. Fred Weyand said, "We had made great progress. People were driving at night. Assassinations were rare." Creighton Abrams mocked the enemy: "Look at Khe Sanh. Poor old Giap—and I'm really convinced

of this—poor old Giap. I *really* feel sorry for him. He *kept* at that thing, kept at that thing, and chewed those divisions up so there wasn't a damn thing left. And yet, if he'd been the brilliant tactical commander the US press says—and strategist—if he had moved one or both of those divisions down on the coast, I just don't know how the hell we'd ever have gotten them out of there!" Marine Jeff Anthony, one of Khe Sanh's garrison, said, "After Tet, we felt we could crawl all over these guys."

Robert McNamara, in his last days at the Pentagon, suggested that an obvious lesson was that South Vietnam's troops should henceforward fight under direct US command. Westmoreland was sensitive enough to veto this proposal, observing that it would be a gift to communist propagandists. The general told Washington he now saw great opportunities: he was encouraged by JCS chairman Earle Wheeler to urge that his command should be massively reinforced. On March 10, the New York Times revealed a military demand for another 206,000 men, requiring a call-up of reservists. This was later described as the most damaging leak of the Johnson presidency, for which the odium and even ridicule fell upon Westmoreland. That same month he was informed that he would be replaced by Creighton Abrams, and three months later he was shuffled home and upstairs to become army chief of staff. His eclipse was partly a reflection of perceived failures of war making, but it derived more importantly from the collapse of his credibility. He had publicly predicted imminent victory, then instead come close to perceived—though never actual—defeat.

Tet caused dreadful devastation, destroying forty-eight thousand Vietnamese homes and creating almost a half million new refugees. The quotation attributed by a journalist to an unnamed US officer in those days—"It became necessary to destroy the town to save it"—is now believed to have been invented, yet the phrase seemed accurately to reflect the ghastly contradiction about America's war "to preserve South Vietnamese freedom." Weyand spoke with pride to Abrams of the "successful defense" of the capital, but as the latter flew away from Weyand's headquarters, he saw that "smoke was billowing up in Saigon, flames shooting up in the air. I have estimated that we can successfully defend Saigon seven more times, and then we're going to be faced with the embarrassment that there's no *city* left."

The battles caused many previously stalwart domestic supporters to sicken. The Wall Street Journal declared, "American people should be getting ready to accept, if they haven't already, the prospect that the whole Vietnam effort may be doomed." An NBC pundit said, "We must decide whether destroying Vietnam to save it is justified." Many Americans on the battlefield were as appalled by the carnage as TV viewers at home. Jerry Dodson of CORDS wrote to Frank Scotton on February 20, "The ball game is over and we might as well throw in the towel. I was in Kontum and Ban Me Thuot a couple of days ago. Kontum is 20% destroyed and BMT 55% after our air strikes and artillery were called in to drive out the VC. Destruction is extensive in I Corps and the Delta. For those who love Vietnam, withdrawal is the only solution." Scotton said: "At great cost, the North had demonstrated that they would never quit." In the Senate the Fulbright committee came close to saying that Congress and the American people had been tricked into war under false pretenses through the Tonkin Gulf Resolution, which indeed they had. Almost Clark Clifford's first act on replacing McNamara as defense secretary was to issue an edict to the military: there were to be no more forecasts of imminent victory.

A devastating intervention came from CBS's Walter Cronkite, a World War II veteran who was the nation's favorite uncle. In February he visited Hue, then told Fred Weyand, "I've seen those thousands of bodies. And I have decided that . . . I'm going to do everything possible in this war to bring it to an end." The general said, "It was particularly troubling . . . because of the incredible respect Walter had from the American people." Weyand was disgusted that Cronkite spoke as if the Americans and South Vietnamese had been responsible for the Hue massacres. "I can see where a person might say, 'Well, this war is so ghastly, it must end.' But how you could turn it and make it seem that the North Vietnamese should be permitted to win is beyond me."

Weyand had a fair point, but on February 27 Cronkite told his millions of viewers: "To say we are closer to victory today is to believe in the face of the evidence . . . optimists who have been wrong. . . . To say we are mired in stalemate seems the only realistic yet unsatisfactory conclusion. . . . It is increasingly clear to this reporter that the only rational way out is

to negotiate—not as victims, but as an honorable people who lived up to their pledge to victory and democracy and did the best they could." Cronkite's words represented wisdom, and no member of his vast audience was more stunned by them than Lyndon Johnson. There is dispute whether the president uttered the response often afterward attributed to him: "If I've lost Walter, I've lost Middle America," but the words accurately reflected the pall of gloom that descended upon the White House.

In the immediate wake of Tet, Americans rallied around the flag. A Louis Harris poll showed a *fall* in support for a bombing halt, from 26 percent in October to 15 percent in February. Some 74 percent of respondents expressed continuing faith. Just 3 percent believed that America would lose in Vietnam, while 39 percent expected stalemate and 43 percent thought the US could still win. Yet beneath this veneer of staunchness, even patriots were tiring of a thankless foreign adventure. In Washington, more and more thoughtful decision makers acknowledged the mismatch in Indochina between the communists—willing to stake everything, including unlimited numbers of their own people's lives—and the United States, whose real national interest seemed to shrivel by the day. On March 1, infantryman Gary Young received a letter from his parents that reflected widespread sentiment at home:

Dear Son,

No sense telling us not to worry, we're only human you know and I realize what's going on over there. . . . Cathy is all excited about getting to the Cotton Blossom dance at the high school tomorrow night. . . . People in this country are fed up with the dilly-dallying we are getting about Vietnam. It seems like a senseless waste of life. I'd better not get started on that subject or I'll never stop. Take care of yourself, if that's possible, we all send our love and hope that all of our boys will soon be home.

Love Mom, Dad and girls

On March 5, Myron Harrington and the 1/5th Marine survivors who had fought in Hue were dispatched into reserve, at a camp that had a shower unit. By the time the captain's turn came around, it had broken down. Instead he threw himself gratefully into the nearby South China Sea, before receiving orders to get on with the war. Joe Allen, the young lieutenant who had joined Delta Company in the midst of the Hue battle, proved a fine officer—and was dating Harrington's sister-in-law Perrin. Harrington said sadly later, "I should have asked for him to be transferred out of my command." One night in May, he sent Allen's platoon out on an ambush. A communist force bumped the neighboring company, recoiled, and crashed into Allen's position, which was overrun. The lieutenant was killed. Harrington said, "My relationship with my sister-in-law was never the same again." He himself succumbed to a spasm of such intense emotion, manifested in tears, that he was almost relieved of his command. When he left Vietnam a few months later, "I felt a sense of relief, that this heavy responsibility was suddenly lifted from me, but also a strong sense of guilt."

It was plain that neither the American people nor Congress would support the huge force increase sought by the military. On March 12 Eugene McCarthy emerged from the New Hampshire presidential primary election with just 350 fewer Democratic and Republican votes than the write-in for the incumbent president. Johnson's old friend and former war supporter Clark Clifford took only a few weeks at McNamara's old desk in the Pentagon to join the ranks of the skeptics. On March 25, the "wise old men," including George Ball, Henry Cabot Lodge, together with generals Ridgway, Taylor, and Bradley, assembled at the president's behest to hear the latest briefings, then offered their own recommendation. Dean Acheson led the group in reporting its change of heart: most no longer believed that the war could be won. Only Abe Fortas, Max Taylor, and Omar Bradley favored fighting on.

On the evening of March 31, Lyndon Johnson delivered a national television address that began, "Good evening, my fellow Americans. Tonight I want to speak to you of peace in Vietnam. . . . No other question

so preoccupies our people." He announced a unilateral cessation of bombing beyond the 20th parallel, and his commitment to open negotiations. Earlier, when speechwriter Harry Macpherson saw the president reworking the draft, he asked a White House colleague, "Is he going to say sayonara?" Yes, he was. Johnson concluded his TV speech by saying, "I shall not seek, and I will not accept, the nomination of my party for another term as your president."

Many viewers had become deeply cynical about their chief executive. They listened in stunned silence; then some decided that this was a trick. a dodge, a gambit, a stunt. It was not. That night, Johnson acknowledged the collapse of his presidency, which had achieved so much at home only to founder in the Big Muddy of Southeast Asia. His enemies, the likes of Kennedy intimate Arthur Schlesinger, branded his decision to quit as "political cowardice," saying Johnson had become convinced—like Harry Truman after the 1952 New Hampshire primary, during the Korean War-that he would be beaten on polling day. Schlesinger later quoted the explanation of Bill Moyers, former White House press secretary, for Johnson's "Vietnam obsession": it was "an atrocious marriage of ego and nationhood, so that Johnson saw himself as America involved in some sort of challenge to manhood." President Eisenhower wrote disdainfully in his personal diary: "To me it seems obvious that the President is at war with himself and while trying vigorously to defend the actions and decisions he had made in the past, and urging the nation to pursue those purposes regardless of costs, he wants to be excused from the burden of office."

Many people linked the president's announcement of abdication to the humiliations inflicted by the Tet offensive. In truth, Johnson had for months been contemplating withdrawing from the race. It was none-theless indisputable that his spirit had been broken by Vietnam. He had become an object of hatred and mockery to many, especially young Americans, because of deceits, failures, and killings for which most blamed him rather than their nation's enemies. Here was a triumph for Hanoi; here was an outcome that enabled Le Duan to clamber over the new mountain of corpses created by his militarily crazy initiative, and hail Tet as a "killer punch." Nobody seemed to notice the American heroism that finally van-

quished the assailants, the fifteen Medals of Honor awarded to those who had seen off the would-be occupiers of Saigon, or the mass murderers of Hue. Dean Rusk admitted sorrowfully, "It was a brilliant political victory for [the communists] here in the United States."

The NLF's Tran Bach Dang said that the Tet offensive was decisive in forcing the US to de-escalate the war—"no other evaluation is possible." Le Duan's authority and historic reputation were thereafter secure within his own society. On April 5, 1968, North Vietnam's foreign minister told CBS interviewer Charles Collingwood—Walter Cronkite had declined the offer of a Hanoi visa, rightly judging that acceptance would present a propaganda coup to the other side—that his country was ready to talk. The president nominated Averell Harriman to lead US negotiators. Though the war still had another seven years—seven years—to run, the outcome that was no longer plausible was North Vietnam's defeat.

CONTINUOUS REPLAYS

1. DYING

In the aftermath of Tet, communist fortunes seemed at a low ebb. Again and again, US and ARVN forces struck battered Vietcong units. One morning in the Delta, a guerrilla command group entered the village of My Loc only to collide with an American sweep. Shells killed a seventeen-year-old whose name was Khang, son of a VC cadre, who wrote, "I sat beside the body with my heart breaking, and spoke to him as if he was still alive: 'Rest in peace, my son, you have done your duty for the revolution.'" In later years, the boy's two brothers also joined the Vietcong. Their mother shrugged and said that if they didn't fight for one side, they'd be conscripted by the other and thus find themselves shooting at their father. He wrote, "I cannot count the number of women who lost three, four, even seven or eight sons and daughters as martyrs for our cause."

In May 1968, orders from COSVN to launch new attacks on towns and cities roused scant enthusiasm. Cadres complained that they were offered neither reinforcements nor new weapons, instead simply invited to reprise the February missions in which comrades had sacrificed so much blood. Groups attacking Saigon were urged to "bring the flames of war right into the enemy's lair," but Huynh Cong Than recalled, "We went into the second wave of Tet assaults feeling like suicide squads." On the night of May 5, VC forces advancing from the north and east were stopped by ARVN and Americans on the outskirts of the capital, while those in

the west and south became locked in street battles, which they quickly lost. By the seventh day, said Than, "We recognized that the situation had become extremely unfavorable. . . . I still do not understand why we attacked the cities again, when the balance of forces had tilted so heavily against us. . . . What led our leaders to believe that millions were boiling over with revolutionary zeal and ready to sacrifice everything?!! We found this was not so. The masses hated the US and puppet regime . . . but this anger had not reached boiling point." Due to the Vietcong's eclipse, hereafter the NVA overwhelmingly dominated the battlefield struggle.

Even so, the Americans and the ARVN never shared much sense of success, of the war getting easier. On June 20, the Thieu government decreed a general mobilization. Mutual confidence between the allies was low: following the May attacks, rumors spread among South Vietnamese, seeping through some barracks, that the Americans had deliberately stood aside, so that Saigon's troops were forced to fight. In the 2012 words of a Vietnamese officer, "[People] argued that the sophisticated US electronic intelligence networks . . . must have been closed down, to let the enemy infiltrate the capital so easily. Some even alleged that US helicopters delivered food to communist soldiers . . . that US Army trucks were moving communist troops. Although the rumors were not credited by all Vietnamese, many still believe them."

Hundreds of thousands of combat deaths from 1968 onward were especially tragic because they took place after the US had abandoned hopes of victory and was battling merely to escape explicit defeat. For those who recalled the Second World War, the Vietnam narrative became baffling. While it entailed movement, most of this was circular. There was no sense of physical progress, as from Sicily into Italy, or Iwo Jima to Okinawa. A vast array of power seemed bewilderingly impotent. Consider the 11th Armored Cavalry, deployed north of Saigon, which—with its supporting engineering, medical, supply, and service personnel, its military police, its chemical, transport, signal, intelligence, radio security, psychological operations, and USAF liaison teams, and its division artillery—mustered 4,600 men. The regiment possessed fifty helicopters—Hueys, Cobras, and OH-6A light observation helicopters, as well as four hundred tracked

vehicles, including M-48A2 tanks, 155mm howitzers, and personnel carriers. One of its officers described the 11th as "a magnificently organized, equipped, and trained instrument. For World War II."

Creighton Abrams deplored the inability of such juggernauts to prevent, for instance, the VC's abduction of twenty peasants who refused to build a roadblock: "It's kind of a sad thing. When the people try to make a little stand, . . . we are not able to secure them. I'll always remember this district chief who said, 'You should never overtly take information from a civilian unless you can guarantee his safety.' Pretty good rule. . . . But this trouble that nobody can see and hear . . . is meaner than hell—just [VC] going around collecting taxes, quietly snatching somebody . . . and shooting him."

This was a *Groundhog Day* conflict, in which contests for a portion of elephant grass, jungle, or rice paddy were repeated not merely month after month, but year upon year, with no Andie MacDowell as prize in the last reel. All that changed were the names and numbers of those who sweated, feared, fought, died. Pfc Jeff Anthony said, "You find yourself doing the same thing again and again in the same place, and it becomes obvious it's not working. There were some really sad moments, when one was trying to figure out what on earth we were doing there." Likewise Sgt. Jim Stevens: "Sometimes you'd hit an LZ you'd dropped on two weeks before—your old trash was still there. You'd say, 'Why don't we fight this war properly, hit these people with everything—or get out?'"

In 1968 the communist military presence was most conspicuous in the three northernmost provinces below the Demilitarized Zone. The main burden of combatting four NVA divisions deployed there fell upon the US Marine Corps. In the first days of May, a battle took place that attracted negligible attention yet wrecked a battalion, which suffered losses worse than those of the notorious Hamburger Hill clashes a year later. American armed strength was close to its peak—543,000 men—yet in a northern corner of Vietnam, on a battlefield barely two miles square embracing a cluster of abandoned hamlets, the NVA was able to leverage violence more effectively than its foes. The story of Daido merits recounting in detail, as an

exemplar for scores of other such battles, bloodier than any that took place in twenty-first-century Iraq or Afghanistan, and probably more futile.

The Marine 2/4th Battalion landing team had fought several significant actions during the previous months and had bled heavily. The unit had its share of the brave and conscientious, even some heroes, but also duds, members of "McNamara's hundred thousand"—men enlisted after the defense secretary lowered service mental and educational requirements to feed the insatiable demand for infantrymen. L/Cpl. James Lashley, an M60 gunner who had been in the bush eight months, thought "we were just going through the motions." His own platoon moving at night "sounded like a herd of water buffalo with tin cans on their backs." The chaplain's wife had become a fervent antiwar campaigner, and started divorce proceedings against her husband for accepting duty in Vietnam.

When Capt. Jim Williams arrived to command one of the 2/4th's companies, he found himself without a flak jacket. A supply sergeant gestured to a heap outside the morgue: "You can maybe find one without blood on it." Williams thought his new unit was "in a terrible state—they'd lost so many people." Such was the turnover through rotations and casualties that officers could not identify all their Marines: Williams knew that his driver was nicknamed Bull but never learned the rest of the man's name before he was killed. In an action on September 11, 1967, the battalion suffered 16 dead and 118 wounded; on the 14th of October, 21 men were killed, 23 wounded; in November and December, 6 were killed and 78 wounded. Late on the afternoon of March 12, 1968, Foxtrot Company lost 18 killed in an ambush. The following day 5 more Marines were shot while retrieving the dead, and a corpse fell out of a helicopter while being ferried to the rear.

A young lance corporal wrote a letter home couched in almost hysterical terms, asserting that everybody around him was dying. The boy's father, understandably distressed, wrote to his representative on Capitol Hill about his son's plight, prompting a "Congressional"—a formal inquiry to the Marine Corps. CO Bill Weise was dragged from his cot at three a.m.

to take a radio call from Division, which gave him two hours to produce an appropriate response. Weise summoned the letter writer, who promptly burst into tears and said, "I'm sorry, colonel." In March 1968, the battalion suffered 59 dead and 360 wounded, while being credited with killing 474 NVA. This last figure was phantasmagorical, but Weise had learned that he was expected to balloon body count if he wished to keep his job.

The battalion commander was thirty-nine years old, son of a blue-collar worker from a tough district of Philadelphia. He caught the tail end of the Korean War, thereafter became a qualified ranger, scuba diver, and master parachutist. He had assumed command of the battalion six months earlier when his predecessor was wounded, and had since worked hard to rebuild discipline and morale. He said, "There were so many things that weren't right. My men were not fully trained: they were sloppy. When I asked for a fire-support plan, the operations officer didn't know how to put one together." Weise was not the type destined to command armies, but instead a courageous, decent, conscientious officer who chain-smoked cheap cigars because they didn't glow at night like cigarettes, and worried somewhat that his wife, Ethel, might not be waiting when he went home, because she was furious with him for soliciting assignment to Vietnam.

When the unit was redeployed north of the Cua Viet River near the DMZ, the Marines were impressed by how quickly the enemy knew about it, probably through wireless intercepts. "Hanoi Hannah," the Englishlanguage propaganda broadcaster, announced that the 2/4th was up there, commanded by Bill Weise. They had spirit enough not to be rattled when she added, "All you Marines are going to die!" On the night of April 27, half of Weise's battalion was engaged on a sweep for an NVA unit known to be nearby. G Company was led by Capt. Robert Mastrion, a small, dark, bespectacled New Yorker commissioned from the ranks, twenty-eight years old but only a month with the battalion, whom few of his people liked or trusted. One Marine said, "We were worn out, but here's this prick who wanted to 'get some.'" Golf Company first knew it was in trouble when a grenade exploded at a man's feet. Somebody shouted, "Jesus, gooks!" Within seconds devastating fire dropped eight of the leading squad. GySgt. Billy Armer, with fragments in his face and chest,

kept mumbling, "Sonofabitch, I'm hit . . . sonofabitch, I'm hit." They had bumped an NVA column crossing their front: the enemy's green tracer clashed with their own red, amid a chaos of shouts and shadows. Mastrion called for reinforcements, but Weise responded, "You're on your own." He feared that if he pushed more men forward through the darkness, Americans would shoot each other.

A corpsman told Mastrion he had a head wound case who would die without medevac. At 0130 a CH-34 Seahorse clattered in from the assault ship *Iwo Jima*. The Marines radioed that the NVA were four hundred yards away, and risked illuminating a strobe light to guide the chopper. This proved a bad decision: the enemy was much closer, and as the Seahorse set down and began loading wounded, there was a thunderous explosion. An RPG-7 shattered its windscreen and blew out the pilot's left eye. The helicopter lifted off, swung south, and staggered three hundred yards before thudding back to earth. The copilot took over and somehow reached the *Iwo Jima*, but the Marine with the head wound had been left behind, screaming incoherently. His buddies wished desperately that a corpsman would administer a morphine overdose, but instead Capt. Mastrion and a squad stayed through the five hours he took to die, while the rest of the company pulled back.

At daybreak, the battalion was secure, but traumatized. Radioman Cpl. Peter Schlesiona wrote home, "It was without doubt the most hairraising night I have spent in Nam." Mastrion was medevacked with excruciating back pain. Capt. Jay Vargas, a twenty-nine-year-old Mexican American from Arizona whom G Company knew and respected, took over. After such intense experiences, Weise's men might have been forgiven for thinking that they had seen their share of action for a while. Unfortunately, war is mean with respites. Division identified two NVA battalions moving in the 2/4th's area, just north of the Bo Dieu tributary, along which supplies were carried the last of the seven miles between the sea and the big US logistics base on its south bank at Dong Ha. Col. Milton Hull, the regimental commander to whom Bill Weise reported, was morbidly nervous that the enemy intended to attack Dong Ha. He thus spread his available forces perilously thin along the banks of the Cua Viet

and the Bo Dieu, as a screen against such an enemy movement, which intelligence guessed might climax on May Day, a big date in communist calendars.

In truth, the NVA were not ambitious enough to try for Dong Ha: instead they planned merely to use rockets and machine guns to harass river traffic. Unusually, their 6/52nd Infantry had access to supporting fire from two heavy guns positioned beyond the DMZ. They completed digging bunkers and laying field telephone lines between the adjacent hamlets of Daido, An Lac, and Dong Huan at 0500 on April 29, twenty-four hours before the 2/4th Marines came into their lives. It was their explicit purpose to provoke the Americans to attack, on what they considered favorable terms for themselves.

Early on April 30, in accordance with orders from Col. Hull, the four companies of Weise's battalion were widely dispersed, up to seven miles apart, north and east of the communists' as yet undetermined positions. On the roof of an abandoned house near the river, Capt. Jim Williams watched through field glasses as US Navy craft exchanged fire with enemy in the hamlets on his own shore. There was an explosion against the hull of an American landing craft: at a range of five hundred yards, a 57mm recoilless rifle round struck, killing one sailor and wounding two more. While patrol boats sprayed the shore, the convoy turned back west to Dong Ha, and the Navy declared the Bo Dieu closed until the NVA had been dislodged.

At 0818 L/Cpl. James O'Neill, a sniper accompanying a patrol from Williams's H Company, glimpsed movement five hundred yards out, and said, "Sir, I think we got a whole bunch of gooks in front." His lieutenant said, "Shoot one of them." In the heat haze, O'Neill could not see clearly through the telescopic sight of his Remington 700, but after firing twice he observed a figure sitting on the edge of a hole, lacking half its head. Then Williams received orders from Weise, radio callsign Dixie Diner 6: his H Company was to assault the hamlet of Dong Huan from the north, while neighboring F attacked Daido, two thousand yards to their right. Regiment at this stage permitted Weise to use only these two companies, less one platoon. Here was a first blunder: by committing American

strength piecemeal, the enemy in their path was granted superiority of numbers.

F and H mustered fewer than a hundred men apiece thanks to depletions from casualties, sickness, and R&Rs. On the shoreline, Weise and his command group boarded a shallow-draft armored monitor craft, from which they could observe progress, pulsing slowly upriver in sync with the infantry ashore. As usual, intelligence was nonexistent: they might meet two communists with a recoilless rifle, or two hundred, or two thousand. American 105mm and 155mm artillery began to plaster the objectives with high-explosive and smoke rounds. Around 1330 the lead platoons of H were approaching Dong Huan when they met ferocious fire from a screen of trees. Weise's report to Regiment—that the enemy was obviously positioned in strength—secured him additional support from two M-48 tanks and from the Navy offshore. A recon man fired a single M16 bullet at an enemy soldier, and exclaimed "Jee-sus Christ!" when he saw his target disintegrate: the Marine failed to realize that a tank had simultaneously landed a 90mm round. The infantrymen crawled forward until they were close to Dong Huan, then clambered to their feet, formed a line five yards apart, and advanced firing from the hip.

Some communist soldiers leaped out of their spider holes and scuttled away, but others kept shooting. Marines started running forward, but Williams, a famously courageous thirty-year-old Minnesotan, dashed among them slowing the pace, lest they overtake their own barrage. Amid the cacophony, out of the corner of his eye he glimpsed an enemy emerging from a nearby hole and tossing a grenade. It bounced before exploding, blowing the company commander off his feet and piercing his legs and buttocks with agonizing fragments. Unable to stand, with small-arms fire and explosions still deafening all comers, he told his radio operator to fetch the senior NCO. The man loped away, ducking, then returned to report that the sergeant would not come: "He's in a hole, and won't leave it!" Williams ordered his radioman to go tell the skulker he had better come fast, or the captain would shoot him. Another officer said in mitigation, "The guy had seen a lot of action, and he was gun-shy even before this." Lt. Alex "Scotty" Prescott assumed command of H Company.

The firefight continued. A staff sergeant blown over by a blast staggered to his feet and ran forward again only to meet another grenade that blew the shotgun out of his hands and the diver's watch off his wrist. When he clambered up and found his head spinning, he told a corpsman to slap his face—which worked. It then took the remains of the company fifteen minutes to work through Dong Huan, taking casualties at almost every step as enemy soldiers leaped from bypassed spider holes. "Goddamn there was dead gooks all over the place," said Sgt. Joe Jones, huge and black, who took over a platoon when his lieutenant was hit. "Wounded Marines . . . everybody was all mixed up then; different squads from different platoons was all over the damn ville." Lt. Carl Gibson, three feet behind Prescott as they emerged on the south side of the village, dropped dead with a bullet in the head. Married a month, he had been in Vietnam ten days.

The survivors formed a perimeter in the midst of the continuing bedlam. A corpsman cried hysterically over a wounded friend; as a sergeant lay turning gray from loss of blood, another corpsman shouted, "We gotta get him out—he's dying, he's dying!" No helicopter could land. Instead, at 1530 small boats—"skimmers"—touched the riverbank a few hundred yards south of the battlefield, bringing ammunition and evacuating thirty wounded. Col. Hull suddenly appeared and began quizzing Scotty Prescott. The bombastic, iron-tough regimental commander believed that Weise and his men were displaying insufficient aggression. He urged the CO to "belly up" to the enemy, which caused his operations officer to protest that "we were so close already that the NVA could slit Weise's belly with a knife." Williams found himself being evacuated in a boat wherein a discarded canteen floated on blood, some of it his own. Voicing a preoccupation common to many wounded men, he said to a Navy corpsman, "I'm so numb I can't feel anything. Can you check my balls are still there?" The battalion's own "Big John" Malnar had lost a testicle in Korea. The man examined the sensitive area and responded, "They look fine to me, sir." Such an exchange would be comic if it were not terrible.

The wounded were flown offshore to the *Iwo Jima*, where successive waves of choppers were preceded by loudspeaker broadcasts: "Medevacs inbound... medevacs inbound." A Marine entered the ship's crowded

sick bay and announced that the 2/4th were in trouble, and that anybody fit to fight should return ashore. Several bandaged figures walked stiffly to the hangar deck, strewn with bloody flak jackets and gear, equipped themselves with essentials, and flew back, albeit not into the battle. While corpsmen in the field had a fine reputation, this did not extend up the medical chain: every infantryman heard of possessions plundered. When Jim Williams aboard *Iwo Jima* was invited to surrender his pistol, despite acute pain he clutched it and snarled, "No goddamn sailor is going to take my weapon!" He eventually released the .45 to a Marine. It was months before he could sit comfortably, a year before he was fit for duty.

Even as Hotel Company—H—was taking punishment to secure Dong Huan, two thousand yards further west and very late, at 1350 Foxtrot approached Daido from the north riding atop amphibious tractors, wholly ignorant of what to expect. An incoming rocket exploded against a vehicle carrying five radio operators, one of whom fell off, wounded and screaming. More RPGs exploded as they dismounted and moved hesitantly forward. Most of the company went to ground a hundred yards out from the objective, the right flank platoon hugging a little cemetery.

Company commander Capt. James Butler, a soft-spoken twenty-five-year-old Texan, son of a general, directed a napalm strike—tin cans tumbling out of the sky until they burst red, billowing clouds of fire that turned suddenly black—within forty yards of one of F's lieutenants. He radioed, "Goddamn, it's hot here—don't get it any closer!" Four hours into the fight, Butler reported to Weise that he had only twenty-six effectives left, and sought permission to pull back. Weise agreed, though it took two hours for the dispirited group to break contact, covered by Phantoms and the amphtracs' .50 caliber machine guns. If the NVA had chosen to pursue, said Butler, "they had a good opportunity to really clean our clocks," but they did not.

At 1700, Bravo Company of the 1st Marines was ferried across the river to reinforce the 2/4th. This was not a happy body of men: Bravo had been suffering disciplinary difficulties, with NCOs brawling among themselves, together with a stoned radio operator who threatened them

with a grenade. The amphtracs hit the shoreline beside the hamlet of An Lac, their passengers supposing they were merely headed to support Weise's battalion attacking Daido. Instead, within seconds of crawling onto the sand, they faced a hail of close-quarter enemy fire, which killed their commander, along with a lieutenant, a sergeant, and seven other men, leaving another fourteen badly wounded. "It was total chaos," said L/Cpl. Doug Urban. "Everybody just freaked. We weren't a company anymore. We were just a bunch of people lying on the ground."

Norman Doucette, a lifer and Korean vet, said to a sergeant, "We got to get in the tree line. We gotta secure that fuckin' tree line!" The man declined to move. Then, as Doucette leaned sideways to check a dead man, he himself dropped, hit in the face, losing most of his tongue and teeth. For some time he lay alone, believing that he was bleeding to death and reflecting bitterly, "Somebody went and left us lying right here to just get slaughtered." Then a gutsy Filipino corpsman ran over and bandaged him. The survivors of Bravo secured the western half of An Lac, where Robert Robinson, a deep-throated black platoon sergeant, won a Silver Star for keeping shooting despite a shoulder wound sealed with mud. They were not in a good way, however: their only remaining officer, a bewildered lieutenant, froze where he crouched.

From the volume of enemy fire, Weise estimated at least a regiment fighting them. In truth, at this stage only one NVA battalion was committed, the 6/52nd, whose officers made a mirror misjudgment of American strength, reporting that they faced two Marine battalions supported by twelve tanks. The communists cursed the American artillery, which repeatedly severed their field telephone links, though doing little harm to the occupants of deep bunkers. Out on the river aboard their monitor craft, Weise was himself firing an 81mm mortar, while "Big John" Malnar, his sergeant-major, a fabled forty-one-year-old veteran of World War II Pacific and then Korean battles, manned a .50 caliber machine gun. Malnar had never married; the Marine Corps was his life. They saw two sampans drifting offshore which might have contained fishermen but seemed more likely to be spotting for the communists; the Americans blew them out of the water.

As the light faded, Weise told Col. Hull that he believed higher command still did not understand the opposition's strength: "We're in a world of hurt here. There's a whole lot of bad guys and not many of us good guys." He was told that he was not the only one with problems. Four miles westward, another battalion was in heavy action and had already suffered 144 casualties. Operations officer Maj. George "Fritz" Warren later wrote, "I knew that Bill Weise was in a shit sandwich." The battalion CO secured reluctant approval to bring forward his own Golf Company, then three thousand yards northwestward. Two platoons of G duly boarded Sea Knights, but once in the air, they saw NV shells and tracer hitting their intended LZ, causing Jay Vargas to abort the move. Landing back at the patrol base, he told his men, "No free ride today—we have to walk." They took only their fighting gear for the two-mile hike. In gathering darkness, NCOs had to shout at some exhausted men to keep them moving. The communists spotted the long files, and soon shells and mortar bombs were falling nearby. Lt. Jim Ferland said, "The troops were on the verge of panic, but Capt. Vargas kept good control."

Though gunfire ebbed during the night, there was no tranquility. Back in Dong Huan, Cpl. Richard Tyrell yanked at a sandaled foot beneath some hay, which he assumed was attached to a corpse. Instead, a thoroughly alive NVA soldier burst forth. Tyrell fired his M16 once before it jammed, then grabbed a pistol from another soldier and emptied it toward the fleeing figure. A newly arrived replacement urinated into the open mouth of a dead communist, before being shoved away by a disgusted companion. Weise exploded at James Butler when he discovered that F Company still had fifty-five effective Marines, not the twenty-six that officer had claimed to support his request to withdraw. Weise said later, "It was then that I realized Butler had lost control." Another officer dismissed the Texan as "just a nice, decent, mild-mannered Clark Kent, who never turned into Superman."

There were night alarms as trapped NVA soldiers sought to slip out of the American perimeter. In the neighboring shoreside hamlet of An Lac, Bravo found the enemy jamming its radios. Weise came ashore to impose a change of frequency—and took a mortar splinter in his thigh. American illuminants were bursting over Daido, but these did more to show Marines to the communists than the other way around. An incoming blast knocked Jay Vargas into a creek, and thereafter he marched and fought with splinters in his knee and calf. At the battalion command post, the captain was told that landing craft would take Golf's men the last few hundred yards upriver, yet the boats failed to appear: their commander declined to risk a passage in darkness, exposed to fire. Vargas snatched thirty minutes' sleep, then at 0100 on May Day briefed his platoon commanders to renew the attack on Daido.

At dawn, a patrol found that the NVA had abandoned their foothold in An Lac, which Bravo secured at a cost of five more casualties. Two hours later, the Americans were puzzled to behold a large body of enemy moving across their front, in obvious disarray. They plastered the communists with fire, Weise saying with satisfaction, "It was a real turkey shoot." Morale was further boosted by napalm strikes from two F-4s. The observer in a "bird dog" spotter aircraft warned the Phantoms over the radio, "You're takin' fire! You're takin' fire!," which caused an F-4 pilot to retort sardonically, "Uhhhh, uhhhh . . . I think that's only fair." On the riverbank, Bravo Company reported itself still unable to advance, and indeed it accomplished little that day or the next: the traumatized survivors were in no mood for heroics.

Weise reboarded the monitor and made the short passage downriver to meet G Company. Its new attack on Daido, supported by two tanks, began after a Skyhawk prepping strike at 1253. What followed was an epic of courage and sacrifice, in a frontal attack that should never have happened, across seven hundred yards of open ground. The communists were firing from bunkers built on heavy bamboo A-frames reinforced with layers of earth and rice matting. During the night, the 6/52nd NVA had been reinforced by a company from their 48th Regiment, which now reported itself under attack by three Marine battalions supported by fourteen tanks.

Many Americans thought the assault crazy, among them L/Cpl. Jim Lashley, due to go home in seventeen days: "We're getting too short for this shit, man." L/Cpl. James Parkins of Golf shrugged. "There was a lot of animosity, but you couldn't say 'This is stupid and I'm not going to do

The Battle of Daido, 30 April-2 May 1968

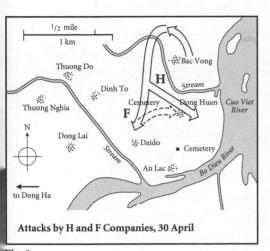

1/2 mile 1 km Bac Vong Thuong Do Dinh To Thuong Nghia Cemetery Dong Huan Cuo Viet River H Daido Bo Dieu River Dong Lai Cemetery Assault by B Company, An Lac, 30 April

Fig. 1

Fig. 3

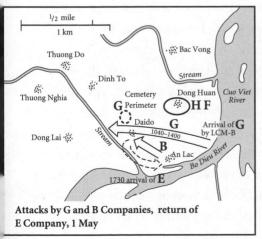

Fig. 4

Fig. 2

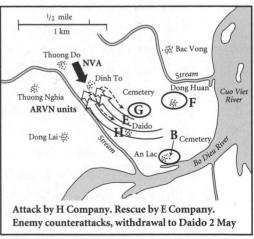

it,' 'cause if you weren't there and your buddy got shot, you'd think, *Oh man.* . . . You kept the thoughts to yourself, just kind of mumbling as you went forward." Several Marines had three-piece cleaning rods assembled and taped to the plastic stocks of their M16s to clear rounds, which so often jammed—and would jam that day. The Americans had advanced two hundred yards through thigh-high brown grass when NVA small arms began to hit them, from spider holes dotting the fields. Lashley was shot in the left arm, shattering his elbow. For a few seconds he remained upright, in agony, then stumbled and collapsed: pain persisted through two shots of morphine.

Lt. Ferland's platoon stopped and dropped. Jay Vargas ran back and urged men onto their feet and forward, though one of Ferland's squads soon had two dead, six wounded. Bravo Company, lingering in An Lac, reported by radio that they could see a hundred NVA on Golf's left flank. One of the supporting tanks started shooting that way, directed by a Marine standing on the hull, until a blast blew him to the ground. The tank commander, dismayed by incoming fire, started pulling back. Jay Vargas ran forward, grabbed the hull phone and shouted that he would have the commander court-martialed unless he stayed. "Go to hell," said the tanker, who grudgingly lingered long enough for some wounded men to be laid on the hull, then backpedaled the M-48 off the battlefield.

The other tank exhausted its sixty-seven 90mm rounds, then likewise began to withdraw. When Vargas argued by radio, the tanker responded that he could do nothing more. But you can, urged the Marine: the moral effect is tremendous, for both friend and foe, of a steel monster moving across the paddy. Weise, monitoring the net, cut in: the tank must stay. NVA artillery suddenly shifted fire from Golf onto Foxtrot, wounding eight men. Lt. Ferland picked up a discarded AK-47, because he hated his own M16. Some Marines lay motionless in the grass, hoping neither side would notice them.

Golf lingered in Daido under mortar fire for two hours, steadily losing men. In a macabre moment, a Marine headed toward the rear, shouldercarrying the headless corpse of a buddy. Then the North Vietnamese counterattacked. Air strikes came in, shooting at whatever pilots could see, while Vargas popped green smoke to mark his own position. At 1625, his survivors began pulling back, three wounded men limping together, while he and his FAC covered the withdrawal, shooting hard. G had started the day with 150 men; now, 45 survivors took refuge in a drainage ditch. The NVA triumphantly claimed to have counted 300 American corpses.

At 1700 Weise decided to commit Bravo. But that company's spirits, already low, were further eroded when they were herded away from a ration truck to board amphtracs, which rolled forward before they could eat. Three hundred yards short of Daido, the Marines began to receive fire, leaped down, and went to ground. The company's new commander and his radioman led an attempt to renew the advance, then found nobody following. An RPG exploded, seriously wounding the captain in the shoulder. A greenhorn platoon commander thus became Bravo's only officer. He screamed hysterically into the radio, "You gotta help me! We're surrounded out here! They're all over the place! They're going to kill us all!" Jay Vargas came calmly up on the net. "Now listen to me, Bravo, take it easy, I'm right over here. You're okay; just pull your line in and talk to your people and stop yelling."

It was plain that B Company would play no further active part in the day. Nonetheless, its brief movement distracted the NVA's attention long enough to allow Vargas and his remaining men to pull back another two hundred yards eastward, where they took advantage of the cover of burial mounds to receive ammunition. In the course of the night that followed, aided by artillery and illuminants, they repulsed several NVA probes. The captain himself finished off one enemy soldier who kept tossing grenades, even after being repeatedly hit.

Shortly before Bravo stopped, the fourth of Weise's rifle companies reached the battlefield, having been belatedly released by Col. Hull. Echo was commanded by Jim Livingston, a dedicated warrior from McRae, Georgia, who had no patience for fools, fainthearts, weaklings, or pot smokers and liked to lead training runs for which his men were weighted with flak jackets. "I had a very strong mother," he said with gusto. "She would knock the hell out of me. I was a pretty tough guy. I really wanted to get into a scrap." Pfc Michael Helms said, "We blamed the skipper for

our woes because it seemed he was always volunteering us. A lot of us figured he would win the Medal of Honor or die trying. We used to gripe and bitch among ourselves that he would probably kill us all getting it, but he definitely had our respect." Weise said that Livingston gave his men "tough love," adding that he was supremely "battle smart."

Livingston's company lost several men to enemy fire on the two-mile tramp southeastward, including a sergeant whom everybody hated and was happy to see go. They reached An Lac after fording a deep stream by forming a chain of tall Marines with arms linked, to help shorter men through the water. Livingston, according to Weise, was "itching to get stuck in." The Georgian quickly fulfilled his first mission—to cover the extraction of the remains of Bravo Company, saying, "Those kids . . . had had the shit beaten out of them."

Thus at nightfall on May Day, the 2/4th Marines remained arm-locked with a communist force of roughly equal strength. The NVA enjoyed the advantage of fighting from strong, prepared positions. The Americans had air support and far more artillery, but were using tactics that maximized the communists' opportunities. It remains baffling that higher commanders permitted, never mind insisted upon, renewal of attacks that had already cost dreadful losses. There was never any sign that the communists intended to cross the Bo Dieu River toward Dong Ha. Yet the battalion was ordered to keep punching by senior officers who said, "You've got to keep the pressure on!"

Pressure on whom? It remains as hard now as it was then to see the virtue in sustaining the assaults. That evening of May 1, in both camps there was weary, intense discussion about the morrow. The NVA considered withdrawal, because it was obvious that the Marines would come again. Nonetheless, their objective was to kill Americans, and the omens for achieving this remained propitious. The 6/52nd Infantry had suffered heavily, but the 3/48th was almost unscathed. At the conclusion of the Party committee's battlefield conference, a new joint headquarters was established to direct the next day's fighting, headed by the deputy CO of the 52nd Regiment and deputy political officer of the 48th.

Weise brought his command group ashore and told Livingston that

in the morning he must retake Daido with E Company, his own, and the remains of G. Their two tanks were no longer available, but the battalion was promised priority for air support. What followed on May 2 was an epic that won Livingston the Medal of Honor to go with his Silver and Bronze Stars. He directed his men to fix bayonets, one of the rarest orders in modern war. Then the two companies, led by himself and Vargas, headed forward. At 0715, when E Company was two hundred yards short of the hamlet, the NVA opened fire. Two platoons of Echo stalled, but the third dashed through them. They overran the hamlet and drove on beyond, harrowed every yard by enemy fire.

One advancing Marine got ahead of the line and was accidentally shot in the back by a comrade, causing rounds in his bandolier to "cook off." A flak jacket saved his life, but when he also took a flesh wound in the stomach from an AK-47, he bolted for the rear. Another Marine who sprinted forward crashed headlong after receiving three bullets in the leg. Pfc Marshall Serna, an inveterate pothead and cocaine user who obtained a regular morphine supply from the corpsmen, won a Silver Star. Though some men showed courage, others did not: a corporal who helped a wounded man to the rear was not seen again. As Gy. Sgt. Jim Eggleston was carrying back a mortally wounded Marine, he called on men huddled behind burial mounds to help him. None moved. One merely shouted, "We're taking fire here!" It was a morning of horrors: after a Marine was caught in the path of an exploding RPG, his comrades saw his severed leg cartwheel through the air.

At 0914 Livingston reported Daido secure, at a cost of ten dead and sixty wounded: "They hurt Echo pretty bad." The NVA had already begun to mortar the new US positions when Col. Hull arrived in a skimmer. The battalion must "maintain momentum," said the regimental commander sternly. They should hit the next hamlet, Dinh To, within an hour. An ARVN mechanized unit on their left would mount a simultaneous assault, securing their flank. Weise suggested a different plan: commit a fresh American force farther north, and drive the NVA back onto the Marines holding Daido; in other words, force the communists into the open. Hull dismissed this notion: H Company must attack. Scotty Prescott's

seventy-five men moved out at 0955, with five hundred yards of open ground to cross. Lt. Vic Taylor wrote later, "The day was still, the heat intense. We had guzzled all the water we could hold. . . . Now the sweat poured out, and uniforms were soaked. Little puffs of dust rose from the dry rice paddy at each step. The metal of weapons was almost too hot to touch. The firing had ceased. Maybe this would be easier than I expected."

Then they found themselves surrounded by dense green foliage and banana trees, with enemies apparently everywhere, shooting from cover. In one squad all the M16s jammed, so instead they threw grenades. In worsening confusion, men sought cover. The NVA were so close that Prescott could not demand mortar or artillery support. At 1200 he told Weise that Hotel would be overrun unless reinforced. Then he himself was hit and found his back and legs immobilized. Crawling into a hut, he was traumatized by thoughts of a wheelchair future. Taylor assumed command and radioed Weise that he had little ammunition and casualties everywhere. Hold on, he was told: Echo is coming. Only after Prescott had been evacuated was he boundlessly relieved to find sensation returning to his legs. A bullet had hit his canteen, ricocheted off a stud on his cartridge belt, torn apart his second canteen, inflicting shock and a massive bruise, but nothing worse.

Now Livingston loped forward with his .45 "grease gun," leading Echo. Col. Hull came up on the net from Regiment, demanding imperiously, how was the attack going? He urged Weise to "exploit your advantage, exploit your advantage! Don't hold back—exploit your success!" At 1340 the communists counterattacked in Dinh To, precipitating a murderous close-quarter melee. Livingston's weapon jammed and he tossed it away, grabbing a rifle. Some men whose M16s proved useless began using pistols. Even Echo's commander, the tireless warrior, felt obliged to radio Weise: "We can't stay here and get all these kids killed." They began to fall back, the NVA pushing hard on their rear. Livingston was everywhere at once until at 1430 he took a machine-gun round in the leg and grenade fragments in the thigh. His men were appalled to see their armor-plated leader go down. "I bled pretty good, and I told them to leave me. Instead a couple of black guys dragged me back." The captain's fall precipitated

panic; he alone had been holding the Marines together, though some cursed him for their plight. L/Cpl. Phil Cornwell said, "They destroyed us. There were so few of us left, it was unreal. The boys were angry, and word was out that the captain was shot by one of our own troops because he had led us into a slaughter. I'm glad he got capped—by one of our own guys or the gooks, it doesn't matter." E Company was shattered.

Weise told his regimental commander, "Colonel, we're out of steam." Yet Hull remained implacable: "Weise, we have to keep the pressure on. Keep pushing." The promised attack by an ARVN mechanized unit on their left would divert the enemy's attention, he said. Hull ordered the 2/4th, though now a ruined battalion, to mount a new assault on Dinh To. Golf Company must make it, supported by Foxtrot, fifty-four men in all, more than a few of them armed with AK-47s because their M16s had failed. In an extraordinary gesture, perhaps born of desperation, Bill Weise elected to go up front with them himself. Scarcely a man at the start line had slept for three nights; exhausted and hungry, most were deeply despondent.

The advance began quietly, but suddenly the Marines took fire from their left, where the South Vietnamese were supposed to be attacking. Weise's operator radioed their US adviser, saying to watch where they were shooting. Then Big John Malnar exclaimed, "Hey Colonel, that's not ARVN, it's NVA." The South Vietnamese attack did not happen, for reasons never explained but wretchedly familiar in that war—a failure at best of liaison, at worst of will. The Americans found themselves under fire from all sides. At 1505 they briefly broke into a charge, yelling and screaming. Foxtrot, on the eastern flank, reported itself pinned down and taking heavy casualties. James Butler was supposed to follow G Company and pass through, but he failed to do so. He said later that he merely followed orders, but Weise said F's commander had misunderstood them, willfully or otherwise. The colonel's subsequent report terminated Butler's Marine Corps career.

At 1645 two companies of NVA counterattacked the survivors of Golf, precipitating a panic-stricken flight by the outnumbered Americans. A Marine prodded an officer who was watching his front, saying, "Sir,

everybody's taking off!" Weise and Big John Malnar found themselves shooting it out with advancing enemy at point-blank range. A Marine said, "Chaos began to break out, with people shouting 'Pull back! Pull back!" The men on either side of Jay Vargas were killed. An RPG struck Malnar as he covered the rear with a pump shotgun, destroying this lonely legend who had survived the worst that Japanese, North Korean, and Chinese enemies could do to him. An AK-47 round felled Weise, whom two Marines dragged back. Lt. Judson Hilton abandoned his role as air controller and fired an M-79 Thumper as he crawled back up a ditch. One Marine was glimpsed fleeing naked but for jungle boots. Jay Vargas was hit three times, but continued to exercise command throughout the disengagement, for which he was awarded a Medal of Honor. The battalion left behind forty-one dead in Dinh To.

The NVA withdrew overnight from Daido, which another Marine battalion then occupied. The Americans, drawing up the balance sheet for three days' fighting, claimed 537 enemy killed by infantry action and another 268 by air and artillery. Offshore warships had fired 2,383 rounds in support of the 2/4th, artillery 5,272 rounds, together with 1,147 mortar bombs; twenty-seven air strikes had been delivered. The battalion lost 81 killed and 297 wounded, plus a hundred slightly wounded. Half of all these casualties were incurred on the last day, May 2. One platoon commander, who started out with 48 Marines, wound up with 3. On April 30, the battalion had mustered 650 effectives, subsequently reinforced by another 200; it finished with 150 Marines fit to fight, commanded by Fritz Warren, almost the only unwounded officer.

The communists have never published casualty figures for Daido. American claims are not believable, but the NVA certainly had many more killed than did the 2/4th. There are veiled references in communist official histories, describing their situation on May 2: "We too had suffered losses. . . . The fighting strength of our infantry was now very limited. . . . [The 6/52nd] had few troops left." Yet the resilience of the NVA emphasizes the limitations of American fire and air power against dug-in troops. Jim Livingston was impressed: "They wouldn't give up.

Clockwise from left: Duong Van Mai in her days as a RAND researcher; Nguyen Thi Chinh, who became film star Kieu Chinh; Vietcong doctor Dang Thuy Tram.

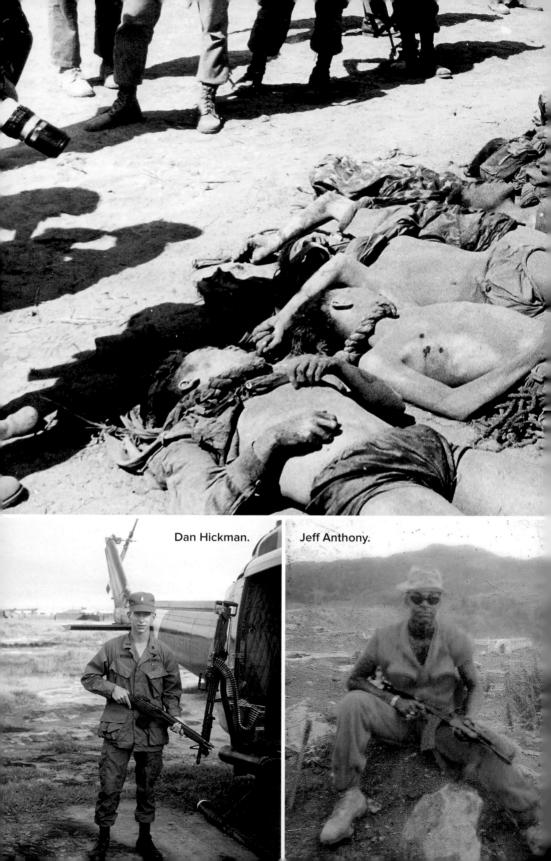

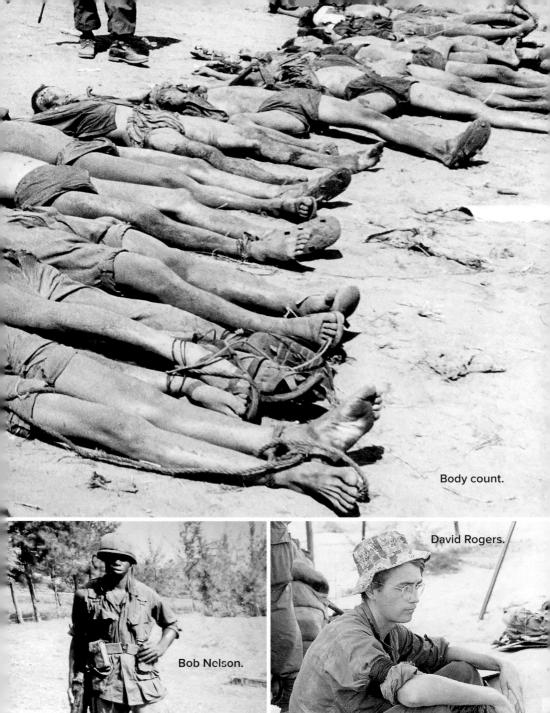

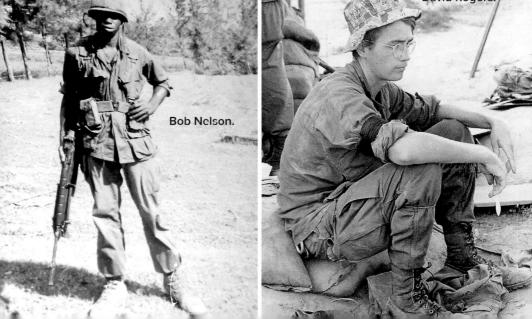

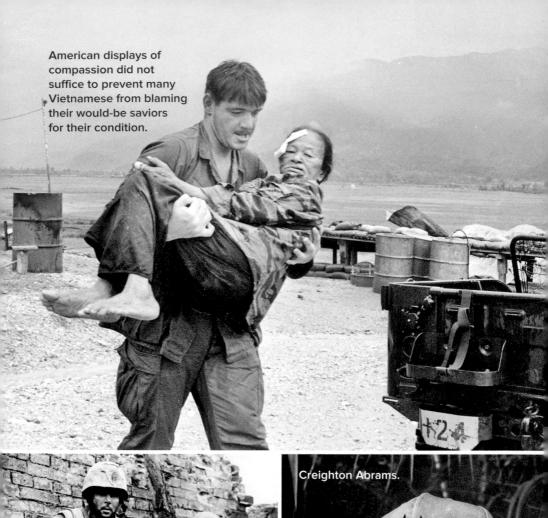

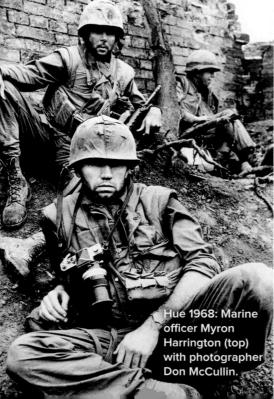

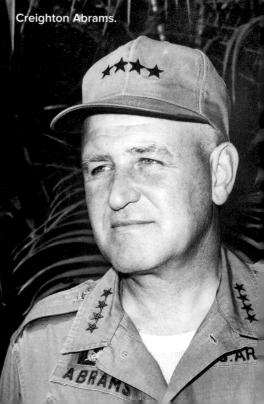

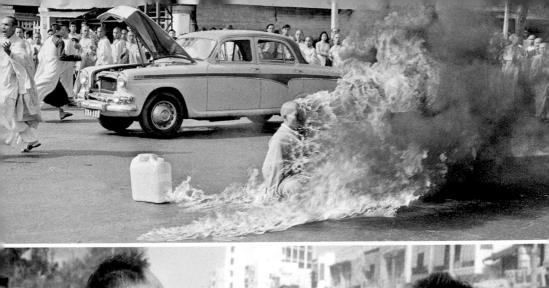

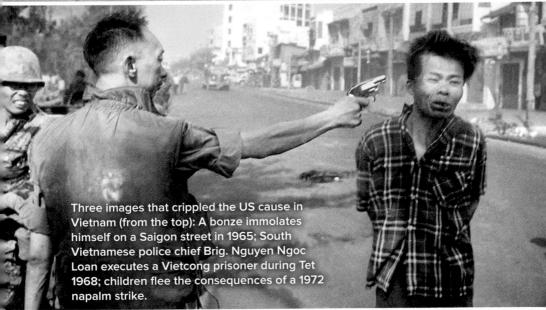

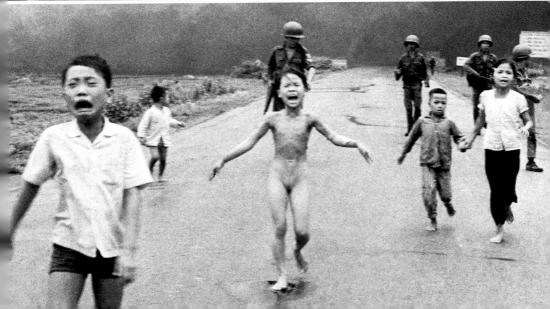

"How long do you Americans want to fight, Mr Salisbury? ... One year? ... Twenty years? We shall be glad to accommodate you." New York Times correspondent Harrison Salisbury in Hanoi with premier Pham Van Dong, 1966.

Fallen hopes: North Vietnamese salvage wreckage from a downed US aircraft.

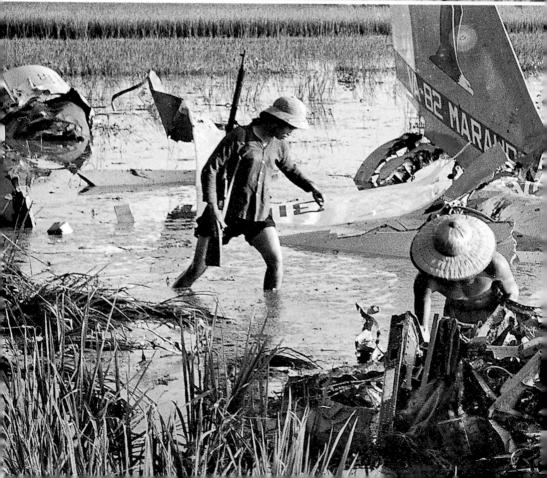

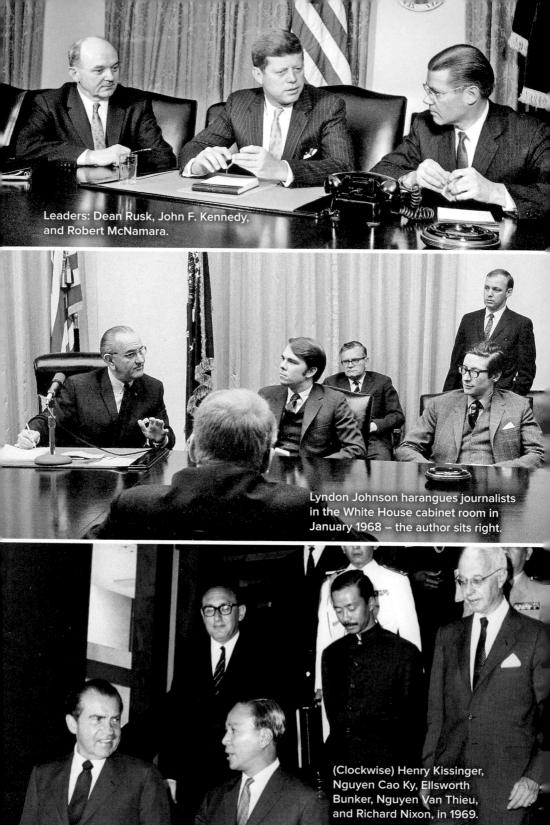

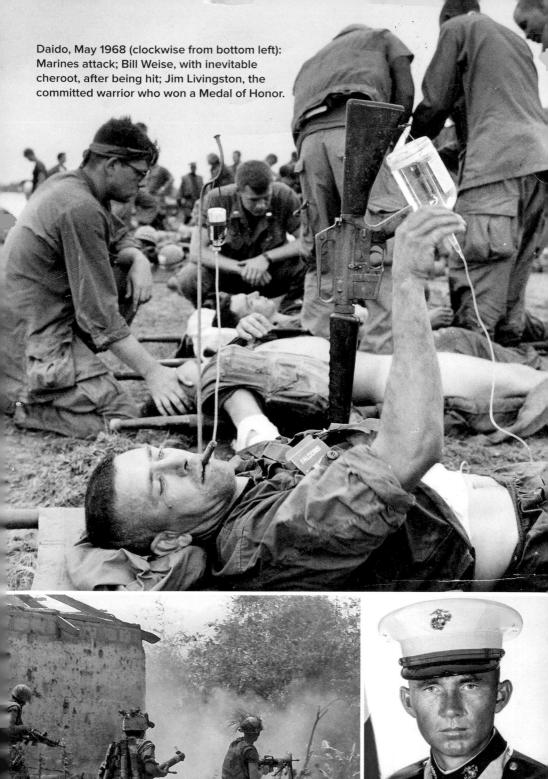

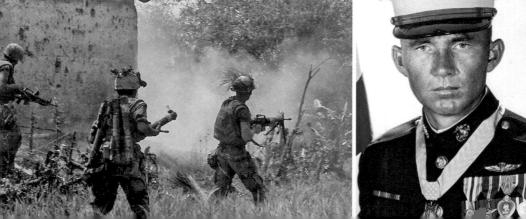

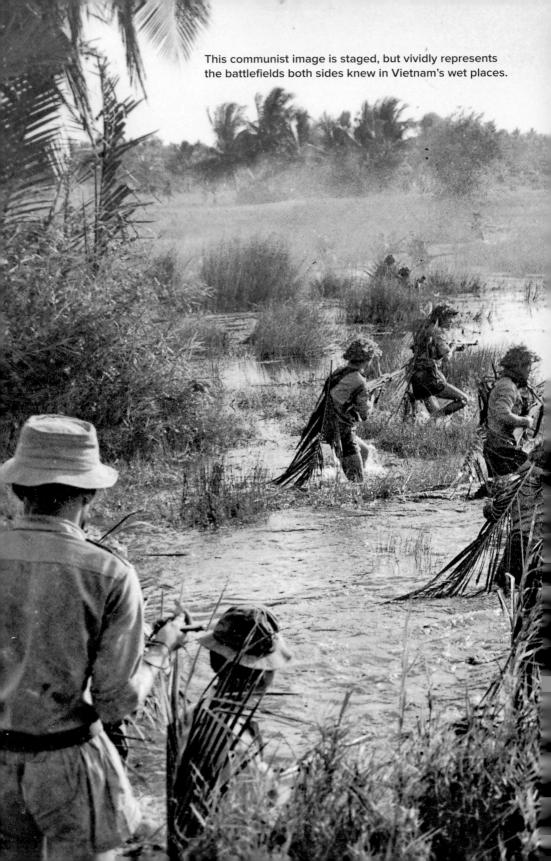

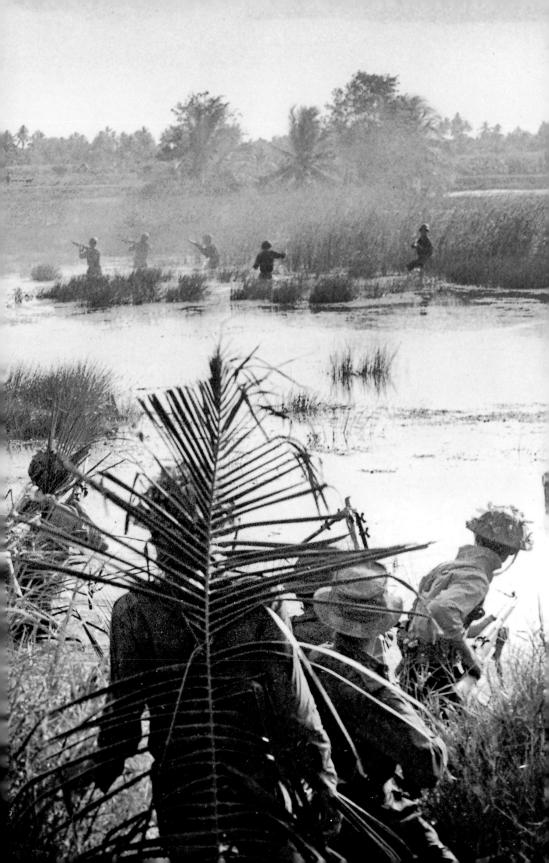

Innocent bystander – twentyyear-old Catherine Anne Warnes, shot dead while performing in Danang in 1969 by a US soldier thought to have been aiming at one of his own officers.

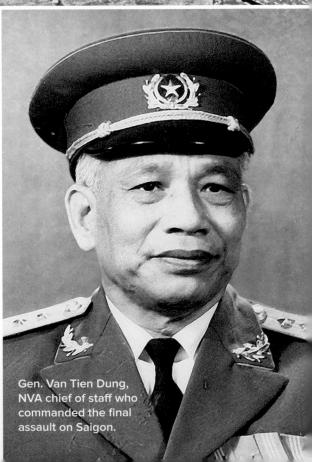

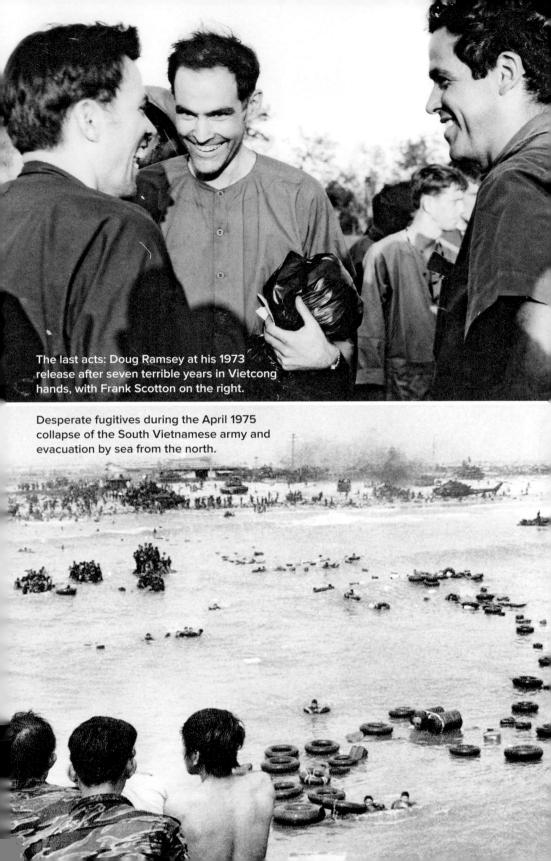

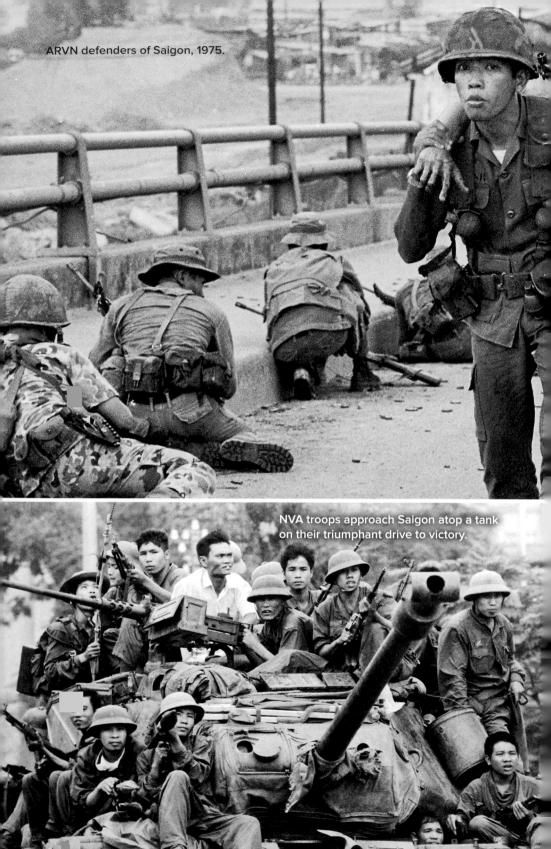

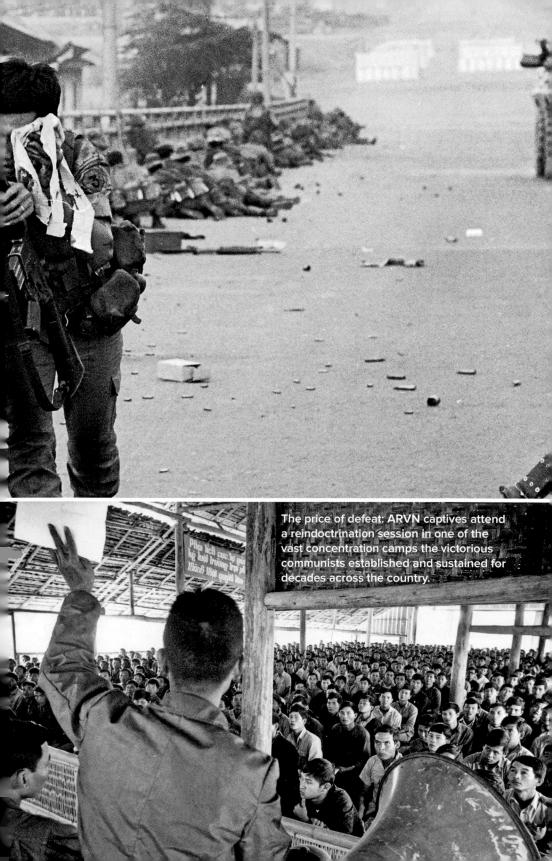

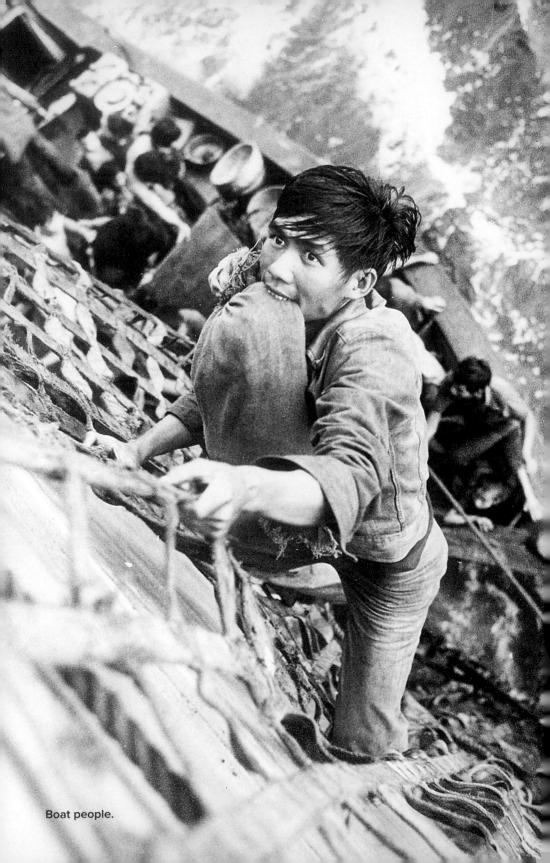

They were tough little bastards who understood cover. You put them in a bunker and they would fight to the death." The tactical weakness of the Americans at Daido, and in many other battles, was that they made themselves visible, vulnerable targets, while the enemy seldom did so.

The NVA claimed a victory and distributed medals as lavishly as the Americans. They claimed to have fought on May 2 against three Marine battalions "and significant elements of the US 73rd Air Cavalry Brigade," a force that didn't exist. Their account concludes: "The entire US battalion, which was tightly bunched, disintegrated into complete disorder as men died and were wounded in droves. . . . In just thirty minutes the entire battalion was shattered, and more than two hundred bodies were left lying on the battlefield. . . . The blood of the American aggressors dyed red the water of the Cua Viet. . . . In a single afternoon almost 500 Americans had paid for their crimes with their lives." Of the battalion's ten survivors, said the communist historian, two "had been driven totally insane with terror." This account merits quotation merely to illustrate how twenty-first-century Vietnam recounts the war story. Yet infantryman Bao Ninh's words instead emphasize the commonality of experience among his own comrades, grunts, and ARVN: "Some are brave, some not so brave." North Vietnamese soldiers had a profound respect for US firepower, he said, "even if the Americans did not understand people."

Half a century on, it is hard to regard Daido as anything but an act of sustained folly, a view adopted at the time by many 2/4th survivors. A twenty-two-year-old corpsman, Roger "Doc" Pittman, said, "It was absolutely—absolutely—ridiculous, and I always felt that somebody ought to have been hung." The Marines' immediate instinct was to blame Weise, though he himself did not walk for three weeks and returned to duty only after a year. How did his wife, Ethel, take it? "She was kind—kinder than I thought she would be." Justice seems to place rightful blame on Col. Milton Hull and Maj. Gen. Rathvon McClure Tompkins of the 3rd Marine Division. It is understandable that on April 30 those officers sent two companies to clear the shore of the Bo Dieu, when they had little idea what enemy were present. It is extraordinary that they insisted upon

continuing frontal assaults through May 1 and 2. Weise said, "I don't believe Tompkins ever realized what was going on. He seemed paralyzed. On that third day when they told us to keep going, I said, 'This is stupid.'"

Gen. Creighton Abrams once said to his staff, "I wonder if we could arrange a swap of division commanders [with the NVA]—we'd take two of theirs and give them two of ours." He was sure, he added, that the allied cause would not lose by the deal, and perhaps he was thinking of Tompkins. Hull afterward claimed that the Americans at Daido had faced two NVA regiments. He described the situation on the night of May 2 in words that represent a parody of the reality: "After three very hard counter-attacks, 2/4th Marines had suffered some casualties but their ranks were still very well-organized and they were full of motivation and wanted to continue the attack and drive the enemy back. However I... thought it was time to give the battalion a little rest."

The battle at Daido is barely noticed in war histories. Weise said, "I kind of believe the Marine Corps covered this up." He may be right. Some, indeed most, of what went wrong in Vietnam may justly be blamed on the politicians who started it all and kept it going. But few American commanders covered themselves in glory, and some displayed folly of Crimean proportions, as at Daido.

2. TALKING

A week after Daido ended, on May 10, 1968, at the Hôtel Majestic in Paris, a US team led by Averell Harriman met a North Vietnamese delegation headed by a middle-ranking cadre, Xuan Thuy. The communist choice of envoy should have sufficed to check the surge of euphoria that swept the international community—delusions that a peace settlement would be reached within weeks, at worst months. Though Le Duc Tho, Le Duan's most important associate, was also present, Xuan Thuy was front man. The North Vietnamese proved willing to be seen to talk, but to no early purpose. This confused the American electorate. Here was the twin-track policy of "talk-fight." Week after week, and then month after month, the rival delegations droned at each other in Paris. The Americans

clung to an insistence that North Vietnamese troops must quit the South as part of a general withdrawal of "foreign" forces, while Hanoi demanded a role for the Vietcong in a Saigon coalition government. Neither proposition being acceptable to the opposing party, three years of diplomatic sterility ensued.

Lyndon Johnson's announcement of his withdrawal from the election race crippled US diplomacy, because it increased North Vietnam's triumphalism, its conviction that victory was at hand, despite the parlous condition of the Vietcong. In Washington, Soviet ambassador Anatoly Dobrynin was told by his Polish counterpart that Premier Pham Van Dong favored accepting South Vietnam's neutralization, to halt the devastation. This was conceivably true but wholly at odds with the unyielding posture of Le Duan and Le Duc Tho. The Russians, desperate to stop paying bills for the North's war effort, pleaded with Hanoi to show flexibility—and were rebuffed. Dobrynin wrote, "In Moscow there was no less consternation than in Washington. . . . Privately . . . many [Soviet] Politburo members cursed the Americans, Chinese, and Vietnamese for their unwillingness to seek a compromise. Brezhnev once told me angrily that he had no wish 'to sink in the swamps of Vietnam.'"

The US administration sustained its delusions that Russia could end the war if it chose, especially when the Chinese became immersed in the domestic horrors of Mao's Cultural Revolution that in 1969 they withdrew almost all their personnel from Vietnam. Washington repeatedly urged Moscow to accept an intermediary role. The Soviets reiterated wearily that the US must deal bilaterally with the Northerners. The Americans could not understand, wrote Dobrynin, that however much Russia wanted peace, when it faced a Chinese challenge for leadership of the socialist world, it could not withdraw support from its most notable revolutionary clients. Moscow was so convinced that a presidential election victory for Hubert Humphrey would end the war that its envoys vainly implored Le Duan to give the Democratic candidate a diplomatic break. The specter of Richard Nixon persuaded the Russians to go even further: they offered Humphrey's campaign secret financial support, which was politely refused.

In that turbulent, bloody election year, America was divided as never since the Civil War. Lyndon Johnson now regretted his abdication and nursed vain hopes of being belatedly drafted as Democratic candidate. Bitterness about his own plight intensified the disdain, even contempt, he harbored toward his vice president. Throughout America, hostility to the armed forces became a widespread and unprecedented phenomenon: USN Cmdr. Jim Koltes, serving as a staff officer at the Pentagon, became as unwilling as were most of his colleagues to wear uniform in the streets of Washington: "You were liable to get into a fight." Yet even now, no serious presidential candidate, not even Eugene McCarthy or Robert Kennedy, dared to advocate unconditional US withdrawal from Vietnam—explicit acknowledgment of defeat. There also remained a few dogged escalators, advocates of a formal declaration of war on the North, though such a proposition would never have passed Congress.

In 1968 Americans saw death all around them: another Kennedy and Martin Luther King martyred, race riots in the cities. As for Vietnam, on May 28, Michael Minehan, a young machine gunner in Quang Tri Province, wrote home: "Today we are ninth day in the field and there isn't much to say because all we are doing is walking in the mountains looking for gooks. . . . I thought I would drop you a line to say everything is fine." Five days later, however, it stopped being fine. Minehan's parents in Marlborough, Massachusetts, received a telegram: "From Marine Corps commandant. Deeply regret to confirm that your son . . . died on June 2, 1968. . . . He sustained fragmentation wounds to the body from friendly air strikes which fell short of the target area. . . . His remains will be prepared, encased and shipped at no expense to you accompanied by an escort either to a funeral home or national cemetery selected by you. In addition you will be reimbursed to an amount not to exceed five hundred dollars toward funeral and interment expenses. Please wire collect to Marine Corps headquarters your wishes in this respect."

By the end of the year, 16,899 such telegrams had been received in homes throughout the land—over three hundred a week—and Americans were tiring of them. The US high command in Saigon fumed that nobody would concede the credit the soldiers believed they deserved for

having smashed Tet and then mini-Tet. Pacification chief Robert Komer said during a weekly intelligence update meeting on June 29, "We won a campaign and nobody knows it." The Army's new field commander, Gen. Creighton Abrams, concurred, saying of the media, "They're calling you out before the throw is made to the plate. The umpire out there, represented by the [news] bureau chiefs, he's swinging his thumb over the shoulder and, hell, the left fielder still hasn't thrown the ball. . . . The umpires are all against us."

One of Abrams's senior staff officers lamented, "It seems to me we've jockeyed ourselves into a funny position in Paris. . . . If anything goes well for the enemy and he's able to mount [an] offensive, then he gets credit in the headlines for power and so on, like he did at Tet. On the other hand, if by virtue of our efforts here, we succeed in pre-empting him and prevent his offensive, he gets credit for de-escalation." Abrams concurred.

In August, provincial NLF and Vietcong chiefs received terse, arbitrary wirelessed orders from COSVN decreeing that there was to be a "third wave" of Tet. Some of the tactical instructions were absurd. Fighters were told to conceal themselves in tunnels and bunkers in the middle of Saigon, hiding the excavations with wooden covers carried for the purpose. This order was belatedly canceled, mere local commando attacks substituted. Elsewhere in the region, groups launched sporadic bombardments of American bases, using rockets left from February's stockpiles. The August attacks concentrated on Tay Ninh Province, and most were easily repulsed.

These were bad days for the Vietcong. Throughout the Mekong Delta, guerrilla river and canal communications were impeded or cut by intense American and Vietnamese boat patrolling, aided at night by searchlights. The guerrillas were too depleted to challenge renewed sweeps. Traditional sanctuaries suddenly became vulnerable. Units were forced to disperse, and most withdrew toward Cambodia. Their aid stations suffered repeated attacks. The Delta Vietcong's best battalion commander, Muoi Xuong, was dispatched to Saigon to discover the fate of a unit with which contact had been lost. He himself was promptly killed after US troops discovered his underground hiding place. Desertions from VC units became endemic.

On August 31, with American commanders seeing themselves on a roll, "Blowtorch" Komer expressed alarm at the possibility that Hanoi might propose an unconditional cease-fire before the US election. "Both candidates would support it: How can you be against a cease-fire? It's like motherhood." Earle Wheeler told the president in October, "Abrams's assessment is highly favorable. If we haven't won the war militarily, we are well on the way to it." The chief of staff of the notorious US 9th Division in the Delta described how his formation tallied its achievements for 1968: "The retail concept of returns on operations, that is, a large number of small enemy eliminations, as compared to the wholesale concept . . . was the way to go. For example, if all thirty-nine [rifle] companies would eliminate just one VC a day, that would amount to 1,170 a month." Here was a vivid example of the statistical lunacy, the mountain of gobbledygook, that passed for strategy.

The men who fought at Daido and elsewhere saw more than a hundred helicopters being lost per month. They knew that in 1968 the communists mounted 1,500 ground attacks and the depleted Vietcong contrived 9,400 recorded terrorist incidents, which cost the lives of 5,400 civilians; they noticed the ARVN record of 139,670 desertions by Christmas. They were no longer convinced that the war was either being won or winnable. Maj. William Haponski wrote, "My experiences, I believe, are important as a reflection of the whole war, its instances of what appeared to be American successes. . . . We were plowing what seemed like new ground, hopeful of a good harvest, but in fact the fields had been almost entirely ruined by what had happened earlier, and very little good could grow there."

A man in Pfc John Hall's infantry company suddenly announced, "I ain't going in the field no more." His comrades begged and pleaded with him, urging that he could not want a dishonorable discharge, but he stayed stubborn: "I don't give a shit. I don't want to die." He was duly dispatched to the rear for disciplinary proceedings, but there were plenty more like him coming. Draftees who caught planes for Saigon after witnessing the strife on the streets of Chicago during August's Democratic Convention were hard to persuade that they were joining a war worth dying for.

The bewilderment besetting Americans of every political hue was re-

flected in a letter published in the New York Times on September 2, from an upstate history professor. He said that, although a registered Democrat for twenty-four years, he proposed to abstain in November, because "it seems to me that an electorate which could conceivably go for Hubert Humphrey deserves to end up with Richard Nixon." The Republican presidential candidate knew that his own prospects of victory hinged on a sufficiency of voters believing that he, and he alone, could end the war without exposing the United States to humiliation. He allowed it to be supposed—though a misguided reporter, rather than Nixon himself, originated the story—that he had a secret peace plan, ready to be unveiled when he entered office. This was a fiction: in truth, he intended merely to exploit communist fears that he, the implacable Cold Warrior, was willing to embrace every extreme of violence if the enemy declined to cut a deal. On October 25, he attempted to torpedo LBJ's bombing halt plan through duplicitous secret maneuvers designed to prevent a settlement before polling day, notably by urging South Vietnam's President Thieu—using Madame Chennault, widow of Claire, the legendary World War II American air chief in China, as an intermediary—to boycott the Paris talks.

A week later, on the 31st, in a belated counterstroke timed to scupper the Republican candidate, Lyndon Johnson delivered a national TV address in which he announced a cessation of all US bombing of North Vietnam. It is unlikely that any of this changed the election outcome, but it is certain that in January 1969, with less than a 1 percent edge of the popular vote over Humphrey, Richard Nixon became US president. Johnson's war thereafter became Nixon's war. As the latter wrote in his memoirs, however, "It was no longer a question of whether [I] would withdraw our troops, but of how they would leave and what they would leave behind."

NIXON'S INHERITANCE

1. A CRUMBLING ARMY

One evening in December 1968, Frank Scotton walked into Saigon's Continental Palace Hotel and beheld a group of distinguished Vietnamese being casually insulted by three drunken grunts. Scotton persuaded the Americans to move on, but one of the Vietnamese, a senator, asked in distress, "How can this happen, how can this happen?" Scotton answered that here was a symptom of a country unable to defend itself. Young communist doctor Dang Thuy Tram celebrated Tet 1969 with an NVA unit that passed by her hospital. Their coming, at this third new year of her service in the South, prompted a spasm of melancholy, which caused her to walk alone through the early evening to her quarters: "A cold breeze sighs. . . . An immense sadness and longing make me stop. Instead of being used to the loneliness of living in an unfamiliar land, instead of feeling cheered by the warmth and friendship of the folks, . . . I feel as though it were my first day here. My only true wish is to live with Mom and Dad in our warm family nest . . . still a little girl wanting to be spoiled." A few miles away, thousands of her capitalist contemporaries could have succumbed to matching outbursts of sentimentality.

Neither Vietnamese nor Americans discerned much change in their battlefield circumstances after the ascent of a new US president and a change of MACV commanders. President Nixon wanted a settlement but had no intention of being branded a quitter. In his January inauguration

speech, he did not mention Vietnam. His national security adviser, Henry Kissinger, wrote later, "The overriding issue was to keep faith"—he might more justly have said, "to appear to keep faith"—"with the tens of millions who, in reliance on American assurances, had tied their destinies to ours." The war continued to cost \$2.5 billion a month and over two hundred American lives a week—one-third fewer than in 1968, but still more than 1967. US forces consumed an average of 128,400 tons of munitions a month through 1969. In June Dan Bullock from Brooklyn, New York, became the war's youngest American to die. Having lied about his age to enlist, the fourteen-year-old black kid wrote home to his sister, "I think I joined the Marines at the wrong time. Pray for me, because I won't be coming home." Just twenty-one days after landing at Danang, he was killed by a communist satchel charge tossed into his bunker.

Gen. Creighton Abrams was a rumpled bear of a man, in contrast to the lean, immaculately creased Westmoreland. A former Springfield, Massachusetts, high school football star and World War II armored brigadier under Patton, the fifty-four-year-old received an enthusiastic welcome from the US media, as something fresh on the block. Nonetheless, even if "search-and-destroy" was supposedly supplanted by "clear-and-hold," Abrams's coming signaled no meaningful change of strategy. Westmoreland's successor realized that, in the face of fading will at home, everything must be done fast. Many VC and NVA units aspired to avoid headlong collisions with US troops, thus the energetic Abrams emphasized the importance of making the most of opportunities. He ordered that any US officer commanding a company or more who lost contact with the enemy must explain why.

He railed against demands from Washington to reduce civilian casualties. In 1968 the monthly tempo of B-52 sorties against targets in South Vietnam and Laos almost doubled to fifteen hundred, and in March 1969 the giant planes dropped 130,000 tons of bombs. MACV remained chronically short of tactical intelligence, however: Fred Weyand acknowledged that "allied forces had no information base in the local population." In April 1969 Abrams nonetheless told a reporter, "When we have maintained the initiative, . . . our kill ratio is spectacular."

The most aggressive of his subordinates, and the most notoriously indifferent to Vietnamese interests, was Maj. Gen. Julian Ewell, a tigerish Airborne veteran of World War II. In 1968–69, Ewell commanded the 9th Division in the Mekong Delta, then took over II Field Force. He wrote, "The 'hearts and minds' approach can be overdone. In the Delta the only way to overcome VC control and terror is by brute force." Ewell rejected the findings of the MACV inspector general, that seven thousand civilians perished in his formation's six-month-long Operation Speedy Express. In April 1969, illicit fuel drainage from the army pipeline north to Phu Cat reached 600,000 gallons a month, and national losses hit four and a half million gallons. At MACV's weekly command conference, there was discussion about making an example of some thieves. One officer protested, "You can't shoot people for petty larceny."

Ewell responded, "B-U-L-L-shit."

Abrams expressed discomfort about promiscuous killing.

Ewell said, "I don't agree with you, general. You get a sapper unit mining the road and you kill two or three, and they'll knock it off. These people can count. And boy, when you line up them [bodies], their enthusiasm is highly reduced. That's the way we opened up Highway 4—just killing them."

Abrams prompted laughter around the table by saying, "All right, we'll study it." He nonetheless urged care in handling civilians: "We don't want to get a US terrorism rate that's higher than the VC." Ewell carried on regardless. A Huey gunship pilot found himself working for one of 9th Division's brigadiers, John "Mal Hombre" Geraci. "His orders were, 'Kill everything that moves.'" Geraci affected a swagger stick with which he was wont to poke officers in the chest for emphasis: "I want kills." The 9th Division perfected a technique of sealing an area with infantry, then pounding everything inside it with air and artillery. Body counts were assuredly impressive but not remotely matched by weapons captures, the most plausible indicator that the right people were dying.

On November 12, 1969, Associated Press wires carried the first report by freelance investigator Seymour Hersh indicating that men of the 23rd Americal Division had carried out a massacre of civilians at My Lai, a few miles inland from the sea in Quang Ngai Province, for which courts-martial were to be convened. During the months and years that followed, it emerged that on March 16, 1968, at least 504 peasants of all ages and both sexes had been murdered without provocation by C Company of 1/20th Infantry, most of them in "My Lai 4," a hamlet properly called Tu Cung.

My Lai—known to some grunts as Pinkville—is believed to have been the largest of the war's many unprovoked killings, though there are allegations that South Korean troops accomplished worse things. Capt. Ernest Medina, commanding C Company, had earlier ordered the shooting in cold blood of two offshore fishermen, and men of the unit murdered other civilians without incurring censure. Rapists were not subjected to disciplinary action. The day before the massacre, chaplain Carl Creswell attended a divisional briefing at which a major played the mood music for the impending sweep by saying, "We're going in there, and if we get one round, we're going to level it." Creswell said fastidiously, "You know, I didn't really think we made war that way." The major shrugged. "It's a tough war, Chaplain."

This was the view adopted by every senior officer in the region. During the months after My Lai, even more shocking than the killings was the institutionalized cover-up. Commanders ignored a vivid, immediate report made by helicopter pilot W/O Hugh Thompson Jr., who courageously raised hell on the day about what he saw, and kept raising hell afterward. Task Force commander Lt. Col. Frank Barker dismissed expressions of unease about the 1/20th's claims to have killed 128 enemy without capturing a single weapon, saying, "It was tragic that we killed these women and children, but it was in a combat situation." In March 1969, helicopter door gunner Ronald Ridenhour wrote to thirty members of Congress, describing atrocities credibly recounted to him by buddies; his account stirred a small bow wave of dismay back home, which much later swelled to a flood tide. Nonetheless, 23rd Division staff officer Maj. Colin Powell, later US secretary of state, produced a memorandum for the adjutant general that was an uncompromising whitewash, asserting that "relations between Americal soldiers and the Vietnamese people are excellent." Powell

failed to interview Pvt. Tom Glen, a twenty-one-year-old from Tucson who had written a brave letter to Creighton Abrams about Americal atrocities.

The inquiries into My Lai produced evidence of other war crimes committed at the same period by Bravo Company of 4/3rd Infantry, for which no one was ever convicted. When Lt. Gen. William Peers belatedly conducted a full investigation in November 1969, his findings named twenty-eight officers, including two generals and four colonels, whom he accused of 224 serious military offenses, ranging from false testimony and failure to report war crimes to conspiring to suppress information and participation in or failure to prevent war crimes. More than forty of C Company's 103 men were found to have taken part in the massacre, and not one infantryman sought to halt it or the accompanying gang rapes. Although 23rd Division commander Maj. Gen. Samuel Koster was belatedly demoted to brigadier, no court-martial conviction was secured for any serious offense, except that of 1st Platoon commander Lt. William Calley, on March 29, 1971. Though Calley was sentenced to imprisonment, the president immediately intervened to order that he should merely be "confined to quarters."

When Capt. Medina was acquitted, the judge wished him a happy birthday. Five thousand telegrams sent to the White House about Calley's conviction ran a hundred to one in the stubby lieutenant's support, and the national commander of the Veterans of Foreign Wars said, "For the first time in our history we have tried a soldier for performing his duty." Nixon exclaimed repeatedly to a White House aide in November 1969, as the press headlined the My Lai story, "It's those dirty rotten Jews from New York who are behind it." Recruits marching at Fort Benning chanted, "Calley . . . Calley . . . He's our man." AFN Saigon repeatedly played a ballad recorded by an Alabama vocal group that called itself C Company: "My name is William Calley, I'm a soldier of this land. / I've vowed to do my duty and to gain the upper hand, / But they've made me out a villain, they have stamped me with a brand." MACV eventually ordered the radio station to stop running the disc, which sold two hundred thousand copies, but it could not suppress grunt graffiti in Saigon, such as KILL A GOOK FOR

CALLEY. In September 1974, a federal judge ordered Calley to be released on parole on the grounds his trial had been prejudiced by adverse publicity. He was released after serving just forty-two months' confinement to quarters.

The My Lai massacre has come to symbolize all that was worst about the US armed forces' conduct of the war. The "patriot lobby" back home was not wrong in asserting that Calley was a scapegoat. The lieutenant stretched the truth when he asserted that his actions were "just following orders," but he could legitimately have stated that the killing reflected a culture of casual murder, a racial contempt for Vietnamese, which infected many US units—and their commanders. Justice would have been well served by imposing exemplary custodial sentences on several senior officers named by the Peers inquiry, Koster foremost among them.

Meanwhile, it seems no more justifiable to blame Abrams than his MACV predecessors for failure to win the war, because his options were so meager. He was mandated to achieve battlefield success with forces that soon began to shrink. He did what soldiers are supposed to do—kill the enemy—but he had no power to fix the apparently immutable, intractable reality, that South Vietnam's government had no relationship with its own people. Given a thousand-mile western border to hold, and beyond it multiple communist sanctuaries, like Westmoreland he deplored Washington's refusal to permit him to thrust into Laos and Cambodia. The NVA-run Hak Ly trucking company in Cambodia, in which the Phnom Penh government held a profitable stake, was shifting fourteen thousand tons of supplies a year from the port of Sihanoukville to North Vietnamese bases in the east of the country.

Abrams fumed, "Its criminal to let these enemy units fatten up over there . . . getting a free ride." Yet when he suggested to Lt. Gen. Andrew Goodpaster that some B-52 Arc Light strikes might "accidentally" drift over the border, his deputy responded firmly that a Washington policy decision would be required. Abrams was further infuriated by a CIA study that suggested that military action against the sanctuaries would achieve little. Greg Daddis observes that the MACV command change repre-

sented more a shift in rhetoric than a change of strategy. Under Abrams, the 101st Airborne's operations, and the May 1969 assaults on Hill 937 in the A Shau Valley—what became known as Hamburger Hill, barely a mile from the Laotian border—were indistinguishable from many battles fought on Westmoreland's watch.

Another such episode achieved notoriety as the theme of Karl Marlantes's fictionalized fragment of autobiography, Matterhorn. Diplomat's son Lt. Landon Thorne, a fellow platoon commander with Marlantes in C Company of the 1/4th Marines, was one of relatively few upper-crust Americans who accepted Vietnam service without demur. His grandfather had been a career Marine; his father, a radar officer on the wartime carrier Hornet. Thorne wanted to discover whether he could match up to them. In the last months before the twenty-five-year-old New Yorker graduated from Yale, his classmates agonized about whether to go to the war, and most decided against: "I got progressively more worried as I got to learn more. I was getting, 'Hey, did you hear about Charlie? He just got killed.' But a number of people seriously distorted their lives to avoid service, and for some it became a lasting guilt trip." In San Francisco for embarkation, Thorne was kept company on the ride to the bus station from the city's smartest rendezvous, the Top of the Mark, by his sister Julia. She then set off for finishing school in Europe and became a fervent antiwar protester.

At Danang, Thorne and his fellow new arrivals were greeted by a crowd of tour-expired vets who said bleakly, "Welcome to the greenest mud on earth. You'll be sorry." He waited two days for a CH-46 to FSB Argonne, which melded with events at LZ Mack to become Marlantes's fictional Matterhorn—where he found the company gazing at the NVA on a hill just over a mile away on the Laotian border. The Americans were attacked the first night. "You could hear the *doomp, doomp, doomp* as their mortars fired, probing our positions." Thorne discovered that he had joined an unhappy unit: "The CO tried to seek performance beyond what was reasonable. If young Marines are with you, they can do fantastic things. But poor leadership can make things much more difficult." Thereafter they spent weeks clearing a nearby hilltop code-named Neville, where Thorne was sent to serve as FO for three 105mm guns. He was on

the position, defended by just two platoons, when in the early morning darkness of February 25 two hundred NVA, smart in green fatigues and sandals, launched a surprise attack through the jungle that ran right up their wire. "We got overrun three times, ran out of Claymores, couldn't get air resupply, mortared by 60mms and 82mms." Listening posts were told, "Lie chilly"—stay silent and hope the enemy doesn't notice you. Fires broke out, fed by loose powder bags around the gun pits, one of which fell briefly into enemy hands.

The NVA sappers were evicted after a three-hour battle sometimes fought with entrenching tools as well as rifles and grenades, but twelve Marines and two navy corpsmen lay dead, and many survivors had sustained hearing damage from repeated close-quarter explosions. The enemy harassed Neville's shrunken perimeter for days, during which helicopters could not land and parachuted ammunition drifted beyond reach. Thorne found himself too scared to eat: "There was so much adrenaline running. You've been emotionally destabilized, because you've accepted death. When you live, you're a different person afterward. The second night the big problem was fire discipline, because everyone was jumpy. There was a tendency to squeeze off a rifle or pop a Claymore. I had artillery in as soon as we heard movement." On the third day, having suffered painful constipation, he felt the urge for a bowel movement and had just squatted on an ammunition box when the hated doong! doong! started again. Incoming. "But at that moment I was prepared to die to take a crap."

The attacks tapered off. The weather was still too bad for helos, but they tried to fix the gaps in their wire. A company sent to support them had to walk all the way, which took a week. Then CH-46 Sea Knights belatedly arrived. Corpsmen cleaned the maggots off the American dead and threw enemy corpses over the hill. "The NVA went off to give Karl and C Company their difficult days." Thorne was summoned to Dong Ha to become an aerial observer. His first thought was, How can I leave you guys? His second was, How could they be so fucked up at headquarters as to have put us out here? The 1/4th's subsequent misfortunes, vividly described by Marlantes, reflected the reckless yet familiar willingness of some commanders

to expose relatively small forces in predicaments that conceded advantage to the enemy. Fighting in the area persisted into April. The 1/4th's colonel, one of the architects of their woes, was among its victims—killed by a mortar bomb. Though as usual the NVA's losses significantly exceeded those of the Americans, it was the latter who emerged feeling like losers.

The apparent contradiction is that the communists later acknowledged 1969 as their own worst year of the war, measured in losses and morale. In the mountains of Quang Ngai Province, in June even the fervently committed young revolutionary Dr. Dang Thuy Tram confessed that she and her comrades were exhausted, their spirits sagging, many men too weary even to eat: "Day and night we are deafened by the explosions of bombs, the noise of jets, gunships, and UH-1As circling above. The forest is gouged and scarred by bombs, the remaining trees stained yellow by toxic chemicals. We're affected, too. All cadres are desperately tired."

NVA soldier Bao Ninh wrote of the Jungle of Screaming Souls, an area where a battalion had been almost wiped out: "The sobbing whispers were heard deep in the jungle at night, the howls carried on the wind. . . . One could hear birds crying like human beings. They never flew, they only cried among the branches. And nowhere else in these Central Highlands could one find bamboo shoots of such a horrible color. . . . As for the fireflies, they were huge. Here, when it is dark, trees and plants moan in awful harmony. When the ghostly music begins, it unhinges the soul and the entire wood looks the same no matter where you are standing. Not a place for the timid. Living here one could go mad or be frightened to death. Here, these communist soldiers established a secret Buddhist altar, and prayed before it for their dead comrades."

Their weariness was matched by no allied sense of achievement, however. Intelligence chief Brig. Gen. Phil Davidson spoke bitterly of the US as the battlefield "where the enemy won his greatest victory of 1968." On March 15, he reported to Abrams a reduction in truck traffic on the Ho Chi Minh Trail. The general wagged a half-satirical finger: "Let's be careful that we don't sound some hopeful note in this."

Davidson: "Oh, no, sir. I'm never *hopeful*, sir." He fulminated: "We've got to defend our bases and the cities and populated areas. Let's say that

the *enemy* had to defend what he's got—bases, areas, and populace. We'd win the war in a month! We'd kick his tail right out into the ocean!"

COSVN's Directive 55, promulgated in April, mandated a more pragmatic communist approach, warning that commanders should not stake their entire forces on any given operation "but instead preserve combat potential for sustained future action." Directives 81 and 88, issued soon afterward, identified the NLF's objectives as being "to compel the enemy to accept negotiations with us, to withdraw troops, to . . . accept a coalition government." Communist forces displayed sufficient energy and aggression to sustain a steady flow of American and ARVN casualties, but whereas in October 1965 the NVA had represented just a quarter of combat strength in the South, now it contributed 70 percent and rising.

In Saigon, the media had irredeemably lost faith. Peter Braestrup, who served four years as *Washington Post* bureau chief, wrote in his skeptical analysis of the correspondents' performance, especially in 1968, that most were "adventurers, and to some extent, voyeurs. At their best they were also shrewd observers and interrogators, and perceptive tellers of tales," but they focused on such conspicuous dramas as Khe Sanh, Saigon, and Hue at the expense of broader analysis, and they "committed major sins of omission. . . . Most analyses were the hasty reactions of the half-informed." After saturation coverage of Tet, said Braestrup, global media interest in Vietnam declined steeply. Though it became increasingly clear that Hanoi had suffered a major defeat, this reevaluation gained little attention. "At Tet, the press shouted that the patient was dying, then weeks later began to whisper that he somehow seemed to be recovering—whispers apparently not heard amid the clamorous domestic reaction to the initial shouts."

Yet while Braestrup was narrowly correct, no military achievement overcame the problem that, while many South Vietnamese hated the communists, their own government remained unloved. The inhumanity of Le Duan invites posterity's repugnance, yet Hanoi sustained a more effective war machine with incomparably fewer material resources than did Saigon. North Vietnam's leaders, recognizing that the American people had lost patience, were prepared to endure further years of pain in anticipation of

an ultimate victory that now seemed assured. Indeed, they had inflicted so much grief on their own people that they could afford to settle for nothing less. Meanwhile on the other side, by the time Frank Snepp joined Saigon's CIA station in the summer of 1969, "we were not fixed on winning or losing, but on setting up an endgame."

There was a further critical point. Whatever tactical successes Abrams's forces achieved, the US Army was crumbling from within—a slow, inexorable, deadly process that attained a nadir in 1973. It was driven by three related and mutually reinforcing elements: drug abuse; racial strife, powerfully influenced by the US domestic Black Power movement; and a decline of discipline and will to fight. A US general said later, "We went into Korea with a rotten army, and came out with a fine one; we went into Vietnam with a great army, and finished with a terrible one."

When Capt. Linwood Burney took over an Airborne company late in 1968, he felt obliged to initiate routine drug searches. The military police made eleven thousand drug arrests in the following year, yet the proportion of grunt pot smokers continued to rise, to almost 60 percent in 1971. Many were using the super-strong variety known to bar girls as Buddha grass; a pack of joints cost a dollar. In 1969 only 2 percent of personnel had experience of heroin, yet within two years this soared to 22 percent—an awesome statistic—with seven hundred recorded addicts. The drug was imported from neighboring Laos by Royal Air Laos and Air Vietnam, then trucked around the country by ARVN. At least a few of those Americans who volunteered for second or third Vietnam tours did so to retain access to narcotics. Sixteen 1969 MACV overdose deaths were followed by thirty-five in the first eighteen days of 1970. Abrams acknowledged that he didn't dare to "kick ass"—adopt a hard-line policy toward users—though he strove to punish traders.

Company commander Maj. Don Hudson retained a passionate belief in his soldiers and attributed most problems to the shortcomings of officers: "We had some fine young men over there and the leadership, as I perceived it, is the ones that ruined [some, by] not caring for them." He described problems with pay, promotions, sometimes going a month without mail: "It was criminal. [The] drug problem haunted me. . . . Any

resupplies going out, I found capsules of heroin wrapped in plastic bags stuffed down in water cans." Hudson deplored institutional indulgence of illegal drugs, reflected by a case in which he caught a soldier with five hundred caps of pure heroin, yet charges were dropped "for lack of evidence": "I would say I had about five key ringleaders that were really on the criminal side." He found that an ambush squad had sat in the bush for three days high on marijuana, "led by a sorry team leader. . . . The bad actors had started taking over the organization. Once I weeded out the hardcore drug users, the guys that were making money by supplying," matters improved.

The dealers responded, first by threatening Hudson, then by attempting to lay countercharges that he had been drunk on duty. He still refused to back off: "The way I look at that, if they are going to frag you, they're going to do that. They're not going to tell you. Soldiers like a winner, and you can be as hard as you want and if you're not getting casualties and you're taking care of them the right way, . . . don't worry about if the soldier likes you." In the later years of the war, many American officers continued to display courage in the face of the enemy, but relatively few matched Maj. Hudson's guts in controlling their own men. Pvt. Richard Ford's all-black reconnaissance team had a private joke that they were knights of the Round Table. One night a soldier named Taylor, smoking a joint, began to insist that a lone tree he could see was the Statue of Liberty: "Sir Ford. Sir Ford. Ain't that the bitch? The world moves, right? Well, we getting closer to New York, 'cause I can see the bitch." The others had to tranquilize him. Substance abuse was overwhelmingly an enlisted men's issue, but some officers and NCOs were equally damaged by drink: a significant minority became alcoholics.

As for discipline, Capt. David Johnson took over an infantry company in October 1968 and was appalled to find men refusing to go into the field, conduct unknown during his previous tour. Following an operation, soldiers "just flaked out"—declining to clean weapons and equipment. His platoon sergeants were incapable of directing mortar or artillery fire, and he lacked confidence in what the company would, or would not, do under fire. "Many of us were questioning whether we should be there.

Soldiers were constantly asking themselves, 'Can I hang on? Can I last the tour out?' I'm talking about my own feelings as well as that of the men. . . . People would do weird things, crazy things. I had a soldier [who] ate some C-4 plastic explosive, and he died, . . . fell in six feet of water and drowned. The fact that we were hitting a lot of booby traps without a lot of enemy results . . . was a big morale factor. I had twenty casualties in sixty days, seventeen by booby traps, and that included myself."

Elsewhere two pilots killed each other practicing quickdraw with handguns. The Air Force assumed this to be a unique moment of madness until a few months later, when it happened again, though this time only one pilot died. The general reporting the incident mused in bewilderment, "Now, why would people do that?" On July 20, 1969, a pretty little twenty-year-old Australian singer, Catherine-Anne Warnes, suddenly fell dead on stage while performing in a USO show at a Marine base. She was the victim of a single shot fired from behind a screen with a silenced .22 automatic. A twenty-eight-year-old sergeant, James Killen, was convicted of killing the girl in a moment of crazed drunkenness, with suggestions that the intended victim was his executive officer. Killen served less than two years before being acquitted by a retrial.

On February 5, 1970, two grenades were tossed into Andy's Pub, an enlisted men's facility, while a three-girl Australian group named the Chiffons were singing. One exploded, killing a corporal and injuring sixty-two others. It emerged that earlier the same day more than twenty black Marines had met on the camp basketball court to vent alleged grievances. A lance corporal promised, "We're going to do some beasts [whites] tonight." Blacks were warned not to attend the Chiffons' show. At the subsequent trial, prosecuting counsel said, "This was a deliberate, carefully thought-out attempt to kill a hell of a lot of people . . . strictly because of racial problems." The two prime suspects were nonetheless acquitted, which caused a third trial to be aborted. Nobody was ever convicted for the Andy's Pub grenading.

In all wars, unpopular officers have been killed by their own men, usually shot in action under cover of exchanges of fire. In Vietnam, however, a new brand of cold-blooded attacks was introduced, often with frag-

mentation grenades—"fragging." The history of the Marine Corps legal branch records that such acts had "never been so widespread, so callously carried out." Its narrative identified over a hundred such incidents, while the Army between 1969 and 1971 recorded more than six hundred fraggings, resulting in 82 deaths and 651 injuries. A psychiatrist who studied twenty-eight cases found that most of those responsible were support personnel and that 87.2 percent had either been drunk or high on drugs. Few displayed contrition afterward.

A chronic shortage of competent junior officers and NCOs became compounded by departures of career officers who quit the service in despair: 148 of the 596 graduates of West Point's class of 1965 resigned their commissions in 1970. Maj. Michael Barry, an unwilling draftee doctor who served at Danang's 95th Evacuation Hospital, said he became depressed by the responsibility of repeatedly handling victims of fraggings. Moreover, he had no belief in the cause: "We were backing the wrong people." Drugs were a "very serious problem; . . . the heroin they were getting was so pure, about 80% compared with the stuff Stateside that was 5%." One day six black corpsmen brought in a dead buddy. Barry said, "They had been having a heroin party. They were so stoned nobody realized that he had stopped breathing."

At Christmas, the 101st Airborne's commanding general wished a black soldier compliments of the season—then saw the man reject his outstretched hand. The platoon Landon Thorne inherited was "a complete and utter mess. They were good kids, but they had evolved into three sections racially—all the black dudes in one, white Southerners in another, city boys in the third. I scrambled them. That was a dangerous time, the kind when you can get fragged, but the platoon sergeant sorted it out. These platoons and companies became almost like street gangs, very close-knit. New people were vulnerable, particularly lieutenants." While blacks constituted 13 percent of Marine strength, they were defendants in half the Corps's Vietnam courts-martial. There is no reason to suppose this disproportion represented racial victimization; rather, it reflected the depth of black alienation. The desertion rate became the highest in modern history, twice that of Korea and almost four times that

of World War II. In 1969, about 2,500 military absentees were loose incountry, most engaged in crime. The historian of Army lawyers describes an extraordinary escalation in their role: "Judge advocates . . . wrestled with . . . a soldier population beset by drug addiction, racial strife, and mutinous behavior."

In February 1969, Gy. Sgt. Joseph Lopez returned for a third Vietnam tour and was appalled by the prevailing indiscipline: "Tell a man to square his cover away, the man looks at you like he was gonna kill you. . . . Never did I see anybody give a superior NCO the looks that these young people give us nowadays." Between April and September that year, the Watch Committee monitoring racial tensions recorded an average of one "large-scale riot" a month in the Marine Corps operational area, as well as many lesser incidents.

Sgt. Harold Hunt, the black soldier from Detroit who had been badly wounded near Cu Chi in 1966, had insisted upon remaining an infantry-man and was posted back to Vietnam in May 1969. His old wounds sometimes troubled him, but he was uncommonly fit and exercised hard. Once back in-country, he was shocked to discover how much had changed. "The soldier was different. My platoon had fifty percent draftees. You had the racial strife, doping, indiscipline. It was hard to lead, to give people an order and get them to just do it."

Hunt was as different as could be from most black soldiers of that time and place, because his own loyalty was unequivocally to the Army and not to any soul brother. When he told them fiercely that he would stand for no crap, and especially no dope in the field, one day he found a note pinned to the door of his hooch: we frag motherfuckers like you. Somehow Hunt got through his time, by persuading his men that their best chance of survival was to do what he said. "But my focus was totally different from my previous tours. I wasn't trying to keep South Vietnam free—just to keep myself and my men alive." Career Marine Walt Boomer said, "The racial issue came close to destroying the fabric of the US Army and Marine Corps. It was ugly, ugly, ugly—ripped units apart. We always said, a Marine is a Marine. But suddenly black Marines were not only unhappy, they were mad about being in Vietnam."

Australian special forces officer Andrew Freemantle thought the best Americans "very good indeed," but like many others, he was appalled by the indiscipline he witnessed in 1970-71. "Even at some special forces camps you'd see people smoking pot, women queuing at the gate." Lt. Tim Rohweller commanded a company of the 3/9th Marines. Determined to tighten discipline, he displayed no patience with men who sought excuses to remain at base rather than going into the field. Pvt. Reginald Smith and other blacks pretended to convince themselves that the lieutenant was responsible for unnecessary deaths in combat. Late on the night of April 20, 1969, as Smith and his buddies smoked marijuana in their hooch, the Marine announced that he was "going to 'do' that motherfucker as soon as he crashes." At 2:10 a.m., a fragmentation grenade exploded under the lieutenant's bunk, inflicting multiple injuries, from which Rohweller died next day. One of Smith's companions later testified that the Marine had returned to their hooch flourishing a grenade ring, saying, "I did that motherfucker. He won't fuck with nobody else no more." Smith died in prison after serving thirteen years of a life sentence.

A white captain one day asked a black soldier named Davis what sort of car he planned to buy when he got back to the States. Davis answered, "I'm not gonna get a car, sir. I'm gonna get me a Exxon station and give gas away to the brothers. Let them finish burnin' down what they leave." Both whites and blacks thought that line hysterically funny, but of course it was not, because of the undercurrent of real menace; two white majors were shot for ordering blacks to turn down their music.

Racial abuse went both ways. Whites described blacks as maumau, reindeer, spooks, brownies, coons. A Southern surgeon affected an Ole Miss T-shirt to wind the brothers up. Meanwhile the Appalachian John Hall, whom his platoon dubbed Hillbilly, felt that he got a hard time from his black sergeant, who had no time for Southern white boys. That same NCO always stayed in the rear when they went into the bush, and Hall once lashed back at him: "Don't give me bullshit, you nigger lifer. You're not man enough to go in the field!" Hall made the further point, common to most combat units, that on operations racial hostilities were suspended: "Once the platoon got outside the wire, we were all in it together."

Black Marine Jeff Anthony formed a close relationship with a Texan buddy, "Bojo" Tyler, who introduced him to Country and Western. Tyler told his parents about his new friend in a letter. They wrote back saying, "Don't you go bringing no niggers here with you when you come home." Anthony said, "Much as I loved this guy, there was no way I was going home with him." Col. Sid Berry wrote about the fate of a fellow officer seriously wounded in action. Describing him as "a negro from North Carolina," Berry mused bitterly, "I wonder if some self-righteous white bigots objected to his children attending school with theirs while Capt. Williams was being wounded in action for his country—and theirs."

One day in 1969, an infantry company returned to their firebase from the boonies with the promise of a USO entertainment show. Racial tensions ran as high in the unit as most. That evening, assembled before an improvised stage, the soldiers were dumbfounded to find themselves watching seventy-one-year-old Georgie Jessel perform a 1920s Al Jolson minstrel turn. A soldier described his fear there would be a riot: "I couldn't believe what I was hearing. This old white Jewish vaudeville entertainer sang 'Mammy Mine.' Yet the really weird thing was that we didn't mind." Black and white alike were merely grateful for the diversion: "He was from the world."

Black soldier Arthur "Gene" Woodley went home to Baltimore an embittered man after a 1969 tour with special forces: "This country befell upon us one big atrocity. It lied. They had us naïve, young, dumb-ass niggers believin' the war was for democracy and independence. It was fought for money. All those big corporations made billions on the war, and then America left." Woodley's view was widely held among black soldiers who served in the war's later years. Despite the fraggings, racial aggravation, and drug abuse, many soldiers and Marines, both white and black, continued to do their duty, to fight their corner on the apparently interminable succession of Vietnam battlefields. But no witness doubted that from 1968 until the end, the effectiveness of American forces was in relentless decline. While the enemy was always out there, it became progressively harder to persuade Abrams's men to match the communists' commitment and warcraft, even in the interests of their own survival.

2. AUSSIES AND KIWIS

When a historian afterward suggested to Australian Lt. Neil Smith that by the time he started his 1969 tour, the war was obviously a mess, the former infantryman responded with professed astonishment: "It wasn't a mess where we were." Three Australian infantry battalions served in southeastern Vietnam, with support arms, special forces, and a New Zealand contingent. They constituted a tiny element of allied strength—peaking at 8,000 in mid-1969, with 543 New Zealanders—but they achieved a notable reputation. Creighton Abrams considered the Australians and New Zealanders "really first-class people"—indeed, the only foreign contingent worth its salt: "The rest of them will take Uncle Sam for anything they can." American Lt. John Harrison spoke almost with awe of the Australian Special Air Service team that handled a company of Montagnards on his patch: "They were unbelievable—run by their warrant officers. They didn't give a shit for anything." In the course of the war, the SAS claimed some five hundred enemy dead for just seven operational deaths of their own, and those statistics are credible. They attributed their success chiefly to a fanatical emphasis on fieldcraft. An SAS officer said with wry satisfaction, "We always heard them before they heard us."

An ARVN officer wrote that Vietnamese considered the Aussies the most sympathetic of their allies, because they were the most disciplined in using firepower: "The 1966 Long Tan battle—in which the Australians killed 257 communists for the loss of just 18 of their own—proved that there was at least one way to fight the war successfully." The same major said that the Australians and Thais were the only foreign soldiers whom he never heard reported as wantonly firing on bystanders. Australian Lt. Rob Franklin said, "I really worried about killing civilians. One night a party of bloody woodcutters walked into our ambush. Thank God, our guys didn't open up—I was really proud of them for that."

However, his country's commitment divided Australia more deeply than any other issue in its modern history—at times almost as painfully as the war racked the United States. Robert Menzies, prime minister until January 1966, defied his civil servants' advice and the Labor Party's

opposition to dispatch a modest contingent, sharing Washington's conviction that this was the place to stop the "thrust by Communist China between the Indian and Pacific Oceans." A draft was introduced, and soon after a second Australian battalion reached Vietnam, the first conscript was killed; nobody was told that Pvt. Errol Noack was a victim of friendly fire. From the outset, there was vociferous domestic opposition. A hundred thousand young Australians a year turned twenty, and onetenth of them were chosen by ballot for military service. Mothers formed an anti-conscription group, SOS-Save Our Sons. Future Labor cabinet minister Jim Cairns published an influential book entitled Living with Asia, which argued that his country must learn to coexist with the continent's revolutions and revolutionaries, rather than fight them. When the 1st Battalion, Royal Australian Regiment (1RAR) paraded through Sydney amid crowds of more than three hundred thousand people, a woman protester drenched herself in red paint, then threw herself on their colonel and as many of his men as she could smear.

Following Britain's 1967 decision to withdraw its armed forces from east of Suez, a traumatized Australian government concluded that it must bond with the US more closely than ever before. Menzies's successor as prime minister, Harold Holt, visited Washington and physically embraced LBJ; he attacked British leader Harold Wilson for criticizing US bombing. Late that year, Canberra reluctantly acceded to a Washington request for more troops, dispatching a third infantry battalion and some tanks. The government of neighboring New Zealand was always uncomfortable about Vietnam. When Australia committed, however, the "Kiwis" felt obliged to follow suit. Phuoc Tuy Province, southeast of Saigon, became the designated turf of the Anzacs—a collective name for all down-under service personnel, from the World War I Australian and New Zealand Army Corps. Most of the province's hundred thousand population were either neutral or pro-communist, and until the NVA arrived, the Anzacs' adversary was the Vietcong's D445 mobile battalion, together with two regular regiments. The Anzacs established a base at Nui Dat—as far as they could contrive from any town—with helicopters and logistics outside the port of Vung Tau.

Opposition grew to extravagant proportions in Melbourne and Sydney. Though smaller cities and rural areas were less agitated, the Seamen's Union of Australia refused to service ships destined for the war zone. When Harold Holt mysteriously drowned in December 1967, some suggested that he had committed suicide as a result of the stresses induced by Vietnam. Demonstrations became increasingly violent, with the New Left enlisting astonishing youth support in a country that was traditionally conservative. The Monash University Labor Club raised funds for the NLF; Melbourne Maoists applauded the Chinese Cultural Revolution; students chanted, "One side right, one side wrong—victory to the Vietcong!" Postal workers for a time declined to handle mail for Australian troops. In August 1969, polls for the first time showed a majority of voters wanting out of Vietnam: after the October national elections, one battalion was withdrawn

Until the last stage of the war, however, Australian soldiers on the battlefield remained little troubled by the tumult at home, indeed almost oblivious of it. Lt. Neil Smith, adopted son of a Perth laborer, said afterward, "I wouldn't have missed the experience for quids. It's what every professional yearns for. You want to test yourself. I guess it's all part of young men's stupidity." Australians found themselves thrown into some bitter battles. On May 12, 1968, the newly arrived 1st RAR deployed to FSB Coral with a supporting New Zealand artillery battery. On its first night, the battalion faced an NVA surprise attack, which its men were poorly organized to meet. The communists were repelled by mortars and guns firing over open sights, which killed fifty-two NVA at a cost of eleven Australian dead and twenty-eight wounded. Three nights later, the communists came again, inflicting twenty-four casualties for the loss of thirtyfour of their own dead. The Australians emerged from these encounters impressed by the NVA, whom they described as "a race apart" from the local VC they were accustomed to meet farther south. After years in which the Australian Army had prided itself on its prowess at counterinsurgency, honed by experience in Malaysia and Borneo, where almost everything happened in company strength, suddenly its men understood that they were involved in a much bigger, increasingly conventional war.

The Aussies and Kiwis did things in their own way, wearing bush hats rather than helmets and carrying the semiautomatic 7.62mm rifle, which they preferred to the M16 because its heavier bullet had more stopping power. Some men got their parents to send out garden shears, which they found handier for breaking trail than army-issue machetes. While every American base employed an army of local cooks, cleaners, and laundry staff, the Australians refused to allow Vietnamese labor inside their wire; for security reasons, even the dirtiest tasks were undertaken by their own personnel. They regarded some of their allies in the field as suicidally careless, especially about noise. Neil Smith, overnighting on a US firebase, was surprised to discover that officers slept apart from their men, and even more startled by the racket: "On an Australian position at night, you could hear a pin drop."

American Capt. Arthur Carey, who worked with the Australians in 1968, was impressed by their radio discipline. Whereas most US units provided R/T sitreps every few minutes, Carey reported with approval that "it was not uncommon for the [Australian] command net to go two, three hours with nobody talking. [They were] very calm on radio. I can't recall hearing the words 'body count' the whole time I was with them." This last was one of the reasons that, while such junior Americans as Carey thought well of the Australians, some senior ones did not. Westmoreland deplored their modest kill scores and thought the practice mistaken whereby they rotated units through the theater rather than constantly refilling them with individual replacements. 7RAR recorded a visit from Lt. Gen. Julian Ewell, who criticized the unit's "painstaking patrolling.... He emphasised the importance of statistics and body count. The atmosphere of his discussion with [the Australian battalion's CO] was cold and one of overbearing disagreement. His visit was not one to be remembered with either respect or affection." The Australians decided that Ewell was unaccustomed to frank, informal debate: he sought instead an unquestioning obedience such as their nation has never favored, least of all on its battlefields.

Australian successes were not attained by displays of suicidal courage, but rather by junior leaders picking their moments. In the midst of a firefight before a VC bunker system, SAS patrol leader Andrew Freemantle made a decision: "I thought, If we get up and advance, do a banzai charge, a lot of people are going to get killed, and is this really worth it?" Instead, he ordered withdrawal. That night, one of his men came into his hooch and said, "Boss, we thought you might be feeling bad about what you did. We wanted you to know we were bloody grateful. We wouldn't be here now if you hadn't done that." The young officer felt better about himself, yet this was the sort of tactical decision that caused some US generals to suspect the Aussies of faintheartedness.

Australian higher commanders were often considered—by their own countrymen as well as by Americans-much less impressive than the junior leaders and "diggers." Brig. Stuart Weir, who ran the 1969-70 Australian task force, was a notoriously harsh and aggressive figure whose explosions of temper, in the words of his country's historian, "led senior officers to question his fitness." Anzac operations continued to be dogged by a grievous blunder made by one of Weir's predecessors. In January 1967 the little-loved Brig. Stuart Graham shifted emphasis from cautious cordon-and-searches to aggressive search-and-destroys, which caused casualties to rise sharply. The communists had little trouble sidestepping S&D sweeps, as they did the July 1967 Operation Paddington, an attempt by nine battalions of Americans, Australians, and South Vietnamese to trap a VC regiment. The following spring, another big operation, Pinnaroo, was successful in destroying bunker systems and capturing weapons, but the Australians suffered severely from booby traps. Their contingent lacked sufficient mass to clear the so-called Minh Dam Secret Zone in the Long Hai Hills, which remained a communist sanctuary until the war's end.

An Australian described an operation in words any American would have found familiar: "It was always the same dreary and exhausting patrolling, humping great loads along thorny tracks, dropping your hat for the fiftieth time, losing count of paces, never having enough time to brew up [some tea], continually searching what the gods of Infantry considered to be 'interesting' areas, and being sodden with stream- and swampwading for 24 hours a day."

Brig. Graham's fateful answer to his shortage of troops was to exploit technology to separate the enemy from the people and their rice: a barrier, eight miles long, stretching from the hills down to the coast. In the hundred-yard-wide ribbon between two parallel barbed-wire fences, his engineers laid 22,600 mines. Graham ordained that Australians should patrol one side, while Vietnamese troops handled the other. For a few months, this proved effective: some communist units, cut off from food sources, were reduced to eating jungle roots and leaves. But then they observed that the minefield was carelessly monitored. The guerrillas moved in, and with their accustomed ingenuity lifted thousands of mines, which they relaid elsewhere. Through the years that followed, the Anzacs suffered a stream of losses—one in ten of all fatalities—from this source. A single battalion was involved in sixty-four mine incidents, forty-eight of them caused by their own ordnance in enemy hands. They encountered further problems when they acknowledged the minefield's failure and tried to clear it: tanks and engineers suffered so severely that they had to quit. This creeping disaster was headlined as a scandal by media back home. Opposition politicians denounced it as "a tragic example of the waste and futility of Australian participation in the war."

"Funny place, Vietnam," mused Lt. Rob Franklin, a truck driver's son from Brisbane. "In World War I, you went over the top and you knew the enemy was there. But in the bush you never knew where he was. You might go weeks without hearing a shot fired. It was very hard to keep your vigilance at the same high pitch. Then suddenly, all hell breaks loose." On almost Franklin's first day, a fire mission went wrong in a fashion that could have been disastrous: 82mm mortars for which he was responsible plastered the ground within fifteen yards of his battalion's attached New Zealand rifle company. The lieutenant felt that he aged ten years, as a result of agonized awareness of his own blunder. He thought, *I don't think I can cope with this*. After a troubled night, his knees knocked when he was ordered to report to the Kiwi company commander. "But he was fantastic, said, 'Just be careful.'" Thereafter, Franklin was.

Though his battalion had prepared intensively before leaving its home base at Townsville, in the bush they changed tactics. "In training, if you came under fire, the machine gunner broke right, the riflemen left. But after a few contacts, we did it all completely differently: got the guys to deploy on as wide a front as possible, with all three platoon machine guns putting out a hundred rounds each as quick as they could—suppressive fire. You learned to bivouac in the thickest bit of bush you could find. You got smarter and tougher." There were some enthusiasts: one of Franklin's mortarmen chose transfer to a rifle platoon because he wanted more action. He was swiftly killed in a firefight, leaving behind a pregnant girl-friend.

Within days of their 1969 arrival, nineteen-year-old West Australian Neil Smith and three other newcomers were taken on a getting-to-know-you patrol by the outgoing battalion. When the group found itself in a brief contact, the lieutenant embarrassed himself by becoming the only man to prostrate himself in the paddy. On a night ambush, Smith and his three fellow novices were deployed in the rear as a "cut-off party," lacking communication with the veterans facing front. In the heart of the darkness, the petrified young lieutenant glimpsed a file of eight enemy soldiers. He realized that he had set his Claymores so close that they themselves would be devastated by backblast if he detonated them. Instead he lay motionless while the enemy passed, praying that his sleeping mates would not snore. Through the rest of a long army career, he was troubled by the memory of his confusion that night, common as was such an experience to thousands of young men on both sides.

Smith was fascinated by the exotic night sights of Vietnam: distant flares and gunflashes, ubiquitous fireflies. When they lay down to sleep, he was bemused by the range of creatures that emerged from the surrounding earth. Once as he was digging, shirtless, he mopped his chest, then howled as a scorpion on his sweat rag bit his left nipple. At that moment a firefight broke out, causing impatient medics "politely to urge me to suck it in"—Australian parlance for quiet down—as he ran around screaming in agony. He wrote to his parents on December 31, 1969, describing the New Year cease-fire as "a load of crap, doesn't make any difference to us. Only gives the Nogs a free hand to reorganize themselves. . . . I feel rather lonely and sad at the moment. This is a bitch of a way to fight a war. Nothing

happens for days, yet you know no one is really safe." He described how the stench of gangrene enabled his unit to locate a group of VC: "One poor sod had half his face shot away and was being eaten by maggots."

Although there is a traditional tension between big, brassy Australia and modest New Zealand across the sea, in the field the two nations' soldiers made common cause, as they always have. The enemy were alleged to be especially fearful of the Kiwis' Maori soldiers, whom they believed to be cannibals. Australian units contained many officers and NCOs who had served in World War II, Korea, or Malaya. There were also some foreigners. Neil Smith recoiled from one sergeant-major, a veteran of the Hitler Youth, who welcomed opportunities to kill Vietnamese of any complexion: "He was really evil."

At the other extreme, the RAAF's squadrons appreciated a contingent of British pilots, while the Australian SAS included a former member of the Italian Alpini and some British Army veterans, among them Andrew Freemantle. After completing a jungle warfare course, Freemantle was impatient to see some action, not then on offer with his own service anywhere more exotic than Northern Ireland: "I wrote to the South African, Rhodesian, and Australian special forces, saying, 'I'm a trained killer. Have you got a job for me?'" All three responded positively, but the Australians clinched the deal by offering a first-class air ticket. Freemantle spent three years with their SAS, one of them in Vietnam, and loved it—"a really exciting environment for a professional." Although his comrades gave him as hard a time, as their nation gives every Brit, he worked well with them in the jungle. An enormous NCO nicknamed Oddjob told him reassuringly, "We know you'll stick yer head up first and take the blame when there's a fuckup."

Neil Smith saw no significant distinction between the performance of volunteers and draftees, partly because few of the latter went unwillingly to Vietnam. He said, "If a bloke really didn't want to do it, you'd be a fool to take him." A core of veterans acted as steel reinforcing rods, men like the 8th RAR's Company Sgt. Maj. Hepplewaite, who was caught defecating when a contact started. Smith said admiringly, "Even before he pulled up his trousers, he stood there directing fire—so cool, a picture of total

dignity." The Australians were passionately committed to patrolling, and thus puzzled that from 1969 onward, some US units declined to venture outside their own wire. Patrol numbers varied: the Australian SAS usually worked in fives, on the principle that if one man was hit, two would be needed to carry him, two more to cover them. It was common practice to take Vietnamese who provided information—either a *chieu hoi* defector or a local man—on a mission to exploit it. "If they gave it to us wrong, they got drilled first." Another veteran said, "Patience was the byword." Yet the Australians suffered as much as every contingent from the paucity of local intelligence: peasants, wrote an officer resignedly, felt unable to put their trust in foreigners who would soon be gone.

Andrew Freemantle immensely respected the enemy, especially after stumbling on one of their tunnel systems. "We'd sat down to listen, always a good thing to do on patrol, and we spotted this pipe sticking up. We dropped a smoke grenade down it, put a hat on top, and a minute or so later saw puffs coming out of a bush yards away." He and a mate descended and explored. Fortunately the system was untenanted, but the tunnels ran five hundred yards. Freemantle thought, My gosh, anybody who can do this has got something. Two tons of C-4 explosive were required to destroy the complex. While conducting surveillance on a VC camp, the SAS watched fascinated as enemy soldiers steamed explosive out of unexploded bombs to make grenades and booby traps. Freemantle noted how well maintained were arms and equipment found on dead NVA. As the former British soldier watched through binoculars an enemy unit advancing, their officer with his wireless operator, lead squad in arrowhead formation, "I thought, These could be our guys on Salisbury Plain."

In the later days of the war, the Australian contingent suffered some of the same disciplinary problems as the Americans, though fomented by alcohol rather than unnecessary drug abuse. Rob Franklin said, "We were into the grog, not the dope." Men were officially limited to two daily cans of canteen beer, but since this was cumulative, after a twenty-day operation they became eligible for forty cans. One of the relatively rare Australian courts-martial was that of a lieutenant who hit a private with his pistol during a beer-fueled fight. On Christmas Day 1970, a drunken

private soldier emptied his rifle into the Nui Dat sergeants' mess, killing two NCOs and seriously wounding a third. Earlier fatal fraggings had killed two officers. Almost immediately after Neil Smith's arrival, he was sleeping with a mate in a tent adjoining that of Lt. Bob Convery. A thunderous explosion caused the two newcomers to prostrate themselves in the belief they were being mortared. When no further concussions followed, they rose to explore and discovered that an aggrieved soldier had dropped a grenade on the cot of Convery, killing him instantly. Fragging was a much less serious Australian than American problem, but it happened.

Vung Tau was the Australians' in-country rest and recuperation center. They enjoyed a running joke that the enemy used the port for the same purpose, "that every second bloke you saw was a VC on R&R just like you. It certainly seemed to suit both sides to have no shooting down there." Officers gravitated to the Hotel Grand, owned by a welcoming half-French woman who made no secret of her belief that her guests' side was losing the war, and kept bags packed in readiness for a departure to Europe. Meanwhile, enlisted men bonded with girls and grog, then staged some impressive fights. Throughout Vietnam, it was notable how often, when a body flew through a bar window, either the thrower or the thrown turned out to be Australian.

Back at home, the violence of antiwar passions rose in a crescendo. After one infantryman was killed, protesters telephoned his parents and said, "He got what he deserved." Late in 1970, Australian infantry found themselves withdrawn from an operation in the Long Hai Hills after suffering a stream of losses to mines, because domestic sensitivity was running so high. When a unit was about to return to Australia at the end of that year, its CO briefed his officers: "Get a grip on your blokes. I don't want any of our diggers butt-stroking"—in Australian language, beating the hell out of—civilians who mocked or criticized them. One of his audience said that when they reached home and beheld the rage of the antiwar lobby, "We were completely astonished. We couldn't understand it. We thought we were right to have gone, right to have done what we did." By 1972, one of the key planks of Labor leader Gough Whitlam's successful Australian election campaign was an end of the draft and extraction from

Vietnam. The last Aussies and Kiwis were indeed out by the year's end. In all, 60,000 Australians served in Vietnam, of whom 521 died; 37 of the 3,890 New Zealand personnel also fell.

It is widely agreed among modern Antipodean historians that Robert Menzies's original commitment was made with remarkable carelessness—a reflexive Cold War gesture that his successor prime ministers lamented their inability to retract. Nonetheless, Australian writer Peter Edwards puts the case for his nation's 1965 government: "Vietnam was not an example of fighting 'other people's wars'; in the minds of Menzies and his principal advisers, it was a matter of getting the United States to fight a war for Australian security." He adds a corollary, that the strategic position of Australia, Thailand, Malaysia, and Indonesia vis-à-vis the communist threat was far stronger in 1975 than it had been a decade earlier. In the minds of some thoughtful people in all those countries, the allied war effort had contributed importantly to those stabler polities. Singapore's Lee Kuan Yew often told Americans, "If you had not fought, we would have been gone."

The Anzacs performed with distinction in Vietnam, but it would seem mistaken to suggest, as do some of their admirers, that the war's outcome would have been different if everybody else had operated as they did. The enemy sustained as vigorous an armed presence in the Australian area of operations as everywhere else, even if he bled for the privilege. Moreover, it is among the themes of this book that the foremost challenge for the allies was not to win firefights, but instead to associate themselves with a credible Vietnamese political and social order. Dr. Norman Wyndham, a sixty-year-old Australian surgeon who led a volunteer medical team in a Vung Tau hospital, was a devout Christian who made himself a fluent Vietnamese speaker. He wrote in 1967 of the local people, "Most want a united Vietnam, but not one controlled by the communists.... [Yet] the feeling is growing... that anything would be better than life as it is today." Two years later, such sentiment had strengthened throughout the South.

3. GODS

In the eyes of history and certainly those of Hollywood, the war was defined by the Huey helicopter. Sure, there were also Sea Knights and Jolly Green Giants, Chinooks, "Flying Bananas," Tarhe heavy-lift carriers, CIA Jet Rangers, and many more, but the Huey's is the image that dominates. Here was one of the great flying machines of all time, developed by Bell in the 1950s as the Iroquois, designated first the HU-1, then the UH-1. It became a symbol of the stupendous and apparently invincible might of the United States, then somehow also of its emasculation. The D, commonest of many successive variants, was a four-ton beast that first flew in Vietnam in 1963, propelled by its Lycoming engine at a maximum speed of 130 mph. In its transport role as a slick, it carried nine fully armed men; as a dust-off, six litters; as a gunship, many combinations of rockets, miniguns, and other automatic weapons. Sixteen thousand were finally built, and in the bad times a thousand a year were lost to enemy fire, mechanical failure, or pilot excess. Even men who hated the war loved the Huey; the heavenly cold air that rushed past as they sat at the open doorway with boots on the skids and maybe a careless arm around a stanchion, looking at Southeast Asia the best way anybody could-all those dull reds and browns and brilliant greens from a couple of thousand feet up, seldom with sissy seat belts.

CORDS adviser Lt. Brian Walrath wrote, "Sitting on the hard floor of the chopper, we are overwhelmed by noise. The engine throbs behind us, the gearbox whines as it transfers power to the main and tail rotors, the rotors whop away and the wind whistles past our ears. We are in the pilot's hands, defenseless against any enemy who wants to take a shot at us in a thin aluminum shell. Below the crazy quilt of rice paddies and fields flashes by, soon to give way to denser foliage as we head west toward the mountains."

Groundlings looked on the fliers as magicians, often as saviors. Lt. Mel Stephens of the US Navy never forgot the experience of a night evacuation from the riverine assault boat on which he had been wounded, his surge of wonder and gratitude toward the crew that got him out: "Those pilots seemed gods to us." This impression was heightened by their impersonality, features masked by helmet sun visors. "I never saw a pilot's eyes," said Brian Walrath, who knew fliers only from his cargo-compartment view of their upper backs, protruding above angular green armored seats; their gloved hands flicking switches and shifting levers.

Most pilots were dashing, skillful, callous young men, apparently as careless about their own lives as other people's. Australian Cpl. Roy Savage was once standing on the skids of an American Huey, having helped the last of his squad aboard, when it soared skyward. Momentarily terrified as the earth receded, he found his webbing seized by an enormous black door gunner who heaved him into the cargo compartment. The pilot glanced over his shoulder and shouted cheerfully, "Nearly left you behind that time, boy!" Correspondent Neil Sheehan sometimes begged his aerial chauffeurs to go a little easier on the palm trees, with which they loved to flirt. Some who used the forty-eight-foot rotors to thrash a downward passage into triple-canopy jungle pushed their luck too far, though an amazing number got away with it.

One Huey pilot must here do duty for thousands. Dan Hickman first flew helicopters as a twenty-year-old in 1967 and loved them forever after. He hailed from a North Carolina tobacco farm, "where my dad put me through ranger school." On the first day at Fort Walters, Texas, the commanding colonel addressed two hundred cadets, saying, "Half of you will wash out. One will crash right here. The other ninety-nine will go to Vietnam." They spent five months at Walters and clocked 120 hours apiece on little Hughes trainers before moving to Savannah, Georgia, and the 1,300-horsepower Huey. Hickman said, "It was big and strong, looked enormous after the Hughes—it was terrific. Learning to fly a helicopter is like learning to ride a bike: there's a period of uncertainty, then suddenly it clicks." He grasped some hazards: "It was not as nimble as the LOH, or OH-6. If you made a low-level turn downwind, you did not want then to turn left or you were liable to be in the ground. If you lost power, at five hundred feet you had eight seconds in which to save yourself." He spent four months at Savannah before taking the monthlong tactical course that introduced him to the deadly array of helo armament.

All through the schools, he was terrified Vietnam would finish before he could get there. It did not, of course. Hickman arrived in September 1968 and was posted to Di An, near Tay Ninh. He was heartened by finding himself among people who obviously knew what they were doing, but jarred by the abruptness with which he was thrust into combat. A flight commander said, "You can sleep in this cot here. You wanna take a mission tomorrow?" Yes, he wanna. "You can fly copilot on a Cobra rescue." Next morning when he walked out to the flight line with his new comrades, one asked another, "Did you kill anybody yesterday?" "Yeah, three." Hickman thought, *These guys are crazy*.

Thereafter, he sometimes flew thirteen hours a day: "You were always overloaded, and landings were the problem because in the last few feet the dust threw up a brown fog that hid the ground. You had to look at the Plexiglass beneath your boots until a hole appeared." The flying none-theless seemed to him fabulous, because there were no power lines, no meaningful restraints. Much later, when as a brigadier-general he took a National Guard unit to Iraq in 2004, he was shocked to discover how risk-averse the Army had become: "It had taken all the fun out of war."

In his cavalry troop, there were ten OH-6 light observation helicopters armed with mini-guns, six "slicks" with door-mounted M60 machine guns that pumped out 550 rounds per minute, ten AH-1 Cobra attack helicopters, and an airmobile infantry platoon. They flew either at 1,500 feet or on the deck, brushing trees and leaping over houses. "We were living by our reflexes. I wouldn't take medication of any kind." A tank of J-4 jet fuel kept a Huey aloft for 150 minutes; then they were usually "hot refueled," turning over fifteen others coupled by hoses to huge rubber bladders. During battles, engines were seldom shut down. Hickman found that the helicopters were much more carefully maintained than those at flight school. Engine filters, prone to choke with dust, were checked daily. Machines received twenty-five-hour intermediate and one-hundred-hour full inspections; the latter took eight hours.

They lived on powdered egg, corned beef, powdered milk, and coarse bread; drank liquor in the evenings, when it was available. During the night hours, Hickman wrote to a girl named Carol back in Savannah. As a warrant officer, he was paid \$500 a month: on R&R in Hong Kong he spent \$1,700 in four days, some of it on buying six suits, six pairs of shoes, and a big stereo set. They had cold-water showers, and hated the morning stink of burning crap, as barrels from the previous day's latrines were set ablaze with aviation fuel. They craved American food, and when they heard of a place in Saigon that did real hamburgers, one day a bunch of them took the crazy risk of driving a lone jeep thirty miles across country to get to it. They paid next day, with vomiting and bowel explosions that caused them to spend hours sitting on a plank in the latrine; Hickman thought he was going to die.

Other than the grunts, nobody got closer to the action than Huey people. "One guy was kill-crazy," said Hickman wonderingly. A fair proportion of his own flight school class were killed or wounded; in all, four thousand helicopter aircrew perished in Vietnam. Once, Hickman's crew chief's helmet shattered under fire. The pilot assumed that was the end of the man, but a bullet had merely grazed his skull. On another mission, Hickman hung close enough to the ground to toss a grenade from the cockpit window into a hooch a couple of yards away. He once saw a grunt slump, hit, even as the man loaded casualties into their cargo compartment. Their crew chief in a careless moment shot a hole through the helo with his own .45. Like naughty schoolboys they hammered the punctured metal inwards, so that it looked as if they had taken an enemy round.

"My best friends were Jim Newman and Elmore Jordan, a black guy from Washington, DC. We had a running joke that if one of us realized he was not going to make it back, he would throw out his wallet for the others." One day, Hickman heard Jordan on the radio reporting his ship on fire. Then as he struggled toward the field, he voiced again: "I've lost my hydraulics." His crew chief crammed into the cockpit with the pilots, and the Huey was trailing black smoke. Finally Jordan radioed, "There goes our engine." Hickman thought wretchedly, "Well, I guess Elmore is throwing out his wallet." They saw a sudden plume of black smoke creep beyond a tree line, where the Huey had crashed a few hundred yards from the airstrip. Miraculously, however, Jordan survived: his crew chief jumped out as the chopper struck, then ran back to drag the two pilots

from the flaming wreck. On another occasion Jim Newman got shot in the neck. He, too, somehow failed to get around to throwing out his wallet.

"One day Jim shot me down. We were going into an LZ when we started taking fire. I said to the Cobras, 'Put me in some rockets close.' There was a lot of noise, and we got Jim's shrapnel through our console. We made it to a little field before coming down. I said to him, 'Shoot down four more, and you'll be an enemy ace.'" The unit's best pilot was Harley Goff, but all his skill failed to save him from a transmission failure and a devastating crash. Goff emerged unrecognizable, having broken three of four limbs and lost all his teeth—testament to the huge part played by luck in all events of war.

On each Huey, the crew chief manned one door gun, an infantry-man the other. "They were your eyes," said Hickman. The M60s jammed unless kept meticulously clean, and the port-side man needed to guard against wind blast blowing his ammunition belt all over the countryside. For the psychological effect, Hickman made his gunners load solid tracer, in defiance of SOPs, which decreed one round in five. "Tracer burned out the barrels pretty quick, but in an assault you wanted to keep the enemy's heads down." Anyway, he knew how seldom a door gunner hit what he aimed at, from a platform shifting all ways at once.

Though Cobras and Hueys were the same loaded weight, 9,500 pounds, the latter were quieter and smoother in the gunship role, carrying sixty-two rockets and four thousand mini-gun rounds. Never in history had so many tactical helicopters been deployed—nor ever since. "There were times when over a hundred were in the air over a battle," said Hickman. "When you saw a ten-ship lift going into an assault with four supporting gunships and a smoke ship, it was just awesome." Vietnam's clammy heat never bothered the North Carolinian, who had grown up without air-conditioning. On a night flare drop, however, the contrast was shivery between the warmth on takeoff and the icy cold at six thousand feet. Moreover, Mk24 million-candlepower flares were risky loads. "I hated those missions," said Hickman: several ships were lost when flares ignited in the cargo compartment.

After a relative lull during the winter of 1968, with enemy hard to find, "by January the war was back on again." Sometimes Hickman flew threeday missions out toward the Cambodian border, guided into night landings by flaming barrels filled with sand and oil, sleeping on the ground by his machine. There always seemed to be the odd VC poking a few tracer into the air, but no serious opposition. Then, suddenly, things got serious, and they once more experienced "hot flushes"—heavy fire—in the air. One night they were sent to rescue survivors of a long-range recon team, hard-pressed by enemy on the ground. They radioed a circling Vietnamese spooky gunship to put down suppressive fire, but the VNAF plane declined to get close. Two Cobras were also flying in support, but since even in good hands their weapons had a twenty-yard margin of error, they couldn't risk firing in darkness. Hickman spent an hour circling, struggling to coordinate the rescue. At last the beleaguered men switched on a strobe light masked in a helmet, to guide the Hueys into an ever-so-slim gap in the jungle, and Hickman's crews got the Rangers out. Another night they sank twenty-three sampans coming out of Cambodia. "We marked them with tracer, then the Cobras came in from up high and rocketed. At briefings, they told us we were killing more enemy than the rest of 9th Division."

Of three hundred men in the unit, some forty aircrew flew missions. Rank never decided who commanded. "There were very few sirs—we were mostly twenty-one-year-olds trying to do the right thing without adult supervision." One unit commanding officer was unwilling to operate below two thousand feet, while his successor "was courageous, but could never fly well." Hickman handled mostly day missions on Hueys, night ones on Cobras. Once, when he was detailed to take a slick through darkness to extract a stranded recon team, he asked his flight commander, "Why me?" He was flattered by the answer: "Because you've got the best chance of getting back alive." They lost several aircraft flying into trees—"just the sort of thing that happens with aggressive young men." Cobras had the lowest casualty rate, LOHs the highest, because "they were fighting the war from twenty feet."

Although the unit suffered a few cases of self-inflicted wounds and pilot requests for transfer to ground duties, "most people can buck up and do what has to be done." Hickman remained convinced that Vietnam should have been won: "But by 1969 it was obvious that we either had to go into North Vietnam, or forget it. I felt let down by the antiwar movement. They were a bunch of college kids who knew nothing. I believed in the Army. Within it, a lot of individuals were trying to do the right thing."

4. VIETNAMIZATION

In the first months of the Nixon presidency, the incumbent and his advisers groped for new approaches to ending the war. Defense Secretary Melvin Laird, a former Wisconsin congressman, told Creighton Abrams during a March 1969 visit to Saigon that the change of administration had bought a breathing space: "I think we've got some time, and . . . we've got to develop a national policy that we can go to the [American] people with." There must be a program, he said, "to reduce the United States contribution, not only in the form of men, but in casualties and materiel and dollars. . . . I'm going to be asked a lot about the use of the B-52." Abrams, alarmed, immediately made the case for this supremely efficacious weapon: "There's nothing really as responsive. . . . It only takes a couple of hours to change the whole *weight* and put it wherever you want, in whatever quantity you want it."

The role of national security adviser assumed unprecedented importance, at first unperceived by the media or the Washington establishment. Until the election, Henry Kissinger had been an adherent of Nixon's rival, Nelson Rockefeller. Now he became the president's principal foreign policy instrument. An exponent of the historic and wherever necessary cynical concept of realpolitik, first articulated by Ludwig von Rochau in the mid-nineteenth century, Kissinger had never supposed Vietnam winnable. He shared with Nixon the conviction that, whatever the merits of the allied cause, the war was draining wholly excessive political attention, material resources, and moral authority from the pursuit of US vital interests elsewhere. This brilliant, charismatic figure overcame his employer's

dislike of both Jews and intellectuals by displaying first his loyalty, then an unscrupulousness to match the president's own. Though essentially an ice-cold human being, he was skilled at simulating warmth and geniality. Arthur Schlesinger wrote in those early Nixon days, "I like Henry very much, and respect him, though I cannot rid myself of the fear that he says one thing to me and other sorts of things to, say, [conservative ideologue] Bill Buckley."

White House chief of staff H. R. Haldeman once noted, "Henry made the point that the President's best course is brutal unpredictability." This was the view of Nixon's mind-set that from the outset Kissinger sought to establish in Hanoi. He believed the North Vietnamese could be induced to compromise only "by being confronted by insuperable obstacles on the ground." A first step was to launch massive but secret B-52 bombings of communist sanctuaries. On the afternoon of Sunday, March 16, Haldeman recorded without apparent irony that after attending church, Nixon authorized the bombing of Cambodia: "Historic day. K[issinger]'s 'Operation Breakfast' finally came off at 2:00 pm our time. K really excited, as is P[resident]." During the next three years, the USAF poured 108,823 tons of bombs onto Sihanouk's hapless country. When one B-52 crew made an error which precipitated the near annihilation of the population of a Cambodian village, the US ambassador visited the area and distributed \$100 apiece among survivors. The airman who had miscalculated was fined \$700.

The White House was fiercely angered by a renewed display of communist aggression at Tet 1969, when over a hundred South Vietnamese cities and towns suffered pinprick attacks. Nixon viewed these almost as a personal insult, a gesture designed to show that Hanoi proposed to treat him no differently from Lyndon Johnson. The bombing became part of what Kissinger called coercive diplomacy. In the same spirit, the National Security Council propounded a case for Operation Duck Hook, a four-day intensive blitz of North Vietnam, which might include tactical nuclear weapons. Kissinger informed the Soviet ambassador Anatoly Dobrynin about the Duck Hook concept, and in July Nixon wrote a personal letter to Ho Chi Minh, threatening "measures of great consequences"

and force" if Hanoi declined to deal. On October 13, 1969, he initiated a nuclear alert embracing US forces worldwide, designed to convince the communist bloc that he was a trigger-happy commander in chief, prone to act dangerously, even recklessly, if crossed. Yet the Russians scarcely noticed the alert, and none of the other presidential posturing appeared to impress the enemy. They perceived Nixon not as a madman, but instead as a rational politician, desperate to find means of evading not American defeat, but an explicit admission of it.

So much has been said about Kissinger's "genius" that it bears emphasis how importantly wrong he and Nixon were in supposing that the route to peace lay through Moscow. The president in his first autumn of office told Dobrynin, "I want you to understand that the Soviet Union is going to be stuck with me for the next three years and three months. . . . We will not hold still for being diddled to death in Vietnam." Contrary to their assumptions, it was a source of chronic frustration to the Soviets how little leverage in Hanoi their annual half-billion dollars of aid secured. Before Pham Van Dong flew to Moscow in 1970, the Soviet ambassador in Hanoi urged upon the Vietnamese Russia's desire that the Northern delegation should show itself "more constructive . . . and more sincere" at the Paris peace talks. He wasted his breath.

And even as the White House sought fulcrums with which to shift the communists, it identified an incompatible domestic imperative: to reduce the US troop commitment. Before the NSC, Kissinger endeavored to persuade others, and perhaps also himself, that such a course did not represent a contradiction of the rest of administration policy. Force reductions, he said, "by making US presence more sustainable, could be another form of pressure." This was nonsense, though Kissinger was right when he also asserted that his nation could not just walk away from South Vietnam "as if we were switching a television channel."

While both Nixon and his national security adviser treated the defense secretary with scant respect, it was Melvin Laird who articulated a decisive, even drastic change of US direction, and he also gave this a name that stuck, though Vietnamese hated it: Vietnamization. The adminis-

tration renounced the strategy implemented since 1965 of delegating the serious war fighting to Americans. Instead, MACV would merely support the ARVN in their own struggle. On May 14, 1969, Nixon delivered a national television address in which he asserted a continuing commitment to ensuring that the Vietnamese people could choose their own destinies. To achieve this, and to secure peace, it would be necessary for all foreign forces—meaning the North Vietnamese Army as well as the Americans to quit the South. The first fruits of Vietnamization should be the withdrawal of 50,000 to 70,000 US troops. The White House decreed that American casualties must forthwith fall, though May 1969 witnessed the extraordinary folly of Operation Apache Snow, successive assaults on Ap Bia Hill—Hamburger Hill—in which 72 members of the 101st Airborne Division were killed, another 372 wounded, with additional ARVN losses, merely to assert American commanders' determination to prevail. Its principal consequence was to intensify antiwar fever: Senator Edward Kennedy branded the battle "madness."

Vietnamization was officially launched on June 8, at a mid-Pacific meeting on Midway between the two presidents, Nixon and Thieu. A twenty-five-thousand-man initial US troop drawdown was set for August. Conservative columnist Joseph Alsop likened it to the cynical deed of the Russian woman who throws her children off a sled fleeing through the snow, to distract pursuing wolves. Creighton Abrams voiced dismay at a September 1969 NSC meeting attended by Nixon: "Where we are in South Vietnam is due to the application of raw power. . . . When you turn off the power, you have got an entirely new ball game." Abrams saw in 1969 what historian Ken Hughes observed long afterward: "Vietnamization was not a strategy Nixon seriously pursued; it was a fraud he perpetrated." On November 19, Melvin Laird told the Senate Foreign Relations Committee that the Saigon government had been consulted before the policy was introduced. He lied, as Kissinger also lied on the same issue: Thieu was merely informed after it was decided.

On August 4 in Paris, Kissinger began what became a seemingly endless round of secret negotiations with the North Vietnamese. Averell

Harriman, still conducting the formal talks, had despaired of a successful outcome as long as successive administrations remained wedded to sustaining both the Thieu regime and a US army in the South. Kissinger held almost no cards. He had opposed unilateral troop reductions because he knew these would relieve the communists of any obligation to yield concessions. But the national security adviser bore no responsibility—at this stage, anyway—for the administration's domestic political trajectory, and thus he was overruled.

Kissinger briefly harbored illusions that Ho Chi Minh's death on September 2 would shake North Vietnamese confidence, stability, and morale. Yet, while the begetter of his country was passionately mourned, he had long ceased to guide its destinies. The old man's greatness seems indisputable, measured by his influence upon great events. A part of this derived from a grace, charm, and dignity that persuaded much of the world of his benignity. In truth, however, as with all successful revolutionaries, Ho's ruthlessness was absolute, his capacity for compassion moot, given the systemic cruelties, privations, and denial of personal freedom over which he had presided since 1954.

Le Duan's grip on power was assured. Following the shambles of Tet, he no longer expected to achieve absolute military victory before the Americans quit Vietnam. But he was confident that his people's will was stronger than theirs, all the more so after the vast October 15 nationwide US demonstrations in the name of the Vietnam Moratorium, of which a highlight was a hundred-thousand-strong rally on Boston Common. The only crumb of comfort for Nixon's men talking in Paris was that the North Vietnamese ceased to inflict willful torture—though they sustained relentless privation—on the American prisoners held in Hanoi. A minimal standard of well-being was thereafter deemed expedient, for the POWs' fate would obviously be a key issue in negotiations. By a directive of June 10, the NLF renamed itself the PRG, Provisional Revolutionary Government, personified by a cluster of ministers-in-waiting deep in the jungle on the Cambodian border. Cadres were told that even after the US had signed a treaty, "the war will be continued." In short, and as ever, only communist victory would suffice.

Abrams said, "[The enemy] is . . . pouring *more* resources in, and we're pulling resources *out*. . . . With just that basic fact he's bound to do better, and we're bound to do worse." Lt. Landon Thorne, now flying as an artillery observer in an L-19 spotter plane, suddenly found his guns' ammunition allocation cut. He thought, *In a war you're supposed to win, you get everything you need*. Quite so.

LOSING BY INSTALLMENTS

1. THE FISHHOOK AND THE PARROT'S BEAK

Back in March 1969, Creighton Abrams and his intelligence chief held one of many conversations about the possibility, and unlikelihood, of being permitted to attack the communists' Cambodian sanctuaries. Brig. Gen. Phil Davidson ruminated: "Boy, if the doves have savaged old Johnson—and they did, they drove him from office—think what they would do with Nixon if he went into Laos and Cambodia!" A year on, however, Henry Kissinger desperately needed to strengthen his hand in the Paris secret negotiations. He said, "We have to be tough." On April 29, 1970, allied forces, which peaked at 19,300 Americans and 29,000 Vietnamese, launched a series of thrusts into border areas of Cambodia known from their map shapes as the Parrot's Beak and the Fishhook. Abrams admitted that there was scant enthusiasm for the operation among his own men: "It has taken some doing to get the American troops in an offensive mood." Meanwhile a new bomber offensive was launched against North Vietnam.

The Cambodian incursions were precipitated by a March 18 army coup in Phnom Penh led by Gen. Lon Nol, who seized power with a junta of fellow officers while Prince Norodom Sihanouk was on his way to Beijing—ironically, in hopes of getting the Chinese to induce the North Vietnamese to curb operations in eastern Cambodia, which they treated

as their own fiefdom. Indeed, Hanoi's conduct was as devoid of moral justification as that of Washington: both sides were indifferent to the interests of the Cambodian people, whom Vietnamese despised. There is still no evidence of direct American complicity in the coup, and Sihanouk's erratic, eccentric rule over his erratic, eccentric little country had for years been precarious. A Westerner described the prince denouncing in a radio broadcast some alleged Vietnamese slanderer, screaming abuse in a piercing falsetto, sounding "less like a head of state making a diplomatic détente than a schoolgirl hockey player accusing another of 'sticks.'"

Lon Nol and his fellow plotters were driven by a genuine disgust and exasperation at the North Vietnamese occupation and the US bombings it had provoked, mingled with more mundane concerns: the Sihanouk family was thought to be appropriating too many of the spoils of power, the generals receiving too few. All the same, if Washington had made it explicitly plain to the usurpers that it would not back them, it is unlikely they would have dared to overthrow the prince. In the event, however, Senior VC cadre Tran Bach Dang chanced to reach Phnom Penh from COSVN in the immediate aftermath of the coup and was shocked to discover that he and his kind, who for years had come and gone at will, were suddenly hunted men. Possessed of only a T-shirt and shorts, he sought sanctuary in the Cuban Embassy, whence he was whisked to Hanoi via Shanghai, arriving in time to enjoy a macabre privilege: he watched Soviet technicians thaw the frozen corpse of Ho Chi Minh for embalming.

Cambodia's new rulers appealed to the Americans for aid. Washington responded with sufficient arms and cash to sustain Lon Nol's regime for the next five years but not nearly enough to crush the indigenous communist Khmer Rouge, which almost overnight became a serious military force. Cambodia's ramshackle army, which had just twenty surgeons, was cruelly mauled. By autumn the Khmer Rouge threatened Phnom Penh, where refugees from American bombing and communist terror eventually swelled the population by two million destitute people. After an April 24–25 conference held on the Vietnam-Laos border, the Pathet Lao, Khmer Rouge, and North Vietnam proclaimed a common struggle. Sihanouk,

for all his limitations, commanded immense prestige among his own people. When this was placed at the disposal of the communists following his overthrow, the prince became a serviceable tool.

The US and North Vietnam shared responsibility for the tragedy that engulfed Cambodia in the decades that followed, a struggle merciless even by the standard sustained in Indochina since 1945. Journalist Jon Swain described an encounter with two wounded North Vietnamese soldiers, captured by the Cambodian Army near Kompong Cham: "Their coarse olive-green uniforms were caked in a mixture of mud and blood. They were terribly mutilated, in agony, whimpering like animals in a trap. Suddenly aware of a foreign presence, they stirred, opened their eyes, and looked at me in the dim light [with] intense hatred." Swain asked a Cambodian major if he could take the men to a hospital. Instead, the soldier prodded their wounds with a cane and said, "Let them die. We did not invite them to come to our country." One was an NVA officer, Lt. Dao An Tuat. Swain leafed through his notebook, noted the faded photograph of Ho Chi Minh, and a scribbling by the owner in his own language:

To live is to give oneself to the fatherland,
It is to give oneself to the earth, the mountains and the rivers,
It is to clench one's teeth in the face of the enemy,
To live is to sustain one's courage in times of sorrow,
It is to laugh in times of anger . . .
We must drink deeply of the blood of the foe.

Tuat, who duly expired in the stinking hut, was plainly a committed cadre, and the Cambodians burned the gasoline-soaked bodies of him and his comrade before tossing the remains into the Mekong. If the fortunes of war had decreed differently, those North Vietnamese would probably—and the unspeakably brutal Khmer Rouge would certainly—have done likewise to inconvenient POWs.

As for the US-ARVN incursions, though some American soldiers exulted about implementing an initiative they had advocated for years, polls showed that 60 percent of their countrymen opposed it, as did Secretary of State William Rogers. Substantial munitions and ration dumps were seized; a MACV briefer told Abrams on May 12 that the invaders had thus far captured "6,500 man-years of rice." Yet the general was himself uneasy: "The weapons I saw out there are a lot of *junk*.... What you're building up is a *big fraud*, and that's what they'll *tag* you with.... It's really very sickening to sit around here and contemplate the fact that we've been talking about a basketful of fog." As so often, advance intelligence was poor; to preserve secrecy, the South Vietnamese had been cut out of the planning loop. Although the NVA suffered significant casualties, the bulk of enemy forces withdrew westward, declining to lock horns with the invaders.

Doug Ramsey, a prisoner of the communists, observed later that the US incursion seemed to represent "either a blind leap away into cloud-cuckoo land or a cynical, opportunistic attempt not to win the war in Vietnam, but simply to help delay its loss... at unconscionable cost to Cambodia." He believed that intervention might have been a rational gambit four or five years earlier, but not in 1970: "We were sacrificing the long-term vital interests of a tiny, distant country, previously anxious to avoid involvement in the Indochina conflict, to the peripheral and ephemeral interests of one or two generations of our own policy makers.... We had bestowed on ourselves exceptional prerogatives that we would never have permitted others to assume."

The administration asserted at the outset that the Cambodian operation was limited in both time and space, that the invaders would penetrate not more than eighteen miles beyond the border nor stay past June. Nixon said in a national TV address, "Tonight American and South Vietnamese units will attack the headquarters for the entire communist military operation in South Vietnam." But COSVN was a group of footloose people, not a building complex such as the president appeared to envisage. Leading members of the PRG merely abandoned one set of huts in favor of another, beyond the Americans' self-imposed limits. Phil Davidson said gloomily to Abrams on May 19, "I think it's clear to everybody that COSVN displaced before we went across the border." This was so: almost two months earlier, the communist leadership anticipated such a thrust

and moved deeper into Cambodia. Cadres bolted along prearranged escape routes, covered by the NVA 7th Division. Their flight was harassed by American aircraft and beset by torrential rain. A PRG minister wrote, "Our exertions were imbued not merely with the desperation of men fleeing the clutches of a merciless foe, but with fears for the very existence of our struggle." Another PRG leader, Dr. Duong Quynh Hoa, was seven months pregnant; she gave birth under the stress of the flight, to the accompaniment of artillery and small-arms fire. The baby was safely delivered but died of malaria a few months later. The leadership reached the Cambodian town of Kratie without casualties, though Truong Nhu Tang acknowledged that "the whole affair gave us a bad fright, not to mention a spell of acute physical hardship."

Tang described Nixon's Cambodian adventure as "an enduring gift to Vietnam's revolution. . . . [because] it helped to separate the US leadership from its domestic base and instilled in many Americans an enduring skepticism about their government's moral compass." The operation formed an element in Kissinger's "coercive diplomacy," yet inflicted nothing like sufficient strategic pain on the enemy to compensate for the political damage Nixon suffered at home. Amid a dramatic intensification of antiwar protests, on May 4, 1970, at Ohio's Kent State University, National Guardsmen killed four unarmed students, two of them mere passers-by, and wounded nine others. Two more students were killed by police and twelve wounded at Mississippi's Jackson State College.

Following the latest round of Indochina turmoil, a MACV briefer cataloged the seven interrelated but separate conflicts across the region: civil war in northern Laos, the NVA's struggle to sustain its logistics links in southern Laos and Cambodia, the Cambodian civil war, the COSVN border theater in South Vietnam, the battle in the Delta, the central war zone, and the northern one. Deep in the South, Vietcong doctor Dang Thuy Tram wrote, "The mad dog Nixon has foolishly enlarged the fighting. . . . Oh! Why are there such terrible, cruel people who want to water their own golden trees with our blood? . . . Oh, my country! . . . Has any on earth suffered as much? Have any people fought as courageously, persistently, and tirelessly as ourselves? . . . I am still a soldier in this struggle. I keep

smiling . . . even when gunships bring down rockets on my head . . . I remember Lenin's words, 'Revolutionaries have the warmest hearts.' This is me." On the morning of June 22, a patrol of the US 4/21st Infantry heard voices and the sound of a radio playing Vietnamese music. Other members of the same unit, alerted, later encountered nearby four people advancing toward them along a jungle trail. This was a free-fire zone, where all human movement was deemed hostile: two communists escaped the ensuing M16 bursts, but two fell. One of them, dressed in black pajamas and Ho Chi Minh sandals, was twenty-seven-year-old Tram. Found among her scanty possessions were a Sony radio, a medical notebook, bottles of Novocain, bandages, a photograph of her beloved NVA captain, and poems written by him, along with her diary.

The American incursions, together with Operation Menu—the secret B-52 bombings—caused the NVA serious logistical difficulties. They were not, however, the game changers sought by Nixon and Kissinger; the latter fulminated about the USAF's inability to block the Ho Chi Minh Trail. Congress had initially treated the Nixon White House with considerable deference and acquiesced in the president's determination not to be seen to quit. "A great nation," he declared sonorously, "cannot renege on its pledges." He reasserted the familiar US government position that abandonment of the South Vietnamese would raise worldwide doubts among both the nation's friends and foes. Melvin Laird rehearsed the administration's goals: to make a success of Vietnamization, minimize US casualties, continue troop withdrawals, and stimulate meaningful negotiations.

In the course of that year, however, influenced by the equivocal outcome of the Cambodian lunge, more and more Americans began to crave escape from Indochina on almost any terms, or even none. Senators Mark Hatfield of Oregon and George McGovern of South Dakota led a charge against further funding for the war. Ambassador Ellsworth Bunker returned from a home visit to tell Abrams in Saigon on May 23, "The disturbing thing, I thought, was some of the people who have been pretty strong supporters"—he cited the example of Dean Acheson—"now say, 'Well if this is going to tear the country apart it isn't worth it.'" Against such a background, what's surprising is not that American troops became

562 .

ever more reluctant to hazard their lives, but that some remained willing to do so.

Nixon and Kissinger might have gained crumbs of comfort if they'd known more about the difficulties of the other side. Given the size of the US intelligence apparatus, it is extraordinary how little Washington ever understood about North Vietnam, especially the Hanoi politburo. The CIA depended for humint almost exclusively upon the British SIS station in their Hanoi consulate general, then run by the formidable Daphne Park, who flew down to Saigon every two months to brief "the cousins." The British were unable to run agents, send coded cables, or own a wireless transmitter. They nonetheless talked freely to East European diplomats, the Soviet ambassador notable among them—Park was a fluent Russian and French speaker. When the Americans asked SIS to service a dead-letter drop, they met a flat refusal: the consulate's personnel were too closely watched. They had little access to top North Vietnamese, though a member of the politburo once arrived unannounced and talked on their balcony for six hours.

One day at Bangkok airport, a British academic met Park returning from a short leave: he described her sitting on a mound of shopping bags, "as unmistakably English as Agatha Christie's Miss Marple." He asked if she was taking back supplies for SIS. "Oh no," she responded cheerfully, "this stuff is all for the East European mission people who won't eat Vietnamese food." Park described in her October 1970 valedictory dispatch how she and her sole colleague walked miles through Hanoi by day and night, pursued by children shrieking "Lien Xo!"—"Russian!"—who left them black-and-blue with mischievous pinches. The British spies gazed on Vietnamese "gathered around the family brazier on the pavement, eating their rice, or already asleep. In the hottest months, young and old, like battered bundles, sleep on the steps of the Ministry of Trade, on the pavement, in doorways, anywhere out of the stifling courtyards and the houses where they live, a family to each room. The rats run over them as they sleep, fight over scraps of garbage, and sometimes drown in the water which gathers in the open concrete shelter-holes. . . . There are rats even in the cinema."

Julian Harston, another SIS officer, described how they would try to estimate the size of the latest army call-up by counting used inoculation syringes in trash bins outside the military hospital. When the consulate's local staff dared to accept small gifts, such was their poverty that they chose bicycle repair kits, razor blades, Aspirin, or even empty bottles. All this constituted thin stuff from which to form an intelligence picture, though interestingly, in late 1970 Daphne Park was among those who thought the regime was in trouble.

The Chinese withdrawal of personnel—though not shipments of materiel-injured the prestige of Le Duan and Le Duc Tho, Mao's keenest adherents. At January's Eighteenth Plenum of the Central Committee, a resolution was passed asserting that the country "must respond to enemy attacks not only with armed resistance and political activity, but also with diplomacy." This opaque observation did not represent a rupture at the top-no full-fledged doves dared take wing in Hanoi-but it made plain that many North Vietnamese craved peace. Tensions grew between the politburo and Southern communists. Such PRG ministers as Truong Nhu Tang and Nguyen Van Kiet found themselves derided by Hanoi "proletarians" for their bourgeois backgrounds. An injured Tang wrote, "Many of us were from well-to-do families and had been used to the good life before we enlisted. Our motives varied, but we regarded ourselves as people who had already sacrificed a great deal for the nation, and remained ready to sacrifice all." Tang claimed never to have considered himself a communist, but recognized that "as far back as 1920, the only ally Vietnamese nationalism had known was the Comintern. Ho Chi Minh accepted its support with the fervor of a drowning man." Nonetheless, Tang was increasingly uncomfortable with the ideological rigor of Le Duan and his comrades, writing, "They had sacrificed conscience and pragmatism for the certitudes of their political religion. Amid their steely arrogance, there was no latitude for compromise."

North Vietnam's army was suffering a manpower crisis, the effects of which pervaded its entire society: security police staged one of their periodic crackdowns on expressions of antiwar sentiment. Such was the NVA's shortage of recruits that it felt obliged to accept in its ranks such

men as thirty-three-year-old Nguyen Hai Dinh, for decades an outcast as the son of a landlord. Dinh had only one military ambition—to defect. "In the North, I had nothing." He cherished a distant dream of getting to America. He suffered the usual privations on the Trail with the NVA's 28th Battalion, and labored so assiduously at doctrine that he was appointed an acting political officer. "It was all in my head, not my heart. Everybody who thinks for himself but wishes to survive in a communist society becomes a good actor."

Dinh suffered a perforated eardrum in a B-52 strike before the Cambodian maelstrom provided his chance to slip away from his unit and hide in a school. On May 23, waving a white cloth, he cautiously emerged to surrender to the US 25th Division. He had not eaten for two days, but when presented with rice and canned meat, he could not get them down. Dispatched to the chieu hoi center in Saigon, he felt uneasy among the peasants who made up most of its residents: "Some were genuine anticommunists, but many had simply got sick of fighting." After a year's reeducation, they were granted six months' liberty before being obliged to join the ARVN. Dinh had no interest in further fighting for either side. Denied any prospect of migration to America, he used a remote family connection to secure an introduction to a local Catholic seminary. There he spent the ensuing four years, serving as an altar boy and supposedly training to be a priest. A droll fellow, as he read the Bible, with which he became intimately familiar, he was amused that the seminary was located immediately behind the home of CORDS chief Bill Colby. Most important, "For the first time since 1954 I had enough to eat." Dinh's weight increased by a comfortable sixty pounds, making him one of the few beneficiaries of Nixon's Cambodian adventure.

2. COUNTERTERROR

Over two hundred thousand ex-NVA and Vietcong fighters *chieu-hoi*-ed by 1972, most in the same spirit as Dinh, because they wanted out of the war, rather than from enthusiasm for the Saigon regime. One evening the CIA's Frank Snepp and an interpreter took a defector whom he was woo-

ing to a Saigon bar, where there was the usual crowd of girls and drunken GIs. After a while, the communist muttered something. With some reluctance, the interpreter told the American that the man had said, "I've made the wrong choice. I don't belong here." Snepp never again made the mistake of embarking on such a night out: "He didn't want wine, women, and song. The experience just convinced him that our side didn't have what it took."

A more potent force in undermining the Southern communist nexus was Phoenix, conceived by William Colby as an intelligence/action program, empowering the South Vietnamese to capture or kill key cadres. Between 1969 and 1972, its chiefs claimed to have neutralized eighty thousand, a quarter of them killed. Phoenix's so-called provincial reconnaissance units were made up of Vietnamese funded by the CIA and paid three times ARVN salaries. Some Americans assert that if the allies had embarked on such a program earlier, matching the Vietcong's targeted terrorism, they might have changed the war's outcome. Marine Capt. Andy Finlayson loved his time working with a PRU, based in a CIA villa at Tay Ninh where the food and living conditions were palatial: "I thought I was living a Graham Greene novel." The teams "marshalled intelligence at local level in a way that had never been done before," and exploited this to devastate NLF cells. Frank Scotton agreed that Phoenix was effective, "though I would have preferred a less lethal approach." The PRUs achieved an exceptional reputation for ruthlessness: Australian SAS officer Andrew Freemantle described them as "absolute savages . . . I once saw them use secateurs to cut off a man's ring finger."

What is certain is that when the excesses of Phoenix were publicly revealed, they drove another nail into the coffin of US domestic support for the war. Before a Senate committee in February 1970, Colby denied that this was a counterterror operation, but scarcely anyone believed him. Frank Snepp agreed that it "really hurt the communists," but "Colby lied and lied, when he declared that Phoenix chiefly captured Vietnamese. It was always a killing program." It could justly be said that the Vietcong did worse things: US researcher Guenter Lewy claims that the Ban-an-ninh—"Security Section," the terror arm of the NLF—killed 36,725 Vietnamese

and abducted 58,499, and such figures are credible. But Americans yearned to believe that their own side behaved better. Like Bob Kerrey, for instance.

Kerrey, a former college football star from Nebraska, was justifiably proud when he graduated as a member of the US Navy's elite SEAL Team One in the summer of 1968. He nonetheless hoped that Vietnam would be over before he had to participate: "My reasons were personal and not geopolitical.... I just preferred to miss this one without my having to refuse to go. . . . My real romantic ambition was to command a destroyer." He accepted his duty to serve, however, "and I would serve enthusiastically." Kerrey was twenty-five when he landed at Cam Ranh Bay with his platoon early in 1969. Their commanding officer was uncertain what to do with SEALs. The young lieutenant grasped merely that he was supposed to help the Saigon government defeat the communists in the fashion Phoenix was making fashionable, by killing some. On his own initiative, Kerrey launched a program of Swift Boat landings at beaches on the eastern coast, from which they patrolled and laid ambushes inland. When no contacts resulted, they transferred themselves to the Mekong Delta, where they planned a patrol out of Cat Lo into an area of Kien Hoa Province (now Ben Tre) controlled by the Vietcong. Intelligence reported that, on a given date, communist cadres would meet in Thanh Phong, some seventy-five miles southeast of Saigon, an identified landing site for VC arms supplies. Kerrey and his team had been in-country just five weeks. Mike Ambrose, an enlisted member with experience from a previous tour, argued against undertaking the operation. Their Vietnamese scout/interpreter was on leave, and the SEALs' local knowledge could be recorded on a postage stamp. Kerrey determined to go ahead anyway: he described in a later memoir that he was assured by the district chief that Thanh Phong lay in a free-fire zone.

On the night of February 25, 1969, a Swift Boat carried the SEALs up a canal to a landing place a thousand yards from the hamlet. When they reached the first house, "I did not have to give an order to begin the killing, but I could have stopped it and I didn't. In truth, I remember very little of what happened in a clear and reliable way." After eliminating the

occupants of one hooch, "we were certain there were armed cadres in the village now on full alert. We had two choices: withdraw or continue to search houses in the dark. Before we could make the decision, somebody shot at us from the direction of the women and children, trapping them in a crossfire. We returned a tremendous barrage of fire, and began to withdraw. I saw women and children in front of us being hit and cut to pieces. I heard their cries and other voices in the darkness as we made our retreat." The Americans rendezvoused with their boats and were back in Cat Lo within the hour. Kerrey wrote later, "Our actions were not considered out of the ordinary for guerrilla warfare where the number of civilian casualties is quite high." He admitted, "I felt a sickness in my heart for what we had done," yet he testified in an official Navy after-action report that he and his men had killed twenty-one Vietcong, a feat which won him a Bronze Star.

A week later, the SEALs learned that a defector was willing to lead Americans to the camp of a sapper group bivouacked on Hon Tam Island, off Nha Trang. Their landing in deep darkness on March 14, 1969, and a subsequent 350-foot cliff climb went as planned. The guide led the Americans to a soundly sleeping enemy detachment. Kerrey left four of his seven men to watch, and led the other three in search of more VC they knew to be nearby. They met oncoming enemy a few minutes later, and Kerrey fired only a single burst before being blown flat by a grenade explosion. He fell back, knowing himself seriously wounded. In agonizing pain he groped down his right leg, and realized that his foot was all but severed. Kerrey's corpsman, himself stricken by splinters in one eye, could do nothing.

The lieutenant tied a tourniquet above his knee while gunfire and explosions raged around him, then with difficulty hauled himself upright to direct his men's fire. When the action at last subsided, he injected a morphine syrette into his leg; a fellow SEAL stuck a Camel between his lips. Their radioman summoned a medevac helicopter, for which they waited in a silence broken only by city noise from Nha Trang across the water. When at last the chopper came, its crew chief lowered a sling, in which Kerrey was winched upward. At dawn, he landed in dizzy semiconsciousness,

vaguely aware that his war and his brief career as a SEAL had ended after just fifty days.

One morning at the White House more than a year later, the laconic Nebraskan was among twelve veterans who received the Medal of Honor from Richard Nixon. He wrote that he felt uncomfortable when the president told them that they were heroes, because the war by then seemed to him such a mistake. He nonetheless decided that there was indeed something heroic "about American men who were willing to travel to that strange country and fight for the freedom of people they did not know or understand."

So much for Kerrey's account, published when he had become a very famous American-former governor of Nebraska, US senator, and lover of film star Debra Winger, of whom he said memorably, "She swept me off my foot." This stunningly handsome and personable hero had morphed into a prominent antiwar campaigner. Only much later was the extent of Kerrey's memory loss revealed. In April 2001, the New York Times published jointly with CBS TV an investigation into the Thanh Phong episode, much at variance with Kerrey's contemporary claims. First, they showed that he was disingenuous in claiming ignorance of the village his team had assaulted: the SEALs had reconnoitered the place ten days earlier. Thereafter, systematic killing appears to have taken place, in which no attempt was made to distinguish victims. Kerrey told the New York Times, "Standard operating procedure was to dispose of the people we made contact with." His men killed the occupants of the first hooch with knives in an attempt to preserve silence. When they approached the hamlet proper, one patrol member, German-born Gerhard Klann, testified that the SEALs herded together and shot another fifteen inhabitants, mostly women and children. A screaming baby was the last to die. Klann said, "There were blood and guts everywhere." Another SEAL, William Tucker, told the New York Times that he had turned to Kerrey in the boat on the way home and said unhappily, "I don't like this stuff," to which Kerrey responded, "I don't like it either."

Other patrol members disputed the newspaper's claim that Vietnamese had been slaughtered without provocation, asserting that they heard

incoming fire before starting the massacre. Whatever the truth of this, a February 27, 1969, report was uncovered, recording how an elderly Vietnamese had presented himself before US Army officers to demand retribution for an alleged atrocity at Thanh Phong, in which unknown Americans had killed twenty-four people, of whom thirteen were women and children. The same Army document noted that Navy SEALs were known to have been operating in the area. After being confronted with this evidence, Kerrey said, "It's far more than guilt. It's the shame. You can never, never get away from it. I thought dying for your country was the worst thing that could happen to you, and I don't think it is. Killing for your country can be a lot worse." During Kerrey's political career, colleagues on Capitol Hill were often baffled by enigmas about him they could not unravel. Thirty years after those events in Vietnam, a possible explanation became apparent.

Precise details of what took place at Thanh Phong remain disputed, but the fundamentals seem plain. A group of gung-ho commandos raided an area of which they knew little, wherein they were granted a license to kill of a kind not infrequently abused by special forces of all nationalities in all wars. They used this to murder civilians—though it remains possible they may also have killed some VC—then lied about what they had done, an unfailing indication of misconduct. The US Navy as an institution emerges worse from the story than do those who attacked the village. It empowered its SEALs to act as they did, then distributed decorations in a fashion that suggested an eagerness to identify American heroes greater than its commitment to a responsible or even civilized contribution to operations against the enemy.

Moreover, such operations as Thanh Phong—and there were many—exacted a political as well as moral toll. The Vietcong exploited their own excellent local intelligence networks to eliminate enemies, often with conspicuous sadism. Yet none of the villagers assembled to witness beheadings and live burials doubted why appointed victims were killed: for opposing the revolution. By contrast, when Americans or ARVN killed civilians, while some were communist activists or sympathizers, as may have been the case at Thanh Phong, others were not. The indiscriminate nature of

American-led terror, caused by ignorance about the identities, never mind loyalties, of many of those whom its warriors killed, inflicted as much damage upon US strategic objectives as upon the moral legitimacy of its war effort.

The operations of Kerrey's SEAL team were supervised by the US Navy's Capt. Roy Hoffman, who kept a chart on his office wall recording enemy KIAs. In Kerrey's words, "They needed bodies." The admirals were seeking to increase their market share in the war, and in any glory that was available. "Our story came out publicly right after Kent State, and was a godsend to the US Navy." He says that he almost turned down his Medal of Honor, but he felt unjustly traduced by the 2001 allegations made about Thanh Phong, but he adds, "I make no appeal for sympathy. I survived." He also makes the point that whatever his SEAL team did or did not do at Thanh Phong, US Navy patrol boats were roaming the waterways of the Delta free-fire zones, killing at will, as did US aircraft overhead. Implicit in these remarks is a claim that it is unjust to denounce excesses committed by himself and his men, head-to-head with the enemy, when the vast American war machine was carelessly killing by the hundreds, without those at the helms of patrol boats or the controls of aircraft being held accountable, as his accusers sought to make him all those years afterward.

When Andy Finlayson interrogated a senior NVA prisoner captured in Cambodia, the man portrayed the communist predicament as grave, not least because of Phoenix. The American asked if that meant Hanoi's forces were doomed to defeat. The enemy officer smiled, shook his head, and responded, "You are far from home and you do not understand the strategic realities of this country. Your people will grow weary as they see more and more Americans dying without anything to show. Your president has already said that you are leaving. We will wait until you are gone and then we will attack, attack, attack until the puppet regime falls from its own weight. Victory for us is inevitable." The CIA's Frank Snepp said, "I became fascinated by the [communists] I interrogated. One man in particular seemed the most perfectly disciplined human being I ever met.

I was bemused by how much he hated us. Americans aren't used to that. I was looking at somebody willing to do absolutely anything to achieve his objectives. That made a huge impression on me."

In November 1970, Fred Weyand attended the handover to the ARVN of his old 25th Division headquarters, and confessed to profound discomfort: "We were going, and they were not ready to take it over. We just no longer had much leverage on the North once we started that withdrawal." RF and PF militias were accepting heavier losses than their regular brethren, losing 15,783 dead to the ARVN's 5,602 in 1970, with proportionately worse casualties in the following year. South Vietnam's armed forces were the fourth largest in the world, yet their will and skill remained problematic.

At every turn, the Americans seemed doomed to have luck run against them. Nixon was desperate to display his concern for the fate of POWs held in the North, an increasingly emotive domestic issue: he feared that some prisoners' families would make common cause with the antiwar movement. Thus he authorized a November 1970 raid on Son Tay, twenty miles north of Hanoi, in hopes of liberating some Americans said to be held here. Three days ahead of the mission, aerial surveillance showed the compound empty—the POWs had been moved out. Washington nonetheless ordered that the heliborne raid should be executed anyway, on the night of the 20th/21st. The raiders returned empty-handed.

Admirers of Gen. Creighton Abrams assert that by late 1970 the struggle was going America's way, and that only the collapse of domestic political will prevented exploitation of a newly established dominance on the ground. Historian Lewis Sorley, foremost standard-bearer for MACV's chieftain, has written, "The fighting wasn't over, but the war was won." Even at the sharp end, there were still some true believers. Lt. Mel Stephens left Vietnam late in 1969, having won a Silver Star, Bronze Star, two Purple Hearts, and assorted commendations serving with the USN's riverine operations, and thereafter became personal aide to Adm. Elmo "Bud" Zumwalt as chief of naval operations. After leaving the Navy, he joined some other veterans publicly to endorse the Vietnam commitment, even testified to that effect to the Senate Foreign Relations

Committee. He said, "For me, it was the good war. I had extraordinary experiences, and my combat record opened extraordinary doors for me. I believed that Vietnamization could work, and that the ducks were falling into line."

It may well be true that, with the Vietcong drastically depleted by Phoenix and battlefield attrition, South Vietnam might have been stabilized under the control of a noncommunist regime but for the continuing commitment of the North Vietnamese and the American people's disenchantment. Unfortunately for the Nixon administration, however, Le Duan and the NVA were as much immutable realities as were monsoons and scorpions. Abrams, recalling his 1944–45 experiences, said ruefully that the North Vietnamese were "just like the Germans—you give them thirty-six hours and, goddamn it, you've got to start the war all over again." By the end of 1970 he was seeking to achieve this with a much smaller army than he had started with: 140,000 US troops had gone home. In Paris, Kissinger withdrew his demand for a matching NVA drawdown: he no longer believed in Santa Claus.

3. LAM SON 719

It is a curiosity that North Vietnam was a cruelly disciplined totalitarian society but was governed by civilians. South Vietnam purported to be a democracy but was ruled by generals who displayed little talent for either politics or military affairs. Lewis Sorley in his biography of Creighton Abrams makes the remarkable assertion that Nguyen Van Thieu "was arguably a more honest and decent man than Lyndon Johnson, and—given the differences in their respective circumstances—quite likely a more effective president of his country." Sorley likewise compares the 1965–75 ARVN chief of staff Gen. Cao Van Vien favorably with Earle Wheeler, arguing that the former was "probably less irrelevant." Yet Thieu displayed greater skill in sustaining the trust and goodwill of Americans, chiefly by compliance with their wishes, than of his own people. Vien was a reasonably competent officer but was hamstrung by his president's insistence on appointing commanders chosen for loyalty rather than for their fitness to direct troops.

Vietnamization thrust a huge burden on both men and their closed circle of subordinates: suddenly they were invited to govern their own country and run their own war instead of acquiescing while Americans did so. Yet contradictorily, the very continued existence of Thieu's regime was being disputed in Paris between the North Vietnamese and an American—Henry Kissinger—without any Saigon representative getting a serious hearing. The communists were scarcely unjust in branding Thieu and his associates as US puppets. Meanwhile, however harsh a view may be taken of the Hanoi politburo, nobody beyond the White House and the US conservative media any longer characterized Le Duan and his comrades as mere stooges of the Soviets or the Chinese.

Characteristically, the decision to launch the ARVN on a big battle-field test of Vietnamization was taken not in Saigon but in Washington. Despite meager dividends from the 1970 Cambodian incursion, an imperative persisted to maintain military pressure on the North Vietnamese if there was to be any hope of extracting concessions from them in Paris. Kissinger told Arthur Schlesinger, "I have been thinking a lot about resignation," but then added that he was engaged in something he could not talk about but must see through to the end. Schlesinger rightly assumed this meant secret negotiations. On Nixon personally, Kissinger said, "He is a shy man, who needs compassion." He added that as the 1972 election began to loom while protests about Vietnam raged, "[Nixon] has enough support to win, but not enough to govern."

New congressional action—the December 1970 Cooper-Church amendment—prohibited the administration from committing US ground troops beyond the border of South Vietnam. The huge problem persisted of stemming the flow of men and supplies down the Ho Chi Minh Trail. In 1970 the North Vietnamese received accelerated deliveries of Russian and Chinese materiel, estimated at two and a half million tons, including five hundred trucks a month. MACV reported, "The logistics war of southern Laos and north-eastern Cambodia now stands as the critical conflict for the VC/NVA." Early in 1971, Seventh Air Force commander Gen. Lucius Clay described his instructions from Creighton Abrams: "He wants that Ho Chi Minh Trail in such a shape that a crow has to carry his

rations to fly over it." Clay's staff identified four choke points—the Mu Gia, Ban Karai, and Ban Raving passes, and another location just west of the DMZ. New movement sensors were installed, monitored by surveillance drones. Each choke point was designated to receive daily for sixty days at least 27 sorties by B-52s and 125 by tactical air units. Bombing and rains indeed rendered stretches of the Trail impassable by vehicles for weeks, yet somehow the NVA in the South continued to receive just enough supplies and munitions to keep fighting.

Meanwhile, congressional willingness to fund Vietnamization was wearing thin, and USAF sorties were ever more restricted. The fourteen thousand a month now authorized represented less than half the 1969 quota. Late in 1970, Nixon and Melvin Laird faced the prospect of financing the war through the following year with only \$11 billion, as compared to \$30 billion in 1969. Therefore, it was decided to risk a battlefield plunge: to commit a large South Vietnamese force, supported by American air and firepower, against the NVA in Laos. In December 1970, Kissinger's military assistant, the increasingly influential Brig. Gen. Alexander Haig, was dispatched to Saigon to explain this proposal to Abrams. Controversy persists about who originated the operation that was somewhat clumsily code-named Lam Son 719. Lewis Sorley, Abrams's standard-bearer, says it was Haig; Haig later asserted that it came from Nixon and Kissinger.

Abrams's boss, C-in-C Pacific Adm. John McCain, whose own commitment to the war was intensified by his Navy flier son's captivity in Hanoi, had favored the Cambodian incursion, and now rooted for a drive into Laos, though he told Abrams, "I recognize that the operation may present many problems." The general went off to inform Thieu, who agreed to commit the ARVN to a thrust of which the final objective was the Laotian town of Tchepone. On December 10, Adm. Thomas Moorer, Earle Wheeler's successor as chairman of the Joint Chiefs, forwarded to Abrams a presidential order for the operation. Moorer said that it would bolster Vietnamization. "The enemy's lack of mobility should enable us to isolate the battlefield and ensure a South Vietnamese victory." The Americans believed that if the ARVN could wreak havoc upon the NVA's supply routes, they could buy a year's breathing space for themselves. Abrams was

uneasy about Vietnamese capabilities to execute the operation; he warned that in Laos "the enemy can be expected to defend his base area and logistics centers," as it had not done in Cambodia. He did not, however, seek to impose a veto and indeed accepted overall responsibility. Abrams must thus bear considerable blame for what took place.

At a meeting of regional ambassadors in Saigon on the 17th, CIA station chief Ted Shackley reported that the communists expected the allies to launch another thrust into their sanctuaries. The NVA deployed strong forces in southern Laos, where in the dense jungle there were few plausible helicopter LZs. On January 26, 1971, the Agency also received a decrypted enemy signal that anticipated an assault and that concluded, "Prepare to mobilize and strike the enemy hard. Be vigilant." A postwar Hanoi study frankly acknowledged the weakness of the communists' position in South Vietnam at that time: "Our offensive capability had been depleted," and guerrilla operations had tailed off. In Laos, by contrast-on their own doorstep—they felt far more confident: "We held the strategic initiative and were stronger than the enemy." Hanoi, almost certainly tipped off by an ARVN informant, forecast that Saigon would attempt an operation involving fifteen to twenty battalions. The politburo decreed, "This will be a battle of decisive strategic importance." Dragon Court identified the Ban Dong-Tchepone area as a battlefield favorable to its own troops-close to North Vietnam, its jungle offering good overhead cover from aircraft. Communist planners declared an objective of killing twelve thousand Southern troops and destroying three hundred aircraft and helicopters.

In Saigon, as the ordained February 1971 assault date drew nearer, Abrams became ever more uneasy, fretting about the ARVN: "We're pushing them too hard...going too far too fast." On January 29, he warned Moorer that the communists would be waiting, yet still didn't demand cancellation. The most grievous error, in which the entire US leadership was complicit, was failure to recognize that the risk of Lam Son 719 outweighed any possible gain. If the communists defeated an assault of this magnitude, as many officers thought likely, the whole façade of Vietnamization would totter at a time when the American political climate was deteriorating. In January Nixon had signed the Foreign Sales

Act, to which was attached repeal of the Tonkin Gulf Resolution, though the White House denied that this imposed any new limitations upon its authority to keep fighting inside Vietnam.

Within reach of Saigon's intended thrusts, the NVA could call upon some sixty thousand men, with eight sapper battalions, plentiful artillery, even some tanks. The South Vietnamese were to air-assault and drive armor toward nine immediate objectives, between twenty and forty miles west of Khe Sanh. I Corps commander, Hoang Xuan Lam, whose unfitness was plain, held overall command. Lt. Gen. Alexander "Jock" Sutherland, who headed the US XXIV Corps, controlled American troops supporting the operation, together with fifty-three Chinooks, five hundred Hueys, eighteen 155mm howitzers, sixteen 175mm guns, and eight 8-inch howitzers. A hundred yards short of the Laotian border stood a sign: WARNING: NO US PERSONNEL BEYOND THIS POINT. Maj. Tran Ngoc Hue, who had commanded the "Black Panthers" in the 1968 Hue fighting, had a bad feeling about this immensely ambitious operation. Before he led the 2/2nd Infantry into action, he spoke earnestly to Dave Wiseman, the battalion's adviser, who was staying behind, asking if the American would adopt his children.

Lam Son 719 got under way on February 8, 1971. An armored column of 62 tanks and 162 M-113s made the main drive west along Route 9, while Airborne troops and Rangers protected its northern flank, 1st Infantry the southern. Hueys crewed by both Americans and Vietnamese bore ARVN into air assaults. So sure were the communists that the Southerners would be coming that they had prepared tracks around the prospective battlefield, pre-positioned munitions, fortified some hills and bridges. They conducted careful terrain reconnaissance, and some units had exercised on the ground. Nonetheless, the South Vietnamese achieved temporary tactical surprise because the communists, stunned by the size of the incoming helicopter armada, responded slowly. Few NVA officers had experience of big all-arms battles. Furthermore, a shortage of radios caused command-and-control failures.

Through the first few days, nothing terrible happened to the attackers. In vile weather, Saigon's tanks linked with an Airborne battalion at Ban Dong (A Luoi on American maps), twelve miles into Laos. Infantry es-

tablished firebases and dug in. Hanoi later admitted that some of its commanders set off on the wrong foot: "We did not have a firm grasp of all [the enemy's] activities. . . . Many units deployed for battle prematurely." On the 13th, Gen. Vien told Abrams that President Thieu had decreed that his forces should advance no farther westward. Rumor, never confirmed, held that Thieu also secretly ordered that the operation should be aborted if or when South Vietnamese casualties exceeded three thousand.

In Laos, the battlefield balance tilted slowly but inexorably against the Southerners as the communists concentrated ever more powerful forces around the invaders' sixteen battalions. Abrams in vain urged the Vietnamese to keep moving, warning that if they merely sat tight, the enemy could hit them piecemeal and at leisure. On the night of February 18, two NVA battalions struck the 39th Rangers, who were soon in retreat. ARVN firebases were relentlessly hammered by shellfire—one was abandoned after all its guns were knocked out. Three hundred miles southward, on February 23 the respected Gen. Do Cao Tri perished in a helicopter crash. His death had an impact on Lam Son 719, because it had been rumored that he would be sent to replace Gen. Lam, whose incompetence had become painful to behold.

A week later, a badly rattled Sutherland told MACV by secure phone, "The enemy is all over that goddamn area and seems to be getting stronger. . . . There's a real fight going on up there." Abrams raged at his subordinate, whom he accused of failing to get a grip on a deteriorating situation. For the first time in the war, tanks were fighting tanks. Air support was having limited impact for lack of American FACs on the ground; few Southern officers had the language skills to communicate effectively with US fliers, and flak was worsening by the day, causing alarming attrition. Least expectedly and most embarrassingly, US helicopter serviceability declined steeply—only a quarter of all Huey gunships were flying. Lt. Gen. Fred Weyand fumed: "You've got a corps commander up there who's supposed to be keeping track of every fucking bird. There's something wrong there. . . . He just doesn't know what the hell's going on." Abrams, too, raged at Sutherland: "The entire national strategic concept is at stake here!"

The White House grew increasingly alarmed. Kissinger said late in February, "I do not understand what Abrams is doing." Lt. Gen. Bruce Palmer, Army vice chief of staff, wrote sourly, "Kissinger willingly assumed a field marshal role when things went well, but not understanding the nature of war and its treacherous uncertainties, became irritable and upset when Lam Son 719 stalled." Meanwhile MACV's chief refused to despair: "We're in a real tough fight. We're just going to have to stick with it and win. . . . We've been inundated by the prophets of doom before." Abrams's optimism persisted on March 9: he was "more and more convinced that what you've got here is maybe the only decisive battle of the war," which could be won by superior firepower. A major difficulty for US commanders was that they couldn't see what was happening on the ground, nor could they send people whose word they trusted to see for them.

Creighton Abrams made a personal approach to Thieu, the only man with authority to shift army formations, urging him to commit 2nd Division to turn the battle. The president said he'd do that only if a US formation was deployed as well. While fighting raged on, Thieu's generals urged him to quit Laos. Contrarily, Alexander Haig arrived on March 18 and told Sutherland that the White House wanted the ARVN to sustain the battle through April. In Washington, spirits rose following reports that air power was hurting the communists. Every eight minutes a C-130 landed at Khe Sanh bearing ammunition and supplies, while three flareships and three gunships remained on station over the battlefield throughout the hours of darkness. In the course of the battle, American tactical aircraft flew 8,000 sorties, nearly 150 a day, while B-52s made 1,280. The NVA's Col. An wrote of the area around his command post beside the Sa Mu River: "The reeds and tall grass on the hills were completely burned away by napalm. Our forest became a little isolated island amid a blackened ocean of desolation."

Nevertheless, the Southerners had already suffered 5,500 casualties. Brig. Gen. Haig abruptly changed his mind and said that it seemed time to wind up the operation. On March 18, the NVA struck hard to cut off some exposed South Vietnamese units. One of An's men, a squad leader from Hanoi, wrote: "The moon was bright that night. We set out for

the road just after dark. The enemy walked artillery barrages from the road up the hill to our fortified position, then down again, over and over again. We had two men wounded, leaving only seven fit to fight. Every man dug a firing position as fast as he could, some using bomb craters or old foxholes dug by the enemy. Then I lay down, pulled my hammock up over my stomach, and slept like a log. I woke just before dawn. Rain had soaked through my clothes. It was so cold that I could not keep my teeth from chattering. The colder I felt, the hungrier I became. . . . The strength from the rice ball, a little bigger than a fist, that we had eaten the previous afternoon had been used up by our dash through the barrage." Then one of his men came from a hasty forage bearing a helmet filled with rice that he'd found in an abandoned enemy bunker. "I was as happy as if we had won a battle!"

Indeed he had. The communists were isolating successive Southern positions, then battering them into ruin, employing 122mm guns with a range of almost fourteen miles and 130mms that reached seventeen miles; they seemed indifferent to their own casualties. The Northerners were playing energetic radio games, both to jam their communications and to broadcast propaganda. Men of the two armies exchanged abuse in their common tongue; South Vietnamese Marines were disconcerted to hear battle orders being issued by a female voice. An NVA soldier described how he made his squad search the battlefield for discarded M-79 Thumpers, then held a hasty practice session with them. "We got quite accurate." Within the hour, they were lobbing 40mm shells in earnest, at an ARVN convoy. The battlefield finally fell silent after the South Vietnamese retreated. The communists advanced cautiously down the road, counting enemy bodies, amid abandoned trucks whose engines were still running.

Southern officer Tran Ngoc Hue was promoted to colonel even as his battalion endured a Northern bombardment of its positions on Hill 660. Himself wounded by mortar fragments, when the survivors belatedly withdrew, he told them to leave him behind—just one captain and sixty enlisted men escaped. After falling into communist hands, Hue stumbled up the Ho Chi Minh Trail missing several fingers, with insects and worms feeding on his body wounds. He was twenty-nine when he reached

Hanoi, and spent the ensuing thirteen years in captivity, like many others who participated in Lam Son. Thieu made a personal decision, for prestige reasons, to insist that his troops reach their designated objective of Tchepone, toward which they launched a new air assault on March 3. After a savage struggle, South Vietnamese spearheads reached the town, only to be swiftly forced back.

While South Vietnam's soldiers fought for their lives, its generals displayed a familiar petulance and ineptitude. Lam, the corps commander, seemed paralyzed, and the top Airborne officer declined to discuss the operation with him; the country's most senior Marine refused to leave Saigon. Lam Son, wrote Col. Nguyen Duy Hinh "was plagued by dissension verging on insubordination by some ARVN field commanders. President Thieu and Gen. Vien were probably aware of the discord, but took no remedial action . . . perhaps [because] these generals were considered pillars of the regime." On the battlefield, while five of the Airborne's nine battalion commanders were killed or wounded, one who was unhurt forced his way onto a dust-off for evacuation. On March 27, Fred Wevand told an American command meeting that it seemed time to face the fact that the world saw Lam Son 719 as a failure: "We've got a public relations problem or a psychological problem . . . which is very, very important." Abrams fumed at press treatment of the battle. He spoke especially strongly against Gloria Emerson of the New York Times—"that big horse of a woman"—and spoke almost despairingly of the US-Vietnamese relationship: "There's a cultural chasm there that's pretty big, and for some Americans it's just impossible for them to ever bridge it."

The first South Vietnamese withdrawals from Laos had taken place on March 3, and a progressive retreat continued through the month, in ever worsening chaos. Less than half of Saigon's tanks and little more than one-third of their APCs survived; the rest broke down, ran out of fuel, or were destroyed by communist fire. The Americans lost over 100 helicopters, with another 544 damaged. One of their briefers said with notable understatement, "The air mobility concept received a severe test during this operation." As the evacuation was pressed ever harder by the NVA, panic overtook many of Thieu's soldiers, so that the abiding image of

Lam Son 719 derived from photographs of fugitives mobbing helicopters, some flying out clinging to the skids. By the time the operation reached a ragged, threadbare conclusion, the South Vietnamese had fought in Laos for forty-two days and lost almost half the forces committed, some 8,000 casualties, including many taken prisoner.

MACV estimated that 13,000 NVA had been killed, but this seemed a considerable exaggeration. Postwar North Vietnam admitted a loss in the battle of 2,163 killed and 6,176 wounded, believable numbers amounting to 13 percent of its committed strength. The communist narrative attributed half their casualties to artillery and mortars; more than one-third to air attack, including a surprisingly low 2 percent to the napalm that so impressed US and Vietnamese troops; and the balance to small arms. Their history states that almost half of all losses were incurred behind the front, which probably meant from American rather than Vietnamese fire. They acknowledged heavy materiel losses: 670 AA guns, 600 trucks, one in five of their mortars, 88 tanks.

CIA officer Merle Pribbenow had become friendly with two Vietnamese Airborne privates, who visited his apartment whenever they were in Saigon. After Lam Son, one of them arrived unannounced and visibly stricken, having lost his friend and most of their unit in Laos. Pribbenow thought if this was how a soldier of an elite formation now looked and felt, "the rest of the ARVN must be in a hell of a fix." Bob Destatte, veteran Vietnamese-speaking POW interrogator, said savagely, "If there were any criminals in Lam Son 719, they were not ordinary soldiers, who fought their hearts out, but instead the people who put them in there." Col. Nguyen Duy Hinh wrote sadly, "ARVN forces had to leave behind in Laos a substantial number of their dead and wounded. This came as a horrendous trauma for those unlucky families who, in their traditional devotion to the cult of the dead and their attachment to the living, were condemned to live in perpetual sorrow and doubt. It was a violation of beliefs and familial piety that Vietnamese would never forget or forgive." The CIA's Frank Snepp said, "Lam Son 719 told us everything we needed to know about where Vietnamization had really got to—and it told Hanoi the same things."

VIETNAM

The debacle precipitated fury in the White House, though Nixon was obliged to assume a brave face, saying in an April 7 TV broadcast, "The South Vietnamese demonstrated that without American advisers they could fight effectively against the very best troops North Vietnam could put into the field." In reality, however, the operation's outcome was the reverse of that which was intended: it weakened, rather than strengthened, the American hand in the Paris negotiations. While the requirements of domestic politics meant that troop withdrawals must continue unchecked, the credibility of the Thieu regime, and of its army as a fighting force, had received a shattering blow.

The administration chose to lay blame partly upon the Vietnamese—the focus of Kissinger's anger—but chiefly upon the US military. Alexander Haig said, "President Nixon and those of us in the White House involved in the planning were appalled by the Defense Department's handling of the operation." In his rage, Nixon's initial instinct was to sack Abrams and replace him with the nearest officer to hand. He told Haig, "Get on the first available plane and fly to Saigon. You're taking command." Haig claimed later that he persuaded the president to hold off and take some deep breaths for twenty-four hours before making such a decision. Thereafter, of course, Nixon relented. Kissinger disputes Haig's account, but it is believable. The national security adviser said that he would never believe another word Abrams spoke.

The approaching presidential campaign loomed ever larger in White House calculations. On March 19, 1971, Kissinger said, "We can't have [South Vietnam] knocked over—brutally—to put it brutally—before the election." Nixon: "That's right." Kissinger asserted that if the president was seen to give up on Vietnam before Americans voted, he would be denied reelection: he urged against doing the "popular thing" by bringing all troops home that year. Nixon, Kissinger, and Haldeman never appear to have discussed whether keeping the war going past 1972's US election day would do anything meaningful for the people of Vietnam. The White House was now resigned to sacrificing them: the challenge was to hold out for an appropriate moment to do so.

The issue of almost six hundred US prisoners in communist hands

increasingly dominated domestic debate. Americans bought 50 million stickers and 135 million postage stamps expressing support for the POWs. The administration pleaded constantly with Congress to provide funding for a residual war effort, which alone could add clout to the US negotiating position in Paris. Yet after a Hill briefing before the president broadcast to the nation on April 7, a senator demanded to be told how, if half a million soldiers had previously failed to persuade Hanoi to exchange prisoners, keeping fifty thousand Americans in Vietnam would now help anybody. Next day Nixon told Kissinger, "Of course I couldn't say to him, 'Look, when we get down to fifty thousand, then we'll make a straight-out trade—fifty thousand for the prisoners of war—and they'll do it in a minute, 'cause they want to get our ass out of there." "That's right," said Kissinger. Nixon laughed: "You know? Jesus!"

John Paul Vann, newly appointed pacification chief and senior American in the Central Highlands, with civilian status equivalent to a two-star general, said after Lam Son, "The war is gradually shifting to the northern two corps [areas], and moving toward a more conventional confrontation between North and South Vietnam." This was an accurate assessment. On April 7, air reconnaissance showed truck traffic on the Ho Chi Minh Trail in Laos restored to its pre–Lam Son 719 density.

Between killings, there were also spasmodic lunges into comedy. Abrams was briefed on the deployment at Cam Ranh Bay of five US Navy bottlenose dolphins trained to attack swimming saboteurs. "The enemy," said the briefer, "has been led to believe that the dolphin is trained to attack a male swimmer's privates. Our latest information is that the enemy plan to counteract this by employing female swimmers in the future." The general was informed that one dolphin had already deserted. Meanwhile, the collapse of morale at a special forces camp at Bu Prang proved to be caused by tensions between Montagnards and Cambodians serving there. The Montagnards worshipped a python that lived in nearby jungle, to which they periodically offered sacrifices until one day the Cambodians killed and ate it. American advisers brokered an uneasy truce, whereby it was agreed that harmony could be restored by the sacrifice of a white water buffalo. SF officers scoured the region until a suitable animal was found,

purchased, and conveyed to the camp beneath a C-7 transport helicopter. Unfortunately the sling became entangled in the animal's testicles, so that during the flight it strangled itself, arriving dead and thus unfit for sacrifice. After further elaborate parleys, the Montagnards agreed that two hundred chickens would represent acceptable substitutes, which were duly flown to Bu Prang, sacrificed, and eaten.

One day not long after the Laos debacle, Abrams attended a commemoration ceremony at the Vietnamese national cemetery outside Saigon. His helicopter failed to return before the proceedings concluded, and thus he was obliged to linger after the dignitaries, troops, and bands departed. Eventually, only the general himself and his personal escort were left, chafing impatiently. Then he saw approaching the cemetery on foot an ARVN sergeant with his wife and children. "She was pregnant. And they had three little kids. He was carrying one of them. . . . Well, it was a long walk. And then there was a little boy. I guess he was probably nine. He was carrying a big bag, plastic bag, a handbag. And it had a big wad of those joss sticks sticking up the top of it, and I suppose a little lunch or something in there. They were on their way to . . . I imagine, some relative." Abrams, like many warriors, was prone to spasms of intense sentimentality. One such now overtook him: "All this stuff about 'The Asians . . . don't value life' and all that-I think it's a real myth. I think they feel about these things a lot like our people do."

COLLATERAL DAMAGE

1. MARY ANN

In the course of 1971, many US Army and Marine Corps units atrophied, amid tensions created by disaffection, race, drugs, and a competition to avoid becoming the last American to die in a cause widely believed to be discredited. An illusion spread, that men were entitled to resign from the struggle if they felt that way. In March fifty-three Marines near Khe Sanh refused combat, yet faced no disciplinary action; soldiers at FSB Pace rejected orders to patrol. Word traveled of such gestures, infecting other units. An extreme manifestation was the disaster that unfolded at Firebase Mary Ann on the night of March 27-28, 1971, in which thirty of its residents—few could justly be described as defenders—were killed and eighty-two wounded. Mary Ann, named for its first commanding officer's sister, was the usual shantytown of steel containers and sandbags, encircled by wire and adorned with a forest of antennas atop a barren ridge in the midst of Quang Tin Province thirty miles from the Laotian border. It was garrisoned by C Company of the 1/46th Infantry, part of the 23rd Americal Division, whose reputation had been brought low by its role in the 1968 My Lai massacre, for which Lt. William Calley had recently been sentenced. C Company's men did not take their role very seriously, because within weeks Mary Ann was scheduled for transfer to the South Vietnamese, who already manned artillery on the position.

Pfc Ed Voros said, "The war didn't make any sense anymore. We

586 · VIETNAM

all thought it was bullshit. . . . We were just there, and it basically came down to staying alive and keeping your buddies alive." Pfc James Creaven agreed: "We weren't stupid. We knew we were pulling out, and we knew the ARVN weren't willing to fight their own war. Why risk your life for people who didn't even appreciate your being there? The only ones who wanted to be there were career officers. Anybody who was gung-ho and wanted to kill gooks was incredibly suspect." Out on ambush, Creaven and his kin were content to let the enemy come and go unscathed. "These people never did a damn thing to me."

Discipline in the 1/46th was somewhat, though not immensely, worse than in many other units. There were repeated refusals of combat, including one by an entire company. Lt. Brian Magrath, an adviser with a nearby Vietnamese unit, heard radio exchanges involving Mary Ann's garrison "in which patrols refused to move into certain areas that seemed particularly dangerous." One of the battalion's men had died and three others almost did, after prying the back off a Claymore and eating its C-4 plastic explosive, having heard a rumor that this would give them a high. Capt. Paul Spilberg wrote home about one element of the 1/46th: "This company really is a mess. . . . The troops sit around reading newspapers, playing cards . . . most of the time they don't even carry their weapons." The writer was recognized as a keen, driving professional, but one of his platoon leaders said, "Spilberg used to get on us lieutenants for being good guys with the troops, but if I had gone in with the attitude that I was the lieutenant and you're going to do what I said, I may have gotten fragged."

Senior officers said after the debacle that what happened at Mary Ann was a failure of leadership. Yet Lt. Col. Bill Doyle, the short, stocky thirty-nine-year-old Irish American who commanded the battalion, was brave to the point of recklessness. He repeatedly fired his own weapon at the enemy, because he believed in leading by example. A sign stood outside his operations center: FT. COURAGE. KILL PROFESSIONALLY, topped by a water buffalo's skull and horns. He was said to fight hard and party hard, causing critics to brand him "full of piss and wind."

Doyle's officers and NCOs were a mixed bunch, some competent, others much less so. During a February firefight, a C Company lieutenant

adjusted artillery onto his own platoon, killing a man. A fundamental dilemma faced all commanders: how much dared they ask of their soldiers without facing likely fraggings and at worst collective combat refusal—mutiny, though the Army recoiled from using that word? There were daily negotiations, humiliating for good officers, about what operations their troops were or were not willing to undertake. The 1/46th's D Company once declined to make a sweep unless provided with scout dogs, Cobra gunships, and a circling medevac Huey. Only after being harangued by Lt. Col. Doyle did the men grudgingly move out.

A month after that incident, on the moonless night of March 27, the battalion commander was slumbering in Mary Ann's operations center, Capt. Spilberg likewise in another hooch. Defense was in the hands of C Company commander Capt. Richard Knight, a bespectacled twenty-four-year-old who had dropped out of college to join the army. The son of a Florida restaurant owner, Knight was an enthusiastic officer on his second tour, after being badly wounded in 1968. Yet he lacked either inclination or personal authority to persuade his men, guarding a perimeter five hundred yards long by two hundred wide, to man all their twenty-two bunkers. Or to reset trip-flares and Claymores. Or to renew wire entanglements. Or to remain awake. Or to abstain from alcohol and marijuana. The assortment of officers, radio operators, mortar teams, gunners, riflemen, cooks, and odd bodies on the firebase comprised in all 231 Americans and 21 ARVN personnel.

One man in four was supposed to be pulling guard. However an almost crazed complacency caused most of the designated perimeter watchers on Mary Ann, which had never suffered an attack, to be sleeping, playing cards, drunk, or stoned—copious alcohol consumption is undisputed, though argument persists about the prevalence of other drugs. Knight left supervision to his platoon leaders and NCOs, who appear to have been inert. At 0200 a twenty-three-inch jeep-mounted searchlight swept the cleared ground beyond the FSB's wire, as its crew was accustomed to do every night. Seeing nothing amiss, after twenty minutes they switched off, shut down the generator, and retired to their hooches.

One day around this time, at another firebase an ex-NVA sapper who

had "rallied" gave a demonstration to US officers among the acres of wire protecting a firebase perimeter. Creighton Abrams said, "This apparently was a very shocking experience. They saw that little character get out there and come through that damn thing like it wasn't even there, and not a sound." This is what happened on a grand scale at Mary Ann at 0240 on March 28. Some fifty sappers, wearing only green shorts, their exposed bodies blackened with grease and charcoal, launched a meticulously planned attack. They came from the southwest, slithering forward to cut four large gaps first, in outer double concertina wire, then in the two inner barriers, which were ill maintained. They lay for some time just in front of the bunkers, awaiting a mortar barrage that was the signal to attack. The first the Americans knew of these terrifying apparitions was a storm of satchel charges, grenades, CS gas canisters, and AK-47 fire in the darkness, which precipitated panic and paralysis. Capt. Knight was ignominiously killed inside his bunker, along with his communications sergeant. The NVA charged through the firebase, shooting and bombing with cold efficiency, lobbing explosives into each hooch in turn, while two demolition teams raced for the artillery positions on the crest.

The attackers were drawn from the NVA's 409th Sapper Battalion, and their assault followed two months' surveillance of Mary Ann—they named the position Xa Doc, after the nearest village. They conducted night probes of its perimeter to prepare paths through the wire. Briefings were conducted on a terrain model, and each squad leader studied his objectives from an observation post. On the afternoon of the assault, the sudden appearance of helicopters and an L-19 spotter plane, together with reports of a US special forces patrol nearby, led the sappers to fear that their operation was blown. Even when this alarm proved groundless, after nightfall the sudden blaze of Mary Ann's searchlight prompted some heart-stopping minutes during which eight communist spearhead groups lay motionless among the wire entanglements. Some, no doubt, reflected on their empty stomachs; the sappers had been on short rations for days and launched the attack after a supper of manioc roots.

The garrison responded to the orgy of explosions by huddling mute in its bunkers, either from fear or because some men believed that they faced only a mortar barrage. Contrary to brigade standing orders, Lt. Col. Doyle had posted no guards outside his ops center. He was thus confounded by the detonation of a tossed-in satchel charge, which hurled him to the floor and inflicted a slight leg wound. Capt. Spilberg appeared clutching a pistol and choking as he said, "Sir, they're using CS!" The colonel gasped, "No fucking shit!" The North Vietnamese packed the captured gas in some of their mortar bombs, as well as in satchel charges, intensifying confusion as Americans groped for masks.

Sappers ran hither and thither, knowing exactly what they were doing, as the garrison did not. Men fled from the communications facility when it became filled with yellow smoke. Almost all wireless links went down, though an operator on a residual artillery frequency demanded illuminants. He did not, however, report Mary Ann under ground attack, so that higher headquarters remained befuddled. One charge detonated a crate of white phosphorus grenades, which set fire to the operations bunker. Doyle remained conscious but concussed or perhaps merely in shock. During the ensuing thirty minutes, most of Mary Ann's men lay in hiding, praying to escape the enemy's attentions. Few got to their rifles, so that they were either unarmed or, at best, clutching pistols. Sappers loosed bursts of AK-47 fire wherever they glimpsed Americans. Some defenders heard the enemy chattering to each other and watched them lob Coke-can grenades before slamming bunker doors to contain the blasts.

Several attackers snatched watches from the wrists of prostrate Americans, either dead or pretending to be. One bent down to address a wounded man in English: "Are you okay, GI? Are you dead, GI?" before administering a contemptuous kick. The soldier held his breath and lay motionless while his wallet and watch were lifted. Lt. Jerry Sams had commanded his platoon for a month without hearing a shot fired. Now, as he struggled to pull on his boots, a grenade explosion permanently blinded him in one eye and inflicted multiple fragment wounds. He lay nursing his agony in a Conex: "I could hear 'em killing my people!" At one end of the position stood an ARVN howitzer battery, which never fired. Engulfed by clouds of CS gas in the old mess hall, cooks screamed in a panic intensified by a shower of grenades.

Only a few men fought back. It was claimed that Lt. Barry McGee, a West Pointer disliked by his men, who had been a Golden Gloves boxer, killed a sapper with his bare hands before himself being shot. Tony Jorgensen used a pistol to shoot an attacker who was kicking him, but he was then wounded by the man's grenade and lay splattered with mingled American and Vietnamese blood. Two supply men, Louis Meads and William Meek, were stunned by a grenade explosion, but poked their heads out of the debris far enough to see two attackers muttering to each other, whom they shot. Meek said, "I felt so good because I knew the sonofabitch wasn't going to get me." The NVA account of the action describes a hand-to-hand grapple between their own little Pvt. Trung and a large American who tried to throttle him, which ended with the attacker detonating a grenade which killed his assailant. Another sapper allegedly brained a defender with a section of bangalore torpedo tubing.

Capt. Spilberg described Lt. Col. Doyle and two others wrestling with the useless radios amid the fires in the command bunker. A hysterical officer casualty, Ed McKay, shouted, "We're all going to die!" The colonel slapped him across the face and bellowed, "Shut the fuck up, lieutenant!" The heat in the bunker became intolerable: its occupants managed to scramble unnoticed through the darkness toward a nearby aid station, which was deserted.

Higher headquarters still had no idea what was taking place on Mary Ann. Illuminants revealed little, because the firebase was shrouded in smoke from burning hooches and ordnance. When Spilberg suggested to Doyle that they should make a move, the traumatized colonel dissented, telling the captain, "Paul, this is where we're going to die." Yet there was now silence around their own refuge on the south side of the FSB. The officers could hear continued firing only at the north end, where the enemy were busy destroying two 155mm guns and shooting gunners as they stumbled out of a bunkhouse. An artilleryman later gave evidence to the army inquiry about his comrades: "They were so shook up and scared they just ran in all different directions." Two medics almost tripped over a supply sergeant lying with both legs blown off.

The North Vietnamese broke off their attack at 0325, forty-five min-

utes after it began, when the first American gunship, a Night Hawk Huey equipped with infrared, appeared above Mary Ann; its spotlights and tracer caught some attackers retiring through the wire. Soon afterward, a dust-off landed. Sgt. John Calhoun, one of the first casualties to be evacuated, had been hit in five places. He said, "Being from the country, we used to butcher hogs. You get a smell when you gut a hog—and I could smell it on the chopper from intestinal wounds. It was a sickening smell, and people were moaning and groaning and pleading."

Back on the firebase, order was slowly restored. Lt. Col. Doyle hobbled among the casualties with his own leg bandaged, making wan little jests about men's "million-dollar wounds." Fires still blazed, and the darkness was periodically punctured by flashes from ordnance explosions. Rotorwash fanned flames as the shocked brigade commander disembarked from a helo. A medevac pilot asked if body bags were needed. A soldier replied, "As many as you can get." Some American dead were burned to charcoal. Five severely mangled communist corpses were burned in the trash dump, which subsequently prompted a threat of war crimes charges against officers responsible.

The attackers retired triumphant but faced further privations: lacking rice, for the next four days they lived on jungle plants. They admitted the loss of fourteen of their own men, and carried away twenty-one wounded—which shows that at least a small minority of Americans resisted effectively. Following Doyle's evacuation, a new CO was appointed to Mary Ann, who set about imposing belated discipline. On Lt. Col. Clyde Tate's second day, when he found whiskey in the operations room, he smashed the bottle. Survivors, nursing trauma and bitterness, convinced themselves they were victims of an inside job—that the ARVN on the firebase, whose quarters were not attacked, had provided information and maybe access for the sappers. This was a fantasy, but it reflected the pervasive lack of trust between Americans and "their" Vietnamese.

The 23rd Division inspector general's report told a dismal story: men assigned to guard duties were asleep; most had sought refuge rather than engage the enemy. He was brutal in asserting that many casualties were "victims of their own failure to do what they were told to do." He also

592 · VIETNAM

acknowledged the courage and professionalism of the attackers. Among US troops, he said, "there is . . . an understandable reluctance to acknowledge that in any given circumstance the VC/NVA might just do a better job than we do . . most VC/NVA soldiers appear to . . . believe in the rightness of their cause. . . . The same could not be said of the average American soldier in Vietnam in the spring of 1971." Divisional commander Maj. Gen. James Baldwin chose not to relieve Doyle of command of the 1/46th, but Abrams in Saigon overruled him. Baldwin was himself also sacked, together with the brigade commander.

MACV's report, delivered in July, found the dead Capt. Knight guilty of "dereliction of duty," and branded several other key personnel "ineffective"; Doyle was fortunate to escape court-martial. As facts about Mary Ann trickled out, the press had a field day. In the wake of the Calley trial, however, the US Army had no appetite for flaunting yet more dirty linen. Westmoreland wrote from Washington, "The Secretary [of the Army] and I want to do our best to reduce the number of self-inflicted wounds which the Army is receiving." Doyle was allowed to keep his uniform and rank, albeit in non-operational postings. Both he and Baldwin, their lives blighted, died relatively young. Apologists for the two men later claimed that they were scapegoated. This is true insofar as the tragedy reflected an institutional malaise: it had become hard for commanders at any level to impose their authority, to extract from their men even minimal standards of soldierly conduct.

No other single episode demonstrated so graphically the folly of trying to abandon the war unilaterally while within reach of the enemy. It almost defies belief that officers acquiesced in the indolence and even decadence that prevailed on Mary Ann. Many people afterward took pity on the garrison because its losses had been so grievous. Yet almost every man, from Lt. Col. Doyle downward, contributed toward his own nemesis.

Whatever was still being done by South Vietnamese forces, US air power, and some Army units, the bulk of America's ground forces were no longer remotely as motivated and disciplined, and thus as effective, as their communist foes. Lt. Brian Walrath, an American adviser working near Mary Ann, wrote later, "I doubt that the troops [manning the FSB]

were much different than most . . . at that stage." There was another such episode on May 21, when a firebase was struck by eleven 122mm rockets, which killed thirty-three Americans and wounded another twenty-one, chiefly because they had all been in a mess hall when the attack began, then fled to a single bunker, which received a direct hit.

Abrams was furious, because the unit had received warning of an imminent attack. He said, "You shouldn't fool with this stuff [intelligence alerts]. What you're doing is fooling with men's lives." The same happened again at LZ English, where men were playing volleyball and assembling for a movie when the enemy struck. Abrams shouted in frustration: "It was failure—a failure of command. They had the intelligence. . . . I don't know what the hell they're thinking of." They were thinking of going home: a month after the attack on Mary Ann, the Americans quit the hill forever. On Christmas Day 1971, the troops threw eggs at the brass assembled at Bob Hope's Christmas show at Bien Hoa.

2. THE "GOAT"

America's senior soldiers recognized that whatever further ground fighting took place, their own combat formations would no longer play a significant role. Fred Weyand said in May 1971, "Our air is going to be the glue that holds all this together. . . . If it weren't for that air, which is driving this guy [the enemy] right up the wall, we'd be in very bad shape, and yet these people back in Washington keep wanting to whack at that, too." He meant that there was constant political pressure—expressed in congressional funding cuts—to reduce the US air as well as ground presence in Vietnam. As American troops went home, air power became the principal weapon at the disposal of Nixon and Kissinger. Between March 1969 and May 1970, the president had personally mandated 4,308 B-52 sorties against targets in Cambodia, which were undisclosed even to USAF chief Gen. John Ryan. Before flying missions over Cambodia and Laos, navigators were required to sign a nondisclosure agreement; since Hanoi denied its own troops' presence in those countries, its leaders could scarcely make propaganda capital out of the illegal American campaigns there. Strategic

Air Command kept two sets of after-action reports: one for very limited circulation, identifying real targets; the other recording fictional attacks inside South Vietnam.

Another such deceit, however, is less well-known, and casts extraordinary light on the manner in which American war making was conducted in those days. From 1969 onward, Nixon pressed his air commanders to hit the North Vietnamese as hard as they could, wherever they could. He had formed a low opinion of the military, often complaining about their alleged timidity. For domestic reasons, however, the administration was unwilling to seek escalatory adjustments of the rules of engagement, which would attract the unwelcome attention of Congress and the media.

In the latter months of 1971, the president personally authorized repeated strikes against armor and vehicle concentrations north of the DMZ. These were perfectly rational measures against an enemy who was massing forces for a spring offensive, yet they breached the established RoE. In November Adm. Thomas Moorer, chairman of the Joint Chiefs, told Lt. Gen. Jack Lavelle, commanding Seventh Air Force in Saigon, to dispatch reconnaissance flights against Dong Hoi Air Base in North Vietnam, because the communists would be sure to fire on them, thus justifying bombing. Here was an issue that would become central to the so-called Lavelle scandal. RoE prevailing since 1968 permitted US aircraft to attack gun and missile positions in the North only if these had first fired on them; and on radar installations only if these were already vectoring MiG-21 fighters onto American aircraft. Rationally absurd though such restrictions might be, they assumed the status of holy writ at a time when many members of Congress were bent upon using every ounce of their powers to shut down the war.

The RoE allowed a certain license in interpretation—for instance, authorizing attacks on radar stations known to have locked on to American planes before their linked missile launchers could fire. But in December 1971 the communists began to fire SAMs instantaneously with radar lock-on, which denied pilots arrival tone warnings. Confusion increased in the minds of airmen and commanders, about how far they might go in launching unprovoked attacks on enemy launchers that might shoot

down aircraft. The mood music from the White House was never in doubt: Nixon wanted the communists hurt. He repeatedly complained that the Air Force was not doing enough, partly because radar bombing through overcast was often ineffectual. In December 1971, Gen. Ryan visited Udorn Air Base in Thailand and told crews that he was bitterly disappointed by their "dismal performance." But when Defense Secretary Melvin Laird visited Saigon and Lt. Gen. Lavelle requested additional RoE latitude, Laird turned him down. Instead, said the defense secretary, Seventh's chief should "make maximum use of the authority we had and he would support us in Washington." Yet a month later, Laird, who was not in the White House loop, said contradictorily that radar installations should be attacked only if they were controlling MiGs that were already "airborne and hostile."

On February 2, 1972, Adm. Moorer told Nixon that he had directed Creighton Abrams—in his capacity as Lavelle's superior—"to increase his airfield reconnaissance and to make certain these reconnaissance aircraft are heavily supported with bombing aircraft, and if these aircraft are fired on, which they always are, he was to then attack the airfield, and so we have been doing a series of operations of this type, sir." The president said, "I just want to be sure that [the RoE] are being interpreted very, very broadly." On the following day, he briefed Ambassador Ellsworth Bunker, who was visiting Washington, that he must tell Abrams, "He can hit SAM sites, period. But he is not to build up publicity. . . . And, if it does get out, . . . he says it's a 'protective reaction strike.'"

Such operations now precipitated a huge row. In January, Lavelle, a World War II fighter ace, had indeed ordered some "protective reaction" strikes. When attack crews said afterward that the enemy had not responded, they were warned against admitting this in their computerized OPREP-4 afteraction reports. The following month, an intelligence specialist at Udorn Air Base named Sgt. Lonnie Franks wrote to antiwar senator Harold Hughes, saying that aircrew were making false postmission reports to justify bombing. Hereafter, the story played out in public. Gen. Ryan, with whom Lavelle had had longstanding differences, dispatched Air Force inspector general Louis Wilson to Saigon to investigate these charges. He reported

596 .

back, on the most questionable evidence, that Seventh's commander had ordered missions that clearly violated the agreed RoE. Lavelle was promptly recalled to Washington and retired from the USAF on "health grounds" with the rank of major general, forfeiting two stars.

At this stage, President Nixon knew nothing, but he held a personal meeting with Lt. Gen. John Vogt, newly appointed replacement commander of the Seventh Air Force, with Kissinger in attendance, at which he told Vogt that he wanted much more aggression from the Air Force. The airman later described Nixon at this encounter as "wild-eyed." Then came front-page media leaks about Lavelle's dismissal. Editorial writers excoriated the general for having carried out a "private air war" in defiance of his superiors, for which he had engaged pilots and subordinate commanders in "a widespread conspiracy." At a meeting with Kissinger and Secretary of State Rogers on June 14, for the first time Nixon focused on the disgraced general: "What the hell is that all about?" he demanded. "Who is Lavelle? Is he being made a goat? If he is . . . it's not good." Kissinger and Rogers explained Sgt. Franks's letter and what had followed. At another meeting later that day, Kissinger said, "What happened with Lavelle was he had reason to believe that we wanted him to take aggressive steps." Nixon responded, "That's right, that's right." Kissinger: "And then suddenly Laird came down on him like a ton of bricks." Nixon: "I don't want a man persecuted for doing what he thought was right." Kissinger grumbled about the military: "They all turn on each other like rats," to which Nixon assented. He then said, "Can we do anything to stop this damn thing?"

Now ruthless politics took over. Kissinger said, "I think this will go away. I think we should just say, ah . . . we took corrective steps." Nixon heaved one more ritual sigh over the grave of Lavelle's career: "It's just a hell of a damn. And it's a bad rap for him, Henry." That was the end of the airman. Kissinger was not wrong about the rats "turning on each other." Moorer testified to a Senate committee in September 1972 that he had never advocated protective-reaction air strikes against the North—which was a falsehood. Abrams told the same hearings, "[Lavelle] acted against the Rules, and I think Rules are a little different than policy." Abrams's equivocations emphasized what a tangle of deceits the war had become.

Lavelle's dismissal for executing the oft-expressed wishes of his commander in chief reflected deplorably upon his superiors Moorer and Ryan, who indeed made him a "goat," to use Nixon's word. The RoE under which the USAF was required to operate were ridiculous and hypocritical. There was only one rational choice: for the Americans either to conduct an air war against the North, or not to do so. But in the increasingly deranged world of Washington policy making, neither reason nor honesty was available.

3. "LET'S GO HOME"

Creighton Abrams had become a shadow of his former self, a victim of ulcers, pneumonia, high blood pressure, and excessive alcohol consumption: on those grounds alone, heedless of the forfeiture of White House confidence, it is remarkable that he remained in his job. One of the most vivid exchanges between Nixon and Kissinger took place on the morning of May 29, 1971, just before the national security adviser embarked on a new round of secret negotiations. He outlined his plans to make a deal in time for the next presidential election: "So we get through '72. I'm being perfectly cynical about this, Mr. President."

Nixon: "Yes."

Kissinger: "If we can, in October of '72, go around the country saying we ended the war and the Democrats wanted to turn it over to the Communists. . . . "

Nixon: "That's right."

Kissinger: "Then we're in great shape."

He spoke freely about the likely fate of Saigon: "If it's got to go to the Communists, it'd be better to have it happen in the first six months of the new term than have it go on and on and on."

Nixon: "Sure."

Kissinger: "I'm being very cold-blooded about it."

Nixon: "I know exactly what we're up to."

On June 13, the *New York Times* began publication of what became known as the Pentagon Papers, the highly classified report commissioned

598 · VIETNAM

five years earlier by Robert McNamara, which recorded with icy candor the deceits and misjudgments whereby the country had become entangled in Vietnam. Though the administration's initial fury focused on Daniel Ellsberg, the official who had leaked them, their release increased the ever deepening conviction of the American people that they never should have been in Vietnam and now needed to leave that place of doom as swiftly as possible.

Alexander Haig said it had become obvious that the US must accept a coalition government in Saigon, including communist representation. For Hanoi, however, this was not remotely enough; the communists insisted upon the removal of President Nguyen Van Thieu with an obduracy that prolonged the stagnation of negotiations. The State Department, in an absolute reversal of decade-old policy, urged South Vietnam's president to reach out to the communists. Nixon told Kissinger in July, "They know they've got us by the balls." By the end of 1971, both the president and his adviser were ready to accept a cease-fire in place rather than continue to insist upon an NVA withdrawal from the South.

Probably the most important and certainly the most imaginative achievement of Richard Nixon's presidency—and it is sometimes forgotten that there were achievements—was détente with China. It is hard in the twenty-first century to recall the immensity of the political, moral, and strategic distance an American government was required to travel to seek a pragmatic reconciliation with a regime regarded by conservatives for almost a quarter of a century as a cradle of evil and Mao Zedong as architect of a historic US humiliation, the "loss of China." In conceiving the initial approach to Beijing, made through East European intermediaries, Nixon and Kissinger had two objectives. First was to initiate a dialogue that would deepen divisions in the communist camp and isolate the Soviet Union. Second and even more important was to advance a Vietnam peace settlement. The administration still believed that withdrawal of Chinese and Soviet support would render Hanoi's war effort no longer viable.

In a narrow sense, of course, they were correct. But they continued to underrate the overriding ideological pressure on Moscow to sustain support for North Vietnam. Soviet credibility would be devastated in the eyes of socialists the world over if Le Duan's heroic revolutionaries were abandoned in their hour of trial, and it was never plausible that this would happen. Kissinger, especially, by now set the bar very low for an acceptable peace deal. He wrote in a briefing book on the plane to Beijing for his first secret meeting with Premier Zhou Enlai in July 1971: "We want a decent interval." He meant that the Americans needed to be able to withdraw with dignity before Vietnam fell into communist hands. This message was repeated at his second, publicized, Beijing rendezvous in October, which stunned the world and caused acute alarm in Hanoi. Thereafter all Vietnamese, Northerners and Southerners alike, shared a new predicament created by the fact that the rulers of China and the US became vastly more interested in developing the bilateral relationship of their two huge nations than in the fate of either Hanoi or Saigon. This did not bring early peace to Vietnam, but it became a critical factor in the diplomatic processes surrounding it.

When South Vietnam held what proved to be its last presidential election in October 1971, to the embarrassment of Washington and to worldwide derision, Nguyen Van Thieu ran unopposed. Both of his rivals, Vice President Ky and Big Minh, withdrew their candidacies, increasing the implausibility of branding the war as a crusade for democracy. Yet still decision makers declined to countenance absolute defeat, US eviction from Vietnam. Neil Sheehan said wearily, "Americans could never get it into their minds that they had to go." When Tom Polgar was about to fly to Saigon as CIA station chief, he told Melvin Laird that he was uneasy about the safety of his family there. "Oh, don't worry," said the defense secretary. "We're going to have a residual force in Vietnam for thirty years, just like in Germany." But American troop withdrawals continued apace, as did their malign consequences. When the 173rd Airborne Brigade quit Binh Dinh Province, pacification collapsed and the communists secured political dominance. In July, Bill Colby, mastermind of CORDS and Phoenix, left Vietnam. By the close of the year, although there were still 175,000 Americans in the theater, most fulfilled support functions: only two US combat divisions remained, one of them deactivated.

Even among the relatively steady Australian contingent, in the last

600 · VIETNAM

months of Lt. Rob Franklin's 1971 tour, he thought, *I'm just about over this*. He had developed a deep respect for the communists—"really senior soldiers"—matched by a keen personal desire not to die at this point of the war. "They might call the missions 'search-and-destroy,' but by then I felt it was more like 'search-and-avoid.' You could tell this thing was all over." One day Franklin was leading a rifle platoon that bumped into a couple of Vietcong, whom they pursued into a rubber plantation. It was late in the day, and light was fading. Franklin signaled a halt. His sergeant, Arthur Francis, asked, "What're we stopping for, boss?" The lieutenant replied, "Franger"—Francis's nickname—"these guys have got this far. Let 'em go. Let's go home."

THE BIGGEST BATTLE

1. LE DUAN FORCES THE PACE

Many histories of the war view everything that happened beyond Tet 1968 as aftermath, because from that moment American extraction was decreed, and thus South Vietnam's doom was sealed. The latter proposition is possibly true, yet a towering reality persists: 1972 witnessed the largest battles of the entire conflict—all-arms clashes on a scale and of an intensity dwarfing those of 1968, with massive casualties on both sides. Meanwhile, in that year also, the world's greatest nations conducted historic summits; negotiations in Paris languished, then began their tortured dalliance with an outcome. And Richard Nixon secured reelection.

Le Duan did his serious thinking either at the coastal resort of Do Son or in Hanoi's Quang Ba Guest House. In the autumn of 1971, he spent time at both before making a momentous decision: the NVA would launch a conventional offensive, to lay bare before the world the failure of Vietnamization. He dismissed the objections of some comrades, who believed that American air power would prove fatal to this ambition. Implacable as ever, he saw his country engaged in a battle of wills with the United States, in which exposure of the debility of the Saigon regime would strengthen Hanoi's hand, perhaps precipitate the fall of Thieu. He was indifferent to the prospect that tens of thousands more of his own people must perish, at a time when US withdrawal was already assured.

602 · VIETNAM

If America's war leadership often flaunted its inhumanity, that of North Vietnam matched it cruelty for cruelty.

Because preparations could not be concealed for a ten-division offensive such as the communists intended, of which the northern arm was code-named Nguyen Hue in honor of an eighteenth-century Vietnamese ruler who vanquished the Chinese, the Americans received unusually explicit warnings. After a briefing on December 22, 1971, Creighton Abrams mused that the enemy was obviously "working at something. The signs are all there . . . I just don't like the smell of it." He summarized at another meeting ten days later: "We don't know when or where. . . . The only thing we know is that [the enemy] has decided . . . that at an appropriate time . . . he's willing to commit the whole damn thing." He meant all but two of North Vietnam's regular formations. On January 20, 1972, a MACV briefer told commanders, "There is no doubt this is to be a major campaign. Main thrust is expected to be against [Central Highlands and northern Quang Tri Province]." He added two days later, "For the first time since 1965 we face a situation in which a major enemy offensive must be defeated largely by [South Vietnamese] resources." He concluded, "No one will have all the assets he would like." This prompted a gale of laughter, ironic and apprehensive.

On February 2, Abrams himself said, "The show is on! The curtain's drawn, and we're in it." At a briefing for a visiting South Korean delegation, he suggested presciently that the communist objective would be "to go to the weakest thing in the whole set-up, the will of the American people. . . . If they can capture Ben Het, or Kontum City, for a week . . . and threaten Quang Tri, the press will say Vietnamization has failed. And the last few remaining members of Congress who would support continuing economic assistance, would have lost their faith." The above record makes it all the more astonishing that when the North Vietnamese struck, they achieved a large measure of surprise. This was partly because Abrams expected them to move at Tet; after they failed to do so, he was derided by the media for crying wolf. Moreover, nobody in Washington wished to hear the warnings. The national security adviser, especially, seemed confi-

dent that he was successfully managing the communists in Paris and was preoccupied with other geostrategic issues.

On February 21, the president began his historic visit to China, which was a triumph for both himself and his travel agent: Kissinger made the cover of *Time* magazine, though the inspiration for the initiative was Nixon's. The two sides spoke with considerable frankness, agreeing to differ about Taiwan. The president made plain his determination to get out of South Vietnam and his indifference to what took place thereafter, so long as, before the communists took over, there was a "reasonable interval," "sufficient interval," "time interval"—all phrases used at various times by Kissinger to Zhou Enlai. The Chinese asserted a desire, which proved sincere, for an end to their isolation, a new working relationship with the US for which they were prepared to make political sacrifices. They would not, however, cut off aid to Hanoi, and it was naïve of the two Americans to fantasize that they might. While Nixon's visit secured him magnificent headlines, he had flown to China hoping to secure peace in Vietnam but failed to get it.

Nonetheless, he returned home confident that he could now do almost anything he liked to the North, with the decade-long specter of Chinese intervention banished. His Indochina policies would hereafter be constrained by the American people, represented in Congress, rather than by China or the Soviet Union. Le Duan and his comrades in Hanoi grasped this shift in the strategic balance and were furious about what they perceived as a betrayal by Mao, who might with warning words to the US president have spared them from a new rain of bombs. A senior cadre grumbled that for China's chairman to receive Nixon was "throwing a life raft to a drowning pirate." Hanoi's sense of grievance was not assuaged by a new deluge of Chinese military aid.

Since 1968, vacuous formal talks between North Vietnam and the US had continued in Paris, successively fronted by Averell Harriman, Henry Cabot Lodge, and David Bruce. Fred Weyand, who served a stint as military adviser to the American delegation, recalled with distaste that the communists were "just implacable foes. No give in them

at all. When [Madame Nguyen Thi Binh] was sitting at that table, you just knew there was someone there filled with hate." The only meetings that mattered, however, were intermittent secret sessions, held in a white-stuccoed villa owned by the French Communist Party, between Kissinger and North Vietnam's Le Duc Tho. These stagnated because of Hanoi's insistence on the removal of President Thieu, matched by the US demand for an NVA withdrawal from the South—though from the summer of 1971 onward, the Americans knew that at best they would secure only gestures toward this end. In the year of Nixon's presidential reelection campaign, he was determined not to be seen to surrender, repeatedly asserting, "We cannot lose this war." Yet he had originally intended to bring home all armed forces personnel well before Americans voted, and was dissuaded only by Kissinger, who insisted that some forces must linger even past election day. It is interesting that, throughout many Nixon-Kissinger conversations recorded on the White House tapes, the national security adviser emphasizes the centrality of the 1972 presidential election more insistently than does the candidate himself, while indulging his master's vanity in a fashion that King Louis XIV might have found a trifle fulsome. "I'm probably the toughest guy that's been in this office-probably since Theodore Roosevelt," asserted the president. Kissinger concurred: "No question."

Nixon viewed aerial bombardment as a means of exerting pressure on the North that American voters—as reflected in polls, which he studied assiduously—found palatable and even curiously praiseworthy, as ground troops were not. Much later in 1972, it would become a moot point how far the president's escalation of bombing was driven by diplomatic imperatives and how far by a manic personal determination to be seen to prevail. Scholars continue fiercely to debate the nuances and timings of US shifts of position during the Vietnam peace process. It seems unnecessary to choose among their rival views. The key realities were clear; only admission of them was deferred. The American people were determined to escape from Vietnam; they now cared almost exclusively about the fate of their own men in communist hands, on which much verbiage was expended—gratuitously, since Hanoi would obviously surrender the pris-

oners once the last American forces went home. B-52 gunner Jack Cortel wrote, "Getting our POWs back was the only thing that gave us a sense of purpose."

Meanwhile the South Vietnamese will to fight, and their soldiers' enthusiasm for the Saigon regime, were now tenuous. ARVN Maj. Nguyen Cong Luan discussed his country's hundred-odd generals with fellow officers, who concluded that around twenty were competent and honest, while ten were both monstrously corrupt and irredeemably incompetent. In the midst of a discussion with the Americans about how Southern troop morale might be improved, Gen. Ngo Dzu's contribution was to propose reintroduction of the French army system of mobile field brothels. A young Vietnamese officer wrote to a British correspondent, expressing delight that both he and his closest friend were in noncombat branches of Saigon's army: "So we are not forced to kill anyone—and that gives us great joy."

Once the Americans were gone, it was extraordinarily unlikely that South Vietnam could survive, and neither Kissinger nor Nixon deluded themselves otherwise. They were concerned merely to maintain through an intermission of eighteen months to two years a pretense of commitment to the country's future. Kissinger, especially, was far more honest with China and Russia, America's foes, than with its friends. Apologists for the two men argue that they were saddled with responsibility for extricating America from a war not of their making, and played a losing hand as skillfully as possible. At least the first of these propositions is valid. The historic charge against them is, instead, that they presided over gratuitous years of carnage, merely to conceal from the American electorate, for their own partisan purposes, the inevitability of humiliation in Indochina.

Early in 1972 Maj. Walt Boomer was serving at Firebase Sarge in Quang Tri Province as adviser to a Vietnamese Marine battalion. Back in Bethesda, Maryland, his wife, Adele, said in weary bewilderment before he took off, "I can't understand why you're doing this." Boomer replied, "It's what I do. It's what I am." Arrived at Danang, however, he was shocked by its desolation, with so many Americans gone; cavernous facilities crumbling. He found that his predecessor had made himself hated by the Vietnamese for his bullying ways, and it took a while to create a better

606 · VIETNAM

understanding. Boomer was troubled by the chasm between officers and men. "The major would dish out discipline with a big stick. I sensed that if we ever got into a world of trouble, this could be an issue. I was lonely—read a lot, worked out a lot. I was not comfortable being with them. They were not looking for a fight; they were kind of worn-out." In the days before the North Vietnamese assault came, the American urged aggressive patrolling, but after one such mission got into a firefight, the major declined to send his men out again. Boomer said, "We've got to disrupt their buildup." The Vietnamese shrugged. "We don't have the strength." The American did not think them cowards, "but they were in a mind-set where they wouldn't take any risk they didn't have to." Now, however, South Vietnam's million men under arms found themselves confronting real and present danger, stark and inescapable.

2. THE STORM BREAKS

Lt. Col. Gerry Turley was on a familiarization visit to 3rd Division headquarters in Quang Tri, due to fly back to Saigon on March 29th, 1972, but his helo was delayed. At noon next day, "the world came apart." The communists achieved surprise by trampling the last tatters of the 1954 Geneva Accords, racing tanks south through the Demilitarized Zone, while also attacking from the west. The enemy had registered heavy guns on northern firebases that were soon tottering. As the offensive developed, Northern chief of staff Gen. Van Tien Dung also launched major attacks in the Central Highlands and toward the key town of An Loc, just sixty miles north of Saigon, while the Vietcong and NVA spread further havoc in the Mekong Delta. The Americans and South Vietnamese were shocked not merely by the weight of the assaults, but by the enemy's new Soviet and Chinese weapons: six hundred light and heavy tanks, state-of-the-art SAM-7 Strelá shoulder-fired antiaircraft missiles, and antitank missiles, including the wire-guided Sagger, for which thousands of communist personnel had been trained abroad, most in Eastern Europe.

In the north, a season of disasters unfolded. The egregious Hoang Xuan Lam, commanding I Corps, declined to acknowledge the strength of the enemy thrust. "Lam would not report bad news," said Gen. Vien at Tan Son Nhut. Ellsworth Bunker, the ambassador, had left the country for Easter; likewise Creighton Abrams. The MACV chief was in Bangkok with his wife, in the process of converting to Catholicism, so Fred Weyand, his deputy, was in temporary command. Weyand sought to stem panic talk, yet "in this case, no matter how you described it, it was a human wave attack, because there was just a hell of a lot of people coming across into your wire." The communists had timed their assault for Quang Tri's monsoon season: especially in the first days, low cloud severely dampened the American air response.

On the morning of April 2, Easter Sunday, communist tanks were spotted heading south toward the Dong Ha Bridge across the Cua Viet River. At 0915 an embattled Gerry Turley found himself appointed chief adviser to the collapsing 3rd Division after his American superior fled along with the Vietnamese divisional commander. Turley described the scene: "ARVN staff officers and their enlisted men simply stood up, grabbed their personal gear, and left the bunker. The most senior officers left first. Radios were left on and simply abandoned; maps and classified materials lay where last used. Order melted into chaos as frightened men, who had ceased to be soldiers, ran for the nearest vehicle. Frightened American soldiers carrying radios and stereo equipment scurried to the LZ with desperation on their faces. It was a dark and tragic day."

Turley was obliged to give one would-be fugitive US officer a direct order to remain—and later had to repeat himself twice more. He himself thought, The weather is against us; the ARVN infantry are disappearing; their artillery won't shoot back; tanks are coming straight at us. He was so amazed by the instruction that he take charge that, as evidence of authenticity, he demanded the social security number of the full colonel who issued it—a fortunate precaution because when Abrams arrived back in Saigon and received dire reports from the north, he exploded in disbelief. The general was told, "A Marine lieutenant colonel adviser at Quang Tri combat base says the situation there is desperate"—this was Turley. However, Turley's superior, Maj. Gen. Fred Kroesen at Danang, claimed that the man on the spot was wrong and had succumbed to panic.

Abrams, furious, said, "My impression is that there's a hell of a lot of marijuana smoking going on. . . . I don't know all the moves that have got to be made to stop this crap, but . . . I want this shit stopped!" However, responsibility for the "shit" rested with the North Vietnamese, and they had only just started. ARVN leadership in the north collapsed. Turley said, "The key issue is always: who's in charge? After six years, we still hadn't figured that out. There was no unity of command. In the north, after we pulled out seventy thousand Americans, the South Vietnamese couldn't fill the holes."

There was a bitter row between US officers on the ground and the USAF when a pilot's survival radio beeped inside the DMZ after his EB-66 was shot down. While a huge effort was mounted to rescue him, the Air Force imposed a ban on artillery fire extending fifteen miles around the downed flier's reported position, a radius that included the corridor through which NVA columns were pouring south. Air support adviser Maj. David Brookbank wrote in a bitter after-action report, "This gave the enemy an opportunity unprecedented in the annals of warfare to advance at will." The missing pilot was eventually recovered on April 12 by South Vietnamese SEALs and their US Navy advisers, after two fixed-wing search aircraft and a Jolly Green Giant helo had been lost to communist missiles. Though seventy thousand Americans remained in Vietnam, only six thousand were combat troops: the battles now developing would be decided by Southern troops and their advisers—and above all by air power.

It was often said that helicopter aircrew were the only institutional element of the US Army and Marine Corps in Vietnam whose courage and commitment never flagged. Among the foremost heroes of the 1972 battles were American pilots who took fantastic risks to rescue advisers trapped in the path of the onslaught. A Huey flew with an escort of two Cobras to rescue a five-man FO team from bunker Alpha 2, just below the DMZ. It landed under artillery fire, and Lt. Joel Eisenstein sprinted thirty yards to the bunker, where he found Lt. Dave Bruggeman desperately wounded by shrapnel in the head—the young man had given his helmet to a frightened Vietnamese Marine whose own had been stolen. Eisenstein

dragged the officer to the chopper, pulled aboard some wounded soldiers, then took off as one Vietnamese, enraged that they could not take him, aimed a Thumper at them. The American experienced a spasm of terror: "The thought raced through my mind: That son of a bitch is going to blow us out of the sky. If he can't go, he's not going to let anyone else go, either. The Vietnamese held his fire, but Bruggeman died in the air, in Eisenstein's arms. Later, when they extracted more Americans from the big base at Ai Tu, the area's top Saigon officer elbowed his way aboard first.

In the operations center at Quang Tri, the VNAF tactical air controller had vanished, along with many others. Turley told Danang that the Dong Ha Bridge south must be destroyed ahead of the enemy's tanks, but this was vetoed by senior US officers: it would be needed for a counterattack. The Marine then urged the Vietnamese to reinforce the bridge's defenders, fast. The divisional chief of staff refused. Turley pleaded instead with the brigade commander to act on his own initiative. After a long, expressionless pause, the Vietnamese looked at the map, then at Turley, blinked, and said—not without the approval of his commandant in Saigon. The despairing American begged and implored the Vietnamese, who "finally said in the most beautiful English, 'I will give the battalion commander the order to hold Dong Ha.'" Turley shouted, "God, maybe there is a chance after all!"

The Southern Vietnamese deployed three LAW antiarmor teams on the south side of the bridge. They watched the invaders hoist their flag on one of its steel girders, even as refugees and stragglers still streamed across. Against orders, Turley instructed Capt. John Ripley, an infantry adviser, "Somehow blow up the Dong Ha bridge." A few days earlier, Ripley was assuaging chronic boredom by assembling a thousand-piece jigsaw of King Kong. Now he hitched a ride on an M-48 tank east through the city of Dong Ha, the road already strewn with debris and wrecked vehicles from communist shelling. On the north bank of the river, where four years earlier Capt. Jim Livingston and his Marine company had deployed before the battle of Daido, an enemy column of twenty tanks was visible. Some of the fugitive Vietnamese troops streaming toward the rear hijacked the American advisers' jeep with its secure communications. The headquarters log recorded, "The 57th Regiment has broken and is in complete

rout." A Vietnamese Marine major jumped down from a tank and seized a fleeing soldier, shouting, "Where are you going?" The man cried, "No use, no use." The officer drew his pistol and shot his compatriot dead, but as a deterrent the execution was a failure: hundreds and soon thousands of Saigon's troops were in flight.

Yet some stayed—and fought gallantly. At the Dong Ha Bridge a corporal named Luom fired a LAW at the lead communist tank but missed. A second shot exploded below the turret, causing the tank hastily to reverse away; Luom was killed a few weeks later. The invaders diverted their infantry to the old French rail bridge nearby, of which one span had been shattered in 1967, but its fallen wreckage remained negotiable by men on foot. John Ripley called in US naval gunfire, which checked the infantry and thereafter destroyed four enemy tanks. Saigon tanks on the south bank began to fire on communist armor across the river.

Then Ripley and the Army's Maj. Jim Smock set about destroying the highway bridge, where they found five disconsolate ARVN engineers contemplating a stack of boxes of plastic explosive. Ripley said later, "They seemed to be wondering if we were sent to kill them or if they should save us the trouble and kill themselves. No humans . . . ever looked more hopeless or helpless." While the Americans searched in vain for blasting caps, the South Vietnamese vanished. Between the bridge and the explosives was a big fence. Ripley crossed, then Smock heaved over twenty-five boxes, one by one, both men shredding their arms on the barbed wire.

The Marine clambered out onto the girders and began laying charges, watched from the north bank by the enemy. They started firing at Smock but, oddly, not at Ripley, though a T-54 tank eventually lobbed a few shells his way. After three hours of painful, exhausting, nerve-racking labor during which the devout thirty-three-year-old repeatedly muttered to himself, "Jesus, Mary, get me there," the bridge was set. They found a box of electrical detonators, then ran with the wires back to the ARVN lines, took a battery out of a wrecked jeep whose tires were blazing, and triggered a hellbox. Nothing happened. Desperately they pressed it again and again, until suddenly there was a huge explosion, and the southern span collapsed into the river. Ripley radioed Gerry Turley, "The Dong Ha

Bridge is down. I say again . . . the bridge is down. Over." Turley logged the message at 1630. Walt Boomer, facing troubles of his own farther west, said later with profound gratitude, "Ripley saved our lives." In Saigon a briefer told Abrams that the Marine had blown the bridge "while waiting for clearance," which prompted relieved laughter among the command group. Ripley later received a Navy Cross: his feat played a critical role in slowing the southward communist advance.

Farther west, at Camp Carroll, Southern regimental commander Col. Pham Van Dinh, who had led a battalion at Hue in 1968, claimed to have received a stark message from his local NVA counterpart: "Surrender or die." He requested a cease-fire to discuss this demand with his officers, thirteen of whom met in his operations room at 1500 on April 2. He told them, "If we continue to fight, many people will be killed. Even if we die or are wounded and win a victory, nobody will take care of us. Now, we must take care of ourselves." A lone major urged fighting on, while the rest remained mute. Dinh secured a vote for surrender, then approached his advisers, Lt. Col. William Camper and Maj. Joe Brown. Camper already regarded the regiment, which contained many former deserters, as "a disaster looking for a place to occur." He had met Dinh seven years earlier, and even before the current debacle was shocked by the change in him—the Vietnamese seemed "pudgy and apathetic."

Dinh himself later admitted "some problems in my head." His men would not fight anymore, he told the advisers, and suggested that they might care to shoot themselves "to save us from embarrassment." Camper said, "That's not what Americans do," and momentarily considered shooting the Vietnamese. Then he radioed Turley and said enigmatically that he was leaving his position "for reasons he could not explain." Turley, knowing nothing of what was taking place, said, "No, Colonel, stay where you are and do your damn job!" But when the Americans made plain their desperate circumstances, a helicopter ducked in through a hail of communist fire that damaged its hydraulic lines. Covered by five Cobra gunships, it retrieved the advisers, who eventually reached Quang Tri. At Carroll, eighteen hundred prisoners and five batteries of artillery fell into communist hands: Dinh was rewarded with a commission in the NVA.

612 · VIETNAM

When Turley reported these developments to MACV, he received an enraged response: "Colonel, you're crazy. [The Southern corps staff] doesn't know about any such surrender. Camp Carroll has twenty-two guns, two thousand ARVN soldiers. . . . You've flipped." Shortly afterward, Turley was ordered to leave his post forthwith, fly to Saigon, and report personally to Abrams. He was brutally reprimanded, saved from disciplinary action only because he could show his orders in writing. At a time when everywhere from the White House downward a hunt for scapegoats had begun, it was the Marine's misfortune that he bore the first ill tidings.

The communist assault on FSB Sarge, west of Carroll, started with a storm of rockets. The neighboring hilltop was swiftly overrun, and its defenders melted away. Walt Boomer, profoundly lonely, never expected to see fellow adviser Ray Smith again—and had little hope of going home himself, either. The shelling of Sarge intensified, and casualties mounted, including two young American electronic eavesdroppers killed. After the Marine's bunker took a direct hit, it was plain the position could not hold, and he urged the Vietnamese CO to pull out. Eventually the major assented: "We go now." They set off in darkness, accompanied by their walking wounded, and spent the ensuing two days in jungle, never seeing enemies but often hearing them. Then, as they emerged into open country, communist soldiers spotted them, and cut loose.

Boomer's Vietnamese companions broke and ran in all directions. The American shouted in English that meant nothing to them, "Stop! Don't run! Don't leave your wounded!" He was tempted to shoot his own Vietnamese wireless operator when he found that the man had thrown away his set—Boomer's lifeline. As for other fugitives, Boomer said, "I can remember clearly the terrified look in their eyes as they streamed past me. . . . At that point it was every man for himself." Their small group kept walking—or rather, stumbling at the outer limits of physical and emotional exhaustion—until they reached another firebase, still in friendly hands. To Boomer's amazement, Ray Smith also appeared, having carried out a wounded Southern officer aided by just one Vietnamese—his battalion's other sixty-eight survivors declined to help. They knew they must

keep moving ahead of the communist tide, but Boomer felt too exhausted to march another mile. Smith tied a rope around his colleague's wrist and knotted it on his own belt: thus joined, the two staggered on their way through darkness. At dawn they approached Quang Tri. Smith, who still had a wireless, contacted astonished Americans, who had assumed them dead and who now sent a Huey. Half their battalion were dead or captive, however. And the communists had hardly started.

On April 3, the NVA made its first move in the Central Highlands, against FSB Delta. In the weeks that followed, the key figure in the region's defense was John Paul Vann—he who had presided over disaster at Ap Bac in January 1963. In the intervening years, a transformation had overcome him, which few of his old admirers thought benign. From being the shrewd skeptic, the reckless antiauthoritarian, he had become the obsessive warrior. David Elliott said, "Vann had gone off his rocker. In his last years he was saying stuff that the old Vann would have completely rejected." By forging an unlikely alliance with II Corps's commander, the heavy, indolent Gen. Ngo Dzu, Vann had secured appointment as its senior American, a civilian with two-star ranking who acted the part of local warlord. Though Abrams disliked Vann, the little man's messianic commitment had won the admiration of Richard Nixon, Fred Weyand—and Southern officers, who called him Mister B-52 because of his extraordinary ability to magic up air strikes in desperate situations.

In the Central Highlands during what proved the last two months of Vann's wild life, he deployed every ounce of his energy and fury to repel the North Vietnamese. He flew resupply sorties, directed air support, goaded commanders, and flew through firefights in a fashion that eventually broke the nerve of his longtime favorite pilot, Bob Richards, so that even copious infusions of whiskey no longer persuaded the flier to play chauffeur to a man indifferent to bullets. Vann treated Vietnam as if the struggle was his personal property, so that many Americans found it impossible to imagine Vann without the war, the war without Vann. His courage was that of a near madman, yet one who was intelligent enough maybe to know, in his heart, that he was striving to defy destiny.

A weariness—that of years rather than of mere days or weeks—oppressed many Southern troops as they deployed in the Highlands. Airborne operations officer Capt. Doan Phuong Hai recalled as his unit drove up Route 14 toward Kontum that he had been wounded in an action on the same road in 1967, then treated in a local Catholic church by its muchloved French priest, "Father Joe." Now, Hai saw that the church's steeple had collapsed and the structure was reduced to rubble. His 11th Airborne Battalion was deployed to hold Firebase Charlie, six miles southwest of Tan Canh. Its commander, Lt. Col. Nguyen Dinh Bao, "Brother Five" to his officers, was deeply unhappy about his orders, which as so often required the unit to hold a fixed position, leaving the initiative to the enemy. Patrols soon met strong forces of Northerners, digging bunkers and gun positions within easy range.

The two sides began exchanging artillery fire. On April 6, the NVA launched a major ground assault on FSB Delta, south of Charlie, which continued all night. The attackers broke through Delta's perimeter and overran half its positions. By dawn they had been driven out with heavy loss, but the men of the 11th knew that it would be their turn next. Bao, who was much respected, told his two most trusted subordinates, Maj. Le Van Me and Capt. Hai, to occupy bunkers a distance from his own, so that one of them could assume command if he was killed. He urged parsimony with ammunition, had every available Claymore planted, and pushed out listening posts. Hai wrote, "The battalion prepared for terrible times."

At night as the enemy buildup continued, they watched convoys of Molotova trucks moving freely down the Ho Chi Minh Trail with headlights blazing. "Our guns lacked the range to reach them. We called for air strikes, but none were available. We asked [the unit's adviser Maj. John] Duffy for B-52s, but nothing happened." Bao had attended jungle warfare school in Malaysia, where he acquired a British camouflage parachute smock, which he loved to wear. His superstitious soldiers, however, fixed on this garment as a bad omen: they begged him to take it off, but he remained impervious to their pleas.

In the succeeding days, a storm of artillery fire fell on Charlie, followed on April 9 by the first infantry attack. This was repulsed with heavy

losses, but the enemy's 130mm guns inflicted increasing punishment on the defenders. On the 10th, after another pulverizing bombardment, the enemy's 320th Division launched a succession of assaults. Late that night, Brother Five's officers renewed their pleas for him to discard his smock. He said dismissively, "All right, I'll think about it tomorrow—which will be in about thirty minutes. You guys just like to give me a hard time, or maybe you want to get your hands on my smock. Clothes don't have a fucking thing to do with luck!"

Then B-52s came, summoned by John Duffy. Hai wrote: "Suddenly the earth shook and flames boiled into the sky. . . . It was hard to breathe. I stood bracing myself against the wall of the communication trench with hands covering my ears and mouth open to counter the concussions, but I still felt like the blood was about to burst from my chest. . . . Dirt, rocks, branches rattled off my helmet. Next day there were no enemy ground attacks, and only spasmodic artillery rounds." Yet flak remained heavy enough to hold off medevac choppers; one that tried to land was hit and limped away, bleeding smoke. Brother Five conferred with his officers, who begged him to abandon the position. Early morning mists and the darkness that descended at 1600 severely inhibited air support, even when planes were available. Hai said, "If we just sit here waiting to be clobbered, we're dead." The CO replied, "I've already told headquarters that, but no one will listen. I'm as sick as you are of the words 'Hold on to the last man!"

Morale sank, not assisted by the moans and cries of wounded men, for whom medical supplies were almost exhausted. In the early hours of April 12, Hai renewed his pleas to Brother Five to change his smock. The colonel wearily agreed. "You guys read all those damn astrology books and come up with all kinds of stupid ideas. I'm going back to my bunker to write a letter—call me if anything happens." He delivered a parting injunction to collect weapons and ammunition from the dead, since they would receive no more resupply. Then enemy shelling and rocketing began again, thudding into the hilltop. John Duffy said later. "The NVA FO above Charlie was good. He took out three of four command bunkers in ten minutes." The colonel's suffered a direct hit, and his staff dragged out his body . . . still clad in its British Airborne smock.

By late afternoon, shells had killed or badly wounded thirty men, and another hundred were slightly injured. The position was shrouded in smoke and dust when the artillery abruptly stopped and the Southerners saw line upon line of enemy infantry rise and advance on Charlie, their pressed-paper helmets and khaki tunics adorned with leafy camouflage. Artillery and air-dropped napalm ploughed swathes in their ranks—in all, during the two-week battle, Duffy directed 188 strikes by Cobras and fixed-wing aircraft—but two planes were hit and one came down. At last communist survivors withdrew, leaving behind a stench of burned flesh.

Yet with ammunition dwindling and garrison numbers much reduced, the Vietnamese commander and Duffy decided that the position was no longer defensible. Renewed B-52 strikes bought time for the survivors to withdraw at nightfall on April 14, stumbling downhill in thin lines totaling 167 men weakened by exhaustion, wounds, and hunger-rations had run out two days earlier. Next morning they were awaiting helicopter evacuation when heavy firing broke out: the enemy was pressing their rear. Two Cobras swooped, shooting and rocketing, driving away the communists even as a Huey lifted out one group of Airborne. Three further loads escaped safely, until only a handful of Vietnamese were left with Duffy. Two more Cobras struck, pushing back the communists yet again. Then another Huey dipped to earth. The exhausted men piled gratefully aboard, even as enemy fire ripped into the fragile hull, wounding the copilot. As they rose into the sky with Duffy still on the strut, Hai was hit twice in the leg by AK-47 fire, and toppled off the side. The adviser caught the little captain by his web gear and yanked him back aboard. The Huey clattered toward safety, as Duffy tended the crew chief, hit in the chest: the American died a few minutes later, one day before he was to leave Vietnam.

Just 37 of the 471 men who garrisoned Charlie escaped by air. FSBs Delta and Metro fell along with Charlie, and on April 24 Tan Canh was lost. Duffy, a special forces officer, later received a Distinguished Service Cross. So much has been written about tensions in the relationship between American soldiers and Vietnamese that the saga of the 11th Airborne and the fine part played by their adviser deserve notice. The defense

of FSB Charlie remains a proud memory of ARVN veterans, to set off against such disgraces as Camp Carroll's surrender.

Meanwhile north of Quang Tri, there were fierce encounters between rival tank forces. When M-48s knocked out the first of a column of communist T-54s, exultant South Vietnamese infantrymen leaped to their feet and clapped their hands shouting, "That was just like the movies! It's over!" It was not, of course. An officer wrote, "One corner of the horizon was filled with flames, smoke, the acrid stench of burning flesh mingled with that of cordite." The Ai Tu ammunition dump caught fire, and communist artillery began to pound Quang Tri. Abrams said, "What Giap's got on here is what in basketball they call a full court press. He's committed every *goddamn* thing he *owns*!"

And Hanoi had done this against the explicit wishes of the Russians. On April 20 in Moscow, even as the battle raged in Indochina, Kissinger met Soviet leader Leonid Brezhnev, whom he found eager to fix a summit meeting with Nixon. A prevailing theme of that year was that, while the Soviets continued vociferously to denounce American conduct in Vietnam and to make large weapons deliveries to the North, privately they made plain their indifference; like the Chinese, their foremost priority was détente—deals on such issues as strategic arms limitation. Just as the US government sustained its support for Saigon for overwhelmingly domestic political reasons, so China and the Soviet Union did likewise for Hanoi, to assuage sentiment within their own ideological constituencies.

John Vann had sworn that FSB Delta and the town of Tan Canh could be held against the two attacking Northern divisions, and for a time he made good his word. Following the loss of Delta, however, the Southern 22nd Division holding Tan Canh collapsed ignominiously. Defenders were shocked to see their tanks being destroyed by Sagger missiles, one of which hit the command bunker. Vann played a prominent role in evacuating surviving US advisers, who found themselves shooting advancing communists at almost point-blank range even as they sprang aboard helos. As well as acts of courage, there were also deeds of shame: while American dust-off pilots would famously risk all to evacuate casualties, some of

their VNAF counterparts sold seats on Hueys to unwounded fugitives. Many Regional and Popular Forces militiamen fled in disarray. Gen. Dzu suffered a nervous collapse and disgusted Vann by seeking to persuade President Thieu to abandon the entire Central Highlands.

The region, and especially the provincial capital of Kontum, a town of twenty-five thousand people on Route 14, were saved because the communists paused to regroup for three priceless weeks after taking Tan Canh, enabling the South Vietnamese to reinforce and the Americans to deploy two gunships fitted with TOW antiarmor missiles, which proved invaluable against T-54s. Some Saigon generals had odd notions about how to encourage subordinates. A corps commander exhorted the man appointed to defend Kontum, "Ba, do your best and don't run away!" Col. Ly Tong Ba was the Vietnamese officer who almost a decade earlier had incurred John Vann's scorn at Ap Bac. Now, however, the two men forged a remarkably successful battlefield partnership.

Among the communist troops fighting in the north at Quang Tri was seventeen-year-old gunner Pham Thanh Hung, experiencing his first battle. From the moment that a bullet glanced off his helmet, Hung felt convinced that he was properly destined to become a poet rather than a hero: "I was terrified, the sweat pouring down my back." He was an unusual man in that army, one who dared to think for himself. Hung's father had conducted a long struggle to keep his son away from the war, and might have succeeded but for the North's manpower crisis. At the end of the teenager's first year at Hanoi University, students were suddenly informed that, although they were not being drafted, they must "volunteer" for military service. The night before their medical exam, Hung and a friend sat for hours on the roof of their dormitory, fantasizing about how they might escape the hated prospect by drinking coffee laced with tobacco, which somebody said would send their blood pressure soaring. This proposition was never tested, partly because neither knew where to get tobacco in a hurry; moreover, they fell asleep as they talked, and awoke to find the sun high and the medical board in session. A few weeks later, their entire year assembled in the university's grand hall, to be addressed by its president.

In the midst of his speech, the platform on which he stood collapsed. Much of his audience dissolved into tears, convinced this was a terrible omen: "We really thought it meant we were all going to die."

The students represented North Vietnam's intellectual elite. Such was their naïveté about the nature of the experience that awaited them that some reported for induction clutching guitars and books—English novels were fashionable, though like Shakespeare these caused identified readers to become ideologically suspect. The girls of their year told them to make sure they all came home as colonels. The boys cracked nervous little jokes at each other: "Either the grass will be green or your chest red," meaning that they would win either graves or heroes' quotas of medals.

In Quang Tri Province, Hung's unit was bivouacked in territory newly occupied by the Northerners; several nights in succession men were shot, though no enemy unit was within miles. The killer was found to be a seventy-year-old local woman who sought vengeance for the deaths of two Southern soldier sons. She was promptly executed, causing Hung discomfort. True, he thought, she was helping the other side, but was she not, in her own way, a sort of national heroine? This was a dangerous rumination for a soldier of Hanoi's army, yet not his only one. He and comrades in a 37mm AA battery were disgusted by officers who "just wanted to make themselves heroes." They received a citation for having allegedly shot down six American aircraft, but the gunner said, "It was all just propaganda. I don't remember us shooting down anything."

On April 21, a devastating air strike hit the battery, killing one-third of the gunners, wounding another third, and destroying their guns. Men asked bitterly, "Why did the officers have to poke a stick into a hornets' nest by opening fire?" In the wake of the disaster, morale plunged. Some survivors reported sick. A squad leader shot himself in the leg: as Hung helped him to an aid station, the man pleaded for the teenager's corroboration in convincing doctors that he had fallen victim to an enemy bullet, but he was arrested and charged anyway. Amid the wreck of his unit, Hung was disgusted to find the packs of his dead comrades being ransacked by passing soldiers: their owners had no more need of them, said the pillagers, "and we do." Transferred to a 130mm battery, Hung found

620 · VIETNAM

that most of its men were ex-deserters who had accepted this alternative to jail. Then they, too, suffered a devastating air attack, which killed scores of soldiers and temporarily buried Hung in a slit trench. He was ordered to take around a bucket and collect loose body parts: "I was so terrified that I decided that not only was I unfit to be a hero, but I didn't think I could become a poet, either."

The moral of Hung's story is not that his comrades were villains or cowards, but rather that they represented the same blend of humanity as fills the ranks of all armies. Bao Ninh said, "No one in their right mind wanted to be there. . . . But we had a duty." Their leadership, discipline, and training were, on the whole, superior to those of the ARVN. But the Northern army's higher direction in the 1972 campaign was little more impressive than it had been during the 1968 Tet offensive: it was merely marginally better than that of South Vietnam.

Two northwestern firebases, Bastogne and Checkmate, succumbed to the communists only after staging protracted defenses, but in the last days of April, the "Dong Ha Line" bent, then broke. Though the attackers were savaged by air strikes, these were much less effective than farther south, because in Quang Tri Province the Americans had surrendered responsibility for forward air control to the Vietnamese. Moreover, below the DMZ the communists had their strongest missile defenses: an estimated thousand SAM-2s were fired at American and VNAF aircraft during the campaign.

As Northern columns streamed south across the Cam Lo Bridge, it became plain that Quang Tri was no longer defensible. The last Vietnamese and their American advisers pulled out on May 1, and next day the communists occupied the city. Amazing scenes took place as some Vietnamese fled half-naked, having torn off their military garb. I Corps commander Lam was belatedly sacked, replaced by Lt. Gen. Ngo Quang Truong, whom Abrams called "the most professionally qualified officer ARVN has got." The hapless divisional commander in Quang Tri was nominated official scapegoat for the disaster, and with considerable injustice was sentenced to five years' imprisonment for "desertion in the face of the enemy."

On May Day in Paris, Kissinger again met Le Duc Tho. The communist subjected the national security adviser to a propaganda monologue. It had become plain that the best the US could hope to extract from a peace deal was a cease-fire in place, though Kissinger continued to demand the withdrawal of the Northern forces engaged in the ongoing offensive. Communist field commanders were disgusted when Le Duc Tho established a direct radio link from Paris to the Southern battlefield, bypassing Dragon Court, sometimes issuing orders himself and always demanding further attacks. "Incredible!" said one officer later. "The staff did not agree with this way of doing things, but we had no idea to whom we could protest." In the later stages of the 1972 offensive, communist attacks were launched not in expectation of gaining ground, but instead to win headlines around the world, to move American public opinion, and to sustain pressure on Kissinger in Paris. In pursuing those political objectives, Le Duc Tho was notably successful.

On the afternoon of May 2, south of the My Chanh River south of Quang Tri, South Vietnamese and their advisers contemplated the wreckage of an infantry division, four Ranger groups, an armored brigade, two cavalry squadrons, and a Marine brigade, as well as RF, PF, and support units. Few officers or men had distinguished themselves, but survivors cherished the story of Dinh Thi Thach, wife of a sergeant major. After her village near Quang Tri was overrun, for weeks at risk of her life she sheltered a dozen Southern fugitives in her cellar and later guided them safely to their own lines.

The retreat became ever more chaotic. A tank officer wrote, "God, how can one describe the tragedy that befell [us] on reaching Highway 1? The men had no order, the road in front was blocked by the enemy, whose forces were also crowding our rear and pouring fire onto our heads." Some despairing drivers slammed their feet down on the accelerators, drowning their M-48s in the waters of the Thach Han River. Others dropped illuminant grenades down the hatches and watched their tanks burn before joining the flood of fugitives wading streams and trudging across waterlogged fields toward Hue.

In Saigon, Abrams fumed at South Vietnamese complaints that they lacked arms and equipment. "The ARVN haven't lost their tanks because the enemy tanks knocked them out. The ARVN lost their tanks because goddamn it, they abandoned them. And, shit, if they had the Josef Stalin 3 [tank], it wouldn't have been any better." He likewise harangued President Thieu and Vien, Saigon's chief of staff: "Equipment is not what you need. You need men that will fight. And you need officers that will fight, and will lead the men. . . . You've got all the equipment you need. . . . You lost most of your artillery because it was abandoned." Much of the Western media predicted that the latest battlefield disasters would bring down the curtain on South Vietnam.

The last three hundred military patients in Quang Tri Hospital were loaded aboard a road convoy, which became stranded on Highway 1 South among a throng of refugees and wrecked vehicles. Communist artillery fire pounded the ambulances into scrap. Dr. Pham Viet Tu, an Airborne medic, wrote of the fate of civilians: "There were hundreds of cars, trucks, bikes, motorbikes riddled with communist bullets and shell fragments, some burned to ashes. Human skeletons lay scattered on the roadbed. . . . The image that sent a surge of pity thrusting through my heart was that of the skeleton of a child about two years old inside a large aluminium wash basin. A tiny pair of rubber sandals lay beside its mother's remains."

Abrams and the South Vietnamese were astonished that the communists, after taking Quang Tri, didn't race south to seize Hue, which lay open for the taking. A Saigon officer wrote, "Hue seemed a lawless city; the few police and MPs could not control a mass of refugees and soldiers. There were robberies, lootings, car hijackings. Beside the main roads, many straggling children, from toddlers to early teens, cried and watched the people flow by. I saw a boy about twelve years old holding his brother of around three leaning on a roadside tree. The older one clutched a piece of letter-size paper on which he had scribbled, 'We are children of Mr. Xuan of Quang Tri. Can't find our parents. Please help us.'"

Hundreds of brief messages were scrawled on walls with chalk or charcoal or scribbled in pencil on paper stuck to tree trunks with a lump of rice, such as "To Pfc Nguyen Van Ba, 1/57th Btn. The children and I

are moving to Auntie's home in Da Nang" and "Corporal Bay 3/2 Inf to wife: I'm alive and fighting. Buddha blesses you and our kids." One read: "Wife Hoa to husband Sgt. Truong RF—Quang Tri. VC mortar killed our baby girl yesterday. The boy is safe with me. Don't worry and don't go AWOL." Mrs. Ngo Thi Bong, the Hue housewife who had endured terrifying experiences during the 1968 Tet offensive, now wrote to a friend: "My only surviving son has left home. I am alone with my daughter and my little grandchild. It is so lonely. If my dear son is killed, I don't know what I should do. We think now this terrible war will never end. . . . My poor children."

Maj. Nguyen Cong Luan met a young captain taking his battalion forward into action, who seemed dispirited. When the man complained that the Americans now fulfilled less than half his air-support requests, Luan suggested that the decisive factor in influencing American responses would be that the Southern army displayed its own will to fight. Of its 1972 materiel losses of 200 tanks, 275 APCs, 634 trucks, and 300 guns, half were abandoned or destroyed in the north. It was fortunate for the Saigon regime that the communist advance in the north and the Central Highlands lost momentum after taking Quang Tri and Tan Canh. The invaders had suffered a huge number of casualties, mostly to air strikes, and lacked the logistics support to push on. In the course of May, the Southerners formed a defensive line, stemmed the faltering enemy advance. Later in the summer a long, slow counteroffensive began to regain Quang Tri.

Some of the fiercest May fighting focused on Kontum, a provincial capital set in a valley in the northern Central Highlands, bordered on three sides by a river. A relatively prosperous place boasting nine Catholic churches, it was defended by the ARVN 23rd Division, supported by some tanks, artillery, and Popular Forces. The communists cut Route 14 south of the city before committing elements of three divisions to an assault from the north and northwest that began on May 13. Brig. Ba wrote later, "It was a hell on earth—every day as bad as the last, shellfire for forty days." John Vann was everywhere—dropping in munitions, directing three hundred B-52 strikes in three weeks, and urging on flagging commanders.

624 .

When Ba's bunker received a direct hit, medics had to triage and bandage the wounded, remove the dead, even as around them staff officers continued to run the battle. The night of May 18 was among the worst, when the Northerners overran half of Kontum before being driven back. Air attacks repeatedly caught NVA tanks in the open. There was fierce fighting in three cemeteries bordering the city. By 0900 on the morning of May 26, a communist officer admitted that the assault had run out of steam. Two of his remaining tanks struck ARVN mines, and the last two were destroyed by gunships. Hanoi's history of the war acknowledges, "Our attacks began to slow and became progressively less effective. Meanwhile the enemy had brought up reinforcements, strengthened his defenses, and stepped up counterattacks. On the night of 5–6 June, Front headquarters ordered a withdrawal from Kontum, and closed down the Northern Central Highlands campaign."

Americans and South Vietnamese alike afterward agreed that, without John Vann, Kontum would have fallen. He survived countless brushes with disaster, once using a rifle butt to fight off Vietnamese fugitives mobbing his Jet Ranger as it took off. Ba wrote sentimentally, "The victory belonged to no one more than this man whose sole objective was to enable the ARVN to defeat the communist aggressors. I often asked myself, 'Why should an American devote his life to this struggle? Why should he have accepted the perils of Ap Bac, and now those of the Central Highlands?'" Ba described Vann as a martyr who deserved the gratitude of every Vietnamese.

The man himself became convinced of his own invincibility, but was proved wrong, as such wild figures usually are. On June 9, flying with an inexperienced pilot in failing light, Vann was killed when his helicopter crashed. He was forty-seven, and he left behind a debris of ill-maintained wives, lovers, and offspring, American and Vietnamese. Neil Sheehan, author of Vann's biography A Bright Shining Lie, one of the great Vietnam books, observed that while Vann saved Kontum, he did so in a fashion that negated his own purpose. He showed that without Americans like him wielding US air power, the South Vietnamese could not hold. Thus,

all the subsequent fighting and dying merely postponed an outcome that was now ordained.

Abrams said in the midst of the 1972 campaign, "The level of violence, and the level of brutality . . . is on a scale not before achieved." Even as the Quang Tri and Kontum battles were fought, farther south three communist divisions advanced out of Cambodia, overrunning Loc Ninh before approaching An Loc, capital of Binh Long Province. This was a garrison town of ten thousand people, situated between two rivers in the highland plateau region sixty miles north of Saigon. On the evening of April 5, enemy sappers captured its nearby airfield, from which defenders fled at the first glimpse of communist tanks. The invaders also cut the road farther south, so that An Loc was thereafter dependent on air supply.

Over the radio as the 3rd Ranger Group was airlifted into the town on April 7, its commander Maj. Nguyen Van Biet—known as Anh Hai, Eldest Brother—warned that the airfield was under shellfire. As the helicopters touched the ground and men poured out, they found that the group's headquarters staff had already suffered severe casualties. The Southern 5th Division's commander, Col. Le Van Hung, told Maj. Biet, "You guys have arrived in the nick of time." His own men were wavering, one regiment already overrun.

There followed a brief pause before the communist onslaught, during which a Ranger officer watched townspeople continue about their daily business as government loudspeaker trucks cruised the streets, urging them to stay calm, promising that reinforcements were coming, telling them to report sightings of communist infiltrators immediately. When the North Vietnamese opened their bombardment, there was no pretense of respecting civilian life; 122mm rockets and 155mm shells from guns captured at Loc Ninh rained down on every quarter of the city. A Southern officer wrote, "Agonizing screams, bodies and body parts blown everywhere and even hanging from branches and rooftops, spelled tragedy. Many civilians took refuge in army bunkers." Up to two thousand artillery and mortar rounds a day fell on An Loc.

One evening the Rangers were thrown into consternation when,

without explanation, their American advisers dashed for a helicopter, which disappeared into the eastern sky. What did this signify? Was the garrison being abandoned? The mystery was resolved only at dawn next day when a new adviser team arrived. Its commander apologized for the switch, which he said was made without warning to preserve security. He promised that An Loc would receive the full weight of American air support; morale revived when this pledge was fulfilled.

At 0230 on April 13, the communists launched their first major ground attack. The spearhead tanks at first caused consternation. "Our soldiers were terrified," wrote a defender. But then a Regional Forces unit destroyed one with a LAW rocket. The garrison began to see that the tracked monsters were highly vulnerable in city streets, and they knocked out tank after tank, with American aircraft joining in. Northern armored crews showed themselves pitifully inept. In early morning darkness one T-54 plunged into a bomb crater. Its companions made a disastrous tactical error, speeding on alone into the city, where they were destroyed piecemeal by LAW rockets and air strikes. By 0830, with seven NVA tanks gone, the survivors turned back.

Adviser Capt. Hal Moffett said later, "[The communists] didn't use their tanks properly, and thank God for that. If they had used a good coordinated attack, they would have rolled right on through, but they were completely disorganized, and till this day I don't understand what they were trying to do with the tanks, sending in four or five at a time." Southern troops now received cash bounties for every tank they destroyed, and impoverished soldiers proved more willing to risk all for money than for their country. Some infantry with LAWs, said Moffett, "would let the tanks get within ten, thirty yards of them and then fire." At the key bridge from the east, "these little guys sat there and waited until that tank got right in the middle of that bridge and blew its shit away." The rest of the attacking armored column turned away and tried to ford the stream lower down, only to fall victim to the USAF.

The infantry fighting continued fierce and bloody. The defenders lost ground, and one Ranger battalion was almost wiped out. Wireless traf-

fic was frequently interrupted by communist voices urging, "Surrender and live! Or resist and die!" The North Vietnamese gained control of some northeastern districts and were repelled only when, in the midst of a rainstorm, an overhead US Spooky gunship delivered automatic fire with extraordinary precision. An exultant Southern officer called over the radio, "Right on the money! Keep going!" As enemy bunkers collapsed, the same man reported, "A few terrified enemy soldiers ran out, gasping for breath and looking half-drowned by the rain."

At 0430 on the 15th, the besiegers launched another barrage, which started fires in several residential areas. Half an hour later, a second major assault began in darkness. One Northern tank threw a track and another's engine seized for lack of oil, so that just seven accompanied the infantry forward. By dawn the communists held outlying areas, only to repeat the mistake they had made two days earlier—sending forward unsupported tanks. Southerners with LAWs knocked out more T-54s, the attack stalled, and the communists fell back. Another two Airborne battalions and a Ranger group arrived to reinforce the town. Though in the week that followed some outlying positions were lost, the communists failed to penetrate the center of An Loc.

The attacks were poorly managed and prompted the sacking of a Northern divisional commander, but the defense was no masterpiece of the military art either. Col. William Miller, senior adviser, reported wearily that Hung, 5th Division's commander, was "tired—unstable—irrational—irritable—inadvisable—and unapproachable." Between April 22 and May 10, besiegers and besieged sparred uneasily. By night, the sky glowed from the illuminants dropped by C-47 flareships. Air strikes hammered the communist lines. The garrison, now 6,200 strong with 25 American advisers, launched counterattacks that pushed back the North Vietnamese, and communist historians admit that their morale slumped. On May 10 in Saigon, President Thieu declared a national state of emergency. He noted proudly that, in the face of the crisis, more than 53,000 South Vietnamese had volunteered for military service: the prospect of apparently imminent communist victory concentrated some

628 .

minds. It also deserves historic notice, that while tens of thousands of Saigon soldiers deserted from Thieu's army, scarcely any did so in order to join the communist ranks; they just wanted to go home.

However, the communist leaders at An Loc remained implacable; having committed themselves, they refused to brook failure. On May 11, reinforced with thirty-five new tanks, they launched another attack by five regiments, advancing from four directions. In the headquarters bunker, the South Vietnamese could hear NVA tank engines, as smoke and dust drifted through the fighting holes. An American adviser warned his Vietnamese interpreter, "I should tell you—we may not be able to hold, so if you want to save your neck, stick with me, and be ready to go." In An Loc as elsewhere, the decisive force, attested by Hal Moffett, was air power that broke up attack after attack. "A 'daisy cutter' [big bomb] stopped a battalion. Their leaders were hollering to the [American] unit to get up and attack. Charge. Screaming at them. We could hear them. But the people wouldn't attack. We annihilated the northeastern penetration up there. I saw them running. We could have won the battle that day; we had the [NVA] running. But everything stopped for three hours."

Northern casualty numbers had become enormous; the communists had almost shot their bolt. Moffett provided a vivid after-action account. Some Southerners, he said, fought like tigers. "The Airborne troops were just fantastic . . . real go-getters." Others were not: one Ranger group "was completely pushed off the perimeter by approximately six [enemy soldiers]. They would not return fire and withdrew by throwing grenades. They said firing their weapons would give their positions away. . . . I had [their] colonel come up to me crying . . . I mean just like a baby, tears running down [from] his eyes, wanting to know why they couldn't get air support."

Moffett was exasperated by some defenders' passivity, allowing the attackers to set up mortars within plain view. But they faced one of the heaviest communist barrages of the war, in which An Loc's hospital complex was devastated: "I would estimate that they killed three to five hundred people—women, children, kids, soldiers, the whole works. They just bombarded the hell out of it." Meanwhile Cobras were obliged to fire

from five thousand feet to escape the fearsome new ground-to-air missiles. Strike aircraft had to attack from behind the ARVN positions rather than across them, to reduce their exposure to enemy fire.

Even as strife raged in the streets, a Southern division pushed north up Highway 13 in an attempt to break the siege. It never achieved this, but at least the thrust monopolized the attentions of the communist formation blocking its path. The Americans committed a phenomenal air effort to supplying the beleaguered garrison: 2,693 tons of ammunition and rations were parachuted. On May 11, B-52s dumped pulverizing loads almost hourly around the clock, accompanied by an average of almost three hundred tactical air strikes a day. Senior adviser Maj. Gen. James Hollingsworth told MACV, "If it hadn't been for the advisers, you would have the [communists] . . . in Saigon, I do believe." This was so, not because of the "advice" Americans provided, but thanks to their role as forward air controllers. In this last hurrah of the US Army and Marine Corps in Vietnam, after so many setbacks and failures, many officers and NCOs in the adviser teams displayed high courage, commitment, and professional skill, which were decisive in stemming the communist offensive. Moffett and his group spent fifty-three days in An Loc. "When we came out, we had to pull Vietnamese off the helicopter; we wouldn't take any wounded because you take one out you have to take them all.... I pulled four Vietnamese off the bird myself, just throwing them off so I could get on." Interpreter Tran Van De acknowledged, "A lot of people tried to desert, or pleaded wounds to get out."

Moffett's army interviewer, in a conversation immediately after his extraction, asked if An Loc could survive another attack as heavy as that of May 10. "No, sir. . . . There are too many holes in the line, and they are too weak. If the [communists] came in like they did the last time . . . in my opinion, [next time] they are going to have their shit together. . . . I don't think [the Southerners] would stay." The adviser was fiercely critical of some Vietnamese officers who flinched from leaving their bunkers. He saw commanders send men under fire to fetch them cigarettes or a wet rag to wipe the sweat off their bodies, "and the private didn't look like he'd had a bath since he'd been there. . . . Nobody seemed to give a shit about

630 · VIETNAM

the private fighting the war." Here was a familiar institutional weakness of the South Vietnamese Army.

Though the communists sustained An Loc's encirclement until June 8, by mid-May the threat was receding. The NVA General Staff's history comments, "We had not fought well." The South Vietnamese suffered 12,500 casualties to hold the city. The attackers' losses were probably nearer 25,000, as well as thirty-six precious tanks.

While Thieu's army struggled in the South, President Nixon unleashed upon the North the heaviest air bombardment of the war, to punish Hanoi for its hubris. Between May 1 and June 30, the USAF and US Navy mounted 18,000 sorties, losing twenty-nine aircraft. On May 8 in a national TV broadcast, Nixon told the American people that he was taking "decisive action to end the war": an assault on the North's logistics and communications, code-named Linebacker, involving 330 sorties a day and including the first mining of the approaches to Haiphong Harbor. Moreover, at the height of the 1972 fighting, five US Navy carrier groups, three bombardment cruisers, and thirty-eight destroyers provided naval support to the South Vietnamese. This dramatic riposte to the grand insult of the communist offensive won Nixon astonishing popular enthusiasm: Americans applauded hitting the enemy from the air, as they had never much favored engaging him in his own swamps and jungles.

During April and May, huge air reinforcements were dispatched to the theater, so that 210 B-52s were eventually operating out of Guam and Thailand, together with 374 F-4s. The emphasis was on communications targets, including the Yen Vien rail yards and Hanoi's Paul Doumer Bridge, which was taken down by twenty-nine laser- and electro-optically guided bombs. Between April and October, 155,548 tons of bombs fell on the North. Overland imports were reduced from 160,000 tons a month to 30,000; those by sea from 250,000 tons to nil. The Chinese suspended shipments and closed their railways. Linebacker wrecked almost all of North Vietnam's oil storage and 70 percent of its generating capacity. From the American viewpoint, the operation was far from cost-free. Many aircrew were now relatively inexperienced, and this showed in June, when

communist MiGs shot down seven American fighters for the loss of only two of their own. Overall, Linebacker cost forty-four planes. Meanwhile, though tactical air power made a devastating and almost certainly decisive impact on the Southern battles, so lean and mean was the North's infrastructure that the bombing's effects on its war effort were marginal.

Nixon declined to recognize the latter point, however. His patience with Creighton Abrams finally expired when the soldiers opposed Linebacker, urging instead a concentration of air resources in the South. Kissinger said, with his accustomed instinct for the jugular, "He's had it. Look, he's fat, he's drinking too much, and he's not able to do the job." In June Abrams came home, to be replaced in the last months of MACV's existence by Fred Weyand. Abrams was not sacked, but was instead removed upstairs, to succeed Westmoreland as army chief of staff. He was a competent, decent officer well suited to conventional warfare in Europe. His progressive deterioration through his years of tenure in Saigon, especially in the last months, could be attributed to facing political and military pressures that might have overwhelmed any commander. A colleague who said that Abrams was required to "run a war on foundations of Jell-O" did not much exaggerate.

On May 22, Nixon became the first American president to visit Moscow, beginning a week of summit talks with Soviet leader Leonid Brezhnev. Each side was irked by the difficulty of discussing the vital nuclear issues that most concerned them, as long as the specter of the war hovered above the table. Brezhnev's interpreter wrote later, "If Vietnam was mentioned from time to time, it was with the sole purpose of 'ticking the box' in order afterward to be able to report to the Vietnamese and to our allies on the strong and unwavering posture of the USSR's leadership." Soviet premier Alexei Kosygin warned that any further American escalation would oblige Hanoi to seek the assistance of Chinese forces. "Nixon listened with his teeth clenched. He then calmly but firmly rejected what he regarded as unfounded allegations and stressed his intention to end the bloodshed. He attributed lack of progress to Vietnamese intransigence, and appealed to us to influence our friends and allies." Though the Russians used strong words in response, their tone was notably mild.

They feared Nixon and were deeply anxious to prevent Vietnam from

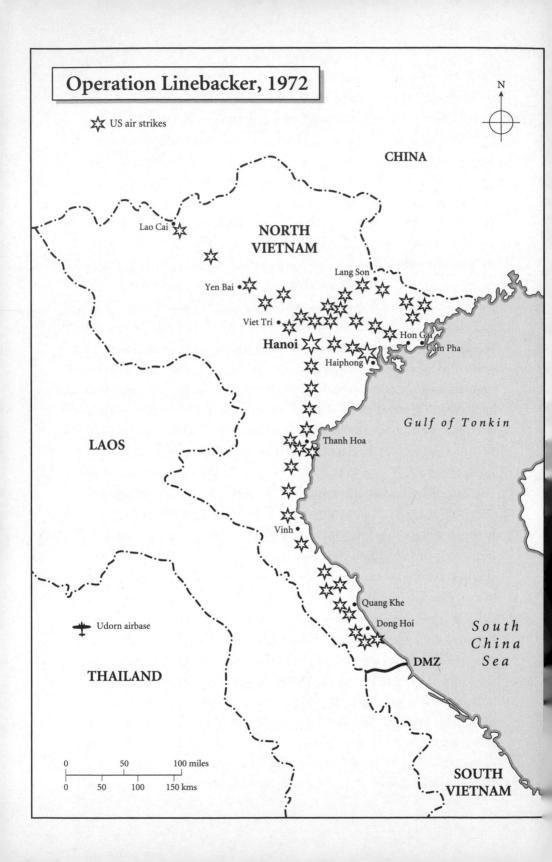

thwarting an accommodation with him. Several times during the summit, the Russians responded to American urgings that they should persuade the Vietnamese to negotiate in earnest by accusing the US of failing to curb Israeli excesses toward the Palestinians. This ball flew to and fro across the net. The Americans said, Israel is an independent state with which we have close relations, but which we cannot force to change its policies. The Russians replied, the same is true of us and North Vietnam. The Moscow summit culminated in the ABM and SALT I treaties, which, in the views of both parties, were of vastly more import than Indochina.

3. AN EMPTY VICTORY

In South Vietnam, from June through the autumn, US aircraft battered the Northern forces into retreat, enabling Saigon's troops slowly to recover some lost territory. Communist losses rose to levels that no national leader less ruthless than Le Duan would have countenanced. The commander of the 308th Division sent a personal signal to Giap, urging that the offensive be abandoned. He complained that political officers branded as a coward anyone who urged withdrawal, "yet this is what I recommend. As we are now placed, we would struggle to engage a single enemy platoon." Outside Quang Tri in June, with infinite labor communist engineers moved forty-two pontoon sections to a ford—only to watch them destroyed by an air strike in which their protective flak unit was wiped out. An artillery brigade was likewise wrecked before even reaching the battlefield. Renewed infantry assaults went ahead anyway, but in the words of Gen. Phi Long, "At the end of a week's fighting our resources were exhausted. Every battalion was reduced to thirty or forty men." Several senior officers were superseded after collapsing with exhaustion of various hues. The North Vietnamese had been taught the brutal lesson that, whatever the limitations of air power against guerrillas and jungle supply lines, it was devastating to conventional forces, especially on armor caught in motion. Moreover, neglect of logistics, against the advice of Giap, whose role in the campaign appears to have been administrative and honorific rather than operational, caused many gratuitous difficulties.

On July 11, a South Vietnamese heliborne assault marked the first step in a long struggle to recover Quang Tri. As the communists grudgingly fell back, the veteran Col. An was dispatched to join their battle to retain the city. Arriving in torrential rain to find most infantry companies reduced to 20 percent of strength, the survivors in poor health and low spirits, he wrote, "The enemy was hammering and overwhelming us." An, too, favored breaking off operations, as did another senior officer who said, "It's clear that the enemy has gained the initiative. . . . I know the other cadres in the division agree, but no one dares to say so out loud."

An wrote, "Perhaps because the phrase 'the Revolution only attacks' had been so deeply etched into our mind-set, anyone who suggested adopting a defensive posture was likely to be accused of 'negativist ideological thoughts.' . . . The rainy season caused countless difficulties. Trenches were forever filled with water and mud. Even when we bailed out bunkers, within a few hours they flooded again. . . . No matter how hard transport personnel worked, supplies were insufficient. Our soldiers . . . were hungry, cold, filthy, and sick."

Pham Hung of the 308th Division celebrated his eighteenth birthday on August 26, in Quang Tri under ARVN shellfire. He decided to hold a little celebration, for which he would catch some fish from a nearby pond, using a familiar soldiers' technique: during a lull he leaped out of his foxhole, ran to a nearby pond and emptied his AK-47 into its occupants. Collecting the floating corpses, he dashed back toward cover just too slowly to escape a deluge of American bombs. An explosion hurled him stunned to the ground, where he lay reflecting dreamily, *I am dying, and not honorably. Instead of being a hero, I am clutching a handful of dead fish. I have never made love to a girl.*

He was very unhappy, but after a time he understood that he was not dying, though quite bloody. He tried to cry out for help but could hear no sound. The company medic had been killed, but he succeeded in attracting the attention of the man's replacement, a veterinary student, who bandaged wounds in his arm and head. Two men were detailed to carry him to the aid station, but confronted by a new air strike, they dropped him abruptly and painfully in the open, before dashing for cover. When

the bombing stopped and they returned, he said, "Let me crawl. It's less painful than being dropped." On reaching the aid station, his companions congratulated him on his good fortune: he was alive and would go home; they must suffer on.

Hung thought their remarks odd, especially when he was so bloody. A week after being hit, he joined a column of walking wounded for a long, slow, painful progress back up the Trail: "We looked a terrible sight, a defeated army. We sang songs as we went, but they were very sad songs. At that time we felt the war must go on forever and that we could not possibly win. We kept meeting drafts of new recruits going the other way, and we felt even sorrier for them. We said to each other, 'If those kids knew what they were heading for, they would turn around and run home.'"

Yet once they were back in the North, it was amazing how spirits rose among those battered men. Approaching the Kien Giang River, someone shouted, "Just the other side is where Giap was born!" Hung said, "We thought, So long as Giap is still with us, we can win. It was as if a dry tree had been watered. Suddenly I, too, felt that we could prevail; that I must go and fight again." In the event, his wounds were too severe, but he stayed in uniform for two more years to spare his younger brother from being drafted as a substitute. When he was finally discharged in May 1974, he felt bitter at the lack of recognition for what he had endured—he left the army with hearing and mental disabilities that persisted for years; he was made to pay cash for several items of lost equipment and made to walk nine miles to catch a bus home.

In the South by autumn 1972, a Northern artillery regiment commander admitted, "Our men just could not take it anymore." Bao Ninh said that morale slumped: "The losses had been worse than in 1968." Back home in Hanoi, teacher Do Thi Thu sobbed when she learned that three former pupils from her own graduating class had died at Quang Tri. After the tide turned, Southern morale briefly soared. At the Saigon home of Airborne Col. Ly Van Quang, all night he and fellow officers downed *ruou de*—rice alcohol—and swapped experiences. They roared with laughter as they discussed the follies of communist tank commanders at An Loc. In the

words of a family witness, "They were so proud: it was the first time the ARVN had done something really important on their own." Communist senior cadre Truong Nhu Tang acknowledged that the South Vietnamese and their American sponsors had once more prevailed, "just as they did during Tet, in Cambodia, and in so many of the pitched battles in which they confronted Vietcong and North Vietnamese main forces. Our losses had been prodigious." Nonetheless "the paradox was that despite this, the spring offensive was a decisive triumph for us. . . . The US and South Vietnam had already lost the war—and so also, if only we had known it, had the Vietcong." Tang meant that the Northerners would ultimately impose a new oppression upon all Southerners, heedless of their past allegiances.

Kissinger warned President Thieu that he needed to recapture as much ground as possible before a peace treaty was signed, because whatever the communists then held, they would keep. Although South Vietnamese Marines claimed a significant prestige victory by reoccupying the citadel of Quang Tri on September 16 after desperate fighting and five thousand casualties, thereafter they were too exhausted to advance farther and retake the lost firebases along Route 9 and the area south of the DMZ. Dong Ha, once a key American base, became for the war's last three years the port through which the communists shipped supplies up the Cua Viet River from the sea. Half the territory of South Vietnam's four northern provinces—one-tenth of the entire country—remained permanently under communist domination, as did the western borderlands adjoining Laos and Cambodia.

Even while Thieu's soldiers were fighting their desperate battles, during the first six months of 1972, another 135,000 Americans went home, leaving behind just 49,000. A South Vietnamese officer described the eerie experience of driving through abandoned barracks and camps at Phu Bai, Dong Tam, and Qui Nhon and seeing nearby shantytowns that had once provided bars, nightclubs, and whorehouses deserted and crumbling. In the Mekong Delta, where earlier in the war the NVA never ventured, Hanoi now deployed 8,000 regular troops. An American adviser in My Tho recorded bleakly, "We've got North Vietnamese soldiers up to our ears." Another adviser, in the Delta town of Vinh Kim, reported that

five hundred communists had just pillaged the US compound: "They're standing and fighting. We call in B-52s and they're still there. These people are not backing down. This really is a different ballgame from what we're used to in these parts." Amid a hemorrhage of Southern troops to fight the big battles farther north, the government withdrew from local posts, leaving the communists to take over whole districts. Moreover the communists showed notably more sensitivity than Saigon's troops in managing their relations with local people, who were soon offering them food. The resurgent Vietcong embarked upon a new wave of assassinations of those who assisted the Saigon regime.

The outcome of the great battles of 1972 was a tactical victory for the South, won at a cost of eleven thousand men killed, perhaps fifty thousand casualties in all. Most of the three hundred Americans who fell that year perished during the spring offensive. The Northerner's casualties probably exceeded a hundred thousand. They lost over half their committed armored force—at least 250 tanks—and most of their heavy artillery. Some twenty-five thousand civilians were killed, "collateral damage" impressive even by the standards of Vietnam. The Chinese bitterly criticized Hanoi for overreaching itself. "Our military men said they had lost Quang Tri because of Le Duan's order to take Hue," said a senior cadre.

On the American side, a few professional optimists, such as Creighton Abrams, hailed a victory secured by the Southerners, saying, "With all the screw-ups that have occurred, and with all the bad performances that have occurred, . . . we wouldn't be where we are . . . if some number . . . hadn't decided to stand and fight," adding later, "By God, the South Vietnamese can hack it!" Few others agreed. The CIA's Merle Pribbenow, then in Saigon, said, "It was clear that without massive US air support, the country would have fallen." Most of his informed compatriots agreed with that judgment, yet many members of Congress constantly agitated to tighten the screw on funding for air operations.

The North Vietnamese politburo was well satisfied with the outcome of its campaign. Saigon's armed forces had made their last serious stand: thereafter, morally exhausted, most proved capable only of flirting with war. Maj. David Johnson was one among many US advisers who emerged

despairing from his 1972 experiences: "I tried to do a job, but my heart wasn't in it." As ever more departing Americans shuffled toward embarkation at air bases, much of the country they left behind resembled a junkyard of broken or worn-out consumer goods and military equipment. All the dollars, all the war, had failed to confer upon the rulers of South Vietnam and their supporters three vital elements: dignity, self-respect, and sufficient human sympathy to achieve an accord with their own people. Absent these things, battlefield success counted for little.

BIG UGLY FAT FELLERS

1. "IT WILL ABSOLUTELY, TOTALLY, WIPE OUT MCGOVERN"

Henry Kissinger achieved superstar status for his role in negotiating the settlement that promised to extricate his country from its quagmire. In October 1972, both the American people and the national security adviser convinced themselves that his brilliant diplomacy had brought the Paris talks close to an outcome. In truth, however, the US eventually settled on the only terms North Vietnam cared about, whereby its own troops remained in the South, while the Americans went home. Almost all the other provisions of the final Accords were such as neither side supposed would be observed. The only change in the communist position, the face-saver that opened the way for Washington to accede, was that Hanoi abandoned its earlier insistence on President Nguyen Van Thieu's removal as leader of South Vietnam.

Two factors were in play here. During the summer the Northerners recognized that Nixon was assured of reelection. Not only could they not hope to negotiate with a different and more sympathetic US government, but once polling was over, the White House might play rougher. Moreover Hanoi made the pragmatic calculation that getting rid of the Americans was the only objective that mattered; once the "imperialists" quit Indochina, destruction of their Saigon clients should neither prove difficult nor take intolerably long. This perception was shared by the government of South Vietnam.

The exchanges at the White House between Nixon and Kissinger about Vietnam are chronicled in an incontrovertible detail unprecedented in history, because tape-recorded. The two men cherished few illusions about what they were doing, though bent upon ensuring that the American people did. Kissinger professed to regard Hanoi's shift about Thieu as a diplomatic victory, because it opened the way for a "decent interval." He told Nixon on August 3, "If a year or two years from now North Vietnam gobbles up South Vietnam, we can have a viable foreign policy if it looks like it's the result of South Vietnamese incompetence. If we now sell out in such a way that, say, within a three- to four-month period, we have pushed President Thieu over the brink," he thought that even the Chinese would be dismayed by American clumsiness and cynicism. Everything in the later negotiations was about timing outcomes to make things look right.

In Paris on September 26–27, Le Duc Tho and Kissinger found themselves close to agreement on a paper formula for a three-party "election commission" or "Commission of National Reconciliation" for South Vietnam—touching distance from the North's demand for a three-party coalition government. Kissinger explained this to Nixon on September 29: "You see, Mr. President, this is all baloney, because the practical consequence of our proposal, as of their proposal, is a cease-fire. There'll never be elections." Nixon asked, "So then what happens? They—they just resume the war later, huh? But we'll be gone." Kissinger said, "Yeah."

During the days that followed, Nixon displayed flashes of anger toward the North—implicitly, perhaps, spasms of guilt about the abandonment of the South that his emissary was crafting. He talked about an intensive new bombing campaign: "I have determined that I am not going to sit here and preside over fifty-five thousand American dead for a defeat." Yet on the morning of October 6, Kissinger confronted his master with a stark choice: he himself was about to fly to Paris, where Le Duc Tho would place on the table a menu of proposals headed by a cease-fire in place, with the other vacuous provisions previously discussed. Would the president authorize his emissary to receive these favorably? In the long, tough conversation that followed, Nixon wavered. He was fearful that South Vietnam's president, less than a month before US election day, would publicly

expose the deal as a scllout. Kissinger acknowledged to Nixon, "Thieu is right, that our terms will eventually destroy him." The two men discussed the possibility of arranging a coup in Saigon, to change South Vietnam's government. Finally rejecting this option, they agreed that it must be Thieu who presided over his country's almost assured descent to oblivion.

Kissinger smoothed the president's unease by saying that he would get the communists to promise withdrawal from Laos and Cambodia, abandoning the Ho Chi Minh Trail. Nixon said, "I'd get the commitment. I wouldn't worry about it. They're never going to withdraw." Kissinger agreed: "No, but I'll get it in writing." He offered his employer valedictory comfort by recalling the example of de Gaulle, who took France out of Algeria in 1962 and whom "everyone thinks a great man." He said that Hanoi had expressed its desire for respective foreign ministers to sign the prospective settlement, adding, "I don't want to sign the goddamn thing. You should sign it." Nixon demurred. "I don't think we should dignify it by my signature." Then the president of the United States authorized Kissinger to receive Le Duc Tho's proposals.

At four p.m. on October 8, 1972, in the familiar villa at Gif-sur-Yvette on the outskirts of Paris, Le Duc Tho opened a green folder and set out the North's conditions. His draft conformed to expectations and passed Kissinger's low, low threshold: release of POWs and a cease-fire in place for North and South Vietnamese forces in exchange for total American withdrawal. Hanoi insisted upon the principle of matching replacements of weapons; if the Americans were to continue arming the ARVN, the North would do likewise for its own forces in the South, while professing "strict respect" for the sovereignty of Laos and Cambodia. It proposed that the United States should pay North Vietnam reparations for the war damage it had inflicted.

Kissinger emerged from the session exultant and was exasperated when the State Department's John Negroponte predicted fury in Saigon. Kissinger shouted at him: "You don't understand. I want to meet their terms. . . . I want to end this war before the elections." On October 12, he returned to Washington bursting with excitement. The communists were ready to sign, and there was still almost a month before polling

day. He told Nixon, "The deal we've got, Mr. President, is so far better than anything we dreamt of. I mean, it will absolutely, totally, wipe out McGovern."

It was Nixon's good fortune that his 1972 Democratic opponent, Senator George McGovern of South Dakota, was one of the least impressive presidential candidates of modern times. Had the Republican nominee instead been obliged to fight Senator Edward Kennedy, fatally tarnished by the Chappaquiddick scandal, he would probably still have won, but his Vietnam policy would have faced much more piercing scrutiny. Kennedy denounced Vietnamization as a charade before the unveiling of a deal to be struck with the communists on the eve of the election. He was correct: private debate within the administration focused only upon the duration of a politically acceptable pause before the communists took over Saigon. Kissinger thought eighteen months should be enough; he had told Nixon in August, "If we settle it, say, this October, by January '74 no one will give a damn."

Now, discussing the deal with Nixon, Kissinger called the reparations proposal "our best guarantee that they'll observe the agreement." The entire US foreign aid budget was less than two billion dollars, but the president said indulgently, "Give 'em ten billion." At luncheon with Haldeman and Haig, Nixon ordered 1957 Château Lafite Rothschild to be served all round. Here was munificence: it was his usual practice to confine the White House's finest vintages to his own glass, while subordinates were given a California red. He took pains to put in writing to Kissinger an instruction that election timing should influence nothing thereafter said or done to either the North or South Vietnamese: this note might have looked good to historians, had it not been shown to be at variance with every waking thought within the White House.

Back in Paris on October 17, there was quibbling with the North Vietnamese about prisoners: beyond the exchange of military POWs, Le Duc Tho sought the release of thirty thousand civilians held by Saigon on suspicion of being communist cadres. Kissinger warned that such a proposal would probably be a deal breaker for Thieu, whom it was now the national security adviser's herculean task to persuade to endorse an agree-

ment the Vietnamese had no part in making but which would determine his beleaguered country's fate. Nixon told Kissinger, "Basically, you've got to brutalize him." The presidential emissary landed in Saigon to a glacial reception. Thieu's intelligence service had warned him about the looming Paris deal long before the Americans saw fit to say anything. Capt. Phan Tan Nguu, a Special Branch officer, submitted a formal report, based on information from an authoritative communist double agent, "the Tay Ninh source," saying that cadres agreed that a settlement was imminent, and Thieu was in no doubt about its grim significance for his regime.

Yet Kissinger assured the president that communist troops would progressively quit his country: "It is the judgment of our military people, that the present North Vietnamese forces without reinforcement will eventually have to be withdrawn." There was to be an avalanche of new American weapons, to bolster South Vietnam's defenses ahead of the treaty. For a year, Kissinger had been assuring the communists that, granted a decent interval, the US would not again intervene in the South after an agreement was signed and residual American forces withdrew. Yet to secure Thieu's endorsement, he offered an absolutely contradictory promise, of immediate military action if Hanoi breached the terms: "It is inconceivable that President Nixon would stand by if North Vietnam attacked again."

Creighton Abrams, newly sworn in as US Army chief of staff, joined the national security adviser to persuade Thieu that Americans were men of their word. Kissinger told the Vietnamese, "You have to trust me," to which the president responded that he saw no reason to do any such thing. The visitor claimed mendaciously that no Vietnamese version of the draft agreement was available. But Thieu had already read a summary circulated down to communist district level and supplied by the Tay Ninh source.

At a meeting on October 21, Thieu's foreign minister presented a list of twenty-three demands for changes to the draft Paris agreement, foremost among which was the withdrawal of all Northern troops from the South. Kissinger said, "I believe there is no possibility whatever of getting them to agree to this." Nixon cabled, directing Kissinger to push Thieu to the limit, but to avoid "forcing him to break publicly with us before November 7." Next morning, the 22nd, Kissinger deployed threats and

blandishments, before making the short flight to Phnom Penh, to brief Cambodia's president Lon Nol.

On the American emissary's return to Saigon late that afternoon, Thieu denounced the deal as a sham. The proposed election commission, he said, was merely a disguised coalition government: "The US has connived with the Soviets and China. Now that you recognize the presence of North Vietnamese here, the South Vietnamese will assume that we have been sold out by the US and that North Vietnam has won the war." Several times during their meeting, the president shed tears. Kissinger said, "I can only deeply resent your suggestion that we have connived with the Soviets and the Chinese." Prominent among Thieu's objections was that, by conceding territory all over South Vietnam, the US acquiesced in the creation of a "leopard-spot" polity that few people would suppose viable. Moreover, communists and anticommunists were granted matching status on the planned election commission. Kissinger messaged the White House, warning that Thieu's obduracy created a new crisis. He also cabled Hanoi to express anger that Premier Pham Van Dong had revealed most of the proposed terms to a Newsweek interviewer, worsening the febrile mood in Saigon.

On returning to Washington, Kissinger embarked on more hasty "conniving": his first act was to call Soviet ambassador Dobrynin, urging the Russians to explain to Hanoi that two weeks before US election day, the administration must act and speak publicly in such a way as to avoid an open breach with Saigon. He also pleaded for a symbolic North Vietnamese troop withdrawal from the South and told the ambassador: "[Hanoi] may think we are deliberately delaying [a deal] beyond November 7th so we can bomb them or something. I give you the solemn assurance of the president that is not the case." Even as Kissinger spoke, down the hall in the Oval Office, Nixon was telling Alexander Haig, "After the election, we'll bomb the bejeezus out of them. I'm not going to tell Henry that, but that's how we're going to do it."

The White House players worked hard to persuade each other that a betrayal of Saigon constituted no betrayal because the Southern regime had never been much of a government in the first place. Haig said to Nixon, "If [Thieu] can't cut it with a million men with all that equipment, then goddamn it, he wasn't worth saving." Kissinger told Nixon, "I have come to the reluctant conclusion, Mr. President, and it breaks my heart to say it, that the system in South Vietnam is geared to a war which we sustain and that these guys cannot imagine what peace would be like. And that they're terrified not so much of the communists. They're terrified of—of peace."

When Nixon and Kissinger discussed the danger that the Saigon regime might fall precipitately, the adviser said, "I think our honor is—is intact. They won't collapse that fast." On October 24, he told the Chinese ambassador with characteristically witty self-deprecation, "I have achieved the unity of the Vietnamese—both of them dislike me." As Mao's man waited for his car, he asked Kissinger's aide if there was any hope of a deal being signed before election day. He was told that delay was to the communists' advantage: if there was a bust-up with Saigon before November 7, the president would be obliged to take its side against Hanoi; after the voting, the reverse would be true. Privately, the administration made plain to both Moscow and Beijing that it did not expect that the North Vietnamese would honor the terms of the settlement; it merely sought their signatures on the paperwork.

Many leaders of many nations have conversed on matters of state the way Nixon and Kissinger did, but never before had voice recordings been made laying bare their cynicism. The only question that matters to posterity is whether they had real choices. The war was almost certainly beyond winning before Nixon entered the White House. President Thieu and his associates had done little to serve the interests of the society they governed, and only experience would show that the communists did less. Nixon's heinous offense, in which Kissinger served as his instrument, was to sacrifice twenty-one thousand American lives and vastly more Vietnamese ones in military and diplomatic maneuvers designed not to benefit anyone in Indochina but only the president's political interests.

In some degree, the American electorate may be held complicit: even in the last war years, many voters still craved an outcome that did not make explicit the frustration of national will. Nixon and Kissinger sought to assuage that sentiment not by substantive statesmanship, but instead by a feat of stage carpentry—the creation of a set just sufficiently convincing to get them through a limited season of performances preceding and following the 1972 election. Their tactical skills in contriving such an outcome demand high respect, though it is hard to extend this to their morality. Kissinger showed that he had no master in the art of realpolitik, which he esteemed so highly. On October 23, he told Thieu face-to-face, "The US will never sacrifice a trusted friend." Back in Washington two days later, he told Commerce Secretary Pete Peterson, "I have only one desire—to turn the Vietnamese loose on each other in the hope the maximum will kill each other off."

On the 26th, the North Vietnamese revealed to the world the terms of the proposed settlement, demanding that America sign by the 31st, as had previously been discussed between Le Duc Tho and Kissinger. Hanoi's announcement created a sensation in the United States and persuaded Nixon to mandate Kissinger to make the first of countless appearances as a star of TV news shows—hitherto, he had seldom spoken in public. His inexperience showed, but his authority, apparent frankness, and apolitical status carried all before him. "Ladies and gentlemen," he told a packed White House press conference, "it is obvious that a war that has been raging for ten years is drawing to a conclusion."

Hanoi, he said, had abandoned its demand for a coalition government in the South; meanwhile, it was scarcely surprising that Saigon had raised issues. ABC TV headlined its report of his remarks, "Peace Is at Hand." Two weeks before election day, Kissinger delivered to Nixon the promise of a triumph.

The president said to him on the phone that night, "They think you've got peace?"

"Yeah."

"That's what they think, but that's all right. Let them think it."

Praise was heaped on the national security adviser from across the political spectrum. Senator James Buckley, brother of William F., rang to congratulate him, seeking only token reassurance: "May I assume that what has been done will not pull any rugs out from any regime?"

"Absolutely, totally, 100 percent."
"Great."

James Reston of the *New York Times* said, "Your country owes you a great debt, Henry." Democratic candidate George McGovern made yet another of a long catalog of campaign blunders, denouncing Nixon for refusing to abandon Thieu, oblivious of the fact that his opponent was at that very hour marinating the South Vietnamese leader to become the main dish at a communist barbecue.

Saigon continued for a few more days to sidestep an outright breach with Washington. Thieu said delphically that the South would never accept a settlement that worked against its people's interests, without adding that Kissinger's deal was exactly that. Next day, he told the National Assembly that North Vietnamese troop withdrawal was his "minimum demand," causing the *New York Times* to charge Thieu with obduracy. On October 27, the *Los Angeles Times* top story was "US Insists Hanoi Pull Back Troops: Requires Action on Withdrawal of 145,000 Men Before Signing." This was quite untrue, but national reverberations of the story strengthened Kissinger's reputation for toughness and drowned out important developments in the growing Watergate scandal—reports of wrongdoing by senior members of the Nixon campaign team.

Almost all US comment in those days reflected a pervasive, desperate desire to view Dr. Henry Kissinger as the nation's deliverer. The yearning of Americans of every political hue to escape from Vietnam, to believe that peace with some shreds of dignity was attainable, subsumed the concern of a minority about the fate of Thieu's people. Many judged that any outcome without bombs, bullets, and napalm would be better than more of the same. And who can dismiss such a view as ignoble?

Kissinger had earlier opposed launching further air attacks on the North after the election. Now, however, infuriated by both the intransigence of Saigon and the contemptuous slights from Hanoi, he had come to favor this course. On October 31 he told Nixon, "I think we ought to start moving the B-52s further north." The president agreed: "Absolutely." Kissinger continued, "Because the only thing those sons of bitches [understand?] . . . If after a week they don't answer, we ought to start bombing again." Next

day, Thieu explicitly denounced the draft accords as "surrender to the communists." George McGovern attacked both Nixon and the South Vietnamese for not signing the draft deal: he accused the president of planning four more years of war to keep Thieu in power—a risible distortion of reality.

Theodore White, serial chronicler of presidential elections, marveled that, after decades in which the Republican candidate had been one of the least fondly regarded politicians in America, in the last days of the 1972 campaign, crowds displayed love for Richard Nixon. One of the last GOP campaign ads before the election urged people, "This time vote like your whole world depended on it." On November 7, Nixon secured a historically overwhelming victory, with 60.7 percent of the popular vote against 37.5 percent for McGovern.

The story of Vietnam diplomacy through the months that followed was dominated by the administration's continuing efforts to shake the recalcitrance of Saigon, to persuade Thieu to accept the draft deal struck in Paris. Back at Gif-sur-Yvette on November 20, Kissinger presented to Le Duc Tho a list of sixty-nine changes in the draft agreement proposed by the Thieu government, foremost among them the demand for a total withdrawal of Northern forces—which Hanoi did not admit were in the South at all. Most likely, the American negotiator sought thus to emphasize to the communists the obstacles he confronted in bringing the Southerners to heel. Next day Le Duc Tho said of the changes, "We shall never accept them." Hanoi was sincerely uncomprehending of the Americans' inability to make their Saigon puppets dance to order. Tho renewed his demand for the release of thirty thousand civilian prisoners. Kissinger then read out a note from his president, instructing him to break off the talks.

The contradiction about what followed was that the Nixon administration focused its public wrath on Hanoi while privately deploying a barrage of promises and threats in order to secure a change of heart in Saigon. When Nixon met a South Vietnamese emissary at the White House on November 29, he was brutally direct, threatening to cut off all support:

"Without aid, you can't survive. Understand?" Yet still Thieu refused to accept the Paris deal. Le Duc Tho withdrew the North's demand for release of the thirty thousand civilian prisoners, but on December 12, he said he must return to Hanoi for consultations.

What followed was among the most grotesque twists of the war. President Nixon mandated an intensive new bombing campaign, supposedly in response to the communists' obduracy and explicitly for their failure to return American POWs. Yet Le Duc Tho's position in December was not significantly changed from that of October. All that was different was that South Vietnam had declined to endorse the proposed settlement. The most plausible explanation of what became known as Nixon's Christmas bombing campaign, Operation Linebacker II, is that it was designed as a show of strength to convince Saigon and the American people of the might and resolve underpinning the US commitment to South Vietnam—and to punish the North for four years' resistance to the will of Richard Nixon. The devastation changed nothing of diplomatic significance, but it proved to be the last important military act of America's intervention in Vietnam.

2. "WE'LL BOMB THE BEJEEZUS OUT OF THEM"

At 1100 on Monday, December 18, 1972, in the B-52s' crew briefing room at Andersen Air Force Base, Guam, Tennessean Col. James McCarthy pulled aside a curtain to reveal the route map and proclaimed theatrically, "Gentlemen, tonight your target is . . . Hanoi!" Flier Vince Osborne said, "I'm sure cheering was expected . . . but the crews sat there with very serious looks on their faces and mentally screaming, 'Oh, shit!'" Capt. Ed Petersen was almost disbelieving on hearing that he and his fellow fliers were headed "Downtown," saying later, "I almost thought it was a joke at first." The airmen had kidded themselves that, for Americans, the war was all but over. Yet during the ensuing eleven days, 729 B-52 sorties dropped 15,237 tons of bombs on North Vietnam, while tactical aircraft delivered another 5,000. Linebacker II was the largest B-52 commitment of the war, with 155 bombers crowding onto five miles of parking space before taking off to consume two million gallons of jet fuel a day. Everybody

hated Andersen, and some of its inhabitants called themselves crewdogs or POGs—prisoners on Guam. Base vehicles featured bumper stickers cruelly mimicking those about the POWs in the North: FREE THE POGS. Twelve thousand personnel were shoehorned into spaces with accommodation for a quarter that number: when a crew was shot down, comrades hastened to appropriate their furniture. Here was the climax of the vast air campaign waged with intermissions since 1965.

Fliers in all wars inhabit a universe parallel to that of the grunts on the ground. In place of hooches and hammocks beneath the jungle canopy, the B-52 men lived in air-conditioned quarters set on concrete deserts where not a shot nor explosion was heard. Most days, they showered and ate American breakfasts before taking off for enemy territory. Much later they landed back, taxied their whining-engined monsters to revetments or stands, then headed toward a cocktail in the officers' club. This should not imply, however, that they waged a cushy war: the psychological strain was immense as they repeatedly exchanged the humdrum routines of Guam for the missile-trailed skies over North Vietnam.

The world thinks of the bombing of Indochina principally in the context of its victims, which is just. But those who flew thought little about the people who lay invisible on the ground far below them; much, instead, about the hazards that they themselves faced. Some "fighter jocks" enjoyed their role, as each successive generation of young pilots revels in the thrills of high-speed flight, combat, and indeed destruction. But many nursed fear, and never more so than during the 1972 Christmas bombings. The Navy's Cmdr. John Nichols wrote, "Nobody wanted to be the last to die in a winless war." Many became unashamed of dodging danger. A man might wail in response to a threatened assignment: "Hey, wait a minute. I had a flak suppressor yesterday. It's not my turn." Some detected technical glitches to escape takeoff or return early. There were ugly rumors that the communists felt they had enough prisoners and were not taking more.

Carrier fliers, together with the USAF fighters and B-52s that operated out of U-Tapao, Thailand, made round-trips of only three or four hours. The Guam-based B-52s, by contrast, started out almost three thousand miles east of North Vietnamese targets. Most crews dropped their

bombs only after a nine-hour passage to targets and had traveled more than eight thousand miles before landing back on "the Rock" after at least one rendezvous with Okinawa-based tankers. Though some autopilot slumber was possible, even before encountering the enemy the handling of a B-52 was immensely demanding. Jim McCarthy wrote, "Unlike a high-performance fighter or the newer B-52 models, the B-52D does not have powered controls. It takes a lot of old-fashioned muscle power to fly precision formation or maneuvers." Handling the D, wrote the pilot, "has been compared to driving an 18-wheel truck without power steering, air brakes, or automatic transmission in downtown Washington during the rush hours."

Every mission committed an armada of aircraft of many types and functions. Ahead of the Stratofortresses, fighters struck at enemy gun and missile sites. Electronic countermeasures aircraft strove to jam communist communication channels and radar signals. F-4 Phantoms strewed chaff. Alongside the bombers, more Phantoms provided close cover against MiGs. B-52s were manned by crews of six: two pilots; a two-man "defense team," consisting of an electronic warfare officer and a gunner, who sat peering into their screens and dials in rear-facing seats a few feet behind the cockpit; and an "offense team" of navigator and radar-navigator—the latter being what was once known as the bombardier—in a compartment below. The four .50 caliber machine guns in the plane's tail were a hangover from World War II and seldom did much harm to the enemy, though they did claim two MiGs during Linebacker II.

On Guam the B-52s were maintained by five thousand ground crew based in the "Bicycle Works." It was a huge task to sustain a type designed in 1949 and first flown four years later; some planes bombing Hanoi were seventeen years old. The Stratofortress had ten independent hydraulic systems and four big generators, powered by hot-air turbines, for which compressed air was bled from the engines. A leak could be disastrous, for temperatures in the ducts, which ran alongside control cables, fuel tanks, and oxygen lines, could reach 250 degrees Celsius.

When Andersen or "U-T" (U-Tapao Air Base in Thailand) was operating at high pressure, a bomber could be fueled and bombed-up in

four hours—half the usual Stateside time—and major inspections were completed in eight hours. A full internal load consisted of eighty-four 500-pounders, packed in prepacked cells. The demands were enormous on those shifting ordnance in temperatures that could exceed a hundred degrees Fahrenheit, periodically interrupted by tropical rainstorms. Ground crews sometimes displayed heroic commitment: when one bombed-up plane burst a tire as it taxied for takeoff, a wheel replacement that normally took 150 minutes was made in fifteen, without killing the engines.

Before every mission, planners spent hours debating targets, offset aiming points, and optimum axes of attack amid the mosaic of SAM sites and radar installations marked on maps and air photographs taken by high-flying SR-71 reconnaissance aircraft. Two "cells," each of three B-52s, carrying up to thirty tons of ordnance apiece when the wing racks were filled, could eliminate almost every living thing within a "box"—a rectangle on the ground five-eighths of a mile wide, two miles long: here was the most chilling of "carpet-bombing." In the light of the latest intelligence and target selections, "frags"—fragmentary orders—were issued to crews. Targets were located in one of two zones, respectively identified as low- or high-threat, according to the density of ground defenses. A priority target caused a mission to be designated a "Press-On," which meant that crews must go through with it, whatever level of opposition or aircraft system failures they encountered.

After briefing, chaplains offered Catholics last rites, which some found helpful, but caused others to recoil. Crews rode out to their planes laden with bulging survival vests, sidearms, ration boxes, and oversized briefcases filled with aircraft technical manuals, bombing computation tables, celestial navigation data, and classified briefing material. They also carried cold-weather gear, redundant if the aircraft heating system functioned, but indispensable if it failed, plunging the cockpit temperature to minus 70 degrees Fahrenheit.

Fighter pilots called the B-52s BUFFs—big ugly fat fellers, the last word commonly expressed as an obscenity. Strategic Air Command preferred the more dignified phrase "parade of elephants" to describe a column of the huge bombers progressing down the taxiway to takeoff.

Operational launches drew a crowd of spectators, ground personnel, and off-duty aircrew, standing in clusters on the flight lines, outside offices, on balconies. One by one the BUFFs accelerated to takeoff, black smoke belching from engine tailpipes as injected water increased thrust.

Gaining height, they passed over the Russian trawler that lay offshore counting heads. Crews settled in for the long haul west; the two navigators might play chess or write letters. One airman addressed the problems in a school algebra textbook; others pursued correspondence courses, one of them in dentistry. When they wanted to be indiscreet, crack jokes, or question a procedure, they passed each other notes, to escape scrutiny by SAC inspectors who monitored cockpit voice recordings. Over the sea, whole crews often fell asleep. It was wise to start out feeling fit and well, because flying at high altitude with a heavy cold or a blocked ear or sinus was intensely painful and could lead to serious infection. Unpredicted weather raised issues: headwinds increased fuel consumption, sometimes necessitating extra airborne refueling.

Nobody stayed asleep when the bombers approached targets. By December 1972, North Vietnam possessed formidable MiG, flak, and missile defenses. SAM-2 crews began launching salvos skyward the moment American aircraft approached within range. Cockpit reactions varied. Pilot Robert Clark, who led the third wave of bombers on December 18, said, "I was ready to do it; my nav was just absolutely terrified; my gunner was a hawk; my electronic warfare officer was horribly curious about whether his equipment was going to work—he was excited but scared." Les Dyer felt insouciant: "I was young, bulletproof, and invulnerable." Bruce Woody described himself as "scared out of one's wits." Jerry Wickline said, "The whole time I thought I would be dead the next second. . . . Several times I was blinded by a near missile detonation or from the brilliant glare of their rocket trails as they went past me. The B-52 right behind me was shot down." He added, "I found out on that mission I was not a coward. I begged for an excuse to turn that airplane around and not fly through those missiles, but I was more afraid of being branded a coward than of dying."

Accurate bombing demanded four minutes of stable, straight flight

during the target approach, heedless of upcoming missiles. Three-ship cells flew in close formation to confuse enemy radar; if a nervous pilot allowed his aircraft to drift away from its mates, the protective envelope was weakened. Crews might hear heart-stopping words from the electronic warfare officer: "SAM uplink!" A pilot would ask, "How far out from the target are we, Radar?"

"We're ten seconds out. Five. Four. Three. Two. One. BOMBS AWAY! Start your . . . turn, Pilot." This opening attack of the campaign began at 1945 on December 18, when the first of a long trail of cells released. There was a slight shudder as thirty tons of ordnance fell away from each aircraft. A steep turn could temporarily black out radar emitters, masking a plane's defenses for seconds that could prove lethal. Col. Hensley Conner, flying as a mission commander, described an experience as his pilot swung the huge bomber one moonlit night: "KABOOM! We were hit. It felt like we had been in the center of a clap of thunder. The noise was deafening. Everything went really bright for an instant, then dark again. I could smell ozone from burnt powder, and had felt a slight jerk on my right shoulder." Over the interphone he quizzed Cliff Ashley, the pilot, who responded, "I'm fine, but the airplane is in bad shape."

The enemy missile had exploded off the B-52's port side, taking out two engines and the wingtip. Flames were streaming from the stump, cabin pressurization was gone, along with most instruments. Though based on Guam, they set a course for Thailand and called for escorts. Two F-4s replied almost instantly, "We're here, buddy." They began a rapid descent from thirty thousand feet, desperate to avoid bailing out over North Vietnam or Laos: "We knew they did not take many prisoners in Laos." Thirty minutes later, they felt a surge of relief as they crossed into Thai airspace, and started to think they might be able to land. Then one of the accompanying F-4 pilots warned that flames were intensifying, the whole left wing blazing: "I don't think you'll make it." All six regular crew members had their own ejector seats, and a few seconds later the red ABANDON light came on. *Bam!* The navigator vanished. Conner, with no seat of his own, clambered over wreckage to the hole through which the last man had vanished and gazed at the ground far below. Then he jumped

and seconds later pulled the ripcord on his parachute. He glanced up to see the plane burning fiercely as it spun toward the ground. He landed in the midst of a cluster of Thai villagers, who offered him water. Twenty minutes later, he was rescued by a Marine helicopter, which had already retrieved the B-52's six crew members.

On Linebacker II's first night, Richard Jones counted fifty-six SAMs fired at his formation, and John Filmore Graham saw thirty during an attack on Hanoi's Phuc Yen Airfield. Maj. Don Aldridge, flying as a deputy airborne controller, scribbled impressions of his glimpses of the night sky: "Started to see [flak] . . . most of it was around 20–25 thousand feet, but fairly heavy. MiG activity west of Hanoi, but were being engaged by F-4s. Starting seeing SAM firings . . . some 122mm unguided rockets. . . . Gunner reports . . . cell moving as one aircraft. SAMs getting pretty thick but most missing by at least one-half mile. . . . 120 seconds to go—the two SAMs at one o'clock are well off target—exploded high about one-half-mile horizontal range. . . . SAMs over the aircraft—I can see the exhaust—they both explode above . . . then straight and level, on bomb run heading . . . 31 SAMs fired at Green Cell."

After Capt. John Alward's B-52 suffered severe damage from a near miss, with two engines dead and two more ailing, he headed south across the DMZ toward Danang, which was close but had a desperately short runway for a big, crippled bomber. He approached in poor weather, only to find the base suffering a communist mortar and rocket attack. Alward, a relatively inexperienced pilot, discussed with the crew whether to bail out over the sea. They agreed to try a landing, but came in fast. When the copilot pulled the lever to activate their tail drag chute, however, nothing happened: its cable was cut. Surging along the runway toward a minefield, Alward clawed the throttles and dragged the huge plane back into the air. They circled for a second approach, which was miraculously successful.

The Americans discerned a clear pattern of competence and otherwise among enemy gunners and SAM teams. One Vietnamese missile battalion was mocked as F Troop, after the TV comedy show, because of its low success rate. By contrast, another, southwest of Hanoi, was dubbed Killer. Site VN-549 and became the target of repeated attempts to knock it out.

656 .

North Vietnam's MiG fighters often took up station at a safe distance alongside the B-52s; the Americans grasped that they were "playing traffic cops for the SAMs"—relaying fixes on the bombers' altitudes to enable missile crews on the ground to fire even without achieving a radar lock. To many pilots, the flak was even more frightening than the missiles, because crew couldn't see shells until they exploded, and North Vietnamese 100mm guns were effective above thirty thousand feet.

Five miles below was a Russian antiaircraft adviser, twenty-one-year-old Lt. Valery Miroshnichenko, who said later, "We were watching *Liberation*, a movie about World War II brought in by the mobile cinema. One minute tanks were firing on the screen, the next minute explosions started outside too. We wondered if there was a thunderstorm. Then we looked up and saw B-52s. We saw one aircraft falling, flaming like a torch." The North Vietnamese today refer to the December 1972 bombing as "the Dienbienphu of the air," meaning that they claim to have inflicted a decisive defeat on the USAF. The campaign followed a bad time earlier in the year, when the failures of missile batteries caused a slump in their crews' morale. One man wrote: "Some people whispered that we were incompetent and impotent," in the face of intensified American electronic countermeasures.

One day that autumn, Lt. Nguyen Kien had just launched two SAMs toward a US aircraft at a range of six miles "when I heard somebody shout 'Watch out, there's a Shrike!'" The battalion commander rejected their requests to reduce power on their tracking radar to lower its profile and thus vulnerability. Kien wrote, "Two or three seconds later a shattering explosion blew me against my screen. When I turned around I saw that the van's door had been blasted open, and the air was full of smoke and dust. Almost everybody in the guidance van had been wounded, and our equipment was wrecked." In the site's generator truck, Kien found a comrade slumped motionless at his controls. "I called to him but he did not respond. His body was limp and a few drops of blood were visible on his chest. A small fragment of metal from the Shrike had pierced his heart." It was the first time in six years' service that Kien had seen a man die, and

he was shocked—also filled with remorse, because he felt that his team had blundered.

The real US objective in the Christmas attacks was not material but moral: planners sought to cause maximum distress to the population by striking at night—and they succeeded. Late on December 18, Kien slumped exhausted onto his mat "hoping for a few minutes' rest to regain my strength" after engaging with two waves of B-52s. He had scarcely closed his eyes when a new alert came—this time prompted by incoming F-111s. When they had gone, once again Kien lay wearily down, only to hear just before 0400 on the 19th that a third wave of B-52s was approaching, their jamming bands swamping North Vietnamese screens. By the time a chilly dawn came, the exhausted missile crews ate breakfast disconsolately: their regiment had engaged six waves of US aircraft, and failed to shoot down one; other units claimed three B-52s. By the early morning of December 21, "we had endured four or five combat alerts, and everyone was exhausted by lack of sleep and nervous strain. When we heard the gong clanging everyone threw off blankets, pulled on shoes and ran to his action station in defiance of freezing cold." A few days later, cluster bombs dropped by a US F-4 wiped out his battery.

Among the American POWs in the "Hanoi Hilton," the sound of exploding bombs prompted extraordinary scenes of jubilation. Prisoners leaped up and down and applauded, causing a bewildered guard to challenge Col. Robinson Risner: "But these planes are trying to kill you." The prisoner replied defiantly: "No they're not, they're trying to kill you!"

As for civilians, Nguyen Thanh Binh lived many miles east of Hanoi, but during Linebacker she often stood with a host of others, gazing on the distant horizon, which seemed to them to resemble "an erupting volcano," as wave upon wave of bombers discharged their loads. The young woman said, "B-52s seemed to cover the sky, to blot out the moon," a description that was surely figurative, for the planes were far too high to be visible in darkness to those who peered upward or crouched in ill-lit shelters. All that was certain was that the bombing prompted fear and bitterness among millions of Le Duan's people.

Miles above, American EWOs and radar navigators in their "black holes" glimpsed nothing of cities and villages, prison complexes, and SAM sites. They inhabited a weird universe, with a view only through radar scopes. Navigator Phil Blaufuss said enemy fire was "an evil [you] had to ignore . . . when you're . . . stuck in the belly of an airplane with no windows to see all the hell that's breaking loose, no guns to shoot, no ECM equipment to jam with, and no control column or throttle to maneuver." Yet for an electronic warfare officer it was a bleak experience to watch his aircraft's potential SAM-2 nemesis approach as a dot on the scope. One such, Maj. Allen Johnson, just had time to cry out, "They've got us!" before a violent explosion fatally crippled the aircraft and killed him.

All young men flying over enemy territory are sustained by training and discipline; they solace each other with shouts of bravado. Radar navigator Dick Parrish recalled a night when his pilot glimpsed repeated SAMs and a fireball that must have been created by an exploding B-52. They took drastic evasive action when the gunner sighted two missile traces on his radar scope. Just as they began to feel a little safer, approaching Laos on the run back to U-Tapao, from the cockpit they saw another big explosion on the ground, almost certainly an American aircraft. Parrish said later, "All of the sightings the pilot made, plus what we had experienced on our own, sort of got to us, I think. As we headed on down-country and toward the water, I tried to break the ice with some weak joke. Dick Enkler, our EWO, had been staring at all that wild stuff on his scope. . . . He promptly chewed on me for trying to act happy. . . . Then I got to thinking, What the heck. We did the job and we're out in one piece. I think there's plenty to be happy about."

John Allen and his crew used to sing along to the Doobie Brothers' "Listen to the Music" patched over the intercom, in sheer relief as they headed east over the Pacific, back toward Andersen. Yet no mission was over until it was over. Ken Simpson, a navigator, was once sent back by his pilot to investigate a warning light indicating a bomb hung up, just before they were due to land back at base. Finding the bomb bay clear, he crawled into the wheel well, plugged in his intercom cable, and reported the good news. This prompted the pilot to lower the landing gear, leaving

the parachuteless Simpson gazing in terror upon early morning sun glinting on the Gulf of Thailand, far below. He somehow clung on until the pilot was persuaded to retract the gear again, enabling the shaken airman to regain his seat.

Back on the ground after that first operation of the campaign, almost all aircraft were alleged to have hit their targets: three B-52s had been lost, two more severely damaged. There was dismay among crews when they discovered that many would be required to operate again the following night, and that they would again have to follow a single track decreed by commanders back at SAC headquarters in Omaha. Maj. Gen. Pete Sianis, deputy chief of staff for operations, had heard his officers' proposals for the attacks on Hanoi and Haiphong using multiple approach routes. Then he said decisively, "That's not the way we do it!" He moved the colored tapes from the map, and mandated: "One way in and one way out!" His tactics appeared to be vindicated on the night of December 19, when though two of ninety-three B-52s that attacked were damaged, none was shot down.

As bombers approached Hanoi on the following night, the 20th, most of the city's defending SAM batteries were ordered to reduce salvos from three to two, because missiles were running short and American strikes were impeding deliveries; SAMs were also now reserved exclusively for B-52s. Despite these handicaps, as the attacks developed, the missile crews found their task made much easier by the rigor of SAC's flight planning. In the December 20 raids, six B-52s were shot down out of ninety-nine that bombed. In the words of a North Vietnamese officer "the US Air Force had fully exposed their pattern of operations [and] . . . flight paths from the north-northeast. . . . The enemy's approach sector, timing, and flight formation still had not changed." John Filmore Graham was among the angry fliers, saying, "We were like ducks in a carnival." On December 26, SAC belatedly and reluctantly agreed to change tactics: 120 B-52s approached Hanoi and Haiphong on ten different axes, and all bombed within a fifteen-minute span. Two aircraft were lost.

Lt. Col. Bill Conlee, an electronic warfare officer aboard one of them that night, described his path to captivity, after ten SAMs exploded

660 .

around his cell in the last seconds before it reached release point. His plane was bracketed by two missiles, which started a fire in the left wing and wounded five crewmen. Cabin pressurization collapsed, and electrical power was lost. The alarm light went on; the crew ejected. As Conlee descended on his parachute, he had the unnerving experience of seeing two SAMs whoosh past. He was bleeding profusely from multiple abrasions as he hit the ground, where a rattle of small-arms fire was directed at him. A crowd of Vietnamese closed in, seized the American, and stripped him to his underwear. Local people struck him repeatedly with farm implements and staves as he was marched toward a road, breaking several ribs and injuring his right knee. He was bundled, face down onto the floor of a truck for the hour-long ride to Hanoi, then thrown out onto the tarmac, dislocating his shoulder. Two soldiers dragged him into the courtyard of what he found to be the Hanoi Hilton, where he was placed in solitary confinement.

Back at base between missions, frustration, exhaustion, and stress were vented in familiar ways. By the second day of Linebacker, said Robert Clark, when a man walked into the Andersen officers' club, "you could smell the fear. Guys were hanging onto each other and just revalidating the fact they're still alive." There was heavy drinking and some fights; Christmas trees and sea-marker dye were tossed into the pool; flares were fired on the golf course; a life raft exploded into inflation on the dance floor. Jon Bisher said, "If you're a prisoner on Death Row, you're pretty free to do what you want. . . . The attitude was they can't do anything to you, they're not going to send you home." Mark Clodfelter has written that a key factor in plummeting morale was "the failure of US political and military leadership to articulate exactly what the crews needed to do to achieve success. . . . They could see no end to the missions that they flew."

Casualty reporting was not always handled sensitively. Katie Turner was at the Andersen officers' club pool when she was told that her husband would not be coming home. Some wives of aircrew posted as missing went years without learning more, and commanders were probably wrong to have kept alive hope of their survival. "Cruise widows" back at the Califor-

nia naval air stations also found themselves in a state of prolonged, agonizing uncertainty. There was bitterness in both the USAF and USN that the Nixon administration did not take a tougher line with Hanoi about demanding answers about missing men, though most likely the communists themselves knew nothing about the identities of some charred corpses, let alone ones that were vaporized.

As Linebacker II continued, it was considered necessary to eliminate crew rest periods. More than a dozen men reported sick after the first couple of missions rather than endure another. Toward the end, this figure crept nearer to forty, around one-tenth of the aircrew flying each operation. Two friends and comrades of Paul Munninghoff "went on strike, and [I] heard second-hand of several others." Likewise pilot Ted Hanchett "[could] attest to crew desertions. . . . We kept putting our lives at risk when we could end this quickly if our leaders wanted to." Wing commanders handled refuseniks gently: they were spared disciplinary action. Both fliers and defenders became ever more stressed and weary. Some B-52 pilots flouted the order to approach targets straight and level, instead adopting drastic evasive maneuvers. In all, during those eleven nights around a thousand SAMs were fired, sometimes in very effective barrages.

When Washington ordered a halt to Linebacker II on December 29, fifteen B-52s had been lost, and the airmen had no means of knowing that they wouldn't be asked to bomb again. On January 3, 1973, SAC's commander, Gen. John Meyer, a distinguished former World War II fighter pilot, staged a morale-boosting trip to Andersen, which was disastrous. Meyer had previously visited Guam accompanied by his family, which galled men pained by their own separations. Now there was unease when he pinned an Air Force Cross on Col. McCarthy, the wing commander, who had flown only two Linebacker II missions, both as a passenger. During a subsequent Q&A with crews, a flier complained about the strain that intensive operations imposed on relationships. This caused the general to chortle and say, "Some marriages weren't meant to last." Then Meyer harangued crews about the need for cell discipline on bomb runs, adding a threat of courts-martial for those who strayed. This prompted astonishing, unprecedented scenes between aircrew and a USAF general.

662 · VIETNAM

Some men walked out in disgust; others booed and catcalled; chairs, Coke cans, briefing books were hurled at the stage, hitting Meyer several times. A cluster of senior officers closed in and hustled the visitor out. As he drove away, his car was pelted with gravel by enraged pilots. This was one of the most extraordinary episodes in the history of Strategic Air Command.

Some aircrew were embarrassed by such behavior, but many believed that Meyer brought his humiliation upon himself. In the words of James Rash, "Most of these crews had spent too many hours in the air in a hostile environment. . . . And a good many of us had friends who were living in close comradeship a few days ago and now were dead."

As for the world's response to the Christmas bombing, both at home in the US and internationally, it was overwhelmingly unfavorable. Hanoi handled its propaganda activities with cold brilliance, showcasing film footage of dead and screaming children and a wrecked hospital. The USAF's targets were mostly rail centers and electricity plants, whose capacity fell from 115,000 kilowatts to 29,000, and a quarter of all the country's fuel stocks were destroyed. But the mayor of Hanoi announced that the raids had killed 1,318 civilians, and another 305 were reported dead in Haiphong. The Washington Post denounced the attacks as "the most savage and senseless act of war ever visited . . . by one sovereign people upon another." Tom Wicker's New York Times comment was titled "Shame on Earth." In London The Times said the bombing was "not the conduct of a man who wants peace very badly," while the Daily Mirror headlined "Nixon's Christmas Deluge of Death." Hamburg's Die Zeit wrote, "Even allies must call this a crime against humanity." Senator Edward Kennedy said the attacks "should outrage the conscience of all Americans." In Canberra, Gough Whitlam's newly installed Australian Labor government dissociated itself from the US and denounced Linebacker II. One minister, Tom Uren, condemned Nixon and Kissinger's "mentality of thuggery." Another called the air campaign "the most monstrous act in human history, the policy of maniacs."

Such intemperate language reflected a melding of wild passions generated over a decade with a tide of liberal loathing for Nixon, rising almost

daily under the influence of Watergate revelations. Many American conservatives kept faith with both the president and his policies: they accepted his claim that the bombing was necessary to pressure the communists to release POWs. Globally, however, Linebacker II strengthened an image of the North Vietnamese as hapless victims of unbridled US violence. The language used to denounce the bombing was hyperbolic, but almost half a century later the evidence suggests that Linebacker II was unjustified politically or militarily, except to serve the partisan purposes of the president.

Hanoi newspapers claimed that, since the campaign began, its forces had downed 3,500 aircraft, though in reality since 1964 the US had lost over the North a total of 944 planes and 10 helicopters. The Seventh Air Force's Gen. William Momyer wrote long afterward to a fellow airman: "My regret is that we didn't win the war. We had the force, skill and intelligence, but our civilian betters wouldn't turn us loose. Surely our air force has lived up to all expectations. . . . If there is one lesson to come out of this, it must be a reaffirmation of the axiom—don't get in a fight unless you are prepared to do whatever is necessary to win." In the post–World War II universe, his remark constituted strategic illiteracy. There is no reason to suppose that air power could have changed the outcome of the Vietnam conflict unless Momyer and his kin had been permitted to unleash nuclear weapons—as indeed some wished.

The Christmas bombing altered the diplomatic landscape by scarcely a jot or tittle from what it had been in October. A deal would come whenever the Saigon regime could be persuaded to swallow it. Hanoi was already confident of securing at the conference table most of what it wanted, with the balance to follow as a final payment.

A KISS BEFORE DYING

1. THE PRISONER

Few men cared more about the outcome of the Paris negotiations than almost six hundred American prisoners of the communists. Most were aircrew, held in or around Hanoi. However, some twenty or thirty captured in the South—the number varied between 1965 and 1973—were dispersed in jungle camps around the Cambodian border. Foremost among these was Foreign Service officer Doug Ramsey, in the hands of the Vietcong since January 1966. For much of his early captivity, he occupied a bamboo cage shorter than his own ill-nourished frame, infested with ants, scorpions, termites, and mosquitoes. He was allowed to shave, painfully, only monthly. He received letters from home twice in seven years, and once went seven weeks without an opportunity to wash. For a time he shared his quarters with a six-foot black-and-yellow banded krait, which he found in his bed. Eventually it slithered away, to be spotted and killed by guards.

At the outset, Ramsey sought to convince his captors that he was an unimportant civilian. They asked, not unreasonably: why, then, your AR-15 carbine? What about the grenades in your truck cab? As for his supposed insignificance, the communists discovered that the *Washington Post* had described him as "the most important prisoner taken to date," ranking as a lieutenant colonel. The Associated Press said that he was "one of the most knowledgeable officers in the civilian ranks of the US

mission." He was a highly cultured man, whose view of war was formed by Thucydides and Sun Tzu. His father was a retired US government official, a New Dealer who saw much of the hardship of the Depression, and Doug was infected by his parent's cynicism about political appointees in public service, comparing them unfavorably with the integrity of career professionals. Following Harvard graduate school, where Mac Bundy was among his teachers, he spent two years with US Air Force Intelligence in Japan and Okinawa. After a spell at the State Department's Lebanon desk, he rejected an offer to transfer to the CIA, because he had always thought poorly of James Bond. Yet his captors took it for granted that he was an intelligence officer.

Ramsey and other prisoners intermittently held with him were spared the tortures to which those in Hanoi were subjected until 1969, but they suffered worse privations. They never knew when or whether they might be killed, the fate of some other Americans who had fallen into VC hands. Ramsey heard that US military prisoners Sgt. Ken Roraback and Capt. Humbert Versace had been executed shortly before his own capture, by being led to a table as if for a feast, then shot in the head from behind. He begged that, if he was to go the same way, he should be granted fifteen minutes in which to write a letter to his parents. For the first two years, maintained by his captors in a contrived state of terror, he suffered insomnia and nightmares about his own execution: "I don't know how I held up psychologically."

He was forced to seek guards' permission to sit up, lie down, or brush his teeth; orders were emphasized by whistle blasts. The VC shot Americans who absolutely declined to communicate. Assisted by his command of Vietnamese, Ramsey engaged in frequent exchanges, telling his captors—truthfully—that he favored village socialism for their country. When he eventually signed a propaganda statement to this effect, there was much argument among the cadres about whether its wording was sufficiently humble. Ramsey was repeatedly quizzed about, for instance, how many troops the US might commit to an invasion of the North. He guessed four hundred thousand to seven hundred thousand, which prompted a cadre to say approvingly, "Now you are on the road to life."

666 .

Yet near-starvation remained the norm. Some prisoners died because they could not endure the diet—a lethal squeamishness that had been known to earlier US prisoners in North Korea as give-up-itis. Marine Maj. Don Cook, by contrast, forced himself to eat his own vomit.

Ramsey suffered an impressive range of diseases—hookworm, typhoid, scurvy, hepatitis, beriberi. Malaria attacked both sides indiscriminately, and his deputy camp commandant was among those who died of it; he himself suffered 123 attacks. There were also, naturally, dysentery and its amoebic variation. The slightest cut became infected. Ramsey wrote later of the condition of himself and fellow prisoners: "Each of us had been reduced to a shrunken, embarrassed parody of his former physical self... so weak at one time or another that he had to be carried to the latrine—frequently too late. Until one becomes conditioned to prison camp life, few things are apt to be more humiliating to grown men, especially in a group containing gung-ho Marines and macho special forces officers. Worse yet, however, is the humiliation of waking up after lying in your own filth for hours or even days because you are shackled down and/or are in solitary confinement." A prisoner once defecated eighty-four times in a single day.

Ramsey described a malaria attack, accompanied by cramps, violent shivering, and loss of bowel control. Under a rainstorm "I managed to slosh my way in slow motion to the end of my chain, dig a tiny cathole, squirt out a diarrhetic flood, and stagger back—all without passing out, but only by dint of a number of trees and posts which I was able to hold onto." Then he missed his hammock and collapsed into six inches of muddy water, where he sat for ten minutes, "too weak even to swear." With a high fever, for four days he was unable to eat; the acute phase persisted for a fortnight. A fellow prisoner, Pvt. Charlie Crafts from Maine, described the sensations: "You feel like someone has shoved the hose from a vacuum up your ass and sucked out all your insides." At one point in his own bout, Ramsey lapsed into convulsions, causing his fellow prisoners to believe that he was doomed.

They wore the same black pajamas as the guards, and spent long periods harnessed to trees, "a heavy chain rubbing your ankle and a big

lock banging away on your anklebone." Physical labor came hard to these enfeebled men, so that Ramsey suffered dizziness when ordered to chop wood. In the winter of 1969, the prisoners were forced to construct their own new camp, a task that took five weeks. Tensions mounted as the POWs argued about who was, and was not, doing their share of work. As they could not shout at the Vietcong, instead they abused each other for snoring or farting. Yet Ramsey bore no lasting ill will toward fellow prisoners who behaved badly, including two civilian contractors. "Most POWs who have themselves suffered extreme hardship tend not to be too judgmental toward others, even if they have cracked under duress."

At one point, COSVN decreed that Charlie Crafts should be released. The guards argued against this, proposing that instead Don Cook should be let go, because he had done two years. Cook, however, urged successfully that Crafts should be the supremely fortunate man, because the soldier's entire body system was collapsing. After a couple of years, a senior cadre who visited the camp told Ramsey that it had been decided he should be kept alive, provided he made no attempt to escape. When Cook told this coldly impressive Vietnamese that he was a Catholic, the cadre promptly responded, "Pax hominibus bonae voluntatis"—"Peace towards men of goodwill." When Ramsey and Cook were allowed to converse, they held long debates on Catholic doctrine.

In the course of seven years, Ramsey gained passing access to just five books—Tom Sawyer, Three Men in a Boat, David Copperfield, and two works by Australian communist Wilfred Burchett. The Bible was explicitly forbidden, a source of deep distress to some prisoners. Once Ramsey and Cook caught a snatch of a BBC broadcast of a Bach concert: "We both cried like babies." In his fifth year of imprisonment, Ramsey got a deck of cards, with which he played serial solitaire. As for his dreams, "I would sometimes visualize myself in a \$600 Brooks Brothers custom sharkskin suit and a pair of Florsheim Imperials, posing casually with a well-built showgirl draped over the hood of a Mercedes 600 outside the Las Vegas Strip's largest resort hotel—then sending a framed, wish-you-were-here sixteen-by-twenty-inch color photograph to one VC guard whose tastes I strongly suspected ran to such things. But these images didn't seem nearly

as important to me as the Van Gogh sun shining on a Van Gogh field, or a hot bath, Coke, conversation, and heavy classical music at ninety decibels."

Ramsey thought a lot about philosophy and quantum mechanics: "Since I couldn't control the environment in my own corner of the world, it seemed sensible to think about the universe instead. It was mental masturbation." There were few humorous moments in those long years. When laughter came, it was about stupid immediacies, such as the sight of a chicken that fell into the latrine, then fluttered out and shook its feathers all over a cadre whom nobody liked. Once when a prisoner was absent, seriously ill, the others were fed monkey meat. An American picked up a primate paw on his plate and examined it theatrically: he said he wanted to be sure he was not eating his cellmate. From time to time, disease killed a prisoner, always a blow to morale. Cook, whom Ramsey described as "the most impressive POW I ever encountered—I needed him both to keep me in line and to cheer me by example"—died of malaria in 1967. Ramsey describes kidney malfunction as the cause of adviser Maj. John R. Schumann's death, though the soldier is still officially listed as missing.

It was fortunate for Ramsey's sanity that he did not know until long afterward that he could have been spared the last eighteen months of his ordeal if Washington had willed it. In December 1970, Nguyen Tai became one of the most senior cadres ever to fall into Saigon's hands. For six years, he had been directing espionage and terrorist operations in Saigon. In October 1971, the PRG offered a swap: Tai and another top communist for Doug Ramsey. Neither Thieu's men nor the CIA would approve such a deal. Tai, especially, they said, was too important: he remained confined until the fall of Saigon. Ramsey's fate awaited an outcome of the Paris talks.

2. "PEACE"

Early in 1973, as an *Essex*-class carrier left San Francisco for what proved to be its final deployment on Yankee Station in the Tonkin Gulf, aircrew and sailors gazed in gloomy wonder at traffic snarl-ups on each side of

the deserted Golden Gate. The bridge had been closed by police ahead of their passage, lest antiwar protesters drop rocks or even explosives onto the ship: to such depths had the war brought domestic ferment. Yet now, at last, Americans were approaching a point of departure, even if Vietnam's own hapless people were denied escape. In 2013, Henry Kissinger itemized changes in the October 1972 draft Paris agreement that were secured, he said, by the Christmas bombings: an unrestricted right for the US to continue providing munitions and equipment to South Vietnam, communist withdrawal from Laos and Cambodia, a strengthening of the internal control machinery ("all of which is bullshit, to tell the truth," Kissinger had privately told Nixon on October 12, 1972, ". . . but it will read good for the soft-hearts, for the soft-heads"), and minor technical amendments.

The first point had been settled four months earlier. The other stipulations were either trivial or never likely to be observed by the communists. Kissinger also emphasized that, supposedly as a consequence of the bombings, in January 1973 his interlocutor, Le Duc Tho, moved swiftly to agree to what became known to history as the Paris Accords. Yet the previous October, the North Vietnamese had been furious that the Americans failed to sign what was in every significant respect the same deal. The State Department's John Negroponte said bitterly, "We bombed the North Vietnamese into accepting our concessions."

The decisive January change of heart took place not in Hanoi, but in Saigon. Under pressure from two prominent hawks, Senators Barry Goldwater and John Stennis, President Thieu reluctantly acquiesced. On January 23, a deal was announced from the Oval Office: President Nixon told the American people that, after a general cease-fire, their POWs would be coming home within sixty days. He called for scrupulous adherence to the Paris terms. "The United States," he said, "will continue to recognize the government of the Republic of Vietnam as the sole legitimate government of South Vietnam. We shall continue to aid South Vietnam within the terms of the agreement and we shall support efforts by the people of South Vietnam to settle their problems peacefully."

He was studiedly vague about the consequences of violations: "We shall do everything the agreement requires of us and we shall expect the 670 · VIETNAM

other parties to do everything it requires of them." Most Americans believed that Nixon's toughness, reflected in the Christmas bombing campaign, had secured the peace that had eluded successive administrations for so long. The president's personal approval rating soared to 68 percent. On January 27, Secretary of State William Rogers signed the Paris treaty, and the last twenty-seven thousand US troops and advisers began to come home, a process completed by March 29. Twenty-one thousand Americans had died in Vietnam since Nixon assumed the presidency supposedly armed with a plan for peace. Communist prisoners being repatriated tore off the clothes issued to them by the Saigon government and hurled them from the trucks that bore them northward through the DMZ in a symbolic gesture matching that of homebound North Korean POWs after the 1953 armistice. In Hanoi, there was a giant fireworks display.

Kissinger told his master that he was terrified the North Vietnamese would launch a major offensive to complete unification as early as that autumn, precipitating a nightmare dilemma for the administration about how to respond. Nixon said to Haldeman later that day, March 14, "Well, Henry's exactly right. We've got to do everything we can to see that [the Paris agreement] sticks for a while, but as far as a couple of years from now, nobody's going to give a goddamn what happens in Vietnam." Then the president started to fret about the midterm elections, little knowing that he himself would be driven out of the White House by Watergate in August 1974, before these took place.

Under the terms of the Accords, South Vietnam released 26,508 communist POWs, while the North freed 4,608 ARVN soldiers, 588 Americans, and 9 citizens of other nations. The return of the US POWs, almost all flown out of Hanoi, prompted wildly emotional scenes back home, made more intense when their sufferings in captivity were revealed. Much had changed since they went away. Fighter pilot Col. Fred Cherry, absent for almost eight years, found that his wife had had a baby by another man, and two of his sons had dropped out of high school, and Mrs. Cherry had squandered the family savings. The deeply religious Capt. Norm McDaniel suffered culture shock: he was dismayed by the explicitness of sex in movies, the openness of homosexuality, fancy colored pants and wide

belts for men, and store prices that seemed fabulously high. "I came back with a 1966 time frame. We knew very little about riots and assassinations. I had a lot of trouble with memory. I learned to pick and choose what to focus on."

McDaniel secured a comfort blanket of familiarity by remaining on active duty with the Air Force. Moreover, he had sufficient generosity of spirit to feel pity for the North Vietnamese whom he left behind: "I came back to something better. They just had more of the same." He was thirty-five years old, but vitamin deficiencies had caused his bone structure to become that of a sixty-year-old. He said, "America treated us POWs much better than it did ordinary war vets. A lot of grunts needed closure—and didn't get it." Some former prisoners made full physical and psychological recoveries and went on to build successful careers beyond the armed forces, foremost among them Senator John McCain. Others never threw off the pain and the memories.

Before the release of Doug Ramsey and other Americans held in the South, their camp commandant addressed them. After their release, he said, a period of bitterness was inevitable, and in some measure deserved. Though the circumstances of war had rendered some of their privations in captivity inescapable, others had resulted from shortcomings in VC behavior. He nonetheless hoped that, as mature individuals, the Americans would come to see that they were fortunate to have been allowed to live, when it would have been more convenient to shoot them. He hoped that the prisoners would persuade their fellow countrymen not to repeat elsewhere the Vietnam intervention. Having themselves lived the lives of have-nots, they might better understand the plight of those obliged to exist without even the hope of having. The immediate response of most of his American listeners was cynical, indeed contemptuous; none was about to go home and become a "freedom fighter." Ramsey later concluded, however, that what the communist said contained elements of truth "and even of profound wisdom."

They were released, twenty-seven men in all, on February 12, 1973, at Loc Ninh, where their personal possessions were handed back. Jim Rollins was given a cheap Seiko watch, which a cadre told him was a replacement

for his own gold Rolex, lost "due to wartime exigencies." This caused Rollins to explode. "Bullshit! I saw that Rolex on the wrist of your cousin only a couple of weeks ago!" A communist colonel at the handover to their fellow countrymen, who included Ramsey's old comrade Frank Scotton, asked to examine the cockpit of the Americans' big helicopter. He said he hoped that his own son might one day study in the US, which seemed to his adversaries a revealing glimpse of North Vietnamese consciousness of the limitations of their own society. The prisoners were appalled when they learned, at the last moment before liberation, that one of their guards' children had been killed and another had lost an arm in the Christmas bombing of Haiphong. This man nonetheless shook their hands, wished them well, and gave them his tobacco ration. Ramsey said that here was the most impressive gesture the man could have made for his own cause: "Most Americans, under such circumstances, would have had to be restrained from grabbing an AK-47 and carrying out a My Lai-style massacre of the POW contingent."

To this day, some hawks believe that if Nixon had remained in the White House, he would have committed air power to save the Saigon regime when the North launched its final offensive. Yet in February and March 1973, the president made it plain—on one occasion to a returned POW—that he viewed renewed military action as a political impossibility. On June 29, House minority leader Gerald Ford stunned Congress by announcing that the president would sign a bill prohibiting all US combat activity in, above, or off the coast of the four components of Indochina-this just two days after he had vetoed legislation to ban US bombing of Cambodia. The bill was duly passed into law, 278-124 in the House and 64-26 in the Senate, after Ford spoke on the telephone to Nixon at San Clemente, California, to ensure that he correctly understood the commander in chief's intention. Though Nixon would later thrust blame upon Congress for permitting South Vietnam's collapse, the record shows that he voluntarily surrendered his own discretion. There can be little doubt of the motive: when the long-expected North Vietnamese final offensive took place, Nixon wanted no part of a dilemma about whether to launch a new intervention.

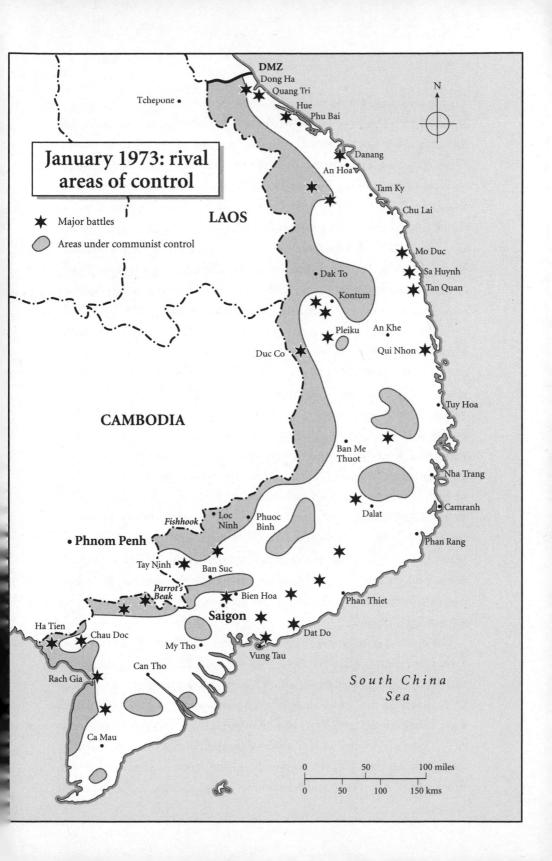

Though there are no tapes of his conversations at San Clemente, on March 29 in Washington, he told Kissinger, "On Cambodia, we've got to bomb the goddamn place until the Congress takes away the power. [Then?] we can blame them for the whole thing going to pot." In June he abdicated responsibility for Indochina. With or without Watergate, this was a wise decision. The United States and its people had been riven asunder by the war, but the Paris Accords signaled the beginnings of a closure. On August 4, 1973, Nixon signed into law the bill that he himself had initiated, barring further US combat activity. In a gesture worthy of Pilate, he then wrote to congressional leaders, warning that if as a consequence the communists overran Indochina, blame would belong on Capitol Hill.

More than two years earlier, on February 18, 1971, Kissinger had told Nixon that he proposed to say to Le Duc Tho, "Look, we're willing to give you a fixed deadline of total withdrawal next year for the release of all prisoners and a ceasefire." To the president, he added, "What we can then tell the South Vietnamese—they've got a year without war to build up." During the subsequent half century, Kissinger has often asserted that he achieved a decent settlement, which was wrecked by Watergate, communist perfidy, and congressional pusillanimity. Yet the record, as established by such scholars as Jeffrey Kimball and Ken Hughes from the evidence of the White House tapes, shows that both Kissinger and Nixon always recognized South Vietnam as doomed. Watergate changed nothing. Once again, the charge against the two men is not that they failed to preserve the Saigon regime, a nigh-impossible task, but that they sought to persuade the American people at the time, and posterity since, that they ever supposed they could.

Six months after Nixon resigned, Kissinger characterized him thus to Arthur Schlesinger: "He was both more evil and better than people supposed." The secretary of state, which Kissinger had become in December 1973, described his boss as astonishingly lazy, noting that he often failed to read important papers. "His work habits," said Nixon's principal instrument, "were very much like Hitler's as described by Speer. . . . Everything was weird in that slightly homosexual, embattled atmosphere of the White House. . . . You could not believe a word he said." This was vin-

tage Kissinger: so far distancing himself that it eventually came to seem that through those White House years he had been merely an interested astronomer, viewing the by-then-disgraced president's doings through a lunar telescope.

Kissinger deserved the gratitude of the American people for extricating them from their long nightmare, clad in a threadbare shift of dignity. He merited none from the Vietnamese people, however: his reputation will be forever tainted by the share in the Nobel Peace Prize which vanity caused him to accept, and which Le Duc Tho prudently declined. Most exiles to this day hate Kissinger for what they perceive as betrayal. South Vietnamese historian Nguyen Ky Phong is unusual in the temperance of his verdict: "His job was simply to do whatever it took to get the Americans out of Vietnam, and that is what he did."

3. WAR OF THE FLAGS

When a North Vietnamese military delegation landed at Tan Son Nhut at the end of January 1973 to establish a liaison office, there was a stand-off on the tarmac because the newcomers refused to comply with immigration procedures, which would have implied recognition of South Vietnam's legitimacy. Some American spectators relished the spectacle of their former enemies literally sweating it out, but eventually formalities were waived. Lt. Nghien Khiem, who commanded the VNAF security detail that day, said of the communists, "They walked and talked like men who knew they were on top." Some of his own company demanded "Lieutenant, how come they are all generals?" The ubiquitous gold stars on Northern uniforms of all ranks bewildered the Southerners.

Throughout the communist camp, there was exultation. According to an NVA squad leader, "Morale was sky-high because we were absolutely certain we stood on the brink of victory." His unit celebrated wildly, "because we thought this meant we would all live to go home." With the end of bombing of the Ho Chi Minh Trail, the logistics of Hanoi's soldiers—especially rations—were transformed for the better. The veteran Col. An wrote, "It was as if someone had turned the OFF switch on a radio—cassette

676 · VIETNAM

player: all the noise suddenly stopped." Communist soldiers reveled in being able to sleep through the night, eat in the open, and gaze at the heavens without searching them for hostile aircraft. Theater troupes were dispatched from the North to entertain the soldiers, some of their performances watched at a safe distance by their Southern once-and-future foes. Bao Ninh's unit began to receive small comforts, including books, "though these were all unreadable propaganda."

There was some fraternization. Tri, a former Hanoi University student, found himself gossiping with a young Saigonese whose studies had also been interrupted. They agreed that a soldier must do his part, whichever side he was on, and that blame—if there was to be blame—must lie with the big people at the top. A mushroom growth of rival propaganda billboards sprouted throughout the country, such as one planted in reeds at the boundary of a Vietcong area: SOLDIERS, LET US PUT ASIDE VENGEANCE. NOW WE NEED RECONSTRUCTION AND FRIENDSHIP. Mai Elliott said, "There was a brief spasm of optimism. It was not that people doubted that the communists would win eventually, but they thought it might take a long time."

The Saigon CIA's Merle Pribbenow was astonished to find some State Department colleagues convinced that the South could survive. Langley's chief of Vietnam operations flew into town and sought the views of junior staff: "Virtually all of us agreed that Hanoi would not give up," said Pribbenow. "There would be another massive offensive. Yet the official Agency view was that this was manageable, that the North had been hurt very badly in the 1972 fighting and now needed US economic aid."

The optimists were thus far right, that in the first weeks after the Paris Accords, voices were raised in Hanoi, including that of Giap, to urge that the terms should be respected. The old general believed a period of stabilization, and the Americans' promised cash, would be precious prizes for his exhausted country. As always, however, Le Duan rejected even a temporary accommodation. This iron man, so proud of subordinating human frailties to the revolution, told an expanded meeting of the Hanoi politburo on March 27, 1973, that their objective must be to reinforce in

the field, while ensuring that odium for breaching the cease-fire fell upon the other side.

Hanoi's pivotal decision was that the war should continue. Though Soviet and Chinese aid was cut back, the NVA held ample stocks of weapons, now no longer vulnerable to attrition by air strikes. In the course of 1973, twenty-seven thousand tons of arms and ammunition, forty thousand tons of rice, and six thousand tons of fuel were shipped to the South—four times the volume dispatched in the previous year. A hundred thousand fresh troops moved down the Trail, boosting communist strength below the Demilitarized Zone to four hundred thousand men. Kissinger urged military action to stem this traffic, but even before the congressional veto, Nixon, buffeted by the rising breakers of Watergate, had no appetite for renewed bombing.

Nor was it only the North Vietnamese who set about flouting the Paris terms. For understandable reasons, President Nguyen Van Thieu found it intolerable that large tracts of his country should remain in communist hands. Some historians write as if the Paris Accords were a sustainable settlement if their provisions had been observed. Yet few rational people could suppose that a nation represented on the map by a patchwork of communities interspersed with communist enclaves, as determined by the cease-fire in place and soon delineated on the ground by ten thousand rival flags, was economically and politically viable. Moreover Thieu, now aged fifty, found himself in a bewildering predicament. He had forged a career out of compliance with American wishes, yet henceforward the keenest desire of many of Nixon's fellow countrymen was that he should disappear into a hole. Clark Clifford, Lyndon Johnson's former defense secretary, publicly described the Vietnamese president as an obstacle to peace, saying that if he quit, a "truly neutral and representative government could be formed in Saigon which would negotiate in good faith with the other side."

This made no sense: even if Thieu resigned, the communists had no interest in any outcome other than their own mastery of a unified Vietnam. Clifford's remarks reflected the understandable yet unedifying desire

678 .

of many Americans not for a change of government, but for damnable and probably damned Vietnam to vanish altogether from their consciousness. Thieu could boast no significant achievement through the last two years of his partitioned nation's existence, but it is implausible that any of his compatriots would have done better. He continued the war partly because Le Duan obliged him to do so, but also perhaps because—as Kissinger once cruelly observed—the struggle had become the sole rationale for his rackety regime.

Thieu made no attempt to reform his army nor to put commands in the hands of competent officers rather than political placemen, despite the new reality that the steel corset of American might had been stripped from the nation's torso. He was rash enough to believe that Washington would keep its word, repeatedly rehearsed to him by Kissinger, that if South Vietnam faced renewed communist aggression, American air and firepower would once more be unleashed, though any half-savvy Washingtonian would have told the South Vietnamese president that no more B-52s were coming under any circumstances whatsoever.

After the cease-fire, advisers bade farewell to the South Vietnamese units they had mentored and—far more important—provided with access to American firepower. Lt. Col. Gerry Turley told his Vietnamese Marine counterpart that there would be no more gunfire support from the US Navy. The colonel replied, "Today, you have cut off my right arm." Watching as North Vietnamese and Vietcong flags rose over many villages, Turley felt no doubt the colonel was right, that "the South Vietnamese were going down the drain." Intelligence adviser Edward Brady said, "The Vietnamese never felt we were selling them down the river until the . . . Accords. Before that they thought we were dumb, but we were with them." Naval Cmdr. Nguyen Tri used language since adopted by many of his former countrymen: "The communists didn't win. The Americans simply decided to go home and let South Vietnam lose."

Three years earlier, Creighton Abrams expressed a weary disdain for his Vietnamese allies, telling his staff, "I know these people have struggled with this *goddamn* war for twenty years. I mean, they really haven't had a hell of a lot of peace around here. And they're tired, and all. *But*... if

they're going to *really* come out on top of this, *goddamn* it, they've still to sacrifice and they've got to sacrifice a lot. And the *alternative* to that . . . is that in the next five or six years, *goddamn* it, they'll be Communist." Here was an authentic expression of the impatience felt by a host of Americans, even more emphatic in 1973 than it had been in 1970: it would henceforward be in the hands of the South Vietnamese people, and especially of their soldiers, to determine whether they escaped subjection to a communist tyranny.

Saigon was denied the breathing space, the "year without war" that Kissinger had once aspired to. He himself flew to Hanoi in mid-February for exploratory talks and perceived that there was no basis for a working relationship. In the "war of the flags" that stuttered into being throughout the South, the two sides fought increasingly fierce local battles to gain or hold territory. Southern commanders rotated units out of areas where they were deemed to have become too friendly with their enemies. An NVA soldier appeared one morning at a rendezvous where he was accustomed to exchange fruit with Southerners—and was nearly killed by a land mine planted by their newly arrived replacements. On March 29, MACV was formally closed down; most of its people folded their tents, or rather relinquished their air-conditioned quarters. The Defense Attaché's Office, which assumed its residual functions, employed 2,500 American civilian contract workers and 400 local civilians but only 50 serving US officers.

Vice President Ky wrote bitterly later that when the Americans left, they pointed with pride to the vast South Vietnamese armed forces they had created, but "could never admit, even to themselves, that a million armed men were led by a group of venal toadies, with Thieu serving as the prototype." This was true, though the airman might have admitted that he himself was cast from the same mold. A Southern captain said of the Paris treaty, "It was a death sentence for us." John Vann told an American audience shortly before his death, "The overwhelming majority of the population—somewhere around 95 percent—prefer the government of Vietnam to a Communist government." In truth, while only a minority of South Vietnamese welcomed a prospect of Hanoi's victory, those

680 · VIETNAM

who recoiled from communism loved their own nation-state too little and craved peace too much to fight with conviction any longer.

Blame for progressively destroying the cease-fire was shared between the two sides. On March 3, 1973, the ARVN launched a big offensive aimed at sealing the approaches to the enemy strongholds in the U Minh Forest, in the Delta's Chuong Thien Province. This met fierce resistance and was finally thrown back. Giap later claimed that such South Vietnamese initiatives caused him to abandon his own support for observing the Paris terms. Yet it was never plausible that either side would hold back: the North because it saw victory so close and the South because the dispensation bequeathed by the Americans was unsustainable.

An ARVN general wrote that the war "had brought [South Vietnam] to the brink of moral and material bankruptcy." Most of its people, he said, had exhausted their capacity for sacrifice; they now listened eagerly to the siren songs of Trinh Cong Son, a well-known Saigon antiwar balladeer. A captain said, "Most of our ordinary soldiers had no reason to hate the enemy, because they had not seen what communism could do." Lt. Nguyen Quoc Si said gloomily, "It didn't matter who was running the Saigon government—the Americans were always pulling the levers. They fought the war so long as they thought it was in their interests, then quit and left us." He said of his own post-Paris combat experience, "People did not want to die, because they knew the war was almost over." In 1970-72 Southern troops had claimed a favorable "kill ratio" of five enemy for each of their own losses. Whether or not this statistic was authentic, in 1973 it fell to two to one; in the following year, to little better than even. By then, as ammunition shortages hit fighting formations, soldiers were being urged to use their weapons in single-shot mode rather than rock 'n' roll—automatic

In the autumn of 1973, a journalist visited the South Vietnamese war cemetery at Bien Hoa, which held more than twelve thousand soldiers' graves, a tiny fraction of the national loss. Under the new "peace" dispensation, each day ten more were being added; throughout the country, 6,600 Southern soldiers died in the first three months following the Paris deal. The visitor wrote, "The air was loud with the wailing of widows and

the crying of children, and through the sobs could be heard the dull 'thud-thud' of spades digging more graves for the next day's bodies." Overlaid upon its battlefield travails, Thieu's state fell prey to economic woes. For a decade, outside the rice paddies, the principal profitable activity had been servicing the legions of South Vietnam's unimaginably rich foreign visitors, sponsors, and occupiers. Now, two million city folk—one-third of the workforce—found themselves unemployed. A Saigon car dealer lamented that he sold just one car a month, compared with a hundred the previous August. TV sets, scooters, and imported cigarettes vanished from shops. The price of rice doubled. The October 1973 Middle East War and consequent soaring cost of oil and fertilizer wreaked havoc, making "miracle rice" an uneconomic crop. In December a communist sapper attack destroyed half of Saigon's oil storage facilities. Inflation rose to 30 percent, then 40 percent.

A young Southern officer said to a journalist friend, Gavin Young, "The argument against communism must be material or moral, mustn't it, Gavin? But the conditions we find here now are unemployment, rising prices, and corruption, *n'est-ce pas*? So no moral or material argument exists; there is no real patriotism in Saigon, I mean. So how can we resist? And yet we want to resist—most of us, you know—and we cannot. Isn't that the tragedy of it, Gavin?"

Indeed it was. In 1970 a rural-tenure reform program, "Land to the Tiller," had been adopted by Saigon. Three years later, at a cost of almost half a billion US dollars, this had given 1.2 million families the ownership rights they had craved for decades; absentee landlordism was almost extinct. But the radical measure had come far too late, as did early offshore oil exploration that would eventually yield 1.5 billion barrels, within a decade transforming Vietnam's finances. It was as if a terminally ill patient was belatedly told that he would receive a fortune in a will . . . if he lived long enough.

The Thieu regime remained chronically ineffectual, army morale sapped by worsening shortages of materiel and munitions. These reflected less congressional parsimony than the fact that the Americans had created a Vietnamese military machine in their own image, dependent on expen-

sive technology—in 1974 still consuming fifty-six tons of munitions for every ton expended by the communists—yet less serviceable than the simpler model of their enemies. Moreover corruption remained institutionalized. Jacques Leslie of the *Los Angeles Times* uncovered a scam whereby Southern commanders had been selling shell cases—those of pre-1968 manufacture yielded scrap brass—for fabulous prices in Singapore, fortifying David Elliott's conviction that "no amount of additional aid in 1973–75 would have benefited anyone save those generals." US Embassy political officer Hal Meinheit said, "It was a divided society with no common sense of where its people wanted to go." An ARVN major wrote, "Many fence-sitters foresaw communist victory. . . . Popular support for Saigon dwindled quickly. Many people who had sided with the government now began supporting the communists."

President Thieu, wrote the same officer disdainfully and not unjustly, "was not strong enough to be a dictator. . . . Was there any country at war that allowed such fierce criticism of the government? How many Third World countries permitted journalists publicly to denounce corrupt ministers and generals and to castigate the president?" Treachery was etched deep into South Vietnamese society. The CIA's Sam Adams wrote a devastating report, concluding that the regime's infrastructure was a Swiss cheese: an estimated twelve thousand enemy informants were serving in the government or armed forces. Capt. Phan Tan Nguu was posted to run police Special Branch intelligence operations in Tay Ninh, where he noticed that his driver, whenever off duty, disappeared toward the Cambodian border. Surveillance revealed that he was meeting communist officers, and subsequent interrogation, that he had been tasked to kill Nguu. "I am so sorry," said the driver inadequately, before being shown to a cell.

Early in 1974, State Department intelligence analysts compiled a report on South Vietnam's prospects, drawing upon "bootleg" sources in the Saigon mission—officers whose bleak views US ambassador Graham Martin, who had replaced Ellsworth Bunker the previous July, would not permit to be cabled to Washington. Hal Meinheit, one of the authors, said, "We concluded that unless a high level of US aid was sustained, the regime's prospects were very poor." The CIA, now directed by Wil-

liam Colby, challenged this view, ironically arguing that State's gloom was designed merely to justify the ambassador's intemperate demands for more funding. As fighting intensified, on January 4, 1974, President Thieu made a speech in Can Tho in which he declared, "We cannot sit idly by. We must take appropriate action to punish the communists' aggressive actions. The war has begun again." Washington was as dismayed by South Vietnamese attempts to expand Saigon's territory as by those of the communists to shrink it, because both alike threatened the precarious status quo.

Two big Northern strategy conferences were held in the upper-floor conference room of Hanoi's Dragon Court in March and April 1974. Officers agreed on the important good news, that the Ho Chi Minh Trail—now dominated by vehicles rather than human portage—was operating more smoothly than at any time in its history. An astonishing thousand-mile oil pipeline had been laid, to fuel the NVA's vehicles in the South. On the debit side, the Vietcong remained weak; indeed, it had never recovered from Tet '68, and the communists thus had only a meager presence in urban areas. Much Northern armor and heavy artillery was in poor condition. Most important, uncertainty persisted about whether the Americans would intervene if Hanoi unleashed a major offensive.

Earlier in the war, the communists paid little heed to US domestic politics. Now, however, Hanoi and the southern Provisional Government, which had established a temporary capital in Loc Ninh, scrutinized events in Washington, through BBC and Voice of America, "with an almost obsessive curiosity," in the words of a PRG minister. Analysis of these sources produced conclusions heartening for their own cause. In January 1974, the Chinese staged a naval coup to seize and annex South Vietnam's outlying Paracel Islands. This provoked no substantive American response. In the first eighteen months following the Paris Accords, twenty-six thousand South Vietnamese troops perished on the battlefield, yet the US Congress continued to slash military aid. Funding for Saigon was halved in 1974, from \$2.1 billion to \$1.1 billion, then cut again to \$1 billion.

Hanoi's first significant strategic decision of 1974 was to continue fighting through the spring wet season, traditionally a time for regrouping

and resupply. In March there was heavy fighting west of Saigon, initiated by the North Vietnamese, but met by the last serious ARVN counteroffensive of the war. This bloodied the communists but also eroded the South Vietnamese army's dwindling will to fight. The same pattern was discernible two months later, when the Northern 9th Division launched a major attack west of Ben Cat, in the long-contested Iron Triangle, during which both sides deployed armor. Through subsequent months of heavy fighting, Southern counterattacks regained lost ground and prevented a communist breakthrough, but at heavy cost: Saigon's 18th Division lost 275 men killed, 1,000 wounded. The local corps commander was dismayed when he requested 150,000 rounds of artillery ammunition but had to content himself with one-third of that allocation. By the time the Route 7 battles petered out in November, some South Vietnamese infantry battalions had lost a quarter of their strength. The NVA had suffered at least as severely, but as usual minded less. The Hanoi politburo's skeptics grumbled: "Brother Ba"—Le Duan—"is burning up our troops again as he did in 1968 and 1972," yet North Vietnam's leader remained implacable. Down in the Mekong Delta, communist forces sustained a steady pressure, further weakening the ARVN and local militias.

It is an injustice to tens of thousands of Vietnamese dead that historians recount few details of the murderous 1973–74 battles. This is partly because little reliable evidence exists—published narratives seem fanciful. Partly also, soldiers on both sides were by now playing out their parts in the conviction that ultimate communist victory was almost assured. South Vietnamese forces lost 25,473 dead in 1973, almost 31,000 in the following years. Lt. Nguyen Quoc Si, twenty-year-old son of a ranking Saigon police officer, was dispatched to a Popular Forces militia unit in the southeast, near Vung Tau. This had previously been a rest area, where the VC were content to live and let live. Now, however, with the rekindling of the war, Si found himself in a contact on his first day in the field. His platoon seldom mustered more than eighteen men with a few M16s, otherwise mostly old Garand M1 rifles. "You can't beat AK-47s with those. You're dead."

They were always short of ammunition, and in one contact he found

himself engaging Vietcong with just a single grenade in his pouch. Helicopter medevac was no longer available: a wounded man had to be carried to a road, if he was fortunate enough to live so long. Si's men were "a mixed bunch"—some passionately anticommunist because their families had suffered at the enemy's hands, others anxious merely to stay out of trouble, to escape irrevocable commitment to either side. Local people sometimes accompanied their patrols, in hopes of thus traveling safely that were not always fulfilled. One day a pregnant woman followed Si's soldiers, who suddenly heard a violent explosion in their rear. The girl had strayed a yard from their tracks, onto a booby trap. "That lady just disappear, thrown into the jungle. The whole of her lower body was gone. It was unbelievably horrible—her baby come out," said the young officer. He added thoughtfully, "You see a lot of things."

Northern sapper Cpl. Vu Quang Hien was hit in the thigh in one of the battles of that period, then left behind when his unit retreated. A tiny local woman helped him to stagger into a thick clump of brush beside a pond. Hien told her, "Leave me here now, and if you hear a shot in the next few hours, you'll know I'm dead. If you don't, come back at nightfall and get me out." This she did, bringing her husband to assist, because Hien was a big man. The sapper said later, "She was not a supporter of either side. She just hated to see me lying there helpless."

On July 18, 1974, Giap, after reviewing the General Staff's report "Outline Study of a Campaign to Win the War in the South," ordered preparations for an offensive designed to secure final victory by the end of 1976. This would commence with an assault in the Central Highlands. The timing of what followed would be determined by how events on the battlefield played out. The plan was completed on August 26, then approved at an October politburo session. Although controversy persists about the personal role of Giap, there is a consensus that after his January 1974 return from Moscow, where he received treatment for gallstones that had seemed likely to kill him, the old general indeed directed the final offensive. The most plausible explanation for his temporary restoration to operational command is that following the communists' 1968 and 1972 failures, Le Duan grudgingly accepted that Giap's prestige and brilliance

686 · VIETNAM

were indispensable for their decisive throw of the dice on the battlefield. Hanoi's decision making was also influenced by the change of US president. The communists found it impossible to believe that Nixon's successor, Gerald Ford, even with Henry Kissinger as secretary of state, would subject his fragile new administration, together with the American people, to the anguish of reengagement in Vietnam.

On August 10, 1974, Ford wrote personally to Saigon, assuring Thieu that he would honor the commitments made by Nixon, but such promises looked threadbare when Congress was seeking to reduce the aid allocation from \$1 billion to \$700 million, and indeed went on to do this. At a time when inflation had raised the price of ammunition and much other materiel, the impact on the ARVN was dire. On September 13, an exasperated Kissinger exploded, saying he found it inconceivable that his country should be giving a billion dollars to Israel—which it then was—while denying a matching sum to Vietnam, where so many Americans had died.

Much has been written above about the secretary of state's pragmatism. Yet Kissinger here grasped an important moral, material, and political point, from which Congress and most of the American people chose to avert their eyes. The withdrawal of direct military support was both inevitable and right. It was nonetheless indefensible for the US legislature thereafter to half choke the aid pipe to Saigon while the Russians and Chinese kept open their own to Hanoi. Mere money, at this stage, was most unlikely to change outcomes: Saigon's armed forces were too feeble to stay the distance. But continuance of generous aid might have gone far to preserve America's honor in this last phase of the war, while withdrawal tarnished it. Congress indeed bore responsibility for this unworthy deed, whatever earlier misjudgments and betrayals were properly attributable to the White House.

In the final reckoning, Saigon received \$945 million in 1974, but this was not remotely enough to sustain a million-man army trained, organized, conditioned, and addicted to fighting on an American model. The VNAF was obliged to ground 224 aircraft, including 65 helicopters; operational hours for the remainder were almost halved. Half the ARVN truck inventory was mothballed for lack of fuel; communications were

impaired by shortages of radio batteries. In January and again in April 1975, Congress rejected desperate appeals, endorsed by the Chiefs of Staff, for funding to enable the South Vietnamese to purchase additional ammunition, fuel, and spare parts. Many of Thieu's soldiers now lived and fought in a state of chronic hunger; inflation shrank still further their miserable rations.

Contemplating the condition of Saigon late in 1974, the CIA's Merle Pribbenow said, "I was convinced this was not going to last long." His Vietnamese wife, Thuy, wanted to buy for her mother some land north of Bien Hoa, which the family drove north to view. On approaching the area, they were dismayed to see that no government flag flew in any neighboring hamlet. They turned around and returned to Saigon without purchasing the land, suddenly very conscious that the Thieu regime was losing the "war of the flags." In November Doug Ramsey came to Saigon as a guest of its government for what proved President Thieu's last celebration of National Day. Ramsey was grimly amused to sense that his guide was committed to the cause of Hanoi: "He knew stuff about communist dialectic that you can only know if you are one of them."

VNAF officer Nghien Khiem said, "We knew things were not going right. We still kept hoping and hoping, but our faith faded as we lost battle after battle." Frank Scotton predicted at a US Embassy dinner that the regime could not survive beyond 1976. Most of the mission's veteran field officers agreed that Hanoi would prevail in that year or in 1977, "the only debate being whether the end would be a slide through [political] coalition or battlefield collapse." The Vietnamese Navy's chief of intelligence told Bob Destatte in January 1975, "The communists are not going to win this year, but they may do so next, and certainly will the one after." Destatte encountered a hoary old Vietnamese Ranger sergeant who threatened to kill him-because he was an American. The man said he had just come out of a battle on the Cambodian border in which his unit had suffered heavy losses and run out of ammunition—because of the US "betrayal." A taxi driver told the American he was sick of the war and just wanted to see his country out of it at any price; this was the dominant sentiment in the lower layers of Vietnamese society.

So desperate was Thieu that he considered strategic withdrawals from territory that his forces were too stretched to defend, including the entire north of South Vietnam. The embattled and embittered president clung to hopes that, even if his dominions continued to shrink, some fragments might remain defensible. Unfortunately for such hopes, in Hanoi there was a growing sense of urgency about initiating decisive action. The North Vietnamese leaders saw the United States in post-Watergate disarray, with Congress and world opinion conspicuously unsympathetic to Saigon. The South's economy was in straits almost as desperate as those of the North, while lacking its ruthlessly effective machinery of control. Hanoi noted increasing agitation on the streets, protests against corruption, led by Catholic priests. Parts of the Southern army continued to fight effectively, but many of Thieu's troops were visibly disaffected. In fierce strife between August and December, the NVA gained high ground west of Danang and thwarted counterattacks by two Saigon formations. In six weeks of brutal fighting for Hill 1062, the elite Airborne Division suffered 2,500 casualties.

Events in northern South Vietnam convinced Dragon Court that head-to-head, its army could now prevail on the battlefield. Its formations were poised to launch attacks from salients deep in Thieu's territory; some communist troops stood within thirty miles of Saigon. Le Duan and his comrades, for once in concord with Giap, concluded that there would never be a better moment to strike. Seven of the eleven members of the Hanoi politburo are said to have endorsed the proposal to launch in 1975 a new "General Offensive and Uprising," to complete the unification of Vietnam.

THE LAST ACT

1. INVASION

In the northern hills of South Vietnam early in March 1975, Vietminh veteran Maj. Gen. Nguyen Huu An found himself gazing upon scenes that recalled youthful experiences at Dienbienphu: "There was mud, mud and more mud." His infantry and engineers struggled through driving rain to drag 105mm howitzers, captured in 1972, up steep ascents to positions from which they could harrow Southern firebases. An had been appointed a corps commander for Le Duan's big push, unleashing overwhelming force to complete the unification of Vietnam: half a million men—fifteen infantry divisions together with seventeen sapper, ten armored, and fifty artillery battalions. The first phase, code-named K-175, was scheduled for March to May, to be followed by a second offensive in July to August if conditions seemed propitious. An's corps was tasked to seize Hue and Danang, in operations urged onward by the slogans "Speed is strength" and "Go like lightning." Yet An admitted that comrades who had experienced the crushing disappointments of 1968 and 1972 were privately skeptical whether K-175 would meet with any greater success. The North enjoyed the big advantage of being able to choose where to concentrate its strength, but the South retained a substantial superiority of mobility, firepower, and air support.

The plan had gone through eight drafts. The key imponderable was not "What will Saigon do?" but "How will Washington react?" The

communists knew that neither China nor Russia would lift a finger to check any US intervention; everything instead hinged upon how the Republican administration gauged the will of the American people. Kissinger remained secretary of state, and a notably hubristic one: he lectured his uncerebral commander in chief about foreign policy, ordered wiretaps on allegedly indiscreet staffers and their media conduits, and dominated meetings with his monologues. What might his grand vision of history cause him now to urge upon President Gerald Ford? Good news, from Hanoi's viewpoint, was that since the October 1973 Yom Kippur War and subsequent oil crisis, Kissinger was preoccupied with the Middle East; Vietnam was leftovers.

Between December 13, 1974, and January 6, 1975, Northern troops conducted a two-division assault on Phuoc Long Province, a hundred miles northeast of Saigon. Hanoi watched closely for a US response to an indisputable, unprovoked expansion of its territory. Washington dallied with committing aircraft from the Enterprise carrier group, then backed off, just as it remained passive while Khmer Rouge forces tightened the encirclement of Cambodia's capital, Phnom Penh. At a January 21 TV news conference, President Ford asserted that he could anticipate no circumstances in which forces would again be sent to Indochina. Two weeks later, Congress rejected new aid requests. North Vietnam's premier, Pham Van Dong, asserted confidently to his politburo comrades that "the Americans would not return if you offered them candy to do so." Yet no one could be sure. As Maj. Gen. An and his colleagues watched porters sweating beneath loads of munitions destined for gun positions on Route 14, they remained acutely conscious of the B-52s on Guam. Giap still anticipated that victory would require a conclusive campaign in the following year.

The 1975 strategic plan was the North's most imaginative of the war. Principal objective for its first phase was Ban Me Thuot, a city of a hundred thousand people that was capital of the Central Highlands. Surrounded by coffee plantations offering useful cover, it straddled a junction on the north-south Route 14 between Kontum and Saigon, thirty miles from the Cambodian border. Col. Gen. Tran Van Tra, COSVN's vain

and ambitious military chief, bore a lingering stigma for his role in the tactical failures of Tet 1968. Now he yearned for glory to redress that defeat. Tra afterward claimed credit for proposing the 1975 thrust through the Central Highlands, though Lt. Gen. Hoang Minh Thao urged the same course and was given local direction of it.

Instead of immediately hurling troops into a direct assault on Ban Me Thuot, the communists first isolated the city, cutting roads around Pleiku, a hundred miles farther north, in a series of coordinated attacks that began early on the morning of March 4. NVA chief of staff Gen. Van Tien Dung assumed overall command of the Central Highlands operations, in which four divisions were committed to strike where Southern forces were relatively weak. Success would give Hanoi a good chance of splitting South Vietnam, cutting off Saigon's powerful formations farther north.

The Thieu regime received considerable intelligence warning about the threat to Ban Me Thuot, not least from NVA prisoners. As usual, however, there was also plenty of "noise"—as intelligence officers characterize multiple conflicting indicators—to mask the "signal," Hanoi's real purpose. The North's attacking formations sustained radio silence while generating deceptive wireless traffic around Pleiku. On March 8, they severed Route 14 north of Ban Me Thuot, then Route 21 to the coast. The communists completed the befuddlement of the hapless Thieu by simultaneously launching new attacks east and north of Saigon, in the Delta, and in Thua Thien and Quang Tri provinces, where Gen. An's formations stood poised.

At 0545 on March 8, An's guns began firing on nearby Southern fire-bases; an infantry assault followed. Files of grimly expectant soldiers of the 324th Division advanced across a landscape shrouded in early morning mist. Those first actions generated no easy communist triumph. The Northerners' command and control, always a weakness, was as muddled as ever. Some attacking units got lost; others were ravaged by ARVN artillery and mortars. Next day, the 9th, the South Vietnamese launched successful counterattacks. The contest for one key position, Hill 224, persisted for a week, with neither side giving way, Southern guns firing 4,600 rounds a day. An wrote with unexpected frankness about his own men:

"The corps' combat efficiency during this phase was low." After eight days' fighting, there had been no communist breakthrough in the north—which deserves emphasis in view of the widespread belief that South Vietnam's entire army crumpled from the outset.

Yet even as those battles were taking place and increasing Saigon's confusion about Hanoi's intentions, in the Central Highlands a grim saga unfolded, at first in accordance with Dragon Court's script, then dramatically outperforming its expectations. On March 9, NVA infantry, supported by just two 105mm guns with fifty rounds, overran Duc Lap, fifty miles southwest of Ban Me Thuot. The first abject collapses took place, of three Saigon battalions. The attackers captured fourteen guns and twenty armored vehicles before heading north toward Ban Me Thuot, where sappers and small bodies of infantry had already infiltrated the city. These spearheads made for the airfields and ARVN HQ when the general assault began early on March 10, involving twelve regiments led by sixty-four tanks and APCs. Infantryman Bao Ninh viewed with amazement and indeed awe this gathering of power on a scale few communist soldiers had seen before. "Almost all our fighting had been as guerrillas, in company strength." Morale was high, because while they had no notion of how swiftly victory would come, none doubted its inevitability: "We knew that without the Americans, the Southerners were half what they had been."

Saigon's local corps commander was Pham Van Phu, a forty-seven-year-old veteran of Dienbienphu, who proved ill-suited to direct a defense against a complex communist onslaught. Phu had convinced himself that Pleiku was the enemy's main objective and concentrated his strength accordingly. Fierce flak drove off VNAF air strikes, and after thirty-two hours of fighting, Gen. Dung was able to report to Hanoi the capture of the 23rd Division's headquarters and huge ammunition stocks, in exchange for only light losses. Yet Southern troops continued staunchly to defend the wired and fortified base of the 53rd Regiment, at the air-field three miles east of the city. The North Vietnamese, cocky after their earlier successes, on March 14 risked committing armor to night attacks, which descended into farce. One tank smashed its gun by hitting a tree; another fell into a ditch. Communist infantry were repulsed with heavy

loss, some of them shot off tank hulls. Base commander Lt. Col. Nguyen Vo An showed himself a determined and effective officer, whose stand at the head of five hundred men deserves to be remembered.

The communist attack was renewed on the evening of March 16, when sappers accepted severe losses to lay bangalore torpedoes that breached the perimeter wire. Nine hours of fighting followed, during which the attackers made little headway. However at 0500 on the 17th, four tanks broke through; the base was overrun three hours later. Lt. Col. Vo An and some survivors escaped; he reached the coast on the 24th at the head of thirty men. The North accepted that some of its units, and especially tank commanders, displayed the sort of ineptitude that had become familiar in 1972. Yet a key reality persisted: the communists were victorious. Four hundred South Vietnamese casualties were abandoned in Ban Me Thuot's hospitals.

Saigon's chief of staff, Gen. Cao Van Vien, said of the fall of the city, "This was the most critical juncture of the entire war. . . . Our armed forces now faced a showdown with an adversary who continuously upped the ante." President Thieu succumbed to panic, prompting him to make a succession of disastrous decisions. First, he removed a locking pin from the north's defense by ordering the crack Airborne Division to abandon its positions and join the garrison of Saigon. Then he demanded a counterattack east of Ban Me Thuot, which failed miserably. Following the communist breakthrough, Kontum and Pleiku were deemed indefensible. Troops there were ordered to pull back toward the coast along the old, crumbling French Route 7b. Vien warned Thieu of the likely consequences, recalling the 1954 disaster the Vietminh had inflicted on France's Groupe Mobile 100, in the same region and similar circumstances.

The president neither consulted US officers about the decision to abandon the Central Highlands—announced to his own commanders at a March 14 crisis meeting at Cam Ranh Bay—nor informed them that he had made it. Frank Snepp believed this was because "he was simply terrified that the Americans would go mad and withdraw support from him." Thieu's order, far from being impulsive, reflected personal thinking that had evolved through the previous year. He cherished a belief that, if

he could shorten the impossibly long defensive perimeter imposed by the shape of South Vietnam, his forces might yet successfully hold its rich southern bulge. While this was implausible, worse was his insistence that within days twenty-five thousand men retire 150 miles through mountainous terrain to the coast. He ignored the huge issue of soldiers' families quartered in the Highlands, not to mention the civilian population. Gen. Phu is alleged to have burst into tears on the flight from Cam Ranh Bay back to Pleiku, saying that neither he nor South Vietnam any longer had a future. He himself withdrew eastward by helicopter, leaving a brigadier to supervise the leaden motions of his corps and its stupendous array of men, vehicles, munitions, and equipment down the long, rough road through successive passes.

Air America pilot Fred Anderson said later, "I will never forget the sight of the highway out of Pleiku. It was a solid mass of bodies walking and carrying what they had. And you just knew there would be thousands dying." AA flights evacuating US personnel were spasmodically fired on by bitter and frightened South Vietnamese. Another pilot said, "A lot of it was out of frustration. People get excited; they want out and don't think. It was sheer anarchy, man reduced to his lowest level."

The first two days of the withdrawal, March 16–17, passed without much incident, save that a throng of refugees closed in behind the troops. Their troubles began at the small town of Cheo Reo, fifty miles down the road, where nine hundred vehicles jammed a narrow thoroughfare. Anarchy descended, with scavenging, looting, and shooting by renegade soldiers. Then communist troops made a dash to block the pass ahead. After a clumsy Southern night attack failed to break through, on March 18 Rangers succeeded, only to fall victim to a misplaced friendly air strike which killed their colonel and decimated the ranks. As the Northerners began to shell the mass of humanity and vehicles trapped in Cheo Reo, some tanks and trucks sought alternative escape routes across country. A Ranger battalion was among the few that maintained cohesion, smashing through successive communist blocking positions to reach Tuy Hoa at 2100 on March 27, having lost half its strength. One in four of the twenty-five thousand troops in the Central Highlands eventually strag-

gled through to the coast, together with some five thousand dependents and civilians. Gen. Vien estimated that three-quarters of the combat capability in II Corps—central South Vietnam—had been destroyed in ten days. The communists afterward acknowledged nine hundred Northern troops dead in the Central Highlands campaign, most of those losses probably sustained in its opening days.

Events following the fall of Ban Me Thuot created the first of what became a succession of human tragedies embracing millions of people. Gen. Vien described the retreat as "ignominious," reflecting a failure of leadership at every level. On the road eastward, Saigon journalist Nguyen Tu wrote of refugees "who now have nothing left but the dusty, sweat-soaked clothes on their backs. Their feet are swollen and their eyes lifeless and devoid of hope. Small children . . . struggle along behind." Mass desertions by soldiers desperate to protect their own families became an ongoing feature of the campaign; so did crowds of civilians and their vehicles clogging roads that became impassable for government troops, even before the enemy intervened. The cauldron of chaos and misery into which the region subsided was kept bubbling by sporadic communist shell and mortar fire.

On March 18, Giap in Hanoi informed the politburo that the critical moment had come: they must exploit the Northerners' stunning local successes by launching a general offensive. It had become plain that the Americans would not commit air power and that many of Thieu's soldiers had exhausted their will to fight. Despite much written later concerning South Vietnam's shortage of munitions, there is no reason to believe that the events of early spring would have unfolded differently even if more arms had been available. South Vietnamese exile historian Nguyen Ky Phong suggests that the regime still possessed a year's worth of war materiel, and this is evidenced by the huge quantities that later fell into the NVA's hands—eighteen thousand tons in the Central Highlands alone. The fact that much equipment and ammunition was in the wrong places, because the South Vietnamese logistics system was crippled by inefficiency and corruption, cannot justly be blamed on the US.

Ambassador Graham Martin, visiting Washington in March, appealed

directly to leading congressmen to support a new aid package—and met a stone wall. Martin was a poor advocate, but at this point it is unlikely that an orator with the gifts of Cicero could have induced the legislature to save the Saigon government. Most congressmen and senators perceived that the will of their constituents demanded disconnection of South Vietnam's life-support machine. Yet this did not prevent the ambassador from penning a deplorably mendacious letter to President Thieu, delivered in Saigon on March 15, which asserted, "I can give you the most categorical assurances that the President and Secretaries of State and Defense are determined that when the Washington battle is over you will have the resources you need."

Martin then retired for ten days to his North Carolina farm to recuperate from dental surgery. It is unlikely that anything he could have said or done would have altered events, but his conduct was ignoble, as was that of Congress. The refusal of mere money to the nation's longtime client, arguably also its victim, sent an unmistakable signal to both sides in the war: the American people, yearning for closure, had hardened their hearts, in Frank Snepp's words "shown themselves stunningly uninterested in the fate of the Vietnamese." The moral impact of aid cuts was more important than the material one. Scarcely a Southern soldier from general to private failed to understand that the Saigon regime had been disowned by its patron, so it became hard to believe that a doomed cause merited further sacrifices from them. In South Vietnamese minds, an enduring legend was born of America's "stab in the back." The collapse of the Central Highlands merely imposed an immediate disaster upon the deeper sense of destiny that already suffused Thieu's formations. Only US air power could have shifted the odds, and in Washington a weak president recoiled from defying congressional opposition to such action.

A dramatic directive was now issued by the Hanoi politburo, ordering its forces by May to complete the conquest of South Vietnam. "The situation changed at a dizzying pace," said Maj. Gen. An. In the north on March 20, his artillery redeployed toward the vital north—south Route 1. Within hours of opening fire, shelling closed it to traffic between Hue and Danang: scores of vehicles seeking to escape southward were obliged to

turn back. A local Vietcong female cadre interrupted a corps conference to report that thousands of enemy deserters were fleeing through her village. She sought help to mop them up and was duly given some men to collect weapons. Fugitives might run free, she was told; caged, they would merely become a burden. An said, "I realized that the enemy formations were collapsing." Southern units ceased to encrypt wireless messages, sometimes hurling plain-language obscenities at each other across the ether.

Throughout these last months, Saigon's forces operated in a fog created by lack of intelligence about the movements and intentions of their enemies. Contrarily, Hanoi was thoroughly informed by Saigon traitors—notably a sergeant clerk in the ARVN chief of staff's office—about almost every detail of its enemies' doings, including Thieu's strategic decision to abandon swathes of territory. Giap's great fear was that South Vietnamese forces would withdraw into enclaves around such cities as Hue and Danang, from which they might prove difficult to dislodge; this increased his sense of urgency about disrupting organized Southern redeployments. His strategy in the north was to strike fast eastward on several axes, severing arteries of which Route 1 was the most important.

In the first week of fighting, the Southern I Corps commander, Ngo Quang Truong, felt that his forces had held their ground well, and An, his enemy counterpart, agreed. Some Regional Forces showed courage and determination, and the Marines launched effective counterattacks. Now, however, the defense unraveled with terrifying speed, a chain of events precipitated by Thieu's response to the Central Highlands collapse. The president's order to withdraw the Airborne dealt Truong a moral and tactical body blow. The general would have been even more dismayed if he had known that the president also intended to take away his Marine Division. In 1972 those same Marines had bled copiously to retake Quang Tri. Now when they withdrew southward, the city was lost in a day, precipitating another mass exodus.

As in the Highlands, roads became jammed with civilians on foot and in vehicles of every kind. More and more people in the northern regions, both uniformed and civilian, saw that they faced abandonment, that their own government no longer considered this extremity of South

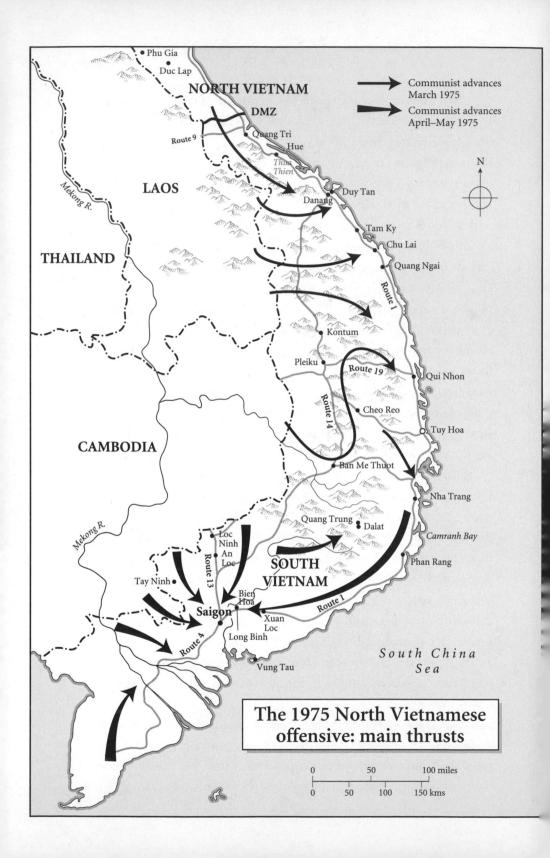

Vietnam defensible. Despite some stubborn ARVN stands, at a dozen key points from north of Hue to south of Danang, communist forces thrust insistently toward the coast; Truong and his corps were losing control as the region was carved up around them. Thieu dithered, at one moment demanding that Hue must be held to the last; at the next, proposing to relinquish it.

After two weeks' fighting in which I Corps suffered two thousand casualties and claimed to have fired two hundred thousand rounds of artillery ammunition, on March 21 the NVA overran Rangers defending critical hills above Route 1. Thereafter the communists began attacking north toward Hue. At 1300 on March 25, a soldier named Nguyen Van Phuong raised the North Vietnamese flag in the old capital. An found drivers for fifty abandoned tanks and APCs, which joined his advance southward. Mobs of bewildered and disarmed Southern soldiers milled in the streets, and hundreds of officers became prisoners.

During evacuations from the northern coastline, the sorely tried Marine Division's discipline collapsed. An American defense attaché had warned the previous year of the danger that an enemy offensive in the north would precipitate "a Dunkirk without ships," which is what now took place: a disordered and woefully inadequate rabble of vessels sought to retrieve vast numbers of desperate soldiers and civilians. Patchy local resistance caused the NVA's Gen. An fewer difficulties than moving rice to his scattered units in mud clogging every track from his supply line further west.

Tens of thousands of soldiers and civilians who fled from Hue in warships or small craft were disgorged a few hours' sailing farther south at Danang and there surged through the streets spreading the plague virus of panic. In the distance, artillery fire was already audible, as resistance at Phu Gia, north of the city, slowed An's battalions briefly. By the last days of March, an estimated million refugees swarmed in Danang's streets. Thick black smoke eddied in the courtyard of the US consulate as staff and Marine guards burned files. Exultant North Vietnamese columns hastened toward the city, cheered on by civilians who sensed a historic transfer of mastery.

Cmdr. Nguyen Tri, who was responsible for the Vietnamese Navy's

small craft at Danang, repeatedly sought orders, but his admiral responded with a numbed silence. On March 28, Tri visited army head-quarters, which had retired into the naval base, and found it buzzing with officers laden with sandbags filled with personal possessions. Helicopters wafted to safety these privileged fugitives, leaving disorder in their wake. Tri embarked his own and the flotilla crews' families, then cast off, speeding down the coast. At Qui Nhon, to their dismay, they found the same scenes; a similar collapse of authority.

Gen. Truong wrote later of the last days of his command of I Corps that soldiers attempting to deploy "were swallowed up in the mass of humanity that choked Route 1 and intermediate land masses. Confusion, frustration, and ultimately panic began to grip some combat units." An American eyewitness, Air America pilot Wayne Lennin, said of Danang, "It didn't fall; it came apart.... The soldiers went berserk. They were running down the streets machine-gunning civilians, . . . ripping the jewelry off bodies and raping girls." Dreadful scenes took place at the airport, where hysterical crowds mobbed the few departing aircraft, convinced that each would be the last; men who huddled in wheel wells were crushed when ascending pilots retracted undercarriages. Efforts to fly out military stretcher cases foundered amid mobs of troops and refugees; five thousand patients and medical staff were abandoned at Duy Tan General Hospital. On the shoreline, soldiers drove tanks and trucks into the surf and mobbed barges. "There were Rangers, Marines, tanks," said a Vietnamese eyewitness. "One ship came in first and the Marines shoot at everyone else [who] want to be on the ship, and the Rangers were so mad they shot at the Marines and then finally the ship sank."

On March 29, Northern forces entered Danang after overrunning great tracts of territory at an estimated cost of less than three thousand casualties. An's regiments reorganized with a huge accession of transport, including 487 GMC trucks. They had also acquired PRC-25 radios, priceless to an army chronically short of communications, now for the first time issued down to company level. Every infantry squad boasted two M-79 Thumper grenade launchers. One in three of An's artillery pieces was a captured weapon.

The next challenge was to move this formidable force six hundred miles southward, reinforced by two more divisions that had hastened from North Vietnam to join the drive on Saigon. The Coastal Column, as it became known, was placed under the overall command of Gen. Le Trong Tan, and comprised 2,276 vehicles. Gen. An felt somewhat overwhelmed as it set forth on April 7: "This was the first time in my career I had controlled such a long, long column with so many specialized branch elements." Crowds stood cheering by the roadside, among them surrendered government soldiers begging for food. There were frequent halts while repairs were improvised to broken or blown bridges—between Danang and Xuan Loc they negotiated 569 crossings. An dispatched advance parties to ensure access to fuel stocks at Qui Nhon, Nha Trang, and Cam Ranh Bay. For almost two heady weeks, his corps's movement averaged sixty miles in each twenty hours, driving by day and night.

The plight of South Vietnam gripped the attention of tens of millions of Americans. None of the images of massed human suffering, however, shifted the national mood, overwhelmingly resistant to reengagement. A domestic economic recession provided one justification for congressional opposition. Another was cited by California Democrat Representative Henry Waxman: "We cannot promote the peace by providing the means of war. . . . Providing more military aid to Saigon only increases resistance to substantive negotiations." The American leaders who behaved worst were those who promised the South Vietnamese help, knowing this would not be forthcoming. Senator Hubert Humphrey made supportive noises, then voted against an aid package. Thieu told Ford frankly that without American intervention—especially B-52s—his country was probably doomed. On March 22, the US president responded, pledging support while remaining studiedly vague about what form this might take. Thieu reminded him of explicit promises made by Nixon and Kissinger after the Paris Accords. Ford nonetheless determined that he would not risk a constitutional crisis by ordering air strikes. On March 25 he said, "I regret I do not have the authority to do some of the things President Nixon could do."

Throughout those days, Ford's secretary of state remained characteristically clear-sighted, citing the futility of diplomacy in checking the communist onslaught. "I am convinced," said Henry Kissinger, "that North Vietnam will do absolutely nothing except under military pressure." There was a proposal to commit the US Navy to assist the evacuations from Hue and Danang, but the White House drew back when commanders said troops would need to land. Instead, Military Sealift Command was mandated to charter merchantmen, which rescued thousands of fugitives in dramatic and sometimes violent circumstances. On March 28, Kissinger reported to Ford, "I don't think South Vietnam can make it. . . . It is a moral collapse of the United States." Next day he told a meeting of his own staffers, "The disgrace is ours." When one of them proposed asking Moscow to intervene, Kissinger responded, "We can't ask the Soviets in the spirit of détente to save us from ourselves."

In Hanoi, Giap prepared for the last stage of what he was determined should be recognized as a personal triumph. He moved his bed into Dragon Court and remained there around the clock until the fall of Saigon, except for one quick trip South to meet field commanders. Every hour thereafter, "Van," as he was codenamed, emphasized to his generals the need for speed, speed, speed—to seize Saigon before the rains descended in earnest or the Americans changed their minds and started to bomb. At seven o'clock each evening, Le Duan was briefed. Postwar communist narratives emphasize his role as "de facto supreme commander," effacing the legend of Giap, though there is little doubt that the campaign reflected the old general's brief restoration to strategic primacy.

Between March 10 and 31, four NVA divisions, supported by Vietcong guerrillas, carried out attacks north and east of Saigon, which were contained but left invaders poised within forty miles of the capital. In the last days of the month, Le Duan urged Dung, in the Central Highlands, to launch a dash for final victory. The general was brave and stubborn enough to demur, insisting upon first completing the destruction of the ARVN's II Corps. On March 31, his forces broke through an Airborne brigade holding the key M'Drak Pass. The port city of Qui Nhon was overrun, and next day NVA armor swept into Tuy Hoa, farther south.

The American consulate at Nha Trang was evacuated amid turbulent and terrible scenes. As whole Southern units disintegrated, Cam Ranh Bay fell. On April 2, Gen. Phu, his corps shattered, fled to Saigon.

All the important passes on Route 1 were now in Northern hands. Frank Snepp says of some twenty-first-century revisionists who seek to suggest that South Vietnam staged a coherent national defense, "They weren't there to witness the shambles. Attempts to impose clarity on the ARVN story are nonsense." This is certainly true of Thieu's strategy, such as it was, which failed miserably. Yet a few South Vietnamese troops fought with courage worthy of a better national leader.

Le Duan asserted in a long April 1 message to his commanders that, in Northern operations thus far, "There have been few military casualties"—they had secured much of South Vietnam in exchange for far smaller losses than those of 1972. For the first time in the war, Hanoi dispatched cameramen and reporters to accompany the NVA on its victory road. Among these was Phung Bat Tho, newly returned to his homeland after twenty years in Europe, where he had become a successful filmmaker. The army issued Tho a uniform and camera, then sent him south to witness the triumph of the revolution. "It was so thrilling," he said emotionally. At first he and his comrades of the communist media were full of fears amid the turmoil in newly conquered Southern cities, "but then we saw that it was all going to be alright." The throngs of people whom they passed, both military and civilian, had no thought of doing them harm—indeed, one of the bizarre spectacles that became familiar was that of Southern soldiers stripped to their shorts, having discarded their uniforms.

One American who found the events of those days especially harrowing was Jim Livingston, winner of a Medal of Honor at Daido seven years before and now operations officer of the Marine amphibious brigade, aboard the command ship *Blue Ridge* offshore. He went briefly ashore at Danang and "felt sick" at what he saw. A colonel from the South Vietnamese Black Cat Division who attempted to board the warship off Cam Ranh Bay was repulsed by Livingston, disgusted at his abandonment of his men: "I'll go back with you and fight, you sonofabitch!" said the Marine, a histrionic offer the Vietnamese rejected. Others adopted a different

course: the first of many suicides took place. At Qui Nhon the ARVN 42nd Regiment's CO waved farewell to his men boarding shipping vessels, then disappeared into a house, where he shot himself.

Giap initially hoped that the leading NVA formations might capture Saigon "on the run," sustaining the momentum of the previous weeks, without waiting for the Coastal Column to arrive from the north. He ordered Gen. Tra's troops to isolate the capital from the Mekong Delta, but their attacks met stronger resistance than the NVA had experienced in the Central Highlands. There were violent exchanges with South Vietnamese riverine gunboats; a mid-April attack on Can Tho was repulsed; Long An RF and PF militia held off the Northern 5th Division for four days.

The most significant battle the communists had to fight took place thirty-seven miles northeast of Saigon. The town of Xuan Loc, capital of Long Khanh Province, occupied a key road junction on Route 1, surrounded by rubber and banana plantations. The action that began there on April 9 enabled the army of South Vietnam, for the last time in its history, to display courage and determination in the face of odds, though it could not deflect the irresistible course of events.

The 18th Division's commander, Brig. Le Minh Dao, his features seldom fully visible under enormous and somewhat sinister sunglasses, had a playboy reputation more conspicuous than his military one, and he was celebrated as a sing-along guitarist. He and his officers nonetheless prepared skillfully to meet the looming communist assault. They removed most soldiers' families to Long Binh, and pre-sighted guns on the approach routes the communists had used in their Tet 1968 attacks, correctly anticipating that they would come the same ways again. Dao sent troops to occupy high ground the enemy might use for artillery observation, emplaced his own thirty-six guns in bunkers, stockpiled ammunition, and monitored NVA wireless channels.

Almost the first shell of the bombardment that began at 0540 on April 9 wrecked Dao's own quarters near the Catholic church. In the days that followed, communist artillery would reduce much of Xuan Loc to rubble without doing much harm to the defenders, dug in on the outskirts. At 0640 two red flares signaled the advance of armor and infantry.

ORM 3007 USE PREVIOUS

IN 545121

TOFIRDB-315/04194-75

WARNING NOTICE SENSITIVE INTELLIGENCE SOURCES AND METHODS INVOLVED

PAGE 4 OF & PAGES

SECRET

NO FOREIGN DISSEM/CONTROLLED DISSEM/NO DISSEM ARROAD/THIS INFORMATION IS NOT TO BE INCLUDED IN ANY OTHER DOCUMENT OR PUBLICATION.

COMMUNIST MISSIONS FOR THE YEAR ARE TO DEFEAT FUNDAMENTALLY
RURAL PACIFICATION, WIN GREAT VICTORIES AGAINST THE GVN, AND
BRING ABOUT CONDITIONS WHICH WILL HELP TO ACHIEVE TOTAL VICTORY
IN 1976. HOWEVER, THE MOST OPPORTUNE MOMENT FOR THE COMMUNIST
SIDE HAS ARRIVED, AND COMMUNIST FORCES MUST CONTINUE MOVING
FORWARD. THE VC WILL NOT WAIT FOR 1976, THAT IS, FROM "NOH"
UNTIL THE END OF 1975, REGARDLESS OF WHAT HAPPENS, COMMUNIST
FORCES WILL CONTINUE HITTING THE GVN HARD TO COMPLETELY DEFEAT
GVN PACIFICATION AND ENCROACHMENT AND WIN TOTAL VICTORY. THE
CAPTURED WEAPONS AND WAR MATERIALS ADDED TO SOME OF THE COMMUNISTS'
OWN RESOURCES HAVE MADE THE VC STRONG ENOUGH TO LIBERATE ALL OF

CIA intelligence information cable, April 1975, emphasizing Hanoi's determination to reject any political settlement, and to enforce absolute military victory.

On the eastern flank, the invaders' 7th Division was quickly checked by barbed wire, mines, and VNAF air strikes. The 341st, attacking from the northeast, penetrated the town, but Southern fire drove back its green teenage infantry. The 6th Division achieved the only important communist success, advancing from the south to cut Route 1 between Xuan Loc and Saigon. Thereafter, the town was isolated.

During the next two days, Dao's men staged some successful counterattacks and repulsed renewed enemy assaults. In the last mass helicopter operation of the war, a hundred Hueys lifted an Airborne brigade to reinforce the garrison. Communist shelling made the lives of the civilian inhabitants wretched, but Hanoi's commanders understood that they had made a succession of mistakes. First, Gen. Tra had failed to fulfill orders to interdict takeoffs from Bien Hoa, to deny Xuan Loc air support; only on April 15 did Northern shell and rocket fire begin to accomplish this. Meanwhile, after weeks of fighting, the attacking 7th Division was weary. The South Vietnamese seem to have done almost everything right, and the communists were punished for their hubris in rushing a frontal assault on strongly fortified positions. They also suffered considerably from the effects of fifteen-thousand-pound BLU-82 "Daisy-Cutter" bombs, used here by the VNAF for the first time, along with a deadly CBU-55 airdenying cluster fuel bomb.

Xuan Loc lingered as a bastion along the crumbling front. Brig. Dao's stand caused Hanoi to postpone its assault on Saigon, originally planned for April 15, and wait for the rest of its army to catch up. Western media were flown into Xuan Loc to applaud the defense, though the effect was marred by a rush of townspeople, desperate to flee, mobbing the helicopters that lifted reporters out. The weary defenders lapsed into passivity and could do nothing to check the Northern buildup in their rear, west of the town.

On April 20, Xuan Loc was evacuated. The garrison withdrew on foot southward through rubber plantations, the 1st Airborne Brigade acting as rear guard. Dao, "wearing the haggard face of a man who had not slept much," in the words of a soldier, honorably marched out among them rather than escape by Huey. Xuan Loc was the final multiformation clash

of the war. Hanoi has never published credible figures for its own casualties, but three or four thousand seems a fair guess. It was foolish for the NVA to have fought there at all: its commanders could easily have bypassed the town and continued their advance, leaving Dao and his men to stew. Surviving South Vietnamese soldiers anyway cherish Xuan Loc as a shining memory, in the midst of a grand narrative of humiliation.

Even as that battle was being fought, there were clashes at Phan Rang, a coastal city on Route 1 south of Cam Ranh Bay and more than two hundred miles northeast of Saigon, where Southern troops for a few days clung to the air base. On April 3, US Navy ships offshore began to provide humanitarian assistance to refugees, but their commanders rejected pleas for gunfire support. VNAF aircraft strafed the advancing communists and in a dramatic helicopter operation recovered eight hundred survivors of the Airborne brigade that had defended the M'Drak Pass. They were flown to reinforce the defenders of Saigon.

On April 16, lead elements of the NVA Coastal Column took over the assault on Phan Rang. The port and city fell quickly, though the air base held out a little longer. Gen. An's gunners found themselves exchanging fire with South Vietnamese warships. The plethora of captured transport in communist ownership prompted mishaps, often caused by Vietcong who for decades had taken for granted that anyone occupying a vehicle must be a foe. The commander of Northern air defense division was fatally wounded by a B40 rocket that hit his truck; communist tanks came under friendly fire. Gen. An was thrilled with a brand-new jeep he appropriated from an abandoned South Vietnamese corps headquarters, but on the night of April 16 became less so when he was shot up by guerrillas, fortunate to escape on flat tires; his armored commander suffered a similar fright.

Among the prisoners taken in the coastal fighting were corps commander Lt. Gen. Nguyen Vinh Nghi and James Lewis of the CIA, both of whom were flown to Hanoi. A Northern propaganda officer demanded of the captured general, "How should we phrase appeals to puppet soldiers, to lay down their arms?" Nghi responded despairingly, "What's the need for appeals? The army has already fallen apart." South Vietnamese in Washington sought to exploit the evidence of Xuan Loc

to convince American legislators that their army still had the will to fight if the US would provide support. Senators remained immovable. An overpowering sense of doom overhung South Vietnam, intensified by the collapse of neighboring Cambodia, from which President Lon Nol had fled on April 1. The victorious Khmer Rouge, a creation of the North Vietnamese though later disowned by them, entered Phnom Penh on the 17th, and soon afterward commenced their genocide against Cambodia's people.

2. "AH, MY COUNTRY, MY POOR COUNTRY"

Around the country through much of April, clashes of arms and stampedes of terrified people persisted, beyond the view of the world's media and thus little known to posterity. Thousands of cadres were dispatched from North Vietnam to assume control of what were described—pejoratively so, Southerners came to believe—as "liberated territories." On April 2, Le Duc Tho accompanied Gen. Dung, now tasked to command the assault on Saigon, to set up their headquarters beside COSVN's base at Loc Ninh. Dung's insistence on completing the destruction of II Corps before redirecting his forces south from the Central Highlands proved to be well judged. The coastal panics and troop collapses confirmed to the world, and especially to the American and South Vietnamese peoples, the terminal predicament of the Saigon regime and its armed forces. What is remarkable is not that many ARVN formations crumbled but that some mounted last-ditch stands in the face of an irresistible enemy tide.

In the capital a strange unreality persisted. However powerful the logic of looming communist triumph, many people, both Vietnamese and American, found it impossible to acknowledge that everything familiar in their lives, for good and ill, was about to be swept away. Foremost among the deniers was Graham Martin. In February a visiting congressional delegation was accompanied by Frank Scotton, who was furious when he found that Frank Snepp, the man most likely to tell the truth about how bad things were, had been barred from the briefing team by the ambassa-

dor. Scotton ensured that the CIA analyst spoke privately with the congressional group.

On April 8, the CIA forwarded to Washington a cable detailing information from their tried-and-trusted Tay Ninh source about Hanoi's decision to dash for all-embracing victory, "regardless of what happens. . . . There will be no question of negotiations or a tripartite government. Communist forces will strike at Saigon." Yet until the last, with almost deranged obstinacy, Ambassador Martin defied his advisers to insist that some deal would be cut with Hanoi to preserve the rump of South Vietnam. The most important consequence was that he resisted demands for an evacuation of tens of thousands of the Vietnamese most vulnerable to communist vengeance, an operation that thus began too little and too late. The ambassador's attitude, like his earlier bullish dispatches to Washington, enraged staffers desperately concerned for South Vietnamese friends and colleagues. Only in the week of April 21 did USAF transport aircraft belatedly commence sorties out of Tan Son Nhut, 304 in all, which evacuated almost forty-three thousand Americans and Vietnamese.

During Saigon's last weeks as Thieu's capital, many Vietnamese who lacked magic-carpet connections struggled to secure passages out of the country, despite the emotional cost that exile imposed upon people wedded to the culture of family, of belonging. Meanwhile members of the French community, their ambassador prominent among them, taunted the unhappy Americans with a cruelty rooted in confidence—later pleasingly shown to be unfounded—that a special relationship with Hanoi would secure France's position in a communist Vietnam.

The value of the piaster collapsed, so that foreigners with dollars found themselves partying almost for free. An Air America pilot calculated that the real price of the most beautiful bar girl in Saigon was 66¢ for a short time, \$1.11 for the night. Bacchic orgies, their frenzy rooted in the fear gripping the participants, took place in bars and hotels. Americans vainly urged the Thieu government to avow to its people at least some portion of reality. Instead, amid the vacuities and deceits of official spokesmen, rumor held sway. There were many sleepwalkers; the South Vietnamese

command and staff school at Long Binh continued its courses until April 28. Senior officer students spent hours debating battlefield scenarios and agreed that the Americans would not abandon the nation for which they had sacrificed fifty-eight thousand dead.

While many prominent Vietnamese were selling everything to raise cash to escape, some came home. Nguyen Thi Chinh, the 1954 teenage fugitive from Hanoi who had since become the South's biggest TV and screen star, was shooting a movie in Singapore but felt that she must return to Saigon: "It was wrong for my reason, but right for my heart." On April 1, Maj. Nguyen Cong Luan, a twenty-year Southern veteran who had just completed a Fort Benning course, boarded a plane at San Francisco with three comrades. At Tan Son Nhut, a girl checking the arrivals manifest asked them in bewilderment, "Why did you come back? Dalat fell last night."

Though Australians had played a notable role in South Vietnam's defense, now their country's Labor government ordered that RAAF aircraft evacuating their residual personnel should not carry refugees. Prime Minister Gough Whitlam insisted on acceptance of Hanoi's public assurances that South Vietnamese had nothing to fear from the incoming communist government. Of 3,667 people who sought Australian visas in those days, only 342 applications were successful, and just 76 eventually traveled; the embassy's Vietnamese staff people were abandoned. Meanwhile, flights were organized by crassly sentimental foreign philanthropists to evacuate Saigon orphanages. No sane person could suppose that the victorious communists would murder pretty children. Instead, potbellied ARVN officers, unlovely bureaucrats, and policemen faced mortal peril, but they were bereft of foreign friends.

Lt. Nghien Khiem said, "We understood that we were losing, but we couldn't think what to do. We didn't even dare talk much to each other, in case we started a panic. We lied to our men, to reassure them." As the son of a prosperous businessman, Khiem had relations in Europe who kept telephoning home, urging insistently, "Get out, get out!" He said, "They knew more than we did. But how to escape?" Ngo Thi Bong, a matriarch who had survived Hue's horrors during Tet 1968, wrote from Saigon to

her English friend Gavin Young: "Everything is lost now. My very dear, my only son, Minh, was in Danang. . . . Can he still be alive? Or is he dead already? It is so, so sad, unimaginable for a poor mother. I cannot express my feelings because we live from minute to minute. . . . I have no more tears left to weep for my little Minh and at the same time for my grandchildren. Ah, my country, my poor country."

Almost three million American veterans watched with a special fascination the drama unfolding across the Pacific. Former US Marine Capt. Hays Parks suggested sadly, "If the South Vietnamese had known what the future was, they would have fought harder." Lt. Gen. Bruce Palmer fumed. "The hard truth lingers on, that when South Vietnam in its dying hours turned to us in despair, the US looked the other way. . . . Our South Vietnamese friends can never forget the tragic nightmare of those last scenes." Army nurse Phyllis Breen agreed. "I just felt so bad for all the Vietnamese who had trusted us."

British journalist Richard West, who knew Indochina intimately and had once been passionately anti-American, now wrote remorsefully from Saigon, "It is not true to portray South Vietnam as a fascist regime overthrown by a revolutionary movement. Even at this eleventh hour opposition movements have some right of protest, while Saigon's press is less timid than London's in its exposure of rascals in office. The Vietcong, or indigenous Southern Communists, now play only a tiny part in the war; the Saigon proletariat, which ignored two calls for an uprising in 1968, seems apathetic. . . . What began as a revolutionary war has turned into an old-fashioned conventional invasion of the South by the North. . . . It is distasteful, here in Saigon, to read the gloating tone of some foreign newspapers over the fate of anti-communists here."

This last remark reflected the triumph of Hanoi's propaganda. Hundreds of millions of people around the world, including more than a few Americans, believed that the impending North Vietnamese victory was a just outcome.

Out in the US processing area at Tan Son Nhut, thousands of terrified Vietnamese queued outside the base bowling alley and mustered on its tennis courts as they awaited refugee flights. On the afternoon of April 23, forty-five-year-old Le Thi Thu Van, widow of murdered South Vietnamese politician Nguyen Van Bong, met a friend, an elderly French literature teacher who suddenly shrieked in dismay. A briefcase containing \$2,000, his entire disposable wealth, had vanished from his side, obviously stolen. The old man announced that he refused to enter the United States as a beggar; he would return to his home in the city. His cousin, the government's deputy education minister, accompanied him, an impulsive decision that condemned both to years in communist reeducation camps.

Once aboard a C-130, Thu Van and her children secured four canvas seats. A tall, young American civilian pushed his way through the crowded hold with a Vietnamese woman and gestured to the widow and her brood to remove themselves. When she refused, in his anger the man dropped a lead-heavy bag on her toes. "Hey girl," he said, as he and his companion squatted on the floor, "do you know what you're going to do in my country? You'll be washing laundry." Thu Van wrote, "So I left my country with a heavy heart and crushed feet."

Former VNAF fighter pilot Tran Hoi's family escaped aboard a World Airways flight arranged by friends who owed him. When his mother-in-law declined to accompany them, he solemnly handed her the deeds to his house and titles to two cars, saying reassuringly, "Don't worry, Mom, this is only temporary. As soon as the situation calms down, your grand-children will come back." Then Hoi flew to Guam aboard a USAF C-141 Starlifter; the prized possessions that he left behind would become victors' spoils. Eva Kim, secretary to Graham Martin, said to Merle Pribbenow, "You've got a Vietnamese family—I can get you a few places on a 'black' flight." So she did, providing the address of a safe house from which his mother-in-law and niece escaped to safety; his wife and son had already left. Kim, an exemplary woman, provided a similar service for many others.

Some children, like nine-year-old Bong, viewed the whole evacuation as "kind of a neat adventure, going to new and exciting places." The boy couldn't understand why the adults around him spent so much time crying. His mother, like almost all the fugitives, had said nothing to neighbors about plans to leave, but in the Tan Son Nhut bowling alley, they met

friends, colleagues, and classmates, sharing an embarrassment as well as a misery that they recoiled from articulating. Through two long days and nights they lingered there, until at last they boarded a C-130, to suffer a few moments of terror as they rose into the air, fearing that the communists, now so close, would fire on the aircraft. Once safely over the sea, they settled down to endure the weary discomfort of the flight to the Philippines. A deplorable aspect of the evacuation was that some Americans and Vietnamese with authority to include names on manifests sold space; hundreds of bar girls with "green money"—US dollars—became beneficiaries. Meanwhile, over \$50,000 in bribes was paid by the Americans to Vietnamese military and police personnel at Tan Son Nhut to permit their compatriots' evacuation to proceed unhindered.

As for South Vietnam's leader, figurehead, and president, what did Nguyen Van Thieu think, sitting almost alone in the great echoing Independence Palace as his government collapsed about his head? "Thieu would have made a great Las Vegas poker player," said Frank Scotton. "He was completely opaque." Frank Snepp said, "As soon as we didn't control a Vietnamese leader, we disowned him. Thieu was a tragic figure." A senior air force officer suggested that the president had always been haunted by the memory of Diem, fearing that if he defied the will of Washington, he would meet the same fate. "And so, when Americans looked at Thieu, they saw simply a little guy." PRG minister-in-waiting Truong Nhu Tang argued that Thieu naïvely supposed that the Americans cherished almost a blood loyalty toward him. He "simply could not bring himself to believe that in this extremity they would abandon him."

The latter speculation seems plausible, though unprovable, for in exile Thieu sustained an unbroken silence. Through his last weeks of power—or, more appropriately, of impotence—he displayed the same political insensitivity that had characterized his eight-year rule. In mid-March he rejected calls for resignation from opposition leaders Father Tran Huu Thanh and former vice president Ky—the latter had sulked on a farm since quitting the 1971 presidential race. Ten people were jailed for allegedly plotting the government's overthrow. Thieu dismissed a Saigon Senate vote calling for his eviction. On April 4, he belatedly reshuffled the

cabinet, though his survival in office depended now, as always, upon the loyalty of generals. The CIA's Tay Ninh source, "Agent Hackle," reported Hanoi completely uninterested in a deal with any Southern faction. Why should the North bargain, when it stood on the brink of military triumph? Only Ambassador Martin and a handful of Vietnamese power brokers clung to delusions that an outcome might be contrived that deflected a communist takeover.

To posterity Thieu seems an unsympathetic figure who failed to relate to the mass of his own countrymen and governed through a handful of more or less corrupt warlords. No anecdotes exist to endow this preternaturally cool man with a human face. The best that may be said is that he was not among the cruelest of the world's autocrats. He belatedly resigned the presidency on April 21 and left his country for the last time four nights later, accompanied by former prime minister Tran Thien Khiem. Frank Snepp was Thieu's driver on the short ride through darkness from his private residence inside the Tan Son Nhut base to a waiting USAF C-118 Liftmaster. The president shook the hand of the CIA officer and said a terse thank-you as he blinked back tears. A knot of American spooks, diplomats, and guards, all in civilian clothes, joked a trifle nervously among themselves about the gunfire audible in the distance.

The ambassador exchanged a few words with Thieu at the foot of the aircraft steps. "I just told him good-bye," said Martin afterward. "Nothing historic. Just good-bye." As the plane's engines whined, there was a preposterous moment as the envoy, chest heaving, set about dragging away the steps himself. Snepp shouted, "Mr. Ambassador! Can I do that for you?" For years afterward, rumor held that Thieu bore away in his baggage South Vietnam's gold reserves, yet in exile neither he nor his family displayed evidence of massive portable wealth. In Orange County, California, in 2016, his widow relied on the generosity of friends to purchase a burial plot. Thieu's epitaph must be that he became a collapsed puppet, when the Americans chose to drop his strings.

Seventy-one-year-old ex-schoolteacher Tran Van Huong assumed the presidency for a few wretched days, while Lt. Gen. Nguyen Van Toan prepared to direct the defense of Saigon. He positioned sixty thousand

regular troops and about the same number of RF and PF militia. These could not suffice to ring the city, so its southern approaches lay almost naked. No one on either side supposed that the South Vietnamese could long resist the North's masses, but some officers and politicians clung to hopes that they might fight long enough to secure negotiated terms rather than make an abject surrender. The NSA intercepted an enemy wireless message ordering artillery to fire if the Americans were not gone before Dung's columns reached the city center. It is still uncertain whether this was a bluff, but senior US personnel planned their departures accordingly, ahead of the communist spearheads.

Dung disposed more than a quarter of a million troops in five corps, fourteen divisions, and ten independent brigades and regiments, together with a battalion of SA-2 air defense missiles shipped down from the North. A few pilots had been rushed through conversion training from MiG-17s to A-37s so that they could fly captured aircraft. Hanoi didn't use its own Russian-built fighters for fear of provoking an American response. Dung's multiple-axis assault focused on key headquarters and symbols of military and political power, including Tan Son Nhut and Independence Palace. Fourteen bridges lay between communist start lines and the city center, which sappers were tasked to secure ahead of the armored columns. The overarching intent was to pin and destroy South Vietnamese forces at the periphery, averting a destructive struggle in the city center.

On April 25, Le Duc Tho dispatched a long cable to his politburo colleagues in Hanoi, seeking to calm their fears that the endgame was being dangerously delayed, that even after losing the capital, Saigon's forces might retire to make a final stand in the Delta. "You may be at ease," messaged Tho. Everything would be fine; Saigon was poised to fall, and the regime would perish with it.

In the last days out at Tan Son Nhut, the men of a VNAF security detail asked their commander, "Okay, LT, now what?" Lt. Nghien Khiem remained mute for several minutes, because he had no constructive answer. Eventually he said, "Go home. The best thing you can do is take care of yourselves." In those days, this exchange was repeated ten thousand times,

among South Vietnamese both in uniforms and out of them. Khiem mounted a moped and set off for his family home. Just outside the base, in the middle of the road, he saw a pathetic sight: two small, lonely figures, a boy of around ten and a girl perhaps six years old, sitting atop a mountain of baggage and possessions. Khiem swung the bike and approached them, asking, "What are you doing?" The boy answered, "Our parents told us to stay here and wait for them."

"When was that?"

"Early morning."

It was now midafternoon. Khiem made the only gesture he could think of: crossing to a nearby stall, he bought some fruit juice and handed it to the children. He said, "You'd better leave the luggage. Go on home and wait there." They nodded uncertainly as he continued on his way, leaving the forlorn pair where they sat.

The North Vietnamese scheduled their six-pronged final attack on Saigon for April 27, but the Coastal Column was authorized to move a day earlier, because it had two rivers to cross. Early on the 26th, twenty battalions of artillery opened fire from the east; tanks and infantry rolled soon after. On the following day, the ARVN 18th Division, heroes of Xuan Loc, were brutally handled by the Northern 4th Corps, forced into retreat while An's 2nd Corps attacked Southern forces defending the only road link between Saigon and the sea. An himself wrote, "The fighting grew more intense with each passing minute, surging back and forth as the troops fought for control of every shattered wall, bunker, rubber tree, tank against tank, howitzer against howitzer." Regional Forces for a time clung to the town of Long Thanh; the remains of the Airborne held their positions until outflanked, then retired toward the port of Vung Tau.

On the evening of the 28th, five captured A-37s flown by communist pilots bombed Tan Son Nhut, destroying several aircraft and traumatizing defenders. Ten hours later, a rocket and artillery bombardment scoured the air base, killing two US Marine guards. Communist sappers seized and for some hours held the Newport Bridge, close to the heart of the city, prompting a firefight watched with grim fascination by scores of Western media reporters and cameramen. Vietnamese Marines are said to have

made an impressive stand farther north, but this availed the defenders nothing, for their lines were soon breached in twenty places by communist troops surging toward the capital.

The North's 10th Division, which had done more fighting than any other since the start of the campaign, advanced along the last miles of Route 1 led by tanks with infantrymen cramming their hulls. The columns that raced past Cu Chi, once a base with a symbolically intricate Vietcong tunnel complex beneath the Americans' feet, were composed of a mixture of their own T-54 and K-63 tanks, most at the limits of engine life, together with captured American M-41s and M-48s. Pushed relentlessly by commanders, drivers were told to smash headlong past opposition rather than waste the hours necessary for infantry to deploy off-road for set-piece attacks. By 0600 on the 29th, sappers and infantry had secured the Sang Bridge. This promptly collapsed under the weight of two tanks, and attackers found themselves addressing "stubborn resistance" at Dong Du. More tanks bogged down in a stream, from which they had to be rescued by engineers, then clashed with Southern armor and found the way ahead-Route 4-blocked by trucks. In heavy rain, the South Vietnamese sustained resistance through most of the morning at the Vinatex textile mill and Tham Luong Bridge. There was a spectacular explosion in a bomb dump at Tan Son Nhut before, late in the afternoon, Northern tanks began firing on aircraft parked inside the base. At last light they halted, awaiting dawn to renew their assault.

Meanwhile in central Saigon, the city's inhabitants were belatedly forced to acknowledge the imminence of the volcanic eruption that was to bury their society. ARVN chief of staff Cao Van Vien had resigned his post and flown to sanctuary aboard a US carrier on the 28th, followed next day by Gen. Toan and other officers. Former vice president Ky made a flatulent speech, calling on his fellow countrymen to turn Saigon into a second Stalingrad, before piloting a Huey onto the carrier *Midway*. To escape the humiliation of being disarmed by American sailors, he and his companions tossed their own sidearms into the sea, including a pistol that had been presented to Ky by John Wayne. The ship's captain, greeting him, pointed to a Vietnamese medal ribbon on his own breast and said,

718 .

"You gave this to me." Ky wrote, "My eyes filled. Great sobs wracked my body. The captain withdrew, quietly shutting the cabin door, and left me with my tears." Despite a reputation for venality, Ky was almost penniless when he began a new life in California.

Helicopters clattered ceaselessly across the sky, first lifting evacuees from Tan Son Nhut, then on April 29 from the US Embassy compound and a handful of mission buildings that became the last American enclaves. That afternoon, Lt. Khiem reached his parents' Saigon house to find his elderly grandfather and other family members in tears, which flowed in rivers that day. By the custom of the country, Khiem asked the formal consent of his father-in-law to take his wife, Lien, to the embassy to escape to the Seventh Fleet offshore. He then bore her on his moped the few blocks to the compound, protected by US Marines from an increasingly frantic crowd outside the walls. Her father came too, carrying two of her sisters on a Lambretta. They rendezvoused with Khiem's brother before the lieutenant forced a path to the gates.

Privileged connections caused a sight of his ID to persuade the US Marines to admit the entire group. However his younger brother, a twenty-three-year-old law student, was missing. Khiem returned to the family house, where the young man appeared soon afterward. Once again Khiem fought through the crowd to the embassy gates, and after pressing \$100 into his brother's hand, by brute strength pushed him over the gates, then himself returned home.

Tran Tan was twenty-five and like Khiem had close contact with the Americans—he worked as USAID's night switchboard operator. His bosses asked him to remain as "essential personnel," which conferred a right of passage on an evacuation flight. He phoned his parents—an American home phone was another perk of the job—and asked that his fifteen-year-old brother, Hung, bring him food and clothes at the USAID office. When the boy arrived, Tan told him to stick around. He asked the Americans if his other two brothers, whose details he had already given them, could come too. No, they said sternly; both were soldiers, and President Thieu had decreed that no military personnel should quit the country. Tan said later, "I was stupid—when we got to Guam and saw all the

ARVN men there, I learned that if we had just found a few dollars to give someone, my brothers could have come too." His father refused to leave, shrugging and saying, "I'm too old to care whether I live or die." When Tan and Hung boarded a helicopter out of the US Embassy at six p.m. on April 29, their departure opened a chasm in their family, as in countless others, that would persist for years. Tan learned to be grateful that his brothers were mere enlisted men: their lowly status spared them from the horrors of the communist camps that awaited ex-officers.

On that final day of the evacuation, shamefaced CIA staff listened to the bleats and whistles of unanswered radios in the operations room, static-crackling pleas for help on every channel, coming from all over Vietnam: "I'm Mr. Han, the translator. . . ." Frank Snepp called these calls "soundmares." It was never plausible that the Americans could conduct an ordered extraction of all those Vietnamese linked to the US, even if the ambassador had displayed greater foresight. Instead, vast numbers of panic-stricken people embarked on escapes in ships and small craft of every shape and size, which dotted the seas off South Vietnam through the weeks that followed; a few fortunate folk flew away.

On the last night in the embassy, an aide to Martin, Ken Moorefield, chatted to CIA station chief Tom Polgar, a short, stocky, bald Hungarian "obviously in great pain and despair." Polgar had shared to the end the ambassador's false hopes of a political deal. Now he lamented despairingly, "If only we hadn't cut off their supplies." Moorefield wrote of the scene in the compound before he himself flew out: "An almost eerie calm had descended. There was almost no noise at all. No sound of gunfire. No sense of what was about to take place." In that final lift from Saigon, Marine helicopters flew 682 sorties to lift 1,373 Americans and 5,595 people of other nationalities, overwhelmingly Vietnamese, to warships of the Seventh Fleet. Ambassador Martin departed at 0458 on April 30, when the agreed-upon code words "Tiger, Tiger, Tiger" were passed to the command ship. Several hundred Vietnamese were abandoned in the compound after Washington insisted on foreclosing the evacuation so that the last Marines could fly out at 0753.

Even as vestigial Americans were airborne, the Southerners were

making another stand at the training base of Quang Trung, knocking out four Northern tanks, then holding on through the night. Communist attacks resumed at 0530 on the 30th and still met resistance. One tank was hit by both an M-72 rocket and a shell from an ARVN tank, which a communist T-54 then rammed, causing its crew to bail out and flee. An NVA unit that got lost persuaded a young bystander to board a tank and show the way. When the column came under fire, however, the guide jumped off the hull and fled, causing the tanks promptly to take another wrong turn. Communist narratives speak of "increasingly dogged resistance." The first NVA tank to approach Tan Son Nhut's main gate was set ablaze. "Our infantry were pinned down, the lead element . . . became so weakened it could not continue the attack." Officers dashed forward to view the situation, then committed reinforcements.

An attack by VNAF aircraft—one of the last of the war—knocked out two more tanks. By 1015, as Northern armored losses mounted, "the situation was becoming extremely complicated." Then attacking infantry broke through, overrunning bunkers west of the main gate. A column of tanks and carriers surged forward, fanning out inside the perimeter, firing as they went. Clusters of defenders began to emerge, making gestures of surrender. By early afternoon, the last resistance at the base had been mopped up.

Veteran Vietcong leader Huynh Cong Than led a division-size force into Saigon from the south. He observed that, while the big picture was of Southern collapse, his units faced a succession of fierce little battles that cost a stream of casualties. One attack on a district military HQ was repulsed; the VC finally bypassed the compound, then crossed the Can Giuoc River with vivid memories of following the same route at Tet 1968, with much less favorable consequences. Than's war concluded with his occupation of the National Police HQ and Navy HQ in the heart of the city. "Our soldiers' faces were lit bright by smiles of victory," he wrote. The symbolic climax of the 30th came when one of the tanks that led Maj. Gen. An's 304th Division smashed through the gates of Thieu's abandoned Independence Palace.

Former president Duong Van "Big" Minh, whose younger brother was a senior NVA officer, had reassumed the nominal state leadership three days earlier. He retained vain hopes of orchestrating a cease-fire, but the communists would no more recognize Minh's mandate than that of any other Southerner. On that morning of April 30, the general performed his only serviceable deed by issuing a declaration of surrender, repeatedly broadcast thereafter, which saved many lives by persuading ARVN soldiers to lay down their arms. All significant fighting ended by nightfall.

Tens of thousands of Vietnamese continued to escape from Saigon that day, and indeed through the weeks that followed. Lt. Khiem returned exhausted from the embassy to join his parents and grandfather at their home. "There was no time to cry: I was just wondering how to survive." On the morning of the 30th, the family learned that—at a price—there was a chance for them to board a boat at the riverside. Khiem begged his mother to accompany them, but she insisted that she must stay to look after his grandfather. His father drove him down to the dock in one of the family business's trucks, bidding his son an emotional but hasty farewell. The young officer sprang aboard a boat already laden with some two thousand people, landing atop a throng of bodies even as communist rockets exploded nearby. He told some sailors, "Cut the cable!" and so they did. That morning a convoy of Navy ships ran the gauntlet of communist fire down the Saigon River to the sea. They were already offshore when they heard on portable radios that South Vietnam had formally surrendered, precipitating a new orgy of tears . . . and prayers.

Nguyen Hai Dinh, a defector from the NVA who had spent the previous four years in a Saigon seminary pretending to train as a Catholic priest, knew that his future would be brief indeed if he awaited the victors. On April 30, he fought his way through a bewildered, surging mass of people to join fifteen Airborne soldiers aboard a tiny fishing boat leaving a Saigon quay, from which they transferred offshore to a bulk carrier with four thousand other fugitives aboard. Amid the terrors and hardships that ensued when its engines broke down, Dinh tossed away his South

Vietnamese identity card and his certificate as a *chieu hoi*. They finally disembarked at Hong Kong, where he spent nine months. His lifelong ambition for a new life in the US died in the departure from Saigon. Like many fellow countrymen, he now viewed the Americans as betrayers and chose instead to make a home in Britain.

Out on the South China Sea, as the state of South Vietnam became history, a multitude of emotionally exhausted people gazed in wonderment upon a vast armada of warships large and small, transports, tankers, and small craft crowding the billows, a scene that reflected the bitterest humiliation ever to befall the United States, though its deepest pain fell upon the people of South Vietnam.

As communist forces approached Vung Tau, many Saigon soldiers suddenly donned red armbands, proclaiming their new allegiance to the victors. Lt. Nguyen Quoc Si had passed up opportunities to flee, "because I loved Vietnam and had no wish at all to live in the United States." He witnessed terrible scenes during the last hours before the port was overrun. "There were paratroopers who made last-ditch stands. Some people killed themselves and their families." A boatload of fugitives offshore suffered a direct hit from communist artillery. Then Si and other Southern officers watched troops of the North's 3rd "Yellow Star" Division march into the town. Their first impression was of the enemy's embarrassing juvenility. "Many were maybe thirteen, fourteen, fifteen. We said to each other, 'How could we have lost the war to boys like this? Surely we should have been able to beat these people.' We were very, very sad. The communists had no idea what to do with us. I handed my Colt .45 to a boy who started playing with it like a toy. I had to take it back and remove the bullets before he shot himself." The surrendered officers were first detailed by their captors to bury the stinking bodies that littered the countryside from the war's final battles, including those from the carnage around Xuan Loc.

Cmdr. Tri's Navy flotilla had lain in Vung Tau Harbor since April 6 while its officers and men argued fiercely over whether or not to flee.

About half chose instead to disembark. Tri said dryly, "If they had known how the communists would behave, everyone would have left." Those who chose exile set a course for Subic Bay aboard a landing ship, which carried fifteen hundred people on a voyage tranquil and almost comfortable by comparison with the ordeals that faced hundreds of thousands of others. By contrast, two old landing craft from Can Tho, crammed with Vietnamese and a handful of US consular staff, endured an ordeal of rain, hunger, thirst, and seasickness before being picked up by the old Liberty ship *Pioneer Contender*. The exhausted and embittered American passengers had felt abandoned; their spirits were not now improved by seeing a nonchalant figure gazing down on them from the stern rail of the big ship—a CIA officer who had made a comfortable exit by helicopter. "Hey," he shouted, "too bad you had to get wet."

In Tay Ninh, no one had more reason to fear the communists' arrival than Special Branch Lt. Col. Phan Tan Nguu, whose wife, Nguyet, also worked in his department. His CIA adviser had offered them seats on a Huey, but they declined because their two children were away staying with grandparents. On April 30, after burning his files, Nguu set out on a Honda with his wife to try to reach the family, only to find the road blocked by NVA. They briefly took refuge in a temple but that evening were taken prisoner. Maj. Nguyen Thuy of the Saigon police, thirty-two years old, knew her own likely fate if she fell into communist hands, yet likewise felt unable to flee because her youngest son—"the one I loved most"—was with her parents in My Tho. She spent the next thirteen years in a reeducation camp, while her ARVN officer husband served six. All the couple's property, including their house and that of their parents, was sequestered.

Just before the communists occupied Saigon, Maj. Nguyen Cong Luan drank half a bottle of bourbon, more than ever before in his sober life, without getting drunk. He put a pistol to his head, but his driver said, "Don't do that, please, I beg you. If you decide to end your life to go down there in the netherworld, let me go with you, and I will keep being your

driver." This made Luan laugh and abandon thoughts of suicide. Others, however, decided differently. A few doors down lived another army major who ate a lavish lunch with his wife and seven children before giving the family sleeping pills, then shooting them one by one before killing himself. He left a note: "Dear neighbors, my family can't live under the communist regime. Please forgive us and help my relatives bury us. In our safe there is a little money. Please use it for our burial expenses. Thank you and farewell!"

At five p.m. on April 30, the people of North Vietnam heard echoing through a myriad of street loudspeakers the familiar theme tune "Kill the Fascists," which preceded news from the Voice of Vietnam. Then an announcer said, "Fellow countrymen, you are invited to listen to a special victory proclamation." A song was played: "If only Uncle Ho could be with us, to share this happy day."

In Saigon Northern soldiers were awed by the wealth of goods in the shops. A young lieutenant hastened into the Khai Tri ("Enlightenment") Bookstore, where he used his tiny stock of money to buy two Vietnamese-English dictionaries, one for himself and one for his sister: "I wanted to return to college, and we couldn't get such things in Hanoi." Bao Ninh gained the impression that many Southerners were simply glad the war was over. He was assuredly correct that the first reaction of millions of Thieu's former people was a surge of relief, which for a time overcame their fears for the future.

Communist histories provide only fragmentary statistics for the final campaign of the war. They indicate over twelve thousand casualties during the fighting at Xuan Loc, Phan Rang, and Saigon's western approaches, and in the final assault on the capital. A senior NVA officer observed dryly, "The march to victory was not conducted along a red carpet laid for us by the enemy, as many people suppose." The 1975 battles probably cost North Vietnam around ten thousand dead, few enough when heaped atop the mountain of his people's corpses that Le Duan had already climbed to secure Vietnam's reunification.

Henry Kissinger was stunned by the vast human tragedy that unfolded

during the days that preceded and followed the communist triumph. Yet when Graham Martin at last reported to him in Washington after his ordeal, the secretary of state contrived for the ex-ambassador a characteristic gallows jest: "Well, you'd better get back out, because in the devil theory of history we have to have someone to blame."

AFTERWARD

1. VENGEANCE

When the guns fell silent, the homecomings of victorious communist veterans were as dispiriting as those of their former American foes. A Southerner, Chau Phat, said sardonically, "The Northerners found winning much less meaningful than they had expected." Bao Ninh describes in his autobiographical novel The Sorrow of War a return to Hanoi after the 1975 campaign, aboard the so-called Unification Train, packed with wounded and demobilized soldiers: "Knapsacks were jammed together on the luggage racks and in every corner. Hammocks were strung vertically and horizontally, making the compartments look a little like resting stations in the jungle. There had been no trumpets for the victorious soldiers, no drums, no music. The general population didn't care about them. Nor did their own leaders." He likened the noisy stations through which they passed to afternoon markets, and he wearied of the repeated searches for loot to which soldiers were subjected. "Loudspeakers blared, blasting the ears of the wounded, sick, blind, white-eyed, gray-lipped malarial soldiers. Into their ears poured an endless stream of the most ironic messages, urging them to ignore the spirit of reconciliation, to dismiss the warmth and humanity in the ruins of the defeated, sybaritic society of the South. And especially to guard against the idea of its people having fought valiantly or been in any way deserving of respect." Ninh and most of his comrades despised "this barrage of nonsense."

Former secret cadre and PRG justice minister Truong Nhu Tang was among those embittered, indeed alienated, by the manner in which the "liberation" of South Vietnam was implemented. "The Hanoi Communist Party concentrated power in the hands of corrupt and incompetent bureaucrats and brutal security organizations. They fought among themselves to sequester the best houses, the richest plantations and black market luxuries." Tang never forgot the Party assembly at which the Northerners asserted their intention to rule, dismissing the claims of NLF veterans, including Tang himself. "No photograph has yet been published of the Rex Dance Hall [meeting], scene of the Southern revolution's final humiliation on 18 July 1975." He found friends fiercely reproaching him: "At least under Diem and Thieu there was honor among thieves. But these Party people are wolfing down everything in sight. Was it really such a good idea to throw out the Americans?" Northern cadres and army officers, "after being subjected for years to the rigors of military life, were suddenly confronted [in Saigon] with what seemed to them fairy-tale riches, theirs for the taking. It was as if the city had been invaded by a swarm of locusts."

Meanwhile, the last Americans returned home ashamed that amid the shambles of the evacuation, so many of their allies had been abandoned to face communist retribution. Frank Snepp told an August 1975 audience at Washington's Foreign Service Institute, "We left behind on the tarmac or outside the embassy walls four to five hundred of the Saigon special police force whom we'd trained, . . . about twelve hundred members of Saigon's central intelligence organization, . . . and thirty thousand cadres of our Phoenix counterterror program." He highlighted the comprehensive failure to destroy files containing tens of thousands of names of Vietnamese who had served the Americans or the regime, and estimated that only about one-third of the most vulnerable had escaped. Snepp's audience, drawn from the political establishment, listened in stunned silence. They deplored not what Americans had done or failed to do, but instead Snepp's exposure of it. His angry 1977 book, Decent Interval, prompted a prosecution by the US government and confiscation of his earnings, together with imposition of pariah status upon the author by the intelligence community.

As for the fugitives who fled Vietnam in such terrible circumstances, their numbers overwhelmed accessible American shipping. When Lt. Nghien Khiem's overcrowded refugee boat encountered a warship in the South China Sea, the American crew emphasized their insistence that the refugees should sheer off by spattering the waves with warning bursts of automatic weapons fire, which some voyagers deemed a suitably symbolic gesture. Setting a course by the stars, they eventually reached Singapore after extraordinary adventures and privations. In Saigon, Khiem's father was stripped of his business and all his possessions. His mother opened a coffee stall to support the family until they were permitted to leave seven years later, as destitute as they had been on quitting Hanoi back in 1954. In Khiem's rueful phrase, "And so, twice in a lifetime, we washed our hands clean."

Nguyen Thi Chinh flew out of Saigon carrying the diplomatic passport that she was privileged to hold as South Vietnam's foremost screen star. However, when she reached Singapore, where she had recently been filming, she was arrested. With the collapse of the Thieu regime, her credentials became a mere losers' visiting card. After two days, she was deported, bearing a round-the-world air ticket bought by friends. This launched her upon a lonely odyssey. In Paris she briefly glimpsed her sister through the glass wall of the immigration hall before being shuffled onward to London, where she was again barred. Across the Atlantic, she was turned away at New York's JFK Airport. On May 2, she was at last admitted in Toronto. "I became Canada's first Vietnamese refugee." A few days earlier, she had been a relatively wealthy woman, but everything she owned was back in Saigon, forever beyond reach. Canadian social services gave her a coat and \$75; as a condition of entry, she was required to seek immediate employment. In a scenario that would seem incredible in a fictional movie, she became a cleaner on a chicken farm, paid two dollars an hour to wield a pressure hose.

In desperation, she took up her only asset, an address book, and made painfully expensive calls to Hollywood stars whom she had met or worked with. First she tried William Holden, who was away in Europe. Glenn Ford's butler regretted that the great man did not remember her. Burt Reynolds's office repeatedly claimed that Mr. Reynolds was unavailable. Finally, almost at the end of her little pool of cash, she telephoned a woman she had met just once—Tippi Hedren. "I was a drowning person. I cried down the phone—and she cried, too." Then Hedren said, "Slow down," and took Chinh's details. Within three days, the former Hitchcock star enabled this Vietnamese actress to escape from the nightmare chicken farm with a plane ticket and a visa for the US, where Hedren invited Chinh to her home and opened her own wardrobe to her destitute guest. When Bill Holden returned from his hunting trip, he sent her the biggest box of roses she had ever seen, accompanied by a note saying, "Welcome to America. Make this land your home." Chinh was one among three-quarters of a million South Vietnamese who did just that, in 1975 and the years that followed. She appeared in almost a hundred more movies, known to the world as Kieu Chinh.

In the heady days after Saigon's fall, an NVA general offered his new comrades of the South a nod toward reconciliation, saying, "Only the Americans are the vanquished." Yet twenty-year-old history student Kim Thanh's family, who lived near Tan Son Nhut, remained for days in hiding in the cellar of her great-uncle's house. The old man, like her own parents, had migrated from the North in 1954. "They knew the communists, and what they would do." When the family finally emerged, they saw the first manifestations of Northern victory: bodies lying in the street, victims of spontaneous executions. In justice to Hanoi, most of the unquantified number of killings that took place in the summer of 1975—probably in the low thousands—were local initiatives by vengeful cadres and Vietcong, not mandated by the politburo. Such spasms of hatred explode at the end of all such struggles. In 1944-45 France, for instance, during "l'epuration"—"the cleansing"—former Resisters murdered or summarily executed fellow countrymen thought to have collaborated with the Nazis. Some Vietnamese committed suicide to preempt an inevitable fate, such as Tay Ninh Special Branch officer Phan Tan Nguu's key Vietcong

informant, Vo Van Ba, the Tay Ninh source. He told Nguu before the end, "Because I know the communists so well, I know what life under them will be like."

As the new rulers tightened their grip, South Vietnam's people progressively learned the meaning of "communism," hitherto a mere weapon word, brandished or parried by the rival combatants. Le Duc Tho had assured foreigners during the Paris negotiations, "We have no wish to impose communism on the South." Yet now, in the words of Michael Howard, "A gray totalitarian pall" descended upon the country. A Hanoi doctor inspected the equipment of Saigon's main hospital and said, "You have too much. We cure many diseases without all these things." Truckloads of medical equipment were removed and shipped North, along with much else. Cadres evicted wholesale from Cong Hoa Military Hospital a thousand ARVN wounded. They vandalized South Vietnam's principal military cemetery, erecting a sign outside its gate: HERE LIE THE AMERICANS' PUPPET SOLDIERS WHO HAVE PAID THE PRICE FOR THEIR CRIMES.

For months after fighting ended, Northerners in the South were warned to remain armed and vigilant for fear of attacks by embittered supporters of the vanquished regime, though scarcely any took place. A former Southern sergeant watched with grim amusement the reaction of NVA soldiers to the riches of the former capital, renamed Ho Chi Minh City. "Their eyes were opened: they saw what we had and they did not." Lifelong communist Nam Ly, who had "regrouped" to Hanoi in 1955 while the rest of her family remained, now traveled South bringing gifts for the mother with whom she had not communicated for twenty years: a dozen rice bowls, two kilos of sugar, and two cans of condensed milk. Ly had unquestioningly swallowed the Party's assurances that the South's people were victims of privations far greater than their own.

After two months, Kim Thanh was allowed to resume her studies at Saigon University, where she found the history syllabus drastically amended. "Some of the emperors whom we had been told were bad now turned out to be good, and the other way around." Her father, a retired army master sergeant, owned a little farmland, which was confiscated for distribution to peasant collectives. Uncompensated issues of new currency

destroyed the savings of tens of thousands of families. By the end of 1975, many people in the South were struggling for subsistence, and severe hunger struck a few months later. "There was no rice to be had. We ate sweet corn, sweet potatoes, manioc—all sort of things we had scarcely seen before." The sufferings of the South Vietnamese in the years thereafter, due to the failure of Hanoi's economic policies and pillaging of the vanquished to serve the victors, were cruel indeed. Communists of all ranks wandered into homes, removing anything that took their fancy. Northerners treated Southerners—especially those who could be branded lackeys of the fallen regime—as milch cows, providers of spoils. The Soviets took their own modest share in kind—ten thousand M16 rifles and ten million rounds of ammunition, which KGB boss Yuri Andropov assured Giap "will be used in the fight against imperialism and to meet the needs of national liberation movements."

In the year following "liberation," some three hundred thousand South Vietnamese were arrested. All those with the slightest association with the fallen government were tainted for life. The cashier at Saigon's Majestic Hotel escaped imprisonment, but was denied further employment and repeatedly interrogated because he had accepted payment for so many bills from Americans. Approximately two-thirds of detainees, including all exofficers, were dispatched to reeducation camps, where they remained for between three and seventeen years. A record of opposition to the Thieu regime provided no immunity: among those confined was Buddhist monk Tri Quang, who had created such embarrassments for Saigon's generals.

A film scripted by the famous poet Nha Ca had been banned by the former rulers as an alleged incitement to pacifism. Back in 1968, however, she had been present in Hue during the communist massacres, and she published an emotional elegy, *Mourning Headband for Hue*. For this she was now dispatched to a camp, and a copy of her Hue poem was exhibited in Hanoi's Museum of War Crimes as a specimen of "puppet lies." No fixed term was set for prisoners' incarceration, determined by Party whim. Le Minh Dao, who commanded the South's 18th Division at Xuan Loc, remained behind barbed wire until 1991, much longer than Stalin held captured Nazi generals after World War II.

Thousands of ex-ARVN officers were shipped to camps in the North, where one group laboring under guard found themselves fiercely reproached by an elderly villager. "Since 1954, we have been waiting for you to liberate us. Instead you come here at last as prisoners. You are shameful! It's because you didn't fight hard enough, you tolerated corruption, you enjoyed too much. You have betrayed us." One of his hearers, Maj. Luan, wrote, "[We] quietly swallowed the stinging words as a punishment we deserved." He himself was held for seven years, then eked an existence in Saigon for another nine before escaping to the US. His guard sergeant told him when he was freed, "You are leaving the smaller prison and will begin to live in the larger one with me and our seventy million compatriots."

Former lieutenant Si found himself working on the Cambodian border, in conditions little superior to those prevailing in World War II Japanese prison camps. He and his comrades spent countless hours composing confessions of supposed crimes. They were told that they would be released only when judged fit to play their parts in the New Society. Uncertainty about when this might be drove some men to madness. "An army doctor one day slashed his wrists. Then next morning we found his name on a list for release." Because the only medicine available was aspirin, almost any disease sufficed to kill. Si's own father, a former Saigon police officer aged fifty-nine, perished in the first months of his own incarceration, probably from chronic liver trouble, though the family was never informed. One of Si's fellow prisoners died of asthma. Another, unaccustomed to agricultural tasks, was fatally injured by a jagged bamboo that sprang back and slashed him as he strove ineffectually to fell it. Dysentery was endemic.

Starvation was employed as a psychological weapon. Former ARVN medical officer Ly Van Quy became enraged by the behavior of one of his eight-man team of prisoners. When distributing the group's daily rice ration out of an old ammunition can, this man always took a fraction extra for himself. Quy finally snapped, leaping to his feet, bent on killing the thief. Anticlimax followed: debility caused him to topple over and collapse before striking a blow. "That night I felt so ashamed. I thought, This is exactly what the communists want us to do to each other. I am playing their game. I never behaved in such a way again." Quy worked on a burial

detail at the first camp in which he was confined. Three years later, he chanced to be returned to the same compound and found its cemetery much expanded.

Camp routine began at five a.m., when prisoners were issued a rice ball to sustain them through the day, then marched into the fields to work. One among each eight-man squad was permitted to forage for wild edibles while the others fulfilled his output quota—a concession that narrowly staved off death from inanition. They returned to the huts at six p.m., where evenings were devoted to ideological indoctrination. Most were soon eager to say anything, agree to anything, in exchange for freedom. Si said, "Had I been told that if I cried enough, I would be released, I would have become the best crier in that camp. I watched the hair of one man turn white, who was just twenty-two."

Some of those dispatched to the camps were relatively elderly city dwellers, ill adapted to a primitive life with minimal sanitation and chronic malaria. Nobody knows how many prisoners died, but a death rate of 5 percent—a conservative estimate—would indicate at least ten thousand. After release, they remained without civil rights; most were dispatched to "New Economic Zones," raw jungle areas where they were expected to create communities amid privations little less stringent than those of the camps. Some eventually received exit visas in return for surrendering everything they owned. When Nguyen Thi Minh-Ha left in 1980, the destitute widow carried with her only the ashes of her husband, who had perished in a camp, which she eventually scattered in the sea off Britain's shores.

Her brother Si, released in 1978, was permitted to make one brief visit to his old Saigon home before being exiled to a New Economic Zone. In the following year, with the help of friends abroad and the surrender of the house, he was allowed to leave Vietnam with twenty dollars. He had secretly married Kim Thanh, whom he had known since school days and now worked as a teacher; only in 1984 was she permitted to join him in Britain. Hundreds of thousands of Vietnamese unable to secure exit visas became instead "boat people," braving appalling perils and hardships to escape by sea from what had become a national prison.

Some better-off Southerners had initially embraced the end of the war, even though its outcome was not that which they would have chosen. Among these was retired Southern colonel Ly Van Quang's wife, who had three sons serving in the military and another already dead in Lam Son 719. Her brother was Thien Le, a general in the North Vietnamese Army. She was rashly confident that this connection would preserve the family from persecution. Instead her three sons, Thien Le's nephews, endured years in the camps.

The family was puzzled that their father was meanwhile left in peace. Only much later was this anomaly explained: through twenty years as an Airborne officer, Col. Quang was served by a devoted personal aide named Thong. This man became so much a part of their family life that the children called him Uncle Thong. On the colonel's recommendation, Thong was commissioned, attaining a captaincy. A year after the fall of Saigon, he reappeared at the family house in the uniform of a communist officer and revealed that for more than a decade he had been an enemy informant. Thong now assured the family they would come to no harm, because he recognized the colonel as a good and honest man. Far from expressing gratitude, the elderly veteran turned gray with rage and hurled a chair, shouting, "Get out of my house, you treacherous bastard!" His son said, "To my father, everything was black and white."

Nguyen Cong Hoan, an antiwar South Vietnamese who served two terms in the post-1975 National Assembly before fleeing in a refugee boat, said six years later, "I am very regretful that I did not understand the communists before. The communists always speak in lofty terms that appeal to the better part of people. Then they are used for a tragic end. I believed them; I was wrong." Hai Thuan, a veteran who fought with the Vietminh and then lived in the North through the war, returned to Saigon to work in its new Justice Ministry. He was horrified to find that his own son, a former Southern officer, had been sent to a camp, and that his impassioned protest to the politburo was dismissed. One fine morning, Thuan threw himself off the roof of a high building on Le Loi Street, leaving behind two letters. One was addressed to the Party leadership, denouncing

its brutality and mendacity. The second begged forgiveness from his wife and son.

Truong Nhu Tang, the PRG's justice minister, found that no more than any other Southerner could he get news about his own two brothers, imprisoned at Long Thanh. He eventually secured permission to visit the camp but was forbidden to communicate directly with them. Having caught a brief glimpse of his siblings, he wrote later, "Even now their faces haunt me: pale, thin, frightened, their eyes fixed in a glazed stare. I can't even imagine what they must have thought, seeing me in the back seat of a government car driving around that place." The minister eventually secured the release of one brother, but the other was dispatched to spend more than a decade at another camp in the North, because he had been associated with Saigon's former National Assembly.

Tang had joined the resistance movement "believing that Ho Chi Minh, Pham Van Dong and the Vietnamese Communist Party were patriots who would place the national interest above personal and ideological objectives. Because of love for my country I gave up my family, everything, for this dream. I would not listen when my father warned me, 'In return for your service, the communists will not even give you a part of what you have now. Worse, they will betray and persecute you all your life.'" Which they did. "The politburo's real policy," Tang wrote bitterly, "was vicious and ultimately destructive to the nation."

Police Special Branch officer Phan Tan Nguu escaped execution—the fate of several of his colleagues—but served seventeen years' imprisonment. His wife completed five years, then on a fourth escape attempt among boat people reached America with her children. The family was finally reunited when Nguu was allowed to join them in 1996, having been separated for more than twenty years. He found that his sons, of whom he had been permitted to know nothing, were students at Johns Hopkins Medical School; both later became successful surgeons.

Phan Phuong, daughter of another Special Branch officer, was fifteen when Saigon fell, and her adored father was removed to serve eight years' imprisonment. At first, she and her eight brothers and sisters were able to continue to attend school. Her mother traded a little in the market because the family was barred from fixed employment, and they gradually sold their few possessions. Then her mother, too, was sent to prison for a year, and Phuong became the sole breadwinner, making and selling banana ice cream. She begged food for her siblings in a new universe in which desperation made self-preservation the only objective. One day seeing a neighbor with a bunch of sweet potatoes, she pleaded for just one for the family-and was refused. "Each night I prayed for a miracle, until at last my mum came back. I was so happy." The family finally escaped from Vietnam in 1991. Doug Ramsey professed lack of surprise about communist ruthlessness. "If anything, I was amazed that it wasn't harsher—think of the Chinese principle of seeking vengeance upon at least three generations, sometimes seven." NVA veteran Bao Ninh says that after Hanoi's triumph, "it was asking too much of the victors not to seize the opportunity to oblige the losers to accept their way of thinking. But the camps went on far too long."

In Viet Thanh Nguyen's best-selling 2016 novel, *The Sympathizer*, there is mention of an attempt by exiles to mount a guerrilla campaign against the Hanoi regime. Such a scheme was indeed launched in 1977. Fiercely aggressive fund-raising among the US Vietnamese exile community paid for the creation of a training camp in northern Thailand. A few years later, Frank Scotton, then serving at the US Embassy in Bangkok, was deputed to disperse the deluded counterrevolutionaries. He told them they should be ashamed of themselves for risking getting people killed for nothing. Yet they persisted until the late 1980s, seeking to infiltrate guerrillas via Laos: several hundred of these "resistance fighters" died, including their leader, a former South Vietnamese naval officer, in the course of operations that were tragic because futile.

The war's ending inflicted an unwelcome shock upon Vietnam's leaders: the superpowers of both East and West relegated their country—which for two decades had sustained a prominence far beyond that conferred by its size or strength—to the margin of affairs. China became increasingly adversarial. By the late 1970s, Beijing officials referred contemptuously to one Hanoi politburo member as the beggar, because of the frequency

with which he appealed for aid. In 1979 China and Vietnam waged a brief but bloody frontier war. Russian aid dwindled dramatically and with the collapse of the Soviet Union disappeared altogether. By 1980 resource-rich Vietnam had become one of the poorest nations on earth.

Through the decade that followed, its people suffered terribly, yet their elderly leaders remained unwilling to abandon collectivism or to engage with the noncommunist world, for fear of polluting Vietnam's ideological purity. Only after the 1986 Sixth Party Congress did the Hanoi politburo grudgingly begin to modify some policies, allowing southerners to dally anew with commerce, which they understood much better than their northern compatriots. In 1988 famine swept large parts of the north, imposing terrible suffering on more than nine million people; an unknown number died. Yet still ideologues in Hanoi, together with some military men and especially members of the powerful intelligence apparatus, found it hard to reconcile themselves to compromises with economic rationality. Nguyen Van Linh said in a speech in September 1989 to the Party's Ideological Training Institute, "Capitalism will certainly be replaced by socialism, because that is the law of human history, which nobody can deny." Le Duc Tho wrote a poem shortly before his death in 1990, glorifying the lost joys of shared poverty and suffering:

In the past we had strong emotion

Sharing life and death, sharing a bowl of rice and a shirt

But now people take money

And individuality as a measure for emotion and feelings.

The sense of camaraderie has faded.

Le Duan died in 1986, but the successors to Tho and himself have shown no inclination either to indulge personal freedom or to sacrifice a jot of the power of the Party. Marxist-Leninist theory continues to be taught in every secondary school. Hanoi's gerontocratic leadership has acknowledged merely the necessity to allow individuals and private enterprises to make money, which some have done with notable success. As for neighbors and allies, most of Hanoi's soldiers left Laos in 1988 and Cambodia

738 .

in the following year. Diplomatic relations with the United States were restored in 1995. That year Vietnam also joined the ASEAN political and trade organization, and the WTO a decade later. The processes of the Hanoi leadership remain cloaked in secrecy, but it is apparent that an alliance of old men who cherish Vietnamese ideological exceptionalism and younger men and women whose families have achieved power within the Party continues to block liberalization. Many top people have become spectacularly rich personal beneficiaries of their country's economic gains.

As for its enormous and still growing exile community, the US Congress's 1975 Indochina Migration and Refugee Assistance Act represented an enlightened initial response to a humanitarian crisis. Nonetheless, Chau Phat says, "Nobody had reason to be happy about the outcome of the war, but being labeled losers was harder to live with than being called winners." Many of those who started new lives abroad struggled in their early years. "They had been misinformed for too long. They supposed the Americans had gone to Vietnam to help them. Instead they went only to use the country as a platform to challenge international communism." Phat has become a successful businessman and philanthropist, now known as Frank Jao.

Former South Vietnamese Air Force officer Nghien Khiem also began a new life in Southern California, where he worked as a laborer for \$2.50 an hour until he could train as a computer technician. One day soon after his arrival, a man leaned out of a truck cab and shouted at him, "Go home!" "That hurt," said Khiem, but he added, "I have since met a lot of good people." Like an astonishing number of Vietnamese Americans, he has made a success of his new life. Don Graham hired thirty refugees to work at his family's newspaper, the *Washington Post*. "They proved the most loyal and hardworking people we had." Nguyen Tri, once the youngest commander in the Vietnamese Navy, has become a contented citizen of Orange County. He says, "Today I am simply proud to be an American. I want to live for the future, not in the past. I regret only that after the communists conquered South Vietnam, they did not behave as generously as did the North after the US Civil War."

2. THE AUDIT OF WAR

The concluding pages of Vietnam's eight-volume war history, entitled Total Victory, suggests casualty figures: almost two million civilians killed, two million more crippled or disabled, another two million exposed to poisonous chemicals. On the battlefield, Hanoi estimates 1.4 million men killed and missing, six hundred thousand wounded. The civilian numbers seem exaggerated, but the military statistics are of the right order of magnitude; nobody will ever know for sure. It is noteworthy that ARVN veterans, especially the disabled, remain to this day unpersons in the eyes of Vietnam's rulers. The authors conclude their peroration thus: "Our entire Party, army, and population in both halves of Vietnam had successfully carried out the strategic concept laid down by our beloved Uncle Ho in his 1969 'Tet Greeting': 'Fight to force the Americans to go home, fight to topple the puppets.' Our country was united . . . the Vietnamese people had defeated a neocolonialist campaign of aggression that became the biggest, longest, and fiercest struggle since the Second World War." Robert McNamara once asked Giap who was the best general of the struggle, to which the Vietnamese answered with unassailable ideological correctness, "The people."

By contrast, Ronald Reagan said a decade after Saigon's fall, "It's time that we recognized that ours was, in truth, a noble cause." While American conservative writer Michael Lind acknowledges the struggle as "a horrible debacle . . . waged by methods that were often counterproductive and sometimes arguably immoral," he and some of his political kin today view it as merely "a failed campaign in a successful world war . . . [that] had to be fought to preserve the military and diplomatic credibility of the United States."

Posterity will continue to debate whether the praiseworthy achievement of Ho Chi Minh and his followers in expelling French colonialism from Indochina justified the economic and social tragedy that they subsequently inflicted on the Vietnamese people, first in the North and later nationwide. Many Southerners who espoused the communist cause until

1975 ceased to do so after experiencing the implementation of Hanoi's ideology.

Could the US involvement have had a different outcome? Many Americans—the likes of Frank Scotton, Doug Ramsey, and Sid Berry went to Vietnam inspired by the highest ideals of service. Scotton recalls a remark of his old colleague John Paul Vann. "John said that we had assisted the Vietnamese to rise high in the sky in a heavier-than-air machine, and must help them come down as gently as possible, rather than crash." Scotton asked him what the difference would be. Vann replied, "There are more survivors that way." The two men once landed a tiny LOH chopper at a Regional Forces outpost that had been overrun during the night. They somehow crammed a badly wounded soldier into the cockpit, then headed fast for Pleiku. The man bled all over Scotton's lap, before dying in the air. When they landed, Vann stood banging his fist furiously on the Plexiglass, saying again and again, "Just another twenty minutes! Just another twenty minutes and he would have made it!" Scotton thought, This is a guy whom John has never met in his life, yet he cares terribly about him, because he's on our side.

The anecdote is moving, yet the American commitment was fatally flawed by its foundation not upon the interests of the Vietnamese people, but instead on the perceived requirements of US domestic and foreign policy: reelections and containment of China foremost among them. The decisions for escalation by successive administrations command the bewilderment of posterity, because key players recognized the inadequacy of the Saigon regime upon which they depended to provide an indigenous façade for an American edifice. In 1965 the Joint Chiefs warned McNamara about the "lack of a viable politico/economic structure . . . of stability in the central government, the low state of morale of the leadership, and the poorly trained civil service. . . . The solutions, primarily political, to these problems are critical to the eventual termination of the insurgency." America's leaders nonetheless deluded themselves that all these complex challenges could be met by an overwhelming application of military power, as if by using a flamethrower to weed a flower border.

Since this was the core US Vietnam policy failure, it seems inappro-

priate to lay extravagant blame upon the generals, unimpressive though some of them were. In 1964 William Westmoreland rejoiced in having secured the most important field command conferred upon any American soldier since the Korean armistice. By the time he went home four years later, he had been transformed into the fall guy for a national humiliation. David Elliott says justly, "There never was a clever way to fight the war." Gen. James Gavin was among those who warned from the outset, "If a village is fought over five or six times, a great many civilians will die. The whole pattern of life will be altered. . . . As the war continues to drag on, we ourselves destroy the objective for which we fight."

Even before considering the kinetic consequences, American decision makers failed to recognize the economic and cultural impact of a huge army upon an Asian peasant society. A Vietnamese secretary at USAID earned more than an ARVN colonel. Bulldozers and Conexes, antennae and armored vehicles, watchtowers, sandbags, and concertina wire ravaged the environment even before the guns began to fire, before helicopters swirled overhead, and before huge soldiers started to buy the sexual attentions of tiny women. This was not a curse unique to Vietnam; it hangs over all Western military interventions in far-flung places, however well intentioned.

The communists enjoyed the critical propaganda advantage that they were almost invisible to most of the people most of the time. They set a light footprint on the land, contrasted with that of the Americans, whose steps might be compared—and were, by cultured Vietnamese—with those of some sci-fi movie giant lumbering across the landscape, expunging tranquility, and smashing fragile structures in its path. In the twenty-first century, Western military commanders still fail to understand the folly of sending their soldiers to wage "wars among the people" wearing sunglasses, helmets, and body armor that give them the appearance of robots empowered to kill, impossible to love or even to recognize as fellow human beings.

In both North and South, wherever the communists' writ ran, they propagated terror and abolished personal freedom. For all the adulation heaped by the Western Left upon Ho Chi Minh and Le Duan,

they presided over a fundamentally inhumane totalitarian regime. Yet its mandate seemed more credible than that of its foes. In most societies, including the modern US, rural dwellers feel an instinctive mistrust of metropolitan elites. This was especially acute in South Vietnam, where Saigon was seen as the embodiment of a French colonial rather than an indigenous culture. While few people had much interest in Marxist-Leninist theory, many were impressed by the promise of land reform that would cast off the yoke of landlords and money lenders, promote government by and for Vietnamese, and expel foreigners. Southerner Chau Phat says, "The communists could ceaselessly remind us how humiliating it was to be occupied." His father, a former Northerner, said from an early stage of the war, "There's no hope. We're going to lose." His son said, "He could see into the minds of the people: he understood that the other side had the monopoly of patriotism."

The PRG's Truong Nhu Tang spoke contemptuously of the ease with which the communists manipulated Western media, saying, "We were not so much looking for supporters, but rather for opponents of the American and Saigon regimes. . . . Not only were the South Vietnamese and American publics lied to by the communists. Even those of us who lived in the jungle and made sacrifices and fought . . . were made victims."

The North Vietnamese depended upon Soviet and Chinese cash and weapons, but the people of the South never encountered these foreign armorers, seeing instead only their communist fellow countrymen, conspicuous for lack of material possessions, alongside the ostentatious spoils amassed by the servants of Saigon. It was plain to the humblest peasant that the men who ruled the South, whether in fatigues or tuxedos, could not rise in the morning without asking their "longnose" paymasters which side of the bed to get out from. Few Americans understood how grievously the conspicuousness of their own dominance crippled the war effort. Communist victory was attributable less to the military prowess of the NVA and Vietcong than to the fact that they were Vietnamese. Hanoi told many lies about many things, but it spoke truth when it asserted that the leaders of the Saigon regime were puppets.

It is sometimes said that there are no parallels between Vietnam and

the West's twenty-first-century struggles in Iraq and Afghanistan. Yet an obvious one is that the US and its allies experience chronic difficulties in translating battlefield successes into sustainable polities. That fine American officer Lt. Gen. H. R. McMaster described to the author in 2006 his experiences and achievements commanding an armored cavalry regiment in 2004–05 Iraq. He concluded sadly, "The problem was that there was nothing to join up to." Neil Sheehan says, "In South Vietnam, too, there never was anything to join up to." In the absence of credible local governance, winning firefights was, and always will be, meaningless. In Vietnam, the communists were the only belligerents who conducted an integrated political and military struggle.

Yet if the war could not have been won on the battlefield, the US might have contrived to inflict less damage, through the excesses of its armed forces, upon its own stature as a standard-bearer for civilized values. It is a common illusion that beneath fatigues young Westerners fighting abroad remain decent hometown boys. Some do, others do not. Soldiers are trained to become killers. The circumstances of combat oblige them to live a semi-animal existence that coarsens sensibilities. Many warriors come to hold cheap the lives of bystanders, people whom they do not know, especially when their own casualties are high. In Vietnam grunts were often baffled by rules of engagement designed to limit civilian losses. One protested to Michael Herr, "That's what a fucked-up war it's getting to be. . . . I mean, if we can't shoot these people, what are we doing here?"

It is hard to fine-tune the conduct of young men in possession of lethal weapons who are—like most soldiers most of the time—hot or cold, filthy, hungry, suffering constipation or diarrhea, thirsty, lonely, weary, ignorant, holding their nerves and rifles on hair triggers because only thus can they hope to survive. Soviet and Nazi precedent suggests that merciless occupiers can suppress resistance by force. In Vietnam, the US Army contrived to be sufficiently intrusive and racially contemptuous, and also intermittently murderous enough, to earn the hostility of the population, yet it was not savage enough to deter many peasants from supporting the communists. Americans burned enough villages to incur the world's censure, but too few to prevent local people from sheltering guerrillas.

Almost as dismaying was the willingness of their fellow countrymen to shrug off My Lai and similar horrors. A 1969 Time poll showed 69 percent of Americans endorsing the proposition "Things like that happen in time of war." A just measure of any society is not whether its soldiers spasmodically commit atrocities, but whether these are judged institutionally acceptable, as they were in Hitler's army and those of its World War II Russian and Japanese counterparts, none of which seem appropriate exemplars for a modern Western democracy. Excesses by US forces in Vietnam, while not universal, were sufficiently commonplace to show that many uniformed Americans considered Vietnamese inferior beings, their lives worth less than those of "round eyes." In August 1967 Operation Benton, which almost nobody has heard of, was a brigade-strength search-and-destroy directed against an NVA regiment. During its course, some ten thousand Vietnamese in Quang Tin Province south of Danang lost their homes. In an area six miles by thirteen, 282 tons of bombs and 116 tons of napalm were dropped, and 1,000 rockets, 132,820 20mm rounds, 119,350 7.62mm cartridges, and 8,488 shells were fired. An enemy body count of 397 was announced; 640 civilians were evacuated to refugee camps. Such a fortnight's work may be deemed representative. Moreover, it was a terrible symbolic mistake to allow Vietnamese to shine the humblest Pfc's boots and clean his hooch.

American commanders committed much energy to civic action programs. As professional warriors, however, they were conditioned to regard battle as their principal business. Most felt in their marrow that if their troops were not fighting, they were not earning their pay. Furthermore, career officers were properly ambitious to burnish their reputations and credentials for promotion. It was unlikely they could achieve this by reporting a tally of schools opened and villages visited by MEDCAP teams; nobody got a Medal of Honor for distributing candy in orphanages. The gold standard had to be numbers of enemy engaged and destroyed. Every nation needs soldiers to defend its interests, but at its peril does it concede them free rein in the midst of civil societies. Army doctor Russ Zajtchuk came to hate MEDCAP visits: "When you have a village that was bombed

and people burned, and you go in later with a few vitamins and soap, I never felt very comfortable about it. In fact I felt a hypocrite."

In the conflict's later stages, guerrilla warfare gave way to a conventional clash of arms, in which it is possible that US forces might have defeated the communists, had not the will of the American people already been broken. Even if firepower had prevailed, however, it is hard to envisage to what good end. The Saigon regime commanded negligible popular support: there was still "nothing to join up to." Arguably, the people of Vietnam had to experience the communist model, as they did at dreadful cost after 1975, before they could reject it.

The war cost the United States \$150 billion, much less than Iraq two generations later. Yet the true price was paid not in mere money, nor even in the fifty-eight thousand lost American lives—as a proportion of population, a smaller forfeit than the nation paid in Korea. The true price was in the trauma that it inflicted. Neil Sheehan observes that previous historical experience had shown Americans that foreign wars were a good thing: "You won; you were welcomed home. Then Vietnam came along. A lot of people got killed for nothing. All the other war memorials honor victories. The Vietnam Memorial commemorates sadness and waste." The Army and Marine Corps took fifteen years to recover from their descent into mutinous near rabbles, to become again outstanding fighting forces.

The American people's belief in both their own moral rectitude and military invincibility—created by the outcome of World II matched by an economic success so awesome that it seemed almost logical to believe that it reflected the will of a Higher Being—suffered devastating injury. Gen. Walt Boomer says, "The Vietnam war did more to change this country than anything in our recent history. It created a suspicion and mistrust we've never been able to redeem."

Even though the antiwar movement's younger zealots flaunted their naïveté by proclaiming the virtues of Ho, Mao Zedong, and Che Guevara, its supporters correctly identified Vietnam as a catastrophe. When Daniel Ellsberg was asked how he could justify his devastating revelation of the seven thousand pages of secrets in the Pentagon Papers, he responded,

746 .

"I wonder if it has occurred to you to ask any of the other officials [involved in directing the war] how they justify to themselves *not* doing what I did? What made them feel they had a right to keep silent about the lies that had been told, . . . the crimes that had been committed, the illegalities, the deception of the American public?" Ellsberg made a fair, indeed concussive point. Walt Boomer, who went on to command the Marine Expeditionary Force in the 1991 First Gulf War, says that the great lesson he himself carried home from Vietnam was "Tell the truth."

A former USAF navigator wrote about his Vietnam experience, saying, "Though I'm proud to have served as a B-52 crew member, I've spent the last forty-plus years trying to forget that damned war . . . a useless waste of time, money, and human capital. And at the end . . . our political leaders tuck their tails and run, abandoning the very people to whom we made so many promises." Frank Scotton discerns inside the US today two rival narratives: "When many American veterans gather, they tell each other how badly the South Vietnamese screwed up. And when South Vietnamese exiles get together, they talk about how the Americans did." After the war, he "felt that the most important part of my life was over. I was never again willing to put my life on the line for a cause." In Southern California, he finally made obeisance to Kim Vui, a longtime lover whom he had abandoned in Dalat in 1966, and they were married in November 2015: "She says I owe her fifty years." Doug Ramsey eventually moved into his parents' old house in Boulder City, Nevada: "It seemed a good place to recover whatever sense of normality I can, though nowadays I realize I should have stayed around Washington, where the care is much better." Almost wholly disabled, obliged to rely upon inadequate Medicare and workers' compensation, he said, "I share with Vietnamese veterans the belief that we have been screwed by our respective governments." Ramsey died in February 2018.

Former air force officer Nghien Khiem says that he still seeks to avoid any contact with Northerners. "We are the same people, but some of my family, friends, men whom I commanded died at their hands." Today he is no longer an angry man, but he cannot forget. Nor can NVA soldier Pham Thanh Hung, who suffered terrible wounds at Quang Tri in 1972. "Some-

times I still have nightmares about being under an air strike—and worse ones about being called back to the army to fight in a new war. I, and some of my generation, feel somehow cheated by what happened to us."

Maj. Don Hudson, who commanded an infantry company in 1970, said of the disillusionment of US veterans, "They thought they were going home with their uniforms on and their little medals and everybody would be really happy to see them. They found out that was not true." David Rogers is among those who still looks back with profound emotion: "The experience was huge. I don't have a lot of big thoughts—so much is personal. I tried to write a book, but didn't have the skill to carry it off. I had a lot of trouble coming home and going to church. I couldn't confess. I felt dirty. I'd been part of killing." Some contemporaries recoiled from him, merely because of his association with the struggle. "One girl who had gone to Canada with her boyfriend was very judgmental." The only memory that still matters to Rogers, like millions of his former comrades, is that of his own platoon: "to be able to say that as a corpsman I was there for them."

Around one-third of "his people" were killed or wounded. Living close to Washington, DC, he sometimes visits its memorial Wall at five, six in the morning. "I won't go when there are others around. To me it's a big headstone. I'm glad I have it. I have about ten names—Tony from Chicago, Jerry Johnson from Minnesota, Sam, and some more. Moments come back. Seeing a tree line behind the salt ponds up at Martha's Vine-yard, I thought, *That's like Vietnam*. The prettiest sights I saw there were choppers over tree lines. Reading writers like Neil Sheehan, I get so angry with *them*—the people who ran America. They knew what was happening. We didn't. I did the pace count and that was it." Sgt. Maj. Jimmie Spencer says, "People are reevaluating. At least now we can separate the war from the warriors. They were blamed for something they didn't start. Never again will we allow one group of veterans to turn their backs on another."

At this distance of time, it may also be possible to extend forgiveness to some of the "big people" who made disastrous decisions that damned their historic reputations but for which they later repented. Late one 1967

afternoon in Robert McNamara's huge Pentagon office, he was discussing ammunition requisitions with staffer William Brehm. "Let's see. That would be two thousand rounds for every enemy infiltrator. That oughta be enough." Then Brehm noticed that the defense secretary's body was shaking; he was staring up at the portrait of his predecessor James Forrestal on the wall, and tears were streaming down his cheeks. He knew that Forrestal like himself had been destroyed by the experience of the office.

Former Marine Gen. Al Gray says that he refuses to visit Vietnam "until I'm sure all our people are out of their jails." America has been racked for years by rumors, accusations, and alleged scandals surrounding the fate of missing men. Yet, there remain victims of every war who cannot be accounted for, including a host of Vietnamese. Throughout the South lie many NVA headstones marked only *Liet Sy Vo Danh*—"An Unknown Martyr." There is no credible evidence that Hanoi retained American prisoners against their will.* Bob Destatte, who spent twenty-three years researching MIA and POW cases for the Defense Intelligence Agency, says, "We left no one behind." He is an intelligent man with enormous personal experience of Vietnam: there is no reason to doubt his conclusion.

Counterfactuals are seldom profitable either to historians or readers, but two seem to merit notice. First, the North Vietnamese never carried their fight to the West, and explicitly to the American continent through terrorism, as do modern Muslim insurgents; it probably never occurred to Hanoi to do so, in those days before globalization. Forbearance served the communists well, because it denied Americans any immediate and visible cause to consider Ho's people direct enemies, a threat to their own polity.

It is also interesting to speculate upon the consequences if the North Vietnamese had refrained from sponsoring armed struggle in the South. Plausibly, the indigenous National Liberation Front could have been contained. In many other Asian countries between 1960 and 1990, authoritarian military rule gave way to democracy. In the absence of war,

^{*} Cpl. Robert Garwood chose to remain in the North until 1979, when he returned to the US and was court-martialed.

Vietnamese energy and ingenuity could have enabled the Southern economy to prosper. The Hanoi regime would have struggled to weather the typhoon of economic and political change that swept the world in the last decades of the twentieth century, discrediting Marxism.

Success justifies all: nobody outside Pyongyang today questions the legitimacy of South Korea as a state, because it is a functioning democracy with a dynamic economy. Meanwhile, its old adversary, North Korea, is a showpiece for the failure of totalitarian communism. Yet for decades after the 1953 armistice, the South was ruled by a dictatorship almost as repressive as its Northern counterpart. The Seoul regime was fortunate enough to retain American military and economic support, together with just sufficient popular consent to survive this experience and move on to better things. South Vietnam was no more and no less a credible independent state than its Korean counterpart. Granted the same opportunities, it, too, might have preserved its status and prospered—but we shall never know.

Meanwhile only the "liberation struggle" and Hanoi's military triumph conferred the prestige and legitimacy that have enabled the old Northern regime to retain power to this day, clinging to its fig leaves, the trappings of revolution. Oxford professor Archie Brown is no friend of communism—"as an alternative way of organizing human society . . . a ghastly failure." Nonetheless, he notes that the mere fact of the successful reunification struggle has empowered Hanoi's old men ever since: "In spite of the harshness of the regime, . . . it has not been difficult to project the 'enemy' image of the US or to evoke terrible memories of the war and a measure of gratitude to Vietnam's peacetime rulers for rebuilding the country." The conflict continues to define Vietnam as surely as the Second World War does Russia, victories in the respective struggles being the Communist Party's only conspicuous successes since 1917.

In 1993 David Rogers returned to Vietnam as a reporter and was taken to the area near Tay Ninh where his own unit had fought. He found himself feted by former Vietcong cadres. "They were under orders to be really nice to Americans, because they needed Congress to pass a trade deal." He found himself musing: "If all you guys wanted was a McDonald's, surely we could have worked this out a long time ago." Many modern

American tourists are disarmed by the warmth of the welcome they receive in Vietnam, from people mostly unborn when the war was fought. This is partly because an overwhelming majority now recognize the virtues of liberal democracy and the limitations of the alternative. President Barack Obama received a rapturous reception when he visited Vietnam in 2015, contrasted with the bleak attitude displayed a year later toward China's President Xi Jinping.

Visitors impressed by the glitzy towers of Saigon and the natural beauty of the countryside often fail to notice the harsh rural poverty and the denial of freedom of speech. The rulers of twenty-first-century Vietnam concede to their people some latitude to make money but none to express political opinions or to frankly debate the past. Many American histories are flawed by treating the war as if it was the consequence solely of the actions of one party, the United States. This is partly because a vast body of evidence is available about its doings, while information on North Vietnam's wartime processes is spooned forth as meanly as gruel in a poorhouse. Much has been said above about MACV's wartime "credibility gap," yet in Hanoi, mendacity remains institutionalized.

A conspicuous lesson of the past century is that economic forces are at least as important as military ones in determining outcomes. North Vietnam's dead revolutionaries would recoil in disgust from the spectacle of modern Saigon—the name Ho Chi Minh City is falling from favor and will probably vanish in the way that Leningrad has become Saint Petersburg again. Its glittering shops, each one a temple of consumerism, burst with brand names, jewelry, and designer clothes. It may plausibly be argued that, while the United States lost the war militarily almost half a century ago, it has since seen its economic and cultural influence reverse this outcome. Whereas the US armed forces failed with B-52s, defoliants, and Spooky gunships, YouTube and Johnny Depp have proved irresistible.

If fighting the war became the principal rationale for the defunct Saigon regime's existence, the same proved true for that of Hanoi. Within a few years of the fall of Saigon, communist veterans developed a nostalgia

for the struggle's perceived virtues. The more apparent became the failure of other policies, the more reverently Northerners sanctified the unification struggle. David Elliott remarks that an older generation looks back on it as "a time of simplicity, belief, focus, equality of poverty. People helped each other. There was a sense of mission." Bao Ninh concludes his war novel by evoking the nostalgia of his fictional self, Kien, common among veterans of every conflict: "He returns time and time again to his love, friendship, comradeship, those human bonds which had helped us overcome the thousand sufferings of war." Kien envied his lost self, with its inspiration and optimism: "They were caring days, when we knew what we were living and fighting for, and why we needed to suffer and sacrifice. Those were the days when all of us were very young, very pure, and very sincere."

Yet today the author himself rejects such sentimentality: "The vision of humanity and solidarity is much overstated, indeed has become a myth. The bond between soldier and soldier was real enough, but there was also plenty of social injustice in the North. The poor people went to fight while others with political privileges were able to send their sons abroad to study, and some of them to enjoy luxurious lives. Those times were incredibly brutal: the war went on far too long, and people became terribly weary. So much was destroyed—not just buildings but institutions, the social compact." Bao Ninh notes that the British people were fortunate enough to enjoy the freedom in 1945 to evict from office at a general election their great war leader Winston Churchill, "whereas in Vietnam the generals have clung to power."

Truong Huy San was a thirteen-year-old boy wrestling playfully with a friend on a hillside in North Vietnam on the day in 1975 that his village loudspeakers announced triumphantly that Saigon had been "liberated." "According to what we had been taught at school," he wrote long afterward in his book *The Winning Side*, "this would be the end of two decades of misery for South Vietnam. I thought, 'We must quickly set about educating its misguided children.'" Yet in 2012 that same boy observed, "Many people who have carefully reviewed the past . . . are stunned when they

752 .

realize that it feels like the side that was really liberated was the North." South Vietnam, he argues, has proved to be the historic victor, because its values increasingly dominate the country.

"What was it all about?" muses Walt Boomer. "It bothers me that we didn't learn a lot. If we had, we would not have invaded Iraq."

ACKNOWLEDGMENTS

In the course of researching this book, I traveled widely both in the United States and Vietnam, interviewing scores of contemporary witnesses who were generous with their time and understanding. I garnered rich prizes from the archives of the US Army's Heritage and Education Center at Carlisle Barracks, Pennsylvania, and those of the US Marine Corps at Quantico, Virginia. I am grateful to Con Crane and his staff at Carlisle, to Jim Ginther's team at Quantico. I have also consulted the Vietnamese Oral History Archive at the University of California's Irvine campus. Erik Villard of the US Army's Historical Center gave me some significant introductions, foremost among them to Merle Pribbenow. Merle, who served with the CIA's Saigon station from 1970 until the final evacuation, has made a unique contribution to my research by providing hundreds of thousands of words of translated Vietnamese documents, histories, and memoirs, a treasure trove for which he has declined to accept any reward whatsoever. The work itself is his prize, he says. My debt to him extends to the pleasure of his company, and he has provided many corrections to the text.

Doug Ramsey not only talked to me for four hours at his home in Boulder City, Nevada, but also gave me a huge unpublished typescript memoir describing his fascinating and terrible experiences. Gu Renquan has translated Chinese material. My peerless Russian researcher and translator, Dr. Lyuba Vinogradovna, had the inspirational notion that in Ukraine there are accessible Soviet veterans who served in wartime air defense units in North Vietnam; subsequent interviews yielded some fascinating insights. My country neighbor, the late Col. John Cameron-Hayes, gave me a vivid account of his experiences among the first British troops to land in Saigon in 1945.

Professor Pham Quang Minh of Hanoi University provided introductions of the highest value. My interpreter in the capital, Le Hoang Giang, is a young man who obviously possesses the highest gifts, and I hope he will be granted the opportunities to fulfill them. In 1978, when most of the big players were still alive, the BBC's Michael Charlton and Anthony Moncrieff conducted interviews with a host of Americans about US decision making between 1945 and 1975. Some of their material was broadcast in a series of radio documentaries, and the full transcripts were subsequently published as a book, surprisingly little used by historians since. I value it highly, because Charlton posed many of the questions I would have asked myself, had I enjoyed the same opportunities. Among the war's vast literature, I have made extensive use of the works of David and Mai Elliott, especially the former's monumental study of life in the Mekong Delta throughout the struggle, and the latter's memoir. The magnificent books of Fred Logevall, The Embers of War and Choosing War, have powerfully influenced my own narrative, as have Greg Daddis's fine campaign studies. Professor Mark Clodfelter, an authoritative historian of the air war, has generously read and commented upon my chapters on the bombing. The great Tim O'Brien, my fellow alumnus of Macalester College in Saint Paul, Minnesota, checked the section headed "Fieldcraft." My old friend Dr. Williamson Murray made invaluable corrections to the entire draft, as did Con Crane and David Elliott. Margaret MacMillan provided some authoritative comments about Nixon in China. Professor Peter Edwards read the pages on Australia's role. I have profited from meetings with all the above authors. An old and dear friend, Professor Sir Michael Howard OM, CH, MC, read my initial draft and made comments that improved—and considerably shortened—the final text. I am indebted to Professor Edwin Moise for flagging some errors in the draft text and maps.

My agents in London and New York, Michael Sissons and Peter Matson, have filled same indispensable roles in my life for the past thirty-five years. Publishers Arabella Pike and Robert Lacey in London and Jonathan Jao in New York are everything the best of their trade aspire to be yet seldom are—sympathetic, supportive, and wise. My secretary, Rachel

Lawrence, has been picking up broken china in my wake since 1986, and for this book she also organized my complex travel arrangements. A friend told me recently that my wife, Penny, is being considered for canonization, but this would not suffice adequately to recognize her extraordinary contribution to my life and work—and to the happiness of everyone else who knows her.

NOTES

Because this is a work for the general reader, I have here confined myself to attributing sources for quotations used in the text, which derive from published articles and books or from my own original researches. I have not sourced historical facts or quotations that are common ground in many existing works. Where only one book by a given writer is cited in the bibliography, I give below only the author's name after first reference, but add titles where multiple works by the same author are cited.

USAHEC denotes the archive of the US Army's Heritage and Education Center at Carlisle, Pennsylvania. USMCA denotes the historical archive of the US Marine Corps at Quantico, Virginia. FRUS refers to the State Department archive series, Foreign Relations of the United States. UKNA denotes the United Kingdom National Archive. AI indicates an author interview carried out by myself or by my Russian or Chinese researchers. MP references interviews in Hanoi conducted by Merle Pribbenow in 2007. The *Abrams Tapes* constitute an extraordinary source, unprecedented in the annals of warfare, recording the command meetings of Creighton Abrams during his 1968–72 tenure at the summit of MACV. Lewis Sorley has edited transcripts from the originals held at Carlisle. Some references below to Vietnamese online material are necessarily imprecise.

CHAPTER 1: BEAUTY AND MANY BEASTS

- 1 Among Hai's earliest memories: Doan Phuong Hai, *The Sea on the Horizon* (San Jose CA: Dong Van Publishing, 2000), 35.
- 1 "some that made our hearts thrill": Ibid., 40.

- 2 "Let us, gentlemen": Stanley Karnow, Vietnam: A History (Century, 1983), 85.
- 3 Almost every visitor who escaped: Richard West, War and Peace in Vietnam (Sinclair-Stevenson, 1965), 3.
- 3 "sound to me like charming ducks": Gavin Young, A Wavering Grace (Viking, 1997), 18.
- 4 "the old slave-owning aristocracies": Norman Lewis, *A Dragon Apparent* (Jonathan Cape, 1951), 99.
- 4 "Your ancestors were Vietnamese": MP interview Luu Doan Huynh.
- 4 "unbroken history and ancient civilization": Wyndham MS, 14.
- 4 He never knew his parents to entertain: AI Duong, Nov. 10, 2016.
- 4 "a French town in a hot country": Lewis, 19.
- 5 "Who is this man with the teeth of a dog?": Ibid., 24.
- 5 "They are too civilized to spit": Ibid., 27.
- 5 "How can a grasshopper?": David W. P. Elliott, *The Vietnamese War: Revolution and Social Change in the Mekong Delta 1930–1975* vol. 1 (M. E. Sharpe, 2003), 34.
- 6 "It is impossible": David Andelman, A Shattered Peace (Wiley, 2008), 128.
- 6 "I always thought I would become": Karnow, 123.
- 7 "He exuded an air of frailty": Truong Nhu Tang, A Vietcong Memoir (Vintage, 1986), 11.
- 8 "We thought to ourselves": MP interview Trang Trong Trung.
- 9 "You wouldn't do that if you remembered 1945": AI Tran, July 9, 2016.
- 9 "Skinny bodies in rags": Nguyen Cong Luan, *Nationalist in the Viet Nam Wars* (Indiana University Press, 2012), 25.
- 9 "When you opened the front door": MP interview Van Ky.
- 10 oai—"awe-inspiring": Duong Van Mai Elliott, *The Sacred Willow: Four Generations in the Life of a Vietnamese Family* (Oxford University Press, 1999), 105.
- 10 "because if the Japanese": MP interview Trung.
- 11 "The seven intelligence men": *People's Public Security* newspaper, Apr. 21, 2014.
- 11 "by frank and open recognition": Jean Lacouture and Philippe Devillers, End of a War (Pall Mall, 1969), 138.
- 12 "The French have fled": Documents of the DRV.
- 12 "Our teachers were so happy": James W. Trullinger, Village at War: An Account of Revolution in Vietnam (Longman, 1980), 43.
- 12 "I perhaps was somewhat naïve": Michael Charlton and Anthony Moncrieff, eds., *Many Reasons Why: The American Involvement in Vietnam* (London: Scolar Press, 1978), 12.

NOTES . 759

- 12 "the one name": Nguyen Cao Ky, Buddha's Child: My Fight to Save Vietnam (St. Martin's, 2002), 19.
- 12 "We were hungry for a hero": Luan, 35.
- 14 "They came to see me": AI John Cameron-Hayes, Apr. 14, 2016.
- 15 "I knew nothing about communism": AI Bang, Oct. 7, 2016.
- 16 "without the Empire": Raoul Girardet, *L'idée coloniale en France* (Table Ronde, 1972), 281.
- 17 there would have been no contradiction: Fredrik Logevall, *The Embers of War* (Random House, 2012), 106.
- 18 "Voila! The youth of our great family": Tang, 12.
- 20 "If we have to choose": AI Hoi, Sept. 14, 2016.

CHAPTER 2: THE "DIRTY WAR"

- 22 A Vietminh document: Pierre Rocolle, *Pourquoi Dien Bien Phu?* (Flammarion, 1968), 95.
- 22 at a mayoral reception: Elliott, Sacred Willow, 201.
- 23 A village on the north-south Highway 1: Luan, 116.
- 23 "I had seen many corpses": Ibid., 81.
- 24 "Somehow, as he spoke": Lewis, 18.
- 24 massacre of some three hundred: Christopher Goscha, *The Penguin History of Modern Vietnam* (Allen Lane, 2016), 244.
- 24 "floating down the river": Bernard Fall, "The Political-Religious Sects of Vietnam," *Pacific Affairs* 28, no. 3 (Sept. 1955): 246.
- 24 "that it was only by making people understand": Lewis, 177.
- 25 Legionnaires entered her home: Elliott, Sacred Willow, 148.
- 25 French soldiers stripped them: Ibid., 152.
- 25 how could it fail?: Howard R. Simpson, *Tiger in the Barbed Wire* (Kodansha International, 1992), 92.
- 26 "Instead they all administered": Goscha, 242.
- 27 Among their couriers: Xuan Ba, a series of articles and interviews with Le Duan's second wife, published in *Tien Phong* newspaper, June 25, 2006, and in succeeding weeks.
- 28 "Our submission to the French": Luan, 4, 67.
- 28 Lt. Gen. Sir Gerald Templer: John Cloake, *Templer: Tiger of Malaya* (Harrap, 1985), 263.
- 29 "We marveled that mankind": AI Pham Phu Bang, Oct. 7, 2016.
- 32 "I never knew a man": Graham Greene, *The Quiet American* (Heinemann, 1955), 72, 214.

- 33 "On the evening of February 14": Michael Lind, *Vietnam: The Necessary War* (Free Press, 1999), 1.
- 34 "Here we were in this deadly": Charlton and Moncrieff, 50.
- 34 "Why, therefore, do we tie?": quoted in Karnow, 178.
- 35 "There is now in the United States": UKNA FO371/103518 23.8.53.
- 36 "from the books I read": Luan, 114.
- 36 "Without a father you could still": AI Vu Anh Tram, Oct. 16, 2016.
- 37 "Everybody knew each other": Ibid.
- 38 At twenty she became: AI Binh, Oct. 5, 2016.
- 38 Debtors could become body slaves: Elliott, Delta, vol. 1, p. 123.
- 38 "Our enemies are slowly converting us": Lewis, 309.
- 38 "simple men whose world view": Martin Windrow, *The Last Valley* (Weidenfeld & Nicolson, 2004), 161.
- 38 "not a few innocent people": Elliott, Delta, vol. 1, p. 92.
- 39 When Nguyen Cong Luan's father died: Luan, 94.
- 39 At My Thanh: Elliott, Delta, vol. 1, p. 83.
- 39 "a lot of those people": AI Binh, Oct. 5, 2016.
- 40 "The people were very happy": Elliott, Delta, vol. 1, p. 144.
- 40 Anh, a daughter of landowning parents: Le Thi Anh in Al Santoli, *To Bear Any Burden: The Vietnamese War and Its Aftermath* (Sphere, 1986), 35.
- 40 "The spirit was marvelous!": MP interview Van Ky.
- 41 "There was something very interesting": Ibid.
- 41 "red with the yellow star": Trullinger, 43.
- 42 "The injustice of it all": Nguyen Duc Huy with Nguyen Thong Nhat, *A Soldier's Life* (Hanoi: People's Army Publishing House, 2011), 35.
- 42 "They made things hard for me": MP Oral History interview 2007.
- 42 "For them the Resistance": Ky, 19.

CHAPTER 3: THE FORTRESS THAT NEVER WAS

- 45 "to oblige the enemy": Rocolle, 57, Nov. 13, 1953.
- 45 Giap was always better informed: Ibid., 47.
- 50 "Each night when freezing fog": Ibid., 251.
- 51 "On va leur montrer!": Ibid., 329.
- 51 "Time passes slowly": Ibid., 327.
- 51 Langlais once found: Ibid., 70.
- 52 "We believed we could destroy": Ibid., 335.
- 53 "bombing and shelling scared people": Luan, 63.
- 56 the garrison might have fared better: Rocolle, 275.

- 59 "A stupor fell upon all": Ibid., 352.
- 59 Navarre observed: Ibid., 371, letter of Mar. 21, 1954.
- 60 Navarre instead proposed: Ibid., 411.
- 61 Before the end, doctors: Ibid., 307.
- 61 French officers had always feared: Ibid., 37.
- 61 "between the men of a national army": Ibid., 407.
- 62 "Whether it rains or hails": Vo Nguyen Giap, *Collected Writings* (Saigon Cultural Publishing House, 2009), 132.
- 62 "rice so rotten": Rocolle, 324.
- 62 "Cries. Tears": Bernard Fall, Hell Is a Very Small Place (Lippincott, 1966), 162.
- 63 "Certainement, the helicopter crews": Rocolle, 390.
- 63 "had given a deplorable example": Ibid., 404.
- 63 "sang the 'Marseillaise'": Ibid., 296, quoting Bigeard.
- 63 "He has the weaknesses": Ibid., 372.
- 64 "enemy parachutages": Giap, 130.

CHAPTER 4: BLOODY FOOTPRINTS

- 69 "Blunt notice is given": U.S. News & World Report, Apr. 9, 1954.
- 71 "May it not be that our nations?": Logevall, Embers, 475.
- 71 "go over very quickly": Ibid., 479.
- 74 "Those who can't stand": Rocolle, 480.
- 74 "if Ho Chi Minh": Spectator, Apr. 30, 1954.
- 75 "The loss of the fortress": UKNA FO371/112057.
- 75 "UK attitude is one": James Cable, *The Geneva Conference of 1954* (Macmillan, 1986), 65.
- 76 "take a good smacking": Logevall, Embers, 508.
- 76 "The whole damn country": Bernard Fall, *Street Without Joy* (Stackpole, 1967), 260.
- 77 "As well as military honor": Rocolle, 489.
- 77 "My refusal to send them": Ibid., 513.
- 79 "There are only ten of us left": J. Pouget, *Nous Etions à Dien Bien Phu* (Paris: Presses de la Cité, 1964), 329 30.
- 79 Meanwhile around the dressing station: Rocolle, 538, quoting Dr. Grauwin.
- 80 "Under the harsh, naked": Pouget, 328.
- 80 "This was an unbelievable victory": MP interview Van Ky.
- 80 "a triumph of the will": Ibid., MP interview Trung 2007.
- 81 "You are here for an indeterminate period": Windrow, 644.
- 81 "Dienbienphu became an imperious": Rocolle, 568.

- 82 "I wonder that we could have taken ourselves in": AI Ramsey, Sept. 22, 2016.
- 83 "The American position": New York Herald Tribune, Apr. 29, 1954.
- 87 "The key to the Korea issue": Logevall, Embers, 597.
- 92 "so sad that they seemed to be sobbing": Hai, 37.
- 92 "Indian Army officers": Simpson, 136.
- 92 "They came forward in two files": Ibid., 139.
- 93 This won him a cheer: Ibid., 142.
- 93 "whether it had all been worth it": Lewis, 316.
- 93 "The happiest day": Trullinger, 72.

CHAPTER 5: THE TWIN TYRANNIES

- 96 Nguyen Duong's modestly prosperous family: AI Duong, Nov. 10, 2016.
- 96 "Come outside": AI Kieu Chinh, Sept. 17, 2016.
- 97 "Why? Because I was very stupid": AI Dinh, July 9, 2016.
- 99 several French officers: Fall, Street Without Joy, 278.
- 99 "banish selfish and pacifist doctrine": Pierre Asselin, *Hanoi's Road to the Viet-nam War 1954–1965* (University of California Press, 2013), 24.
- 99 "demonization of the United States": Ibid., 26.
- 100 "The state had removed an incentive": Elliott, Sacred Willow, 354.
- 100 "We indiscriminately viewed": Giap, 107.
- 100 Assets and draft animals: Elliott, Sacred Willow, 231.
- 100 Doan Phuong Hai's grandmother: Hai, 38.
- 101 "Many things happened": MP interview Toan.
- 101 "enemies of [the] people": Tang, 299.
- 101 "reactionary Catholic priests": Nguyen Hung Linh and Hoang Mac, Anti-Reactionary Forces: Chronology of Events 1954–75 (Hanoi: Ministry of Interior, Political Security Department III, Public Security), 54.
- 101 Between 1956 and 1959: Ibid., 105.
- 102 Chinh secured this glimpse: AI Kieu Chinh, Sept. 16, 2016.
- 102 Ho profited greatly: Santoli, 40.
- 103 "with tears streaming down our cheeks": Tran Quynh, "Memories of Le Duan," http://vanhoavn.blogspot.com/2012/09/blog-post_7386.html.
- 103 "There is little point in speaking": Asselin, 46.
- 104 "See you in two years": Muoi Thap in Elliott, Delta, vol. 1, p. 169.
- "Tell Ho it will be twenty years": Xuan Ba, a series of articles and interviews with Le Duan's second wife, published in *Tien Phong* newspaper, June 25, 2006, and in succeeding weeks.
- 105 "We took our lives for granted": AI Nguyen Quoc Si, May 21, 2016.

- 105 "for many of us... the years": Nguyen Duc Cuong, born 1941, quoted in Maxwell Taylor, *Swords and Plowshares* (Norton, 1972), 93.
- 105 "a paradise": Le Ly Hayslip and Jay Wurts, When Heaven and Earth Changed Places (Doubleday, 1989), 146.
- 107 "What I respected": AI Frank Scotton, Sept. 11, 2016.
- 108 Lansdale liked to tell a story: Ibid.
- 108 "M. Diem has many of the qualities": UKNA FO371/123388.
- 109 "Every son, daughter": Life, May 16, 1955.
- 110 "Turn Catholic and have rice to eat": Frances FitzGerald, Fire in the Lake (Vintage, 1972), 139.
- 110 "repair war damage": Logevall, Embers, 647.
- 110 "To take an Annamite to bed": Greene, 5.
- 111 "Each Sunday we would gather": Tang, 1, 3, 4.
- "War is my enemy": AI Kieu Chinh, Sept. 14, 2016.
- 112 "I regarded this period": Elliott, Delta, vol. 1, p. 167.
- 113 "Vietnam's Man of Steel": New York Times, May 7, 1957; Boston Globe June 5, 1957.
- 113 "The Tough Miracle Man": Life, May 13, 1957.
- 113 "like a puppet": Marguerite Higgins, *Our Vietnam Nightmare* (Harper & Row, 1971), 168.
- 113 "great big children": Vietnam: A Television History (PBS, 1983), program 2.
- 114 "The people in Hanoi": AI Neil Sheehan, Mar. 5, 2016.
- 115 The nurse running the local dispensary: Trullinger, 76.
- 116 "It is not impossible": Logevall, Embers, xix.
- 116 in the three years: Joseph Buttinger, *Vietnam: A Dragon Embattled* (Praeger, 1967), 131.
- 116 "Do you know why?": Santoli, 59.
- 116 A peasant told American researcher: Trullinger, 79.
- 117 The new arrivals nonetheless sneaked out: Huy Duc, 145.
- 117 "They have abandoned us": Ibid., 146.
- 117 "taciturn and chilly": Tang, 127.
- Only in the twenty-first century: Xuan Ba, a series of articles and interviews with Nguyen Thuy Nga, published in *Tien Phong* newspaper, June 25, 2006, and in succeeding weeks.
- 119 "Uncle Ho!": Asselin, 56.
- 119 "only [in 1959] did we finally acknowledge": MP interview Tran Trong Trung.
- 120 The Czech ambassador: Asselin, 83.
- 120 "the standard of living": BNA Vietnam Annual Report, 1959, p. 13.
- 120 "ready for an uprising": Asselin, 83.

- 121 "I hated the soldiers": FitzGerald, 153.
- 121 "I got excited": Elliott, Delta, vol. 1, p. 227.
- 122 "The Tiger has awakened!": Ibid., 255.
- 122 "Better the head of a rat": Ibid., 306.
- 122 their magic rice cookers: Ibid., 250.
- 123 "cruel terrorism": Asselin, 70.
- 123 "Because of the jungle vastness": Elliott, Delta, vol. 1, p. 217.
- 124 Durbrow submitted a memo: House Committee on Armed Services hearings on Vietnam, Dec. 23, 1960, pp. 1353–55.
- 125 The avowed objectives: Tang, 71.

CHAPTER 6: SOME OF THE WAY WITH JFK

- 127 "a nation of homosexuals": Arthur Schlesinger, *Journals* 1956–2002 (Penguin, 2007), 150, Mar. 31, 1962.
- 128 "a great place to have a war": Joshua Kurlantzick, A Great Place to Have a War (Simon & Schuster, 2017), 15.
- 128 "they have so much land": Tran Quynh, "Memories of Le Duan."
- 129 the British were desperate: UKNA FO371/159715.
- 129 As a West Point cadet: AI Eiland, Nov. 14, 2016.
- 130 "He had given our word": David Halberstam, *The Best and the Brightest* (Random House, 1972), 135.
- 130 "The Vietnamese are an able and energetic people": Memo Lansdale to Taylor, Oct. 23, 1961, in FRUS 1961–63, vol. 1, doc. 185, pp. 418–19.
- 131 "force the peasants": Duong Van Mai Elliott, RAND in Southeast Asia: A History of the Vietnam War Era (RAND Corporation, 2010), 31.
- 131 "It isn't just!": Simpson, 193.
- 132 She was fascinated by the US: Elliott, Sacred Willow, 286.
- 132 "This was where it was happening": AI David Elliott, Sept. 23, 2016.
- 133 "I didn't want them to feel": AI Scotton, Sept. 11, 2016.
- 133 "That is the colonial language": Ibid.
- 134 "the imbecility of our policies": AI Ramsey, Sept. 22, 2016.
- 134 "I wanted to see something": AI Destatte, Sept. 12, 2016.
- 135 It never occurred to the Americans: Frank Scotton, *Uphill Battle* (Texas Tech University Press, 2014), 53.
- 135 "really wasn't a military problem": Charlton and Moncrieff, 76.
- 136 "I felt what we were doing": AI Gray, Nov. 14, 2016.
- 136 "I would have been relieved": Scotton, 48.
- 136 "C'est la guerre psychologique!": Ibid., 61.

- 137 "The one common failing": Greg Daddis, Westmoreland's War: Reassessing American Strategy in Vietnam (Oxford University Press, 2014), 14.
- 138 "No superior anticipated": Santoli, 118.
- 139 That confrontation was eventually defused: Luan, 154.
- 139 "It could be hard to get [them] out": Ibid., 99.
- 139 "a military answer": Arthur Schlesinger, Robert Kennedy and His Times (Houghton Mifflin, 1978), 469.
- 140 "isn't a war, it's a political struggle": Hilsman interview 1969, quoted in Daddis, Westmoreland's War, 23.
- 140 "The task in South Vietnam": William Colby, *Lost Victory* (Chicago: Contemporary Books, 1989), 34.
- 140 "Don't ask for trouble": Anatoly Dobrynin, In Confidence: Moscow's Ambassador to America's Six Cold War Presidents (Times Books, 1995), 51.
- 141 "difficult, if not impossible": Charlton and Moncrieff, 82.
- 141 "Well, Lyndon": Halberstam, 41.
- 142 "Some [US officers] looked like": Luan, 235, ref. McNamara visit of Sept. 1963.
- 142 "seemed like a monastery": Michael Howard, *Captain Professor* (New York: Continuum, 2006), 172–73; he visited in 1960.
- 143 "There were no pacifists at RAND": Elliott, RAND, 25.
- "I hope the Americans can hold on": UKNA FO371/170133, Home minute of Apr. 7, 1963.
- 143 "You must go to Vietnam": Robert Thompson, *Make for the Hills* (Pen and Sword, 1989), 121; Rahman spoke in 1961.
- 144 "disastrous to British interests": 3.1.62 UKNA FO371/166698.
- "Why is Australia getting involved?": Warner in *Sydney Morning Herald*, May 12, 1962.
- "the struggle may be prolonged": Deborah Shapley, *Promise and Power: The Life and Times of Robert McNamara* (Little, Brown, 1993), 132.
- 146 "every quantitative measurement": Ibid.
- 146 "He willed himself to believe": Neil Sheehan, A Bright Shining Lie: John Paul Vann and America in Vietnam (Random House, 1988), 291.
- 147 Hanson Baldwin, the respected: Saturday Evening Post, Mar. 9, 1963.
- 147 "He has the sincerity": New York Times, Apr. 22, 1966.
- 147 "idyllic, just a sleepy town": AI Sullivan, Mar. 12, 2016.
- 148 "Hell, I don't even know": Scotton, 19.
- 148 "I only told the Americans": AI Nguu, Sept. 20, 2016.
- 149 "People were incredibly uninformed": AI Mai Elliott, Sept. 23, 2016.
- "The emptier a barrel": Dinh Duc Thien, in Tran Quynh, "Memories of Le Duan."

- 150 "Why are you people?": Ibid.
- 150 "we are weaker than the enemy": Asselin, 94.
- 151 "There were fifty soldiers": Elliott, Delta, vol. 1, p. 601.
- 151 a credible estimate: William Andrews, *The Village War* (University of Missouri Press, 1973), 57–58.
- 152 Nam Kinh, a local commander: Elliott, Delta, vol. 1, p. 377.
- 152 "Talking to me about political matters": Ibid., 381.
- 152 "You can't really believe that?": Scotton, 85.
- 152 The Vietcong once entered a village: Malcolm Browne, *The New Face of War* (Bobbs-Merrill, 1965), 103.
- 153 between a quarter and half: Doug Ramsey, unpublished MS of Vietnam experience given to author, MS II C19.

CHAPTER 7: 1963: COFFINS FOR TWO PRESIDENTS

- 156 "Saigon was a very nice place": AI Sheehan, Mar. 5, 2016.
- 157 published letters home: USAHEC, William M. Hammond, Public Affairs: The Military and the Media (Army Center of American History, 1990), 77; Indianapolis News, Mar. 28, 1964.
- 157 The use of napalm: Hammond, 16.
- 157 "This is a war fought": New York Times, Oct. 21, 1962.
- 158 Homer Bigart wrote: New York Times, July 23, 1962.
- 158 Marine helicopters: Newsweek, Aug., 20, 1962.
- 159 Women said that, if you had to marry a soldier: Elliott, *Delta*, vol. 1, p. 399.
- 160 trawlers from the North delivered 112 tons: Merle Pribbenow, 1963: Laying the Military Foundation for the Communist Decision to Seek a "Decisive Victory" (National Archive and Texas Tech University Press, Oct. 2013)
- 160 Den shook his head: Elliott, Delta, vol. 1, p. 402.
- 161 "The communists seemed to know": Lt. Nguyen Van Go, in Robert K. Brigham, ARVN: Life and Death in the South Vietnamese Army (University Press of Kansas, 2006), 41.
- 161 Vietcong recruits were told: Elliott, Delta, vol. 1, p. 392.
- 162 "I've got a problem": Sheehan, Lie, 223.
- 162 "Ba! If you don't get your vehicles": Ha Mai Viet, Steel and Blood: Armor during the Vietnam War (Sugarland, TX: self-published, 2005), 246-50.
- 163 "Look, there's my daddy": Sheehan, Lie, 222.
- 164 "We knew this was the biggest": Ibid., 274.
- 164 "The United States had . . . made": FitzGerald, 163.

- 164 "but a collection of individuals": Ibid., 164.
- 165 "greatly hurt ARVN morale": Luan, 221.
- 165 "articles filled with malicious arguments": Ha Mai Viet, 246-50.
- 165 "It seems fair to say": Wyndham MS, 12.
- 166 "individualism and its attendant corruption": FitzGerald, 590.
- 166 "Seldom has an imperial power": Michael Burleigh, *Small Wars, Faraway Places* (Macmillan, 2013), 485.
- 167 "Most of the bonzes": AI Scotton, Sept. 18, 2016.
- 167 Reporter Marguerite Higgins: Higgins, 28-29.
- 167 "The [Buddhist] crisis was like a great fire": Luan, 237.
- 167 "The conflict between the South Vietnamese": *New York Times*, June 10, 14, 16, and 22, 1963.
- 168 "I could have prevented": Nieman Reports 26 (Mar. 1972), 8.
- 169 "The president has a habit": Schlesinger, Journals, 138, Oct. 11, 1961.
- 170 "From most of the reports": Pentagon Papers, vol. 2 (McGraw Hill, 1993), 46.
- 170 They killed six defenders: Elliott, Delta, vol. 1, p. 410.
- 170 "It was apparent that many": Scotton, 71.
- 172 "Charlie, I can't let Vietnam go": Seymour Hersh, *The Dark Side of Camelot* (Little, Brown, 1997), 418.
- 172 "American planners would spend": Fredrik Logevall, *Choosing War* (University of California Press, 1999), 47.
- 173 "If there is no settlement": New York Herald Tribune, Sept. 3, 1963.
- 173 Chester Cooper wrote from Saigon: Logevall, Choosing War, 49.
- 173 "There was an almost total absence": Colby, 133.
- 174 beneath Conein's posturings: AI Scotton, Sept. 11, 2016.
- 174 George Ball later argued: Charlton and Moncrieff, 91.
- 174 "My comrades and I believed": Luan, 188.
- 175 South Vietnam had become unstable: Hoang Van Thai, "A Few Strategic Issues in the Spring 1968 Tet Offensive," address to March 1986 Ho Chi Minh City conference, in Vietnam's *Military History* magazine, issue 2 (216), 1988.
- 178 "If you stuck with Diem": AI Sheehan, Mar. 5, 2016.
- 179 "Diem knew that if [American combat troops] came in": AI Uc, Sept. 11, 2016.
- 179 "After Diem's death": AI Nguyen Tri, Sept. 16, 2016.
- 179 "Killing Diem was a catastrophic mistake": AI Scotton, Sept. 11, 2016.
- 179 "Some of these generals": Scotton, 75.
- 179 "confident that we were doing the right thing": AI Elliott, Sept. 23, 2016.
- 179 "What Americans have not learnt": Wyndham MS, 8.

- 180 "I wanted to sit down and cry": Howard Jones, *Death of a Generation* (Oxford University Press, 2003), 436.
- 180 "On the world stage": Times of London, Nov. 23, 1963.
- 180 "He knows little": Schlesinger, Journals, Mar. 11, 1964.
- 180 the defense secretary's biographer: Shapley, 263.
- 181 "I heard [Kennedy] say many times": Galbraith on NBC TV Vietnam Hindsight, 1971, quoted in Larry Berman, Planning a Tragedy: The Americanization of the War in Vietnam (Norton, 1982), 23.
- 182 "Fine. Give us TV": Rufus Phillips quoted in Santoli, 3.
- 184 "The first major turning point": AI Johnson, Mar. 8, 2016.

CHAPTER 8: THE MAZE

- 185 West Point, "because it represented": AI Snider, Mar. 9, 2016.
- 186 "If I get captured": AI Scotton, Sept. 18, 2016.
- 186 "His last letter wandered": Erik Jurgen-Karl Dietrich, *The Kraut* (privately printed, 2015), 127.
- 186 "The fabric of this government": Ramsey MS II D9.
- 187 "small, determined, reverse-slanting eyes": Ibid., III A21.
- 187 "John's idea of relaxation": AI Ramsey, Sept. 21, 2016.
- 188 "shooting into school yards": Ramsey MS III E4.
- 188 "And sobered to witness": Ramsey MS II D26-27.
- 188 "At worst, being in Nam": Ibid., III A23.
- 189 His best claims to employment: Frank Snepp, *Irreparable Harm* (Random House, 1999), xiv.
- 189 "I fell in love with Vietnam": AI Snepp, Sept. 10, 2016.
- 189 "The sleepy colonial capital": Simpson, 187.
- 190 "Saigon has greatly changed": USAHEC, Sidney Berry Papers, Box 39, letter of Nov. 14, 1965.
- 190 "A good rest this weekend": Ibid., Nov. 15, 1965.
- 191 "Gee, after your experiences": AI Scotton, Sept. 18, 2016.
- 191 "and got huge satisfaction": AI Uc, Sept. 11, 2016.
- 191 "I felt stunned": Phan Nhat Nam, *The Mark of a Warrior 1963–1973: War Notes* (Saigon: Hien Dai Publishing, 1973), 41.
- 192 "What kind of life?": Ibid., 44.
- 192 "The Vietnamese wounded": USAHEC, Sidney Berry Papers, Box 38.
- 193 "My hands shook": Young, 193.
- 193 "In the extended family culture": Santoli, 125.
- 194 "Most senior Vietnamese officers": Ky, 334.

- 194 So bitter became: Huy Duc, 147.
- 195 "You always criticize the imperialists": Elliott, Delta, vol. 2, p. 677.
- 195 "Brute force and subterfuge": Ibid., 656.
- 195 The commander of one such: Ibid., 830.
- 197 "As a result of this battle": Ibid., 745; this episode took place in January 1965.
- 197 "[The government] will kill you": Ibid., 754.
- 197 "I knew from the start": Doris Kearns Goodwin, *Lyndon Johnson and the American Dream* (Harper & Row, 1976), 263.
- 198 "kept on the eleven cowhands": Schlesinger, Journals, 286, Apr. 4, 1968.
- 198 "Lyndon Johnson is not going down": Logevall, Choosing War, 77.
- 199 "Oh, I must have forgotten": Karnow, 336-37.
- 200 "It seems increasingly probable": UKNA FO371/175468.
- 200 the Southern cause was doomed: Taylor, Voices from the Second Republic of Vietnam, 12.
- 201 "We young cadets": Hai, 58, 61.
- 201 "with an abrasive voice": Bruce Palmer, *The 25-Year War: America's Military Role in Vietnam* (Touchstone, 1984), 20.
- 201 "You fly one of these damned Hueys": Ibid., 27.
- 202 "prompt, positive, dramatic": Wallace Greene, The Greene Papers: General Wallace M. Greene Jr. and the Escalation of the Vietnam War, ed. Nicholas Schlosser (Quantico, VA: US Marine Corps, 2015), 12.
- 202 "However, the bitter fact was": Ibid., 15.
- 203 "Why do you not go and fight?": AI Ramsey, Sept. 22, 2016.
- 204 "would have to go North": H. R. McMaster, Dereliction of Duty: Lyndon Johnson, Robert McNamara, the Joint Chiefs of Staff, and the Lies That Led to Vietnam (HarperCollins, 1997), 94.
- 204 "I don't mind its being called McNamara's war": Shapley, 199.
- 204 the US should either get out: Logevall, Choosing War, 112.
- 204 "under the direction of the Hanoi government": Ibid., 166—in June 1964.
- 205 "You always think we can turn this thing off": Halberstam, 368.
- 205 "70% to avoid a humiliating defeat": memo of Mar. 25, 1965, in George C. Herring, ed., *The Pentagon Papers* (McGraw-Hill, 1993), 115.
- 205 "Soon all the people in Washington": Henry G. Gole, General William DePuy: Preparing the Army for Modern War (University Press of Kentucky, 2004), 145.
- 205 Gen. Khanh had assigned him this task: Santoli, 87.
- 206 "We had carefully, painfully": Ibid., 86.
- 206 "a hell of a mess": Greene Papers, 27.
- 207 to his surprise, Vietnam was scarcely mentioned: Dobrynin, 120.
- 207 "the last time in which a loyal bureaucrat": Charlton and Moncrieff, 175.

770 · NOTES

- 207 "I sense a potentially difficult": Greene Papers, 59.
- 208 "I haven't made up my mind": Gole, DePuy, 145.
- 208 "Kennedy had demanded sacrifice": Theodore White, *The Making of the President 1964* (Atheneum, 1965), 254.
- 209 "I inherited this political chaos": Charlton and Moncrieff, 135.
- 209 It is alleged by some: Dr. Williamson Murray to the author, July 10, 2017.
- 209 "He has a good grasp": USMCA, Chaisson letters JA/A/5/6.
- 210 "Very much ringing in my ears": Charlton and Moncrieff, 134.
- 210 "I soon learned": Simpson, 186.
- 211 "callous disregard": Scotton, 181.
- 211 "My task was that of the Dutch boy": Charlton and Moncrieff, 102.
- 211 "We can't win, but we can perhaps keep from losing": Gole, DePuy, 146.
- 211 "the situation had bottomed out": FRUS 1964-68, vol. 1, pp. 412-22.
- 211 "the crème de la crème" Gole, DePuy, 55.
- 211 "There is a great collection of brass": Ibid., 146
- 212 "violation of a fundamental military principle": Greene Papers, 157.

CHAPTER 9: INTO THE GULF

- 213 "In my shop . . . you assumed": Sedgwick Tourison, Secret Army, Secret War (Naval Institute Press, 1995), 55.
- 213 "The message sent to me": Ibid., 100.
- "We did commit most of these people": Ibid., 125.
- 214 Craft operated in pairs: AI Nguyen Tri, Sept. 16, 2016.
- 215 "It was great to be taking the war to the North": Ibid.
- 215 "determining DRV [Democratic Republic of Vietnam] coastal patrol activity": Robert Hanyok, "Skunks, Bogies, Silent Hounds, and the Flying Fish: The Gulf of Tonkin Mystery 2–4 August 1964," Cryptologic Quarterly, Spring 2005, pp. 5–6.
- 216 "What? They're asking how we should respond?": Col. Hoang Nghia Khanh, *The Road to the General Headquarters Staff* (Hanoi: People's Army Publishing House, 2008), 111.
- 216 At Saigon's Tan Son Nhut: AI Williams, Jan 21, 2016.
- 217 "at a time when we are trying to limit the conflict": Khanh memoir, 111.
- 220 "By 0700 local conduct": USAHEC Vietnam War Document Collection, Box 2, Folder 7.
- 221 "The more USA spreads war": Asselin, 191.
- 221 "The proposition was": Charlton and Moncrieff, 163.
- "as near to spontaneous": UKNA FO371/175481.

NOTES · 77I

- 222 "I began to see that the lives": Nguyen Dinh Kien, A Soldier and the Skies over Hanoi (Hanoi: People's Army Publishing House, 2013), 36.
- 223 "Even if we don't attack them": Van Tien Dung in Huy Duc, 149.
- 223 "He's as timid as a rabbit": Thanh Tin, *Their True Colors: The Political Memoirs of Bui Tin* (Turpin Press, 1994), 192.
- "It is no bad thing to negotiate": Odd Arne Westad et al., eds., 77 Conversations between Chinese and Foreign Leaders on the Wars in Indochina 1964–77 (Wilson Center, Working Paper 22, online), 74–77.
- 224 "The deft response": White, Making of the President 1964, 274.
- 225 "convinced that communism": Young, 20.
- 225 "A yellow-robed monk": Nam, 49.
- 225 "One guy, with a sharp rat face": Ibid., 50.
- 226 Nam felt a stab of wretchedness: Ibid., 52.
- 226 "If you were twenty years old": Ramsey MS I 17.
- 226 "a gigantic gamble": Greene Papers, 197.
- 226 the administration should give Khanh: Ibid., on Oct. 5, 1964.
- 226 "for the purposes of either": Ibid., 222.
- 226 "Maybe he is, but that might allow for floating": Scotton, 129.
- 228 "like a poisonous snake": Shapley, 313.
- 230 "the elemental man": Halberstam, 432.
- 230 "Why is it that the North Vietnamese?": Dec. 21, 1964, Air Force chief of staff in *Greene Papers*, 278.
- 230 "the Vietnamese—at least in Saigon": Ibid., 289.
- 230 "If we add up everything Westy has said": Ibid., 286.
- 231 "a few soldiers in British uniforms": UKNA PREM13/104.
- 231 McNamara once said: Logevall, Choosing War, 373.
- 231 "When the Russians invade Sussex": Ibid., 133.
- 231 "We Young Turks": Ky, 112.
- 231 "In all my years serving": Luan, 260.
- When a soldier begged: Nam, 53.
- 232 "was enough to destroy": Ibid., 54.

CHAPTER 10: "WE ARE PUZZLED ABOUT HOW TO PROCEED"

- 234 "a high tide of mass insurrection": Nguyen Huu An, as told to Nguyen Tu Duong, *New Battlefield* (Hanoi: People's Army Publishing House, 2002), 28.
- 234 An had commanded: This account is taken from New Battlefield, chap. 1.
- 234 "because of the requirements of our struggle": Pham Gia Duuc, The 325th

- Division, 2 vols. (Hanoi: People's Army Publishing House, 1986), vol. 2, p. 44.
- 235 on the Trail, he felt envious: AI Ninh, Oct. 7, 2016.
- 238 "acting in the name of the American imperialists": Luan, 253.
- 238 "The situation was too complicated": Ibid., 259.
- 238 "You do not know how hard": Hayslip and Wurts, 366.
- 238 "It was very dangerous": Elliott, Delta, vol. 1, p. 591.
- 239 "It was the 5 percent": AI Elliott, Sept. 23, 2016.
- 239 "Saigon . . . sounded like heaven": Hayslip and Wurts, 115.
- 239 to stay with her brother: Elliott, Delta, vol. 2, p. 908.
- 239 "The remarkable phenomenon": Elliott, RAND, 58.
- 240 "Do they believe in God?": Ibid., 63.
- 240 "John, I think we're signed up": Ibid., 65.
- 240 "The unrestrained irresponsibility": Tang, 59.
- 241 "You ask me who is in power": Gole, DePuy, 143, letter of Jan. 18, 1965.
- 243 "All he needs is a cigar": Greene Papers, 349, Mar. 3, 1965.
- 243 "The time has come to call a spade a bloody shovel": *New York Times*, Feb. 9, 1965.
- 244 "deep personal instinct": Shapley, 314.
- 244 he saw no alternative: UKNA FO371/180542.
- 244 "Vietnam was not forced on the US": McMaster, 323.
- 244 "the decisions to attack": Ibid., 326.
- 244 "Of course the debate would have been divisive": Bundy private letter to Sir Michael Howard, Mar. 20, 1979. Howard Archive.
- 245 "The trouble was that this turned out badly": Charlton and Moncrieff, 121.
- 245 He was disgusted by: UKNA PREM11/692.
- 246 "It was curious how hard": Taylor, Swords and Plowshares, 338.
- 246 "to guarantee 100 percent protection": Greene Papers, 314.
- 246 "These weren't draftees": AI Koltes, Oct. 11, 2016.
- 246 "Okay, listen up": Philip Caputo, A Rumor of War (Holt, Rinehart & Winston, 1977), 58.
- 247 "If he was the King of Camelot": Ibid., 27, 82.
- 247 "Good air strikes": USMA, Sidney Berry Papers, Box 38, operation on Sept. 24, 1965.
- 247 "What we were trying to do": Charlton and Moncrieff, 130.
- 248 "We're incredibly lucky": Elliott, Sacred Willow, 312.
- 248 "the only player who seemed to understand": Scotton, 145.
- 249 "When I first joined": Nguyen Van Thanh, in Brigham, 43.
- 249 "I would appreciate it": Palmer, 25-Year War, 26.

- 250 "Report that at least one platoon": Ramsey MS III B1.
- 250 "Military discipline, never very good": Ramsey letter of June 6, 1965.
- 250 "We cursed to each other": Hai, 174.
- 251 Lt. Hai sniffed repeatedly: Ibid., 177.
- 252 "Our battalion had virtually disintegrated": Ibid., 186.
- 252 "almost the only surviving officer": Ibid., 197.
- 254 "We are puzzled": July 3, 1965, memo, Johnson Library, quoted in Ilya V. Gaiduk, *The Soviet Union and the Vietnam War* (Ivan R. Dee, 1996), 50.
- 254 "I see no course of action": Gareth Porter and Stuart Loory, *Vietnam: The Definitive Documents of Human Decisions*, vol. 1 (London: Heyden, 1979), 374.
- 255 "as a matter of law": Ibid., 375, Katzenbach memo, June 10, 1965.
- 255 "The job had all the excitement": Mark Clodfelter, *The Limits of Air Power* (Free Press, 1989), 77.
- 255 "that seemed to do nothing": Ibid., 84.

CHAPTER 11: THE ESCALATOR

- 257 "Ky made a spectacular entrance": Chester Cooper, *The Lost Crusade* (Dodd, Mead, 1970), 281.
- 257 "'executive agent'": Vietnam: The Definitive Documents, 386, memo to LBJ, July 20, 1965.
- warned Gen. Greene that "General Westmoreland": Greene Memorandum for the record, June 28, 1965, in *Greene Papers*.
- 257 "What should my role have been?": Harold Johnson Oral History Transcript, LBJ Library, pp. 6, 12–13, quoted in McMaster, 318.
- 258 "Politically SV is a lost cause": Ball, June 28, 1965.
- 258 "the US in 1965 is responding": Memorandum of July 23, 1965.
- 259 "thinks of docile calves": July 13, 1965, quoted in Berman, Tragedy, 5.
- 259 "What Vietnam needs": Charlton and Moncrieff, 220.
- 259 "relying on assumptions": Christopher Thorne, *Allies of a Kind* (Hamish Hamilton, 1978), 694.
- 261 "The least desirable alternative": Jack Valenti, A Very Human President (Norton, 1975), 317.
- 262 "The mixture of apprehension": Michael Howard, "'Many Reasons' for Vietnam," Encounter, May 1979, p. 21.
- 262 "'Why did I go along?'": David McDonald, *The Reminiscences of Admiral David Lamar McDonald* (Annapolis: Naval Institute Press, 1976), 390, 393.
- 263 "We never made any effort": Charlton and Moncrieff, 115.
- 263 "All American journalists": Ibid., 154.

- 264 "The Chiefs . . . failed": McMaster, 328.
- 264 "They could not bring themselves": Palmer, 25-Year War, 46.
- 265 "There was no 'other side'": Charlton and Moncrieff, 159.
- 265 "The moral issue as I saw it": Ibid., 166.
- 265 Doug Ramsey suggested: Ramsey MS II B9.
- 266 "Everything we did was secret": Charlton and Moncrieff, 174.
- 266 "There was a general sense of reassurance": Vietnam: The Definitive Documents, vol. 3, p. 391.
- 267 "The main perplexity": Ibid., 392.
- 267 "filled us with sick anticipation": Tang, 58.
- 268 "I was scared to death": Wallace Terry, *Bloods: Black Veterans of the Vietnam War* (Presidio, 2006), 229.
- 268 "Okay, everybody, form up": John M. Del Vecchio, *The 13th Valley* (Sphere, 1983), 3.
- 268 "It looked to me as if the United States had taken over": AI Spencer, Mar. 12, 2016.
- 268 "back before it was popular": Ibid., Mar. 10, 2016.
- 268 Capt. Henry Gole: Gole, Soldiering (Potomac Books, 2004), 141.
- 268 "Are there still wild Indians?": USMCA, Finch MS Collection 1527.
- 269 "some soldiers thought it cute": USAHEC, Company Commanders' Oral Histories, Box 12, Folder 6, Joseph Fitzgerald.
- 269 "The first Vietnamese words": Terry, 6.
- 269 "VC Number One!": Elliott, Delta, vol. 2, p. 1005.
- 269 "Hell no, Major": AI Judd Kinne, Oct. 2, 2016.
- 270 "Florid, bull-necked": Snepp, Irreparable Harm, 21.
- 271 "turned the forest white": Col. Gen. Dang Vu Hiep, *Highland Memories* (Hanoi: People's Army Publishing House, 2000), 86.
- 271 "It's sort of exciting": USAHEC, Oral History, Medical Personnel, Bystran.
- 271 "There was no pattern": Caputo, 107.
- 272 "We have no basis for assuming": Ball to LBJ, July 1, 1965, Vietnam: The Definitive Documents, vol. 3.
- 272 "If we made contact": AI Jimmie Spencer, Mar. 11, 2016.
- 272 "fired with its machine-gun on a boy": USMCA A/30/B/5/2.
- 273 "Keep the enemy constantly": Tran Quoc Tuan et al., History of the General Staff during the Resistance War against the Americans to Save the Nation 1954-75 (Hanoi: People's Army Publishing House, 2010), vol. 3, p. 22.
- 274 "self-confident and proud": Caputo, 32.
- 274 "I was willing to do anything": AI Boomer, Mar. 3, 2016.
- 274 "the willful and unilateral burning": Ramsey MS III C2.

- 274 "The present leaders, bureaucrats": Ibid., III C1.
- 274 "Vietnam Town Regains Prosperity": Elliott, *Delta*. vol. 2, p. 873; Higgins story, London *Star*, Aug. 10, 1965.
- 275 "I smiled stupidly": Caputo, 100.
- 275 "Some of them were not so decent": Ibid., 150.
- 275 At his subsequent court-martial: Gary D. Solis, *Marines and Military Law in Vietnam: Trial by Fire* (US Marine Corps, 1989), 33.
- 276 "who had an exceptional rapport": AI Elliott, Sept. 23, 2016.
- 277 "In those days, you didn't see many of them": AI Smith, Sept. 6, 2016.
- 277 Menzies fiercely rebutted: Peter Edwards, *Australia and the Vietnam War* (Australian War Memorial, 2014), 184.
- 277 "We were building, instead of an army": Ramsey MS II B37.
- 277 "as I was running up": AI Hoi, Sept. 14, 2016.
- 277 "Are you trying to get me shot?": AI Ly Van Quy, Sept. 15, 2016.
- 278 "Unless you have experienced it": AI Tran Hoi, Sept. 16, 2016.
- 278 "We ought to be dead": AI Uc, Sept. 11, 2016.
- 279 "I must say I admire": Elliott, Delta, vol. 2, p. 786.
- 279 The world never heard of the Ranger: Luan, 291; the incident took place in September 1965.
- 279 helicopters were sent to extract the child's family: Ibid., 290.
- 280 "Insensitivity to appearances": Ky, 296.
- 280 "suspected military formations": Ramsey MS 32.
- 281 "I had one guy shot": AI Hickman, Feb. 22, 2016.
- 281 The communists learned to exploit: Ramsey MS 32.
- 281 morale languished: Hiep, 87.
- 282 "They looked sad and tired": Elliott, Delta, vol. 1, p. 641—attack in 1964.
- 282 "Security Operations against the Puppet Police": Linh and Mac, 228.
- 282 "In that case, why do you find it necessary?": Park obituary, *Guardian*, Mar. 28, 2010.
- To the glee of Hanoi: Linh and Mac, 234; the killing took place on Jan. 7, 1966.
- 283 "Seeing the evidence": Malcolm Gladwell interview on *Revisionist History* podcast, "Saigon, 1965," June 2016.
- 283 "I hated the war": Elliott, Sacred Willow, 324.
- 283 "I was suddenly struck by the thought": Scotton, 156.
- 283 "fugitives from responsibility": Jeffrey J. Clarke, *Advice and Support: The Final Years* (US Army Center of Military History, Fort Lesley J. McNair, 1992), 198–99.
- 283 "The existential question": AI Eiland, Nov. 14, 2016.
- 284 "gave us the chance": An memoir, 30.

- 285 From his perspective: Ibid., 37.
- 285 "This does not mean that fighting the Americans was easy": Ibid., 40.
- 286 They were especially grateful that Ann-Margret: AI Mike Sutton, Nov. 12, 2016.
- 286 "some of the cutest": USAHEC, Sidney Berry Papers, Box 38.
- 286 especially liked "Oh I love the girl": USAHEC, Berry Letters, Box 40.
- 286 "US killed-in-action": McNamara memorandum of Nov. 30, 1965, in *Vietnam: The Definitive Documents*, vol. 2, pp. 400–401.
- 287 "withdrawal with honor": Shapley, 361.
- 287 "he did not regard a military solution as possible": Schlesinger, *Journals*, 243, Jan. 21, 1966.
- 287 "It turned out to be a marathon": AI Spencer, Mar. 16, 2016.
- 287 "I would be nowhere else": on Jan. 2, 1966; USAHEC, Berry Letters, Box 40.

CHAPTER 12: "TRYING TO GRAB SMOKE"

- 288 "That's the infantry's job": Andrew Finlayson, *Rice Paddy Recon* (Jefferson, NC: McFarland, 2014), 127.
- 288 "trying to come up with something different": USAHEC, Company Command Oral Histories, Box 7, File 3, Hood.
- 289 "the biggest surprise of my life": Terry, 238.
- 289 "Camranh Bay was paradise": Ibid., 258.
- 289 "I didn't believe Nha Trang": Ibid., 36.
- 289 "The children thought it was fun": West, War and Peace in Vietnam, 51.
- 289 Medic Charlie Shyab arrived: AI Shyab, Nov. 11, 2016.
- 290 "The doctors and nurses": AI Rogers, Mar. 6, 2016.
- 290 "It looked like a full house": AI Kinne, Oct. 2, 2016.
- 290 "If I had been an agent of death": Caputo, 184-85.
- 290 "He has been talking with people": USAHEC, Sidney Berry Papers, Box 38.
- 290 "Why are men fighting?": George Bonville, You Ain't Nothing but a Swamp Rat (Professional Press, 2016), 139.
- 291 "Just look out, son": Ibid., 98.
- 291 an NVA General Staff conference: on Sept. 7, 1965; Tuan, vol. 3, p. 24.
- 291 "The plan that was approved": Ibid., 65.
- 292 "Helicopters filled the air": Maj. Gen. Huynh Cong Than, as told to Nguyen Huu, On the Long An Battlefield: A Memoir (Hanoi: People's Army Publishing House, 1994), 113.
- 292 called for an increase of between 30 and 50 percent: Sharp and Westmore-

- land, Report on the War in Vietnam (US Government Printing House, 1969), 113-14.
- 293 "Our weakness is rooted in our inability": USAHEC, Vietnam War Documents, Box 2, Folder 15.
- 293 "like trying to grab smoke": West, War and Peace in Vietnam, 31.
- 294 the head of a third man: Ramsey MS I B7-B11.
- 295 "The more I see of this war": USMCA, Chaisson letters JA/A/5/6.
- 296 "To me, the mark of a real leader": Gole, DePuy, 173.
- 296 "It's very popular to say": Ibid., 195.
- 296 "Up at 3.30am": Bonville, 153.
- 296 "She was maybe twenty": Ibid., 167.
- 297 "I thought, What barbarians!": AI Sutton, December 11, 2016.
- 297 "It was a cool hat": AI Eiland, Nov. 14, 2016.
- 299 "We looked after each other": Terry, 23.
- 299 He spent his later childhood: AI Nelson, Nov. 12, 2016.
- 300 "Goddam. This is fucking beautiful": Terry, 8.
- 300 "By a peculiar syllogism": Scotton, 73.
- 300 "Old papa-sans were getting killed": Bonville, 384.
- 300 "Man, he loved his gun": AI Nelson, Nov. 12, 2016.
- 301 "You stupid Americans!": Bonville, 175.
- 301 "The only thing they told us": Terry, 4.
- 302 Only two other patrol members: Solis, 53-54.
- 302 "You think it's just gonna fall over and die": Terry, 15.
- 302 "There's just a bitch and two kids": AI Nelson, Nov. 12, 2016.
- 302 "Sometimes it was serious": Ibid.
- 302 Mike Sutton was advancing: AI Sutton, Nov. 12, 2016.
- 303 The prongs were irremovably trapped: Terry, 20.
- 303 "innocent people died": AI Nelson, Nov. 12, 2016.
- 303 "The enemy does not confront you": Lu Mong Lan, in Santoli, 155.
- 304 "Not many of the kids I knew": AI Hunt, Nov. 13, 2016.
- 304 Vietnam started going equally badly: AI Nelson, Nov. 12, 2016.
- 305 "personally to direct": Than, 120.
- 305 "The people did not automatically": Ibid., 116.
- 306 "There is a fundamental fear": USAHEC, Company Commanders' Oral Histories, Box 6, Folder 1, Dan Campbell.
- 306 "Fellman was something": AI Harrison, Mar. 11, 2016.
- 306 "We enjoyed what we did": Hickey in PBS's Vietnam: A Television History program 4.
- 306 superb shot who killed: Washington Post Magazine, Jan. 18, 1987.

- 307 "I was taken to the company commander": Santoli, 128.
- 307 "I really didn't have a political commitment": USAHEC, Medical Personnel Oral Histories, Shirley Purcell.
- 309 "far eclipsed any military gain": Hoang Ngoc Lung, *Strategy and Tactics* (Ann Arbor: University of Michigan Library, 1980), 124.
- 309 constantly handled defoliants: Luan, 205.
- 310 "Most of the problems": Edwards, 402.
- 310 "We knew we were going out as bait": USAHEC, Company Commanders' Oral Histories, Theodore Fichtl.

CHAPTER 13: GRAFT AND PEPPERMINT OIL

- 312 "The newly affluent class": Elliott, Sacred Willow, 314.
- 312 "For us 'Western culture'": Hayslip and Wurts, xiii.
- 313 "These changes did not improve": Dong Van Khuyen.
- deplored the typical case of a man: Vien in Lewis Sorley, ed., *The Vietnam War: An Assessment by South Vietnam's Generals* (Texas Tech University Press, 2010), 311.
- 313 in descending order: homesickness: Sorley, Vietnam War, 32.
- 313 Black market currency: Much of the account that follows derives from Jonathan Marshall, "Dirty Wars: French and American Piaster Profiteering in Indochina 1945–75," *Asia-Pacific Journal* 12, issue 32, no. 2 (Aug. 11, 2014), and from the author's contemporary knowledge.
- 313 the police officer responsible: Ky, 162.
- 313 "[surpassed] the capacity": George S. Prugh, "Judges in Command: The Judicialized Uniform Code of Military Justice in Combat," in *Harvard Journal of Law and Public Policy* 4 (1980): 1–93.
- 313 The ring was eventually broken: Solis, 161.
- 314 "I had expected Vietnamese corruption": Meinheit MS given to author.
- 315 "everything I touched": Ky, 167.
- 315 "I admire Hitler": Uwe Duc Siemon-Netto, *A Reporter's Love for the Wounded People of Vietnam* (CreateSpace Independent Publishing Platform, 2013), 121.
- 316 "If Americans, who came": Ky, 249.
- 318 "the army was being systematically subverted": USAHEC, Westmoreland History, Book 6, Tabs G-4, B-2, and B-1.
- 318 "Before I let you kill me": Ky, 212.
- 319 "a tangle of competing individuals": New York Times, Apr. 3, 1966.
- 320 "Americans are active": Nguyen Duy Hinh, in Sorley, Vietnam War, 741.
- 321 "Thieu knew how to play": AI Sheehan, Mar. 5, 2016.

- 321 "Gradually it dawned on me": Elliott, Sacred Willow, 317.
- 322 "excellent propaganda material": USAHEC, Wheeler Papers, Box 2.
- 322 "If tree-leaves suddenly withered": An memoir, 55.
- 322 "We killed an awful lot of people": AI Sutton, Nov. 12, 2016.
- 322 "Vietcong brutality was individualistic": AI Elliott, Sept. 23, 2016.
- 323 "Yes, Neil, it is a problem": August 1966, in Sheehan, Lie, 621.
- 323 "where they could be more effectively screened": Elliott, *RAND*, 83, quoting Southeast Asia Trip Report, 18.
- 324 "I have the answer right here": Ibid., 88.
- 324 "What can you do with a million?": Ibid., 103.
- 324 "Oh, I talked to Bob McNamara yesterday": Ibid., 133.
- 325 "friction, the contingent": Howard, Captain Professor, 173.
- 325 "appalled by the enormous tonnage": Thompson, To Hanoi and Back, 15.
- 326 "This is crap": Elliott, RAND, 180.
- 326 "We're going to out-guerrilla the guerrilla": Life, Nov. 11, 1966.

CHAPTER 14: ROLLING THUNDER

- 328 "My solution . . . would be": Curtis LeMay, with MacKinlay Kantor, *Mission with LeMay* (Doubleday, 1965), 565.
- 328 "it is hard to bomb something": Ramsey MS IV A5.
- 328 "If we were going to bend their will": USAHEC, Oral History Transcripts, Weyand.
- 330 "Really, the policy was making itself": Bundy Oral History interview, quoted in Clodfelter, *Limits*, 63.
- 330 "It seemed as if we were trying": John B. Nichols and Barrett Tillman, *On Yankee Station* (Bantam, 1988), 16.
- 330 "What's a military convoy?": quoted in Clodfelter, Limits, 121.
- 330 "for most of his presidency": Palmer, 25-Year War, 37.
- 331 "If you told him of a sure-fire way": Cooper, 420.
- 332 "The absence of a single air commander": Clodfelter, Limits, 128.
- 333 "if LBJ only kept up": Schlesinger, Journals, 251, July 28, 1966.
- 333 "It looked as if we had wiped out": Peter Mersky and Norman Polmar, *The Naval Air War in Vietnam* (Annapolis: Naval Institute Press, 1981), 121.
- 336 Rostow was the most dangerous: Dobrynin, 141.
- 337 "I was looking for a fight": Jack Broughton, *Thud Ridge* (Lippincott, 1969), 246.
- 338 "I heard them scream": Thompson, To Hanoi and Back, 86.
- 339 "It's not done": Ibid., 93.

- 340 "Me or the war": Nichols and Tillman, 35.
- 340 "They got knee-walking": Ibid., 48.
- 345 "They could fill a five-square-mile column": Ibid., 52.
- 347 "about three minutes": Ibid., 110.
- 347 "Foul deck": Ibid., 111.
- 347 "The first sign of trouble": Broughton, 93.
- 348 "I thought they might chop": Terry, 271.
- 348 "I never hated to lose anybody so much": Ibid., 280.
- 348 "If my father got to the whiskey": AI McDaniel, Nov. 14, 2016.
- 351 how few readers seemed troubled: AI Snepp, Sept. 10, 2016.
- 351 "casual toleration": Ramsey MS II B42.
- 352 "What did my wife think about it?": AI Nolan, Mar. 12, 2016.
- 352 "Anyone who is not completely terrified": Broughton, 65.
- 352 "You sweated so badly": Ibid., 67.
- 354 It was a magnificent display: Nichols and Tillman, 64.
- 355 "For the pilots who fought": Ibid., 119.
- 356 "The price of admission": Palmer, 25-Year War, 33.
- 357 "a selected series of vital targets": 9AF Manual 2–6 and 3–2, quoted in Mark Clodfelter, *Beneficial Bombing* (University of Nebraska Press, 2010), 243–44.
- 357 "In any two-week period": USA Today, July 27, 1986,

CHAPTER 15: TAKING THE PAIN

- 358 "even if we must sacrifice everything": Huy Duc, 152.
- 358 "To our people, [the bombing]": MP interview Ky.
- 359 A teenager said: AI Nguyen Van Hien, Oct. 5, 2016.
- 359 "We had an ideal": AI Nguyen Thanh Binh, Oct. 14, 2016.
- 359 "For years Vietnamese have been told": AI Pham Thanh Hung, Oct. 8, 2016.
- 359 "It was a terrible time": AI Do Thi Thu, Oct. 7, 2016.
- 359 "His story was a real human tragedy": AI Pham Thanh Hung, Oct. 8, 2016.
- 360 He duly went to the army: AI Pham Dai, Sept. 17, 2016.
- 360 One day her mother: AI Hung, Oct. 8, 2016.
- 361 "the name Nixon": E. P. Glazunov et al., eds., *Voina vo Vietname—Kak Eto Bylo* [The War in Vietnam—How It Was] (Moscow: Ekzamen Publisher, 2005).
- 361 Yet some days the hapless woman: Kien memoir, 15.
- 361 "Endless columns of lorries": Anatoly Zaitsev, *Na Gromykovskikh kovrakh* [On Gromyko's Carpets] (Moscow, 2001), 33.
- 362 "Some strangers took it away": Kuin Hiong memoir.

- 362 "We were good kids": AI Do Thi Thu, Oct. 7, 2016.
- 362 Pham Phuong felt no animosity: AI Pham Thi Khanh Phuong, Oct. 6, 2016.
- 363 "unsound" class background: Ibid.
- 363 "he has not yet worked hard enough": Kien memoir, 52.
- 363 Their first intimation of tragedy: Ibid., 31.
- 364 "I was very keen": AI Kislitsyn, Feb. 27, 2016
- 365 "extremely chic": AI Miroshnichenko, Feb. 12, 2016.
- 365 "It was a special time": AI Panov, Feb. 21, 2016.
- 366 "The peasants would kill them": Ibid.
- 366 "Vietnamese feeling against the Americans": AI Malevanyi, Feb. 22, 2016.
- 366 A radar controller peered: AI Zalipsky, Feb. 3, 2016.
- 367 "Two bright spots appeared": Kien memoir, 107.
- 367 "Even my old eyes can see the target": Merle L. Pribbenow, "Theology War: Technology and Ideology in the Vietnamese Defense of Hanoi 1967," Journal of Military History 67, no. 1 (Jan. 2003): 178.
- 368 "and maybe allow a few kisses": AI Zalipsky, Feb. 3, 2016.
- 368 "I was so scared of his height": Kuin Hiong memoir.
- 369 "delicious, with sweet white flesh": AI Zalipsky, Feb. 3, 2016.
- 369 "Anything can happen in the flying business": Pyotr Isaev, in Glazunov et al.
- 369 joked with the local girls: AI Zalipsky, Feb. 2, 2016.
- 370 Anatoly Zaitsev recalled a song: Zaitsev, 69.
- 370 "there would be nothing left": AI Miroshnichenko, Feb. 14, 2016.
- 370 "Our military specialists": *Kommesant Vlast* weekly, no. 19 (May 26, 1998): 79.
- 370 the Russians wrote angrily: Gaiduk, 71.
- 370 A member of the Russian mission: Col. Le Ngoc Bon et al., in *Glorious History of the Heroic People's Security Forces* (Hanoi, 2006), 34, trans. MP.
- "Had we been defeated": an exchange on Aug. 23, 1966, quoted in Gaiduk, 80.
- 371 China dispatched to Vietnam: Han Nianlong, ed., *Contemporary China's Diplomacy* (Beijing: China Social Science Publishing House, 1988), 34; and Wang Taiping, ed., *Diplomatic History of the People's Republic of China*, 2 vols. (Beijing: World Knowledge Publishing House, 1998), 35.
- More than 170,000 troops: Han Huanzhi, ed., Contemporary China: Military Work of the Chinese Army, 2 vols. (Beijing: China Social Science Publishing House, 1989), 514; and Historical Research Department of the Academy of Military Sciences of the People's Liberation Army of China, eds., Chinese People's Liberation Army Sixty-Year Event Record (Beijing: Military Science Publishing, 1988), 616.

- 371 Fifty-seven-year-old Col. Guilin Long: This account derives from Guilin Long, *Memoirs* (Beijing: 1996), 176–77.
- 374 North Korea initially committed: Maj. Gen. Pham Van Thach, *History of the Resistance War Against the Americans to Save the Nation 1954–75*, 8 vols. (Hanoi: Military History Institute of Vietnam, 2008), vol. 5 (2001), p. 271; and letter to *Tuoi Tre* newspaper, Aug. 17, 2007.
- 374 Salisbury encountered difficulties: The author was comparably bamboozled on a 1971 visit to China as a reporter for BBC TV.
- 375 "Even if a pilot correctly identified a target": Wayne Thompson, *To Hanoi and Back: The United States Air Force and North Vietnam 1966–1973* (US Air Force, 2000), 45.
- 376 A February 1967 poll: Lou Harris, Washington Post, Feb. 12, 1967.
- 376 In 1966 the air campaign: Pentagon Papers, Gravel edition, vol. 4, p. 136.
- 376 "Because it is in the interests": quoted in Ulysses S. Grant Sharp, *Strategy for Defeat* (Presidio Press, 1978), 99.
- 376 "The frustration comes": quoted in Mersky and Polmar, 180-81.
- 376 "I can't tell you how I feel": Halberstam, 138-39.
- 377 "a direct, frontal attack": Institute for Defense Analyses, JASON study, Aug. 29, 1966, in *Pentagon Papers*, Gravel edition, vol. 4, p. 505.
- 377 "The US campaign may have presented": Oleg Hoeffding, *Bombing North Vietnam: An Appraisal of Economic and Political Effects* (RAND Corporation publication RM5213, available online), 22.
- 377 "Hanoi has reaped substantial benefits": Ibid., v.
- 377 "There is some possibility": USAHEC, Wheeler Papers, Box 2.

CHAPTER 16: "WAIST DEEP IN THE BIG MUDDY"

- 380 "the aggressor and the Vietcong": New York Times, May 7, 1967.
- 381 "When I challenged that": AI Scotton, Sept. 18, 2016—he spoke in September 1967.
- 381 "inexhaustible masochism": Henry Kissinger, *The White House Years* (Little, Brown, 1979), 112.
- 381 "More capable of writing": Lewis Sorley, ed., *The Abrams Tapes 1968–72* (Texas Tech University Press, 2004), 36.
- 382 "I had read tons of books": Terry, 202.
- 382 "Unfortunately I could not give": Finlayson, Rice Paddy Recon, 66.
- 382 "hurt by evidences of civil dissention": McNamara private letter to Michael Sissons, Mar. 23, 1967.
- 383 "We admire his ideology": AI Ramsey, Sept. 22, 2016.

- 383 Statistics show: Much of the data that follows derives from Lawrence M. Baskir and William A. Strauss, *Chance and Circumstance: The Draft, the War and the Vietnam Generation* (Knopf, 1978).
- 383 "a cynical avoidance of service": Ibid., 7.
- 383 "My dad could never forget": AI Graham, Mar. 6, 2016.
- 384 "If we had been called up": Baskir and Strauss, 49.
- 384 "The draftees who fought and died": Ibid., 9.
- 384 "the only ones that . . . paid": Charlton and Moncrieff, 137.
- 384 Nevertheless, US Army historian Conrad Crane: To the author, Nov. 6, 2017.
- 386 "and you will regret it": AI Senator Larry Pressler, Jan. 21, 2017.
- 386 "There were no good choices": AI Rogers, Mar. 6, 2016.
- 386 "It was obvious we were making a lot of mistakes": AI Scotton, Sept. 11, 2016.
- 387 "royally chewed out": Palmer, 25-Year War, 60.
- 387 "you'd send out a sweep": USAHEC, Oral History Transcript.
- 388 "a little bit sensitive to that body-count crap": USAHEC, Oral Histories, Vincent Felletter.
- 388 Regional and Popular Forces scored: Ira A. Hunt, *The 9th Division in Vietnam* (University Press of Kentucky, 2010), 93, May 1968.
- 388 A wall graph eventually showed: Ibid., 97.
- 388 Abrams later fulminated: Abrams Tapes, 407, Apr. 18, 1970.
- 388 "a shameful 9th Division rampage": Scotton, 240.
- 389 "dread of protracted war": James J. Wirtz, *The Tet Offensive: Intelligence Failure in War* (Cornell University Press, 1991), 34.
- 389 "Wastefully, expensively": Pentagon Papers, New York Times edition, 558.
- 389 "that the Americans fight fiercely": David W. P. Elliott and Mai Elliott, *Documents of an Elite Viet Cong Delta Unit: The Demolition Platoon of the 514th Battalion* (RAND Corporation, 1969, available online), 1030.
- 389 "Current strategy and military actions": USAHEC, Wheeler Papers, Box 2.
- 389 "differing opinions were expressed": Tuan, vol. 3, p. 287.
- 389 "Aside from the American": Ibid., 282.
- 390 "concentration of maximum effort": Ibid., 284.
- 390 "Our government has repeatedly": USAHEC, Wheeler Papers, Box 2.
- 390 "You know, I'd trade": USAHEC, Weyand Oral History interview conversation took place in 1970.
- 391 Then the Vietnamese explained: Palmer, 25-Year War, 57.
- 391 "It . . . became perfectly clear": Ibid., 74.
- 391 "On the main street": West, War and Peace in Vietnam, 25.
- 392 "If ever there was a good time": AI Boomer, Mar. 3, 2016.
- 392 "you can get into the hinterland": McNamara to Sissons, Mar. 23, 1967.

- 393 "We were looking for a fight": AI Boomer, Mar. 2, 2016.
- 393 As for rations: Andrew Finlayson, *Killer Kane* (Jefferson, NC: McFarland, 2013), 114.
- 394 underpants bred crotch fungus: AI Williams, Sept. 16, 2016.
- 394 "Everything rotted": Caputo, 247.
- 394 "No single piece of earth": USAHEC, Vietnam War Documents, Box 2, Folder 15.
- 394 "The best way to get killed": Finlayson, Rice Paddy Recon, 115.
- 395 In Judd Kinne's platoon: AI Kinne, Oct. 2, 2016.
- 395 Reg Edwards became less afraid: Terry, 7.
- 395 "If you weren't humping": Tim O'Brien, *The Things They Carried* (Flamingo/ HarperCollins, 1990), 33.
- 395 "creates emotional pressures": Caputo, 315.
- 396 Concussed, he recalled nothing: AI Charlie Shyab, Nov. 11, 2016.
- 396 "You cryin' cause you gettin' ready to die": Terry, 41.
- 396 "Feeling sorry for us": USAHEC, Company Commanders' Oral Histories, Box 6, File 4.
- 396 "His nose is legendary": An memoir, 49.
- 396 Australian animal-lovers: Michael O'Brien, Conscripts and Regulars: With the Seventh Battalion in Vietnam (Allen & Unwin, 1995), 39.
- 397 "so they knew the difference": AI Thorne, Feb. 7, 2016.
- 397 "was keeping my men sharp enough": USAHEC, Company Commanders' Oral Histories, Box 18, Folder 10.
- 397 "Yea, though I walk through this valley": Del Vecchio, 503.
- 397 He never forgot: AI Sutton, Nov. 12, 2016.
- 397 "As tired and bored": USMCA, Hardwick MS A/30/J/5/1.
- 398 "We felt pretty evenly matched": AI Rogers, Mar. 6, 2016.
- 398 "Simply by speaking a few words": Caputo, 13.
- 398 The only blood pools: Finlayson, Killer Kane, 185.
- 399 "Poor fire discipline was endemic": USMCA, Hardwick MS A/30/J/5/1.
- 399 "In one case I saw an enemy soldier": USMCA, Tenney MS A/25/B/5/1.
- 399 in one that lasted just thirty seconds: Caputo, 243—patrol in Sept. 1965.
- 400 "I swear to God": Santoli, 190.
- 400 men "who just didn't want to do it": AI Shyab, Nov. 11, 2016.
- 400 "went into shock. He just wasn't there for us": Ibid.
- 401 "the emotional attraction": USAHEC, Company Commanders' Oral Histories, Box 18, Folder 2.
- 401 "Part of that was just an excuse": Keith William Nolan, *The Magnificent Bastards* (Novato, CA: Presidio, 2007), 53.

- 401 "They carried too many luxuries": AI Pham Phu Bang, Oct. 7, 2016.
- 401 "Soon all of us were laughing": Finlayson, Killer Kane, 134.
- 402 "Just a few years ago": McNamara letter to Sissons, Mar. 23, 1967.
- 402 Don Graham felt "really proud": AI Graham, Mar. 6, 2016.
- 402 "Please, God, let the bombs fall": Jacqueline E. Whitt, *Bringing God to Men:*American Military Chaplains and the Vietnam War (University of North Carolina Press, 2014), 171.
- 403 They brewed instant coffee: Del Vecchio, 199.
- 404 He soaked up history: Finlayson, Killer Kane, 197.
- 404 "when I couldn't find any Playboys": Terry, 30.
- 404 "For many soldiers Vietnam": Del Vecchio, 106.
- 404 "The average age": O'Brien, Things, 35.
- 405 "I always stayed awake": Nolan, Sappers in the Wire: The Life and Death of Firebase Ann (Texas A&M Press, 2007), 93.
- 405 "Too many men slept": USMCA, Tenney MS A/25/B/5/1.
- 405 Wayne Miller sometimes got so cold: AI Miller, Nov. 13, 2016.
- 407 In October 1962: The following account derives chiefly from C. J. Chivers, *The Gun* (Simon & Schuster, 2010), 272ff.
- 408 He admitted some doubts: Ibid., 290.
- 408 The gun's historian: Ibid., 316.
- 409 Some men wrote home: AI Spencer, Feb. 12, 2016.
- 410 Capt. Gerry Turley: AI Turley, Mar. 2, 2016.
- 410 Walt Boomer said: AI Boomer, Mar. 2, 2016.
- 410 Likewise, Judd Kinne: AI Kinne, Oct. 2, 2016.
- 410 Enthusiasm for the rival AK-47: Luan, 267.
- 411 "Sir, what exactly do you do?": AI Graham, Mar. 6, 2016.
- 411 "Stop griping": Philadelphia Inquirer, Sept. 17, 1967.
- 412 "Between the VC/NVA and myself": McNamara to Sissons, Mar. 23, 1967.
- 412 "I was confused then": AI Graham, Mar. 6, 2016.
- 412 Slowly and almost disbelievingly: AI Bang, Oct. 7, 2016.
- 412 they killed more than 250: Luan, 362.

CHAPTER 17: OUR GUYS, THEIR GUYS: THE VIETNAMESE WAR

- 413 "As we passed field after lush field": Ramsey MS I A40.
- 414 "We learned to run": AI Khiem, Sept. 13, 2016.
- 414 "I was successful": AI Nguu, Sept. 20, 2016.
- 414 A fellow driver said later: AI Johnny Underwood, Oct. 11, 2016.
- 415 "The scene that presented itself": Tang, 110.

- 415 a man who afterward became: Ibid., 101.
- 416 even after Tang was revealed: Ibid., 261.
- 416 "It's easy for you": Elliott, Delta, 617.
- 417 when American aid later shrank: Tran Quang Minh, writing in Taylor, Voices from the Second Republic of Vietnam, 75.
- 417 "Our line of march": Ramsey MS IV F10.
- 417 "The peasants want nothing more than peace": Wyndham MS, 17.
- 417 Creighton Abrams characterized: Abrams Tapes, 252, Aug. 23, 1969.
- 418 ten years of "earthly hell": West, War and Peace in Vietnam, 52.
- 418 "Having gone into battle": Nguyen Tien Dich [3rd] *Division Memories* (Hanoi: People's Army Publishing House, 1995), online at www.vnmilitary history.net/index.php?topic=31148.0.
- 419 "At each end of the fortified village": Finlayson, Killer Kane, 40.
- 419 "The best of the VC": Ramsey MS IV A65.
- 419 "There were truly beautiful people": Ibid., IV B14.
- 420 "Thoi ke me no?": Elliott, Delta, vol. 2, p. 868.
- 420 "Why do they fill the path?": Dang Thuy Tram, Last Night I Dreamed of Peace (Harmony, 2007), 139, Aug. 20, 1968.
- 420 "One comrade falls": Ibid., 12, Apr. 22, 1968, and 23, May 31, 1968.
- 420 "My heart has banished all private dreams": Ibid., 59, Oct. 11, 1968.
- 420 "Could anything make one more proud?": Ibid., 61, Oct. 29, 1968.
- 421 PLEDGE RESOLUTELY: Ibid., 101, Mar. 19, 1969.
- 421 "North Vietnam's leaders": A. J. Langguth, *Our Vietnam* (Simon & Schuster, 2000), 668.
- 421 "With regard to Vietnam": quoted in Lind, 178.
- 422 war songs, "frightening in their obvious": Ramsey MS VI C3.
- 423 "after just a few puffs": Bao Ninh, The Sorrow of War (Vintage, 1998), 9.
- 423 "Politics continuous": Ibid., 5.
- 423 the Ernest Hemingway of Vietnam: AI Bang, Oct. 7, 2016.
- 424 "Once as we marched": An memoir, 62.
- 424 "But, oh God": Ninh, 5.
- 424 One day in 1967: Nguyen Van Tanh, cited in Luan, 308.
- 425 "Every night, hundreds of trucks": An memoir, 95.
- 426 "Quite often rain": AI Pham Phu Bang, Oct. 7, 2016.
- 426 "Perhaps nothing is sadder": Tram, 111, Apr. 27, 1969.
- 426 "We trudge up the hill": Ibid., 112.
- 427 "The first sign of it": Tang, 128.
- 427 "like hunted animals": Ibid., 157.
- 427 "a rubbery substance": Ibid., 159.

- 428 "The concussive whump": Ibid., 167, 168, 177.
- 429 "the enemy apparently fought so much better": Hamilton Howse, *Vietnam:* An Epilogue (Association of the US Army, July 1975), 1–2.
- 429 "If you compared the average ARVN officer": AI Ramsey, Sept. 22, 2016.
- The Vietcong asserted mockingly: Tran Bach Dang, "Tet '68: A Strategic Exercise," Vietnam's *Military History* magazine, issue 2, 1988, p. 59.
- 429 "I was awed by their generosity": AI Hoi, Sept. 18, 2016.
- 429 "I knew how cunning": Ibid., Sept. 17, 2016.
- 430 "No, cannot do": Bonville, 336.
- 430 "Of course it was really": AI Sutton, Nov. 12, 2016.
- 431 "I never thought about getting married": AI Nguyen Quoc Si, May 21, 2016.
- 431 "How can we fight on empty stomachs?" Sorley, 53.
- 431 "I saw infantry school instructors": Ibid., 61—Dong Van Khuyen.
- 431 "More than a few American soldiers": Tang, 160.
- 432 appalled to see a huge tapeworm: AI Breen, Mar. 7, 2016.
- Thus, according to Buddhist teaching: Young, 30.
- 432 "When you listen to briefs": Ibid., 37.
- 432 "We are not defeated": Tram, July 24, 1969.

CHAPTER 18: TET

- 435 "Talks will begin when": Truong Cong Dong, quoted in Gaiduk, 142.
- 435 "If you wanted victory": MP interview Tran Trong Trung.
- 436 "glory will smile on the NLF": Elliott, Delta, vol. 2, p. 1083.
- 436 told a Delta peasant that 1968: Ibid., 1084.
- 436 Giap's associates carried to their graves: Huy Duc, 156.
- 437 He acquiesced in the plan: Ibid., 159.
- 437 "Tet General Offensive-General Insurrection": Merle Pribbenow, "General Vo Nguyen Giap and the Mysterious Evolution of the Plan for the 1968 Tet Offensive," *Journal of Vietnamese Studies* 3, no. 2 (Summer 2008): 1–33.
- 438 produced a brilliantly prescient assessment: see Wirtz passim.
- 439 "campaign to kill tyrants": Tong Ho Trinh, *The 1968 Tet Offensive in the Tri-Thien-Hue Theater* (Hanoi: Ministry of Defense, 1986; trans. Bob Destatte and Merle Pribbenow for US Army Center for Military History), 21.
- 439 "The word is out": Wirtz, 183.
- 440 "They appeared fresh": Ramsey MS IV F9.
- 440 "This is Khe Sanh": USMCA, Fulkerson MS A/30/7/5/1.
- 440 "raw as a wound": West, War and Peace in Vietnam, 56.
- Receiving no reply, they opened fire: Huy Duc, 57.

- 441 Two more Northern divisions: This account is partially based on Nguyen Huy Toan and Pham Quang Dinh, *The 304th Division* (Hanoi: People's Army Publishing House, 1990), vol. 2, chap. 2.
- 442 "to generate enough noise": Wirtz, 81.
- 442 "The probability of Khe Sanh": Lung, *Intelligence*, Indochina Monographs (Washington, D.C.: US Army Center of Military History), 354–55.
- 444 "A7 to A404: D-Day": Tran Bach Dang, *Life and Memories* (Ho Chi Minh City: Tre Publishing House, 2006), 158.
- 444 They were astonished and dismayed: Ibid.
- 445 "No one could understand": Than, 130.
- 447 "The situation is extremely critical": Ibid., 131.
- 447 "Resolution! Attack! Attack!": Dang, Life and Memories, 165.
- 448 Gen. Tran Do, who exercised political command: Gen. Tran Do, 1968 Tet Offensive Review Conference, reported in Vietnam's *Military History* magazine, issue 2 (56), 1988.
- 448 "Mount a general offensive": Gen. Tran Van Quang, "Hue: 25 Days and Nights," address to March 1988 Hanoi Anniversary Conference, reported in Vietnam's *Military History* magazine, issue 2 (26), 1988.
- 448 On the afternoon of January 30: This account is based on VC cadre Tong Ho Trinh, 30.
- 449 "I'm going to bed": USAHEC, Vietnam Document Collection, Box 2, Folder 13.
- 449 "Charlie came into town": Scotton, 226.
- 449 Ngo Thi Bong and her family: Young, 35–37.
- 450 Twenty-six-year-old Lt. Tran Ngoc Hue: This account is from Andrew Wiest, *Vietnam's Forgotten Army: Heroism and Betrayal in the ARVN* (New York University Press, 2008), 101ff.
- 451 "if we wanted the masses to rise up": Trinh, 67.
- 453 "We only had to advance": Charles A. Krohn, *The Lost Battalion of Tet* (Annapolis: Naval Institute Press, 2008), 3, 5.
- 453 "Some four hundred of us": Ibid., 66.
- 453 "We had spoken earlier": Ibid., 69.
- 454 "The NVA had better": Ibid., 51.
- 454 "You are hot": AI Harrison, Mar. 14, 2016.
- 454 "Are you the longnoses?": AI Destatte, Sept. 12, 2016.
- 455 "I realized I was dealing with a madman": Nichols and Tillman, 40.
- 457 "I thought I was living my last": AI Wendt, Nov. 14, 2016.
- 458 "The morning was spectacularly beautiful": USAHEC, Vietnam War Documents, Box 3, Folder 5, Speedy narrative.

- 458 "It was like somebody's introduced nuclear": Terry, 122.
- 459 "I suggest you get this place cleaned up": AI Wendt, Nov. 14, 2016.
- 460 "How could any effort?": Peter Braestrup, Big Story: How the American Press and Television Reported and Interpreted the Crisis of Tet 1968 (Anchor, 1978), 118.

CHAPTER 19: THE GIANT REELS

- 461 "There's a lot of noise": AI Tan, Sept. 21, 2016.
- 461 "For now, let's be happy": Elliott, Delta, vol. 2, p. 1098.
- 462 "Events during the first day": Than, 133.
- 463 "I am a student": AI De, July 9, 2016.
- 463 "I knew when I saw him lift up that drainpipe": O'Brien, Conscripts and Regulars, 124.
- 464 "The marathon started": USAHEC, Medical Personnel Oral Histories.
- 464 "The situation is very, very bad": Hammond, 345.
- 464 "after years of fighting": New York Times, Feb. 2, 1968.
- 465 "This is really a fantastic effort": USMCA, Chaisson Papers.
- 466 "I was very conscious of being green": AI Harrington, Mar. 4, 2016.
- 466 "Suddenly a lot of them were behind us": AI Harrison, Mar. 3, 2016.
- 467 "of that Viet Cong blowing away": Santoli, 185.
- 467 "In the click of a shutter": Ky, 265
- 468 "that group of buzzards": USMCA, Chaisson letter of Feb. 2, 1968.
- 468 something was "awfully wrong": "The South Vietnamese," Wall Street Journal, Feb. 6, 1968.
- 468 "Little Big Horn, Dakota": Washington Post, Feb. 6, 1968.
- Westmoreland told the Pentagon: USAHEC, Wheeler Papers, Westmoreland MAC1614 message to Wheeler, Feb. 4, 1968.
- 469 "In this time of great need": USAHEC, Abrams letter copy, Feb. 23, 1968, Westmoreland Papers.
- 469 "Some of them did remarkably well": USAHEC, Weyand Oral History interview.
- 469 "The suburbs are a meat-grinder": Than, 146.
- 469 "Although I feel we can hold": USAHEC, Westmoreland Papers, Box 3.
- 470 "intends to make Khe Sanh": Ibid., MAC 1901.
- 470 But then the general himself: William Westmoreland, A Soldier Reports (Doubleday, 1976), 338.
- one man in five: Rear Services Operations during the Route 9-Khe Sanh Campaign (Hanoi: Military History Institute of Vietnam, 1988), 281.

790 · NOTES

- 472 The regiment had suffered: Huy Duc, 62.
- 472 One bomb exploded by a command bunker: Ibid., 74.
- 472 "jolted like jelly": USMCA, Fulkerson MS A/30/7/5/1.
- 472 Jeff Anthony, among the defenders of Hill 861: AI Anthony, Nov. 13, 2016.
- 473 Its morale-boosting effect: Toan and Dinh, 115.
- 473 including an alleged body count: Ibid., 100.
- 473 "the tall, heavy, slow Americans": Ibid., 94.
- 473 "problems . . . in the thinking": Ibid., 96.
- 473 "lack of offensive spirit": Ibid., 122.
- 474 A cadre later expressed his bitterness: Gen. Tran Van Quang, address to Tet Aniversary Conference, reported in Vietnam's *Military History* magazine, issue 2 (30), 1988; and Hai address to 1986 conference, p. 24.
- 474 "Everyone was afraid to speak": An memoir, 88.
- 474 "These things were made by men": Abrams Tapes, 516, Jan. 2, 1971.
- 474 An American who clambered: Mark Bowden, *Hue 1968* (Grove Atlantic, 2017), 143.
- 474 "My darling, for the first time": Ibid., 353.
- 475 "Nobody knew what was happening": AI Harrington, Mar. 4, 2016.
- 478 "The man who lived there": Young, 39.
- 479 Also murdered was: Don Oberdorfer, *Tet! The Turning Point in the Vietnam War* (Johns Hopkins University Press, 2001), 229.
- 479 "One can understand the hate": Ian McNeill, *The Team: Australian Advisers in Vietnam* (Hippocrene, 1984), 152.
- 480 "They yielded far too readily": Hammond, 387.
- 480 "It is undeniable . . . that press reports": Ibid., 388.
- 480 "the battlefield had temporarily turned": Tuan, vol. 4, p. 18.
- 480 "There was no time in my whole military career": Than, 157.
- 480 "We learned that a general insurrection": MP interview Tran Trong Trung.
- 481 A divisional commander said: Julian Ewell in *Abrams Tapes*, 208, June 12, 1969.
- 481 "Tet clearly changed": audiotape transcribed from 1986 Hanoi Conference proceedings, 47.
- 481 "Many of our people lost heart": An memoir, 91.
- 481 "We had made great progress": USAHEC, Weyand Oral Histories.
- 481 "Look at Khe Sanh": Abrams Tapes, 33.
- 482 "After Tet, we felt we could crawl": AI Anthony, Nov. 13, 2016.
- 482 "smoke was billowing up": Lewis Sorley, ed., A Better War: The Unexamined Victories and Final Tragedy of America's Last Years in Vietnam (Harvest, 1999), 29.

- 483 "We must decide whether": NBC, Mar. 3, 1968.
- 483 "The ball game is over": Scotton, 226.
- 483 "At great cost, the North": AI Scotton, Sept. 18, 2016.
- 483 "I've seen those thousands": USAHEC, Weyand Oral History transcripts.
- 484 Just 3 percent believed that America would lose: Hammond, 372.
- 484 "Dear Son": USAHEC, Vietnam War Document Collection, Box 3, Folder 15.
- 486 "political cowardice": Schlesinger, Journals, 286, Apr. 3, 1968.
- 486 "an atrocious marriage": Ibid., 144, Nov. 11, 1971.
- 486 "To me it seems obvious": Berman, Tragedy, 153.
- 487 "It was a brilliant political victory": Charlton and Moncrieff, 121.
- 487 "no other evaluation is possible": Tran Bach Dang address to anniversary conference, reported in Vietnam's *Military History* magazine, issue 2 (58), 1988.

CHAPTER 20: CONTINUOUS REPLAYS

- 488 "'Rest in peace, my son'": Than, 136.
- 488 "bring the flames of war": Ibid., 137.
- 488 "We went into the second wave": Ibid., 139.
- 489 "We recognized that the situation": Ibid. 141-42.
- 489 "[People] argued that the sophisticated": Luan, 328.
- 490 "a magnificently organized": William Haponski, *An Idea, and Bullets* (Combatant Books, 2016), 330.
- 490 "It's kind of a sad thing": Abrams Tapes, 15, 17, July 6, 1968.
- 490 "You find yourself doing the same thing": AI Anthony, Nov. 13, 2016.
- 490 "Sometimes you'd hit an LZ": AI Stevens, Nov. 9, 2016.
- 491 The unit had its share: The account that follows derives from author interviews with participants Brig. Gen. Bill Weise, Maj. Gen. James Livingston, and Col. Jim Williams; Nolan, *Bastards*; a 2014 US Marine Corps documentary film narrative of the battle; USMC records of the 1st Amtrac Battalion, PR/F/4/2; and Vietnamese histories as detailed below.
- 491 "we were just going through the motions": Nolan, Bastards, 11.
- 491 "You can maybe find one": AI Williams, Sept. 16, 2016.
- 492 "There were so many things": AI Weise, Mar. 5, 2016.
- 492 "All you Marines": AI Williams, Sept. 16, 2016.
- 492 On the night of April 27: Nolan, Bastards, 12ff.
- 492 "We were worn out": 12.
- 493 This proved a bad decision: Ibid., 16.
- 493 "It was without doubt": Ibid., 21.

792 · NOTES

- 494 They completed digging bunkers: Battles of Vietnamese Artillery during the War of Liberation, vol. 2 (Hanoi: Military History Institute of Vietnam, 1990), 8ff.
- 494 "Shoot one of them": Nolan, Bastards, 42.
- 496 "Wounded Marines . . . everybody": Ibid., 59.
- 496 "we were so close": James E. Livingston, with Colin D. Heaton and Anne-Marie Lewis, *Noble Warrior* (Zenith Press, 2010), 47.
- 497 "No goddamn sailor": AI Williams, Sept. 16, 2016.
- 497 "they had a good opportunity": Nolan, Bastards, 87.
- 497 Bravo had been suffering: Ibid., 80.
- 498 "Everybody just freaked": Ibid., 82.
- 498 "Somebody went and left us": Ibid., 84.
- 498 at this stage only one: *History of the 320th Lowland Division* (Hanoi: Military History Institute of Vietnam, 1984), 75ff.
- 499 "We're in a world of hurt": Nolan, Bastards, 77.
- 499 "I knew that Bill Weise": Ibid., 133.
- 499 "The troops were on the verge": Ibid., 92.
- 500 "There was a lot of animosity": Ibid., 104.
- 503 The NVA triumphantly claimed: History of the 320th Lowland Division, 76.
- 503 "I had a very strong mother": AI Livingston, Mar. 3, 2016.
- 503 "We blamed the skipper": Nolan, Bastards, 146.
- 504 "Those kids . . . had had the shit beaten out of them": Ibid., 136.
- 506 "The day was still, the heat intense": Ibid., 169.
- 506 "I bled pretty good": AI Livingston, Mar. 3, 2016.
- 507 "They destroyed us": Nolan, Bastards, 195.
- 508 "We too had suffered losses": *Battles of the Vietnamese Artillery*, vol. 2, p. 16.
- 508 "They wouldn't give up": AI Livingston, Mar. 3, 2016.
- 509 "The entire US battalion": History of the 320th Lowland Division, 81.
- 509 "In a single afternoon": Ibid., 84.
- 509 "somebody ought to have been hung": Nolan, Bastards, 305.
- 510 "I said, 'This is stupid'": AI Weise, Mar. 5, 2016.
- 510 "I wonder if we could arrange": Abrams Tapes, 238, Aug. 2, 1969.
- 510 "After three very hard counter-attacks": USMCA, 1st Amtrac Battalion PR/F/4/2.
- 510 "I kind of believe the Marine Corps covered this up": AI Weise, Mar. 5, 2016.
- 511 unyielding posture of Le Duan and Le Duc Tho: Dobrynin, 170.
- 511 "to sink in the swamps of Vietnam": Ibid., 143.

- 512 they offered Humphrey's campaign secret financial support: Ibid., 175.
- 512 "You were liable to get into a fight": AI Koltes, Oct. 11, 2016.
- 512 "Today we are ninth day": USMCA, Minehan letters A/5/L/3/5.
- 513 "We won a campaign and nobody knows it": Abrams Tapes, 8, June 29, 1968.
- 513 "It seems to me we've jockeyed ourselves": Ibid., 29, Aug. 17, 1968.
- 514 "Both candidates would support it": Ibid., 40.
- 514 "If we haven't won the war": FRUS 1964-68, vol. 7, p. 189.
- 514 "The retail concept": Hunt, 9th Division, 106.
- 514 The men who fought at Daido: Abrams Tapes, 27, Sept. 27, 1969.
- 514 "My experiences, I believe": Haponski, 328.
- 514 "I don't give a shit": AI Hall, Nov. 12, 2016.
- 515 "what they would leave behind": Richard Nixon, *No More Vietnams* (Arbor House, 1985), 96.

CHAPTER 21: NIXON'S INHERITANCE

- 516 "How can this happen?": Scotton, 235.
- 516 "A cold breeze sighs": Tram, 91, Feb. 14, 1969.
- 517 "with the tens of millions": Henry Kissinger, *Ending the Vietnam War* (Simon & Schuster, 2003), 8.
- 517 He ordered that any US officer: Greg Daddis, *Withdrawal* (Oxford University Press, 2017), 41.
- 517 "allied forces had no information base": Ibid., 33.
- 518 "The 'hearts and minds' approach can be overdone": in April 1969.
- 518 "B-U-L-L-shit": Abrams Tapes, 213.
- 518 "His orders were, 'Kill everything that moves'": AI Dan Hickman, Feb. 5, 2016.
- 519 "It's a tough war, Chaplain": Whitt, 98.
- 521 "It's criminal to let these enemy units": Abrams Tapes, 77, Nov. 11, 1968.
- 521 Greg Daddis observes: Daddis, Withdrawal, 19.
- 522 "I got progressively more": AI Thorne, Mar. 3, 2016.
- 524 "Day and night we are deafened": Tram, 125, June 11, 1969.
- 524 "The sobbing whispers": Ninh, 4.
- 524 "where the enemy won": Abrams Tapes, 79.
- 524 "Let's be careful that we don't": Ibid., 154.
- 524 "We've got to defend": Ibid., 139, Mar. 5, 1969.
- 525 "adventurers, and to some extent, voyeurs": Braestrup, 515.
- 525 "At Tet, the press shouted": Ibid., 517.

794 · NOTES

- 526 When Capt. Linwood Burney took over: USAHEC, Company Commanders' Oral Histories, Box 5, Folder 7.
- 526 Abrams acknowledged that he didn't dare: Sorley, Better War, 294.
- 526 "We had some fine young men": USAHEC, Company Commanders' Oral Histories, Box 18.
- 527 "Sir Ford. Sir Ford": Terry, 48.
- 527 Capt. David Johnson took over: USAHEC, Company Commanders' Oral Histories, Box 18, Folder 9.
- 528 "Now, why would people do that?": Abrams Tapes, 379, Feb. 21, 1970.
- 528 Killen served less than two years: Solis, 129-31.
- 528 "This was a deliberate": Ibid., 193.
- 529 "never been so widespread": Ibid., 110.
- 529 Its narrative identified over a hundred: Ibid., 110–12.
- 529 Maj. Michael Barry: USAHEC, Medical Personnel Oral History files.
- 529 "a complete and utter mess": AI Thorne, Mar. 3, 2016.
- 529 the depth of black alienation: Solis, 171.
- 530 "Judge advocates . . . wrestled with": Frederic L. Borch III, Judge Advocates in Vietnam: Army Lawyers in Southeast Asia 1959–75 (Fort Leavenworth, KS: US Army Combat Studies Institute, 2003), 112.
- 530 "Tell a man to square his cover": USMCA, Oral History Tape 4749, 1970.
- 530 one "large-scale riot" a month: Solis, 130.
- 530 "The soldier was different": AI Hunt, Nov. 13, 2016.
- 530 "The racial issue came close to destroying": AI Boomer, Mar. 2, 2016.
- 531 "Even at some special forces camps": AI Freemantle, Feb. 6, 2017.
- 531 "I did that motherfucker": Solis, 136-38.
- 531 "I'm not gonna get a car": Terry, 39.
- 531 A Southern surgeon: USAHEC, Medical Personnel Oral Histories, Mary Ellen Smith.
- 531 "Once the platoon got outside the wire": AI Hall. Nov. 12, 2016.
- 532 "Much as I loved this guy": AI Anthony, Nov. 13, 2016.
- 532 "I wonder if some self-righteous white bigots": USMA, Sidney Berry Papers, Box 38, Oct. 3, 1965.
- One day in 1969, an infantry company: AI Dave Rogers, Mar. 6, 2016.
- 532 "This country befell upon us": Terry, 256.
- 533 "It wasn't a mess where we were": AI Smith, Sept. 6, 2016.
- 533 "really first-class people": Abrams Tapes, 245, Aug. 5, 1969.
- 533 "The rest of them will take Uncle Sam": Ibid., 339, Jan. 15, 1970.
- 533 "They were unbelievable": AI Harrison, Mar. 11, 2016.
- 533 "We always heard them": AI Andrew Freemantle, Feb. 6, 2017.

- 533 "The 1966 Long Tan battle": Luan, 427.
- 533 The same major said: Ibid., 363.
- 533 "I really worried about killing civilians": AI Franklin, Apr. 16, 2017.
- 534 "thrust by Communist China": This narrative owes much to Peter Edwards's authoritative Australia and the Vietnam War.
- 535 "I wouldn't have missed the experience": AI Smith, Sept. 6, 2016.
- 536 "On an Australian position at night": Ibid.
- 536 American Capt. Arthur Carey: USAHEC, Company Commanders' Oral Histories, Box 6, Folder 2.
- 536 "painstaking patrolling": O'Brien, Conscripts and Regulars, 166-67.
- 537 "I thought, If we get up": AI Freemantle, Feb. 6, 2017.
- 537 Australian higher commanders: Edwards, 327.
- 537 "It was always the same dreary": O'Brien, Conscripts and Regulars, 54.
- 538 A single battalion was involved: Ibid., 242.
- 538 "a tragic example of the waste": Edwards, 261.
- 538 "Funny place, Vietnam": AI Franklin, Feb. 16, 2016.
- 539 Through the rest of a long army career: AI Smith, Sept. 6, 2016.
- 539 "a load of crap": Australian War Memorial PR87/157.
- 540 "He was really evil": AI Smith, Sept. 6, 2016.
- 540 "'I'm a trained killer'": AI Freemantle, Feb. 6, 2017.
- 540 "If a bloke really didn't want to do it": AI Smith, Sept. 6, 2016.
- 541 "If they gave it to us wrong": AI Freemantle, Feb. 6, 2017.
- 541 "Patience was the byword": O'Brien, Conscripts and Regulars, 252.
- 541 peasants, wrote an officer resignedly: Ibid., 202.
- 541 "We'd sat down to listen": AI Freemantle, Jan. 6, 2017.
- 542 Earlier fatal fraggings: Edwards, 332.
- 542 When no further concussions: AI Smith, Sept. 6, 2016.
- 542 "that every second bloke": Ibid.
- 542 "He got what he deserved": O'Brien, Conscripts and Regulars, 116.
- 542 "We were completely astonished": AI Smith, Sept. 6, 2016.
- 543 "Vietnam was not an example": Edwards, 410.
- 543 "Most want a united Vietnam": Wyndham MS, 17.
- 544 "Sitting on the hard floor": Brian Walrath, unpublished MS of Vietnam MAT (mobile advisory team) experiences given to author.
- 544 "Those pilots seemed gods": AI Stephens, May 17, 2016.
- 545 Australian Cpl. Roy Savage: O'Brien, Conscripts and Regulars, 39.
- 545 Correspondent Neil Sheehan: AI Sheehan, Mar. 5, 2016.
- 545 "my dad put me through ranger school": AI Hickman, Feb. 6, 2016.
- 550 "I think we've got some time": Abrams Tapes, 140, Mar. 10, 1969.

- 550 "There's nothing really as responsive": Ibid., 142.
- 551 "I like Henry very much": Schlesinger, Journals, Dec. 14, 1969.
- 551 "brutal unpredictability": H. R. Haldeman, *The Haldeman Diaries* (Berkley Books, 1994), 557, Dec. 18, 1972.
- 551 "insuperable obstacles": Kissinger, White House Years, 436.
- 552 "being diddled to death": Richard Nixon, RN: The Memoirs of Richard Nixon (New York: Grosset & Dunlap, 1978), 399, conversation of Oct. 20, 1969.
- 552 "more constructive . . . and more sincere": Gaiduk, 220.
- 552 "as if we were switching a television channel": Jeremi Suri, *Henry Kissinger* and the American Century (Harvard University Press, 2007), 213.
- 553 Conservative columnist Joseph Alsop: Los Angeles Times, June 12, 1969.
- 553 "Where we are in South Vietnam": FRUS 1969-76, vol. 6, 400.
- 553 "Vietnamization was not a strategy": Ken Hughes, Fatal Politics: The Nixon Tapes, the Vietnam War, and the Casualties of Reelection (University of Virginia Press, 2015), 180.
- 555 Abrams said: Abrams Tapes, 364, Feb. 9, 1970.
- 555 In a war you're supposed to win: AI Thorne, Feb. 6, 2016.

CHAPTER 22: LOSING BY INSTALLMENTS

- 556 "Boy, if the doves have savaged": Abrams Tapes, 151, Mar. 5, 1969.
- 556 "We have to be tough": Langguth, 565.
- 556 "It has taken some doing": Abrams to Moorer, quoted in Sorley, *Better War*, 206.
- 557 "less like a head of state": West, War and Peace in Vietnam, 5.
- 557 Senior VC cadre Tran Bach Dang, Than, 124.
- 557 thaw the frozen corpse: Dang, Life and Memories, 197-202.
- 558 "Their coarse olive-green uniforms": Jon Swain, *River of Time* (Heinemann, 1995), 41.
- 559 "The weapons I saw out there": *Abrams Tapes*, 414, May 10, 1970, and 415, May 6, 1970.
- 559 "a blind leap away into cloud-cuckoo land": Ramsey MS IV 34.
- 559 "We were sacrificing the long-term vital interests": Ibid., V 38.
- 559 "I think it's clear to everybody": Abrams Tapes, 417, May 19, 1970.
- 560 "Our exertions were imbued": Tang, 180.
- 560 "the whole affair gave us a bad fright": Ibid., 183.
- 560 "an enduring gift to Vietnam's revolution": Ibid., 213.
- seven interrelated but separate conflicts: Abrams Tapes, 506, Nov. 7, 1970.
- 560 "The mad dog Nixon": Tram, 210, May 5, 1970, and 212, May 19, 1970.

NOTES · 797

- 561 "The disturbing thing, I thought": Abrams Tapes, 425, May 23, 1970.
- the consulate's personnel: Paddy Hayes, Queen of Spies (Duckworth, 2015), 232.
- 562 "as unmistakably English": Sir Michael Howard to the author, May 9, 2017.
- 562 "Lien Xo!"—"Russian!": Hayes, 222.
- 563 by counting used inoculation syringes: Ibid., 224.
- 563 "Many of us were from well-to-do families": Tang, 187.
- 563 "as far back as 1920": Ibid., 190.
- 563 "They had sacrificed conscience": Ibid., 225.
- 564 "In the North, I had nothing": AI Dinh, July 9, 2016.
- 564 "Some were genuine anticommunists": Ibid.
- 565 "He didn't want wine, women": AI Snepp, Sept. 10, 2016.
- 565 "living a Graham Greene novel": AI Finlayson, Jan. 20, 2017.
- 565 "would have preferred a less lethal approach": AI Scotton, Sept. 18, 2016.
- 565 "absolute savages": AI Freemantle, Feb. 6, 2017.
- 566 "My reasons were personal": Bob Kerrey, When I Was a Young Man (Harcourt, 2002), 150.
- 567 "Our actions were not considered out of the ordinary": Ibid., 185.
- 568 He wrote that he felt uncomfortable: Ibid., 255.
- 568 they showed that he was disingenuous: Gregory Vistica, New York Times, Apr. 25, 2001.
- 568 "I don't like this stuff": Ibid.
- 570 "They needed bodies": AI Kerrey, Nov. 15, 2016.
- 570 "Our story came out publicly": Ibid.
- 570 "I make no appeal for sympathy": Ibid.
- 570 "You are far from home": Finlayson, Rice Paddy Recon, 265.
- 571 "We were going": USAHEC, Weyand Oral History Transcript.
- 571 "The fighting wasn't over": Sorley, Better War, 217.
- 571 Lt. Mel Stephens: AI Stephens, June 14, 2016.
- 572 "just like the Germans": Abrams Tapes, 412, May 6, 1970.
- 572 "was arguably a more honest": Sorley, Better War, 186.
- 573 "I have been thinking a lot about resignation": Schlesinger, *Journals*, 325, May 22, 1970.
- 573 "The logistics war of southern Laos": MAC 14841, quoted in Sorley, *Better War*, 232.
- 574 "I recognize that the operation may present many problems": Ibid., 233.
- 575 "Prepare to mobilize": Ibid., 241.
- 575 "Our offensive capability had been depleted": Nghi Huynh et al., *The Route* 9–Southern Laos Counteroffensive Campaign 1971 (Hanoi: Military History Institute of Vietnam, 1987), 5.

- 576 So sure were the communists: Ibid., 37–38; An memoir, 105–6; and Toan and Dinh, 156–58.
- 577 "The enemy is all over": Sorley, Better War, 250.
- 577 "You've got a corps commander": Ibid., 251.
- 578 "Kissinger willingly assumed a field marshal role": Palmer, 25-Year War, 115.
- 578 "We're in a real tough fight": Abrams Tapes, 549, Feb. 27, 1971.
- 578 "more and more convinced": Ibid., 558, Mar. 9, 1971.
- 578 "The reeds and tall grass": An memoir, 110.
- 578 "The moon was bright that night": Tran Van Thom, in ibid., 131.
- 579 search the battlefield for discarded M-79 Thumpers: Ibid., 135.
- 580 "was plagued by dissension": Hinh, 600.
- 580 "We've got a public relations problem": Abrams Tapes, 578, Mar. 27, 1971.
- 580 "that big horse of a woman": Ibid., 592, Apr. 15, 1971.
- 580 "There's a cultural chasm": Ibid., 624, May 20, 1971.
- 580 "The air mobility concept": Ibid., 608, Apr. 26, 1971.
- 581 "the rest of the ARVN": AI Pribbenow, Nov. 9, 2016.
- 581 "If there were any criminals": AI Destatte, Sept. 12, 2016.
- 581 "ARVN forces had to leave behind": Hinh, 595.
- 581 "Lam Son 719 told us everything": AI Snepp, Sept. 10, 2016.
- 582 "President Nixon and those of us": Sorley interview with Haig, Nov. 29, 1988, quoted in *Better War*, 263.
- Thereafter, of course: Alexander Haig and Charles McCarry, *Inner Circles: How America Changed the World* (New York: Grand Central, 1994), 276.
- 582 "We can't have [South Vietnam] knocked": White House tapes, quoted in Hughes, 8.
- 583 "Of course I couldn't say to him": Ibid., 9.
- 583 "The war is gradually shifting": Message Vann to Potts, May 1971, quoted in Sorley, *Better War*, 273.
- 583 Abrams was briefed: Abrams Tapes, 519, Jan. 2, 1971.
- 584 After further elaborate parleys: Ibid., 383, Feb. 28, 1970.
- 584 Eventually, only the general: Ibid., 641, June 20, 1971.

CHAPTER 23: COLLATERAL DAMAGE

- "The war didn't make any sense": Nolan, Sappers, 16. Much of the account that follows of the American experience on Mary Ann derives from interviews conducted for his book Sappers in the Wire: The Life and Death of Firebase Mary Ann (Texas A&M Press, 2007).
- 586 "These people never did a damn thing to me": Ibid., 16-17.

NOTES · 799

- 586 "in which patrols refused": Walrath MS.
- 586 "This company really is a mess": Nolan, Sappers, 25.
- 586 "Spilberg used to get on us lieutenants": Ibid., 39.
- 588 "This apparently was a very shocking experience": Abrams Tapes, 774, Jan. 29, 1972.
- The attackers were drawn from the NVA's 409th Sapper Battalion: This account of the communist version of the night's events is taken from the History of MR5 Sapper Troops, 258ff; History of the Sapper Forces, vol. 1, p. 261; History of Chemical Troops 1958–2008, p. 286; and Vietnam Military Encyclopedia, 1113, all published in Hanoi.
- 589 "Are you okay, GI?" Nolan, Sappers, 145.
- 589 "I could hear 'em killing my people!": Ibid., 147.
- 590 "I felt so good": Ibid., 162.
- 592 "The Secretary [of the Army]": USAHEC, Abrams Papers, July 23, 1971, ARV2479 to McCaffery.
- 592 "I doubt that the troops": Walrath MS.
- 593 "You shouldn't fool with this stuff": Abrams Tapes, 628, May 22, 1971.
- 593 "Our air is going to be the glue": Abrams Tapes, 613, May 5, 1971.
- 594 From 1969 onward: The account that follows owes much to Mark Clodfelter's 2016 National War College study *Violating Reality: The Lavelle Af*fair, Nixon, and the Parsing of Truth.
- 595 "make maximum use of the authority we had": Ibid., 16.
- 595 "to increase his airfield reconnaisance": meeting of Nixon and NSC, Feb. 2, 1972.
- 596 "wild-eyed": Clodfelter Violating Reality, 40.
- 596 "[Lavelle] acted against the Rules": Senate Armed Forces Committee Hearings, Sept. 13, 1972, p. 79.
- 597 "So we get through '72": White House tapes, May 29, 1971, quoted in Hughes, 29.
- 599 "Americans could never get it into their minds": AI Sheehan, Mar. 5, 2016.
- 599 "Oh, don't worry": Polgar quoted in Kim Willenson, *The Bad War* (New York: Dutton, 1987), 102.
- 599 I'm just about over this: AI Franklin, Feb. 16, 2016.

CHAPTER 24: THE BIGGEST BATTLE

- 602 "working at something": Abrams Tapes, 724.
- 602 "We don't know when or where": Ibid., 734.
- 602 "There is no doubt this is to be a major campaign": Ibid., 753.

800 · NOTES

- 602 "For the first time since 1965": Ibid., 758.
- 602 "The show is on!": Ibid., 775.
- 602 "to go to the weakest thing": Ibid., 778, Feb. 10, 1972.
- 603 "reasonable interval": Hughes, 175.
- 603 the communists were "just implacable foes": USAHEC, Weyand Oral History interview.
- 604 "I'm probably the toughest guy": White House tapes, conversation 532–011, June 30, 1971, quoted in Hughes, 29.
- 605 "Getting our POWs back": Mark Clodfelter, Fifty Shades of Friction: Combat Climate, B-52 Crews, and the Vietnam War (National War College, 2016), 33.
- 605 monstrously corrupt and irredeemably incompetent: Luan, 395.
- 605 Gen. Ngo Dzu's contribution: Scotton, 288.
- 605 "So we are not forced to kill": Young, 53.
- 605 "It's what I do": AI Boomer, Mar. 2, 2016.
- 606 "the world came apart": AI Turley, Mar. 2, 2016.
- 607 "Lam would not report bad news": Vien in Sorley, Vietnam War, 306.
- 607 "in this case, no matter how you described it": USAHEC, Weyand Oral History transcript.
- 607 a fortunate precaution: Gerald H. Turley, The Easter Offensive: The Last American Advisors, Vietnam, 1972 (Annapolis: Naval Institute Press, 1985), 139.
- 607 "A Marine lieutenant colonel adviser": Abrams Tapes, 805, Apr. 2, 1972.
- 608 "The key issue is always": AI Turley, Feb. 4, 2016.
- 608 "This gave the enemy an opportunity": Turley, 202.
- 609 "Somehow blow up the Dong Ha bridge": Richard Botkin, *Ride the Thunder* (WND Books, 2009), 235.
- 610 "They seemed to be wondering": Turley, 177.
- 611 "If we continue to fight": Wiest, 259.
- 611 "pudgy and apathetic": Ibid., 241.
- 611 "some problems in my head": Ibid., 242.
- 611 "for reasons he could not explain": Turley, 165.
- 613 "Vann had gone off his rocker": AI Elliott, Sept. 23, 2016.
- 614 the structure was reduced to rubble: Hai, 73.
- 614 "The battalion prepared for terrible times": Ibid., 78.
- 615 "All right, I'll think about it": Ibid., 82.
- 615 "If we just sit here waiting": Ibid., 84.
- 615 "You guys read all those damn astrology books": Ibid., 85.
- 615 "The NVA FO above Charlie": John Duffy to the author, Nov. 1, 2016.

NOTES · 80I

- 617 "That was just like the movies!": Phuong Quang in *Cavalry*, June 2006, p. 101.
- 617 "What Giap's got on here": Abrams Tapes, 813, Apr. 7, 1972.
- 618 "Ba, do your best and don't run away!": Ly Tong Ba, Memoir of 25 Years of War: Thoughts of a General Who Commanded Troops on the Battlefield (San Marcos, TX: Self-published, 1999), 176.
- 618 "I was terrified": AI Hung, Oct. 8, 2016.
- 619 "It was all just propaganda": Ibid.
- 620 "No one in their right mind": AI Ninh, Oct. 7, 2016.
- 620 "the most professionally qualified officer": Abrams Tapes, 639, June 12, 1971.
- 621 "The staff did not agree": Phi Long quoted in Huy Duc, 431.
- 621 "God, how can one describe the tragedy?": Phuong Quang in Cavalry, 103.
- 622 "The ARVN haven't lost their tanks": Abrams Tapes, 841, May 12, 1972.
- 622 The last three hundred military patients: Khuyen, 57.
- 622 "There were hundreds of cars, trucks, bikes": Ibid., 70.
- 622 "Hue seemed a lawless city": Luan, 401.
- 623 "Wife Hoa to husband": Ibid., 402.
- 623 "My only surviving son has left home": Young, 53.
- 623 Luan suggested: Ibid., 407.
- 623 "It was a hell on earth": Ly Tong Ba memoir, 170.
- 624 "Our attacks began to slow": Tuan, vol. 4, p. 383.
- 624 "The victory belonged to no one more": Ly Tong Ba memoir, 177.
- 625 "You guys have arrived in the nick of time": This account chiefly derives from Nguyen Quoc Khue, "3rd Ranger Group and the Battle of An Loc/Binh Long," *Ranger Magazine*, no. 7, Mar. 2003, p. 77ff.
- 625 during which a Ranger officer: Ibid., 87.
- 625 "Agonizing screams": Ibid., 88.
- 626 "Our soldiers were terrified": Ibid., 96.
- 626 In early morning darkness one T-54: Armored Command (Bo Tu Lenh Thiet Giap), *Some Battles Fought by Our Armored Troops*, vol. 4 (Hanoi: General Staff Printing, 1983), 42.
- 626 "didn't use their tanks properly": USAHEC, Advisers' Oral Histories, Box 2, Folder 6.
- 627 "Right on the money!" Khue, 102.
- 627 and communist historians admit: Armored Command, *Some Battles Fought*, 52.
- 628 "I should tell you": AI Tran, July 9, 2016.
- 628 "The Airborne troops were just fantastic": USAHEC, Oral History, Box 2, Folder 6.

- 629 "If it hadn't been for the advisers": Abrams Tapes, 847, May 9, 1972.
- 629 "A lot of people tried to desert": AI De, July 9, 2016.
- 630 "We had not fought well": Tuan, vol. 4, p. 397.
- 631 "If Vietnam was mentioned": Viktor Sukhodrev, *Yazyk moi—drug moi* (My Tongue Is My Friend) (Moscow: AST, 2008), 112.
- 631 "Nixon listened with his teeth clenched": Ibid., 114.
- 633 Outside Quang Tri in June: Huy Duc, 429.
- 633 neglect of logistics: Combat Operations Department, *History of the Combat Operations Department 1945–2000* (Hanoi: People's Army Publishing House, 2005, online on http://quansuvn.net.
- 634 "The enemy was hammering": An memoir, 171.
- 634 "It's clear that the enemy has gained": Ibid., 173.
- 634 "'the Revolution only attacks'": Ibid., 179.
- 634 "The rainy season caused": Ibid., 180.
- 634 I am dying: AI Hung, Oct. 11, 2016.
- 635 "The losses had been worse": AI Ninh, Oct. 7, 2016.
- 636 "They were so proud": AI Ly, Sept. 15, 2016.
- 636 "just as they did during Tet": Tang, 211.
- 636 "the paradox was that": Ibid., 205.
- 636 seeing nearby shantytowns: Luan, 389.
- 636 "North Vietnamese soldiers up to our ears": Elliott, Delta, vol. 2, p. 1314.
- 637 "They're standing and fighting": Ibid., 1315.
- 637 "With all the screw-ups": Abrams Tapes, 826, Apr. 22, 1972.
- 637 "By God, the South Vietnamese can hack it!": Palmer, 25-Year War, 122.
- 637 "It was clear that without massive US air": AI Pribbenow, Nov. 9, 2016.
- 638 "I tried to do a job": USAHEC, Advisers' Oral Histories, Box 18, Folder 9.

CHAPTER 25: BIG UGLY FAT FELLERS

- 640 "If a year or two years from now": Hughes, 85. This narrative relies heavily on extracts from the White House tapes, collated by Ken Hughes in *Fatal Politics*.
- 640 "You see, Mr. President, this is all baloney": Ibid., 87.
- 641 "Thieu is right": Ibid., 91.
- 641 "I'd get the commitment": Ibid., 94.
- 641 "I don't think we should dignify it": Ibid., 97.
- 641 "You don't understand": Seymour Hersh, *The Price of Power* (Summit Books, 1985), 584.
- 642 "The deal we've got": Hughes, 104.
- 642 "Give 'em ten billion": Ibid., 105.

NOTES . 803

- 643 "Basically, you've got to brutalize him": Ibid.
- 643 cadres agreed that a settlement was imminent: AI Nguu, Sept. 20, 2016.
- 643 "It is the judgment of our military people": Hughes, 113.
- supplied by the Tay Ninh source: Thomas L. Ahern Jr., CIA and the Generals: Covert Support to the Military Government in South Vietnam, CIA FOIA Reading Room, https://www.cia.gov/library/readingroom/docs/1.
- 643 "I believe there is no possibility": Hughes, 116.
- 644 "[Hanoi] may think": Ibid., 120.
- 645 "I have come to the reluctant conclusion": Ibid., 123, Oct. 23, 1972.
- 645 He was told that delay: Ibid., 126.
- 649 "Without aid, you can't survive": Ibid., 149.
- 649 "I'm sure cheering was expected": Much of the narrative below is taken from Clodfelter, *Friction*.
- 649 "I almost thought it was a joke": *History of 307th Strategic Wing*, quoted in Clodfelter, *Limits*, 186.
- 650 "Nobody wanted to be the last": Nichols and Tillman, 42.
- 650 "Hey, wait a minute": Ibid., 43.
- 651 "Unlike a high-performance fighter": James R. McCarthy, George B. Allison, and Robert E. Rayfield, *Linebacker II: A View from the Rock* (Maxwell Air Force Base, AL: Air University, 1976), 158.
- 653 "I was ready to do it": Clodfelter, Friction, 25.
- 653 "scared out of one's wits": Ibid., 18
- 653 "The whole time I thought I would be dead": Ibid., 20.
- 654 "How far out from the target are we?": McCarthy, 61.
- 654 "KABOOM! We were hit": Ibid., 62-63.
- 655 On Linebacker II's first night: Clodfelter, Friction, 17.
- 655 "Started to see [flak]": McCarthy, 152.
- 656 "We were watching Liberation": AI Miroshnichenko, Mar. 14, 2016.
- 656 "Some people whispered": Kien memoir, 184.
- 656 "Two or three seconds later": Ibid., 212.
- 657 "hoping for a few minutes' rest": Ibid., 234.
- 657 "we had endured four or five": Ibid., 246.
- 657 "an erupting volcano": AI Binh, Oct. 5, 2016.
- 657 "B-52s seemed to cover the sky": AI Phuong, Oct. 6, 2016.
- 658 "They've got us!": McCarthy, Linebacker II, 152.
- 658 "All of the sightings": Oral narrative to Col. Allison, USAF, Oct. 24, 1977.
- 659 He somehow clung on: Clodfelter, Friction, 8.
- 659 "the US Air Force had fully exposed": Kien memoir, 243.
- 659 "We were like ducks in a carnival": Clodfelter, Friction, 19.

described his path to captivity: Conlee narrative to McCarthy, in *Linebacker II*, 140.

NOTES

- 660 "you could smell the fear": Clodfelter, Friction, 19.
- 660 "If you're a prisoner on Death Row": Ibid., 29.
- 660 her husband would not be coming home: Ibid., 26.
- 661 "went on strike": Ibid., 27.
- one of the most extraordinary episodes: Ibid., 30.
- 662 "the most savage and senseless": Washington Post, Dec. 28, 1972.
- 662 "Shame on Earth": New York Times, Dec. 26, 1972.
- 663 In the post–World War II universe: Papers of General John P. McConnell, quoted in Clodfelter, *Limits*, 145.

CHAPTER 26: A KISS BEFORE DYING

- 665 He was a highly cultured man: AI Ramsey, Sept. 22, 2016.
- 665 led to a table as if for a feast: Ramsey MS IV C56.
- 665 "Now you are on the road to life": Ibid., IV C18.
- 666 his deputy camp commandant: AI Ramsey, Sept. 22, 2016.
- 666 "Each of us had been reduced": Ramsey MS IA 43.
- 666 "I managed to slosh my way": Ibid., IV C65.
- 667 "Most PoWs who have themselves suffered": Ibid., IV D7.
- 667 "Pax hominibus": Ibid., IV D5.
- 667 "I would sometimes visualize": Ibid., 31.
- 668 "Since I couldn't control the environment": AI Ramsey, Sept. 22, 2016.
- 668 "the most impressive POW": Ramsey MS IV F-11.
- 668 For six years, he had been directing espionage: Frank Snepp, *Decent Interval* (Random House, 1977), 43–49; and Ahern, 105–6.
- 669 "all of which is bullshit": White House tapes, conversation 366–006, quoted in Hughes.
- 669 The first point had been settled: *Henry Kissinger: The Complete Memoirs*, E-book boxed set (Simon & Schuster, 2013).
- 670 he was terrified the North Vietnamese would launch: Mar. 14, 1973, in Hughes, 160.
- 670 Mrs. Cherry had squandered the family savings: Terry, 280.
- 671 "America treated us POWs much better": AI McDaniel, Nov. 14, 2016.
- a period of bitterness: Ramsey MS VII A31.
- 672 "Most Americans, under such circumstances": AI Ramsey, Sept. 16, 2016.
- 672 the president made it plain: Hughes, 162.
- 674 "On Cambodia, we've got to bomb": Ibid., 167.

NOTES . 805

- 674 "Look, we're willing to give you a fixed deadline": Ibid., 187.
- 674 "He was both more evil and better": Schlesinger, Journals, Jan, 27, 1975.
- 675 "His job was simply to do whatever it took": AI Phong, Jan. 22, 2017.
- 675 "They walked and talked": AI Khiem, Sept. 13, 2016.
- 675 "Morale was sky-high": AI Ngo Dang Tri, Oct. 5, 2016.
- 675 "It was as if someone had turned the OFF switch": An memoir, 184.
- 676 "though these were all unreadable": AI Ninh, Oct. 7, 2016.
- 676 soldiers, let us put aside vengeance: Young, 63.
- 676 "There was a brief spasm of optimism": AI Mai Elliott, Sept. 23, 2016.
- 676 "Virtually all of us agreed": AI Pribbenow, Nov. 9, 2016.
- 678 "The Vietnamese never felt we were selling them": Santoli, 205.
- 678 "The communists didn't win": AI Tri, Sept. 16, 2016.
- 678 "I know these people have struggled": Abrams Tapes, 345, Jan. 17, 1970.
- 679 "could never admit": Ky, 332.
- 679 "It was a death sentence": Dao Truong in PBS's Vietnam: A Television History, program 7.
- 679 "The overwhelming majority": Vann in a Jan. 1972 speech in Kentucky, Vann Papers, quoted in Sorley, *Better War*, 348.
- 680 "had brought [South Vietnam] to the brink": Nguyen Duy Hinh, in Sorley, *Vietnam War*, 742, 734.
- 680 "Most of our ordinary soldiers": AI Trach Gam, Sept. 15, 2016.
- 680 "The air was loud with the wailing": Swain, 80.
- 681 "The argument against communism": Young, 55.
- 682 "no amount of additional aid": AI Elliott, Sept. 23, 2016; and Jacques Leslie, The Mark: A War Correspondent's Memoir of Vietnam and Cambodia (New York: Four Walls Eight Windows, 1995), 194ff.
- 682 "It was a divided society": AI Meinheit, Jan. 21, 2017.
- 682 "Many fence-sitters": Luan, 425.
- 682 "was not strong enough to be a dictator": Ibid., 394.
- twelve thousand enemy informants: for Adams's wider role in disputing MACV's errors and falsehoods about communist strength, see his post-humously published book, *War of Numbers: An Intelligence Memoir* (Hanover, NH: Steerforth Press, 1994).
- 682 "I am so sorry": AI Nguu, Sept. 20, 2016.
- 682 "We concluded that unless a high level of US aid": AI Meinheit, Jan. 21, 2017.
- 683 "with an almost obsessive curiosity": Tang, 229.
- 684 "Brother Ba": Tran Quynh, "Memories of Le Duan."
- dispatched to a Popular Forces militia unit: AI Si, May 21, 2016.

- 685 "She was not a supporter of either side": AI Hien, Oct. 5, 2016.
- 687 "I was convinced this was not going to last long": AI Pribbenow, Nov. 9, 2016.
- 687 "He knew stuff about communist dialectic": AI Ramsey, Sept. 22, 2016.
- 687 "We knew things were not going right": AI Khiem, Sept. 13, 2016.
- 687 "the only debate being": Scotton, 419.
- 687 "The communists are not going to win this year": AI Destatte, Sept. 12, 2016.

CHAPTER 27: THE LAST ACT

- 689 "There was mud, mud and more mud": An memoir, 195.
- 692 On March 9, NVA infantry: This account relies heavily upon Merle L. Pribbenow, "North Vietnam's Final Offensive: Strategic Endgame Nonpareil," Parameters, Winter 1999–2000, pp. 58–71; and George J. Veith, Black April: The Fall of South Vietnam 1973–75 (New York: Encounter Books, 2012), passim.
- 692 "Almost all our fighting had been as guerrillas": AI Ninh, Oct. 7, 2016.
- 692 Yet Southern troops continued staunchly: This account derives from Armored Command, *Some Battles Fought*.
- 693 "This was the most critical juncture": Vien in Sorley, Vietnam War, 804.
- 693 "he was simply terrified": AI Snepp, Sept. 10, 2016.
- 694 neither he nor South Vietnam: Veith, 178.
- 694 "I will never forget the sight": Robbins, Invisible Air Force, 266.
- 695 estimated that three-quarters: Vien in Sorley, Vietnam War, 809.
- 695 described the retreat as "ignominious": Ibid., 307.
- 695 "who now have nothing left": Veith, 231.
- 695 the regime still possessed a year's worth: AI Phong, Jan. 22, 2017.
- 696 "shown themselves stunningly uninterested": AI Snepp, Sept. 10, 2016.
- 696 "The situation changed at a dizzying pace": An memoir, 208.
- 697 She sought help to mop them up: Ibid., 214.
- 700 "were swallowed up in the mass of humanity": Veith, 329.
- 700 "It didn't fall; it came apart": Robbins, Invisible Air Force, 266-67.
- 701 "This was the first time in my career": An memoir, 233.
- 701 "We cannot promote the peace": Congressional Quarterly, Feb. 15, 1975.
- 702 "I don't think South Vietnam can make it": US Policy, part II, no. 1552.
- 703 "They weren't there to witness the shambles": AI Snepp, Sept. 10, 2016.
- 703 "It was so thrilling": AI Tho, Oct. 11, 2016.
- 703 "I'll go back with you and fight": AI Livingston, Mar. 3, 2016.

NOTES . 807

- 704 disappeared into a house: Veith, 347.
- 704 The most significant battle: George J. Veith and Merle L. Pribbenow, "Fighting Is an Art': The Army of the Republic of Vietnam's Defense of Xuan Loc 9–21 April 1975," *Journal of Military History* 68, no. 1 (Jan. 2004): 163–213.
- 709 Scotton ensured that the CIA analyst spoke: AI Scotton, Sept. 11, 2016.
- 710 Senior officer students spent hours debating: AI Nguyen Van Uc, Sept. 11, 2016.
- 710 "It was wrong for my reason": AI Kieu Chinh, Sept. 14, 2016.
- 710 "We understood that we were losing": AI Khiem, Sept. 13, 2016.
- 711 "Everything is lost now": Young, 69.
- 711 "If the South Vietnamese had known": AI Parks, Mar. 13, 2016.
- 711 "The hard truth lingers on": Palmer, 25-Year War, 151.
- 711 "I just felt so bad": AI Breen, Mar. 7, 2016.
- 711 "It is not true to portray South Vietnam as a fascist regime": West, War and Peace in Vietnam, 179.
- 712 Le Thi Thu Van, widow: Jackie Bong-Wright, *Autumn Cloud: From Viet-namese War Widow to American Activist* (Sterling, VA: Capital Books, 2001), 200.
- 712 Thu Van and her children: Ibid., 201.
- 712 "Don't worry, Mom": Hoi Tran e-memoir, loc. 411.
- 713 "Thieu would have made a great Las Vegas poker player": AI Scotton, Sept. 11, 2016.
- 713 "As soon as we didn't control": AI Snepp, Sept. 10, 2016.
- 713 "And so, when Americans looked at Thieu": AI Nguyen Van Uc, Sept. 13, 2016.
- 713 He "simply could not bring himself to believe": Tang, 137.
- 714 The president shook the hand of the CIA officer: Snepp, Interval, 344.
- 714 In Orange County, California, in 2016: private information to the author, Sept. 16, 2016.
- 716 "You'd better leave the luggage": AI Khiem, Sept. 13, 2016.
- 716 "The fighting grew more intense": An memoir, 253.
- 717 Pushed relentlessly by commanders: This account derives from Armored Command, *Some Battles Fought*.
- 718 "My eyes filled": Ky, 344.
- 718 "I was stupid": AI Tan, Sept. 21, 2016.
- 719 "I'm Mr. Han, the translator": Snepp, Irreparable Harm, 29.
- 719 "obviously in great pain and despair": Santoli, 237.
- 720 "increasingly dogged resistance": Armored Command, *Some Battles Fought*, 22.

808 · NOTES

- 720 "Our soldiers' faces were lit bright": Than, 176.
- 722 Like many fellow countrymen: AI Dinh, July 9, 2016.
- 722 "because I loved Vietnam": AI Si, May 21, 2016.
- 723 "If they had known how the communists would behave": AI Tri, Sept. 16, 2016.
- 723 "too bad you had to get wet": Santoli, 17.
- 723 They briefly took refuge in a temple: AI Nguu, Sept. 20, 2016.
- 723 All the couple's property: AI Thuy, Sept. 13, 2016.
- 723 "Don't do that, please": Luan, 456.
- 724 "Dear neighbors, my family can't live": Ibid., 458.
- 724 "I wanted to return to college": AI Nguyen Chieu, Oct. 7, 2016.
- 724 "The march to victory": Ho De in People's Army newspaper, Apr. 29, 2006.

CHAPTER 28: AFTERWARD

- 726 "The Northerners found winning much less meaningful": AI Phat, Sept. 11, 2016.
- 726 so-called Unification Train: Ninh, 72-73.
- 727 "The Hanoi Communist Party concentrated power": Tang, 206.
- 727 "At least under Diem and Thieu": Ibid., 288.
- 727 "We left behind on the tarmac": Snepp, Irreparable Harm, 23.
- 728 "I became Canada's first Vietnamese refugee": AI Kieu Chinh, Sept. 14, 2016.
- 729 "They knew the communists": AI Thanh, July 14, 2016.
- 730 "Because I know the communists so well": AI Nguu, Sept. 20, 2016.
- 730 "A gray totalitarian pall": Howard, Encounter, 25.
- 730 "You have too much": AI Tran, July 9, 2016.
- 730 Ly had unquestioningly swallowed: Bong-Wright, 45.
- 730 "Some of the emperors": AI Thanh, May 21, 2016.
- 731 she had been present in Hue: Goscha, 371.
- 732 "Since 1954, we have been waiting": Luan, 512.
- 732 "An army doctor one day slashed his wrists": AI Si, July 13, 2016.
- 732 "That night I felt so ashamed": AI Quy, Sept. 15, 2016.
- 733 the destitute widow: AI Minh-Ha, July 6, 2016.
- 734 She was rashly confident: AI Ly Van Quy, Sept. 15, 2016.
- 734 "To my father, everything was black and white": Ibid.
- 734 "I am very regretful": Santoli, 333.
- 735 "Even now their faces haunt me": Tang, 279.
- 735 He found that his sons: AI Nguu, Sept. 20, 2016.

NOTES . 809

- 736 "Each night I prayed for a miracle": AI Phuong, Jan. 22, 2017.
- 736 "If anything, I was amazed that it wasn't harsher": AI Ramsey, Sept. 22, 2016.
- 736 "it was asking too much of the victors": AI Ninh, Oct. 7, 2016.
- 736 He told them they should be ashamed of themselves: AI Scotton, Sept. 18, 2016.
- 738 "Nobody had reason to be happy": AI Phat, Sept. 11, 2016.
- 738 "Today I am simply proud to be an American": AI Tri, Sept. 16, 2016.
- 739 almost two million civilians killed: Thach, ed., *History of the Resistance War*, vol. 8, p. 463.
- 739 "Our entire Party": Ibid.
- 739 "The people": MP interview Tran Trong Trung.
- 739 "a horrible debacle": Lind, 282, 284.
- 740 "John said that we had assisted": AI Scotton, Sept. 11, 2016.
- 740 "lack of a viable politico/economic structure": *Pentagon Papers* (McGraw Hill, 1993), vol. 4, pp. 294–95.
- 741 "There never was a clever way": AI Elliott, Sept. 23, 2016.
- 741 "If a village is fought over": James Gavin, *Crisis Now* (Random House, 1968), 62.
- 742 "The communists could ceaselessly remind us": AI Phat, Sept. 11, 2016.
- 743 "In South Vietnam, too": AI Sheehan, Mar. 5, 2016.
- 743 "That's what a fucked-up war": Michael Herr, Dispatches (Picador, 1979), 31.
- 745 "The Vietnam war did more to change this country": AI Boomer, Mar. 2, 2016.
- 746 "I wonder if it has occurred to you": Charlton and Moncrieff, 179.
- 746 "Though I'm proud to have served": Clodfelter, Friction, 34.
- 746 "When many American veterans gather": AI Scotton, Sept. 18, 2016.
- 746 "It seemed a good place to recover": AI Ramsey, Sept. 22, 2016.
- 746 "We are the same people, but": AI Khiem, Sept. 13, 2016.
- 746 "Sometimes I still have nightmares": AI Hung, Oct. 8, 2016.
- 747 "They thought they were going home": USAHEC, Company Commanders' Oral Histories, Box 18.
- 747 "People are reevaluating": AI Spencer, Mar. 8, 2016.
- 748 "Let's see. That would be two thousand rounds": Shapley, 415.
- 748 "until I'm sure all our people are out": AI Gray, Sept. 10, 2016.
- 748 "We left no one behind": AI Destatte, Sept. 12, 2016.
- 749 "as an alternative way": Archie Brown, *The Rise and Fall of Communism* (Bodley Head, 2009), 609.
- 751 "a time of simplicity": AI Elliott, Sept. 23, 2016.

810 · NOTES

751 "He returns time and time": Ninh, 217.

- 751 "The vision of humanity": AI Ninh, Oct. 7, 2016.
- 751 "According to what we had been taught": Huy Duc, xi.
- 751 Many people who have carefully reviewed the past": Ibid., xii.
- 752 "What was it all about?": AI Boomer, Mar. 2, 2016.

SELECT BIBLIOGRAPHY

The literature of the Vietnam War is immense. I have listed below only titles that have had direct influence on my narrative, albeit often modest or even negative. Failure to include titles, even well-known ones, should not imply lack of respect for a writer—it is merely that some outstanding books have not been directly relevant to my own work. The Vietnamese material has been translated by Merle Pribbenow, unless otherwise stated.

ARTICLES AND ONLINE SOURCES

- Ahern, Thomas L., Jr. CIA and the Generals: Covert Support to the Military Government in South Vietnam. CIA FOIA Reading Room (https://www.cia.gov/library/readingroom), n.d., released 2009.
- Andrew, Rod, Jr. *The First Fight: US Marines in Operation Starlite*. Quantico, VA: History Division, Marine Corps University, 2015.
- Anonymous. "Battle of Dai Do: Seven Days in May," in *The Fighting Third*. Quantico, VA: US Marine Corps, 1969.
- Anonymous. Obituary, "Senior Colonel Tran Hieu, First Director of the DRV's Intelligence Department" [Đại tá Trần Hiệu, Thủ trưởng đầu tiên của Cơ quan Tình báo Chiến lược]. *People's Public Security* newspaper, accessed online Apr. 21, 2014.
- Anonymous. "Seven Revolutionary Warriors Who Returned to Vietnam by British Aircraft in 1942" [7 Chién Sĩ Cách Mạng Được Máy Bay Anh Đưa Về Việt Nam Năm 1942]. People's Public Security newspaper, Sept. 2, 2005, accessed online Sept. 16, 2005.
- Association for Diplomatic Studies and Training. Oral History Project, online archive, interview, Ambassador Allan Wendt, May 20, 1998.
- Bergen, John D. A Test for Technology. Washington, DC: US Army Center of Military History, Fort Lesley J. McNair, 1986.
- Clemis, Martin. "The Control War: Communist Revolutionary Warfare, Pacifi-

- cation, and the Struggle for South Vietnam, 1968–1975." Temple University dissertation, via Proquest 2015.
- Clodfelter, Mark. Fifty Shades of Friction: Combat Climate, B-52 Crews, and the Vietnam War. Washington, DC: National War College, 2016.
- Violating Reality: The Lavelle Affair, Nixon, and the Parsing of Truth. Washington, DC: National War College, National Defense University Press, 2016.
- Combat Operations Department [Cục Tác Chiến]. History of the Combat Operations Department 1945–2000 [Lịch Sử Cục Tác Chiến 1945–2000]. Hanoi: People's Army Publishing House, 2005; www.quansuvn.net.
- Daddis, Gregory. "On Lewis Sorley's Westmoreland: The General Who Lost Vietnam," review essay. Parameters, Autumn 2011.
- Elliott, David W. P., and Mai Elliott. *Documents of an Elite Viet Cong Delta Unit:* The Demolition Platoon of the 514th Battalion. RAND Corporation, 1969, available online.
- Fall, Bernard. "The Political-Religious Sects of Vietnam." *Pacific Affairs* 28, no. 3 (Sept. 1955): 235–53.
- Finlayson, Andrew R. *The Tay Ninh PRU and Its Role in the Phoenix Program 1969.* Studies in Intelligence 15, no. 2, online, CIA website.
- . "Vietnam Strategies." Marine Corps Gazette, Aug. 1988, pp. 90-94.
- Grossheim, Martin. "The Democratic Republic of Vietnam Before the Second Indochina War." *Journal of Vietnamese Studies* 8, no.1 (Fall 2012): 80–129.
- Hanyok, Robert. "Skunks, Bogies, Silent Hounds, and the Flying Fish: The Gulf of Tonkin Mystery 2–4 August 1964." *Cryptologic Quarterly*, Spring 2005.
- Harkins, Michael. "Medals of Honor at Dai Do." *Vietnam*, Summer 1989, pp. 42–59.
- Haun, Phil, and Colin Jackson. "Breaker of Armies: Air Power in the Easter Offensive." *International Security* 40, no. 3 (Winter 2015–16): 139–78.
- Hồ Đê, General. "Victory Was Not Achieved down a Red Carpet." *People's Army* newspaper [Quân đội Nhân dân], Apr. 29, 2006.
- Hoàng Đan et al. *The Spring-Summer 1968 Route 9—Khe Sanh Offensive* [Chiến dịch tiến công Đường 9—Khe Sanh Xuân Hè 1968]. Hanoi: Military History Institute of Vietnam, 1987.
- Hoàng Văn Thái. "A Few Strategic Issues in the Spring 1968 Tet Offensive" [Mấy Văn Để về Chiến Lược trong Cuộc Tiến Công và Nổi Dậy Xuân 1968], address to Ho Chi Minh City conference, Mar. 1986. Vietnam's Military History magazine [Tạp Chí Lịch Sử Quân Sử], issue 2 (26), 1988.
- Hoeffding, Oleg. *Bombing North Vietnam: An Appraisal of Economic and Political Effects*. RAND Corporation publication RM5213, available online.

- Hoffman, George. The Path to War: US Marine Corps Operations 1961-65. Quantico, VA: History Division, Marine Corps University, 2014.
- Howard, Michael. "'Many Reasons' for Vietnam." Encounter, May 1979.
- Howse, Hamilton. *Vietnam: An Epilogue*. Association of the US Army, July 1975, pp. 1–2.
- Kaiser, Robert. "The Disaster of Richard Nixon." New York Review of Books, Apr. 21, 2016.
- Lâm Chương. "Battles Not Described in Military Histories" [Những Trận Đánh Không Tên Trong Quân Sử]. *Vietnam Monthly* [Nguyệt San Việt Nam], Vancouver, 2003, pp. 95–111.
- Lê Đức Thọ. "Comrade Le Duc Tho Discusses Issues Relating to the War" [Đồng chí Lê Đức Thọ nói về một số vấn đề tổng kết chiến tranh và biên soạn lịch sư quân sự]. Vietnam's *Military History* magazine [Tạp Chí Lịch Sử Quân Sự], issue 2 (26), 1988.
- Logevall, Fredrik. "Bernard Fall: The Man Who Knew the War." New York Times, Feb. 21, 2017.
- Long, Joseph. Hill of Angels: US Marines and the Battle for Con Thien. US Department of Defense, 2016.
- Marshall, Jonathan. "Dirty Wars: French and American Piaster Profiteering in Indochina 1945–75." *Asia-Pacific Journal* 12, issue 32, no. 2 (Aug. 11, 2014).
- Military Region 5 Headquarters [Bộ Tư Lệnh Quân Khu 5] and Tran Quy Cat [Trần Quý Cát]. History of Military Region 5 Sapper Troops 1952–1975 [Lịch Sử Bộ Đội Đặc Công Quân Khu 5]. Hanoi: People's Army Publishing House, 1998, internal distribution.
- "Ngọc An Rocket Battalion 224" [Tiểu Đoàn Hỏa Tiễn 224]. Vietnam's *Military History* magazine [Tạp Chí Lịch Sử Quân Sự], issue 4, 1997.
- Nguyễn Quốc Khuê. "3rd Ranger Group and the Battle of An Loc/Binh Long" [LĐ3/BĐQ Với Trận Chiến An Lộc/Bình Long]. *Ranger Magazine* [Tạp san Biệt Động Quân], no. 7 (Mar. 2003): 77.
- Nhân Trí Võ. Vietnam's Economic Policy since 1975. Singapore: Institute of Southeast Asian Studies, 1990.
- Pace, Eric. "Harrison E. Salisbury, 84, Author and Reporter, Dies." New York Times, July 7, 1993.
- Palmer, Bruce. "U.S. Intelligence and Vietnam." *Studies in Intelligence* 28 (special issue) 1984.
- Phan Khắc Hy, Major General. Letter about North Korean aircrew participation in the war, published in Tuổi Trẻ newspaper, Aug. 28, 2007.

- Phương Quang. "New Unit and Historic Battles" [Đơn vị mới và những trận đánh lịch sử] in *Ky Binh* [Ky Binh], issue 5, June 2006, Portland, OR.
- ——. "The -Ology War: Technology and Ideology in the Vietnamese Defense of Hanoi 1967." *Journal of Military History* 67, no. 1 (Jan. 2003): 175–200.
- Pribbenow, Merle L. 1963: Laying The Military Foundation for the Communist Decision to Seek a "Decisive Victory." National Archive and Texas Tech University Press, Oct. 2013.
- ———. "Drugs, Corruption, and Justice in Vietnam and Afghanistan: A Cautionary Tale." *Decoded* magazine, Washington, DC, Nov. 11, 2009.
- ——. The Man in the Snow White Cell. Center for the Study of Intelligence Publications vol. 48, no.1, and Texas Tech University Press, 1993.
- -----. "The Most Famous Unknown Spies of the Vietnam War." Presentation to Vietnam Center conference, Texas Tech University, Lubbock, TX, Oct. 2006.
- ——. "North Vietnam's Final Offensive: Strategic Endgame Nonpareil." *Parameters*, Winter 1999–2000, pp. 58–71.
- ——. Soviet-Vietnamese Intelligence Co-operation. Woodrow Wilson Center lecture December 2014.
- ------. "Theology War: Technology and Ideology in the Vietnamese Defense of Hanoi 1967." *Journal of Military History* 67, no. 1 (Jan. 2003): 175–200.
- Ramsey, Doug. Unpublished MS of Vietnam experience given to author.
- Tổng Hồ Trinh. *The 1968 Tet Offensive in the Tri-Thien-Hue Theater* [Hướng tiến công và nổi dậy Tết Mậu Thân ở Tri-Thiên Huế (năm 1968)], trans. Bob Destatte and Merle Pribbenow for US Army Center for Military History. Hanoi: Ministry of Defense, 1986.
- Trần Bạch Đằng. "Tet '68: A Strategic Exercise" [Cuộc Tổng Diễn Tập Chiến Lược]. Vietnam's *Military History* magazine [Tạp Chí Lịch Sử Quân Sự], issue 2 (26), 1988.
- Trần Độ. Audiotape on Tet offensive transcribed in March 1986 Hanoi Conference proceedings. Vietnam's *Military History* magazine [Tạp Chí Lịch Sử Quân Sự], issue 2 (26), 1988.
- Trần Quỳnh. "Memories of Le Duan" [Những Kỷ Niệm Về Lê Duẩn], http://van hoavn.blogspot.com/2012/09/blog-post_7386.html.
- Trần Văn Quang. "Hue: 25 Days and Nights" [Huế: 25 ngày đêm], address to March 1988 Hanoi Conference. Vietnam's *Military History* magazine [Tap Chí Lịch Sử Quân Sự], issue 2 (26), 1988.

- Trục Lâm. "The Fate of a Mole" [Số phận một nội gián]. *People's Army* newspaper [Quân đội Nhân dân], July 22, 1995, p. 7.
- Veith, George J., and Merle L. Pribbenow. "Fighting Is an Art': The Army of the Republic of Vietnam's Defense of Xuan Loc 9–21 April 1975." *Journal of Military History* 68, no. 1 (Jan. 2004): 163–213.
- Walrath, Brian. Unpublished MS of Vietnam MAT (mobile advisory team) experiences given to author.
- Westad, Odd Arne, et al., eds. 77 Conversations between Chinese and Foreign Leaders on the Wars in Indochina 1964–77. Orono, ME: Wilson Center, Working Paper 22, online.
- Wyndham, Norman. *Through Vietnamese Eyes*, privately circulated memorandum, 1968, in possession of Lord Egremont.
- Xuân Ba. Series of articles and interviews with Le Duan's second wife, published in *Tien Phong* [Tiên Phong] newspaper, June 25, 2006, and in succeeding weeks.

BOOKS

Adams, Sam. War of Numbers: An Intelligence Memoir. Hanover, NH: Steerforth Press, 1994.

Andradé, Dale. Ashes to Ashes: The Phoenix Program and the Vietnam War. Lexington Books/Rowman & Littlefield, 1990.

Andrews, William. The Village War. University of Missouri Press, 1973.

Appy, Christian G. Patriots: The Vietnam War Remembered from All Sides. Viking, 2003.

Arbatov, Georgi. The System: An Insider's Life in Soviet Politics. Times Books, 1992.

Armored Command [Bộ Tư lệnh Thiết giáp]. Some Battles Fought by Our Armored Troops [Những trận đánh của Pháo binh Việt Nam], vol. 4. Hanoi: General Staff Printing, 1983.

Asselin, Pierre. *Hanoi's Road to the Vietnam War 1954–1965*. University of California Press, 2013.

Atkinson, Rick. The Long Gray Line. Houghton Mifflin, 1989.

Autry, Jerry Davis. Gun-Totin' Chaplain. Airborne Press, 2006.

Bảo Ninh. The Sorrow of War. Vintage, 1998.

Baskir, Lawrence M., and William A. Strauss. *Chance and Circumstance: The Draft, the War, and the Vietnam Generation*. Knopf, 1978.

Battles of Vietnamese Artillery during the War of Liberation, vol. 2. Military History Institute of Vietnam, 1990.

Beckwith, Charlie, and Donald Knox. Delta Force. Harcourt Brace, 1983.

Beech, Keyes. Not Without the Americans. Doubleday, 1971.

Berman, Larry. No Peace, No Honor: Nixon, Kissinger, and Betrayal in Vietnam. Free Press, 2001.

——. Planning a Tragedy: The Americanization of the War in Vietnam. Norton, 1982.

Biggs, David. Quagmire: Nation-Building and Nature in the Mekong Delta. University of Washington Press, 2010.

Bilton, Michael, and Kevin Sim. Four Hours in My Lai. Viking, 1992.

Bonds, Ray, ed. *The Vietnam War: The Illustrated History*. London: Salamander Books, 1979.

Bong-Wright, Jackie. Autumn Cloud: From Vietnamese War Widow to American Activist. Sterling, VA: Capital Books, 2001.

Bonville, George. You Ain't Nothing but a Swamp Rat. Chapel Hill, NC: Professional Press, 2016.

Boot, Max. The Road Not Taken: Edward Lansdale and the American Tragedy in Vietnam. Norton, 2017.

Borch, Frederic L. III. Judge Advocates in Vietnam: Army Lawyers in Southeast Asia 1959–75. US Army Combat Studies Institute, 2003.

Botkin, Richard. Ride the Thunder. Centreville, VA: WND Books, 2009.

Bowden, Mark. Hue 1968. Grove Atlantic, 2017.

Bradley, Mark Philip. Vietnam at War. Oxford University Press, 2009.

Braestrup, Peter. Big Story: How the American Press and Television Reported and Interpreted the Crisis of Tet 1968. Anchor, 1978.

Brigham, Robert K. ARVN: Life and Death in the South Vietnamese Army. University Press of Kansas, 2006.

Brodie, Bernard. War and Politics. Macmillan, 1973.

Broughton, Jack. Thud Ridge. Lippincott, 1969.

Brown, Archie. The Rise and Fall of Communism. Bodley Head, 2009.

Browne, Malcolm. The New Face of War. Bobbs-Merrill, 1965.

Bùi Vinh Phương, ed. *Military Encyclopedia of Vietnam* [Từ Điển Bách Hoa Quân Sự Việt Nam]. Hanoi: People's Army Publishing House, 2004.

Bunting, Josiah, III. The Lionheads. George Braziller, 1973.

Burkett, B. G., and Glenna Whitley. Stolen Valor: How the Vietnam Generation Was Robbed of Its Heroes and Its History. Dallas, TX: Verity Press, 1998.

Burleigh, Michael. Small Wars, Faraway Places. Macmillan, 2013.

Burr, William, and Jeffrey P. Kimball. Nixon's Nuclear Specter: The Secret Alert of 1969, Madman Diplomacy, and the Vietnam War. University Press of Kansas, 2015.

Busch, Peter. All the Way with JFK? Britain, the U.S. and the Vietnam War. Oxford University Press, 2003.

Buttinger, Joseph. Vietnam: A Dragon Embattled. Praeger, 1967.

Caputo, Philip. A Rumor of War. Holt, Rinehart & Winston, 1977.

Charlton, Michael, and Anthony Moncrieff, eds. *Many Reasons Why: The American Involvement in Vietnam*. London: Scolar Press, 1978.

Chivers, C. J. The Gun. Simon & Schuster, 2010.

Clarke, Jeffrey J. Advice and Support: The Final Years. Washington, DC: US Army Center of Military History, Fort Lesley J. McNair, 1992.

Cloake, John. Templer: Tiger of Malaya. Harrap, 1985.

Clodfelter, Mark. Beneficial Bombing. University of Nebraska Press, 2010.

——. The Limits of Air Power. Free Press, 1989.

Colby, William. Lost Victory. Chicago: Contemporary Books, 1989.

Conboy, Kenneth, and Dale Andrade. Spies and Commandos: How America Lost the Secret War in North Vietnam. University Press of Kansas, 2000.

Cooper, Chester. The Lost Crusade. Dodd, Mead, 1970.

Corn, David. *Blond Ghost: Ted Shackley and the CIA's Crusades*. Simon & Schuster, 1994.

Daddis, Greg. No Sure Victory. Oxford University Press, 2011.

———. Westmoreland's War: Reassessing American Strategy in Vietnam. Oxford University Press, 2014.

-----. Withdrawal. Oxford University Press, 2017.

Đặng Thuỷ Trầm. Last Night I Dreamed of Peace. Harmony, 2007.

Đặng Vũ Hiệp, Colonel General. *Highland Memories* [Ký ức Tây Nguyên]. Hanoi: Peoples' Army Publishing House, 2000.

Davidson, Philip B. Vietnam at War 1946–1975. London: Sidgwick & Jackson, 1988.

Del Vecchio, John M. The 13th Valley. Sphere, 1983.

Dietrich, Erik Jurgen-Karl. The Kraut. Privately printed, 2015.

Đoàn Phương Hải. *The Sea on the Horizon* [Góc biển chân trời]. San Jose CA: Dong Van Publishing, 2000 (in Vietnamese).

Dobrynin, Anatoly. In Confidence: Moscow's Ambassador to America's Six Cold War Presidents. Times Books, 1995.

Doyle, Michael W. Ways of War and Peace. Norton, 1997.

Edwards, Peter. Australia and the Vietnam War. Sydney, Australia: New South Wales Press, 2014.

Elliott, David W. P. Changing Worlds: Vietnam's Transition from Cold War to Globalization. Oxford University Press, 2012.

———. The Vietnamese War: Revolution and Social Change in the Mekong Delta 1930–1975, 2 vols. Armonk, NY: M. E. Sharpe, 2003.

Elliott, Duong Van Mai. RAND in Southeast Asia: A History of the Vietnam War Era. RAND Corporation, 2010.

——. The Sacred Willow: Four Generations in the Life of a Vietnamese Family. Oxford University Press, 1999.

Falabella, J. Robert. Vietnam Memoirs. New York: Pageant Press, 1971.

Fall, Bernard. Street Without Joy. Mechanicsburg, PA: Stackpole, 1967.

Finlayson, Andrew. Killer Kane. Jefferson, NC: McFarland, 2013.

. Rice Paddy Recon. Jefferson, NC: McFarland, 2014.

FitzGerald, Frances. Fire in the Lake. Vintage, 1972.

French, David. *The British Way in Counter-Insurgency 1945-67*. Oxford University Press, 2011.

Fulton, William B. Vietnam Studies: Riverine Operations 1966–1969. Nashville, TN: Turner Publishing, 1997.

Gaiduk, Ilya V. The Soviet Union and the Vietnam War. Ivan R. Dee, 1996.

Gavin, James. Crisis Now. Random House, 1968.

Giap, Vo Nguyen. Collected Writings. Saigon Cultural Publishing House, 2009.

Giles, Frank. The Locust Years. London: Secker & Warburg, 1991.

Glazunov, E. P., et al., eds. *Voina vo Vietname—Kak Eto Bylo* [The War in Vietnam—How It Was]. Moscow: Ekzamen Publisher, 2005.

Gole, Henry G. General William DePuy: Preparing the Army for Modern War. University Press of Kentucky, 2004.

-----. Soldiering. Potomac Books, 2005.

Goscha, Christopher. The Penguin History of Modern Vietnam. Allen Lane, 2016.

Greene, Graham. The Quiet American. Heinemann, 1955.

Greene, Wallace. The Greene Papers: General Wallace M. Greene Jr. and the Escalation of the Vietnam War, ed. Nicholas Schlosser, Quantico, VA: US Marine Corps, 2015.

Hà Mai Việt. Steel and Blood: Armor during the Vietnam War. Sugarland, TX: self-published, 2005; Annapolis: Naval Institute Press, 2008.

Hackworth, David. Steel My Soldiers' Hearts. Simon & Schuster, 2002.

Haig, Alexander, and Charles McCarry. *Inner Circles: How America Changed the World*. New York: Grand Central, 1994.

Halberstam, David. The Best and the Brightest. Random House, 1972.

Haldeman, H. R. The Haldeman Diaries. Berkley Books, 1994.

Ham, Paul. Vietnam: The Australian War. HarperCollins Australia, 2007.

Hamilton-Paterson, James. A Very Personal War: The Story of Cornelius Hawkridge. Faber & Faber, 1971.

Hammond, William M. *Public Affairs: The Military and the Media*. Washington, DC: US Army Center of Military History, Fort Lesley J. McNair, 1990.

Haponski, William. An Idea, and Bullets. Combatant Books, 2016.

Hayes, Paddy. Queen of Spies. Duckworth, 2015.

Hayslip, Le Ly, and Jay Wurts. When Heaven and Earth Changed Places. Doubleday, 1989.

Herr, Michael. Dispatches. Picador, 1979.

Hersh, Seymour. The Dark Side of Camelot. Little, Brown, 1997.

Higgins, Marguerite. Our Vietnam Nightmare. Harper & Row, 1971.

History of the 320th Lowland Division. Military History Institute of Vietnam, 1984.

Hồ Văn Kỳ Thoại. [Can trường trong chiến bại]. Self-published in Virginia, 2010.

Hoàng Nghĩa Khánh. *The Road to the General Headquarters Staff* [Đường lên cơ quan Tổng hành dinh]. Hanoi: People's Army Publishing House, 2008.

Hodges, Michael. AK47: The Story of the People's Gun. Sceptre/Hodder & Stoughton, 2007.

Howard, Michael. Captain Professor. New York: Continuum, 2006.

Hughes, Ken. Fatal Politics: The Nixon Tapes, the Vietnam War, and the Casualties of Reelection. University of Virginia Press, 2015.

Hunt, Harold. A Soldier's Journal. Hanover, MD: Hunt Enterprises, 1991.

Hunt, Ira A. The 9th Infantry Division in Vietnam. University Press of Kentucky, 2010.

Hunt, Richard A. Melvin Laird and the Foundation of the Post-Vietnam Military 1969-71. Historical Office of the Secretary of Defense, 2015.

Huy Đức. *The Victors* [Bên thắng cuộc], vol. 2, *Power* [Quyển lực]. Los Angeles: Osinbook, 2012.

Huỳnh Công Thân, Major General, as told to Nguyễn Hữu. *On the Long An Battlefield: A Memoir* [Ở chiến trường Long An]. Hanoi: People's Army Publishing House, 1994.

Isaacs, Arnold. Without Honor: Defeat in Vietnam and Cambodia. Johns Hopkins University Press, 1983.

Jones, Howard. My Lai: Vietnam 1968 and the Descent into Darkness. Oxford University Press, 2017.

Karnow, Stanley. Vietnam: A History. Century, 1983.

Kerrey, Bob. When I Was a Young Man. Harcourt, 2002.

Kimball, Jeffrey. Nixon's Vietnam War. University Press of Kansas, 1998.

——. The Vietnam War Files: Uncovering the Secret History of Nixon-Fra Strategy. University Press of Kansas, 2004.

Kissinger, Henry. Ending the Vietnam War. Simon & Schuster, 2003.

Krohn, Charles A. The Lost Battalion of Tet. Annapolis: Naval Institute Press, 2008.

Kurlantzick, Joshua. A Great Place to Have a War: Laos and the Militarization of the CIA. Simon & Schuster, 2017.

Ky, Nguyen Cao, see Nguyen Cao Ky.

Laidig, Scott. Al Gray, Marine. Potomac Institute Press, 2012.

Langguth, A. J. Our Vietnam. Simon & Schuster, 2000.

Larteguy, Jean. Les Centurions. Paris: Presses de la Cité, 1960.

Lavalle, A. J. C., ed. Air Power and the 1972 Spring Invasion. US Air Force, Southeast Asia Monographs, vol. 2, no. 3.

LeMay, Curtis, with MacKinlay Kantor. Mission with LeMay. Doubleday, 1965.

Leslie, Jacques. The Mark: A War Correspondent's Memoir of Vietnam and Cambodia. New York: Four Walls Eight Windows, 1995.

Lewis, Norman. A Dragon Apparent. Jonathan Cape, 1951.

Lind, Michael. Vietnam: The Necessary War. Free Press, 1999.

Livingston, James E., with Colin D. Heaton and Anne-Marie Lewis. *Noble War*rior. Zenith Press, 2010.

Logevall, Fredrik. Choosing War. University of California Press, 1999.

Long, Guilin. Memoirs. Beijing: 1995.

Lunn, Hugh. Vietnam: A Reporter's War. University of Queensland Press, 1985.

Lý Tổng Bá, General. Memoir of 25 Years of War: Thoughts of a General Who Commanded Troops on the Battlefield [Hối ký 25 năm khói lửa: Cảm nghĩ của một tướng cầm quân ở mặt trận]. San Marcos, TX: self-published, 1999.

Macdonald, Peter. Giap: The Victor in Vietnam. Norton, 1992.

Maclear, Michael. Vietnam: The Ten Thousand Day War. Thames Methuen, 1981.

Marlantes, Karl. Matterhorn. Atlantic Monthly Press, 2010.

McCarthy, James R., George B. Allison, and Robert E. Rayfield. *Linebacker II: A View from the Rock*. Maxwell Air Force Base, AL: Air University, 1976.

McCoy, Alfred. The Politics of Heroin in Southeast Asia. Harper & Row, 1972.

McMaster, H. R. Dereliction of Duty: Lyndon Johnson, Robert McNamara, the Joint Chiefs of Staff, and the Lies That Led to Vietnam. HarperCollins, 1997.

Memmi, Albert. The Colonizer and the Colonized. Souvenir, 2016.

Mersky, Peter, and Norman Polmar. *The Naval Air War in Vietnam*. Annapolis, MD: Naval Institute Press, 1981.

Michel, Marshall L., III. *The 11 Days Of Christmas: America's Last Vietnam Battle*. New York: Encounter Books, 2001.

———. Clashes: Air Combat over North Vietnam 1965–72. Annapolis: Naval Institute Press, 1997.

Millie, David. Team 19 in Vietnam: An Australian Soldier at War. University Press of Kentucky, 2013.

Moise, Edwin. The Tonkin Gulf and the Escalation of the Vietnam War. University of North Carolina Press, 1996.

- Nghĩ Huỳnh, Trịnh Văn Noi, and Nguyễn Hùng Sinh. *The Route 9—Southern Laos Counteroffensive Campaign 1971* [Chiến dịch phản công Đừong số 9—Nam Lao năm 1971]. Military History Institute of Vietnam, 1987.
- Nguyễn Cao Kỳ. Buddha's Child: My Fight to Save Vietnam. St. Martin's, 2002.
- Nguyễn Công Luận. *Nationalist in the Vietnam Wars*. Indiana University Press, 2012.
- Nguyễn Đình Kiên, *A Soldier and the Skies over Hanoi* [Người lính với bầu trời Hà Nội]. Hanoi: People's Army Publishing House, 2013.
- Nguyễn Đức Huy, with Nguyễn Thống Nhất. *A Soldier's Life* [Một đời binh nghiệp]. Hanoi: People's Army Publishing House, 2011.
- Nguyễn Dương. Vietnam: The Other Side (Challenging All Odds). Privately published, 2015.
- Nguyễn Hùng Lĩnh and Hoàng Mạc. Anti-Reactionary Forces: Chronology of Events 1954–75 [Lực lượng chống phản động: Lịch sử biên niên (1954–1975)]. Hanoi: Ministry of Interior, Political Security Department III, Public Security.
- Nguyễn Hữu An, as told to Nguyên Tu Duong. *New Battlefield* [Chiến trường mới]. Hanoi: People's Army Publishing House, 2002.
- Nguyễn Huy Toàn and Phạm Quang Định. *The 304th Division, Volume II* [Sư đoàn 304, tập II]. Hanoi: People's Army Publishing House, 1990.
- Nguyễn, Nathalie Huỳnh Châu. South Vietnamese Soldiers. Praeger, 2016.
- Nguyen Quoc Minh [Nguyễn Quốc Minh], et al. *History of the Sapper Forces, vol. 1* [Lịch sử Binh chủng Đặc công, tập I]. Hanoi: People's Army Publishing House, 1987.
- Nguyễn Tài. Face to Face with the CIA [Đối mặt với CIA Mỹ]. Hanoi: Writers' Association, 1999.
- Nguyễn Thị Liên-Hằng, Professor. *Hanoi's War: An International History*. University of North Carolina Press, 2012.
- Nguyễn Tiến Đích. [3rd] *Division Memories* [Ký Úc Sư Đoàn]. Hanoi: People's Army Publishing House, 1995. www.vnmilitaryhistory.net/index.php?topic=31148.0.
- Nguyen Van Nhien [Nguyễn Văn Nhiên] and Nguyen Thanh Huu [Nguyễn Thành Hữu]. *History of Chemical Troops 1958–2008* [Lịch sử Bộ đội hoá học (1958–2008)]. Hanoi: People's Army Publishing House, 2008.
- Nguyen Van Phap [Nguyễn Văn Pháp] et al. *History of the Air Defense Service* [Lịch sử Quân chủng Phòng Không, tập I]. Hanoi: 1991.
- Nguyễn Xuân Mậu. *Defending the Skies: A Memoir* [Bảo vệ bầu trời: Hồi ký]. Hanoi: 1982.
- Nichols, John B., and Barrett Tillman. On Yankee Station. Bantam, 1988.
- Nixon, Richard. No More Vietnams. Arbor House, 1985.
- -----. RN: The Memoirs of Richard Nixon. Grosset & Dunlap, 1978.

- Nolan, Keith William. The Magnificent Bastards. Novato, CA: Presidio, 2007.
- ——. Sappers in the Wire: The Life and Death of Firebase Mary Ann. Texas A&M University Press, 2007.
- Nolting, Frederick. From Trust to Tragedy. Praeger, 1988.
- Oberdorfer, Don. *Tet! The Turning Point in the Vietnam War*. Johns Hopkins University Press, 2001.
- O'Brien, Michael. Conscripts and Regulars: With the Seventh Battalion in Vietnam. Allen & Unwin, 1995.
- O'Brien, Tim. The Things They Carried. Flamingo/HarperCollins, 1990.
- Palmer, Bruce. The 25-Year War: America's Military Role in Vietnam. Touchstone, 1984.
- Payne, Kenneth. The Psychology of Strategy: Exploring Rationality in the Vietnam War. London: Hurst, 2015.
- Phạm Gia Đại. The Last Prisoners. Prototech, 2016.
- Phạm Gia Đức. *The 325th Division* [Sư đoàn 325], 2 vols. Hanoi: People's Army Publishing House, 1986.
- Phạm Huy Thưởng, et al. *The Lowlands Division (Central Highlands Corps)*, vol. 3 [Sư đoàn Đồng bằng, Binh đoàn Tây Nguyên, tập Ba]. Hanoi: People's Army Publishing House, 1984.
- Phạm Văn Chung et al. *The Vietnamese Marine Corps's Twenty-One Years of War-fare (1954–75), vol. 2* [Hai mươi một năm chiến của Thuỷ quân lục chiến Việt Nam 1954–1975, tập 2]. Santa Ana, CA: Vietnamese Marine Association in the United States, 2005 (in Vietnamese).
- Phạm Văn Thạch, Major General, ed. History of the Resistance War Against the Americans to Save the Nation 1954–75, 8 vols. [Lịch sử kháng chiến chống Mỹ, cứu nước 1954–1975]. Hanoi: Military History Institute of Vietnam, 2008.
- Phan Nhật Nam. *The Mark of a Warrior 1963–1973: War Notes* [Dấu binh lửa 1963–73: Bút ký chiến tranh]. Saigon: Hien Dai Publishing, 1973.
- Pike, Douglas. Viet Cong: The Organization and Techniques of the National Liberation Front of South Vietnam. MIT Press, 1966.
- Porter, Gareth, and Stuart Loory. Vietnam: The Definitive Documentation of Human Decisions, 2 vols. London: Heyden, 1979.
- Pouget, J. Nous etions à Dien Bien Phu. Paris: Presses de la Cité, 1964; Hanoi: People's Army Publishing House, 1997 (circulated internally only).
- Prados, John. Vietnam: The History of an Unwinnable War 1945-75. University Press of Kansas, 2009.
- Raskin, Marcus G., and Bernard B. Fall, eds. *The Vietnam Reader*. Vintage Books, 1967.

Robbins, Christopher. The Invisible Air Force: The Story of the CIA's Secret Airline. Macmillan, 1979.

_____. The Ravens. Crown, 1987.

Robinson, Anthony, ed. Weapons of the Vietnam War. Gallery/Simon & Schuster, 1983.

Rocolle, Pierre. Pourquoi Dien Bien Phu? Flammarion, 1968.

Salisbury, Harrison. Behind the Lines-Hanoi. Harper & Row, 1967.

Samuels, Charlie. *Machinery and Weapons of the Vietnam War*. New York: Gareth Stevens, 2013.

Santoli, Al. To Bear Any Burden: The Vietnamese War and Its Aftermath. Sphere, 1986.

Schlesinger, Arthur. Journals 1956-2002. Penguin, 2007.

-----. Robert Kennedy and His Times. Houghton Mifflin, 1978.

Scotton, Frank. Uphill Battle. Texas Tech University Press, 2014.

Shapley, Deborah. Promise and Power: The Life and Times of Robert McNamara. Little, Brown, 1993.

Shaw, Geoffrey. The Lost Mandate of Heaven. San Francisco: Ignatius Press, 2015.

Shawcross, William. Sideshow: Kissinger, Nixon, and the Destruction of Cambodia. London: André Deutsch, 1979.

Sheehan, Neil. A Bright Shining Lie: John Paul Vann and America in Vietnam. Random House, 1988.

Shepherd, Jack, and Christopher Wren, eds. *Quotations from Chairman LBJ*. Simon & Schuster, 1968.

Siemon-Netto, Uwe Duc. A Reporter's Love for the Wounded People of Vietnam. CreateSpace Independent Publishing Platform, 2013.

Simpson, Howard R. Tiger in the Barbed Wire. Tokyo: Kodansha International, 1992.

Smith, Ralph. An International History of the Vietnam War. Macmillan, 1985.

——. *Vietnam and the West*. Cornell University Press, 1971. Snepp, Frank. *Decent Interval*. Random House, 1977.

-----. Irreparable Harm. Random House, 1999.

Solis, Gary D. Marines and Military Law in Vietnam: Trial by Fire. US Marine Corps, 1989.

Sorley, Lewis, ed. The Abrams Tapes 1968-72. Texas Tech University Press, 2004.

———, ed. A Better War: The Unexamined Victories and Final Tragedy of America's Last Years in Vietnam. Harvest, 1999.

———, ed. *The Vietnam War: An Assessment by South Vietnam's Generals*. Texas Tech University Press, 2010.

Spector, Ronald H. *Advice and Support: The Early Years*. Washington, DC: US Army Center of Military History, Fort Lesley J. McNair, 1985.

Sukhodrev, Viktor. Yazyk moi—drug moi (My Tongue Is My Friend). Moscow: AST, 2008.

Suri, Jeremi. Henry Kissinger and the American Century. Harvard University Press, 2007.

Swain, Jon. River of Time. Heinemann, 1995.

Taylor, K. W., ed. Voices from the Second Republic of South Vietnam (1967–1975). Cornell University Press, 2014.

Taylor, Maxwell. Swords and Plowshares. Norton, 1972.

Terry, Wallace. Bloods: Black Veterans of the Vietnam War. Novato, CA: Presidio 2006.

Thành Tín (pseudonym of Bùi Tín). Their True Colors: The Political Memoirs of Bui Tin [Mặt thật: Hồi ký chính trị của Bùi Tín]. Turpin Press, 1994.

Thompson, Robert. Defeating Communist Insurgency. Chatto & Windus, 1966.

. Make for the Hills. Barnsley, South Yorkshire, UK: Pen and Sword, 1989.

Thompson, Wayne. To Hanoi and Back: The United States Air Force and North Vietnam 1966–1973. Washington, DC: US Air Force, 2000.

Thorne, Christopher. Allies of a Kind. Hamish Hamilton, 1978.

Tougas, Shelley. Weapons, Gear, and Uniforms of the Vietnam War. Capstone, 2012.

Tourison, Sedgwick. Secret Army, Secret War. Annapolis: Naval Institute Press 1995.

Trạch Gầm. "On the War's Sidelines" [Bên lê chiến tranh]. Viet Tide Corp., 2015.

Trần Bạch Đằng. *Life and Memories* [Cuộc Đời và Ký Úc]. Ho Chi Minh City: Tre Publishing House, 2006.

Trân Hội. A Vietnamese Fighter Pilot in an American War. Xlibris, 2014.

Trần Ngọc Châu. Vietnam Labyrinth. Texas Tech University Press, 2012.

Trần Quốc Tuấn, et al. History of the General Staff during the Resistance War against the Americans to Save the Nation 1954–75, Vol. 4 [Lịch sử Bộ Tổng tham mưu trong khang chiến chống Mỹ, cứu nước (1954–1975), Tập 4 (1969–1972)]. Hanoi: People's Army Publishing House, 2010.

Trần Trọng Trung. Supreme Commander Vo Nguyen Giap during the Years of American Imperialist Escalation of the War (1965–1969) [Tổng Tư Lệnh Võ Nguyên Giáp Trong Nhũng Năm Đế Quốc Mỹ Leo Thang Chiến Tranh (1965–1969)]. Hanoi: National Political Truth Publishing House, 2015.

Trần Văn Đôn. Our Endless War: Inside Vietnam. Novato, CA: Presidio Press, 1978.

Trần Văn Nhựt, with Christian Arevian. An Loc: The Unfinished War. Texas Tech University Press, 2009.

Trullinger, James W. Village at War: An Account of Revolution in Vietnam. Longman, 1980.

Trương Như Tảng. A Vietcong Memoir. Vintage, 1986.

Tucker, Spencer C., ed. Encyclopedia of the Vietnam War. ABC-Clio, 1998.

Turley, Gerald H. *The Easter Offensive: The Last American Advisors, Vietnam 1972*. Annapolis: Naval Institute Press, 1985.

U.S. Army in Vietnam, 11 vols. Washington, DC: US Army Center of Military History, Fort Lesley J. McNair.

Viet Thanh Nguyen [Nguyễn Thanh Việt]. *The Sympathizer*. Atlantic Monthly Press, 2015.

Veith, George J. Black April: The Fall of South Vietnam 1973–75. New York: Encounter Books, 2012.

Weinberger, Sharon. The Imagineers of War. Penguin Random House, 2017.

West, Richard. Victory in Vietnam. London: Private Eye/André Deutsch, 1974.

-----. War and Peace in Vietnam. London: Sinclair-Stevenson, 1995.

Westad, Odd Arne. The Cold War: A World History. Allen Lane, 2017.

Westmoreland, William. A Soldier Reports. Doubleday, 1976.

White, Theodore. The Making of the President 1964. Athenaeum, 1965.

-----. The Making of the President 1968. Jonathan Cape, 1969.

-----. The Making of the President 1972. Jonathan Cape, 1973.

Whitt, Jacqueline E. Bringing God to Men: American Military Chaplains and the Vietnam War. University of North Carolina Press, 2014.

Wiest, Andrew. Vietnam's Forgotten Army: Heroism and Betrayal in the ARVN. New York University Press, 2008.

Windrow, Martin. The Last Valley. Weidenfeld & Nicolson, 2004.

Wirtz, James J. The Tet Offensive: Intelligence Failure in War. Cornell University Press, 1991.

Woods, Randall. Shadow Warrior: William Egan Colby and the CIA. Basic Books, 2013.

Young, Gavin. A Wavering Grace. Viking, 1997.

Zaitsev, Anatoly. Na Gromykovskikh kovrakh [On Gromyko's Carpets]. Moscow: 2001.

INDEX

NOTE: Page numbers in italics indicate a map or illustration

Abrams, Creighton	Agent Orange, 142, 196, 271, 309-10
on Americans' failure to heed	agriculture, 416, 417
intelligence, 593	aircraft carriers, US, 216, 217, 220,
appealing to Thieu for Lam Son 719	341–48, 354
support, 578	Air Force. See United States Air Force
on ARVN Marines in Hue post-Tet,	AK-47s, 406-7, 410-11, 507-8
469	alcohol and alcoholism
biographical info, 517	Australians, 541-42
on charts, 388	of France's mercenaries, 29
on civilian casualties, 517-18	murders related to, 528, 530
on drawdowns, 555	of pilots, 340
health challenges, 597	and smoking marijuana, 527
on Khe Sanh and Giap, 481-82	US soldiers insulting a Vietnamese
on media, 513	senator, 516
on NVA plans for an offensive strike,	Algeria, 16
602	Algerian soldiers fighting for France, 59,
ordering destruction of Ho Chi Minh	63, 67–68, 78
Trail, 573–74	Allen, Chuck, 139
restricted from entering Laos and	Allen, Joe, 485
Cambodia, 521–22	Allen, John, 658–59
on Saigon's district chiefs, 417-18	Alsop, Joseph, 263
on South Vietnamese after Americans	Alvarez, Everett, 220
left, 679	Americans
on US inability to protect peasants, 490	acts of kindness, 307-8
on Vietnamese values, 584	antiwar protesters, 250, 379-85, 386,
Acheson, Dean, 34	391–92, 568, 668–69
Adams, Eddie, 467	behavior of, 414
Advanced Research Development	inappropriate political rally in
Agency (ARDA), 409	Vietnam, 134–35
AFC (Armed Forces Council), 227, 231,	mercenaries fighting in France's war in
241	Vietnam, 77

Americans (cont.) Army. See United States Army patriotism and public passivity, 229 Army of the Republic of South Vietnam. post-Tet Offensive rally, 484 See ARVN shame at abandoning South ARVN (Army of the Republic of [South] Vietnamese allies, 728 Viet Nam) See also antiwar protesters in the overview, 160-61, 164 United States; United States attitude of soldiers, 429-30, 432 Amory, Robert, 128 and Australians, 533 Anderson, Fred, 694 Binh Xuyen street battle with, 109 André, Valérie, 43 as bystanders to US operations, 387 An (Nguyen Huu An) casualties at Tet, 481 on air bombardment, 322 communist infiltration, 390-91, 439 attack in Ia Drang Valley, 283-85 conscription of young men, 160-61 biographical info, 232, 423-24 gentleman's agreement with VC, 247 on communists' unwillingness to and NVA offensive to expose debility admit bad news, 474 of Thieu regime, 601-18, 620-30 and conquest of South Vietnam, officers skimming off the top, 430-31 696-97, 699, 701, 707, 716 officer suicides, 704 as corps commander for Le Duan's big patrol boat raids on North Vietnam push, 689-90 targets, 214-15 on deforestation, 578 pilots, 429-30 on Ho Chi Minh Trail, 232-36 post-Tet Offensive funk, 468-69, injured on his way to Hanoi, 425-26 479 - 80on NVA funk post-Tet, 481 running away from NVA, 612-13 on United States military, 285, 322 soldiers shipped to camps in North Anthony, Jeff, 490, 532 Vietnam, 732 successes, 196-97 antiwar protesters in Australia, 534-35, 542 - 43taking produce from peasants, 417 antiwar protesters in the United States unit runs away, 134 overview, 379-85, 386 and US military advisers, 131, draft dodgers, 385, 391-92 138-40, 193-94 Golden Gate Bridge closed to, 668-69 US rejects requests for air support, Kerrey, former Navy SEAL, 568 National Guardsmen shooting college Vietcong attack escalation, 121–24, students, 560 232 Asselin, Pierre, 99 response to bombing in North Vietnam, 250 Australia Apache Snow Operation, 553 antiwar protesters, 534-35, 542-43 Ap Bac, battle of, 159-66 leaving Vietnam, 599-600 ARDA (Advanced Research and post-Paris Accords attack by Development Agency), 409 NVA, 710 Armed Forces Council (AFC), 227, 231, refusing involvement in Vietnam, 241 230 - 31

troops in Vietnam, 145, 276–77, 308–9, 310, 533–43

B-52 bombers, 255, 428–29, 472, 615, 616, 650–56

Baldwin, Hanson, 147, 207

Baldwin, James, 592

Ball, George, 204, 228–29, 254–55, 258–61, 272

Ba Me, 436

Ban Me Thuot, 483, 690-93, 695

Bao Dai, emperor of Vietnam, 11, 25–26, 85, 88, 109

Bao (Nguyen Dinh Bao), 614

Bao Ninh, 422-23, 524, 620, 751

Barker, Frank, 519

Barrel Roll Operation, 229-30

Barry, Michael, 529

Bartlett, Charles, 172

Basic Doctrine Manual (USAF), 357

Baskir, Lawrence, 384

Battle of Daido, 489-500, 501, 502-10

Bay Den, 160

Bay of Pigs invasion, Cuba, 140

Bay Vien, 108, 109

Berlin Wall, 140

Berry, Sid, 189-90, 192, 247, 290

Bidault, Georges, 72-73, 75-75, 82

Bigart, Homer, 158

Bigeard, Marcel, 43

Binh Xuyen (mafia), 108, 109

Bizard, Alain, 69

Black Power movement, 526

Blaufuss, Phil, 658

Bob Hope's Christmas in Vietnam show, 286

Boccia, Frank, 397

bombers and bombing

B-52 bombers, 255, 428-29, 472, 615,

616, 650-56

bombing Hanoi during peace negotiations, 649–63, 669–70

in Cambodia, 551-52, 556-58

civilian casualties, 280-81, 303-4,

305, 322–23, 374–76, 517–18, 662 futility of bombing, 378

Ho Chi Minh Trail, 229–30

limitations of bombing, 322, 329,

472 - 73

pilot stress and challenges, 650-51

resolution to start bombing, 208

Russian ship hit by US bomber,

337-38

for untroubled killing, 24, 323

US bombing rallies citizens of North

Vietnam, 358-59

Walleye TV-guided bombs, 336, 356,

367

See also Rolling Thunder Operation

Bonville, George, 290-91, 296, 300

booby traps, 302-5, 397

Boomer, Walt, 274, 392, 393, 394,

401–2, 405–6, 605–6, 612, 752

Boxer (carrier), 71

Braestrup, Peter, 460, 525

Brannigan, David, 469

Breen, Phyllis, 711

Brewster, Kingman, 383

Brinks Hotel explosion, Saigon, 232

Britain

domination in Malaya, 143

fear about China and Hong Kong, 75

refusing involvement in Vietnam,

72-73, 91, 231

and Soviet interest in Laos, 129

and US troops in Indochina, 143-44

British and Indian troops in Vietnam, 14

Broughton, Jack, 337-38, 347

Brown, Archie, 749

Browne, Malcolm, 168

Bruggeman, Dave, 608-9

Brunbrouck, Paul, 68

oranoroach, radi, o

Bryan, Harold, 303

Buchwald, Art, 468

Buckley, James, 646-47

Buckley, Tom, 464-65

Buddhists Carey, Arthur, 536 demonstrations, 166-70, 205-6, Castries, Christian de, 43, 50-51, 55, 225-26, 231, 241, 318 61-65, 73-74, 77-81 Catch-22 (Heller), 430 as scapegoats, 318 Catholic Vietnamese Bui Diem, 200 and Buddhists, 166-67, 360 Bumgardner, Ev, 113, 226-27 choosing to live in South Vietnam, Bundy, McGeorge "Mac" concern for troops, 262 96, 120 on deterioration of US position, and communists, 101-2, 232, 462, 623, 688 demanding right to migrate south, recommending US escalation, 242 resolution to start bombing, 208 Diem's favoritism toward, 114, 115, on threatening use of nuclear weapons, 140, 166 328 urging LBJ to include Congress in massacre of, 191 as means for North Vietnamese to decision-making process, 244-45 Bundy, William, 229-30, 230-31, defect, 564, 721-22 See also Diem 329 - 30Central Office for South Vietnam. See Bunker, Ellsworth, 380, 561, 607 COSVN Burney, Linwood, 526 Chaisson, John, 295, 458, 465, 468, 469 Burns, Ken, xxiii Chalamont, 68 Bush, George W., 384 Butler, James, 497, 499, 507 charismatic leadership, 12, 18 Charton, Pierre, 30-31 Bystran, Sharon, 271 Cheatham, Ernie, 452 Calhoun, John, 591 Cherry, Fred, 347-48, 670 Chervenak, Michael, 410 Calley, William, 520-21, 585 Chiang Kai-shek, 14-15 Cambodia Khmer Rouge, 555-58, 690, 708 aid and advisers for North Vietnam, NVA soldiers in, 558 364, 371-74 US-ARVN incursions, 558-61 American détente with, 598-99 US bombing in, 551-52, 556-58 as collaborators in occupation of Campbell, Dan, 306 Vietnam, 14-15 Campbell, Denis, 479 Camper, William, 611 Cultural Revolution, 414, 511 at Geneva Conference, 83, 84, 87 Cam Ranh Bay, 289 the Great Leap Forward, 120 Cao Bang, fall of, 30-31 and Le Duan, 150-51, 182 Cao Van Vien, 313, 693 Capodanno, Vincent, 402 Mao Zedong's ruthless oppression, 28 seizure of South Vietnam's Paracel Cappelli, Charles "Cappy," 339 Islands, 683 Caputo, Phil, 246-47, 271-72, 275, 290, and Soviet Union, 120, 369-70 394, 395-96 support for NVA, 438, 603

Caravelle Manifesto, 124-25

support for Vietminh, 14-15, 26, 43, South Vietnam's people learning 48, 82, 85-86, 87 meaning of, 730 withdrawing aid from North Vietnam, Soviet Communist imperialism, 146 Stalinism, 13, 101, 103, 125, 182, See also Mao Zedong 421-22 Chinh (Nguyen Thi Chinh), 96-97, US fears of spread to Indochina, 102, 111-12, 728-29 33-35, 66-67 Chivers, C. J., 408 See also Party Central Committee; Christian Science Monitor, 468 Vietminh Christmas in Vietnam show, Bob communists Hope's, 286 atrocities, 23, 39-40, 43, 187-88, 412 Church, Frank, 264 awe at wealth of goods in Saigon, 724, Churchill, Winston, 35, 72, 75, 76 gathering the spoils of war from South CIA (Central Intelligence Agency), 135 CIA intelligence information cable, 705 Vietnamese, 731 civilian casualties propaganda, 9 Christmas bombing of Hanoi, 662 savagery as weapon, 152-53 promiscuously broadcast ordnance, shaming and cruelty with a purpose, 322 - 23of SEAL Swift Boat patrols and torturing US pilots, 350-51 massacres, 566-67 Conein, Lucien "Lou," 93, 108, 156, 174, of US bombing, 280-81, 303-4, 305, 175-78, 199 322-23, 374-76, 517-18 Conlee, Bill, 659-60 Clark, Robert, 660 Constellation (carrier), 217, 220 Clay, Lucius, 573-74 Cooper, Chester, 173, 257 "cleansing" campaign of Vietminh, 39 Cooper, Doug, 255 Clifford, Clark, 262, 485 Cornwell, Phil, 507 Clinton, Bill, 383 corpsman (medic), 400-401, 403, 498 Clodfelter, Mark, 332, 660 corruption Cochinchina, Vietnam, 2, 17 overview, 312-15 Cogne, René, 46, 48, 59, 68–69, 78–80 of Diem, 116, 119-20 Colby, William "Bill," 115, 135, 137-38, paying for lighter prison time, 415 140, 169, 213-14, 565 US complacency, 313-14 Cold War, 124, 142, 181 US grasps at justification for bombing Collins, Joseph "Lightning Joe," 109 policy, 322-26 COSVN (Central Office for South Comer, Andrew, 272-73 Commercial Import Program (CIP), 312 Vietnam) communism chronic disease among senior cadres, and Ho, 7, 12-13 land redistribution as incentive, directive for pragmatism, 525 38-40, 49, 73-74, 115, 123, 125, directive for savagery, 282 239, 730 discussions about Tet Offensive. Mao Zedong advising Vietminh, 28 434-37

COSVN (Central Office for South Dawkins, Peter, 276 Vietnam) (cont.) Deak & Company, Hong Kong branch, headquarters, 427 de Castries, Christian, 43, 48, 50-51, 55, and Le Duan, 27-28, 104 61-65, 73-74, 77-81 ordering coordinated uprisings, 123-24 Decent Interval (Snepp), 727 Defense Advanced Research Projects Tet Offensive II, as suicide squads, Agency (DARPA), 142 488-89 Defense Intelligence Agency, 334 Thanh appointed as chief, 223 Vietcong frustration with, 123 defoliation program Agent Orange, 142, 196, 271, 309-10, co tuong (Chinese war game), 193 coups defoliation of South Vietnam peasants' AFC replaces Huong with Khanh, 241 against Big Minh, 199 crops, 325 chaos created by, 119, 206, 231-32, napalm, 63, 157, 243, 330, 398, 497, 248 - 49de Gaulle, Charles, 14, 17, 21, 172-73, against Diem, 170-71, 173-80 Khanh replaced with Phan Huy Quat, 203, 248 245 - 46de Lattre de Tassigny, Jean, 35 Demilitarized Zone (DMZ) Le Duan's plans for, 238 electronic and explosive barrier for, Crane, Conrad, 384-85 Creaven, James, 586 322 Creswell, Carl, 519 establishment of, 104 Cronkite, Walter, 470, 483-84 Huev rescue, 608-9 North Vietnamese missile defenses Cuban Missile Crisis, 145-46 cultural clashes between US advisers and south of, 620 Vietnamese, 138-40, 298 search for downed pilot in, 608 US bombing slightly north of, Daddis, Greg, 137 594 Daido, 489-500, 501, 502-10 US Marines combating NVA divisions, 490-91, 492-500, Daily News (Washington newspaper), 409 502 - 10US Marines looking for North Dai The Gioi, Cholon, 108 Vietnamese, 405-6 Dalat Military Academy, 138-39 Danang, 246, 605-6, 703 Dengler, Dieter, 355-56 Dang Thuy Tram, 420-21, 432-33, 516, DePuy, William, 208, 211-12, 241, 560-61 295-96 Dao An Tuat, 558 DEROS (Date Estimated Return from d'Argenlieu, Georges Thierry, 14, 18 OverSeas), 404 DARPA (Defense Advanced Research DESOTO mission, 215-18 Destatte, Bob, 134, 454, 687, 748 Projects Agency), 142 Davidson, Phil, 449, 524-25, 556, diary of a communist revolutionary, 559 420-21, 432-33

Diem (Ngo Dinh Diem) Doyle, Bill, 586-91, 592 and American journalists, 157-58 draft and draft dodgers, 381-82, biographical info, 105-7, 113-14, 115 383-85, 522 Colby's opinion on, 140 drought and floods of 1944, 8-9 corruption of, 116, 119-20 drug trafficking, 312, 526-27 defeat of Binh Xuyen, 109 drug use by US soldiers, 382, 526-27, inability to govern effectively, 107, 529, 585-87, 591-92 108-9, 133-34, 137, 169-70 Duffy, John, 614-17 and Lansdale, 107-8 Dulles, John Foster losing credibility, 166, 167 asking Britain for air support for and partition, 88, 90-91 French war, 74-76 as president and head of state, 109, and Diem, 109 disdain for Britain, 72 and US policies, 109, 112-14, 170-71, and Geneva Conference, 83, 88 173 - 80supporting France's Vietnam War, 46, US support for, 130 67, 69-71, 72-73 Dienbienphu, Vietnam Duong Quynh Hoa, 560 overview, 45-46, 48, 55 Duong Van "Big" Minh, 175, 199-200, commander de Castries, 48 fall of, 78-80 Duong Van Mai, 25, 99-100, 114, 132, French choose as battlefield, 44 149, 283, 312, 321 French occupation of, 46-48 Dupont d'Isigny, Paule, 43 French POWs, 80-81 Durbrow, Elbridge, 124-25 map of, 57 Operation Condor by French, 78 Eden, Anthony, 72, 75, 84–85, 90 Vietminh siege, 53-65, 67-72, 73-74, Edwards, Peter, 543 77 - 78Edwards, Reg, 269, 301, 302 Vietminh siege preparations, 48-53 Eiland, Mike, 128, 283, 297-98 Dietrich, Erik, 186 Eisenhower, Dwight D. Dinh (Nguyen Hai Dinh), 97, 564, briefing JFK, 127 721-22 domino theory of spread of Dinh (Pham Van Dinh), 611 communism, 75 DMZ. See Demilitarized Zone on Johnson's abdication, 486 Doan Phuong Hai, 1-2, 92, 100-101, support for France's Vietnam War, 35, 201, 251, 614 66-67,76Do Cai Tri, 577 elephant meat feast, 423-24 Dodson, Jerry, 483 Elliott, David, 132, 613, 751 Dong Ha Bridge, US destruction of, Elliott, David and Mai, 179, 195, 239, 610-11 276, 322-23, 456 Dong Khe, fall of, 30 Ellsberg, Daniel, 207, 598, 745-46 Dooley, Tom, 97 Ély, Paul, 67 Do Thi Thu, 362 Enterprise (carrier), 342 Doucette, Norman, 498 Essex (carrier), 71

Estocin, Mike, 353–54 Etherington-Smith, Gordon, 200 Ewell, Julian, 388–89, 518, 536

Faas, Horst, 301
Fall, Bernard, 25, 76–77, 99, 172, 386
famines in North Vietnam, 9, 15,
148–49, 737
Faure, Edgar, 107
Felletter, Vince, 388, 396, 399, 400
Fellman, Michael, 306
Fichtl, Ted, 305–6, 310–11
Finlayson, Andy, 394, 401, 403–4, 419,
565, 570–71

First Indochina War, 25, 53–54, 83–88, 90. *See also* France's Vietnam War

Fisher, Roger, 322
Fitzgerald, Frances, 166, 265
Fitzgerald, Joseph, 268–69
floods of 1944, 8–9
Ford, Gerald, 686, 701
Ford, Richard, 289
Foreign Relations Committee, 266, 267,

316, 571–72
Forrestal (carrier), 342, 343–44

Fosdick, Raymond, 34 foxholes, digging, 402–3

fragging, 528-29, 531, 542, 587

France's Vietnam War ("the dirty war") overview, 21, 41–43

China backing Vietminh, 14–15, 26, 43, 48, 82, 85–86, 87

continuing after capitulation at Dienbienphu, 85–86

foreigner soldiers fighting for France, 25, 29, 30–31, 59, 61, 63, 67–68, 77–80

French atrocities, 23–26, 28–29 Frenchmen left behind at end of, 99 French overwhelmed, 26–27, 30–32 French successes, 29, 31

Geneva Accords, 90-91, 129-30

Geneva Conference, 82–90 indecisiveness in France, 45 ineffective fortifications, 42–43 POWs and casualties, 30–31, 61–62, 80–81, 99 preordained outcome, 81–82 US paying for, 32–36 Vietminh atrocities, 23, 39–40, 43 Vietminh successes, 29–32, 41, 42–43

See also Dienbienphu

Franklin, Rob, 538–39, 599–600 Freemantle, Andrew, 531, 537, 540, 541, 565

565
French Indochina, *xvi*French occupation of Vietnam overview, 1 addictions to opium and leisure, 4–5 departure of French, 92, 116 end of, 91–92 as means to recover from WWII, 16 ruthless takeover and rule, 2, 3–5, 7, 8, 16, 19–20, 28–29
Vietnamese resistance, 5–8, 9–10, 14, 22–23

See also France's Vietnam War friendly fire, 300–302, 322–23, 478 Fromson, Murray, 470 Fulbright, William, 34, 380, 470

Gaucher, Jules, 51, 58
Geneva Accords, 90–91, 129–30, 143–44
Geneva Conference, 82–90
George, Alex, 142–43
Geraci, "Mal Hombre," 518
Gia Long, Emperor, 2
Giap (Vo Nguyen Giap) on death, 13
diminished influence of, 149, 291–92
disciplinary action for attack on Maddox, 222–23

formation of Liberation Army, 11 and Frenchmen, 18 and Ho. 8, 82 in Hungary, 436-37 332 leading 60,000 soldiers in Vietnam War with France, 29-32 strongholds, 19 and Liuzhou conference, 87-88 on North Vietnamese policies, 100 337-38 opposition to Tet Offensive, 436-37 258, 329, 334 ordering offensive for final victory, 685-86, 695, 697, 701, 702-4, 716 - 25Red River Delta offensive, 85-86 seizing Nghia Lo, 43 success of, 82 See also Dienbienphu, Vietnam; Vietminh Gibson, Carl, 496 Giong Dinh outpost VC attack, 279 - 80Goodpaster, Andrew, 203 Goscha, Christopher, 26 Gouré, Leon, 323-26 government of Vietnam, xxi-xxii Hardwick, Bill, 399 Gracey, Douglas, 14 Graham, Don, 383, 412, 738 Graham, Stuart, 537-38 163, 165, 176 Grauwin, Paul, 78 Harper, Ron, 457 Gray, Al, 135-36, 190, 748 Green Berets. See United States Army Special Forces 603 - 4Greene, Graham, 32 Greene, Wallace, 201-2, 207, 212, 226, 257 Harston, Julian, 563 Groupement de Commandos Mixtes Aéroportés (GCMA), 22 Hasluck, Paul, 276 Guam, 651 Guilin Long, 371–72

Hai Chau, 41 Hai (Doan Phuong Hai), 1–2, 92, 100–101, 201, 251, 614

Haig, Alexander, 578, 582, 598 Haiphong Harbor, Hanoi firing at US bombers from ships in, French bombardment of Vietminh Russian ship hit by US bomber, US debate about mining or closure, US evacuation of North Vietnamese, US mining approaches to, 630 Halberstam, David, 130, 156, 157, 163-65, 167-68, 230, 253 Haldeman, H. R., 551 Hallock, Richard, 409 Halyburton, Porter, 348 Hamburger Hill, 521-22, 553 Hammond, William, 480 Hancock (carrier), 346 Hanoi, 414. See also North Vietnam "Hanoi Hannah," 492 Haponski, William, 514 Hargis, Billy James, 380 Harkins, Paul, 131-32, 146, 157-58, Harriman, Averell, 129-30, 170-71, 318, 336, 487, 510-11, 553-54, Harrington, Myron, 466, 475, 485 Harrison, John, 306, 454, 466-67 Harwood, Richard, 391 Hastings, Max, xviii-xix Hate America Month, 319 Hathcock, Carlos Norman II, 306-7 Hawkridge, Cornelius, 314 Hayden, Tom, 382-83

Hedren, Tippi, 729

helicopters, mainly "Hueys"	as voice of legitimacy for Vietnamese,
overview, 544-45, 548, 549, 608	116
air assault onto a hot landing zone,	See also Vietminh
395–96	Ho Chi Minh Trail
battalion commanders hovering over	Abrams orders for destruction of,
battles in, 399-400	573–74
dust blowing from, 271	map of, 237
Hickman's story, 545-50	North Vietnamese troops on, 119-20,
losses per month, 514	129–30, 232–36
peasant vs. enemy determinations,	secret bombing of, 229-30
280-81	and Tet Offensive, 439, 440
for pilot rescue, 354-55	US monitoring system for, 190
TV clip of Huey in action, 163	US plan for electronic, explosive
and VC attack of US Embassy in	barrier, 322
Saigon, 457, 458	Hoeffding, Oleg, 377
VC attacks against, 161, 278	Hoffman, Roy, 570
Heller, Joseph, 430	Holcombe, Robert, 381–82
Henrico (troop transport), 246	Holden, William, 728, 729
Hepplewaite (dignified CO with his	Holloman, Emmanuel, 302
pants down), 540-41	Hong Kong, 75
heroin abuse, 526	beginning of Indochinese Communist
Herrick, John, 215, 216, 218-19	Party, 7
Hersh, Seymour, 517-18	Hong Kong for R&R, 547
Hervouet, Yves, 79	Hope, Bob, 286
Hickman, Dan, 545-50	House, Charles, 295
Hilsman, Roger, 140	House 7 radio station, 278
Hitler, Ky's admiration for, 315	Hovey, Joseph, 438-39
Hoang Xuan Lam, 319, 576, 577, 580,	Howard, Michael, 142, 262
606–7	"How the US Can Win" (Waters), 326
Ho Chi Minh	Hudson, Don, 526-27
in Beijing for rest during Tet planning,	Hue
436	devastation in, 478
biographical info, 5-8, 82	map of, 477
charisma, 12-13, 18	NVA seizure of, 689, 691, 699
death of, 554	Quoc Hoc high school, 6
and Diem, 106	Tet Offensive attacks, 448–53,
dwindling influence of, 182	474–76, 478–80
as figurehead, 149	US Marines fighting NVA at citadel,
forming a Vietnamese state, 11, 12–13	475–77
in France for "peace" talks, 17–18	Hughes, Ken, xxiii
on French war tactics, 47	Hughes, Richard, 164-65
life in North Vietnam, 102-3	Hull, Milton, 493–94, 496, 503, 505,
ruthless about human lives, 13	506–7, 509–10

Humphrey, Hubert, 109, 245 hunger of NVA soldiers, 423–24 Hung (Pham Hung), 359, 360 Hunt, Harold, 304, 530 Huntley, Chet, 464 Huong (Tran Van Huong), 227, 241 Huu Nghi Quan (Friendship Pass), 371–74 Huy (Nguyen Duc Huy), 41–42 Huynh Cong Than, 462, 488–89, 720

Ia Drang Valley SF camp, 283–86
ICC (International Control
Commission), 92, 99, 129, 151, 334

Independence (carrier), 342 independence from France and Japan, 11–12, 15

Indochinese Communist Party, 7 International Control Commission, 92 International Control Commission (ICC), 92, 99, 129, 151, 334

(ICC), 92, 99, 129, 151, 334 Iron Triangle, 195 Isaev, Pyotr, 369 Iwo Jima (assault ship), 493, 496–97

Jacobson, George, 458–59 Japan, 8, 10–11 JCS (Joint Chiefs of Staff), 129–30, 201–3, 209–12, 261, 264–65, 338, 377–78, 389

Johnson, Doug, 184 Johnson, Harold, 249, 257, 283, 296 Johnson, Julius, 397

Johnson, David, 527-28

Johnson, Lyndon Baines (LBJ) abdication announcement, 486, 511 biographical info, 198, 230 on coup against Diem, 176

creating illusions about Vietnam War, 244–45, 248

election concerns keep Vietnam War going, 198–205, 206–7, 224, 226 escalating Vietnam conflict, 259–65, 326–27
fears and uncertainties, 378
Great Society legislation, 224
landslide victory over Goldwater, 227
loss of faith in Westmoreland, 465
on *Maddox* attack by North Vietnam, 219, 220
and McNamara, 267

and McNamara, 267 offering a bribe to North Vietnamese, 253–54

253–54
and peace proposals, 337
post-Tet Offensive speech, 485–87
as POTUS, 180, 203
reaction to Kennedy Round Table, 141
replacing Lodge and MACV
commander, 208–9
seeking allies for Vietnam War,
230–31
strategic plan of, 258–65, 266

strategic plan of, 258–65, 266 talking to reporters, xviii–xix target selection for Rolling Thunder, 330–34 in Vietnam, 320

on Vietnamese leaders, 107, 130, 139–40, 176 on Vietnam War, 197

warning Ky and Thieu, 316 Joint Chiefs of Staff (JCS), 129–30, 201–3, 209–12, 261, 264–65, 338, 377–78, 389

Joint US Public Affairs Office (JUSPAO), xxi Jones, Joe, 496

Jordan, Elmore, 547–48 journalists, 301

overview, 155–58, 159, 204 on Ap Bac attack, 164–65 aversion to racism of US soldiers, 158–59

bias against South Vietnam, 165 deaths, 386 freedom to roam in Vietnam, xxi journalists (cont.) loading bodies and getting shot at, 158-59, 163, 301 post-Tet Offensive, 468, 479-80 skepticism about administration's claims, 243 and VC attack of US Embassy in Saigon, 457-58, 459, 460 on Vietminh siege at Dienbienphu, 62 See also individual journalists

Kattenberg, Paul, 110 Katzenbach, Nicholas, 255 Kellen, Konrad, 325 Kelly, Bob, 134-35, 449, 478 Kennan, George, 316 Kennedy, Edward, 380 Kennedy, John F. assassination of, 180, 184 Bay of Pigs invasion, 140 and coup in South Vietnam, 170-71, 175, 178-79 debate about advisory role vs. combat units, 136-38 Eisenhower's briefing, 127 inaugural address, 210 Lodge acts to unseat Diem, 170-71 reelection concerns, 171, 172, 180-81 and Vietnam, 130 visit to Vietnam during France's war, Kennedy, Robert, 139, 326 Kerrey, Bob, 566-70 Khanh (Nguyen Khanh), 199, 200-201, 204, 205-6, 224, 226-27, 241-42 Khe Sanh attack as Tet Offensive distraction, 440 - 43

NVA persistence in face of bombardment, 472-73 post-Tet belief in importance of, 469-70, 471 Khiem, Nghien, 687

Khiem (Nghien Khiem), 414, 710, 738, Khmer Rouge, 555-58, 690, 708 Khrushchev, Nikita, 103, 140-41 Kien (Nguyen Dinh Kien), 363, 367, 656-57, 751 Killen, James, 528 kill ratio, 393, 517, 680 King, Martin Luther, Jr., 380 Kinne, Judd, 290 Kislitsyn, Yury, 364, 369 Kissinger, Henry announcing US withdrawal, 599 attempt to create peace in Vietnam, 679 biographical info, 550-51 erroneous assumptions about Russia, 551-52 grasp of the situation, 686-87 on keeping faith with those who relied on the US, 517 on Lam Son 719 aftermath, 582-83 on Lavelle scandal, 596 and Le Duc Tho/peace negotiations, 621, 640-44, 648 on masochism of American intellectuals, 381 and Nixon, 644-56 on Nixon, 573 and Nixon's resignation, 674-75 and Nixon talking about ending the Vietnam War, 597 Nobel Peace Prize, 675 positioned as nation's deliverer, 647 on possible Paris agreement violations, public speaking about ending the war, 646 secret negotiations with North Vietnamese, 553-54, 556, 597 and Thieu, 644

Kissinger peace initiative, 339, 603-4,

640 - 42

Kittyhawk (carrier), 246 Laos Klein, Henry, 276 overview, 127-29 Knight, Richard, 587 neutralization pact, 129-30, 172 Koltes, Jim, 246 Vietminh in, 43 Komer, Robert "Blowtorch," 293, 320, See also Ho Chi Minh Trail 389, 513, 514 Lashley, James, 491 Korean War, 33-34, 35 Lavelle, Jack, 594, 595-97 Kosygin, Alexei, 242 Layton, Gilbert, 213 Krock, Arthur, 164, 243 Leclerc, Philippe, 18 Krohn, Charles, 453-54 Ledoux, Jerry, 405 Krulak, Victor "Brute," 131 Le Duan Ky (Nguyen Cao Ky) on Americans fortitude, 281 on Americans' insensitivity, 280, 316-17 biographical info, 27, 117-19 biographical info, 12-13, 42, 110-11, call to arms to protect South 256-57 Vietnamese communists, 117 on bombing temples of Hue to kill and China, 182, 224, 371, 563 VC, 474 death of, 737-38 and corruption, 313, 315 as driving force for reunification, on damage caused by violent 125 - 26photograph, 467 as leader of North Vietnam, 149-50, elections, 319-20 182-83, 435-36, 554 obfuscations, 317-18 and Mao's desire to ignore Russia, as prime minister, 256 as puppet of US, 320-21 marriage to Nga, 27-28, 104, 118-19 sacking Thi of Hue, 317 on northern operations, 703 and Tet Offensive, 456 and offensive to expose debility of and Thieu, as leaders in South Thieu regime, 601-2, 601-18 Vietnam, 227, 245-46 staying in South Vietnam, 104 Tet Offensive as political victory, Lacouture, Jean, 421-22 486 - 87Lair, Bill, 128 and Tet Offensive plans, 435-38 Laird, Melvin, 550 Le Duc Tho, 117-18, 121, 194, 434-35, Lam (Hoang Xuan Lam), 319, 576, 577, 604, 621, 640-41, 646 580, 606-7, 620 leeches, 269, 372, 397 Lam Son 719 operation, 574-83 LeMay, Curtis, 201-2, 203-4, 207-8, land redistribution, 38-40, 49, 73-74, 328, 357 Le Minh Dao, 703

Lennin, Wayne, 700

Le Page, Marcell, 30

Le Thi Thu Van, 712

Liberation Army, 11

Lind, Michael, 33

Lewis, Norman, 4, 23-24, 93

115, 123, 125, 239, 730 Langlais, Pierre, 47, 51, 56-57, 60, 63-64, 68, 79 Lang Son, fall of, 31 Laniel, Georges, 86 Lansdale, Edward, 107-10, 112, 113, 130-31, 144, 319

Linebacker, 630, 631, 632
Linebacker II, 649–63
Linebacker II Operation, 649–63, 669–70
Linebacker Operation, 630, 631, 632
Lippmann, Walter, 83, 173, 247
Liuzhou conference, China, 87–88. See also Geneva Conference
Livingston, Jim, 503–6, 508–9, 609, 703
Loan (Nguyen Ngoc Loan), 318–19, 467
Lodge, Henry Cabot biographical info, 169 coup against Diem, 170–71, 173–79 on Ky's incompetence, 317–18

return to South Vietnam, 258 Logevall, Fredrik, 17 Los Angeles Times, 647 Luce, Henry, 33, 109 Ly Tong Ba, 162, 165, 618 Ly Van Quy, 732–33

M16 (automatic weapon), 398, 406, 408-11, 499, 502, 506-8, 731 M60 machine gun "pig," 398 Macmillan, Harold, 129, 143-44 Macpherson, Harry, 259 MACV (US Military Assistance Command Vietnam) aircraft used by, 340-41 closure of, 679 credibility gap analysis, 750 failure to recognize Diem's ineffectiveness, 169-70 and flight campaign, 340-42 leaflets airdropped, 271 lies from, xxi lying to and misleading journalists, 156-57, 158 on NVA 1972 offensive, 602 offensive in Mekong Delta, 198-99 plan for American troops, 253

post-Tet Offensive chaos, 463-64 and Tet Offensive attack of US Embassy in Saigon, 457-59 Tet Offensive response, 465-68 Madagascar, 16 Maddox (destroyer), 215-17, 218-19, 221, 222 Magrath, Brian, 586 Making of the President 1964 (White), Malaya, British domination of, 143 Malnar, "Big John," 498, 508 Mankiewicz, Joseph, 111 Mansfield, Mike, 106, 208, 228, 243, 262-63, 266, 267 Mao Zedong advising Vietminh on establishing a communist society, 28 civil war triumph, 87 and Geneva Accords, 91 on Laos, 128-29 support for North Vietnamese, 26, on Vietnam War escalation, 223-24 See also China maps, list of, xv. See also specific maps marijuana use, 382, 423, 526 Marines. See United States Marine Corps Marlantes, Karl, 522 Martin, Duane, 355-56, 714 Martin, Graham, 682, 695-96, 708-9 Mary Ann, 585-93 massacre of Vietnamese at My Trach, by French, 24 Mastrion, Robert, 492-93 Matthias, Willard, 204-5 McCain, John, 574-75, 671 McCarthy, Eugene, 221, 265, 470-71 McCarthy, James, 649 McCarthyite effect, 34, 66-67 McClendon, Sarah, 464 McCone, John, 245 McConnell, John, 376-77

McDaniel, Norm, 348-51, 670-71	media
McDonald, David, 262	effect of war images on television,
McGee, Barry, 590	xx–xxi
McGhee, Marion, 275	House 7 radio station, 278
McIntire, Carl, 380	lack of faith in military
McKay, Ed, 590	pronouncements, 391
McMaster, H. R., 244, 743	and mutilation of enemy dead, 401
McNamara, John, 382, 402, 412, 482,	post-Tet Offensive reporting, 464-65,
485	468–69, 470–71, 483–84
McNamara, Robert	See also journalists
on ammunition requisitions, 748	Medina, Ernest, 519, 520
on attacking China, 243	Meinheit, Hal, 314-15, 682
and Ball's memo on exiting Vietnam,	Mekong Delta region
228–29	fighting in, 418
biographical info, 145-46, 147	French reoccupation in 1946, 16
briefing Lodge, 258	MACV offensive, 198–99
on chaos in South Vietnam, 206	post-Diem's death, 181-82
convert to futility of bombing, 378	US training local defense forces,
on expected duration of Vietnam War,	185–86
132	Mendès-France, Pierre, 86
fact-finding mission in Vietnam,	Menzies, Robert, 276, 533-34, 543
174–75	Messmer, Pierre, 14
on futility of US effort, 287	Meyer, John, 661-62
and Gouré, 324-25	Midway (carrier), 717-18
on Khanh, 205	MiGs, 335-36, 338-39, 344-46
and LBJ, 267	Military Assistance Command Vietnam.
and LBJ's refusal to mobilize reserves,	See MACV
261–62	Miller, Bob, 24-25
No Committee on bombing missions,	Miller, Roger, 286
336–37	Miller, Wayne, 405
offending Vietnamese, 141–42 promoting military force, 219–21, 265	Miroshnichenko, Valery, 365, 368, 371, 656
reporting to members of Congress,	Molotov, Vyacheslav, 54, 86
241	Momyer, William, 325, 332-33, 335,
responding with force to bogus attack,	663
219	Monnerville, Gaston, 16
on strikes to the North, 227	Moorer, Thomas, 594
on US escalation, 204, 244	Moroccan soldiers fighting for France, 25
on US in Vietnam, 146	Morrison, Norman, 283
"McNamara Monarchy, The" (Baldwin),	Morse, Wayne, 204
147	movie career of Nguyen Thi Chinh,
McNaughton, John, 205, 212, 292	111–12
Meacham, James, 439	Moyers, Bill, 486

Mundt, Karl, 314 mutilation of enemy dead, 401 My Lai massacre, 518–21, 585, 744 My Phuoc Tay NLF training base, 153

Nam Kinh, 152 Nam Ky insurrection, 8 napalm, 63, 157, 243, 330, 398, 497, 744 National Liberation Front (NLF) overview, 194-95 advisers remain in background, 280 on all-out US engagement, 267 credibility gap, 196-97 deployed in Iron Triangle, 195 infiltration in Saigon, 415 rebranding for western acceptance, toppling Diem's government, 169-70 US and ARVN attempts to destroy HQ, 426-27 See also Vietcong National Security Council (NSC), 71,

National Security Council (NSC), 71, 107, 176, 206, 243, 551–52. See also Bundy, McGeorge "Mac"

National Security Memorandum (NSAM) 288 of the NSC, 206

Navarre, Henri, 44, 46, 68–69. *See also* Dienbienphu

Navy. See United States Navy

Nazism, 8, 26

Nelson, Bob, 299-300, 302, 304-5

New, David, 204

New Economic Zones, 733

Newman, Jim, 547–48

New York Times, 471, 482

New Zealand

refusing involvement in Vietnam, 230–31

troops in South Vietnam, 277, 533, 536, 540

Nga (Le Duan's wife), 27–28, 104, 118–19

Nghien Khiem, 414, 710, 738, 746

Ngo Dinh Diem. See Diem

Ngo Dinh Ho, 418

Ngo Dinh Nhu. See Nhu

Ngo Quang Truong, 620, 697, 700

Ngo Thi Bong, 432, 449, 451, 623, 710–11

Nguyen Cao Ky. See Ky

Nguyen Chanh Thi, 317, 318

Nguyen Chi Thanh, 223, 435-36

Nguyen Cong Hoan, 734

Nguyen Cong Luan, 28, 174, 605, 710, 723–24

Nguyen Dinh Bao, 614

Nguyen Dinh Kien, 363, 367, 656–57, 751

Nguyen Duc Huy, 41-42

Nguyen Duong, 4, 96

Nguyen Duy Hinh, 580, 581

Nguyen Hai Dinh, 97, 564, 721-22

Nguyen Hien, 363

Nguyen Huu An. See An

Nguyen Khanh, 199, 200-201, 204,

205–6, 224, 226–27, 241–42

Nguyen Ngoc Loan, 318-19, 467

Nguyen Quoc Si, 680, 722, 732, 733

Nguyen Tai, 668

Nguyen Tat Thong, 479

Nguyen Thanh Binh, 39, 657

Nguyen Thi Chinh, 96–97, 102, 111–12, 728–29

Nguyen Thi Ngoc Toan, 42, 81, 101

Nguyen Thi Thanh Binh, 37-38

Nguyen Thuy Nga, 27-28, 104, 118-19

Nguyen Tri, 699-700, 738

Nguyen Tuan, 467

Nguyen Van Lem, 467

Nguyen Van Linh, 737 Nguyen Van Moi, 279

Nguyen Van Nhung, 199–200

Nguyen Van Thieu. See Thieu

Nguyen Van Uc, 191

Nguyen Viet Than, 736

Nhu, Madame, 114, 168

Nhung (Big Minh's body guard), 177–78	domestic challenges and Party power
Nhu (Ngo Dinh Nhu)	struggles, 103, 120–21, 123–24
biographical info, 114	elite class, 100
and Buddhists, 167–68, 169, 175–76 Colby's support for, 140	escalation to unification through violence, 119–20
and coup against Diem, 176–78 Diem hanging on to, 170–72	exodus from, during grace period, 96–98
reporting restrictions on journalists,	and fall of Diem, 182
157	famines in, 9, 15, 148-49, 737
Nichols, John, 340, 345, 650	Ho Chi Minh's role, 102-3
night patrols, 405	hunger protesters, 148-49
1966 JASON study (Pentagon), 377	Le Duan's call to arms to protect
Nixon, Richard	South Vietnamese communists, 117
approval rating after Christmas bombing, 670	liberated zones in war with France, 40–41, 42
bombing Hanoi during peace	life in, 98–99, 118–19, 359–64,
negotiations, 649–63, 669–70	368–71, 372–74, 420–29
bombing in Cambodia, 551–52	military delegation to South Vietnam,
Congress seeks to end funding for war,	675–76
561–62	mistrust of Americans after Tet
and Kissinger, 644-56	Offensive, 489
not a quitter, 514, 515-16, 561	people's total support for the war, xxii
and POWs, 571, 582-83	propaganda, 9, 360, 375, 382
prospects of victory, 515	and Russia-China conflict, 120
reelection considerations, 582, 597, 604	South Vietnam compared to, 95 support for Vietcong, 124–25
resignation, 674	US bombing rallies citizens, 358–59
searching for ways to end the war,	Vietnam War with France, 29-32
550-55	North Vietnamese Army (NVA)
troop drawdowns fraud, 553-54	overview, 389
Nixon Tapes, The (Hughes), xxiii	atrocities, 412
NLF. See National Liberation Front	attacking newly-arrived US soldiers,
No Committee on bombing missions,	283–86
336–37	attacking US special forces camps,
Nolan, Jack, 351-54	295, 471
Nolting, Frederick "Fritz," 141, 180	and Australians, 535
North Korea, 749	chronic diseases of soldiers, 471-72
North Vietnam	claiming victory at Daido, 509
collectivization and institutionalized humiliation, 99–102	continued fighting post-Paris Accords, 683–84, 688
demonization of the United States,	crippling losses, 418
99	divisions in South Vietnam, 490
discrediting Diem, 171-72	elephant meat feast, 423-24

North Vietnamese Army (NVA) (cont.) Nixon's threats, 552 Firebase Mary Ann attack, 587-91 life as a soldier, 423-29 manpower crisis, 563-65 morale of soldiers, 281-82 at Neville hilltop battle, 522-25 offensive for conquest of South Vietnam, 685-86, 691-95 offensive to expose debility of Thieu regime, 601-18, 620-30 private with malaria defects, 424-25 provoking attack in Daido, 494, 504 reconciliation after fall of Saigon, respect for produce of peasants, 417 soldiers awed by wealth of goods in Saigon, 724 soldiers letters home from Ho Chi Minh Trail, 278 spontaneous executions separate from politburo, 729-30 strategies, 291 Tet Offensive losses, 471-74, 480-82 and US bombing of Cambodia, 561 on US escalation, 291 US Marines combating NVA divisions in DMZ, 490-91, 492-500, 502-10 and Vietcong, 291-92 weaponry, 223, 606 See also SAM sites in North Vietnam: Tet Offensive; Vietminh North Vietnamese Offensive of 1975, Main Thrusts, 698 Novick, Lynn, xxiii NSC (National Security Council), 71, 107, 176, 206, 243, 551-52. See also Bundy, McGeorge "Mac" nuclear weapons on the table Bundy on threatening use of, 328 China as target, 54 Dienbienphu, Vietnam as target, 67, 75

post-Tet, 470-71 NVA. See North Vietnamese Army O'Brien, Tim, 395, 399, 404 O'Daniel, John "Iron Mike," 43-44 Office of Strategic Services (OSS-US), 10 - 11Olds, Robin, 335-36, 338 O'Neill, James, 494-95 opium, 4-5 OPLAN34-A, 213-14 orangutan carcass, 424 Oriskany (carrier), 343 OSS-US (Office of Strategic Services), 10 - 11

P-38 fighters, 12 Palmer, Bruce, 356, 390-91, 711 Panov, Valery, 365, 366, 369 Paracel Islands, China's seizure of, 683 Park, Daphne, 562 Parks, Hays, 711 partition discussions and enactment, 84-88, 89, 90, 92, 95 Party Central Committee, North Vietnam post-Diem's death, 182 Resolution 9, 183, 194-95 Resolution 15, 119-21 Thanh appointed chief of COSVN, 223 and US air attacks, 222-33 See also Tet Offensive Pathet Lao, 128-29, 557-58 Patti, Archimedes, 10, 12 Paul Doumer Bridge, Hanoi, 330-31, 338 PAVN (People's Army of Vietnam). See North Vietnamese Army Pentagon Papers, 597-98, 745-46 Péraud, Jean, 62 PF (Popular Forces militia), 195-96

Pham Duy, 319 North Vietnamese success with. Pham Hung, 359, 360 421 Pham Ngoc Thao, 238 Vietminh austerity as, 28-29 Pham Phu Bang, 15, 412, 423 Vietnamese attraction to, 152 Pham Phuong, 362–63 Vietnamese peasants juxtaposed with Pham Thanh Hung, 618-20, 746-47 US power, xx-xxi Pham Van Dinh, 611 Pueblo (electronic surveillance ship), Pham Van Dong, 84, 149, 254, 327, 690 NVA seizure of, 439-40 Pham Van Phu, 692, 694, 703 Pumphrey, Louis, 449 Phan Huy Quat, 245-46 Purcell, Shirley, 307-8 Phan Nhat Nam, 191-92, 225-26 Phan Phuong, 735-36 Quang Ngai Province, Dang Thuy Phan Tan Nguu, 148, 414, 735 Tram's diary from, 420-21, Philippine troops in South Vietnam, 276 432 - 33Phillips, Rufus, 180, 205-6 Quiet American, The (Greene), 32, 111, Phoenix operation, 565-66, 572, 727 112 Phung Thi Le Ly, 105 Quoc Hoc high school, Hue, 6 Phu (Pham Van Phu), 692, 694, 703 Piroth, Charles, 60 racism in US military, 526, 528-32, Pittman, Roger "Doc," 509 529 - 30Pleiku raid, 242-43 Radford, Arthur, 67, 70, 74-76 Polansky, Jonathan, 307 Rahman, Tunku Abdul, 143 Polgar, Tom, 599, 719 Ramsey, Doug Popular Forces militia (PF), 195-96 camp commandant's speech before Potter, John, 301-2 release, 671 Pouget, Jean, 79, 80 capture of, 294 **POWs** on civilian casualties, 280-81 celebrating US B-52 bomber runs, on communism and Vietnamese, 657 265-66, 736 from France's Vietnam War, 30-31, diary on VC attack, 250 61-62, 80-81, 99 on Diem, 133-34, 186-88 Nixon's focus on, 571, 582-83 interrogator asks about Hayden, North Vietnamese camp commandant 382 - 83speech before release, 671 as POW, 351, 419, 422, 664-68 Ramsey as, 351, 419, 422, 664-68 return to Saigon, 687 release of per Paris Accords, 670-72 survey of students in Long An Prescott, Alex "Scotty," 495-96, 505-6 Province, 153 Pribbenow, Merle, 581, 676, 687, 712 on touring the Vietnamese prisoner abuse, 350-51 countryside, 413-14 propaganda on US incursions into Cambodia, of communists, 9, 360, 375, 382 communists' advantage, 741-42 RAND Corporation, 142-43, 239-40, "Hanoi Hannah," 492 283, 321, 323-26, 377

Rash, James, 662 Reagan, Ronald, 739 reeducation camps, 40 Regional Forces militia (RF), 195-96 Reindenlaugh, Chuck, 293, 394 religious faith of US soldiers, 402 reporters. See journalists; media Resolution 9 (Party Central Committee), 183, 194-95 Resolution 15 (Party Central Committee), 119-21 Reston, James, 243 RF (Regional Forces militia), 195-96 Ridgway, Matthew, 67 Ripley, John, 609-11 Roberts, Gene, 480 Robinson, Robert, 498 Rocolle, Pierre, 81 RoE (Rules of Engagement), 594-97 Rogers, David, 290, 386, 393, 398, 400, 404, 747 Rogers, William, 670 Rohweller, Tim, 531 Rolling Thunder Operation overview, 249-50, 328-29, 340, 356-57, 377-78 aircraft, 331, 340-48, 351-56 and Chinese MiGs, 335-36, 338-39, 344 - 46Chinese repairing bridges and railroad in North Vietnam, 371-74 control centers, 342 discussions in Washington, 336-37, enemy casualties, 376 final phase, 339-40 limitations of bombing, 329-30 MACV aircraft, 340-41 North Vietnamese pilots, 346 pilots' love for flying, 340 restrictions on bombing, 330-33 SAM placement in North Vietnam, 332

SAM sites in North Vietnam, 332, 335, 339, 345, 347, 349-50, 353, 356-57 Soviets establishing air defenses in North Vietnam, 364-67, 371 target selection, 330-34, 338, 353 unexpected consequences, 334-35 USAF aircraft and responsibilities, 340-41, 351-56 US expenditures, 376-77 US Navy aircraft and aircraft carriers, 340, 341-48Rostow, Walt, 130, 203, 336, 338 Rowen, Harry, 240, 325 Rubin, Jerry, 379 Rudd, Mark, 383 Rules of Engagement (RoE), 594-97 Rusk, Dean, 34, 137, 212, 263, 287 Russell, Clyde, 214 Russell, Richard, 221 Russia, Le Duan's disdain for, 150, See also Soviets

SAC (Strategic Air Command), 593-94 Saigon overview, 414-15 Binh Xuven street battle with South Vietnamese Army, 109 boom time, 110-16 Buddhist demonstrations, 166-70, 205-6, 225-26, 231, 241, 318 changes related to Americans, 189-91 grenades left in US Embassy, 108 last week as capital, 709, 716-211 North Vietnam final attack, 716-25 and NVA's final offensive, 701 prison inmates' suffering, 415 Tet Offensive attacks, 455-60, 462-64, 469-70 US-established radio station, 278 Vietcong attacks in and near, 230, 232 Salisbury, Harrison, 374-76 Sams, Jerry, 589

SAM sites in North Vietnam Shyab, Charlie, 289-90, 400 and broad RoE, 595-97 Sianis, Pete, 659 improved weaponry, 594-95, 606, Simpson, Howard, 25, 131, 210-11 620, 653-56, 658-61 Si (Nguyen Quoc Si), 680, 722, 732, 733 and Rolling Thunder, 332, 335, 339, Smith, Neil, 277, 533, 535, 539-40, 345, 347, 349-50, 353, 356-57 540 - 41Russian technicians and advisers, Smith, Ray, 612-13 364-67, 371 Smith, Walter Bedell "Beadle," 84, 85, Scanlon, Jim, 162 86, 88 Schlesinger, Arthur, 169, 486, 551 Smothers Brothers Comedy Hour (CBS Schlesiona, Peter, 493 TV), 379 Scotton, Frank Snepp, Frank, 188-89, 351, 415-16, 526, biographical info, 132-34 564-66, 570-71, 581, 693, 696, on Buddhist crisis, 167 708-9, 713, 727 on different perceptions of the Snider, Don, 185-86 Vietnam War, 746 SOE-Britain (Special Operations on murdering Diem, 179 Executive), 11 roaming the countryside, 136 Sorley, Lewis, 571, 572 on Vietnamese culture, 300 Sorrow of War, The (Bao Ninh), 422-23 in Vietnamese village with VC, 188 South Korean troops in South Vietnam, on winning the war, 283, 386-87 276 scout dogs, 396 South Vietnam Second Indochina War, 121-22, 479-80. overview, 98 See also Vietnam War becoming a showcase for the free Seeger, Pete, 379 world, 105 self-immolations, public, 168, 318 Caravelle Manifesto, 124-25 Senegalese soldiers fighting for France, chaos created by successive coups, 199, 68 206, 231-32, 248-49 Shackley, Ted, 575 constitution for, 205 Shank, Edwin "Jerry," 157 corruption leading to deterioration of Sheehan, Neil the social order, 114-16, 119-20 enjoying Vietnam, 155-56 detainees die of food poisoning, 119 on government in South Vietnam, economy of, 109-10 178, 321, 599 exodus from, during grace period, loading corpses, 158-59 104 on McNamara, 146 life in, 105-6, 112-13, 114 newspapers advise VC of US troop on the Saigon press corps, 158-59 at Tua Hai, Tay Ninh Province, locations, 250-51 163 - 65North Vietnam and VC flags raised on Vann, 624-25 in, 678 on Vietnam War, 743, 745, 747 North Vietnam compared to, 95 and Westmoreland, 253, 323 North Vietnam military delegation Shotgun Operation, 321-22 arrives in, 675-76

South Vietnam (cont.) Stennis subcommittee demand for air NVA troops arriving en masse, escalation, 338 676-77 Stephens, Mel, 571-72 ravages of war, 414-17 Stevens, Jim, 490 security force atrocities, 153 Stockdale, James, 376 ten thousand undercover Vietminh Strategic Air Command (SAC), 593-94 in. 104 Strauss, William, 384 US bombing in, 330 suicide bombers, 444 US not allowing invasion of the suicides in South Vietnam after takeover North, 200 by NVA, 724, 734-35 See also ARVN; coups suicides of ARVN officers, 704 Souvanna Phouma, Prince, 129-30 Sullivan, George, 407 Soviets Sullivan, Gordon, 147-48, 168-69, 187, aid and advisers for North Vietnam. 268 Sully, François, 158 120, 280, 364-71, 598-99 and China, 120, 369-70 Sutherland, Alexander "Jock," 576, encouraging US-North Vietnam 577-78 peace talks, 511 Sutton, Mike, 297, 430 fear of nuclear war, 140-41 Sympathizer, The (Nguyen Viet Than), gathering the spoils of war from South 736 Vietnamese, 731 and Le Duan, 194, 242 Tang (Truong Nhu Tang) materiel shipments to Laos, 129 on B-52 bomber attacks, 428-29 Nixon's and Kissinger's beliefs about, biographical info, 111, 415, 425, 552, 598-99 427-28, 563 offering financial support to on communist executions, 101 Humphrey, 511-12 on communist manipulation of providing antiaircraft missiles, 331 Western media, 742 US belief in their control of North and Ho, 17-18 Vietnam, 254 and liberation of South Vietnam, 727 Special Forces. See United States Army on Nixon's "Cambodian adventure," Special Forces 560 Special Operations Executive on Saigon government, 240-41 (SOE-Britain), 11 in Saigon prison, 415-16 seeing his brothers in a prison camp, speculation about different results, 740-41, 742-43, 748-49, 751 Speedy, Jack, 458, 459 on South Vietnam losing the war, 636, Speedy Express Operation, 518 727 Spencer, Jimmie, 268, 274, 287 on Thieu, 713 Spilberg, Paul, 586, 590 Tan Son Nhut Air Base, Saigon, 216, 387 Stalinism, 13, 101, 103, 125, 182, Task Force Bayard, 30 421-22 Tate, Clyde, 591-92 Stennis, John, 465 Ta Vinh, 315-16

Taylor, Maxwell "Max" time differences in North vs. South, appointment as ambassador, 209 fact-finding mission in Vietnam, VC activation, 444-45, 447-48 174-75 VC withdrawal, 469 as JCS chair, 201-2 Tet Offensive III, 513 on politicking of Armed Forces Thai Nguyen ironworks, 336 Council, 231 Thai soldiers in Vietnam, 61, 78, 533 replacing with Lodge, 258 Thanh Giang, 423 on Rolling Thunder, 330 Thanh Hai, 152 on taking the fight to the North, 226 Thanh Hoa rail bridge, 356 on US troops in Vietnam, 136-37, Thanh (Nguyen Chi Thanh), 223, 246, 247, 249, 263 435-36 television, effect of war images on, xx-Thick Quang Duc's self-immolation, 168 Thieu (Nguyen Van Thieu) Templer, Gerald, 28-29 overview, 713-14 Tenney, Joe, 399, 405 Abrams appeal for Lam Son 719 terror attacks during war with France, 22 support, 578 Tet Offensive commandant at Dalat Military American media reports on, 464-65, Academy, 138-39 468-69, 470-71, 483-84 conversion to Catholicism, 110 Americans failure to anticipate the denouncing Kissinger's deal with North Vietnam, 644 scope, 448-49 ARVN captures tapes announcing the dilemma after Paris Accords take operation, 444 effect, 677-78 attacks on Saigon, 455-60, 462-64, dominating North Vietnamese 469-70 politics, 245-46 devastation from, 482-84 elections, 319-20 genesis of, 390 as head of state, 253 Hue attacks, 448-53, 474-76, increasing importance of, 226-27 478 - 80and NVA's final assault, 691, 693-94 Khe Sanh distraction, 440-43 on peace settlement, 647 LBJ's post-Tet speech, 485-87 post-Paris Accords ineffectiveness, losses, 473 681-82, 683 as puppet of US, 320-21 MACV post-Tet chaos, 463-64 MACV response, 465-68 refusing the Paris deal, 648-49 map of, 446 running unopposed for president, NVA and VC losses, 471-74, 480-82 objective, 437-38 Sorley on integrity of, 572 plans and preparations, 434-39, 481 Thi (Nguyen Chanh Thi), 317, 318 results, 461-62, 487 Tho, Phung Bat, 703 seizure of Pueblo, 439-40 Thompson, Robert, 144, 476 successes, 453-60 Thompson, Wayne, 375 suicide bombers, 444 Thoms, Bob, 476

850 · INDEX

attack on Vietcong at Ap Bac, 159-66

complacency in corruption, 313-14

cultural faux pas, 280

debate about advisory role vs. combat Thomson, James, 245 Thorne, Christopher, 259 units, 136-38, 232-33 Thorne, Landon, 522-24, 529 détente with China, 598-99 Ticonderoga (carrier), 216, 217, 220, 354 and Diem, 109, 112-14, 170-71, Times of London (newspaper), 181, 254 173-200 Tokyo. See Japan disrespect for France, 76-77 escalation of conflict in Vietnam, Tomalin, Nicholas "Nick," xxi Tompkins, Rathvon McClure, 509-10 204, 242, 244, 259-65, 270-71, Tonkin Gulf, 71, 219-20, 222, 224, 342 326 - 27Tonkin Gulf Resolution, 221, 483 failing to consider Vietnamese people, totalitarianism's need for enemies, 99 88, 141-42, 247, 280, 305, 318-20, Total Victory (war history), 739 321-22, 323-26 Tozer, Eliot, 376 fighting a lost cause, refusing to Tran Bach Dang, 455, 465-66, 469, 487 surrender, 487, 512 Tran Do, 448 financial support for France's Tran Hoi, 97, 179, 429-30, 712 occupation and war, 16-17, 32-36, Tran Ngoc Hue, 450, 576, 579-80 54-55, 63, 66-67, 81 Tran Quy Hai, 216, 222-23 financial support for Laos, 127-28 Tran Tan, 461 financial support for South Vietnam, Tran Thien Khiem, 199 107, 109-10, 112-13, 131 Tran Trong Trung, 80 and Geneva Accords, 143-44 Tran Van De, 462-63 at Geneva Conference, 83, 85, 86 Tran Van Huong, 227, 241 Great Society legislation, 224 Tran Van Tra, 690-91 impact in Vietnam, 137-41 Trenet, Charles, 21 international diplomacy, 112-13 marriage to Vietnamese woman, 134 Truman, Harry S., 33 Trump, Donald, 383, 384 mismatch with South Vietnam, 320 Truong Huy San, 751-52 No Committee on bombing missions, Truong Mealy, 153 336 - 37Truong Nhu Tang. See Tang policies (See United States policies) truth determined by politburo in North speculation about different results, Vietnam, 101 740-41, 742-43, 748-49, 751 Tuat (Dao An Tuat), 558 strategy conference, 210-11, 212 Turley, Gerry, 410, 606, 607-9, 612, 678 Truman doctrine injustices, 33 Turner Joy (destroyer), 217-18 See also Americans 24 Hours (BBC TV), xix United States Air Force overview, 252-53, 306 United States aircraft, 331, 340-42, 347, 351-56 asking Britain to support French war B-52 bombers, 255, 428-29, 472, 615, in Vietnam, 74-76 616, 650-56

Basic Doctrine Manual, 357

374-76

civilian deaths in South Vietnam,

"Cruise widows," 660-61 nurses (women) in camp with soldiers, morale of flight crews, 356-57 271 pilots captured, 348, 350-51, 366, NVA attack of newly-arrived soldiers, 381, 659-60 283-86 pilots' experience levels, 351-52 OPLAN34-A, 213-14 pilots rescued, 354-56 patriots serving in, 386 pilots walk out on Gen. Meyer, perception of Vietnamese, 151-52, 661-62 210 - 11promiscuously broadcast ordnance, "pinned down," 399, 401 322 - 23proving a kill, 299-300 racism in soldiers, 158-59, 277 rejects ARVN requests for air support, rape and murder charges, 301-2 251 - 52removal of psychological aversion to retribution against innocent civilians, killing, 329 305 Rolling Thunder aircraft and scout dogs, 396-97 scouts, 396 responsibilities, 340-41, 351-56 VC analysis of activities, 292 soldier assignments, 289-90, 405-6 See also Rolling Thunder Operation soldiers recognize war is unwinnable, United States Air Force, MAJOR 514-15 UNITS South Vietnam newspapers advise VC of US troop locations, 250-51 335th Tactical Fighter Wing, 331 Seventh Air Force, 325, 332-33, 334, strategies, 292-93, 329-30, 514 573-74, 594-96, 663 successes, 389 United States Army support for South Vietnam, 124-25 air assault onto a hot landing zone, Tet Offensive response, 452 395-96 troops go to South Vietnam, 246-50, and booby traps, 302-5, 397 253-55, 257, 263 desertions from, 248-49, 430-31, and Vietnamese villagers, 274, 275, 473, 529, 661 301 - 2digging foxholes, 402-3 weaponry, 398, 406-11, 489-90 erroneous methods and expectations, weight carried by soldiers, 393, 401 See also bombers and bombing; 271 - 74fragging, 528-29, 531, 542, 587 helicopters, mainly "Hueys"; infantry action, 310-11 helicopters "Hueys"; Westmoreland, infantryman's experience, 393-97, William United States Army Air Force (USAAF), 398-406, 409-10 infantry's contempt for commanders, 12, 376 399-400 United States Army BATTALIONS M16s, 398, 406, 408-11, 499, 502, 1/7th Cavalry, 284-86, 408 506-8, 731 1/9th Cavalry, 303 Military Mission, 107-10 1/20th Infantry, 519 My Lai massacre, 518-21, 585, 744 1/26th Infantry, 387 night patrols, 405 1/46th Infantry, 585-93

United States Army BATTALIONS (cont.) A Teams, 139, 190, 290-91, 297-98 2/7th Cavalry, 284-85 VC attack at Pleiku, 242-43 2/12 Cavalry, 453-54 United States Marine Corps 2/18th Infantry, 310-11 overview, 491-92, 522 2/27th Infantry, 304 assignments, 290 3/5th Cavalry, 462 atrocities by, 274, 275, 301-2, 474-75 battalions sent to Vietnam, 249-50 4/3rd Infantry, 520 4/21st Infantry, 561 blowing up Dong Ha Bridge, 610-11 716th MP Battalion, 457, 458 and booby traps, 302-3 United States Army BRIGADE, 173rd career Marine Al Gray, 135-36, 190 Airborne, 246, 292, 599 casualties, 273-74, 306-7, 333, 399, United States Army CORPS 452, 478 II Field Force, 443, 463, 518 combating NVA divisions in DMZ, XXIV Corps, 576 490-91, 492-500, 502-10 United States Army DIVISIONS deserters, 313-14 1st Cavalry, 253, 283-86, 289, in Dominican Republic, 264 292, 295-96, 402, 411, 418, fragging, 528-29 469-70 friendly fire, 300-301 1st Infantry, 576 in Hue, 475-76, 478, 479 9th, 388-89, 514, 518, 684 and K-9s, 396-97 at Khe Sanh, 440-42, 470, 471-74, 23rd Americal, 518-20, 585 25th, 304, 387, 564, 571 482 82nd Airborne, 264 and M16s, 408, 409-11 101st Airborne, 307, 388-89, 404, on Neville hilltop, 522-25 Operation Starlight, 272-73 522, 529, 553 502nd Airborne, 458-59 refusing combat and/or resigning, United States Army REGIMENTS 585, 607 3rd Infantry, 520 and South Vietnamese, 275, 474 5th Cavalry, 462 "strategic-hamlets" program, 131 7th Cavalry, 284-86, 408 support for taking the war to the 9th Cavalry, 303, 391 enemy, 201, 212, 226, 261 11th Armored Cavalry, 489-90 telegrams to families of the dead, 12th Cavalry, 453 512-13 18th Infantry, 310-11 and Tet Offensive, 466 20th Infantry, 519-20 tightening discipline, 531 21st Infantry, 561 training, 299 26th Infantry, 387 unrealistic orders, 452-53 27th Infantry, 304 and US base at Danang, 246-47, 46th Infantry, 585 293 United States Army Special Forces and VC attack on US Embassy, (Green Berets) 456-59 See also Boomer, Walt; helicopters, camps, 242-43, 283-86, 295, mainly "Hueys" 297-98, 471

United States Marine Corps See also individual branches of the **BATTALIONS** military 1/3rd, 273-74 United States military advisers 1/4th, 522, 523-24 overview, 125, 275-76 1/5th, 466, 485 and ARVN, 131, 138-40, 193-94 1/9th, 290 Britain's protests as number increases, 2/3rd, 409-10 143 - 442/4th, 491-94, 496-98, 504, 507-10 at Camp Carroll, 611-13 3/3rd, 272-73, 275-76 cultural clashes with Vietnamese, 3/9th, 246 138-40, 298 United States Marine Corps debate about advisory role vs. combat REGIMENTS units, 136-38, 232-33 1st, 452, 497-500, 502 delivering medicine in Mekong Delta, 3rd, 272-74, 275-76, 409-10 147 - 484th, 491-94, 496-98, 504, 507-10, forging relationships with locals, 522, 523-24 185-89 9th, 246, 290 on killing VC POWs, 468 United States military in North Vietnam, 93 overview, 392-93, 743 rotating out when trained, 276 advisers (See United States military United States military casualties advisers) overview, 310-11, 333, 517, 670 atrocities, 153, 274, 275, 301-2, 468, 33rd Ranger Battalion, 250 474-75, 518-21, 585, 744 dying in the hospital, 307-8 black soldiers and racism, 526, electronic eavesdroppers, on FSB 528-32, 529-30 Sarge, 612 black soldiers as heroes, 268, 299in Hue, 478 300, 302, 304, 347-51, 384-85, at Ia Drang, 285-86 396, 530 from malfunctioning M16s, 409-10, and Bob Hope's Christmas show, 286 499, 502, 506-7 camp amenities, 271, 289, 485, 547, in Operation Apache Snow, 553 650 at Pleiku, 242-43 casualties (See United States military statistics discounting societal reasons casualties) for, 384-85 changes in Vietnam related to, Tet Offensive, 481 189 - 93United States Navy cultural clashes, 130-31, 138-40, 148 aircraft and carriers, 216, 217, 220, the draft and draft dodgers, 381-82, 340-42, 341-48, 354 383-85, 522 Rolling Thunder aircraft and aircraft drug abuse, racial strife, and decline of carriers, 340, 341-48 discipline, 526-32, 585-87, 591-92 SEAL Swift Boat patrols and electronic eavesdropping, 189, 215, massacres, 566-70 218 Walleye TV-guided bombs, 336, 356, nurses (women) in, 271 367

United States Navy VESSELS US Military Assistance Command Vietnam, See MACV Boxer, 71 Constellation, 78, 220 Enterprise, 342 Vampatella, Phil, 346-47 Essex, 71 Vang Pao, 128 Vanguard Youth, 15-16 Forrestal, 342, 343-44 Hancock, 346 Van Ky, 9-10, 40-41, 80 Vann, John Paul, 159-66, 187, 388, 583, Henrico, 246 Independence, 342 613, 617 Iwo Jima, 493, 496-97 Van Tien Dung, 435, 606, 691, 692, 702-3, 708, 715 Kittyhawk, 246 Maddox, 215-17, 218-19, 221, 222 Vanusem, Paul, 43 Vargas, Jay, 493, 499-500, 502-3, Midway, 717-18 Oriskany, 343 502-4, 505, 508 VC. See Vietcong Pueblo, 439-40 Ticonderoga, 216, 217, 220, 354 Vecchio, John Del, 404 Turner Joy, 217-18 Very Private War, A (Hawkridge), 314 United States policies Vien (Bay Vien), 108, 109 overview, 10-11, 146-48 Vien (bugler), 1-2 Vientiane, Laos, 128 bombing policy, 322-26, 330 debates on taking the fight to the Vietcong (VC/Vietnamese Communists) overview, 195-96 North, 226, 227-30 to defend South Vietnam, Laos, and atrocities, 122-23, 296-97, 467-68, Cambodia, 86-87 479 attacking US special forces camps, and Diem, 109, 112-14, 170-71, 242-43, 283-86, 298 173 - 80capturing Americans, 294 military vs. diplomatic response to crises, 34 casualties, 226, 295, 311 no strikes allowed into North COSVN orders Tet Offensive III, 513 Vietnam, 200, 203-4, 333 and Diem's corruption, 116, 119-20 effect of Resolution 9, 194-95 OPLAN34-A covert missions, 213 - 14escalation of attacks, 121-24, 234, troops restricted from entering Laos fighting massive numbers of American and Cambodia, 521-22 troops, 272 Urban, Doug, 498 US. See entries beginning with "United gentleman's agreement with ARVN, States" guerrilla warfare, 282, 292 USAID report on corruption, 313 Hate America Month, 319 US Embassy, Saigon, 108, 456-57 homegrown vs. foreign US Information Agency (USIA), encouragement, 125-26 133-34, 226-27, 259, 269, 478 and NVA, 291-92 "US Insists Hanoi Pull Back Troops"

(Los Angeles Times), 647

Pleiku raid, 242-43

post-Tet Offensive funk, 479-80 strategies, 292, 293 terrorist attacks, 120-25 Tet Offensive losses, 471-74, 480-82 US attack at Ap Bac, 159-66 US influence on consumers, 278-79 weaponry, 151, 153, 160 See also National Liberation Front; Tet Offensive Vietminh (Vietnam Independence League) overview, 38 advantage from freedom to act without scrutiny, 31-32 austerity as propaganda, 28-29 and British troops, 14 Chinese backing, 14-15, 26, 43, 48, 82, 85-86, 87 and Chinese troops, 15 death squads and people's court, 39-40, 43 declaring independence, 11-12, 15 French crackdown on, 19-20 and Geneva Conference, 83-84, 87-88, 91 at Geneva Conference, 83 Ho becomes leader, 7-8 land redistribution as motivation. 38-40, 49, 73-74 in Laos, 43 malaria endemic to, 73-74 migrating to North Vietnam after Geneva Accords, 104 returnees to the south, 151 ruthless about human lives, 13, 38-40 sapping French strength with multiple fronts, 51-52, 66 siege of Dienbienphu, 53-65 siege of Dienbienphu preparations, suppression of opposition groups, 15-16 ten thousand stay undercover in South Vietnam, 104

victory march into Hanoi, 92-93 Vietnamese resistance to, 36-44 weaponry, 19, 43, 48, 50, 62, 78 See also France's Vietnam War Vietnam overview, xvii, xviii, 2, 290-91 deterioration of cease fire, 680 as dumping ground for US consumer goods, 391 New Economic Zones, 733 partition discussions and enactment, 84-88, 89, 90, 92, 95 post-Tet devastation, 478, 482-84 Rival Areas of Control, January 1973, speculation about JFK's plans, 180, tourist experiences, 3 See also defoliation program Vietnamese acts of bravery, 279 defoliation of peasants' crops, 325 effect of US escalation, 270-71 families burying loved ones, 153, 488 family ties between North and South, 277 mismatch with US, 320 pragmatism of, 415-16 resistance to occupations, 5-8, 9-10 resistance to Vietminh, 36-44 soldiers fighting for France, 61, 81 terrorized woman's allegory, 191-92 Vietnamese culture, 36-38, 280, 300. See also Buddhists; Catholic Vietnamese Vietnamese Liberation Army Propaganda Unit, 11 Vietnam Independence League. See Vietminh Vietnamization, 29, 552-53, 561, 573-75, 581, 592, 601-2, 642

Vietnam Memorial, Washington, DC,

745

Wallace, Mike, 465 Vietnam War overview, xxii-xxiii, 154, 157, 288-91 Walleye TV-guided bombs, 336, 356, allied nations sending troops, 276 - 77Wall Street Journal, 468, 483 American antiwar protesters, 250, Walrath, Brian, 544 379-85, 386 Walt, Lew, 409 "War Just Doesn't Add Up, The" booby traps, 302-5, 397 (Harwood), 391 as circular movement costing lives, Warner, Denis, 145 warniks, 386-92 Congressional authority for, 221 friendly fire, 300-302, 322-23, Warnke, Paul, 247-48 Warrren, George "Fritz," 499 importance of body count, 388-89, wars, xx-xxi. See also specific wars Washington Post, 169 393, 492, 508 Kennedy years, 130, 131-32, Weir, Stuart, 537 136 - 39Weise, Bill, 491-92, 493, 494-500, LBJ's illusions about, 244-45 502-10 My Lai massacre, 518-21, 585, 744 Wendt, Allan, 457, 459 North's advantages, xxii West, Richard, 432, 711 peace negotiations, 339, 510-15, Westerman, Bill, 354-55 603-4, 640-42 Westin, Andy, 474 potential for peace negotiations, Westin, Brian, 354-55 183-84, 358 Westmoreland, William and Australian kill scores, 536 respite for national holidays, 360 biographical info, 209-10 US atrocities, 153, 274, 275, 301-2, 468, 474-75, 518-21, 585, 744 on civilian casualties, 322-23 US casualties, 121-22, 745 criticizing Marines after battle for Hue, 479 US expenditures, 326-27, 376-77, LBJ's loss of faith in, 465 517, 745 US's best chance for nonhumiliating lying about success in Vietnam, 211, exit, 207 230, 411-12 US soldiers recognize war is post-Tet Offensive response, 469 request for 206,000 soldiers post-Tet, unwinnable, 514-15 warniks, 386-92 world view cartoons, 260 response to VC attack on US Embassy See also civilian casualties; France's in Saigon, 459-60 Vietnam War and Tet Offensive, 438-39, 442, Vietnam War, The (Burns and Novick), 452 - 53and troops in South Vietnam, 249-50, xxiii Vinh (Ta Vinh), 315-16 253, 254-55, 257, 286, 387 on US superiority, 326-27 Vo Nguyen Giap. See Giap Weyand, Fred, 146, 187, 328, 387-88, Voros, Ed, 585-86 443, 469, 483, 593 Vu Quang Hien, 685

Wheeler, Earle, 209, 257–58, 377–78, 390, 482
White, Theodore, 208, 224, 648
Wildfang, Henry, 441–42
Willcox, William, 276
Williams, Harry, 189, 190
Williams, Jim, 392, 393–94, 491, 494, 496–97
Williams, Sam, 125

Wilson, Harold, 471
Wilson, Woodrow, 6
Winning Side, The (Truong Huy San),
751–52

Woodley, Arthur "Gene," 289, 532 Woolridge, William, 314 World War II

overview, xvii–xviii bombs dropped on Japan in last six months, 376 comparing North Vietnam to Russia, xxii French in Vietnam seeking to atone for, 69 and Vietnamese independence, 11–12 Wright, John, 290 Wyndham, Norman, 543

Xa Loi Temple, 169 Xuan Loc, *706* Xuan Thuy, 510–11

York, Robert, 163 Young, Gary, 484 Young, Gavin, 225, 711

Zalipsky, Pyotr, 365–66, 369 Zhou Enlai, 83, 87–88, 91, 150, 223–24, 603

ABOUT THE AUTHOR

Max Hastings chronicles Vietnam with the benefit of vivid personal memories: first of reporting in 1967–68 from the United States, where he encountered many of the war's decision makers, including President Lyndon Johnson; then of successive assignments in Indochina for newspapers and BBC TV. He rode a helicopter out of the US Saigon embassy compound during the 1975 final evacuation. He is the author of twenty-six books, most about conflict, and between 1986 and 2002 served as editor in chief of the *Daily Telegraph*, then as editor of the *Evening Standard*. He has won many prizes both for journalism and his books, which include *All Hell Let Loose*, *Catastrophe*, and *The Secret War*, all of them bestsellers translated around the world. He has two grown children, Charlotte and Harry, and lives with his wife, Penny, in West Berkshire, England, where they garden enthusiastically.